# WARHOL

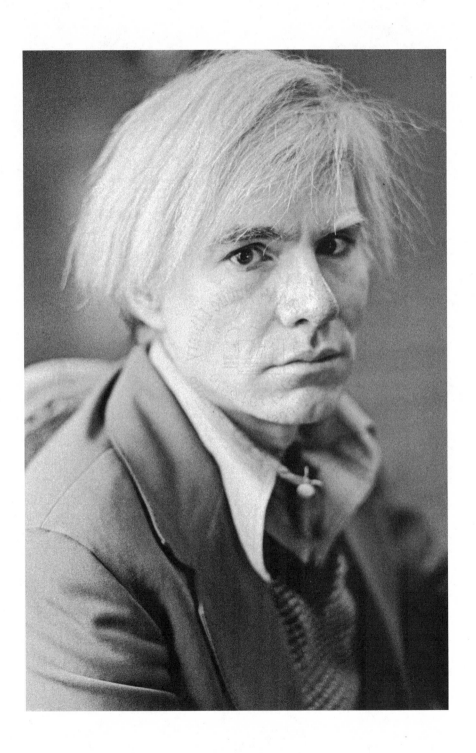

# WARHOL

## BLAKE GOPNIK

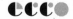

*An Imprint of* HarperCollins*Publishers*

FIRST EDITION

*Designed by Suet Yee Chong*

Library of Congress Cataloging-in-Publication Data has been applied for.

ISBN 978-0-06-229839-3

20 21 22 23 24   LSC   10 9 8 7 6 5 4 3 2 1

To Lucy Hogg,
without whom this book—and its author—would barely exist.

And in memory of Matt Wrbican,
a lost mother lode of all things Warholian.
He wanted this book to be . . . longer.

# CONTENTS

# WARHOL

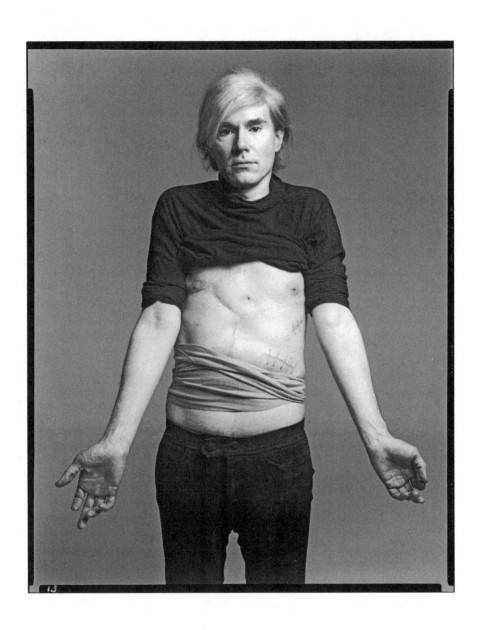

*Warhol showing the scars from his shooting.*

# PRELUDE

## DEATH

Andy Warhol died, for the first time, at 4:51 P.M. on the third of June 1968. Or that was the grim verdict of the interns and residents in the emergency room of Columbus Hospital in New York. Some twenty minutes earlier, the artist had been shot by Valerie Solanas, a troubled hanger-on at his famous studio, the Factory, which had recently moved to a new spot on Union Square. During the time it took for the ambulance to arrive, Warhol slowly bled to death. Once the patient was dropped at the hospital, a few blocks away, the young doctors in the E.R. couldn't find a pulse. There was no blood pressure to speak of. The patient's color was newsprint tinged with blue. By any normal measure, this thirty-nine-year-old Caucasian, five foot eight, 145 pounds, was D.O.A.

At the moment that the dead-ish victim was being wheeled in on his gurney, a gifted private-practice surgeon named Giuseppe Rossi, forty years old, was checking on a patient recovering in the intensive care unit. He heard the page on the P.A. and rushed to emergency to see if he was needed. As his juniors filled him in on the case, he reached out to make one final check on the fresh corpse where it lay unmoving, eyes closed, soaking the gurney in blood. He lifted an eyelid and watched as a still-living pupil contracted in the glare of hospital lights. There was work to be done.

Rossi rushed to figure out why his patient, who he took for one of Union Square's tramps, had gone into deep shock. He found the tidy entry wound of a single bullet on Warhol's right side, about midway down his chest, and furious bleeding from a ragged exit in his back on the left. The doctors installed a chest tube to deal with a collapsing right lung, pushed a breathing tube down Warhol's windpipe, started pumping in oxygen, called for blood and sped their patient along corridors and on up in the elevator to get to the operating room before he died.

Warhol was lucky in having Rossi for his doctor that day. The surgeon had immigrated from Italy after the war, when an expanding American medical system let him get training in the new field of open-heart surgery.

Since it could still be hard for a foreigner like Rossi to get a staff position, he found gigs in emergency rooms all over New York—including in Harlem, where he saw plenty of gunshot wounds. Years before hospitals had trauma specialists, by pure chance Warhol had ended up in the hands of a highly trained thoracic surgeon who knew all about bullets.

Residents sliced into the veins in Warhol's elbows, pushing in tubes for fluids and blood; they left scars that could have passed for stigmata in the arms of this lifelong churchgoer. Without wasting time on the usual five-minute hand wash, Rossi raced to find the source of the bleeding that was about to turn the body in front of him into a cadaver. He cut open Warhol's left chest—the first tissues he sliced through were too drained to bleed—and found a nasty rip in the bottom lobe of the lung; a huge metal clamp took care of that for the moment. Even as Rossi worked the anesthetist declared a cardiac arrest. Rossi cut open the sac around Warhol's heart, untouched by the bullet, and massaged the organ by hand. Death averted, once again.

Now Rossi cut into Warhol's right side, slicing from near the entry wound almost to the breastbone as he hunted for damage. Stories have been told of three or four bullets piercing Warhol's body, or of the lead from a single slug ricocheting inside his torso like some hellish pinball game, but Rossi found that a single slug had punched straight through the dying man. He saw where it had nicked the inferior vena cava, a garden-hose vein in the middle of the body that feeds blood from the legs back up to the heart, and that a clot had formed there that was keeping Warhol from instantly bleeding out. Making a new slice into the dying man's chest, down to the bottom of the breastbone then deep through Warhol's abs and straight toward his belly button, Rossi ratcheted the mess open with a steel retractor to get a clear look at the damage. "I'd never seen so much blood in my life," recalled Maurizio Daliana, the chief surgical resident at the time.

Rossi found more destruction: two holes in the arc of the diaphragm muscle, pierced both right and left as the bullet crossed through Warhol's body; an esophagus severed from the stomach, so that food and gastric acid were spilling out from below; a liver whose left lobe was mashed and bleeding and a spleen utterly destroyed and spilling more blood than any of the other organs. Solanas's bullet had also cut a ragged hole in Warhol's intestines, releasing feces and upping the chances of fatal infection.

What was left of the spleen had to go while the liver's injured lobe was also a hopeless case. Rossi used huge stitches to seal it off from the bulk of the organ so it could be sliced away without losing more blood, which was still flowing into Warhol as a transfusion and out again through the new holes in

his body. By the end of the operation, he'd received twelve units of blood; a body without leaks normally holds ten.

Just as things were getting under control, the O.R. was thrown into turmoil again by a visit from the hospital's top doctors. They told the surgeons that the man whose life they had better be saving was the superstar artist Andy Warhol—the very man who had made the term "superstar" famous—and a crowd of reporters and groupies was waiting downstairs. "He cannot die," said the visitors.

Rossi had barely heard of the artist or his antics.

He returned to the open body and took on the tricky repairs that remained. He tackled the oozing intestines, cutting out the damaged part and stitching together the clean ends. Then there was the severed esophagus to reattach, the most finicky procedure that evening. Rossi had to use the finest silk sutures and make sure the connection to the stomach was perfect. Any misalignment or excess scarring might have left Warhol in misery, unable to swallow properly. He did in fact go on to have trouble eating, remembered one doctor friend.

Exhausted from a long and tense operation, Rossi inserted all the standard tubes for drainage and closed up the body whose innards he had gotten to know. For convenience and safety—and maybe because he wasn't at all sure his patient would live to care—Rossi used huge stitches that gave Warhol's torso a network of Frankenstein scars. He showed them off for years to come.

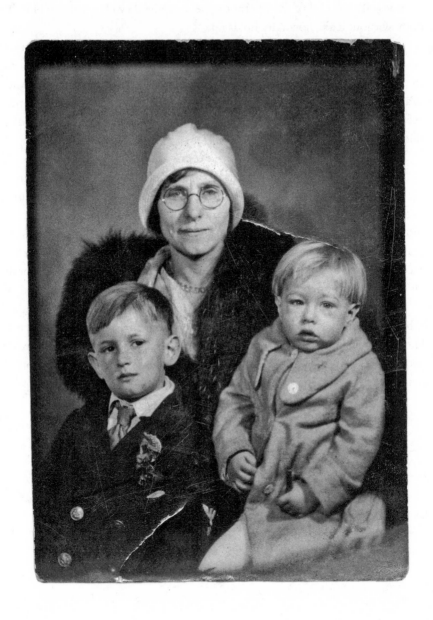

*. . . with Julia Warhola and big brother John.*

# 1928–1934

*"The worst place I have ever been in my life"*

Andy Warhol—or rather Andrew Warhola—was born on the sixth of August 1928, in a grim little flat on Orr Street, in Pittsburgh's Soho neighborhood, on a middling-hot day under overcast skies.

Andy's eldest brother Paul, who was born in the same room six years earlier, told the story that he'd heard his mother's screams "and then somebody said, 'It's half past five'"—although whether that was morning or evening has never been clear. Depending on who you believe, either a doctor or a midwife was in attendance.

Warhol's father was also Andrew (born Andrej or Andrii), a Slav who became an American a few months before his namesake was born.

Andrej was a laborer, like the thousands who worked in the Jones and Laughlin steel mill, a few steps down the hill on the shores of the toxic Monongahela River. He worked there before he went into heavy construction, when he traveled widely for a firm that moved buildings on rollers. It seems he would always have preferred the "easier," indoor, more settled life of a millworker, but somehow couldn't manage it. Although he was only five feet five inches tall he weighed 185 pounds and people remarked on his massive arms. A little after Warhol's birth, Andrej—likewise always known as "Andy," which was even how he signed his will—had his gallbladder removed, without complete success according to his son Paul. Six decades later, Andy Jr. would die after the same operation.

The screaming young mother was named Julia. She was thirty-six years old, an immigrant housewife with almost no English and a husband and three boys to tend: A middle son named John was three years older than Andy. For weeks or even months at a time her husband would live on construction sites across several states. A 1930 photo shows him and his work crew in

Indianapolis, shifting a 12,000-ton building that was still occupied. Julia was a sort of work widow—when things were going well. With the arrival of the Great Depression in 1929, there were times when Andrej had no work at all and Julia cleaned houses and sold crafts door to door. According to one story Warhol told, their soup wasn't Campbell's. It was made from water, salt, pepper and ketchup—Heinz brand, of course, a signature Pittsburgh product produced by a family that became patrons of the artist.

The Orr Street "apartment" was two rooms on the second floor of a tiny wooden row house. The walls were "just wooden panels going across—not even panels, just slats," one neighbor remembered. There was only cold water to wash in and the toilet was an outhouse in the alley—not a special indignity in the Warholas' world, but it couldn't have been fun in winter. A bit earlier, a Pittsburgh reformer's study of the Soho neighborhood had voiced contempt for its "insanitary, disease breeding vaults without sewer connection, ever ready to spread contamination and endanger the health of the neighborhood" and had described its houses as "veritable fire traps." In 1922, the year Paul Warhola was born, a newly published history of the city was describing the neighborhood's housing as "old and not attractive . . . populated by foreign mill workers and their families."

Within two years of Warhol's birth the Warholas had moved twice, ending up just down the street, and a touch up the ladder, in a four-room flat with a potbellied stove, a galvanized hip bath and an indoor but unplumbed toilet. The three boys slept in one bed, "but you didn't feel you were poor, because everybody else lived the same way," recalled John Warhola. They shared that house on Beelen Street with another family and paid $18 a month for the privilege, about a quarter of their monthly income.

The Pittsburgh that Andy Warhol grew up in wasn't just an example of blue-collar America. It was *the* archetype of that life and its struggles. In 1914, a charitable organization called the Russell Sage Foundation finished publishing *The Pittsburgh Survey*, whose six massive volumes contained the nation's first notable example of systematic urban sociology. The *Survey* became famous worldwide and made the city it treated famous, too, as a potential site of industrial progress and an actual site of hardship. As H. L. Mencken put it, in a famous essay written not long before Warhol was born, "Here was wealth beyond computation, almost beyond imagination—and here were human habitations so abominable that they would have disgraced a race of alley cats."

In American culture, being from Pittsburgh and working class was a distinctly "marked" condition, like being from Los Angeles and in movies. And for all his adult life Warhol did more to escape his clinging roots, or

obscure them, than to exploit or explore them. In 1949, when Warhol had just arrived in New York, a magazine editor asked him for a potted biography. Warhol gave him almost nothing: "My life wouldn't fill a penny postcard. I was born in Pittsburgh in 1928, like everybody else in a steel mill," he wrote, getting the steeler cliché out of the way even though it didn't quite apply to him, given a father who actually worked on faraway building sites. Yet that vita was a high point of self-revelation. Once he'd truly made it in New York, Warhol's story got even vaguer: He was born in 1929, or maybe '30, or even '33—he lied about his age even to his doctor—in toney Philadelphia or Newport, Rhode Island, or in humble Forest City or McKeesport, Pennsylvania. Over Warhol's thirty-eight years in New York, he barely returned a handful of times to his hometown, "the worst place I have ever been in my life," as he described it; he once reminisced with a college classmate about how the smog would turn a white shirt black by the end of the day. "I never give my background, and anyway, I make it all up different every time I'm asked," Warhol once admitted—more or less, in an interview in which his words were rearranged and sometimes made up. By '65, he'd told *Who's Who* that he was born in Cleveland to the aristocratic—and fictional—"von Warhols." Two years later, a Warhol scholar threw up his hands: "It is generally believed that he was born sometime between July 27 and August 17 and that he is somewhere between 39 and 47." The confusion lasted into the '90s.

Warhol's Pop Art is sometimes described as a celebration of his lowly origins—many of the other Popsters were more middle class—but it's just as much about moving up from those roots. His actual childhood didn't involve supermarket tuna, cans of Campbell's Soup or any of the other shiny brands of Eisenhower America that Warhol later showed in his art—before World War II, those were still products targeted at the elites. (It was only in the early 1960s, when Warhol was riffing on these brands, that the working class was being coaxed to buy them.) A 1930s neighbor of the Warholas, still living in her childhood home in 2015, didn't remember any canned goods of any kind in her mother's kitchen, even though their family was relatively prosperous. "Canning," she said, meant putting up your own vegetables in glass jars.

Julia cooked with crude utensils handcrafted by Andrej, and when the Warholas could afford better than watered-down ketchup their soup was immigrant fare, made by Julia herself, almost daily, from homegrown tomatoes, kohlrabi and radishes, or, as one brother remembered, from the pet chicken in the yard. The family made their own "kolbasi" sausage, rather than buying it ready-made from a butcher. Even once Warhol's career was taking off in New York, Julia was still offering visitors chicken soup cooked from scratch, not poured from a tin.

Andy Warhol wasn't born on the ladder's bottom rung. Even by the low standards of working-class Pittsburgh, he was in the mud at its feet. His parents' thick accent wasn't any of the standard, almost-respectable ones: Scottish or German, Irish or Italian. The Warholas would have been thought of as generic "Slavs" and, as *The Pittsburgh Survey* would have it, "a Slav is slow and unspectacular in making an impress upon the imagination of the community . . . [and] lacks the animation so characteristic of the Italian."

A chapter heading in the *Survey* had to remind its genteel readers—in the decent Scottish brogue of a Carnegie—that "A slav's a man for a' that." The *Survey* condemns the higher rents Slavs were forced to pay, and the contempt they were held in by their immigrant neighbors because of "their willingness at the outset to work at any wages and under any conditions." Among unskilled laborers, the *Survey* explains, "the Slovak, Croatian, Servian, and Russian (Greek Orthodox) may be said to perform tasks the roughest and most risky, and the most injurious to health." Something like 80 percent of the laborers at the giant Carnegie Steel were Slavs.

Andrej Warhola Sr., one of the "sturdy and submissive" Slavs that Pittsburgh's foremen sought out, was born in 1886 in a hungry village called Mikova, on what was then the remote eastern edge of the Austro-Hungarian Empire. It was populated by a little-known ethnic group now called the Carpatho-Rusyns, and one Pittsburgh Rusyn remembered a 1930s article in *Life* magazine that described her homeland as where "the least civilized people of Europe live." The village is still hungry but is now in Slovakia, huddling on its border with Ukraine and Poland, on the edge of the Carpathian Mountains. For most of Warhol's life Mikova was in the artificial, pan-ethnic country of Czechoslovakia and Warhol usually referred to that nation-state as his family's homeland, even though he was well aware that it was a purely artificial, political entity of recent date. Like many immigrants of his era, he preferred the ethnic vagueness of political borders to greater cultural specificity—although he certainly knew that Czechoslovakia itself was founded in part by his fellow Rusyns, in Pittsburgh no less, when his father was a new arrival there.

Mikova had fewer than five hundred occupants when Andrej was young, although that was enough to divide it into an "upper" and "lower" town. Its inhabitants lived off the land: Every family had a little mill to grind its grains, while local flax and hemp were spun into cloth and each family's sheep provided cheese, wool and hides. Still, it was hard to make ends meet without finding seasonal work on larger farms in the Magyar or Slovak lowlands. By

1914, something like a quarter-million of these villagers considered a brutal, bankrupting, even illegal trip to America, followed by brutalizing manual labor once there, as an improvement over life at home.

In 1909, the Warholas—or rather "Varcholas"—from the upper town and with a decent little plot of land and several beehives, were better off than some Mikovans, but that wasn't saying much. It wasn't, at any rate, enough to impress the seventeen-year-old Julia Zavacky, a fellow villager of Andrej's whose family, also from Upper Mikova, had about the same middling-poor status as his. Six decades later, Julia remembered having wept at the prospect of her arranged marriage, even to the "so good-looking" Andrej, until he bought her affections with a legendary gift of candy. Andrej's sweets might have meant less than his American connections: He'd already made one foray to the New World sometime around 1905, when he probably worked for a bit as a coal miner. That was the standard first employment for new Slavic immigrants to Pennsylvania, and it's the stock workingman's occupation that Warhol sometimes liked to claim for his dad—when he wasn't busy denying it.

When the May wedding came, it was, as Julia remembered it, a grand three-day affair, with her hair dressed "like gold." Andrej wore ribbons and a white coat and there was a feast of "eggs, rice with buttered sugar, chickens, noodles, prunes with sugar, bread, nice bread, cookies made at home," as well as a band of fully seven Roma playing music.

Within a few years, however, Andrej was off to America again, this time with his younger brother Jozef, leaving behind his wife and four-day-old daughter, never to return again. He was fleeing conscription into the Austro-Hungarian army. Steamship agents working for American industrialists, but wearing local folk dress to avoid the imperial authorities, would remind young men of their impending service as they sold them tickets for the American passage. One Warhola brother who stayed behind did end up in the army and died from wounds sustained in World War I. Although around the time of Andrej and Julia's wedding, a Pittsburgh veteran of Russia's wars said that he "looked upon his experience on the battlefields as quite commonplace compared with his experience in the steel mills. From the first he emerged without a scratch; in the second he lost a leg."

Andrej's departure couldn't have much surprised Julia. It was a standard event in the region, and several of her own siblings had already settled near Pittsburgh, in the area around Lyndora where their descendants still live. But it did leave her in a difficult fix. She was stranded among her aging Warhola in-laws, who she was expected to serve hand and foot while also caring for younger siblings and an infant. Her life's first tragedy came when she lost the baby after only six weeks.

During World War I, the Germans and Russians fought over and through the region, with the conflict reaching right into Mikova, leaving the earth scattered with skulls of dead soldiers that shone "like large white mushrooms," as Julia remembered. She fled up the mountains and into the woods, her house was torched and she lost everything—"War, war, war. . . . Oh, you don't know how bad." Her father (yet another Andrej) had died the year of her marriage, and her mother died in the war's last year—of grief over a false story that her son had been killed in battle, says one tale—leaving Julia with two much younger sisters to care for. Family lore said that Andrej often tried to send money for his wife to join him in America, and that it was always stolen en route. In 1921, Julia finally arranged the trip for herself, thanks to a loan from a village priest.

―――――――

It's not hard to imagine the contrast between life with five hundred near neighbors and kin among the fields and forests of the Carpathian mountains and life in a smoke-choked city of six hundred thousand people, bustling with Italians and Germans and Irish and Jews—as well as the occasional Presbyterian busy voicing contempt for the others. Andrej didn't even arrange for the couple to live among their own, in the so-called *Ruska dolina*—the "Rusyn valley"—down deep in a creek-bottom "run" where other villagers had crowded together and built a church.

If life in the United States might have been dislocating for Julia, that was a dislocation shared by all her kin in *Ruska dolina,* even more than by your average immigrants. Back in the Old Country, Mikovans like the Warholas and Zavackys were just "our people," with no more specific ethnic identity than that, or any need for one. They were set off from other groups by where they lived, in villages in the back of beyond in the mountains, more than by some idea of who they "were." In the United States, however, these newcomers were expected to fit into an ethnic pigeonhole, the way other Ellis Islanders did. Were they Poles? No. Romanians? Certainly not. Hungarians, Serbians, Croats? None of the above. They had a language that was distinct to them, rather like Slovak and not that far from Russian or Ukrainian but also quite different from all three—*po nashomu,* Warhol's kinfolk called it, meaning "what we speak." It's only since the fall of the Iron Curtain that "Carpatho-Rusyn" has become the preferred term for the group, recognized as distinct by most of the countries where they now live.

American immigration records, and *The Pittsburgh Survey,* sometimes set Warhol's people off from other Slavs as "Ruthenians," except that that name could also cover people who were more clearly Ukrainian or Slo-

vak. The Warholas and their ilk might also be called "Rusyns," unless they were going by "Rusnak"—or even, confusingly, "Ukrainian" or "Russian." A Zavacky from Warhol's generation said that he referred to himself as Russian, knowing that he wasn't, "because it was a big country everyone knew." To this day Julia's relatives in Lyndora call their old-timers' language "Russian," rather than using the other misnomers, "Slavish" or "Czech" or "Slovak," favored by Warhol and even today by some Pittsburgh Warholas. A woman who lived near the Warholas in Soho described them as "Slovak and Pollack"—like Slavic pushmi-pullyus—while their more Americanized neighbors simply thought of the Warholas as a few more "Hunkies" to be despised and made fun of. It didn't help that their Rusyn Bibles and ethnic newspapers were often written in the same Cyrillic script favored by commies.

The world movement for Carpatho-Rusyn culture has tried to spot the roots of Warhol's art in his parents' rural homeland. His "touch" has been compared to the touch on the Rusyns' hand-painted Easter eggs, ignoring the fact that one of Warhol's more notable achievements was to push back against both signature touch and hand painting. And while it's true that there is a notable folk element in his early commercial art, rather than being specifically Rusyn, it is generic enough to have come out of almost any peasant culture—or to have been invented whole by any good illustrator. Folksy styles were everywhere in Warhol's early years, as has now been largely forgotten.

It may be more sensible to see how being a Rusyn—or Rusnak or Ruthenian or Russian—might actually have left Warhol in a particularly good place to make his new country's most all-American art. On a rare occasion when he was asked about his ethnic identity, Warhol denied any interest in it: "I always feel American—100 per cent." Since the Rusyns never had much hope of getting their own ethnically based state, they could make a special investment in America's nonethnic nationhood, as well as in its pan-ethnic consumption—of canned soup, tuna fish, cars and movie stars, all subjects of Warhol's greatest art. In this the Rusyns were a bit like the world's wandering Jews, except without the binding force of evident and wholesale persecution. Warhol's people were hyphenated Americans, just like all the Italian-Americans and Hungarian-Americans they had as neighbors, but with the unique distinction of having nothing to put before their hyphen. Warhol grew up "one of us" at home, and pretty much a blank slate—a "figment," as a reporter suggested his tombstone should say—out in the wider world. This underspecified outsiderism might have been the most precious gift his forefathers handed down to him. It let him adopt the role of American Everyman:

He could explain the nation's culture to itself as only an outside observer could, while also reshaping it from deep inside.

————————

A few days after Warhol's sixth birthday, just before he entered first grade, his family moved up in the world to the newly built, pan-ethnic Dawson Street, on the southern edge of a bourgeois East Pittsburgh neighborhood called Oakland but also just up the hill from the Rusyn enclave. In the depths of the Great Depression, Andrej had somehow found the $3,200 in cash to buy a nice little house being repossessed by the bank, next door to a home already owned by his brother Jozef—"Joseph," by then—a giant man who worked in the mills. The brothers had matching scars on their faces earned during a drunken fight after a wedding, and people were afraid of them. Real estate records list Andrej's new home as having been bought for one dollar, which might signal some sort of tax dodge—the kind of thing Warhol was not above trying later, once he began to make money.

The Dawson Street house, semidetached and faced in brick, was only eight years old. It had both a yard and a bathtub, unheard-of luxuries by Soho standards and especially prized by the six-year-old Warhol. Despite the repossession, the price of the house—a little less than three years of a working man's salary—matches others for sale in Pittsburgh at the time. It looks as though the years in cheap-and-uncheerful Soho could have been a financial choice, to help save for a home, rather than because the family simply could not afford better. Andrej had a reputation as a penny-pincher: In Soho days, the family would be uprooted each time Andrej found a place that would save a few dollars a month on rent; he fixed his own children's shoes with tools that survive to this day. With work scarce during the Great Depression, he spent his time getting the new house ready for the family to move in, sanding floors, scraping wallpaper and getting a painter cousin to refinish the walls because he was "real reasonable."

Andrej also seems to have had notable social aspirations. One neighbor described him as "a little bit of a step above," while *The Pittsburgh Survey* describes "Slovaks" like him as "the most ambitious and pushing" of Slavs. The family's new East Pittsburgh location must have been chosen in part for the opportunities it represented: The area's development was held up by planners as a model of the new City Beautiful movement, while the *Survey* launches its denunciation of Soho by contrasting its horrors to the carefully planned and much publicized glories of Oakland, with its parks and impressive new museums, concert halls and library.

For most of Warhol's childhood, the ultimate symbol of Oakland's

excellence was going up just blocks from Dawson Street. Both the sky-line and headlines were dominated by the new Cathedral of Learning, a forty-two-story, neo-Gothic skyscraper at the heart of the University of Pittsburgh, and a huge source of civic pride. As a publicity stunt for the Cathedral, the university got ninety-seven thousand of the city's schoolkids to contribute dimes to a buy-a-brick program that supported the construction, with Warhol's own school raising $76. He would have watched the tower's completion from his front porch—he even took pictures of it—and this colossal childhood presence must have lurked behind one of Warhol's most important film works, his eight-hour observation of that other colossus on his later horizons, the Empire State Building.

Warhol's school was Holmes Elementary, housed in a grand 1893 building that was only a few doors up on Dawson Street where more than one thousand kids from every ethnic group took their lessons. "It was the most wonderful place to go to school," said one classmate of Warhol's, recalling its orchestra and other ambitious offerings.

Like many schools that had bought into the twentieth century's progres-sive education movement, Holmes offered its students ambitious art classes. "This little kid was very, very good at drawing," remembered Catherine Metz, Warhol's second-grade teacher, fifty years after she'd taught him. "All his teachers seemed to recognize his art ability, and they would get him to come in and maybe make a border for the room or something."

Without money for toys or entertainments, or even a radio until Warhol was eight, Julia kept her boys busy with art. That's a major theme in the older brothers' accounts of their youth—"the three of us used to make all As in art," said John. Julia rewarded good pictures with candy bars, often won by Warhol, and made sure basic art supplies were at hand. The three boys based their pictures on magazine photos ("football players, airplanes, and the like") as Warhol went on to do for his entire professional life, while Julia particularly encouraged pictures of butterflies and angels, which became staples of Warhol's commercial imagery in the 1950s.

A telling story has circulated, in various forms, about Warhol's first day in first grade—or possibly kindergarten, in a version that seems set near the first Warhola homes in Soho. Dragged to school by his big brother Paul, or in some accounts by a neighbor, Warhol had such a miserable time that he ran home early in tears. One explanation for the tears has Warhol getting slapped by a little girl, who Paul Warhola has sometimes described as black. That hazy first-day-of-school story often gets paired with another that places Warhol in the outfield of a neighborhood baseball game, but disappearing halfway through to make drawings on the Warholas' front stoop. Whether

the slap or the ball game ever happened hardly matters: These are important genesis stories, told to establish the origins of someone who was clearly less virile than Pittsburgh expected of a boy child, and who went on to be a pioneer transgressor of gender roles. "He was drawing pictures of like flowers and butterflies—that's where I noticed he was different," recalled his brother John of that fateful baseball day, and also described the colorful tulips that a ten-year-old Warhol later tended in their garden. Forty years later Warhol could proudly proclaim his difference: "Everybody knows that I'm a queen."

The ultimate proof of Warhol's particular brand of "difference" might have come when his brother Paul bought him one of the manly meat-and-French-fry sandwiches from Primanti's famous lunchroom, and he could only get through half of it.

--------

When the Warholas chose their new Oakland home, one big selling point was how close it was to the family church of St. John Chrysostom, which belonged to its Greek (a.k.a. "Byzantine") Catholic congregation. It was down the hill in *Ruska dolina,* and every Sunday since Soho days, Julia and the boys, with Andrej if he was in town, trekked there to confess and hear various services; they might go other days as well, for other liturgies their church year offered up. Andrej's sons remembered him as strict and devout, forbidding all play or work on Sundays, "but all the people were like that," said John Warhola. Julia's religiosity was probably similar: more churchy than some, but not bizarrely so, for a community that was built around prayer—or by it, they'd have said. There has been awed talk of Julia's "six-mile" walk to church from the family's Soho apartments, but that counts both going and coming, and a three-mile trudge at that time was unremarkable, not a sign of extreme, penitent devotion. When the trolleys shut down after the great flood of 1936, Julia made her boys walk even farther just to call on a relation, while her brother-in-law in Mikova dragged his family many times farther to get to the particular church he preferred. After the move to Dawson Street, the Warholas' walk to church was cut to a pleasant half hour down shady lanes and cobblestoned streets.

Chrysostom had been founded in 1910 by some of Pittsburgh's new Rusyn immigrants. At first they built a wooden church and steeple in an almost New England style that didn't carry any memory of the beautiful timber churches of their Carpathian homeland. That was where Warhol was baptized. But by 1932 the flourishing parish needed something bigger. Instead of tearing down the old building, they put it on rollers and moved it over one lot so their new, Byzantine-inspired masonry church could go where the

original one had stood. Since Andrej Warhola worked on house-moving teams, it's likely that he was involved in the project—later, he actually went on to work for the very firm that had handled the church's move.

St. John Chrysostom inaugurated its grand new building just as the Warholas moved to its neighborhood. That church was the focus of their Rusyn community, and of Julia's life in it. Rusyn identity, such as it was, was as much religious as strictly ethnic. The Carpatho-Rusyns' very peculiar history as Christians was inseparable from who they were and where they came from. Christian devotions in the Carpathian Mountains had always been built around Eastern Orthodox rites and rules: The liturgy was chanted in Church Slavonic (the Slavic equivalent of Latin), priests could marry and children were confirmed when they were still infants. About four hundred years ago, however, these rural worshippers were convinced to pay allegiance to Rome and the Pope, as a new "Uniate" or "Ruthenian" church that wasn't asked to change much in its worship. Strictly speaking, that made the Warholas, Zavackys and their kinfolk Roman Catholics. Once in the United States, however, they were suddenly asked to obey Irish bishops who couldn't stand the way these Slavs did things, and vice versa. In the 1920s, the conflict led Rome to grant American Rusyns their own level of church administration called the Apostolic Exarchate for the Byzantine-Rite Faithful of Subcarpathia, which had its base in Pittsburgh and fingers reaching back into the Old Country. The name alone gives a sense of the baroque complexities of these ecclesiastical politics.

All the many Warhol explicators who simply label him "Catholic" ignore what a vexed term that was in Andrej and Julia's world. Warhol's brother John remembered a "natural animosity" and even actual violence between the Irish and "Slovak" Catholics in their childhood neighborhood.

"No Byzantine Catholics would consider themselves Roman Catholic," said the Rusyn theologian David Petras. If Julia Warhola had spent a Sunday in a Roman Catholic church of her era, what she heard and saw would have felt deeply alien. Why did the priest mutter in Latin instead of chanting boldly in Church Slavonic? What was with all those parishioners sitting silently with their rosaries, instead of joining in with the liturgy as she and her kin did? Why didn't the men and the women keep to their own sides of the church, and why did these Irish prefer dour, thin hymns to the lusty folk singing she was used to?

The year that the Warholas moved to Oakland, the Vatican itself said that it was worried that the Old Country customs of Byzantine Catholics, especially their married priests, would be "a source of painful perplexity or scandal to the majority of American Catholics."

Both as a child and a grown man, Warhol felt that his peculiar religious identity made him stand out awkwardly: Byzantines crossed themselves "backward" and celebrated Christmas on the "wrong" day. A niece of Warhol's talked about Byzantine Christmas being "so very special and meaningful" compared to the Roman Catholic masses, and the Warhola church of St. John Chrysostom was a militant force in preserving such specialness, pushing back against the Catholic establishment when some Rusyn churches were giving in.

The crowd of mainstream Roman Catholics in Warhol's later circles, often mentioned as telling, may be nothing more than a standard statistical fluke. The Warhol studio counts as a sample size of one, so there's no reason to expect it to show an even distribution of America's religions. It may be more accurate to say that Warhol favored outsiders, strivers and fellow immigrants—not to mention beautiful young men with curly black hair—and that those categories would naturally net a large Catholic contingent, not to mention several Jews. At least some of Warhol's most prominent followers—Edie Sedgwick, most notably—were old-time American Protestants, his boyfriend for all of the '70s was Lutheran and one of his closest confidantes of later years was a Christian Scientist. In any case, it's hard to know how he would have gone about guaranteeing a Catholic majority among his followers: There's no record of Warhol making newcomers fill out a religious questionnaire or of him dropping an acolyte who turned out not to also genuflect to the Pope.

The links between Warhol's religious background and his later identity are complex. "When Andy was a boy, we thought he was going to be a priest. Even under pressure he never swore," John Warhola once said, but that sounds more like a general comment on the boy's demeanor than a real assertion of his religiosity—he never even took the lessons in Church Slavonic that his brothers endured. Throughout his life, Warhol was certainly a regular churchgoer, at least off and on; one Rusyn source claims he was an actual "supporting member" of his mother's Byzantine Catholic parish in New York. But there's no way to look into the artist's heart and know whether this shows deep religiosity or instead a mix of aesthetics and of a quite practical superstition—after all, he also wore crystals to ward off disease, and it can't be right to bill that as less sensible or normal or less effective than Christian prayer.

In terms of sheer word count, Warhol's diaries show him having a much keener interest in his crystals than in his religion. The way he sprinkled holy water around the house, as a kind of heavenly disinfectant, seems more pagan than Vatican II. Warhol certainly wasn't "religious" in the sense

of knowing or caring about the details of his faith's actual precepts and theology—which must be a requirement for counting as a good Catholic of either the Byzantine or the Roman rite.

According to his longtime employee Bob Colacello, raised Roman Catholic, "He said mass took too long, and confession was impossible because he was sure the priest would recognize him through the screen and gossip about his sins, and he never took communion because he knew that it was sacrilege to do without confessing."

His frequent Sunday visits to church only occasionally took place during Mass. Mostly, he would show up either before or after the liturgy, when he would sit quietly toward the back in the shadows. "I always go for five minutes," he said in his diary. "Ten or five minutes." Warhol actively denied the existence of an afterlife, which is just about the most basic belief of any Christian faith. "I believe in death after death," he once said. And, "When it's over, it's over."

Warhol could sometimes sound less like a divine than an aesthete, like all the atheists and Jews who also adore and study ecclesiastical architecture and liturgies: "I like church. It's empty when I go. I walk around. There are so many beautiful Catholic churches in New York. I used to go to some Episcopal churches too." The Roman Catholic Church of St. Vincent Ferrer, which he frequented in his later years, was in fact a stunning, neo-Gothic pile that looked very like one of New York's posh Protestant minsters, and would have attracted a visit from anyone at all with an eye for beauty. Warhol said that he'd always found the Catholic liturgy "delightful."

Ethnic habit might have played a fair role in his churchgoing, such as it was. As one Rusyn activist said of her own visits to Warhol's childhood church, "I'm a heathen, but I'm still there every Sunday."

One of Warhol's very first boyfriends insisted that the artist never went to church when they were sleeping together in the early 1950s, and a follower who spent several years in close contact with Warhol in the mid-1960s said that she couldn't imagine him having any religion at all. In the early 1970s, after the religious "awakening" that Warhol was supposed to have experienced on recovering from being shot, he answered point-blank questions about whether he was a Catholic, or in any way religious, with a clear-cut "no." (Although a few years later, when asked "Do you believe in God?" his answer was "I guess I do.")

Warhol certainly lived a less holy life, made more profane art and committed more mortal sins than should have been on the conscience of any devout Catholic, as defined in his era. On Good Friday of 1977, a day of commemoration for the death of his Lord, Warhol's choice of evening

entertainment was a screening of the grotesque horror film *Carrie*. One of his later followers, a Catholic, said he believed that acting in Warhol's films was a sin; his priest agreed, but said it could be forgiven because it was done only to survive. The prior of Warhol's last church, who clearly had some tolerance for Warhol, nevertheless said that the artist's lifestyle was "absolutely irreconcilable" with Catholic doctrine.

After Warhol's death, the Roman Catholic clergy in New York were willing to give his ungodly behavior a pass by allowing a memorial to be held in St. Patrick's Cathedral. But the eulogy he got at his funeral in Pittsburgh, from a Byzantine Catholic priest, described Warhol as having wandered far from the Church. It compared him to the sinning thief who Jesus managed to forgive. "I had to adopt some defensive measures, to stand up for the image of the Church," said that Ruthenian eulogist when he came under fire.

Maybe the most important thing to recognize, whatever the internal, unknowable state of Warhol's soul, is that he came across to his contemporaries as your standard secular, gay, lefty, party-going avant-gardist, and that was the image he chose to let loose on the world. "Church is a fun place to go" was his comment on religion in one of his very last interviews. Since his death, some of Warhol's greatest supporters have wanted to sanitize his mores and morals and memory, as though their artistic hero would be greater were he more conventional and rule bound in his ways, when in fact a lot of his greatness and identity always derived from his transgressions.

Even in more practical terms, as a stylistic influence, it's hard to know what his childhood attendance at St. John Chrysostom might have meant. His art's use of repetition has been compared to the ranks of images decorating the church, but seriality was everywhere in modern art and image culture by the time Warhol came of age. Besides, the point of Orthodox icons is that each one has an utterly distinct meaning and identity, as expounded by Byzantine Catholic priests in their homilies, whereas Warhol's endless repetitions were as much about diluting an image's essence and power as reinforcing them. He turns Marilyn Monroe's unique face into just another product on the supermarket shelf, surrounded by more of the same. In branding terms, she was the "Heinz" to Liz Taylor's "Hunts."

More coherently, observers have often compared the glowing gold background on a handful of Warhol's Marilyn paintings to the gold-ground paintings on view today on the giant altar screen of his family's church. Unfortunately for that theory, old photos prove that all those gilded images weren't installed until long after Warhol's Sundays at Chrysostom. In his era, the altar screen was covered in images of saints posing against landscape backgrounds, inspired by Italian Renaissance paintings. Those were also the

model for the saints that parishioners would have seen painted in churches in the Old Country, where blue skies were more in evidence than burnished gold.

A more likely source for Warhol's gold were the Russian icons in a famous exhibition held in 1944 at the local art museum, where Warhol took classes; the show launched a national craze for the art form during his last year in high school. His college art text also included a chapter on "Early Christian and Byzantine Art," with a subsection on icons and with a gold-ground mosaic as the chapter's only color plate. "We looked at all sorts of art books—this is what he was good at, picking up on things," remembered one college classmate. By 1954, a *New York Times* article about Christmas cards—including a goofy one by Warhol—mentioned how a taste for the Byzantine was gaining ground.

Or maybe sacred gold of any kind is a red herring in thinking about Warhol's Pop Art, as one '60s boyfriend of his believed: "The gold is there because Andy was into gold and glitter. . . . The gold in *Gold Marilyn* doesn't represent Byzantine icons; if it represents anything, it represents Miami Beach."

There's one last mental image at Chrysostom that's hard to resist. It's of the young Warhol, sitting in church every July for the major Byzantine Catholic feast of Saints Peter and Paul, staring at the day's icon of the two apostles—who were often shown kissing. Utterly chastely, of course.

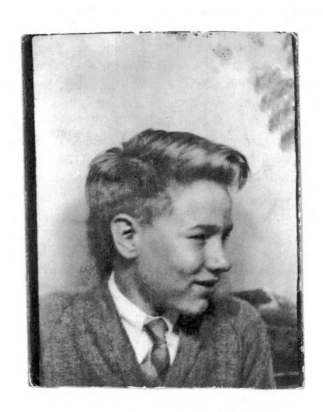

*. . . as a cheerful Pittsburgh kid.*

# 1934-1945

FAMILY LIFE | SCHOOL | ILLNESS | THE CARNEGIE
INSTITUTE | SCHENLEY HIGH | COLLEGE BOUND

*"As genuine as a fingerprint"*

The photos show a contented, ordinary American boy: a skinny first grader with a bowl cut and goofy grin sitting next to his stylish mother; a gap-toothed eight-year-old wearing a tie and too much Brylcreem on his corn-silk hair; a middle school boy joshing with his teenage brothers. Through his first years on Dawson Street, and even beyond, Warhol's existence looked pretty much like any other neighborhood kid's.

Warhol played with his brothers and neighbors and Lucy the family pet, a shaggy blond dog named for Lucille Ball. (There was also a white cat as well as two fluffy rabbits in a hutch in the yard: The black one was John's and the white was for Warhol, who took it hard when it died.) Warhol went to school, went roller-skating and sledding in the park, read comics and dabbled in art. One childhood friend remembered him being just as interested in having fun as any other neighborhood kid—but also how he would collapse at the slightest contact during games of street hockey. Like every Pittsburgh child, he watched movies as often as he could. If Julia couldn't spare him the eleven cents for admission—ten cents plus a one-cent tax—Warhol's brothers might treat him. They earned an extra dime or two, or ten, hawking papers and peanuts at the ballpark, where Paul got smaller kids to subcontract from him, teaching them how to make the bags of nuts look bigger than they were. The boys also sold used bottles to moonshiners and old boxes to the junkyards, or in the winter they shoveled walks and carted coal ash. Paul would fill in for observant Jewish neighbors when they couldn't tend their businesses on the Sabbath or holy days, and he attributed his work ethic to that Jewish influence. The Warholas were, to say the

least, an industrious family, setting a standard for hard work and business savvy that Warhol stuck to until his last day.

Julia was also bringing in extra cash, especially when the Great Depression kept Andrej from earning enough, since the Eichleay Co., where he worked moving buildings, cut back heavily in the 1930s. By the end of the decade Andrej was bouncing from job to job as a laborer. He told census takers he had earned $1,200 in all of 1939; a decade later, a Pittsburgh steelworker said that even earning double that still meant "making out the grocery order with a pruning knife." The family also took in boarders, something quite standard for Rusyn families and for others throughout their neighborhood. To make way for some Jewish tenants—"they had the businesses; they were the ones that had the money"—the boys all slept on one mattress on the attic floor, beside their parents' bed. "What I used to dream about," Warhol recalled in his heyday, "was having a glass of fresh orange juice in the morning and a bathroom of my own." In fact, breakfast on Dawson Street was always the same: a bowl of oatmeal, half an orange and Warhol's daily glass of milk with Ovaltine powder.

On top of her housecleaning jobs—standard work at the time for immigrant women from Eastern Europe—Julia Warhola also crafted sparkly flowers out of old peach tins, selling them door-to-door with her kids for a quarter and using the funds for Warhol's new sneakers. Not long before he died, Warhol credited Julia's cans as the inspiration for his decision to paint the ones from Campbell's. Whether or not that was a true tale about the birth of Pop Art, which had happened twenty-five years before he told it, it shows Warhol wanting to credit his mother as the source of his first blockbuster work.

You'd imagine that little Andy might have been mortified to help flog his mother's crafts, but it turns out he shared her entrepreneurial spirit. He earned his own movie money by offering to draw portraits of neighbors. Those first Oakland patrons prefigure the Dolly Partons, Giorgio Armanis and other paying sitters who made the artist's last decade so profitable.

Especially as a teen and young adult, Warhol gained a reputation for shyness, but it may always have been more theatrical than disabling. Zavacky girl cousins recalled that Warhol was so mischievous they had to tie him to the bedpost when they were babysitting. (They made sure his mother didn't find out.) The landlord's son in Soho remembered Warhol as "a holy terror devil" who once peed on him, not quite the move of someone eager to avoid attracting notice. In his college psychology textbook, next to a passage describing bedwetting as an "attention-getting behavior," he scribbled, "Wet my bed! Ha! Sorry ma."

What Warhol could not have known is that bedwetting is also a common symptom of a neurological disorder he seems to have had as a kid, and that shaped the rest of his childhood and maybe the rest of his life. It struck in the spring of 1937, when he was eight years old and just finishing third grade, after he contracted a streptococcal infection that turned into scarlet fever. Because the illness was untreatable in that era before antibiotics, it led to the dangerous autoimmune disorder known as rheumatic fever. Warhol's disease progressed, as it often did in those days, into a neurological condition called Sydenham's chorea, then known as St. Vitus' Dance. Almost overnight, a perfectly normal child became a mess of writhing limbs and uncontrollable grunts. Sydenham's was only just being defined at the time, and one young doctor described how "twitching and sudden spasm of the muscles of the face produce the most abrupt and bizarre changes in facial expression. . . . Loss of moral sense is almost invariably present. The child displays an increasing peevishness, sensitiveness, disobedience or selfishness." Today, doctors might also consider a diagnosis of PANDAS, a similar poststreptococcal condition with tics and psychiatric symptoms—including bedwetting—that are especially close to what Warhol suffered. All his relatives cite this as a transformative moment, to the point that the illness sometimes gets mythologized into something close to the plague. Warhol's levelheaded brother John, however, insisted that the illness wasn't as bad as others have made out.

The reality is that the original, life-threatening sickness would most likely have kept Warhol in bed for a few weeks, and then the Sydenham's chorea or PANDAS would have afflicted the little boy with a few more weeks or months of spasms, and in Warhol's case blackouts, but no lasting disability. (Although recurrences aren't all that rare, records show that Warhol's memory of three yearly attacks was accurate.) More interestingly, scientists have recently discovered a correlation between rheumatic fever in children and adult psychiatric problems such as obsessive-compulsive behaviors and the severe body-image issues of what's now called body dysmorphia—just the symptoms Warhol displayed as an adult hoarder and hygiene freak who was fixated on the idea that he was hideous. In 1973, when *Vogue* magazine asked Warhol what was on his mind, half his answers had to do with such classic OCD preoccupations as hygiene ("I can't go to sleep if I know there's dust in a bureau drawer") and safety ("Are the cigarettes out? Is the back door closed? Is the elevator working?"). Warhol once said that he felt as though he was "missing chemicals" that other people had, which sounds like a realistic intuition about a difference in how his brain was wired. It is possible that his relatives were more right than they knew, and that Andrew Warhola started becoming the artist Andy Warhol, in a quite concrete and even neurological

sense, in tandem with his childhood illness. Those shakes were what first made him stand out from the people around him: A playmate remembered Dawson Street kids making fun of his twitching. The disease's effects on his psyche may have doubled down on that difference.

One other symptom of PANDAS is an unreasonable attachment to a parent, and family lore had Warhol moving into bed with his mother in the dining room while his father slept upstairs with Paul and John. But as far as art lovers are concerned, the illness probably did more good than harm. Walter Hopps, a curator and friend of Warhol's in the 1960s—who also had the strangest of habits as an adult—remembered childhood spells of rheumatic fever leaving him "cut off from other kids, so the life of the imagination was what I had." Warhol was in the same boat, except that he had his mother to help feed his imaginings. Bed rest left him in the perfect position to absorb her creative eccentricity.

"My mother would read to me in her thick Czechoslovakian accent as best she could, and I would always say 'Thanks, Mom,' after she finished with *Dick Tracy,* even if I hadn't understood a word."

———

The key background to Warhol's later excellence as an artist probably has little to do with his generically Rusyn, Warhola roots—the brothers' anecdotes barely ever mention their father, who Paul considered a "shadowy figure"—and everything to do with being Julia Zavacky's son. After all, how many laborers' wives thought it natural to keep their sons busy with art, or kept the supplies on hand to do it? Once, when a critic was planning a book about Warhol, the artist demurred: "The book should be about my mother. She's so-o-o interesting."

All the stories of Julia's childhood mention her artistic talents. Whether those stories' details are correct or not, they give a good idea of how others remembered her. (Caution is called for: They were "remembering" someone who they knew went on to be the mother of one of history's greatest artists; they needed to recall her in that role.) As a girl, legend has it, Julia had helped decorate the church in Mikova, a job usually reserved for men. She was also said to have practiced the Rusyn art of ornamental house painting, figuring out how to mix the traditional colors when there was no money for premixed paints.

She was known for singing Orthodox chants in church—again, something usually reserved for men—and folksongs at home. (The two genres of music had more overlap among Rusyns than in other groups.) Julia didn't pass any musical talent down to Warhol, except maybe as a kind of overall urge to perform, revealed in his forays into dance and theater.

The most important gift Julia gave to her son might have been some-
thing you could call the Zavacky Way—a willingness to be recognized as
different and eccentric and, in some indefinable way, a touch more cultured
and interesting than others. Warhol's circle in New York may have seen the
woman living in Warhol's basement as a standard-issue babushka from the Old
Country, but that was because they couldn't see through their own clichés to
the more interesting woman beneath. "Everyone who went there thought
she was stupid, but she was brilliant beyond belief . . . marvelous. And much
smarter than Andy . . . much smarter," recalled one friend who got to know
her especially well. Warhol built an underground movie around Julia in 1966,
and it shows her playing along with the babushka clichés but also messing
with them in ways worthy of her artist son.

Recent visits to the Zavackys of Lyndora, who Warhol saw many week-
ends as a boy, found them still living in the peculiar family compound where
they'd gathered for decades, and still reveling in a sort of cultured singularity.
Warhol's Lyndora cousins are famous for treating visiting Warhol scholars
to daylong feasts of stories and Rusyn pierogies. They have been caught on
film fearlessly bellowing Old Country songs and declaring their kinship to
the family's most famous character: "When we read some of his *Philosophy,*
we laughed, because we didn't realize he was so much like us." They've
described grandfather Jan (later "John") Zavacky, Julia's brother, as having
had a constitution unsuited to his peers' factory work. It led him to open a
general store. Jan had taught himself to play violin and cello, on which he
would accompany the classical records he bought. (Warhol himself took
violin lessons as a kid, but quit because his teacher was mean.)

Jan is also remembered as notably lettered, an eager reader in Russian,
Greek, Rusyn, Old Church Slavonic and English, in both Cyrillic and Roman
scripts—both of which Warhol's parents also knew, Andrej even mixing
them in his letters. Julia's brother was a founder and leader of Lyndora's
Byzantine Catholic church, giving this business owner a cultural eminence
his brother-in-law Andrej, the laborer, could never claim.

Warhol's illness may have been read, by the boy and his mother and her
kin, as just another sign of Zavacky uniqueness, and as an opportunity to
make him more of a Zavacky than ever.

———

Being sick gave Warhol a rare chance to experience a life filled only with
"culture," of one kind or another, since he remembered his mother always
saying, "You can't go anywhere or do anything." His summers were spent
"listening to the radio and lying in bed with my Charlie McCarthy doll and

my un-cut-out cut-out paper dolls all over the spread and under the pillow," wrote Warhol. There were also all the supplies he needed to draw and color (Snow White was a favorite, girlish coloring book) as well as comics to copy pictures from, as he did in his very first Pop paintings a quarter century later.

"Andy always wanted pictures," recalled his mother, a few years before her death. "Comic books I buy him. Cut, cut, cut nice. Cut out pictures. Oh, he liked pictures from comic books." His brother Paul said he taught Warhol to use a ball of warm wax to transfer the pictures from the Sunday funnies to another piece of paper, foreshadowing the blotting techniques Warhol perfected in art school.

It looks as though it was also around this time that Warhol started using the family's new $1.25 Baby Brownie Special camera. Before long his brothers had built him a darkroom in the basement fruit cellar, which their father had dug out with his own two hands. This may be the true moment when Warhol's artistic future was born, since almost every important image he went on to draw or paint was based on a photo. An art historian from Mars could easily read him as a photographer who happened to silkscreen his images rather than as a painter who worked from photographs.

But movies were what really started to dominate Warhol's cultural life. Maybe even more than the rest of the nation, Pittsburgh was movie mad— the city boasted of having opened the world's first dedicated cinema. Warhol shared the obsession. When he couldn't find the dime it cost for a ticket, or get a neighbor to pay him for taking their kid, he'd sneak in past the ushers, which his brother John described as "the worst thing that Andy ever did."

It seems also to have been a time when Warhol ran his own cinema, of sorts, foreshadowing the pornographic one he ran in the later sixties. Saving her earnings from housecleaning, Julia had spent fully nine dollars—nine days of her work—to get her youngest boy one of the new home-movie projectors he'd asked for, apparently buying it without her husband's knowledge. Her money paid for an electric machine that was more than half-decent.

"He'd buy a film of Mickey Mouse or something like that and show it on the wall over and over again," recalled John Warhola. Decades later Warhol told a friend that Mickey was his favorite actor and Minnie his favorite actress. "When a relative would give him a quarter he'd save it and then buy another film," his brother said.

This could have been the era when Warhol started his Hollywood scrapbook, which held the photos of stars that were handed out in theaters after certain movies or that he bought for a cent from vending machines at the local amusement park. He also wrote to celebrities for autographed

pictures, or would get his brothers to write away for them, as Paul claimed he did for Warhol's famous eight-by-ten of Shirley Temple.

The scrapbook survives, and it showcases an almost random assortment of major movie and big band stars, from Henry Fonda to Carmen Miranda to Mae West, but also even more second-raters. "Best Chesterfield Wishes," wrote the smoking trumpeter Harry James, or some flack or machine signing for him. In a nice reversal, once Warhol became famous it was his turn to cope with the flood of autograph hunters whose requests still litter his archives; mostly, he was a devoted signer.

Little Miss Temple, born the same year as Warhol, had a page to herself in the scrapbook—but lest we make too much of that, she shares that honor with the little-known actor John Shelton. The starlette may have been the inspiration for Warhol's childhood ambition to grow up to be a tap dancer, which of course was shared with thousands of other kids at the time.

Given the iconic paintings that Warhol later made about movie stars, as well as his own work in film and his constant efforts to infiltrate Hollywood, it's tempting to read his childhood cinephilia as all that in embryo. It's equally easy to overread it. Almost every kid in America was at least as bitten by movies as Warhol: Old fan-club images and even entire scrapbooks survive in vast numbers on eBay. Warhol's elementary school had to take action against nearby cinemas that were attracting pupils during school hours. We don't need to imagine Warhol as some odd-duck Hollywood obsessive. What made him matter was his ability to clue in to the obsessions that were shared across America, and then to come at them from the oblique angle of art. When, in a 1966 photo, we witness him displaying that Shirley Temple headshot on his New York mantel, it was a normal detail from his working-class youth re-presented as ironic and arch.

Another gay Pittsburgher who kept a movie-star scrapbook just when Warhol did—who ran away from home twice to see *The Wizard of Oz*—may have an interesting take on the artist's filmic interests: "I can't imagine straight boys being interested in [scrapbooks] at all."

The scholar Blake Stimson has talked about the complex role that certain Hollywood stars like Mae West and Shirley Temple could have played in building a young boy's gay identity. In Warhol's case that particular identity, with all its rewards and challenges, went on to power an art that was all about being in the mainstream but not of it.

By the fall of 1937, in fourth grade, a separation between Warhol and his peers began to gel as his artsy identity took shape. Art classes at Holmes were being given by a teacher named Annie Vickermann, a busty woman with a booming voice who recited the Gettysburg Address to her students. She gave

rigorous, old-fashioned training in color, composition and perspective. "All her children could really draw," said a colleague, and Warhol was always the best of them. Miss Vickermann got Warhol admitted to Saturday drawing classes at the Carnegie Institute, a lavish complex of museums "where we kids in Oakland hung out in winter after school—it was our place, a special place," said one childhood friend, and Warhol and his brothers were among its regulars. "It didn't cost you a penny," remembered a neighborhood playmate.

———

Twenty minutes up from the Warholas' house, the Carnegie Institute was an inescapable landmark of downtown Oakland. Its grand concert hall, museums and library (a special favorite of Warhol's) filled an imposing Beaux Arts building that had the names of the West's cultural heroes carved into its façade. A painter such as Leonardo got to shoulder up against other titans like Goethe and Beethoven—all three becoming subjects of Warhol's later art. Given the modest culture of the Warhola home, the immersion Warhol would have needed in the language of art could only have begun in that building. Without knowing what artists and audiences had seen and appreciated and *counted* as art in the past, Warhol could never have carried his culture's art forward.

Crossing the Carnegie's soaring atrium on the way to his new art classes—there are photos of pupils making that trip—Warhol was treated to a deluxe suite of murals that began with a hellish view of the city's mills, depicted from precisely the smoke-choked hills of Soho where Warhol was born. As he and his classmates climbed the stairs, the smoke was shown giving way before the Angels of Art anointing an ascendant figure of Labor—Andrew Carnegie himself, costumed as a knight. This was an allegory of cultural and social ascension that Warhol seems to have taken to heart.

The kids in the museum's art classes were known as Tam o'Shanters, apparently a Scottified, Carnegie'd reference to the classic Montmartre artist's beret. The world-famous program was just a few years old when Warhol joined. The most notable of the program's teachers was a certain Joseph Fitzpatrick, who happened to be a Warhola neighbor in tidy South Oakland. A slim, tall man who taught in a natty suit and tie, he was barely in his thirties when Warhol knew him. He'd spent a few years as art supervisor for the public school system, which had a notably ambitious cultural agenda for its students, and then taught at Warhol's own Schenley High in Oakland.

Fitzpatrick was famously strict, and his lessons might seem a touch Victorian: as many as six hundred children sitting in the Institute's grand

Music Hall—"the largest art class in the world"—all in ties and tidy dresses and all drawing pictures of the same thing. But Fitzpatrick also voiced more modern attitudes: "I looked for the boys and girls to express themselves in their own ways. In other words, I didn't say that a drawing had to be this way, or that way . . . but I did say it had to be excellent."

Another Carnegie teacher wanted his students "to learn to see beautifully." He played Debussy on the piano while the little Tam o'Shanters drew "forms that sprang into life from hearing the inspiring notes." Sometimes that teacher made his own abstractions as the little ones sang. Fitzpatrick and his colleagues had their charges "all on fire . . . about art, as an idea" according to one Tam o'Shanter friend of Warhol's.

Warhol prospered, winning accolade after accolade for "very realistic work . . . with a decorative quality that was very becoming," recalled Fitzpatrick, more than a half century after Warhol was supposed to have made that impression. "I distinctly remember how individual his style was. . . . From the very start he was quite original." Yet in 1939, the Carnegie art classes had almost twenty-five thousand names on their attendance sheets, with several kids nominated from every public and private school, so it would be a mistake to dwell too much on young Warhol as part of some budding artistic elite. Even his brother John had enough artistic talent to start classes there at the same time as Warhol, but quit because he didn't have his sibling's willingness to miss out on playing ball with the neighborhood boys.

A statement by the Carnegie might as well have had Warhol in mind: "We are looking forward to a time when we shall search out and find the potential artist. We shall nurture him, like the queen bee, on special artistic food. . . . [s]o that a leader in this field shall not be lost."

If the lessons were important for Warhol's future, their setting may have mattered even more. The Carnegie art students sketched and eventually made watercolors right inside the museum's Old World galleries, where Warhol got the chance to know the museum's permanent collection. In those early days, there weren't many masterpieces on view—Andrew Carnegie had wanted his museum to focus on recent art of a conservative bent—but its decent holdings in Old Master portraits set Warhol up for his career as the greatest portraitist of his era.

The shortcomings in the Carnegie's permanent collection were made up for by an ambitious roster of special exhibitions, which would have fleshed out the thorough grounding in art history Warhol had got from Miss Vickermann at Holmes. Looking at the exhibition program from Warhol's time as a student at the Carnegie museum is like looking at a prehistory of his career. When he was almost twelve, the museum brought in a show of

European "masterpieces," which gave Warhol his first taste of classic works by the likes of Rembrandt, Rubens and Poussin, setting the bar high for his later ambitions. In 1941 there was a blockbuster Picasso show, on tour from the Museum of Modern Art, which included *Guernica,* the era's celebrity painting. It let the young Warhol take the measure of his most important twentieth-century rival, who was a special favorite of his in college. Later, at the height of his Pop Art fame, Warhol made the rivalry explicit by wearing the striped T-shirts Picasso was famous for.

A silkscreen exhibition gave him early exposure to his signature Pop medium. Surveys of the French outsider Henri Rousseau and of American "primitives" sparked his lifelong interest in outsider and folk art, which was a vital model for his work in the 1950s and which he collected all his life. As late as 1976, Warhol was still including "American primitive painters" on his list of all-time favorite artists. When a Pittsburgh paper raved about the Carnegie's "magnificent" survey of Rousseau, it described him as an artist who "paints a child's world in adult terms. . . . We suspect many modern artists of also going back to their childhood, only their excursions lack the unforced directness [of] Rousseau." A good part of the appeal of Warhol's 1950s illustrations came from their simulation, at least, of a childlike directness.

A Carnegie survey of contemporary self-portraits launched Warhol into depicting himself, which he started early and never abandoned. Other Carnegie exhibitions—"The Artist as Reporter," "The American Weekly Exhibit of Magazine Art," annual photo shows, the landmark survey of Russian icons— seem tailor-made to turn Warhol into the particular artist he became.

In April 1940, the Carnegie published a photo of a crowd of its art students. One of them is a scrawny young man whose shock of blond hair bears a suspicious resemblance to the hairstyle of a certain preteen named Andrew Warhola. Whether that's him in the shot or not, what really matters is what those Saturday pupils are doing: They are hard at work sketching the piles of advanced contemporary art that the museum brought in once a year for its famous Carnegie International.

Every October since 1896 the museum had hosted that show, the country's only survey of the latest in world art, rivaled only by the Venice Biennale in scale and importance. During Warhol's early Pittsburgh years, it was organized by a man named Homer Saint-Gaudens, son of the celebrated sculptor Augustus Saint-Gaudens. Homer was brought up among America's first modern artists—John Singer Sargent painted him at age ten—but he was also a toff who captained the Harvard fencing team.

In Paris or New York, his tastes might have seemed a bit tame, but he claimed his Internationals had been wild enough to blow up Pittsburgh's

"self-contented ignorance." The local press agreed with him, and didn't like it. One paper gave front-page play to a New York critic's reactionary attack on the first prize that the International's "stupid" jury awarded to a quite demure Picasso portrait.

Of course, controversy had its benefits (another important lesson for Warhol): Crowds thronged to one International that included a controversial first-prize painting titled *Suicide in Costume*. Its artist said that his grotesque dead clown symbolized "our civilization." The painting was the talk of Pittsburgh for decades. But by 1950, a year after Warhol left the city, Saint-Gaudens could claim that he'd won the fight for Pittsburghers' hearts: "They used to spit at 50 yards at a modern painting; now they say, 'I don't know anything about it—it may be all right.'"

On top of teaching Warhol that backing the avant-garde paid cultural and social dividends, the Carnegie International under Saint-Gaudens promoted an advanced view of art as involved in the world around it. It regularly showcased works about the horrors of industry and Jim Crow, sometimes even including black artists in its mix. Art, wrote Saint-Gaudens, "must justify itself; must be measured by its effects on the social orders." Warhol took that lesson to heart. His mature work certainly did have—was intended to have—such an effect, at a time when many other artists were busy exploring and expressing their interior lives. The first-prize picture at the Carnegie's 1941 exhibition depicted lynchings and other troubles of the American South; it might as well have been one of Warhol's highly charged Death and Disaster pictures, in embryo, with their depictions of police attacking black marchers and electric chairs awaiting their next victims.

In 1940, with war raging in Europe, the annual show got cut back to artists in the U.S.A., including émigré art stars such as Max Ernst and George Grosz and major American figures such as Georgia O'Keeffe, Milton Avery and Edward Hopper. It's especially nice to know that the young Warhol had a chance almost every year to see some notable painting by Stuart Davis, the one true avatar of Pop Art in this earlier generation. Davis's pictures of store signs and cigarette packs, done in the bold, bright styles of package design, set an example for Warhol of how it was possible to make world-class pictures that riffed on popular culture. Davis's influence was acknowledged decades later by Henry Geldzahler, the powerful curator who "discovered" Warhol and Pop Art.

As a Pittsburgh teenager Warhol had no way of knowing that by scanting abstraction, the Carnegie's annual was missing out on the sharpest cutting edge. The Warholas shared Pittsburgh's general skepticism about abstract art, and that may have been at the root of Warhol's later tendency

to see abstraction as a desirably daring form he didn't quite have access to.

"American art, now in the process of creation, belongs to the future . . . a fresh, vigorous creation of a new form rapidly approaching maturity, perhaps its Golden Age," proclaimed Warhol's college art text, published while Warhol was still in elementary school. That important—but in fact incorrect—idea that American English was the normal language of the avant-garde would already have been planted in the young Warhol by the Carnegie's wartime annuals. In the 1930s, when those lines in the textbook were written, they represented wishful thinking, but their ideas still set a target for Warhol's ambitions. A truly American creativity, his textbook informed him, would someday "transcend the incomplete experiments of the early twentieth century so that a universal art and a more comprehensive meaning may be created for mankind's future." Warhol gave himself a role in building such a future.

———

Saturdays in the 1930s saw Warhol learning how to be an artist. Post chorea, it looks as though the rest of the week also saw him pulling away from his peers.

His most notable friendship was with a neighbor boy named Nick Kish, whose family came from near Mikova. They were both outcasts, said Kish, who chose not to "loaf with the cliques on the corners" or play craps with the neighborhood roughs. The boys had artistic interests instead. They spent hours at each other's houses, sketching trees and the sky from life or girls from their imaginations: "Any girl who had not been properly introduced would not walk into your house without mom or dad kicking them out."

Sometimes the two of them went sketching in Schenley Park, a spread of manicured nature that overlooked the city. "I painted his hand, he painted mine. I painted Andy, he painted me," Kish recalled not long after Warhol died. It's tempting to think that a surviving image of two naked boys in an embrace, drawn in the late 1940s or early 1950s, was Warhol's fantasy of moments with Kish in Schenley Park—by the time of the drawing, Warhol would have known of the park's Prospect Drive, dubbed the "fruit loop," as a gay cruising ground.

This must have been about the time when his home life was getting complicated. Around 1939, the abdominal trouble that Warhol's father had suffered from for years began to get worse. Family lore says that he drank "bad water" on a construction site in West Virginia and came home sick and disabled, confirmed by records that have him missing weeks of work that year and even more the following one. He went to "German doctors" for a

"tea," and it looks like he had a reprieve: Tender letters he wrote to Julia in March 1941 show him on the road and hard at work again. But by May 6, 1942, just when Warhol was getting ready for his graduation from Holmes Elementary, Andrej had been admitted to Montefiore Hospital. He died nine days later from what his autopsy described as tubercular peritonitis—a bellyful of tuberculosis, that is, that would almost certainly have drifted down from infected lungs rather than being gulped in with bad water.

His youngest son was deeply distraught, as any thirteen-year-old might be, and then is said to have gone haywire at the standard Carpatho-Rusyn custom of displaying the body in the dead man's home, in this case for three days. There's even a story that Warhol stayed under his bed for the duration of the wake. Rusyn culture gives high marks to a good laying-out and funeral, all carefully planned by the deceased during life, so Warhol's withdrawal would have seemed particularly eccentric and distressing.

Within just a few months of that crisis at home, Warhol moved up to Oakland's Schenley High, where his existence didn't get any easier. He had mostly lost his shakes, only to be plagued with serious skin problems. He was called "spotty" from the day he arrived, and a pattern of disfiguring, "piebald" blotches made his face look like some kind of world map. Areas that had lost pigment seemed like they'd been splashed with bleach, a problem that he shared with a Zavacky relative who got the cruel nickname of "pinto pony," but who outgrew the condition once all pigment had quite disappeared from her skin. Warhol's blotches remained into the 1960s, despite records of treatments, and it was still on his mind in the year of his death, when he duplicated its look in a series of grim self-portraits that layer a camouflage pattern over his face. The nude swimming classes, standard at the time, were a nightmare for Warhol: He spent them in the showers facing the wall. "If someone asked me, 'What's your problem?' I'd have to say, 'Skin,'" he once wrote. As late as 1964, *Life* magazine was advancing the absurd notion that a bad complexion, especially when coupled with shyness, could actually "cause" homosexuality, a claim Warhol might have dismissed but couldn't have ignored.

"As genuine as a fingerprint" was the tag line printed beside Warhol's yearbook photo at Schenley, and that seems to be a polite way of signaling a growing quirkiness that he turned into a central part of his adult identity. At Schenley, he was already playing around with who he wanted to be. A high school portrait he did of Nick Kish is very clearly signed "A. Warhol," although we may not want to make too much of Warhol's early name changes: Slavic names in Pittsburgh were always in flux. More significant may be John Warhola's memory of his little brother getting protection from an "Irish kid" who later became a cop. You don't get protection in high school unless there's

something about you that puts you at risk. "We used to refer to him as a queer. He seemed to carry his books in a very feminine way and loaf with the other sissies," remembered a high school classmate. "It was the wrong thing to say, looking back. . . . He and one or two other boys used to loaf together all the time, in a little corner somewhere in [Schenley] Park or by the Schenley Hotel." John Warhola once referred to his brother as "loafing with a rough crowd" when he was fourteen or fifteen.

Warhol seemed to take refuge in his budding skills as an artist. "When he was about 14, his interest in art was apparent. He changed then," remembered a cousin. At a benefit for a local art center, Joseph Fitzpatrick, then Schenley's senior art teacher, got his favorite student to raise funds by doing one-dollar portraits. "A more talented person than Andy Warhol I never knew. He was magnificently talented" is how Fitzpatrick remembered his student many decades later, after he'd achieved international celebrity.

"He was too thin. I used to wonder if there was enough food at home. . . . There was a poetic quality about him—sensitive, interested in art," said Mary Adeline McKibbin, a tenth-grade art teacher who always marked Warhol as "outstanding." His later Pop work fared less well with her: "His reliance on sensationalism disappoints me," she once told a reporter. In the late 1980s, McKibbin said that she encouraged Warhol to enter Scholastic Magazines' national art contest, for which it turns out she was the local organizer. The competition was open to high school students from across the country, and finalists from each region sent in a jaw-dropping twenty thousand works to be judged and displayed each year at the Carnegie art museum.

McKibbin said that Warhol won a prize, and that's often mentioned as a sign of his early brilliance. But a pile of local coverage for both the 1944 and '45 contests shows that it couldn't have been one of the top awards or college scholarships, or even one of the War Bonds handed out to the best of Pittsburgh's local contestants. It looks as though the most Warhol could have achieved was an unnewsworthy "honorable mention," whose gold pin he wore in the '80s. Before he came up with his glorious ideas for Pop Art, Warhol's artistic genius was never as clear as hindsight makes us imagine.

---

At Schenley, Warhol remembered, "I wasn't amazingly popular, although I guess I wanted to be, because when I would see the kids telling one another their problems, I felt left out. No one confided in me."

McKibbin recalled the teenage Warhol as "quiet, sensitive, intense. In my classes, he seemed to pal with no one, but to become immersed in his work. He was in no way a problem, but hard to know personally." Fitzpatrick, her

fellow art teacher, had a similar memory of his favorite pupil as "personally not attractive, and a little bit obnoxious. He had no consideration for other people. He lacked all the amenities. He was socially inept at the time and showed little or no appreciation for anything. He was not pleasant with the members of his class or with any of the people with whom he associated." A classmate agreed that he was "a loner," but he was also normal enough, and nerdy enough, to have been on the school safety patrol and involved with a new "teenage canteen" called The Hi-Spot that held dances and hang-outs Friday nights at the Oakland YWCA. "I didn't think Andy was the greatest jitterbugger, but he did slow dance very nicely," recalled one female friend. In his junior year Warhol proudly wore a boosterish Schenley sweatshirt. For a medical history taken in 1960, he described "lessening nervousness" across his high school years. Maybe it was beginning to dawn on him that his exemplary outsider status could be a magnet for other outcasts like him.

Warhol spent a lot of his time at Schenley with a new best friend, Eleanor ("Ellie") Simon, who came from a modest but cultured Jewish background and in college earned a reputation as a bohemian. Her brother Sidney, another college classmate of Warhol's, became a prominent curator. In the 1950s, when he visited Warhol in New York, he was researching Stuart Davis, the proto-Pop artist whose work Warhol had often seen at the Carnegie. Ellie said that she helped Warhol with his Schenley assignments, even doing them from scratch and getting Warhol to copy them out.

This fits with a common notion that Warhol was deeply un- or even anti-intellectual, and maybe marginally illiterate or at least dyslexic. Despite comically bad handwriting, spelling and grammar throughout his life, severe dyslexia seems almost impossible, or at least irrelevant, given all the books we know he treasured and collected, and the vast evidence for his extensive reading. When it wasn't a deliberate artistic conceit, Warhol's terrible handwriting could actually have been a sign not of dyslexia, or of the plain inanity that detractors have alleged, but of PANDAS, the autoimmune disorder that might have caused Warhol's childhood spasms—as late as 1975 he was still referring to his "shaking hand." As an adult Warhol read several newspapers as well as thick popular books and sometimes quite obscure ones. Stendhal's *The Red and the Black* and a history of painting were his airplane reading on his first trip to Paris, in 1965.

He brought both Kitty Kelley's new biography of Frank Sinatra and Jean Cocteau's diaries to the hospital where he died, and not long before had been reading *The Merchant of Venice* aloud with a friend. One writer who knew Warhol in the 1970s said that Warhol was always careful to hide the fact that he was "exceptionally well and widely read: far more so than most visual art-

ists, including many thought to be much brainier than he was"—in fact War-
hol knew that author's quite obscure novel, and commented on it with acuity.

And then there's the fact that, for a supposedly illiterate painter, a fair
part of Warhol's creative output consisted of publishing books and a famous
magazine. In 1957 the French author Philippe Jullian, a wildly cultured friend
of Warhol's, received a letter from the artist and replied, "You know how to
write—a shock to me."

It's obvious that Warhol was no academic or man of letters. It's also
clear that he was sharp as could be, as was obvious to people who got really
close. "Warhol only plays dumb. It's his style. . . . He's incredibly analytical,
intellectual, and perceptive," said Henry Geldzahler, a 1960s friend of
Warhol's who was a curator at the Metropolitan Museum of Art. "Why,
Andy can make puns in French. But still every so often I fall into the trap.
Like once Andy said, 'What was the First World War all about?' and I said,
'Well, the First World War . . .' And then I thought, 'Listen, he knows more
about it than you do.'" Emile de Antonio, Warhol's first art-world friend,
got incensed at the common notion that Warhol came up with his master-
pieces by luck, without knowing why he did or what they meant: "Bullshit.
Andy always knows."

Warhol certainly enjoyed the accomplishments and also the company
of eggheads throughout his life. For some time in the 1950s and '60s, he
hung out and went to the theater with the prominent Shakespeare scholar
Paul Bertram, who said that Warhol's conversation about the plays they
saw was as sophisticated as any other amateur's. Bertram once warned
Warhol not to rush through a "deceptively straightforward" book by Upton
Sinclair. One family tale even has Warhol skipping first grade after acing an
intelligence test. Although that isn't borne out by his report cards, it does
show that a tale of big brains was seen as credible.

If Warhol had really been the dullard that stories of his cheating at
Schenley imply, it's hard to imagine his teachers not smelling a rat when he
turned in fine assignments and got good grades. In an era before "social pro-
motion," if he had shown serious signs of weakness his teachers would not
have hesitated to demote him from the higher, "academic" stream he was in.

Warhol was already on the Honor Roll at Schenley in his first weeks
there—Ellie Simon was, too—and he later took Latin and trigonometry
and was a proud assistant in the Schenley chemistry lab. He got mostly
Bs (including in English and American History) but also quite a few As
(in Art, of course—which he took only through tenth grade—but also in
French, World History, Biology and Elementary Algebra). Just a few years
later, Warhol's nephew "Pauly" Warhola was proudly describing his own

straight Cs as "good marks." Warhol was tested at a perfectly respectable IQ of 104, for whatever that's worth, and graduated in the top 20 percent of his class, at a time when many of Warhol's peers would not have been expected to earn their diplomas at all. Only seventy-five boys from his high school year did. (There were twice as many female graduates.) As his mother later remembered, "Andy very good for school. He keep school nice. He says, 'I like school.' He finished school in Pittsburgh and my neighbor say, 'Oh Andy, he's a good boy. He finish school.'"

These were the war years, so for most boys—and Warhol's homeroom only had boys in it—"finishing school" would have meant graduation into the military, at least until victories over the Nazis in the fall of 1944, when Warhol entered eleventh grade. Luckily, Warhol's good grades offered an escape: Since 1942, college-bound students had been accelerated out of high school a year early to get at least some higher education, or even an entire degree, before going to war. Thanks to summer school, Warhol's last two years of secondary education were compressed into one.

The war had also added to tensions in Warhol's home life. Paul Warhola had been contributing to the household since 1941, laboring in the steel mills, but after his father's death he left for the merchant marine. John took over his financial duties by driving an ice-cream van, and then, when the war ended and the job market was flooded, by joining a Zavacky cousin in operating a studio that shot photo-booth portraits—shades of Warhol's own photo-booth works of the 1960s. "To me, Andy was just like one of my sons, instead of a brother," John recalled.

In 1943, before going to sea, Paul married Anna Lemak, a neighborhood girl whose mother was from very near Mikova. Still, Julia wasn't happy: Anna was already pregnant and her new mother-in-law had planned on a different bride for her eldest son. The couple nevertheless moved into the top floor of the Dawson Street house, paying rent for it to Julia. The new bride's arrival caused conflict in the home, especially given her disdain for Warhol's effeminacy. A video of Anna in her nineties shows her mimicking a fey hand gesture and saying, "It came to me whenever he would wave his hand, that he was from another world—you know what I mean?" In an early interview, Warhol's college friend Philip Pearlstein recalled Warhol's brothers as having also been unsympathetic to their sibling's uniqueness: "They made fun of him."

Although Julia later said that Andrej had left her $11,000—more than five years of a laborer's wages—there's no sign of that in his estate's documents, which list $1,514.07 in assets and no real estate. Despite Social Security payments for Julia, that left her boys saddled with supporting the household. Warhol helped out by doing a stint as a soda jerk—he never lost his taste for

old-fashioned diners, eventually scheming to open one—while Julia rented one of the Dawson Street bedrooms to returning soldiers for five dollars a month.

She was also bringing in cash with her house cleaning, until she was laid low by colon cancer, originally considered mere bleeding hemorrhoids. She had her large bowel removed in the fall of 1944. The five-hour operation left her wearing a colostomy bag for the rest of her life, and it seems she didn't even know quite what was being done to her until she awoke from the anesthetic, not that surprising given the medical ethics of the era.

"I'll never forget the first day Andy come down there after she was operated on. The first thing he asked me, he says, 'Did Mumma die?'" remembered his brother Paul. "Andy had a lot of sadness. . . . We tried to listen to my mother and we just prayed, we prayed a lot. We visited mother in the hospital every day." Warhol's fear of hospitals could have dated to this moment, coming on top of his father's death under medical care just a few years earlier. But the life-saving success of Julia's operation could as easily have fostered a deeper faith in medical interventions—Warhol, always a hypochondriac, was also a frequent and eager patient of any number of doctors.

John Warhola said that, in order to care for his mother's yearlong convalescence, he switched to a job that began at 4 P.M. That way he could hand nursing duties over to a teenage Warhol fresh home from high school, where he had dropped his optional art class and saw all his grades suffer. This may at last be when tinned soup enters the Rusyn household. John Warhola claims to have fed himself and his little brother on Campbell's at almost every meal, and Warhol once said that he'd only ever eaten it when he was "in school." The boys' nursing must have worked: Julia eventually became a star example of the operation's success, shown off to others about to undergo it.

On June 22, 1945, a bare few weeks after the Nazi surrender, the sixteen-year-old Warhol received his Schenley diploma. During his last year of high school, Warhol and his friend Nick Kish had both applied to the University of Pittsburgh. Warhol was accepted into the education department, apparently with the idea of becoming an art teacher like his mentor, Joseph Fitzpatrick.

He was on his way to being the first college-bound member of his family, in a world where class mobility was almost nonexistent—"you graduated from high school and you went to the mill," as a Dawson Street neighbor put it. Warhol had to have shown pretty extraordinary signs of talent and even brains for anyone to have imagined him moving further in his education.

Warhol's Schenley transcript said he had "no evidence of bad habits" (that wouldn't last), that his "manner and appearance" were "pleasing," and that he

had good emotional control, although a similar document forwarded to Pitt rated him low in "Acceptance by Classmates." When Kish, who was older, was drafted and had to postpone college, Warhol put in an application instead to the Carnegie Institute of Technology, maybe to pursue its program in art education.

He would already have attended rigorous art classes held at Tech every Saturday morning during his high school years; they were the normal culmination of the Tam o'Shanter program, at least for its best students. That, together with a scholarship that often went with the Saturday classes, might have pushed him toward dumping Pitt for Tech.

The application process for Tech's art department was ferocious. Warhol had to sit through four solid days of testing, to check on his abilities in such things as life drawing and general creativity. Applicants were asked to draw their room from memory and to portray themselves as seen from the back. According to a story that a veteran Tech instructor liked to tell, one of the assignments was to draw a Coke bottle without looking at one, "and in all those years, Andy was the only one who'd got it right"—a legend that pushes the prehistory of Pop Art back about as far as it will go.

Coke bottle or no, Warhol passed the tests, but that wasn't the final hurdle. According to his brother John, "They weren't going to accept him because he was going to just go in the evenings to save money, but my mother told him to go back and tell them that he'll go in the daytime and she gave him the money. I think it was $200 a semester." That number is right, although Tech estimated that students would spend that much again in likely incidentals each year. The money seems to have come out of the $1,500 left behind by Andrej, which he'd wanted used for his youngest son's education. Considering that an early estimate put Warhol's own estate at a conservative $215 million—it has since grown into billions—college turned out to be a fine investment.

*. . . as a college senior, sketched by a gay instructor.*

# 3

## 1945-1947

FINE ARTS AT CARNEGIE TECH | CLASSMATES AND
TEACHERS | A DOSE OF FAILURE | WINDOW DRESSING |
GAY LIFE AND ITS DANGERS | ARTISTIC ROLE MODELS

*"The question always was—'Should Andy stay or go?'"*

Q: Why do you desire to come to this institution?
A: Because it is noted as the best College for Art in the state.
Q: Why did you select the course of study you plan to pursue?
A: Because I am interested in Art and wish to continue my education.

That little interrogation, from Warhol's application to the Carnegie Institute of Technology, just about sums up his modest ambitions and savvy on the eve of art school. He was barely seventeen. A photo taken the day before he started classes makes him look like any other goofy freshman, with a messy blond pompadour and a giant white collar that frames his face like a clown's. He's got a lovely, shy smile, but the shot can't quite hide the blotches that covered his ghostly white skin, or just how scrawny he was. He wished he wasn't: On his college application, he added an inch to his height and fattened himself by ten pounds.

"He wore whatever he had to keep warm and covered," recalled one of his new teachers. "The campus was full of returned GIs, and they at least had a little money. Andy was poor and had a rough time."

October 2, 1945, was Warhol's first day of class at Carnegie Tech. What he found there over the next four years shaped the man and artist he became.

Right off the bat, the Tech campus brought Warhol face-to-face with the delicate balance between tradition and the avant-garde that governed his entire career. At the south end of the grounds, about a twenty-five-minute walk from the Warhola home—that family didn't believe in the expense of

trolleys—the first thing he encountered was the College of Fine Arts building, one of the oldest structures on campus. It was a grand Beaux Arts pile from 1916, with a façade full of curlicues and historical details that invoked all the Old Master achievements the young artist was supposed to emulate—and that the mature Warhol was keen to outdo or undo.

Inside, casts of classical sculptures, still there in the twenty-first century, were meant to provide inspiration as well as actual models to copy, in an art college that had long considered itself a "drawing school" of a traditional bent. One young professor of Warhol's referred to the Fine Arts building itself as part and parcel of "the heroic efforts of the academy to stem the tide of modern art," and Warhol's own college textbook pointed to the draughtsmanly strand in American art schools as "evidence of our lack of creative imagination."

Right next door, however, the avant-garde lay in wait for the freshman Warhol. Skibo Hall, Carnegie Tech's student union, had started life as a World War I hangar, but just when Warhol arrived a new renovation had left it with a Bauhaus look—low-slung, sleek and industrial in its gridded glass façade. It was proudly featured in the college yearbook for 1947, itself an impressive piece of modernist design put together by Warhol's peers. Skibo was the necessary hangout for art students at Tech and Warhol went on to hold court there.

He was enrolled in the Department of Painting and Design, whose students were always known as "P&Ds," and he majored in its newly re-named Pictorial Design program, once known as Painting and Illustration. The new name was meant to signal the arrival of a cutting-edge pedagogy: Rather than giving narrow expertise, the new curriculum was designed to encourage "the development of habits of observation and analysis and the acquisition of skills necessary to the most effective expression of ideas"— just what Warhol, the noted observer and analyst, went on to build his art around. A Warhol classmate said they were taught "the ideal that there was no line between the fine and the applied arts and there [are] certain fundamental principles of design and certain aspects of creative expression that all work together."

This was "Bauhaus stuff," heavy on idea and light on technique, accord-ing to one of Warhol's teachers. Despite Warhol's reputation as an anti- or postmodernist—Clement Greenberg, modernism's white knight, accused him of killing the modern avant-garde—he explored Tech's modernist Bau-haus ideals for the rest of his life. He crossed over between different me-dia (photography, painting, printmaking) and between "low" and "high"

disciplines (illustration and fine art), and always valued conception over execution.

The freshman Warhol knew some of his instructors from the Saturday classes he would already have attended at Tech. But by his second week as an undergrad he had got a full sense of their aesthetic range, since their works had just been included in the latest of the Carnegie museum's annual shows. Warhol said those annual exhibits were the best things he saw during his time at Tech.

Samuel Rosenberg, a relatively traditional figurative painter who was just then moving into abstraction, was one of Tech's senior faculty. He won an honorable mention that year for a vaguely cubist painting of a rabbi, matching the wise-old-man role he went on to play for Warhol.

The 1945 Carnegie annual also included Russell Twiggs, the art department's beloved and influential "massier"—Tech's Frenchified term for the studio manager who hung student work when professors gathered to judge it. For years, Twiggs had been heavily covered in the local press as the city's first maker of abstract art, the style "which makes the public gasp, 'What under heaven is art coming to, anyway?'" according to one Twiggs review. That criticism alone was a clear sign of the kind of modern avant-gardism that would have attracted Warhol's attention. The admiration was mutual: Twiggs was in charge of choosing which student works would enter the college collection, and he chose Warhol's.

Twiggs also happened to be Pittsburgh's most important devotee of the hot new art of silkscreen printing. He even used it to make paintings, as Warhol went on to do. That means Warhol's famous move to silkscreening, in 1962, wasn't quite the watershed it's been made out to be. A classmate who bought a painting from Warhol in their senior year remembers that they learned the technique in class. Another P&D remembered Warhol going out of his way to try silkscreening.

The most substantial figure in the art department was Balcomb Greene, a Paris-trained abstractionist, novelist and intellectual who had studied philosophy, literature, art history and also psychology—in Vienna, as a disciple of Freud. He was six foot five, square jawed and dashing, a dead ringer for Gregory Peck and a genuine art star. "I advocate arrogance, not arrogance in painting, but complete arrogance," Greene said. His wife was a sculptor who went by "Peter" (but wasn't otherwise gender-bending), and the pair were once arrested for punching out cops who were raiding a speakeasy.

In Warhol's freshman year, Greene was working out a high-profile new

style, Gorky-ish and de Kooning–esque, that prefigured the Abstract Expressionism that was about to be hot. Four years later, during Warhol's last term at Tech, Greene was named the city's "Man of the Year in Art," and a photo of him at his easel was splashed across the cover of the *Bulletin Index* ("Pittsburgh's Weekly Newsmagazine"). Whatever else he taught Warhol, Greene showed him that being an artist was also about staying in the public eye.

At Tech, Greene shocked his more craftsmanly colleagues by declaring that art schools needed to scrape off the "barnacles" of technique. He endeared himself to his idealistic students by declaring that "the social meaning of art is that it opposes conformity and is a constant indictment of materialistic forces."

Greene gave a new, mandatory "Arts and Civilization" class that Warhol attended every day of his junior year. It covered everything from Picasso, Dada and Bergsonian philosophy to Flaubert, Zola and Ibsen, by way of Brecht, Stravinsky's *Le Sacre du printemps* and *The Cabinet of Dr. Caligari*. Its textbook included bold discussions of whether beauty mattered in art and whether form could ever trump meaning, issues at the heart of Warhol's later achievements. Presciently, given the engaged artist Warhol would become, the book also stressed the social functions and meanings of art, describing art history as "cultural and social geography"—this in an era when analysis in terms of pure color, composition, texture and line was much more the fashion. Warhol got a proto-postmodern education while the rest of the art world was still working through modernism.

Greene did such a good job schooling his P&Ds in the most radical modern culture that a couple of Warhol's classmates went on to write graduate theses on Dada artists. Greene's own M.A. dissertation, completed not long before Warhol became his student, had been titled *Mechanistic Tendencies in Painting, from 1901 to 1908*, and he taught his students "the emotions characteristic of the mechanical"—perfect training for the most famous machine-inspired artist of all time.

Greene could also be impenetrable. "I always had the impression that he was saying something profound, because I couldn't understand what he said," remembered one student. Others called him "Mumbles" and fell asleep in his class. But if young Andrew Warhola had even half listened to his lectures—he later remembered Greene and his slide lectures as "wonderful"—he would have had vital grounding in the art he would go on to compete with. Three decades later, Warhol could still hold out comfortably on such topics as Caravaggio's chiaroscuro—at least when there wasn't a journalist around to witness his performance.

Greene also helped shape Warhol's Oedipal relationship to abstraction. In the late 1930s in New York, Greene had been the founding chairman of the uncompromising American Abstract Artists group, insisting that "the abstract artist can approach man through the most immediate of aesthetic experiences." By Warhol's Tech years, his teacher was in touch with the Abstract Expressionists in New York—Willem de Kooning said he'd been influenced by Greene, and the two had once been close colleagues—but had also started to feel that abstraction was a dead end. He began to take nude photos and make paintings that were inspired by them as part of "his answer to the trend back toward the realm of natural appearances," as one critic put it in 1947. Warhol took his doubts about abstraction even further than Greene did: As early as 1961 or '62, he moved into Pop Art by pissing on AbEx—almost literally, in a series of urine-covered canvases—and continued to do ironic riffs on abstraction for the rest of his life. The postwar moment when abstraction seemed to have finally won the Battle of the Styles was also the moment, as always with such things, that its value began to be questioned, with Warhol as one of its leading inquisitors.

But even Greene didn't buy into all of Warhol's radicalism. He was writing about the "excesses" of neo-Dada (as Pop Art was first known) as early as May 1961, just after his former student had shown his own Pop work for the first time in a department store window in New York. "I think of Pop as essentially phony, artificial, attention-getting," Greene later said, and attacked Warhol by name.

———

In his years at Tech, Warhol's Pop reputation as sphinx and con man was still a long way off. He was an "angel in the sky," according to one college friend. Another remembered Warhol's personality as "quite different from what you'd expect. He was very shy and cuddly, very much like a bunny rabbit." Warhol, he felt, "was not sophisticated, he was not corrupt . . . and he was not a manipulator of people. He was, as Shakespeare would say, 'an innocent,' and he appealed to the maternal and paternal instincts in people in those days."

That bunny soon become the coddled baby of the program's women, since most of the returning G.I.s at Tech were notably older than both Warhol's female classmates and than Warhol himself, who was one of only two males fresh out of high school in the entire program. Ellie Simon, Warhol's high school friend and Tech classmate, became particularly close and maternal in college. "She was always saying 'Did Andy have breakfast?'" remembered

one member of their crowd. "'Did he have lunch? Who's taking care of him for supper?'"

"We could always tell when Andy was happy because he would skip across campus," recalled Betty Asche Douglas, who was the only black P&D and felt a special kinship with Warhol because of his outsider status. Another classmate and later roommate said that art school at last gave Warhol a place where he could feel at home among other misfits like him.

"I can remember several parties where Andy and I were sitting on the steps just before you get into the room just watching everybody else," said Douglas. "And he would make these wry little remarks and comments about who was doing what and what was going on." For the rest of his life, Warhol turned observation into his own special kind of acting out. "If I really want to know what happened somewhere, I ask Andy," said a friend of his in the 1960s. "He may have only stayed three minutes and never raised his eyes, but there's nothing he hasn't observed."

This got its start when Warhol was at Tech, as "a listener, an observer, a loner, always the odd man out when a group of students got together and paired off," according to one particularly social classmate. In the same psychology textbook where Warhol scribbled his confession to bedwetting he also added heavy underlining to the page on "Withdrawing as a Defense: Seclusiveness and Timidity."

Toward the end of Warhol's first year, he must have taken special pleasure in observing the exaggerated, avant-garde misfitism of the art department's famous Beaux Arts Ball. In April 1946, a surrealist theme was meant to bring the dance back to life after a decade of dormancy: A newspaper report talked about a bunch of "junior illustrators" who shared a caterpillar costume while two students, the Misses Waichler and Schroeder, paired up as a "split personality." Photos make the ball look like something straight out of a painting by Salvador Dalí. In his junior year, already billing himself as "Andy Warhol," he was honored with a place on the ball's planning committee, which decided on the less demanding theme of Bali. The boys—including, delightfully, Warhol—went topless in flowered sarongs, with glitter on their torsos and golden armbands. The students' labors won them a luscious spread in *Life* magazine, the first of several that Warhol would score over the course of his career.

But if Warhol was finding a place for himself in his new milieu, he was also at risk of flunking out of it. Tech had just launched a tough new humanities curriculum meant to "correct the limitations of the typical art student," according to the dean at the time, and Warhol seemed to need a lot of correcting. He had special trouble with the "Thought and Expression" class,

which met every day for two terms and was meant to cram an entire liberal arts education into a single course. It was taught by Gladys Schmitt, a prolific novelist who was *"the* teacher to have at the time . . . a terribly stimulating and exciting person," according to one P&D. Schmitt despaired at Warhol's "mutilations of the English language." She made Warhol repeat her course in his second year, then gave him straight Ds.

These kind of troubles are hardly rare among working-class students in their first year at a rigorous college, but a lot was at stake: Doing badly put Warhol's Carnegie scholarship at risk, since it depended on his keeping a decent GPA.

He wasn't just bad at the new academic courses. Some instructors also considered Warhol a lousy draughtsman. By midterm of freshman year, he'd been given Cs or Ds in Color, in Pictorial and Decorative Design and in Drawing I, where he seemed to have problems with charcoal and perspective. A sketch of his cousin Joe is at best middling good; an anatomical drawing that survives by Warhol looks much better, at least to twenty-first-century eyes, but standards were so high at Tech that it only received a grade of B. As of that January, Warhol and his freshman class were in fierce competition with a newly arrived cohort of G.I.s, since the Bomb had been dropped on Hiroshima the previous August—on Warhol's birthday, no less. The department made it clear that only the fittest would survive to the following year. By early spring, Warhol looked bound for the long list of students who were put on probation or flunked.

End-of-year evaluations took place on what was known as "judgment day." Russell Twiggs would hang all the students' work in a gallery that spanned the building's top floor. Then, in private, a crowd of faculty would skitter along in front of the art on a long bench on wheels, horse-trading their opinions until a final decision was reached on each pupil. As one professor remembered: "The question always was—'Should Andy stay or go?'" That first year, the answer was "go." Or at least, after more jockeying among the faculty and some melodrama from Warhol—"I created a big scene and cried"—the decision was that he'd have to take a makeup class and produce drawings during the summer months that would prove him worthy of re-admission in the fall.

———

That summer of 1946, Warhol worked alongside his brother Paul selling produce door-to-door off the back of a truck—"huckstering," it was called. Despite the name, it was a perfectly respectable part of Pittsburgh's retail landscape. It's not known whether Warhol was any good at flogging peaches

or tomatoes—mostly he seems to have carried orders up clients' stairs—but we do know that he started a sideline drawing caricatures of the customers. "The 25 cents he got for the pictures helped him to buy the art supplies he needed," recalled his brother John.

More important, by far, those drawings were designed to win him re-admission to Tech. They are strikingly fluent and also funny—one shows Warhol himself suffering the torments of customer service—and are better, at least in traditional terms, than almost anything else from Warhol's college years. During just those few months, Warhol perfected a line that traced the outlines of his subjects and the urban scene around them in a mess of calligraphic loops. His new style even acted as a kind of X-ray vision, so that shoppers' comically sagging breasts and bulging bottoms showed right through their clothes. You get the sense that Warhol was getting quiet revenge on the women whose orders he had to lug.

But to properly understand the nature of Warhol's emerging genius—the same genius he deployed for the next forty years—it's important to realize that Warhol's "new" manner was borrowed straight from the caricatures of Honoré Daumier, one hundred of which had been presented to Pittsburghers at the Carnegie art museum the previous January. We don't know exactly which images were included, but there's an overwhelming resemblance between Warhol's produce-truck caricatures and a Daumier such as *Smell the Merchandise Before Manhandling It,* from the 1842 *Parisian Types* suite. In fact, a local newspaper article on Warhol's summer drawings began with an anecdote about the huckster's customers manhandling the merchandise, a story that could have been fed to the reporter only by Warhol.

Warhol's debt to Daumier is an early sign of his extraordinary, lifelong skill as a sponge, repurposing ideas, images and styles he found ready-made in the world, whether in the works of other artists or in the supermarket aisle. That debt also meshes with Warhol's own account of his forced "re-education" that summer. He believed that Tech faculty simply hadn't liked his drawing style—"they do not appreciate my artwork," he told one neighbor, in high dudgeon—so, with his trademark flexibility, he changed to one he knew they'd prefer.

Warhol's freshman-year professors were right: He never had the innate talent for realistic drawing that even many minor artists have. Throughout his life, whenever he was making a purely functional and private sketch, say for the composition of a magazine page or to lay out an exhibition, the result was almost always a comically awkward image such as a more natural draughtsman could never bear to turn out. "Andy was a good art-

ist, but he could never draw, you know—he would never draw realistically, he would never force himself to search; he would always do it a mechanical way," remembered one art-director friend from the 1950s. A later critic called Warhol's manner "straight efficiency drawing. . . . What Roland Barthes would call zero-degree drawing"—the artist's line, that is, being reduced to fulfilling its most essential, mechanical tasks without leaving any fine art residue.

But across all his four busy decades as a draughtsman, Warhol overcame his innate limitations by taking on (and sometimes inventing) a series of very artful styles that he could channel his images through, the way a pasta maker pushes dough through shaped dies. You can't tell a Warhol drawing by its "hand," as connoisseurs like to say. The best you can do is spot which of his several trademark styles it was made in, and wonder if maybe you're witnessing that style being aped by a well-trained assistant, as was in fact often the case. Warhol was, you could say, a style maker first and an artist—at least in the traditional sense—second. Milton Glaser, the noted postwar graphic artist, recognized precisely this: "In terms of what it means to draw beautifully, in terms of control, I don't think he was very notable." But, said Glaser, "he had an enormous sense of style, and he could bring that burnished style to a product."

This began in that summer of 1946, when he pushed his weak freshman drawings through the art of Daumier and turned out winning art goods. In October, he went back to Tech as a recipient of the $40 Martin B. Leisser Prize, awarded to him and two classmates for "unsupervised art work" made during the summer vacation.

The drawings won him his very first solo exhibition, held for a single day in the gallery at Tech, as well as something he would have valued even more: A big article on page two of the *Pittsburgh Press,* one Sunday in November, that had photos of both him and his art. The text has so few direct quotes that it looks like Warhol was already clamming up with reporters fifteen years before reticence became his trademark. "People are funny" was about the best line he offered. Otherwise, the coverage of his drawings done on Pittsburgh streets provided an early lesson in a truth that Warhol took to heart later with Pop: Art built around the public's own culture can grab that public's attention.

Warhol's sophomore year continued to go better than his first. At home, Julia had moved upstairs to leave the ground floor to her son and his art projects. His brother John recalled how Warhol would listen to the radio, do his homework and eavesdrop on kitchen conversations, all at the same time—

the same virtuoso multitasking that kept him productive even in the chaos of his 1960s Factory scene.

At school, Warhol settled into a circle of ambitious friends, including Philip Pearlstein, the one classmate who went on to be a noted artist. Pearlstein was a working-class Pittsburgher whose huckster father knew Paul Warhola. Four years older than Warhol, Pearlstein had been drafted after his first year as a scholarship student at Tech, in the spring of 1943, and was only now returning, with full funding through the G.I. Bill.

What first brought the two students together was Warhol's fascination with Pearlstein's early success and exposure as an artist. Back in 1941, Pearlstein had already won both first and third prize at the Carnegie's national exhibition of high school art. Still more impressive, Pearlstein had two of his winning paintings reproduced in color in a *Life* magazine feature on the show. "Andy asked me: 'How does it feel to be famous?' My spontaneous answer was, 'It only lasted five minutes,'" said Pearlstein, laying claim to the genesis moment for Warhol's trademark idea that fame can be counted on the clock—although Pearlstein has told that story in so many versions, and so many others have competing claims for inspiring Warhol's celebrated "fifteen minutes of fame" line, that skepticism is in order.

Warhol's tight little group at Tech included Pearlstein's future wife Dorothy Cantor as well as the couple Ethel and Leonard Kessler (called "Pappy" because he was older), diehard lefties who taught the others about activism. Warhol was "our little pet," Leonard Kessler remembered, claiming that he took his impoverished new friend to his very first restaurant, a Jewish place where Warhol marveled at the free radishes brought to every table. Kessler described Warhol as having been "the most shy, reticent, uncommunicative, non-verbal person—but absolutely extremely gifted, the only truly intuitive artist I've ever known in my life. He could not do anything wrong in his work, really, and he could never explain why."

Another member of their set, if only for one year, was the openly gay George Klauber, who had studied already at Pratt in New York and, after the war, in Paris and Oxford, which led him to speak English "with an accent of his own invention, with elements of French and Oxford accents," according to Philip Pearlstein. Pearlstein said that Klauber impressed the rest of them because he was up-to-date on "the abstract painting of Pablo Picasso and Piet Mondrian, the architecture of Corbusier and the music of Gustav Mahler, and had read most of the *Remembrance of Things Past*, by Marcel Proust."

Photographs of the group sprawling on the campus grass make them

look like an Our Gang of artsies. "We went to the Pittsburgh Symphony concerts every Friday night, as well as movies at the art theater," remembered Pearlstein, while his classmate Art Elias mentioned them going to every exhibition at the Carnegie art museum. One in particular seems telling: Toward the end of Warhol's sophomore year, the museum opened a big show of works by Henri de Toulouse-Lautrec, and the picture it gave of Toulouse-Lautrec as a radical avant-gardist, in life and art, might as well be the template for Warhol's life as an artist. (Toulouse-Lautrec was one of the first artists Warhol bought when he started earning good money in the later 1950s.) The show's catalog sums up Toulouse-Lautrec in a passage that could easily pass as a summary of Warhol's Pop career: "First impressions are that he played a lone hand. This was not true. It was also said of him that he was shockingly cruel and cynical. That is not the way to express it. . . . He was chiefly interested in putting down without irony or bitterness what he saw in life. . . . He was charitable to even the most neurotic and morbid tinge of this grotesque society. . . . He was not concerned with boundaries, social, literary, illustrative, or commercial."

Warhol was learning the culture and values of an artiste, and he naturally started to dress the part—"very ill-kept . . . sort of a pre-beatnick." (He received a D in a Tech course called Hygiene.) One P&D remembered him wearing "a faded gray corduroy sports jacket and tennis shoes painted with all these bright colors," while another had him in a turtleneck and paint-spattered jeans, worn with the brown-and-white saddle shoes that were then in fashion but with the white parts painted over in black. When Warhol got a summer job, he arrived so disheveled that colleagues mounted a kind of clothing drive to dress him. He thanked them, then immediately cut the sleeves off the shirts and slapped silver paint on the shoes—or so the story went, as it was told and retold some forty years later. These are our first glimpses of the so-called Raggedy Andy look that Warhol was still affecting for his first few years in New York, in the early 1950s, until success let him start shopping at Brooks Brothers.

By the end of his sophomore year, at the latest, Warhol began to go by the echt-bohemian name of André—especially easy to adopt as a Frenchification of his father's Rusyn name—and college friends continued to address their letters to "André" for at least another decade. It was Corinne ("Corky") Kessler, sister of Pappy Leonard, who had encouraged Warhol's name change, but he didn't need much encouragement: The end papers of one of his college textbooks show him working on variations of his moniker—he scribbled "Andre," "Warhold," "Warol," "Narhold," "Narol" and "harold."

Pearlstein recalled that Corky was the one responsible for changing Warhol from a "very likeable kid" into a poseur. Corky also launched Warhol into his lifelong love of modern dance, since she was enrolled in some kind of dance program in Pittsburgh. As a sophomore he saw the Pittsburgh native Martha Graham make a splash with her *Appalachian Spring,* and later told Graham herself that it had touched him deeply. One Tech classmate said that their crowd counted Graham as "very 'in'" and that her Pittsburgh appearances were an important influence on Warhol's taste for the cutting edge.

In the 1940s, modern dance still counted as a radically new art form, not at all a part of the standard cultural mix that it would be on a twenty-first-century campus. Warhol's interest in it required a notable emotional and social investment. Snapshots taken on the Tech campus show him striking unironic ballet poses, and he eventually became the only male in the school's modern-dance club, founded a decade earlier. Year after year, that club had been featured in Tech's yearbooks with photos of its smiling girls—only girls—set above cheery little texts about the club's parties and visits to all the local dance events. Then suddenly, in the 1949 blurb on the club, the photo turns almost comic. It shows five pert young ladies in leotards alongside a sullen, balding Warhol, in chinos and dress shirt, above a text that still talks only about the "women" who make up the club. Miss Kanrich, the club's longtime faculty supervisor, looks less than amused in the shot. Warhol, she said, "was a nut!"

He must have been serious and skilled enough to get through the club's auditions—he also drew a recruitment poster for it—but one P&D nevertheless recalled Warhol as less than impressive: "Members danced to music from a record player, and Andy tried to keep up with the others but appeared awkward and uncoordinated. He came into art class one day with his elbows bruised from learning to fall." In a charming riff on his predicament, Warhol made and mailed a droll Christmas card featuring five pink-skinned male dancers in tight mauve tops and scarlet shorty-shorts. The card's fey look—sketches for it had included fluttering butterflies—points to something vital in Warhol's existence around this time: a willingness to experiment with an openly "queer" persona and to play with gender norms.

———

Warhol's relationship to his own sexuality, at first in the face of Eisenhower America's vicious opposition to it, became a driving force behind his entire

conception of how to make art and live life. Openly displaying an identity that most of society had contempt for put him at risk, of course, but it could also be empowering. It represented a certain kind of courage and boldness, in a society that wasn't likely to grant either virtue to men like him. Warhol's identity as a gay man, almost but never quite out, shaped reactions to him for decades, whether among homophobes, sympathetic straights or the other gay men whose worlds he moved in. Without those tensions and complications, and the distance they gave him from the mainstream, Warhol would never have become the great and enigmatic artist he was. And it's at Tech that this identity began to take shape. For one self-portrait assignment, Warhol went so far as to depict himself as a girl with Shirley Temple ringlets, shocking both teacher and class. "Who the hell is that? Is that your sister?" one classmate is supposed to have asked. "No," replied Warhol, "I always want to know what I would look like if I was a girl."

There's only circumstantial evidence for Warhol's first explorations of his homosexual self. We know that Warhol was utterly immersed in the gay community almost as soon as he arrived in New York in 1949. For another dozen years—right up until the explosion of Pop—he lived his life, and made his art, almost entirely within its borders. Given that, there must have been some major moment before then, in Pittsburgh, when he would have come out, at least to himself and other gay men—the original meaning of "coming out," before it meant revealing oneself to straights. It must have happened at the latest by the fall of 1947, after he had replaced his jobs selling milk, jerking soda and hawking produce with a summer job at the Joseph Horne Company in downtown Pittsburgh, "a luxurious department store that catered to the upper class," according to one longtime employee. The store installed air-conditioning before any of its rivals and escalators just months before Warhol got there, and boasted that an entire floor for women's fashions had been designed by the great Raymond Loewy himself, father of streamlined design. Locals would make a special trip just to ogle its high-end store windows.

Warhol ended up working in the department that created those window displays. In one of his classic understatements, he said that his job merely involved thumbing through glamorous fashion magazines to look for ideas, without "ever finding one or getting one." In fact, early sources have him getting his hands properly dirty in the store's street-side fashion windows. One photo that survives of a window he worked on shows a display full of sexy women's beachwear, with the words "male-tested" plastered all over the window's plate glass—guaranteed to have sparked

a smile among the men who painted those words, since their interest in bikinis was limited.

"In the display department there were a number of flaming queens and [Warhol] was fascinated with them and always intrigued by their conversation," remembered Perry Davis, an art teacher at Tech. (Kauffman's, Pittsburgh's other leading department store, had notably straight window trimmers, according to a gay friend of Warhol's who worked there.) The display boss at Horne's was a gay man named Larry Vollmer, who had hired Warhol "right in the elevator" and described his new staffer as "really a wild bird, an odd duck," but also as an extraordinary talent who was "academic and fantastically original, all at once." Vollmer had once designed windows at the Bonwit Teller department store in New York, as Warhol later did, and he told his new protégé war stories about fighting over a display with Salvador Dalí, who ended up in jail and on the front page of the *New York Times* when his bathtub "made of Persian lamb" crashed through the store window. It's no wonder Warhol, a lifelong fan of Dalí and his larks, described Vollmer as the idol of his student years.

Charming photos from Horne's, date-stamped August and October 1947, show Warhol mugging with the other members of his department among the toy monkeys and giant spectacles they used for displays. Warhol's gay colleagues "would talk about their costume parties. Some of them were very talented people, but what Andy noticed about them was the bizarre dress, mannerisms and that sort of thing," said Davis. Warhol took note: He spent the fifty cents an hour he earned at Horne's on a snazzy corduroy outfit his friends called his "dream suit," a pink one, according to a gay Pittsburgh teen who admired it at the time as a "unique, challenging and beautiful outfit." It made Warhol the instant center of attention: "You didn't go downtown in Pittsburgh in a pink suit," said another gay man who came of age there. Corduroy was getting an especially hard sell that year by the collegians who manned Horne's Campus Shop, near such manly departments as Guns, Cameras and Sporting Goods, but Warhol didn't exactly style his gear as those virile young salesmen advised. He wore his suit with mismatched shoes, a tie dipped in paint and brightly colored fingernails. Oscar Wilde once said that "one should either be a work of art, or wear a work of art." At Horne's we get our first sign of Warhol aiming for both.

Perry Davis felt that Warhol's classmates were wrong to think of him as innocent and sexless; all he needed was some exposure to gay sexuality. His job at Horne's gave him that.

Department store toilets were often "tearooms," gay code for likely spots for casual sexual encounters. "There were so few places for men to meet each

other," said one gay Pittsburgher of Warhol's generation who remembered Horne's as having "the most beautiful men's rooms." You flushed the toilet by stepping on a button in the floor.

Horne's position at the very west end of downtown also meant that it was right up against a scruffy warehouse district, known as The Point, full of "cheap saloons, prostitutes—you wouldn't want to go down there during the day, let alone at night," one veteran Horne's employee recalled. The Point was also a major gay cruising zone, making it prime hunting ground for cops looking for "sex deviates" to beat up and arrest.

The late 1940s in the United States was about as bad a time and place as could be imagined for a young man to discover his attraction to other men. Warhol took a junior-year class called Psychology of Adjustment (on "human behavior in the group and individual sense") and his copy of its textbook survives, with its pages on homosexuality underlined more heavily than any other part of the book. The psych text's first words on gay desire might have sparked some hope in Warhol: "Few conditions of behavior are so misunderstood or so despised in popular opinion. Homosexuality is not a 'sign of degeneracy.'" But that hope got dashed by the book's next lines: "[Homosexuality] is an inadequate sexual adjustment, often a maldevelopment." The author explains that most sufferers manage their condition without descending to "overt sexual acts," but that "more pronounced cases" can lead all the way to action. Warhol would have read, with either worry or delight, that a "cure" was often difficult, "because the person affected is satisfied with his form of adjustment, often defending it with elaborate rationalizations," causing "severe anxiety . . . which is relieved only on sexual readjustment"—a hellish pseudotreatment that Warhol was luckily spared.

In a little-known self-portrait that Warhol painted at Tech he portrays himself with such an absurdly, self-consciously limp wrist—maybe even with white nail polish, a later favorite of his—that there's no way local homophobes wouldn't have spotted him as a "fairy." He comes off the same way in a portrait by his classmate Philip Pearlstein. "He would always do little things like stick his finger up or something to make himself stand out," Pearlstein remembered.

Warhol's effeminate manner would have made him an easy target for the college boys of Oakland, known to be especially cruel, even violent, toward homosexuals. Decades later, Warhol made self-portraits that show him being punched or strangled.

Homophobia was fully institutionalized across postwar America. In 1950, the United States Senate, self-declared as "the world's greatest deliberative

body," issued a report titled "Employment of Homosexuals and Other Sex Perverts in Government." It gives some useful general tips for prospective inquisitors ("contrary to a common belief, all homosexual males do not have feminine mannerisms") before concluding that "One homosexual can pollute a Government office." The report launched a Lavender Scare that led to wholesale persecution. In 1977, when the FBI finally destroyed the records of J. Edgar Hoover's "Sex Deviate" program, there were 330,000 pages of documents to be burned.

For gay men in Pittsburgh, the orderly witch hunt going on in Washington might have seemed almost the bright side of the picture. In 1948, two Pittsburgh judges referred to homosexuals as "society's greatest menace," citing police lists with the names of one thousand of these "known perverts."

In Pennsylvania as a whole, the crime of sodomy (which included oral sex) could be punished by up to ten years of hard labor, and in 1949 prosecutors piled charges onto one McKeesport man until his sentences totaled fifteen to thirty years—of which he served fully nineteen before proving he'd been framed by the police. In 1951, Pennsylvania's maximum sentence for sodomy was increased to life, a penalty otherwise reserved for treason, murder, kidnapping and prison hostage taking, but now extended even to "solicitation to commit sodomy." A psychiatric examination helped determine your fate, maybe replacing hard time with an indefinite stay in a mental hospital. As one gay Pittsburgher remembered, "If you got caught, they had two choices, jail or shock treatments."

At just the moment when Warhol was coming out, the odds that you would get caught began to soar. In September 1948, a year after Warhol's summer at Horne's, the Pittsburgh police department created a special "Morals Squad" whose only job was to arrest gay men. Those were the cops who cruised the Point district behind Horne's and attacked gays with "vicious brutal and unprovoked assaults." Within the first two weeks of the unit's creation its cops had shot two gay men.

Almost as soon as the Morals Squad was formed, its thirty-six members realized that they'd just been handed a ready-made extortion racket: What gay man wouldn't cough up a tidy $200 to have all charges dropped, if it would avoid exposure in the newspaper, the likely loss of a job and possibly a decade in prison? One clerk from a smaller department store a few blocks from Horne's was a regular at the Point, and remembered being arrested there by undercover squad members even before he'd had a chance to make any advances. The Morals Squad soon discovered that their extortion worked just as well on straight men out late alone, who would rather

pay up than be shamed with a charge of "deviance." One straight friend of Warhol's, out walking at night with a female P&D, discovered that even he wasn't safe, once the Squad had decided his parents would rather pay up than see him facing a morals charge. (He fought the charges and eventually won.)

As the *Pittsburgh Press* put it, when the scandal finally broke in 1951, "decent, respectable men could not enter certain public places in downtown Pittsburgh without endangering their reputations, homes and families." The less "respectable" men of Pittsbugh were in a full-blown, paranoid panic.

A state grand jury eventually handed down indictments against twelve corrupt members of the Morals Squad although, tellingly, the scandal wasn't described in terms of its vicious effect on the almost eight hundred men who were arrested. Instead, it was held up as an example of how corruption was hindering the important work of cleaning up the "conditions of unbelievable depravity involving male homosexuality."

This was Warhol's world. His difference from the average male put him at risk, but like many young gays he also used it as a source of individuality and power. Warhol's homosexuality was pushing him toward the social cutting edge, which had always also been a place for cutting-edge art. The two would never be separate for Warhol; part of his brilliance was helping others recognize the connection. You can see it already in his best student piece, although we only know it from a single description.

One of his junior-year assignments was to illustrate a scene from a short story completed in 1920 by Willa Cather, Pittsburgh's best-loved author. The story was called "Paul's Case: A Study in Temperament"—"temperamental" then being a euphemism for "gay." Cather's adolescent hero is described as a "dandy" who wears a "scandalous red carnation" and whose eyes are "remarkable for a certain hysterical brilliancy" deployed "in a conscious, theatrical sort of way, peculiarly offensive in a boy." He loses himself among the pictures in the Carnegie Institute's art museum and then sits in its concert hall "intoxicated" by a soprano singing opera—as Warhol was later in New York, whether listening live at the Met or with Maria Callas cranked up on his stereo.

Of course Cather's antihero is ill suited to life and school in Pittsburgh, where his only pleasure is found among the thespians at a local theater, which has "all the allurement of a secret love." He gets all the stars there to sign their photographs. Kicked out of school, Paul steals a fortune from his employer and runs off for a week of flowers and champagne in a fancy New York hotel. He parties with "a wild San Francisco boy, a freshman at Yale" and discovers

that high society, and the money that buys access to it, means everything to him. Cather might as well have written the story just for Warhol—or about him, almost.

Paul's forbidden pleasures cannot last, and he ends up dead in the snow under the wheels of a train, which was the moment that Warhol and his classmates were supposed to illustrate. The whole class did standard images of locomotives and mangled corpses. Warhol, in his first clear moment of artistic brilliance, presented his puzzled instructor with a blank white sheet with one big splat of blood-red paint in its middle. This was an abstraction that was up-to-date with the latest splats from Jackson Pollock and his crew, who were much on the mind of Tech's P&Ds, but it also counts as the first of Warhol's Death and Disaster pictures, done exactly fifteen years before that Pop Art series came about. The piece also hints at Warhol's body-fluid abstractions, this picture's "blood" preceding the semen and urine that came later as materials for Warhol's paintings. The image also expressed the continuing pain of being a gay teenager in Pittsburgh, forty years after Cather published her story. "We used to average 12, 15, 20 people a year committing suicide," said a gay bartender who came out in the 1940s. "Our people met in parks and we dreamed of love and all that stuff, but there wasn't the arena for that."

Yet there were glimmers of hope even in Warhol's homophobic hometown. A certain condescending tolerance existed for the most outrageous gay men—the Horne's window dressers, for example—to whom 1940s straights "afforded a liberty not unlike that granted by peasants to the village idiot."

A local gallery called Outlines also showed Warhol that there could be some quiet openness toward homosexuality: It hosted some of the first public appearances together of the composer John Cage and dancer Merce Cunningham, who had only recently become partners in art and life. They had an apartment in Pittsburgh during a residency that lasted for all of June 1946, so Warhol had the chance to notice that this creative duo were more than just friends and that their creativity and intimacy might just be connected. Warhol explored that connection between gay life and the avant-garde for the next forty years, and it helped make him a central figure in American culture.

Pittsburgh even had a small network of short-lived gay clubs, although one of the earliest, in McKeesport, was so secret its entrance could only be reached by climbing across the roof. Could memories of that club, where Warhol might possibly have been "born" as a gay man, have fed into his standard lie about having been born in McKeesport? There were also close-knit

networks of gay friends and lovers who, in utmost secrecy, would perform clandestine gay weddings.

Warhol was probably too young and naïve to have been a part of that hush-hush world, but he would have known at least one example of an elite professional who lived life as someone evidently "queer," as later theorists would say, if not as an avowed homosexual. This was Andrey Avinoff, head of the Carnegie Institute's natural history museum, where Warhol (another Andrej) went to draw on many Saturdays.

Avinoff, described by a relative as "an elegant, sparrow-boned man, with pince-nez and natty bowtie," was a Russian aristocrat who had begun his American exile as a successful society portraitist and commercial artist in New York. The Russian also had a legendary knowledge of butterflies, gained during his Czarist youth, and he parlayed that into a career in the Carnegie Institute's natural history wing. He was a national celebrity, profiled in *The New Yorker* in 1948 and scheduled for big play in *Life* when he was felled by a heart attack in the summer of 1949.

In Warhol's hometown, Avinoff, the noted entomologist, was also a celebrated painter: He taught art at the University of Pittsburgh and exhibited and lectured at Carnegie Tech. At the end of Warhol's junior year, the Russian had an exhibition of his fey flower-and-butterfly paintings at the Carnegie art museum at about the same time that Warhol, at Tech, was doing his fey drawing of boy dancers with butterflies. A few years later, Warhol made a drawing of a toddler with a butterfly on his head, on which he wrote: "Here is Andy at the age of two—Looking wistfully at you—He has wings like a butterfly—And if you ask the reason why—He will say: I'm a butterfly you see—Won't you come and fly with me."

Avinoff was also part of a discreet circle of gays at the highest levels of Pittsburgh society. These included married bigwigs such as Alcoa heir Roy Hunt (who funded Tech's library) and aviation tycoon George R. Hann (the owner of Russian icons that Avinoff showed and who was also, it seems, Avinoff's lover), as well as Edgar Kaufmann Jr., the design-savvy son of a local department store magnate. Later, as a curator at the Museum of Modern Art, Edgar Jr. helped Warhol find work in New York.

Avinoff "descended on our city like a fabulous creature from another planet," said a man who studied art in Pittsburgh. "He was the idol of my youth," he continued, "like a twirling Christmas ornament in a department store window, he reflected in muted brilliance all the facets of the world around him"—a store-window "fabulousness" that also sounds like code for Avinoff's queer style.

In his inner circle, at least, Avinoff's homosexuality was "merely a small

part of his charm, everybody knew about it, nobody was bothered by it." He attended one Pittsburgh soiree dressed as a butterfly, and was caricatured as one in a *Pittsburgh Post-Gazette* cartoon that made a barely veiled poke at his queerness. After Avinoff left the Carnegie, he started hatching plans for a gay association in New York, designing a wildly pornographic frieze for its clubhouse that culminated decades' worth of more private erotica. Some kind of contact seems likely between Avinoff and Warhol, two successful gay illustrators from Pittsburgh who did life-drawing sessions at the same institutions, in the same era, and who both built pictures around penises and butterflies. In fact, Avinoff had found many of his nude models among the students at Tech and was a judge for that Scholastic art contest that had once given Warhol some kind of a prize.

By the middle of Warhol's junior year, Avinoff was sharing his soft-core art, and stories of the gay life behind it, with a very important new pen pal who he'd first met in entomological circles: the sexologist Alfred Kinsey, whose *Sexual Behavior in the Human Male* had just made a big splash. By April 1948 its publicity had boosted sales of a stodgy old whiskey named "Kinsey's" by 50 percent; by year's end, the report had earned a line in Cole Porter's *Kiss Me, Kate.*

*Life,* which Warhol read, gave the book huge play. Warhol learned that, for the first time in American history, it was possible to treat homosexual acts and people as a normal part of American life. One of the biggest bomb-shells dropped by the book was Kinsey's finding that 25 percent of adult men under fifty-five had had "more than incidental" homosexual experiences for at least three years straight in their lives. This was a promising vision for a nineteen-year-old who had recently discovered that he was at-tracted to other men.

Within weeks of Kinsey's book appearing, Warhol got a chance to read even more about his "condition," which was at last beginning to seem more like an identity than a disease. Gore Vidal's third novel, *The City and the Pillar,* a book built around homosexual culture, hit the best-seller list that same winter—Vidal said he lived off its royalties for ages. By the following year an underground guide to gay life was saying that its "accurate dialog and color" made it "unlikely to be surpassed" in its treatment of queer realities.

Despite the standard tragic ending for its gay hero, most of the book takes the radical position that homosexuality ought to be a quite acceptable part of America's sexual and cultural mix—a minority taste, for sure, and stigmatized, but not in itself all that strange or remarkable, or shameful. The book dares to imagine "a world where sex was natural and not fear-

some, where men could love men naturally, the way they were meant to." There's no way of being certain that Warhol read Vidal: The *Washington Post*, worried that the novel was at risk of making a perfectly respectable homophobia seem boorish and bigoted, said the book belonged in psychology libraries, "not in the hands of effeminate boys, pampering their pathological inclinations." But with buzz like that, how could the novel not have been the subject of constant discussion among Warhol's gay friends?

It's clear that Warhol absolutely devoured yet another gay-themed book that appeared around the same time, which, given postwar homophobia, turned out to be an unlikely watershed for gay writing. It was a novella called *Other Voices, Other Rooms,* by the twenty-three-year-old prodigy Truman Capote, who appeared on its back cover in a sultry photo that caused a commotion. There's even a story that on a trip to New York the following spring, Warhol went so far as to nab an enlargement of that portrait from the offices of *Theater Arts,* a magazine he eventually worked for.

Capote's text must have been as important as his photo for the nineteen-year-old Warhol, who stalked its author in the 1950s and became his close friend in the '70s. One writer who was in college when *Other Voices* appeared remembered how, surrounded by "truculent" veterans on the G.I. Bill, she and her fellow aesthetes found each other through Capote's new book: "To walk with Capote in your grasp was as distinctive, and as dissenting from the world's values, as a monk's habit."

At some point during his early years, Warhol went to the trouble of writing out a full page of notes on the book's characters, as though planning to illustrate them. In general, it looks as though Warhol took more inspiration from Capote's camp, flamboyant but also closeted vision of queerness than from the inklings in Vidal of an open but unremarkable gay culture that can meld perfectly with the mainstream. According to an early review in the *New York Times,* Capote's book is "fascinated by decadence and . . . evil, or perhaps only by weakness . . . [and] filled with sibilant whispering"—a not-so-veiled hint at its homosexual moments and characters.

The book's hero is the thirteen-year-old Joel, a blond waif described as offending mainstream notions "of what a 'real' boy should look like . . . he was too pretty, too delicate and fair-skinned; each of his features was shaped with a sensitive accuracy, and a girlish tenderness softened his eyes." That's not a bad evocation of Warhol at that same age. A cruel playmate of Joel's even tells him to "go on home and cut out paper dolls, sissy-britches," just as Warhol did during his childhood illness.

Other passages evoke the man Warhol will become, maybe because they helped bring it about. Joel read movie magazines "till he knew the latest do-

ings of the Hollywood stars by heart," and had an irresistible, distinctly War-
holian urge to "keep and catalogue trifles . . . magazine photos and foreign
coins, books and no-two-alike rocks, and a wonderful conglomeration he'd
labeled simply Miscellany."

We also meet an older relation of Joel's who is a decadent, neurasthenic,
cross-dressing aesthete "neither man nor woman . . . whose every identity
cancelled the other, a grab-bag of disguises." His room is absurdly crowded
with Victoriana and gewgaws, "carved tables, velvet chairs, candelabras, a
German music box, books and paintings"—a gay-fabulous style that's like
the décor in Warhol's own later homes. Reading one of the most famous
books of its time (the "fairy *Huckleberry Finn*" as one wag called it) Warhol
would have been pleased to discover that his alter ego, Joel, comes out of
the tale intact, unlike the gay hero in Cather or even in Vidal and in almost
all earlier fiction.

In fact, the tiny, hermetic world of Carnegie Tech also offered hints of a
reality that could turn out well for gays. Like almost nowhere else in town,
except maybe the display departments in the biggest stores, Tech's College
of Fine Arts was a haven for a minority that could be almost openly homo-
sexual.

Warhol had friends in the college dance scene there who were not to-
tally closeted, and in the art department itself "homosexuality was pretty
well accepted," said Perry Davis, the gay teacher who had noticed the "flam-
ing queens" at Horne's and once recommended Capote as an author worth
watching. Davis himself wrote lyrics for drag queens who performed at a
Black music club.

Warhol's fellow student George Klauber was fully out, and went on
to be part of an openly gay crowd in New York: He became Warhol's first
and most important contact in that world. Roger Anliker, a teacher who
arrived only in Warhol's senior year, was gay but mostly closeted. He said
he counted Warhol more as his friend than his student and drew a very
intimate and sensitive—and effeminate—life portrait of the younger man
holding a tiny toy bird.

Perry Davis himself was "very gay and flamboyant," according to Doro-
thy Cantor. He wore hot pink shirts, seen at the time as a sure sign of homo-
sexuality, and in photos he comes off as slight and pretty. One cruel student
called him "the little fruitcake."

At one art-student party held in Davis's flat Warhol arrived with his
hair dyed chartreuse—a sure reference to a new movie called *The Boy with
Green Hair*. It premiered in November 1948 and starred the child actor Dean
Stockwell, who as an adult would show up at a Hollywood party given for

Warhol in 1963. The movie's plot involves a twelve-year-old orphan who wakes up one day to discover that he's become "different" from everyone else—because of his suddenly green hair—and has to learn to cope with discrimination and even beatings. Warhol and the P&Ds who watched him parade his emerald dye job could only have read this as a parable for coming out gay in Pittsburgh.

*. . . in front of the College of Fine Arts with Dorothy Cantor and Philip Pearlstein.*

# 4

## 1947-1949

DADA AND FILM AT TECH | OUTLINES GALLERY
AND THE AVANT-GARDE | STAR STUDENT | ORIGINS
OF THE BLOTTED LINE | NEW YORK HORIZONS

*"Andy did what he damn well pleased;*
*he got approval by being impossible"*

In his junior year, as Warhol was dipping his toe into gay culture, he
was also taking his first deep plunge into avant-garde art. "Make it new"
was modernism's most vital ideal, and however postmodern Warhol can
sometimes seem, that ideal shaped everything he made and did. You
could say that he was only led into the stranger corners of postmodernism
by his early training in modernist innovation: If there's any single force
behind the wild range of Warhol's art, it is his hatred of the already done.
Philip Pearlstein remembered that, more than anyone else in their clique,
the young Warhol believed "that you should always try to find something
new." This idea, so central to Warhol's entire career, wasn't something
he was born with; we can track him learning it as a student aesthete in
Pittsburgh. A teacher of his at Tech is supposed to have laid down the
law to him: "You have got to do things the way you want them, and be
damned with what I think, be damned with what anybody else around
you thinks. Go do it the way you see it, to please yourself, or you'll never
amount to anything."

At Tech, the P&Ds were in full backlash against a local art scene
that was still under the sway of the social realists and American Region-
alists who dominated the Carnegie annuals. "Abstraction and Abstract
Expressionism—that was the new frontier, essentially. Those were the guys
that we admired," said one student. Their teacher Robert Lepper remem-
bered both being baffled by Jackson Pollock and also being convinced that

abstraction had to be defended, however reluctantly, as the "inevitable" destination of art in an industrial society. When a Tech assignment asked him for a depiction of "rain," Warhol turned in a mess of dribbled paint in yellow, blue and red.

Pearlstein recalled that he himself "deliberately did not do anything representational" in his later years at Tech. His surviving paintings, almost all figurative, make clear that this wasn't strictly accurate, but the memory is even more telling for being false: "Abstract" was the word to conjure with, and Warhol later came to use it for almost any art—any *anything*—that came with notable complications.

Out beyond even abstraction's cutting edge, Betty Asche Douglas especially remembered Warhol listening in on heated discussions about Marcel Duchamp "and whether or not what he had done or was doing in art—whether it was legitimately an art issue or whether it was peripheral in some way."

Students cooked up "our own little version of the Dadaist happenings. . . . The idea was to do something unique or unexpected," said Douglas. There was general silliness, involving dressing up like vintage movie stars—Warhol was already expressing his love of Shirley Temple—as well as more serious avant-gardism. The students tried their hand at experimental films, including one that could almost pass for a '60s work by Warhol: "We got on a street car in costume, down in the heart of Oakland, and rode out to the campus, and then we had a guy out there who rolled out the red carpet off the streetcar, to walk on, while somebody else was on the sidewalk shooting."

A classmate described that project, done on a lark by the entire junior year class, as "a very controversial film in its day . . . one of the first underground films." The movie began like one of the Surrealists' "exquisite corpses," with each student contributing ten seconds of footage. To add color, the P&Ds placed gels in front of their projector, anticipating the light effects Warhol devised for his Exploding Plastic Inevitable productions in the mid-1960s. Warhol himself played a notable role in the film.

Around 1965, when Warhol left behind his vast success as a Pop painter to take up radical filmmaking, the move seemed to come out of the blue, but in fact it had deep roots in his college years. Tech instructors were struggling to keep up with their charges' newfound cinephilia: The students had founded a Film Arts club, meant to produce a new movie each year, and had begun weekly screenings of "experimental motion pictures" such as the brand-new *Beauty and the Beast* by Jean Cocteau, one of Warhol's lifelong

heroes. Their art-history text, way ahead of its time, made the astonishing claim that the venerable, static arts of sculpture and painting were inexorably losing ground to "the more dynamic dance, music and drama in a development which has come . . . to find its most satisfying synthesis in the colored talking motion picture." This was pretty much what Warhol was thinking, some fifteen years later, when he officially quit painting for film and managing the Velvet Underground. "Andy was the one who pushed [art] to all conceivable limits. . . . So there was nothing else he could do but go on to rock and roll and movies," as one early supporter put it.

Music was also important at Tech—Pearlstein and Warhol both took piano lessons there—and even the most recent, most aggressively modern compositions were being explored. A gang of students went so far as to turn an old college instrument into the latest in cutting-edge "prepared" pianos, which had just been pioneered by the radical composer John Cage: "[We] tore all the pads off, put thumbtacks and stuff like that in."

If all this sounds too forward-looking for a bunch of Pittsburgh art students, they would have learned to look that far ahead at that long-forgotten local gallery called Outlines, where Warhol got his first big dose of advanced art ideas even before he started Tech. That was where no less a figure than Cage himself had appeared, first while Warhol was still in high school and then three times when he was in college. Warhol said that he remembered meeting the composer, who remained an important role model for decades. In the 1960s, one of Warhol's most ardent defenders saw Cage at the root of his art and persona. Philip Pearlstein remembered that he and Warhol went to a Cage lecture at Outlines that meant a great deal to him, and its hard to imagine how Warhol could have become the dedicated avant-gardist he was if that gallery had not been around. Outlines aimed "to give Pittsburghers modern art whether they like it or not," according to one doubter in the local press, and Pearlstein tells us that he and Warhol and their crew frequented the place, which was still getting big media coverage in their junior year.

Outlines opened in 1941 as the brainchild of a local twenty-one-year-old named Betty Rockwell, always described as a "socialite" in the papers. During its six-year existence, at one time in a space near Warhol's home, the list of events held at Outlines is stunning, more daring than at almost any other venue in the country. As one P&D described it, this "gallery of tomorrow" might as well have been a branch of the Museum of Modern Art. It showed an astonishing range of modern artists, including Alexander Calder with his *Circus* and the first solo show of Joseph Cornell, later a pal

of Warhol's. Outlines's cutting-edge offerings in photography featured such giants as Beaumont Newhall, Berenice Abbott and Henri Cartier-Bresson. The gallery also showed Paul Klee, whose influence on the young Warhol has always been obvious; Cocteau, whose gay aesthetic became crucial for Warhol; and even Duchamp, the central figure behind Warhol's entire approach to art making. Betty Rockwell owned a signed and dedicated copy of Duchamp's deluxe *Boîte-en-valise,* a collection of all his works reproduced in miniature. The *Boîte* was one of several Duchamps that Warhol collected during his early Pop years.

Just as notable, given Warhol's later practice in Pop Art, was a show Rockwell did of silkscreens that declared the technique an especially democratic "direct painting medium"—an idiosyncratic position that Warhol went on to uphold almost polemically in his own silkscreen "paintings."

Warhol's later ideas about film also got their first impetus at Outlines, which screened all kinds of mainstream and art movies, including premieres of experimental films by Cornell and an early screening by the underground pioneer Maya Deren, who Philip Pearlstein remembered as sporting the first afro he'd ever seen. Numerous visits by Parker Tyler, one of the first major thinkers on Hollywood, might have been the source of Warhol's later interest in stardom, making it less the childlike "obsession" it often gets billed as than a genuine intellectual fascination.

Outlines's program of feature films, which ranged from *Metropolis* to *Duck Soup* by way of Paul Strand's *The Wave,* could have been taken from the syllabus for any history of film survey today—just what Warhol needed, later, to move the medium forward. In fact, his interest in early Hollywood could have had more to do with the programming at Outlines, where those films were shown as serious art, than with his childhood moviegoing. The avant-garde collision of Hollywood movies with experimental film, which Warhol first experienced at Outlines, became his trademark as a filmmaker.

———

In the fall of 1947, when money troubles led Outlines to close, Warhol entered his junior year at Tech and started his move up to star-student status: For the first time, he got more A grades than anything else. "He was talented, there was no question about that—the faculty knew that, as did all the students," said a classmate who remembered Warhol excelling even in a G.I.-filled class that was especially driven and potent. A number of instructors were so impressed by their pupil that they held on to his work, a compliment that even the best art students don't often get.

The year didn't begin all that auspiciously, however, as Warhol struggled

to finance his degree. One story says that his mother decided to cut off the funds, but the college's own estimate of Warhol's costs show that his father's bequest could simply have run out: Tuition had gone up in his sophomore year and so did the cost of living. A professor at Tech remembered that Warhol couldn't join in campus partying because he worked after school to get money for food, and Warhol's brother Paul was annoyed when Warhol refused an offer of $75 for a painting that he'd priced at $90, an extravagant sum for student work at the time: "I says, 'Andy, why can't you use common sense, as bad as we need the money?'" Betty Asche Douglas, who was equally hard up, remembered how the two would scrounge for scraps of fine paper thrown out by the richer students in the architecture department. But Warhol somehow managed to keep going, probably with emergency funding from Tech. He even dropped the more career-friendly notion of majoring in art education and declared instead for a degree in Pictorial Design.

When Warhol signed on for a major that combined fine and commercial art, it was a pairing that held special promise. At just that moment, in Pittsburgh and beyond, there was a live polemic pulling the two fields together.

Already while Warhol was in high school Outlines had organized a lecture called "The Advance Guard in Advertising," given by Tech's prominent art teacher Robert Lepper. The gallery also showed actual magazine illustrations, mounting solos for Saul Steinberg and William Steig—both crucial influences on Warhol's commercial career—plus an "Artists as Illustrators" survey that included such masters as Picasso, Matisse and Calder.

The Carnegie Institute, for its part, had opened a show on magazine art just when Warhol was beginning Tech's junior-year classes, and Warhol went to it. Homer Saint-Gaudens, in charge of art at the Carnegie, opined that "we are apt to make too much of a distinction between commercial art and fine art. When a commercial artist is good he becomes a fine artist." Saint-Gaudens focused special praise on the star illustrator Joseph Christian Leyendecker, an artist whose Arrow Shirt ads, featuring gorgeous jazz-age dandies at ease together, are now seen as early emblems of gay companionship. They would have meant more to Warhol than to many other visitors.

A Pittsburgh review of New York's "National Exhibition of Advertising Art"—a show Warhol himself was in a few years later—said that the survey reflected "the trend towards modern art in national advertising. . . . Surrealism and abstract techniques, or a high degree of stylization, seem to

achieve both better art and better advertising than do more conventional paintings."

In the face of all this, how could Warhol have stayed *unconvinced* that lowly illustration had potential as credible fine art, and vice versa? Almost all the work that Warhol went on to make was built around the promising tension between those poles. He figured out that you could help sell your commercial work by making it seem more fine, and make your fine art more radical by cross-breeding it with the commercial. Even two decades later, the noted film critic Jonas Mekas was still arguing for the idea that "there is no art, that everything is craft"—with his friend Warhol and his Brillo Boxes as Exhibit A.

---

Despite the influence of Outlines and the Carnegie art museum, and for all Warhol's growing reputation at Tech, his own work as a junior continued being more adept than radical—more based on finding a signature style than on coming up with the brand-new ideas about art that his later greatness was all about.

He finally began to lose his Daumier loopiness, still visible in some short story illustrations he did that year. He replaced it with his famous "blotted-line" technique, which became his secret weapon on New York's commercial scene in the 1950s. It took the smooth pen strokes of a conventional drawing and made them skitter across the paper in a series of dots and dashes that only just defined the subject at hand, like "embroidery done with coarse, slightly hairy twine," as a later client described it. (See color insert.) The new technique was based on a fractured, lightning-bolt line made famous by the artist and illustrator Ben Shahn, an admitted hero of Warhol's who everyone recognized as the source of his style. According to one classmate, "he developed a variation on that Ben Shahn line and it became the Andy Warhol line."

Warhol and his crowd knew Shahn's work from any number of magazines and from several Carnegie annuals, as well as from Shahn's blockbuster MoMA survey in 1947. By the following year, *Look* magazine had named him one of the country's ten best artists, just the kind of coverage certain to grab Warhol's attention. In Warhol's version of Shahn, however, the older artist's hand-drawn line, angular and angstful, gets turned into something more romantically distressed. Its hesitations don't feel like the result of raw emotion and pain; they feel like a nostalgic fade into the past, as though the world were being looked at through a softening scrim.

To execute one of his "blots," Warhol would start by making a standard drawing, then hinge it with tape to another sheet of paper that could fold down overtop. Next he'd retrace the lines of his original drawing in heavy wet ink, inch by inch, bringing down the hinged sheet each time he added more ink. The top sheet would blot up the pooled, surplus ink from below, so that it copied the drawing Warhol had started with and became his finished work. In this final blotted image, the clean outline drawing from the bottom sheet got broken down until it barely traced a contour. Unlike Shahn's crisp work, a Warhol blot seems strangely distanced and mechanical, like an old picture that's been copied and printed so many times its lines have begun to break down.

Warhol once told a friend, "I always wanted to see how my work would look if it was printed," and his blotted line is often billed as the first sign of his later fascination with mass production and the artist as machine. But it's not that simple: After all, Warhol's blotting technique actually involves more old-fashioned hand labor than the original sketch would have done. At least at first, Warhol doesn't even seem to have blotted any drawing more than once, a labor-saving strategy that you'd think would be part of the point. There are dozens of early blotted images of his so-called musical sprites, but with few if any repetitions among them. Pretending his production was industrial was always an artistic conceit. In New York in the early 1950s, the artisanal labor of blotting got so tedious that Warhol was paying assistants to do it. In the 1960s, even Warhol's Pop silkscreening remained closer to cottage labor than to true machine production.

There's a tale or two accounting for the birth of Warhol's new technique. One genesis story, told by Warhol's teacher Robert Lepper, says that Warhol's poverty forced him to use cheap newsprint for his art, and that made his ink drawings go all blotty. Another legend says that once upon a time, when Warhol was sketching with friends in a local restaurant, he blotted his ink drawing with a napkin and, eureka, discovered his signature line. Warhol himself didn't invoke the restaurant story when he thought back on the origin of his line: He talked about how he had "hated" the way his own line looked when he drew, and about some kind of blotting task they were given in class "and then I realized you can do an ink blot and do that kind of look, and then it would look printed somehow."

Warhol's new blotted works must have been what earned him the $20 prize for "progress" that he won at the end of his junior year.

---

A strange thing has happened over five decades of Warhol fandom: In an unneccessary effort to make him more palatable as a "master," some surprisingly conservative enthusiasts (and investors) have downplayed his radicalism, advancing instead the notion that underneath his avant-garde surface stood a talented traditional craftsman and aesthete. That's why his blotted-line drawings still have such a following, even though they don't come close to his truly transformative work of the 1960s and beyond. His blotted line may have been skilled and appealing, but it wasn't new and it was just a technique. It did not really involve the kind of thoroughgoing Bauhaus—or Dada—rethinking that was held up as the ultimate model at Outlines and Tech.

A first hint of a more aggressive creativity was visible in a piece that Warhol and Pearlstein did together for a drama student's play at a Tech "Arts Night" in May of '48. It was "a huge proto–Pop Art backdrop of the prices for candy bars and ice cream cones [painted] in a graffiti-like manner," Pearlstein said, meant to set the scene for a drama about a Brooklyn street corner. The one surviving photo shows that at least part of the backdrop also included real newspapers, taped up, as well as trompe l'oeil paintings of newspapers, prefiguring Warhol's later use of the daily paper as the subject and source of his very first Pop paintings.

Also that spring of 1948, the two friends tried out advanced politics. The activist Kesslers, along with massier Russell Twiggs, got Pearlstein and Warhol to join the thousands of Pittsburghers who signed a petition supporting Henry Wallace, a far-left New Dealer who had announced his presidential candidacy in Pittsburgh the previous November, when he also appeared before crowds of supporters at Tech. He had a poster designed by Ben Shahn himself, and one Tech student remembered that Shahn's leftist politics made him acceptable as part of the avant-garde. His early work in the new medium of silkscreen associated him with the most socially conscious art, which had adopted the medium before others did. That association may have lingered as part of silkscreen's appeal for Warhol, a dozen years later. The red-baiting *Pittsburgh Press* attacked Wallace as a communist, and on April 7 it went so far as to "out" his local followers by publishing all the names that were on the petition—Pearlstein's parents were not happy to see their son's name in print.

Warhol often gets described as apolitical, which isn't right. During his college years, a preference for the modern itself counted as a left-wing stance. All the modern art that Warhol loved was being pilloried as a dastardly communist plot at just the moment he was first coming to terms with it. Pittsburgh itself had always been a political hotbed—on Warhol's

first day of college a massive miners' strike had earned banner headlines—and from his Wallace moment onward the artist gave quiet but consistent support to the same kind of solidly leftist causes that his heroes like Shahn also backed. In 1972, Warhol designed a poster for the Democrat George McGovern that was based on prototypes by Shahn, including the 1948 Wallace poster. A lot of Warhol's best art has always been read as having left-wing, even anticapitalist leanings, and plenty of his comments express clearly liberal ideas: "They guess that there are between 300,000 and two million people living on the streets in America. This country is so rich. And I think I see more homeless people on the street every month. How can we let this keep happening?" His archives are crammed with decades' worth of thank-you notes from progressive organizations he supported.

———

Summer breaks had always been fruitful times for Warhol: In 1946 he'd done the huckster drawings, in '47 he'd been at Horne's and now, in '48, Warhol, Pearlstein and another few friends were allowed to rent a carriage house ("the Barn") on the grounds of an old mansion owned by the college. They used it as a studio, to sharpen their skills and produce portfolio-worthy personal work. Pearlstein refers to having wasted time "fooling around with abstraction." Warhol "practiced his modern dance movements," as we see him doing in lovely photos shot in the Barn, and generally worked on assuming a visibly artistic persona. "We had a lot of people in and out: friends. We had a little chamber orchestra which came when we first moved in," remembered one of the Barn-ers. He described that "really incredible" moment as "the most influential period in all of our lives . . . we all decided that summer to be painters."

By the time classes began again in the fall, it looks like the Barn crew had done some notable maturing. Warhol moved out of the family house, at least for a while and maybe with a classmate, to the now-demolished Mawhinney Street, putting him directly across the road from the Carnegie museums, as they then were, and in fact inside the expanded art museum as it now stands—a lovely thought, given that he is by far the most important product of that institution. Warhol and Pearlstein both returned to college ranked in the top 10 percent of Tech students. Warhol began his duties as art editor of the student literary magazine, called *Cano*.

*Cano* was an ambitious little publication—its stories were ever so existential and its editors quoted Ayn Rand. It was also pretentious—its title is Latin for "I sing," from the first line of Virgil's *Aeneid*. Warhol used his position on

the masthead there to place his first-ever published illustration. It filled the cover of the November 1948 issue with an orchestra of goofy, round-faced string players, now known to Warhol scholars as "sprites." They seem to derive from the crowd of musicians in Max Weber's *Wind Orchestra,* which won an award at the Carnegie annual in Warhol's sophomore year and was mentioned in local coverage, but Weber's look was transformed by the first notable outing of Warhol's new blotted-line technique.

The sheer crudeness of the cover's drawing gives it a dose of aggressive outsiderism, thanks to all the folk art Warhol saw at the Carnegie museum and in Balcomb Greene's classes. It also gives it a link to the messy new Abstract Expressionism that was just then taking off in New York: Within a couple of years, the painter Larry Rivers, a rising star at the time, was doing dotty-blotty drawings of figures that were explicitly inspired by Jackson Pollock's abstract lines and that look very like some of Warhol's *Cano* figures. An advanced, modernist edge also creeps into the cover in the way Warhol repeats almost the same figure fifteen times and lets them get cropped by the page—call it seriality lite, with a dash of Paul Klee or even a soupçon of John Cage. Warhol's orchestra cover gave a first prefiguration of the repetitions that became his Pop Art signature almost fifteen years later. At this early point, however, Warhol actually made each head rather different, even though blotting would have made it easy to repeat them. This is still a classic theme-and-variations approach, rather than the unceasing duplications of Warhol's Pop era.

If Warhol wasn't at his most daring in his work for *Cano,* compared to some other work he did at Tech, that may have been a symptom of a deep ambivalence about putting your art at the service of other people's texts, as "mere" illustration. All P&Ds assumed they'd make their living doing commercial work—Tech said it aimed to "build a solid foundation for their professional career in pictorial design, industrial design, or art education." But it was always so that they could then go home and make fine art at night, according to Betty Asche Douglas. At Tech, she said, "being an illustrator was almost like a bad word: 'Don't call me an illustrator!'—that meant that you didn't have anything to say." The word "illustration" had been excised from the department's name as far back as 1933, and by the late '40s the best P&Ds considered their illustration teacher, the newly arrived Howard Worner, "the joke" of the school. Worner returned the compliment, at least where Warhol was concerned, by telling cruel stories about him within a few years of his graduation.

It's clear that any timidity that Warhol may have started out with at Tech, as the youngest guy in the class, soon got replaced with quite startling self-possession, even arrogance. Warhol "wasn't the best at taking a problem and solving it within the confines of an assignment" is how Worner later voiced his displeasure, diplomatically. "If he had been running a tailor shop and [you] went in for a pair of pants, you'd come out with a lovely coat."

Roger Anliker, a special friend of Warhol's among the Tech instructors, remembered how "Andy did what he damn well pleased; he got approval by being impossible." This iconoclasm led to tension between him and the senior faculty member Robert Lepper, who had a heavy presence in the last two years of the art program at Tech. He described Warhol as "provocative and controversial," saying that he already had a bad reputation by the beginning of junior year, when they first met: "I knew him as a timid little boy who was often in academic difficulty. . . . Andy was regularly proposed for 'drop' from the institution for failure to maintain 'standards.'"

In his earliest interviews about Tech's most famous alumnus, Lepper couldn't recall having had any "direct contact with his mind," and Warhol later returned the compliment by claiming that he barely remembered his teacher. Warhol "probably" got a B in his course, Lepper vaguely recalled, because his part-time job at Horne's "probably" made him miss class. In fact Warhol got three A grades and only one B across the four terms of the course.

As Warhol's celebrity grew, Lepper's memories somehow got clearer and more varied. Directly after Warhol's death he went as far as saying, "I should have flunked the bastard" and "If anybody had asked me who was least likely to succeed, I would've said Andy Warhola. What a guesser I am." But just weeks later he was already amending that to "Andy will go down in history in the same league as Alexander Pope, William Hogarth, Toulouse-Lautrec and Goya—as a social critic."

When he taught Warhol, Lepper was in his early forties, a Tech alumnus who'd already been on the faculty for almost twenty years. A compulsive smoker, he was "the color of tobacco stain" with a bristly mustache and thick glasses that gave him a walrus look—at least in a caricature of him by Warhol. As an artist, he specialized in machine-age subjects that blended Fernand Léger and a bit of Art Deco, in paintings and sculptures that haven't aged well.

Lepper "radiated enthusiasm" for Bauhaus-style modernism, according to one student, but himself had a degree in lowly illustration. Eager, maybe, to establish his intellectual credentials, Lepper had designed a knotty four-semester course on Pictorial Design that was mandatory in the last two

years of Tech's art program. Despite its straightforward title, the new class stressed "the artist as social participator and collaborator" and was built around advanced texts like John Dewey's *Art as Experience* and Ruth Benedict's *Patterns of Culture*. "I was concerned with sources of conception, with ideas," Lepper said, reflecting the ambitious new "critical-thinking" pedagogy that Tech's president, Robert E. Doherty, was putting in place, and that to this day plays a role in American education.

The first year of the course consisted of a series of five or six tricky pedagogical exercises, or "problems"—President Doherty's favorite term—that were meant to provide basic training to a young artist's eye and mind, but were expressed in a way that went right over the head of many students. "Andy didn't understand anything he said; I would interpret for him," remembered Pearlstein.

The second, more practical year was taken up with mock-commercial and illustration assignments that had to be turned around quickly, as practice for future professional deadlines. The workload was massive and Warhol pulled all-nighters to get it all done. Because his brother's little kids were too much of a distraction on Dawson Street, he often labored in a makeshift studio in the cellar of the Pearlstein home—one of the city's new modernist houses, as it happened, made of poured concrete.

Lepper assigned a problem about portraying heads and hands, and Warhol addressed it with such panache that a classmate spent $30 to buy his solution, an image of an estranged couple in bed that has a daring erotic and neurotic charge and that one Tech instructor declared "immoral." Like the "Paul's Case" suicide painting, Warhol's bed painting manages to twist and surpass the brief he's been given—as Warhol reliably does for the rest of his life in art.

As part of Lepper's effort to "enculturate" his charges, as he put it, in their final year he had the class read and illustrate the controversial new novel *All the King's Men,* which traced the rise and fall of the Southern demagogue Huey Long and had just won the Pulitzer Prize for Robert Penn Warren—who Warhol photographed years later, when Warhol was just hitting it big with Pop Art and could revel in the attention of the giant he'd read in college. Warhol's vibrant, Shahn-inspired drawings for Lepper capture the story's angst and aggression and some of its pathos. In one, crowds are enthralled by an orator's rant. In another, Warhol makes hands and fedoras as expressive as eyes and lips. The drawings were so good they were exhibited in the college halls and retained as examples of fine student work. Looked at closely, they also reveal that Warhol was using news photos as sources for his figures, as was still considered shocking at Tech and in much

of the art world. It's no wonder that Balcomb Greene kept his own use of photographs secret, even though—or because—he'd declared photography to be "unparalleled in the social effectiveness of its story and . . . its documentary quality makes the effort of the social realist painter negligible." Photographic sources were controversial even in the work of Ben Shahn, and Warhol's own (covertly) photo-based drawings look ahead to the (polemically) photo-based Pop that became his trademark.

Lepper's lessons foreshadowed other sides of Warhol's future. A major component of his course was the so-called Oakland Project, "The Study of a Social Organism," which asked each student to go out into the college neighborhood and dig deep into its social significance and structures. The idea was that art should intersect with the normal world around it—with the "social flux," as Lepper put it—and that was a notion that became central to everything Warhol did once he hit his stride in Pop. If the details of Lepper's teachings weren't strictly speaking necessary to Warhol's later development—other influences were also at work—they played a part in preparing him for it. Lepper does deserve credit for Warhol's lifelong conception of art as a series of "problems" that need to be solved, with whatever tools, techniques and images he found at hand.

———————

The creative height of Warhol's college years, aside from that lost blood-on-snow painting, seems to come at about the same time as his encounters with Lepper—but not because of them. Beginning in the summer of '48, in the Barn, Warhol started to make a number of "personal" works that included what can be called his Nosepicker series: They portray that title's action in everything from nasal close-up to full-figure view. One Tech instructor remembered Warhol attaching actual Kleenex to the surface of one picture. The series is bratty and droll and also fairly extreme, even to twenty-first-century eyes; it must have come off as deeply aggressive back then. By that point, however, the entire art department already knew that this was becoming Warhol's M.O.: "He was going to be himself, no matter what. You could laugh, you could cry, you could cuss him out—you could do whatever, and he could just totally ignore you if he chose to."

Late in his life, and in his tall-tale telling, Paul Warhola brushed away the nasty subject of the Nosepicker paintings with a story about the constant nasal excavations of his own children, and how Warhol's pictures were meant to be cautionary, so his kids "could see how they looked." But that can't explain the most daring work in the series: a painting that did indeed begin life as a normal little boy wearing shorts but was soon reworked into

a full-frontal of a young man with a shock of blond hair and an adult's chest hair, completely naked except for a pair of girlish Mary Janes on his feet. There's no way that anyone who knew Warhol could have read the painting as anything other than a brazen self-portrait by an unrepentant homosexual, the pinky finger up his nose being a stand-in for a middle finger raised in general defiance.

The series did a lovely and very Warholian job of combining an in-your-face figurative subject and a scratched and tortured surface that had all the radicalism of an up-to-date Abstract Expressionist technique. *The Broad Gave Me My Face But I Can Pick My Own Nose* is the name that Warhol is supposed to have chosen for at least one of the works in the series, and that must have added to its bite as a naughty reworking of some banal saying such as "The Lord gave me my fate but I can pick my own road."

The result turned out to be intolerable for the Pittsburgh art world, although probably gratifying for Warhol and his crew. In February 1949, or so the story goes, one painting from the series—usually identified as the one that's a close-up on the nosepicker's face and hugely distended nostril—is supposed to have caused a commotion when it was rejected from the annual exhibition of the Associated Artists of Pittsburgh, which had just named Balcomb Greene as its Man of the Year.

The Nosepicker legend tells of a fierce debate among the celebrity jurors for that 1949 A.A.P. show, including the German expressionist George Grosz and the Russian constructivist Alexander Archipenko, but also the self-taught American Regionalist and communist Joe Jones. The story goes that Grosz went head to head with Jones to get the Nosepicker painting included in the show, but lost the battle and had to settle for putting in a much tamer Warhol.

Warhol seems to have got a kind of consolation prize when his offending painting was included, six months later, in a graduation show of Tech students' work that Warhol's friend Leonard Kessler helped organize at the Pittsburgh Arts and Crafts Center. One classmate described the "curiosity seekers who flocked to the Center, many specifically to view Warhol's previously outlawed painting," but piles of period documents don't even hint at the work itself or the fuss.

Whatever the scandal around Warhol's senior-year work, and despite rumors that he lacked the mandatory Phys. Ed. credits from his first two years—actually, his transcript shows him passing all four semesters—Warhol was deemed worthy of graduation. His photo doesn't appear among the graduating students in the college yearbook, so it could be that his fate

was still in doubt when it was laid out. But on June 16, 1949, in the vast, Orientalist spaces of the so-called Syria Mosque in Oakland, Warhol was one of forty-seven P&Ds awarded their degrees, as a member of the largest graduating class Tech had ever fielded.

What next? According to John Warhola, his little brother first applied to teach art in the Midwest. When his portfolio wasn't well received, "he was very upset and that's when he said, 'Well, I'm going to New York.'"

Warhol had already been there once or twice a year while he was at Tech, riding the night bus or train with Pearlstein and other friends who took snapshots—which survive—around the city's museums. He even told friends the unlikely story that on one of those trips he'd played chess with Marcel Duchamp. Whether that happened or not, it matters that it was a tale he deemed worth telling, in a world where most art students wouldn't have considered Duchamp an obvious hero.

He would have known other tales of New York, both inspiring and cautionary, that might have touched off his strong feelings about the metropolis. Late in 1947, the Tech English teacher Gladys Schmitt, who taught the terrifying Thought and Expression class that almost sank the freshman Warhol, published a novel that was about "a creative person" who moves to New York and suffers "the hazards of perfection," as a rave review in the local paper put it. Warhol got Schmitt to autograph a copy for him, and kept the volume for the rest of his life. The novel's young protagonist is an undernourished, poverty-stricken, ghostly pale and oversensitive neurotic who haunts the Carnegie Institute's library and art museum as well as Schenley Park, and is utterly at odds with daily life in Pittsburgh. "I would like to be famous. . . . So that everybody would love me," says the character. Enrollment and then success in the arts at Tech leads the character to stardom in Manhattan. The parallels to Warhol's own life and attitudes are uncanny, and he must have seen them as such—even if the character in question happens to be a girl, and her vocation is drama rather than art.

And then there was this promising passage, from Gore Vidal's 1948 novel of gay life: "It seemed that from all over the country the homosexuals had come to New York as a center, a new Sodom; for here, among the millions, they could be unnoticed by the enemy and yet known to one another. . . . The thousands in New York were either the strong and brave or else the effeminate and marked, people who had nothing to lose by being free and reasonably open in their behavior."

Warhol's final, deciding New York trip came when a bunch of his crowd

headed there during Tech's Easter break in 1949. Their old friend George Klauber had invited Pearlstein and Warhol to share his apartment in Brooklyn, all three of them in one bed, which yields the delectable image of the straight and straitlaced Pearlstein sandwiched between his two new-minted gay friends.

Klauber also invited his two guests to use the contacts in the Rolodex of his boss Will Burtin, the cutting-edge art director of *Fortune* magazine and head of the same Art Directors Club that went on to give prizes to Warhol a few years later. According to Pearlstein, Klauber helped him and Warhol show their portfolios to art directors around town, and Warhol claimed that he'd cajoled a promise of future work out of Tina Fredericks, art director at *Glamour,* who did, in fact, give him assignments the following fall.

Warhol visited the Museum of Modern Art, where he got to take in "The Exact Instant," a pioneering show of photojournalism that foreshadows his own later use and production of newsy photos. In the short run, however, he might have gotten more out of another MoMA show that had been organized by Will Burtin himself. It presented the "most advanced trends" in advertising art, according to a rave in the *New York Times.* The review praised ads and illustrations that were "superior to a lot that passes pretentiously as 'fine' art." It spotted the strong influence of the elite avant-garde—Piet Mondrian, Hans Arp, Joan Miró and Paul Klee—on celebrity ad men such as Paul Rand, William Golden and Ben Shahn, whose famous and very Warholian "orchestra" image for CBS was given a big chunk of the *Times* page. It's hard to imagine a show, or a review, more perfectly suited to feed Warhol's hopes and ambitions, or to be better bait for his move to New York.

Julia Warhola and her older sons weren't keen on the idea of losing their innocent Andy to the big, bad city. His mother cited the cautionary tale of a certain "Bogdansky" of their acquaintance, a Rusyn artist who had tried the same move and ended up dying in poverty. "Andy says, 'I'm going to New York,'" his brother Paul remembered. "And she says, 'You are not going to New York. You get yourself a job here, working. I'm not letting you go. You're too young to go to New York.'"

It took some wheedling from Pearlstein to overcome the family's doubts: "They knew my father, who, like them, made a living as a huckster. . . . So Andy's brothers and I had a meeting, and they decided that as I was several years older, and an army veteran as well, that I would be able to look after him, but they would let him go only on the condition that he and I would live together." Balcomb Greene, in favor of the venture, set the boys up with

a three-month sublet on New York's Lower East Side in the home of one of his cofounders in the American Abstract Artists group, away on a fellowship with his artist wife.

Packing their worldly goods into paper shopping bags—a goofy, cheapskate idea of Pearlstein's—the pair trotted off to Pittsburgh's grand Art Deco bus station, a miracle of modern streamlining, where they boarded the all-night Greyhound to New York.

*. . . as a new New Yorker.*

# 5

## 1949

*"Within a few weeks in New York, he certainly didn't need
anyone to take care of him—he did it all on his own"*

"JACKSON POLLOCK: Is he the greatest living painter in the United States?"
On Andy Warhol's twenty-first birthday—August 6, 1949—that headline was
getting big play in the latest issue of *Life* magazine. The feature on Pollock,
in color no less, describes a guy who was *really* from the sticks (Cody, Wyo-
ming), who'd been trained in tired realism and yet still managed to break
through into the New York art world. He sold his radical abstractions for
thousands of dollars apiece and achieved the ultimate in American celebrity:
his portrait in *Life*. No birthday greeting could have been more auspicious for
our new New Yorker, newly come of age. Decades later, when Warhol was
involved in a documentary series on American icons, he was adamant that
Pollock be included.

On the commercial-art front, *Life* might have given Warhol equal reasons
for optimism about his prospects, if only because its ads were so obviously
below the standards set at Tech. On page after page, *Life*'s ads offered comi-
cally lame realist illustrations and banal studio photos. Warhol couldn't have
seen them as either inspiration or competition; even at that date they must
have registered as amusing kitsch. A cheesy, full-page Campbell's Soup ad
("IT'S COOL! IT'S REFRESHING! IT'S DELICIOUS—CAMPBELL'S CON-
SOMMÉ . . . *SERVED JELLIED*) featured its already-iconic can three times. It
must have been stored up in Warhol's mind as source material for his first
Pop riffs on similar advertising—not necessarily in admiration of it, as many
critics have claimed, but more likely in amazement at the old-fashioned me-
diocrity of postwar marketing, even once modern design was supposed to
have taken hold. At its best, Warhol's art always balanced on the edge be-

tween satire and reverence, whether its subjects were soup cans or celebrities.

Warhol read *Life*'s Pollock profile while subletting the home of a well-recognized painter, proof that not all serious artists ended up being starving Bogdanskys, even if they weren't stars like Pollock. The apartment was a sixth-floor walkup on the street called St. Mark's Place, on the Lower East Side just off the corner of Avenue A and catty-corner to the verdant Tompkins Square Park. If it didn't exactly scream of Pollock-like financial achievement, it did have the cultural cachet of a classic artist's garret, facing south and light-filled on its sixth-floor perch. The building, at number 121, was (and is) an ornate 1907 structure in tan brick with elaborate stone detailing, meant for workers in an up-and-coming New York. Inside, however, it was "a tenement in un-retouched condition," as Pearlstein described it: Three rooms with walls that were a dingy, discolored white and bare lights hanging from the ceilings. In classic New York fashion, a single, linoleum-floored space did duty as kitchen, living room and, in this case, art studio. The table was an enameled top that rested on a claw-foot bathtub.

The sublet did have a few gentrifying touches, at least by the standards of that time and place. There was an electric fridge instead of an icebox, a toilet installed in a closet that saved the trip to the communal bathroom in the hallway, and, as Pearlstein remembered, "a functioning candlestick style dial telephone, which we made great use of." It signals the start of Warhol's addiction to calling. In the early '50s, long before he invented the aloof "plastic" persona of the Factory years, Warhol was already almost silent in public—"shy, very shy," according to one friend from that era. The reticence was only in person, however. "Get him on the phone and he would talk for a long time. But he seemed to always have to have that something in between—that distance." Warhol's family hadn't even had a phone until he was fifteen, and that deprivation might have given special emotional weight to the device. In those first years in New York, Warhol settled into his lifelong habit of calling friends to get lurid details of their sex lives. A decade later, when he chose a telephone as the subject of one of his first Pop Art paintings, it was an old-fashioned candlestick model like the one at St. Mark's Place, when a more modern version might have made more artistic sense. As the scholar Reva Wolf has argued, there's often a more personal subtext in Warhol's art than critics tend to think.

Another prominent fixture of the apartment, and of the next few that Warhol lived in, was a horde of cockroaches that came out every night, settling into any open container and even eating art supplies. Both Pearlstein and Warhol tell horror stories (sometimes identical ones) about bugs crawling out of their portfolios when they went for interviews, and Warhol came to call this his "Cockroach Period," making it sound more lively, maybe, than the young

Picasso's merely Blue and Rose ones. Roaches kept company with lice, which Paul Warhola and his kids caught when they visited from Pittsburgh.

St. Mark's Place was a "tiny island" of Greenwich Village bohemia in a sea of immigrant grit, according to the *New York Times*. The street's newly arrived bohemians included Larry Rivers, another artist on the rise who soon became a close friend and Pop Art colleague. As for the immigrants, Warhol would have felt especially at home among the area's particular brand of hyphenated Americans. After World War II, a flood of people from around the Warhola homelands had fled Stalin and moved into the neighborhood, which got the nickname "Little Ukraine" and was filled with other Greek Catholics like Warhol. It didn't gain its artsy reputation as the East Village—or at first, "Village East"—until the demolition of the elevated train on Third Avenue in 1956.

Pearlstein remembered heading out to explore the neighborhood on their first day, and discovering Rappaport's and Ratner's, two Jewish delis that George Klauber had pointed them to. "They were where we usually ate during that summer, mostly because they featured complimentary plates of rolls and slices of bread which we wolfed down while reading the menu, only to order a bowl of 'fruit soup' for our 'main course,' and maybe apple pie for dessert. The waiters were older men and friendly, and they never complained." Although Warhol had arrived in New York with $200—$150 of it as a gift from his brother—money was clearly tight. He set out at once to fix this.

Supplied with Klauber's list of art directors, the roommates agreed that Warhol would make his pitches first. Pearlstein, admitting to a less "salable" portfolio, would wait another ten days before reaching out to the same people. In late June, when they hit New York, the city was enduring a proper heat wave and August peaked at close to one hundred degrees. Throughout it all, Warhol went job-hunting in his now-grungy corduroy "dream suit," which he wore baggy and crumpled with an ever-present bow tie and big round glasses that gave him a vaguely literary look. "When Andy described his first appointment he said he told the receptionist that he was about to faint and asked for a glass of water," Pearlstein remembered. "The whole staff scurried around to help him get comfortable. He wondered if he could use that routine again."

After a few days of tepid responses to his work, Warhol made his way to the grand headquarters of the Condé Nast publishing empire in the Graybar Building, a skyscraper once billed as the biggest office building in the world. It was as New York as could be, catty-corner to the Chrysler Building and looming over Grand Central Station, which Warhol later remembered as the central point in his life at the time. Riding up to the nineteenth-floor offices of *Glamour*, Warhol's first encounter was with a twenty-two-year-old named Margaret "Kett" Zegart, who was assistant to the magazine's art editor and

the first line of defense against hordes of hopeful creatives who came by. More than six decades later Zegart still had strong memories of "André Warhola" as a classically "shabby, eager artist," but also as a showman who sought attention. In the early 1950s, when a friend warned Warhol that he'd spilled ink on his shoes, the artist proudly pointed out that there were also razor cuts in his suit. He explained that he'd messed himself up just so clients would ask what had happened—his early glass-of-water trick taken to the next level.

Zegart and Warhol sat down at a long glass table where he spread out his best work from Tech. Zegart judged it "very strong, very personal, very clearly and competently done." But also not at all suited to the work in fashion illustration that Warhol said he was looking for. Before sending the young man on his way, however, she had the best work from his portfolio "photostatted" to present to her boss, a sign of her belief in Warhol's talent.

"His ink lines were electrifying. Fragmented, broken and intriguing, they grabbed at you with their spontaneous intensity," remembered that boss, art director Tina Fredericks, all of twenty-seven years old and five months pregnant when she received Warhol. *Glamour* had begun its life covering Hollywood—Warhol might have known it in that incarnation when he was a star-crazed kid—but by Fredericks's era its tag line proclaimed it to be the magazine "for the girl with a job," a new creature born when the war effort first gave work to American women. The magazine was bought by six hundred thousand of them.

Warhol showed up for their meeting in his Raggedy Andy look, "all one color: pale chinos, pale wispy hair, pale eyes, a strange beige birthmark over the side of his face." Fredericks especially remembered his breathy voice, "slight, un-emphatic, whispery, covered over with a smile." The big black portfolio that he presented to Fredericks was meagerly filled. There were some flowers, a bigger, color version of the orchestra cover for *Cano* (signed "André Warhola") and some nude figure studies.

Fredericks was worried that "his basic thing wasn't fashiony or girly or pretty," and that her readers wouldn't "thrill to this particular art much," but she still saw Warhol as obviously talented. (At least as she remembered it four decades later—maybe overestimating her initial enthusiasm in light of his later success.) She decided to give him a chance at some work. "Could you draw something more practical, merchandisey?" she remembered asking. "I can draw anything," he replied, with the cockiness that his surface diffidence never quite hid. Fatefully, Fredericks decided to try him on shoes, an almost haphazard choice that within a few years had blossomed into Warhol's reputation as the man to go to for pictures of footwear. Six model pumps were sought from *Glamour*'s new "shoe editor"—the famous Geraldine Stutz, who

became a major client of Warhol's a few years later at I. Miller shoes—and Warhol turned the job around overnight.

"He was *fast*," Fredericks said. He also did it all wrong. This became clear in the morning when Warhol returned with drawings tumbling out of a brown bag, the new "portfolio" that became his trademark and eventually had him signing himself "Andy Paperbag." He pulled out reams of beautiful drawings, "shoes with the swells and cracks and wrinkles of true personality, full of character"—precisely what he'd been asked to draw for an assignment at Tech, in fact.

They were also, as Fredericks informed Warhol, just what was *not* wanted in images meant to move product: "You have to see every stitch, you have to really want to wear them, or be able to tell what they're like . . . they have to look fresh from the racks at Bonwit's," she explained, not predicting that Warhol would make his fortune as an illustrator by breaking every one of those rules.

She let Warhol have a second chance. He dragged the shoes back to the sublet again, where the meticulous Pearlstein showed him how to get the detailing and perspective right. Warhol then stayed up all night translating the drawings into his dainty blotted style.

"He returned the next morning with flawless renderings," Fredericks remembered. She used them on the first of eight pages that she then assigned to Warhol, for a special high-end insert featuring essays on a career girl's challenges, each to be illustrated with a "ladder of success" and a cutesy-pie girl climbing it. Since those seven later pages were product free, they gave Warhol room to put as much "character" as he wanted into Fredericks's concept. He deployed his best outsiderish style in pictures that don't look at all like an art student's maiden flight; Fredericks respected him enough to send him proofs of his pages, which he kept until the day he died. Warhol had snagged "a major job that people in New York had been knocking themselves out trying to get that kind of job for years," recalled Pearlstein.

"Success Is a Job in New York" is the famous headline on the first of the *Glamour* essays, and that's always been taken as proclaiming Warhol's own newbie view at the time—not that he would have written a word of the copy. (Although he must have smiled at the feature's first line: "Success! It's a lovely word . . . gay and triumphant"—just what Warhol had hopes of becoming.)

A few of the other essays' titles might also have resonated with him. There was "Success Is a Flying Start"—he'd just got one of those—and, over a two-page spread, "Success Is the Men Who Love You," an idea that Warhol's new city let him test. On his very first assignment, Warhol had been asked to put himself in the shoes of the opposite sex, launching a gender-bending

thread that got woven through the rest of his art and his life, at least once he'd settled into New York's gay culture.

That did not happen right away. That summer, the roommates' "rather full social life" was mostly spent with a bunch of their Pittsburgh friends and classmates who were staying in the city.

Outings included trips to the beaches around New York. Lovely photographs survive of those warm seaside days, with the girls in shorts and halter tops, the guys in swimming trunks and Warhol in . . . long pants and a turtleneck. With his paper-white skin, he could have used Woody Allen's line: "I don't tan; I stroke." Even later in the 1950s, a friend remembered how Warhol "always wore a lot of heavy sweaters and a muffler and a turtleneck turned up, even during the summer," which calls to mind Glenn Gould and other geniuses with an eccentric streak.

Pearlstein said that a friend from the Tech drama department played an important role at that moment. He pointed the boys toward the new drama they needed to see in New York, and told them how to nab standing-room tickets for all of $1.50. They saw *Death of a Salesman* and *Kiss Me, Kate* (both still big hits when they got there) as well as *The Member of the Wedding* (which opened the following January). Pearlstein has also talked about several visits to the Metropolitan Opera as well as to the ballet for Stravinsky's *Firebird,* a landmark George Balanchine staging with sets by Marc Chagall that was a huge hit in New York City Ballet's very first season. It looks as though Warhol's contact with the high arts during his first while in New York was as much about drama and dance as painting and sculpture. One of his first Manhattan boyfriends describes theater as Warhol's one passion in the early 1950s, with almost nightly trips to see shows whose tickets were picked up "on impulse, even if it meant buying the most expensive seats." Warhol never lost his taste for the stage. He tried his hand at theatrical design and production more than once, and kept his ticket stubs and programs for plays of every sort, from the radically experimental to Tennessee Williams—an obsession of Warhol's—and on to Stephen Sondheim, *A Chorus Line* and *Cats.* His archives are also full of receipts for subscriptions to the opera and ballet. Dance, especially, was newly fashionable in 1950s New York, and most notably in its homosexual circles: "80 to 90 percent of the gay world" would head to the New York City Ballet to see the latest from Balanchine, said one of his dancers. One young man, just then discovering his love for other men, described a Balanchine performance where "the combination of the aesthetic and the erotic so overwhelmed me that within thirty seconds I was a dedicated balletomane for life." Something like thirty-five years later, in the weeks before his death, Warhol was still speaking fondly of the Balanchine dancers he'd seen in the 1950s, recalling each one by name.

A Pittsburgh cousin of Warhol's remembered him taking her to some kind of "very strange" Greenwich Village ballet. She found it boring but it left him "completely in a trance, the whole time he was literally sitting on the edge of his seat. . . . Andy was in ecstasies: 'Wow, that's wonderful! Aren't the dancers beautiful?'"

———————

"Within a few weeks in New York, he certainly didn't need anyone to take care of him—he did it all on his own," remembered Pearlstein, who never quite got to play the big-brother role the Warholas had cast him in. Once Warhol got the *Glamour* gig, his workload in their flat "never let up," said Pearlstein. The lead time for magazine work was long—easily ninety days—so the illustrations that readers got to see that Andy-mad fall would actually have been commissioned and executed toward the start of a summer filled with cold calls on the street and all-nighters at the work table.

With his usual luck, Warhol had turned up in New York at an unusually auspicious moment for commercial artists. Writing just then, the legendary ad man John P. Cunningham described how an industry that had been devoted to clever copy was at last realizing "that ideas expressed in art can do more and reach more people." Most commercial artists, he said, were still hawking clichés—oldsters in rocking chairs, lovers in clinches—"no more than an illustration of what the headline clearly says." That left a desperate need for a new breed of illustrator whose images could hold a page, and sell a product, on their own merits.

Enter Andy Warhol.

Robert M. Jones, a well-known illustrator who was then the art director at Columbia Records, remembered the morning that a fellow designer called to tell him about a new and "very hot talent" who he should look into for his album covers. By that afternoon Warhol had made the two-hour trip to Columbia's offices in Bridgeport, Connecticut. He was "shy and timid— unbelievable compared to his popular image. And I gave him three little spots to do for the corners of the standard albums. He needed money," said Jones. "Two days later he came back with a stack of drawings like *that* to satisfy the three drawings we needed." Jones remembered Warhol supplying more different versions of an assignment than any of his rivals ever did. "You were always going to get Andy—but that was why you called him in the first place. But he gave you alternatives, you could exercise your judgment related to sales, to the popular field, discount the art or the personality but count all the other influences that entered—what made a record jacket." (Warhol had had practice at Tech, where students were made to do album covers.) For

providing all that service Warhol got $50 per cover, decent pay for a total be-ginner. A trade magazine at that time mentions $49.88 as the average bill for any piece of commercial art, and Warhol's little black-and-white drawings, which only take up maybe a quarter of each record cover, must have been simpler than most assignments.

Two of Warhol's first Columbia covers are known, both blotted-line draw-ings of no huge distinction. They're for the company's high-end Masterworks label, which lets us in on something important: Although at this pre-Pop point in his career Warhol was still a "lowly" commercial artist, from the very start he was at the arty, high-prestige end of that trade.

It's easy to think of twelve-inch record covers as normal postwar con-sumer goods, but in 1949 the 33rpm vinyl album was in fact still a brand-new, elite product. It had been invented by Columbia itself and was launched onto the market only a year before Warhol got his cover contracts. The "revolu-tionary new Columbia long-playing (LP) Microgroove Record" was a flag-ship product whose more elaborate album covers gave artists and designers the "widest opportunity for expression," according to Jones. Prestigious clas-sical recordings, which were central to any record company's image, were the focus of Columbia's new line of products.

Even within that select and still experimental market, Warhol worked at the rarefied end, producing the kind of "artsy-smartsy" work that got Jones "crucified" at sales meetings, he said. One of Warhol's covers was for an al-bum commissioned by the Museum of Modern Art, of music arranged by a Mexican avant-gardist for a major MoMA show. Warhol based his drawing on a reproduction from a seventeenth-century manuscript, no doubt imagin-ing its likely appeal to museumgoers' tastes. The other record cover was for Sergei Prokofiev's soundtrack to Sergei Eisenstein's *Alexander Nevsky,* which Warhol would have seen at Outlines gallery in 1946, when the movie was less than a decade old but already an icon of experimental Russian film. Some mention of having seen *Nevsky* could have helped him win the Columbia gig.

Warhol knew that such record covers had cultural heft. As Jones remem-bered, "You would go to the hip couple, the swinging couple, the young bach-elor or the lady who preferred to live alone, and on the coffee table you would find three or four albums laying out, where today generally you find some expensive picture books. It was a status symbol, and they would have a qual-ity that allowed them to act as a social symbol."

In his work as a commercial illustrator, Warhol didn't have all that much to do with the mass of low-end product advertising flooding America after the war, the kind of banal images that polluted that August 6 issue of *Life*. The link that's typically made between Warhol's later Pop Art riffs on consumer prod-

ucts and his own commercial career is mostly a red herring. His Soup Cans and Brillo Boxes are all about low culture being looked at from on high, and Warhol was already occupying those heights in his particular corner of commercial art. His illustrations were all about appealing to a class of elite consumers that was born in the late nineteenth century and considered itself "a new type of aristocracy, one not of birth but of spirit—superior individuals who would forge a personal mode of consumption far above the banalities of the everyday."

The following spring, a trade magazine for the advertising business published the very first write-up on "Andrew Warhola, a young man from Carnegie Tech with an unusual technique," written by the celebrated ad man Charles Coiner, who had been pointed to Warhol by a design aficionado from Pittsburgh. Coiner later gave Warhol several contracts, but in this early coverage he billed the young artist as specializing in record covers but needing to expand beyond that.

"Do you have any work for me?" reads one begging postcard from Warhol to Bob Cato, the new designer at *Theater Arts,* which was a respected little magazine just then being revamped. That first summer in New York, Cato gave Warhol a contract for a pair of tiny portraits of Broadway producers for the October issue, although those were not much more than minor decorative filler—or spot art, as it was called—in a magazine with a circulation less than one-tenth of *Glamour's.*

Moving up in the publishing world, by December Warhol's work could be seen illustrating a short story in *Harper's Magazine,* which went out to 150,000 elite culturati and was the only client he bothered mentioning when he wrote back to Tech about his New York successes.

On top of his magazine work, Warhol got at least one proper advertising contract almost at once, for a Philadelphia fabric company. We can tell the ad's early because it is signed "Warhola," probably the last time that name appears. That early ad launched a lifetime of work around textiles that rarely gets mentioned, including actual yard goods that Warhol designed as well as vintage weavings he collected in depth. Even the repetitive patterning in a lot of Warhol's Pop silkscreens, not to mention in his wallpapers, have links to fine fabrics. Experimenting with textiles comes as part of Warhol's ongoing willingness to try his hand at the "low" arts—Tech had taught him that this downshifting could actually count as high-art avant-gardism—and even to play games with what men and women are supposed to care about. He once said that the "ladies' art" of textiles is "yet another proof that women are the world's major artists." So much, once again, for Warhol's supposed lack of politics.

*. . . at his easel with one of his horde of Siamese cats.*

# 6

## 1949-1951

*"We had one problem which was money. But other
than that, you know the world was our oyster"*

*im sitting here and our stupid castrated persian CAt keeps staring at me.
martha came with the studio like everything else—percussion instruments,
piano, drums, ubangy and chinese records, books, plants, tapestries. naked
statues of franizka Boas—the woman with whom we share the studio
with, and another lady who writes on nudity.-very strange. but don't
misunderstand me. we have our own room. we share the studio we paint
and she dances. Come up any time. anytime you nothing to do its really a
very arty place. real nice*

This is how Warhol describes his second New York home in a letter to
Kett Zegart, the assistant who'd given him his break that first day at
*Glamour*. In September 1949, he and Pearlstein started sharing a loft with
the pioneering dance therapist Franziska Boas. It was an arrangement that
Pearlstein has described as "exotic and immediately interesting." It was the
moment, he said, "when Andy became Andy Warhol—from Andy Warhola.
I am not quite sure what went on in the relationship that got established
there, but he became the personality that became famous." That means
Pearlstein was witness to one of the most important moments in his
friend's development.

In August, with their St. Mark's sublet running out, the boys had dug into
the classified ads to find a new home. What they got was another sublet, this

time in the dance studio run by Boas. She was the daughter of Franz Boas, a titan of modern anthropology who taught a roster of future giants that included Ruth Benedict, a thinker Warhol had admired at Tech. Franziska, on top of her innovations in dance, had founded the West's first all-percussion ensemble. John Cage himself had taught in her radical studio. Flyers for it bill him as a "composer and director of percussion orchestras" who was in charge of "movement analysis and body building." Boas had also performed with Cage's lover, Merce Cunningham, an astonishing coincidence given Warhol's own Pittsburgh encounters with the pair. The studio's piano, mentioned by Warhol himself in his letter, had been "prepared" by Cage, and the couple must have come up in the long conversations that Boas and Warhol are supposed to have had.

On the first of September, Warhol and Pearlstein left behind St. Mark's Place, with a fridge now covered in mold and a bathtub filled with drowned roaches, and moved thirteen blocks north to 323 West Twenty-First Street, at the far west end of Chelsea between Eighth and Ninth Avenues—a run-down neighborhood just then on its way up. They were two blocks from the louche Chelsea Hotel that Warhol would later make famous, but also within shouting distance of several Catholic churches, which some sources claim Warhol attended. Their new digs were on the second floor of a four-story brick building built in 1865 as a firehouse. Boas had given dance classes there since 1940, to students of every race. In an early case of affirmative action, she didn't charge tuition to blacks.

The Boas studio was a scene of true bohemian chaos—just what Warhol re-created exactly fifteen years later in his Factory. There were the disturbed children, "screaming and beating drums," who Boas was trying to help with her dance therapy. There were also her marathon classes for adults, whose "structured improvisations" sometimes didn't even begin until 8 P.M. "Just as you would give a kid paint and paper and say, Paint, paint anything you like, I give them controls and technique and say, Here is your body, and you. Move!" Boas said to one newspaper writer. The first-floor tenant complained that the dancing was shaking the lights off his ceiling and another neighbor once scrawled an irate note to Boas: "In the name of God, give the tenants a rest from the beating of your tom-toms on Sunday, at least. What are you, Jews?"

In the midst of all this, Pearlstein and Warhol settled into a bright room that spanned all twenty-five feet at the front end of the wood-floored per-formance space, which was a full one hundred feet deep and had an alcove curtained off for Boas at the other end. It was an illegal arrangement, so there

was no stove, just a hotplate and a shared bathroom that also housed the ice-box. It was also artsy enough that Warhol mentioned it the very first time he was given space on a magazine's "Contributors" page.

The boys' bit of the loft was furnished with a pair of cots, a glass-fronted bookcase full of Franz Boas's notes and books and a pile of tribal instruments that Boas Sr. had collected, plus van Gogh and Picasso reproductions pinned up by our pair. Boas herself had training as a sculptor and continued to draw constantly in her loft, no doubt with Warhol by her side. The Boas studio even offered life-drawing sessions, where any artist with fifty cents could sketch the assembled dancers—a practice that became central to Warhol's fine art of the '50s.

Boas shared her end of the dance space with a sometimes cross-dressing female partner who had given herself the name Jan Gay. Gay had been a well-known author of children's books, always an interest of Warhol's; within a few years he was publishing in the same series as her. As mentioned in his note to Zegart, Gay was also an evangelist for nudism—her notorious movie about it prefigures Warhol's own "nudies." She was also a pioneering sex researcher and activist for homosexual rights, which helps explain her cropped hair and masculine dress and the new last name she'd chosen for herself. The word "gay" was taking on its current meaning at that very moment, but only among homosexuals. For others, "gay" still mostly meant "cheery." Boas's daughter believed that Warhol had actually met Jan Gay in homosexual circles in New York before he and Pearlstein moved to Twenty-First Street.

Pearlstein recalled how the heavyset Gay, nude under an untied kimono, was a regular presence in their room, "painting Johnson's 'No Roach' around the base of the floor along the walls. It never helped and Andy always drank soda all day, and the bottles by morning would be filled with roaches. . . . And we also ate Campbell's Soup every day for lunch, usually tomato soup, and I'm sure those cans were filled with roaches too." Almost every recollection of Warhol's early days comes clogged with soup cans. That could be because they really were his staple diet, but it's equally likely that they got written into the historical record after the fact, since he later became so famous for them.

In addition to the bugs, the Twenty-First Street menagerie included Martha, that "stupid Persian cat" whose portrait Warhol actually included in his letter to Zegart, as the earliest of the hundreds of cat pictures he went on to make. This castrated, cross-gendered "Martha" was the first of the feline companions that became a bohemian trademark of Warhol's during

his pre-Pop years. S/he kept company in Boas's loft with a big Egyptian sheepdog named Naimh, pronounced "Neev" or "Niehve," from the Irish. Boas's papers include loving photos of the dog, which soon added a litter of eight pups to the premises, whelped in a cardboard box in the subletters' room. Even six decades later, Pearlstein still remembered the pet as a nuisance and an ill-tempered barker.

It's lovely to watch the intimacy grow between Boas and her lodgers. Her account books start by listing payments from "Warhola" and "Pearlstein" (they seem to have alternated paying the $75 rent) but they soon become "Andy and Philip." The importance of this intimacy in this setting at this moment in Warhol's life can hardly be overstated. His daily exposure to Boas and her experimental classes would have confirmed his connection to dance as a radical art form, which had begun in Pittsburgh and never faded. Her radical approach to improvisation, attacked at the time, came alive again with the Judson Church dancers who Warhol knew in the early 1960s. It also turns out that Boas was keenly interested in mastering the techniques of moviemaking, which could have spurred Warhol's interest in the medium.

But more important than any of those specifics is the fact that the Twenty-First Street loft gave him his first full exposure to the general excitements of a "very arty" lifestyle and culture, where "arty" also happens to mean "gay."

Boas described Warhol, who she saw every day, as "nice, pleasant to be around," and as Pearlstein remembered it, with some bitterness, Boas and Gay "took Andy over," leading him into a "double life" that was closed to Pearlstein. It seems Warhol's new mentors soon told him to dump his dull "boyfriend" who they'd decided was "not very helpful in his development," said Pearlstein. "They misunderstood our relationship, assuming it was homosexual." Pearlstein and Warhol had always had an almost silent relationship, working together but barely talking, and that couldn't compete with the excitement of their new hosts. The designer George Klauber, Warhol's mentor in gay culture, became a regular visitor to the Boas studio, and there's a lovely photo of him mugging with Warhol in the loft, bare-legged after his pants got soaked in a downpour.

The Brooklyn Heights scene around Klauber was an important setting for the "queering" of Warhol, as a newcomer to New York, but it has left few documentary traces. Three decades later, Warhol remembered Klauber as "the first person who told me about the gay life." Brooklyn Heights was known as a hangout for the city's better-off homosexuals, with notable cruising action on its Promenade as well as in the showers and gym at the St. George

Hotel. Klauber's memory of that moment gives a hint of its significance: "The wonderful thing about the fifties was the emergence of the feeling that you weren't isolated. For the first time, one had a sense of being affiliated with a group of sensitive and informed people, and to be proud rather than denying."

In Boas's loft, Pearlstein, who had just gotten a day job as a designer's assistant, was the "square" in the household. He played Gustav Mahler LPs on his new phonograph and Boas had to spell out what she meant when she attacked them as "kitsch." He kept listening to them—through headphones. Warhol must have been the one who really took in Boas's definition, toying with kitsch for the rest of his life.

Warhol's own taste in records came with serious avant-garde credentials. One album that he kept on constant rotation featured the radical music of William Walton paired with the British modernist Edith Sitwell reading her "Façade," which was almost-nonsense verse that made "abstract patterns in the sense in which certain pictures are abstract patterns," she explained. Warhol was still talking about his love of Sitwell thirty years later.

The other album Warhol blasted out daily was also by a woman: Bessie Smith singing her classic, raunchy blues numbers. Smith was at the other end of the social spectrum from Sitwell, but ranked at least as high in the cultural terms of that moment, when the American avant-garde was beginning to insist on links between popular and high-art forms, even before Warhol's Pop made that the official vanguard position.

Jan Gay also contributed to the Twenty-First Street bedlam. She was an alcoholic who had mental problems; her treatment involved daily visits from a shrink, who she paid with dance lessons, "like Hindu god positions," given to the sound of a Boas drum. One day when things were going particularly badly for Gay, she threw a friend down the stairs and, as Warhol told the story when Pearlstein got home from work, was carted off in a straitjacket to Bellevue Hospital, where she was already a regular.

Artistically, at least, the two women were wrong about Pearlstein's dulling effect on Warhol. With his new commercial job under his belt, Pearlstein had started making fine art again in the evenings. One painting presented a blow-up of the standard dollar sign. Inspired by the sight of his huge $, "the idea of a series of paintings of icons hit me," he recalled. Over the next little while, Pearlstein painted the American Eagle, the Statue of Liberty and those two newer icons, Superman and Dick Tracy. Although those paintings had all sorts of allegorical flourishes and were extravagantly painted—"influenced by probably Clyfford Still and Willem

de Kooning, whose work we somehow got to know during that year"—there's no way they didn't sow the seed for his roommate's later, much more direct treatment of some of the same subjects in his 1960s Pop Art. A decade before that, however, when Pearlstein first tested his icon paintings on his peers, their shocked silence led him to paint most of them over. The *Superman* did eventually get shown, but only once Pop Art had prepared the ground for it.

Although Pearlstein described his Twenty-First Street roommate as a "workaholic," it's hard to know what Warhol might have worked *on* once they'd gotten to Boas's loft. Aside from one two-page spread that appeared in the February 1950 *Mademoiselle,* not a single magazine page survives from before late the following summer, and there's only one record cover known from late 1949. Unless there are piles of unsigned ads that have yet to be discovered, that fall and spring Warhol must have been living off his first few invoices from St. Mark's Place: The first *Glamour* assignment alone might have paid as much as $100 for each of its eight pages, the standard fee at Condé Nast at the time. As Warhol wrote to Kett Zegart, not too much later, "i guess if it wasn't for mrs. fredricks i wouldnt be here. i did do some other work but nothing that paid as wonderful as the glamour job. Im still carrying mine own portfolio—sounds like a song title."

Warhol filled some of his abundant free time that fall and winter with trips to his new city's museums and galleries, which he would already have known from their involvement in the last few Carnegie annuals. Pierre Matisse was the head of one of these, and Warhol couldn't have missed the show that the dealer gave to Jean Dubuffet, a pioneer of the outsiderish styles that Warhol was starting to channel. At the Whitney Museum of American Art, a show presented hundreds of drawings that the U.S. government had paid artists to make of folk objects, a genre that Warhol riffed on in his own illustrations and then collected as soon as he had any money.

But the top of Warhol's "to see" list would have been taken up by shows at the Museum of Modern Art, whose schedule might have been planned just to suit the young artist's needs. That October, the museum celebrated its twentieth birthday with the giant "Modern Art in Your Life" exhibition, meant to show "how modern art is a source and catalyst for much of our daily environment, from Fifth Avenue windows" (which Warhol was soon designing) "to newspaper advertisements" (which became his claim to fame and main profit center). If Tech and Outlines had seeded the idea that a commercial artist could compete with more serious and radical figures, then the

MoMA show absolutely confirmed it. It included album covers by Robert M. Jones himself, who was just then assigning those Columbia LPs to Warhol, as well as a bunch of show windows by Gene Moore, the pioneer who was soon giving Warhol his display work.

Thanks to such New York events, with their unique prestige, the first impressions of modern art that Warhol had formed in Pittsburgh, as a kid and then college student, coalesced into the clearer, adult vision that drove his career. Although Warhol's greatest creations can sometimes seem to come out of nowhere, like all artists he needed to know the art of his time in order to take it to new places.

———————

Sometime in the late winter or spring of 1950, Warhol's cozy bohemian life came unstuck. After months of legal wrangling, Boas's landlord got fed up with her living and drumming arrangements and kicked the lot of them out. Warhol was heartbroken at having to part from the dog and her puppies and furious with Boas for losing the apartment. "That ruined the friendship," recalled Boas's daughter. The eviction hurt Boas more than anyone. Poverty forced her to leave behind her entire career and community, including Jan Gay, to take a job teaching in Georgia, where she spent the rest of her working life.

Pearlstein moved in with Dorothy Cantor, now his fiancée. As for Warhol, his luck held, for the umpteenth time. Ellie Simon, his best friend from high school and Tech, had moved to New York several months earlier. She'd met up with another P&D named Leila Davies, and at just the moment that Warhol found himself on the street the two young women were moving into a large, illegal sublet on the far Upper West Side. It was in the basement of the massive Northport Building, on 103rd Street in what Davies called a "very Puerto Rican" neighborhood worthy of *West Side Story*. When Warhol accepted their offer to join them, probably around April 1, he became something like the seventh or eighth roommate in the ménage. The apartment's residents included a bunch of dancers and also an actor, at least some of whom were drama students Warhol knew from Tech, as well as a painter in graduate school and a young man in publishing.

George Klauber described the apartment as "one of the most transient, uncomfortable places I've been in my life. Dreary furniture. It had only lights, not lamps." It was also fiendishly crowded, with two other men sleeping in the same room as Warhol, which was where he set up his elbow lamp and drafting table "and all over it, he had all of his pens, and ink things were

all neatly placed, and everything was in its place"—unlike the mess he was famous for working in within a few years. Like so many young men on their own for the first time, the boys were night owls. Breakfast could easily happen at 6 P.M., apparently prepared for these goofy males by one or another of the female roommates. No wonder Warhol referred to Leila Davies as "mother."

Warhol later described the setup as an "art commune." When the roommates weren't out at the galleries, they'd be heading to the movies—tons of Cocteau's avant-gardism but also the latest Fred Astaire—or madly devouring ballet. "One or two of us would buy the cheapest possible tickets in the gods and the rest of us would hang out at the bar across the street and in intermission time we'd all congregate and talk and we'd all walk back in." Warhol used those soirees for more practical ends, as well: At one ballet, he "shyly" went up to the new editor of the prestigious *Dance Magazine* and flattered her on her work; she ended up assigning him illustrations throughout the decade. Thus did he always mix pleasure with business, the social with the expedient.

Davies also remembered going for long sightseeing walks across the city, with a wide-eyed Warhol beside her, marveling at what they saw: "Oh look at that! That's so beautiful! Gosh." New York seemed to supercharge his observational skills. A year or two later, walking a new client to her office, he exulted in all sorts of details she said no one else would ever have noticed: a pile of sand with handprints in it, from where workers were fixing the street; the giant clogs the asphalters wore; the tiny brass lions' heads decorating her building's elevator. Although Warhol is rarely classed as a realist, observation came to be the heart of much of his art, from his 1963 film of a boyfriend sleeping to his snapshots of 1980s partygoers. "It's really much more interesting what you see walking from one gallery to another than what you see in the galleries" were his words to a budding art historian in the mid-1960s.

The 103rd Street roommates were "like young people in those days—with no money and always want[ing] to go to parties, eating spaghetti," remembered an acquaintance. Like Warhol, most of the roommates were struggling to break into the New York scene, and happy to pay their small share of the $125 rent. "The dancers—when they were making money they were making money, but when they weren't, they weren't," said Davies. "I happened to have a full-time job but I was making $35 a week." Within the decade, Warhol was earning forty times that, but at that moment he was struggling to survive on "whatever few little jobs he could come across." In

fact, we only know of a couple of new drawings for *Theater Arts* and *Harper's*, plus Warhol's first magazine cover, for the *New Yorker* knock-off called *Park East*. A roommate remembered him also working on a contract for a shoe drawing—hinting at his later specialization—but there's no trace of one published near that time.

With paying clients in short supply, Warhol launched into a bunch of time-consuming fine art projects. His most notable experiment was a very big canvas based on the famous Bloody Saturday photo from *Life*, showing a wounded baby crying in the bombed-out ruins of Shanghai in 1937. The piece is lost, but it certainly sounds like the first germ of Warhol's radical idea that art could be based on chaos pulled from the media, an approach he didn't return to for another decade.

Even when he'd lived on 103rd, Warhol had been "somewhat of a whiner—but he would generally complain in a humorous way," said a roommate. Warhol's grumbling continued a quarter century later, with memories of the apartment that aren't all positive. He complained that his roommates' emotional life had been limited to whose salami had been stolen by whom, and lamented that he felt "left out" because they didn't confide their deeper problems to him. To which Davies replied, "We really didn't have problems—we had one problem, which was money! But other than that, you know the world was our oyster and I don't think any of us were deeply concerned about him."

Davies especially remembered their partying, describing one bash that they decided to throw for the American Ballet Theatre's return from the road to New York. "They all came! I mean all the stars came in this little stupid basement apartment, but we had a great time. It was wild." Warhol was especially excited at the arrival of Hurd Hatfield, a heartthrob of the moment who had starred as an epicene British aristocrat in the movie of Oscar Wilde's *Picture of Dorian Gray*. Hatfield once summed up the movie, with its "hints of bisexuality"—some 1940s critics saw them as more than hints—as "too odd, too avant-garde, too ahead of its time." The movie's voice-over describes the character that stands for Oscar Wilde in terms that match the persona Warhol went on to cultivate: "His greatest pleasure was to observe the emotions of his friends while experiencing none of his own. He diverted himself by exercising a subtle influence on the lives of others."

One roommate on 103rd Street remembered Warhol as a "star-idolizer" who wrote endless fan mail. "He would just be breathless when he'd see Somebody or Someone. . . . We were all star-crazy." But Hatfield would

have been more than usually welcome at that party because he was quite clearly gay, like most of the men living at 103rd Street. As Calvin Tomkins put it in a famous profile of Warhol, "They had a communal crush on Judy Garland."

Warhol's "crew," as one female roommate called them, made their sexuality close to explicit when they arrived at a Halloween party costumed as a garland of flowers, "daisy chain" then being gay slang for a round-robin orgy. One member of the household who was still closeted remembered being upset at the caper: "It exposed me in a way that I was unhappy about. I guess it was Andy's idea, and it became, I think, an indication of what came later in his personality and his habits and his way of life."

After his spell living with a proudly lesbian couple and then some months in his artistic "commune" on the far Upper West Side, Warhol was at last in a position to express his gay identity.

In the shared flat on 103rd Street, Warhol's first and most notable crush was on a pen pal. Early in the life of the "commune," a young artist named Tommy Jackson drove by in his Model A Ford to help a friend who was moving out. He was a blond-haired hunk known to turn heads—of both men and women—and some kind of significant connection formed between him and Warhol. They immediately became raunchy correspondents. (Although Jackson was straight and has said that they were never intimate.) Jackson, who was four years younger than Warhol, first lived in Boston, then for a while in St. Paul, Minnesota, and penny postcards started flying back and forth between them, sometimes every few days, often written in such familiar and intimate shorthand that only Warhol could have known what they meant. Some say as little as "sex" or "yes, girl" or "tra-la tra-la so have ah."

One of Jackson's first cards, in early August, jokes about the blood test for syphilis: "It is better to have failed your wassermann than never to have loved at all." A letter from five days later is inside an envelope that Jackson addresses to the whole 103rd Street gang as "creators of the orgy wild." Its contents are written as modernist poetry—no spaces at all between words; whole lines whose meanings are almost indecipherable; hardly a capital letter in sight, in keeping with the standard avant-garde style that Warhol knew from Carnegie Tech—but with hints that some kind of "fireworks" had taken place in the apartment that Fourth of July.

Within a few months of meeting Warhol, Jackson sends him a card that reads "i dont think you love me anymore / because you never write to me" and then a follow-up postcard that asks, for any mailman to read, "WHOS THAT FAGGOT YOURE LIVING WITH?" (Warhol had moved on from

103rd Street into a smaller apartment shared with yet another Tech alumnus.) Another card asks "cant we just be friends"—no way to know if that's in jest or not—while two cards give the comically polite dictionary definitions of "gay" and "daisy chain," a term that seems to have been on the mind of Warhol's crowd.

Jackson matters as more than just a love interest, however. He's also one of the first conduits between Warhol and the new, truly cutting-edge contemporary culture of the 1950s. Somewhere around February 1951, Jackson began studying at Black Mountain College in North Carolina, a Bauhaus-inspired (and at first Bauhaus-staffed) center for advanced art and ideas. Warhol knew the place already from Pittsburgh in the 1940s, because of Black Mountain's strong ties with the Bauhaus-y Outlines gallery. By the early 1950s, however, Black Mountain was the focus of a new generation of more radical innovators such as Robert Rauschenberg, who Tommy Jackson knew (and disliked), and John Cage, who was a poker partner of Jackson's and is credited with staging the first-ever happening while he was at the college. Cage's partner Merce Cunningham was also there, along with artists Cy Twombly and Ray Johnson (Warhol became a fan and friend). This crowd of important gay creators turned Black Mountain into a rare refuge for homosexuals in those years.

With Jackson ensconced in that scene there's a sense that he was deliberately leading Warhol down the path toward difficult, Black Mountain–ish art and ideas. Jackson sent Warhol the first issue of the *Black Mountain Review* as well as an announcement for *Ceremonies in Bachelor-Space,* a chapbook of difficult modernist prose poems he'd put out. Warhol sent back a card asking if he'd understand it, to which Jackson replied only, "if you're smart enough." Warhol went on to produce a decade's worth of self-published, limited-edition chapbooks of his own.

Even without Jackson's direct connection to the college, Warhol would have come across radical Black Mountain approaches. The same year that Jackson was in North Carolina, Robert Motherwell, another Black Mountaineer, published his anthology *The Dada Painters and Poets,* which became the bible of a postabstract avant-garde that was born at this time and that Warhol joined, a bit late, with Pop Art. This was also the moment that Robert Rauschenberg, Black Mountain trained, was getting his first substantial exposure: *Life* magazine devoted three pages to his life-size blueprint silhouettes. Weeks after that *Life* coverage, Betty Parsons, one of New York's best dealers, gave Rauschenberg his first solo show, full of deeply peculiar semiabstractions. Those hinted at the conceptual approaches he

and his lover Jasper Johns pioneered over the next few years, and which were a sure model for Warhol's own first efforts in Pop in the early '60s. Decades later, Warhol was asked which artist he admired above all others: "I love Rauschenberg. . . . I've always loved him. It's somebody I liked a long time ago," he answered.

"What was new, really new—what were the things that all the artists were talking about, what directions were they moving in and all those kind of things"—that was what Warhol was obsessed with at that moment, according to his roommate Leila Davies. The latest bunch of exhibitions at MoMA were certainly on the agenda.

There was a show that MoMA advertised as featuring "highly controversial works by younger American abstract painters," a description that was sure to spark Warhol's interest. It included Motherwell and Pollock—and Balcomb Greene, whose presence still loomed at this point in his student's life.

But by far the most important and Warholian event of that MoMA season was a full-scale retrospective of the American painter Charles Demuth, who had died in 1935. Demuth "expressed his highly complex personality with extraordinary sensitivity," said MoMA's press release, and dealt with sex in terms of "his own disquieting psychological tensions"—about as close to a frank discussion of Demuth's homosexuality as was possible at the time. Demuth, MoMA said, was determined to "paint as he pleased"—and *what* he pleased, including men wrapped around men—"whatever the social or economic consequences." Incredibly, the first image in a Demuth book that had recently been issued by the Whitney Museum had shown a top-hatted toff and a sailor cuddling in front of a preposterously phallic "abstraction" by Constantin Brancusi. The MoMA show itself presented a series of Demuth illustrations that, its curator said, came with "explicit suggestions of decadence, not to say evil"—for instance, a watercolor of the artist hanging out with his close friend Marcel Duchamp at the Greenwich Village gay bar called the Golden Swan (a.k.a. "The Hell Hole"). That would have been as appealing a subject as could be for the young Warhol. Within a couple of years, the "carefully studied perversity" of Warhol's first solo show was being compared "for various reasons"—all unnamable at the time—to Demuth's, as well as to the queer art of Aubrey Beardsley and Jean Cocteau, both on Warhol's radar since college. Thanks to MoMA, the equation of same-sex love and avant-garde art was at last fully fixed in Warhol's mind, and became the rock that a lifetime of work was built on.

Most any afternoon early in the winter of 1950, a customer heading to the
printers, signmakers and waterworks at the foot of East Twenty-Fourth
Street in New York would have passed the undraped windows of a tiny
ground-floor apartment and seen a slender, balding youth hard at work
inside. Light from the room's sunset-orange walls reflected off his work
table, gilding the drifts of paper that covered it. Or he might have been
spotted sprawled on the bed with the phone to his ear, cold-calling clients
in the wisp of a voice that he affected, charming some and maddening oth-
ers. (One annoyed colleague compared that whisper to Marilyn Monroe's.)
"I planted some bird seed in the park yesterday. Would you like to order a
bird? Do you have any work for me?" Warhol would purr into the receiver,
or, "Hello. I'm just sitting on my bed here, playing with my yo-yo." Or even,
in response to a client's automatic "How are you?" giving the whispered
response, "I'm okay but I have diarrhea." This was Andy Warhol coming
into his own in New York, and getting down to his own peculiar idea of
business.

Sometime in the fall of '50, Warhol's 103rd Street "commune" seems
to have dissolved—it's said that Warhol got tired of paying his roommates'
massive phone bills—and by November, Tommy Jackson's notes start being
addressed to "Andy Warhol, c/o Groell, 319 E 24th, apt 1-E." This was the
little apartment that Philip Pearlstein had found after losing the Boas loft,
and that he'd given up that August when he married his fellow P&D Doro-
thy Cantor. Connections to Tech still being strong, Pearlstein's apartment
had been handed over to yet another P&D named Joseph Groell. He had
been close to the instructor Perry Davis and worked in the New York studio
of Balcomb Greene, Warhol's favorite professor. Groell had come to New
York with an offer to stay with a Tech English teacher who bore the glori-
ous name of Astere Evarist Claeyssens; he affected a cape and Byronic airs.
When Claeyssens turned out to have designs on Groell's virtue, the younger
man fled to Pearlstein's empty place. Warhol joined him when his own ac-
commodations fell apart, but the new roommate doesn't seem to have suited
Groell that much better than Claeyssens had: "When I was living with him
it was a little bit embarrassing to go out with him to the neighborhood bar,
because I thought he appeared to be a homosexual." (Pearlstein said that he
and Warhol had also been taken for a gay couple, but that it didn't bother
him "one way or the other.")

Warhol moved in while Groell was on a trip to Pittsburgh, dealing with
the draft board there rather than in New York "because I thought they were
less up on the tricks you would use to stay out of the army." Warhol also
stayed registered with the board in Pittsburgh, no doubt for the same reason

and maybe at Groell's suggestion. It was while living on Twenty-Fourth Street that he somehow got his status moved down from a ready-for-Korea 1A, awarded in 1949 when he turned twenty-one, to a medically unfit 4F. There was no change in his health, so it's hard to imagine any reason for the revision other than his homosexuality. His irrepressibly fey manner could have led some doctor to "diagnose" him as gay, or he could have deliberately camped it up to get out of the draft, as many people did.

One year into Warhol's life in New York, it sounds as though the new, quieter living arrangements helped him concentrate on his career. Imilda Vaughan, yet another Tech friend of Warhol's who had moved to New York shortly after him, told a story about Warhol visiting MoMA with her, and telling a random staff member they ran into that he wanted to do Christmas cards for the museum—and, amazingly, getting a gig to do just that. It earned him all of $128.83, but maybe profit wasn't the motive: Through sheer force of chutzpah he got his work into the museum by the back door, you could say, long before he made anything worthy of hanging on its walls.

Vaughan also remembered him leafing through a bookstore's record bins and jotting down the names of aesthetically ambitious labels. "Then he went home, called up the companies, and said, 'I'm Andy Warhol, I'd like to do a record jacket for you.' His name meant nothing at that time. But out of the fifteen companies he called, he got maybe six appointments, and out of those, he got to do four or five jackets."

The young Warhol was also using his old Pittsburgh connections to angle for work. Edgar Kaufmann Jr., the gay scion of the department store clan and MoMA's powerful design curator at precisely this time, was recommending Warhol to contacts such as the art director Charles Coiner, known for getting famous fine artists to do ads. Warhol and Kaufmann were close enough for the curator to send him cheery Christmas greetings a year later.

Groell said his roommate was constantly on the phone, drumming up assignments and doing his very deliberate best to come off as "creative" to the art directors he courted, via those bird-seed and yo-yo ploys. Warhol used his "diarrhea" line on no less a figure than the design guru Paul Rand, although there is no sign that such labored kookiness won him work with the master. "I think they weren't just extremes because he was an extrem-ist. I think there were actually purposes to these extremes. In other words, they were carefully planned effects," said an early printer of Warhol's. "He's sharp. He is very much sharper than anybody knows." That same printer recalled that "anything Andy had to do with anybody was to get more work, more illustrations, more jobs. . . . I don't think he made friends for

friendship's sake alone. Andy was the most opportunistic person I've ever known."

When it came to getting assignments, Warhol the bashful elf had a cold, calculating heart that he was almost ashamed of. Groell said that his room-mate would put down the phone after one of his wacky cold calls and say "Isn't that ridiculous?" or "I don't want to behave like this."

As one of Warhol's first boyfriends put it, "You might think, 'Oh, here's this nice little boy who is very naive, and he dresses like a hick from Penn-sylvania, and he acts sort of sickly and naively, and he doesn't know what the score is.' Well, he did. But he was always involved with it on the level of a game or play. . . . He couldn't understand why people were taking things so seriously." Another early friend said that he had the feeling that Warhol was always "laughing at the world or poking fun at everything." Even when War-hol went on to make some of history's most serious art, an unserious manner was central to his public persona.

In the later 1960s and beyond, Warhol was sometimes criticized for his callous disregard of his friends' troubles, Edie Sedgwick being Exhibit A. "Now and then, someone would accuse me of being evil—of letting people destroy themselves while I watched, just so I could film them and tape-record them," Warhol wrote. The real problem may have been that he couldn't see his followers' antics, or much of anything in the world, as more than a pass-ing show there for him to record—as a TV program, he liked to say. He as-sumed that others were playacting as often as he was.

During Warhol's months on Twenty-Fourth Street, the maneuvers de-scribed by Groell began to pay off. We know of at least one more record cover that Warhol worked on, and copies survive of four illustration jobs for magazines, three of them pretty minor. The fourth was more notable. It was a cover image for *Interiors* magazine, which had recently been recast to concentrate on the latest in modern design. Maybe that avant-garde edge was what got Warhol to do that cover, and then a further four, for free—but with his name given unusually prominent front-page play on all four. He liked the magazine so much he got an early boyfriend to subscribe.

By spring, Warhol's star has risen far enough for him to earn his first substantial coverage, a full-page "Upcoming Artist" feature in the trade rag *Art Director and Studio News*. It lists the magazine assignments we know, plus a pile of others and promotional work for NBC. Since the profile was published in the April issue, it has to be talking about a period quite a few months earlier when this newcomer, after at most eighteen months in New York, was already so successful he had drawn the editors' attention. The

profile also mentions, in passing, a whole other field that became impor-
tant in Warhol's commercial career. It says that Warhol had already nabbed
contracts for book jackets (plural) from the prestigious, cutting-edge New
Directions publishing house, whose success had partly been built on using
high design to sell its high-concept prose and verse.

As usual with Warhol, personal connections might have been involved.
Warhol had been introduced to the company by the noted designer and Black
Mountain–eer Alvin Lustig, a major force in bringing New Directions' covers
up to speed: His book jackets had tripled their sales and one even got featured
in that MoMA show on "Modern Art in Your Life." It so happens that Lustig
was close friends with Will Burtin, that mentor of George Klauber's whose
Rolodex Warhol had mined.

But connections or no, the thing to notice is that Warhol and his images
were seen to mesh well with the fancy, esoteric cultural agenda of New Di-
rections. It couldn't be an accident that two of the books with Warhol cov-
ers were by evidently homosexual authors, including the infamous Baron
Corvo. The introduction to the New Directions edition of Corvo, by the gay
poet W. H. Auden, described it as reflecting the worldview of a "homosexual
paranoid."

Maybe it was all these signs of approaching success, and acceptance, that
gave Warhol the nerve to finally look for a place of his own. In December he
was fishing for accommodations in Brooklyn Heights, near Klauber and his
gay friends, but that fell through. By early March 1951 he'd signed a deal on
what he wanted, his very first solo apartment, newly painted and papered
but only costing $52.90 a month, according to a lease Warhol never threw
out. A friend called that rent "as cheap as you could possibly get."

The address was 216 East Seventy-Fifth Street, a classic New York build-
ing with fine fenestration and an ornate façade that time hadn't been kind
to. Warhol was in apartment 1A, which seems to have been one room in
a semibasement, only two windows wide but with kitchen and bathroom.
One early biographer says that the place came without hot water but with
plenty of rats, and Warhol complained of its pink wallpaper studded with
silver stars—a strange complaint since that sounds more to his taste than not.
On the plus side, however, was the fact that it was on the edge of the fancy
Upper East Side of New York, which Warhol might have meant as a signal,
to himself and to others, that he was moving up in the world. It was the
neighborhood where he chose to buy both his homes once he really started
to come into money. Warhol was also following in the footsteps of Philip
Pearlstein, who had recently moved in a few blocks away, and of the hand-

some dancer Victor Reilly, from the 103rd Street "commune," who lived in the building Warhol was moving into.

The move launches two full years of frantic work and hectic growing up for Warhol, but it's a period that tends to be glossed over. More than before or after, Warhol's social life seems to have taken place outside his home. The dingy basement flat never becomes the setting for friends' anecdotes, because not many of them ever gained admission to it. For Warhol, appearances were starting to matter.

*. . . as a successful illustrator, mugging in his stylish new suit.*

# 7

## 1951-1952

NEW LUXURIES | OTTO FENN | STALKING CAPOTE |
JULIA WARHOLA ARRIVES | COMMERCIAL
SUCCESS | WHIMSICAL CHAPBOOKS

*"That wasn't a chick. I've got his name
somewhere . . . er . . . Andy Warhol"*

It was the new version of his "dream suit," and for a few years it became
Warhol's trademark: a three-button gray-flannel outfit, bought from toney
Brooks Brothers. It signaled that work was starting to come in and Warhol
was ready to go out, and come out, on the New York scene. "Once he started
to make a little bit of money, things relaxed a lot for him," recalled his former
"mother" Leila Davies. "He was able to pay more attention to his clothes and
things like that that he hadn't before. . . . He felt like he was getting some-
where." But that didn't mean that Warhol, now "an overdressed dude [who]
could only talk about shoes, shirts," was willing to plunge all the way into
the mainstream. One acquaintance described him as dressing "so terribly fey
that I was astounded." That gray flannel, which cost more than a month's
rent, wasn't as businesslike as it sounds: Instead of a row of buttons up the
sleeves, the jacket's cuffs had a stylish single button that attached with a tab.
"When he wore it, it was all askew," remembered one of Warhol's first New
York boyfriends, describing unlaced shoes and socks of different colors—all,
however, from Brooks Brothers. "It was calculated, and charming. He was
very boyish, and I think people like this." Warhol's goal was to seem shabby,
"like a prince who could afford expensive shoes but couldn't care less and
treated them as worthless."

He wouldn't wear his deluxe shoes until they'd acquired the right patina,
hastened by the application of water, spilled paint or even cat pee, and he kept
the look up right through the '50s. At a Christmas party once, when someone

pointed out that Warhol was dragging his fancy coat on the floor, "Andy said, 'Good,' he wanted it to have a lived-in look." Warhol was busy, that is, showing off the posh trappings that his success in commercial art could buy him at the same time as he was madly signaling that his main faith was still in the bohemian habits of the artistic vanguard. He might have been *in* illustration, but he wasn't *of* it. This very visible double commitment, to elite culture and its cash rewards as well as to avant-garde values, shaped the rest of his career. Its tensions helped power his art.

Warhol and his carefully distressed dandy's gear would have been on view in a stylish bar he frequented called the Café Winslow, in a hotel at Madison and Fifty-Fifth Street, that had dark paneling and an atmosphere that one magazine described as "almost always informal, chummy and gay." That last word was true in both senses: The Winslow had a notable homosexual clientele, on the edge of the so-called Bird Circuit of midtown bars where elegantly suited "giddy queens" could be found "discreetly ogling each other," according to a young man who was part of that world. The gay composer Ned Rorem said that on cruising trips to New York in the 1940s he cleaned himself up in the Winslow's "shining private wash-rooms."

Many nights, Warhol would have moved on from the Winslow to dinner at Café Nicholson, around the corner on Fifty-Eighth Street. That trendy restaurant had been launched around the time Warhol arrived in New York by a young window dresser and antiques dealer named Johnny Nicholson (né Bulica). Warhol "liked the boys who ran it, and it was expensive," remembered a friend, who felt the cost was part of its appeal. Even when he'd been church-mouse poor, on 103rd Street, Warhol had been known to stop off at the Plaza Hotel's pricey, queer-friendly bar, and it became a regular stomping ground. (A decade later, he recommended it to a young friend as a good pickup spot.)

Nicholson has taken credit for inventing gay-fabulous vintage décor, the style Warhol soon adopted. His restaurant was full of unloved Edwardiana sold cheap by the city's restaurant suppliers and the crowd of antiques shops nearby. Café Nicholson's pseudo-Mediterranean garden was *the* haunt of New York's racier *littérateurs,* including Gore Vidal and Tennessee Williams, two men as close to "out" as anyone could be at the time, in a city where gay sex was still illegal. These New Bohemians were photographed in 1949 in the Nicholson garden for a famous magazine feature. The article described them as having turned the arts into "a paying proposition on a widespread scale" and as being dedicated to "the cultivation of social prestige and of

the ego." It's no wonder that Warhol worked so hard to become part of the Café Nicholson world. Once he'd become a regular, he'd pay his check with dollar bills pulled from his shoes and every pocket, and they'd tumble out alongside razor blades, pencils and rubber bands.

There was another attraction in the café's neighborhood: The stretch of Lexington Avenue south of the café was hustler central, where a "horde of homosexuals . . . parade in mincing steps in pairs and trios up both sides of the avenue," according to the comically hard-boiled, and wildly homophobic, *New York: Confidential!*, a best-selling guidebook from this time. In a groundbreaking documentary from the following decade, a hustler who called himself Jason Holiday said the area was "groovy" for finding a clientele that was "a little more refined."

It's not clear what kind of impression Warhol made on the people he met, or the men he cruised, at any of these venues. One boyfriend said he was especially drawn to Warhol's unique laugh—"it would just bubble up out of him, and it was charming." In photos Warhol can come across as handsome, in an exotic Slavic way, with high cheekbones and an almost bee-stung mouth. "He had quite beautiful lips," remembered one of the first men to kiss them, and a 1951 drawing by his close friend Nathan Gluck portrays Warhol as a distinctly pretty dandy, in French cuffs and a plaid bow tie. In an entire contact sheet of portraits taken in 1958 he comes off as elegant and debonair; he's wearing a well-integrated blond toupee and a crisp white shirt with a stylish placket that hides its buttons. In more relaxed photos he's often wearing the "scuffed loafers, chinos and a gray sweater over a white shirt and conservative tie" that the *New York Times* described as the artists' uniform of that moment.

Even Warhol's straight friend Art Elias described him as "rather desirous-looking—good-looking" and Philip Pearlstein concurred. Warhol was a slim five foot eight, 145 pounds, with a nicely boyish physique. One early shot of him half-undressed in bed shows him looking fit and sexy, with well-turned calves and hairy legs, contradicting the long-lived myth that Warhol was entirely hairless.

"He thought of himself as ugly," remembered a boyfriend from the early 1960s. "But when you saw Andy naked, he looked like a beautiful boy. And I'd say, 'Andy, don't you look at yourself in the mirror? You're beautiful.'" That boyfriend adds one irresistible detail to our picture: Warhol, he remembered, "had a big dick—*quite* a big dick." Photographs confirm it.

Our standard image of Warhol as a feeble, androgynous waif—a male

version of his '60s friend Edie Sedgwick—was a mirage for public consumption. It was not what he wanted to see when he looked in the mirror. Already by the late 1950s Warhol was lifting weights two or three times a week with a friend at the Y.M.C.A. and had a gym membership in a far corner of Queens. His weightlifting buddy remembered Warhol doing fifteen dips on the parallel bars, "and I don't think an average person could do one." Warhol worked out for the rest of his life, and by the late 1960s was strong enough to pin the arms of the proto-punk rocker Lou Reed, who said: "He's like a demon, his strength is incredible."

But despite some positive opinions on Warhol's looks, and photographs that match them, he could somehow still leave a negative impression. "Andy was one of the plainest boys I've ever seen in my life," said an art dealer from the mid-1950s, "a pimply faced adolescent with a deformed, bulbous nose that was always inflamed." A lover of Warhol's from the early 1960s described him as "almost repulsive in the physical sense."

At least early on, his piebald complexion couldn't have helped. George Klauber dwelled on Warhol's skin when he recalled his look at the time and, in a clever half -compliment, one client compared his complexion to the stained abstractions of Helen Frankenthaler. Philip Pearlstein was smart enough to do a portrait of Warhol where his patchy skin looks like it's just the result of an avant-garde painting technique.

In the spring of '53, Warhol got a letter from his high-end dermatologist (who was also, strangely, a high-ranking syphilis expert) explaining that treatments were limited to a bleaching cream that might help even things out. That might have had some effect, since a boyfriend from that year remembered that the discolorations only really showed when Warhol blushed, and that Warhol was overanxious about them.

Then there was that notably—but not grossly—bulbous nose that Warhol had inherited from his mother. A photo from the late 1940s has them looking eerily alike. "Frankly, it was not as bulbous or awful as everyone says—one sees worse noses," remembered one longtime assistant. But that didn't stop Warhol from hating his own. "He had an idea that if he operated on his nose . . . then suddenly that would change his life," recalled a close friend at the time. Warhol first did "surgery" on several photos of himself— he'd use black ink to give his nose an upturned tip—then in June 1957 he paid a full $500 to have work done on what Dorothy Cantor called "the Ping-Pong ball at the end of his nose." By then he had the funds, pull and taste to get hold of a vastly overqualified reconstructive surgeon who was also an exhibiting artist: "Art was the thing that interested me in plastic surgery," said the hotshot doctor. "Design is important when you're re-creating a face."

Warhol's nose job had such resonance for him that he took it as the subject for several of his very first Pop Art paintings, which copied "before and after" ads for comically reworked proboscises. A crush of Warhol's at the time of the operation remembered how the artist had thought the procedure would leave him an Adonis, and was heartbroken when it didn't.

Decades after his own procedure Warhol gave a cartoonish account of it: "They spray frozen stuff all over your face from a spray can. Then they take a sandpaperer and spin it around all over your face. It's very painful afterwards. You stay in for two weeks waiting for the scab to fall off. I did all that and it actually made my pores bigger. I was really disappointed." Photos show that the fleshy tip of Warhol's nose was slightly reduced, but he was right about those pores: Later close-ups of Warhol without his usual pancake makeup, described by one friend as "heavy layers of Calamine," make his nose look like the lunar surface.

Warhol's eyes were also a problem. He was terribly nearsighted: Without his glasses he couldn't have recognized a friend who was more than an arm's length away. On arriving in New York he'd worn children's frames because they were cheaper than adult ones. But then, for a while at least, he wore a pair of decidedly unsexy pinhole spectacles that his friend Tina Fredericks had got some optometrist to cook up for him. Standard tortoiseshell frames were fitted with sheets of solid black plastic covered in perforations— a piece of opthalmological quackery that the American government was still cracking down on in the 1990s. Warhol's pinhole glasses survive, broken, in his archive. Looking through them is like peering through a clouded kaleidoscope; they would have made Warhol look like some kind of blind bug. Still, one Warholian claimed they had done some good while another felt that Warhol had enjoyed their camp effect. By 1958, Warhol was buying contact lenses, although he was still ordering glasses, five pairs at a time, in 1970.

And then there was the biggest bane of Warhol's life: His hair, or lack of such, which photos from the 1950s show as thin, thinning and then almost gone—a few wispy follicles barely hiding his scalp. What was left was also going prematurely gray. The arrival of his first toupee, a light brown one that matched his hair, is variously dated to 1951, 1953—when photos still show him with a decent natural thatch—and 1955, and is improbably said to have cost him $1,000. His friend Imilda Vaughan remembered a humiliating moment when a boyfriend of Warhol's pulled off the artist's brand-new hairpiece, saying "Look at what Andy's got!" In the later '50s Warhol sometimes preferred to go blond, with long bangs à la Truman Capote; he would hang out in the Palm Court at the Plaza Hotel in hopes of being mistaken for the pretty author.

As with his nose job, Warhol's earliest Pop Art included several drawings about baldness remedies and then a painting based on an image of wigs. He collaged that image next to a newspaper ad that read "MAKE HIM WANT YOU."

But whatever Warhol's real beauty faults, and however hideous he may have imagined himself—there was that "body dysmorphia" that could have followed from the rheumatic fever of his boyhood—he didn't seem paralyzed on the social scene. "He was at more parties than not. . . . He just fit that fifties fairyland like a glove," recalled one friend who was part of that world.

Almost as soon as he got to Seventy-Fifth Street, or maybe a bit before that, Warhol struck up a friendship with Nathan Gluck, an artist who was well ensconced among gay culturati. By May 1951 Gluck was sending him a fanciful postcard with a message written in rainbow colors. He also did a careful portrait drawing of Warhol inscribed to his new friend "André," to which Warhol made a comic addition, almost as though the two were drawing side by side. A few years later Gluck signed on as Warhol's main assistant and remained that for a decade.

By December of '51, Warhol had formed an equally close relationship with a young poet named Ralph "Corkie" Ward, "tall, lithe, talented," who was also a boyfriend of George Klauber's—"my second great love," Klauber called him. (Although Ward was actually living with yet another man at the time.) Klauber told the Warhol biographer Victor Bockris about a wild Christmas Eve in 1951: After seeing a French film, the three of them bought a tree for Klauber's Brooklyn Heights apartment and launched into a kind of Rite of Winter around it: "I had taken my trousers off and Ralph and I were waltzing wildly around and crashed into a table and when I got up I had this big gash in my side so we called for an ambulance, which meant the police would come too. Andy got quite sick with apprehension and flew the scene. He was just really terrified." It took years for Warhol to get the self-confidence of New York's more established gay men; memories of Pittsburgh's police lingered.

Warhol started to bombard Ward with love letters. Ward's version of the relationship is that the artist was always more fond of him than vice versa—as almost every one of Warhol's boyfriends seems to have insisted. The pair remained close just long enough to collaborate on five coquettish book projects, a series they worked on (and maybe concluded) at Ward's place and in the Seventy-Fifth Street flat, with Ward writing comic verses that Warhol illustrated. One typical sheet, never published, has Warhol's blotted

drawing of two men kissing below a dozen racy lines by Ward: "as I wait on the hill to keep / A rendezvous with Bill, / I think how good, and sweet, and kind, is Peter whom I left behind."

Warhol and Ward actually had their little chapbooks offset-printed in as many as one hundred copies, as gifts to Warhol's growing roster of clients but also with hopes of mainstream publication—hopes that were dashed when publishers responded with a pile of rejection slips, all mailed on the same August day in 1953. The collaborations with Ward featured just about the full range of Warhol's trademark styles: his ragged blotted line; his sinuous, Matisse-y outline; his stick-figure sketching and his folksy doodling mode. Surprisingly, those looks had been established already by Warhol's first year or two in New York. They barely shifted over the following decade.

By the time Warhol was buying Christmas trees with Ward and Klauber, he had also become close to the notable fashion photographer Otto Fenn. Early on, Tina Fredericks of *Glamour* had sent Warhol to him for advice on breaking into New York's commercial scene, and Fenn had let him court some of his clients. Fenn's two-story studio was just up the street from Café Nicholson, and the basement ceiling had little rounds of glass that let you look up at the feet of passersby on the sidewalk above. By the time that Warhol became a regular there the studio had hosted Jean Cocteau and also Gore Vidal, newly famous for his gay novel and photographed by his good friend Fenn in a topless sailor pose.

Otto Fenn, fifteen years older than Warhol, was a gay man who had started life as a painter. He became a kind of mentor to Warhol, who paid him almost daily visits and made some of his own works in Fenn's studio while also providing Fenn with painted props for his shoots. They even collaborated on a Christmas card sent out from Fenn's studio. Warhol was still wearing his corduroy suit from Pittsburgh when Fenn shot a tender portrait of him in a kittenish pose.

In the summer of 1952, Warhol started sending Fenn a series of clever, campy postcards riffing on the 1936 Greta Garbo melodrama *Camille*. The cards featured a still from the film, which Warhol then collaged with speech bubbles filled with phrases clipped from a French-class textbook, or in one case with the meowing of a cat, typed out by hand. The cards had originally been issued by no less a publisher than the Museum of Modern Art, in tribute to Garbo, a Hollywood star who MoMA curators took seriously as an artist—proving once again how, even at this pre-Pop moment in Warhol's career, popular and avant-garde cultures were already crossing over. This was just around

the time that Warhol got his friend Klauber to photograph him in the famous hands-on-head pose of Garbo, "the great serious idol of camp taste," as the actress was once described.

A series of Warhol drawings of men in drag were based on photos by Fenn—including some of Fenn himself, mugging in furs in a Lord & Taylor's store window—and those are important as one of the first of many times that Warhol and his art brushed up against transvestitism, following up on that self-portrait-as-a-girl that he did while at Tech.

Looking back on all this from the twenty-first century, when gay culture sometimes gets taken for granted, it's easy to overlook how Warhol's arrival in New York is matched by a sudden outpouring of work with queer themes—an aesthetic "coming out" that is significant for everything he does later.

————

"my name is andy miss ives gave me your address she said she talk to you about me." That's one side of a penny postcard that Warhol typed in his Seventy-Fifth Street apartment. It marks the beginning of one of his most important early relationships with another man, despite its being pretty much unrequited. Here's the name and address Warhol put on the card's other side: "mr capote/1060 park avenue/new york city."

"I started getting these letters from somebody who called himself Andy Warhol. They were, you know, fan letters," Capote recalled thirty years later. "Not answering these Warhol letters didn't seem to faze him at all. I became Andy's Shirley Temple. After a while I began getting letters from him every day." It's no wonder Warhol had fixed on Capote as the object of his attentions: In a piece published a few years before, the author had described a year in his childhood that, like Warhol, he'd spent "mostly in bed" fixated on "the most beautiful woman in the world"—none other than Warhol's own favorite, Greta Garbo. The young Warhol must have sensed an inescapable karmic link between him and his almost doppelgänger.

By the first of March 1952, it had got to the point where that "Miss Ives" (Marian, who was Capote's agent) had to write a letter asking Warhol to cease and desist. It's clear from its tone, however, that Warhol had already worked his charm on her, and that she counted herself in his corner. Ives jokes that "[Capote] said he'd been receiving inane notes from one Warhol, and thinks you must be slightly insane. So of course I told him you were."

We can't tell if Warhol's notes ever stopped, but at some point the obses-

sion moved beyond mail to proper stalking. His friends once found a visibly agitated Warhol waiting to pounce outside the fashionable Stork Club where Capote was dining. And Capote discovered that Warhol was visiting his building in person: One day he looked out his window to see his admirer "staked out," as he put it, against a lamppost below, like some film noir hoodlum. Somehow, Warhol's direct approach seems to have worked. He managed to get himself invited upstairs into the flat, maybe when Capote's eccentric, alcoholic mother took pity on the stalker downstairs. "She just wanted somebody to drink with," Warhol remembered. Capote later said that he'd appreciated that Warhol would drink with his mother so that he didn't have to. "She took me to the Blarney Stone on Third Avenue," said Warhol, "and we drank boilermakers and talked about Truman's problems." Having "a problem" was Warhol's code for being gay, so you wonder what they discussed.

As Capote told the story, he was home when the artist visited and he found Warhol "the loneliest, most friendless person I'd ever seen in my life"— which shows how badly Capote read Warhol, who actually had a rather lively social life and could never understand why Capote had pitied him. Warhol seems to have taken the meeting as license to start telephoning his hero ("every day," in Capote's probable exaggeration) until Mrs. Capote decided she'd had enough, and launched such a tirade at Warhol that he was scared off for the next several years. The two men only became proper friends in the 1970s, when their cultural status began to match as the paired "queens" of New York's literary and artistic worlds.

In the spring of '51, while Warhol was still settling into the basement on Seventy-Fifth Street, he made another contact that would last for years. Decades later he recalled "the humiliation of bringing my portfolio up to Carmel Snow's office at *Harper's Bazaar* and unzipping it only to have a roach crawl out and down the leg of the table. She felt so sorry for me that she gave me a job." Snow was New York's great fashion editrix—Richard Avedon once said she taught him everything he knew—and *Bazaar* was the Hearst Corporation's flagship women's magazine. Confirming Warhol's story of pity assignments, Snow gave Warhol a modest start there doing negligible shoe illustrations, as minor ornaments in a huge photo spread by Avedon. After a while, however, she started assigning him entire pages, so that he eventually managed to place his work in a total of sixty-nine issues. That means Warhol also had to be approved by the stringent genius Alexey Brodovitch, *Bazaar's* design czar, whose tongue-lashings Warhol remembered years later. Warhol's many, many shoes for *Bazaar* helped confirm him as the go-to guy

for footwear, later his main income stream. In 1951, however, Warhol was nothing more than "a young man doing spot illustration for Harper's Bazaar and other magazines," according to no less a figure than Amy Vanderbilt, whose publisher got Warhol to illustrate her first etiquette book, which came out the following year. (She didn't want photographs used because she felt they would date more easily than drawings.) "He was a slim thing in dirty sneakers and a sweat shirt and he didn't know which side of the plate the fork went on. He was living in one room, and he had one fork, one knife and one plate," she remembered.

Over the following year, Warhol's career began to take off. He got more work from every single one of the art directors who'd used him in his first months in New York, plus the *Bazaar* gigs and a bunch of new commissions from NBC (an unlikely ad for the new TV sports broadcasts), *Dance Magazine*, *Town and Country* and the *New York Times*, where he started out with the tag line "Drawings by Andy." Warhol the neophyte was already doing something few of his rivals could ever manage: working on a regular basis for magazines published by both Condé Nast and the Hearst Corporation, fierce competitors who normally demanded a freelancer's loyalty.

He was also getting prestigious contracts for drug company brochures which, like record jackets, were "good to be put in a portfolio to go calling on the advertising agencies, because it would express [your] creativity," according to one of Warhol's own record-company clients. Warhol needed to start cultivating as much ad work as possible, since magazine illustrations are always pretty much loss leaders for artists, meant to impress the Madison Avenue types whose contracts could actually pay the bills. A staffer at the *New York Times* remembered how Warhol would almost crash into her as he bicycled madly around midtown, delivering drawings and drumming up work. He wore a suit as he rode, she said, but looked so wan and hungry that she would sometimes make an extra-big lunch so she'd have food to pass on to him.

One way or another, Warhol was earning enough to hire his cash-strapped friend Pearlstein, living around the corner on Eighty-Second Street, to stretch some canvases for his fine art production. Warhol never gave up on his self-image as a serious artist, however busy he might have been as a commercial one. He'd have found support for wearing both hats in a show by the top illustrator Saul Steinberg that was shared between the prestigious Sidney Janis and Betty Parsons galleries. The exhibition opened just when Warhol was fan-mailing Capote, and a *Times* feature quoted Steinberg attacking New York's fashionable expressionism as "a kind of blackmail on the spectator" and insisting instead on the very Warholian

idea that "the artist's feelings must be sublimated and objectivized through the language of art."

Many of Steinberg's statements in the article could as easily have come from Warhol: "I would copy anything from anyone, even my mother," Steinberg said, just before Warhol started doing that very thing, and Steinberg talked about wanting to try his hand at film and television and even a theater décor "of drawings exhibited by a projector," which evokes Warhol's projections from a decade later.

———

One day late in the winter of 1952, in the middle of all this professional rush, Julia Warhola showed up for a visit. To the surprise of all her relatives, she didn't leave again for two decades. That October, her grandson Pauly was still asking, "When are you coming home?" It's worth noting, however, that "home" would have just undergone a big change: Warhola's middle son John, who lived with her, got married that year, so there would have been a new daughter-in-law in the household, and Warhola might have feared a repeat of her problems with the first one.

"I come here to take care of my Andy, and when he's okay I go home," Warhola explained to Leonard Kessler, Warhol's later studio mate. And as he added, "Andy was never okay." Maybe Warhola had found her son in a shambles: "He desperately needed someone to take care of him," remembered one friend from that moment. Warhola once mentioned discovering ninety-seven unwashed shirts in her son's closet that day she arrived, although no one has ever claimed fastidiousness as one of her notable virtues. Or maybe the canny Warhola figured that her Andy was himself on his way *out* of the closet, and she thought that her presence might keep him a tiny bit in. She never ceased looking for a "nice girl" for him to marry and once said she was only staying until she found one. On the other hand, Julia Warhola once wrote a letter to a female cousin asking why her Andy was "different." When she referred to a lover of Warhol's as his "boyfriend," she might have known perfectly well that this meant more than "chum," and that he didn't only sleep over because they worked late. Another early boyfriend of Warhol's felt sure she knew what the score was.

It could also be that Warhol had missed Warhola's maternal embrace and grabbed her from his brothers of his own accord. According to one art director, who actually met the mother before the son, the way Warhola told the story of her move was that it was Warhol who got her to stay in New York "and that she resented that very much." Warhol could have found one other upside in Warhola's presence: A boyfriend said that Warhol didn't want to

have sex at home so long as his mother was asleep in her room, which might mean she was being used as a convenient shield against intimacy.

Whatever the reason, after a separation that had lasted all of three years this is when Julia Warhola once again became a fixture in Warhol's daily life, even though he had originally said she could stay only until he got a burglar alarm—or at least that was how he told the story decades later. Joseph Giordano, the art director who described Warhol's mother as "brilliant beyond belief . . . much smarter than Andy," said that she once ran back to Pittsburgh in a huff, only to return and demand her due respect. "She came in and slammed the suitcase on the ground and she turned around. She looked at him and she said, 'I am Andy Warhol.'" Giordano was alone in seeing Warhola as the source of some of the artist's troubles as well as his talents: "He felt so, so unloved. It just makes me want to cry. . . . I just knew she made him feel so insignificant. She made him feel that he was the ugliest creature that God put on this earth."

All of Warhol's friends were struck by this strange presence in his home. Warhola cleaned for her son "like a Czech chore woman," and did the cooking as well, for him and whoever was over, although she wouldn't eat with them. Lunch was often a sandwich or Saltines and Campbell's Soup (what else are people going to remember?) while dinner might be cabbage and beef or "strange things . . . Czechoslovakian pancakes or something with various stuffings," according to one WASP guest. Warhola fixed the kind of Slavic food that Warhol always loved, even though he went on to promote an all-American image of himself as an eater of white bread and vanilla shakes. It's not often mentioned, but Warhol himself could be an eager and even ambitious cook on the few occasions when he had time for the kitchen— one 1950s friend remembered him cooking her a Thanksgiving dinner of pheasant under glass.

Warhola was "as funny as Andy and she loved to laugh at funny things," a boyfriend remembered: "She liked to play at being a peasant— she was partly that—but she was quite astute." She talked with her son in her native Rusyn, which Warhol both spoke and read, and when they had visitors she'd converse endlessly in her own version of English, comically halting but perfectly communicative. "You every day grow bigger, bigger, bigger," she tells a Warhol boyfriend, in footage Warhol shot in the 1960s for a fictional biopic of his mother. As she riffs on the bare threads of plot and dialogue she's been given for that movie, her performance makes clear that Warhola had a strange and wily wit, not so far from her son's. Julia Warhola's persona as the classic Old Country crone was camouflage for a clever and complex eccentric. Some photos of Warhola do show her hiding

her hair under a regulation babushka, but others have her in stylish getups of her own devising.

Warhola's tension between the goofy naïf and the knowing stylist is also the force that powered most of the art Warhol made in his early years. From the first orchestra picture he drew for *Cano*, with its faux-nursery flair, through a decade's worth of pretty shoes and prettier boys, Warhol played on the border between outsider art (a Pittsburgh specialty) and mannered sophistication (New York's local dish).

An assistant compared Warhola to the painter Grandma Moses, and Warhol himself praised his mother for making art that was "real good and correct . . . like the primitives." That was the proper art-historical term in Warhol's youth, when the Carnegie's annuals had shown both the truly untrained like Grandma Moses and commercial faux-naïfs like Carol Blanchard, a prominent illustrator Warhol had idolized at Tech. Before Warhol's mother had been in New York more than a year or two he had her adding captions to his drawings, deploying the insanely curlicued handwriting she'd learned as a child and used for all her correspondence. As one grandson recalled from his visits to Warhola in New York, "She'd have her dipping pen, and she'd be looking over and jabbering at me [in Rusyn, her native language]. And all the time, her hands would be moving. It was almost like a maestro performing."

Warhola's calligraphy wasn't unique to her: Warhol's father and other Old Country Rusyns had been taught to use the same steel-nib script. But in the context of New York, and of rigorous modern art and design, it read as gloriously artless and fresh. Her writing, with its constant spelling errors, counted as the perfect addition to Warhol's other faux-naïf stylings. Before her arrival, Warhol had used any number of badly spelled scrawls of his own whenever lettering was called for. He kept them in his repertoire for the rest of the 1950s, even once he had chosen to put Warhola's script at the very center of his corporate identity, playing it big on his business cards, stationery and publicity materials.

Warhola's writing for Warhol had one other important dimension. Back in 1948, when Warhol was reading Capote's first novella, he'd have come across a passage that describes a fancy cursive as a sure sign of a character's queerness: "It was a maze of curlicues and dainty i's dotted with daintier o's. What the hell kind of a man would write like that?" Precisely the kind of man Warhol was selling to clients.

By 1957, Warhola got to deploy her cursive all on its own on Warhol's latest high-culture commission: an album cover on the new Prestige jazz label. The recording presented the exotic performer known as Moondog,

who was a kind of cultural doppelgänger for Warhola. He was a semi- or pseudo-outsider—blind, sometimes homeless, Viking-horned but also conservatory trained—whose wild beats and yelps instantly conjure visions of the turtlenecks and berets of advanced Greenwich Village clubs, just as Warhola's writing had a home in cutting-edge graphic design. The only ornament on the entire cover of Moondog's 1957 album was a paragraph about him in Warhola's goofy lettering, which won her a graphic-arts prize . . . sort of.

The recipient of the award was given as "Andy Warhol's Mother," which means she was being billed not as a truly independent creator but as an untrained adjunct to her son's pro career. Calling her "Andy Warhol's Mother" was a way to flag her as an outsider artist "discovered" (or more accurately, appropriated) by her fully trained son. Her maternal title made her a close cousin to Grandma Moses, the most famous naïve artist on the American scene at the time. Or, since Warhol got a prize under his own name in the same contest, many observers may have imagined that the "Mother" named on the Moondog album didn't exist at all, except as a gender-bending alter ego of Warhol's, the way Marcel Duchamp had cross-dressed as Rrose Sélavy. They weren't totally wrong: Even on the Moondog album, Warhol had done a cut-and-paste job on Warhola's original attempts at lettering, and before too long, with his mother feeling too frail to do the work, Warhol and his assistant learned to copy her handwriting. Eventually, Warhol even had it made into rub-on Letraset letters.

But however much Warhol might have admired and used his mother's art, he was always nervous about her outsider presence in his insider's social life. "Mrs. Warhola was not glamorous, and I think he felt a little bit ashamed of her. . . . If you got to meet Andy's mother, then you knew that Andy liked you very much," said a friend. As Warhol's star rose, and Warhola started to drink more and more—tumblers of whiskey "for her heart"—fewer and fewer people were exposed to her singular presence.

———

On Wednesday, May 14, 1952, at whatever time in the afternoon Warhol was getting up, he would have found reason to celebrate. His name had been printed, for the first time of many, in no less a venue than the *New York Times*. The paper announced that the Art Directors Club of New York had given Warhol one of its annual prizes—an actual gold-colored medal—and had included his winning piece in its annual exhibition of Advertising and Editorial Art, where Warhol was featured in all but one year over the following decade, always with more than one item. The club and its contest had special resonance for Warhol: George Klauber's mentor Will Burtin

had been A.D.C. president when Warhol first encountered him in 1949, the only year the show of A.D.C. winners was staged at MoMA, where Warhol would have seen it on his spring trip to New York. Burtin was giving him work in '52.

Warhol's winning illustration for the A.D.C. in '52 was an impressive full-page ad that had appeared the previous fall already in the *Times*, although without any credit to Warhol. It was promoting a deluxe, noir-ish CBS radio documentary about organized crime. Warhol's cleverly tortured blotted-line image of a junkie shooting up, with his face turned away in shame and pain, was selling the show's first episode, about the drug trade.

Lou Dorfsman, the famous CBS art director who designed the campaign, explained that the new medium of television, still a "stepchild growing up," was threatening to take over at the network, so they were working extra hard to keep radio vital. Dorfsman decided to make his ad for the audio documentary stand out by using a drawn image, when all his competitors were rushing toward photography ("I took the position that when everyone was zigging, I would zag") and by creating a page "that was really in the category of art rather than illustration." Warhol was too elite to use for lesser, "prime-time" entertainment, Dorfsman said, but he had "the visual impact that I wanted for such a subject. There's a gritty quality about [his] style."

For all that, Dorfsman's rave was distinctly qualified. He said that he'd only chosen Warhol for how well he channeled Ben Shahn's look, and other sources agree that Warhol was often chosen for jobs because he counted as "a cheaper Ben Shahn," and without Shahn's taint of far-left politics. Shahn was the leading figure in illustration at the time—the model for "every art student in New York," according to one Warhol client—and he dominated the A.D.C. exhibitions for the next decade at least. Warhol himself collected Shahn's work, framing one piece in gold for his apartment wall.

If there seems to be a disconnect between these art directors' modest appraisal of Warhol's "Shahnian" talents and the award he won, it disappears once you start looking into that 1952 A.D.C. competition. It was like the caucus race in *Alice in Wonderland:* Everyone got a prize, or very nearly. Forty-one awards were spread out over a vast range of categories, including "Direct Mail and Brochures," "Posters and Point of Sale" and "Company Magazines—House Organs." Warhol won for "Newspaper Advertising Art: General Illustration." His most notable fellow winners included the photographers Henri Cartier-Bresson and Irving Penn—their names were just below his on the A.D.C. prize brochure—which confirms photography's encroachment into illustration's territory as "the big new thing," in Warhol's words.

This points to one trick that Warhol had up his sleeve that, a decade later, he'd parlay into more radical work: However hand-drawn his illustrations might seem, any viewer could feel that photographs lurked behind many of them. (His archives include the photos he used for his drug-addict drawing as well as for many other commercial projects.) Reading between the lines of Dorfsman's comments, you can see that this was exactly what an art director like him was looking for at this transitional moment: A photographic essence that came with the patina of handmade high art. Although those 1952 A.D.C. prizes may show photography gaining ground, it still tended to carry the taint of low-end advertising, like the kind that Warhol would have spotted in the Pollock issue of *Life* when he first landed in New York. When art directors hired Warhol, it gave them an excuse to include a hint of photography in a layout without quite acknowledging that they were sinking so low (or moving so far ahead, if they knew current trends but didn't trust their audience to follow them there). Warhol tended to work for elite clients—fashion editors, deluxe record labels, serious publishers and also big pharma—who, as Dorfsman suggests, couldn't quite stomach a photographic approach but could no longer do without it, either.

In looking at Warhol's work in illustration, it's important to recognize that his success depended on how well he'd mastered a manner that appealed to the established tastes of his era. He was still a long way from making the serious, challenging art he got up to later. In 1952 already, in the catalog to the A.D.C. show, there are images in three of Warhol's signature styles that you'd swear were by him, if it weren't for the other artists' names that they carry. Some years later, when he drew a tattooed lady for a promotional flyer for his very own business, it was very close to (or borrowed from) the tattooed lady mural on a postcard that he'd received from a well-known bar in Miami. Around that same time, a magazine article on the leading design and ad agency Sudler & Hennessey included one illustration they got from Warhol, alongside many others that are in styles very close to his. "I could have gotten maybe two or three dozen artists to do the ads, we would have gotten I think the same acclaim," said one of his art directors—clearly exaggerating, but not entirely. "His specialty was shoes," said one of the agents who sold Warhol's services at the time. "He was not known more than other people, but he had a good name." Or as another client—and admirer—put it, "He was regarded as an accessory artist, and that's not very great." Just months before he died, when a critic was insisting that Warhol's 1950s expertise in commercial art must have affected the fine art he made later, Warhol's response was, "Well, I just did shoes."

Without the greatness of that later fine art to make his name count on

a larger stage, Warhol's commercial art would have long since faded from view.

Warhol would have had his own doubts about his place in the art pecking order. He had been schooled as an avant-gardist in Pittsburgh and then confronted advanced art wherever he looked in New York. That left him perfectly well aware that his huge debt to Shahn left his work looking backward at an approach from a fading era. Even at Tech, some of his peers had already sensed Shahn as passé. Of course Warhol enjoyed the money and recognition that his mainstream style had brought him. But he also realized that sensitive, expressive, hand-drawn figuration, even when filtered through tracings and blottings, was losing credit in the world of serious art.

When Dorfsman said that he was looking for a style that was more like art than illustration, what he really meant was that he wanted something that a mass audience would instantly recognize as "arty"—just what any self-respecting avant-gardist knew to avoid. As early as 1948, the new "mathematical" and procedural approach of John Cage was explicitly being contrasted to Shahn's older, more "communicative" mode, meaning a choice was being offered between two of Warhol's heroes. He knew which one would come out on top: "You know who I think is so interesting? . . . You know, well, John Cage and Merce Cunningham. John Cage is really so responsible for so much that's going on," opined Warhol just as his career in Pop Art was getting underway.

Warhol's old-fashioned illustrations did have one newfangled selling point, which comes clear in an anecdote told by his friend Philip Pearlstein. Just after they'd arrived in New York, Pearlstein arranged to show his own portfolio to Brodovitch at *Harper's Bazaar,* and got this response from the great man: "I could never hire you even to do paste-ups. Your virility shows in everything you touch." It was Warhol's nonvirility—*anti*virility, even—that helped make him more salable than his roommate.

"'Light in his loafers.' That's what they used to call someone like Andy. It meant very effete, very precious, very delicate, very . . . fey," recalled one of Warhol's closest gay friends from the early 1950s. Many clients and colleagues also used that word "fey" to describe Warhol and his work, including one who summed Warhol up as having "a sweet, fey, little-boy quality . . . and that was the quality of his work, too. It was light, it had great charm." As the decade wore on, Warhol tried to move out from under Ben Shahn's shadow by replacing Shahn's perfectly manly grit, well suited to illustrating a radio show about drugs, with a whimsical, even camp version of the style that was ideal for women's beauty products and shoes. Those subjects almost completely took over Warhol's business. There might even

have been a sense that, in a world where fashion illustrators were almost all men, Warhol managed to come closest to channeling the feminine sensibility that female readers and buyers were supposed to have—Warhol's own brother referred to the girlishness of the signature that their mother came up with for Warhol. His faux-naïf style clearly owes a lot to the wildly girlish work of Carol Blanchard, that artist-illustrator he'd worshipped in his student days and who he befriended in New York, where she was one of the rare women on the commercial scene. Her singularly eccentric ads for Lord & Taylor's department store were close precedents, in women's fashion, to the explicitly "campy" campaign Warhol did later for I. Miller shoes.

By the mid-1950s, the female publisher and editor of *American Girl,* the deluxe monthly put out by the Girl Scouts, was seeing Warhol as the perfect illustrator for the magazine's princess-power stories, which he matched with drawings done in an especially frail line washed in pink and mauve. Whereas at that same moment, when he got commissions to illustrate men's fashions for the manly *Esquire,* famous for its pin-ups, he knew to adopt a spare, analytic technique that had almost nothing in common with his work for women's magazines. Always acutely attuned to his clients' needs, Warhol also understood their gender assumptions. "Andy had such a good feel for the delicate, the feminine," said one (male) art director who hired Warhol to work on a campaign for menstrual pads. According to the scholar Richard Meyer, "Warhol's commercial work did not simply address the female consumer; it pictured a feminized world."

Warhol was so wrapped up in the feminine that, in 1953, a rejection letter for two chapbooks he was pitching around to New York's publishers was addressed to "Miss Andie Warhol," clearly in response to the books' girlish style and to the feminine spelling of Warhol's first name that he himself had used in his pitch. Around that same time, when an art director—male, again—asked a colleague about "the hopeful blonde female illustrator" who'd just stopped by, the laughing answer was "That wasn't a chick. I've got his name somewhere . . . er . . . Andy Warhol." The details of the anecdote seem far-fetched—Warhol wasn't nearly that gender-bending—but it still shows that "regular guys" remembered him as someone who was insufficiently male.

If Warhol's queer style had some kind of fit with the magazine world, it had almost no place at all in fine art, which was where he always wanted to end up. In the early 1950s, with Abstract Expressionist machismo so much on display—*Life* had given big play to Jackson Pollock and his fellow "Irascibles"—Warhol counted as a distant outlier when he recognized the avant-garde potential of homosexual culture. As late as 1968, Abbie Hoff-

man, the purported revolutionary, was still dismissing Warhol as a "fag," while also acknowledging that in a culture grown utterly permissive homosexuality was the last forbidden zone for a radical to explore.

In the 1950s, Warhol realized that investing in this new kind of radical content, barely ventured before, could get him out from under the conventionally arty style he was still using. He decided to make fine art that was distinctly, even flamboyantly, gay, which meant that he was moving into uncharted postmodern territory. That was where he'd be for decades to come.

*. . . with his mother in their lower Lexington flat.*

# 1952-1954

*"I knew things was good, but I didn't know you had a pussy"*

"I used to get very mad at him because I thought that he wasn't really uti-
lizing all his talents and he really had so much more to offer than just the
commercial kinds of stuff," recalled Leila Davies, Warhol's roommate from
the "commune" on 103rd Street. "And he, you know, kind of shrugged and
said, 'Yeah, but I need to make money and I need to be successful.'" By the
summer of 1952, Warhol clearly felt he was doing well enough at filling both
needs to go hunting for his first gallery show, still decked out in his Raggedy
Andy gear.

"This young man, quite pimply-faced and poor-looking, wandered into
the gallery and said, 'Would you like to look at my things?'" said David
Mann, a dealer who received him. "He looked right off the boat; he was
very poorly dressed and carried a torn portfolio under his arm." But what
was in that portfolio was good enough to win Warhol a spot, at least in a
two-man show with another art-world beginner and with Warhol paying
$100 toward costs—in a space a friend of Warhol's actually described as a
"vanity gallery."

"Andy Warhol: Fifteen Drawings Based on the Writings of Truman
Capote" opened on June 16, 1952, at the Hugo Gallery in Manhattan. The
young artist's name, seen in the art world for the first time and played big
on the invitation, was being aligned with one of the few famous gays on
the scene. Warhol claimed that he had in fact made the drawings to attract
the interest of Capote when he first cold-called him, which must have al-
ready happened that spring. Although Capote showed no interest in seeing

the pictures, his mother, Warhol claimed, was intrigued enough to invite the artist up for that first meeting in their flat. Once the exhibition opened, it is supposed to have pulled in both Capote and his mother, who apparently liked the work. David Mann said that Capote had actually hoped that his publisher would use the drawings to illustrate future editions of *Other Voices*.

The exhibition ran for only three weeks, as a last-minute add-on to the slow tail end of the spring season, whereas Warhol had actually hoped for a slot the following winter. Worse, instead of being in the main space it got stuck in a back room run by a bookshop upstairs. No sales came out of it. It also got panned. But all those negatives were outweighed by the surprising prominence of the venue that the rookie artist had managed to nab, which was better than any of the spaces Warhol showed in over the following decade. The Hugo Gallery, named after a moneyed Madame Hugo, a.k.a. "the Duchess de Gramont," was an eight-year-old venture with a fine reputation. It sat perched upstairs in a town house on Fifty-Fifth Street, just doors away from the Winslow bar where Warhol hung out. Its walls were covered in blue velvet, the perfect decadent background for Warhol's louche work as well as for the antics of the gallery's founder, Alexander Iolas. He was a retired ballet dancer once of some note and so flamboyantly out that as late as 2014 he was described as a "nelly Big Bang whose long-range queeny shock waves are still vibrating." Marcel Duchamp was a fan, and the gallery was a favorite of the art dealers Eleanor Ward and Leo Castelli, both of whom later represented Warhol—as Iolas did again in 1987, when he gave Warhol his final show, just as he had given him his first.

Iolas claimed that he had first spotted Warhol on the street as a tempting eccentric, accosting him and demanding that he visit the gallery with his portfolio. Seeing it, Iolas is supposed to have said (but probably didn't), "Dear Sir, till this day you were a shoe designer. As of this moment, you have to start working on your own one man show at the Hugo Gallery."

Warhol would already have recognized the gallery as a haven for big-name European modernists such as Georges Braque, Max Ernst and Rene Magritte, as well as for Warhol's gay heroes Jean Cocteau and Pavel Tchelitchew. It also showed outsider artists and their close kin such as Joseph Cornell, who Warhol knew from his Pittsburgh showings at Outlines and then later through a mutual friend. The *New York Sun* had given big play to the Hugo's notoriously extravagant group show called "Bloodflames," describing it as "the extreme of the extreme, designed to puzzle the world and

succeeding perfectly," while that same show's *Times* review ran under the headline "Modernism Rampant." Nothing could have gotten Warhol more excited than a gallery with a reputation like that.

We don't know much about the pictures Warhol included in his Capote show, except that they were blotted line drawings with washes of color. The exhibition garnered two tiny reviews, both fairly negative. Their descriptions make clear that some at least of the new drawings had the sly sex appeal of Warhol's pictures of beautiful boys from the same era.

According to the review in *ARTnews*, Warhol's drawings were full of boys, tomboys and butterflies done "in pale outline" splashed with "magenta or violet," and they compared badly to his gallery mate's more virile pieces, rendered in "strong, free, black lines" that rendered subjects such as "smug cats prowling and strutting their stuff." (Maybe Warhol went on to circulate his own feline drawings after seeing the reception cats had won for his rival.) For the *Art Digest* critic, Warhol's "fragile impressions" were "less impressive altogether" than the other Hugo artist's "sprawling, posturing, neo-classical, Picassoid" drawings. Warhol's images, he said, had "an air of preciosity, of carefully studied perversity" that recalled Beardsley, Demuth and Cocteau—all of which was homophobic code, of course, for the gay content and manner of Warhol's images. The young artist kept copies of the clippings, while choosing not to mention the show in a list of accomplishments—specifically as "an artist"—that he sent back later that summer to Tech.

But bad reviews were not enough, then or ever, to make Warhol actually change his tune, or his art. He knew perfectly well that his gay content had avant-garde potential. He'd seen hints of the same with Demuth and the Black Mountain crowd. He continued, almost naïvely, to bank on the same themes, even if it took another decade or more for them to get him anywhere. Warhol is often billed as a schemer and careerist, but it turns out he was willing to back the art he believed in even when it wasn't any help to him or his career. This was true right through to the moment of his death.

Around the time of the Hugo show, or maybe even a bit earlier, Warhol tried to use his homoerotic imagery to sidle into the Tanager Gallery, one of the city's exciting new co-op spaces. Its members included several former classmates, and there was a general tendency toward manly Abstract Expressionism but also quite a bit of figuration and several female members. Joe Groell, who was in the co-op, recalled Warhol approaching him with pictures of boys kissing that he was "embarrassed" by, as he said he had

been in bars by his roommate's unmanly manner. He and another member judged that Warhol's pictures "weren't anything we wanted the gallery to be associated with."

That rebuff didn't stop Warhol from trying the Tanager again, the following winter, once again with the same kind of boy-on-boy imagery. This time he wandered into the gallery unannounced and showed his portfolio to a member named George Ortman. He didn't know who Warhol was, but six decades later still had a clear memory of the images being proffered: "Two male full figures embracing." He also recalled telling the profferer that there was no way those would be shown at the Tanager, and that the gallery was mostly dedicated to abstraction, anyway.

Still not enough to dissuade Warhol. More than half a decade later, after Philip Pearlstein had joined the Tanager and had a show that scored a strong *Times* review—with a big reproduction, no less—Warhol bought one of the pieces and asked his old roommate to intercede for him once again with his fellow members of the Tanager. Pearlstein did his best, he said, but the portfolio, still with pictures of boys "with their tongues in each others mouth," met with overwhelming opposition from the gallery's other "macho oriented" members. Warhol's subject, Pearlstein said, was "totally unacceptable . . . de Kooning was the big dog"—his studio was next door, in fact—so only "more neutral" subjects could work for the gallery. Warhol blamed his rejection on Pearlstein's halfhearted salesmanship. Pearlstein said the incident killed their friendship.

Warhol would have to wait for national celebrity as a Pop painter and then the beginning of his work in film before "out" art could win him a decent reception.

———

In the spring of 1953, if you wanted to direct friends to the tiny apartment building at 242 Lexington Avenue, on the west side of the road between Thirty-Fourth and Thirty-Fifth Streets, you told them to look for the seedy bar called Florence's, a.k.a. the Pin-Up Room, decorated with the pictures that gave it that name. Florence's, known for its loose women, was so notorious that it earned a place in the "Hooker" chapter of a book called *New York Unexpurgated: An Amoral Guide for the Jaded, Tired, Evil, Non-conforming, Corrupt, Condemned, and the Curious, Humans and Otherwise, to Under Underground Manhattan.* But it was also a joint where the cultured would go slumming: For a few months in 1955, the chanteuse Mabel Mercer appeared there singing Alec Wilder's modernist tunes. The place had even shown up in a Pepsi

ad as a "famous restaurant" where stars would drink their favorite cola. It also happened to fill the basement of the building where Andy Warhol lived and worked for the last seven years of the 1950s. The slender building had originally been designed with a certain orderly elegance, but by the time Warhol moved in it had fallen on hard times, with cracked plaster and bare bulbs in its hallways.

In April 1953, Warhol's two-year lease on Seventy-Fifth Street had been up and a rent increase due, so once again he relied on Pittsburgh connections to find a new flat. Before Warhol got it, the fourth-floor walk-up on Lexington had first housed Pearlstein and Dorothy Cantor, for a few months just before their marriage, and then his college friend Leonard Kessler, who was breaking out as a book illustrator. Kessler kept the lease, and he sublet the apartment to Warhol on condition that he could keep using one room as a studio, coming in from his new home in Queens during the day when Warhol was mostly out hustling contracts.

Sometimes Kessler and Warhol would be there together, encouraged to "verk, verk, verk" by Julia Warhola, who would reward them with a lunch of old-country sauerkraut stew: "I make kapusta—kapusta make you feel good," she'd say, even on the hottest summer's day. As far as she was concerned, her son's freelance career was just fill-in for the lack of a proper job in New York—she claimed he earned enough to live and no more.

From his new place, Warhol now had only an eight-minute walk to his art directors at Condé Nast, a few minutes further to that "queer parade" in the upper Forties and then on up just a bit to the Hugo Gallery, the Winslow's bar and Café Nicholson. His new neighborhood was called Murray Hill, and that was its phone prefix, too, changed by Warhol in some stationery to "Murry Hell." For about a century it had been a genteel residential quarter of mansions and town houses, but when Warhol moved in modern apartment buildings were going up all around. One now stands where his building did.

The rent was just under $100, which Warhol's mother called "very costly"—but probably wasn't. She also complained that she had to carry all their shopping up four flights of stairs. An upside of the new flat was that it was some forty blocks closer to her Greek Catholic church, on East Thirteenth Street. A new, very modern home for the church, on Fifteenth Street, was being built just when Warhol was in Murray Hill. Warhola's weekly donations helped put it up and Warhol was known to contribute as well, and even to bus there with her.

The apartment shared by mother and son was a four-room railroad flat

with fireplaces and elegant moldings, taking up the entire top floor. They slept in a pair of small spaces at the back, behind the kitchen, on single-bed mattresses on the floor. Other than one framed butterfly print by Warhol, the décor was sparse and a bit prim: chenille bedspreads, some hooked rugs, a few throw pillows and an old mandolin.

At the other end of the apartment, a bright living room, with a row of big windows onto the avenue, functioned as Warhol's studio. One client who visited remembered that front space as "like a bat-cave: funny room just filled with things like boxes and things, and not a stick of furniture. And for a desk, he used a door, a door taken off a wall and on two saw horses. He was also working while we were there, and he was sitting on a typewriter case, which was funny." Warhol's worktable had a pair of big elbow lamps perched on one side and beside them, on top of an old stool, stood a small TV, always on. Anyone helping Warhol would sit nearby at a proper drafting table, working with "brushes that were so old they'd have three hairs, but he didn't want to get new brushes," one of them said. Images would be traced from magazines—*Life* was a favorite—and then enlarged if necessary with an opaque projector. Once Warhol's commissions really took off, the mess was amazing. The studio floor was covered in drifts and floes of source images and original drawings, discarded once they'd been traced and blotted. They'd get a final touch in India ink from bottles knocked over by the studio's Siamese cats. There are still paw prints on some of the works done in the Lexington apartment.

"The cats went everywhere. No one had time to train them," recalled one frequent visitor. "They left messes on the drafting table, in the bathtub, everywhere. Andy's poor mother was always mopping up after the cats. The beds had to be covered with plastic. And the smell!" Those cats are the most famous roommates of Warhol's, although their precise number varies with every source.

Warhol's first cat seems to have arrived in the summer of 1951, in the vermin-infested Seventy-Fifth Street apartment, when his friend Tommy Jackson seems surprised to discover it there: "I knew things was good, but I didn't know you had a pussy," Jackson wrote on one of his cards to Warhol. That pet was probably the tom Warhol said had gone cross-eyed at the sound of nearby fire trucks, which sounds like a classic Warholian invention—except that the firehouse is still there on Seventy-Fifth Street, directly across the road from where Warhol lived. "He was such an incredibly dumb, weird and distorted-looking cat," remembered one boyfriend of Warhol's. That tom, named Sam, kept company with the famous Hester,

who Warhol was proud to have perched on his shoulder as he fulfilled his first contracts in that tiny flat. She was the materfamilias responsible for Warhol's Malthusian difficulties.

There were almost certainly *not* twenty-five Warholian felines, ever, since there are only seventeen on view even in Warhol's famous *25 Cats Name Sam and One Blue Pussy,* the chapbook whose title gave rise to that now-mythic number. The feline overpopulation on Lexington lasted a few years at most, and was only sometimes as insane as people have said. The tiny biographies Warhol supplied to the "contributors" page of *Interiors* magazine go from eight cats in 1953 to ten in 1954, and by early 1958 he's telling the readers of *American Girl* that his Siamese count was once up to seventeen (a number mentioned by several Warhol friends) but had since fallen to three. One friend and sometimes art assistant said that he'd heard about nine previous "Sams"—Warhol practiced thrift in naming—although by the time he'd arrived in late 1957 the number was already down to two, apparently the original Sam and Hester (a.k.a. "Sama"). Warhol's idea of feline birth control was to wrap an old sweater around Hester's loins. He liked to say that he'd got her from Gloria Swanson but his brother mentions Swanson's maid instead, with neither one explaining how this early movie-star connection came about. Hester was a serious biter but after she died Warhola still mourned her in a book called *Holy Cats by Andy Warhol's Mother,* with a dedication to "my little Hester who left for pussy heaven." (That book, too, failed to sell.) Three decades later, when Warhol includes a heartfelt mention of Hester's death in his diaries, it feels as though the book, and the tears, were actually his: "That's when I gave up caring," he said. There are actually moments when Warhola comes off as anti-cat.

Mother and son seem to have had the cockamamie idea that there was money in their pride of felines. Although the cats were famously neurotic, the product of "incest within incest," Warhol hoped to get $10 per kitten, a tidy sum for a cat in the 1950s, and he did sell at least a few. Mostly, however, the decline in Warhol's feline population over the course of the '50s seems to have been due to a constant outflow of kittens that Warhol gave away as "gifts," welcome or not but mentioned by almost every friend from that era as well as by clients and bare acquaintances. Warhola knew each of her charges on sight—"that's the good Sam, that's the bad Sam, that's the dumb Sam"—and she was still living with one of the earliest Sams as late as 1969, when a vet bill lists him as "feline—Siamese—M—20 years— Sam." But the cats may have been at their best, and least malodorous, in the

scores of illustrations her son did of them. They were his most consistent muses—or mewses—of the 1950s.

As so often, with his cats Warhol was plugging into the surrounding culture. Cats, and especially Siamese, were in fashion around then. Already in 1949, in Pittsburgh, Horne's department store had given big play to a brand-new cat book by the children's illustrator Tony Palazzo, and toward the end of the 1950s Warhol's own *25 Cats Name Sam* was copying its imagery from a couple of feline photo books, one of which was actually all about a cat named Sam.

In his early work, Warhol risked looking derivative when he borrowed. He once actually presented someone else's drawings as his, and got caught. His eureka came a decade later, when he figured out that by copying his models even more faithfully and overtly he could turn the vice of derivation into virtuous appropriation. A Campbell's Soup by Warhol looked almost exactly like the company's cans, and that actually let it mean something very new in the culture of modern art.

———

Warhol's move to Lexington Avenue coincided with a step up in his love life. His new paramour was a twenty-year-old Iowan named Carlton Alfred Willers—Warhol insisted on calling him "Alfred," and enjoyed the fact that this gave them the same initials. Willers had moved to New York in the summer of 1953 and got a job clerking in the vast Picture Collection of the New York Public Library. New Yorkers trawled—and still trawl—through it for images of any subject under the sun, which librarians had clipped out of every kind of publication. The great Joseph Cornell was a regular—he was invited to screen his art films there—and so was his fan Andy Warhol, who mined the collection for images to base his drawings on.

"Oh, you just go to the Public Library and take out as much as you want," Warhol told a friend, "and you just say that you lost them, or they were burned. And you only have to pay two cents a picture." Willers, who assisted the head of the Picture Collection, remembered Warhol paying hundreds of dollars in fines but never being barred from further borrowing, even if by the end of the decade the library's special investigator was coming after him.

Warhol made the first move in their relationship, inviting Willers to a "very elegant" communal picnic held at night in Central Park. They were close for the next few years, consuming high culture together. They would do the galleries ("Andy wanted to know what was going on, and where he might show his own art"), hang out at "literary places" such as Café Nicholson, attend any number of poetry readings and go to the theater, a favorite

of Warhol's, to see such sober fare as Gian Carlo Menotti's *Saint of Bleecker Street*. Like "80 to 90 percent of the gay world," they would keep track of Balanchine at the New York City Ballet. Warhol, Willers remembered, "had innate taste—not something he learned or faked."

Warhol and Willers were intimate. It's sometimes even said that Willers was the artist's very first lover, mostly because Warhol once claimed that he was a virgin until he was twenty-five, although "virginity" is always a complicated concept and "twenty-five years" is the kind of round number that should always be suspect. Whether Warhol was virginal or not, he was clearly lousy in bed, as his friend Willers described and as he was deemed by lovers for the rest of his life. "He was certainly not passionate. He was more passionate about food and eating," said Willers. Or rather, as Willers clarified, his boyfriend's passion was for the beautiful people who owned and frequented certain restaurants. Even after much coaxing, Willers said, Warhol could barely manage intimacy, not so surprising given the shame and danger that came with gay sex during all of Warhol's youth in Pittsburgh.

Warhol was better at looking than touching, and maybe best at looking when there was art involved: He got Willers to pose for him, nude—"like Truman Capote lying down"—for a vast series of canvases where he scaled up his blotted-line process to painting size. Only one of dozens of Willers pictures seems to have survived, plus a few other early examples of similar blottings onto canvas that prove that it's a technique that doesn't really hold up at that scale. Warhol was right to drop it.

Willers has given an unusual insight into Warhol's mental life. He said that every now and then, in an intimate moment when they were cuddling, Warhol would cry. He'd tell Willers that he'd been thinking about something sad from his past, but it seems just as likely that Warhol had a lifelong depressive streak that few got to see—unless they looked closely at his art, which often has a plangent note.

As an at-least-occasional bedmate of Warhol's, Willers was one of the last friends to see Warhol's own hair, or what little there was left of it. "We'd go to rather nice dinner parties with rather nice prestigious people and he wouldn't take his hat off. He wouldn't even take his cap off in the theater. One day I said, 'Andy, why don't you get a hairpiece or something?' He actually did. He went to some place and got a very nice, well-matched hairpiece. He looked great in it. It looked like his real hair." In that sexy photo of Warhol in bed, he's got a shock of hair that's suspiciously thicker and darker than in pictures from a few years before.

Thanks to Willers, we get lovely details of Warhol's daily life in the mid-1950s. The artist got up late and worked into the wee hours, on a diet of sweets

and éclairs gulped down the moment he got them home: "He liked ice cream, and that got him through the night sometimes." Over the next decade, his papers include piles of dessert receipts, especially the deliciously pink ones from Colette French Pastries, of "Trianon Chocolate Cake" fame. There are very few for groceries. Warhol worried about getting fat and within a few years he was going to a weight-loss club. For a while he decided to restrict his diet to chocolate and newly fashionable avocados, the "semi-tropical fruit with the rich, nutty flavor" that the *Times* was still explaining to its readers the summer that Warhol moved to Lexington Avenue. Warhola would mash up her son's "alligator pear" and serve it up "in a 10-cent Woolworth coffee cup, cursing out her son in Czech all the while."

Willers made almost nightly visits to Warhol's new apartment on Lexington, and Otto Fenn took lovely, tender photos of the two in bed, Willers entirely naked and Warhol armored in pants and dress shirt and wool vest. (A Siamese cat made it a ménage à trois.) Warhola was fond of her son's new friend: The two went to an Easter-basket blessing at her church and she cried a few years later when Willers didn't invite her to celebrate his (short-lived) marriage to a woman.

On Lexington, Willers helped his workaholic boyfriend complete the never-ending assignments that he had due, and that were already making him "piles of money."

As Warhol worked, he never stopped watching TV, Willers remembered, evoking Warhol's childhood multitasking: "Sometimes he would have the TV on and the record player on, and he would be working in the midst of all this."

The records were musical comedies, playing on endless repeat wherever and whenever Warhol was working. (In the 1960s, musicals were replaced by rock and roll and R&B tunes and opera, also played to death.) "I can remember hearing *The Golden Apple* a thousand times," Willers said, referring to a 1954 musical with high-culture aspirations. The music was by a classical composer and the book set Homer's *Iliad* and *Odyssey* in small-town America circa 1910. The public stayed away in droves, even though the show was a hit with the critics and New York's elites—among whom, at this point, Warhol clearly meant to be counted. And of course this combination of high and low genres became central to what his own art was about.

The combination was there also in the television watching Willers mentioned. Back when Warhol began his infatuation with TV, which included him hunting for commercial assignments from the networks, the medium wasn't the mass-cultural "boob tube" it became later.

Like the LP, broadcast television began life as a prestige medium: A college professor of Warhol's had quoted the august modernist Virgil Thomson on television's promise as "a new audio-visual art form." At NBC in 1951, a year when Warhol was illustrating their promotions, executives launched "Operation Frontal Lobes" to encourage programing that would enlighten the network's viewers. CBS, run by the MoMA board member William S. Paley, was known as the "Tiffany Network" because of its elite programming, promoting television as "the eighth art" and getting the likes of Stravinsky to sing its praises. Warhol's titles for a 1953 CBS drama were included in an article about how the network was commissioning "well-known artists" to do work for it, proving yet again that Warhol's 1950s illustrations were considered elite products, far removed from everyday commercial art . . . such as soup-can labels.

When Warhol himself decided to produce actual TV programs, in the 1970s and '80s, it was with memories of that earlier moment when it was a mass medium that held fine art promise. His idea of suitable content for an MTV episode included segments on avant-garde ballet and Mozart opera, followed by the gay actor Ian McKellen reading the most explicit of Shakespeare's homoerotic sonnets.

---

- *The Way of the World,* an urbane comedy by William Congreve that premiered in 1700.
- *The Three Sisters* and *The Cherry Orchard,* dense dramas that Anton Chekhov wrote two centuries later.
- Bertolt Brecht's *Good Woman of Szechuan, Caucasian Chalk Circle,* and *Fear and Misery of the Third Reich,* all written while the radical playwright was in flight from the Nazis.

This was the substantial culture that Andy Warhol was bathing in during his first years of success in New York, however cat mad he might also have been. Beginning around Labor Day of 1953, on the top floor of a Twelfth Street town house in the heart of Greenwich Village, a little circle of theatrical types got regular glimpses of Warhol's more cerebral appetites.

Thanks to his Tech friends George Klauber and Art and Lois Elias—she'd had professional acting experience in Pittsburgh—Warhol was introduced to a not-so-secret society of ad-agency thespians who met to hold readings of plays that weren't likely to be seen onstage.

McCarthyism was in full swing, and for this gang of left-leaning cul-

turati, digging into the theatrical radicalism of an earlier era was a form of resistance to that "dull, deadening time in America" said Bert Green, an art director and sometime-playwright who helped launch the theatrical soirées. "We were always interested in the outrageous. . . . When we first started out on Brecht it was like light in the wilderness."

Readings were held every Monday night in Green's big apartment, but before long those evolved into private weekend performances acted in the round—the cutting-edge way to stage plays at the time. Outsiders began to show up, extra chairs were rented, ads were placed in a Greenwich Village paper, a flyer (by Warhol) was printed up. "We were the very beginning of off-Broadway," said Green.

Thus did Warhol become one of the self-proclaimed 12th Street Players—although not exactly the best of them. "He was a very bad reader, and a very bad actor. He has no voice, and he has no ability to project at all," said Green. "It was a big public embarrassment, to not be able to read in front of all these other people, but he wasn't abashed at all." Thirty years later, when he was a celebrity with his own TV show, outtakes show him still flubbing almost every line—even with cue cards—and still mostly unfazed by his failure.

Warhol the failed actor added to the group's morale anyway. He'd give sweet little presents to his playmates: a hollowed-out walnut that he'd stuffed with a tiny doll, a Mickey Mouse watch, drawings with messages like "I'm happy to be here tonight." And it didn't take long for everyone, including Warhol, to realize that he could make a more practical contribution by designing sets for the new plays some of the troupe's members were writing. Using the most minimal means—photographers' seamless paper and a pot of india ink—Warhol pulled together evocations of the shows' subjects. For one production, he designed a "modernistic restaurant," with a paper piano and a wall of crude portraits that mimicked the caricatures at Sardi's, the Broadway actors' hangout, right down to their frames. "It was very two-dimensional, very unrealistic, very stylized," Green said. By leaving all the seams showing in their productions, the troupe aimed for the self-conscious artifice of Brecht. That interest in Brechtian alienation bore fruit a decade later when Warhol perfected his deadpan Pop works, which left the mechanisms of their making on view. He even admitted a knowledge of Brecht in his first major statement on Pop.

When it came to Warhol's design work with the 12th Street Players, you could say that he was a victim of his own success. After less than a year, things were going so well at Green's place that the troupe decided to up its

game, with coaches brought in to teach voice and blocking. That meant that the whole affair was becoming too serious and professionalized for Warhol, who just wanted to "read and listen." By February 1954, the 12th Street Players had a spot in a semiprofessional weekend at the elite National Arts Club, putting on the plays Warhol had designed. By August, the ensemble, rechristened Theater 12, had moved on to decent reviews in a real Off-Broadway playhouse, and Warhol had drifted away.

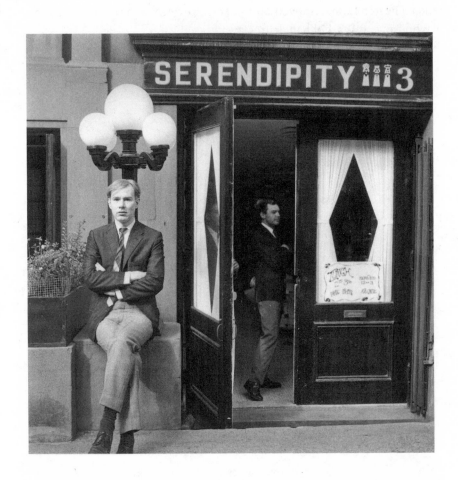

. . . at his camp hangout.

# 1954-1955

SERENDIPITY CAFÉ | COLORING PARTIES |
CAMP | THE LOFT GALLERY

*"Oh, crumpled paper! God!*
*Andy, do you think anybody will buy that?"*

The entrance wasn't auspicious: Under an old iron staircase and down into the basement of a six-story tenement on East Fifty-Eighth Street, not far from Otto Fenn's studio and the Warholian hangouts Café Nicholson and the Winslow bar. Once you made the descent into darkness, however, a glowing *Alice in Wonderland* world opened up. Burlap walls painted white bounced light onto a clutter of potted palms, bentwood chairs and genteel bistro tables laid all in snowy porcelain. Tiffany lamps added bright spots of color, their glass butterflies taking flight in the room. One of the city's rare espresso machines—an ancient "monster"—gleamed and hissed in a corner. This was the eccentric café called Serendipity 3, and one afternoon in the fall of 1954, within weeks of its launch, a pale young man in rumpled clothes and pinhole glasses could be seen descending its stairs for the first time. Over coming decades, Andy Warhol would head down that rabbit hole a thousand times.

"It was a meeting of minds—he was very sensitive and creative," said Stephen Bruce, one of the three sensitive and creative young men who had founded the place. They were the "3" in its name, a trio of triple threats who'd started out baking pecan pies in their shared apartment then opened the basement space in a gamble on going pro. They chose the street because it was known for a number of fashionable restaurants, including Café Nicholson, that drew an ad-agency crowd. Tiny Serendipity, which served only coffee and dessert, hoped to capture the same clientele by offering them an extra stop before or after supper.

Legend has it that the "boys," as the founders were always known, found the term "Serendipity" in a crossword puzzle. It described the fortuitous pleasures you were supposed to encounter in their space, among the piles of "gouty

Victorian" bric-a-brac they garbage-picked from the city's fancier curbs. Everything in the décor was for sale, from the white porcelain dinnerware to the white tables it sat on, while shelves came stocked with such "treasures" as antique feather dusters and even, made just for the café, an "unusual swimsuit for men. . . . fashioned after the old-style tank suits—complete with cut-outs under the arms and a skirted front."

Warhol was addicted to cappuccino—the drink was still "a symbol of subversive sophistication"—and so became such a regular at Serendipity that word got out that he was a part owner. He offered the actual owners his finest ideas for retailing—for instance, that they should sell real Hollywood stars' underwear, used and new—but he was probably of more use as a one-man revenue stream. Within a few years, he was running up a yearly tab in the thousands.

In the beginning the restaurant only opened in the evening, which was why that first visit of Warhol's that afternoon found him alone with Bruce in the empty space, collapsing into a chair after the trauma of a morning visit to Diana Vreeland at *Harper's Bazaar,* where the legendary cockroach had just crawled out of his portfolio. (The bug seems to have been unusually mobile, since Warhol's story has also had it appearing in the office of Vreeland's boss Carmel Snow.) After his months with the players on 12th Street, Warhol must have felt particularly at home alongside the three stylish performers who'd founded the café and the gang of actor friends they gathered there. Soon the café was also hosting Warhol's mentor Otto Fenn as well as his idols Truman Capote, Tennessee Williams and the "adorable" photographer Cecil Beaton, as Bruce described him, all three of whom also dined by Warhol at Café Nicholson.

Bruce said the scene at his place was "very effete," and in fact his establishment was one of the most open settings for queer culture in New York. As one friend of Warhol's put it, "In the milieu we moved in, gay meant nothing"— because just about everyone in it was gay. Beginning around the time the café opened, Warhol's circle begins to read like a Who's Who of queer New York. Aside from his contacts with Capote and the other Café Nicholson celebrities, he was also assembling a collection of ferociously ambitious young talents: the textile designer Jack Lenor Larsen, the jewelry maker Kenneth Jay Lane and the Balanchine protégé Jacques d'Amboise, as well as Philippe Jullian, a French writer and antiques expert who became the champion of a neo-Decadent aesthetic. (He had a hand in the revivals of Aubrey Beardsley and Art Nouveau; Bruce showed him at Serendipity and once asked him to design playing cards for the store.) Not all of these men were homosexual, but all counted as part of the new, gender-fluid culture that Serendipity fostered.

Warhol, Bruce said, would fall under the spell of "every attractive young man in the city, including me." On one visit, Warhol sat drawing as Bruce,

barely in his twenties at the time, arranged the café's merchandise. Warhol's sketchbook, presented as a gift to the sitter the very day it was filled, is wonderfully tender, like a Shakespeare sonnet offered up to the Fair Youth. The artist scrawled "Play Book of You S. Bruce" on the pad's cover, maybe in homage to his 12th Street theater work, and its twenty-four fluid drawings are awash in fluttering hearts. They land on the sitter's lips, his crotch, his tie, while the drawings also record the café's assorted sugar bowls and bentwood chairs and even its visiting iceman. Although the session was carefully art-directed by Warhol, who put Bruce through a range of considered poses, the effect is of carefree nonchalance. The drawings were done with the newly invented ballpoint pen—more evidence of Warhol's lifelong technophilia, always a surprise in someone who resisted guy culture—and it seems to float over the page to kiss each subject it depicts. "It was very romantic—it was a great Valentine to me," said Bruce, although he never succumbed to its come-on.

Warhol's next Serendipitous crush was on a Wisconsin artist named Dudley Huppler. He was an occasional visitor to New York who was part of the café's crowd and remained close to Warhol for several years, sometimes getting described as his boyfriend. (Although he could also be a catty rival, once describing Warhol as "dumb and nice—with bulb nose. Awful young and callow." He turned against his friend in the Pop era.)

Huppler was "quite startling, physically," said one acquaintance from those years, "short and husky, a little bantam rooster who really did look well hung. He bragged about fucking all the Italian boys in the neighborhood."

By the moment of Serendipity's launch, before Huppler and Warhol had even met, the two were in regular long-distance contact, thanks to some kind of introduction from Otto Fenn, who must have recognized them as alike in eccentricity. Even at this early date, it's clear that the artistic persona created by Warhol was as important as his actual art. Huppler described his new pen- and phone-pal in a letter:

> If I don't explain Andy very clearly, it's because he is all a delightful atmosphere that doesn't take shape. He writes letters of just one phrase or indeed sometimes nothing at all, but every time I get one something jumps in me—I feel, This is a uniqueness, a quintessentialness—a real invention in personality. Never saw him but talked on the phone, when he offered me enough drawings to paper a room, and then when I said 'No, a cat'—my choice of 17 Siamese!

Huppler's deep roots in the art world would have made him especially cat-worthy in the eyes of Warhol. Huppler was born eleven years to the day

before Warhol, and already by the 1940s had shown at the Art Institute of Chicago and had been featured in *View,* the prestigious Surrealist magazine founded by writers Charles Henri Ford and Parker Tyler, who both later moved in Warhol's Pop circles. By 1950 Huppler's art had hit New York in a well-reviewed solo show and in a feature in *Flair,* a short-lived but highly touted monthly. (It's where the Café Nicholson scene got its first play.) Serendipity ended up selling twelve-packs of postcards ornamented by Huppler.

Huppler's drawings, which he mailed to Warhol by the dozen, make Warhol's fey blottings seem almost macho: The Wisconsinite specialized in precious pen-and-ink pictures built from thousands of tiny black dots, assembled to conjure an enchanted world of willowy satyrs and gorgeous youths kissing.

By May 1955 Huppler's work had won him a spot at the prestigious Yaddo residency, in the country in upstate New York, after he'd tried to get Warhol to apply as well. Warhol never got there, but he profited from the place nonetheless: From Yaddo, Huppler wrote to Warhol about a "phenomenally bright writer" (and painter) named Ralph Pomeroy who longed to be drawn by Warhol. He became Warhol's next infatuation.

Pomeroy, all of twenty-eight years old when Warhol met him, had already been published in the prestigious *Poetry* magazine and was about to be picked up by *The New Yorker.* The poet Edward Field gives a lovely account of Pomeroy in Paris in the summer of '48, after he'd been kicked out of the military for homosexuality: "Under his blond bangs, Ralph Pomeroy had a painter's clear, gray-blue eyes, and a sulky, vulnerable mouth. He was often called 'le faux Truman' for his startling resemblance to the author in the jacket photo. . . . Actually, Ralph looked more like the photo than the real-life Truman Capote did. He was the idealized version."

In New York in the 1950s, Pomeroy's high-end circle overlapped with Huppler's: George Platt Lynes, Marianne Moore and Katherine Anne Porter were all in it, plus Gore Vidal and Dame Edith Sitwell, whose recording Warhol had once all but worn out. With his looks and culture and connections—more of all of those than Warhol could claim—how could Warhol have resisted Pomeroy? He didn't. The two became close, even collaborating on a (satirically) Proustian book called *A La Recherche du Shoe Perdu,* clearly meant to cement Warhol's reputation in the trade as the master of footwear. Fifteen fantastical drawings of boots and pumps and mules were paired with blithe captions by Pomeroy that, in a typically Warholian mix, referenced both low and high culture: "Dial M. for Shoe" and "I Dream of Jeannie with the Light Brown Shoes" but also "Beauty Is Shoe, Shoe Beauty" (after Keats), "The Autobiography of Alice B. Shoe" (Gertrude Stein) and "To Shoe or Not to Shoe."

The books were cheaply printed in black-and-white, but they also existed in hand-painted versions executed at the famous "coloring parties" that Warhol held in the afternoons at Serendipity, around a big round table still at the café in the twenty-first century. "He had an entourage of boys constantly," said Bruce. Like Tom Sawyer painting his picket fence, Warhol would con his young beauties into tinting his blotted-line butterflies, cats and shoes.

Some of the sheets that got colored in the café would end up bound into the deluxe versions of Warhol's "delightful pansy books" that were stocked on Serendipity's shelves. Other drawings would migrate up onto the restaurant's walls and even onto its ceiling where, framed in gold, they rhymed beautifully with the Tiffany lamps and became a fixture of the décor. As Warhol explained at the time, for each image he did for a commercial client he'd do another that he could keep as his "art," and sell as such if he wanted. Six decades later Bruce remembered pricing them at $25, split fifty-fifty between the artist and the café, and selling them out within weeks. But that only partly squares with surviving records: The price is about right, but Warhol was obliged to accept returns on quite a bit of unsold merchandise. In one case the artist had to take back more than three-quarters of the ninety-nine chapbooks he'd left on consignment. The volume that failed to sell, for the then-sizable sum of $10, was called *In the Bottom of My Garden,* a.k.a. "The Fairy Book," and it was admittedly one of the most louche of Warhol's products. At the chapbook's launch, he signed copies while standing in front of a folding screen (shades of his theater sets) on which he'd painted two chubby sodomites shown pretty much in flagrante delicto.

---

There's only one word adequate to describing the style of Warhol's Fairy Book, of the café that stocked it and of its creator—a word that was just then coming into its own, and that Bruce himself used to describe his establishment: "camp."

It had entered America's gay slang a few years earlier, mostly as a verb, "to camp," meaning to act exaggeratedly queer, and was often used as a pejorative. Warhol owned a copy of a new, ardently pro-gay magazine that nevertheless could describe "camping" behavior as "a source of great dismay" among many gays.

Warhol had the good luck to hit the New York scene just when this was changing—when camp culture was coming into its own and going mainstream as well.

In 1965, the *New York Times* at last decided to educate its middlebrow readers on what it called the "bewildering" concept of camp, just then "becoming

dominant over what is today generally accepted as good taste." It said the word referred to "the curious attraction that everyone—to some degree, at least—has for the bizarre, the unnatural, the artificial and the blatantly outrageous." And where else to find the bizarre, unnatural, artificial and outrageous than among gays, who American culture saw as inevitably copping to all those descriptors?

"Homosexuals, by and large, constitute the vanguard—and most articulate audience—of Camp," said the *Times,* in a quote from a recent disquisition on the subject by Susan Sontag, who it called "the Sir Isaac Newton of Camp." And the best place to see camp in its native habitat, according to the paper, was at a pair of midtown restaurants: Café Nicholson and Serendipity 3.

Both establishments celebrated the fin de siècle era that camp was most closely tied to: The *Times* lists Tiffany lamps, feather boas, stereoscopes, Art Nouveau and Oscar Wilde as icons of the style, and also the gay author Ronald Firbank, who died in 1926 and whose book cover Warhol had done.

"We had a very artistic nature, so we had an Art Nouveau theme," recalled Stephen Bruce. That points to something important about his café: Serendipity wasn't about preaching camp to the converted—or the inverted, as gays were then known—but about its spread into a broader "artistic" ether. "If we'd had to depend on a gay clientele we never would have made it," said Bruce. The reason they did "make it" was because their aesthetic was catching on among New York's straight culturati. As Gore Vidal put it in his novel of gay life, "there was a half-world where normal and homosexual people met with a certain degree of frankness; this was true of many theatrical and literary groups. It was also true of the society of certain cafes." One hetero male, often dragged to Serendipity by his lady friends, described the place as "so quaint it was emetic . . . and the whole idea of being quaint on purpose is kind of campy."

But Serendipity's décor didn't simply yield to camp's sentimental and nostalgic impulses. Its camp design was also in keeping with the kind of forward-looking modernist ideals Warhol had learned at Tech. It was, Bruce said, about releasing flamboyant Victorian objects from their original dark and overstuffed interiors into an up-to-date white cube (or at least white basement) where they could stand out as modern touches of color—they weren't so far, that is, from the patches of red, blue and yellow that Piet Mondrian had set into his otherwise all-white abstractions. Bruce sold a Tiffany lamp to no less a person than the modernist designer Paul Mayen, the life partner of Warhol's early patron Edgar Kaufmann Jr., design curator at the Museum of Modern Art. "We created a sort of avant-garde furor because everything we had was Art Nouveau," said Bruce.

MoMA itself had tried to recast Art Nouveau as modernism in an exhibi-

tion held just after Warhol arrived in town: "The curved and ornate style of this period is generally regarded with horror," said the show's press release, arguing that in fact it needed to be reevaluated as "a reaction against revivalism which opened the way to subsequent movements in modern design." MoMA's first full display of its design collection made sure to include a suite of turn-of-the-century bentwood chairs that were trumpeted with a headline of their own in the *Times*. "In fashionable decorating circles, they are now the last word," said the article—and it told readers to head to Serendipity to buy them. (By the end of the decade, Warhol was hired to illustrate a sales brochure for bentwood.)

This was a cultural setting where Warhol's 1950s manner (of drawing, and of being) could truly flourish, and where his modernist training and queer culture could come together. More than most New Yorkers—more even than the city's official art-world elite—the clients that Serendipity attracted from the magazine and ad-agency worlds seemed open to the idea that the spare modernism of a Brodovitch layout with sleek photos by Avedon could happily coexist with Warhol's effete, even effeminate and clearly camp stylings. One art director used the *C* word itself to describe Warhol's wildly successful shoe ads, and according to Sontag "in persons, Camp responds particularly to the markedly attenuated and to the strongly exaggerated"—not at all a bad description of Warhol. In 1965, a book called *The Camp Followers' Guide!* (note the campy exclamation point) compiled signs of camp culture that included such Warhol favorites as greenback-printed toilet paper (a Serendipity creation), Scopitone jukeboxes, rattan furniture, old movie stills, Judy Garland, Jack Smith's movie *Flaming Creatures,* the *Shadow* radio show and also Warhol's own Campbell Soup paintings and underground films. That same year, the *Times* was trumpeting Warhol himself as "the most prominent single figure on the New York camp scene."

———

Surprisingly, camp wasn't on the agenda when Warhol staged his first exhibition of fine art since the Capote-themed event at the Hugo Gallery. In the spring of 1954, after a full two-year break from showing, Warhol offered his public, such as it was, a series of mostly abstract paper sculptures unlike anything he'd done before or would do again. For a group show in midtown Manhattan, he'd taken large sheets of heavy paper and folded them into irregular geometric shapes—pyramids and boxes of various kinds—then pinned them to the gallery wall. "Pleasant paper designs" with a "decorative drift" was as much as one critic could say for them, while another complained that "Andy Warhol strains patience by crumpling up the paper on which he

has painted his abstract designs." Warhol may have been the great reviver of postwar figuration, but abstraction always counted for him as a modern cutting edge he secretly aspired to. "He knew we were expecting drawings," said Warhol's friend Vito Giallo, "so he thought he'd do something we didn't expect"—a classic modernist strategy.

There were a few small hints that something more than abstraction was going on in the folded-paper pieces: When Warhol's pins wouldn't hold in the walls' hard pegboard, he allowed his objects to live on the floor where they'd fallen ("crumpled," apparently), making room for the love of chance and disorder that governed the radical new approaches of his college hero John Cage. Also, before folding his sheets of paper Warhol had "marbleized" many of them in a bath of black ink, making them look like the endpapers from an antique book. (The ink "bath" was just that—his Lexington Avenue bathtub was filthy afterward.) This was a technique with appeal in the fashion industry: The following year, Alan and Diane Arbus posed models against marbleized paper in a fashion shoot, and it was also used as the background for a Bloomingdale's window. That crossover with the "women's world" of shopping might have given the show's paper sculptures a tiny hint of gender transgression—a subtle dose of camp for those attuned to that mode. Warhol's marbleizing even left room for him to apply patches of girlish pink paint and the occasional delicate drawing of a face. But if gender norms were on the table in these works, no critic seemed to catch on or care, unless "decorative drift" is a nudge in that direction. (It could easily be: Homosexuality was such a taboo that even homophobes couched their attacks in euphemisms that can be hard to decipher today.)

One college classmate of Warhol's judged the Loft show to be a work of genius, "because it was anti-art, the death-knell of abstract expressionism." But that opinion must have been born of affection."Oh, crumpled paper!" had been the response of Warhol's older artist friend Nathan Gluck. "God! Andy, do you think anybody will buy that?" As far as we can tell, they didn't. The only reason not to call the show one of the most resounding failures that Warhol ever suffered is that it clearly failed to sound much at all. "I know nobody even looked at this show," said a gallery mate.

The venue couldn't have helped. By the standards of that moment's art world, the brand-new Loft Gallery where Warhol was showing was "far out of the way, and arduously reached in its East 45th Street location"–very close in fact to where Warhol would open his Factory exactly one decade later, when he could better afford to stake out his own territory. In 1954, however, the wildly unfashionable east-midtown location, at the top of a five-story walkup (the *Times* made a joke about its "lofty" location) had been the best

and cheapest option open to a collective of ambitious beginners eager to make their mark in New York.

"A group of young artists—in search of a wall to hang their work on—has pooled its time and energy to open a new gallery covering the widest possible range of young contemporary painting," said the Loft's press release, fashionably designed without a single capital letter just like Warhol's own correspondence from this era. The Loft's seven founders were a motley crew with no shared approach, as the release acknowledged, or any particular connection other than the fact that several of them had gone to Carnegie Tech.

It's hard not to think that Warhol's stab at abstraction in the Loft's inaugural show came in reaction to the earlier dismissal of his fey, Capote-themed drawings at the Hugo. Once the folded sculptures hadn't done any better for him, however, Warhol seems to have gone back at once to a queer mode: Something like three weeks after the Loft's opening salvo it held an exhibition of just three of its members, and a magazine critic said that Warhol's contributions demonstrated a "willingness to obligate himself to that narrow horizon on which appear attractive and demanding young men involved in the business of being as much like Truman Capote or his heroes as possible"—a homophobe's code that clearly describes campy drawings of gorgeous young boys. The *Times* for its part described Warhol as an illustrator (that must have hurt) working in "a coy manner that might be that of a provincial imitator of Jean Cocteau," still more code for his gay style.

The following October, when Warhol at last had a Loft show to himself—he went so far as to plug it in *Interiors* magazine—he seems to have headed further in the same damn-the-torpedoes direction: The show's poster was of five pretty boys and its drawings and paintings were of a celebrity dancer and choreographer named John Butler, who Warhol had already known for a while by then. Butler had worked with Warhol's beloved Martha Graham and was especially known for bringing ballet to Warhol's cherished medium of television. The October of Warhol's solo at the Loft, Butler was the choreographer in a grand David O. Selznick production, shared between NBC and CBS, in honor of the seventy-fifth anniversary of Edison's light bulb.

"Oh, my God, John Butler!" was the reaction of one gay member of the Loft when the dancer, also gay, made a visit to the show and bought some of its works. Those that survive, including several that Butler once owned, are minimal line drawings that capture a few crucial features of the dancer's face—especially his famously huge eyebrows and boyish Tintin forelock—but rarely show him in action as a dancer. Although Warhol was a regular at the ballet, Butler's exotic beauty seems to have mattered more to him than his terpsichorean skills.

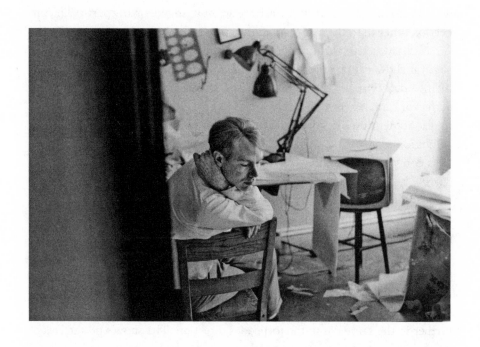

*. . . in the mess of his studio with his trusty TV.*

# 1955-1956

*"I thought that his art was just totally trivial and
beneath notice. It just looked hopelessly innocuous"*

"I've given up commercial art for painting," Warhol told Art Elias, his Tech
friend among the 12th Street Players. Given the three Loft shows he'd par-
ticipated in during the gallery's first year, that seems to reflect a true ambi-
tion that Warhol kept for the rest of his life. In 1955, the year the Loft shut
down, it was also wishful thinking. The famous book and exhibition called
*Modern Art in Advertising* had billed commercial work as a necessary, even
useful evil that could let serious artists get on with their "independent work,
free of economic care"; a friend said that was also Warhol's model.

By the middle of the 1950s, Warhol's career as an illustrator was explod-
ing. He had been discovered by *Graphis,* the top Swiss design magazine, and
also by a vast range of clients. They gave him contracts for every kind of
work, from greeting cards—including that one for MoMA—to pop-record
sleeves to book covers to illustrations for kids' storybooks to a poster for a
CBS radio show of "startling actuality recordings dealing with the causes
and prevention of traffic accidents." (Warhol drew . . . a traffic accident.) He
designed placemats for a department store café as well as actual yardgoods,
was in the first issue of *Sports Illustrated*—with an improbably macho draw-
ing of boxing gloves—and even did weather reports on morning TV, draw-
ing live cartoons to go with the forecaster's words, all the rage in those early
days of the infotainment industry. "He had to get up at 5 A.M. and go to the
studio and have his hand made up because otherwise it looked too white."

By the end of the decade, a blurb on Warhol was describing his "unique
talent" as much in business terms as in aesthetic ones: "He is able to create

with equal skill and imagination anything from an industrial advertisement to a fashion page to a window display."

Those store windows would have been Warhol's most promising assignments, at least in creative terms. "Display—the new medium of expression and livelihood for creative people—is the most lucrative, versatile and open field for anyone with artistic ability," wrote Lester Gaba, the dean of the discipline, in a book he published in 1952. (It gave several shoutouts to Warhol's former boss in display at Horne's.)

In the first half of the twentieth century, department stores weren't just efficient places to get some shopping done; they were elite institutions that responded to the nation's cultural aspirations. They were, for instance, perfectly respectable venues for art exhibitions: The head of the Metropolitan Museum once told a crowd of store heads that "you are the most fruitful source of art in America." Their streetfront windows could act almost as an extension of any official arts programming that went on inside. In 1952, Warhol's soon-to-be boss at Bonwit Teller filled some of its windows with a display of hats inspired by Cézanne.

"The less deliberate advertising a show window betrays, the surer is its advertising effect," said one introduction to the subject that Warhol owned. The window dresser "is always poised between business and art, between the direct and practical object of selling and the aspirations of the artist," said another survey of the field, getting at the tensions that powered Warhol's entire career.

New York's leading department stores changed their windows once a week—several news services would document what they came up with—and crowds of gawkers gathered to watch the brown paper come down to reveal the next batch of displays.

At their best, those could be stylish and even challenging: A designer could fill a window's background with a perfectly spaced grid of factory clocks for no other reason than because they looked impressively modern; or he could use figures made from bentwood chairs (those again) to make an impression on passersby. If it weren't for their retail settings, such installations could easily have passed for serious experiments in modern aesthetics. As a *Times* critic put it, "Since, when abstraction is intelligently employed, it is always decorative, no mystery attaches to the extensive use of abstract design by contemporary designers."

The best display departments didn't hesitate to borrow from the most radical movements in modern art: Surrealism, Gaba pointed out, became all the rage in store windows after the splash that Salvador Dalí had made, in 1939, with his window at the Bonwit Teller department store. In Pittsburgh, Outlines gallery had even held lectures for department store staff, including

one by Warhol's favorite teacher Balcomb Greene on "The Modern Move-
ment as Applied to Retailing"—given on April 8, 1947, not long before Warhol
started his job in display at Horne's. There had in fact been window displays
in MoMA's "Modern Art in Your Life" exhibition, which was making a splash
when Warhol first arrived in New York. "I thought department stores were
the new museums," Warhol observed in the early 1970s. He clearly said it to
shock the art-world bigwigs he was sitting with, since that view was well out
of fashion by then. But his faux-naïf pronouncement had once been the stuff
of sophisticates.

There was one other important attraction to the world of New York store
windows: As in Pittsburgh, it was a haven for gay men's self-expression. In 1950,
the male clique at Bonwit's, sometimes said to have already included Warhol,
went so far as to put photos of a man in drag in its windows, pretending to the
public that "she"—in fact a gorgeous boyfriend of the design director—was just
another high-class Swedish model selling perfume.

This was the world Warhol was entering in the summer of 1955, when
he got commissions for a series of windows at the elite Bonwit Teller depart-
ment store, where he'd been doing newspaper shoe ads for a year already. The
store's young design director, Gene Moore, was considered one of the best in
the country, and after being introduced to Warhol by a mutual friend, it looks
as though he decided to give the neophyte artist a tryout at a moment when
messing up might not matter too much. Every year for the week around
the Fourth of July, when so many shoppers left town, Bonwit's would take
the opportunity to repaint and renovate its sixteen main street-side vitrines,
whose infrastructure took a beating from their weekly remaking. Rather than
simply leaving the windows papered over while the renovating went on in the
space behind, Bonwit's would install boards across the front of the window,
with little niches set into them to display a few high-profit bottles of perfume.
Those were the modest windows that Warhol was commissioned to decorate
in July of '55. His solution was ingenious. He turned the boards into a sort of
scrappy front-yard fence—the kind you might read about in a Southern story by
Capote. He then "advertised" the perfumes on these boards in fake-graffiti that
imitated a school kid's scrawls but also echoed some of the scrappy, distressed
effects in the very latest fine art by Robert Rauschenberg, who had recently got
a rave review as the "enfant terrible of the New York School."

"BONWIT'S LOVES MISTIGRI" Warhol stenciled onto the boards of
a window featuring that perfume, using the kind of typeface you'd see in
a "POST NO BILLS" warning. Below it his imaginary kid went to work,
scribbling pictures of cats playing cards and signing the work "IMiLDA
AGE 3," an insider's nod to Warhol's close friend Imilda Vaughan. Warhol

had done background research: In French, a language Warhol had studied and always liked to play with, "Mistigri" is the word for both a cat and a card game, a fact that few Bonwit's customers could have known but that Warhol got right anyway, as his Tech teachers would have insisted. In a neighboring window Warhol's graffiti tells us that Bonwit's "loves" the perfume called Ma Griffe—this time "my claw," in French—and sure enough Warhol's fence is covered in goofy birds, this time signed by one "andy morningstar AGe 9."

"When I was little I was going to take [the name] 'Morningstar,' Andy Morningstar. I thought it was so beautiful. And I came so close to actually using it for my career," Warhol said three decades later.

A friend of Warhol's called the windows "very campy and very amusing." A trade publication was even more enthusiastic: "A STOPPER—THESE WINDOWS BRING OUT THE 'FENCE-SKETCHER' IN EVERYBODY" raved its caption, without crediting Warhol for the work even though he'd been allowed to sign his name on one of the windows—a privilege rarely given to window dressers at the time. The success of those windows earned Warhol more of the same assignments. One set of Bonwit's windows had him painting a fireplace right onto the plate glass, through which you glimpsed the "living room" décor inside the vitrine "and it was as if you were in the fireplace, looking through. They were great fun," said his boss in display at Bonwit's.

As an extra reward for providing all this "fun," the department store gave Warhol the honor of breaking out of a purely commercial context and showing his art, *as* art, in a window display, as artists did in stores across the city. In late January of '56, in a week where Warhol had decorated a whole suite of "fun" unsigned displays, another window, on a side street, featured three rather unassuming, barely visible pen sketches on its back wall; below, a handwritten scroll identified them as "drawings by Andy Warhol one of the young American artists who have worked with us on window displays." He was in good company. Something like once a year, in order to give the store "a reputation for being avant-garde, for having truly modern taste," the display director at Bonwit's would fill some of his windows with an exhibition of all the artists who had done displays for him that year, "their serious work." Both Jasper Johns and Robert Rauschenberg, "proto-Pop" artists who went on to greatness, were there beside Warhol in that winter of 1956—in the depths of retail's post-Christmas lull, that is, when the display space could most easily be spared for "art." The two were there again but without Warhol in January of '57, maybe because Warhol's wan drawings from the year before had failed to impress.

When Warhol showed his fine art at Bonwit's, there was an upside be-

yond prestige. The store paid something like $400 to use his pictures, which he then took back to sell if he could, and that was more money than he got for most of his strictly commercial work. The blue stars he painted for the cover of *Harper's Bazaar* brought in all of $75 and made him cede all rights to his image, while he got $100 from CBS for his "car crash" poster and $125 from Lord & Taylor's for his café placemats—and that was considered far more than most stores would have paid for the job. Warhol had a reputation for driving a hard bargain and also for endlessly complaining about his fee even once a bargain was struck. But the modest amounts Warhol was earning could add up to a good living, at least for someone with his talent for courting clients and churning out blots, although it was a precarious business, one that kept his mother up nights—and still saw Warhol borrowing from a cousin.

The spring of 1955 counts as a financial watershed in Warhol's career: After five years spent building his reputation as New York's go-to guy for footwear, Warhol attracted the attention of a new batch of executives at the venerable I. Miller shoe company, and they came calling with a deal. He would become the signature illustrator for a new ad blitz, across newspapers and store displays, and in exchange, they would guarantee to assign him a minimum $12,000 a year in work billable at his normal rates—nowhere near the $20,000 or even $50,000 cited in some Warhol biographies, but a healthy number anyway for that era. Warhol would have to work as hard as ever to earn his money—he was used to that—but his lifelong fear of not making rent would be allayed, at least for a while. Warhol shook hands on the deal and started churning out the advertisements that made his name.

Some of the I. Miller ads were actual pictures of ladies' shoes, although often more fanciful than descriptive. (Not always: When the copy described important new features Warhol put them in his image; when he got them wrong, an art director was happy to ask for changes.) Warhol's trademark stylization was to taffy-pull the footwear into an elegant teardrop, a shape he is supposed to have come to by mistake and then stuck with on a roommate's suggestion: "Why don't you just make it longer. Just exaggerate it!" But if those shoe images were described as "high-style," the I. Miller marketing department came up with other ads that were distinctly high-concept, sometimes impenetrably so. To go with copy that begins "there's no color like our no-color," Warhol was asked to draw a series of paint cans with a shoe or glove or purse floating in each one—presumably meant to portray a series of different colors of paint, but how are readers supposed to get that in a black-and-white ad, and how does that count as "no-color"? Or in an ad for

a shoe, purse, and stocking color called "shadow" ("paler and softer than our famous no-color") there are no shoes—or purses or stockings—to be seen. Instead we get bolts of cloth in a stack, with the almost invisible shadow of a well-shod woman cast onto their sides. Once the I. Miller campaign got so well established that readers went looking for its ads every week, it seems that the goal was as much to dare them to find the product as to sell them on its virtues.

Just before Warhol was hired, I. Miller had decided to take centralized control of the marketing for its fourteen quasi-independent stores, whose ads had been bouncing between different artists and techniques, but winning kudos regardless. "We needed a new concept of why we were in business," explained one executive at the time—and that concept turned out to be Andy Warhol.

On March 20, 1955, the company launched an unprecedented campaign for I. Miller, paying for big chunks of New York Times real estate—usually in the glitzy society section and sometimes full pages in the Sunday paper— where it could run Warhol's shoe illustrations. "In a sea of tiny little images, which were the pages of the Times, these bold, blockbuster fantasies were extraordinarily effective," an executive recalled decades later. "What the ads did was revitalize and revive the I. Miller brand, and from a dowdy, musty-fusty-dusty dowager establishment it became a stylish emporium for debutantes." What they did for Warhol, aside from bringing in cash, was to take his illustrations out of the ghetto of women's magazines and into the presence of the very widest of bourgeois publics, which was where he would stand for the rest of his life.

"Possibly, shoes are the most tedious of all merchandise to present in a style that is both distinctive and effective," said a big article on the campaign that appeared in far-off Germany. It's no wonder, then, that by the fall of 1955, after less than six months, the bosses at I. Miller were crowing about their success. In a feature in an American trade magazine, they said that the "idea art" that Warhol brought to the ads, although shocking to some in the business, was working to promote a sophisticated, even cutting-edge corporate image that would appeal to a woman's "good taste and to her emotions." The idea was that actual merchandise could be left out of an ad so long as enticing art took its place—selling the sizzle not the steak, according to an already venerable cliché, or in this case the step rather than the instep. "The artist, Andy Warhol, is allowed a certain amount of freedom. We believe that this contributes to the ad. We're trying to sell fashion in the most contemporary way that we can," said I. Miller art director Peter Palazzo. (Palazzo had met Warhol in his first months in New York, hiring him to work on a State De-

partment publication that went out in Russian to the U.S.S.R.) "The more realistic the picture," said an introduction to advertising at the time, "the broader is the appeal to the masses"—precisely the mass appeal that fancy I. Miller was not going for. Within a couple of years, Warhol and I. Miller had won a major award for a shoe ad that didn't even bother to feature any shoes.

But to begin with, at least, Warhol wasn't the inevitable man for the contract. Palazzo felt that there were "two or three dozen" other illustrators who might have done the trick. (In fact, the company's magazine ads went to someone else who worked in an ethereal style that also won praise.) The company had actually started its newspaper campaign with the top graphic artist Bob Gill, who at that early moment was still working in a bold, woodcut manner that was close to Warhol's blottings. It was only when Gill moved on that Palazzo turned to Warhol, "an unknown freelance illustrator" who had the good luck to be already familiar with shoes from his work for women's magazines. It could be that I. Miller executives offered Warhol his $12,000 deal less out of appreciation for his unique skills than because they wanted to be sure not to lose him, the way they'd lost Gill. It couldn't have hurt that Warhol, always a virtuoso schmoozer, had presented them with an entire portfolio of hand-tinted *Shoe Perdu* drawings.

But when Palazzo billed Warhol's illustrations as standard, replaceable fare, he was only thinking in terms of the style they were drawn in. What Warhol added to his era's standard Shahn look was a very special aura of camp that he alone, as Serendipity's house artist, had expertise in.

Warhol's campy I. Miller images had an especially good fit with what female viewers were going through in that postwar moment. After almost half a decade spent working in wartime factories, women were suddenly supposed to return to ladylike Victorian manners while also boldly climbing *Glamour*'s new Ladders of Success. The camp imagery they witnessed in Warhol's ads, drawn for women by an effeminate man, reflected the pressures being put on gender at that moment. When I. Miller said that Warhol's ads were helping it sell fashion in the latest way, the company may have understood, at least intuitively, that camp had to be part of the mix. As the scholar Richard Meyer has put it, "Even as Warhol summons the visual codes of the old-fashioned and the outmoded, however, he does so in order to hawk the new and the now."

Warhol's skills as a camp-er also had an almost practical aspect for I. Miller. At that particular moment, one of the company's star shoe designers had them making knockoffs of Edwardian styles—one ad referred to "the original second-decade shoe . . . very much in step with 1956 fashion." No one could have been better placed than Warhol to match that look in his

drawings. Serendipity had given him deep roots in Edwardiana. In fact, his archives are full of vintage shoe ads that he'd borrowed (permanently) from the New York Public Library to use as sources for his imagery. Some of what we've now come to think of as the signature stylizations of Warhol's shoe ads—those absurdly long uppers and compact heels—is really him being relatively faithful to the peculiarly stylized merchandise his client was manufacturing at that moment.

When Warhol showed up at one literary party in the later 1950s, an avant-garde poet who had no part in the fashion world—who had never even heard of Serendipity—already knew about Warhol from the I. Miller campaign, "so startling, so original, so almost-sneering at the high-fashion illustrations in the other ads," as the poet remembered. This gets at something that mattered throughout Warhol's career: No matter how sold out his work could seem to some—it might look like he was shilling for canned soup or Hollywood or rich portrait sitters—there was always a little edge of distance, even of critique, that kept it feeling fresher than the competition.

The year that followed Warhol's I. Miller deal must have felt like his annus mirabilis. He finally had a guaranteed floor to his income and the capacity to reach a high ceiling: Despite all the work coming in from the shoe company, Warhol didn't stop fulfilling a vast number of other contracts. He could even afford to take on assistants. At first it was Vito Giallo, who lived down the street and knew Warhol from the Loft Gallery and their work for big pharma. Giallo said that his single task was to take over Warhol's blotting, with only one blot to be done per drawing—contradicting the art-historical cliché that the blots foreshadow the quasi-industrial strategy Warhol came to with his Pop Art, reproducing the same image again and again from a single printing screen. In fact, his blots were successful because they mimicked an expressive, one-off, handmade line; when other illustrators tried to figure out how Warhol managed his look, they always imagined some kind of trick of the pen.

Giallo worked as an assistant for only a bit, and only off and on, before he got replaced by Warhol's early-1950s friend Nathan Gluck, who remained in the studio for a decade. Gluck was an impressive hire, closer to being a colleague of his new boss than his junior: Both men, for instance, had been chosen to do almost yearly Christmas cards for MoMA, alongside such notables as Joseph Cornell, Henri Matisse, Pablo Picasso and Ben Shahn. At first, Gluck might have even counted as more prominent than Warhol. He was exactly ten years older, had served in the Pacific, was erudite and an

opera fanatic and came with a notable cultural pedigree: He had dined with the eminent designer Paul Rand and also with Marcel Duchamp well before Warhol could boast of the same, and was known among the city's dealers in modernist prints and books. He'd even had a poster selected for the actual MoMA collection, where Warhol wouldn't manage to place his work for another decade. In Warhol's place on Lexington Avenue, Gluck became the general factotum. While the boss was out hunting for new contracts, Gluck took care of the day-to-day, from drawing the stream of shoes and jewelry that poured into the studio to blotting each of those drawings once Warhol had approved or tweaked it. "When I was helping him, I would recast myself and try to do things à la Andy," he said, although Warhol still had to simplify Gluck drawings that came out too fine and detailed.

Gluck eventually took responsibility for adding text that faked Julia Warhola's handwriting, after she'd become too weak to do the writing herself, and he once had to draw a Warhol-ish pin-the-tail-on-the-donkey when his boss needed one for a little girl's birthday party.

In the 1960s and '70s, as his art veered toward the conceptual, Warhol played with the notion that he was the head of a corporate enterprise that turned out objects that were branded "Warhol" but that could in fact have been produced by any minion. In the 1950s, that was already the hidden reality behind his production.

Warhol's new "studio system" paid off: After a few lean years in the race for awards, the spring of '56 brought him a new flood of professional recognition. The Art Directors Club included four of his images in its annual exhibition and book and gave awards to two of them: a book cover and, at last, a shoe.

The book cover, campy and vaguely louche, was for a well-reviewed volume of light verse by the gay author William Plomer, put out by the elite publishers at the new Noonday Press. A critic emphasized that the book's poems were based on news stories—"the kind one can scissor out of any evening paper in New York or London"—which means that they foreshadow the hand-drawn copies of newspaper pages that Warhol was about to begin making as he worked his way up to Pop Art.

The award-winning shoe ad, which the A.D.C. declared of "Distinctive Merit," was one of the new ones for I. Miller. Even before the ad won its prize, *Mademoiselle*'s editors were writing about how Warhol was so much in demand that he had to turn down jobs, since he was "a name in fashion illustration" whose "drawings for I. Miller are currently creating a stir." The following year, after Warhol had won even more A.D.C. awards, a fashion columnist described him as "I. Miller's da Vinci of shoes." The sculptor Claes Oldenburg, later Warhol's colleague in Pop, remembered arriving in town

around that moment and being taken to meet Warhol as though he were already a budding luminary.

Warhol's talent in footwear brought him attention at the very top of the art-world food chain—or that was how he himself may have (mis-)read the situation. That spring of 1956, not long before winning his first A.D.C. award for I. Miller, a big shoe drawing of his got included in a show called "Recent Drawings U.S.A." at no less a venue than the Museum of Modern Art. The *Times* even mentioned him as one of the show's more notable new talents (in a list that included twenty others). But the exhibition was patently a B-grade affair, with little connection to the museum's prestigious curators. It was put together instead by volunteers from MoMA's Junior Council, a new group of young donors-in-training who were meant to "extend the Museum's services to Members and to the community." The drawings show was part of that community "extension" and involved an open invitation to any American who wanted to enter.

Warhol had actually submitted three works of which only the shoe made it in, maybe because his drawings were up against more than five thousand other submissions, sent in by a few known names but also by a taxi driver, a mimeograph operator, a bricklayer and an X-ray technician. One artist who was well known at the time actually withdrew when he heard that the exhibition was "a jury thing," because that counted as a low rung on the ladder of art-world events. Rather than giving the show a proper review, as it did for almost all exhibitions, the *Times* wrote it up in a newsy art column.

Works were for sale, mostly for under $100—less than Warhol got for some of his commercial blots.

We know that Warhol's shoe drawing didn't sell, because later in the year he tried to donate it to the museum—which, after serious consideration, chose to decline the offer. Warhol got back a famous letter signed by no less a figure than Alfred Barr, MoMA's founding director, politely rejecting the drawing "since we feel it is not fair to accept as a gift a work which may be shown only infrequently." This is often billed as one of those comic cases where the establishment was blind to brave new talent, and it's true that MoMA was slow to catch on to Warhol's greatness in the 1960s and beyond. But back in 1956, it was Warhol who had got things wrong by imagining that a successful commercial illustration could sidle sideways, unchanged, into the realm of fine art—his notion of doing "one for the client and one for himself." Even the Bauhaus had only imagined the two categories collapsing if and when commercial imagery took on the lessons and look of "advanced" modern art. That was something Warhol's drawings conspicuously failed to do, at least by the standards of 1950s New York. In MoMA's juried drawings

show, most works, including a bunch that the museum did in fact buy or accept as gifts, were angular and angstful and evidently "serious," none of which could be said of Warhol's shoe.

The art world had certainly sent strong signals already that Warhol was doing something wrong. His Hugo and Loft shows had been critical failures, to the extent that they were noticed at all, and he'd been rebuffed more than once by the Tanager. He was getting "constant rejections" from other galleries as well.

The best Warhol could do was a series of shows at the new Bodley Gallery and Bookshop that had settled in around the corner from Serendipity in early 1955. It was run by David Mann, who had been involved with Warhol's Capote show at the Hugo, but it seems to have been known as a "decorators'" space. The venue had so little presence on the scene that one gallery-going friend of Warhol's managed to remain totally unaware of his Bodley exhibitions.

The art world's paper of record often put the Bodley's shows last—because least—in its gallery roundups. The little writing the *Times* did devote to the gallery, however, hints at something interesting: Its roster seems to have had an almost openly gay slant. An early solo by an artist who went on to show with Warhol at the Loft Gallery was described as "devious and personal" and "in the tradition of Demuth," while a decade later the gallery put up "tender and observant slightly obsessive paintings of adolescent body-builders." Another Bodley artist was the celebrated fop Stephen Tennant, whose art reminded the *Times* of the writings of gay author Ronald Firbank—Warhol had done that Firbank book cover back in 1951—and of a world of "dangerous joys and banished pleasures on the streets near the waterfront of Marseilles."

Warhol's first Bodley show, in 1956, fit perfectly into that context. Its two-week run began on Valentine's Day and the exhibition had the forthright title *Studies for a Boy Book.* We don't know if the "book" part was accurate; there's no sign that Warhol ever intended to publish the show's drawings. The "boy" part certainly was: The drawings were of Warhol's "beauties"—or maybe just one of them—at least sometimes shown nude, but with hearts on the pubic hair and nipples. The two-sentence review in one newspaper said the images were "in doubtful taste" while another two sentences in the *Times* described the drawings as "sly" and full of "private meaning"—as close as a family paper could get to acknowledging homoeroticism. Then the *Times* critic twisted the knife: "[They] might have been done by Jean Cocteau on an off day"—a perceptive slight, given that they were in fact directly inspired by illustrations that Cocteau had done in 1947 for Jean Genet's *Querelle de Brest,* a shockingly explicit French novel that a friend had shown to

Warhol. But, typically, where Cocteau's images of gay desire were explicit and raunchy, even scatological, Warhol's "had a cheeriness that made you bubble with simple laughter," remembered a friend. Even later, with his infamous film called *Blow Job,* Warhol preferred coyness to the explicit. We never actually see the act promised in the movie's title.

We have certain knowledge of only one of the drawings that Warhol showed at the Bodley, but piles of likely candidates survive which, even when they show men in full-frontal nudity, mostly seem sweet and well mannered. As it glides and pirouettes across the paper, Warhol's ballpoint refuses to recognize the difference between a penis and the daisy or pear that he lays down beside it.

"Andy had this great passion for drawing people's cocks and he had pads and pads and pads of drawings of people's lower regions," said his friend and assistant Nathan Gluck. "They're drawings of the penis, the balls and everything, and there'd be a little heart on them or tied with a little ribbon. . . . Every time he got to know somebody, even as a friend sometimes, he'd say, 'Let me draw your cock' . . . They'd drop their pants, and Andy would make a drawing. That was it. And then he'd say, 'Thank you.'" As one boyfriend recalled, "It's amazing how many people were perfectly happy to disrobe and pose for him. It was his personality—it never seemed demeaning, or obscene." Warhol had begged one new acquaintance to reveal his "big meat" so he could draw it, "and before I knew it—we were all very young and silly—I was sitting with my pants down, with a daffodil wound around my dick. That was my first meeting with Andy."

But if the Bodley's boy drawings captured this lighthearted side to Warhol's gay life, that could count against his work: An art critic who met Warhol around this time found him to be an unusual and very appealing character, but judged his illustrator's art to be "just totally trivial and beneath notice . . . hopelessly innocuous." The friend who described the *Boy Book* drawings as cheery said that "you walked away thinking that they were not original, and some of my friends considered him second or third rate." In a 1950s art world that was looking for innovations in how pictures *looked,* it wasn't easy to recognize originality that lay mostly in their *content*—especially when that content was all about camp's carefree gender play, subtly resisting the mainstream. As one theorist of the style put it, "To be camp is to present oneself as being committed to the marginal with a commitment greater than the marginal merits"—which means that marginal tastes were being used to stand for, and secretly celebrate, gay life's place on society's margins. That, of course, made the whole style seem . . . marginal. Even Susan Sontag read camp as delightfully empty surface style that completely blocked out any interest in deeper substance. When

Warhol eventually went fully to bat for content with his style-free Campbell's Soup paintings, he was careful to keep camp more buried than he had before. It became a motive force rather than a series of surface clichés.

It looks as though Warhol registered the resistance to his first Bodley show, since the others he did there kept sex in the background. For Christmas of '56, in the gift-y holiday slot that Warhol often got stuck with, he went to his safe place: shoes. (See color insert.) "The Golden Slipper Show or Shoes Shoe in America" was filled with drawings done in Warhol's I. Miller mode but camped up with golden paint and metallic trimmings. Thinking back on the verve that Ralph Pomeroy's words had added to similar drawings in *A la Recherche du Shoe Perdu,* Warhol came up with a new conceit, associating each of the Bodley images with a different celebrity. He dedicated a golden slipper to the twenty-one-year-old Julie Andrews, who was just then making her first splash in *My Fair Lady,* where she sang and danced in campy Edwardian costumes designed by Warhol's new pal Cecil Beaton, the British style maven and photographer. (Warhol begged a mutual friend to get Andrews to visit the show; she did, but didn't buy her shoe because Warhol's mother had written the star's name as "Julia" on the drawing.) Elvis Presley, also twenty-one and a new-minted star, got gilded cavalier's boots. The most quietly radical of the shoes may have been the one dedicated to Christine Jorgensen, celebrated as America's first transsexual. She was a childhood neighbor of Candy Darling, the transgendered superstar who became a friend of Warhol's a decade after the Bodley show. Since college days, and for the rest of his life, drag had pull on Warhol's self-expression.

Another gender-bending image in the shoe show was dedicated to Truman Capote, who got assigned a lady's mule filled with the South's wilted blooms. (It was also a reference to Capote's musical *House of Flowers;* Warhol had drawn its dancer, Geoffrey Holder.) A friend of Capote's bought the shoe drawing for him, explaining that Warhol was "becoming very well known. Very on-coming." Capote was surprised: "As far as I knew he was a window decorator. . . . Let's say a window-decorator type."

Coverage in the *Times* could have been read as both very positive and strangely ambivalent: "Criticism holds itself in suspense, at the Bodley Gallery, when dealing with Andy Warhol's dandified pictures of shoes, which threaten to become the most entertaining images on the contemporary scene"—the critical suspension clearly coming from the fact that the illustrator's images, however "entertaining" on the "scene," aren't quite the stuff of art criticism.

That might have also been the message Warhol took home from some wildly impressive coverage that his drawings got soon after the show closed, in no less a venue than *Life* magazine, where Warhol wouldn't appear again for another seven years. He could only have been thrilled by the vast play he

was given, with six giant images splashed across a double-page color spread. I. Miller bought a big space in the *Times* to boast about *Life's* coverage of "our own shoe artist," and announced that the *Life* pictures were on display in the window of the company's flagship Fifth Avenue store. On the other hand, Warhol's feature in *Life* was part of a standing series, called Speaking of Pictures, that was more likely to show photos of a ballerina crammed into a phone booth than any timeless works of fine art. The tiny text that went with Warhol's shoes might have disappointed still further: It billed Warhol as a "commercial artist" who made his Bodley work as a hobby, and says the shoes have "candy-box decorations."

No doubt on the basis of the *Life* coverage, an acquaintance of Warhol's from Aspen toured some kind of show of Bodley and Serendipity pictures out West, but only managed to sell one, a goofy *Happy Bug Day* image, to the wife of the illustrious patron Walter Paepcke, head of the Container Corporation of America, known for getting his company's advertising done by famous fine artists—including Warhol, but only once he was a famous master of Pop. Otherwise, the Western "tour" of Warhol's art ended ignominiously, with his pictures rented out for display in fancy shoe stores in Denver and Cincinnati. The Bodley show didn't do any better: Its only sales were to friends begged into buying by Warhol.

Warhol's next show at the Bodley came the following year, at Christmas again, among what the *Times* called "exhibitions designed to attract the shopper." But it seemed to be pushing back against a context in commercial art: There was hardly a product—or a gag—in sight. As with Warhol's first Bodley outing, he was showing pictures for a book, although this time it was one he actually went on to have printed, in something like five hundred copies. And he stayed with the gold that had worked for his shoes, deciding to draw (and later print) directly onto gilded paper.

But unlike his gilded shoes, the subjects in Warhol's *A Gold Book* now had a sobriety and lyrical bent that were meant to flag their more serious artistic ambitions. Warhol provided drawings based on socially conscious photojournalism—including a begging child in China—while he kept males and females in some kind of balance and limited his erotica to a male rear end that could have come from any life-drawing class.

All this new sobriety doesn't seem to have helped the show's reception. The *Times* couldn't even spot the transformation, judging the new work "frankly artificial, decorative and luxurious, and none the worse for that"— praise so faint it reads as damning.

By the time of Warhol's final Bodley exhibition, at Christmas of 1959 and after a gap of two years, it feels as though he's given up on producing "seri-

ous" art, at least for shows in that venue. The last of them was called *Wild Raspberries* (as was the book that came out of it), and that was a play on *Wild Strawberries,* the title of Ingmar Bergman's dour filmic masterpiece. With the help of Suzie Frankfurt, a girlfriend from Serendipity, Warhol had come up with "a funny cookbook for people who don't cook," full of gag recipes for such dishes as "A&P Surprise" and "Chocolate Balls à la Chambord" ("to be served with no-cal ginger ale . . . to very thin people"). But even Warhol's own collaborator could only sum up the piece as "dippy" and "a joke, perfect for Christmas presents," while a mention in the serious magazine *Arts* couldn't see it as more than "delightfully graphic horseplay." The exhibition did manage to win Warhol his very first headline in the *Times*—but on a food page, alongside such stories as "Price of Pepper Due to Rise Here" and "Fruitcake Kept Fresh in Foil." When the paper's actual art critic weighed in, he famously described the Bodley show as "clever frivolity in excelsis"; less famous is the fact that that's *all* the critic said about it, in a one-sentence mention that also made room for another artist who was sharing the Bodley's Christmas slot.

Warhol's Bodley exhibitions never won him more than glancing attention, even though his desperate changes in direction—from erotica to shoes to sober gilding to dippy cookery—look like an attempt to hit on a recipe for success. And those exhibitions were certainly not a profit center, any more than the Serendipity shows ever were. The Bodley's owner admitted that sales of the actual artworks were minimal, and Warhol once had to pay to have twenty-five unsold pictures shipped back from the gallery to his place above the Pin-Up Room, while another time the movers were paid to haul twenty more. The chapbooks didn't do that much better. "I went around with shopping bags full of books and tried to sell them, and nobody wanted them, and nobody was interested in them at the time," said Warhol's coauthor on the *Wild Raspberries* volume. When the gallery did sell twenty-four copies of that pseudocookbook it sent Warhol only $300, from a show where he'd already had to pay almost $100 for ads, postage, glasses, "butler" and ice, not to mention the money that he spent on the opening's drinks. His mother seethed at champagne costs of "$5,000," with no sales to offset them. (Although surviving bills for the bubbly come to more like $100.)

The Bodley shows were clearly self-funded vanity projects, of a sort, but you wonder how much they could have boosted Warhol's ego. They might have worked better as a loss leader for his commercial work: The Bodley's director managed to get Warhol several commissions based on images in his exhibitions.

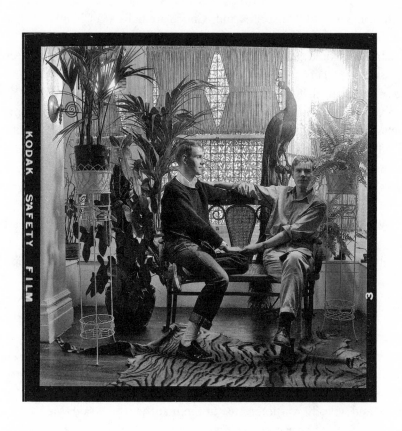

. . . *with his friend Ted Carey in the fancy décor his illustrations paid for.*

# 1956-1959

GENEROSITY | CHARLES LISANBY | THE WORLD TOUR |
COMPULSIVE SHOPPING | EDWARD WALLOWITCH | RAY
JOHNSON | THE FOOT BOOK | A SILVER DÉCOR FOR THE
THEATER | 1,000 NAMES AND WHERE TO DROP THEM

*"Andy was just like a feather floating through,
a feather that really weighed 5,000 tons"*

Warhol's commercial career might have been taking off by the mid-1950s, but
that success doesn't seem to have gone to his head. Again and again, people
who knew him in that era described him in the most positive terms. "He al-
ways seemed so nice and uncomplicated," remembered his boss at Bonwit's.
"A very sweet, reverberating personality. A sweeter than sweet person" is
how one Greenwich Village type remembered the 1950s Warhol, while a
gallery mate called him "always generous and loyal. . . . God, I thought, can
anybody be as sweet as this guy?" She also remembered him taking women
seriously as artists, something "not normal for males of his time." Philippe
Jullian, the French connoisseur and historian of camp, told Warhol he was
"the most charming of all the people I met in New York, like a dear sister
found after many years."

The "bunny" from Carnegie Tech was still a long way from turning into
Drella, the vampiric eccentric who became famous at the Factory.

There were certainly people who found Warhol's sweetness saccharine.
He would turn somersaults to gain a client, and the pains he went to in curry-
ing favor and attracting attention could seem transparent and cringeworthy.
As one colleague put it, "I knew there was a little computer brain in there
going ninety miles an hour," while another described Warhol as "just like a
feather floating through—a feather that really weighed 5,000 tons." Assum-
ing that the piles of thank-you notes that survive are a small part of the total,
there couldn't have been an art director in New York who didn't receive flow-

ers or a butterfly print from Warhol. If you were someone who could really boost his career, you'd rate his latest chapbook or a bottle of champagne or maybe liqueur. The *New York Times* critic Stuart Preston, who often wrote about Warhol, accepted piles of drawings and prints from him, a conflict of interest that Preston somehow got away with.

The gift giving worked. Clients seemed universally charmed by their presents, not worried about ulterior motives. Maybe they could feel that Warhol's toadying came mixed with real generosity and graciousness. Some people sensed that side of him—had concrete examples of it, in fact—until the end of his days, even as others were describing him as a freak or a monster.

Warhol's altruism may have revealed itself most clearly some time in April 1956, when his dear old Tech friend Imilda Vaughan, despite being gay, gave him the news that she was pregnant "out of wedlock," as they said in those days. Warhol, now doing well, could have paid for an abortion or offered help with a diaper service, but he came up with a much grander plan than that. He was in the process of planning an extravagant around-the-world vacation in celebration of his newfound wealth. Why didn't Imilda join him for the trip, and when they came back he'd declare that he was the baby's father? Of course she refused his goofy, impractical offer, just the first of several lackadaisical efforts Warhol would make to acquire a kid: Two decades later, when Warhol was asked what was still left for him to do, he answered, "Have a baby." But the proposal's absurdity doesn't make it any less admirable. Especially because the *other* traveling companion he'd had in mind for the trip, and who Vaughan would have displaced, was one of the dishier catches in Warhol's crowd.

According to Charles Lisanby, he and Warhol had first met a couple of years earlier, at a party given by a CBS set designer who held a regular salon at his loft on Seventh Avenue where Warhol was known to draw the guests, no doubt as an alternative to small talk. "He always looked, and I'm sure felt, so awkward at parties. He didn't know how to join and have fun and meet people. He had no social graces," said Lisanby, who had been raised into such graciousness. Warhol couldn't have been immune to the gorgeous and classy Lisanby, a tall, dark youth from a horsy Southern family. A friend from camp circles in New York said that he imagined painting a portrait of Lisanby "under a white portico surrounded by slender slaves and peacocks."

That first evening that he met Warhol, Lisanby said, he'd made the first approach, "to a strange little guy who sat in the corner all evening long." They talked about art and Lisanby recognized his new friend's name—not yet a famous one but familiar to Lisanby because they moved and worked in similar circles.

"I had to leave early and Andy said he was leaving also," Lisanby remembered. "Down on the street it had started to rain, and we were standing under the awning of a taxidermy shop. In the window was a stuffed peacock on a pedestal. I told him I grew up on a farm in Kentucky with a flock of pet peacocks. We shared a cab and Andy dropped me off. As the cab pulled away I realized I didn't know his phone number . . . but after I came home from work next day, there was this stuffed peacock waiting in front of my apartment. That's how we got to know each other."

Lisanby was four years older than Warhol and a bit further into his career by the time they met: He had lucked into work as a production designer for the barely budding world of television, where Warhol had also been dipping a toe. (Lisanby went on to be a major player in TV set design.)

For the next few years, Lisanby and Warhol kept up a relationship that hovered between a friendship, a flirtation and a love affair—probably depending on which of the two you'd have asked to describe it. Lisanby's version was that they were "best friends for many, many years," and it does look as though they had only rarely been physical. "I don't think [Warhol] wanted to have sex," recalled Lisanby. "He said he thought sex was 'messy.' That was his word, it was too 'messy and distasteful.' He told me he'd had sex a few times, he had tried it and didn't really like it." It could be, however, that Warhol's statement to Lisanby was all about putting a good face on his failure to score with his gorgeous friend, since there's plenty of evidence that Warhol did enjoy all kinds of erotic contact in those early years and over the course of his life. Lisanby emphasized that when it came to sexual function, his friend was "normal in all respects"—implying some kind of direct knowledge of the matter. One friend from the 1950s quoted Warhol saying, "Oh, my bum is so sore tonight because I met this number, and he screwed the ass off me." That friend didn't believe Warhol; he had bought into a common image of him as asexual that may not hold water.

Within a few years Warhol was having surgery for anal warts and a tear and a decade later he was taking penicillin for a venereal disease. Taylor Mead, one of Warhol's closest gay collaborators throughout the 1960s, once claimed that his friend "blows like crazy—or wherever he can get it." Several other friends from the Pop era either witnessed Warhol having sex or heard him bragging about it. Back around the time Warhol was courting Lisanby, he got annoyed with his former assistant Vito Giallo for not joining him for the Wednesday night "sex lessons" the artist was getting from a friend and her sailor lover. (Warhol later said he'd had sex with women.) "It was too strange for me," said Giallo, a gay man who was hardly straitlaced.

The persistent myth that Warhol didn't like sex or have sex may involve

some remaining homophobia in our culture: If we've finally come to accept that one of our artistic icons was gay, we still prefer not to picture him caught in the act with men. Given the homophobic world Warhol grew up in, he also liked to discourage any thoughts of himself taking pleasure in bed.

———

Having failed to turn Lisanby into a lover, Warhol added him to his list of phone confidants. The two shared four or five calls even on days when they were due to dine together, at hangouts such as Serendipity and Café Nicholson. They also had regular Sunday drawing dates that they called "sketch class." Lisanby's "great hero" was Norman Rockwell, and his traditional if stodgy skills as a draughtsman would have impressed or at least intrigued Warhol. Meeting at Lisanby's flat, they drew friends or flowers or the objets d'art scattered across the décor, including a statuette of a rooster—a "cock," obviously—that the two men once sketched at the same time.

Early in their friendship, Warhol had taken audacious if unsuccessful steps to win Lisanby over, sprinkling the initials "C. L." into ads for I. Miller and even painting a flurry of them onto a window for Bonwit Teller. He covered a sheet of paper in fifty-two hearts—one for each week of the year—and inscribed it "C. L." as well. By February 1956, Warhol had given Lisanby a starring role in the *Boy Book* show at the Bodley. It's no wonder that within a few months, around the time that his earlier boyfriend Carlton Willers was admitting to his new marriage, Warhol was planning on taking that world tour with Lisanby. They couldn't have been more in tune with the zeitgeist: A few months after their return, the movie *Around the World in 80 Days,* filmed in many of the same exotic locales they visited, cleaned up at the box office and won all sorts of Oscars.

By the middle of May, Warhol had gotten himself a learner's permit and was paying for driving lessons for both himself and Lisanby, although during one of them he smashed into a taxi on Park Avenue and gave up on being a driver, for good. "My mind wanders too much to drive," he said. "I've always wondered how people could drive cars. I can never remember what to do."

Warhol also got his first passport, which listed him as a blond. That must have been his wig color that day; he wore a dark hairpiece during the trip. One month later, with his mother and the remaining cats safely stashed away with Warhol's eldest brother in Pittsburgh, the two friends took to the air, tourist class, on a mad dash around the globe that looks like one of those if-it's-Tuesday-this-must-be-Belgium affairs. The travel agent's flight itinerary takes a full three pages, and seven weeks, to wend its way from New York to Amsterdam by way of airports in San Francisco, Honolulu, Tokyo,

Djakarta, Bangkok, Calcutta, Rome and another eighteen cities, plus all the midtrip destinations that the friends reached by car, train or boat. This being the moment just before the Jet Age, the propeller-powered trip from Hawaii to Japan, then one of the longest flights in the world, lasted something like eighteen hours.

The tour got off to a rocky start, according to Lisanby. On the first of their two days in Honolulu, while Warhol rested in their room Lisanby went out to the beach to cruise. He met up with a charming young hustler who came back with him to the hotel for them to take some "pictures." When the two showed up at the room, Warhol went berserk: "How dare you bring someone back here?" he's supposed to have screamed, attacking his best friend with both fists.

Lisanby backed off and returned that evening to deal with Warhol:

> He really did totally break down crying and then it got worse and he couldn't stop. He really couldn't stop sobbing hysterically and crying on the bed. . . . He said, in a soft, trembling voice, "I love you." I said, "Andy, I know, and I love you too." And he said, "It's not the same thing." And I said, "I know it's not the same thing, you just have to understand that, but I do love you."

Warhol may never have had a vast amount of luck with romance—how many gay men of that era did?—but people who were close to him felt that even under his coolest, most plastic Pop surface he always remained a heartfelt romantic. Like so many of us, he was deeply invested in finding some kind of soul mate and was confused and miserable whenever his search went awry, as it often did. "My heart's been broken several times," Warhol said a few years before his death, after the last of his many breakups with lovers. But he was also a tough survivor. In recollecting the Lisanby trip, Warhol is supposed to have said that "sometimes people let the same problems make them miserable for years when they should just say so what. That's one of my favorite things to say. So what. My mother didn't love me. So what. My husband won't ball me. So what."

By the morning after their fight the so-what-ing Warhol was gamboling with his friend on the beach, Lisanby looking studly in a tiny swimsuit while Warhol, as always, was in pants and long sleeves.

The rest of the trip went perfectly well. Surprisingly, Warhol turned out to be as intrepid a traveler as Lisanby. They encountered bizarre foods, cobra hunters in loincloths and a death-defying drive over a bridge of split tree trunks, and even when Lisanby was losing it Warhol kept cool and enjoyed

the ride. A steely heart always lay beneath his milquetoast surface. Or at the very least his passivity could help him keep his cool: "Sometimes, he didn't know quite where he was. He just went along, day to day," remembered Lisanby.

The trip's most important moments, for Warhol, might have been artistic. He and Lisanby visited all the famous Asian sites, like the ruins at Angkor Wat and temples in Japan and Bali, which must have reminded Warhol of working on Tech's Bali-themed Beaux Arts Ball a decade earlier. Warhol sketched all these scenes like mad, or photographed them or sometimes maybe drew them from photographs. Surviving shots show that Warhol had a fine eye for classic compositions; later, when he went for a more casual, snapshot look in his photos, that was clearly by choice not from lack of skill.

Lisanby got deathly ill in Calcutta, so the friends changed their plans and fled to Europe for the last two weeks of their trip. The invalid wanted to recuperate in comfort at the home of his "friend the contessa" who ran a *pensione* at the foot of the Spanish Steps in Rome. Warhol profited from his companion's illness. In that final fortnight, instead of touring Nepal as planned he got to visit all kinds of European monuments and museums—the Baths of Caracalla in Rome, the Baptistery in Florence, the Rijksmuseum in Amsterdam—getting his first in-the-flesh taste of some of the masterpieces he would have to measure himself against as an artist. This must have been one of the triggers for the more serious and cultured tone that he adopted for that 1957 *Gold Book*. It echoed the glinting backgrounds of the Florentine mosaics, which Warhol had paid a few cents to see floodlit. (He kept the receipt.) From the start Warhol had billed the trip as a hunt for "new art ideas" and it looks as though he found some. Almost two years later, he was still talking about the "beautiful pictures" he was planning to paint based on his memories of the Orient.

There are stories about Warhol being depressed and anxious after the trip, and angry at Lisanby for the Hawaii incident, but there was clearly enough affection left for them to work and play together. Their most important collaboration involved an original, extended text that Lisanby wrote for "25 Cats Named Sam," which he had imagined seeing written out in full by Julia Warhola and illustrated by her son. When the book actually came out, however, all that remained of Lisanby's literary labors was the title, complete with a new misspelling by Warhola (she'd dropped the "d" on "named") and the subtitle "And One Blue Pussy"; Warhol had completely excised the text of Lisanby's original story and reduced the cat count to twenty. That decision makes good artistic sense: Having a tally of cats that doesn't match the title is more striking, and worthily Warholian, than dutifully presenting twenty-

six drawings of cats to go with a tale about twenty-six of the creatures—
including the "blue pussy"—as the more hidebound Lisanby might have
done. Being a well-trained modernist, Warhol always preferred breakdown
to perfection and that was one of the secrets to his lifelong genius: "If a job
didn't come out right, Andy, maybe, even liked it better. . . . Sometimes he felt
that it added different dimensions to something," said the printer of Warhol's
cat book. But there was also a practical dimension to the culling of the book's
animals: According to Lisanby, Warhol didn't want to spend the money on
the extra paper—apparently a full printer's sheet of six uncut pages—that it
would have taken to fit all twenty-six of the original story's felines. While
Warhol the Pop artist became famous for being cheap, this is one of just a few
examples of his penny-pinching from the 1950s—even though, by the time of
*25 Cats,* he was doing better than he ever could have imagined.

———

*Good Housekeeping.*
*Harper's Bazaar.*
*House and Home.*
McCann Erickson.
George Nelson.
The *New York Times.*
Ogilvy, Benson & Mather.
*Redbook.*
Tiffany's.

That's just a small sampling—a *very* small sampling—of the clients who
appear on a list of billings Warhol drew up in the fall of 1956, all on top of
his standing order from I. Miller. A number of agents were bringing him
clients and it looks like he could bring in about $3,000 in a good month,
worth maybe ten times that in twenty-first-century dollars and a pretty fine
income for a young man whose entire career was barely more than five years
old. It was as much as the preeminent artist-illustrators Ben Shahn and Saul
Steinberg were making and more than was considered proper even as the
salary of a department store president. Before long Warhol had got himself
an accountant, turned himself into a company called Andy Warhol Enter-
prises (directors: Andy and Julia Warhol) and set out to spend his newfound
wealth.

The world tour itself had marked the beginning of Warhol's free-
spending ways, since the airfare alone cost almost $1,700, or something like

eighteen months' rent. While abroad, he played shopaholic. The flood of purchases that got shipped home included, from Japan, a folding screen and porcelains. From Thailand there were silks, a bronze Buddha head and a tiger skin that survives to this day. Italy supplied a pile of hand-carved wooden gewgaws. In Hong Kong a tailor made Warhol a closetful of bespoke clothing, including a cashmere sports jacket and a beige suit in raw silk. The new outfits (some still exist) came in the very latest neo-Edwardian styles borrowed from the "smart young men" of London, with three buttons and narrow, high lapels—as Warhol himself had illustrated in *Esquire*. He remained a secret clothes snob for the rest of his life: "No linings, no darts, no finished seams," he complained about the mass-market tailoring of the 1970s.

New York's clothiers fared as well as Hong Kong's. Warhol's first checks from I. Miller had already funded one hundred identical white shirts from Brooks Brothers and those were followed by a $300 suit and more than $200 spent on a couple of handmade overcoats, including a flashy double-breasted number in a black-and-white check with a fuchsia lining—a combination known to have been favored by the French campster Jean Cocteau. Warhol was happy to boast about the cost of a fancy new suit whose trousers had a red paisley lining, which he demonstrated at one Christmas party by dropping his pants. ("Very suggestive, revealing, tight" is how one friend described Warhol's preferred cut of trouser.) And Warhol's new look was topped, as it were, by his famous nose job, which, whether successful or not, still prompted a $500 invoice from the artsy plastic surgeon who performed it.

Opera was another extravagance, and at Lisanby's insistence Warhol donned black tie when they took it in. The winter after the round-the-world trip Warhol made weekly visits to the Met, to see Wagner's entire Ring cycle as well as warhorses such as *La Bohème, Tosca* and *The Marriage of Figaro.* (He still had his Met subscription fifteen years later, when it was costing him $800 a year.) On Broadway, Warhol attended everything from Tennessee Williams and Eugene O'Neill to *West Side Story* and *The Music Man,* as well as a review starring T. C. Jones, the pioneer of female impersonation.

And of course all this splendid socializing required the lubrication of champagne—vintage Piper-Heidsieck, which Warhol bought by the case and stored in a fridge just for it. The myth that Warhol was close to teetotal falls under the weight of evidence: He admitted to his doctor that he was having about four drinks a day, which probably means he was tippling rather more than that. The doctor palpated his liver and told him to cut down.

"He liked to get high on whiskey" is what one friend remembered, and

receipts in his archive show Warhol buying booze by the case—and the case, and the case. He had even planned to do a book of cocktail recipes, although that ode to the high life never came about.

"His idea of a wonderful way to spend a Sunday afternoon was to have brunch at the Palm Court at the Plaza," remembered an art critic who met Warhol in the late 1950s. "Once in a while, craving fast food, he hired a limousine to round up his friends and then whisk them to Nedick's on East Eighty-Sixth. The chauffeur waited while Warhol and his party ate hot dogs."

A friend looked back on Warhol's '50s persona from the vantage point of the later 1960s: "He was so full of fun, so popular—nothing like the rather lugubrious personality he's become. In those years, his house was always filled with the most amusing, fun people: Andy gave the best parties. He had Tiffany fixtures everywhere."

The Tiffany-filled "house" in question was the product of Warhol's biggest posttrip treat to himself: a major expansion of his living space.

It's hard to imagine how crowded the fourth-floor flat must have been getting, what with the amount of work Warhol was bringing in, the assistant he'd installed there and then the piles of clothes and Asian souvenirs that began to arrive. His mother had been annoyed enough to put some of the world-tour purchases out with the trash; others had luckily been shipped direct to Lisanby's address, for storage no doubt until Warhol could find a place for them at home. And then there must have been whole closetfuls of boxes filled with all the receipts, ticket stubs, Christmas cards and other "precious" mementos that Warhol kept to his dying day. The hoarding that became florid in later life must have shown its first symptoms around the time of his first career success.

"This top floor was a mess. I mean, I just cannot describe it—it was piled from floor to ceiling with magazines, old tracing papers, old drawings, a lot of canvases," said a new friend Warhol made at that time. The solution came in November 1957, when Warhol got his hands on a second apartment in his building, two stories down on the much grander main floor. One friend remembered it as "wonderful, very airy and elegant," a "huge apartment" that cost almost twice what Warhol was already paying for his first place upstairs. With the mess of his business now sequestered there, along with Nathan Gluck and the two cats that were left, Warhol set out to make his new piano nobile into a comfortable home for himself and his mother—but more important, into a space for "show" and for entertaining the "gobs of pretties floating around the place." Those included drag queens "of the glamorous '50s showgirl variety," said one art-critic friend from that moment, who drew a distinction between them and the "deliberately tacky

later '60s travesties" that became such an important element in Warhol's 1970s scene and artmaking.

Since one of the "pretties" who founded Serendipity had recently moved into an apartment on a middle floor of the building, Warhol got him and the rest of the café's team to do the décor in his new place. "I used simple, clean lines, as opposed to his work space, which was cluttered," said Stephen Bruce. First, the Serendipitites painted everything white, adding the occasional Art Nouveau flourish, and to maximize the light they installed tightly pleated "café" curtains that only went halfway up the windows. Crowds of potted palms and faux Delft tiles painted onto some of the walls gave the effect of a Victorian solarium.

Warhol "was starting from scratch, and didn't have anything of his own," recalled Bruce, so his Serendipity friends also moved in all of their café's trademark goods: white porcelain dishes, a pile of bentwood furniture and a hanging Tiffany lamp—which they later took back when Warhol refused to pay the $1,200 they wanted for it.

Warhol added to the plenty. On top of all the exotica he got on his world tour, he started to amass the antiques and collectibles that became a lifelong obsession. Lisanby helped teach him to shop for them. But while Warhol at first seemed to follow the tastes of the aristocratic Lisanby, buying such things as Japanese prints and a peacock-themed folding screen, he soon moved toward folk art, Americana and all kinds of curiosities. Before long his apartment was overflowing with ancient cast-iron machines from penny arcades—one called "Whiffs of Fragrance" and another "Punch or Hug Me for Only One Cent." The collection also included a cigar-store sculpture, vintage store signs, carved carousel horses, seating made out of animal horns and twigs and, of course, that camp classic, a stuffed peacock. The giant dance hall mirror ball that became an icon of the 1960s Silver Factory in fact first appeared on the scene as a tripping hazard in the flat on lower Lexington. Philippe Jullian, that friend of Warhol's who was one of history's most notable campy connoisseurs and connoisseurs of camp, wrote that "gays have objects as their children. . . . Ill-adapted to society, the homosexual is more susceptible to nostalgia."

Warhol's collecting became so ferocious that by the late 1950s he was telling a friend he might open an antiques store with all his surplus stock— and getting the dealers he bought from to write "for resale" on their bills, so he could claim his objets d'art as inventory. The idea of Warhol himself becoming a dealer wasn't as absurd as it sounds. The "humble" objects Warhol had been acquiring fetched high prices, even back then: Within a few years the carousel horses were appraised at $1,600, the cigar-store

sculpture at $1,500 and Warhol's four-poster early-American bed at $750, all sizable sums in Kennedy dollars.

Those numbers reflect an important fact: For a while already, such funny old stuff had in fact been moving to the leading edge of modern culture and taste. Around the turn of the twentieth century, all kinds of objects by naïve and anonymous and outsider artists were picked up by the modernist pioneers—Picasso and Klee and other early heroes of Warhol's—who trumpeted them as sources for a new aesthetic. With their very close ties to work by and for children, most of Warhol's 1950s chapbooks and illustrations had a strong faux-naïf edge. Warhol would have seen the playful imagery he was coming up with as echt-modern, even if the New York art world, obsessed with weighty abstraction, couldn't follow him there. The very first time his Pop Art got press, Warhol told the bald-faced lie that he was self-taught. That was how much he counted on the connection between outsiderism and vanguard culture.

A melding of naïve and ultrasophisticated, of vintage and modern, played out in the camp décor of Warhol's new flat—"china ducks . . . in a house of otherwise modernist and modish furniture" being defined as the very essence of camp by one of the style's theorists. The campy old bentwood brought in from Serendipity already counted as modern classics worthy of MoMA, and Warhol paired those vintage pieces with the very latest innovations in design. Even before his world trip he'd started going modern. He spent almost $200 on the latest teak table and, to go on it, he special-ordered some striking Danish Modern flatware, in solid silver, that had the same slender, almost cartoonish lines as his most calligraphic drawings. That table and cutlery lived alongside pieces by the American mid-century modernists Charles Eames, Florence Knoll and Eero Saarinen, purchased as "office supplies" to keep up a pretense, for the tax man, that Warhol's lower flat was being used to conduct business.

Warhol's friend Jack Lenor Larsen, the cutting-edge textile designer, remembered a call he got from Warhol around this time: "It's Andy, and I need your help. My accountant says I need to buy something. What's the most expensive furniture?" Larsen recommended the exquisitely crafted modern pieces made by Dunbar, an elite American firm, and sure enough, next time he walked by Warhol's place, the company was craning furniture up through the window.

Warhol was also spending his new wealth on tidy works by such certified modern artists as Toulouse-Lautrec, Matisse, Magritte, Shahn, Roberto Matta, Pavel Tchelitchew and Leonor Fini, those last three with much bigger reputations than they have now. Warhol would have attached special im-

portance to Tchelitchew because he was a senior figure among gay culturati and the partner of the poet and editor Charles Henri Ford, later a player in Warhol's Pop circle. The most ambitious of several Tchelitchews that War-hol owned hints at these men's shared psychic dilemma: It depicts a single well-dressed youth split down the middle into two selves who seem to be embracing.

Warhol's collecting seems to have centered around the European mod-ernists sold at New York's more traditional galleries such as the Hugo and the Bodley. A newer American vanguard doesn't seem to have gotten Warhol to open his wallet, at least at first.

———

As usual with Warhol, his first exposure to New York's more serious avant-garde may have depended on social connections. After a few years spent settling in among the culture vultures of uptown's queer scene— "the window-dresser and hair-dresser crowd," as one catty friend put it— Warhol seems to have branched out into the more unconventional world of Greenwich Village.

This was a moment when gay New York was split between two radically different circles, according to the dedicated Villager Jean-Claude van Itallie, a playwright friend of Warhol's who at that moment had just come down from Harvard, and come out.

There was uptown, which one guidebook described as "Upper Bohemia," an alternative to the Village for the "well-heeled artistic types" who hung out in its "busy bars for deviates." The scene there could tend toward a very "old-queen" style, according to van Itallie, and was all about drinking and wearing the right clothes. "Shallow was really the operative word in my mind for uptown. . . . You were camping, and you were drunk," said van Itallie, remembering that as Warhol's world. The lone date the two went on took place at a tawdry uptown spot decorated with beach umbrellas, where Warhol asked him to slow-dance "and I was unaccustomed to dancing with other men. . . . We had to decide re positioning our hands who was 'top' and who was 'bottom,' almost as if we were deciding on a later sexual position. For two rather shy and well-bred middle-class guys like Andy and me, it was, well, yes, awkward." (He was also turned off by Warhol's very obvious wig and, later, by Warhol's bad hygiene, something lovers were still complaining about as late as 1965.) For van Itallie, Warhol was "an uptown designer, and I can't say that that's the highest status I would give someone."

At the other end of Manhattan, and of society, there was the dressed-down downtown scene in the Village, whose denizens, as one local put it at

the time, viewed homosexuality "as a matter of taste" and saw "no reason why men and women cannot change sexes as they change their clothes or their style of haircut." In the Village, said van Itallie, being gay and being an artist could seem almost the same and artmaking had to come with a "sacred intent," not a commercial purpose. That was the sphere that Warhol was eager to get closer to. "The Beat generation had transformed lifestyles—it was contagious," said the avant-garde filmmaker Jonas Mekas, who arrived on the Village scene around the same time as Warhol.

There are already hints of Warhol's contact with this world in the *Gold Book* that he sold and showed in December 1957: A number of its most sober drawings were based on the socially conscious photojournalism of Edward Wallowitch, a Village photographer who was four years younger than Warhol and rated a full-page portrait in Warhol's book. Edward had arrived from his native Philadelphia at the tail end of 1955 to live with his older brother John, a Juilliard-trained musician who was then beginning his long career in cabaret as the "dandified embodiment of a traditional piano man."

Nathan Gluck met Edward through that pianist brother and was immediately impressed by the work of the young photographer, who "skyrocketed to fame," as the *New York Times* declared, after the paper had given him and his images major play. Within a few years, one of Wallowitch's photos had earned a spot in the blockbuster "Family of Man" exhibition put together by Edward Steichen, the museum's legendary photo curator and Wallowitch's first big supporter. Gluck introduced Warhol to Wallowitch, a tall Lithuanian with lush dark hair, and the pair hung out together, going off to photograph celebrities at parties, as became Warhol's trademark two decades later. Sometime in 1956 the two friends became lovers.

"Ed couldn't keep his hands off Andy and Andy was all over Ed. . . . My brother was very witty and Andy was very sweet in those days. Adorable. *Artistique*," said John Wallowitch. He described having stumbled on the lovers "going at it like crazy" in his Greenwich Village flat, while a similar tale of flagrante delicto gets told by the Factory playwright Robert Heide, who Wallowitch, a former lover, had first introduced to Warhol in the late '50s.

Ed Wallowitch's many photographs of Warhol paint a more tender picture of their affair, capturing the endearing young illustrator ("good . . . sweet and gentle") who made such a nice impression on people in the 1950s. One whole contact sheet shows Warhol dandling one of his Siamese cats; other shots catch him looking dreamy and sensitive with a bouquet of flowers.

"I thought these guys were going to do something really great together," said John Wallowitch, and his brother and Warhol did make a stab at collaboration. For a feature published in *Seventeen* magazine in early '58,

for instance, they worked together on a photo shoot where a cityscape drawn by Warhol got projected as a slide onto Wallowitch's younger sister Anna Mae, a stunning twenty-one-year-old who sometimes modeled for them and was in Warhol's *Gold Book*. For a while she also acted as Warhol's agent and actually won him contracts, most notably a book cover that became a billboard in Times Square—a sight that must have given Warhol all kinds of pleasure, especially since the book was about Greenwich Village bohemia. In other projects that never got published Wallowitch projected his own slum shots onto Warhol's face, echoing the butterfly projections that Warhol did with Otto Fenn but now with a much more sober, socially conscious edge, and no hint of camp.

Ed Wallowitch had a puritan's commitment to "serious" art: Some of his shots of graffiti evoke the cutting-edge aesthetics of Jean Dubuffet and Claes Oldenburg, and he was known to refuse assignments from mainstream, "sold-out" publications such as *Life* and *Vogue*. That made him a perfect fit for the alternative values of the Greenwich Village circles he and his brother moved in. Their queer-friendly hangouts, such as Caffe Cino and Aldo's restaurant, were starting to rival Serendipity in Warhol's affections. The brothers' own "bohemian-style" basement apartment was another such spot, "a kind of salon for artists, writers, musicians, actors and singers."

From his base at the Wallowitches, Warhol struck up friendships with such echt Village figures as the critic Stanley Amos, who declared himself "more at home in Bohemia than anywhere else." Warhol also got to know the mail artist Ray Johnson.

Although the evidence for Warhol's early friendship with Johnson is mostly circumstantial, it looks as though it was Johnson more than anyone else from that pre-Pop moment who nudged Warhol toward making—or maybe even recognizing—the very latest in museum-worthy art. Johnson had been at Black Mountain College, where he became close to John Cage and Merce Cunningham at a moment when Warhol could still only dream of befriending them. After he arrived in New York in 1949 Johnson had a commercial career in close parallel to Warhol's, probably because Warhol passed on some of his industry knowledge and contacts. Johnson and Warhol, about the same age and both gay, often worked in the same outsiderish mode and sometimes relied on a similar childlike lettering, seen on a number of quite Warholian paeans to shoes by Johnson—a shared subject that argues for substantial time spent together. The two friends ended up doing commercial work for a lot of the same clients: Columbia Records, New Directions, Bonwit Teller's display department and magazines including *Interiors, Harper's Bazaar* and *Seventeen*.

But if Warhol maybe had the lead in the commercial world, Johnson had better credentials and connections in the world of the avant-garde, as would have dawned on Warhol once he became more of a Village regular.

In May 1952, a full-page feature in *Harper's Bazaar* had billed Johnson, along with his friend John Cage, as an "experimental, even stratospheric" artist, at the same moment that the magazine's editors were asking Warhol for trivial illustrations. A few years later, the very first issue of the *Village Voice* had published a feature on Johnson and his radically new art. In 1958, when Jasper Johns's first solo show went up at the brand-new Leo Castelli Gallery, *ARTnews* said that it had earned Johns a place in the new-art firmament alongside "such better-known colleagues as Rauschenberg, Twombly, Kaprow and Ray Johnson"—all of whom, except for Kaprow, were still featuring on Warhol's list of "greatest living artists" two decades later. In the late '50s, no one would have thought of adding Warhol's name to the *ARTnews* tally.

Johnson's art clearly left a mark on Warhol. More than anyone else at that moment—more even than Rauschenberg and Johns—Johnson was making art that foreshadowed Warhol's later Pop work, probably because it helped that work come about. It looks like Johnson introduced Warhol to some of his pop-culture subject matter. By the mid-1950s already, Johnson was building his signature collages around the Lucky Strike cigarette logo, or around Hollywood figures like Greta Garbo, Tony Curtis and Warhol's own '60s muses, Marilyn Monroe, James Dean and Elvis Presley. Henry Geldzahler, the curator and confidant who helped put Warhol on the art map, described Johnson's pieces as "the Plymouth Rock of the Pop movement."

One of Johnson's promotional flyers from the 1950s actually blew up the word "POP" in Pop-ish capital letters; another riffed on a photo of a bottle of Hunts ketchup. (Warhol's own Pop riffs on ketchup of course centered on Heinz, the Pittsburgh firm whose factory he visited as a kid.) In 1957, a well-known cover that Johnson did for a Rimbaud volume from New Directions—an assignment that Warhol would probably have helped him get—featured a vastly magnified headshot of the poet that left visible the same half-tone dots that Warhol came to highlight in his Pop silkscreens. Johnson's Rimbaud cover could easily pass for one of Warhol's Most Wanted Men paintings from 1964.

Warhol, the world's greatest sponge, absorbed untold lessons from his contact with Johnson in the '50s then ran with them early the following decade. A pile of charming Polaroids show Johnson hanging out in the space where the Soup Cans were born, and the two friends were together on the day Jack Kennedy was killed. For the rest of their lives, the publicity-shy Johnson and the PR-mad Warhol remained friends and admired each other's art.

A mutual friend's memories of Johnson suggest the most important lesson of all that Warhol learned from him. "Ray wasn't a person, he was a collage or a sculpture—a living sculpture. He was Ray Johnson's creation." Substitute "Andy" for "Ray" in that quote, and you've got a pretty good description of the Warhol of Pop Art.

Warhol's new downtown context might have triggered work on his first piece with a solid dose of his later Pop spirit. Sometime after he and Lisanby returned from their trip, Warhol made a strange kind of homage to his traveling companion. Taking one of the new ballpoint pens—his trademark tool of that moment—he painstakingly copied out a good part of the front page of the August 23, 1956, *Princeton Leader,* the daily paper in Lisanby's home town in Kentucky. Warhol's copy is close to being word-for-word and photo-for-photo, although it still has a dose of the funny, funky style of the rest of Warhol's '50s work rather than the poker-faced exactitude of real Pop. Warhol kept making hand-drawn copies from the dailies through the end of the decade, clearly doubling down on his copies' artistic potential even though he never showed or sold them.

As Warhol was making these tentative stabs at a new art of the everyday, he would have gained confidence from (or been influenced by) the first glimmers of a postabstract vanguard that was just then coming out of the shadows. Rauschenberg and Johns he already knew from the display world—the couple had even worked on enlarging a Warhol shoe for a "refreshingly different" window at an I. Miller store—and that had also given him the chance to see the latest of their fine art. In 1956, that time that Warhol's two colleagues (or rivals) had been allowed to install some of their "serious" work in windows at Bonwit Teller, Warhol must have recognized that the well-mannered drawings he himself had installed were completely upstaged by the daring styles and completely new subjects that the duo had come up with just a few windows over. Rauschenberg showed a fiercely aggressive collage that was a precursor to the so-called Combines that were soon making his name. Johns was given the chance to display a landmark painting that was not much more than a big American flag portrayed deadpan and foursquare—the most direct ancestor to the deadpan and foursquare Campbell's Soups that Warhol made six years later.

———

Around the same time that Warhol was absorbing the downtown achievements of Johnson, Rauschenberg and Johns, he hadn't let up on his uptown social climbing. (He never would.) The celebrity worship that, a decade earlier, had him swooning over the lead from *Dorian Gray* now had him more

actively hunting for contact with stars, and in a position at last to hobnob with them. He didn't have to stalk Capote anymore; he would run into him at cocktails.

One uptown Ivy League–er named Frederick Eberstadt was notably unimpressed by Warhol's striving. He remembered running into a "weird little creep" hanging around in a friend's kitchen: "He said to me—in the days when I wore a gray flannel suit, a regimental tie and brown shoes—'Do you ever think about being famous?' And of course I said, 'Absolutely not.' And Andy said, 'I want to be as famous as the Queen of England.'"

Warhol was especially keen on the aristocratic bohemia that revolved around Cecil Beaton, and he found a clever way to sidle into it. For a project he described as his "Foot Book"—it may never have existed outside Warhol's fetish-filled head—he arranged to do shoeless drawings of all sorts of notables, including such cultural icons as Leontyne Price, Tallulah Bankhead and Beaton himself. The photographer's toes were finally drawn in Philadelphia, after Warhol finagled an invitation to the Rittenhouse Square home of a posh gay collector and then bagged Beaton's feet as he slept there. By the eve of Warhol's own Pop Art stardom, Beaton was calling him "my sweetie, adorable little Andy."

"I always had the feeling that Andy didn't know a soul," said Marguerite Lamkin, a magazine editor who Warhol referred to as a "Southern girl-around-town." (She was said to be the model for Holly Golightly in Capote's *Breakfast at Tiffany's*.) "I used to call him Sweetness and all my friends called him Sweetness," Lamkin remembered. "I used to take him to parties and hold his hand all the time, he was so shy. Then I felt so funny when I'd go to somebody's big party, and he'd be there. And somebody's dinner, and he'd be there."

Warhol became especially close to Mercedes de Acosta, a sometime playwright who was one of the stars of Beaton's circle and became famous as the most public of lesbians—a lover of Greta Garbo and Marlene Dietrich and others. "She's had the most important women of the 20th century," said Gertrude Stein's partner Alice B. Toklas, who might just have been one of those conquests. Warhol came up with several possible covers for the tell-(almost)-all memoir that de Acosta published in late 1959, shortly after they met, although a much tamer, un-camp design was used in the end, for a book that got its author into all kinds of trouble anyway. It led Garbo to break with her, but not before de Acosta had gotten Warhol invited to a beach picnic with the Great Loner herself. He was so starstruck, however, that the best he could do was silently hand Garbo one of his butterfly drawings. As the story goes, by picnic's end the actress had absently tossed the sketch away, but Warhol

picked it up and then had his mother inscribe it "Crumpled butterfly by Greta Garbo." Is he subtly predicting—or wishfully thinking—that a piece of paper saved by Warhol would someday be worth as much as one touched by Garbo? Throughout his life, Warhol always gives the impression that his desperate status seeking is matched by a sure and accurate sense, in his heart of hearts, that he's actually worth more than the celebrities he worships. His perpetual outsider status gives him the perspective to see that the inside he so badly wants into has very little in it. That doesn't make him want to stay outside.

"Is it more wonderful than awful to know the right people?" a follower once asked him. "Yes" was his answer, "because they're right."

One of the closest witnesses to Warhol's uptown ascent was a social conquest of his named Ted Carey. He was a very pretty, WASP-y graphic designer who did drawings to advertise movies that played on TV. The couple first met at Serendipity, and before long Warhol was giving Carey a hand with his work, helping him on an illustration of Marlon Brando, for instance, a full eight years before he did his own Pop silkscreens of the actor. (As a macho, mainstream star who was thought to sleep with men, Brando was a fixation of New York gays; there's a story that Warhol once stashed a photo of Brando down the front of his pants, and he had been partying with the actor already in 1955.) Carey, who came from money, soon became one of Warhol's tutors in the fine art of shopping for antiques and Americana. Boyish photos show the pair posing amid such treasures on Warhol's parlor floor, reminding us of just how young and playful Warhol still was at the time. Warhol decided to commemorate the friendship with a painted portrait, not by making one himself, however—he could barely have imagined himself as a painter, at that point—but by acting as a patron, a new role his big income made fitting. He first approached the proto-Pop artist Alex Katz, who had won the spot at the Tanager Gallery that Warhol had hoped for, but his cheapskate offer of $150 got turned down flat. Then Warhol turned to the stodgier realist painter Fairfield Porter, who had reviewed Warhol's first group show at the Loft Gallery. Porter made the boys look more like Ivy League roommates than outré swells. They'd commissioned the work, or so Warhol later claimed, with the ulterior motive of cutting the canvas down the middle so they'd get two portraits for the price of one, a plan Porter foiled by painting them almost overlapping on a square canvas. (The story sounds like one of Warhol's tall tales; Carey never mentioned it.) Porter was a noted figure—in 1962, the double portrait was appraised at $1,500, as much as any painting Warhol owned—but he also counted as a conservative choice that would have got Warhol laughed out of the hipper Greenwich Village cafés, and it shows that Warhol still hadn't totally bought into the cutting edge.

A decade later, established on that very edge, he was eager to find a buyer for the painting: "You can't sell your own portrait," said a friend. "What? Sure I can," replied Warhol.

Carey's most memorable role in Warhol's life seems to have been erotic. He was notably oversexed, endlessly cruising the "tearooms" in Grand Central Station and getting up to all sorts of antics in the open relationship that he had with the Englishman John Mann, his (main) boyfriend at the time. Warhol was involved in some of this, at least as a voyeur, frantically drawing the two men having sex. One of Warhol's erotic models remembered the artist sketching in his jockey shorts (dirty ones, apparently—"it kind of confirmed what I had thought about Andy's personal habits") and saying "that he got so hot when he saw men with erections that he couldn't have an orgasm himself."

It was Carey who suggested that Warhol move on from the feet and nude torsos that he'd already been drawing to a more focused attention on penises. That led to the legendary "Cock Book," often mentioned but never seen by man or beast. Piles of unbound crotch drawings do survive, ranging from quiescent anatomical studies to vigorous erotica, with much in between: One drawing shows a man's dangling penis propped up on a plate, with another man's hand prodding it with a fork.

Warhol's penile interests crossed over into one final theatrical project that he took on in the '50s, six years and innumerable blots after his work with the 12th Street Players. In the spring term of 1959, at Barnard women's college, a production of Jean Cocteau's *Orphée* was being put together by a group of student thespians, including the future Broadway playwright Terrence McNally and Michael Kahn, who went on to be a major Shakespearean director. "I just had a total fascination with Cocteau," Kahn remembered. "I guess because he was gay." McNally was a friend of Ted Carey's brother and Kahn knew Warhol from the Greenwich Village gay scene, all of which helped them nab the thirty-year-old illustrator, already a semicelebrity, as their production designer. Of course Warhol had done sets before, beginning in his own student days, and had known Cocteau from films shown at Tech, from a live run-through of *Orphée* itself at Outlines gallery and especially from always hearing his own work compared to the Frenchman's. He also knew Cocteau's pornographic illustrations for Jean Genet, and those might have inspired one aspect at least of Warhol's designs for that Barnard *Orphée*.

After getting his mother to letter the poster, Cecil Beaton to supply the stage furnishings (his trademark white-wicker chairs and tables) and Bendel's department store to lend fine Dior pieces as costumes, Warhol himself

took care of the backdrops. Amazingly, photos show that silver foil was War-
hol's main material, already favored a full five years before it became the sig-
nature of his Pop Factory. He used silvered fabric for the set's doorways and
covered its walls in big silvered cutouts of stars, flowers and butterflies—
and of other objects that might just be giant lollipops with unusually thick
sticks or cherries with strangely straight stems. In fact, those objects had
started life as giant erections. "Andy, this is a girl's school," Kahn, the direc-
tor, had told Warhol when the artist first unveiled his designs. He demanded
that Warhol do damage control: "He chopped the heads off the penises and
said, 'Now they're cherries,'" Kahn recalled. The bowdlerizing worked. The
student newspaper praised the now penis-free design, which it attributed
jointly to Warhol and Ted Carey, as "superior to those of most campus pro-
ductions."

Stuck among the hundreds of thousands of objects in the Warhol archives
is a comic pamphlet titled *1,000 Names and Where to Drop Them,* released
in 1958 by the well-named Random Thoughts Publishing Co. The text is
nothing more than a twenty-page list of names that "originally appeared in
Who's Who, the telephone book, and Burke's Peerage," as the book says, but
here are divided among such standard categories as Fashion, Theater and
Artists. The book's yucks, such as they are, come from mixing up names
and headings, so that the Religion & Philosophy page includes Frank Lloyd
Wright, Charlton Heston and Gin. The Big Business page, for its part, asks
us to chuckle at the presence of the Duchess of Windsor, Edsel Ford—and
a certain Andy Warhol. The surprise isn't so much that he's listed under
Business: He was a successful commercial artist, so why shouldn't he be,
and anyway the page is all about cultural sellouts—Warhol was featured
alongside such luminaries as Grandma Moses, MoMA and Jack Kerouac.
The surprise, and it probably came as one to Warhol at the time, is that he
should rate any kind of entry at all. The very fact of being accused of selling
out means that some reader somewhere might care that you had, or might
even have expected better of you. It's hard to think of a more notable sign
that, almost a decade after landing in New York, Warhol had truly and at
last *arrived.*

One young art critic remembered a Christmas party at which the other
guests, gorging on champagne punch and marzipan strawberries, suddenly
became "very animated, gushing over a small young man who seemed to
have a strawberry colored complexion. Though there were bigger names
there, he was obviously the center of attraction. He carried a copy of the

recently-published novelty book *1,000 Names & Where to Drop Them*. He pointed out his name . . . to everyone who passed by, laughing, obviously pleased with himself and obviously amused by the vanity of it all."

In keeping with Warhol's placement in the book, a sign of success that he might have cared for even more was seeing his name at the top of his tax form for 1959, above an income of $53,000. That was more than almost any-one around him earned, and Warhol knew it because he had recently illus-trated an article headlined "How Much Money Do You Want?" He'd floated images of people grasping at dollars around a text that talks about how a suburban doctor wished he could double his income—to all of $30,000. "Andy *very* much liked money," Ted Carey remembered, "and all the things that money can buy." Warhol's friend Gillian Jagger remembered how he would boast about making $68,000, his income at the very start of the 1960s. But also that he wasn't pleased with what he did to earn it. "He did not want to be known as the I. Miller shoe guy."

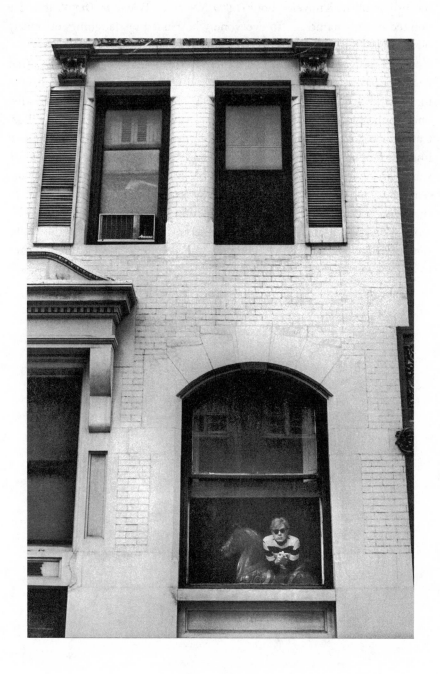

*. . . in the window of his Upper East Side town house.*

# 1960-1961

*"Commercial art at that time was so hard because photography had really taken over, and all of the illustrators were going out of business really fast"*

In 1960, what would have happened if you'd asked Andy Warhol to draw his ideal New York home? He would have come up with something fin de siècle, of course, and bourgeois, with the gentility that this working-class boy was always in awe of. It would be a twee, dollhouse-y building with decoration like the curlicues in his mother's script. And wouldn't he make it baby blue, while he was at it?

That was precisely the house that Warhol took possession of on August 18, 1960, for the then-princely sum of $60,000, paying fully half in cash. The building was four stories tall but only sixteen feet wide, with a façade that came to a droll point on top and had all kinds of carving below. The house had two rooms to a floor and a brick-walled "garden apartment," with a kitchen, on the bottom. That was where his mother and the two remaining cats made their home, along with the mynah bird Echo, alongside a little folk altar that Julia Warhola had cobbled together. The best upstairs room featured elaborately inlaid floors and walnut paneling—and, on wash days, the linens that Warhol's mother insisted on spreading out to dry.

The purchase kept Warhol living on Lexington Avenue, but now at number 1342, on the west side of the avenue just north of Eighty-Ninth Street. His brother Paul and a friend had driven down to help with Warhol's move, loading their truck in the middle of the night for the sake of parking. The stoop where they unloaded was sixty-five blocks uptown from Warhol's Pin-Up Room digs, and that much closer to the elites of the Upper East Side.

Closer but, as they say, no cigar. The Carnegie Hill neighborhood did have posh roots: It got its name from the giant mansion that the Pittsburgh tycoon had begun on upper Fifth Avenue in 1899, at the crest of a wave of gentrification that had also brought in a well-heeled bourgeoisie. When Warhol's genteel row house was built it was given faux-Renaissance detailing worthy of fancy New York landmarks like the Dakota apartments on Central Park West or Warhol's beloved Plaza Hotel—worthy of them because it had been designed by their architect, an elite pedigree Warhol would have cherished.

Within a few decades of the neighborhood's launch, however, New York's immigrant tide had swept in, fleeing from the crowded Lower East Side. By 1960 the intersection of Eighty-Ninth and Lex counted as the northern edge of Yorkville, a.k.a. Kleindeutschland, the German and Hungarian neighborhood that offered "delightfully cheap" housing to the new career girls Warhol's illustrations were aimed at. If in the twenty-first century a move to Warhol's corner would count as a bid at an upper-crust life, in 1960 it would have cast him as a bit of an urban pioneer, along with other cultured arrivals in the neighborhood such as the artists Mark Rothko, Jim Dine and John Chamberlain as well as the cartoonist Al Hirschfeld, who kept a famous salon in his pink house there.

When Warhol bought his town house, its historic block had only recently been saved from becoming a modern apartment building. The subway rumbled below, and Warhol, never a fan of "the commons," felt the Transit Authority should pay him rent for its tunnel beneath his place. There was still a rooming house a few doors down and a modest Finast supermarket soon moved in across the street—offering the soup cans and product boxes that became Warhol's muses at exactly the moment that store opened shop.

As usual with Warhol, the move probably came about because of social connections. In the early 1950s, when he got his first contracts at *Interiors* magazine, its top editor had lived one door north of what became Warhol's new place; that editor's home was then bought by one of the more notable party givers in Greenwich Village, a prominent arts philanthropist who remained Warhol's neighbor throughout Pop's heyday. Warhol's own row house had been owned since 1952 by a Pittsburgh native who was a big-shot psychiatrist of the left—he testified in court that the porn flick *Deep Throat* would "lighten the load of guilt and shame often associated with sex." Warhol actually bought the house from a new owner, yet another doctor, who had flipped it after just a few months, doubling his money in the changed neighborhood.

For all the period ornament that survived at 1342 (every room had a fireplace) some of its ceilings had come covered in doctor's-office acoustic tile, which Warhol once made a feeble attempt to hide under some stapled-up oil cloth. Nathan Gluck, who had made the move from lower Lexington

with Warhol, said that part of the appeal of the new house was that it didn't demand much in the way of renovation. Warhol obliged by giving it hardly any, except for renting a sander to refinish some floors.

The new house had been bought in the name of Andy Warhol Enterprises, and to some extent that was a tax dodge. The garden level was clearly for Julia Warhola's purely personal use—how much lettering could she still have been doing by then? On the second floor, Warhol slept in the front room, afloat in a sea of magazines and candy boxes that surrounded a newly bought four-poster bed with tattered hangings that gave it a Miss Havisham effect; heavily re-stored, it was still his bed twenty-five years later, when he died. In touches that seem out of *Playboy*, a tiger-skin rug graced the foot of his bed, leading to a bath-room with the latest in glass-walled shower stalls. It shocked Warhol's Pitts-burgh nephews. Farther back was a room that had originally been intended for his mother, with a gilt bed worthy of French royalty, but once she'd installed herself downstairs that second bedroom was kept staged with drawings and art supplies, just in case the tax man wanted proof that business was going on.

This was far from a total falsehood. Gluck said that he and his busy work-table were installed in the front room on the first floor, which got bright morning light, in close company with Warhol's "Punch" statue, carousel horses and penny arcade machines. Two stories up, under the eaves, Warhol had his opaque projector (a "Lucy," as it was called in the trade) and "a big drawing table and everywhere drawings pads, inks paints." Accompanied by Gluck's pair of poodles, the two men churned out so much product that, for all the disruption of the move and a spate of illness, 1960 turned out to be Warhol's most profitable year before Pop.

Despite the big move, Warhol's home life seems to have stayed mostly the same. Days were spent courting clients and fulfilling contracts. Evenings mostly involved the old crew. Ted Carey and Charles Lisanby were still on hand to represent the uptown scene, with Serendipity and Café Nicholson as continuing hangouts. Downtown, the sex seems to have cooled between Warhol and Ed Wallowitch—Wallowitch had had some kind of mental breakdown and Warhol had refused to help pay for his treatment. Still, some considerable closeness survived: Well into the decade Warhol was still shoot-ing piles of affectionate Polaroids of his former lover. The artist also turned to him whenever he needed skilled product shots to work from; he even took photography classes from Wallowitch. There's no hint that Warhol found a new love interest for some little while. For the first time since his arrival in New York, his romantic life seems to have been put on hold.

There was certainly some little while when he couldn't have been feel-ing terribly romantic or sexy: For most of 1960 and well into 1961, his painful

and bleeding anal warts and tear had kept him in misery. In August and September of '60, the even more painful—and unsuccessful—surgery for them had kept him out of circulation for weeks, just when he was closing on his new house. If Warhol did go on to have reservations about sex, the discomforts of this moment might have played a role; he was still being treated for rectal problems in the 1980s.

———

Maybe Warhol's search for romance was being replaced, for a while at least, with a hunt for fresh culture and art. "At the end of the '50s, everyone was wondering where it was going to go next . . . and then it all sort of coalesced all of the sudden," said Claes Oldenburg, soon to be Warhol's comrade-in-Pop. After a decade of dominance, Abstract Expressionism had started to feel distinctly old hat.

In the fall of '59, the Museum of Modern Art, until then seen as a bastion of abstraction, held a show called "New Images of Man" whose artists took a first step toward the return of subject matter in art. "The existence of man rather than the essence of form is of the greatest concern to them," said the museum's press release, touting the show's "combination of contemporary form with a new kind of iconography." Warhol's old Tech professor Balcomb Greene was in it, showing how even a founder of American abstraction could be won over to the figure—and also guaranteeing that Warhol would have showed up for the exhibition. The show also promoted any number of artists who would have planted the seeds of Pop Art in Warhol's mind: The Frenchman César was a pioneering accumulator of junked goods; the Scottish artist Eduardo Paolozzi had already made works that most people consider the first authentic examples of Pop, and which the MoMA release described in distinctly Warholian terms as having "the psychological effect of reminding the spectator of the nature of his civilization"; the eccentric, almost-folk assemblages of the Chicago sculptor H. C. Westermann get described as "part of the current Dada revival"—a sure sign of cutting-edge credibility in Warhol's eyes at the time. Within just a couple of years he too was earning the label of "neo-Dada."

Outpacing those first steps at MoMA there was the upstart Leo Castelli Gallery, at first in a little space that the dealer and his family were also living in, reached after a four-story ride on an iffy elevator. By the spring of 1958, the now expanded gallery had given solo shows to both Johns and Rauschenberg and also to Marisol, the single-named female artist whose outsiderish sculptures beat Warhol to the Pop Art punch and who soon became a notable friend and rival. Warhol must have been sick with envy when Castelli's sold-out Johns show—the artist's first solo—even lucked into getting the cover of

*ARTnews,* the most prestigious art magazine of that era, and also managed to move a bunch of works into the MoMA collection. Before long, Castelli's space was also hosting John Chamberlain the car crusher, Cy Twombly the scribbler, and Frank Stella, Ellsworth Kelly and Yves Klein, the three godfathers of American minimalism.

The December before Warhol's move uptown, MoMA had picked up some of Castelli's newcomers for a show called "Sixteen Americans." Its modest name camouflaged sweeping artistic ambitions. "There can be no doubts but these sixteen are 'making it new.' The old forms are no longer capable of containing their ideas," said the *New York Times* review, written by Warhol's 1950s friend Stuart Preston, who actually had trouble coping with the level of newness on display. Years earlier he'd already castigated Rauschenberg for succumbing to "the demon of novelty." Now Preston was complaining that for the new generation at MoMA, "anything goes"—as witnessed especially in the real Coke bottles that Rauschenberg had included in a piece and that Warhol was about to start painting. (A headline from the following spring referred to Rauschenberg as "The Leader of the 'Pop Bottle' School," nicely foreshadowing the rise of Pop itself on Rauschenbergian foundations.) The same MoMA show got savaged by John Canaday, Preston's even more conservative colleague at the *Times,* for appealing more to the mind than the eye—another pan that would have been more encouraging to Warhol than not. "I've often wondered why people who could look at incredible new art and laugh at it, bothered to involve themselves with art at all," Warhol later said, and "New things are always much better than old things"—for once giving a quote that probably reflected how he truly felt.

Warhol's tastes didn't extend only to new art. He also sampled the city's radical new performances. He was spotted at poetry readings given by Taylor Mead, imp of the underground, who was soon to become Warhol's first filmic superstar—he even bought Mead's books. Warhol also became a regular at the pile of new Off-Broadway venues that were opening in the Village. A few months before his move to Carnegie Hill, he'd headed to the Circle in the Square theater, in its brand-new venue on Bleecker Street, to see *The Balcony* by Jean Genet. That was the bad-boy French author who had already inspired Warhol's *Boy Book* drawings. The night of the premiere, the artist ran backstage to meet Sylvia Miles, who had played a female thief in a subplot that involved a man licking her stilettos—as perfect Warhol bait as could be. (A few years later he turned that same action into a film.) "It was a much-talked-about and controversial role. Andy liked anything edgy, so he became a fan," Miles remembered—without quite realizing that edge was only then supplanting camp in Warhol's tastes.

But to see New York's artistic and theatrical vanguards come together in utterly novel ways, Warhol went to church. Not to the Greek Catholic services that he and his mother were still attending just a few blocks east of the bohemian scene, but to the Judson Memorial Church, a venerable Protestant institution on Washington Square in the heart of the Village. The Judson was already wildly progressive in its politics but at the very end of the 1950s one of its junior ministers decided to reach out to new frontiers in the art world, hoping to help the Christian community "understand the place contemporary art ought to have in its liturgical life." By some stroke of luck, he happened to ask for help from the student artists Tom Wesselmann and Jim Dine, about to become fixtures of the Pop Art scene, who then recruited Claes Oldenburg, at the very start of his Pop career but also at one of its most radical moments. In February 1960, Oldenburg and Dine filled the Judson's basement art space with a couple of installations where an insane mess of trash and found objects became the faux-urban setting for some absurd and abject performances.

"We flopped and strutted in manic intensity for a curious art crowd," remembered Patty Mucha, Oldenburg's then wife and collaborator. "Claes in dirty underwear, bandaged with fake gauze and wounds, was grunting and stumbling while I wore large triangular booties made from cardboard, long stuffed black lollypop hair and a painted mask, as I chirped 'yip-yip, yip-yip' into the cold basement air. Meanwhile, Lucas Samaras"—another artist who was about to take off and who Warhol collected—"flicked on and off a bright light in repeated pulses to suggest the staccato moods of the city." The Judson had helped launch some of the first of the '60s Happenings, and they set the standard—soon to be Warhol's standard—for just how radical art could get. The church had to hold a special panel to defend its launch of anti-abstract art ("people think we are kidding") and within a few years, a Warhol fan writing in the *New York Times* was arguing that the fine artists working at the Judson had lit the fuse for the larger explosion of American creativity that defined 1960s culture.

"Warhol was really involved in Judson. He knew it was hot—he was there all the time," said an acquaintance from that era. We know for a fact that Warhol witnessed the splash that Oldenburg and his pals were making there, but you could say that Warhol was in the Village scene but not of it. "When he came downtown, he was known to have a studio uptown, so he wasn't recognized as a fellow Village artist," said one observer. When Oldenburg introduced Warhol to another young artist around this time, it was as a collector, not a fellow creator.

It took a while for the lessons Warhol learned downtown to register in his art. The year before his move, the only artistic project he worked on for truly

public consumption was a set of stage designs that would hardly have counted as worthy of Judson. They had been commissioned for the Spoleto festival in Italy, a two-year-old venture organized by Gian Carlo Menotti, a composer and New York celebrity whose work Warhol had known for a while. Warhol was solicited, at the last minute, to design sets and costumes and some theatrical curtains for Menotti, to use in a Spoleto revue that had enlisted a vast list of stars—and Warhol idols—including John Butler, Truman Capote, Jean Cocteau, Allen Ginsberg and also Ben Shahn, who is supposed to have thought Warhol not worthy of this company. Warhol was charged with doing sets and costumes for a nine-minute operetta by the composer Lukas Foss, with a Menotti libretto. *Introductions and Goodbyes,* as the piece was called, had witty modernist music and an equally witty text set at a cocktail party. It's easy to see why Menotti would have looked for a design from Warhol, a cocktail-party habitué on the same gay scene where Menotti was a player—Warhol was so close to Menotti's partner Samuel Barber that they once got thrown out of a restaurant for laughing too loudly at their own jokes.

Warhol's surviving sketches for the furnishings and clothes—camp Edwardian outfits, of course—are in his standard 1950s style, complete with lettering in his mother's faux-naïf mode. They are witty and charming, for sure, but don't match the opera's modernist sophistication—or the sophistication of the best art being made at that moment. At around the same time, Warhol had tried to make fine art out of a distinctly Ben Shahn–ian illustration of his, of cute birds roosting on rooftop antennas, by enlarging it to mural size. The result looked like . . . an enlarged illustration.

In a little bio published in December 1960, the best Warhol could claim for himself as an artist was that he was doing a bookplate for Audrey Hepburn's nursery. If he had any currency at all on the artistic vanguard it was as one of its fans, eager to make contact with its movers and shakers. In the early 1960s he took more steps to hang out with the art market's powers-that-be, mostly by turning into one of their clients. Warhol always knew that money made the best introductions.

He got to know John Bernard Myers, the "flaming queen" founder of the Tibor de Nagy Gallery, which was one of the most notable venues of that pre-Pop moment and also a rare haven for out-of-the-closet queer culture. The gay poet and MoMA curator Frank O'Hara was a regular there; he was a fan of Johns and Rauschenberg and was close to the sometimes-gay proto-Pop painter Larry Rivers, one of the younger stars of the Myers stable. O'Hara would have been a big draw for Warhol—he'd written for MoMA's "New Images of Man" catalog—although the poet never quite returned the admiration.

In the late 1950s, Warhol shopped at the de Nagy for a playing card draw-

ing by Rivers—he bargained it down from $75 to $25 and then paid it off over five months. Warhol then cemented his de Nagy ties in 1960 with two portrait commissions: That portrait of him and Ted Carey by gallery artist Fairfield Porter (a painter-critic) plus a notably fey one by de Nagy's Jane Wilson, who posed Warhol at home with a vase of mauve lilacs. Like Porter, Wilson was a player on the art scene: She had helped found the artist-run Hansa Gallery, which had fostered some of the first hints of performance and installation art—and even of Pop assemblage—and which was managed by Ivan Karp and Richard Bellamy, who soon became two of Warhol's supporters.

Warhol's ingratiation worked—to a point. Myers told one of his artists to cultivate Warhol as a likely buyer, but he also described their prospective client as "a terrible little man" and "a very boring person." When Warhol did stop by, the same de Nagy artist remembered him as "quite miserable-looking . . . so thin, so little, so miserable. Forlorn. So very neat and clean and well-dressed, in a tweed jacket and necktie, but it didn't come together. He was shy and unassuming."

With the hindsight of art history, the artists Warhol was collecting from Myers don't look terribly radical. At the time, however, as even the dedicated avant-gardist Leo Castelli remembered, the de Nagy crowd represented a daring first move away from abstraction and back to representation. Despite Warhol's lifelong reputation as a social climber—sometimes deserved, sometimes not—it's important to recognize that he wasn't directing his attentions at the most established and prestigious galleries in New York, where he'd have met the town's nabobs and doyennes, but at a more enterprising bunch of taste leaders. Not that that impressed the art scene's true radicals: One young art critic who met Warhol at this moment thought his art collection stank, and that he was nothing more than a "window trimmer and a chichi East Side gadabout who hung around with trashy people."

Within a year or two, Warhol had moved his collecting up several notches, and with it his reputation. He headed to Castelli for a drawing by Jasper Johns, who was just then emerging as a major force. Castelli's gallery director Ivan Karp said that despite Warhol's start as a collector he didn't know him when he came in to shop with a posse of young men who were already clients. The drawing that Warhol settled on dated from the moment of Johns's first Castelli solo, in 1958, and showed Johns coming closer to Pop Art than he ever would again: It was based on a highly realistic sculpture that Johns had made of a standard light bulb. In the sheet that Warhol bought, Johns had managed to make that lowly household object look like a massive public monument. "What a beautiful drawing! Wow!" was Karp's memory of it.

Warhol's friend Ted Carey, one of the "young men" mentioned by Karp,

gives a more detailed version of the story. The two friends had been egg-
ing each other on in their gallery going, getting so "keyed up" that they
decided to buy one of the pioneering Flag paintings by Johns, only to find
that it was beyond their paltry art budget. Instead, the day before the Johns
show closed, Warhol settled on his Light Bulb drawing, putting $200 down
and another $250 on account. This means that he spent less than he had on
his dining room table and chairs. It was also much less than the $2,000 he'd
parted with just a few months earlier for a painting by the Chilean Surrealist
Roberto Matta, a relatively Old World and old-school figure. Maybe Warhol
thought of his Johns as too experimental to be a terribly safe investment of
more significant cash. Warhol's collecting is often billed as being less about
an appetite for art than for status, but there couldn't have been that much of a
social upside in buying art that the vast majority of socialites, from any circle,
would have either ignored or disliked.

Around the same time that Warhol was putting new art on his walls
he was also changing the people in his life. If his 1958 datebook has all the
decade's usual suspects from the uptown advertising world, by 1961 a bunch
of new names from high-end culture start making regular appearances, and
most especially a single one: Emile de Antonio.

The two had first met in 1958 through Tina Fredericks, Warhol's first cli-
ent in commercial art, who de Antonio was living with at the time. Warhol
struck his new friend as "a superintelligent white rabbit." De Antonio ("Dee,"
as he was always called) was the son of a wildly cultured and very wealthy
Italian physician, and he and Warhol shared a deep awareness of their immi-
grant roots. Almost a decade older than his new artist friend, de Antonio was
a third-generation atheist said at the time to have been a monocle-wearing
Harvard toff (expelled for arson), a bomber pilot (thirty-eight missions over
Japan), barge captain (while getting a philosophy M.A.), army-surplus dealer
(with mob connections) and occasional college professor and opera translator.
He also had a lifelong attraction to the far left and later made a name for him-
self as one of the leading activist filmmakers. A magazine profile described de
Antonio as "an enormous, powerfully-built man with a Rabelaisian taste for
life and its varied pleasures"—including four wives at the time and another
two on the way as well as endless quantities of alcohol. ("I don't like water; I
never drink water.") He was tremendously erudite and eloquent, and he and
Warhol must have been quite the Laurel-and-Hardy pair at the dinner parties
de Antonio threw for New York's smartest set, in an apartment around the
corner from Warhol's house. "I introduced him to fancy people. For instance
I gave a little party for a terribly rich woman I knew and I served just
marijuana and Dom Perignon, and Andy did a beautiful menu in French."

A self-described hustler (in the business sense), de Antonio made a for-
tune as an artist and designer's agent, with Johns and Rauschenberg among his
clients—not for the profit, he said, since his big money came from much big-
ger contracts than theirs, but to keep his favorite avant-gardists from starving.
Johns and Rauschenberg were living such a garret life when he met them that
they had to go to his place for showers. "I knew Warhol and Rauschenberg and
Jasper Johns and [Frank] Stella before they ever sold a painting," de Antonio
said. But rather than help his artist friends place their canvases, de Antonio won
them new commercial contracts. He got display work for Rauschenberg and
Johns and, for Warhol, some work on the décor of the new Brasserie restaurant
in the ultra-modern Seagram Building as well as "color consulting" on a movie
theater in Spanish Harlem, up the road from Warhol's new house. The theater's
owner, a friend of de Antonio's who also owned the notable New Yorker art-
house cinema, felt his Harlem concern was "a dog" and out of touch with its
newly Latino neighborhood and he wanted ideas on how to fix it. "Andy and
I went up in a cab. Andy looked at it and said, 'Oh marvelous—paint it Puerto
Rican.' He was paid $500 and I took a %," de Antonio later wrote.

But de Antonio's value to Warhol must have been less about bringing in
cash than cultural capital. By the time Fredericks introduced the two, her
soon-to-be-ex had already become friendly with the Abstract Expressionists
Willem de Kooning and Barnett Newman and then had moved on to promot-
ing the Beat-poet movie *Pull My Daisy,* which put him in close contact with
the downtown counterculture. (Warhol was given a shot at designing a set of
titles for the film, but produced something so deliberately cruddy that they
were taken off the film almost at once.)

De Antonio was especially close to John Cage, who remained his life-
long friend. He said that drunken evenings with the composer in the early
1950s had launched his own serious interest in art, and had then led to
his friendship with Johns and Rauschenberg. De Antonio could hardly have
come with better cultural credentials. As Warhol later put it, "My first big
break was meeting Emile de Antonio."

De Antonio also brought about Warhol's most ambitious art purchase in
this era. One day in the early 1960s, when Warhol was just beginning his ex-
periments in Pop, his friend visited the new Lexington town house with Frank
Stella, the youngest and most daring new abstractionist on the scene. The
two of them brought along a picture from Stella's latest project, known as the
Benjamin Moore canvases. The paintings weren't much more than a bunch
of white lines applied over plain grounds whose colors Stella had chosen from
the venerable paintmaker's catalog, "to keep the paint as good as it was in the
can." The series combined the high-culture aspirations of abstraction with a

low-culture reference to apartment walls and paint stores. (A comic movie about modern artists had just come out with a main character named "Sherman Williams," after the *other* great American paint company.) Stella's series had elements of Minimalism, Conceptualism and Pop Art before any of those movements had been properly launched. One of the paintings in the series, with pale turquoise pinstripes crossing over a field of bright yellow, is close to Pop Art proper: It's a dead ringer for a sheet from a legal pad. Stella himself said that all his striped "abstractions" actually took off from the stripes in Jasper Johns's flags. Warhol was so impressed with what he saw that he paid Stella to make him miniature versions of the entire six-painting suite.

De Antonio, with his impressive pedigree and erudition and cultural know-how, might have been the single most important figure in supercharging Warhol's own ambitions to join the avant-garde. "We always have to test, that really is what the game is about" was how de Antonio summed up the mission of the modern artist. Warhol, who was already prepped for that mission by his education at Tech, was happy to follow where de Antonio led. He gave de Antonio credit for turning him into a painter and also for taking him to his very first underground screening, at the loft of film guru Jonas Mekas—meaning that de Antonio was at the root of all of Warhol's greatest works. Warhol liked to talk about De as "the person I got my art training from," although De himself saw that as one of his friend's typical rewritings of history—a sophisticate recasting himself as ingénue.

———

"Commercial art at that time was so hard because photography had really taken over, and all of the illustrators were going out of business really fast." That was the story that Warhol told about the dawn of his career in Pop Art in one of his last interviews. Even a decade before Pop, when he'd first moved to New York, Warhol had witnessed the rise of a new crop of star photographers such as Richard Avedon, Irving Penn and his own friend Dick Rutledge. If 1950s art directors also supported piles of iconic work by artist-illustrators such as Saul Steinberg and Ben Shahn—and Warhol himself— that represented drawing's last stand against the coming victory of the lens.

By 1961, the Art Directors Club of New York, which had helped promote Warhol's 1950s career, was distributing an annual that featured more than 250 commercial photos from the previous year, by figures such as Avedon, Art Kane and Bert Stern. That was twice the number of drawn illustrations in that same A.D.C. book, with a prize going to only one of those—an I. Miller ad by Warhol, in fact—compared to the pile of awards handed out for photos. A decade earlier, when Warhol had been an A.D.C. medalist for the first time,

the stats had been almost the reverse: Illustrations had outnumbered pho-
tographs in the annual book by something like five to three. As late as 1958
Warhol was still placing six illustrations in the A.D.C. book, but that dropped
to three in '59 and then two in '61 and finally a single one the following year.
When drawn images survived at all in 1960s magazines it was often because
they were faster and cheaper to get than photos.

Even Paul Rand, the design icon of Warhol's youth, was losing battles for
the hand-drawn. He'd parted ways with a partner who thought photography
was the only way to go—and who went on to produce the landmark Volks-
wagen campaign that launched in 1959 with almost clinical photos of the VW
Beetle. That campaign's revolutionary imagery sucked up fully ten spots in
the 1961 Art Directors annual and won two medals. It defined what we think
of as the classic look of 1960s advertising, to the point that Warhol used it as a
source two decades later when he made paintings about famous ads. By com-
parison, Warhol's coquettish illustrations start looking irredeemably '50s. "I
think no matter how charming, whimsical, elegant, beautiful, whatever the
drawing is, it just did not have the impact of a photograph," said one colleague
of Rand's who witnessed the shift.

Warhol's handmade drawings might have had another weakness, when
compared to photography: They came off as effeminate (which they were,
deliberately) when compared to the manly, high-tech product of a lensman.
Warhol himself once referred to the "fairy style" of his 1950s drawings, and
in 1961 the illustrations that Warhol contributed to a corporate benefits
brochure were explicitly rejected as "too fey."

Warhol, who always had a keen eye for where culture was heading, made
some kind of effort to shore up his business. At the very start of 1959, he stepped
up his search for new work by printing up a full one thousand flyers advertis-
ing his services. They featured a classically camp, Edwardian-inspired—and
therefore out-of-date—blotted drawing of a tattooed lady.

Six months later, he took another tack: He signed a new agreement with
his longtime agent that had her selling his future work as a photographer,
whatever they imagined that would be, and he even built himself a dark-
room. Then the following year, he was credited as the photographer for some
kind of brochure on "The New Beauty" put out by Dow Chemicals, a long-
time client for his illustrations. But none of these efforts came close to do-
ing the trick. From a high of $71,000 in 1960, Warhol's income had already
dropped to under $60,000 in 1961. His assistant talked about it as "a point in
time when money was money. Andy was not turning down any kind of jobs,"
no matter how inappropriate to his skills and style.

Most of the drop in income probably came from losing his I. Miller gig.

The company pulled out of guaranteeing Warhol's yearly fee in late 1957—
"we cannot put ourselves in a position where we must pay for art we have not
used"—and went on to drop his monopoly on the company's newspaper ads.
He was soon sharing it with a rival illustrator and several photographers. By
the last months of the decade, the I. Miller ads Warhol put out in the *Times*
started looking more like drawings done from product shots than like the
whimsical riffs he'd been supplying just a few years before.

Early in 1961, I. Miller got a well-known modernist to design a flagship
store on Fifth Avenue that was the ultimate in sleek, midcentury style; it's
hard to imagine Warhol's curlicued imagery fitting in with that setting. The
shoemaker's president had decided on a shift in messaging that didn't leave
room for their "star" illustrator. Warhol was called into the office and sacked.

"He was quite upset when they let him go," remembered Warhol's as-
sistant. It must have hurt his boss's ego almost as much as his bottom line.

---

Warhol's response to his clients' turn to photography? "I started to show my
work with galleries." At first glance, that hardly makes sense: Who goes into
fine art as a business move? Despite the press that Jackson Pollock and company
were starting to get when Warhol arrived in New York, no one would have
imagined an artist's life that didn't involve cold-water lofts and ketchup soup.
At the height of his fame, in 1953, Pollock's best sale was for $6,000. James
Rosenquist, later Warhol's Pop colleague, remembered how even well into
the 1950s, "having a career in the art world was like looking for a ghost.
Essentially, there was no art world and no market, especially for the kind
of art we were making. How could you have a career in that environment?
It would be like grabbing for air."

And yet within just a very few years, and certainly by the end of the de-
cade, it was starting to look like "one could go into art as a career the same
as law, medicine or government," as Warhol's friend and colleague Larry
Rivers remembered. "Discussions on the virtues and problems of figurative
art as opposed to abstract art began mingling with the news of artists get-
ting shows and selling their work and appearing in newspaper and magazine
articles," said Rivers. "You began to hear the word 'career' more often in
relation to what began taking place. . . . I still remember not long afterwards
Bill de Kooning saying to me: 'Well you know, it's a good living!' It sounded
shocking." By 1959, de Kooning had a show that sold out on its first day and
netted $150,000. As one observer put it later that year, "Art is being shoved
in front of everybody; every gallery is using Madison Avenue methods." The
number of galleries had doubled since just 1954, and an American art "boom"

had been widely declared: Parisian dealers were now coming to New York to look for new talent, something that would once have been unthinkable.

It's possible that in Pop's very earliest days, when it was still unsellable, Warhol's decision to depict consumer goods was meant as—or at least read as—an ironic swipe at the out-of-control art market everyone was talking about, and the way it was turning every art object into a commodity. A painting might still be wet, said one dealer who witnessed the change, "when suddenly it begins to be a shoe, a bracelet or a horse or you know anything, an automobile."

James Rosenquist remembered one notable beneficiary of this pre-Pop boom: "One winter morning I walked out of my building, and along came this white four-door Jaguar sedan. At the wheel was Jasper [Johns], wearing a white overcoat. White on white. With his first money he'd bought a coat and a Jaguar. . . . I was happy to see a down-and-out artist finally make a buck." A prominent dealer especially remembered the effect of the art boom on her artists' mouths: "Suddenly, I discovered that everyone had very good, nice, new teeth."

It got to the point that art-world success had become a subject for comic films, including two that got written up in an art magazine—on pages that followed Warhol's first-ever coverage as a Pop artist. The new movies, said the article, show how the American artist had become "a model of adjustment to the acquisitive society . . . on his way to the comforts of togetherness with a Tenth-Street coterie or uptown socialites." Warhol, to a T.

One of the films, a true gem, is about the rise and replacement of AbEx, and has walk-ons by Jim Dine and Lucas Samaras from the Judson Memorial Church crowd. (Both were being collected by Warhol around then.) It stars a hillbilly painter of horses who arrives in New York to try his luck. He gets cruised by a toney gay man in Greenwich Village and chokes on bohemian espresso while he listens to a declaiming Beat: "We will never cease to be alive until we are dead!" He learns to go AbEx and finally moves beyond it when a couple of fried eggs fall onto his abstraction and the wind tops them with a flying scrap of newspaper—an obvious nod to Rauschenberg's newly famous messes.

The culture as a whole was getting comfortable with the concept of the-artist-as-success-story in just the same years that the-commercial-artist-as-failure was starting to be a concept in Warhol's life. At first, Warhol couldn't have been vastly impressed with the amounts that fine art was fetching: Johns got less for the drawing Warhol bought from him than Warhol would have made from one of his smallest commercial assignments. Even Johns's most important and ambitious canvases were only fetching a few times more. But

it was at least becoming clear that there was an uptick in the social and cultural capital to be had in the art world, and that the money was likely to follow. Warhol's crossover into fine art might have struck him as a sensible move, or at least one that wasn't fantastical.

When a friend told Warhol he was heading off to Paris to find a real art scene, Warhol let him know he was out of date. "It's happening here," he explained.

The story about Warhol's early-1960s transition from lowly shoe illustrator to ambitious fine artist has become a fixed part of his legend, as told and retold by him and others, yet he'd actually been dedicated to fine art almost since the day he arrived in New York. Early in the 1950s he had already declared that he was giving up illustration for painting; that decade saw him showing in a gallery almost once a year. When Pop came to be, he was hardly the art neophyte he has been taken for.

Warhol didn't need to change his *identity* from commercial illustrator to fine artist: There had always been plenty of serious talents who had done both ads and art, and he'd even heard some rhetoric that encouraged the crossover. He had also been getting plenty of gallery shows. The problem was that his many exhibitions had utterly failed to signify beyond the tiniest circle of uptown gays. This must have been galling for someone who had been the star of his art school but then had had to settle for the tedium of endless shoe ads. The vast piles of invoices and blottings that survive give a sense of an unrelenting, mind-numbing commercial production line—the true "factory" in Warhol's life that his Pop production never could rival. It's no wonder that, come the turn of the decade, Warhol was doing everything in his power to move his career in a new direction.

De Antonio, who was there to witness Warhol's effort, recognized the courage it took: "As soon as you say 'commercial art,' it's simply judged 'Oh what a nice drawing,' and it passes. Or 'Does it sell shoes?' and then it passes. But to put [art] up for real, then you're being judged. Your ego is on the line—in a very hard way." Warhol's challenge—and he knew it—was to step up and make works that truly mattered, and that were recognized by others as mattering.

But here's the thing: His brave new art started out as mere window dressing.

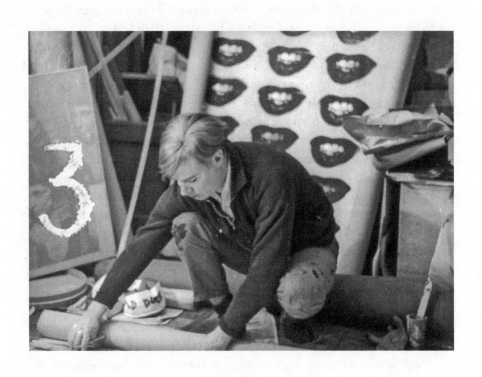

. . . *at home, working on his early Pop Art.*

# 1961

WINDOW PROPS BECOME POP ART | YVES KLEIN | IVAN
KARP AND HENRY GELDZAHLER VISIT THE STUDIO

*"The nation's favorite beverage? Is it beer?
corn liker? soda pop? No sir, it's soup"*

At the tail end of April 1961, a teenage girl walking by the window of the old Gunther Jaeckel shop on Fifty-Seventh Street would have done a double take. The matronly furrier, recently bought out by the neighboring Bonwit Teller department store, had somehow decided to show stylish dresses in bright florals, reds and blues—eye candy sure to appeal to a girl's fashion sweet tooth. The window's displayman was working the same vein, pairing those outfits with props geared to even younger tastes. (See color insert.) Behind the red dress he had hung a hugely enlarged panel from a Lois Lane comic our girl would just have read; Superman's scarlet briefs in that panel were a perfect match for the color of the frock in front of it. The displayman had the blue dress placed in front of an image from a Popeye cartoon that featured a matching hue. Blown-up details from girl-friendly magazine ads—for a nose job, for Pepsi-Cola—hovered in black-and-white behind the multicolored florals. That window's props had been made by a certain Andy Warhol, as the very first of his paintings that went on to count as Pop Art.

And here's what they earned as their first write-up: "CARTOONS GALORE ARE EYE-CATCHERS—A comic strip gallery provides the background for a lineup of manikins modeling dresses." That judgment ran in a window dressers' trade publication, proving that at the moment of their birth Warhol's Pop paintings, used as backgrounds to color-matched goods, were still swimming in the actual popular culture of consumption and ads and comics. His pictures hadn't begun to contemplate that culture from the heights of fine art.

As Warhol recalled, "I did some advertising paintings that were used in the window of Bonwit Teller's"—Gunther Jaeckel's new parent company—"and they left there to go into a gallery." Or, on another occasion, "I was doing the window dressing and I did these pictures for the window and people liked them." But art historians don't seem to have taken him up on this idea, voiced more than once, that those first Pop paintings "were just window art"—that they were truly advertising before they were elevated into gallery goods.

They fit perfectly into their era's culture of commerce. If Warhol's props seem to be speaking to an audience even younger than the one for the dresses set in front of them, that could be because the floor space right behind his window had, until recently, housed the dedicated "Bonwiteen" shop that Gunther Jaeckel's parent company had installed there. (There was also a "dramatic new bag department," explaining the handbag that was literally front and center in Warhol's display.) The new girls' fashions were meant to appeal to a teenage crowd that retailers were starting to study "the way stockmen eye cattle, thinking in terms of how much the creatures will cut-up for," according to one article that discussed Bonwit's focus on this new demographic. Newly moneyed teens were beginning to have their own ideas about what they wanted to wear—"ideas that are often at variance with those of their mothers"—and the cartoons and ads in Warhol's display were clearly meant to appeal to such an adolescent crowd, newly confident in its tastes and desires. Scholars have been paying attention to all kinds of identity issues in Warhol's Pop—to queerness and class and even race. They rarely notice that age is another cultural category he and his art were closely tied to. In 1956, when he was given a chance to show fine art in a Bonwit's window, his drawings of children had already been deemed a good match for the sprightly polka-dot dress in front of them, identified in the window itself as an example of "young American clothes." In his 1961 "Pop Art" window at Gunther Jaeckel, the Pepsi logo in one of his paintings belonged to a brand that had recently got the tagline "for those who think young." The comics he riffed on in the window's other canvases were just then being read by 90 percent of children and teens. Every Monday, after-school TV featured *Popeye* followed by *Superman*—the same pairing as in Warhol's window. Before long Pop Art proper was being condemned as "the pin-headed and contemptible style of gum chewers, bobby soxers, and, worse, delinquents," which, as it turns out, may be an accurate description as much as an attack. Or it could even be praise: It was the teenage culture of Pop Art, said one of its early defenders, that let it push back against standard values. When a reporter once asked Warhol his age, he declined

to provide it but offered a more important insight instead: "If I answer, it's changing my image."

"What almost nobody in 1961 would have seen, had they passed the window at Bonwit Teller, is that it was full of art," remembered the philosopher Arthur Danto, who was around at the time and became one of the leading defenders of Warhol's Pop. "They thought they were looking at women's wear, with some vernacular images taken from the culture by some imaginative, in all likelihood gay, window dresser." "They" would have been absolutely right. And they would have understood what they were looking at, since they had come across similar sights before. Photos of midcentury store windows show lots of framed pictures being used as stylish accessories, and there is rarely any way to tell if those pictures were meant to be read as ephemeral props or lasting fine art. That's because display work, including Warhol's Gunther Jaeckel window, barely distinguished between the two. Warhol's prop-paintings certainly don't seem to have been made with posterity or museums in mind. They were painted with fast-drying casein paints, water based and easy to use and more typical of an illustrator's studio than a fine artist's. One early photo shows just how crudely the Gunther Jaeckel canvases had been stretched before going into Warhol's display. A 1961 image of a Bonwit's vitrine pairing mannequins and Calder-esque mobiles summarized the industry's thinking in its caption: "Contemporary props for contemporary fashions are extremely complimentary."

Viewers of Warhol's prop-paintings wouldn't even have been surprised by their style and subjects. New York's best window dressers had figured out the basic vocabulary of Pop well before it hit the art world. By 1952, the top displayman Lester Gaba had done a perfectly Pop-ish painting of a vastly enlarged eye that prefigures the eye close-up that Warhol had filmed and then projected in 1966. Gaba had based his painting on an eye clipped from some mass-market publication, preserving and even emphasizing the huge half-tone dots that Warhol included in some of his earliest Pop Art and that became the trademark of his rival Roy Lichtenstein— who himself had dressed windows, as had most of the other Pop pioneers. (One text on commercial silkscreening described how "from a novelty point of view, the checkerboard half-tone effect has advertising value"— especially, it said, in window displays.) Gaba had titled his eye painting *The American Look,* and it's notable that he circulated it both as art and as a window prop.

In other anticipations of Pop, at the end of the '50s a Bonwit's window mannequin was posed against a wall of burlap sacks printed—almost certainly *silkscreen* printed, in what became Warhol's signature technique—

with big red hearts, giving an effect that looks straight out of art from the following decade. A window at Tiffany's, Bonwit's sister store, sold jewelry by placing it on a rack of ice-cream cones that foreshadow sculptures by Claes Oldenburg and paintings by Wayne Thiebaud from just a few years later. They prove how much youth culture had entered the world of high-end merchandising, and how little room that left for that moment's established fine art aesthetic—for the AbEx "emotional intensity" that was deemed so ill suited to advertising. It needed the lighthearted play of popular culture instead.

Just when Warhol was propping his Gunther Jaeckel vitrine, his client for it, the famous display director Gene Moore, was writing about how the best window dressing "seems to say that design and artistry can delight lightly, that the transitory can be creative, and entertaining, too. Window display art serves increasingly as a bridge from the seriousness of museums to the paper and string of everyday life"—not a bad account of at least one aspect of Pop Art's appeal. In 1959, the future Pop painter James Rosenquist had filled Bonwit's windows with vast details from popular culture—a painting of Lady Liberty's torch; of the face of a Gibson Girl—and as late as 1966, one critic was still harrumphing about Warhol's "window dresser approach to art."

Another Bonwit's displayman said that Warhol himself actually enjoyed the ephemerality of window work, "here today, gone tomorrow, and the immediacy and the reportage and the journalism of it"—a quality that Warhol went on to inject into his fine art as well, to the everlasting confusion of critics, collectors and the art market. Warhol's Pop wasn't about borrowing a detail or two from commercial work, as many of his closest colleagues did; it was about pulling all its most dubious qualities into the realm of fine art and reveling in the confusion they caused there. "He wants to make something that we could take from the Guggenheim Museum and put it in the window of the A&P over here and have an advertisement instead of a painting," complained one early critic of Warhol's, getting it right, but backward: Pop pictures started in the windows and then migrated to the museums.

By the start of 1963, when "official" Pop Art had barely announced its presence, Lester Gaba was already writing about how perfectly suited the movement was for window work—and how its art, including pictures by Warhol, was already being used in décors selling liquor and cosmetics. The next year, Gaba was seeing Pop everywhere and recommending it for windows of all kinds. The dealer Ivan Karp remembered how the fashion press cottoned onto Pop Art even before the art critics did, "because the material used by the Pop artists related to their world on some level."

Very similar material had been popular in mass-market publications for most of the previous decade: In 1952, the first-ever issue of *Mad* magazine had a comic-inspired page of ironic "WHOMPs!" and "POWs!" and exaggerated half-tone dots fully a decade before Lichtenstein appropriated the same details into his ironic fine art. In '53, a fashion photographer shot a model in front of an endless, utterly Warholian grid of dollar signs, while two years later models got posed in front of a solid wall of Hunts Catsup bottles—in a magazine issue that Warhol owned and that must have been the inspiration for the grid of 210 Coke bottles that he painted five years later. The signature grids and "seriality" of Warhol's Pop Art can be found in lots of earlier ad images—including many by him.

Warhol's own commercial work from the '50s played the same high-low tricks as the fashion press. It was littered with imagery pulled from popular brands, used as a kind of low-culture decoration that Warhol kept in tension with his own far more elite, artisanal stylings. The faux birthday party that he'd propped for Tiffany's early in '59 had included a Coke bottle, which Warhol then fancied up with gold paint; one of his commissioned illustrations paired a Coke and an elegant shoe. Around that same time, in the Tattooed Lady flyer that he sent out to drum up business, Warhol inked up his Edwardian lady with common postwar logos: Pepsodent, Lucky Strike, Hunts Catsup and Dow (already a client of his). He turned her skin into a proto-Pop canvas, just as his Gunther Jaeckel window had been a proto-Pop exhibition.

The prop-paintings that Warhol put into his display window weren't only a reflection of commercial aesthetics. They were just as closely tied to the tastes of '50s camp, which was equally wedded to tokens of popular culture. When Warhol did one of his "cock drawings" of his boyfriend Charles Lisanby, he included a Coke bottle in the picture so as to be "disrespectful," Lisanby said—disrespect being central to camp's love of sniping from the sidelines of culture.

Susan Sontag described how a true connoisseur of camp would find "ingenious" satisfaction "not in Latin poetry and rare wines and velvet jackets, but in the coarsest, commonest pleasures, in the arts of the masses. Mere use does not defile the objects of his pleasure, since he learns to possess them in a rare way." Warhol's eureka moment—one of the greatest in the history of art—came when he realized he could take the tastes for lowly pop culture that he knew from camp and from elite commerce and transplant them, almost unchanged, into the "rare" realm of fine art. In art historical terms, he was taking pop art, in the earliest, British sense of the term, as art made *within* popular culture, and turning it into Pop Art in the American sense, as

fine art made *from* popular culture. Warhol was telling the truth, for once, when he recalled the origins of his Pop Art: "I did some windows for Bonwit's and they were paintings and then a gallery saw them and I just began taking windows and putting them in galleries."

An entire, developed aesthetic of Pop already existed out in the nonart world, that is, and in a move worthy of his hero Marcel Duchamp, Warhol used it as a ready-made, the way Duchamp had used single objects such as urinals and bottle racks. By Duchampian fiat, Warhol made us think that his window at Gunther Jaeckel, filled with pictures that nod to pop culture, might also give a glimpse into his artist's studio filled with fine art.

------------

"The person I got my art training from was Emile de Antonio. . . . De was the first person I know of to see commercial art as real art and real art as commercial art"—those are the words put into Warhol's mouth in his ghost-written memoir of the '60s. They don't get the situation quite right: Pop Art depended for its impact on being gallery art rather than real commercial product, and on preserving the distinction. That is, Pop depended on *not* being window dressing, just as Duchamp's urinal was *not* a toilet.

In the second half of 1961, it looks like Warhol got busy turning his display props into unmistakable art. He added distinctly arty flourishes to his *Superman* painting, for instance, throwing in a bunch of brushstrokes that weren't there when it was in the store window; he also whited out some of its text for an effect that he must have felt was more "poetic." Warhol made new riffs on his other Gunther Jaeckel canvases, crafting a picture that zoomed in more closely on Popeye and others that added Batman and Dick Tracy to his cast of colorful superheroes. He did more paintings based on ads and another bunch based on domestic objects—often campy Edwardian ones like a claw-foot bathtub and a candlestick telephone. He also painted a peculiar picture of the plumber's trap from under a sink that bears a telling resemblance to a piece of piping used as one America's first ready-mades back in 1917, at the same moment that Duchamp came up with his urinal. That famous piece was evoked in a toilet that Warhol also painted in '61. One of Warhol's friends among Tech's gay professors spoke of going with him to see a Duchamp urinal in a show: "I have to pee" was Warhol's droll response. And then he went on to buy a deluxe edition of Duchamp's *Boîte-en-valise,* that collection of miniature facsimiles of the Dadaist's works that Warhol would already have known from Outlines gallery in Pittsburgh.

Warhol's interest in radical art seems to have pushed beyond even Duchamp. Just as he was feeling his way toward Pop he was also taking in

experimental work that completely broke with the old rules; he was even trying his hand at such breaking. He "painted" by putting his canvas out on the pavement and letting the dirty shoes of passersby turn it into an automatic Pollock. Yoko Ono had done something similar in her Chambers Street loft and then in her first solo show at a gallery run by George Maciunas, who had followed Warhol at Carnegie Tech and was a founder of Fluxus, an informal movement of radical innovators in art and performance.

Warhol's own most extreme experiment probably consisted of the paintings he made by urinating on blank canvases, taking the newly fashionable "stain paintings" of certain abstractionists to new levels, and taking the piss out of them too. (He repeated the experiment in the 1970s, more publicly and with more attractive results.)

Warhol had one other momentous contact with the sharpest cutting-edge of his moment, according to the widow of the great French trickster Yves Klein: "I remember once leaving the hotel to go eat, and crossing paths with a group of young people that included Andy Warhol, not yet famous then, and he and Yves exchanged greetings since they knew each other." The setting was the Chelsea Hotel in the spring of 1961, when Klein was already famous, and infamous, for monochrome canvases that were simply plain fields of blue paint. Warhol saw some that same spring in Klein's solo show at Castelli, which was what had brought Klein over from France. Klein once did an entire show of such canvases, all perfectly identical except for very different price tags (he played the same game with prices at Castelli) and *Time* magazine wrote about how Klein had once presented an empty gallery as his art—an article that triggered irate readers' letters. Klein himself told a New York reporter that he'd painted a canvas with his pigment-covered feet (shades of Warhol's stepped-on paintings) and the humorist Art Buchwald had recently published a column about the works Klein made using naked women as his paintbrushes. When he got to New York, the Frenchman did a bunch more of those in the studio of Warhol's good friend Larry Rivers, a wacky performance Warhol must have heard of or even seen.

This was the wild man who Warhol got to know, at least a bit, in April and May of '61. The two would probably have met on one of the vast number of studio visits that Rivers arranged for the Frenchman among New York's artists such as Johns, Rauschenberg, Stella and a host of others, including several emerging figures in Pop Art. One way or another, Warhol was close enough to Klein to receive an invitation to his wedding in Paris only six months later. (The wedding reception was in a studio Rivers was

renting there.) In November 1962, not long after Klein's premature death, Warhol showed up at the opening of another Klein solo and seems to have bought a couple of its monochromes—from Alexander Iolas, no less, the dealer who had given Warhol his first show a decade before and would give him his last one a quarter century later. But even before that, Warhol had been introducing big blank fields into some of his earliest, hand-painted Pop paintings. The first Pop portrait he ever did, of Robert Rauschenberg, was silkscreened in black on top of Klein's trademark blue, thus paying homage to two predecessors at once. By 1963, Warhol had started pairing his Pop paintings with Kleinish canvases that he'd painted a single color. One notable scholar has even seen a strong link between Klein's absurdist parade of identical blue paintings and Warhol's equally unlikely display, weeks after Klein's death, of thirty-two barely different Campbell's Soups.

Klein presented a trickster persona that ranged from sage to simpleton to foppish self-promoter, deploying a deadpan Buster Keaton manner that was both charming and disconcerting. It's hard to think of any other artist who might have been as big an influence on Warhol as he began to construct his own public façade. After all, Klein had insisted that "a painter must paint only one masterpiece: himself, constantly, and thus become a kind of nuclear reactor, a kind of constant generator of beams that permeate the atmosphere." But the Frenchman also proved that such self-creation could do as much harm as good. One critic dismissed Klein as "the latest Sugar-Dada to jet in from the Parisian common market" and another wrote that "if people are foolish enough to take such nonsense seriously one can only congratulate the hoaxer"—pans that are very close to the first ones that Warhol's Pop Art would go on to get. Rivers, a defender of Klein, said that New York artists almost all dismissed him as "an impossibly ambitious phony." Klein, hoaxer and phony, is the most obvious model for Warhol, the "put-on artist," as he was widely described throughout the 1960s. The sheer quantity of coverage that Klein's hoaxing won must have pushed Warhol to go after some of his own. By the early 1970s, Warhol the headline hunter was being billed as an avatar of the long-dead Frenchman.

The influence may also have worked in the other direction. "I shout it out: 'KITSCH, THE CORNY, BAD TASTE.' This is a new notion in ART. While we're at it, let's forget ART altogether"—those words, which might as well have come from Warhol, are in fact from an essay Klein published just after his American trip and had no precedent in anything he'd said before. Almost no one still dares to find anything corny or anti-art in Klein's works, but it made fair sense in New York in 1961. The following year, Klein was

included in the first show that took the pulse of Pop Art, alongside figures such as Oldenburg and Lichtenstein—and Warhol.

———————

It can look as though there weren't a lot of notable events in Warhol's New York life in 1961, but that's a false impression: The action had simply moved inside, to the rooms in his house that he used for making art.

The downstairs parlor where Nathan Gluck was stationed was frantic with commercial work, despite Warhol's fall in income—or maybe to try to make up for it. Warhol mailed out an invoice for almost every single workday of that year, and they bill for everything from fabric designs to "bluegrass invitations" to filmstrips. (Hard to imagine what those filmstrips might have been, but one from 1960 brought in a vast fee of $1,000.) And shoes, shoes, shoes, of course, mostly drawn to advertise the footwear sold at Bonwit Teller, now his main client and the patron of his window work, which continued with displays he produced for the rest of the year in his more typical 1950s style. (His youthful Pop stylings seem to have been reserved for Gunther Jaeckel.)

And all the while, as Gluck remembered, Warhol would be running up and down from his own workroom just above, carrying canvases that his assistant never actually got to see being made but seem to have been Warhol's deep, if secret, preoccupation. He witnessed shows and reviews piling up for all sorts of friends and acquaintances—Philip Pearlstein, Larry Rivers, Alex Katz, Yves Klein, Balcomb Greene, even Warhol's schoolmate Gillian Jagger—while he himself still had almost nothing to show for his troubles.

That only changed because of a disappointment, of sorts, for Warhol. One day early in the fall of 1961, he'd shown up at Castelli's, where he'd become a regular of sorts—on top of his Jasper Johns lithos and Light Bulb drawing, he eventually went on to acquire those Moore paintings of Stella's and a big scrap-metal sculpture by John Chamberlain. (It wouldn't fit through Warhol's living room door so it lived out on the landing for years, as a shelf for courier packages; Warhola would beg her grandsons to help her throw it out.) As gallery director Ivan Karp recalled, he went to show his budding client a piece that a young artist had recently dropped off at the gallery, a comic-book painting by a certain Roy Lichtenstein. "And I showed that," Karp remembered, "and the young man, Warhol, the man with a very, very mottled complexion and a tuft of white hair, said, 'My God, I have, I have things in my studio that look, that look very much like this. Would you come

and visit with me?' I said, 'Well, where is your studio? I don't want to go to Queens.' He said, 'Oh, Queens.' He said, 'Oh, no, it's not Queens. It's a few blocks away on Lexington Avenue.' And I went to his studio the next, next week, and saw his work there for the first time."

But maybe Warhol's reaction to the Lichtensteins wasn't really about disappointment that someone had gotten to comic books first, as Karp himself sometimes told the story. It might have been just as much about his excitement at finding some kind of validation—at the city's most advanced gallery, no less—for his move to turn his display props into art.

Karp remembered visiting Warhol's baby-blue house and finding a very elegant living room with fine Victorian furnishings and some good paintings on the walls of a "generally surrealistic character" (no doubt Warhol's Matta and the Tchelitchew). The artist himself, a touch chubby at this newly bourgeois moment in his life, kept to the shadows to hide his bad skin. Stacked against a wall off to one side were some of the new Warhol canvases. Flipping through them, Karp was hit by "a sitting-up-in-bed kind of thing, thinking something very strange was going on in the art world." He was amazed at the sudden and simultaneous appearance of so much similar art by so many unconnected figures—Warhol plus Lichtenstein and Oldenburg, and also Tom Wesselmann and James Rosenquist. "The idea of doing blank, blunt, bleak stark images like this was contrary to the whole prevailing mood of the arts—but it gave me a chill," Karp remembered. No one saw Pop as light and cheerful until later.

Karp was the son of poor Flatbush Jews for whom success was as much about culture as money. After a bumpy start, he ended up with both. One '60s profile described Karp as dressing in "country-squire style" (corduroy jacket, gray shirt, plaid tie) and summarized his biography as a high school dropout, a factory worker, a film editor, a union organizer, a Good Humor salesman, a *Village Voice* art critic (its first) and finally the man at Castelli who "started the Pop bandwagon rolling." Karp joined de Antonio— another heterosexual—in Warhol's new circle of elite culturati. "Andy and I used to travel around to the shows all the time during his formative period," Karp remembered. "He always had very definite opinions about art, about what he liked. People say that he never talked about art, but he always talked about it." Unlike Warhol, Karp had a true, unironic love for popular culture—he was a connoisseur of the best rock and the worst B movies—and, according to Warhol himself, was one of the few people with a genuine "Pop style."

Karp was the first real booster of Warhol's fine art, bringing any number of people by the studio to see it and seeding Warhol's pictures into the

city's bravest collections. He had less success placing Warhol's paintings with dealers, who at best agreed to keep a picture or two in the back room: They thought Warhol's art was "crass and outrageous and concerned with commercial things," as Karp put it.

Karp pulled one new figure into Warhol's orbit who turned out to be more important than any collector or dealer. That was Henry Geldzahler, a new-minted art lover who had somehow wangled the unglamorous title of "curatorial assistant" at the Metropolitan Museum of Art. His mandate was to bring that "dinosaur"—Geldzahler's word—up to speed on the new ferment in the New York art world. He joined de Antonio and Karp as a third musketeer, with Warhol as their d'Artagnan.

Like Karp, Geldzahler was a Jew, but not the Brooklyn kind that ate Chinese food on the Sabbath. The Orthodox Geldzahlers had been diamond merchants in Belgium, and when Hitler became a threat they transferred their business and wealth from Antwerp to New York. Geldzahler, a brilliant child with an "unhealthy" love of museums, poetry and Broadway shows, went to Yale and then Harvard, where he was "the most cool of a very cool bunch of people." Like Warhol, Geldzahler's first hero in art was Ben Shahn, with the difference that he got to room with that idol's son. Deciding to drop his Harvard Ph.D. on Matisse in order to plunge into the chaos of contemporary art, Geldzahler withdrew his bar mitzvah money to buy one of Frank Stella's new abstractions.

Geldzahler, naïve but "full of high spirits and energy," decided to launch his assault on New York by knocking on Karp's door one summer in Provincetown. "He said, 'Ivan, I'm about to go to New York and I want you to tell me everyone I should meet, everybody I should know, everything I should do, everything I should say, how to speak, how to act, how to dress, how to think, how to talk.' So I gave him a thirty-minute session."

Within a year, Geldzahler had moved to New York for his job at the Met, where he first showed up for work on July 15, 1960. Geldzahler said that he'd got his start at the "lowest end of the curatorial ladder," but the truth is he was barely on it at all. His independent wealth had let him accept a salary of just $5,000 to be the Met's eyes and ears on the new contemporary scene, a job description he wrote for himself. "For five or six years I just was in Happenings and I went to studios and was in movies and got to know the artists and the collectors; it was really on-the-job training." *Life* magazine described him as "the most 'In' and gadabout man in the art world." He was rarely to be seen at his museum, which rankled some of his colleagues, and the trustees almost gave him the boot when he was photographed sailing a rubber dinghy in a performance by Claes Oldenburg.

There was also the fact that the museum got almost no visible product from his labors, in terms of works bought or shows mounted.

The painter David Hockney remembered Geldzahler as utterly cocky, especially given that he was all of twenty-five when he hit the scene. The curator looked even younger than he was, with the soft body of a gym-hating twelve-year-old and sandy-blond hair worn in a sweep of Christopher Robin bangs, absurdly long and girlish for a man of that era. "Henry loved the physical world, he loved food and companionship, he loved his sexuality and he was immensely open about it," Karp said—although Geldzahler had once confessed to his diary that being gay revolted him. De Antonio felt that Geldzahler's parents hadn't "cottoned warmly" to their queer son. "Henry when I first knew him spent many nights on 42nd Street looking for movie ushers to take home for love, cigars and sly tales. . . . He was the safe witty fag that rich fathers and husbands encouraged. The telephone was his instrument of power. He whispered jokes and nasty gossip to ladies of power"—whispering that soon became Warhol's trademark as well.

Geldzahler's job, if it can be described as that, at first mostly involved traipsing after the younger dealers as they did their rounds in the art scene. One epochal day he followed Karp to Warhol's town house, where the artist was at work on his earliest Pop. "I walked into the studio, we looked at each other and we both started laughing. And I saw on a shelf behind him one of Carmen Miranda's shoes that he'd bought at an auction, and he was painting on the floor with the television set playing and he was watching television and painting. I thought, 'That's the most modern thing I ever saw,'" Geldzahler remembered. "I recognized with a kind of thrill that I was in the presence of, well, let's say a genius, or someone who epitomizes the age."

The next day, Geldzahler cemented their bond by letting Warhol into the vaults of the Met for a firsthand look at the childlike paintings of Florine Stettheimer, a 1920s friend of Marcel Duchamp whose style was a close match for (and no doubt an influence on) works by Carol Blanchard, Warhol's favorite illustrator. "He was particularly interested in certain aspects of naïf painting," said Geldzahler, one of the few observers acute enough to recognize this vital strand in Warhol's aesthetic. "We started laughing again and we saw each other every day after that." Geldzahler said that his days came to begin and end with a long call from Warhol—a claim made by so many Warholians that it's hard to see what time Warhol had left for painting.

Geldzahler liked to tell the story of a frantic phone call he once got from

his friend at 2 A.M., begging him to meet him at the toney Brasserie in the
Seagram Building, which Warhol had helped decorate.

> "Andy, it's late," I said. "I'm in bed, can't it wait?"
>
> "No, it's important," he insisted, "we've got to talk."
>
> "O.K., give me half an hour. I'll be there." When I arrived at the
> restaurant, Andy was sitting in a booth, waiting for me. For a minute
> or two there was silence, while I waited for him to broach the sub-
> ject. Finally, I asked him why he had gotten me out of bed.
>
> Andy said, "We've got to talk . . . say something."

---

On Ivan Karp's first studio visit with Warhol, he recognized the audacity and
novelty of the new work. He also warned the artist that most of the art world
would be against him if he kept dealing with such "brutish imagery." Then
he pushed Warhol into making his paintings as brutish as possible, according
to Karp's recollection of one of the first discussions they had about the new
Pop pieces:

WARHOL: Do you really like them?

KARP: Well, they are astonishing, but I like some better than others.

WARHOL: Which ones?

KARP: Well, some of the paintings here have all kinds of drip marks.

WARHOL: Well, you have to do that; you must drip.

KARP: Well, why must you drip?

WARHOL: Well, it means you're an artist, if you drip. And of course
you're paying homage to Pollock and all the great dripsters.

KARP: No, you don't have to drip—maybe you don't have to drip *at all!*
If you're going to deal with these kind of simple images, maybe
you can just deal with them, in God's name.

WARHOL: That's just wonderful that you should say that, because I
don't think that I *want* to drip.

There are a number of strange things about this scene, beyond the fact
that Karp narrated it in any number of different versions. One of the strang-
est is that several other people in Warhol's new circle of friends claimed to
have had the same encounter.

De Antonio in particular talks about a special, boozy evening when
Warhol invited him and Tina Fredericks over for drinks. "Andy had taken off

his casual, quiet air and it was evident that this night counted. First whiskey and gossip—always outrageous, grotesque, usually true"—and then, said de Antonio, a test, although it's hard to know if it was gauging Warhol's art or his friends' acuity. Warhol asked his visitors to look at two almost-identical paintings of a Coca-Cola bottle, one with "Abstract Expressionist hash-marks" added on here and there, as de Antonio described it, and the other just done in outline in bold black-and-white. "Well look, Andy, one of these is a piece of shit, simply a little bit of everything" was de Antonio's reaction. "The other thing is remarkable. It's our society, it's who we are, it's absolutely beautiful and naked, and if you want me to say which is better, there's no doubt that you ought to destroy one and show the other."

If Warhol was testing his friends by showing them the two options for his art, they only got their answers half right. They were correct to see the "clean" option as the better way to go, but they were wrong to see the "messy" option as Abstract Expressionist—Warhol had never shown any interest in joining that movement, and anyway his unfailing nose for the new had told him that AbEx was passé.

"We all know expressionism has moved to the suburbs," wrote Larry Rivers and Frank O'Hara, from the de Nagy crowd, at just the moment of Warhol's Coke test. (Although as late as 1963 a New York guidebook could still describe AbEx as the questionable "fashion of the moment" and suggest that Ben Shahn might be a better bet for the ages.) Warhol himself is supposed to have told an old friend that he was starting Pop Art "because I hate Abstract Expressionism," and a decade later he joked that he wished he was an AbEx-er—because it was such an absurdly easy way to turn out big paintings, fast. When he visited the Cedar Tavern, the famous HQ of AbEx, Warhol went so far as to try to pick up a young man who was there—an obvious affront to the bar's macho traditions. He once complained that Willem de Kooning couldn't really be as important as he was made out to be because "his women are just so similar to Picasso's women."

In fact, the hash marks and drips and haphazard corrections in Warhol's earliest Pop paintings were random, uncontrolled, accidental, just the opposite of the highly willed, self-expressive mark making of the AbEx masters. Where AbEx paintings were supposed to register the passionate "event" of their making, as one famous critic put it, it might be better to describe Warhol's casual messes as the ultimate in nonevents. The roots of Warhol's messes weren't in Jackson Pollock's skeins of paint, that is, but in John Cage's chance operations, with some classic outsiderist chaos thrown in. The sloppy white-outs in the texts of Warhol's comic-book paintings

look like details from old country-store signs; apparently "artful" splashes of color on his copies of ads are actually faithful echoes of scrap paper taped onto the clippings he was copying from. Warhol's Pop Art, said one curator friend of his, had its roots in a crowd of artists, composers and choreographers who had embraced "the random elements of chance which best approximate the chaos they feel in the world." Which really means that the closest kin to his "drippy" paintings were Cageian works by his new heroes Jasper Johns and Robert Rauschenberg, both of whom favored vibrant, scribbly, layered surfaces close to Warhol's.

One of the smartest of the art lovers subjected to Warhol's drip test immediately spotted Rauschenberg, not AbEx, as the source of the messy Coke bottles. The Rauschenberg canvas Warhol had seen in the 1957 Bonwit Teller window was full of random drips; in other landmark works Rauschenberg's drips actually ran down from collaged comic strips that prefigured Warhol's *Superman* and *Popeye*. The Johns drawings Warhol had seen at Castelli in '58 were chockablock with the artist's signature "hash marks"—what one scholar has called "the meta-brushstrokes of his pseudo-gestural pastiches of de Kooning and Pollock," which is a phrase that might apply just as well to the ungainly hatchings on Warhol's Coke-bottle paintings.

And what Warhol had already figured out—what de Antonio and Karp were merely confirming—was that he needed to move beyond all that. There's a story about Warhol taking in a Rauschenberg at MoMA with a friend: "That's a piece of shit!" Warhol said, and then admitted that he'd need to think of something very different if he was going to surpass it. That turned out to involve getting rid of his drips and white-outs, which flagged his debt to Johns and Rauschenberg, the men he most needed to beat in the art-world sweepstakes. As late as 1966, Warhol was still being panned as nothing more than a Johns wannabe.

As the sixties dawned, Johns, just two years past his first solo show, was already being pointed out as a landmark on *Esquire*'s map of "In" New York, getting equal billing with Café Nicholson, Warhol's long-standing hangout. (More painfully for Warhol, Richard Avedon is also listed as "In" and Tiffany lampshades are "Out.") Proof of a matching apotheosis for Rauschenberg came in March 1962, with that year's first issue of *Art in America*, a hardbound and impressive quarterly. It was headlined "New Talent USA," and both front and back covers were given over to an image that had been specially commissioned from Rauschenberg. That image featured scraps of Pop subject matter (a "Danger Ahead" road sign; a commercial clock face; bright red exclamation points) that were almost lost in a welter of the same hash marks

Warhol had been copying. Inside the issue, however, a present was lurking for Warhol: Most of one page was filled with a nice big reproduction of one of his new "advertising" paintings, in this case copying an ad for a storm window, complete with its price of $12.88. But what that reproduction was really advertising was Warhol himself, as just possibly the newest of the New Talents the magazine was promoting. This was the very first coverage that Warhol's Pop Art would receive.

Almost all of the issue's other up-and-comers were still working in the brushy expressive styles that had been standard for most of the previous decade. Even Rauschenberg's cover, with its magpie borrowings from here and there in popular culture, looks relatively conventional compared to Warhol's strange, four-square appropriation of a single found image—still brushy and drippy in parts, but clearly built on a radical premise.

Warhol's new move has usually been described in terms of its new subject matter, lifted up into fine art out of the swamp of pop culture, but that doesn't do justice to his true achievement. After all, in terms of simple subject matter, years before he was propping his Gunther Jaeckel window, a high-culture taste for the "common" had already begun to spread, as several critics recognized in Pop's early days.

Back in 1949, when Warhol's pal Russell Lynes was describing a new elite built on culture, he had said that these highbrows were likely to be comics connoisseurs, and in fact a whole host of 1950s fine artists including Willem de Kooning, Ray Johnson, Robert Rauschenberg and even Warhol's roommate Philip Pearlstein had included comic-strip details in their fine art. Warhol would have heard about the influence of comics on high art as early as 1946, in his college art-history textbook: "The large numbers of murals created in the United States between 1910 and 1935 . . . show the composition and color schemes to be found in the folk art of the colored comic strips to which, over the last forty years, American children have been conditioned."

Brand imagery had been an equally popular motif for artists, from the Champion spark plugs in 1930s paintings by Stuart Davis (researched by a schoolmate of Warhol's), to the Lucky Strike packs in works by Warhol's friend Ray Johnson to the piles of logos in the most recent Rauschenbergs. In the very same magazine that billed Warhol as a "New Talent," the artist and critic Fairfield Porter—who had recently done his portrait of Warhol and Ted Carey—praises a soon-to-be rival of Warhol's named Alex Katz, describing how he "takes off from the comic strip and advertising: He humanizes banality and finds art in the commonplace." Jane Freilicher, a colleague of Porter's in the de Nagy stable, had also made a recent stab at popular subject

matter, painting images of Liz Taylor, Mike Todd and Marilyn Monroe, all of whom Warhol eventually took on as well.

In 1957, when an upper-crust British architect toured the United States, he declared a jukebox, "in its vulgar vitality," to be a "genuine piece of mid-century 'pop art'"—a term that had just then been coined in England—and he was already talking about pop culture's influence on the latest batch of European fine artists before any of them had officially declared themselves Pop. (Warhol might have gotten his first whiff of Pop from a magazine that featured such European art, according to one friend of his.)

A hotshot young writer in New York at the time celebrated "a ruthless love for what is," saying that his compatriots "are hungry and desperate for straightforward communication about the life we are *all leading in common.*" In the same "New Talent" issue of *Art in America* that featured Warhol, the young painter Peter Saul proclaimed his commitment to "an imagery clearly related to contemporary American civilization," and included brand names and price tags in the painting of his that was featured.

Warhol's Pop experiment stood out from all those precedents because of how he deployed the imagery he'd borrowed from the everyday. Instead of making them the subject matter of an art that included other things—Rauschenberg's brand logos, for instance, were just allusive details in his illustrations of Dante—Warhol set out to erase most distinctions between his sources and his finished works. That was what he was really after when he got rid of the arty, drippy messes he'd borrowed from Johns and Rauschenberg. Those messes had let Warhol's two idols cede control to the operations of chance, but that was hardly all that new: It was a move that dated back to Dada and Surrealist experiments with randomness. Warhol's new, clean paintings ceded control as well, but to another, much more radical force outside himself that, in the art world at least, was close to taboo: capitalist consumerism. Warhol's colleague Roy Lichtenstein re-membered how, in those very first moments of Pop, their desire to shock got them to embrace that taboo: "It was hard to get a painting that was despicable enough so that no one would hang it—everybody was hanging everything. . . . The one thing everyone hated was commercial art." So that, of course, is where he and Warhol had headed. Although Warhol was actually a contemporary of Johns and Rauschenberg (Johns was in fact younger than him), his audacious innovation managed the extraordinary and very Warholian trick of aging them out as his "predecessors"—a trick that has stuck in textbooks to this day.

Like so many of his successes, Warhol's crablike entry into the world of serious art might have come about through his social networks. The

opening editorial in that "New Talent" issue had been written by the head of fine arts at Carnegie Tech. He was a member of the *Art in America* board who was up-to-date enough to mention both Cage and Rauschenberg in his essay—and perhaps to have recognized and promoted the talents of his school's most successful alumnus. On top of that, the section of the magazine where Warhol appeared had been curated by a collector and former Hollywood star who was close to Gian Carlo Menotti, the patron of Warhol's operetta designs, and who had married a friend of Warhol's named Ruth Ford. She was the sister of the writer Charles Henri Ford, a giant in the gay circles Warhol moved in and the life partner of Pavel Tchelitchew, whose works Warhol owned.

However stage-managed it might have been, Warhol's designation as a New Talent, and the sheer talent visible in his work, had put him in the thick of the artistic revolution that was brewing in those very months. In December 1961, Claes Oldenburg, who was the only other Popster featured alongside Warhol as a New Talent (in the magazine's sculpture section), had just mounted *The Store*, a landmark installation where he sold papier-mâché copies of everyday merchandise. Warhol saw it and was so sick with jealousy that he skipped a friend's dinner party. Then in January, Lichtenstein had his first solo at Castelli, where he sold every one of his cartoon paintings. And then before that had even closed James Rosenquist opened his own first solo at Green Gallery, a new cutting-edge space, showing giant paintings based on the magazine clippings that papered the walls of his loft—including one clipping from a Campbell's Soup ad. Warhol, said a friend, "was just so depressed that it was all happening and he was not getting any recognition"—a situation remedied at one go, but just barely in time, by his appearance in *Art in America*.

———

Warhol's final breakthrough into '60s Pop came through a project he'd begun in the '50s, his so-called Foot Book. He was still asking for sockless drawing sessions with all kinds of celebrities, semicelebrities and great unknowns. One of those was a minor dealer on the New York scene named Muriel Latow, who was trying to take steps in the art world that paralleled Warhol's. She was a flamboyant decorator, three years younger than Warhol, who had hopes of becoming a serious art dealer with a gallery that never took off. In its two years of existence its shows of minor Abstract Expressionists were mostly panned in the *Times*—with the exception of a canny show of paintings by the celebrated dealer Betty Parsons, whose feet Warhol went on to draw. Feet also brought Warhol and Latow

close. He sketched her with her legs entwined in the legs of her lover, a handsome artist who was Warhol's unrequited crush of the moment: "When he drew us, his eyes got watery and his face was flushed," Latow recalled. She pops up a bit in Warhol's datebook for 1961—they visited MoMA for a Max Ernst show—but there's no sign that she showed any interest in Warhol's new pictures or that he thought of her as a promising merchant for them.

She has, however, gone down in history as Pop Art's most important, if accidental, muse. As the story is told—in at least one of its many, mostly incompatible versions—Latow and their mutual friend Ted Carey came over to Warhol's house in the fall of '61 to console him for having been one-upped by Oldenburg and Lichtenstein and other up-and-comers of Pop who had got the jump on him. "The cartoon paintings . . . it's too late," Warhol is supposed to have said. "I've got to do something that really will have a lot of impact, that will be different enough from Lichtenstein and Rosenquist—that will be very personal, that won't look like I'm do-ing exactly what they're doing." He begged his guests for ideas and Latow came up with one, but wouldn't deliver until Warhol handed over a check for $50. "You've got to find something that's recognizable to almost ev-erybody," she said. "Something you see every day that everybody would recognize. Something like a can of Campbell's Soup." By the very next day, Warhol—or his mother, in another telling—had run out to the Finast supermarket across the street and picked up every Campbell's Soup that it carried, an inventory that he later checked for completeness against a list he got from the soupmaker.

The whole story sounds as apocryphal as most of the other origin stories connected to Warhol—except that the actual check Warhol wrote to Latow seems to have survived.

Over the decades, Warhol himself embroidered and obscured the gen-esis of his signature Campbell's paintings, which his friend Geldzahler once lauded as "the *Nude Descending a Staircase* of the Pop movement." Warhol claimed that as a kid his mother had served him canned soup every day (an unlikely extravagance for a frugal soupmaker like her, in an era when such brands were still targeted at the elites) and that this led to a lifelong love of the Campbell's product—or, as he was equally happy to insist, to an utter hatred of it. Nathan Gluck said that stories of Julia Warhola serving canned soup were "ridiculous," because in fact she always cooked her own for their studio lunches—not tomato but mushroom or potato. When soup comes up as an actual dish in Warhol's life, a dozen years after the Latow incident, he's cooking a fresh-tomato version, from scratch, that sounds like

a sophisticate's repudiation of Campbell's. Even when it came to canned soup, he talked about how the esoteric Mock Turtle flavor was his favorite, "but I must have been the only one buying it because they discontinued it." And toward the end of his life he once again credited his mother as his cans' inspiration but this time without any mention of soup. Instead he cited the flowers that she made out of empty peach tins and sold door-to-door during the Great Depression—an interesting idea if only because there's a painting of a can of Del Monte peaches that seems to predate Warhol's more famous Campbell's images.

The key to understanding the importance of the Campbell's products for Warhol may be less about biography than ubiquity—Latow's "something that's recognizable to almost everybody." Soups might have replaced peaches in Warhol's art and reputation because they were better known, not because they meant more to him. In a Hollywood thriller from 1957, a man tells his dinner date that he's an artist, and she asks, "Soup cans or sunsets?"— with soup cans clearly standing in for all of commercial art. "Soup cans, toothpaste, automobiles" is his answer. About a year before Warhol's first soup works, the publisher Bennett Cerf—who would release a Pop book by Warhol within a few years—wrote a comic newspaper column asking, "The nation's favorite beverage? Is it beer? corn liker? soda pop? No sir, it's soup. . . . Over ten billion bowlfuls of soup were purchased by America's housewives in 1959." Scholar Anthony Grudin has shown how, just around then, famous brands like Campbell's were being retargeted away from elites and toward the working class: "Working class families today are reaching out for the American Dream. . . . They want 'all the good things of life' their Depression-wracked parents could never provide," said one period study on brand advertising.

If Warhol wanted a "recognizable" product of certifiably popular culture to turn into fancy art, Campbell's Soup seemed likely to beat even Superman and Popeye and to get him out from under the shadow of Lichtenstein at the same time. As Grudin has pointed out, being the limner of Campbell's let Warhol construct a working-class connection for himself and his art. That was of a piece with the common-man, Andy Paperbag persona he never really let go of, even when he was appealing to, and running with, the country's highest stratum; it also communicated the left-wing sympathies that Warhol always had, and that were de rigueur among the most serious thinkers of his generation.

The Campbell's can had one other virtue for Warhol at this particular moment: It meshed nicely with the camp, 1950s aesthetic he had yet to shed. The Campbell's label, launched in 1898, fit camp's nostalgic tastes: Both label

and price had barely changed in the fifty years before Warhol's Pop was born. That brought those soup cans under the same umbrella as his Coca-Cola bottles, whose design dated to 1915, as his Dollar Bills, with their equally vintage look, and as the claw-foot bathtub and candlestick telephone that Warhol had been painting that same year. The gay curator Mario Amaya said that "East Side faggots"—that is, the Serendipity crowd—instantly read the cans as a camp joke. In fact Warhol drew the nude feet of one such "faggot" pressed against a Campbell's Soup tin on which only the letters C-A-M-P were left visible.

There's one final reading of the cans, and it's the one that originates with Warhol himself. Shortly after the Campbell's Soups had gone viral, Warhol is supposed to have explained them to an old friend as "the synthesis of nothingness." That gnomic account probably doesn't have to do with the Existentialist, atomic-age doubt that it calls to mind. Warhol's "nothing-ness" probably comes closer to being precisely the opposite of such AbEx "hullaballoo," as Frank Stella called it. Warhol had actually offered it up as what another friend called "the Dada reply": The soups were to be seen as a pure, dumb, Duchampian gesture, a mere "nothing," chosen almost at random—because they were there, the first thing that came to hand—rather than for anything they might represent.

All these decades later, it's hard for us to recognize that achieving simple somethingness—any kind of representation at all, regardless of content— was the big challenge facing ambitious artists around the time that Warhol emerged. One of Warhol's most astute supporters said that the very first time he saw Warhol's Pop paintings he was still so steeped in abstraction that he could only see them at all in terms of their "formal arrangements"; he was still pretty much blind to even the idea of representation. Warhol's friend Larry Rivers might have made paintings that were big stars in the move back toward figuration, but even he couldn't move beyond billing them pretty much as abstractions: "Only for the primitive and the semantically misin-formed can enthusiasm for subject matter be the inspiration for painting." As Henry Geldzahler put it, the question facing everyone was "How, after a period of tremendously convincing abstraction, to bring back a kind of rec-ognizable subject matter into art?"

The most sophisticated viewers who had trouble with Pop Art when it first emerged—and they included some later fans—questioned Pop's subject-ness rather than its particular subjects. As one of them put it, "It is in bad Pop art that we see subjects like . . . Campbell's Soup rendered in a pic-torial or illustrative manner"—that is, rendered without any of the formal inventiveness, the "transformation," that had always made an image count

as art and that might come close to justifying the art of an Oldenburg or a Lichtenstein. Even the brilliant thinker Leo Steinberg said that he couldn't quite tell if Pop Art was art at all, because the sheer intensity of its commitment to subject matter blinded him to "whatever painterly qualities there might be"—"painterly qualities," and not subject matter, being what made art count as art in that post-AbEx moment. Even as late as 1969, when Warhol had spent years as a bona fide art star, a critic could still be worrying about the fact that "his paintings and silk screens have almost invariably been reproductions of things done by other people. . . . His chief function seems to be merely choosing the subjects."

It was just about possible to rethink the panels from a comic book as appealing paintings—they had their own striking style, after all—and you could pretty much do the same with a newspaper ad or a Coke bottle, so long as it had been transformed by means of drips and scrawls and erasures. Pure supermarket merchandising, however, where all that mattered was presenting a product for shoppers to load into their carts, was the ultimate in the unartful. So of course Warhol set out to capture just that in his paintings, as the perfect example of undiluted subject-ness.

In Warhol's commercial career, photography's sheer ability to present us with stuff—the VW Beetle on a white background—had doomed his stylish, hand-drawn illustrations. So Warhol, always willing to fight fire with fire, took photography's directness and turned it into fine art. He got Ed Wallowitch, his ex and still a good friend, to give him photos of soup cans in every state: pristine and flattened, closed and opened, single and stacked. And then, for something like the following year, the front room at the top of his town house saw him meticulously hand-painting those products onto canvases of every size. His goal was to make his soup paintings look as plain and direct as he possibly could, as though the cans had leaped straight from the supermarket shelf, or the kitchen counter or trash, onto his canvases. But in fact he had to come up with all kinds of clever techniques to get that effect, cutting stencils to get his product's labels just right and mixing oil- and water-based paints so as to perfectly capture the speckled look of a can's tarnished tin. That mix let him replace the artistic, haphazard messes of Abstract Expressionism with messes found ready-made on the metal of soup cans, then rendered by Warhol with immaculate care. The sheer perfection of his tarnished metal shows Warhol, so busy pretending to cut all ties to craft and tradition, actually becoming the latest in an ancient line of painters of trompe l'oeil, most craft obsessed and conservative of all Western artists.

Nevertheless, when Warhol told one of his college "mothers" about his

brand-new Campbell's paintings, she was distraught at the waste of the talents he'd acquired in art school: "They just seemed like about as vacuous a statement as you could make as far as painting was concerned," she said, echoing the feelings of his other '50s friends. Warhol, however, was not to be discouraged: "Oh it's the latest thing, the latest thing!" he told her. "You just take something very ordinary, and this is going to be the end thing and it is just gonna take off like a rocket."

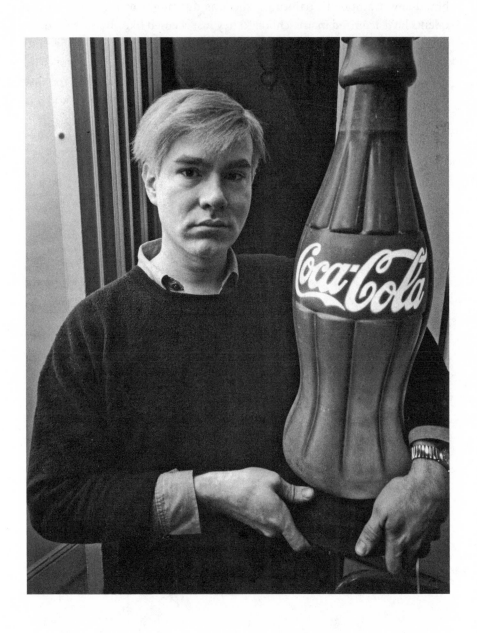

*. . . with a camp collectible.*

# 14

## 1961-1962

*"A sort of gum-chewing, seemingly naive teenybopper,
addicted to the lowest forms of popular culture"*

Poetry in motion
See her gentle sway
A wave out on the ocean
Could never move that way
I love every movement
And there's nothing I would change
She doesn't need improvement
She's much too nice to rearrange

This was the fine poetizing heard by one early visitor to Warhol's town
house, care of the boy-rocker Johnny Tillotson and the custom stereo that
Warhol had paid to have installed. It had a turntable that played the same
single on endless repeat and fancy British speakers that thudded out the
bass notes. "The record seemed a mismating with the highly sophisticated
paintings," said the critic Gene Swenson, who had just been asked to weigh
in on Warhol's drips. "I asked him to turn it off, and he said, in that trick
voice of his, 'Oh, all right.' . . . When I knew him better, I listened more
carefully."

Ivan Karp remembered a similarly saccharine tune playing "ninety
times at incredible volume so it was a difficult experience to be there"—
but possibly less difficult than actually catching a glimpse of Warhol's latest
art. He kept his living room studio in near darkness—its wooden shutters
were almost always closed—and made even the most imperious of collec-

tors join him in wearing little carnival masks that couldn't have helped people see. Exceptionally, the dealer Leo Castelli got away without a mask the first time Karp brought him by the studio, but the theatrics were still too much for him. In a Polaroid from Warhol's town house Karp looks vaguely at home while Castelli looks mildly tortured. The dealer bought a couple of Soup Can paintings but couldn't bring himself to put their weird maker onto his gallery roster. According to Karp, Castelli justified that decision, even to himself, by saying that Warhol's art was too close to Roy Lichtenstein's, who he was already representing, but the real problem was "basically Warhol's character and the whole scene there—it was so bizarre to him."

Warhol has come down as one of our more fearsome eccentrics, but right through the 1950s he was still playing pixie, standing out from the crowd by pretending to barely be there. He might have witnessed Greenwich Village bohemia, and admired it, but he had mostly remained outside of it as a visitor from uptown. Warhol only headed for a more aggressive idiosyncrasy, in his persona, at the same moment in the 1960s that he committed to aggression and idiosyncrasy in his art. His paintings had become so peculiar that even the most sophisticated viewers could barely tell Warhol's comics from a window dresser's props, or his image of a soup can from an ad for soup: "The painting looks as disposable as the original it is modeled from: something to be thrown away, or the cheapest kind of advertising, of no value except as a message to sell." There was doubt about whether Warhol's works could even count as art. To fight this confusion, he needed to make clear that his ambiguous objects had been put on this earth by someone who was every bit the artiste and who played the part with panache. When Duchamp launched his urinal on America, he was already the most famous modern painter in the country; he could play tricks with plumbing supplies and expect them to be understood as tricks about art. In the spring of 1962, Warhol was still a couple of years away from having that luxury. He was still in the early stages of cultivating "the subtle publicity of the myth, the legend that the artist creates around his work," seen as vital to success in one period article about the late-1950s art boom.

"His metamorphosis into a pop persona was calculated and deliberate," wrote his friend the art critic David Bourdon. "The foppery was left behind and he gradually evolved from a sophisticate, who held subscription tickets to the Metropolitan Opera"—Bourdon had first met Warhol in that incarnation—"into a sort of gum-chewing, seemingly naive teenybopper, addicted to the lowest forms of popular culture." Warhol's 1950s illustrations had something childlike about them, as their fans liked to mention. In the

early '60s, as his art became more adult and challenging, his persona became ever more juvenile. A prominent art critic, trying to come to grips with the complexities of Pop Art, nevertheless described Warhol as having "a wide-eyed, charming, impudent face that you expect to see smeared with jam from an after-school sandwich." When *Time* magazine at last decided that it needed to dedicate an issue to the new American teenager (not so new once *Time* got around to the subject), Warhol was the obvious artist to portray those teens for the cover.

Despite its apparent lightheartedness, the ingénue pose that Warhol adopted in the early 1960s actually counted as the latest in avant-garde gestures—a lived polemic against the portentous seriousness of previous generations of American artists. According to Ivan Karp, Warhol came to admire rock and roll for the music's radical directness: "It was good; it was naïve, it was full of spirit and high rhythm. . . . There was no complex worldly wisdom involved. It was just good straightforward stuff."

Ben Shahn, Warhol's college hero but now an obvious fuddy-duddy, had begun to inveigh against a "know-nothing school of aesthetics" that billed "ignorance and instability" as the artist's natural state. That was the stylish new shoe that fit Warhol, and he went out of his way to wear it.

Warhol's juvenilization did not happen overnight. You can see him working his way into his new skin. In that magazine feature that declared him a New Talent, he supplied a little statement that sounds like a sober sophisticate's guide to his art. He begins with an inoculation against accusations of cultural treason: "I adore America." And then he explains, more critically, that his storm-window painting "is a statement of the symbols of the harsh, impersonal products and brash materialist objects on which America is built today. It is a projection of everything that can be bought and sold, the practical but impermanent symbols that sustain us." But that grown-up prose didn't stop him from shaving three years off his age in the bio that went with it, and lying that he had been self-taught.

Within a few months, on Bourdon's first visit to the Lexington Avenue house, Warhol had shaved off another five years, trying to pass himself off as a callow twenty-five-year-old. (Bourdon wasn't buying it.) That same spring an artist friend remembered Warhol stenciling soup can after soup can "in a kind of autistic frenzy . . . with the music of the Shirelles on constantly." The creative furor of a Jackson Pollock had been updated for a new age of youth culture.

The posh British siblings David and Sarah Dalton took Warhol even further down the road to youth: David was not yet twenty and Sarah was only fifteen when they became regulars at the town house, beginning in

the winter and then spring of 1962. Forever after Warhol had a thing for fancy Brits.

The two private schoolers had started out as frequent visitors to Castelli's gallery, and once Ivan Karp decided to show them the "real New York," Warhol became part of the mix. The siblings could be counted on to show up after school and on weekends, when Gluck had gone home and Warhol's fine art life took over. There are polaroids of Sarah in a bikini in the town house—she might have been modeling for an illustration—as she became more and more a kind of "mascot" to Warhol, she said, or maybe a friend whose chronological age matched the teenagehood he aspired to.

"Andy needs to find a nice girl like you, and get married," said Julia Warhola when she peeked in on them one day. (It was a line she went on to use on all of Warhol's female friends.) Sarah Dalton was the first in a string of children and young teens—girls, most especially—who Warhol would befriend over the years, and who all felt sincerely loved by him. In 1961, Warhol's own gum chewing might have been a new pose, but it reflected a genuine and lifelong interest in the worldview and culture of actual gum chewers.

That culture, apparently unserious and superficial, was just then reaching the avant-garde as a source of serious and profound creative ideas. Even the cerebral John Cage admitted that the new postabstract art of Rauschenberg and his crowd was helping him open up to "television, radio, and Muzak. . . . Formerly, for me, they were a source of irritation. Now, they are just as lively as ever, but I have changed. I am more and more realizing, that is to say, that I have ears and can hear."

Karp in particular loved the new rock and roll and remembered bringing the entire Pop crowd, including Lichtenstein and Bourdon, to the Fox Theater in Brooklyn to take it in in the first years of the 1960s. "Andy heard that everybody was out there, and he said, 'How do you get there, and where is it, and what goes on there?'" Karp remembered. "And we sat there in the audience for two sessions completely waiting to see the same people over and over again. It was just very thrilling to us."

Warhol's companions noted that he never became a fan of pop music for its own sake. At best he liked it for "its tremendous force and conviction," according to Karp.

"I don't like to listen to music. . . . I can't stand it when the kids at the office turn it on," Warhol later said. But he was always willing to entertain pop songs as necessary props in building his persona: For one early photo, he posed himself with one of the new transistor radios glued to his ear.

Some Pop music might also have been a more direct artistic inspiration: Some of the singles Warhol is known to have played, such as "Sally Go 'Round the Roses," have lyrics that repeat endlessly much the way that his Pop silkscreens do. In an early letter describing a visit to see Warhol's work, his clever friend Ray Johnson fills a full page and a half with the single repeated phrase "we saw his recent paintings of Liz Taylor as we heard 'That Little Town Flirt.'"

Popular music could also function, in almost Cagean terms, as a subject for aesthetic analysis. When one guest at the town house wondered why they had to hear the same single so many times in a row, Warhol explained that the singer must have rehearsed and recorded it time after time, and, said Warhol, "I really want to suffer along with him and really find out what this is all about." That's closer to the thinking of a psychologist than of a fan boy; it also anticipates the kind of "suffering" that Warhol imposed on his viewers with the endless repetitions in his paintings and films. When one posh collector paid Warhol a visit he was blasting rock and Bach at the same time, in a cacophony worthy of the latest in experimental music.

Friends said that, in private, he could switch off his silly-teen routine at will. An acquaintance with Pittsburgh connections said that when he ran into Warhol at a party in the late 1960s, "We picked up with just ordinary talk. He never talked in that wispy way, he never said 'Oh, I don't know.' . . . We knew the same people in Pittsburgh, and it would have been too fake. He knew that."

The Los Angeles dealers Irving Blum and Walter Hopps, who went on to give Warhol his first Pop Art solo, both remembered having perfectly normal, even "illuminating" conversations about art and the art world on their first visits to the town house, in late 1961. Warhol, Blum said, was "really interested in the art world, and really bright and wonderful to talk to, much more revealing than he was later. He said what he felt about things. . . . He knew exactly who the players were." And Blum remembered such conversation slipping out of Warhol's repertoire as time went on. More and more, Warhol was starting to present himself as a curious mix of sphinx and fool, passive almost to the point of catatonia. An acquaintance described Warhol developing a trademark whisper that sounded "as if someone had just punched you in the stomach." He also described how Warhol's sibilance eventually spread like an infection to the younger men on the scene. In the earliest days of Warhol's Pop he had yet to assume his full cool-cat-in-Ray-Bans uniform; it would be a good few years before chinos and tweed were replaced by his famous leather jacket. But weirdness was on the agenda and

lighthearted camp was on the way out, in a radical personal transformation that was as important for Warhol's life and career as the transformation going on in his art.

*Time* magazine gave the first public account of Warhol as we've come to know him, at just the moment when Pop Art was beginning to become a full-blown media sensation:

> Andy Warhol, 31, best plays the part of what a pop artist might expectably be. In his studio, a single pop tune may blare from his phonograph over and over again. Movie magazines, Elvis Presley albums, copies of Teen Pinups and Teen Stars Albums litter the place. Warhol is known for his literal renditions of soup cans. . . . Though the result can be excruciatingly monotonous, the apparently senseless repetition does have the jangling effect of the syllabic babbling of an infant—not Dada, but dadadadadadadada. In his own way, Warhol is perhaps the truest son of the age of automation. "Paintings are too hard," he says. "The things I want to show are mechanical. Machines have less problems. I'd like to be a machine, wouldn't you?"

"Expectably" is the crucial word here. Warhol knew the kind of artist that his audience needed him to be. He fulfilled those expectations. "The dead-pan, sweet, know-nothing quality of Andy Warhol's personality is continuous with his paintings," wrote Henry Geldzahler, around this same time. "He plays dumb just as his paintings do, but neither deceives us." Actually, all but the very smartest observers were taken in by the dumb play of Warhol and his art; many people still are. Even the critic John Coplans, a notable Warhol fan, was still describing him in 1970 as the only Pop master who had begun with no background in fine art, whereas Warhol was as well educated as any of them; he launched into Pop Art with a longer list of shows and reviews than many of his rivals.

It took another Pop artist to see through Warhol's smokescreen. "Andy keeps saying he is a machine," said Claes Oldenburg, "and yet looking at him I can say that I never saw anybody look less like a machine in my life."

———

In playing the fool Warhol was, as usual, riding the wave of his times. Abstract Expressionism had cultivated an affect of grand seriousness and Existentialist navel-gazing but a decade of that had left people tired. "The enthusiasms of the Abstract Expressionists already begin to read as ex-

cesses," wrote Warhol's friend Geldzahler. Once the Pop movement hit, "art stopped being so intellectual, so introspective," said Emily Tremaine, one of the first collectors to switch from AbEx to Pop. Even Roy Lichtenstein, the most sober and contemplative of the new crew, felt obliged to declare himself "anti-experimental, anti-contemplative, anti-nuance . . . anti-all those brilliant ideas of preceding movements."

As late as 1969, a scholar arguing in favor of the most sophisticated of recent art—silence that could count as a composition; an all-white surface as a painting; an eight-hour shot as a film—wrote that all of it hid behind a "disarming pretense of idiocy." Warhol the "idiot" was mirroring the façade of such art; he even illustrated that scholar's article with illustrations done in his most faux-naïf 1950s style—possibly the last time he ever deployed it. Tremaine said she'd started out by seeing Warhol as a true innocent—a modern Douanier Rousseau, as she put it—but eventually came to think of him as "the most complex of the lot."

Even when the new art might be open in its sophistication, it could demand a stubborn dumbness from its maker. As Frank Stella famously put it, "What you see is what you see"—his art could speak for itself, visually, and didn't need help from him or his clever words. This had been the avant-garde position in literature for a while already: The so-called New Critics condemned explanations based on biography or the creator's intentions, insisting that the author step aside so that the text and its readers could take charge of meaning instead. That notion hit art as well, leading Rauschenberg to say "Meaning belongs to the people" and, of his early all-white paintings, "It is completely irrelevant that I am making them—Today is their creator." He was as good as his word: He gave instructions that whenever his white canvases started looking grubby anyone at all could and should be found to repaint them. That was the anti-authorial notion that Warhol ran with in the 1960s, when he claimed (or lied) that his canvases could as easily be silkscreened by any of his followers, and that they often were. The success Warhol won as a Ben Shahn imitator could have first gotten him doubting artists' "ownership" of their art; those doubts became dogma once his career in Pop took off.

"Warhol's art doesn't flow out of his personality, and it has nothing to do with his character," wrote one early critic. "He regards the artist-as-personality as bankrupt. . . . For Warhol, individualism, the most sacred of our sacred cows, is of no interest. He doesn't sign his work, he permits friends to help him turn out paintings, and he doesn't give a damn for craftsmanship." Geldzahler himself opined that "the fascination of personality as it can be expressed and controlled inch by inch across the canvas"—the AbEx

option—"reads in the current stylistic mood as excess activity." Before long the curator was specifically attacking anyone who asked questions about Warhol's intentions in making his art: "The thing we're really interested in is results." Pop Art was perfectly positioned to resist the search for intention, since it could so easily feel authorless—just a bunch of objects and images transferred from popular culture, with at most a simple "look at this" coming from the artists who did the transferring.

A magazine editor once described the fascinating one-on-one conversations he'd had with Warhol about his art, and Warhol's articulate talk about it. That editor also described how Warhol, in his public persona, was determined "not to explain what he is doing. That's basic to his idea: to have it almost disappear in front of your eyes; to insist it was nothing, anyone can do it."

Denying intentions paid real dividends. The New Critics hadn't fought the "Intentional Fallacy," as they called it, just for the sake of the battle. By insisting that a maker's own explanations were beside the point, they set audiences free to come up with a wild range of smart, complex readings of their own. Thanks to the New Criticism, poems opened up as they never had before. So did Warhol's art, once he concluded that he could leave its meanings in the hands of its smartest fans. Over the half century since the birth of the Campbell's Soups, his work has given rise to more shrewd ideas, over a greater range of thought, than work by all his peers who felt obliged to manage their own reception.

Another conclusion Warhol came to: The very best way to cede control of your art was to pretend that you'd never had any to start with. As a man who was never a good public speaker or propositional thinker, Warhol's halting words could never have lived up to the eloquence of his art, which could leave even the most serious sages tongue-tied. It was easier and safer to play the mute, or even the fool. It was also the most up-to-date artist's costume to wear.

———

About the time he started to do the pop paintings, he got the pop music. And it was very funny, because whenever anyone would come to the house, I would have to go downstairs and vanish because he didn't want anyone to see that he had somebody helping him with his commercial work, and that he was doing any commercial work. And after I'd got downstairs, he would put on the pop records to develop the atmosphere.

That was Nathan Gluck's memory of those first months in Warhol's new life as a fine artist, and as someone who needed to be recognized as making only fine art. It wasn't quite as obvious a course correction as it might seem. Warhol had been educated in an older modernist tradition that actively encouraged crossovers into design and graphic arts. He had heard statements like "We are apt to make too much of a distinction between commercial art and fine art. When a commercial artist is good he becomes a fine artist." His early art idol Ben Shahn had worked in both domains, as had many of his Bauhaus-inspired professors at Tech; a curator Warhol came to know at MoMA had organized a museum-spanning show called "Modern Painters and Sculptors as Illustrators." In the 1950s, there aren't many signs that Warhol was worried about producing both commercial and artistic images, or about their looking so much the same.

But by the time Warhol was settling into New York, Abstract Expressionism had begun to enforce a new segregation. The movement's paintings were supposed to be about the grandest ideals of human consciousness and self-expression, hardly the stuff of commerce. As *Art Director* magazine expressed it: "Certainly a shoe ad neither could nor should be heightened with the emotional intensity that characterizes de Kooning's *Women.* . . . The extreme emotional intensity of abstract-expressionism precludes its being used to any extent for advertising, editorial, and reporting purposes." The AbEx-ers took care to promulgate the same views. One of the movement's great teachers talked about how the Bauhaus had tragically blurred the boundary between fine and applied arts. Strangely, all this strident rhetoric might have been fueled by the fact that the new abstractions, empty of visible content or commentary, were in fact pretty close to attractive modern design and decoration: "Mere wallpaper," their denigrators called them, and "tie fabric." Whether suited or not to selling shoes, by the late 1950s abstract scrawls were ensconced as decoration in department store windows and as backdrops for fashion spreads. In 1958, the designers of the fancy Four Seasons restaurant in New York were happy to commission a suite of brooding, "spiritual" canvases from Mark Rothko—until the painter had second thoughts about sullying his art and pulled them from the venue. New York's Expressionists might have shut themselves off from decorative art in order to deny the inevitable links that their creations had with it.

Once actual fragments of commercial and popular culture started to migrate into cutting-edge art, the fears of the Abstract Expressionists became terrors for their successors. The "impurity" of Rauschenberg's art,

for instance, left it wide open to attack. "I see no difference between his work and the decorative displays which often grace the windows of Bonwit Teller and Bloomingdale's," wrote one famous critic. "Fundamentally, he shares the window dresser's aesthetic to tickle the eye, to arrest attention for a momentary dazzle. . . . Jasper Johns too is a designer." This was the new art-world reality that saw Warhol sending hardworking Nathan Gluck down to the basement while he, an unsullied fine artist, entertained the culturati upstairs.

Warhol's datebooks show him spending far more time courting ad execs than schmoozing art dealers and critics, but he kept his new circle in the dark about how he earned a living. Karp was surprised, one day when they were walking down Madison Avenue, that Warhol seemed to know half its denizens: "'Andy,' I said, 'who are all these people?' He said, 'Oh, Ivan, it's my other life.' I hadn't known that he was in advertising." For the next twenty years, Warhol went to some lengths to hide his decade in illustration; he opposed several attempts to do shows about it in case it might compromise his reputation as a serious artist, and he once let his friend Henry Geldzahler help destroy a pile of his early drawings.

Gerard Malanga, Warhol's first Pop Art assistant, tells a story about the two of them browsing through a used bookstore, sometime in the mid-1960s, and finding an old issue of *Harper's Bazaar* with an illustration by Warhol: "He said, 'Hide that!' He didn't want me to buy it. But I bought it anyway. He was very upset that I had discovered this part of himself, his past." In a diary entry Warhol made in 1985, after decades of success and fame, the mere fact that he'd accepted a commission for a painting, rather than dreaming up its subject himself, could lead to self-flagellation: "I guess I'm a commercial artist. I guess that's the score." A quarter-century earlier, when he first began to build his fine art around commercial culture—around those "harsh, impersonal products and brash materialist objects on which America is built," as he'd written—he had to camouflage the links to commerce that he'd had for a decade. Warhol got the author of one early feature on Pop to remove a mention of illustration as something he still had to do "for a living." A studio visit by another writer, in early March 1962, gives us our first glimpse of Warhol at work on his Campbell's Soups, with canvases on view in all thirty-two flavors. Warhol told his visitor that he preferred "that the Campbell Soup Co. knows nothing about these paintings; the whole point would be lost with any kind of commercial tie-in."

The dangers posed by such potential "tie-ins" might have been at the root of a tension that Warhol sensed between himself and Rauschenberg and Johns. "Why don't Bob and Jap like me?" he asked de Antonio, their mutual

friend. "Why do they cut me dead?" Because, answered de Antonio, "you're a commercial artist, and that really bugs them, because *they* do commercial art—and this is how they survive, by doing windows and by doing jobs that I find them—and they want to disassociate themselves from the whole world of, and idea of, commercial art."

That last claim is not quite as true as has usually been said. Though Rauschenberg and Johns often used the face-saving pseudonym "Matson Jones" for their joint commercial work, as late as 1961 their real names were proudly attached to a Bonwit's window published in a survey of display work put out by the elite *Graphis* magazine—shown on the same page, in fact, as a window by Warhol. They had also been happy to show their "real" artworks—twice—in those Bonwit's windows whose texts outed them as "young American artists who have worked with us on window displays." Still, you can imagine the duo thinking, or feeling, that with advertising culture given even more play in Warhol's fine art than in theirs, the danger he ran of being "polluted" by the commercial might rub off on them. That tied into a basic difference in public persona: "Andy was self-consciously anti-intellectual," Geldzahler remembered. "Jasper's whole Wittgenstein side reared up in horror at Andy."

That was at least as likely an explanation for their aloofness as an alternative one that de Antonio also offered up: "Okay Andy, if you really want to hear it straight, I'll lay it out for you. We both know that they're homosexual, but you're so swish that you upset them, because they wear three-button suits and were in the Army or the Navy or something."

The couple could easily have been among the many buttoned-up gays in postwar America who had problems with visibly queer behavior. "Bob and Jap," de Antonio later explained, "would even have women for dates and masked who they were, which I found interesting and amusing and ridiculous." Whereas Warhol, de Antonio said, "made a big effort to be, perhaps, much more swish than he really was." In May of '62, when the photographer Art Kane came to portray his friend, he covered Warhol's face in flamboyant gold makeup, in honor of his gilded shoes and the "golden-inspired period of Greek homosexuality." A writer for *One,* the new gay-rights magazine that Warhol bought, described the "great dismay" that 1950s gays felt at such signs of effeminacy, "which acts as a label for a person's sexual inclinations." That same writer took pains to explain that when most homosexuals clasp hands it is "not a handshake that is soft, or a hand that is flabby," but rather "vigorous, masculine, hard, strong"—hardly a likely description of Warhol's grasp or of much else about him. On one of the rare occasions where Rauschenberg discussed the romantic ties between himself and Johns (Johns never did),

his account comes in surprisingly macho terms: "It was sort of new to the art world that the two most well-known, up-and-coming studs were affectionately involved." It's easy to contrast that studly picture with the one that Warhol presented to the world, and imagine the two visions in tension—especially since Warhol moved into fine art just when Rauschenberg and Johns were going through an agonizing breakup, sparked by the art world's obsession with their coupledom. "I did not find it odd that their greatest spite in the last moments of their togetherness was aimed at other homosexuals who hadn't suffered as they had," wrote de Antonio. On the other hand, there's so much peculiar homophobia in de Antonio's own journals—"fag" is a favorite word—that his account of Rauschenberg and Johns's problem with Warhol's flamboyance may have expressed a secret discomfort of his own.

"We were not particularly close friends, over the years, but I was fond of Andy and have no memory of ever 'cutting him dead,'" was Johns's puzzled response, late in life, to de Antonio's narrative. His memory seems born out by Warhol's own datebook for 1962, which shows the two men out on the town more than once, while letters from the Pop era have Johns sending cheery greetings to Warhol. In a Polaroid taken a decade later, Johns gives Warhol a giant hug; Warhol, famous for hating to be touched, beams in the embrace. By 1978, they'd bought adjoining plots of land in Colorado. There is also good evidence of close ties between Warhol and Rauschenberg. They traded studio visits and Rauschenberg actually went to Warhol for advice on the new art of the photo silkscreen. Warhol made Rauschenberg the subject of his very first silkscreened portrait, of the hundreds he would go on to do. If Warhol really did read his two friends as aloof (the account comes only from de Antonio) it could have been his own lifelong insecurity speaking rather than an accurate reading of their feelings toward him. Warhol always had a hard time believing that people he admired might also like and admire him.

Whether or not Warhol really was on the receiving end of his friends' swishophobia, or just thought he might be, he does seem to have dialed down the gay themes in his work. In the 1950s, he set his art off from his illustrations by seeding his gallery shows with content that was overtly gay. Once he'd hit upon Pop Art, the situation got reversed: The illustrations that continued to pay his bills were as fey as ever but his new paintings could be read as erotically neutral—just a bunch of products and images pulled from mainstream heterosexual culture. Or at least they could pass as neutral with that mainstream; Warhol himself still saw them as speaking to his private desires. His later acolyte Ultra Violet (admittedly an unreliable witness) claimed that Warhol had once described Dick Tracy and Popeye, two heroes from his window-display paintings, as the subjects of childhood

dreams: "I fantasized about Dick's dick. . . . My mother caught me one day playing with myself and looking at a Popeye cartoon." When he added those "hash marks" to his Coke-bottle painting, it just so happened that they managed to shorten the brand name to "Coc."

Straights could and did still read Pop Art as campy—the *Times* cited the "bad taste" of Pop as the surest sign of camp's ascension—but it was a kind of camping built around class more than sex. "To be camp is to be perversely committed to the trash aesthetic or to a sort of cultural slumming," wrote one early expert on the subject.

That idea of a "perverse commitment" is important for understanding the Warhol of Pop. It's not clear that, in the 1960s at least, he had a genuine connoisseur's taste for popular culture—that he thought about it as something worth serious study in its own right, the way a rock critic or a scholar of Hollywood might. Despite one-liners about his love for soup or comics or rock, there always seemed to be an ironic edge to Warhol's appreciation— the way his friend Stephen Bruce has insisted that Serendipity's celebration of Victoriana was always meant tongue-in-cheek. For Warhol, well trained in the highest of high modernism, popular culture was a recherché art supply he could use to craft a novel modern art and a new artistic persona.

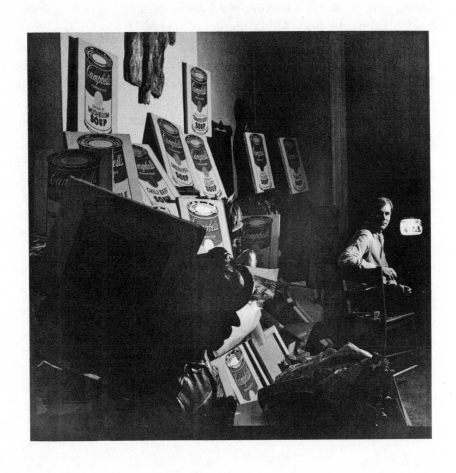

*. . . at home with his famous Campbell's Soups.*

# 1962

WARHOL, A "NEW TALENT" | HUNT FOR A
GALLERY | PAINTING MONEY | SOUP CANS IN
LOS ANGELES | MARTHA JACKSON CANCELS A
SHOW | THE STABLE GALLERY STEPS UP

*"This young 'artist' is either a soft-headed fool
or a hard-headed charlatan"*

By the spring of 1962, Andy Warhol had been named one of the art world's
New Talents. He had turned out a pile of paintings in all sorts of styles, on
all kinds of subjects, that were clearly on the cutting edge. He had streams
of art lovers coming by to see this work; their visits got recorded on Pola-
roid. His datebook shows him out and about with a new posse of high-cred
friends: Johns and Rauschenberg, Pop artists Marisol and Oldenburg, new
abstractionists Stella and Chamberlain. Yet his fine art career still refused
to take off.

It was too early to hope for museum exposure and, despite having Ivan
Karp as a pitchman, the best Warhol could get from the leading dealers was
the occasional backroom sale to some reckless collector. "All I remember
from those years was running around to Elkon, Janis and Castelli"—the top
galleries of that moment—"and trying to get Andy a show," recalled Henry
Geldzahler, "and everybody saying, 'Well, I'm not really sure.'" Even once
Warhol had swallowed hard and settled for a return engagement at the lowly
Bodley Gallery, its owner now balked at the idea of an exhibition. The new
paintings were simply too big a departure: "I thought they were terrible. I
thought they were ridiculous. I don't like them" was how the dealer remem-
bered his reaction.

"If you're not interested in them, I'll take them elsewhere," Warhol
is supposed to have replied—but it wasn't easy to find an elsewhere that

would have them. The best Warhol could do, as his Pop premiere, was a spread of new work in the back room of a short-lived gallery owned by a dealer friend of his named David Herbert. Warhol knew him from gay circles and had become one of his clients as well. "I was instrumental in breaking the way for Andy to enter the fine-art field," Herbert later wrote, reminiscing about a painting Warhol gave him in thanks. But even Warhol's connection to Herbert only won his new paintings the right to play second fiddle to a front-room solo by a newly minted abstractionist. She got a nice review in the *Times,* without even a mention of Warhol. Herbert's interest did end up paying off for Warhol, however, if only across the continent.

In Los Angeles, still Hicksville in art-world terms, the four-year-old Ferus Gallery had been struggling to make a go of it by representing a crowd of the most daring California artists, a few of whom had been taking their own steps toward a Pop aesthetic. The gallery's strategy broadened with the arrival of Irving Blum as its new, more business-minded partner. That dark-haired, debonair, larger-than-life raconteur became a major art-world player over the following decades. He got Ferus to branch out to artists from the cultural capital in New York, where Blum had spent several years hawking modern furniture at the celebrated Knoll showroom on Madison Avenue. He'd also helped supply Knoll with the latest art from nearby galleries. In the summer of '61, Blum traveled to New York with Ferus co-owner Walter Hopps—another colorful eccentric and later a powerful Warhol supporter—and the pair asked their friend David Herbert for advice on the latest East Coast talent. Herbert pointed them to Warhol, an especially likely prospect given that he was still without gallery representation. Hopps already knew Warhol's reputation in illustration, and once the Angelenos had also heard Warhol's name from two other advisers a studio visit was clearly in order. Meeting Warhol at Serendipity, which Blum had known in his Knoll days, they proceeded to the town house.

"Warhol led us into what seemed to be virtually a windowless room," Hopps recalled two decades later. "It was a paneled library, but the bookshelves were empty . . . no pictures on the wall, nothing. Like it was being moved into or moved out of. What really made an impression was that the floor—I may exaggerate a little—was not a foot deep, but certainly covered wall to wall with every sort of pulp movie magazine, fan magazine, and trade sheet, having to do with popular stars from the movies or rock 'n' roll. Warhol wallowed in it." That immersion in mass culture continued in the pile of paintings of comic strips and tabloid ads which Gunther Jaeckel

had just returned from its windows to Warhol. The Californians found them intriguing or at least promisingly obscure but held off committing themselves to a show, giving Warhol yet another disappointment to add to his total. Hopps thought he recognized talent but Blum was less convinced. "I remember not being able to make head or tails of these paintings," said Blum, admitting to having still been in thrall to AbEx. "They were radical, and I wasn't at all prepared for them. . . . However art evolved, I didn't think that would be the way."

In New York again some months later, with some time to kill, Blum and Hopps stopped by Castelli, where slides of the new comic book paintings by Lichtenstein brought back to mind their earlier visit to Warhol and the similar works he'd shown them. An art-historical "event" might just be in the making, Blum thought, so he instantly called Warhol and arranged another encounter. The first three of the latest Campbell's Soups were spread out on the parquet of the living room in the town house. The dealers fell for them, hard.

"When I first saw them, I thought of the wonderful stylization that went on in the paintings of Stuart Davis, whose work I'd always admired," Hopps recalled—and he was right that, in scale and treatment and subject, the latest Soups were closer to Davis's classic proto-Pop paintings of consumer goods than Warhol's earlier works had been. "I remember asking Andy how he'd describe the paintings. He gave me a funny smile, and he said, 'I think they're portraits, don't you?' It was an interesting, ambiguous answer—as though he didn't distinguish between people and things."

Blum's question for Warhol was more concrete: "I said, 'Why three?' And he said, 'I'm going to make thirty-two'"—because, Blum said, the soups came in thirty-two flavors. "I thought on it for a minute," Blum remembered. "I had a feeling that there was something happening. I bit the bullet." Warhol got his first offer of a true solo show—and hesitated, in his turn, at the idea of seeing it happen three thousand miles away. He would have been encouraged to know that the Ferus had already shown the most Pop-y sculptures of Jasper Johns's, including the Light Bulb that Warhol's own Johns drawing was based on. But Blum cited another factor: "As he stood thinking, I took his arm and said, 'Andy, movie stars come into the gallery'—that sealed the deal."

The exhibition would happen in July—Blum managed to sell Warhol on the idea that in Los Angeles, unlike New York, summer was a fine time to show—and would include all thirty-two of the new Soups. Blum knew that some of the earlier, bigger Campbell's paintings were already floating

around dealers' offices in New York, so he was determined to corner all the latest ones for the West Coast.

———

It was almost as though Blum's promise of a solo helped the stars align for Warhol. During the months that passed before his Ferus show opened, his art started to take off, as did the nascent Pop movement it was part of.

At the eminent Martha Jackson Gallery, which had shown big names such as de Kooning and Picasso, Warhols were being traded out of the back office, thanks to a with-it young assistant named John Weber: "I was sort of his first dealer, actually, although he wasn't officially with the gallery."

Aside from liking the work's daring, Weber was already recognizing Warhol's special contacts with "a very wealthy international, titled, playboy set," as he noted at the time in a memo to his boss, noting also that this could add to the gallery's clientele. "Warhol is independently wealthy and therefore will not pressure us for a great deal of money," Weber wrote. "His price is low. His studio, for instance, could most likely be bought out at a startlingly low price." Weber also noted that Warhol was already in conversations with the more modest Allan Stone Gallery, where Warhol had been offered—but declined—a three-man show with other Pop artists. One art critic had already spotted some of Warhol's Soup paintings at Stone's gallery, reviewing them alongside the new pastry-themed canvases of Wayne Thiebaud, which made a splash in a sold-out show at Stone in April (Warhol was a fan). She concluded that there was a novel "soup-to-cake concession" in the nation's art.

Warhol at last got his due as summer arrived, with coverage better than he could have imagined: Illustrated features appeared in both *Mademoiselle* and *Time* magazine, with their millions of average-Joe subscribers. *Time* declared the advent of a new "Slice of Cake School"—the article was pegged to Thiebaud's show of cake paintings at Allan Stone—and treated its readers to mini-profiles of Thiebaud, Lichtenstein, Rosenquist and Warhol. Warhol couldn't have been terribly pleased at a text that outed him as an illustrator for "women's magazines." (*Mademoiselle*, one of those very magazines, said in its feature that he was famous for "his whimsical, delicate drawings.") But he could only have been ecstatic to be the only artist to get his portrait into the *Time* article. Warhol was shown proudly ensconced in his living room studio, next to a barber-pole lamp—he was still showing off his folk-art tastes—and backed by a selection of his new paintings. Even before many of New York's art lovers had been exposed to Warhol's Pop Art in the flesh, here was its maker taking his first big step into the public

eye, right across the nation, and already assuming the naïf Pop persona he favored for the rest of his life: "I just paint things I always thought were beautiful, things you use every day and never think about," Warhol said in the piece. "I'm working on soups, and I've been doing some paintings of money. I just do it because I like it."

Even as Warhol's words appeared in *Time,* he would have known that those "paintings of money" were about to win him more, and more prestigious, exposure in his first real gallery show of the 1960s. Warhol's friend Henry Geldzahler had become close with an impressive young aesthete named Richard Bellamy—half Chinese, half Ohioan and a college dropout—who ran the Green Gallery, "the top avant-garde gallery in New York City," as Yayoi Kusama described it at the time. "Dick Bellamy helped launch the post abstract expressionist generation," Geldzahler later remembered.

Bellamy, Karp and Geldzahler had taken to spending Sundays and Mondays, when the galleries were closed anyway, visiting the studios of up-and-comers . . . such as Warhol. In June of '62 Bellamy had decided to end his gallery's season with a group exhibition of the very latest discoveries he'd made on his studio rounds. It included one of Warhol's most aggressive new works: a vast painting completely covered with two hundred identical images of one-dollar bills, silkscreened onto the canvas one after the other. (In May, it had been in the background of Warhol's *Time* magazine portrait.)

This was Warhol's first use of silkscreening in his fine art, although unlike his later, more groundbreaking silkscreens—of Marilyn and Elvis, for instance—these first ones of dollars were based on drawings, not photos. It looks as though the friend who had made Warhol's screens had insisted on this to steer clear of counterfeiting, which also explains why Warhol made his dollars rather bigger than real ones. (*McCall's* magazine, a client of Warhol's, had recently won a visit from the Secret Service just for an ad with a life-size image of a *stamp.*)

Warhol's currency paintings (he made lots) gave his public its first encounter with the famous idea that he wanted to function like a machine—in this case, a printing press in the U.S. Mint—and that his art had nothing to do with the touch of his hand or his own manual skills and labor. Those same paintings, examined at all closely, show that this was never much more than a myth that he chose to propagate. Fans of silkscreening actually touted the technique as especially well suited to the artisanal setting of a painter's studio, versus older printmaking techniques that often required heavy equipment and presses. If silkscreening always evoked its

"low," industrial roots, that was in fact at odds with how Warhol used it as a fine art technique, as hands-on and small-scale as could be. The critic who ran Warhol's most famous quote about trying to be a machine also recognized it as spin: "All that can be said is that the statement is not true."

Geldzahler once described his friend's very human, artisanal attentiveness:

> I used to watch him in the studio, making the paintings, putting down the silk-screens, and the television set was going and the music was going and he would be working but it was never an accident. I mean, there were as many choices that Warhol made, in the size of the pictures, in the color of the canvas and what kind of paint he used and how to place down the screen on the canvas, how much paint to squeeze through it, whether to make it very black or grey or very white. He also discarded many pictures—he didn't let all the pictures out, so that he's much more of a formal artist, much more interested in the formal qualities of art, than people realize.

The "minted" dollar pictures, especially, involved care and craft, from the hand-drawn faux bills their screens were based on to the fussy process of hand-printing them onto canvas. In paintings of bills that showed them in haphazard piles, Warhol had to use elaborate masking techniques to make one silkscreened banknote look as though it had slipped under another.

Of all his early Pop pictures, Warhol's money paintings may have the deepest pedigree. A teacher at Tech had talked about the American dollar bill, with its Gilbert Stuart portrait of George Washington, as a work of art we all carry in our pockets, while on its very first page, his main college textbook had launched its entire account of the concept of art with a discussion of the function and meaning and design of a coin, emphasizing especially that "every significant work of art has some use"—anathema to the abstractionists Warhol was superseding but vital to the career he went on to have. His two hundred dollars at Green are all about what happens when an image has its function removed without much changing its design. Or rather, as a later critic pointed out, by originally pricing the piece at $200 Warhol was in some ways keeping the function intact even as he transformed the money into art: His two hundred silkscreened dollar bills were *still* functioning as currency in his piece, since their exchange value stayed unchanged once they'd been transferred to canvas.

In the 1950s, Warhol's commercial portfolio was awash in pictures of money; his art directors somehow had a constant need for that imagery. But the differences between those images and his new Pop ones are telling. The '50s illustrations were almost always goofy and comic; the Pop paintings were foursquare and direct, and that could somehow make them feel caustic—more satirical rather than less so. Within a few months of making those paintings, Warhol was using a scribbled list of words to explore the full range of concepts attached to cash: "Fun Money—Blood Money—Dirty Money—Real Money—Printed Money—Death Dead Money—Working Money—Active Money."

Warhol, on the make in the commercial world, had been accused of selling out since pretty soon after college; just a few years before his Pop debut, when that joke book had listed him as one of a thousand names worth dropping, it was on a page devoted to notable "big business" sellouts. Warhol was "The Man Who Paints Money for Money," according to the headline on one of the very first European features on Pop Art, which came out just months after the Green show. What seems to be happening in the early dollar paintings is that Warhol had decided to own his sin of covetousness and convert it into artistic virtue. The painting that marked his most public debut dared to suggest that Warhol and his pictures were themselves the same kind of tradable good that other Pop artists only dared to depict.

Even this early on, Warhol the gum chewer understood that he could upstage his closest peers by inhabiting Pop's themes instead of just portraying them. Posing as the Great American Commodity, Warhol remained one of his own art's central subjects until the day he died, and his treatment of that subject—himself—always hovered between celebration, critique and satire. As Warhol's fame and prices exploded, making a painting, any painting, would become like printing money. By the mid-1970s, Warhol was in a position to trumpet the link between his art and currency. "I like money on the wall," he wrote. "Say you were going to buy a $200,000 painting. I think you should take that money, tie it up, and hang it on the wall. Then when someone visited you, the first thing they would see is the money on the wall."

When Bellamy's show opened in early June he gave Warhol's greenbacks pride of place, alone on the gallery's best wall and confronting visitors the moment they entered. Recovering from the first shock of all that money—posing as art—viewers would then have had to deal with a penis-covered sofa by Yayoi Kusama and Robert Morris's radical *Slab*, the ur-object of the coming Minimalism. The *Times*, ignoring Warhol, called the

whole show "visual burlesque" and "non-art" (and, always genteel, chose to call Kusama's penises "frankfurters"). At this first moment in his fine art career, before Pop Art had been embraced by mass culture, Warhol's work at the Green was keeping company with any and all art that was far out on the cutting edge. What could have pleased him more?

Art-world cognoscenti would have instantly recognized the heft of Warhol's dollar picture at the Green Gallery, because it had roots in some other canvases that had recently made a splash. In late 1961, a twenty-eight-year-old known only as Chryssa had been given simultaneous solos at the legendary Betty Parsons Gallery and at the Guggenheim Museum. The Guggenheim had featured big new paintings covered edge to edge with a grid of newspaper ads and type, which Chryssa had mechanically transferred from the printed page to her canvas. The subject matter was obviously different from what Warhol was showing at the Green (if close to his various newspaper works of that era) but the overall effect—a series of quotidian printed items transplanted unchanged to the gridded flat canvas—was amazingly similar. For a brief moment before Pop took off Chryssa was a rising star such as Warhol still had no hope of being: When she won a coveted place in the 1960 Whitney Annual, a critic called her one of "the bright new people to watch" and raved again a year later in a review of her Guggenheim solo. Not long before Warhol began to screen his dollars, Chryssa was given a proper newspaper profile, which billed her as a kind of proto-Pop "poet of Times Square" and closed with the news that she was hard at work on "a newspaper done to scale." Warhol had to have known about Chryssa and her work: She was intimate with an early collector of his and had been shown by David Herbert the year before Warhol launched in that friendly dealer's back room. This means Warhol's dollar painting doesn't only mark the start of his work with silkscreens, it also signals the beginning of his practice as the great Pop Art sponge, absorbing ideas and influences from all over and then translating them into signature Warholisms.

You could say that the sponging itself is one of his trademark gestures, signaling yet again his refusal of authorship and the originality that was supposed to go with it—a refusal that was itself one of his most shocking and original contributions to art. "His premise is that one person's ideas are as good as another's, that they are all alike," wrote a curator friend of Warhol's, while specifying that this sponging of Warhol's came with the best of avant-garde pedigrees. Warhol's surrender to someone else's ideas, said the curator, echoed the way John Cage and his followers had ceded control of their work to chance.

In fact, however, Warhol's borrowings from Chryssa's use of newspapers—or Rauschenberg's, for that matter—actually did involve some quite deliberate, unchancy transformation of what she had done. Where her paintings had mostly been about borrowing the feel and aesthetics of the daily paper, leaving it largely illegible, Warhol's dollar paintings, and later his reproductions of tabloid front pages, were all about the actual content and meaning of what he was showing. There was and is a sense that Warhol's best and most striking work simply repeats what's in the world, rather than turning it into an art supply the way Chryssa and Rauschenberg tended to do.

That spring of 1962, Warhol's radicalism paid off, to the tune of $1,200. That's the substantial sum that his dollar painting sold for during the Green show. (A Chryssa newspaper painting had already been listed at twice that price—that was how big a star she was—although Warhol's dollar painting did eventually go for twenty thousand times more.) The *200 One Dollar Bills* was certainly the most valuable object Warhol had created up to then, fetching more than most of his paintings sold for even at the height of his Pop fame. And its price, although still a fifth or less of what its buyer was paying for Jasper Johns, would have been especially significant given just how radical the picture was at the time. The following year, the older artist Fairfield Porter, who Warhol had once commissioned to do that double portrait in his lower Lexington flat, was giving a speech that was entirely focused on how art could only be about "looking for differences, looking for distinctions" in a world of ever-increasing homogenization—and here was Warhol, with his money painting, positively celebrating the homogeneous and undifferentiated.

The succès de scandale of the Green show might have brought Warhol more than just money or even recognition. His contacts with Bellamy would have been one more force in encouraging Warhol's aggressive self-creation as a new kind of Pop character. One '60s critic described Bellamy as a court jester who couldn't resist upstaging the patrons he jested for. Bellamy, she said, was "the first self-conscious stylist, calculated personality, I ever knew; someone whose answer to art was to fashion himself in such an image, he seemed to do nothing not contrived for its effect." A year or so later, when that same critic became a friend of Warhol's, she would have seen more of the same in him.

———

It was certainly nice that Bellamy had made a sale: Neophyte artists, including Warhol, have always been used to taking back most works unsold.

But the few hundred dollars that Warhol pocketed could hardly have augured big bucks to come in fine art. Warhol's uptown lifestyle was still utterly dependent on commercial contracts: Even as he prepared for his first Pop solo at Ferus, he was fulfilling endless contracts with clients who wanted the same illustrations he'd been doing for a decade. But during those first years of the 1960s, Warhol also allowed the occasional overlap between those commercial contracts and his new fine art. Or rather, a handful of daring art directors started seeking him out just to make that overlap happen.

In 1961, a young ceramics graduate named Ruth Ansel found her dream job as assistant art director at *Harper's Bazaar,* just after the great Marvin Israel had taken over its design. Israel had hired her for her limited experience in graphic design, not despite it, hoping that she would help him move the magazine beyond clichés. Warhol became part of her toolbox.

Ansel had started out thinking of Warhol as "a known figure, not a star" in the magazine firmament—no genius, but a witty and whimsical avatar of Ben Shahn, "the king of illustration." That started to change, she explained, with the birth of Pop Art, whose first hints were appearing in the cutting-edge galleries that designers like her had begun to frequent. As a childhood friend of the Castelli family, Ansel was especially up on the work of Rauschenberg and Johns. Once she had spotted Warhol's very first, Rauschenberg-inspired Pop on the apartment walls of her friend Emile de Antonio, she realized that Warhol was moving beyond his 1950s illustrations. A visit to the Lexington town house convinced her of the heft of the new, "intentionally brutal" images that she saw there, even if, like most of Warhol's other early visitors, she had a hard time actually liking the work. But that, she felt, was just the impact new art should have.

Early that fateful summer of 1962, a big project came Ansel's way at *Bazaar:* to assign the cover of a special fall issue on international fashion. Warhol's emerging status as the most audacious of fine artists, coupled with his longtime reputation as one of *Bazaar's* most reliable contractors, made him the obvious choice for the job. He turned in an image that represents a perfect but peculiar merging of his two personas: An elegant line drawing of a well-hatted model, pretty much in Warhol's '50s mode, which came almost buried under random hatchings and washes of color with roots in Johns and Rauschenberg. You could say that Warhol was still following the Bauhaus lessons of his college years, when he'd learned to use the styles of cutting-edge fine art to energize commercial illustration. As his art school textbook had insisted, "no art worthy of the name can

lose caste by assisting the other arts." In the fall *Bazaar* cover, we simply see Warhol replacing Ben Shahn as his model with the latest in proto-Pop. Off and on, this was his commercial mode for the first few years of the 1960s—in one doubtful project he'd painted cute faces on real light bulbs and had those photographed—until he realized that the merger was never a happy one. At least at the beginning, Pop paintings needed distance from commerce to have their effect as art. Blending the two just muddied the waters.

Mostly, Warhol's first years as a Pop artist were funded by the 1950s-style illustrations that Nathan Gluck was still churning out at his drafting table in the front room of the town house. He was kept especially busy working for a leather goods company called Fleming-Joffe. Run by a cultured young couple named Theodora ("Teddy") and Arthur Edelman—he'd studied with the poet Stephen Spender at Sarah Lawrence College—the firm's contracts helped keep Warhol fed well into the '60s. The couple had inherited a family business in hides, building up an inventory of two million snakeskins that, with Warhol's help, they hoped to sell as supplies to the major shoemakers. It was a tricky endeavor, given the shoe industry's conservatism, and Warhol was enlisted as the Edelmans' principal snake-hide salesman. Warhol's high-style illustrations "added a nice little glow to what we were doing," said the Edelmans. "We became the king and queen of the leather industry—and he helped" (although Warhol didn't have an exclusive hold on their ads—as usual, he was competing with photographers).

The Edelmans' contracts for print ads, promotional goods and product displays—even for a couple of store awnings, a coloring book and an animation—became a notable source of income during Warhol's Pop years, even at a "few hundred bucks" per image, as the couple remembered. But all that work in hides, however profitable, couldn't have done much for his self-esteem. It was clear that his new clients, and their customers, wanted the same old blotted-line style that had made Warhol's name in the 1950s, and he supplied them with product that was every bit as cute and twee as anything he'd done for I. Miller, with even fewer high-concept touches—images for Fleming-Joffe were sometimes based on illustrations from Warhol's very first years in New York. The quaint folksiness of Julia Warhola's lettering, as mimicked by Nathan Gluck, became a Fleming-Joffe signature—to the point that Warhol agreed to leave the Edelmans with a rub-on Letraset version when he stopped taking contracts from them.

The Edelman work in skins doesn't seem to have made up for losses

elsewhere. The year of Warhol's Pop debut, money was tight. The steady income Warhol had long gotten from drawings for the *New York Times* fashion coverage had dropped by a third. His work for Bonwit Teller actually got canceled because of his fine art labors: The store's head of advertising called Warhol in and gently told him that, if he wanted to be a fine artist, they'd both be better off if he left their ads behind. For all of 1962, Andy Warhol Enterprises saw fit to pay its owner a monthly salary of $1,000—down by almost half from the start of the year. His expenses for the year came to very nearly as much as his revenue. By October, Warhol was begging one client to pay up on a small bill. The next month, he was getting a full appraisal of his art and antiques—$45,000, about the same as that year's very modest billings. Was Warhol gauging his safety net as he considered the wisdom of a final commitment to art?

---

*Dear Andy,*

*Enclosed yet another witless revue. Attendance has been phenomenal but sales have been very poor. No matter, the show is glorious and I'm enjoying it enormously.*

That note, written by Irving Blum on July 23, 1962, must have been a joy for Warhol to receive. Sure, sales at his Ferus exhibition had been slow and the critics cruel, but he'd been used to such news from his decade of New York shows. What mattered now was that his radical new art was getting its very first solo exposure—as Ferus took care to advertise—and even La La Land could not ignore it.

Warhol had shipped off his thirty-two flavors of Campbell's Soup at the end of June and Blum was overjoyed when the box arrived with time to spare for a July 9 opening. (Blum gave Warhol that date on a postcard that showed Hollywood's Walk of Fame, no doubt meant to get the artist excited.) To advertise the event, Ferus mailed out a poster: It featured Warhol's Pepper Pot flavor, a witty nod to the show's spice. Then Blum got busy installing the works. First he tried to hang them in an elegant line on the white wall, but getting them all level was beyond his skill. So he went for another, more interesting option: He installed a little shelf, a few inches deep, at waist height around the entire gallery, then perched his line of paintings on it. The standard take on this has always been that the installation mimicked a supermarket display, but that makes no sense:

Since when were lowly soups given that kind of refined merchandising? As Warhol knew—because he made paintings and a sculpture about it—stores always displayed their canned goods in vast, impenetrable stacks. What Blum had done, rather, was present Warhol's paintings like precious objets d'art in an Old Master print room, waiting for a connoisseur to sidle from one to another to take in their subtleties. There was even a nicely typed label on the wall under each painting, hardly the kind of price tags you'd see at an A&P. In Los Angeles in 1962, works that looked so much like low-end product needed to have their high-end status underlined. It was important that the work of Warhol and other Pop artists should present its borrowings from popular culture out of their original contexts, "transforming them and elevating them to the level of 'fine art,'" as one early fan put it. Claes Oldenburg, for instance, made it very clear that he subscribed to "a very high idea of art" and that his motifs taken from popular culture, however playful and populist they might look, were all about scaling the artistic heights. Even Warhol said that Pop Art's popular look and appeal tended to make it attract "the wrong people"—people who couldn't understand it as art.

This is what angered the haters in L.A.: Not that Warhol had depicted soup cans, as any sign painter might have occasion to do, but that the stage had been set to consider them *art*. A local critic did not hold back: "This young 'artist'"—note the scare quotes—"is either a soft-headed fool or a hard-headed charlatan." Crueler still? He got Warhol's name wrong: "Andy Warhole."

Other detractors preferred ridicule. When the Ferus show opened as part of La Cienega Boulevard's mobbed "Monday Art Walk," one of the other leading galleries on the street filled its window with a pyramid of real Campbell's cans. A sign read, "Do Not Be Misled. Get the Original. Our Low Price 2—33¢."

The "witless" local writer that Blum mentioned chose to poke similar fun: He first got Blum to offer a sober evaluation of Warhol's paintings as "reintroducing subject matter in a very new, fresh way . . . [with] a terrifying, Kafkaesque intensity," and then pretended to find the same qualities in the real cans in the window up the street. A cartoonist followed suit, showing a Ferus beatnik proclaiming that "the cream of asparagus does nothing for me, but the terrifying intensity of the chicken noodle gives me a real Zen feeling."

It looks as though the "reintroduction of subject matter" that Blum had talked about blinded most people to the fact that there was anything more

than pure subject involved in the works. Warhol's canvases were consistently confused with the cans they showed, whereas of course they were totally different. If Warhol had wanted to truly ape mass production, he could have done three dozen perfectly identical cans of tomato soup and avoided the telltale marks of hand painting he chose to leave in. Instead, like Warhol's dollar paintings, the Soup Cans had been laboriously and visibly hand-crafted. Warhol had made all kinds of subtle choices about just how a can's tin should be captured (with the same metallic paint that Jackson Pollock made famous), how its label should look (like something lettered by a modest sign painter) and how much it should be blown up (to portrait size, as Warhol himself had suggested to Hopps). The same British critic who coined the term "Pop Art" referred to Warhol's hand painting, early on, as a "highly personalizing element behind the mask of impersonality which the object presents." (The world would soon see that same mask on the artist.) He also wrote about a Warhol Soup Can as "a found object done by hand"—still a smart aperçu today.

Another critic, writing in the brand-new and ambitious *Artforum* magazine, went all the way back to Roman culture for a model, talking about Warhol's Soup Cans as the household gods of modern American homes. He also caught on to the paintings' tender, camp retrospection, citing their evocation of "the cream colored thirties . . . when 'good, hot soup' sustained us." He saw the show as "a nostalgic call for a return to nature"—after, that is, the denatured art of AbEx. That reading is actually not a million miles from yet another take on the series that Blum remembered coming from Warhol himself: In a future when Campbell's would be making fifty or a hundred kinds of soup, Warhol said, the thirty-two flavors from 1962 would themselves trigger nostalgia—"So it kind of marks a time."

With his Campbell's Soups, Warhol had struck a perfect, delicate balance between the utterly iconic and the completely unremarkable. The Coke and Pepsi brands he'd riffed on earlier had been similarly iconic, but also just a bit too much in the news, even hip, to be the kind of truly neutral subjects that his best art of this moment called for. In the biggest soda campaign ever to hit New York advertising, Pepsi had recently boasted of "a bottle so pretty that art museums are after it." It also spent marketing dollars on actual art events, including "the most elaborate and highest-paying art competition in the country," which happened to land at the Carnegie Institute when Warhol was sketching there as a kid—and it got attacked for commercialism by his teacher Balcomb Greene. Coke, for its part, had one of the most expensive and aggressive ad strategies around, banking on a new use "of high quality photography as against the use of art techniques."

And then there was Campbell's Soup, which was just, well, Campbell's Soup, so present in so many American kitchens that people barely noticed it was there—until a certain Andy Warhol came along.

The actor Dennis Hopper remembered the moment that his good friend Blum first showed him a Warhol Soup Can, in a slide: "I started jumping up and down, saying 'That's it! that's it!' And he said, 'That's what?' And I said, 'That's a return to reality.'" Hopper was out of work in films and had not yet begun to take photos; married to the posh Brooke Hayward, however, he was able to put her money where his mouth was. As she tells the story, Hopper brought the painting he'd just purchased from Blum to the hospital where she had recently given birth: "A Campbell's soup can? What are we going to do with it, put it in the kitchen?" she said. Not at all, replied Hopper: "This is a very important painting—we're going to put it in the living room."

Hopper, who fancied himself a connoisseur of the contemporary, had clearly spotted Warhol's links to an established cutting edge. By providing a whole suite of nearly identical works, Warhol was aligning himself with Yves Klein, his most daring predecessor, whose wallfulls of almost-matching blue paintings had won headlines (and laughter). He was also pointing toward Robert Rauschenberg's radical Factum paintings: two brushy, collage-y canvases shown by Castelli in 1958 that at first looked like spontaneous outpourings of the artist's soul, until you noticed that they were close to identical in every little detail. Marcel Duchamp himself underlined this conceptual pedigree for Warhol's Campbell's Soups, tying them to radical ideas he'd been pushing for almost fifty years: "If you take a Campbell's soup can and repeat it fifty times, you are not interested in the retinal image," he said. "What interests you is the concept that wants to put fifty Campbell's soup cans on a canvas."

As usual, however, Warhol's radicalism came with links to an older high culture: His repetitions put his Ferus show into the venerable company of the theme-and-variations tradition in Western culture. The thirty-two soups would have rhymed with the thirty-two *Goldberg Variations* by Bach, who was a favorite composer of Warhol's; those *Variations* had just become de rigueur listening among culturati.

————

Despite Blum's note to Warhol about disappointing sales, the dealer had actually done a decent job moving the paintings. Hopper and one other local collector bought and took home paintings, and Blum had another four clients who placed works on reserve. Six sales while the show was still up

wasn't bad, for radical new pictures in an unknown and weirdly repetitive style by an artist with zero name recognition and no local ties. But it wasn't long before Blum had another idea for disposing of the series, which he was starting to see as a masterpiece: Blum had become convinced that he should keep all thirty-two paintings together, with himself as their buyer. When Blum called Warhol to discuss his idea, the reply he got back was "I'd love that, they were conceived as a series." Before all the Soup Cans had even been finished, Warhol had already told a New York collector that he thought of them as one giant painting. Blum said he cajoled the six clients who owned or had dibs on his Warhols into surrendering their claims and so ended up with all thirty-two paintings. And then he sweet-talked Warhol into accepting $1,000 for them.

Joseph Helman, who was Blum's business partner in the following decade, knew a different version of the story. He said he was present one day when Warhol and Blum were recalling that Ferus premiere, and they discussed how Warhol had only agreed to exhibit in far-off L.A. after Blum guaranteed him the full sellout price. That's confirmed by a line in Blum's mid-July letter to Warhol, where he says that Warhol should expect a check for $3,000—which would have been the artist's share of thirty-two paintings sold at the advertised price of $200, minus the usual discounts given to some clients.

According to what Helman recalls of the story they told in the '70s, Blum then telephoned Warhol as the show closed with the news that only a half-dozen works had found buyers. "That's too bad," Warhol is supposed to have countered, demanding payment in full. After some heated bargaining they settled on $1,000—there's an invoice to prove it—to be paid out by Blum in ten monthly payments. Each of those, as it happened, was almost twice the new-minted dealer's monthly rent. The total for all thirty-two paintings was also just under what Blum agreed to pay, within months, for one single soup painting by Warhol from 1961, proving the depths of his belief in this art.

Early on, the sharp-eyed Blum realized that his best chance of earning big money as a dealer was to invest in the best works by his own artists. In 1996, he made a small fortune when the Museum of Modern Art paid $15 million for those thirty-two Campbell's Soups that had cost him all of $1,000. They might be worth a half billion now. In 1982, a prominent curator was already calling the series "the single greatest image in art painting as we know it."

Warhol himself knew the Soup Cans were his masterwork: Contacted

about a London retrospective of his Pop Art in 1968, his first instinct was to fill the whole show with just those first Ferus paintings.

———

Good news for Andy Warhol: The first review of the Ferus show that Blum sent him, no matter how mean, had announced the grand fact that he was "slated to join Martha Jackson's star-studded New York stable." That meant a move into the company of such postwar giants as Willem de Kooning and Adolph Gottlieb and more recent stars such as Claes Oldenburg and Jim Dine. And then came bad news: At almost exactly the moment that he heard from Blum about the "phenomenal" attention he was getting in L.A., Warhol received a long letter signed by Martha Jackson herself, canceling the exhibition they had planned for December. She said she had no choice, despite how much she liked Warhol and the work she'd had from him. (This was a fib; she'd bowed to the tastes of her assistant John Weber.) "As this gallery is devoted to artists of an earlier generation, I now feel I must take a stand to support their continuing efforts rather than confuse issues here by beginning to show contemporary Dada," she wrote. "The introduction of your paintings has already had very bad repercussions for us." It's possible that Warhol saw some kind of compliment in this account of his work's radicalism. (Jackson told him to read the troubles he'd caused her as a "good sign" for his art.) But that couldn't have outweighed his vast disappointment. Jackson didn't break off all ties—the gallery was still handling Warhol's work as late as September—but Warhol looked set to be knocking on dealers' doors once again, as though cast back to his first years in New York.

There were promising negotiations with Castelli, but they didn't pan out. And then Emile de Antonio came to the rescue. He'd been trying for a year or so to pair Warhol with Eleanor Ward, an ex-girlfriend of his who owned the prestigious Stable Gallery, but she hadn't shown much interest, even after Warhol wined and dined her on goulash. Now, with Ward's rival Martha Jackson having jumped ship, de Antonio tried yet again to place Warhol in the Stable's stable:

> Eleanor and I met at Andy's one drinking hour—six o'clock—and we both got very smashed. And I said, "Well come on, Eleanor. The point of this meeting, after all, is are you going to give Andy a show or not, because he's very good and he should have a show." She was very drunk, and she took out her wallet and everything

spilled out of it, and she took a two-dollar bill and said, "Andy, if you paint me a two-dollar bill, I'll give you a show." And I guess he did.

Ward's version of the same visit leaves out the new banknote painting—and her ex-lover—and has her being simply "riveted" and "stupefied" by the fine work on display. "I said, 'Andy, by a miracle, I have November—which as you know is the prime month of the year,' and I said 'I can show you in November.' And he said, 'Wow!' So that was it."

But in fact that wasn't quite "it." There was more to Ward's "miracle" than the usual Warhol luck, or the Voice from Above which had called upon Ward to visit Warhol, she said, one day as she lay dreaming at her country place. The November slot at the Stable had originally been meant for Alex Katz, an up-and-coming almost-Pop painter whose work Warhol knew from several shows at the Tanager, the co-op gallery where Warhol had received nothing but rejections. By moving up from the Tanager to the Stable, Katz had once again lapped Warhol on the gallery scene: Katz's first Stable show earned him a headline in the *New York Times* before Warhol's fine art ever got one. And then Katz tripped up. In June of '62, just when Warhol was shipping his Soups to Ferus, Katz showed some works at Ward's rival Martha Jackson. Katz's Jackson show also counted as a betrayal that got Ward to break with him. Succeeding with Warhol in the November slot would let Ward get back at both Katz and Jackson.

This was an era when, for once, the New York art world had left room for a few prominent female dealers, known to the scene's threatened men as the "five menopausal maidens." Ward, a member of New York's haute bourgeoisie, had made an especially big mark as someone with perfect and notably rigorous taste. Since 1952, the Stable "Annuals" had surveyed the city's most important artists, at first among the Abstract Expressionists—including Warhol's teacher Balcomb Greene—and then moving toward the new proto-Pop talents such as Larry Rivers, Marisol and Warhol's idol Rauschenberg, who went on to get a solo from Ward. (He also went through the hell of being her janitor.) Stuart Preston, the *Times* critic who had been a notable fan and friend of Warhol's in the '50s, said the Annuals provided "a field day for up and coming artists, wavelets of the future whose course is unpredictable."

Warhol had been keeping up with the Stable's wavelets: His datebooks note his visits there. Ward's invitation to show at the Stable would have been a pretty good consolation prize for the collapse of negotiations with

Jackson and Castelli, although Warhol was still keeping her overtures secret from his friends as late as the end of August. By the next month, however, the connection was out in the open, as Ward recalled: "I'll never forget the sight of him coming into the gallery that September, in his dirty, filthy clothes and his worn-out sneakers with the laces untied, and a big bunch of canvases rolled up under his arm. 'Look what the cat dragged in,' he said."

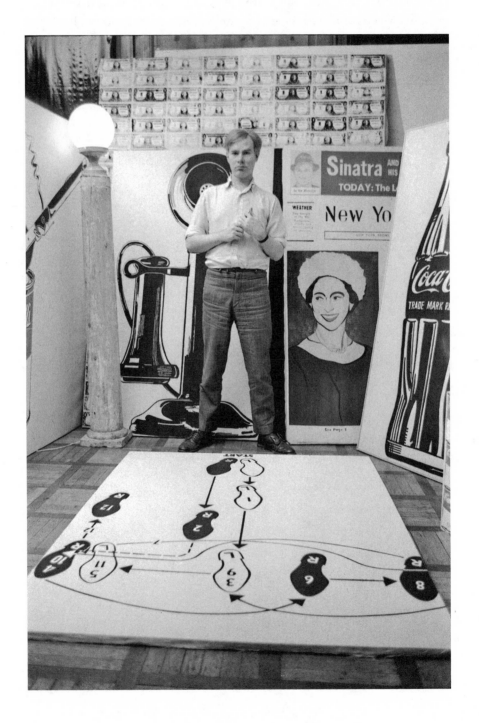

*. . . with his new Pop Art, before he'd been able to show it.*

## 16

# 1962

*"Mechanical means are today, and using them I can get
more art to more people. Art should be for everyone.
Silkscreen work is as honest a method as any"*

The mess and smell must have just about taken over Warhol's town house, which had been more used to conversation than creation during its first seven decades of bourgeois life. That summer of '62, with the Stable show looming, pots of innocuous casein paint gave way to "that nasty silkscreen ink," as one assistant called it. Mannerly brushes like those Rembrandt used got replaced by rubber squeegees from industry. The daily cleanup went from water in a sink to cans of Varnolene, the lung-burning solvent that cleans printing screens and gave Warhol "red blotches and vile sores," he said. Warhol eventually had to put up "No Smoking" signs around works in progress, to make sure the vapors didn't catch fire.

He had dipped a tentative toe into silkscreening that spring, with the dollar-bill imagery that he'd shown at Green. Now he made that technique the new heart of his new art: Once Nathan Gluck had gone home for the day, the front room where he worked on paper became his boss's silkscreening studio; as projects started calling for more and more space, the walnut-paneled living room took over that job, wreaking havoc on its parquet. "This was not easy work—this was like really grunge stuff," said a helper. (See color insert for an example.)

Warhol's collections of art and Americana, which just a year or two earlier had helped advertise the gentility of the new town house, got displaced on his shelves by art supplies—the collector was now flagging himself as a maker. Shelving meant for books got filled up with neatly stacked cans of Campbell's Soup, Dole Pineapple Juice and Ballantine Ale, not for consumption

but as an artist's new props. The living room came to be lined with newly made paintings, which were covered in drop cloths or turned to the wall until the right patron paid a visit. One visiting critic saw "huge, unwinding rolls of canvas dyed violent pink, orange and poison-apple green" keeping company with "colossal flat pieces of canvas, already imprinted with inky silk-screen images" that flapped like laundry from their temporary stretchers.

Silkscreening had first shown up in Warhol's studio in April 1962, when he had done a record cover for RCA featuring a screened, high-contrast photo of the jazz musician Paul Desmond, which counts as the launchpad for all the hundreds of other silkscreened faces he went on to produce. Within something like six weeks, if the postmark on a letter from Irving Blum is correct, Warhol had yet again made the move of transferring a commercial idea into fine art: He found a banal PR shot of Liz Taylor's head, then shipped that image out to be enlarged and transferred to the silk of a printer's screen, which became a kind of photographic stencil. When the screen came back to the town house a few days later, with its silk pulled taught across a heavy frame, Warhol pressed it down against a canvas that he'd painted silver and spread out on the floor—no old-fashioned easel for this new-minted radical—and then he squeegeed black ink through the screen's pores. Using this first image of Liz as a guide, he brushed pink paint over the skin of her face, red over her lips and green for makeup on her eyelids, then squeegeed her face once more in black on top of these colors. This crude transfer onto fine canvas of a cheap photo of Liz turned the painted face of a human being, with its potent evocations and links to Great Art, into something as "blank, blunt, bleak, stark" as any consumable product—which was precisely what Hollywood's media machine had made of Liz. Or maybe the relevant comparison is even blunter: Liz sits on her canvas just as the hand-drawn greenbacks had in Warhol's first silkscreens, the actress now become a perfectly fungible commodity.

Even earlier, or so Warhol claimed in the 1980s, he had tried the same trick on an action shot of Roger Maris, a baseball slugger who had recently broken records. (Warhol was probably inspired yet again by Rauschenberg, who had collaged a baseball shot into one of his "combine" paintings that MoMA had recently shown.) This time, in homage to the motion of his subject, Warhol moved his screen again and again, and squeegeed it over and over, until his single canvas was covered in thirty-six Marises. The repetition evokes the frames in a strip of movie film, before Warhol had actually shot any. There's something especially attentive, even caressing, in the act of silkscreening the same piece of man-flesh so many times, and more than a little irony in knowing that this kind of sports-fan attention has come from an artist as unathletic, unmacho and deliberately swish as Warhol. A decade

later, a stereo company was using Warhol's lack of sports savvy to sell their high-end equipment as effete and therefore elite: "Andy Warhol doesn't play second base for the Chicago Cubs. He doesn't even know who does," read the copy on a photo of him. At the very start of his silkscreen campaign, the baseball painting lets us watch as Warhol starts to turn the gay text of his 1950s exhibitions into a powerful subtext for Pop.

As Warhol's smartest fans have always liked to point out, by working from photos of film stars and athletes he wasn't simply borrowing the most famous subjects of popular culture; he was also borrowing the photographic medium that spread those subjects' fame. His paintings, that is, were as much about the power of photographs as they were about powerful people and icons. Rauschenberg had gotten there first, a few years earlier, when he used lighter fluid to transfer little magazine photos into complex works on paper that included all kinds of imagery, a technique that Warhol had tried early in '61 and apparently found wanting. But Warhol's use of printers' screens allowed him to take that single element in Rauschenberg's arty concatenations and blow it up to entirely fill a viewer's sight. As an assistant of Warhol's said, "He particularly dislikes and puts down 'arty' things for being sentimental and corny. Andy likes clean, plastic images."

———

Warhol and the silkscreen can look like a marriage of convenience—nothing more than an expedient way to transfer complicated images from source to canvas. And in fact the practical advantages of screen printing would have been clear to him since his college days, when Tech students were given deep training in the process. His own commercial practice in the '50s would have given him even closer contact with printers' screens, since they would have been used to produce many of his textiles and fine greeting cards. The normal routine for printing complicated designs like the ones Warhol supplied to his clients would have involved having his drawings photographed on high-contrast film, enlarged or reduced as needed, and then transferred to a screen for printing onto fabric or card stock—precisely the routine he deployed in his Pop Art. Although Warhol liked to pretend that a printer had first taught him about photo silkscreens when he went to make his Dollar Bills, that's almost certainly just another example of the savvy Warhol deciding to play the naïf. By the time he started using them, silkscreen techniques weren't new to Warhol, or to anyone else.

Artistically, however, he was on to something entirely novel. Silkscreening came with all kinds of strange baggage, and Warhol turned that baggage into art.

The technique had taken off early in the twentieth century as a way to

print the little felt pennants sold at baseball games and summer resorts. Eventually, as one early text explained, it got adopted by purveyors of such things as porch gliders, window displays, soft drinks, ice creams, wallpaper and even military maps and signage. (Warhol's roommate Philip Pearlstein had spent his war years screening such matériel, as Warhol must have heard.) And then the process really took off with the advent of the American supermarket and its need for vast quantities of signs and printed displays. One enthusiast explained how "screen-process printing has formed an important link between the advertiser and the buying public. . . . Packed full of selling force, with its brilliant color effects and appropriate design, [it] is the effective closer of sales."

These evocations of the hard sell weren't lost on Warhol and his public when he commandeered silkscreening for Pop Art: It was clear that his new process came from, and talked about, the same world of canned goods and soda bottles that had populated his first, hand-painted Pop paintings. Silkscreening, you might say, was the tomato soup of printing techniques. Its industrial origins seemed to take Warhol so far afield from tradition, according to one early Pop theorist, that he could be accused of "no longer making what is ordinarily considered a work of art." In 1963, a critic claimed that Warhol's most important innovation, and maybe his only one, had come "in adapting the commercial and purely mechanical process of silk screen to the purpose of painting on canvas." Which showed that she didn't know much about the deeper history of the technique in fine art.

Already by the 1940s, when Warhol would have first learned about silkscreening, it had taken on a second set of quite different meanings that had nothing to do with its commercial roots. A decade before, at the height of the Great Depression, the artists of Roosevelt's Works Progress Administration had first transplanted the process into fine art, with the lefty goals you'd imagine. They had adopted silkscreening to make posters and prints that were explicitly meant to eradicate "the preciousness and purist tendencies" of fine printmaking and instead speak to—and sell to—the Common Man. It's no wonder that Ben Shahn was one of the technique's first and biggest fans. (Warhol had bought a Shahn screen print in his first digs on Lexington and copied it in his own illustrations.) These ideas of populism and price seem to have been in play at Pittsburgh's Outlines gallery in 1942 when it hosted a big, early show of screen prints, which came just after a Joseph Campbell lecture on James Joyce's *Finnegans Wake* and not long before a group show with Duchamp—such being the avant-garde company that silkscreening would have kept in Warhol's mind. In 1943, Warhol saw a W.P.A. screenprinting show and seems to have absorbed its populist ethos. A quarter-century later, he told an interviewer that "mechanical means are

today, and using them I can get more art to more people. Art should be for everyone. . . . Silkscreen work is as honest a method as any."

The W.P.A.'s "discovery" of silkscreening gave the technique one other association that would have meant a lot to Warhol and his audience. Screen printing, said one 1960s writer, "bears the unique distinction of being the one truly American contribution in the fine arts field, having been discovered and evolved in this country by American artists"—and American-ness was always one of Warhol's vital art supplies.

By the time Warhol got to college, silkscreening had acquired yet more and still different baggage, via a change of name. The populist "silkscreens" advertised at Outlines had suddenly become hoity-toity "serigraphs," eager to take their place alongside the engravings, etchings and mezzotints in elite print collections. In the new postwar climate, fussy-fine craft replaced New Deal politics, and a race was on to see who could layer the most colors onto a single screenprint (or rather, *serigraph*) or which *serigrapher* could achieve the complexity of the best abstract painters. The advent of "serigraphy" gave silkscreening the credibility as fine art that Warhol, always intensely status conscious, would have understood and appreciated; by the early 1960s, he would also have understood that serigraphy's focus on technique went against everything the modern avant-garde believed in. In a typical Warhol move, he took on the lessons of serigraphy by smashing them to bits.

Just the fact that he used photographic screens was a slap in the face to the stately National Serigraphy Society, which had banned the photo-based technique altogether: "Even if it were ethically permissible, [it] is hardly desirable aesthetically," read one of its editorials. The simple *possibility* that a silkscreen might be based on photos excluded all screen prints, of any kind, from the Print Council of America's definition of an "original print."

"Photographic silk screen stencils often descend to the quality of mimeography," wrote the Serigraphy Society. "Obviously, then, no one can be expected to experience aesthetic enjoyment from the products of such means of reproduction." Unless, of course, you've built a whole new aesthetic around low-end copying. The fall that Warhol was introducing silkscreening into his art he was using actual mimeo stencils as an art supply.

Warhol's 1950s art, whether fine or commercial, had almost always been based on photographs, a shameful fact that he'd worked to hide. In the 1960s, he became entirely shameless about it, making that brazenness a trademark device. The genteel print connoisseur who coined the term "serigraph" had also given it a fixed definition as a print "which the artist made after his own design and for which the artist himself executed the component color stencils." Whereas in Warhol's case, a movie studio and a sports photographer had

supplied the "designs" for some of his first silkscreens, and their "stencils," photographic and almost untouched by Warhol's hand, had been outsourced to commercial screenmakers. As late as 1964, one critic was still ranting that "Warhol and his peers demand that we radically revisit the criteria for aesthetic appreciation—insofar as these artists assert, with often delicious cynicism, a conceptual and technical laziness whereby they prefer the methods of auto-matic reproduction to the vagaries and tiresome aspects of traditional craft."

As Warhol once put it, with deliberate naughtiness: "I find it easier to use a screen. This way, I don't have to work on my objects at all. One of my as-sistants or anyone else, for that matter, can reproduce the design as well as I could." And then, to add injury to his insult to serigraphy, Warhol deliberately avoided any trace of fine craft in the way he used his screens, squeegeeing as badly as a child of six and allowing his images to sit askew on the canvas. "They came out all different, because I guess I didn't know how to really screen," Warhol once said, concealing his deliberate choice in the matter. The meticulous Nathan Gluck remembered pushing his boss to use a tidier silk-screen technique, "and Andy goes, 'Well I kinda like it this w-a-a-a-ay.'"

A smart boyfriend saw error as the driving force behind Warhol's gift:

> A great work of art is the result of a mistake. You have this artist
> and he works away at his work, and it's completely unglamorous,
> and he makes this piece, which afterwards turns out to be abso-
> lutely great, is the great breakthrough affecting all of the world.
> He doesn't know why he did. It was a mistake. He stumbled on it.
> Then it's easy to go on from there.

Whether that's true or not with every artist—does it apply to Giotto and Rubens?—it's a premise of echt modernism that Warhol took deeply to heart. His embrace of the silkscreen was a leap into the void in a career filled with them, all part of a never-ending quest for the truly productive stumble.

As Warhol wrestled with silkscreening there was one final bout that he had to win. In its identity as "serigraphy," the screen process had become bound up with the world of fine prints—more elite, maybe, than pennant making, but still a backwater compared to painting and sculpture. Reviews of serigraphy shows (there were lots) never mentioned artists whose names carried weight; they dwelled on technical mastery. (One fascinating excep-tion: The great serigrapher Sister Mary Corita—later a Pop artist who was mad for Warhol—won four-column coverage, as early as 1959, for silkscreens she was doing for the ad industry. "Advertising: Nun's Art Is Doubly Practi-cal," read the headline in the *Times*.) When printmakers complained that the

Museum of Modern Art barely showed their work, they were raising red flags for Warhol: MoMA had already rejected him once, so why would he align himself with a discipline the museum routinely slighted?

Warhol came up with a clever way out that was witnessed by Irving Blum: "People would say to him, 'It isn't a painting, it's a print.' He would say, 'No, no, not at all. It's a painting.'" That became—still is—one of the fundamental laws of Warholian physics: The sheer fact of being printed onto canvas, one at a time and with a surface confusion that evokes brushwork, automatically elevated Warhol's silkscreens into the realm of painting, which still held the high ground in Parnassus.

Warhol won praise just for the jujitsu of his move from paper to canvas— "as a technical means, and as pictorial image itself, it is absolutely new," wrote a convert to Warhol in the *Village Voice*—yet there was a precedent buried so deep in Warhol's past that only a memory like his could have dredged it up. The "Silkscreen Prints" show held at Outlines when he was a teen had, unaccountably, billed the technique as a "direct painting medium." Once Warhol had made that fiction into fact, it wasn't long before his earlier, hand-painted Pop pictures got shunted up to the attic. He said that they'd been completely superseded by the silkscreens; scholars had to get special dispensation to see them.

———

While Warhol was busy prepping for his solo with Ward, other invitations were pouring in.

His art-director friends at *Harper's Bazaar* had especially precocious faith in him as a fine artist. Late that summer they signed him up for their November issue's feature on the latest in cars, meant as a sop to their automotive advertisers. Rather than having roots in some writer's idea for a story, however, the feature was explicitly billed as a specially commissioned vehicle for Warhol's "experimentation in 'commonism,' or the art of giving the familiar a supra-familiarity"—the first hint most fashion readers would have had of Pop. The magazine didn't ask Warhol to illustrate the piece, in any normal sense, but instead sent a photographer to document a series of car-covered canvases, some silkscreened but some still hand-painted, shown leaning up against the walls of his town house studio. *Bazaar's* audience was being coached that in Warhol's cars it was witnessing works of fine art that happened to be automotive, rather than automotive illustrations that happened to be made by an artist. Warhol's silkscreens were carefully (but incorrectly) described in the captions as high-end "oil paintings."

The highfalutin writing that went with Warhol's art was nothing more than some dead French thinker's decade-old passage on machines. But the

Frenchman's text did do the job of elevating Warhol's images, counteracting their iffy connections to the low. It let his car paintings keep company with phrases like, "Into an antiquated marketplace, where neither the stabile nor the mobile, the real nor the imitation, could find its proper place, the machine hurls its thoroughbred, unequivocal shapes." Almost useless as automotive analyses, maybe, but more significant when you consider that within months Warhol was eagerly describing his ambition to become like a machine, and to make art like one. Warhol and his paintings always aspired to high culture, regardless of the low subject matter he used to get there; his talent lay in camouflaging those aspirations so perfectly. His art's interpreters could take all the credit for the depths and heights that they discovered in it.

As though to confirm the prestige of Pop Art, that August it received its first-ever museum outing, in a survey show at the Wadsworth Atheneum in Connecticut. That was a prestigious venue a few hours from New York that was proud to call itself the oldest public museum in America. A gorgeous and patrician curator named Sam Wagstaff had recently been hired there, and he'd organized a canny show dedicated to local collectors—who happened to include Emily and Burton Tremaine, megacollectors who owned Picassos and de Koonings as well as new pieces by Yves Klein and Jasper Johns and who were among Warhol's very earliest fans. For the Wadsworth show, the Tremaines had loaned Wagstaff a huge, hard-edged, drip-free painting of a soup can, but its glories didn't stop the curator from having almost ontological doubts about the whole Pop Art experiment: "I am not convinced this is painting myself. But it exists. Here it is. We must not dismiss these people. Their comments are worth noting," he said in an interview with the Hartford paper that includes one of the first American uses of the term "Pop Art."

Wagstaff's published doubts didn't stop Warhol from visiting the show the following week, in the company of the rising art critic Jack Kroll. (Warhol was always happy to breach the ethical wall between artist and critic, and Kroll went on to write a series of raves.) "Expensive: ride, dinner, lunch, $25.00 plus," reads the entry for the trip in Warhol's datebook, which mentions the company of Roy Lichtenstein, another beneficiary of the Tremaine's largess.

Warhol was—or was working to be—enmeshed in Pop Art's social networks. A letter to Warhol from the poet and critic John Ashbery shows that the writer viewed his new painter friend as the ideal conduit to all the other new-minted stars of Pop Art. At least at first, an easy camaraderie was seen as central to the remarkably untormented character of the movement and its artists: "They have a kind of amity and friendship. . . . They represent a different breed of personality, in a way, in their social conduct."

A few days after coming home from Connecticut, Warhol would have

read his pal Stuart Preston's rave review of the Atheneum show, which included the *New York Times*'s first-ever coverage of Warhol's new fine art. Preston described the Campbell's paintings as "hammering in the idea of the modern world's wonderful prefabricated civilization and its appalling debris of tin cans. These are no mere unruly incidents but big steps towards art that is socially to the point." A lot of the first reactions to Warhol's Pop read it as pungent critique, as though the work's artistic radicality automatically flavored its politics: Just by virtue of declaring itself to be modern high art it also declared itself to be in opposition to ads and the other "low" products of commercial culture. As Pop became more familiar, its statements began to seem more friendly toward the status quo.

At the same time that the museum show in Hartford was drawing attention, Warhol was offered space in an even more notable group show in New York. It was to open on the last day of October at the Sidney Janis gallery, which was tied with the Stable for prestige: A New York guidebook singled out "Sidney Janis (very avant-garde) and Stable (also terribly avant)" as the galleries to watch at that moment.

"Dear Warhol," read a note Janis sent in late August, "Enjoyed my visit. Your work is very exciting!" And then, in a postscript: "For the catalog: Spelling of your name: Andy? Andrew?" It would still be several months before "Andy" and "Warhol" became an indissoluble cultural pairing.

Janis's gallery was best known for its deep support of Abstract Expressionism—one critic declared it "the leading emporium of American abstract art." So that fall, it was shocking to find it hosting an exhibition titled "The New Realists: An Exhibition of Factual Paintings & Sculpture." The show "hit the New York art world with the force of an earthquake. Within a week, tremors had spread to art centers throughout the country," said *The New Yorker* before "The New Realists" had even closed. Janis himself published a note that highlighted the new work's extreme novelty—a fine selling point in that art-market moment—and that described even Rivers and Rauschenberg as already just a touch too old-fashioned, and not "factual" enough, to have been invited. As Janis concluded, "The long angry silence of Dada has ended, reborn with the healthy cry of a new generation."

The exhibition included everything from a blue-painted sponge by Yves Klein to a bus driver cast in plaster by George Segal. But what got most attention were the show's echt Pop contributions, by Oldenburg, Lichtenstein and their peers great and small. There was a big painting of a Coca-Cola label . . . that was not by Warhol. And another work featuring a Brillo Box . . . again not by Warhol. Warhol's own contributions, however, were him at his best.

He showed two canvases of Campbell's Soup, a subject which even this early on looked set to become Warhol's trademark. That very month, a newspaper headline—in Kansas City, no less—had already asked, "Which Way Is Modern Art Going? Hold Your Breath and Watch the Soup Cans."

One of Warhol's Campbell's paintings at Janis was a huge canvas, as tall as a man, of a can of Beef Noodle soup. Warhol took care to date the work to 1960, an almost certain lie that positioned it as the oldest painting in the entire show and thus the progenitor of all the rest. A year later, the prestigious *Show* magazine chose that painting as the final, most up-to-date item in its list of iconic objects that had determined "the look of things" over the previous fifty years. Warhol's other Campbell's painting at Janis showed two hundred soup cans in any number of flavors, arrayed in serried ranks—thus capturing precisely the solid walls of soups that lined supermarket aisles. Not long before Warhol moved in on upper Lexington—and across the street from that Finast store—*The New York Times Magazine* ran an essay on the new phenomenon of the great American supermarket, "a gaudy symbol of American life, gawked at in wonderment." Such stores, said the article, touched more people than "schools, churches, movies or any other influence except newspapers and TV." How could Warhol resist piggybacking on that?

In its art pages, the *Times* gave "The New Realists" the first of its many reviews, a rave, of sorts, that said the work was "glad, bad and sad, and it may be a fad. But it's welcome." John Ashbery had written in the Janis catalog that this new art marked a "continuing effort to come to grips with the emptiness of industrialized modern life," and the show's two *Times* reviews, like most of the others, read the works as mounting a stinging attack on the "spiritual poverty" of mass culture, that "vast billboard wasteland."

Warhol was one of five artists mentioned by name in the *Times*—he didn't warrant any coverage in a few of the other reviews—with one painting of his called *Fox Trot* getting described, and slighted, as a "clever" thing that "hooks the eye." In fact it was deeply inventive and prescient.

Warhol had appropriated a diagram on dance steps from a "How To" book about ballroom dancing. He enlarged it onto a big canvas displayed flat on its back on the floor. The subject obviously invoked Warhol's own lifelong infatuation with dance and the place that it played in gay culture: Since it doesn't include the female fox-trotter's steps and the man's are rendered at several points in time, you get a feeling of a crowd of male dancers, like that awkward night when Warhol and his date had twirled under a fake palm in a gay club. (Warhol had actually provided a drawing of man-on-man waltzing for a *Dance Magazine* article that was titled "Too Many Boys.") The original printed diagram that *Fox Trot* was based on had even been captioned

"The Double Twinkle—Man," and he must have delighted in this private evocation of light-loafer-ism. He left the caption out when he enlarged the book page onto the public space of his canvas.

The painting made clear reference to Pollock's famous habit of dripping on the horizontal as he danced around his canvases. It also nodded to Rauschenberg's infamous *Monogram*, the assemblage he'd shown at Castelli in 1959: Its stuffed goat stood on a painting that lay on the floor just like Warhol's. As a box lying flat on its back, the Dance Diagram was also a close analog to the minimalist slab that had sat on the floor in front of Warhol's Dollar painting that spring, when Warhol's Pop Art had gotten its first public play. Throughout his career, Warhol almost always threw bones like this to insiders, who always love to play spot-the-precedent.

More mainstream visitors to the Janis show got to feel the instant effect the piece had on their bodies. To this day, once viewers take in Warhol's Diagram, with its footprints and arrows that show where a dancer's feet should move next, they can't resist attempting the same steps themselves. In fact, in its first showing Warhol's dance piece came with instructions for viewers to remove their shoes and try its steps right on top of the glass that protected the painting. Plugging into the most avant-garde trend of its moment, Warhol's Diagram triggered an instant Happening, with art and audience joined as one active unit. (In April, he'd carefully clipped a *Times* article that was headlined, " 'In' Audience Sees Girl Doused: What Happened? A Happening.")

The dance painting even anticipates the radical conceptual work that became hot toward the end of the '60s, which aimed to replace actual art objects with a set of instructions for making them. Warhol himself had actually done his first riff on a dance-step diagram in a shoe ad he'd published a full four years earlier, with his initials proudly tucked under one of the dancing shoes.

Warhol couldn't have been happy to get barely half a sentence in the long, smart review of the Janis show that appeared in *The New Yorker*, most prestigious of venues. But he must have felt himself to be its guiding spirit when the article declared that "the impersonality of advertising-agency art-department productions" was at the root of all the Janis works. "They are entirely cerebral," wrote the critic, "the hand of the artist has no part in the evolution of the work but is the mere executor of the idea man's command, though in this case the artist himself is the idea man. Nor is the self of the artist engaged by the process of creation."

That last notion had been made explicit in the most daring of the four landmark Warhols at Janis that fall, almost all completed quite early in the year. (Eleanor Ward must have reserved the freshest Warhols for the solo she opened the following week.) For a painting titled *Do It Yourself,* Warhol

enlarged a kind of paint-by-numbers image that had come inside a popular kit of colored pencils. Each area on the original black-and-white sheet was printed with a number so you could color it in with the numbered pencil that matched it. For his wall-filling canvas, Warhol had simply enlarged the original outline drawing of a flower bed, complete with its numbers, then filled in a few of its sections with paint.

Paint-by-numbers had been in the news as a raging fad for precisely a decade when Warhol made his painting. He'd already riffed on it in a Bonwit Teller window the previous fall. It was also the bête noire of elites. "Painting by numbers . . . is stifling and inhibiting. In extending the standardizing influence of the machine to his leisure time activities the easily deceived squelches his native urge for creative self-expression," said one critic in high dudgeon. By taking up the democratic and demotic art form of paint-by-numbers at just that moment, Warhol couldn't have found a more perfect way to torment the very thought leaders his art was being shown and sold to at Janis. Around the time of the "New Realists" show, Duchamp was telling an interviewer that the only way left to shock art's shock-loving public might be to show "calendar paintings" of pretty girls or landscapes—he could as easily have mentioned paint-by-numbers.

Warhol wasn't even content to make a winking reference to DIY in his painting by using it as nothing more than the clever subject for carefully handcrafted high art. On the contrary, he really did stick quite closely to the numbers and colors from the kits he'd bought, surrendering the control that had mattered so much in almost all art until then, except maybe in some works by his heroes John Cage and Marcel Duchamp and in a Dada piece or two. Warhol couldn't have missed the chance-based work in the landmark "International Dada" show that Duchamp had organized for Janis in 1953. It included an abstract collage whose parts had been tossed in the air then glued on where they'd fallen. In fact, the works in the "New Realists" show were mostly read by critics as a kind of update on the art of Janis's earlier one, with one critic dwelling especially on their mutual chanciness. Duchamp himself called Pop "just a 'second wind' of Dada."

The *Do It Yourself* painting signaled just how far Warhol would go in abandoning his artist's ego, a move already hinted at in the title itself, chosen over the more obvious *Paint by Numbers*. The original coloring kit had probably been bought as a gift for his school-age nephews who were visiting that summer—sweet Uncle Andy could always be relied on for toys and gag presents—but once Warhol had got the idea to enlarge it onto canvas, it was off-limits as a toy. Instead, he'd turned to the kids themselves to fill it in with color as a work of art. "He'd say, 'Here, paint this with this color' or

he'd ask you what color you'd like, and you'd paint it for probably a couple of hours, and wherever it was finished, he'd say, 'That's it.' The painting was half-finished, but he liked it, and that's the way he'd present it," said his nephew George Warhola.

Warhol's piece was truly do-it-yourself (or rather, do-it-*them*selves) and also a true work of child-made outsider art such as Warhol had merely mimicked in his 1950s window hoardings and chapbooks (which the nephews had also helped him color).

If laymen were still complaining that a child of six could make modern art, Warhol, a contrarian who always pretended to side with the people, was happy to prove them right. When they first encountered his Pop Art, Warhol's most cultured friends from the '50s gay scene were appalled at how it exposed his "ignorance" of the craft of painting.

The Janis show split the art community right down the middle, with artists, collectors and critics lining up on one side of Pop or the other. Even one of the founders of Dada threw up his hands at his heirs:

> How can I judge their work? I discover immediately that there is no point of reference or any frame of sorts from which I could judge the quality of this art or no-art or anti-art. . . . [It] is a challenge to man himself, as a creative person. These objects express a deep doubt about man's ability to communicate anything, except his own failure as a creator. . . . Through its utter boredom, there is no protest, there is no wit. The public goes in and out studying it like the afternoon paper. Nobody laughs, nobody cries and nobody gets infuriated. I would say that a supermarket is more interesting.

The big-shot abstractionists already on the Janis roster left him en masse, but at least a few of the gallery's patrons jumped at the idea that a new movement had arrived for them to buy. The Tremaines had already bought something like a dozen works right out of Warhol's studio. The night of the "New Realists" opening, they invited a bunch of its artists to their Park Avenue apartment, rigorously modern except for its maids in white caps. James Rosenquist remembers being happily ensconced there with the other Pop artists—Warhol got to see a pair of his Marilyns up on the wall—when de Kooning showed up unannounced with Larry Rivers: "Burton Tremaine stopped them in their tracks and said, 'Oh, so nice to see you. But please, at any other time.'"

Within a few years, Warhol had found the most backhanded of ways to

mourn the passing of the previous generation of artists. "Gee, I have this de Kooning," he said to a young pioneer of Conceptual Art. "I paid so much for it, and now it's not worth very much because of Pop Art."

———————

*Dear Mr. Warhol,*

    *Enclosed is a receipt from the store for glasses for the party which you gave in noting your exhibit to the press and dealers and critics. This letter will also certify that I spent $40 given me by you for ham, roast beef and foil paper for the dinner which was served at the party. These were bought at Safeway and I have lost the tickets.*

<div align="right">

*Sincerely,*
*Emile de Antonio*

</div>

Is there something a bit cranky in the overdone formality of de Antonio's note, dated two days after Warhol's solo opened at the Stable? The stuffy tone may have been meant for the tax collector's ears, but it may also signal that Warhol's eagerness to break into the scene, and his fussing about money, struck the well-bred de Antonio as more than a bit déclassé. And maybe it was—Warhol was hardly to the manor born.

"20lb ham 19lb beef," Warhol noted in his datebook on November 6, the day of his Stable opening, and there's something poignant in what all that meat says about Warhol's emotional investment in the event. His launch with Ward signaled his true coming-out as a painter in the New York art world. He was opening there just after his peer Robert Indiana had closed a sold-out show, signaling that Pop might at last have reached critical mass on the New York scene.

Before his Stable outing, Warhol had already got coverage in *Time* and the *Times*—even a mention in a story on hip party guests—which counted as more than his share of attention as a flashy (or trashy) Pop artist. But his art, as art, still had a hard time gaining media attention. In September, when *Life* had published its list of one hundred "young leaders of the big breakthrough," Jim Dine was there, as were Chryssa, of the newspaper paintings, and Marisol, that other single-name star of proto-Pop art, but Warhol and his work were nowhere to be seen. Now was the chance to turn that around. Despite a few violent pans ("speaking of vulgarism, the *sine qua non* was Andy Warhol's show at the Stable Gallery") the Stable show garnered Warhol his first important and thoughtful praise.

"Of all the painters working today in the service—or thrall—of a popu-

lar iconography Andy Warhol is probably the most single-minded and the most spectacular." Those words launched a bold review of Warhol's Stable show by Michael Fried, just about the smartest young critic on the scene at the time. Fried's approval was especially notable since he was building a reputation as an indefatigable—even bellicose—defender of abstraction: In the pages right before his Warhol review he'd raved about a two-artist exhibition of the AbEx masters Willem de Kooning and Barnett Newman. And then, with almost his next breath, Fried was talking about how profoundly moved he had been by "Warhol's beautiful, vulgar heart-breaking icons of Marilyn Monroe . . . and [his] feeling for what is truly human and pathetic in one of the exemplary myths of our time." (See color insert for an example.) For 1962, this was a radical and prescient view of Warhol's work, especially coming in a magazine whose owner and editor had given Warhol his first-ever pan, a dozen years earlier.

"Those [Pop] paintings when you look at them now are really kind of elegant," the curator Sam Green recalled some fifteen years later. "But they weren't then, they were just—crass."

Warhol's first Pop solo in New York didn't just bring him attention right then. Its seventeen works already acted—still act—as a summary of one of the West's finest artistic achievements. It established Warhol, about a year into his fine art career, as a true rival of all the greats who had come before.

Marilyn Monroe was the *dea ex machina* who did this for him, her *machina* being the printer's screen. More than half of the canvases on view at the Stable were silkscreened with Marilyn's face, in every color from blue to mint to lavender. The actress appeared one hundred times in a pair of paintings that measured almost seven feet across. A huge gilded canvas, with a little Marilyn face in its middle, was the work that filled viewers' eyes when they first came through the gallery door. Eight other "flavors" of Marilyn stood near her in the narrow foyer, like attendant spirits. It's no wonder Fried read Marilyn as an icon: Warhol had set things up so it was just about impossible to read her any other way. At precisely this moment, Roy Lichtenstein was talking about Pop as aiming for the universal intelligibility of Byzantine art.

Such ideas echo highbrow interests of Warhol's, who was never the prisoner of popular culture that his Pop Art has seemed to suggest: His interest in Hollywood does not begin and end with the movie-star scrapbook he kept as a kid. It's worth remembering that as a teenager visiting Outlines gallery, Warhol had already been exposed to the analyses of Parker Tyler, one of the first thinkers to take feature films seriously. Tyler saw movies as a source of modern myths that could match the ones of the ancient world. (Warhol and Tyler later became friends.) Then, around the time Warhol was making his

Marilyns, he had bought a new book by an erudite Frenchman who argued for the deep social meaning of movie stars. The book held Marilyn up as a specially potent example of their postwar renaissance: "Marilyn Monroe, the torrid vamp of *Niagara* . . . with her ferocious sexuality and her sulky face, is the perfect symbol of the star system's recovery." Can it be a coincidence that the same decade-old film that the author mentions—hardly the star's signature vehicle—also provided the source image for Warhol's Marilyns?

An accident of history doubled those paintings' heft. The actress had died that August, as Warhol learned from banner headlines the morning of his thirty-fourth birthday. Much later, the story got told that this news had triggered his paintings of her—but that's just the kind of story Warhol would be bound to tell once she'd died, whether true or not. It's not clear her appearance in Warhol's art needed the prompt of her death. Irving Blum had seen a glamour shot of Marilyn hanging in Warhol's town house almost a full year before, when the artist would already have known her as a fellow regular at Serendipity. (Owner Stephen Bruce has claimed that he was the one who nudged Warhol to portray her.) Given that Warhol's screen-printed portraits seem to have launched with Liz Taylor, Marilyn was an obvious, almost inevitable next choice of sex symbol—a perfect pairing for the Elvis Presley and Troy Donahue silkscreens also shown in the Stable solo. What could have made a better camp package than fresh-faced young Donahue; Elvis, glowering and sexy in close-up; and Marilyn, so absurdly femme she was pretty much in drag all the time? She didn't need to die to make that package work.

Henry Geldzahler went so far as to bill Warhol himself as playing the "dumb blonde" when he met the press, which might make the Marilyn paintings operate as semi-self-portraits and yet another instance of Warholian gender-bending.

Even before Warhol had got to her, Marilyn had become a fixture in the first stabs at building high culture around mass tastes. In 1955 already, Martha Jackson herself had chosen *Marilyn Monroe* as the title for a de Kooning she was selling. By 1958, Warhol's friend Ray Johnson was pasting Marilyn into his collages. (He also beat Warhol to Elvis.) By the fall of Warhol's solo at the Stable several other Pop artists had already painted her. Within a couple of months, *Life* magazine was writing about the Marilyn cult that was growing up among poets and painters—without Warhol, still largely unfamous, being mentioned as one of the cultists.

So it wasn't Warhol's decision to depict Marilyn that set his new pictures apart, but the way he'd done it. There was a sense that Marilyn wasn't just the subject of his art, to be processed through his particular aesthetic vision the way Rembrandt brushed up Bathsheba or Picasso cubed a guitar—

as those artists might have done to any number of other subjects, to similar artistic effect. As with the Ferus Campbell's Soups, with Warhol's latest non-paintings it felt as though his subject was all there was to be seen, "masking out" all aesthetic and stylistic qualities, as one critic put it. It's no wonder these radical pictures came across to some as anti-art: When Marilyn's color shifted from canvas to canvas, it read as a casual change of colorway like you'd find in a textile—including the fabrics Warhol himself was making—not as the product of a deeply willed artistic decision. This was the view Warhol himself had of his early silkscreening, when he'd printed image after image onto the same stretch of canvas and then cut them out afterward: "I was just making fabrics," he recalled.

For Warhol's friend Geldzahler, the Marilyns at the Stable evoked the garish tints that flicked across the new color TVs.

Warhol's teacher Balcomb Greene had once written that "modern photography is unparalleled in the social effectiveness of its story and its documentary quality makes the effort of the social realist painter negligible." Warhol had achieved his New Realism by plugging right into photography's social power, then using the multiplier effect of paint on canvas to ramp that power up into art. It's often said that Warhol's silkscreening let him adopt the methods of mass reproduction, but that's wrong. Silkscreening let him paint a picture of the mass reproduction that was already out there in photo-saturated postwar America, using the visibly artisanal means of messy high art. The scholar Hal Foster has talked about Pop Art as being all about presenting an image of *homo imago*—of human beings as they are shaped by the photographed reality they've created for themselves.

The only Warholian icon that went missing from the Stable show was the Campbell's Soup Can, which Warhol and Ward may have judged too well known already. But if the can didn't make it onto the gallery walls, it did make an appearance at the opening: Guests were given little badges printed with a Pea Soup can, with Warhol's name fluttering below on a red-silk ribbon like the ones awarded at county fairs. A pair of babies got beribboned that night, as did a prize squash some joker had brought.

Warhol must have been thrilled at the vast crowd that packed the space. Geldzahler and Karp were there, of course, lending moral support to their protégé. And so were the dealers Richard Bellamy and Leo Castelli, the latter in awe of what Warhol had accomplished, comparing his thunderous success at the Stable to the sudden triumph of the Beatles: "It just astounded me, and I felt like an idiot not having taken him on." (That very month, he was claiming to have been Warhol's discoverer.) Most of the Pop artists came, including Rosenquist and Oldenburg, whose wife Patty had embroidered a

pair of commemorative capri pants for Warhol. Even Jasper Johns showed up, which must have made Warhol's night.

A *Time* magazine photographer—the same one who had shot Warhol for the May feature—judged the Stable opening newsworthy, and his photos show that the Swinging Sixties were on their way. Warhol was still in his 1950s suit and tie, but his wig had "grown" to reach almost down to his collar, branding him a longhair by the standards of that pre-Beatles moment. Other guests were less tentative in their hipsterism: One girl wore some kind of Russian folk outfit that looks almost hippie while cowboy boots and an insane flokati coat could be spotted on two others; several men dared to sport beards. But Warhol (and Ward) must have been equally pleased to spot patrons in pearls, twinsets and ocelot and mink coats. Both groups moved on to the after-party that Geldzahler threw for Warhol, which also included such literary types as Susan Sontag and Norman Mailer. This mix of penthouse and garret, beauty and brains, homo and het went on to be the trademark of Warhol's '60s social life. The assembled multitudes fed on beef and ham and danced the Twist to records deejayed by Karp, while Warhol, doing everything in his power to avoid being cornered for conversation, floated around shooting Polaroids. "He always carried this stupid camera—he hardly talked," recalled one of the night's partygoers.

The high point of Warhol's evening came when Ward gave him the news that Philip Johnson, former MoMA curator and architect to the mighty, had decided to pay $800 for the show's golden Marilyn. Before long—and despite a recent stock market crash and art market panic—Ward had just about sold out the rest of the show, at substantial prices, to a posse of deluxe collectors, to four museums and also to a number of curators buying for themselves, including Geldzahler and the great Alfred Barr of MoMA. Warhol might have netted something like $7,000. That was barely 10 percent of what he had earned in his best year as an illustrator, but it was a sign, at long last, of the same sales success that Lichtenstein and Rosenquist had achieved in their sold-out first solos, almost a year earlier. "Andy was tremendously elated," Ward recalled. "It was his sign of approval in the fine arts."

Despite little evidence to prove it, Warhol was convinced that his work was a good investment. Charles Lisanby, his old crush, couldn't stand his friend's Pop Art and one day turned down a gift of one of the new Marilyns. "Just tell me in your heart of hearts that you know it isn't art," he chided. Rather than argue for the painting's aesthetic worth, however, Warhol pushed its resale value: "Wrap it up in brown paper, put it in the back of a closet—one day it will be worth a million dollars." Lisanby passed. Warhol was right, except that he was off by two orders of magnitude.

Without endorsing the old idea that Warhol was a pure opportunist, we can acknowledge that he always ran to the door when opportunity knocked. Warhol once claimed that one inspiration for his turn to screening was the vast and varied—and profitable—output he'd witnessed coming from the hands of fellow Popster Jim Dine: "He was like a factory you know," said Warhol, "but then he'd always do everything being creative . . . and then, then from that I thought, 'Well why, why do it where you're creative? Just print it.'"

In the first days of Pop Art, its sudden market success was part of the movement's identity. It blurred the lines between the kitchen commodities its artists depicted and the art commodities they produced for collectors—objects subject to planned obsolescence and "pliant to the whims of the marketplace," as one critic complained. No less a figure than the Warhol fan Marcel Duchamp was commenting, just a month after the Stable show, on the inevitability of the new artists' capitulation to "that capitalistic dollar." They accept it, he said, because "it's much too strong a courant d'air—a draft that you cannot go against or lose all your vitality."

When the celebrated Italian designer Ettore Sottsass reviewed "The New Realists" at Janis, he began his article with the sad tale of a young abstractionist who said he couldn't hope to find an outlet for his work: "There are these guys called New Dada, and everyone is buying New Dada and the gallerists and dealers are stocking up on New Dada as quickly as possible, the way shoe salesmen stock up on fashionable ankle boots once they've appeared in *Harper's Bazaar.*"

———

*Dear Andy:*

*As you probably realized when I visited your apartment I was slightly suffering from the night before. I am still not sure whether the scotch brunch, Presley record and paintings helped to fix me up or finish me off. Anyway it was fascinating and I came away very impressed.*

These words were typed out on September 17, six weeks before Warhol's Stable show, by the noted L.A. dealer (and 3M heiress) Virginia Dwan. Warhol would already have known of her daring: She had given solos to heroes of his such as Yves Klein, Robert Rauschenberg and Larry Rivers. The note she sent gives an idea of how Warhol courted such people. At this first moment in his fine art career, and then for its next twenty-five years, he didn't believe in letting his art and its dealers do the selling, as many of his peers did; he

always started by forging friendships and then turning his new friends into patrons and comrades-in-art. Polaroids record visits to the town house by cutting-edge artists such as Ed Kienholz, Larry Poons and Rauschenberg, by dealers such as Karp and Castelli and Michael and Ileana Sonnabend, and even by the novelist Robert Penn Warren, whose work Warhol had illustrated in college. (They also document the unzipped crotches of various unidentified men.)

Rauschenberg's visits were particularly notable, since in September Geldzahler had brought him by to learn the craft of the photo silkscreen, which went on to win prizes for him. "Rauschenberg got the idea of silkscreening from me. Definitely. He had never silkscreened anything before," Warhol remembered, clearly with some irritation. (Around this time Warhol also lent one of his printing screens to Jasper Johns, in another display of either commendable generosity or worrisome toadying.) By November Rauschenberg had become the subject of Warhol's first Pop portraiture, in a whole series of canvases completed a decade before portraits became Warhol's bread and butter. He worked from a particularly fetching photo that Rauschenberg had dropped off, and there's something boyish and somehow poignant in the thought of Warhol sharing his secrets with his hero-in-art and then screening his bust again and again. The Rauschenberg portraits actually pay double homage: Printed in black on deep blue grounds, they deliver a clear salute to the ultramarines of Yves Klein, that other godfather of Pop whose recent death had rocked the avant-garde. Every one of Warhol's first silkscreened portraits is of a friend in art; none were commissioned. Forget toadying. They feel like pure acts of appreciation.

Ray Johnson recalled the easy welcome that Warhol extended in his town house: "If I was uptown at an art opening, I'd casually call up and he'd say, 'Sure, stop by.' He always had music playing. He'd bring out these huge glass tumblers of scotch, and he'd throw that at you."

So brunching Dwan on scotch to the sounds of the latest pop was Warhol in his normal social mode, and couldn't be separated—in Warhol's mind or in Dwan's—from the business of showing her his paintings. Strategic or not, the brunch paid off. All of ten days after Warhol had opened his Stable solo in New York, a big canvas covered in twenty-five Marilyns went on display at Dwan's gallery in L.A., in a survey of the Pop scene with "My Country 'Tis of Thee" as its patriotic—and ironic—title.

The lambasting Warhol had got a few months before at Ferus now extended to his Pop peers at Dwan, whose "ridiculous legpulling," as one L.A. critic put it, "may or may not be art, by any aesthetic standards," but certainly had "an abundance of cynicism and an overt search for novelty and

faddism." The effects of such pans were erased by good sales: Most of the works soon found buyers.

L.A. also delivered praise. Walter Hopps, the Ferus gallery founder who had made early visits to Warhol with Irving Blum, had moved on to be director of the Pasadena Art Museum. In September, he had given Pop Art its first museum survey, in a show called "New Painting of Common Objects" that ran for all of three weeks. In the raging debate over what to call the new movement, Hopps's title pushed toward "Commonism," with its little dig against McCarthyism. Warhol had also favored that name at first, until a gathering of top Popsters, including him, came up with the peculiar term "OK Art." That was more appealing, at least, than "Neo-Dada," which implied copycatting an earlier movement, while no one except the popular press seemed to much like the British-coined term "Pop Art"—which of course won the day.

The Pasadena survey didn't bring Angelenos much fresh news of Warhol: All they got to see were two Soup Cans on loan from the Ferus and one canvas covered in S&H Green Stamps. But an extended rave for Hopps's show in *Artforum* magazine, then based in San Francisco, showed the West Coast out in front of the East in its acceptance of the new.

As usual at this early date, the writer of that rave (John Coplans, soon to be *Artforum*'s celebrated editor) saw Pop Art as casting a biting "moral judgment" on American consumerism and culture. (In a strange irony, in the very next issue of *Artforum* a trendy boutique ran an ad by Warhol, still in his 1950s style, that of course was in aid of such consumption.) More interesting, Coplans sees the new art as notably antiphilosophical and anti-intellectual, as a powerfully "dumb" and very American art form whose "direct response to life" replaces European (read, "degenerate") ratiocination. This kind of rhetoric, a trademark of Pop Art, fed into Warhol's decision to hide his substantial brains and ambition behind a public persona that cast him as a passive outsider, a tuning fork that had the good luck to vibrate along with the larger culture. The telegraphic biography that came with the *Artforum* feature had a similar, mostly fictional take on Warhol's life: "Without exhibiting or even being thought of as a serious artist, developed new work over past two years in almost total seclusion." Already that was far from true, given the notable guests cycling through his studio, but it was certainly the last time that anyone would utter "seclusion" and "Warhol" in the same breath.

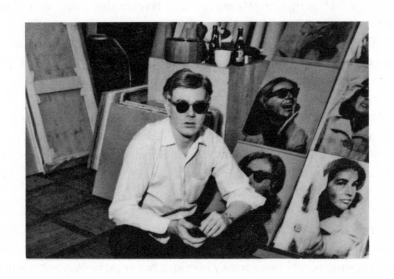

*. . . at home with his portraits of Ethel Scull.*

# 1963

THE FIREHOUSE | DEATH AND DISASTERS | COSTUMES
FOR *THE BEAST IN ME* | PHOTO BOOTH PORTRAITS |
A PORTRAIT OF ETHEL SCULL | MONA LISA

*"The people that you know—they want to do things and
they never do things and they disappear so quickly, and
then they're killed or something like that, you know—
nobody knows about them. So I thought, well maybe I'll do
a painting about a person which you don't know about"*

Memories vary about whether the fireman's pole was still there; some say all that was left was a treacherous hole in the floor. But there's no doubt that the building had once been a grand firehouse: five thousand square feet of soaring space, with ornate ceilings and wood-trimmed walls and all the other Victorian delights that firemen were deemed worthy of in 1868. A century later, it was the perfect, loft-y setting for a rising art star who needed to scale up his work, and his ambitions.

Warhol heard about the newly mothballed building, on Eighty-Seventh Street two blocks south of his town house, just as he was drinking in his success at the Stable. By the middle of November he was writing to the city's real estate division to see if he could rent it, offering the grand sum of $150 a month for the privilege. By the New Year he had paid his two months' deposit and was moving in. It was in fact his second New York firehouse, after the one he'd shared with Philip Pearlstein and the dance therapist in his first months in New York.

On Eighty-Seventh Street, the light and air were amazing and must have seemed a dream after the domestic rooms where Warhol had been making his art for a decade. Reached by a perilous steel-edged staircase—Warhol once fell down it with a lover—the second floor of the firehouse, which was all Warhol rented, had ceilings that were something like fifteen feet high.

Light poured in through a vast skylight and through tiers of windows that faced both street and back alley. The cavernous room stretched back a full one hundred feet, with storage space for a year's worth of paintings. Here's what the building did not include: heat or a roof that kept out the rain, or maybe even electricity. Art that would now be worth millions perished before its time from leaks. But Warhol, ever stoic, soldiered on through the cold and the damp: "He had this vulgar peasant strength that most people wouldn't imagine he had—he was like a little Czech tank," said a young friend who helped make art in the firehouse.

Another friend from that moment dubbed Warhol "the Henry Ford of a new form of capitalist art," and if the firehouse hardly allowed for mass production, it did let Warhol Fordize his process at least a bit. It's the first space Warhol described as a "factory." Rather than silkscreening each painting separately on his living room floor, he could now roll out vast stretches of eight-foot-wide canvas and work on the whole length at once. Photos at the firehouse show Warhol screening images in row after row, ready to be cut out and stretched as paintings of various sizes, at various price points. Nathan Gluck remembered a "bevy of volunteer helpers" on hand, scouring magazines for potent images and then helping Warhol to silkscreen them.

The new studio and new process came with new subjects that Warhol had launched that fall: car crashes, electric chairs, racist police, suicide leaps and botulous cans of tuna fish, their images often sourced from a friend's pile of old press photos that lay scattered around Warhol's town house. These Death and Disaster paintings, as they came to be called somewhat later, as usual get paired with a genesis myth. Here's Henry Geldzahler's recall from a decade later:

> Pop art was being criticized as being a celebration of America, and at a time when maybe everything about America isn't so terrific. And I thought maybe it was time to stop doing subject matter that looked liked it was commercial and try something else. [Warhol] said "What do you mean?" And I had with me—it was at Serendipity—and I'd brought to lunch with me the headline of the newspaper that said "129 Die in Jet" with a big picture of the crash, and I said, "Like this." And he did a painting of that and started doing the crashes and disasters after that.

As usual with Warhol, that genesis myth may indeed be mythical. The front page in question was in fact on newsstands in early June of '62, which would have to have been when Geldzahler had it in hand at Serendipity—a

date by which Warhol (and Pop Art in general) would barely have had coverage of any kind. Although that tabloid front page, blown up onto an eight-foot canvas, was indeed in the November Stable show, the whole painting—including the newspaper's crash-site photo—was hand-painted rather than silkscreened, and so harks back to Warhol's earliest Pop, or even to the newspaper pages he was drawing in the late 1950s. (And also, once again, to Rauschenberg's two Factum paintings shown at Castelli in 1958, which were described in one rave review as "a seemingly random assemblage of *Daily News* catastrophe.") In the spring of '62, there couldn't have been any sense, even for Geldzahler, that *129 Die in Jet!* was working to replace an endless stream of lighthearted commodity paintings with something new and more sober, especially given that most early viewers read even the Campbell's Soups as a hard-nosed critique or an obnoxious Dada provocation.

The truth is that Warhol's Death and Disasters are a natural extension of what he had been doing with soup cans and movie stars—including the dead Marilyn, which Warhol acknowledged as an early Disaster—rather than some kind of switch away from them. They've only looked like a switch in retrospect, after we learned to misread Warhol's first Pop works as cheery and light. And anyway, the very same photos that show Warhol silkscreening cans of poisonous tuna also show him at work on a suite of fun-filled Elvis images—he didn't get to the fun before the pain. If anything, the pain got turned into fun: Once the disaster photos got used as Pop Art they became cheery art-market commodities that were more like canned soups than any news photo might be on its own. As one early Pop critic said, "After World War II the tear glands of the world dried up from over-use. It is this world for which Warhol is spokesman."

Warhol's own explanation of how he came to depict noniconic subjects is more interesting than Geldzahler's. It gives a good view of how complex and eccentric his mind really was—and the explanation is probably true, for once, since it seems too peculiar and fractured to be a PR construction:

> It wasn't the idea of accidents and things like that, it's just something about—well it all started with buttons. I always wanted to know who invented buttons or who was the person who ever thought of making buttons, why they ever thought of buttons. And then I thought of all the people who worked on the pyramids and then all those—I just always sort of wondered whatever happened to them? Why aren't they along? So I always thought, well it would be easier to do a painting of people who died in car crashes, because sometimes you know, you never know who

they are. . . . The people that, you know, they want to do things and they never do things and they disappear so quickly, and then they're killed or something like that, and then, you know, nobody knows about them. So I thought, well maybe I'll do a painting about a person which you don't know about.

So what seems to interest Warhol, at least in this telling—he put forward other explanations as well—is the anonymity and modesty of his jet-crash and food-poisoning victims. They become an extension, not a rejection, of the humble, interchangeable products of his first Pop experiments. The first book ever published on Pop—written by the same friend who gave Warhol the original car-crash and electric-chair photos—makes the claim that the obvious morbidity of the disaster paintings was in fact already there in the relentless, impersonal repetitions of Warhol's soup cans and faces and Coke bottles, all rendered with a coroner's creepy dispassion. The magazine editors who published the rave about Warhol's "heartbreaking" Marilyns chose to illustrate it with his plane-crash painting. So it might make sense to say that the Soup Cans and Movie Stars were already images of disaster—or at least of a cultural death—which then got fully unveiled once Warhol hit his stride in the new studio. The hints of camp nostalgia that had helped camouflage the despair in Warhol's first Pop works almost vanish in the Death and Disasters, which are relentlessly current and newsy. (See color insert for an example.) As one observer recalled, "[Warhol] could hold forth on the politics of his day in a voice that barely rose above a whisper, but with such daring and incisiveness. On that subject, he was *always* right, and he could talk about it brilliantly."

The Electric Chair paintings were based on a photo of the device used in the 1953 execution of Julius and Ethel Rosenberg, American leftists who shared nuclear secrets with the Soviets and were in the papers again when Warhol was doing his silkscreen. Geldzahler declared the series the most powerful of all works of Pop Art: "It brings to mind the remark, attributed to Elaine de Kooning, that the only American contribution to [the history] of furniture is the electric chair. . . . Not merely a celebration or an irony, it's art at its best, a total involvement in much of our lives."

In early 1963, as the civil rights movement was gaining steam and attention, no one could have missed the political engagement in Warhol's image of white policemen siccing dogs on black marchers. As Geldzahler put it, "he's clearly not on the side of the dogs or of the policemen." The inaccurate title that soon got attached to the image, *Race Riot,* might have been some

attempt to temper Warhol's progressive streak for the sake of more conserva-
tive, moneyed collectors.

The Disasters weren't shown at all in the United States in the year they
were conceived. They didn't get any kind of serious presentation until Janu-
ary of '64, when Ileana Sonnabend, Leo Castelli's ex-wife and still his close
associate, built Warhol's first European solo around them in her Paris gal-
lery. Warhol wanted the show to be called "Death in America"—a name just
about impossible to imagine going over in the U.S. at the time—and it made
a splash. "All French people very shock," wrote the Chinese-American poet
Walasse Ting in a letter to Warhol from Paris, and indeed the prestigious *Le
Monde* newspaper panned the show for having left behind the popular es-
sence of Pop. But some locals seemed to appreciate Warhol's new slant. "He
paints a picture of the current state of brutality and death," declared one
French writer in the show's catalog, while another said that the paintings left
us bathing in "a state of pure tragedy" and "a moment of truth lived in the ab-
solute." And all that was a fine thing, according to a review published in Paris
by the New York poet John Ashbery. (As so often with Warhol, the fix was
in: Ashbery had been paid to write one of the exhibition's catalog essays and
in the fall he'd asked Warhol to act as his guide to New York's Pop studios.
Warhol had even given him a work.) Ashbery's review ran under the headline
"Artist's Horror Pictures Silence Snickers." It said that Warhol "brings all his
tremendous talent for meaningful decoration to the task of putting his mes-
sage across. His show shakes you up." Many Europeans had this kind of sober
take on Warhol right until the time of his death. Americans have always had
a harder time trusting in his substance.

----

The severe challenges that Pop Art was presenting to its first New York view-
ers had come clear just when Warhol was sizing up into the firehouse. In early
December, the Museum of Modern Art, final arbiter of vanguard aesthetics,
had convened a public symposium to look into a new movement that, thanks
to the Janis show, had become impossible to ignore. Given the museum's
long-standing commitment to thinking of modern art as the Path to Abstrac-
tion, some staffers saw this new art of common objects as a palpable threat.
Others, including the top man Alfred Barr, worried that Pop might be a Next
Big Thing that MoMA couldn't be seen to oppose. After all, the museum was
about to announce that it had acquired Warhol's golden Marilyn, a flag paint-
ing by Rivers, a Wesselmann nude and meringue pies by Thiebaud. Warhol
kept the announcement for the acquisitions; he couldn't have been happy

that his Marilyn turned out to be nowhere in sight when the show of those new items came around. Two decades later, he complained about the lifelong neglect he suffered from MoMA: "They have just one thing of mine, the little Marilyn. I just hate that. That bothers me."

At MoMA's Pop Art symposium, the supposedly neutral moderator was in fact a lifelong anti-Pop-ist, directing a panel that was stacked with such violent opponents of the movement—and of Warhol—as the reactionary art critic Hilton Kramer. Kramer judged that, at best, "fraudulent" Pop Art was "interesting for what is said about it rather than for what it intrinsically is," thus laying out the perennial and still current bromide that there is no there there in Pop, beyond the critical acrobatics that pretend to find meaning in it. "[It] derives its small, feeble victories," said Kramer, "from the juxtaposition of two clichés: A cliché of form superimposed on a cliché of image." Another panelist went after Pop as an "impoverished" capitulation to vulgarity, while a third calmed his nerves by reminding himself that "art has outlived even worse disasters" and then inveighed against a tyrannical avant-garde, with Warhol's Soup Cans as Exhibit A. Even the eminent art historian Leo Steinberg first admitted that he disliked Pop pictures, and wasn't even sure they were art, before conceding his willingness to imagine that something interesting was going on in the "new shudder" that the new work produced. A proper vindication of Pop Art was left to poor Henry Geldzahler. He was by far the most junior panelist, with no shows and little writing to his name; an almost comic photo shows him seated all by himself at the far end of the dais, with his opponents ranged against him in a row. But even his defense was pretty sheepish. He praised Pop for its stylistic links to fine abstraction, and for its topicality, but all he could muster in the end was a timid request that the other panelists admit the possibility—just the *possibility*—"that this subject matter and these techniques are and can be the legitimate subject matter and technique of art." And his colleagues went on to laugh at him.

The status and popularity that Pop eventually earned can blind us to the cruel world it was born into. Yet however daunting Warhol found Pop's initial reception, he might also have been cheered by it. As he would have heard many times from Pittsburgh's die-hard modernists, art that was truly on the vanguard was supposed to begin life getting more raspberries than kisses. You could almost say that the former were a sure sign that the latter were on their way.

Some of the early opposition was directed toward the new Death and Disaster pictures. A curator friend told Warhol that she wasn't going to hang the *Tunafish Disaster* that he'd just given her because it wouldn't "go abstract" for her; no matter what she did, it just kept being about that canned fish and

botulism. The collector Emily Tremaine, who had been such an ardent and early Warhol fan, turned against the new Death and Disasters as too grim. She did her best to stop a museum from buying one. Eleanor Ward, maybe taking her cue from this major client, refused to show them. Ivan Karp had tried to warn Warhol off the new subjects, but without effect: "I said to him, 'Who the fuck's going to want to look at an eight-foot picture of a hideous car crash, Andy? You're going to kill your economy.' He said, 'Oh well, it has to be done.'"

Not long after Warhol's move to the firehouse, a big "Month in Review" article declared *all* of Pop to be a dead end and a sellout, at best "an aesthetic pause that refreshes," in the words of an old Coke slogan. In place of Pop, the writer proclaimed the conservative nudes of Warhol's old roommate Philip Pearlstein to be the true breakthrough that art had been waiting for since AbEx. You can almost feel Warhol wincing as he read it.

There were antidotes to his pain. In March in New York, a group show at the prestigious Guggenheim Museum, newly settled into its Frank Lloyd Wright spiral, counted as Warhol's biggest accolade yet. "Six Painters and the Object" put him in the impeccable company of the new Pop stars Dine, Lichtenstein, Oldenburg and Rosenquist and also of their precursors Johns and Rauschenberg—although Warhol couldn't have been pleased that Rauschenberg showed silkscreened baseball players and was given credit in the catalog as the technique's pioneer.

The Guggenheim's own director seemed noncommittal in his preface to the show's catalog: "The relationship between the *good* and the *new* in contemporary art is intriguing and baffling" was the strongest support he could muster. His curator, a British critic who had helped launch the term "Pop Art" years before, voiced no such hesitations but was also savvy enough to bill the shocking works on view—he dared to show a Warhol Electric Chair—as a continuation of painting's grand traditions. His essay calls Courbet, van Gogh, Leger and even the eighteenth-century painter Joshua Reynolds as witnesses for the defense.

Funnily enough, at just about the moment when that defense was being mounted Warhol himself was taking a break from the tough radicalism of his most recent Pop Art. He stepped back into the theatrical work he'd toyed with in college and then in the '50s and that he showed an interest in for the rest of his life. An actress he'd admired for her soap-opera stardom had just begun production of a musical review called *The Beast in Me,* based on some comic fables by James Thurber, the celebrated *New Yorker* writer and cartoonist who had recently died.

She invited Warhol to design the show, and he came up with a clever idea

that broke away from the '50s stylings that he'd still been using for the theater even a few years earlier, when he did the wacky costumes for Spoleto. Since Thurber's own illustrations were nothing more than loopy outline drawings that made all his figures look like rag dolls, Warhol tried for the same effect: He dressed his actors in one-piece Dr. Denton pajamas to which he added accessories, as needed, to flesh out their parts in each scene. "Well, it was all very creative," remembered one of the actresses, "but everything was attached with Velcro: There were little pieces of fabric everywhere." Because Warhol was not a member of the scenic artists union—he'd come on board too late for him to even take the union's admissions test—the show's program could only give him an almost invisible credit for "costume concept." That bottom billing was just as well. After insanely last-minute casting, rewrites and rehearsals, plus a postponed premiere, the show got lukewarm reviews (the costumes were "tasteful" and "attractive") and closed on May 18 after only four nights. "Oh dear, failure is always so sordid," wrote the producer, as she and Warhol haggled over his payment for the flop. One fan of the "charming and pleasant" show wrote an essay blaming its failure on the culture's new taste for novelty and extremism, ironic given the avant-gardist ideals of the man who designed its costumes.

Warhol was making a splash on art's cutting edge just as *Beast* rehearsals were getting underway. In the American capital, a new institution called the Washington Gallery of Modern Art had put together a show and festival called "The Popular Image" that threw down a gauntlet for the new art. Strung across four floors of a repurposed town house, the exhibition included an open suitcase by Rauschenberg that invited viewers to add objects to it, a Wesselmann painting of a dinner scene with a real TV built in and a huge canvas silkscreened by Warhol with 210 bottles of Coke, which had also starred in his Stable solo. Another nine paintings by Warhol made him the artist with the most works in the exhibition.

All this raised a ruckus in staid D.C. and beyond, as was clearly the intention. "'New Realism,' 'Pop Art,' 'Neo-Dada,' etc., etc., has provoked a response of extraordinary intensity, stimulating extremes of unabashed delight or renewed anguish" was how the situation was described in the exhibition's own catalog. "The new art stirs such polar responses because it seems to make an active frontal assault on all of our established aesthetic conventions."

Photos of the opening seem placid enough: A black-tied Warhol looks on with a smile as a tieless Rauschenberg does the Twist. But those photos can't convey the "conversational riot" that went on as the show greeted its first VIPs, including two U.S. chiefs of protocol, a deputy assistant secretary of state and the head of the National Gallery, who wondered whether he was even witnessing art.

"I hate it," said one doyenne when confronted by a landmark assemblage of junk by Jasper Johns, who had made the trip to D.C. along with his dealer Leo Castelli. An oversize ham sandwich by Oldenburg, who had also come down for the opening, provoked a local gentleman to exclaim "I wouldn't hang these things in my garage." Even the catalog essay, though claiming to *defend* the innovations of Pop, included dour talk about the artists' allegiance to "the deplorable and grotesque products of the modern commercial industrial world—the world of the hard sell and all it implies, the world of bright color and loud noise too brash for nuance, of cheap and tawdry sentiment aimed at fourteen-year-old intelligences, or images so generalized for the mass audience of millions that they have lost all real human identity . . . what those of us who know better regard as the wasteland of television commercials, comic strips, hot dog stands, billboards, junk yards, hamburger joints, used car lots, juke boxes, slot machines and supermarkets." Or, as expressed in a rave review in the *Washington Post,* "Their thesis is anti-thesis; their philosophy, anti-philosophy; their technique, anti-technique"—just the kind of antitraditional defense that would have let Warhol know he was truly on the vanguard.

That would have been confirmed by the exhibition's program of radical performances. John Cage lectured while three recordings of his own voice played overtop. Oldenburg staged a happening called *Stars* that included foul smells and a striptease. "The place was filled, and no one left until 'Stars' was over," wrote a local doubter. "Such a display of mass cowardice I never hope to see again." New York's experimental dancers staged one of the most famous avant-garde programs of all time, which included a piece designed by Rauschenberg that had performers on roller skates trailing parachutes from their backs.

It looks as though Warhol himself had planned to join in the live events, as the founder of a garage band that in the end never quite made it out of the garage. Its members called themselves "The Druds" and they were the dream team of art school rock: Andy Warhol (backup vocals and lyrics), Jasper Johns (lyrics), Patty Oldenburg (lead vocals), Lucas Samaras (backup vocals), Larry Poons (lead guitar), La Monte Young (sax), Walter De Maria (drums) and happenings artist Gloria Graves (vocals). All the men would go on to art-world fame, if they didn't already have it, and a few of them even knew how to play their instruments. "We met ten times," recalled Warhol, "and there were fights between Lucas and Patty over the music." Johns's song titles seem to relate directly to his own art, and to Warhol's: "The Alphabet Song," "Movie Stars," "Hollywood," "The Coca-Cola Song." A typical lyric went, "Oh mommy, oh mommy, that's the bottle, yes. / So I took up an

opener / And I drank up the bottle." The few minutes of tape that survive, recorded in Washington, show that they never got their game together, although they did manage a kind of manic energy that sounds almost punk. On the tape, they spend as much time laughing as singing, which is lucky, since some of them seem close to tone-deaf. With one member after another dropping out of the band ("It was kind of ridiculous, so I quit after the 2nd rehearsal," Young recalled) Warhol had to give up on his dream of making music to go with his art in D.C.

"It didn't go too well," he remembered, "but if we had just stayed on it it would have been great."

———

Painter and dramatist Rosalyn Drexler, creator of an "unhinged, erotic and venomously funny world"; abstractionist Larry Poons, whose compositions "suggest celestial constellations or even the poetry of higher mathematics"; La Monte Young, "an audacious innovator of what he calls eternal music"— these were a few of the fourteen rising talents featured as "New Faces, New Forces, New Names in the Arts" across two spreads in the June 1963 issue of *Harper's Bazaar*. Another wunderkind in the *Bazaar* feature is also worth a mention: "Andy Warhol, pioneer in the New Realist art, [who] forced an ordinary Photomat to make dramatic portraits of all the personalities, including himself, for these four pages." Not only did Warhol get to appear in this impressive crowd, but he was the only one whose talent was actually on view in the feature, in a series of portraits of his thirteen colleagues that let *him* decide how each of them should look. As usual, Warhol the underdog— the *mere* illustrator of the magazine feature—managed to take control. His portraits *are* the feature, beside texts that are hardly more than captions.

Months earlier—his subjects were still wearing winter coats—Warhol had dragged each of *Bazaar's* New Faces to the penny arcades around Times Square, where he had them mug for the camera in a series of photomat booths, trying on all sorts of poses and expressions. (When a New Face could not be there in person, Warhol held photos of them up in the booth, taking a picture of their picture.) The sessions produced dozens of four-portrait strips, the best of which were cut up and scattered across the two spreads in *Bazaar*, almost as though they'd tumbled straight from the machine onto the page. Their sprightliness fit with the theme of that month's issue, which was dedicated to "youngness—part awareness, part participation, part willingness to stick your neck out." Editors described the issue's New Faces as the names most worth dropping by the kind of hip youths who dared to Twist, but it turns out that the magazine saw its young readers as having more serious

cultural aspirations. Warhol's twin spreads, themselves on culture's cutting edge, got to rub shoulders with such high-status items as a short story by the poet Denise Levertov and an essay by Dylan Thomas.

Warhol's exposure to photomat technology dated back to Pittsburgh in the 1940s, when the machines were a hot fad that his brother John had locked on to, joining a Zavacky cousin in a small-time portrait business. But for once, biography might *not* be the key to unlocking the roots of Warhol's creations. The concept for the *Bazaar* spreads actually started life in the mind of Marvin Israel, an art director at the magazine who had run a feature on photo booths in a recent issue. "It was a no-brainer to recognize the magic of a machine that could take instant photos in a series format with the sitter in the booth," said Israel's assistant and then successor, Ruth Ansel. "They were in your hands in a matter of minutes and we all loved them."

Those earlier roots in mass media might explain why Warhol's photo-booth series had a more friendly, more commercial feeling than his best Pop Art of that moment, which was so deadpan as to feel almost cruel and so opaque as to be almost unreadable. In contrast, his *Bazaar* portraits answered to the old-fashioned, Old Master goal of fully revealing a sitter's character and vocation. The pile of images in the magazine spread are eminently palatable compared, for instance, to Warhol's serial "portraits" of soup flavors or of the dead Marilyn, which are about repetition that yields almost no new information.

Marvin Israel's earlier photomat feature had claimed that the portrait machine acted as an "indubitably honest little lie detector" that laid bare "all sorts of objective, unexpected truths." And that contradicts what Warhol was after in his best work, where he refused to lay bare truths of any kind and suggested that lies—or plain silence—might be worth just as much. For the *Bazaar* project, however, Warhol poked and prodded his sitters in the booths until they assumed the same signs of life and character that portraits had been revealing for centuries. Just a few years before, in fact, an issue of *The New York Times Magazine* that had a blotted-line illustration by Warhol inside it also had, on its cover, twenty-five little photos of President Dwight Eisenhower, showing his expression as it underwent second-by-second changes.

Warhol came up with something pretty close to those shifting Eisenhowers early in the summer of 1963, when he got a commission for a custom-made portrait—the first one in a career that went on to be built around them. It was to be a painting of Ethel Scull, commissioned as a birthday present from her husband Bob, a New York taxi magnate who considered himself "very friendly with Andy." The couple had begun to assemble one of the world's premiere Pop collections, helped by the fact that Bob was the not-quite-silent

partner at the Green Gallery where Warhol first showed, advancing it money as a way of getting his hands on Pop Art at cost.

Ethel remembered the portrait session with Warhol:

> Bob had asked Andy Warhol to do a portrait, which sort of frightened me, naturally, because one never knew what Andy would do. And so he said, "Don't you worry, everything will be splendid." I had great visions of going to Richard Avedon's, see, of having these magnificent pictures of me taken, to be photographed, and then he would do the portrait. And so he came up for me that day, and he said, "All right, we're off!" I said, "Where are we going?" He said, "Down to Forty-second Street and Broadway." And I said, "What are we going to do there?" He says, "I want to take pictures of you." I said, "For what?" He said, "For the portrait." I said, "In those things? My God! I'll look terrible." He said, "Don't worry." And he took out—he had coins, about a hundred dollars' worth of silver coins. . . . He said, "Just watch the red light." And I froze. I watched the red light and never did anything. So Andy would come in and poke me and make me do all kinds of things. I relaxed finally. And you know, I think the whole place, wherever we were, thought they had two nuts there. You see, we were running from one booth to another, and he took all these pictures, and they were drying all over the place. And at the end of the thing he said, "Now, you want to see them?" And they were so sensational that you didn't need Richard Avedon, you see.

And they were indeed sensational, especially once Warhol had enlarged the photos from the shoot onto thirty-five separate canvases just about the size of newspaper pages—and of his earlier thirty-two Campbell's Soups. He printed the silkscreen for each photo on top of a brightly colored background: red or green, yellow or pink, mauve or violet or orange. Over there was pretty Ethel as a mysterious stranger in dark glasses; here she was in an open-mouthed smile; a few canvases away was Ethel as a sexy broad. The portraits had all the fun and good cheer of the *Bazaar* spread. And none of the heft of Warhol's most serious work, including the uncommissioned, more experimental portraits he'd done of artist friends the previous winter, which played with 3-D effects and a tabloid feel. It's notable that those earlier portraits had been done for Warhol's own pleasure and consumption; the sitters didn't always get copies.

When commissioned to do the *Bazaar* portrait photos, Warhol had in-

stinctively catered to the needs of the magazine's editors and readers, who were expecting legible illustration rather than baffling art; he did just the same for his paying art patrons, giving them what he knew they would want and respond to—Bob Scull had, after all, been trained in commercial art and said he liked the "psychological excitement" of his wife's portrait series. If Ethel Scull had hoped for the flattery of an Avedon, Warhol gave it to her, translated into the new Pop language he'd created. Yet, as with the equally flattering society portraits of the '70s, the ones of Ethel Scull may conceal a fiercer undercurrent. Rather than catering to his sitter's cheery surface style Warhol may be recording it in all its superficiality, objectively and unblinkingly, the way his Campbell's Soup series recorded those canned goods without claiming to sing their praises or elevate them beyond what they truly were.

The summer of the portrait series, Warhol invited his friend Wynn Chamberlain to a restaurant with him and Ethel Scull. When his patroness got up to use the bathroom, Chamberlain let loose: "Andy, who is this woman? How can you stand her? Look at all those awful, vulgar diamonds she's wearing!" To which Warhol is supposed to have replied, "Those diamonds are going to be paintings very soon."

For all its overall conservatism, the Scull commission did provide some artistic returns. Late in September, when Warhol delivered the thirty-five little pictures to his patrons' home, they asked him what order they should be hung in, but he refused to take control. Pointing to an installer who was up a ladder with hammer and nails, he said, "Let him do it any way he wants."

He underlined his point by leaving the room as the installation went on. "If you ever get bored, my dear, we can always change it," said Warhol to Ethel Scull. "You can change them yourself."

One of the most fundamental choices any modern artist could make was how a composition should come together, but here was Warhol refusing to make it. Just as a machine had been left to capture Ethel's poses, chance was now being left to assemble them. Or that at least was the avant-garde premise and polemic behind the works. In fact, not much about the final result had been left in the hands of the poor photo machine, given that Warhol had directed Ethel's modeling and then selected which shots were best to keep as well as which ones to silkscreen onto which background colors. Chance was left equally disempowered in their installation. Once the paintings went up in the Sculls' living room, as Ethel remembered, "of course he did come in and give it a critical eye: 'Well, I do think that this should be here and that should be there.'" Warhol, the control-freak aesthete, was never really

willing to leave behind the traditional artistic values he'd acquired in art school, but he did a better job than most in pretending he was.

He played up his links to the Old Masters in another major "portrait," of sorts, from early that spring, when he did a series of riffs on the *Mona Lisa*. Leonardo da Vinci's official "masterpiece" had traveled to the United States on the S.S. *France* in December, on a visit that was a kind of diplomatic gift from the French to John F. Kennedy. Over a million New Yorkers showed up to see the painting at the Metropolitan Museum, waiting in vast lines to get their few seconds with the famous smile.

Even before the show had opened, Warhol had seen a long opinion piece about the loan that might as well have had him in mind: "Mona Lisa has crossed the Atlantic westbound, like the star she is, occupying a first-class cabin-de-luxe amidships to avoid movement and vibration, just as any blonde from Beverly Hills always specifies so that she will be not too shaky before the camera on the morning after her arrival." Long before that, he'd witnessed how one of his art school textbooks devoted vast space to Leonardo—more than to any other artist—with a full-page illustration of the *Mona Lisa* and another full-page describing the painting's greatness. (In another college text Warhol underlined the description of Leonardo as "one of the most profoundly intellectual of painters.") The portrait hadn't lost its appeal by the '60s, even among vanguard artists: Marisol, Warhol's friend and rival, had done a riff on *Mona Lisa* just a few years before, as had Rauschenberg. Their hero Marcel Duchamp had reproduced her, with a mustache, decades earlier. It was Warhol's turn to weigh in, especially since from the very beginning people had felt compelled to compare his Soup Cans to Leonardo's most famous painting, mostly so as to disparage the Cans. He'd considered doing *Mona Lisa* as one of his paint-by-numbers but instead he silkscreened her portrait twice, thrice, four times—thirty times—on canvases of every size. He was paying homage to her, obviously, but also demonstrating how emptied out she'd become through ubiquity. Years later, Warhol told a patron that the vast grid of *Mona Lisa*s titled *30 Are Better Than One* was the best work he'd ever made.

In early 1963, that grid of Leonardos already acted as a kind of summation of what Warhol's art was about: reproduction, celebrity, ubiquity, merchandise, maybe even gender, along with art history and aesthetics. But there was something especially brave and novel about this particular act of reproduction. A silkscreened painting of Marilyn was mostly about Marilyn, the person, and only then about the anonymous, unknown studio photographer whose shot Warhol had copied. Copying the *Mona Lisa*, on the other hand, was barely at all about the long-dead sitter herself; it was almost only

about Leonardo's famous *picture* of her and Warhol's theft of its image. That made Warhol's riff on the *Mona Lisa* one of his most aggressive acts of pure appropriation, putting him in play as a true radical—a postmodern before the term existed. One of Warhol's more fearsome early opponents, who traced the whole "problem" of Pop back to Duchamp's mustachioed Mona Lisa, voiced the common view that the grand course of Western art—the *proper* course of Western art—had proven that a painting absolutely had to involve "some transformation, some metamorphosis" and couldn't be about the "mere transposition" seen in Pop. So of course Warhol, trained in rule breaking since college days, simply had to make a suite of paintings that were all and only about such transposition, straight from the Met's *Mona Lisa* brochure to his canvases. But the particular transposition he chose also let him signal that he was in the same game, and playing in the same league, as even the most titanic Old Master.

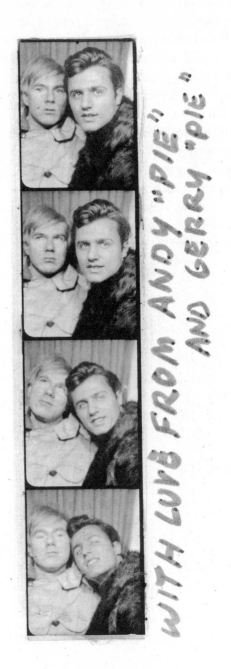

WITH LOVE FROM ANDY "PIE" AND GERRY "PIE"

. . . with Gerard Malanga in photos inscribed to the poet Charles Henri Ford.

# 18

## 1963

GERARD MALANGA STARTS WORK | DOWNTOWN POETS |
AMPHETAMINES | DOWNTOWN FILMMAKERS | HOME
MOVIES WITH JACK SMITH IN OLD LYME | JOHN
GIORNO IN *SLEEP* | *KISS* | THE PUT-ON

*"We found the young man to be a true original—fey, wry, impossible to engage in serious conversation. He is a lark"*

*March 20, 1963*

*Sweetest Gerry:*
   *Lying next to you last night was divine. I've wanted to kiss you for so long, and the few drinks I had gave me the courage to so.*
   *I wish you the happiest of birthdays.*

<div align="right">

*Love,*
*Andy*

</div>

It looks as though those words were (mis-)typed by Warhol on stationery from Wagner College, on Staten Island just off Manhattan, that he must have borrowed or filched from that same "Gerry"—presumably Gerard Malanga, a gorgeous young undergraduate who was at Wagner on a poetry scholarship and was celebrating his twentieth birthday. Malanga would go on to spend the next half decade as one of Warhol's most important assistants and comrades.

   (Malanga has insisted that this letter must be a forgery and that he never had an intimate encounter with Warhol. But it is hard to imagine why or how a forger would have known or researched Malanga's birth date, procured Wagner College stationery, successfully faked Warhol's signature and then hidden the forged note among Malanga's own papers at the Harry Ransom archive in Texas, for it to await rediscovery by this author in June 2014. The Warhol ar-

chives hold a circa 1963 note from Warhol to his dealer Eleanor Ward that is also written on Wagner stationery.)

Warhol would have had a hard time resisting Malanga, a Neapolitan beauty with a Bronx accent and a rocker's pompadour that gave him a whiff of rough trade. Already in high school, at the prestigious School of Industrial Art, his sex appeal had helped him find his way among the local culturati. Daisy Aldan, the school's English teacher and a force in avant-garde publishing, became a mentor to Malanga, introducing him to the latest in poetry and to the people who wrote it. "All these homosexual poets wanted to go to bed with me; I didn't know how to say no," Malanga remembered. One of them was the poet and underground filmmaker Willard Maas. After a few louche encounters ("sex came first, poetry second," Malanga recalled) Maas took Malanga under his artistic wing, proclaiming him a talent to watch: "Like Rimbaud this young poet's genius is unexplainable . . . and I should not be surprised if some day he would surprise us and achieve what Rimbaud did." Although "unexplainable" and all that "surprise" do sound like Maas is hedging his bets.

It was Maas who had first introduced Malanga and Warhol, around Christmas 1962, at a party he gave for the radical filmmaker Stan Brakhage, who the precocious Malanga had already interviewed. Warhol had come with his friend Charles Henri Ford, the veteran gay poet who had recently returned to the United States and who got a glimpse of the stardom Warhol was already courting: "Oh Charles," said Marie Menken, Maas's wife and a leading bohemian filmmaker, "you come back after ten years and you're immediately with it again. Here you turn up with Andy Warhol." Warhol himself recalled how he'd "really spooked" Malanga on their first encounter: "He thought that I was going to put the make on him." Warhol's birthday greeting to Malanga suggests that he may have done just that.

Warhol and Malanga seem to have been out of touch for another few months, until Charles Henri Ford brought them together again at a poetry reading. Ford knew that Warhol needed a new helper after having just lost an earlier one—a color slide from May shows Warhol getting help from a dishy young rocker who has come down to us only as "Max." Malanga seemed a fine replacement. He had studied graphic design and advertising in high school. ("I was gearing up to become a commercial artist on Madison Avenue.") He also had notable experience with silkscreens, having spent a summer printing textiles for a business run by a lover he had in high school. Once Warhol learned that the handsome and well-trained Malanga needed a summer job and would work for $1.25 an hour, the minimum wage—"I didn't know you could get more," said Malanga—he asked him to start at once.

A couple of days later, Malanga spent a morning learning the ropes at the

firehouse: Photos show him helping with a *Tunafish Disaster*, although he later said he'd first worked with Warhol on a Liz Taylor. That afternoon, Warhol showed him the town house for the first time. There was Julia Warhola cooking a lunch of "Czechoslovakian" hamburgers (ground beef with chopped onions and no canned soup in sight), plus the usual chaos of Americana, movie magazines, cats (two of them, Siamese) and a pile of Campbell's Soup paintings, all bathing in the sound of the latest rock. (Although not, as Malanga has often claimed, the song "Sally Go 'Round the Roses," since that wasn't released until the end of the summer.) In Malanga's telling, which seems far-fetched given their previous encounters, he first twigged to who his boss was when he saw some Soup paintings in the town house that day: "Why, of course! . . . Now I know where I've seen his paintings before. He's the one I'd read about in *Show* magazine. He's one of these pop artists." Within a few weeks, Malanga had sent Warhol a photograph of himself inscribed "For Andy 'Pie' with Admiration and Love, Gerard"—a sign that, right from the beginning, this may not have been the usual artist-assistant relationship. Malanga gave Warhol a Wagner College sweatshirt that became the artist's favorite piece of clothing, and photos from two years later show him cozy in bed with an entirely naked Malanga.

In the firehouse studio, they worked modest hours—something like eleven to five—and Malanga remembered the atmosphere as "very relaxed." When work was done, Warhol would pay for Malanga's ten-mile taxi ride home to the Bronx, a story that either refutes Warhol's reputation for cheapness or confirms his affection for his helper.

The younger man's presence in the firehouse had only a modest influence on the art that got made there. Mostly, it let Warhol print more images, faster, and also make bigger pictures from bigger screens—although he'd been working pretty big for a while before Malanga arrived. The two men developed an impressive pas de deux when they worked, laying down the printing frame, inking it and then pulling the squeegee across, side by side, with a wonderful economy of motion.

Simply by being there, Malanga also had an important effect on the conceptual side of Warhol's art, where Pop paintings found a lot of their meaning. He helped bring to life an idea that had been implicit in the silkscreens from the beginning, and was sometimes mentioned by Warhol: Because the technique could, in theory, involve a purely mechanical act that anyone could carry out, it promised to liberate Warhol from the stale, romantic—1950s, AbEx—idea that an artist's own hand should be involved in making each work, revealing genius and soul.

Back when Warhol was still silkscreening on his own, a critic had described him as "a one-man Rubens workshop, turning out single-handedly

the work of a dozen apprentices." Malanga's arrival let Warhol take the next step, insisting, or at least pretending, that truly contemporary artists didn't even have to be present when their work got made. Just a few months after Malanga got hired, or maybe less, he and Warhol were still talking about this promise of liberation as being pretty much hypothetical:

> WARHOL: I think it would be so great if more people would take up silkscreens so that, in turn, no one would know whether my picture was mine or whether it was somebody else . . .
>
> MALANGA: Well, I could do that with your silkscreens. . . . Let me be the first imitator.

The fact of actually having an assistant—and later several of them—allowed those "more people" to take up residence in Warhol's studio. He could work his way up to making his famous pronouncement that, thanks to silkscreening, "one of my assistants, or anyone else, for that matter, can reproduce the design as well as I could." And this meant his process came to be completely in keeping with the branded products he used as subject matter. No one asks who precisely cooks up the recipe for Coke, or who designs the plants that make or bottle it: A bottle of Coke is the product of the Coca-Cola Company, and that's all its consumers need to know. Ditto for a Warhol painting. It could, at least rhetorically, theoretically, count as the product of a corporate creature called Andy Warhol even if the man named Warhol hadn't taken a direct hand in its production.

"Why don't you ask my assistant Gerry Malanga some questions?" Warhol said to one reporter. "He did a lot of my paintings. . . . I just selected the subjects, things that I didn't have to change much."

For all the vital role that Malanga played in Warhol's conception of his art, this new assistant might have had almost as important an effect outside the studio, in Warhol's social and cultural life. As an absurdly gorgeous and precocious poet—he was no star but he was winning prizes—Malanga smoothed Warhol's move into the nascent youth culture and its new undergrounds. For most of the 1950s, Warhol had mostly identified with a gay "decorator" scene that was pretty much segregated from the mainstream avant-garde—a culture so "counter," in that Eisenhower era, that it could work only on the sidelines. Now, with Malanga's hipster help, he moved in on the in crowd. Nathan Gluck, the commercial assistant from that earlier scene, disapproved of the new employee from the day he arrived, wearing, as Gluck remembered, "long girlish curls and a sidewalk-length horsehair coat."

(He must have called up that image from later in the 1960s; when Malanga arrived on the scene photos show his hair in a pompadour.)

Warhol and Malanga made frequent forays downtown, to poetry readings and other such East Village events where the younger man was known: "Malanga was an accepted poet—not big, but he was on the scene," said one observer.

The Café Le Metro, for instance, had just launched on Second Avenue as a kind of 1960s update on Serendipity, selling antiques and cappuccino and dessert but also hosting readings for Malanga and his ilk. Warhol bore these outings "like a real trouper," Malanga recalled, and was especially good at denouncing whatever was "corny" in the new poetry. "I would go to anything in those days," Warhol remembered. "I was curious." He got to meet and befriend such cultural radicals as Allen Ginsberg and his partner Peter Orlovsky, as well as the outlandish imp Taylor Mead, whose poetic chapbooks he began to collect at once. "He just sort of put his finger on Taylor Mead at that time," remembered the poet Charles Henri Ford, "when I hadn't even read him, and I'm a writer."

Warhol, for his part, led Malanga westward to the dance-and-happenings world that he'd been getting to know at Judson Church, and where he was now becoming at least a bit player. Malanga remembers being sent out to buy the glow-in-the-dark paint that was Warhol's contribution to the design of one Judson play. Warhol was already "in" enough with this in crowd for radical performance artists to send him announcements and copies of their scripts and ideas. By midwinter, he could be spotted as one of the invited guests at a workshop performance of *The Dutchman*, a radically political play by black author and activist LeRoi Jones, about to change his name to Amiri Baraka.

And yet, said Malanga, Warhol still came off as "a Peter Pan type—very shy, very reticent, very enthusiastic."

The enthusiasm might have had some help. Warhol said he started taking amphetamines, then a perfectly legal prescription drug, around the time he met Malanga—"because I was always worried about my weight, constantly." The explanation probably had some truth to it. Photos from the early sixties do show him with a hint of a belly, and within a few years his doctor was telling him to lose weight and get more exercise; Malanga remembered his new boss as having been "slightly on the pudgy side" when the two first met, and before the two began fetching Warhol's diet pills from a nearby pharmacy. In 1960, Warhol had already splurged on a $100 Exercycle—it was still hanging around in photos of his later studios—while

in the fall of '63 another $150 bought him his latest membership to a gym, this time Al Roon's Riverside Club on the Upper West Side. Warhol, an early adopter of almost every trend, climbed on the fitness bandwagon before most New Yorkers.

There's no doubt Warhol had to keep himself beautiful to compete with, and appeal to, the gorgeous Malanga and the other young beaux on the scene. On the other hand, speed is speed, whether it's called dexies or benzies or black beauties or Obetrol—Warhol's pharmaceutical brand, prescribed to him "as needed for energy and as aid in weight reduction." However they're compounded, all these drugs have the same way of making you feel alive and wildly energized, at least until you come down. Just about the entire downtown scene was on uppers of some kind. "Speed wasn't considered a hard drug then," said the poet Diane di Prima. Her memoir of the era talks about all the amphetamines she'd "dropped into cups of coffee and drunk down with sweet pastry for breakfast." Some of her '60s friends became true speed freaks, moving from pills to powder to injections, taking far too much, too often.

Warhol was probably never that kind of abuser: Obetrol just wasn't that strong, although there's no way to know how many pills he was taking—a "recommended" dose could involve as many as three of the pills' strongest format, and we know that Warhol sometimes took more than one. One drug connoisseur at the Factory described the 25 mg Obetrols—just a bit bigger than Warhol's standard pill—as "very powerful . . . the best. They were very hard to get, rare and very good. It's a good high, very gay, very lovely speed." But whatever the quantity of speed that Warhol took (and it must have varied) it was more than enough to give, as one knowledgeable user put it, "an exciting tingling feeling in the pit of the stomach and a confident sense of infinitely expanding time, without the teeth-grinding jabbers or the awful crash of Dexedrine and many of the other amphetamine pills." A reel of film survives, probably from the fall of '63, that shows the impish poet Taylor Mead prancing around the Lexington town house as, butler-like, Warhol serves him a bottle of speed on a tray—just about the only time Warhol appears in one of his own films. By the mid-1960s, Warhol was telling a journalist that he survived on Obetrol and coffee alone (and then disproved it at once by downing chocolate, nuts, currants and marzipan), and a teenage acolyte said that he once was lunching with Warhol at the stodgy Schrafft's diner when the artist started popping speed from a little pillbox that he kept by him. If nothing else, said a friend, the drug allowed the shy Warhol "to become sociable and interact with people and be more playful."

Another member of the Factory circle said that he and Warhol had talked

about the role speed had played in Warhol's art, and they'd agreed that the drug could give an erotic edge to death and disaster, from a suicide to Jackie Kennedy's mourning.

It's hard to see how Warhol could have managed *without* some chemical help in those early days, what with his double workload of ads and fine art plus a madcap social and cultural life with Malanga. Over the next two decades or so, with no hint of a letup in his workload or socializing, Warhol seems to have stayed on one stimulant or another. In the early '70s, he was talking about how "it's just so hard to get up in the morning. It would be so much easier to stay in bed all day, wouldn't it? I have to take, uh, a pill to get going." At night, downers helped him make the going stop.

But before anyone climbs on their high horse about Warhol's quite legal drug use, it might be worth thinking hard about an idea voiced by Warhol's friend and lover John Giorno: "Drugs can be very important to a person at a certain moment in their life, because it lets them realize something that maybe they wouldn't have." Amphetamines, in particular, provided "a lot of infinite, positive adrenaline. If you give speed to a stupid person, you get a lot of dumb ideas, and if you give speed to Andy Warhol, you get a lot of great ideas."

———————

As Warhol and Malanga stepped out in New York, their most important outings, art-historically speaking, would have been to the movies. Malanga said that they'd go almost every day after work. They'd take in a fair number of mainstream films. (But not, as has often been mentioned, *The Carpetbaggers*, since it came out almost a year later.) The two men also, and more important, saw rarefied fare like Emile de Antonio's own *Point of Order*, which simply strung together newsreel clips from Joseph McCarthy's anticommunist hearings, foregoing voice-over or any kind of annotation. "Raw, art brut," de Antonio called it. Malanga has said that he and Warhol dissected the film at lunch on his first day at the firehouse. It was an obvious source for the raw, uncommented observation in the movies Warhol was about to make, of a friend sleeping or a skyscraper. De Antonio had been deeply involved with alternative film for several years already, so his presence alone would have pushed Warhol toward the medium's cutting edge. As Warhol reminded de Antonio, "We saw double features and you talked about them and about movies and I started making them."

As early as 1961 Warhol was already publicly claiming, maybe under de Antonio's influence or with memories of his college film scene, that he was at work on "an experimental movie." Or he could, as usual, have been

plugging into the freshest American zeitgeist: Budding industrialists were just then being advised that there was money to be made in supplies for "the field of amateur art movie making." In 1961, Warhol's self-description as a filmmaker was almost certainly a fantasy or at best an ambition, but it's fascinating that he wanted people to think it was true. Over the next couple of years, his datebooks show him heading out to see advanced fare by such art-house innovators as Michelangelo Antonioni (his *Eclisse*) and Federico Fellini (*La Dolce Vita*), and he was even taking in the more extreme fare of local underground filmmakers. He said he decided to take steps to join them early in '63, after de Antonio had taken him to see *Sunday*, a bold, crude, handheld documentary about police clearing Washington Square of its folk singers, who were the point of the spear of the coming youth revolution.

If, as Warhol claimed, that film had a notable influence on him, its venue might have been just as important. The film was screened just off Union Square at the loft-cum-cinematheque of Jonas Mekas, a force in the city's new underground film movement. Warhol "was sitting there on the floor in my loft watching movies for months," Mekas recalled, although the two were introduced a bit later and then became lifelong friends. As Warhol floor-sat through countless repetitions of the same films, he would have gotten a crash course in what filmmaking at its most experimental could be. Mekas screened radical, plot-free works by the likes of Marie Menken, who had first introduced Warhol to Malanga, and by Stan Brakhage, who Malanga had already written about. "When you see things over and over you understand what's good and what's bad, so that's how Andy learned to make movies— sitting through endless 16 mm reels," said a boyfriend of Warhol's who often kept him company.

But the film most certain to have sparked new ideas in Warhol was a work called *Flaming Creatures,* the shockingly fleshy masterpiece of the under-ground filmmaker Jack Smith—"so great," Warhol called him, with his usual concision. While *Flaming Creatures* was still getting private loft screenings— it wasn't clear at first that it could ever be shown in theaters—Mekas had described it as "so beautiful that I feel ashamed even to sit through the current Hollywood and European movies. . . . This movie will be called a pornographic, degenerate, homosexual, trite, disgusting, etc., home movie. It is all that, and it is so much more than that." That was a description Warhol could hardly have resisted, and he didn't: His boyfriend remembered them seeing the film "at least twenty-four times." And what they saw was a mad parade of cross-dressers and naked women and men, groping and cavorting in a rain of falling plaster while on "an enormous amount of hallucinogens." The top secret camping of Warhol's early-1950s gay crowd had at last been

let out of the closet and into the legitimate avant-garde of the city's lofts. Warhol's Pop Art had been almost wiped clean of the camp and queerness of his '50s works, except in certain subtle subtexts. Film was about to let them rise to the surface again.

The shift got its start out in rural Connecticut, not quite Warhol's normal stomping ground.

Over the previous year, he'd become close to a painter named Wynn Chamberlain. They had been acquaintances since the mid-1950s, when Chamberlain was showing his Magic Realist paintings in the same gallery as Warhol's friend Dudley Huppler. But the friendship only really took off once Chamberlain had moved into a classic artist's loft on the Bowery's skid row. Chamberlain was beautiful, bisexual and unbothered by convention— Warhol's opposite in most ways and therefore all the more attractive to him. He became yet another of Warhol's daily phone talkers and yet another of Warhol's guides down into the bohemian underworld: "What's happening tonight? Where are you going?" was Warhol's side of many calls.

For an occasional escape from urban grit, and to paint away in peace, for some summers already Chamberlain had been renting a farmhouse and studio on a vast spread in Old Lyme, Connecticut, owned by "an old New England family of aging Buddhist nudists." One day when Eleanor Ward, of the Stable Gallery, came by for a studio visit with Chamberlain she became so enamoured of the setting that she rented a couple of outbuildings on the same property, even decorating one with a Campbell's Soup canvas. Chamberlain remembered registering the work as "a direct attack on the function of imagination in art," set to supersede everything that modern painting had been until then. "I was so struck by this painting, used as a perch for wrens and a wasp's nest, that it began to frighten me—like some kind of cultural time bomb ticking away in that old chicken coop way out in the Connecticut woods."

One August weekend in '63, when Ward invited Warhol and Malanga and a few others to join her for a country stay—that stone chicken coop was a guest room—the Warholian stars came into perfect alignment. Chamberlain had also invited a notable artist-guest right then: Jack Smith, who planned to shoot his latest film on the farm, on a set built by Claes and Patty Oldenburg. Friday night, after Warhol and Malanga had settled into their digs at Ward's, a cavalcade of downtown notables showed up at Chamberlain's: The poet and indie publisher Diane di Prima; the elfin poet Taylor Mead, who had already starred in a notable art film; the actor and speed freak known as Ondine; and the transvestite Mario Montez. Jack Smith was calling them his "superstars," but once Warhol had met them and begun

filmmaking, it wasn't long before he borrowed both Smith's actors and his term for them.

Dinner was served, as were joints and pills, and the vast crowd bedded down where they could, as Chamberlain recalled in a memoir of that Friday night:

> Early Saturday morning Jack woke me up and asked if he could spray the woods behind the barn pink, along with several cows he had located. . . . While Jack stalked the property for locations, Claes was building a huge circular cake about six feet high and twenty feet in diameter with a secure top, enveloped with canvas and sprayed pink.

By Sunday, after Michelangelo Antonioni himself had shown up to watch the proceedings—Warhol had recently seen his *Eclipse*—the filming began, with Warhol and Malanga coming over from Ward's to see it and be in it.

Smith's movie, never finished, was to be called *Normal Love,* but the footage that remains shows that its love was always meant to be as abnormal as anything in *Flaming Creatures.* One Busby Berkeley sequence set on top of Oldenburg's giant wedding cake included any number of dancers in tiny pink bikinis, gauzy shawls, yarn wigs and turbans—and most of these fetching vixens, with the notable exceptions of a vastly pregnant di Prima and the Pop Art star Marisol, were played by men. Fifty years later, Malanga spotted himself among those actors, in a bathing suit he still remembered as having been the latest thing from Rudi Gernreich. He also recognized Warhol standing nearby, kicking up his heels as he did the cancan "in a floozy red dress, red turban and wearing his trademark sunglasses."

Those shots of a dancing Warhol let us watch as his Pop Art persona begins to loosen up, allowing back in the gender play that he'd jettisoned as he made his first bid as a "serious" artist of the '60s. But what survives of *Normal Love* also shows him in an even smaller walk-on role that may be more momentous: At one point Warhol accidentally wanders into the frame with a movie camera of his own, as he shoots newsreel-style footage of Smith at work on a scene. Warhol's footage was later confiscated and lost—the police seized it along with a copy of *Flaming Creatures* they were after—but it counts as one of his first ventures into filmmaking.

Earlier that summer, he had caught the movie bug when Sally Chamberlain, Wynn's girlfriend at the time and later his wife, lent Warhol a camera that belonged to her father, "a 16 milimeter 1929 Bolex with which he had shot many home movies of our family," as she remembered.

Once Warhol got the Bolex in his hands there was no stopping him. He shot lovely reels of Ward and Warhol's fellow guests drinking cocktails and flying kites and generally swanning about on the croquet pitch. Marisol, Robert Indiana and Taylor Mead are all caught on film—you get the feeling that Warhol is registering the high-cred circles he has moved into—but the camera dwells longest and most adoringly on a beautiful poet-cum-stockbroker named John Giorno, "from a straight, rich, middle-class family," as he put it. His darkling good looks were about to be the source and subject of Warhol's first truly great work on film.

Giorno and Warhol had met the previous fall, three days before the artist's Janis opening. They had been dating almost daily since late winter, when a Wynn Chamberlain dinner party, followed by a visit to a Judson Church dance, had cemented their relationship. Chamberlain remembers Giorno coming to Lyme for a few days of countrified rest:

> Exhausted from his week on Wall Street, Giorno lay sleeping in one of the bedrooms. Curious as to where John was, Andy apparently located him, set up the tripod, screwed on the Bolex, focused on John who was still asleep and began filming. When I happened to come into the room, he was still filming and had just used up my last roll of film.

Thus was born Warhol's landmark film called *Sleep*. Or maybe not. One of the notable things about that weekend in Old Lyme is that almost all the people involved—Chamberlain, Giorno and Warhol himself—have spoken about it at length but have also given very different versions of what went on. Earlier in Warhol's life, the artist himself set out to muddy the historical record, but you can usually just about wade through to the truth. Here, at the moment that he has really begun to matter, a new level of confusion reigns, as it does until the day he dies. The more mythic Warhol becomes, in his status as an artist, the more myths start to adhere to his life.

It's worth quoting at length from Giorno's quite different version of the Book of Lyme—his first of many, but this one from just seven years after the event. It's written with some of a poet's panache and, as the record proves, quite a lot of a poet's license:

> It was one of those 90 degree sweltering June nights. I got really drunk on 150 proof black rum. Andy didn't drink, because he did a lot of speed—Obetrol and dexedrine. I just passed out when my head hit the pillow. I woke up to take a piss as the sun was coming

up. I looked over and there was Andy in bed next to me, his head propped up on his arm, wide-eyed awake from the speed, looking at me. I said with a rubber tongue, "What are you doing?" He said, "Watching you."

I woke again and there were those Bette Davis eyes. *"What are you doing?"* Andy said, *"Watching you sleep."* I went back to sleep, and woke up every once and awhile to see if he was still doing it. I woke up the next time to take a piss. He was laying with his cheek on the pillow drowsily looking at me. I looked at my watch, it was 11:30 in the morning, boiling hot, and did I have a hangover. I said, *"Why are you looking at me?"* He laughed. *"What do you want to know for?"* When I woke the next time, Andy was gone. It was 1:30 in the afternoon and he had watched me sleep for 8 hours.

From this was born the idea for Andy Warhol's first movie *SLEEP*. On the crowded New Haven railroad back to New York, Andy said, "I want to make a movie. Do you want to be the star? I want to make a movie of you sleeping."

"Absolutely," I said, getting closer to him in the jam-packed train. "I want to be a movie star. I want to be like Marilyn Monroe." The air-conditioning on the train was broken and it was hot. "That's what I've been asking you for."

Warhol's first work of film art, it turns out, has its origins in an intense gay love affair.

Giorno was always a heavy sleeper, with help, he said, from his heavy drinking: "Every time Andy telephoned, morning, afternoon or night, I would be asleep. He would say 'What are you doing?' and I would say 'Sleeping.' Or he would say, 'Don't tell me, I know: Sleeping.'" Andy's idea was to make an unbroken "durational" document of this impressive som- nolence. The idea of observing closely as almost nothing goes on was very much in the air. John Cage's four minutes of unplayed piano was one famous precedent. So was a Cage concert that Warhol, Malanga and Giorno went to in early September of '63—just when *Sleep* was being perfected—that presented a composition by Eric Satie, "court musician of Dadaism," that had a tag team of pianists repeating the same snippet of melody for almost two days. Then there were the endless drones of the composer La Monte Young. He had been featured in that *Harper's Bazaar* story Warhol had recently illustrated; it came with a quote from Cage describing how Young was able to "bring it about that what I had been thinking was the same thing, is not the same thing after all but full of variety."

In 1961, an avant-gardist named Jackson Mac Low had even written the following "script" for a film: "Select a tree. Set up and focus a movie camera so that the tree fills most of the picture. Turn on the camera and leave it on without moving it for any number of hours . . . for the word 'tree,' one may substitute 'mountain,' 'sea,' 'flower,' 'lake,' etc." (Mac Low was never sure if Warhol could have known of that script before beginning his own static films.) The Judson dance that Warhol and Giorno had gone to on the night of their first dinner together had in fact included a section called "Sleep."

Giorno has fond memories of the first night of shooting, in his second-floor apartment in a mews-house on East Seventy-Fourth Street, the month after their stay in Old Lyme: "I was naked and getting into bed. And Andy said, 'Mr. Giorno, are you ready for your close-up?'" Over the next few weeks, the couple would come home from their evening screenings and parties, consume their drug of choice—vodka for Giorno, Obetrol for Warhol—and then settle down for the night, one in bed and the other behind the camera.

There were false starts: Warhol's film was advanced through the Bolex by a spring that ran down about every twenty seconds, so that when the first batch of three-minute reels came back from the lab, they were full of jerks every time the camera got wound. For a later film when a bunch of footage came back with flaws, Warhol concluded that "it was artistic in spite of what we did—anything bad is right," which was as close as he ever came to a guiding aesthetic principle. With Sleep, however, he wasn't quite ready to go there. He got advice from a more experienced filmmaker who told Warhol about a plug-in camera motor he could buy, and with that things went more smoothly. Reel after sleepy reel got exposed across a series of nights, when Giorno would awake to find piles of yellow Kodak boxes littering his floor and no sign of the man who had used them. There were times when Warhol let himself in with a key after Giorno was already asleep.

"It was an easy shoot," remembered Giorno. "I loved to sleep. I slept all the time, twelve hours a day every day. It was the only place that felt good: complete oblivion, resting in a warm dream world, taking refuge in the lower realms. Everything awake was horrible. Andy would shoot for about three hours, until 5 A.M. when the sun rose, all by himself."

If the filming itself was straightforward—put the camera on a tripod, plug in a single floodlight and the camera's drive, start the camera rolling—a bigger challenge came in editing together the dozens and dozens of finished reels. All those different nights had actually produced twenty-two different views of Warhol's naked lover: Sometimes he's seen from the feet, sometimes

from the side, sometime from over the headboard. The lighting and exposure change as well and the framing can range from quite tight, almost in close-up, to fairly wide views.

Warhol eventually realized that the sheer inconsistency in his footage didn't work for the unblinking observation he had in mind. He'd have to pick out and edit together all the shots that were most similar and static, a job so boring that when he got fed up he gave it, like Tom Sawyer, to his teen-age friend Sarah Dalton. "Every time it changes drastically, you have to cut it out," Warhol told her, after instruction in the basics of splicing film. (De Antonio had edited his *Point of Order* at home, where Warhol might have had occasion to watch and learn.) To make the finished work even more uniform, Warhol also paid to have some reels duplicated and then he added those in to the edit. The complex reality of his first major film gives the lie to the myth that he'd turned to moviemaking only because it was easier than painting—which of course his silkscreening had already made awfully easy.

Even as late as October Warhol was still shooting new reels, Giorno said, because he wanted the film to be as monotonous and lulling as a night of perfect, unbroken sleep—which is pretty much how it feels, for anyone who has sat through the film's full five and a half hours. Warhol only ended up with that much useful footage, not the iconic eight hours' worth of slumber he had planned on and which had even been announced as forthcoming in the December issue of *Life*.

But the real count didn't seem to matter. From the beginning and for decades afterward, ads and reports and reviews of the film have claimed that it ran the full eight. In fact, Warhol only managed even his five and a half hours of Giorno asleep by insisting that the film be projected much slower than it was shot. That was a new feature on Bolex's own projectors just then being advertised as a "Magic Switch" that would "turn any movie into Amazing Slow Motion."

One of Warhol's several, often contradictory accounts of *Sleep* ties it to Hollywood, and therefore to his earlier movie-star paintings: "People usually just go to the movies to see only the star, to eat him up, so here at last is a chance to look only at the star for as long as you like no matter what he does and to eat him up all you want to." But the truth is that Warhol, supposedly obsessed with Hollywood filmmaking and culture, actually went on to make a decade's worth of films that repudiated almost all the easy pleasures that Tinseltown had always stood for.

*Sleep* itself may actually have its strongest connection to Warhol's even earlier Pop, such as the Campbell's Soups, which were first read as being about pure observation, without any concern for style or emotion or even

art. Their only job seemed to be to point out certain things in the world in "isolation and starkness," as Geldzahler wrote—accomplishing, that is, what philosophers refer to as simple "ostension." That's what gave them their radicalism. They were taken to show that the very notions of beauty and taste and aesthetic value had been superseded, or killed. Warhol once told a fan of his Marilyn paintings that the fan would be better off getting a photo of Marilyn, or better yet a photo of a photo of her, because they would really do the same job as the Warhol silkscreens. Very quickly, however, his first Pop objects started to lose their original edge and came to look more and more like a fashionable style.

With *Sleep,* Warhol went back to portraying something at least as banal as a soup can, using a technique so direct a famous critic dubbed it a "styleless style." In fact, *Sleep*'s Campbell's Soup directness was in tune with, or influenced by, a turn toward the purely "observational" that was in vogue right then among artists. No less a figure than Robert Rauschenberg had told *Time* magazine that he was trying to "kill" the intimate, "souvenir quality" of his early works because "nostalgia tends to eliminate some of the directness. Immediacy is the only thing you can trust." He told another interviewer that he cherished "the possibility of things being seen for themselves, bypassing representation." Just before beginning *Sleep,* Warhol had fallen in love with a new artist's book that was nothing more than twenty-six utterly banal, uninflected photos of American gas stations, shot by the Los Angeles artist Ed Ruscha. He was a gallery mate of Warhol's at the Ferus and had given Warhol the book on a trip through New York. The almost cinematic quality of Ruscha's ostension was already getting full play in the filmmaking that Warhol was seeing just then. Jonas Mekas himself was fond of pointing his camera at whatever happened to be in front of him, while his close colleague Shirley Clarke had a hit with a movie that pretended to be a direct document of a drug den. With the actual filming of *Sleep,* Warhol took such cinema verité to its logical conclusion: No one ever seems to notice that *Sleep* could count as the purest of documentaries. (Although, like all documentaries, it is carefully crafted to achieve its reality effect.)

Warhol always talked about his love of boredom. He once spent hours listening to La Monte Young's taped monotones, long after his companion that day had fled. He liked to compare his own static movies to the venerable art of porch sitting or to a fireplace that does its soothing work even if you only barely pay it attention. "I make movies to read by, to eat by, to sleep by," Warhol said (which doesn't mean he believed it). Stan Brakhage, an even more radical experimenter, said his films should be viewed in living

rooms, not theaters, but Warhol had actually said it first. One curator asked Warhol's permission to show *Sleep* on the gallery wall "like a painting," and that kind of relaxed, half-attentive viewing is how most of us attend to most art of any kind, most of the time. But when a work of fine art gets viewed that way, its extreme reticence and reserve—compared, say, to the song and dance of Hollywood filmmaking—always also invites us to dig much deeper and coax out some kind of conversation. You could say that *Sleep*'s invitation to extended contemplation is a model for all of art looking. "When nothing happens you have a chance to think about everything" was another line of Warhol's. Given the chance, *Sleep* acts as the occasion for extreme contemplation and cogitation about such things as film, time and attention, and how all of those relate to our bodies. As Geldzahler put it in the press release for the first official screening of *Sleep*, "we find that the more that is eliminated the greater concentration is possible on the spare remaining essentials. . . . As less and less happens on the screen, we become satisfied with almost nothing and find the slightest shift in the body of the sleeper or the least movement of the camera interesting enough." This all proves true for anyone who watches *Sleep* start to end.

One collaborator talked about Warhol's real love for even the most "boring" of his own movies: "He would sit and watch them for endless hours with one leg crossed over the other and his face in his hands and his elbows on his knees, with absolute fascination." Another witness, who at first had thought that Warhol's films were a huge put-on, changed his mind when he got a look at their maker during the screening of one: "The expression on his face was one which I'd seen before on the faces of playwrights and directors on opening nights: he really was seriously emotionally involved, and deeply concerned about the public response to his work."

*Sleep* only went public gradually. It was first screened at home in the front room of the town house and also on "an old clacking projector" in Wynn Chamberlain's loft, where Jonas Mekas first fell in love with it. It finally got full but brief public release in mid-January of '64. John Giorno provides a possible reason for the delays: "Andy was terrified that it would be perceived as a gay movie, perceived as a gay man's filming another gay man." The question is, how could it not have been seen that way? Geldzahler once compared *Sleep* to a still life but that may have been a kind of cover-up: It is clearly much more alive than that, with a subject that is hardly inanimate and a roving eye behind the camera that is just as embodied. Early on, even reviews that admired *Sleep* seemed to go out of their way to paper over the man-on-man love that the film is about.

"Love" does seem to be the right word. Despite Giorno's obvious sex ap-

peal, Warhol's gaze seems much less salacious than amorous. One morning that same summer, Warhol shot a home movie of a nude Giorno washing dishes in his sun-filled kitchen. That too could have felt crass and kinky but instead gives a sense of an artist who is giddy with romance and pleasure. If there's one thing that comes clear in Warhol's life it is that he was desperate for fine, old-fashioned love and coupledom. And that he suffered endless disappointment in his bids to find it. It didn't help that he was convinced of his own ugliness, despite what anyone, including Giorno, could say to the contrary. "He had a beautiful body," Giorno remembered. "He was taking diet pills—basically, speed—and he was working all the time, working with his hands, making the silkscreen prints, which is quite a physical job. So he was slim and he had really good muscle definition. . . . He was like a Renaissance statue." But Warhol refused to believe it.

At the same time that he was completing *Sleep* Warhol was already screening *Kiss,* a piece that began life as reel after reel of various couples embracing—osculation given the full Campbell's Soup treatment.

"Anti-film-makers are taking over," wrote Jonas Mekas. "Is Andy Warhol really making movies, or is he playing a joke on us?—this is the talk of the town . . . is this art of kissing or art of cinema?" In fact, Warhol's film was a redo of a pioneering and scandalous Thomas Edison short called *The Kiss,* which was discussed and illustrated in a book Warhol used as a source for other works too. ("I like Edison. Oh, do I like Edison!" Warhol said not long afterward, claiming to be most influenced by movies from "the early 10's. That was about when movies were just starting." So much for him as a film ignoramus.) Warhol's *Kiss* is also a reference to another old film with that title, a 1929 silent vehicle for Warhol's idol Greta Garbo; Warhol couldn't have missed its run as the final film shown at a famous New York art house in May of '63. In another evocation of early Hollywood, Warhol's *Kiss* was first shown in separate installments under the title *Andy Warhol's Serial,* echoing the installment plan dramas of the 1920s. Malanga, who was one of the film's most ardent kissers, also noted a connection to moviemaking from after the war, when self-censorship had kept all Hollywood kisses short and sweet. That certainly can't be said of Warhol's four-minute clenches, which come across as endlessly hard on the jaws of the men and women involved, with far more tongue action than feature films allowed.

"Why don't you have two men kissing?" Giorno is supposed to have asked, early on in the project. "It would be so beautiful." At least at first, Warhol recoiled in fear at the thought, as he had at the notion that *Sleep* would be seen as implying such kissing. New York in the '50s and early '60s was hardly a safe space for visibly gay men like Warhol. His friend Taylor

Mead talked about the weekly beatings he suffered even in Greenwich Village, supposedly a gay haven. "I would be trapped in the Waldorf Cafeteria at 8th Street and 6th Avenue for long periods of time while young neighborhood toughs made threatening remarks and gestures at me." One of them beat him so badly his cheekbones and eye sockets were broken. That kind of violence was so ingrained in gay psyches that, for one of his earliest self-portrait photos, Warhol showed himself in the process of being punched in the face, to not-so-comic effect; in the '70s he portrayed himself being strangled.

Just as Warhol was first picking up a Bolex, Jonas Mekas, godfather and protector of avant-garde movies, had already explained how the plentiful homosexuality in the new cinema, "because of its existence outside the official moral conventions, has unleashed sensitivities and experiences which have been at the bottom of much great poetry since the beginning of humanity." Yet it took Warhol some time to fully embrace that muse. That summer of '63, when he talked about his plans for glow-in-the-dark porn paintings ("if a cop came in, you could just flick out the lights or turn to the regular lights") he described the "big breasts" that would be their subjects. Porn was being seen as a likely next step after Pop, remembered the gay painter Robert Indiana, who scoured New York's studios with his friend Warhol "just to see all the really rather raw pornography that was being done." But it's not clear that Warhol had the courage, at least right at first, to queer that trend.

If there was visible gayness in *Sleep,* it might have lived as much in its style as in its content. As Susan Sontag was writing at almost exactly this moment, "The relation between boredom and Camp taste cannot be overestimated," and the *New York Times* then went on to connect the dots between camp and *Sleep* itself. The *Times* author called it out as one of those "almost unbearably tedious" underground films that are "Camp only in the sense that they worship the banal and are decidely 'too much,' but not in the sense that they delight or charm." The "too much" in *Sleep* was in part an excess of gay culture, and most heterosexuals could not see it as charming. One early critic talked about "the idea, implicit in Warhol's paintings (and explicit in many of his films) that one most effective way to get under the skin of bourgeois America is by threatening its sexual values." The original tape from a famous interview that Warhol gave around the same time he was shooting *Sleep* shows him actually insisting that his talk about homosexuality be included in the printed version, only to see all such talk cut once the piece appeared.

At the four nights of *Sleep*'s premiere, as a benefit for Mekas's Film-

makers' Co-op, the attendance was worse than sparse. Instead of helping Mekas raise funds it lost almost $400. Things looked more promising when *Sleep* first played in Los Angeles, with five hundred people in the theater at the movie's start; by the end, only fifty were left and some of the leavers had demanded their money back. "We'll all come out here and lynch you, buddy," said one of them to the manager. Patrons had to be kept from attacking the screen and one wag ran up to it and shouted "Wake up!" into Giorno's vast ear.

---

"The underground cinema is largely a fabrication of publicity: The students are put-on by *Film Culture* and *The Village Voice,* and then they're fobbed off with . . . Andy Warhol spoofs of experimentation." That was the opinion of no less a figure than Pauline Kael, the imperious film critic of *The New Yorker,* and she wasn't alone in thinking that a film like *Sleep*—or for that matter any other film or painting by Warhol—was one vast hoax and joke, refusing to aim for "beauty or expressiveness or meaning." Here's the thing: She wasn't wrong. There *is* something deliberately absurd, even foolish and childlike, about filming a sleeping lover and then expecting others to watch what you've shot, or painting all the flavors a soup brand comes in. Warhol's friend Marie Menken felt he was just throwing a tantrum against mainstream filmmaking and even Geldzahler worried that *Sleep* might be a reductio ad absurdum. But the absurdity isn't a fault. It's part of Pop's point, of its deliberate effort to unsettle and to push beyond standard ways of thinking—about the world and artists and art. Humor is one of Pop's tools, and it can sometimes verge on slapstick. (Those dance diagrams?)

Warhol's art generates endless profound thoughts, but you're not getting it if you don't also laugh. In Pop's earliest days, Roy Lichtenstein, often billed as the movement's most sober member, was busy defending its funny side: "A lot of people get upset if they find something which they think is supposed to be humorous in art. They think it's supposed to be a joke on them, instead of with them."

In his first solo show at the Stable, Warhol chose to distribute an exhibition "essay" that was actually a hoax term paper written by a very smart college kid named Suzy Stanton. In May of '62, in her assignment for what must have been the first-ever class on Pop Art, Stanton "recorded" the varied responses that she and her classmates had to a studio visit with Warhol—which had never in fact taken place except in her imagination. Here was Warhol, in his New York debut, deliberately staking his reputation and future as a serious artist on an undergraduate fancy. (The original essay sur-

vives, inscribed with the teacher's big A.) Stanton happened to be in Mexico when Warhol phoned, long distance, to ask permission to use her essay, and you can almost hear her jaw drop in the letter she wrote in reply. Warhol promised her a painting in payment, but when she came to his town house to collect it he and a friend were watching a porno flick. It left her so embarrassed she fled empty-handed.

Pop came at the end of a rich jokester tradition in modern art. Just a few years earlier, the great John Cage himself had appeared on a TV game show, happily grinning while he made music with radios and a mechanical fish—and while the host made fun of him. Yves Klein's one-color paintings had been equally playful and sly. "All this is quite lunatic," one critic wrote about them; Klein's lunacy got big New York play at the same time that Warhol's Stable solo was up. And Klein was just the latest in a long line of notable French artists of the *blague*. Even Cubism wasn't about real achievements in painting, said some contemporaries, but was just a willful search for "new amazements . . . a mad, perpetual one upmanship." They got something right when they said it. Dada then took critiques like that as a mission statement, turning the joke and the hoax into potent weapons against the complacent mainstream. So did that movement's neo-Dada heirs five decades later. Back in 1912, a French cartoonist was joking that modern art would end up with artists showing blank canvases. By early 1963, Warhol was doing precisely that, and joking that he only did it for the money.

"A Spoof or Art?" was the headline that ran over coverage of that early Washington survey of Pop while even a fan of the movement called it "impudent." As late as 1965 a major art critic, all in a huff, was still complaining that "the approach of the pop artists is parody and overstatement." You could lay more blame on Warhol than anyone else.

While his Janis and Stable shows were still running, a new art magazine decided to approach him for his first Q&A: "We visited Warhol in his studio and found the young man to be a true original—fey, wry, impossible to engage in serious conversation. He is a lark." In the interview itself, Warhol took care to live up to that larking first impression. He insisted on answering yes or no to the most meaty questions, and when he ventured more words he said even less:

Q: Do you feel you pump life into dead cliches?
A: No.
Or
Q: How close is Pop Art to "Happenings"?
A: I don't know.

Q: What is Pop Art trying to say?
A: I don't know.

Warhol could have given perfectly juicy, credible accounts of all those topics—he'd spoken seriously a year earlier, when he had first been declared a "New Talent," and would again a year later, when he opined that an artist who is "really sincere about working" should be able to bear any pan, and about how artists should quit if they can no longer devote themselves to making the most committed art: "It doesn't matter what you do, just so you do it right." But here, in his first big moment on the art-world stage, he deliberately chose to play the fool. Yet his fooling was clever self-protection: Being monosyllabic let his art speak for itself—no intentional fallacy for Warhol. It also hid the fact that his words could get tangled when they tried to follow his nimble art and nimble mind. (If nothing else, keeping to "Yes" and "No" guaranteed him good grammar.) But far more important, Warhol's Q&A shows him pioneering one of the signature cultural forms of the '60s: the "put-on."

"What was once an occasional surprise tactic—called 'joshing' around the turn of the century and 'kidding' since the twenties—has been refined into the very basis of a new mode of communication" said the author of a book-length study called, of course, *The Put-On*, written four years after Warhol had launched this new mode. The author holds up Warhol's *Sleep* as a prime put-on but cites Lichtenstein and Oldenburg as fellow perpetrators. Even Twiggy, the British model who became an icon of '60s style, is seen as somehow putting one over on the public, with her tweeny weight and "thatched male hair." Surely those couldn't *really* claim to be a new beauty standard?

A new generation of rock and folk stars followed where Warhol had led. Geldzahler said they provided the only parallel to his artist friend's "monumental impenetrability." Bob Dylan made a habit of twisting journalists into knots—the put-on book cited him—and by 1964, the faux documentary *A Hard Day's Night* was presenting the Beatles as the ultimate put-on artists. They're shown in a British press scrum that might as well have been scripted by Warhol:

Q: Tell me, how did you find America?
JOHN: Turned left at Greenland.
Q: Has success changed your life?
GEORGE: Yes.
Q: Are you a mod or a rocker?

RINGO: No, I'm a mocker.
Q: What would you call that hairstyle you're wearing?
GEORGE: Arthur.

*The Put-On* cites a real interview in which the group is supposed to have answered every question with the words "Woof, woof."

Warhol never goes as far in his joshing as the Fab Four because his dumb act was meant to be taken for real. You were supposed to entertain the possibility that Warhol really was a bit simple, whereas with the Beatles you knew that they were rock geniuses (or at least devils) whose fooling came with a wink. Warhol's version of that wink mostly lived in his art, which always hovered between stupid and smart and refused to resolve the tension between them. No matter how seriously you wanted to take Warhol's works, they always also allowed for the possibility that they were part of the "giant con game" of contemporary art, "a refuge of the untalented," as *The Put-On* book suggested. That possibility was part of their content. "Being able to bear put-ons has become one of the responsibilities of the modern audience," said the book.

By being willing to put itself in doubt, Warhol's art had displayed its avant-garde credentials. His put-on persona then pushed that avant-garde doubt even further, keeping all claims about him and his art in flux. There's hardly a single one of his most famous statements that he didn't at some point contradict.

Did he believe that we'd all get our fifteen minutes? Depends on when you asked him.

On Mondays he loved canned soup and on Tuesdays billed it as a sign of the culture's decay.

Lichtenstein and Oldenburg and Warhol's other peers were happy to become certified Modern Masters once Pop became certified Art: For the rest of their lives, they filled a normal high-culture role as makers of prestigious objects. With Warhol, however, a lifelong commitment to the cutting edge meant that his objects were just symptoms and signs of a much larger cultural project that had his jokester role near its heart. His true art form, first perfected in the first days of Pop, was the state of uncertainty he imposed on both his art and his life: You could never say what was true or false, serious or mocking, critique or celebration. He himself billed this uncertainty as a major fact of existence: "You can never really know. People really lie. I mean, they can just lie about anything."

An early essay on the vast and immediate influence of Warhol's art talked about its instability: "Part of what makes the attitude super-sophisticated are

the ambiguities attendant upon it. It is an art that may be a mockery or may not be a mockery, an art that seems most a mockery when most fashionably accepted, most subversive when most a fad."

Examining Warhol's life leaves you in precisely the same state of indecision as his Campbell's Soup paintings do. He never let up on that indecision. In the 1970s, his Piss Paintings begged to be taken as serious abstractions but also took the piss out of the abstract. In the '80s, he was paid for paintings that served as ads and sold pictures of ads as his paintings. He air-kissed at Studio 54 but portrayed himself as a staring death's-head.

There was even the chance that Warhol's put-on was a put-on. Opponents could imagine that Warhol's pose as a fiendishly clever ironist was a pitiful attempt to hide his genuine foolishness. Fans could equally well imagine that, in his brilliance, he put on his put-on to camouflage the deep seriousness of his Pop project, which would hardly be Pop if it broadcast its gravity.

Was his art a put-on, or was the put-on his art? Was he himself a joke or a genius, a radical or a social climber?

As Warhol would have answered: Yes.

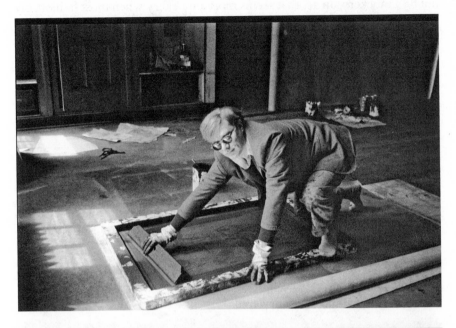

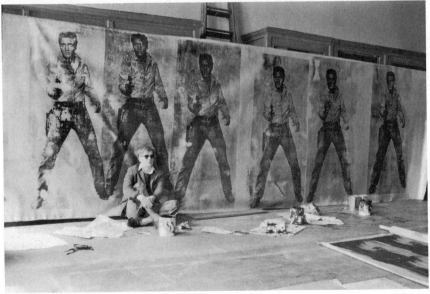

*. . . at work in his firehouse studio.*

# 1963

*"There may well not be another person who has felt and thought
as deeply as Andy. He's in the coldest, loneliest position
because he's decided to accept all the guilt and horror"*

We'll never know whether it was mostly that Warhol was too cheap to fly, or too scared, or if he truly wanted to see the great unwashed nation that critics had told him his work was about. Either way, on September 24, 1963, he and his latest batch of cronies piled into a secondhand Ford and set off for Los Angeles, where Warhol's second Ferus show was due to open six days later. The car, a Falcon station wagon, belonged to Wynn Chamberlain, and he would have to play chauffeur. Neither Warhol nor his sidekick Malanga had licenses. (Warhol's learner's permit from 1956 had never borne fruit and never would, despite the fancy cars he purchased once money began to roll in.) Warhol told Chamberlain that he wanted to get a close look at America, a country he in fact barely knew, whereas Chamberlain had been crisscrossing it for years. At the last minute another driver asked if he could tag along: It was Taylor Mead, the twenty-eight-year-old underground actor and imp who Warhol had met that summer through Geldzahler, and who he had shot with his Bolex at the country place in Old Lyme. Mead was homesick for Venice Beach, Chamberlain said, because he'd had wild times there shooting one of his first underground films. "I called Andy and he reluctantly agreed to Taylor accompanying us." His agreement no doubt came from Mead's growing reputation. A couple of his films had been acclaimed by Jonas Mekas as "coming from deeply 'deranged' and liberated senses"—Mead was a cross between Stan Laurel and Tiny Tim. That summer, Mead had even launched

a public call for revolution in film, and *by* film, in Mekas's prestigious *Film Culture* magazine. Warhol's reluctance, if he really felt any, could only have been about thrift: He had first pitched the trip to Chamberlain as a way to save on the cost of getting his works to L.A., but with Mead taking up room in the car there was no choice but to have the paintings shipped.

Over that spring and summer, the firehouse had been churning out work to fill the walls at Ferus. Irving Blum had originally hoped to do a survey on the order of the Stable one, proving to L.A. that Warhol was more than just Mr. Campbell's Soup. Warhol had other ideas. He preferred to move on to new work that fit the Hollywood setting, as he'd proposed more than a year before when he'd made Liz Taylor his first silkscreen star. In March of '63, it looks as though Warhol had actually canceled a fully scheduled exhibition in Paris just because his dealer there, Ileana Sonnabend, insisted on doing a survey rather than a show of his newer paintings—presumably, the Death and Disasters that Warhol got her to show there nine months later. He always knew how to dig in his heels.

For Blum, Warhol created a vast suite of life-size images of Elvis Presley, silkscreened direct onto silvered canvas that obviously stood for Hollywood's silver screen—but that was also a nod to the aluminum paints used by art stars Jackson Pollock and Frank Stella, whose metallic surfaces were particular favorites of Warhol's. Sticking to the movie theme, Warhol based his Elvis paintings on a PR shot from *Flaming Star,* a B-grade Western released in 1960 to cash in on Presley's celebrity. By avoiding the star's more substantial and soulful rocker persona, which had been on view in a Stable silkscreen in November, Warhol got something that better fit a Tinseltown audience. It also suited the internal logic of his Pop Art as it matured and gained confidence: Presley, as a musician, had a genuine importance that made him more Cordon Bleu than Campbell's Soup; a picture of the man who'd sung "Heartbreak Hotel" could hardly carry the irony and edge that were becoming more and more central to Warhol's art. Depicting the great rocker would have come off either as a simpleminded celebration of pop culture—never Warhol's aim, whatever art critics said—or as a misguided dig at an innovator who any true avant-gardist could only admire. Whereas Elvis as the trashy, sold-out lead in *Flaming Star* was obviously up for grabs—as a symbol, even, of fallen eminence that came with a hint of camp melancholy, the way Marilyn's funereal portrait had. (Ray Johnson, Warhol's model in avant-gardism, had done a performance called "Funeral Music for Elvis Presley" shortly before Warhol began his Elvis paintings for L.A.; Johnson sliced and diced a song by Presley into power chords followed by silence.)

In his camp incarnation, Elvis could even provide a bit of queer energy to Warhol's project. The title of Elvis's movie describes its star as a "flaming" creature, and Warhol's paintings are pretty much built around Elvis's crotch, fetchingly framed by his pair of six-shooters. As they paraded their way around the Ferus walls, Warhol's forty-eight gunmen turned the guy-on-guy action implied in the earlier Dance Diagrams into manifest fact, but now with the added phallic threat of all those pistols pointing our way. Warhol had planned on playing recordings of gunshots in the Ferus space, making all-American death and disaster almost as present there as on the walls of his firehouse, when silkscreens of suicides had kept company with Elvis. In fact, before he fell in love with his Elvis image Warhol had planned on filling the Ferus show with images of Hollywood's greatest screen murders, as a hybrid of his Disasters and his movie-star works.

As so often with Warhol, his apparently lowbrow Elvis imagery might have had highbrow roots, in the same book of French film theory that had links to his Marilyns. Malanga discovered how much Warhol valued that book one day when he "borrowed" it from the shelf without asking, then found that his boss noticed and asked for it back. Years later, Malanga realized that the book contained evidence of another act of borrowing: Its inside front cover lined up ten images of a gun-toting Marlon Brando that were perfectly echoed in Warhol's line of Elvises. Even an "appropriator" as brave and brazen as Warhol didn't always trumpet his borrowings.

Photos of Warhol's studio seem to show him testing two options for the Ferus show, hanging a vast roll of Elvises as one giant frieze but also cutting and stretching other canvases to show single figures and Elvis-times-two. All these avatars of the King were accompanied in Warhol's studio by Liz Taylor herself, who was being silkscreened at about the same time as the rocker. The Liz image that had launched Warhol into his photo-silkscreen career, almost exactly a year earlier, was now being expanded into a series, ready for Warhol's close-up in Hollywood.

When the time came, Blum exiled all ten Liz paintings to the gallery's back room, for viewing on request. The fact that they were so close to being identical must have given him pause—even he couldn't have had that much of a taste for such near-mechanical reproduction. When he'd shown the Campbell's Soups in '62, at least he had different flavors to sell.

All the Ferus paintings got shipped off in advance, arriving in Los Angeles as two crates of stretched Lizes plus a vast roll or two of canvases silkscreened with Elvises, accompanied by stretcher bars but no instructions on where to cut the roll.

"The only thing I really want is that they should be hung edge to edge,

densely around the gallery," Warhol is supposed to have told Blum. "So long as you can manage that, do the best you can." In the end, Billy Al Bengston and Robert Irwin, two soon-to-be-famous West Coast artists, got paid to stretch up the new works by their out-of-town rival. They cut the canvases where and how they saw fit and as quickly as they could, given the paltry amount they were earning. Old footage and photos show ripples in the paintings because of how crudely the two men had worked. "Everyone was outraged that they didn't have any [crop] marks on them," Bengston recalled. "I said, 'Doesn't make any difference—they're all crap!'" Warhol's sexy new Elvises were bound to meet resistance at the Ferus: Its crew of artists were known as the Studs. "Everybody was butch . . . we weren't going to be fems," said one well-known painter. Barney's Beanery, their notorious hangout, had a sign that said, "Fagots—Stay Out."

By the time Warhol set off to join Elvis in L.A., he'd arranged for some star-studded buzz to precede him. A friend at the aptly named *Glamour* magazine had organized things so that Jean Seberg, billed as a starlet who had now "arrived," would be photographed in Warhol's studio in front of his Elvises, with another friend wielding the camera. (Warhol's career being built, as always, around social networks.) The pairing with Seberg made a kind of sense—her new movie was about an angstful if lousy art student—and Warhol couldn't have minded too much that she got twenty-six sentences to the three devoted to his L.A. show. Anyway, the new art he had made for Ferus was all about correcting that balance: It used movie stars to shift the public's attention to him.

———

Reclining on mattresses in the back of the station wagon—one advantage of the Elvises having been sent on ahead—Warhol and Malanga read magazines while Chamberlain and Mead, wreathed in pot smoke or revved up on speed, flew them along the new interstate system. "It was like we were being chauffeured across the country in a station wagon," Warhol recalled. The two chauffeurs were enthusiastic young drivers, to say the least. There were moments when they courted death. "We were driving through total desert—it was like James Dean driving through a vast flatlands," Mead remembered. "We go through this intersection. Wynn goes right through and a car . . . that was nearly the end of us forever. Five minutes later in this total silence, Andy says in this meek voice, 'Wynn, where were you?' He should be called 'super-cool Andy' even when facing death."

Back home, his mother worried about the drive and took to calling Malanga's for mutual reassurance. Mrs. Malanga had an extra reason for

angst: Gerard's presence on the trip meant that he was giving up on his third semester as a scholarship student at Wagner College. He only ever went back for one more term.

The four boys crossed New Jersey and Pennsylvania—Warhol begged to roll through his home state at speed—then on through Ohio, Indiana, Missouri, Kansas, Oklahoma, Texas, New Mexico and Arizona, where Malanga waxed poetic about the highway mirages. As Warhol proceeded down the fabled Route 66 his homeland showed herself in all her tawdry, consumerist glory—pretty much as he must have hoped or even expected. Pop was always being compared to billboards (Jim Rosenquist had once painted them for real) and here were the originals, selling Brylcreem and Burma-Shave to all who drove by. Building-size burgers begged Warhol's crew to stop for a meal, as though Claes Oldenburg had got there before them.

Almost two decades later, a ghostwriter had Warhol talking about the way Pop Art had woken the travelers up to the delights of the low: "The further west we drove, the more 'pop' everything looked on the highways. . . . Once you 'got' pop, you could never see a sign the same way again." But it was more like the other way around: The nation's cognoscenti had a long-standing taste for its roadside glories and that had pushed fine art to appropriate them. Back when Warhol was about to open his Stable solo, before Pop Art was much recognized as a force, the with-it designers at *Show* magazine published a classic photo essay on low-end American culture: Elliott Erwitt, the noted street shooter, had photographed food-shaped food signs, motels at their tackiest and even a pet cemetery. Erwitt, like so many of his peers, was clearly reveling in a so-bad-it's-good aesthetic. As Warhol made his way to L.A., the nation's highways were merely confirming that his art was on the right track.

Not that Warhol was willing to use demotic American culture as much more than inspiration. They stayed in perfectly bourgeois lodgings, with Chamberlain and Mead sharing one room and Warhol and Malanga in another. (Malanga first realized his boss was bewigged one morning when the toupee-gluing kit was left out in plain sight.) When mealtimes rolled around, Warhol steered clear of the wacky diners that Mead preferred and headed instead for tidy steakhouses ("semi-elegant shit," in Mead's phrase) that would take his posh Carte Blanche credit card. Despite pretending otherwise, throughout his life Warhol's tastes in food tended to run more high-end than low. Mead remembered him as "quite a steak eater." One time Mead insisted they try something more roadworthy: "I picked, of course, a truckstop, a magnificent truckstop in the middle of Kansas, or something,

and when we walked in everyone was fascinated by Andy Warhol; they'd never heard of him. . . . But they thought he was just a phenomenon." The fey foursome could hardly miss the threat that came with such fascination, out toward the Great Divide. "Andy was a little unnerved by the experience," Mead wrote in his unpublished memoir, "and we all recognized the potential, one way or another—like a lynching somewhere in Oklahoma. . . . We were a bunch of nellie queens, though Wynn and Gerard were more curious than Gung Ho."

As he crossed the continent with Warhol, Mead offered fellatio to a motley assortment of gas-pumping lads. "A lot of tension there, but it was *good* tension, interesting," Mead fondly recalled of such youthful escapades. "You never knew if the person was gay or receptive or *what*—whether you were going to get bopped or not."

Mead's sexual daring seems to have triggered a strange and nasty response from Warhol and Chamberlain once they got to L.A.: With the excuse of getting Mead to "relax" before an important poetry reading, they exposed themselves ("Andy had a big gray penis") and tried to get him to give them blow jobs. "A couple of thirtyish schoolboys bent on fucking up their confrere's night of individual triumph" was Mead's description of his two "friends." ("Andy was a genius. Hitler was a genius. Who needs genius?" Mead concluded.)

Warhol and Chamberlain might have been getting back at Mead for his escapades and delays on the road. "We had to make it out to L.A. by a certain date and every minute counted," Chamberlain remembered. "Andy would look at his watch while Taylor dallied, Gerry snored in the back seat and I was going quietly mad."

The heat couldn't have helped, in those days when only fancy cars came with air-conditioning. When they finally arrived in Los Angeles, after four mad days of driving, the tail-end of a heat wave was pushing the temperature past one hundred degrees. With most central hotels booked up for a baseball game, they ended up in a seaside motel (The Surf Rider Inn) out by Venice Beach. Mead had spent a couple of bohemian years around there, even acting in *Passion in a Seaside Slum,* the movie that Chamberlain had mentioned to Warhol: "I played a beach-faggot who tries to pick up a fisherman, and with my portable-radio aerial as a magic wand I changed myself into half a dozen drag costumes in a vain attempt to be enticing." Warhol's digs at the Surf Rider put him among the city's artists and bohemians: Claes and Patty Oldenburg had just come from New York to a place near there, as had John Chamberlain, and Jack Smith was visiting too. But the new location also meant a long drive to all their events further south or east in L.A.

The evening of their first day in the city, their drive took them out toward the Hollywood Hills and the new home of the impoverished actor Dennis Hopper and his fancy wife Brooke Hayward, who had been fans of Warhol's since his Campbell's Soup show. Visiting New York the previous spring, the couple had bought one of his Mona Lisa paintings and, hearing about the upcoming Ferus show, had promised Warhol they'd host a "Hollywood" party if he came to L.A. for his opening. The Hoppers liked to decorate with the same folk and nostalgic objets d'art as Warhol—Tiffany lamps and other such Serendipity wares—but their party had pushed them further toward Pop. To get ready for it, Hopper had gone to a company that printed billboards and had them paper his downstairs bathroom: One wall had a hot-dog-eating couple, two or three times life-size, that could have come straight from a Rosenquist painting; the towel rack hung in front of a vast woman's smile. The party's food was also Pop-y: hot dogs and chili, purchased from a hot dog stand that Hopper had arranged to have brought to his home. "One year after his soup can show at Ferus Gallery," Hopper recalled, "Andy comes to Hollywood and sees an environment that actually accepts this kind of new art. It was a very thrilling thing for everybody." His wife remembered how badly they'd wanted to make an impression on Warhol. They succeeded.

"We arrived and Dennis Hopper gave us a Movie Star party that was wonderful," Warhol recalled. "We were dazzled. . . . I was the most impressed with how colorful his house was—that's what really impressed me." He couldn't have been unimpressed when Brooke Hayward got him and his pals the use of her father's suite down the road at the fine Beverly Hills Hotel. "Breakfast was delicious—great roll and orange juice," Mead remembered, but also that they got bored to death and headed back to the wilder climes of the Surf Rider after a couple of nights.

The crowd at the Hopper party was like something straight from a Hollywood gossip column. Mead remembered seeing Peter Fonda, "dressed in a suit and tie and looking like a mathematician," and also a Hollywood action star "looking sexy, dark, strong, and handsome and 'coming-on' to me." Warhol seems to have been more interested in guests such as Sal Mineo, who had played a gay teen in *Rebel Without a Cause,* and also Dean Stockwell, whose queer role in *The Boy with Green Hair* had been mimicked by Warhol in college. With Troy Donahue there as well, Warhol had scored a perfect trifecta of his idols as a gay man.

Mead recalled how "Troy talked about Troy and Troy's career and Troy this and that," and he marveled that it hadn't weakened Warhol's crush on the actor. You have to wonder if Donahue had shown up because someone told him that his face had appeared in a Warhol painting; in

the magazine ad for Warhol's new show, Irving Blum appeared wearing a
T-shirt silkscreened with that Donahue image. Fifteen years later, Warhol
was still swooning over his heartthrob: "Oh, he was so great. God!"

Just as significant as the stars, for Warhol—or maybe secretly more
important—was the art-world attendance. Hayward remembered the party
as "the first time L.A. collectors and artists came together." She and Hopper
were best friends with Irving Blum, which guaranteed the presence of his
proto-Pop Ferus crowd. Virginia Dwan's prestigious gallery was also repre-
sented, since Claes Oldenburg and his wife Patty were due to open a show
there the day after Warhol's launch at the Ferus, while John Chamberlain,
who had made the crushed-car sculpture in Warhol's house, was also in town
to work with Dwan.

Warhol remembered all the pot that was smoked at the fete and Wynn
Chamberlain claimed that smoking grass got him, Malanga and Mead kicked
out by Hayward. The dancing got so wild that Patty Oldenburg broke a
sculpture by local art star Ed Kienholz, a mishap which Hayward never-
theless described as "a high point of the party." (Although they did end up
trading works, Warhol found Kienholz's works too "moral"—too much
comment on popular culture, too little participation in it.)

It was an amazing moment of Pop synergy in L.A., and Hopper had some
right to feel part of it. At that moment at least, Hopper had gone some way to
*being* an artist: A recent issue of *Artforum* had proclaimed his vaguely Pop-y
"photo-assemblages" to be "a black-and-white WOW." The review, of a show
that happened to be at the very gallery that had once teased Warhol and
Blum with a pile of actual soup cans, ended with the classically avant-gardist
invocation, "Welcome brave new images."

---

For all its glories, the Hopper-Hayward party was less important, for art his-
tory at least, than the one that took place the following evening. That was
when the Ferus finally opened the doors to its Warhol show. Visitors were
greeted by a pair of Elvis canvases perched in the gallery's fancy plate-glass
window, and inside there were the other forty-six avatars of the rocker, guns
drawn to blast away at visitors. (But without the taped gunshots that had
been promised.) The paintings occupied exactly the same walls, in very much
the same layout, as the Campbell's Soups had, making the admittedly
unsubtle but still worthwhile point that Hollywood was every bit an in-
dustry, with its own manufactured, reproducible products. For an artist with
a lifelong reputation for sucking up to stars, Warhol also had a lifelong
knack for making art that underlined their shortcomings and hollowness.

In the L.A. art world, the controversy around Pop Art had already caused "verbal street-fighting, with partisans excitedly tossing brickbats back and forth," in the words of one critic on the scene. Warhol, as Exhibit A of the movement, had won more notoriety, earlier, in Los Angeles than in New York. And on that thronged Monday Art Walk, the city got its first look at the man himself. His opening "was a zoo of people—by that time everybody knew who Warhol was, and wanted to know what he was up to in there," remembered Ed Ruscha, another member of the Ferus stable. Warhol dressed himself for the occasion in the hippest clothes he had ever tried out: Still a suit and tie—no sign yet of his famous leather jacket and Beatle boots—but now the white shirt of his Stable and Janis openings had been replaced by a mod-ish dark one, and there was a huge carnation stuck in his lapel. No sign yet, either, of his famous, unblinking anomie: In the photos that survive his smile is as big as his boutonnière.

As one West Coast critic realized, Warhol's uncritical enjoyment of such art-market moments was perfectly suited to a movement that critiqued America's unbridled consumption by jumping in with both feet: "So much of its irony turns on its being produced for—and against—the fashionable world of avant-garde collecting," wrote the critic. "There is so much that is itself Pop about a cocktail opening for an exhibition of soup cans."

That same writer quoted at length from an L.A. artist's reaction to Warhol's work, which must count as one of the most extraordinary paeans ever offered up by one creator to another:

> It is my opinion that Andy Warhol is an incredibly important artist; he has been able to take painting as we know it, and completely change the frame of reference of painting as we know it, and do it successfully in his own terms. These terms are also terms that we may not understand.
>
> Warhol has successfully been able to remove the artist's touch from the art. He has not tried to make a science out of it as Seurat did, but made an anti-science, anti-aesthetic, anti-"artistic," art totally devoid of all considerations that we may have thought of as necessary. He has taken a super-sophisticated attitude and made it the art, and made the paintings an expression of complete boredom for aesthetics as we know it. . . . They even have very little to do with Andy Warhol, maybe nothing, because it is dubious whether he had anything to do with the act of painting them. It is painting in the most absolute and abstract sense . . . visual proof that the "thought" is sincere, considered and deliberate, with absolutely no guesswork,

second guessing, or naive accidents. It is absolute, it is painting, most of all, it is art.

The praise came from Larry Bell, on his way to being one of the most rigorously minimal, un-Pop-y sculptors around, famous for his featureless glass cubes. But even Bell could see that there were hidden depths in Warhol's superficially superficial images. A year after the succès de scandale of the Campbell's Soup show, here was Warhol in L.A. beginning to find simple success, hold the scandal. There were doubters, as always: The main local critic grumped about "non-art" and "Pop Art banalities." But believers were starting to outnumber such folk.

A few days after the Ferus opening, the arts producer at KPFK radio gave Warhol the privilege of a long interview, in a series that had featured such major figures as John Cage and the director Jean Renoir. Warhol didn't give much in return. He was in full-blown put-on mode, fibbing about almost every detail in his life and art. When the interviewer asked, "Are you satirical, Andy?" he answered (satirically), "No, I'm simple." Taylor Mead, along for the taping as Warhol's sidekick, tried to save Pop's reputation by insisting that, far from being simple, Pop Art could address only a sophisticated audience that understood it as "a transvaluation" of America's all-consuming advertising values, but Warhol wouldn't go along. "It's really nothing, so it really has nothing to say," he corrected. Warhol came to life only when Mead made the mistake of attacking Cage, forcing Warhol to jump in with "I think he's really marvelous. . . . He really is great." The only real news that Warhol let slip was that he had just completed—almost completed—"an eight-hour movie on sleeping."

Warhol's appeal with the media did not do much for sales. Blum claimed that the Elvises didn't move at all, or at least not while the show was up—not so surprising, when prices ran as high as $3,500. The only immediate sale, in Blum's telling, was a single one of the Liz paintings that were sequestered in the back room:

> One day a lady came in. She was very elegantly dressed and she said, "This must be some kind of joke." I said, "No, it isn't a joke at all. They are here because I am seriously interested in this artist." She asked why, so I sat and talked to her at great length about my experience with Andy and why I thought the pictures were important. Finally, she asked, "Well what do you ask for one of these." There wasn't a lot of money involved, and she said she'd take one.

But even this sale came with a postscript. Once the show had come down and she'd taken possession, said Blum, the elegant lady was back in his gallery, begging to return her purchase: "My husband hates the painting. My children hate the painting. My friends hate the painting. Mr Blum, the image is so raw, it's as if it were cut out of the front of the daily newspaper." Mr. Blum refunded her money.

Another doubter should have known better. Wynn Chamberlain described the reservations voiced by Cecil Beaton, Warhol's old pal from the East Coast gay scene, at a tea party he gave in his cottage at the Bel-Air Hotel. Beaton's incomprehension seemed especially surprising since he was busy showing off a brand-new book of his portraits where every one of the photos, of such Warholian figures as W. H. Auden and Truman Capote, used the same stuttering, overlapping repeats that Warhol had tried out in the Ferus Elvises—if only at Malanga's suggestion—although those overlaps were deployed by Beaton to a much more traditional surrealist end.

"Very weird," said Malanga, casting his mind back to that moment. "This effect was being used by a photographer. And I was actually trying to duplicate a photographic effect in these paintings beyond the idea that it was a photograph to begin with—to give it some motion, and there it was in Cecil's book, too." Maybe in revenge for Beaton's resistance Warhol stole a glass from his cottage, beginning a tradition of hotel-room pilfering that lasted another few decades.

A party that Warhol himself gave in L.A. was more in touch with the unbridled Spirit of the Sixties that was brewing at that moment. He and his crew rented the old carousel on the Santa Monica Pier, not too far from their beachfront hotel, as the venue. As Mead recalled, "I invited my 'beat' friends from Venice, black and white, and Andy invited his black-and-white-tuxedoed friends from Beverly Hills. . . . Hollywood may have taken its cue from our party and began co-mingling more with the beats and off-beats." Assorted guests got stoned and drunk, and ended up falling off the carousel horses and "getting splinters in their asses" from the weathered floor, Mead said. Things got so out of hand that the party was shut down by the authorities, for safety's sake if nothing else. Cecil Beaton was not there, but he told his diary how much he regretted missing Warhol's "fantastic orgy with people making love on the revolving horses and being photographed betimes for an advanced movie."

That movie was what kept Warhol busy during his long stay in L.A., balancing the demands of his social life. Earlier that summer, he'd gone with Malanga to buy a 16 mm camera of his own, a fancy new-model Bolex. There was no way he could resist bringing it along to Hollywood, where he started

using it almost the second he arrived. He shot jumpy footage of Blum and the Ferus show and then was inspired to think bigger. On the way into Los Angeles the boys had seen a highway sign pointing to the suburb of Tarzana and that triggered the idea of a Tarzan movie. None other than Taylor Mead, the ninety-seven-pound weakling, was to be Lord of the Jungle. Mead had liked the conceit of shooting *Tarzan* in Tarzana, but in the end they shot their silent footage wherever their socializing happened to take them. Their carousel party got its moment on screen, as did the cottage that the Oldenburgs had rented nearby, where Claes played the role of "a peeved homeowner who squirted Tarzan with a hose to get him out of his yard," as Mead remembered. Watts Towers, the famous outsider-art installation in south L.A., became another Tarzan set—a maiden got tied to it, *King Kong* style.

When Mead wasn't up to doing his own "stunts," such as they were, Dennis Hopper sometimes stood in for the poet, giving viewers a taste of a more standard and dishy Tarzan. Warhol took care to get both men on camera at once, underlining Mead's absurdity in the title role. His zebra-skin bathing suit, borrowed from an eight-year-old then torn to fit Mead, looked more like a diaper and often slipped off.

The film was originally going to be called simply *Tarzan,* but that got changed to *Tarzan and Jane Regained . . . Sort Of* because of its introduction of a fresh "starlet" as Jane. She was Naomi Levine, one of the more extravagant bohemians in New York and herself a newly minted filmmaker who was just then winning raves. It was Levine who had convinced Mekas to watch *Sleep* for the first time, and she became one of the most committed kissers in Warhol's *Kiss* reels.

As Warhol recalled, "Naomi Levine was in love with me, and flew out and was with us the entire time. . . . Naomi was really temperamental." Temperamental, as in writing him flower-covered letters with lines like "not that you have ever suggested such a thing but I would love to live with you more than anything else in the world—I can't get married for months—not that you have ever suggested such a thing," or "some think I'm crazy + wild—but—I'm—just—Dots, and everything Dotsy-watsy dots been by turns to LOVE." One of Warhol's rare moments of public anger came a bit later, when she needled him for being gay and he had her forcibly ejected.

Levine, for her part, claimed that she and Warhol had coincided in Los Angeles by accident, and that it was he who had pursued her: "Every time I looked at him he had his hand on me. . . . I was very free and never wore clothes. It was very hot. I just wore this big purple scarf." A more improbable mate for Warhol is hard to imagine. Levine was a zaftig twenty-four-

year-old Jewish bourgeoise, as happy to do without clothes, on camera or off, as Warhol was keen to stay dressed. All this didn't stop Levine from voicing lifelong contempt for the artist's "fraudulent" Pop Art, even as she was attracted to him as a person, for his gentleness. She once told a bizarre tale about a dinner with Warhol at a Los Angeles restaurant where she had her arms stretched out on the table: "He had obviously decided he liked me; and he took a bag of sugar and opened it up and poured it down my arm, and I thought 'Gee, he's so sweet.'"

Mead remembered Levine's sudden appearance in Los Angeles as having been seen, at least at first, as more of a nuisance than not: "To assuage Naomi and get her off our backs, we filmed some scenes with her and me"—including a reel with Levine swimming topless in a "shark infested" swimming pool and another where she was attacked by "savages." But then admiration set in: "When we looked at the 'rushes' or 'dailies' we were amazed at how photogenic and suitable Naomi was as Tarzan's protagonist 'Jane.'" Chamberlain remembered how she became indispensable to the production. "We would run out of film in unlikely locations like the Hollywood Hills or Topanga Canyon," he recalled, "and Naomi who was paying for the film, would stage a tantrum until I agreed to drive her back into downtown Los Angeles in the searing heat to buy more film."

The movie reveled in the incongruous, improbable element that Levine introduced, as in a bathtub scene where Naomi-Jane's vast breasts became the perfect foil for Taylor-Tarzan's sunken chest. *Sleep* had been absurd but with a demanding edge, whereas *Tarzan* took the absurdity in a comic direction. Mead actually referred to himself as "an old silent movie star" while he was in L.A.; Charlie Chaplin had been a friend of his upper-crust family. The movie channeled the nonsense of classic silent comedies to produce a plot-free melting pot of amusing and fey incidents, in the same spirit as the Happenings that were breaking out at that moment.

A rare fan was soon raving in print:

> The evocations of joy, wonder, and sheer playfulness Taylor Mead
> provides . . . are so convincing and remarkably moving it scarcely
> matters that he is also mocking nearly everything he does; it is
> enough that he begins by doing it. He and Warhol have given
> us an hour of Arcadian comedy, sweet and incalculably beguil-
> ing. . . . We see a range of behavior whole through the agency of a
> merciless yet inventive representational intelligence. Notably, the
> film is one in which homosexuality has genuinely been accepted
> to the point where it can be kidded.

As a truly group effort, *Tarzan* introduced the idea of a fully collaborative, improvisational process into Warhol's art. (His paintings had only pretended to have multiple makers.) It also raised the vexed issues of authorship that his collaborations always did. Malanga took umbrage when he saw Warhol getting all the credit for *Tarzan*: "This was always a Taylor Mead movie right from the start, conceived by Taylor"—Mead was the one who had noticed the Tarzana sign—"and starring Taylor and all the parts cast by Taylor. Andy's only involvement was Andy's camera and Andy behind the camera." The film does seem almost a sequel to Mead's pre-Warhol efforts, and he was the one who edited the footage once they'd returned to New York and it was presumably also Mead who came up with credits that said "Warhol Productions Presents" and "Directed Sort of By Andy Warhol." Whatever his own role in the film's creation, Mead was clearly happy to cash in on Warhol's Pop Art celebrity, as followers did for the next several decades, mostly with the artist's full support.

Funnily enough, in the case of *Tarzan,* Warhol was not that happy with the film to which his name was attached, according to a helper who came on board that fall: "It wasn't his creation, so to speak. He didn't come up with his own way of doing things. He stopped doing that style and said, 'No, no, I don't like this hand-held movie stuff. I don't like the story stuff.'" For a while, at least, Warhol went back to the more rigorous concepts behind *Sleep* and *Kiss.*

In L.A., he connected in person to the primal source of such rigor in modern art.

"It was a balmy Indian summer day," Malanga recalled, "when Andy and I walked up to this outdoor café where Marcel Duchamp was seated with his wife Teeny and a few friends. We were on our way to the Pasadena Art Museum just up the road, where Duchamp's first retrospective ever, curated by Walter Hopps, was awaiting his arrival. . . . [Andy] and I were beside ourselves with excitement at meeting our hero for the first time. We were like two kids, in total awe, vying for the Master's attention. Duchamp was amused and offered us chairs. He spoke modestly with those around him, and was certainly a minimalist when it came to conversing. We just listened and hardly said a word." Looking back at the Pop era as it drew to a close, one critic declared that "there is no doubt that Warhol is the most mysterious and the most disruptive artist since Marcel Duchamp."

By the time of the L.A. trip interest in Duchamp had exploded across the art world. Richard Hamilton, arguably the first of all Pop artists, had traveled all the way from Britain just to be at Duchamp's opening. Hamilton and Warhol, godfather and favored son of Pop, met and chatted there for the first time.

That night in Pasadena, Duchamp's opening gave way to an exclusive dinner and dance at a venerable but fading hotel. Photos show Warhol dressed in fine black tie, looking shy and boyish as he chuckled away with the dealer Virginia Dwan and got his cheeks pinched by local artist Billy Al Bengston, the very man who had declared the Elvis paintings "all crap." If anyone was playing rule breaker that night, it was Taylor Mead, to the manor born but as usual happy to ignore his upbringing. He'd shown up without a tuxedo and it took an intervention by Duchamp himself to get Mead admitted to the dinner. "Patty Oldenburg and I did a wild dance that brought down all of Pasadena," Mead recalled, "and Andy got drunk—the first time I've ever seen him affected—on some cheap pink champagne." Duchamp signed the pink cloth on his table, thus turning it into one of his ready-mades, and then all the assembled artists signed as well, including Warhol as "Andy Pie"—meaning that he'd just done a collaborative work with his greatest hero.

---

"Andy was not only super-cool, he was cold. When we came back from this trip, Gerard had this great big suitcase and was headed for the subway," Mead remembered. "I said, 'Andy, can't you give Gerard cab fare? My God, he's been helping us out for two weeks.' And Andy says, 'Oh, he's alright. He'll get home.'" There are a few explanations for Warhol's froideur toward his assistant. There had been an incident at the motel in Venice Beach when Malanga had brought a girl home to their shared room and Warhol had exploded.

The refusal of cab fare may also have been Warhol making clear that, after all those weeks in close quarters, the young man who had been "helping out" was indeed an employee more than a friend. For the next quarter century, Warhol was forever trying to remind staff, and himself, of the distinction. They and he mostly managed to ignore it, which was a source of everlasting tension.

But the most likely explanation is that Warhol wanted to save the cab fare. He had just paid all the costs of a three-week, four-person visit to the far side of the continent, to attend a show he had pictured as a cash cow but that didn't look likely to bring in a dime. The Surf Rider stay alone had cost $225, a notable sum at the time. His filmmaking had also put him in the hole, with just about no chance of a pay-off: The new Bolex had cost something like $1,200—not far from the price of a VW Beetle—and the film and its processing went on to be a constant drain. At home in New York, Nathan Gluck was continuing to churn out ads and illustrations, with an occasional assist

from Warhol himself, now starting to be hired for his Pop cred. Right after he returned from L.A., the business section of the *New York Herald Tribune* ran a huge Warhol drawing as the cover image for a story on trademarks that had become common nouns. Warhol showed *Herald Tribune* readers a Vaseline jar, a bottle of Coke and a Thermos, all drawn in the fractured, slightly outdated, semi-Pop, Jasper Johns–ish style he had first developed for use in *Harper's Bazaar.* He explained the image to John Giorno this way: "I need the seventy-five dollars. I have bills to pay."

Warhol did much better with a more up-to-date Pop ad he worked on that fall for the Container Corporation of America, a company famous for its cultivation of modern artists—and condemned for it by profit purists. Back in 1957 its owner had bought a comic *Happy Bug Day* print by Warhol, when they'd been shown in Colorado, but the ad that got published in 1964 showed the artist in a whole new light, taking advantage of his Pop Art subjects to advance corporate ends. Warhol provided the Container Corporation with a grid of twelve silkscreen paintings of such things as a lemon, a hammer, a glass and a chair in order to illustrate all the goods that might ship in a box: "Does your package promise to preserve, defend, guard, shield, shelter, house, care for, present—and sell—your product?" read the ad's copy. Warhol didn't get the full-blown fine-artist treatment C.C.A. provided in its famous campaign called "Great Ideas of Western Man," which paired artists' images and names with quotes from eminent thinkers. But he did get to see the credit line "Artist: Andy Warhol" on the page. He also got to bill the company $3,000 for the twelve silkscreened canvases, which they then kept as works of art.

With the C.C.A. contract, we're witnessing a complex feedback loop that saw Warhol's Pop Art beginning as commercial window display, then getting an unlikely and radical transposition into fine art and then, thanks to its newfound status and popularity as art, getting reinserted back into commerce. That loop was at work for the rest of his career, launching new income streams but also always calling into question his status as a "true" fine artist.

Mead had somehow heard that Warhol's ad work was bringing in a nice $65,000 a year, but in '63 that meant only that his switch to fine art was more theoretical than practical or financial. As far as the tax man was concerned, he would still have been a commercial artist who made paintings as a hobby. Even the following year, he was still being listed in *Who's Who in Commercial Art,* not in the more elite *Who's Who in American Art.* He didn't win a space there, or in the still more exclusive *Who's Who in America,* until 1966.

Warhol received all of $1,000 for a vast mural contract that got com-

missioned early in that winter of '63 and only something like $700 for the thirty-five Ethel Scull canvases he then did in the summer. In 1963, art galleries were supposed to be New York's fastest-growing industry, yet Warhol managed not to have a single local show that whole year, no doubt because of Eleanor Ward's doubts about his Death and Disaster series. A sad little note exists where Warhol (mis-)typed "elenor is thre any chance that you could send me some money. i have so many sick bills to pay . my mother is still sick." (Warhola seems to have been fighting tuberculosis.)

The shortfall from Ward could hardly have been made up by modest group shows in Toronto and Los Angeles and an edition of Pop banners by a New York dealer.

Things might have seemed more promising across the Atlantic. Warhol had already had a few years' worth of exposure there thanks to Ileana Sonnabend, whose Paris gallery was a kind of branch of the New York operation of Leo Castelli, her ex-husband, who gave her a European monopoly on his artists. When Warhol first appeared on the scene Castelli had rejected Sonnabend's advice to take him on, so she had followed through on her own. Soon she was claiming that her gallery had a stronger and older claim on Warhol's loyalty and output than even the Stable did. (After Warhol pulled out of a solo with Sonnabend in the spring of '63, she dashed off a fearsome letter or two asserting her rights over him.) Still, it's hard to say how much income Sonnabend was actually generating. We know of only six paintings and six drawings that she had for sale, and it's not clear how quickly she could have moved them. When Sonnabend's French landlady saw the dealer unwrapping some Warhol Marilyns, she launched into a rant: "I cannot allow you to show those—it's not art, it's necrophilia."

Yet all this resistance hardly tempered what came out of Warhol's studio. The Death and Disaster pictures faced little demand—and that didn't stop Warhol from churning them out, and then pairing them with blank canvases that could only have made them less sellable. Warhol was clearly in his put-on mode when he claimed he was only adding the blanks to double the Disasters' worth without having to do much extra work. It wasn't hard to spot far more than greed in Warhol's inscrutable pairing of a tabloid tragedy and a blank: "[It] suggests a roll of newsprint awaiting impersonally to be charged with an emotional picture" was one early critic's clever take. Warhol himself would have known perfectly well that his blanks—better known as monochromes—had the most prestigious of precedents in experimental works by Yves Klein, Robert Rauschenberg and Ellsworth Kelly. (He'd seen Kelly's monochromes on a studio visit in the late '50s. "I always liked Ellsworth's work, and that's why I always painted a blank canvas,"

Warhol eventually admitted.) Warhol also would have known that the radical chic of his blanks was more likely to depress his prices than raise them.

Warhol's portraits of artist friends had just as little market value and his experimental silkscreens in 3-D seemed mostly intended as gifts. If Warhol really had the money-grubbing instincts he was always accused of—and there have always been signs that he did—they couldn't compete with his overriding ambition to make great and challenging art.

---

If 1962 must have felt like a steady ascent for Warhol, the year that followed had its ups and downs. In the summer, when MoMA had put on a major survey called "Americans 1963," Warhol's Pop peers Marisol, Oldenburg, Indiana and Rosenquist were all on view while Chryssa got to show her Warhol-ish newspaper paintings, but Warhol himself didn't merit a place. "I was crushed. . . . I was so hurt," he said at the time. That fall, he found himself left out again in a Philadelphia survey called "Art 1963—a New Vocabulary." In December, *Art in America* published a vast feature on the "problem" faced by artists caught up in the new culture boom; once again Warhol was notably absent, though he ought to have been the most obvious boom-er.

This early on, it still took unusual smarts to recognize Warhol's true depths and caustic edge.

Gene Swenson, a brilliant, eccentric young critic who took Pop more seriously than almost anyone else, saw Warhol's blanks, for instance, not as a sign that Warhol was a sellout—however much Warhol himself portrayed them as that—but as exposing collectors' cupidity. Swenson believed that Warhol was using the blanks to say something like, "Those fools will buy even *these*." Back in the fall of '62, Swenson had written one of the first lengthy treatments of Pop. Late in 1963, he published a long Q&A with Warhol, making him out to be the serious artist and thinker he was all along—which was how Warhol had asked to be portrayed. Especially in the much-edited version that got published, barely a hint of a put-on came through.

Readers of the interview got to see Warhol uttering witty little aperçus like, "Dada must have something to do with Pop—it's so funny, the names are really synonyms." (It takes a second for a more average mind to get what he means.) They also witnessed Warhol's riff on how the cultural leveling that Soviet communism aimed for was actually better achieved by American capitalism. And Swenson quoted Warhol's sophisticated thoughts on the way commercial art, however mechanical and uninspired it might actually be, was deeply committed to old ideas of the creative and the expressive, whereas his own truly machine-inspired Pop wanted to escape both clichés.

Making clear that he'd read the prose of Jean Genet, Warhol praised its pornographic purpose: "The thing I like about it is that it makes you forget about style and that sort of thing; style isn't really important." You could hardly get more radical, in the art world at that moment, than to claim that the *look* of a painting mattered less than the simple effects of its subject matter—especially when those effects involved gay titillation.

At the very start of the conversation, Warhol had said, "I think that the whole interview on me should be just on homosexuality"—and amazingly a lot of it was, at least on the original recording that survives. Warhol's oft-quoted claim that Pop is about "liking things" turns out to have been triggered by him saying that everyone, of every sex, should like everything and everyone—in bed. It's a shame that in the printed version, the magazine's editors bowdlerized the transcript so badly that not a hint of its sexy content remained.

One thing that does come through clearly is Warhol's darker side. Sitting with Swenson, Warhol talked up his Death and Disaster pictures, clearly feeling that they did no more than reflect the true state of affairs in the nation, and saying that he planned to make them more and more extreme and painful to look at. He described seeing someone throw a big firecracker into a crowded street ("I thought I was bleeding all over") and how this kind of attack had become so commonplace "it's just part of the scene." The Swenson interview appeared in print in November, which was when the country felt like it was witnessing the ultimate example of this new, senseless violence: the assassination of John F. Kennedy.

According to Malanga, at lunchtime on November 22, when the news of the shooting broke in New York, he and Warhol were walking through Grand Central Station, where his boss's reaction presaged the sangfroid he soon became known for: "Let's go to work," Warhol is supposed to have said. He led Malanga back to the firehouse where they went on with screening a work in progress. It was a picture of Dracula biting a gorgeous blonde, inked and squeegeed so carelessly that the cosmic breakdown signified by the vampire gets reflected in the mess of the image itself. The picture's violence and chaos suited the day's events, but only by accident, since its printing screen would have been ordered a good while before those events transpired.

Malanga's account of Warhol's hard heart might be the source of the words put into the artist's mouth seventeen years later, in the passage on the assassination in his ghostwritten *POPism*: "I don't think I missed a stroke. I wanted to know what was going on out there, but that was the extent of my reaction." The book describes Warhol as disgusted (not unreasonably) by the

media's emotional manipulations that November. He is shown remembering a moment in India, during his world tour, when he saw "a bunch of people in a clearing having a ball because somebody they really liked had just died and . . . I realized then that everything was just how you decided to think about it." He tried to recast his friends' thoughts on their recent loss by inviting a crowd of them to dinner at a German joint near his house, but even lager and wurst could not lift their spirits. (Or maybe Warhol's strategy did work on Ray Johnson, who is supposed to have spent dinnertime inserting mustard-covered coins into the restaurant's pay phone.)

By 1980, Warhol was deeply invested in his reputation for detachment and the account in *POPism* takes care to confirm it. On the other hand, John Giorno told a story of that day that portrays Warhol very differently, as the two of them sat in the town house watching the news unfold on TV: "I started crying and Andy started crying. Hugging each other, weeping big fat tears and kissing. It was exhilarating, like when you get kicked in the head and see stars. Andy kept saying, 'I don't know what it means!'" Years later, Giorno decided that they had only been crying "crocodile tears."

If Warhol did not truly take Kennedy's death deep to heart, he wasn't alone—it seems likely that many of the tears shed that week were reptilian. Danny Fields, the future rock impresario, went ahead with a Thanksgiving bash that he'd planned, now recast as an "assassination party." On the day of J.F.K.'s obsequies, Warhol's friend Billy Klüver, a Bell Labs engineer who had deep art-world ties, carried on with a birthday lunch for Naomi Levine at his home in rural New Jersey. Warhol and Giorno knocked back Bloody Marys alongside a Who's Who of other art-world types, from Marisol to Rosenquist, as the president's funeral played out on a nearby TV. All the guests were "wide-eyed and exhilarated," it seems, and laughing wildly when news came that Kennedy's own shooter had just been shot.

Warhol's most interesting reactions to the national situation were, appropriately, artistic ones. That afternoon at Klüver's, he pulled out his Bolex and filmed the eccentric dance critic Jill Johnston marching about in the woods with a rifle—a grim image that, as so often with Warhol, stood perfectly balanced between satire and dirge. Then, over the next few months, he played with the same dissonance in his famous Jackie series. A total of 309 little canvases got silkscreened with images of Jacqueline Kennedy as both a smiling wife and a grieving widow, with no clear indication that either view could get at who she really was or escape the roles Americans had cast her in. A critic talked about the "ghastly embarrassment" we feel as Warhol both caters to our "impulse to touch tragedy" and foils it at the same time: "Somewhere in the image there is a proposition. It is unclear." When Warhol first made the

series public, one year minus a day after the assassination, it was as a grid of forty-two identical Jackies, all black-on-blue, covering one wall of a gallery that was otherwise filled to bursting with his "wonderful dumb flowers," as one fan called them. The juxtaposition leveled all distinction between the two, adding pathos to the blossoms while also suggesting that the Jackies might, in the end, be just so much decoration.

Or, as that fan of the Flowers believed, maybe the pairing offered a quite coherent statement: "I think it's the most complete indictment of our time. There may well not be another person who has felt and thought as deeply as Andy. He's in the coldest, loneliest position because he's decided to accept all the guilt and horror."

———

Warhol's Jackies were sure to be as nearly unsellable as his earlier Disasters— even John Ashbery, the Disaster fan, had trouble with the "gloomy" Jackie that Warhol had given him. Yet even as he churned out ever more of those, Warhol began to turn out a series of films that were easily as daring and uncommercial, or maybe more so given their almost-explicit gay content. The male-on-male reels of *Kiss* probably started to be filmed at this time and they correct the earlier slant toward straightness in the series. (They also got it pulled from a screening at a university in Canada.) Another movie, originally planned for a shoot at Serendipity, showed Robert Indiana, the only other homosexual among the stars of Pop, slowly and suggestively eating a mushroom. A further batch of films, this time of haircuts, reflected an even more thorough shift toward the gay vanguard in both Warhol's art and his life.

The shift began at Serendipity, Warhol's old haunt, where he'd first met a young man named Billy Linich—or Billy Name, as he rechristened himself in Warhol's later hipster crowd. Name cooked at the café during the day in order to fund his "real" nighttime life as a lighting designer for the performers at the Judson Church, where Warhol got to witness his efforts. Name was in his early twenties, a gay man who had long since fled the strictures of upstate New York for the liberties of Greenwich Village: "We were Americans, but we were a new kind of free," he remembered. He had spent the spring of 1963 in California, hanging out with the radical poets around Diane di Prima, who had danced beside Warhol on Jack Smith's cake in Old Lyme. She remembered Name trying his hand at every kind of art and every kind of drug, "making mots that sounded way hipper than they probably were, and mostly *looking* wise with a little half-smile and crinkly eyes." He was both louche and cute, with dark curly hair and the kind of reed-thin

body Warhol himself was trying to achieve, even if it took speed to get there. Amphetamines, coupled to a long-standing metabolic disorder, had been Name's own route to slimness: He moved in a circle of young gay men, far more "out" than Warhol had been at their age, who were committed speed freaks but also committed to the far reaches of art.

Some time after their first encounters at Serendipity, Name and Warhol began to date. Warhol could hardly have resisted his new friend's avant-garde pedigree: He'd apprenticed in lighting with a Black Mountain alumnus and was close to the radical composer La Monte Young. Name and Warhol went to movies and parties and performances, including, or so Name once claimed, to John Cage's famous concert of Satie's *Vexations,* which Name said he attended as a friend and disciple of Cage. Name became so much Warhol's pet that he got the rare privilege of spending time at the Lexington town house. He would relax among the Elvises in the wood-paneled rear room while Warhol was out front working on his ads. By the end of the year, Name had sent Warhol a note that read "My mother told me to pick the very best one. I pick you." An entry in *Who's Who in the East* written the following spring listed Name as Warhol's son—maybe because the artist had let his protégé write the text. The two were briefly lovers but were "very awkward and shy about the whole sexual thing," Name remembered. "We would lie together sometimes but he was so sensitive it would drive me nuts." Where you might give a hug to some other friend, Name said, you knew that you had to give Warhol lots of space: "If you put your hand on his shoulder he would jump." (On the other hand, Warhol's own touch was apparently so featherlight that it sent one lover into ecstasies; another lover said that Warhol was fairly expert at fellatio.)

Name lived in the East Village in a classic bohemian tenement he shared with the Judson dancer Freddy Herko ("an animated young man with darting eyes, crazy even when he wasn't on drugs") and the sometimes-actor Robert Olivo, or Ondine, as he was known on the Warhol scene. It was Ondine who first introduced Name to speed: "All of the sudden, I had the energy to get off the floor and start doing things," Name remembered. He always said that the amphetamines that he and Warhol consumed were taken in response to a ferocious work ethic rather than as a way to find more time for fun.

With the help of their drug of choice (amphetamine hydrochloride, mostly swallowed and snorted rather than injected) Name and his friends crafted a kind of 1960s, underground version of the gay '50s salons Warhol had hosted on his parlor floor on lower Lexington. But instead of getting together a bunch of young splendids for coloring parties, Name would hold haircutting nights, wielding scissors he'd been taught to use by a barber

relation. "The person who was going to have his hair trimmed would come over around nine, but also like 150 other people—the happenings people, the artists would all come over too, and it would be like a hair-cutting salon," Name remembered. One night Ray Johnson brought Warhol over for a trim (did his toupee take the hit?) and he became fascinated by this new social scene. He made it the subject of a series of Haircut films that restage the nocturnal rituals of Name and his gorgeous, sometimes naked male friends from the dance world. The films were taken seriously enough by the avant-garde to be included in its most esoteric programs, alongside such things as musical pieces composed for distorted magnetic tape. Name's friend Freddy Herko in fact thought of Warhol's footage of the haircuts as a record of some kind of radical dance performance, following the Cagean idea that everyday actions can be declared important aesthetic events: Before Warhol had shown up with his camera nine of Name's haircuts had already been the subject of an opaque dance "review" in an underground newsletter. Warhol would have appreciated this idea of life as art, since it lurked behind all his early Pop work. What the Haircuts added to the mix was the idea that the "everyday" might in fact include queer behaviors out on the cutting edge of underground youth culture.

Malanga had had some contacts with that world already—he says he was there the first time his boss attended a haircut—but it looks as though Name's arrival was what launched Warhol's deeper dive into it. It was where Warhol lived for the next four years.

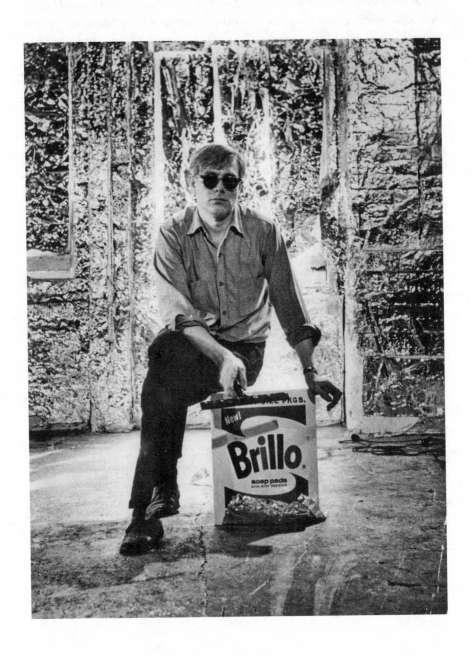

*. . . in the Silver Factory with one of his Brillo Boxes.*

# 20

## 1964

FINDING THE FACTORY | SCREEN TESTS |
BILLY NAME | THE FACTORY, SILVERED |
BOXES AT THE STABLE GALLERY

*"Surrounded in that space by all the silver,
it felt like you were inside of a gem"*

The first time Warhol made the sluggish trip up to the fourth floor of the building—its Patent Friction Rolling Elevator was one of the oldest in the city—he must have been struck by the sheer quantity of open space in front of him. The room was some forty feet wide and stretched back something like seventy-five feet, interrupted only by six thin columns that supported a ceiling of long barrel vaults hovering overhead. The light was decent too, at least at the street end of the room where the elevator opened: Four windows faced south, with the width of Forty-Seventh Street between them and the taller buildings across the way. The rent was only $200 a month.

That was about it for upsides. There were no lights, just bare wires hanging down from the ceiling. The walls were filthy and peeling and wrecked; a big part of one was hidden behind the pipes of a vast radiator, making it useless for making or hanging art. The cold concrete floor had big patches and gaps. At the far, dark end of the room, his-and-hers bathroom stalls had been jerry-built to stick out from the wall. ("Nobody in their right mind would go to the bathroom there," said someone who did. "Please Flush GENTLY" read a sign on the men's toilet, conjuring the mess if you didn't. After a while you had to flush with a bucket.) On Warhol's first visit, ancient machinery still cluttered the floors. But in all that jumble he somehow saw a future for himself and his art. He was right: He was seeing his soon-to-be-famous Factory.

Warhol couldn't ever have thought of the firehouse as a stable setup, and he must have already seen the end in sight when its lease got officially

canceled in May of '63. When he returned from L.A. in October, he got news that the place would be sold to the highest bidder. He was crushed when his own bid came in low. Art making was put on hold while Warhol and Malanga spent week after week searching for a new place, "hoofing it," Malanga remembered, from one end of town to the other. "We checked newspaper listings and made phone calls and appointments and went walking and walking."

The younger man had hoped to end up in the kind of romantic loft that Henry Geldzahler had just been commissioned to hymn for *Glamour*. Maybe an endless warehouse by the East Side docks, like the two that Jim Rosenquist rented. Or a floor in a cast-iron treasure in SoHo, all warm pine and light, such as George Maciunas was just then procuring for his fellow artists in a neighborhood then known as Hell's Hundred Acres. On the newly fashionable Lower East Side, even something crude and vast might have had its charms, like the "aerie" on the Bowery where Wynn Chamberlain had just thrown a famous party, which filled the entire top story and spilled onto the roof. Malanga was crestfallen when, after their endless looking, Warhol decided instead on that chunk of raw space on East Forty-Seventh Street, in a huge, nondescript building half taken up by a garage and otherwise filled with light industry. (Although there's no record of either the hat or the shoe manufacturer normally mentioned as former tenants of Warhol's studio.) The structure had been built in 1887 from brick and stone, meaning its windows had to be smaller than the wall-size ones allowed by SoHo's cast iron. That made Warhol's new space seem more cavernous than airy. Color photos shot right after he took possession show him and a few of his paintings standing out as splashes of life against an endless gloom stretching out beyond.

The neighborhood Warhol and Malanga were moving into, in midtown Manhattan between Third Avenue and the new United Nations building, was a dead zone where no one else of their ilk was likely to venture— a Bickford's coffee shop, up the street at the corner of Third Avenue, was as close as the block came to haute cuisine. For Warhol, the area might have had vaguely artistic associations: Back in 1954, it had been home to the Loft Gallery where he'd shown a few times. A decade later, however, it offered only a couple of amenities of any interest to people like him. Peerless Camera, where Warhol had bought his Bolex, was near the new loft. On the floor right above the studio there was Connoisseur's Corner, a hospital's thrift store, which was the source for the better junk that cluttered Warhol's space. The really crummy furniture, including Warhol's

big worktable, came from a basement crammed with old office discards. Across the street was the ancient Grand Central Y.M.C.A. whose windows gave Warhol glimpses of its hunky weightlifters. Its showers appealed to the men in his Factory crew who lived in cold-water flats or on friends' sofas. They appealed even more to any man with a taste for adventure: Already in the year Warhol arrived from Pittsburgh, Y.M.C.A. shower rooms were being described as "special centers of attraction" in an illicit guide to gay New York called *Gaedicker's Sodom-on-Hudson*. In the wilder years right before Stonewall, New York's Ys became a major site of all-male bacchanals. One of Warhol's transvestite superstars was actually rooming at the Y the first time he crossed the street to the Factory.

As late as January 16, 1964, the entries in Warhol's datebook still say "studio looking"—alongside, as always, the price of the cabs that he took, to be declared as tax expenses. Then finally, on the twenty-seventh, he scribbled "New studio, 231 East 47."

By taking possession of that midtown space, Warhol was cutting himself off from the mainstream of New York's downtown avant-garde. "Some people at the Judson asked me why I was involved with Andy because his studio was so far uptown," said Billy Name. Warhol's move may have been canny. It let him create and inhabit a new cultural universe, with himself at the center and a constellation of youngsters speeding and drifting—and sometimes imploding—in the gravitational field he created.

———

Warhol began to commemorate his new scene in the wonderful filmed portraits that later came to be called his Screen Tests. In 1964 alone he shot about two hundred of these little masterpieces, and then another three hundred or so over the next few years. They were almost all built around a modest conceit: Warhol would load his Bolex with a standard hundred-foot, three-minute reel of Kodak black-and-white film, he'd pose his sitter in a chair in front of the camera under a floodlight or two—often arranged by lighting pro Billy Name—then he'd shoot until the film was used up. "The instructions were very simple," Malanga remembered. "Just look into the camera for three minutes. Most of the time, we'd walk away from the camera . . . so basically, the sitter was confronting his or herself." Name said that it was this surrender to the will of the camera that first made Warhol recognize his vocation in film: "When we got the reels back from the lab, and screened them, Andy said, 'They're Andy Warhol films.' He actually said that." Their greatest artistic novelty may have been the perfect parallel they

created between the sitter looking into the camera and the viewer watching the projection: Their eyes seem to meet at the surface of the screen as their shared minutes of staring run their course.

Although subjects were normally told to sit perfectly still and impassive, in fact anything could happen during those three minutes—one sitter teared up, Irving Blum's straight face dissolved in guffaws and Taylor Mead of course could not keep from mugging. But there's a sense when you watch these films that Warhol's instinct was right: The most happens, artistically, when the sitter does the least. It turns out that those few minutes of stasis feel like an eternity, for both the subject who's facing the camera and a viewer who watches the film once it's done. (The viewer actually has the slightly longer ordeal, since the films were normally projected somewhat slowed down, taking about four minutes to run.) Subjects are like moths pinned to a board—specimens recorded to satisfy the interests of someone else, since chances were slim of their ever seeing the footage. They are left entirely responsible for their self-presentation, after being instructed not to take steps to self-present. "It will be three minutes. Just sit there. You don't have to do anything," Warhol told one of his Screen Test subjects, before walking away. "I remember I smoked a cigarette, and did a whole communication with the camera," said the same sitter, "as if it were a person that you're making eye contact with but can't talk to." Another subject remembered feeling panicked and isolated, like a prisoner in solitary. The Screen Tests give us our first taste of the passive sadism that Warhol became famous for as his Factory scene moved into high gear.

The viewers of Screen Tests, for their part, are forced to spend four minutes—an age in normal art-looking time—interpreting a wall-size portrait that seems to defy interpretation. Rather than conveying some message the artist has in mind, the Screen Tests seem to record a neutral, almost mechanical process, and how are we supposed to find meaning in that? The Screen Tests almost never provide a legible take on a sitter's character, as a Rembrandt or an Avedon is supposed to do. Instead, they seem to revel in the breakdown of our sense of stable personality: Most of Warhol's subjects either achieve a fixed and meaningless stare ("Boy that never Blinked," Warhol scribbled on one reel's box) or they try to assume some legible persona but can't keep it up for the full shooting time. The mask almost always slips, but without letting us see some "real" person beneath. When Factory regulars would get together to project a bunch of the Screen Tests, they'd assign marks to each sitter based on how well their "soul" came through on film: "If they look at the camera and nothing comes through, then they

are soulless, and they get a ten—and then otherwise they get a one." Given Warhol's crowd, there must have been far more tens than ones.

A reporter once asked Warhol why he made his movies. He replied, "It's easier to do than painting, because the camera has a motor and you just turn it on and you just walk away. It just takes over by itself." There's an element of put-on in that response, but also a genuine interest in relinquishing control and letting the art, in a sense, make itself. Asked "Is there anything special you're trying to say in these films?" Warhol gave the same reporter a curt "No," which again was only half-facetious: He didn't have in mind any one thing to say, even though he knew his filmed portraits spoke volumes.

The first Screen Test was actually made before Warhol had found his new studio. One day at the firehouse, Malanga decided that he ought to have an author photo ready for when his poetry began to take off, and he thought it would be stylish to make an enlargement from a strip of two or three consecutive frames from a film. The effect would have been much like one of the Photomat strips Warhol had been making portraits from. Malanga got his boss to shoot the necessary footage with the Bolex and some lights, but when the reel came back from the lab the two men realized that the little movie itself might have a future as avant-garde portraiture.

What hasn't been noticed is that the first Screen Test of Malanga also counted as yet another example of Pop Art appropriation. About a year earlier, the splashy new magazine called *Show* ("The Magazine of the Arts") had run a spread titled "Screen Test #1" that consisted of four strips of film of an aspiring young actress, enlarged on the page just as Malanga had in mind for his author portrait, with the sprocket holes left visible, as he said. As the feature's text explained, "the first traditional hurdle for the theatrical tyro is the screen test. *Show* now adapts that form to give deserving youngsters a first flirtation with a fame we hope will not be fleeting." *Show* went on to run new "Screen Tests" in later issues, including the one from March 1963, where Malanga said that he first encountered a Warhol Soup Can. What Warhol then did with his own Screen Tests was take *Show*'s collection of newcomers (all female) and do his own version, granting un-fleeting fame to his coterie of fresh young things (all male, at least at first).

Malanga's filmed portrait caught him in the last days of his pompadour, looking moody and romantic but also terribly boyish. Within a short time, at first while he was still between studios, Warhol had moved on to screen-test John Giorno, Billy Name and his friend Freddy Herko and then a whole suite of similar lovelies. These were the *Thirteen Most Beautiful Boys*—that was the original title Warhol was still announcing to his sitters even after

the project was moving on to include more than three dozen attractive men. Whatever their number, Warhol never screened the series in public. For a while at least, the Factory acted as a sparkling closet and Warhol didn't quite come out of it.

What's maybe most important about these very first Screen Tests, in terms of Warhol's art and career, is how unimportant most of their sitters are. Gorgeous and promising, yes, but not names to conjure with at a cocktail party, like the art-world power people Warhol had been cultivating even a few years back, and that he'd recorded in Polaroids and paintings. When Warhol moved on to film, his very first reels recorded with-it friends of his like Robert Indiana and Marisol. But once the Factory scene got underway, appeal and verve displaced other measures of worth—Beautiful Boy–ness (or Girl–ness, in a series of female Screen Tests that soon followed) mattered more than any other virtue Warhol's sitters might have. With his Screen Tests, Warhol made clear, maybe to himself as much as to others, that the Factory would present itself more as a clubhouse for kids than as a hub for the cultural elite. When the elite did show up, as they often did, it was to bathe in the reflected glory of the Factory's youth.

Most of the Screen Tests are so foursquare, so impassive, so unrevealing of their sitters, that they function less as a series of true character studies than as a list or catalog of a type of creature, the way Warhol's Campbell's Soups cataloged a particular category of canned good without talking about it as food. As Mr. Soup, Warhol had asserted his commonist credentials. Now, two years later, his parade of boy-beauties let people know he was part of these lads' new '60s world. In one of his more bizarre moments of introspection, Warhol is supposed to have told Malanga that he imagined himself as the keeper of a male brothel, tending the register "in a large dormitory with rows of beds without partitions between them. People would come in and have sex with a boy in a bed and then pay Andy the money on their way out."

The cast list for Warhol's Most Beautiful Boys was also a catalog of his crushes, past, present and future. Malanga was in the "past" category, but still worth commemorating on film, while the romance with Giorno was coming to an end by the winter and spring of '64. It got replaced, for a short time at least, by Warhol's affair with Billy Name, which was followed in turn by a dalliance with another one of the 13 Beautiful Boys called Robert Pincus-Witten. He was nineteen at the time, just beginning a career in art history and with strong connections to the Castelli crowd. "I was a star-fucker, and I wanted to know Andy Warhol," Pincus-Witten remembered, so he sought him out at the new Factory. Like most of Warhol's lovers,

Pincus-Witten said the sex was bad and awkward, even "absurd," and it soon came to an end. (Not before Pincus-Witten had caught crabs: "If it wasn't the couch, it was Andy's crotch.") Pincus-Witten called his connection to Warhol "an intimate acquaintanceship" but it sounds as though Warhol thought more of it than that. He took this latest, egghead-y "boyfriend" around to visit apartments they might consider sharing. That was a romantic conceit, no doubt, rather than a true plan to vacate the new town house, but still a significant gesture.

You get the feeling that Warhol, at least, had fallen in love yet again, and that the failure of sex didn't give him any reason to imagine that the romance was doomed as well. It was a pattern that he seemed to repeat until the day he died. "Andy's idea of sex was to have it once or twice and get it over with—with Andy it wasn't about love, it was about companionship," said Billy Name. But there's a chance Name misunderstood his friend's mind and emotions: For Warhol, as for many old-school romantics, love itself was far more about some ideal of tender companionship than about the mess and complications of sex.

Most of the Screen Tests show their subjects standing out against a deep black background, echoing the cavernous gloom of Warhol's new studio as he first discovered it. A few have backgrounds that gleam and twinkle, reflecting how the space got transformed within its first months. Thanks to Billy Name, Warhol's factory—a term he'd also used for his firehouse—was becoming the Silver Factory of song and story.

Name remembered how it had all started with Warhol's first visit to watch him cut hair, the previous fall:

> I had silvered my apartment. You walk in, it was a totally silver place. All the walls and ceiling are silver. The bathroom, the toilet is silver. The bathtub is silver, the refrigerator silver, the silverware is sprayed silver. . . . He said, "Wow, this is really great Billy. I just got a new place, would you come up and silver it for me? Make it silver?—make it look fabulous like your place here?" I said, "Well I don't know. Depends on what it's like." . . . In the next couple of days I did go up to look at it and gave it an appraisal of whether it was silver-able. . . . I said, "Well its walls are crumbling, the cement floor is crumbling—there's a lot of crumbling going on here. If I just do it all silver it'll look great. It'll look fabulous."

In February of '64, Name became a fixture on Forty-Seventh Street, first installing a full suite of electric lights—his Judson work stood him in good stead—and then wielding a staple gun and endless rolls of aluminum foil to silver just about every surface within reach, including the ceiling, columns, water pipes and even the bathroom stalls. "I would tack it in the corner then I would let the rolls drop and then cut it off, and then do that for a whole wall," Name explained. "It had no wrinkles, it was just the clean foil." Whatever wouldn't take well to foil, like the toilet seats and the pay phone by the door, got brushed or sprayed with silver paint; the floor got a new coat every two weeks. Real mirrors went up here and there—including on the back of the toilet door—to match Name's carefully un-wrinkled foil. Eventually, the silvering became so well known that Reynolds Metals, eager to be known as patrons of new art, comped Warhol on their famous Wrap. (It must have been an improvement on the boxes and boxes of discount "Wonderfoil" you can see in some photos.)

Malanga attributed Name's crazed silvering to the uppers he took: "One of the things about taking amphetamine is that you get obsessed with doing something and you keep doing it without stopping." Over the coming months and years Name's silvering spread to almost every object that found its way into the space: Warhol's fancy stereo became a silver ghost of itself once it moved from his town house to midtown. (Name soon supplemented it with a "gorgeous, exciting, 4-track stereo tape deck" that he extoled in a note to Warhol.) Even the Factory windows eventually got covered in foil, replacing the studio's last trace of nature with artifice. The manufacturer's cave that Warhol had first discovered was now darker still, but with fairy lights. If this final silvering made the space shine it also turned it into a nocturne, and there were dark corners to the scene that grew up there. One witness called the Silver Factory "a bastion of ramshackle Bohemian glamor carved out of an industrial slum."

Warhol's interest in silver had roots that predated Name. Pittsburgh, home to the Aluminum Company of America (a.k.a. Alcoa), had a thing for shiny modern metal: Staff at Warhol's art school were enlisted to sell aluminum's virtues. Warhol seems to have caught the bug, using foil in a college assignment about exhibit design and then, a full ten years later, in that décor he did for the Barnard production of Cocteau in '59. It was around then that he bought his Jazz Age disco ball, a vast mirrored hemisphere that for a while went up in the Factory's women's toilet and then eventually sat here and there on the floor and even got hefted to rock-concert gigs. (Although color photos reveal it as having been golden not silver.) Well before he'd even found the loft that Billy Name worked on, Warhol's connection to

luster was being acknowledged in a Happening titled "Silver City for Andy Warhol," performed in June 1963: "Whenever I see something painted silver, I think of Andy Warhol," said the artist who staged it. (Although he gave the strange caveat that only silver *paint* did the job: "Something that is silver or chromium does not invoke him. There is nothing of Andy in coins, faucets and car adornments.")

In his love of sheen Warhol was, as usual, channeling the zeitgeist. In 1957, the glitter of Sputnik had ushered in the space age and the space race; before long American astronauts, in their silver space suits, were everywhere in the press. By the summer of 1960, crinkled aluminum foil was covering every square inch of a department store window at Saks Fifth Avenue.

Warhol told one actress friend that his new studio décor counted as an "environment," which was the hot new term for immersive artworks. Name echoed that high-culture reading, describing the décor as an "installation" and claiming that it was meant as a deliberately "maximal" reaction to the Minimalism that was starting to challenge Pop: "Surrounded in that space by all the silver, it felt like you were inside of a gem." But the truth is that the whole thing was more goofy than savvy, with stronger evocations of a kitchen product, misused, than of anything high-tech from NASA or high-cred from the Judson. It's hard to imagine any of Warhol's art-world peers making work that was as light or as flighty; any serious critic would have slammed it. It's easier to imagine finding such a tinfoil treatment in the bedroom of a 1960s teenager, and Name himself had been a teen not that long before. That might be what Warhol had in mind when he let Name loose with his foil. Warhol could make himself stand out from the rest of the art world by becoming godfather to a new generation.

Warhol faced immediate complications in dealing with his youngsters. During the months of studio hunting there had been some notion that Malanga would move into whatever space they came up with: Life at home in the Bronx was less than serene and it left Malanga with a twenty-five-mile commute by subway and ferry to his classes on Staten Island. In the very first days at the new Factory, Malanga settled in toward the windowlit front of the space, moving in crates of books and generally making himself very much at home. Once Name came along as the Factory silverizer, he began to spend such long hours in the space and was so often sleeping over that he also took up residence, as both Warhol's helper and, for a little while, as his lover. "It was easy for me to move in there because I didn't have to move into his house and have one of those tacky relationships."

He established himself in a back corner by the toilets, setting up

wooden screens to have some sense of privacy and to keep himself out of Warhol's hair.

Malanga was less skilled at staying in the Factory shadows. "My presence was a little bit larger than Billy's. I was showing off my butt. So he ended up staying at the Factory, not me," Malanga recalled. "Andy felt that one person living in the loft was enough." On March 20, Malanga's twenty-first birthday, he got the happy news that his recently absconded father had left behind $1,100 for him, giving him the funds to grab an apartment passed on to him by his friend Allen Ginsberg.

Name put a sign in the Factory elevator to guide people to the loft: It read "Warhol Linich 4th Floor." As one friend of Warhol's described the Factory, it became "the silver dream palace of a disturbed childhood—a movie theater where every day begins when Billy Linich gets up. Billy Linich is the incredibly thin, silent, obscurely busy tenant of the factory, who rises late to a day of wordless tinkering."

Malanga, for his part, remained an almost constant presence on Forty-Seventh Street, despite not living there. Between his endless commute to Staten Island for classes and the magnetic pull of the Warhol scene, it wasn't long before he dropped out of college.

Tensions took a while to resolve between Warhol's two acolytes. As Name told the story, in the early days Malanga "would go out with Andy certain nights—take him to poetry readings and stuff—and he would act like he was Andy's boy, but I was Andy's boy. And he was acting like he was being kept by Andy and going out to these poetry things. And I got pissed about that. I said, 'I'm Andy's boy. You're not. So don't be acting like that.' So I put up the sign"—a sign that read, "Gerard Is No Longer Allowed in the Factory." Warhol made Name take it down.

Eventually, a truce was declared between the two men. Billy Name was acknowledged as "foreman of the Factory," as Warhol put it—the studio's manager, majordomo and doorkeeper. Gerard Malanga became known as its prime minister.

———

Billy Name remembered that the Factory got its name "through me, Andy, and Ondine brainstorming in that crazy amphetamine way." After considering "the Lodge" and other options, Name said, "the three of us almost simultaneously realized that this had been a factory—a hat factory. We all together just said, 'The Factory.' It sounded so perfect, as if the place itself were inspiring us to come up with that word. The old factory became the Factory." What's notable about Name's story is that it doesn't sound as

though Warhol's pseudomechanical art making had much to do with it. Within the studio's first few months of existence, however, it began to live up to its new moniker. With the help of Malanga and Name, Warhol began to churn out a vast new series of sculptures that were meant to simulate mass-produced objects, in part by themselves getting more or less mass-produced. These were Warhol's famous Brillo Boxes—but also, if less famously, an even greater number of boxes dedicated to Heinz Tomato Ketchup, Mott's Apple Juice, Del Monte Peach Halves, Campbell's Tomato Juice and Kellogg's Corn Flakes.

A first batch of blank plywood boxes had been ordered from a carpenter before Christmas, as the firehouse got packed and cleared out. They began to get Warholized just as the new Factory turned to silver, with more wooden blanks being delivered all the time. Over the space of about eight weeks, they got painted and silkscreened in batches of one hundred: The boxes would be lined up in rows the length and breadth of the studio and then Warhol and his lads would get to work on them, almost like laborers on an assembly line. Even visiting critics might get roped into helping. Warhol and his workers would perform one task at a time on all the boxes before moving on to the next step in the process.

Malanga gave an account of the project, thirty-five years after he'd worked on it (given the lapse of time, he can be excused for getting some details wrong):

> Billy Name and I would take turns painting with Liquitex [acrylic paint] all six sides of each box—which numbered nearly 80—the Campbell's tomato juice for starters, by turning each box around on its side. We waited until the paint dried. Andy and I repeated this process silkscreening all five sides again, down the line. The sixth side—the bottom side—remained blank. We'd talk from time to time while working. At this particular time he provided no specific interpretation to why he thought up the boxes in the first place. When I asked, he said merely that he liked to go shopping. For a guy of 20, I took his shopping for granted.

The last step was to wrap the finished boxes in thick brown paper and stack them high along the studio's walls, to await delivery to their final destination: the Stable gallery, where Warhol's second New York solo was scheduled to open on April 21.

In the end there were something like four hundred of the new sculptures, and they were still being worked on right up to the deadline. Eleanor Ward was

not a huge fan of the project—her staff convinced her to show it—but after the horrors of the Death and Disasters she might have seen this faux packaging as a safe(-ish) return to the commodity culture that had launched Warhol eighteen months before.

Actually, there was a bigger shift between the two Stable shows than critics seemed to recognize: Where the Coca-Cola paintings had been all about the goods a consumer could buy and hold, the new boxes were modeled on the big shipping cartons that consumables sat in as they moved from factory to retailer. It was as though Warhol were moving from the moment of consumption to the moment of production and distribution, getting an ever more zoomed-out view of the American economy that he and his viewers were swimming in. It was a more detached view as well, since not many viewers of Warhol's boxes would have had direct contact with a stockroom's cardboard cartons, the way they did with an iconic Coke bottle or Campbell's can. As Warhol's friend Henry Geldzahler put it at the time, "The disposable container, that which holds the commercial products we eat, clean with and live with, becomes the subject of the sculpture; the disposable husk, the invisible, the means of transportation, is the entire interest." With this depiction of the invisible and impersonal, you could say that Warhol was moving on from camp to cool.

Nathan Gluck remembered being pulled from his ad work to help Warhol with this new chapter in Pop. He was sent out to the supermarket across the street to fetch real packaging to act as models, and he brought back the most attractive boxes he could find—a carton from Blue Parrot fruit, for instance, with an "artsy" vintage look that Warhol the camp collector would once have coveted. "Oh no—I want something ordinary!" was Warhol's reaction, and it fell to Malanga to dig up the much less striking logos that ended up being sent out for transfer onto printer's screens.

Before dwelling on the "ordinary," Everyman side of the new sculptures, it's worth stressing that they had as strong a connection to vanguard high art as Warhol's other early work. They made a very obvious reference, for instance, to the new Minimalism that was already risking to overthrow Pop Art as the Latest Thing. Back in early '62, when the Green Gallery gave Warhol's Pop its first-ever play, a plain Minimalist box, the size of a piano crate, had already kept company with Warhol's Dollar Bill painting. Warhol had clearly conceived his boxes to register as having advanced abstraction in mind; see them as shapes and they might as well be by Donald Judd, although more radically reductive than what that dean of Minimalism had done until then. But—as always when Warhol went abstract—the boxes also count as a joke at abstraction's expense. They hint that the utter rigor of a

Judd may be just as easy to find in supermarket cardboard. By the end of the decade, Warhol was actually claiming that Minimalism was nothing more than a bunch of enlargements of details extracted from Pop.

But the truth is, the box sculptures are the most entirely, transparently *realistic* of all Warhol's works, to the point that they function as full trompe-l'oeil. While the Campbell's Soups had clearly been paintings of tin cans rather than the real thing—however much early viewers ignored the distinction—the silkscreened wooden boxes did a pretty good job of standing in for the everyday objects they represented. Although Warhol's imitation was less slavish than you'd think—when he found a real box looking too small he was happy to scale up his version—as far as viewers could tell, or cared, the boxes pretty much *were* warehouse packaging. You might call them "handmade ready-mades" or artisanal Duchamps. Within a few years, Warhol was happy to show the companies' actual cardboard cartons as his art.

When a young philosopher named Arthur Danto took in the Stable boxes, he was so blown away that he went on to build a major career around the revolution they represented. Within months, he had published a legendary academic paper arguing that once Warhol's boxes had proven that there might not be visible differences between supermarket goods and gallery goods, the only way you could tell whether an object was art or not was to check where it was being shown.

Warhol, always savvy about the challenges that his art presented, took some steps to reduce the confusion. For his earlier Stable show, with its evidently artistic canvases, he'd been happy to distribute that schoolgirl text by Suzy Stanton. But now that he was presenting works that could come across as objects shipped in straight from pop culture, he chose to pair them with words that clearly came from deep within the art world. On the bottom of the show's poster, and in its ads, he published a chewy text by a cutting-edge critic who himself quoted an obscure Scottish philosopher saying things such as "experiencing things and subjects as things and objects is the outcome of holding certain attitudes." The essay ran under the title "The Personality of the Artist," which, said the text, was precisely what you were *not* supposed to attend to in looking at the Stable works. Most of the poster was taken up by a photo of Warhol looking as serious as could be in black tie, like a man who had just received the Nobel Prize. It bore no trace of the "gum-chewing teenybopper" that Warhol had once advertised, but also left you wondering whether his new square look might be a put-on. After all, here was a poster telling you to ignore the artist's persona while presenting a giant photo of him.

———

"Warhol's intuition was that nothing an artist could do would give us more of what art sought than reality already gave us," wrote Danto. On the morning of April 21, with only hours to go before the Stable opening, that same intuition led Warhol and Billy Name to show up at the gallery and turn the hundreds of boxes that were there into a simulation of a down-to-earth commercial "reality." Gone was the tidy white plinth that Warhol's earliest boxes had perched on in a group show in Los Angeles, like a big sign that said "Here be art." The sober poster for the New York show would now be doing that job. Instead, in the gallery's front room, cartons of Campbell's Tomato Juice sat right on the floor in rows, as though waiting for teamsters to hoist them through a loading dock. In the smaller rear space, Brillo Pad boxes were stacked head high and wall to wall, like supplies amassed for long-term storage. Why leave room for a person to come in for a look? The hallway between the two galleries, once home to a phalanx of Marilyns, was now lined with a hoard of Kellogg's Corn Flakes and Mott's Apple Juice, amassed against some run on breakfast food.

"Eleanor looked tight, constipated and ungrateful on the day of the opening," Emile de Antonio later wrote in his journal, and Warhol "fluttered among the guffaws and heehaws of collectors, fruits, art directors, and those he had left behind." The box launch was mobbed and footage of it seems to show the other guests, at least, having a grand time. They were almost crowded out by Warhol's sculptures but happy to push their way through them, often with barely a look. "It was like going through a maze," said fellow Popster Robert Indiana.

Thanks to Warhol, the exhibition turned gallerygoers into random visitors to a stockroom, forced to navigate among boxes set down for some purpose other than their delectation—more like young Andrew Warhola touring the Heinz factory, as he said he had, than aesthetes engaged in contemplation. The boxes were so successful at avoiding the feel of art that the notables at the opening were happy to touch and shift and restack them, with nary a white glove in sight. (Although one grinning wise guy played at faux connoisseurship, peering at a box through a loupe.)

From an artistic and conceptual viewpoint, even a philosophical one, Warhol had scored a huge success. But not every viewer could recognize that at the time. A visitor to the Stable complained that the boxes represented "Anti-Art with capital A's," not understanding that this was what made them important. One critic praised the show for occupying one of the few "extreme

positions" left in art while also declaring that it perfectly expressed "the ugli-
ness of the spirit of the times." At the opening, "the guests were in disbelief
that the gallery would dare to call this art," recalled one man who was there.

That might be why they were so reluctant to buy the work.

The Stable was listing the boxes at $200 to $400 apiece, depending on
size. That was quite a bargain for a hot young artist's original, handmade
sculpture—and the boxes were indeed handmade, despite their industrial
pretense. But it was also, as Danto pointed out right away, something like one
thousand times what you would pay for a real cardboard carton that looked
just the same. The elite-object price was vital in establishing the boxes as art,
but that didn't mean art lovers were about to pay it. "Everybody who saw
them liked them," said Billy Name, "but no one really bought them. For a
while, Andy would take just about anything for the boxes, selling them for
$100 or even $50 just to get rid of them."

A sold-out show of the boxes would have netted something like $60,000
each for artist and dealer, a number you can imagine dancing around in
Warhol's head as he installed them, and maybe even in Ward's. "He thought
everyone was going to buy them on sight, he really and truly did," Ward
said. "We all had visions of people walking down Madison Avenue with
these Campbell's Soup boxes under their arms, but we never saw them."
It looks like even Robert and Ethel Scull, pioneering collectors of Pop, had
their doubts about the new work: They'd announced plans to buy twenty
boxes at $300 each but then never came through. In a pretty standard art-
market move, Warhol and his people took to pretending that boxes had
sold in the hopes of making them seem more buyable. Eventually, with
hundreds of unsold boxes on his hands, Warhol got Nathan Gluck to wrap
them in plastic and heft them up to the crowded top floor of the Lexington
Avenue house; some that stayed unwrapped gave endless pleasure to visit-
ing nephews.

———————

On the night of the Stable opening, one guest had been especially struck
by Warhol's work. He was James Harvey, a dedicated but little-known Ab-
stract Expressionist painter who, as it happened, had a day job as a reluctant
graphic artist, producing such things as the Brillo carton that Warhol had
used as his prototype. Some months earlier, Harvey had expressed utter
contempt for his own creations, belittling his three-year-old Brillo packag-
ing as "a good commercial design but that's all" and saying that he could just
about do such work in his sleep. As one Pop critic said, Harvey's design was

"directed at saleability rather than attractiveness"—precisely why it had appealed to Warhol and also the reason Harvey had no investment in it as art. But when he spotted Warhol's versions he let out a yelp anyway: "Oh my God—I designed those!"

Harvey was already on the record as an opponent of Warhol's Pop—he had compared the soup cans to sentimental Victorian paintings—but a friend who joined him at the Stable said that didn't sour him on the borrowing: "He thought it was amusing. Everyone who walked into the Stable Gallery that night was amused." Harvey even had the good humor to sign one of his own cardboard boxes and send it to a young critic, joining in Warhol's jest since he couldn't beat it. Keeping the joke alive—but also probably in genuine appreciation of Harvey's graphic skills—Warhol then offered the designer a box-for-box trade, but Harvey was struck down by cancer before it could happen.

Rather than there having been talk of a lawsuit and a tsunami of scandal and coverage, as has often been said, the Harvey-Warhol "affair" won all of five sentences at the tail end of a round-up in the *New York Times,* plus a brief comic note at the back of *Time* magazine.

There was one truly newsworthy aspect to Warhol's use of Harvey's Brillo graphic, at least for art historians: Where almost all his other product-based art had been built around iconic logos and brands, or at least venerable ones, using Harvey's new design for Brillo landed Warhol in much more contemporary territory. Warhol's early Pop had depended on giving new life to imagery that was so known and banal it had become almost invisible, but that could hardly be said of a striking Brillo package that was all of three years old—and that had been designed to be the opposite of an old Campbell's label. The clinging nostalgia of '50s camp was finally giving way, in Warhol's art, to more current aesthetic problems.

But there was also a risk involved in going with something as grabby and up-to-date as Harvey's Brillo: It might draw more attention, as design, than Warhol's boxes could do as fine art. Years later, an incensed columnist thought Warhol was aiming to take credit for Harvey's brilliant packaging, when poor Warhol had in fact meant it to stand for the banal. Even dedicated art lovers immediately began to think only of the Brillos whenever Warhol's boxes came up. Thanks to Harvey, the Brillo Box reigns supreme in Warhol Land while the other Pop boxes have faded from our collective psyche, even fifty years later. On the other hand, where Warhol's riffs on Campbell's and Coke had flagged his art as subservient, in some sense, to those already iconic brands—his art depended on them for cultural meaning, rather than

vice versa—Warhol managed to turn Harvey's design into a house brand of his own, to the point where it could just about stand for his entire Pop project. Within six months of the Stable show, the *Times* was describing Warhol as an artist "best known for his facsimiles of Brillo boxes." Harvey's logo, which the Brillo Manufacturing Company didn't think worthy of keeping around for long, has lived on in the culture only on the sides of a Warhol sculpture. Warhol the icon user had become a maker of icons.

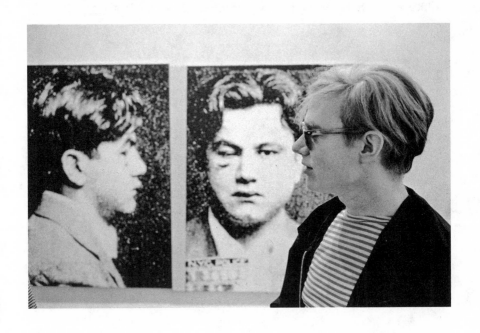

*. . . with one of his* Most Wanted Men.

# 1964

*"The artist's works have almost nothing to do with
his white-streaked hair or his pale skin"*

The evening of Warhol's Stable opening, its most notable guests moved on to his newly tinfoiled Factory, as Emile de Antonio recalled:

> Marguerite [Lamkin] and Ethel Scull gave a party in Andy's aluminum studio on 47th Street. Everybody was there. The Javitses; Allen Ginsberg in a tam o'shanter.
>
> But these women were insane, and Ethel's husband was more so. They'd hired Pinkertons, so these detectives were downstairs and you absolutely had to have an invitation or you couldn't get in. And many of Andy's friends were excluded, because these fashionable women wouldn't invite people like that. "Gerard Malanga? No, I'm sorry, you're not on the list." I was Marguerite's date, so I got in, but the Pinkerton would send the name up, and of course Andy avoided having anything to do with that because he didn't want any responsibility. That party was one of the high points of the '60s.
>
> Ethel and Marguerite hated each other after that party: They were arguing over how much each one had spent, like a lunch check.

Of course, Ethel Scull was that collector whose portrait Warhol had done. Marguerite Lamkin was a Southern socialite and journalist who Warhol had known for several years. (She'd written the first mass media coverage of his move into Pop and also of his Elvises.) "Cohosting" the party meant nothing more than that they split the bills. And yet, despite their foibles, they

had produced, as Emile de Antonio remembered, "the all-time bitch party that was ever given."

For the previous two years Warhol had been slowly getting known as the mildly eccentric maker of some fairly eccentric art—which meant that his "fame," such as it was, didn't move far beyond people who read the art columns. The party at the Silver Factory represented the first step, if still only a baby step, that Warhol took on his way to becoming a truly public celebrity, as famous for his fame as for anything he made.

Warhol had been out and about since his first days in New York, hunting for fun and the right social scene. Now, all of a sudden, he could stay home and watch others come to him.

Everyone who mattered in Pop Art was at the party, but there were also artists of the Color Field school and mail-art pioneer Ray Johnson, plus the radical playwright LeRoi Jones. Some celebrity guests had hardly any connection to contemporary art, such as United States senator Jacob Javits, supermodel Jean Shrimpton and Pittsburgh millionaires Drue and Jack Heinz, who must have been pleased to see their prepared foods at last getting their due from Warhol at the Stable.

The whole night was Pop themed. Warhol and Malanga used one of the screens from the Stable show to print yardage for the seamstress Suzanne Moss, so she could wear a yellow Brillo gown to the party; its long skirt was shaped like the actual box. Stealing an idea from the Hoppers' Pop party in L.A., food was left in the hands of Nathan's Famous, the Coney Island deli, which set up a hot dog stand complete with countermen in white caps and a huge sign that read "Over Eight Million Sold Every Year." That night, a hungry Warhol could be seen making it eight million and one. (He might have liked frankfurters fine, but earlier that day he'd asked a photographer to treat him to the newest and fanciest French restaurant in town.) The rest of the space was set up for real merriment, spurred on by a huge jukebox that had all the "vulgar vitality" one British critic had admired in such "pop" machines. By night's end, things got so wild that the dancer and critic Jill Johnston could be seen swinging from the silvered pipes overhead. Ray Johnson told her it was the best dance he had ever seen: "How brilliant of you to incorporate that foil-covered pipe over the jukebox," he wrote the next day. But Billy Name was desperate to get her to come down before the plumbing burst onto the packed floor below.

All this committed celebration looked set to launch Warhol and his Silver Factory beyond the avant-garde and into the public eye, where he'd barely been until then. Even a month before, he was still finding himself deep in art land. He'd made it to prime-time television, surely a good sign, except that it was public TV, and an interview program where a painfully stodgy

Geldzahler got some Pop artists to justify their new movement. "My art is principally about formal matters," opined Roy Lichtenstein in a straight-faced attempt to counter attacks on his lowly but fascinating content. Warhol had smartly declined to speak at all, instead doing a live demonstration of the screening of one of his Stable boxes, to the sound of "Sally Go 'Round the Roses" playing behind him on set. On public radio in June, Lichtenstein and Oldenburg made a point of insisting on their belief in Pop as high art; Warhol for his part said he was "too high" to answer questions.

"The artist's works have almost nothing to do with his white-streaked hair or his pale skin." That had been loudly proclaimed in the sober text on the Stable poster. It might have made sense as far as the works themselves were concerned—they might indeed have been made by some dark-haired poet or lighting designer. (They sort of were.) But Warhol himself was starting to conceive of his white wig and his white Brillo Boxes as a single cultural package. Bob Scull, the collector, remembered Pop, in its heyday, as being as much a social phenomenon as an artistic one. At Pop openings, he said, "you no longer had women coming in looking like a Gibson Girl. You had them coming right off a motorcycle or a motorbike with just a halter with two stars on their breasts. . . . In other words, it was not just an opening for the little art community but the whole world was happening there."

At the Stable party, a visitor from the twenty-first century might have been most struck by how far Warhol still was from that vision: There he was in a tasteful dark suit, white shirt and tie, worn with a friendly smile on his face and a modest little rose in his lapel. The party might have signaled Warhol's full entry into public life, but the man who was stepping out hadn't changed all that much from who he had been at the end of the previous decade. Almost halfway through 1964, and after two full years of artistic ascension, Warhol had still not become the cool cat we know, or think we know, from '60s lore. In photo after photo from Pop's first years, his day wear seems as unassuming as his party gear: baggy tweed jackets worn over wrinkled dress shirts kept tucked into chinos or jeans, sometimes accessorized with a striped tie and always with battered and paint-splattered oxfords—"tacky shoes with his toes sticking out," recalled Emile de Antonio, "the creepiest shoes you've ever seen." (A pair of those shoes survive, incorporated into a sculptural portrait of Warhol made by his friend Marisol.) He wore this same ensemble, with minor variations, at home, on the street, to fancy restaurants and when making a mess in the studio—at least when there was a camera around to record him. He told Malanga about the fine suits of his commercial years and how he'd now put them away. But he had yet to find a new fine art costume that might draw the same kind of

attention. Around the time of the party, when he decided to paint a new self-portrait he chose to make himself look like a perfectly normal young man in a T-shirt, silkscreened in cheerful Mod colors.

Only a few outward details began to hint at the hipster to come.

For several years already, Warhol and his dark glasses had been close to inseparable. In October 1962, he had them on at night, inside, at the opening of the Janis "New Realists" show, when you'd think the art demanded unhindered vision. (Then again, the same photos show Geldzahler wearing them too, as though a curator as sharp as he was could afford not to see.) Warhol wore sunglasses again, or still, six months later in the firehouse studio, as he finished the *Tunafish* silkscreens, and then on a rainy day when he was starting on Elvis. When an art historian who was partly deaf paid a visit to him at home, she had to beg Warhol to remove his shades, since she found eye contact helped her read lips.

The sunglasses had tan plastic frames, clear and slightly more rounded than the solid black ones the movies had shown on James Bond, and Warhol could be seen wearing them again in the photomat self-portrait he submitted to the catalog of the "Popular Image" show in D.C., yet again in the town house as he was being photographed with his portrait of Ethel Scull and one more time in the dark of his first days in the still-unsilvered and unlit Factory. He pulled them up to peer through his Bolex and even wore them, for very public consumption, as he was being taped on the set of that TV show.

As so often with Warhol, this was mostly about following the latest trend, in this case set by the commanders in chief of 1960s fashion: "The Kennedys are the most important stimulus to this business since Garbo," said an executive from the sunglass industry. The quote is from an article that cited the $110 million that Americans had spent on sunglasses in 1962, up 30 percent from two years before when Jack Kennedy and his shades had won the election. Not too long after that first Factory party, even the *New York Times* had got around to running a trend-spotting feature headlined "Dark Glasses After Dark: For the Eyes or Ego?" It informed readers that a visit to New York's most with-it clubs would reveal "some persons who sit around all evening peering through sunglasses as if they were on a beach instead of in a dimly lighted cellar."

The shade craze had a double ancestry that was perfectly suited to the complex mix of mainstream and underground culture that went into building Warhol's persona. Sunglasses got launched into the public eye in the 1930s by Hollywood stars pretending to seek anonymity—hence the industry executive's reference to Warhol's idol Garbo. They then found a second and separate identity among the beatniks and beboppers of Greenwich Village whose drug use made light hurt their eyes. By the time dark glasses had become a

permanent feature of Warhol's face, one insider was already announcing that "if you're really 'in' you wouldn't be caught dead wearing them indoors or at night because you'd look like somebody who is 'out' but is trying to look 'in.'"

Actually, Warhol had given himself little choice but to keep his dark glasses on, any day that he chose to wear them at all. Asked to analyze the several pairs that survive, an optician found that they were fitted with prescription lenses to correct Warhol's extreme nearsightedness: "Without his glasses, he would barely have been able to recognize a face from a few feet away." So Warhol's shades didn't only look cool. By coming across as a pure fashion statement, they hid the fact that he was a natural four-eyes. "I put sunglasses on when I didn't have my contact lenses and I wanted to be photographed," Warhol once admitted in private—and the admission seems to cover most of the 1960s photos that we have of him, maybe because the only contacts he could buy at the time were still the painful hard kind.

If Warhol found a clever way to hide his bad eyes, the way he camouflaged his baldness had a touch of genius. Already in footage from late 1963 you can see a band of dark hair at the back of his head that reaches down an inch or two beyond his blond wig. That made his bewiggedness more obvious, of course, but also so absurdly evident that the toupee came across as a deliberate and extreme costume choice—more like a wacky hat than a hairpiece that was hiding a lack. Malanga remembered being taken in for the first few months he knew Warhol: "If someone goes bald they'll usually get, like, a plain brown toupee, something they hope doesn't draw attention. Andy got outrageous silver hair. When you looked at Andy, you didn't think, 'He's wearing a toupee,' you thought, 'My God, look at that guy's hair!'" Actually, in '63, Warhol's hairpiece still made him out to be a natural blond; the truly silvered wig didn't arrive until a year or two later, but even then a reporter could believe that Warhol's own hair was on view, worn dark in back and then platinumed by some hairdresser on top.

———

A radical new show; striking hair and cool glasses; a huge party with hip photographers snapping the assembled celebrities—everything was in place for a smash success. Except that almost none of the photos ran, because no one published a piece on the party, because it was celebrating an artist who was still less well known than his art. And even as Warhol munched his Nathan's hot dog, he knew that he had just lost his best chance to make a more public splash. For well over a year, he'd been working on a major public mural to be set before the eyes of the 70 million people expected at the 1964 New York World's Fair. After weeks of nonstop coverage, the Fair was open-

ing the morning after Warhol's Stable launch. And as he partied he knew, and knew that newspaper readers knew, that the fair would go on without his art.

If he looked happy that night in his silvered loft he was doing a fine job hiding a terrible disappointment.

The mural project had begun late in 1962, with an invitation from Philip Johnson, the architect and former MoMA curator who had designed the complex of buildings that made up the New York State Pavilion at the fair. One of them was the Theaterama, a vast cylinder that housed a splashy, 360-degree film about the state, and Johnson had been charged with finding contemporary art to install on the building's blank concrete façade. The new pieces were meant to be "an interesting counter-point to the exhibit of traditional art being shown in the Pavilion, with all of the art works being reflective of the creative artistry traditional to the state." Johnson had chosen almost a dozen of the most advanced abstractionists and Pop artists for the honor of decorating his façade, and it's no surprise that Warhol was among them, even that early in his Pop career: Johnson had already purchased his golden Marilyn and Johnson's life partner, a much younger aesthete named David Whitney, moved in the same gay and artistic circles as Warhol.

That commission must have thrilled Warhol, still barely beginning to find success in fine art. Aside from the crowds who would get to see his first public work, which was also by far his most ambitious one up to then, he'd be in excellent company: Roy Lichtenstein, Robert Indiana, Ellsworth Kelly and John Chamberlain, all favorites of his, would be among his comrades-in-art on the façade of the Theaterama.

As early as September of '63, Indiana had already been licking his lips at the prospect of his vast new audience. "There'll probably be more reproductions of this, and more coverage in the press, than on anything that I might have done otherwise," he told an interviewer. He also knew that fairgoers were not likely to be the most receptive audience for the kind of art he and his peers were going to provide: "I'm sure they'll practically riot against it."

Warhol knew the size of the space he had to fill—twenty feet by twenty feet—and that he'd be getting the then vast sum of $6,000 to do it, but it took him a while yet to figure out what to put there. As the story goes (several stories, actually, that give rather different accounts) he was still wondering what to do well into the spring of 1963, when he enraged his friend Ray Johnson by offering him cash for his suggestions. Help finally came one day late in April, at a coq au vin dinner with some friends, when Wynn Chamberlain suggested that Warhol base his project on police mug shots, like the ones in the Most Wanted flyers that a cop boyfriend of Chamberlain's was bringing home all the time. Warhol loved the idea. It would let him cross-breed

the celebrity faces in his Marilyn and Liz paintings with the grim and even criminal subjects of his Death and Disasters. You also have to wonder if the same police flyers might have lurked behind his grid of photo-booth "mug shots" of Ethel Scull, which seem to have been started after the Chamberlain dinner; it would be just like Warhol to take a private dig at a pushy patron by conceiving of her as a criminal.

Around that gay dinner table, how could Warhol have resisted the idea of a public mural built around the suggestion that manly policemen might have men they most wanted? He had already encountered other crossovers between wanted criminals and his own gay crushes. A movie magazine he owned had featured a huge story on Warren Beatty, subject of one of Warhol's very first silkscreens, that began with the words "WANTED! Have you seen this man? DEAD OR ALIVE: We want Warren Beatty alive—and kicking! Your reward: Read this story and get our sneak preview of Hollywood's sexiest newcomer." The program Warhol brought home from the premiere of the 1955 movie version of *Guys and Dolls* talked about how Marlon Brando, another subject of Warhol's Pop Art, "isn't on the FBI's list but is unquestionably one of the 'most wanted' men in America." Based on his experience in Pittsburgh, with its mob-run gay clubs, there might have been some sense in Warhol's mind that the criminal class—maybe even the working class as a whole—was more relaxed about homosexuality than fancy judges and the police might be.

The art world would have offered models that made the mural concept irresistible. Decades earlier Marcel Duchamp had crafted a famous Wanted poster of himself and had then included it among the little reproductions in the *Boîte-en-valise* that Warhol owned—the poster was mentioned in some coverage of Warhol's own mural. Robert Rauschenberg, possibly second only to Duchamp in his influence on Warhol, had included a police Wanted flyer in an assemblage that had been in his pioneering Castelli show in 1958.

Chamberlain's boyfriend supplied Warhol with a pamphlet published a year earlier by the New York Police Department under the title "Thirteen Most Wanted," and Warhol had four-foot-square screens made from all twenty-two of its mug shots. (Most of the thirteen criminals had been shown in both front and profile views.) The enlargement was so extreme that the crude halftone dots of the flyer's little photos began to look like the big spots on a Lichtenstein—one writer referred to Warhol's "artistic" dot-screening of the mug shots. In 1961, the same British critic who had coined the term "Pop Art" had mentioned how smart painters might take advantage of the fact that faces rendered in heavily screened halftone "lose identity and scale and turn into amorphous, evocative surfaces."

The screens for Warhol's mural arrived at the Factory in February and

March of '64 and got printed in black onto pale boards. That spring, the Factory must have been mad with work, as the Wanted Men competed for time and floor space with the Jackies and hundreds of boxes for the Stable show. By Monday, April 13, however, with a week still to go before the boxes were due, Warhol's *Thirteen Most Wanted Men* were up on the façade of the Theaterama.

By then, trouble was looming. The first mentions of the project had been perfectly cheery: Warhol, in his obligatory dark glasses, was featured in a group shot of Theaterama artists in the February issue of *Harper's Bazaar* and his name had been mentioned here and there in advance coverage of the Fair. By early March, however, a worried Johnson had sent Warhol a telegram warning him not to talk to reporters or give out information on what his mural was about—all reporters seem to have been told was that Warhol had been commissioned to paint "a comment on some sociological factor of American life." As soon as the piece actually went up, you could see why Johnson had been worried. Jimmy Breslin, the celebrated columnist, made a visit to the fair on that Monday and by Tuesday had published an entire piece satirizing Warhol's mural, whose style he dubbed Early Rikers Island, after New York's notorious jail.

"Our very best local sinners stare down from this mural. They must have hired an old warden to be art director for the exhibit," wrote Breslin. He claimed that the piece proved that Warhol was "against commerce and industry and society in general." Breslin being Breslin, he also quoted the bemusement of one local Irishman: "I guess he must have always been drinkin'," the carpenter told Breslin as they stared at one of Warhol's wanted men. "To get in so much trouble that they hang your picture on a building in a World's Fair, a man must have to be drunk all of the time."

Breslin was hardly a delicate soul who took offense at the sight of bank robbers—his man-of-the-people columns were full of such creatures—but it clearly irked him that a pavilion meant as a celebration of New York's creative energies became a celebration of its criminal ones.

At worst, Warhol had intended his mural as a joke and a tease rather than some kind of attack. One young firebrand had actually viewed the project as complicit with the Establishment. He said Warhol would look like a whore if he even considered making art for the corporate masters who ruled the Fair: "How could you exploit yourself and let them use you?" But the Fair's average joes felt that they were the ones who'd been ill used by Warhol.

The day after the Breslin column ran, the main newspaper in Queens published an entire front-page story, complete with a big photo of the mural, that wondered aloud whether Warhol's work would survive the "expected howl of protest" over the propriety of having such art on the façade of a pavilion "designed to project the Empire State's image to the world." The

article quoted any number of incensed bystanders, saying things such as "the Fair's a place for beauty, progress and enjoyment, not a backdrop for criminal billboards" and "a painting with all those criminals will spoil some of the fun at the Fair. It should come down."

The following day, Philip Johnson defended Warhol's mural as the best of the ten he'd commissioned. An official Fair spokesman denied that there had been any "public hue and cry" over it. He predicted that the mural would be up for the two years of the event.

He was off by exactly two years. Within two or three days, the mural had been tarped over. Even before that, a film crew from NBC had been told not to let the piece appear in its shots, guaranteeing Warhol's complete erasure from the Fair's prime-time coverage.

Warhol and Johnson tried to save face, claiming to reporters that Warhol himself had been disappointed by how the panels had looked in situ and that he'd decided to come up with a whole new piece. "I didn't think we had a right to hold him to this one," Johnson said, while insisting that any complaints he might have heard from viewers were about the mural's subject matter and therefore "had nothing to do with the art." He bridled at the suggestion that he and Warhol had caved to pressure from Fair organizers. They almost certainly did.

Various explanations for the censorship cropped up over the following months and years, in public and in private. At one point Warhol told the *Times* that one of the accused had been pardoned, so the mural wasn't "valid" anymore. Later, Johnson mentioned that some of the men in the NYPD flyer had been acquitted, so there was a risk of lawsuits, but also that Nelson Rockefeller, governor of New York and funder of the Pavilion, had called him "in anguish" about the number of Italians among the criminals in the mural. That risked offending a constituency the governor needed in his dark-horse campaign for the Republican presidential nomination, running against the ultra-conservative Barry Goldwater. Rockefeller lost, badly, even without Warhol's mural as a handicap—although, ironically, Malanga read the *Most Wanted Men* as a pandering nod to Rockefeller's tough-on-crime platform.

More recently, scholars have argued that there was homophobia involved in the removal of the *Most Wanted Men*. The city had undertaken a brutal crackdown on gay culture as it "cleaned up" for an influx of World's Fair tourists—Mekas was arrested for screening Jack Smith's *Flaming Creatures*—so a mural that showed a male artist advertising thirteen thugs he might "want" was not about to be tolerated. That very June, the supposedly liberal *Life* magazine—in an issue celebrating the civil rights movement, no less—could publish a long, prurient, finger-wagging exposé on the "social disorder" of homosexuality and

how "today, especially in big cities, homosexuals are discarding their furtive ways and openly admitting, even flaunting, their deviation."

But the truth is that just the complaints about the more general impropriety of Warhol's work, so vehemently voiced by a figure as mighty as Breslin, might by themselves have been enough to torpedo the project. As one scholar has said, the mural was "one of the boldest engagements with criminality ever attempted by a visual artist"—not the most likely material for a World's Fair.

The queer connotations of the mural would certainly have been obvious to Warhol and his circle; queerness might have been a driving force in its making. Warhol had said a giant, knobbly pickle was another early option he'd considered for the commission, and as executed the mural made a bold reference to rough trade, at least for those in the know. When Warhol chose *Thirteen Most Beautiful Boys* as the title for that series of portrait reels he was shooting in early '64, it was clearly named after the *Thirteen Most Wanted Men* mural he'd already conceived, confirming that desire was driving both. But he would have imagined, probably correctly, that this kind of gay content was beyond the imagining of a sexually naïve American mainstream.

"Gentlemen: This serves to confirm that you are hereby authorized to paint over my mural in the New York State Pavilion in a color suitable to the architect," wrote Warhol to the state's Department of Public Works on April 17, the same day that a newspaper announced the work's removal. The next time anyone wrote about the mural, it had been entirely covered in silver paint, as it remained for the two-year life of the Fair. Warhol visited the site of his debacle several times, and by the summer of 1965 he could at least pretend to rationalize the mural's disappearance: "I don't believe in anything so this painting is more me now," he told a reporter for whom the visit must have been staged. "Because silver is so nothing, it makes everything disappear."

Within a few days of the silvering out of Warhol's *Most Wanted Men*, the vast enlargements used to make its silkscreens were being proudly and prominently displayed as portraits on the walls at Warhol's Stable party. He got himself and four other Pop artists photographed against some of these Most Wanteds, maybe as a quiet polemic against the Fair's censorship. (The shot ran in the antifair *Village Voice*.) But however sure Warhol might have been of the excellence of his criminal art, the Fair had dealt a blow to his pride and reputation. The night of the Box opening, the very public failure of Warhol's first public commission must have been the talk of a party intended as a celebration of his success at the Stable.

Wynn Chamberlain said that Warhol never totally forgave him for having suggested the mug shots in the first place: "After this setback, Andy stopped asking me for ideas and stopped experimenting with Social Commentary."

The Bolex, the squeegees and printing screens, the Obetrol—Warhol came to the Factory already equipped with almost everything he needed to make his new art. It fell to Billy Name to provide the one missing art supply: the infamous Factory couch.

> It was out on 47th Street—just on the sidewalk, waiting. Someone had just dumped it out there. I was walking, going to the Factory; I looked at it and said "This goes into the Factory." I tried to push it and—"Wow, great!"—it was on rollers. It was an enormous thing. I just rolled it into the elevator and into the Factory and it became a fixture there.

That sofa, a giant Art Deco piece covered in crimson velvet, became the centerpiece of life and art in the Silver Factory. It even got to play the title role in its own feature film, called of course *Couch,* in which an ever-changing selection of Warholians—old reliables such as Naomi Levine and Malanga but also visitors such as the poets Allen Ginsberg, Jack Kerouac and Piero Heliczer and his wife Kate—are recorded by Warhol's silent Bolex in actions ranging from tame conversation, to sexy preening, to banana eating and finally to full-bore fellatio, anal sex and anal-oral sex. The film's couch-bound antics give a first suggestion that the louche social scene Warhol was creating in his new Factory would also count as the subject and substance of his art: When you were seeing this latest art of Warhol's, you were now also seeing his world.

Warhol had made a valiant if maybe naïve attempt to create advanced art for a fairgoing general public, only to see that public reject his offering. He suffered just as bad a rejection from the art world, also that April, when he was left out of the great Venice Biennale festival that was due to open in June. Warhol's fan Alan Solomon had been in charge of arranging the oversize American contribution, with fully eight slots to fill, and yet had filled them with Warhol rivals such as Claes Oldenburg and Jim Dine. More hurtful yet: When the survey actually opened, Robert Rauschenberg got vast and world-wide attention when he was awarded the top painting prize for the excellence of "his" new silkscreen technique—which of course was totally dependent on Warhol's own work with printing screens. That very same April, Warhol also found himself absent from the summer's vast survey of recent art at the Tate museum in London, even though organizers had seen fit to include almost every one of New York's other Pop artists. The insult got worse when their catalog essay made clear that they knew of another artist's "shelves of cans in

the supermarket" and "rows of identical horrors on the news-stand," and yet didn't even deign to name him.

It feels as though the next few months saw Warhol rejecting the rejectors. When a photographer came by to shoot his portrait, Warhol suggested start-ing the session with him sitting on the Factory toilet—in the stall marked for ladies, no less—with his eyes obscured behind sunglasses. That came close to giving the finger to his public. With the decision to make *Couch*, Warhol seemed to be going out of his way to make work that only the most inside of insiders could love. Even his tamer films of that moment were being described as "way, way, way, way out" by the leading movie critic Vincent Canby. For the first years after it was made, *Couch* itself was only ever screened complete beside the Factory couch itself, to be seen by the kind of people who had starred in and on it. "You debauch, you walk out and have coffee and then come back and watch the movie," remembered one Factory visitor.

Back in January, Warhol had followed up his little films of the gay haircut-ting crowd with a movie called *Blow Job:* For half an hour, Warhol's camera dwells on the emoting face of a pretty young man who is getting something done to him below the belt. Or so we assume from the title, since the foot-age itself is perfectly chaste and never comes to any kind of money shot. Six months later, with *Couch,* Warhol had abandoned such prim propriety.

---

"An 8-hour hard on!" That was how Warhol seems to have conceived of an-other project that came his way in mid-July, somewhere around the time he was shooting *Couch.* Jonas Mekas and a young filmmaker named John Palmer approached Warhol with an idea for a film that had come to them a few days earlier, when they'd gone to mail out the latest issue of Mekas's *Film Culture* magazine:

> The nearest post office was in the Empire State Building. As we were carrying our heavy loads, the Empire State Building was our Star of Bethlehem: It was always there, in front of us, leading us . . .
> Suddenly we both stopped. We had to stop to admire the Empire State Building. I don't remember who said it, John or myself or both of us at the same time: "Isn't it great? This is a perfect Andy Warhol movie."

The concept they pitched to Warhol was to make a new "stillie," as insid-ers were calling the Factory's static films, that would be nothing more than an endless, unedited, single-shot portrait of the Empire State Building—sort

of like *Sleep* redone with an inanimate sleeper who would be sure not to move or blink. Warhol loved the idea. He got a friend named Henry Romney, who was in charge of public relations at the Rockefeller Foundation, to get them nighttime access to his office on the forty-first floor of the Time-Life Building on West Fiftieth Street. It had an enviable view onto the tallest building in the world, whose new floodlighting was being trumpeted just in time for the World's Fair where Warhol had so nearly made his splash, and which like the tower celebrated New York, the "Empire State." In a roundabout way and without knowing it, Fair organizers would be helping Warhol with a notable project after all. Maybe he realized that.

Warhol's collaborators rented a professional newsreel camera that could shoot thirty-three-minute reels instead of the three-minute takes of Warhol's little Bolex. Then, a few minutes before 8 P.M. on Saturday, July 25, Mekas, Palmer, Romney, Malanga and Warhol, accompanied by Henry Geldzahler and the aspiring dancer Marie-Claude Desert, Mekas's girlfriend at the time, elevatored up to their lookout over the city, with a stock not only of film but of sandwiches, beer and pot. (Warhol was no pot virgin, despite his lifelong pretense of abstention.) Mekas and Palmer positioned the camera in front of the window, set the focus on infinity, opened the aperture wide and let Warhol take a look at the framing. They turned out the lights so their reflections wouldn't be seen in the window (although the camera caught them now and then anyway) and then hunkered down on a sofa on the far side of the room. From then on the only notable action came the nine times they had to change the film in the camera.

Here are some notes that Malanga took while they labored:

ANDY: Let's say things intelligent.
GERARD: Listen! We don't want to deceive the public, dear.
JOHN: We're hitting a new milestone.
ANDY: Henry, say Nietzche.
HENRY: Another aphorism?
JOHN: B movies are better than A movies.
ANDY: Jack Smith in every garage.
MARIE: Someday we're all going to live underground and this movie
     will be a smash.
JOHN: The lack of action in the last three 1200 foot rolls is alarming!
HENRY: You have to mark these rolls very carefully so as not to get
     them mixed up.
JOHN: Why are we getting slappy?
MARIE: I read somewhere that art is created in fun.

JONAS: Did you know that the Empire State building sways?!

JOHN: This is the strangest shooting session I've been in.

GERARD: We should set window panes for the audience to look through.

ANDY: The Empire State Building is a star!

JOHN: Has anything happened at all?

MARIE: No.

JOHN: Good!

HENRY: The script calls for a "pan" at this point.

HENRY: I don't see why my artistic advice is being constantly rejected.

HENRY TO ANDY: The bad children are smoking pot again.

ANDY: It's like Flash Gordon flying into space.

JOHN: I don't think anything has happened in the last hundred feet.

GERARD: Jonas, how long is this interview supposed to be?

JONAS: As much as you have.

ANDY: An 8-hour hard on!

At about 3 A.M., the six observers came down again, having finished their night of filming, eating, drinking, talking and toking.

They called their project *Empire,* signaling its vast ambitions, and it was about as unpandering as any work of art could be. It had been conceived to show exactly eight hours—a workingman's shift—of slow-motion footage of the Empire State Building, as the sun went down and its lights came on and just about nothing else happened. Compared to this new film, *Sleep* seemed like a Hollywood thriller. (There's a story that *Empire* so exhausted New York's movie censors, who had to watch it in shifts, that they gave a free pass to all future underground films.)

At least among those in the know, the film was seen as an utter triumph. "I think that Andy Warhol is the most revolutionary of all film-makers working today," opined Mekas a few weeks after helping spawn *Empire*'s revolution. "When the lights [on the building] were turned on, it seemed as though the world had been recreated," said another fan. An art critic felt the film summed up the extreme challenges that lived in even the cheeriest silkscreens of a Pop artist "whose ridiculously simplistic 'works'"–notice the scare quotes—"seem at once a continual taunting of our most tolerant definitions and yet a constant challenge to our sensory awareness." In *Empire,* the critic said, "by repeating a single image beyond normal tolerance, the film escalates the slightest change in [the] scene into a momentous transformation. . . . At the same time that *Empire* is considerably less than an ordinary film, because Warhol has pruned away nearly all the dramatic elements of normal cinema, it also functions as more than a normal film, confronting essential questions about cinematic

character and possibility, as well as instilling visual and durational experiences otherwise unknown in the medium."

Anyone who has had the courage to sit through the whole thing knows he was right.

That didn't stop some viewers from booing and throwing trash at the screen when the film was premiered, which didn't happen until a full seven months later. ("We knew what it was, what it would look like—why see it?" Mekas recalled.)

"Gee, you think they hate it? You think they don't like it?" said Warhol, with either real or feigned bafflement. Foreshadowing most of twenty-first-century art making, Warhol once explained that he was after an art that replaced old-fashioned notions of beauty "or anything like that" with the "just interesting." As one critic wrote, in an essay that Warhol almost certainly read, in the 1960s beauty itself had lost all definition because "standards, ideals, tastes and all the other such concepts can no longer be employed in an authoritarian way to restrict our consciousness." The challenge was to convince others to be as interested in the nonbeautiful as Warhol and a few of his peers were.

---

As his films took him out to the far edge of the avant-garde, Warhol tried out quite another approach in his paintings: How about capitulating to popular taste? Or at least pretending to?

Henry Geldzahler had a part in the surrender. He insisted that he very much liked the mural of *Most Wanted Men* "for the very reasons that Rockefeller had it painted out." But on the very day in May that he and Warhol visited the World's Fair to see the erased version, Geldzahler also prodded his artist friend to move toward imagery in a new, more lighthearted vein. "I said, 'It's enough of disaster; it's time for life again.' And he said, 'What do you mean?' I was at his studio. . . . I picked up a magazine off the floor, I opened it at random to a picture of flowers and I said, 'Like this, for instance.'" Geldzahler's "this" was a splashy, hard-to-miss and completely banal gatefold of hibiscus blossoms which ran under the Pop-y, page-wide headline "It Works!!!!!!!!!!!!!!!!!!!!!!!!"

What was "working" was a new color processor for the home darkroom, as explained in a feature in the latest copy of *Modern Photography*, a low-end magazine for hobbyists. (It probably belonged to Billy Name, who was just then taking on the job of Factory photographer.) The colorful flower photo had been chosen to demonstrate the processor's success, not because anyone had a special belief in the shot's aesthetics. Somehow, that made the photo strike Warhol as the ideal next image for his art. It was, after all, taken from

an article about reproductive technology, which was central to Pop Art's engagement with images of all kinds.

Warhol cropped it down to a square of four exemplary flowers, had his first printing screen made from it by later in June and then went on to turn it into more than 450 paintings. Their colors ran the gamut from garish to Day-Glo and their canvases could be smaller than a record cover or as big as a wall—the screens for printing the biggest ones had to be block-and-tackled up through the Factory window because the elevator was too small to take them.

A curator friend of Warhol's claimed that "the stronger the emotional reaction to the image or the more we are interested in the subject, the more repetitions we are likely to tolerate," and he cited Warhol's Jackies and Marilyns as examples. Warhol's Flowers seem determined to turn their back on precisely the kind of images that matter to us, testing our tolerance for the unemotional and uninteresting repeated ad nauseam.

The Flowers, multiplied to the point of ubiquity, served Warhol as yet another example of the "ordinary" that he had been so keen on when it came to choosing the product boxes for his Stable show, except that the flowers had even less claim on our attention than those. The boxes had, at least, invoked the campy, Pop-y culture of American consumption—the same culture that both Warhol and Dennis Hopper had found striking enough to use for their home décors. Whereas Geldzahler's flower photo was so utterly prosaic and workmanlike that, as a subject for art, it had almost no content or meaning of its own. It was as if Empire had been reshot with a suburban bungalow as its subject. That added quotient of simple dumbness—in the sense both of the idiotic and the mute—made the image all the more compelling to Warhol as the next phase in his art.

Thanks to Warhol's new "pansies" (that's what nongardeners have often said they were), he was able to revisit his 1950s identity as part of the "window-dresser and hair-dresser crowd." In a moment of post-Factory bitterness, Malanga once accused Warhol of having sponged off the floral paintings of Naomi Levine, the bohemienne who had starred as a fleshy Jane in his Tarzan movie. If Malanga was right, and if Levine's paintings were anything like the absurdly girlish flowers she sketched on her letters to Warhol—no trace of her canvases seems to survive—then Warhol's flowers let him inhabit a more feminine aesthetic than he had in a while. You could say that the pansy paintings, often read as poignant and elegiac, were the Death and Disasters in drag, letting Warhol "come out" as his more recherché films had also begun to do.

The Flowers also let Warhol acknowledge the industrial roots of his silkscreen technique as he hadn't quite done before. When he and Malanga bought rolls and rolls of canvas and silkscreened them with hundreds of flowers, the

duo were coming pretty close to the true mass production that Malanga had experienced as a teen in his summer job printing the fabric for neckties.

Warhol had borne witness to the American assembly line as far back as 1959, when he was paid to decorate a surprising window at Bonwit Teller that, instead of offering shoppers the usual choice of goods, seemed to offer them two identical dresses, worn by identical mannequins in identical poses. The window's strange repetition was explained in the cards placed by each dress: Bonwit's was staging a competition between a deluxe, $788 couture frock from France and its mass-produced American knock-off that sold for $45. With America as the obvious winner, the window had made clear, in a surprisingly forthright polemic, that the repetitions of mass culture could rival the one-offs of the high—the same case that the Flowers were making in fine art. Warhol later described the Flowers—*all* the Flowers—as "one big painting that was cut up in small pieces."

More even than when the Stable's boxes were being painted, the Flowers revealed that the Factory was becoming a factory. Although the space is most often remembered for its parties, those didn't happen all that often and only after close of business. During the day, as many Factory regulars have insisted, that fourth-floor loft functioned as a pretty normal studio, fully dedicated to the making of art. "It was called the Factory, not the Party, for a reason," said one of its denizens. Warhol and Malanga would get in every day in the early afternoon and then put in a solid five or six hours of aggressive production, press-ganging any other lads who happened to be hanging around. Meticulous labor was the order of the day: Geldzahler might have directed Warhol to the flower photo in the first place, but an almost absurd amount of work went into adjusting the image he'd found. Warhol cut the flowers out of the magazine page and moved them around into a better composition; he chose the best and most legible of the four stamens and pasted it over other ones that might not read as well on canvas; he played endlessly with color combinations. It was as though, in this one case, he really did care as much about aesthetic results as conceptual premises. Cagean mess had to take a back seat.

Warhol's Flowers were being produced at exactly the moment when flower power was coming to a boutique near you. "Marimekko, Marimekko, how does your garden grow? It blooms with flowers both bold and bright," was the copy on an ad for the Finnish fabric-and-fashion company, newly committed to its famous poppy prints—which as it happened were silkscreened.

"Everything's Coming Up Flowers" was the headline that ran over a newspaper feature that insisted that "the trusty dots, stripes and checks of other years look old hat. The clothes that will give a this-minute look to

wilting summer wardrobes are flower-spattered, young and swinging." Surrounded by his own Flower paintings, Warhol himself proclaimed them "the fashion this year. They look like cheap awnings. They're terrific." Almost all the reviews of the work agreed that he'd achieved something like "pleasant patterns for gift wrappings or fine drapery fabrics," although they rarely meant such descriptions as praise.

Wearing his commercial-artist hat, Warhol had long had a profitable sideline in floral fabric designs, silkscreened in any number of colorways. With his Flower paintings, Warhol took that entire textile culture and transplanted it wholesale into fine art, as Duchamp had done with the culture of plumbing—and as Warhol had done with window display, when he turned his Gunther Jaeckel props into his first stabs at Pop Art. There had already been a textile feel to all the Pop paintings that had repeated the same image across a surface—Warhol himself described one of his Death and Disasters as looking "just like a dress fabric." With the Flowers, he was turning that look into a main effect.

The new series let Warhol double down on a tension that had been in his Pop Art from the beginning: The tension between how his paintings and sculptures worked as high art and the way their subjects clearly belonged deep inside popular culture. Shown in fancy art galleries, his Soup Cans and even his Boxes had pretty clearly fallen on the side of the high; since you couldn't eat his soups and you couldn't open his cartons, they weren't of much use to the man on the street. As Geldzahler liked to point out, the Boxes were unquestionably art because, "being wooden and completely closed, they are useless." But when it came to Warhol's Flowers, the dividing line between high and low was not nearly so clear.

On the one hand, the Flowers cracked a high-art joke about the decorative urge that lay behind the oh-so-serious abstractions of the latest Op and Color Field painters, Warhol's latest crop of rivals. His new series hinted that a gallery full of silkscreened blossoms might not be that different from a show of concentric circles hand-painted by the abstractionist Kenneth Noland, praised to the skies by power critics such as Clement Greenberg and Michael Fried.

"It's as if Warhol got hung up on the cliché that attacks 'modern art' for being like 'wallpaper,' and decided that wallpaper is a pretty good idea, too," wrote one art critic. And indeed, householders with the money to spend really could use those same Warhol Flowers to decorate their houses, just as they used the latest in Marimekko wallpaper or drapes. One of Warhol's dealers actually asked him to paint three extra blossoms "on a black background; in colors other than pink, red or orange" for a collector who needed them "to

make a whole wall." Warhol was truly creating over-the-sofa art, and taking such decoration as his subject as well. There wasn't even a right-way-up with these latest Factory paintings; you could spin them until you found your favorite orientation, the way you might turn a placemat on a table.

The Flowers' full embrace of the low made the new series as genuinely palatable as Marimekko's yardage, which was half the point. These new "low" paintings, produced in quantity, might just be able to spread deeper into American culture than Warhol's earlier and higher works, and certainly deeper than the esoteric films he was making at the same time.

At the start of '64, one dealer in Pop Art was still insisting that the movement's difficulty guaranteed that it would never have the appeal of Abstract Expressionism: "This is definitely not the kind of art you hang over the sofa," he said. Whereas just twenty months later, a critic could explain that consumers of culture had grown "tired of being educated" by the abstruse rigors of AbEx and were now looking for a new art—a Pop and genuinely popular art—that took the trouble to come meet them where, and how, they lived. That was the demand Warhol had filled with his Flowers. "You go to a museum, and they say this is art—and the little squares are hanging on the wall. But everything is art, and nothing is art. Because I think everything is beautiful," Warhol pronounced around the time he first showed his blossoms. Whether he believed it or not, this was the rhetoric he wanted to toy with.

Yet for all their popular appeal, the Flowers were even more complex, in the very "highest" of Duchampian terms, than anything Warhol had done before. As fine art that also chose to work as pure décor, they stood for an ultimate collapse of high and low. Or, more accurate, it was a case of the "low," still as low as ever, declared by Duchampian fiat to be "high," and worthy of display in an art gallery. When, at almost the last minute, Warhol chose to paint those forty-two very somber Jackies to add to his first Flowers show, they hinted that his blossoms also might not be all fun and games—one ghostly set of white blooms was actually dedicated to the dancer Freddy Herko, who had recently fallen to his death from a window. A leading critic praised Warhol's Flowers as "a powerful threat" dressed up in blandness.

These new paintings came at a time when Warhol could barely afford the screens that it took to print them, so they had one final benefit: They actually sold, maybe almost as well as the latest in '60s fashion, "flower-spattered, young and swinging."

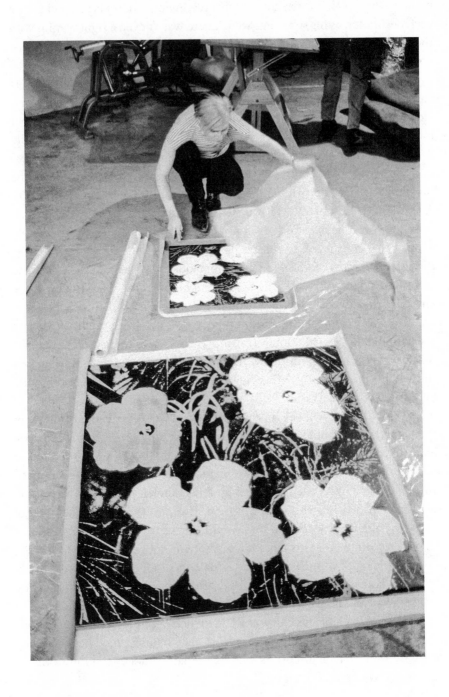

*. . . working on one of his Flowers.*

## 22

# 1964

*"What we are dealing with then is an art that is easy to assimilate—that has no more personal idiom than rock and roll music"*

Dear _____,

    *I'm sorry that I am unable to meet with you personally on this matter but I like to think that we'll both find it easier this way. I plan to sever my association with the gallery at the end of this season, which I believe is in June. I have thought about this decision for quite a while and my final determination does not result from any particular incident but rather from a more general state of things. The Stable gallery is conducted, from what I can tell, with tremendous restraint and decorum which is nothing to complain about except that I expected something different. It's hard to put into words. It has something to do with a state of excitement I think—and my particular state of mind in relation to that. . . .*

    *I hope you will disregard whatever rumors you may hear connected with this matter. Nothing applies except what I have said.*

    *May I thank you and alan for all your kind services and appreciation of my work during my association with you. I hope there will never be any bad feelings between us.*

                          *—affectionately*
                          *or*
                          *—most sincerely*
                          *or*
                          *—cordially*

Thus read a handwritten draft of a letter that Warhol then got typed and addressed to Eleanor Ward, almost exactly a month after the opening of the Boxes show at her gallery. By then it would have been clear that the show was a failure, at least as far as sales were concerned.

The break with Ward doesn't seem that big a surprise. She was never a diplomat at the best of times, and couldn't have hidden her doubts about the worth of Warhol's Boxes or his Disasters—or even of his Marilyns, however well they might have sold. If Warhol was hoping for "a state of excitement" about his work he was looking in the wrong place.

That draft of Warhol's letter shows that he knew a better place to look: It was written by Warhol's friend Ivan Karp, Leo Castelli's right-hand man, on Castelli Gallery letterhead.

Warhol had dreamed of being a Castelli artist at least since he first saw the Johns and Rauschenberg solos, and certainly after Castelli showed Yves Klein's radical all-blue paintings. Warhol was lunching and dining Castelli by early '62, once with Eleanor Ward at the table as well. The two men took some first steps in their mating dance that spring—Castelli actually handled some Warhol sales—but they didn't go further than that.

By showing the Death and Disasters in her Paris gallery in January of '64, Ileana Sonnabend, acting almost as "Castelli Europe," helped bring the two men together again. It's no wonder that Warhol and Castelli were already well along in their negotiations in April, when Ivan Karp was acting all host-like at Eleanor Ward's show of the Boxes, and that by late May Castelli was lending his stationery and gallery director to the Warhol-Ward divorce. In July, a Warhol drawing was already being reproduced in a magazine as "courtesy Leo Castelli"; in August, a critic was writing about rumors of a Warhol-Castelli agreement and in late September inventory was moving from the Factory to Warhol's new gallery. Finally, in late November, the Flowers were hung there as Warhol's first Castelli solo. They had most likely been planned from the start for that venue.

Warhol's attraction to Castelli wasn't because of any favors the new venue would do to his art. The gallery was based in an unexciting haut-bourgeois graystone, with new parquet floors and track lighting, on East Seventy-Seventh Street right off Fifth Avenue. Jim Rosenquist complained that the main room was on the small side—only about twenty-two feet by twenty-four—and did not match the growing scale and ambition of the moment's new paintings and installations.

A lot of Warhol's interest in Castelli must have involved visions of the white Jaguars that Johns had bought thanks to the dealer.

Warhol would have known that Castelli insulated his artists from the foibles of the market by giving them a monthly stipend, as a guaranteed advance on whatever sales the gallery did manage to make. That bit of security must have been especially appealing to Warhol as a working-class child of the Great Depression. Paying the bills—"bringing home the bacon"—was a lifelong worry of Warhol's, however rich and successful he became. It must have been an especially active anxiety as he finished his second year in Pop Art and saw few signs that his income would match what he'd made in illustration. Warhol might truly have been hard up before his Castelli payments kicked in. Just as he was taking up with Castelli, he broke his near silence on a panel to interject the thought that one difference between commercial and fine artists was that "commercial artists are richer." In October, he told a reporter he had no lights to work by because he hadn't paid the Factory's electric bill.

The Castelli stipend seems to have averaged only about $2,000 a month—monthly payments were either $1,500 or $3,000, but occasionally zero—but that already added up to a full third of Warhol's highest-ever income. That meant there was that much less to be made up by Nathan Gluck and his blottings and the occasional—the very occasional—renting out of an underground film.

"My responsibility is mythmaking of myth material," Castelli once said, meaning that he had to spin stories around the artists who spun the stories called art. Dressed in his three-piece banker's suits and speaking any European language a client was likely to use, Castelli's greatest skill was as an Old World rhetorician, convincing others to buy into his vision of what mattered most in art. That was the skill that Warhol would have been most attracted to, especially because it was one skill he lacked.

Like all truly important dealers, the quality and courage of what Castelli showed mattered more to him than how well it sold. As Emile de Antonio put it, "What his enemies say may be true: He loves the power; he loves the money. But he loves the work most and well." Almost a decade into the life of his gallery he was still getting major coverage for "courageously venturing out to the edge of a vision," and that often meant that there was little actual payoff in cash. He was quite willing to harbor a loss leader like a poetry reading by Gerard Malanga or a performance by Joan Jonas—or even some floating silver pillows by Warhol—in the certain knowledge that they would prove the gallery's cultural bona fides.

Savvier than anyone when it came to marketing, Warhol had realized that his best asset would be the "state of excitement" that Castelli, the rhet-

orician, could generate around the myth of Warhol. In the long run, as history would prove—is still proving—that was what really brought home the bacon.

———

Even before Castelli came fully on board, there were signs that Warhol's growing reputation was starting to pay off. The kind of Marilyns that Eleanor Ward had been selling less than two years before for $500 were now being priced by a rival dealer at $5,000. Warhol invoiced something like twice that for a private commission that came in, out of the blue, from the American Republic Insurance Company in Des Moines, Iowa, halfway across the continent. It was the biggest fee he'd ever earned, and for once the client doesn't seem to have had any particular social connection to Warhol. American Republic's founder, Watson Powell Sr., had recently stepped down, and Watson Jr., "a zealous champion of contemporary art," got the unlikely idea that Dad should be honored in the latest Pop style, in a mural for their bold new skyscraper. Warhol was sent a standard boardroom photo of the father to work from, which he then silkscreened onto thirty-two identical canvases.

The choice to screen the image thirty-two times ostensibly reflected the elder Powell's thirty-two years of service to insurance, but there's no way it didn't also rhyme, at least for the Factory crowd, with the number of soup flavors in Warhol's first L.A. show. That rhyme turned the executive into the most interchangeable of American consumer products, maybe with the added idea that people like him only came in one flavor: The American Man or All American became alternate titles used for the portrait. The Watsons had in fact hoped for a grid of bright and varied colors, like the Ethel Scull portrait they'd seen, but Warhol insisted instead on giving them brown ink on tan canvas, perfectly capturing the dullness of Watson Sr., in his original sepia photo. ("It's remarkable how Warhol achieved 32 different expressions," said the son, sticking firm to the most venerable of portrait clichés despite visible evidence to the contrary.) Warhol further revealed how he really felt about both the Midwestern executive and the project by giving the mural portrait a nickname: "Mr. Nobody."

Throughout his Pop career, Warhol was never completely comfortable with the way private commissions brought back to mind how biddable he'd once needed to be as an illustrator. He hadn't left a thriving career in commercial art only to find himself once again working to satisfy clients' whims. Deep down, he always believed in the old-fashioned ideal of the untrammeled, un-sold-out artist. In practice, however, he liked the money that commissions brought in and the way they spread his name.

Warhol's Flowers series opened at the Leo Castelli gallery on November 21, 1964, trumpeted by a garish poster of its four trademark blooms. Castelli hung thirty-six of the canvases on his white walls and kept dozens more in inventory. All the critics recognized the design roots of the paintings, although they differed on what they meant. That writer who described the Flowers as "pleasant patterns for gift wrappings" felt that they were tepid enough for "a staid matron from Westchester." Another writer, who said they were "like printed oilcloth, plastic table-clothes or . . . 'upper wallpaper,'" concluded that they revealed "a mechanical Renaissance man, a genius."

Maybe it was precisely that dual nature, suiting both matrons and mavens, that made the Flowers Warhol's first seriously salable wares. Within two months of the show's opening, more than thirty had sold, priced from $150 to $1,200. Castelli and Karp moved another fifty over the course of the following year, grossing something like $50,000—nearly quadruple what Warhol's first show at the Stable had brought in despite having almost sold out. With their varying sizes, colorways and price points, the Flowers had always had selling as one of their goals. But it was also part of their meaning. They stood for the interchangeable wares of the art market in the same way that Warhol's Soups and Boxes had stood for the interchangeable wares of the supermarket, and that meant that the Flowers came with an equally caustic, satirical edge. They spoofed "the ersatz products of a synthetic civilization," the way other Pop Art was supposed to, but this time the latest art was included among those products. Warhol's faux Marimekkos clearly asked, "How lite can art be and still sell?" By having the courage to ask it they proved they were not lite at all. They turned a sellout into a critique, and that summarizes the trademark, lifelong position that Warhol assumed as he left the art world for the mainstream: If you can't beat 'em, join 'em—and by joining 'em, beat 'em. A year after painting his flowers, Warhol was asked what he thought of the art of Walter Keane, whose doe-eyed girls were the most successful of mass-market paintings: "It has to be good. If it were bad, so many people wouldn't like it." The sheer outrageousness of such a claim, at least in art-world terms, made it an obvious and credible Dada gesture.

The Saturday in late November 1964 that saw Warhol's Flowers going on view ended with a party that gave clues to Warhol's enlarged social scene.

Seven months earlier, the bash that had launched his Boxes had seen New York society slumming its way east to Warhol's Factory; now, the Flowers party saw Warhol himself heading uptown to a big West Side loft, just rented by the blue-blood curator Samuel Adams Green on the top floor of a grand nineteenth-century mansion. Warhol joined "a tidal wave of guests," as *Newsweek* reported, who "frugged in place like a mob of bears back-scratching against the trees of a thick forest." The pad was hip enough—it had fur rugs on the floor and a bar made from four-by-fours—but there's no sign that Factory bohemians had found a welcome there among the crowd of architect and curator types who showed up. (Although a naked man lounging on the furs had been a source "of amusement and contention," according to one partygoer.) There was no sign even of Gerard Malanga.

Moving up to Castelli seems to have involved moving into more public and toney social circles. *Newsweek* quoted Warhol trotting out his standard genesis story about eating nothing but sandwiches and Campbell's Soup. But his social ascension saw him adding a new element to the tale: Now, he said, he'd like to be eating them at the posh Waldorf Towers.

*Newsweek* also added a fresh, high-end character to Warhol's retinue: the twenty-four-year-old socialite and cover model Jane Holzer, dubbed "Baby Jane" by the fashion press. "With her mane of blond hair, her hyperthyroid drive and buckshot hedonism," said *Newsweek,* she represented "the pants-wearing young set who feed on the hybrid world of pop, flick and hip." The same article described Warhol, now in black jeans and a tie-less tuxedo jacket, partying with the fashion crowd in Holzer's twelve-room Park Avenue home. (She had a trust fund; her husband was big in New York real estate.) The occasion was a screening of two close-up Screen Tests of Holzer, looking ultraglamorous except for the toothbrush and chewing gum Warhol had put in her mouth. "It was just like eating a cock, it was incredible, the sexiest thing, because I didn't know what I was doing" recalled Holzer a dozen years later, still stuck in her blonde-bombshell mode. "You've never seen a better piece of film in your life."

Holzer was "really a Jewish princess, but a princess at the top," according to a curator friend of Warhol's, and that made her different from your average socialite. Although functioning deep inside the latest version of New York "society," she was also a bit of an outsider, as Warhol must have appreciated: The anti-Semitism she coped with as a kid in Palm Beach wasn't so far from the taunts of "Hunky" Warhol had heard in Pittsburgh. The prejudice didn't stop once she reached New York, where she was too visibly a "JAP" to get work modeling for some toney magazines. She and Warhol ran into

each other on a New York street just as Holzer was shooting a soon-to-be-famous cover photo for the World's Fair issue of *Show*. "The first thing Andy said was 'Do you wanna be in the movies?' So I said, 'Sure!'" Over the next few months, as Flowers bloomed all over the Factory floor, Warhol cast her in nine separate Screen Tests and in reels for *Kiss* and *Couch*. (Her segments weren't pornographic.) "I started doing films for Andy and I started hanging out at the Factory. Which was amazing. And we just had fun. I mean who doesn't like to be in the movies? It's like, bullshit."

Warhol took care to turn Holzer into a collector as well, sending her to Karp and Castelli. She bought some Flowers, but without ever coming to see them as more than "these very simple beautiful things that made me happy," she recalled. "I never had to think about them. Being that I'm lazy, not thinking was a good thing."

A few weeks after the Flowers show opened, Holzer got a real crack at celebrity. She was the subject of a famous profile by Tom Wolfe, just then perfecting his overheated New Journalism: "Jane Holzer—the sum of it is glamour, of a sort very specific to New York. . . . Here is a single flamboyant girl who sums up everything new and chic in the way of fashion in the Girl of the Year." Wolfe called her "Living Pop Art," and made sure to mention Warhol any number of times in his piece.

Warhol must have been pleased to see his name associated with such a figure, rich and at the crest of the city's tastemakers—a "Girl of the Year" worthy of the kind of sprawling profile he had not gotten. (Yet.) But if he thought he was basking in Holzer's light, it's clear the glory was reflecting in the other direction: She's the one mentioned as being in "Andy Warhol's underground movies," as though that were a new badge of honor. She's shown diving down into his world much more than he's seen waltzing up into hers. "Teen-agers, bohos, camp culturati . . . they have won by default, because, after all, they *do* create styles," wrote Wolfe, who might as well have been speaking of Warhol. "And now the Other Society goes to them for styles, like the decadenti of another age going down to the wharves in Rio to find those raw-vital devils, damn their potent hides . . . doing the tango."

A gossip columnist summed things up more succinctly: "Underground flicks are tops among jet-set kicks these days." He was dishing on that November cover of *Show*, which featured Holzer in weird World's Fair sunglasses—and almost nothing else. The story that sexy cover shot was in aid of? "Underground Movies: How They're Made."

Holzer was useful to Warhol in terms of sheer PR. His experimental films would never have gotten as much play, at least in the nonart press, if

they hadn't been hitched to her wagon, as Billy Name once acknowledged. (By early '65, a columnist was already devoting an entire piece to how fed up he was with Holzer's overexposure—and with Warhol's, he added.) But aside from her PR value, Holzer was also genuinely important to Warhol as an artistic subject—as the latest pop-culture object for him to observe, established as such by the giant play Wolfe and *Show* had given her. Warhol's interest in this spectacle of Holzer, and his desire to see it in his films, wasn't that far from his interest in the giant Coke bottle he kept in his house or the songs he played by Johnny Tillotson—although this particular pop phenom did come with the added advantage of living the high life on Park Avenue.

Warhol's lifelong fascination with high(-ish) society always had a touch of distance to it. It seems to have been more about ogling than about true admiration—the kind of true admiration he had for Cage or Johns or de Antonio. He added high-class people to his social world the way he added gaudy gems or even quaint cookie jars to his horde of goods; it was nothing like the way he acquired the latest and most important and challenging art, which was something he never stopped doing and never quite admitted to.

In the summer of '64, Warhol had cast Holzer, and her moneyed world, in a weirdly Pop-y film called *Soap Opera*, a.k.a. *Wee Love of Life*, a.k.a. *The Lester Persky Story*, which is one of the Factory's least known but most wonderful creations. It was made by intercutting eight television commercials from the 1950s—real ones, produced and then supplied to Warhol by his friend Lester Persky—with nine reels of silent footage. Some of the new footage was of nameless hipsters gyrating and touching themselves, but a lot of it starred Factory regulars such as Holzer and Malanga, sometimes in clothes, sometimes not, kissing and arguing and inaudibly carrying on in a vast range of haut-bourgeois settings. "The locations got grander and grander, depending on who we wanted to hustle that week to get into their apartments," remembered Sam Green, the curator who threw the Flowers party for Warhol and was a main player in the new film, which he remembered as primarily "a way of social climbing." In Green's account, "if somebody knew of somebody who had a terrific bathroom or a wonderful living room or a bunch of terraces, we would call them up and say, 'We're here with a bunch of cameras, we're doing this film'—the idea was just to get to see the beautiful places."

Filmed over many months, on forty reels of film (fully thirty-two were never used) it was by far Warhol's most ambitious movie to date. Although it almost never got presented in public, the film is so scratched that it's clear Warhol loved screening it for himself and his friends.

*Soap Opera* took the fundamental elements of American daytime TV— love, sex, fights and consumption, plus frequent telephone calls—and presented them in a great random heap. But for all its virtues, for a moment at least the project seemed in danger. Warhol had made the mistake of describing his *Wee Love of Life* to reporters as "marvelously sordid and lugubrious," and that got the makers of the real soap opera called *Love of Life* worried about possible confusion between the two works. They sent a letter threatening a lawsuit—the first of many triggered by Warhol's art— which must have been what got the title changed to the more generic *Soap Opera*. Warhol could have settled their worries by screening a bit of his film: It is all about avant-garde confusion not the smooth unspooling of plot you get in mainstream TV, although Warhol was willing to claim considerable similarity between the two. As he told one reporter, "I've always believed in television. A television day is like a twenty-four-hour movie"— the length sometimes claimed for his own *Empire*. "The commercials don't really break up the continuity. . . . Critics complain that our movies are slow. Well, each segment of the *Peyton Place* series runs for half an hour and nothing really happens."

The most important clash in the film isn't between a real soap and War- hol's, but between the Factory's underground footage, which had seemed almost random even to its actors, and Lester Persky's slick and (accidentally) camp ads for such things as the "Roto Broilette," the "Morse-Whitney Cordless Electric Miracle Knife" and the "Amazing Beauty Set Shampoo." ("Big news—science has finally captured the secret of taking one single hair-setting and making it last.") It was a fight the underground was bound to lose, reinforcing the quintessentially Pop claim that the ads are what's most worth paying attention to in our culture.

One sage of the early '60s found skillful commercials "bolder and more arresting than anything I have seen in a motion-picture theater over the last ten years," and Warhol pretended, at least, to agree. "You know, I'm really in love with TV commercials," he later told a *Times* reporter. "I think they're among the best things on TV and they should run much longer than they do." In *Soap Opera,* he was careful to keep the same one-to-one ratio of ad to "drama" that was the norm in daytime TV in that era. But if your average American family might turn the sound off during commercials and back

on during the show, Warhol's *Soap Opera* gives us blaring commercials and silent drama.

The celebrated "people's poet" Carl Sandburg had grumbled that "more than half the commercials are filled with inanity, asininity, silliness and cheap trickery." *Soap Opera* took his complaint and recast it as praise. That made *Soap Opera* the only movie Warhol ever made that overlapped so much with what had gone on in his Pop paintings and sculptures. Completed late in '64, it might even be called Pop's Last Gasp.

---

## MAY CO. STORE HANGS POP ART

> CLEVELAND—Pop art in a variety of wild shapes, sizes and colors hangs from wires and provides a colorful eye-catching background for three front center windows of the May Co. here.
>
> Two mannequins in each window wear pop art and mod styles mixing colors and patterns in the dresses to show the pop art influence on clothing.

That was the top of an article that ran in *Women's Wear Daily* early in 1965. It showed how the Pop Art that Warhol had originally created by playing a Duchampian trick on display props had landed back in a window display, this time with no sign of Duchamp.

"Pop Go the Sales on Pop Art Pants"; "Your Looks: Pop Art Make-Up"; "Silk, Fur and Pop Art Find Favor in Pillows"—those are just a few of the dozens of headlines that prove how deeply Pop Art had penetrated American culture by the time Warhol was working on his first truly Pop film. They also explain why it was his only one, and why the Flowers he was working on at the same time were pretty much his last notable Pop paintings. The triumph of Pop Art in the culture at large wasn't the sign of success it might seem; it sealed Pop's doom as serious art.

"The Day Pop Art Died" was the headline that ran over an essay that talked about the murals on the Theaterama building at the World's Fair (minus of course Warhol's censored one). The writer argued that the artworks couldn't hope to compete against the Pop-y garishness of the consumerist spectacle all around them: "Lost in the material world they hope to mirror," she said, the works were fated to "die in tame retreat." But that argument

failed to realize that Pop Art was never meant to be in competition with popular culture any more than Duchamp was in competition with plumbing suppliers. Pop's high-art aims made it a different beast altogether from anything you might find in a store. That was what got lost when pop culture adopted Pop Art, just about killing it off in the process. A supporter of Warhol's was soon writing about the problems caused by "a fantastic absorption by the ad-mass world of an art form originally intended for a sophisticated few." Almost two years to the day after Warhol's World's Fair debacle, *Newsweek* could run a huge feature called "The Story of Pop" that didn't distinguish in any way between popular culture and Pop Art—between real comic books and painted appropriations by Warhol and Lichtenstein. Pop, it mistakenly concluded, was "anything, basically, fun."

Ben Shahn, Warhol's erstwhile idol, had recently inveighed against 1960s artists "who directly or intentionally appeal to the widest possible public . . . ever alert to the lastest trend," saying that it was an approach that only commercial artists could afford to take. It was getting easy, too easy, to imagine that this was Warhol's approach.

For Pop to do important work, as art, it had to have a decent distance from the popular culture it was riffing on. It couldn't be exactly the same as the Pop-y pillows and fridges that were springing up in that culture. In May 1964, when Campbell's sent Warhol free cans of soup to express admiration for his work, it became that much harder for his own painted Soups to keep their original, more caustic meaning. As Warhol had insisted when he first came up with those paintings, "the whole point would be lost with any kind of commercial tie-in." Amazingly, the soup company actually agreed, refusing to buy one of Warhol's Tomato Juice boxes because "if Campbell were to sponsor or display these works in any way . . . it might interject an element of commercialism into the whole program that would detract from their acceptance as works of art." And yet here was Warhol finding that a costume jewelry firm was selling a Campbell's Soup pin for three dollars.

Even Warhol's films, with their more obvious radical edge, weren't immune from being co-opted. They got big play in *Life* magazine as backgrounds for a fashion spread on "Underground Clothes," as worn by the likes of "Way-out Baby Jane." An article on the reels that made up Warhol's *13 Most Beautiful Women* landed in a special Pop-themed newspaper section that included a design feature titled "Camping It Up" and recipes for soup inspired by Warhol's Soup Cans. The section's front page bore a comic-book speech bubble that read, "POP GO THE CLOTHES! What started

with Pop Art, like Andy Warhol's Tomato Soup Cans, has suddenly become Pop living!"

The art world was also starting to blur the border between Pop and pop.

The month before Warhol got to show his Flowers at Castelli, another notable New York dealer put on an exhibition called "The American Supermarket," in which a normal, elegant gallery space was decked out to look like a true grocery store. The show came complete with freezer cases and aisle numbers and a mailed announcement made to look like a supermarket flyer. Jasper Johns's bronze ale cans were presented as so much beer for sale; Tom Wesselmann's image of a turkey did double duty as a sign for the meat department. And of course Warhol, pretty much the event's patron saint, was represented by his Boxes, stacked up like real shipping cartons, as well as by a Campbell's Soup painting shown above cans of real soup that he'd signed by the caseload.

The press had a field day, with coverage in *Life* and the *Times* and even in Britain. In New York the public crowded in. But the overall effect was to make Pop seem like the easiest art that had ever been seen. Barely a year earlier, a curator had defended a show of Pop and other new work by conceding its challenges: "This is pretty difficult art. One can't come in and have a good time. These pictures don't meet you half way." Clearly that sense was fading fast. Within just a few more years, a writer was reminding Warhol of the moment when "the ad agencies started taking from YOU the things you'd originally taken from them—almost as though they'd never seen it before."

Back in early '63, when most people still felt Pop Art was a challenge, an august curator from MoMA had written a famous essay deriding it as work made for, and almost by, the advertising industry. Pop Art, he said, was an art of "abject conformity . . . too easy to assimilate—much too easy." By late '64, his complaints were starting to ring true. In his weekly column, the window dresser Lester Gaba actually seemed rather in a huff that the "American Supermarket" artists were impinging on the displayman's territory. He didn't mind elevating his windows by putting art in them, but that meant that he also didn't want art debased in the gallery by becoming mere display.

One critic defended Warhol by insisting that he escaped those charges of conformity, since his Soup works were so "decidedly hostile" compared to the other Pop Art in "Supermarket." He was right, but the faux-retail setting sure made that hard to make out. The defense mounted by Warhol himself was (of course) more clever and complex than the critic's. He used his apparent complicity with the forces of commerce to bill himself as a true anti-

art radical: A reporter found him standing among the real Campbell's cans in the show, wearing his man-of-the-people uniform of "a crumpled college sweater, blue jeans, sunglasses and an old raincoat" and talking about how "people get more out of these than they do from my painting because the soup tastes so good."

By the following spring, Warhol was announcing that Pop was finished— killed off, it seems, by the Flowers he was plugging when he made the announcement. A few months earlier, the Tremaines, some of his earliest and best collectors, had also declared the movement's demise: "Pop came and went and when that blazing comet veered away we were left with spots in front of our eyes."

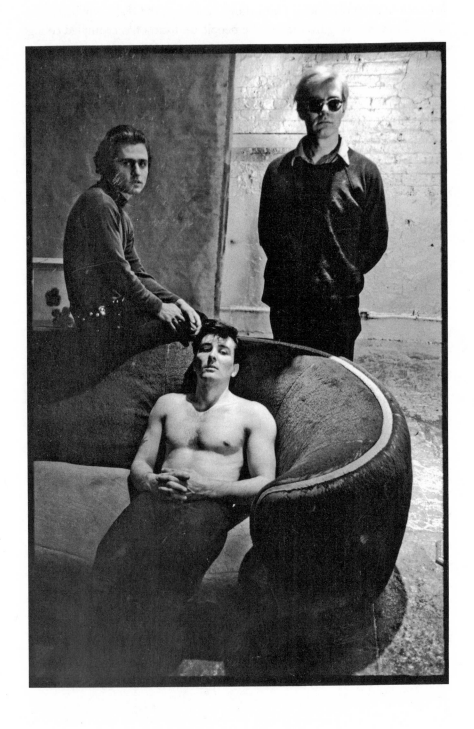

*. . . with his boyfriend Philip Fagan and Gerard Malanga.*

## 23

# 1965

AN ANTI-CHRISTMAS TREE | FILM ACCOLADES |
SPEED FREAKS | HENRY GELDZAHLER SMOKES A CIGAR |
PHILIP FAGAN, FIRST OF THE LIVE-IN LOVERS | 30 FILMS
IN ONE YEAR | MOVIES AND THE DEATH OF PAINTING

*"It seems that perverts today have more creativity, more
visions, more sensitivities . . . than the healthy artists"*

It was just the plainest of blue spruces, without a single ornament—a Christmas tree almost worthy of Charlie Brown. It was also the last notable object that Andy Warhol put before the public in 1964, and for many months that followed.

Warhol had been asked to participate in a charity exhibition at the Hallmark Cards headquarters on Fifth Avenue, where the public would get to admire trees decorated by twenty-two celebrities—or in Warhol's case, not decorated at all. The project was in support of the Children's Aid Society and Hallmark had pitched it to Warhol in the world's most long-winded telegram, explaining that his tree was supposed to "truly represent you, your beliefs, your profession or some special memory or idea suggested by you." So here Warhol was, at last deemed a sufficiently "distinguished person" to take his place among such luminaries as Cecil Beaton, Paul Newman, Helena Rubinstein and Cardinal Francis Spellman, and he chose to represent himself as the Grinch from the Underground. It's hardly surprising that Warhol and his bare tree were somehow left out of the cheery color spread that *Ladies' Home Journal* devoted to the Hallmark event.

In his private life, Warhol tended to make a pretty big deal of Christmas and its gift giving. He could easily have provided Hallmark with the world's fanciest, campiest tree—tinfoiled, maybe, as a Pop update on all the gold and crimson cheer he'd sold to magazines and card makers at Yuletide in the '50s. But at this particular stage in his Pop career, just as he was getting a foothold

in the mainstream, Warhol chose to stand out from the crowd by going grim. When he posed for a PR shot beside his tree, he kept his dark glasses glued to his face, as though his tree were the latest in hipster goods. It did in fact tie into one of the toughest new strands in youth culture: It had political, activist overtones. When it went on display at Hallmark, Warhol's tree came surrounded by oversize gift boxes (shades of his Brillos) which were covered in tough black-and-white photos of the disadvantaged black kids the charity was meant to help. Warhol's unornamented do-gooding actually won him the biggest tree in the show—a seventeen-footer—set up in the gallery's most prominent spot.

As 1965 dawned, Warhol had spent the previous decade and more being read, at least by some, as a gum-chewing elf spreading smiles through the land: His belligerent put-ons could as easily be read as flip jests; his anti-market Flowers could also come off as a Christmas décor at Castelli's. But in the second half of the '60s, that elfin image steadily gave way to Andy Warhol, ruthless King of Cool.

The coronation had come at the tail end of '64, after Jonas Mekas had got *Film Culture,* the magazine he founded, to bestow its annual Independent Film Award on Warhol, now being called the "Cecil B. DeMille of the off-Hollywood movie makers." Honoring *Sleep, Kiss, Haircut, Eat* and *Empire,* the award citation waxed panegyric about their effects:

> The world becomes transposed, intensified, electrified. We see it sharper than before. Not in dramatic, rearranged contexts and meanings, not in the service of something else . . . but as pure as it is in itself: eating as eating, sleeping as sleeping, haircut as haircut. . . . A new way of looking at things and the screen is given through the personal vision of Andy Warhol; a new angle, a new insight—a shift necessitated, no doubt, by the inner changes that are taking place in man. . . . Andy Warhol's cinema is a meditation on the objective world; in a sense, it is a cinema of happiness.

When it came time to actually accept the award, however, Warhol, for all his supposed "happiness," refused to attend the public ceremony and screening that Mekas had planned. Instead, Mekas came to the Factory to do the awarding, bearing a basket of fruit and veggies as the trophy and a Bolex to film its handover.

His footage begins with a sexy Jane Holzer caressing the award issue of *Film Culture,* as though she were spoofing a game show spokesmodel. Then the shot widens to include a small crowd of much tougher, more underground

Factory hands hanging about in front of a huge Flower painting and the famous couch. Warhol passes out produce from the basket—Holzer's banana is absurdly and deliberately phallic, as is Malanga's knubbly cucumber—and we then get to observe the artist and his entourage eating and chatting for the twelve silent minutes of the film.

Although the footage never did get screened on award night, it neverthe-less carried an important message: Warhol's art was, or was soon to be, more than just the works he made; it was also, or maybe mostly, his life and the crowd he chose to share it with. "What Andy is selling, unlike traditional painters, is not art so much as milieu," said one friend of his at the time. "The atmosphere around him is very potent."

It was an atmosphere and a milieu that now came dripping with edge and irony. With Warhol's earlier, more cheery Pop persona, you had to read through it to spot its disdain, which meant you might also miss it. His new persona was up-front in its mockery.

Stan Brakhage, the early pioneer of experimental film, resigned from Mekas's Film-maker's Co-op over Warhol's work, insisting that it represented "forces which I recognize as among the most destructive in the world today: 'dope', self-centred Love, unqualified Hatred, Nihilism, violence to self and society." Brakhage clearly gets the details of his charges wrong—who can find "unqualified" *anything* in Warhol?—but he's right in sensing that some-thing big was afoot.

The December *Newsweek* article had already hinted at the change. Warhol was still mostly a "gleeful" Peter Pan, in the words of the writer, and readers heard him saying "Terrific!" any number of times and got to see him at home with his '50s toys, "old carousel horses, a carnival punching-bag machine, a giant wooden Coke bottle." He was still shown hanging out with the Baby Jane Holzers of this world. But the article also talked about his move into "that new hip world of blurred genders and sharp characters," and ran that description right under a photo of Warhol, the filmmaker, directing a transvestite Jean Harlow as s/he prepared to blow a banana.

———

You could say that Warhol's new scene and persona were not entirely his own creation. In the spring of '64, Billy Name had introduced sparkle into the material life of the Factory. In the summer and fall, he added darkness to its social life.

While Warhol and Malanga silkscreened Flowers at the bright window end of the loft, amid collectors and dealers and other hangers-on from the

mainstream, "there was Billy sort of lurking in the back like this freak," said Jane Holzer. "He was very thin, and very lethal-looking but very gorgeous," remembered a Factory regular who came along a bit later. "And he would be in the back—the back, you know, like the shadow land. Billy was another intense person, viciously intense."

"The back" was the gloom near the bathrooms, and that was also where Name entertained the same circle of gay undergrounders he'd been among when Warhol first met him in Greenwich Village.

The prettiest of them, who went by "Binghamton Birdie," drew explicit gay porn on the silvered toilet stall. There was also Robert Olivo—always known as Ondine, after an Audrey Hepburn role—a sometimes actor whose life, as the "Pope" of Greenwich Village, was a nonstop performance. "Ondine treated Andy as if he were this precious, magical, wonderful thing, and Andy thought Ondine was, like, the most fabulous creature ever from American culture," Name recalled. "We all became pals and would brainstorm together—it would be more like aesthetic-storming."

Freddy Herko, the avant-garde dancer, was another of Name's frequent guests, and also Kenneth Rapp—known as both Rotten Rita and the Mayor—who had a tidy day job working in a fabric showroom alongside Binghamton Birdie. Rotten had a central role in this scene because he was the one who supplied the amphetamines that powered it, giving rise to an alternate name for Billy's friends—"the A-Men." Later, they were sometimes referred to as the Mole People, since their drugs made them need dark glasses. That nickname points to another important fact: They were mostly nocturnal, ruling the Factory after Warhol had gone out or retired to mother and dinner and bed, when the studio became Name's private home and hangout. During the day, when the Factory buckled down to the important business of churning out art, the A-Men might barely be visible.

Name's crowd were a quite separate subculture on the radical fringe of Warhol's scene, "a very tight underground network that was underneath the Factory . . . highly complicated, extremely extreme, bizarre, sometimes brilliant, oftentimes just simply crazy," said Mary Woronov, one of that network's later members. Billy Name himself called this the "drug and criminal element," and admitted to—or maybe took credit for—introducing it into the Factory. Ondine, in particular, was capable of anything: He'd wear garbage bags as clothes, if he felt like it, and any visitor foolish enough to leave their finery behind would find it repurposed by him: "You'd come back, and your cashmere sweater would be a turban or a loincloth. . . . You really had to navigate your way around Ondine. He didn't suffer fools gladly. He could be vicious and cutting," said one of the younger navigators. Woronov

explained that people weren't afraid of Ondine because he was particularly strong or physical, but because his emotions went completely unchecked, "so when he was angry at you it was like suddenly all the walls fell away and there was absolutely no limit to the destruction that he was capable of." When Ondine had first met Warhol a few years before, the artist hadn't measured up to his extremist standards. It was at an orgy, and Ondine got Warhol kicked out because the artist wanted to watch rather than do: "This orgy was run by a friend of mine, and, so, I said to this person, 'Would you please mind throwing that *thing* out of here?' And that thing was thrown out of there."

Billy's imprimatur must have made Ondine change his mind, since he became a Factory regular, appearing in more Warhol films than anyone else—including in a few very early porn reels—and even starring in a tape-recorded novel that Warhol eventually published in 1968, just as the Factory closed up shop.

Freddy Herko's star shone even brighter than Ondine's, but even more briefly. He was considered one of the highlights of the Judson Church scene, pushing hard to rewrite the rules of dance and ballet. He might have had too much help from amphetamines. He took to injecting speed and then mixing its high with LSD. In his last weeks, he was filthy and almost homeless, parading down East Village streets in ballet shoes and a black cape with a set of panpipes at his lips. One October afternoon in 1964 at the home of his friend Johnny Dodd—a fellow star from Warhol's earliest films—he took a bubble bath, danced naked for some twenty minutes and, making a grand finale, stepped out the fifth-story window as Mozart's grand *Coronation Mass* wafted out after him.

Stories have always circulated that Warhol said he was sorry not to have been there to film the fall. If that's true, it may tell us as much about his desire to shock an unshockable underground as about his cold-fish voyeurism. Within a few weeks of the suicide, he had dedicated that white Flower painting to Herko.

Although Billy Name admitted to having introduced his A-Men into the Factory, he also pointed out that they were not at all your normal druggy trash: "They were really like all of these artistic, intellectual people who knew really everything about opera, as well as everything about theater, as well as everything about the stage and movies. You know, they were just all brilliant people—we just used methamphetamine for fuel."

Some of the A-Men were also known as the Opera People. If Warhol silkscreened to the sounds of Motown and the British Invasion ("it makes me mindless, and I paint better") the soundtrack to Billy Name's world came care

of Maria Callas and the other prima donnas of opera. Despite his nickname, Rotten Rita was classy enough to have left a poem behind when he and some companions trashed a friend's apartment. (Although the verse was left carved in the door.) In the '80s he had his own opera show on the radio.

Although the Factory's two musics must have met in the middle (and Warhol himself was still a closet opera fan) it's not clear how much cross-over there really was between the studio's two social worlds. As Malanga explained, there were plenty of spans when the only thing going on was the making of art. Even when the A-Men were there, he said, it didn't mean they impinged: "It was a really big space—a group of people could be socializing on the couch, and me and Andy would be working all the way on the other side of the Factory, uninterrupted." Name's two cats, Ruby and Lacy, paraded the space in between.

The A-Men might barely even have noticed the Factory's more mainstream, Jane Holzer types. "I was just there, pretty girl, hanging out having fun," she recalled, noting that she fled the scene once Name's "freaks" and their drugs became a big presence. Name's crew had a more active contempt for Gerard, as the only person at the Factory who took money to be there. He could come off as more straight than not—a skirt chaser, even—and was too devoted to Warhol to seem quite his own man. There was also a difference in cognitive style: One Factory regular contrasted the sparkle of Ondine— "brilliant I mean, just brilliant"—to the more instinctual and less impressive Malanga.

The role of the A-Men in Warhol's life has probably been exaggerated, mostly for the sake of the bohemian patina they lend it. But that patina is precisely what Warhol was after in welcoming them. His relationship with Name's comrades was more about fascination than friendship—Gerard Malanga recalled Warhol as too withdrawn a person to be truly friends with *anyone* in his scene. Name's crowd, that is, would mostly have appealed to the artist as subjects for his art, just as his interest in canned soup had been more artistic than gastronomic: The A-Men appear in any number of Screen Tests and in some of the more extreme of Warhol's movies. Even quite early in the year, Warhol was making absolutely forbidden, deeply underground fare like *Three:* three reels of film in which the threesome of Malanga, Ondine and another A-Man engage in explicit, gymnastic sex in a Factory toilet stall. Before long he was toying with the idea of shooting a close-up film of an ejaculating penis.

Or maybe the art world was on its way to finding such things a touch less forbidden. Early in '65, in Los Angeles, Warhol was in a soft-core group show called the "Arena of Love." Come '66, Warhol was in one that was more

frankly called "Erotic Art," where he showed the sexier scenes from *Couch* as well as the first of his *Bosoms* paintings, in this case a grid of nine glow-in-the-dark breasts he'd silkscreened two years before for an event called "The First International Girlie Exhibit."

As Jonas Mekas concluded, "It seems that perverts today have more creativity, more visions, more sensitivities needed for the creation of beauty, more than the healthy artists."

Even when Warhol was filming an apparently "healthy," more mainstream friend such as Henry Geldzahler, he set him up to seem freakish. The day after the *Empire* shoot, with two leftover reels of film and time still left on the camera's weekend rental, Warhol decided to do a slow-motion "stillie" of the curator at rest on the Factory couch, but one lasting nearly one hundred minutes rather than the normal four of a Screen Test. It was late on a Sunday night and the two friends were alone in the studio, toking up and idly considering dinner, when Warhol set up his movie camera for the portrait. "What shall I do, smoke a cigar?" asked Geldzahler, who was consuming eight or ten of them a day at that point. Warhol answered "Yes, just sit there and smoke," and that, as Geldzahler remembered, exhausted the artist's role as director:

> Andy never looked through the camera's lens, he was elsewhere in the studio, painting and generally keeping busy and out of the way of this midget enterprise, a non-acted, undirected, black-and-white meditation during which, left on my own, I was meant to fall, through time, into some sort of natural and typical gestures and attitudes, thus revealing to the world (or at least to those several dozen who followed Andy's film career through Jonas Mekas's Anthology Film Archive) what my friends had always known—that one basic persona in which I could be found was that of an Infant Emperor, full of self and delusions.

Geldzahler was right about how he comes off in the piece, but it probably had less to do with his essential character than with Warhol's crafty premise. Just the fact of being caught on film for an hour and a half doing nothing more than contemplating himself, as Geldzahler inevitably seems to be doing in the footage, was a guarantee that he'd seem a monstrous egotist. Who wouldn't under those conditions? The vast, plutocratic cigar that he smokes only adds to an impression of self-regard and unending leisure time—of navel-gazing that's not combined with any sign of true introspection. "Do you think he's acting or being himself?" Warhol asked a crowd of watchers one day when the film was screened in the Factory. He answered

his own question: "He's acting. He's playing The Little King"—who was the hero, as it happens, of one of Warhol's early comic strip paintings.

Geldzahler, shown almost motionless on his couch, becomes the flip side of the Factory's ever-moving speed freaks, but no less peculiar than them. On that July night, Warhol cannily transferred the low-end weirdness of his static movies onto the Met's high-end curator.

———

Not too long after the Geldzahler shoot, Warhol began another that was even more intimate, and even more prolonged. Once again it helps dispel the notion—now a cliché—that Warhol was asexual and emotionally remote.

Late in the fall of '64, a twenty-six-year-old named Philip Norman Fagan became the first in a line of lovers to share Warhol's home. Fagan was scary handsome, with the style of a street tough: jeans, tight black T-shirts, a glossy black pompadour and a winged-skull tattoo on his impressive biceps. As a teen in Fort Worth he'd broken motorcycle speed records (hence the flying skull) and he still looked like a biker, and talked like a Texan, once he'd arrived in New York after stints in the navy and merchant marines. A biker-sailor?—Fagan must have come off as the perfect rough trade fantasy, like some kind of forerunner of the Village People, when Warhol met him at a concert in October of '64.

But Warhol might also have recognized Fagan as someone far more interesting and avant-garde than Factory memoirists have since described him: He had studied ballet at Texas Christian University ("the dance belt, the tights, the whole thing" as one fellow Texan recalled) and had gone down to Mexico to study mime with a famously radical filmmaker and performance artist. He had even had his portrait painted by Paul Swan, an ancient gay artist and dancer who had once been called "the Most Beautiful Man in the World" and who was soon to be captured on film by Warhol. Fagan became friendly with the gay authors William Burroughs and Allen Ginsberg and appeared in experimental movies by Jonas Mekas, Marie Menken and Jack Smith. Once he started frequenting the Factory, he made some skilled little films of his own.

One observer described Fagan as shy and soft-spoken but so beautifully masculine (like the "unspoiled American of pre-war films") that he could be photographed in one of Rudi Gernreich's breast-bearing girl's bathing suits "without any appearance of transvestitism." It's not clear if that's fanciful rhetoric or the description of an actual photo.

Fagan became part of Warhol's silkscreening team that wildly busy fall: An article on Warhol's Flowers named Fagan and "the poet Gerard Malanga"

as Warhol's official assistants on the project, and there's footage of all three at work. In a still photo of Warhol and the two younger men, Fagan, in the foreground and shirtless (as he often was) looks like the rocker that Malanga had seemed when Warhol first met him; Malanga, in a beatnik's black turtle-neck, now wears his hair at a poet's length and stands further back looking cool and unfazed; Warhol, posed behind both of his charges, watches them through his shades with the dispassion of a collector at an auction—which is always a faux detachment.

Other photos show Warhol and Fagan together in all sorts of contexts, and those images certainly seem to reveal a real warmth. In December, the two men jointly signed a card bearing one of Warhol's fey butterfly drawings and wishing Henry Geldzahler a "VERRYMERRYFUCKINGCHRISTMAS." They played together in the town house kitchen, where Fagan taught Warhol to bake and had Julia Warhola judge whose cakes were better.

Fagan has often been described as straight: "If Andy Warhol had been a woman, I could have forgotten you," he is supposed to have said to an old (female) flame. More cynically, and cattily, one Factory regular described Fagan as an experienced "twinkie" or "toy-boy," with a habit of settling in with successful gays and then refusing to put out. But whether Fagan and Warhol were sharing semen or not is a moot point, and frankly unknowable; they were clearly functioning as some kind of loving couple.

Warhol shot more reels of Fagan than just about anyone else: 111 three-minute reels of him alone, plus longer reels of footage for three "feature" films, including the Factory's first talkie, *Harlot*, where he appears paired with Malanga. In a couple of Fagan's Screen Tests he comes off as a tease, curling his tongue lasciviously and peeling an erect banana with his teeth.

Beginning in early November, he became Warhol's muse, in a rare case where the term seems both justified and meaningful. He inspired one of the artist's great, unfinished early projects: Daily Screen Tests that document his boyfriend's appearance over the space of ninety-six days. Fagan adopted almost the same pose and expression in each one—no doubt because Warhol told him to—but radical and very deliberate changes in lighting and some-times in hairstyle made him look very different across the series: "callow, dissolute, thuggish, cheerful, sullen, withdrawn, feral, seductive, poorly groomed, intensely handsome" are one expert's readings of his different personas. Rather than buying into the old cliché that portraits capture true character, it seems as though Warhol might have been just as interested in documenting how portraiture can be an artificial manipulation of appear-ances to make them seem character-full.

The poet Ronald Tavel, a Warhol collaborator who seems to have had a

crush on Fagan ("he was less crazy than some of the others") has suggested that the series, which he titled *Aging* or *Six Months,* was meant to show Fagan getting older, or even very slowly dying, as we all do over time. But that too seems more like an absurdist premise than something Warhol could truly have believed his footage would achieve over the space of just a few months. As so often with Warhol, as with lots of his great modernist ancestors, a compelling failure to accomplish an impossible artistic task is as important as the more clear-cut success of a work.

One film scholar suggested another nice motivation for the Fagan project, if it's true that Warhol had planned for it to last half a year: Maybe he hoped for the series to have the talismanic effect of keeping his boyfriend around for that long. Or if Warhol was thinking of the alternative premise and another title that Tavel mentioned—*Philip Dying*—maybe he was predicting getting dumped once again, and the murderous bitterness he knew he'd feel.

There are conflicting stories about how the relationship actually came to an end. Some sources suggest that Warhol kicked Fagan out sometime around February, which makes sense given that the daily shoots only carry through until then. In late January, as the last ones were being shot, Warhol had also made a whole seventy-minute film just of Fagan, during which an off-screen Ron Tavel, playing "a disembodied examiner intent on humiliating the auditioner," quizzed Fagan with all kinds of cruelly probing questions. That suggests that by then Warhol had grown willing to watch his loved one suffer, although in the end it's Fagan who comes off as the victor, simply by ignoring his inquisitor and thereby claiming control of the film.

Tavel said that within a few weeks of the shoot, Warhol was complaining that Fagan disliked almost everyone at the Factory. "I don't think he understands what we're doing here," Warhol is supposed to have said. "I asked him not to come back."

But Malanga has insisted that the end didn't come until March, when Warhol was due in Toronto and had bought train tickets for himself and his boyfriend plus one for Malanga to join as well. A jealous Fagan demanded that Malanga stay behind, or so the story goes, and when Warhol refused, Fagan packed his bags and walked out. He spent the next four years on a "spiritual quest" across Asia—photos show him getting more and more skeletal—and when he returned to New York asked Warhol for a one-way ticket to get home to Texas. Warhol refused at first, but then a mutual friend convinced him to come through. In the thank-you that Fagan wrote from Fort Worth he took at least some of the blame for their original rift: "What I think about mostly, Maestro, is you because I CARE and I know I did a lot of

awful things to you before. Now I know you cared too and it makes me feel even more bad. . . . I'll always be around if you need me, Maestro, because I really do love you a lot." Not long after, Philip Norman Fagan killed himself.

---

"Claes Oldenburg has bought a movie camera. Jim Dine and Rosenquist have bought movie cameras. Rauschenberg has bought a movie camera," Warhol explained to a critic in the spring of 1965. Left unsaid was the fact that he'd bought one first. Just as with the new art of silkscreening, Warhol had got to cinema before all his Pop peers, but this time he was getting credit. In the fall of 1964, Lincoln Center, the newly opened high-culture venue, hosted the third annual New York Film Festival, and it dared to include four of those "way, way, way, way out" films by Warhol that the *Times* critic Vincent Canby was writing about. They were four of the movies that had just won Warhol his Film Culture award, but this time they were more clearly being shown as avant-garde art. Thanks to a new marketing technology guaranteed to "sell your product anywhere," four TV-size projection boxes had been set up in the festival's lobby, where no one could avoid them, and each one looped a segment from one of those Warhol films—*Eat, Sleep, Kiss* and *Haircut*. As an avant-garde cherry on top, a soundtrack got added by the radical composer La Monte Young (Warhol's former bandmate in the Druds) that was nothing more than a one-note drone played endlessly and at earsplitting volume. Much later, Warhol is said to have complained about having been segregated from the festival's other movies, but in fact his special treatment probably increased the visibility and impact of his films as art: The *Times* gave his presence at the festival a headline of its own, talking about the four works as "Pop movies" that represented "modern art in one of its wilder forms."

Warhol had been moving in that direction for a year already. Despite all the work he did in '64 on his *Thirteen Most Wanted Men*, his Boxes, his Jackies and his Flowers, Warhol was at least as committed to churning out films: Something like thirty from that year have been given the honor of titles and many more reels have survived without names, all in a vast range of styles.

Like Warhol's earlier passage from illustration to fine art, his transition from painting to film looks smart, even inevitable, only in hindsight. At the time, it was an unlikely and a quite wild move that must have taken real courage. The odds of forging a glorious and glamorous career in underground film were even longer than in fine art; the idea of making money from it was even more absurd. The expenses involved in moviemaking dwarfed the costs

of Warhol's Pop paintings: Gerard Malanga remembered that the film stock and lab fees for even the most modest project could easily add up to $450; the printing screen and canvas for a quite major silkscreen might have cost one-tenth of that. Meanwhile, any income (let alone profits) from one of Warhol's experimental, frankly off-putting films couldn't possibly match what his paintings brought in. He received a total of $1,672.20 for most of his film rentals in 1965, barely more than the income he got from a single big Flower painting. Warhol called his filmmaking a "frightfully expensive" hobby that brought in no cash to speak of: "All my painting money goes into it."

A number of Warhol's actors went on to complain that they had somehow been shortchanged of rightful income from his films, but there would almost never have been any profits to share with them, or any expectation that there might be when those films were shot. Bibbe Hansen was in several Warhol movies, and she recalled how absolutely nobody in the world of 1960s underground film and performance would have expected to be paid, for what was often no more than a few hours' work that could seem more like play, or like creation. "We felt fortunate to collaborate with Andy," said Hansen. "We lived to serve the work. Just to have access to a theater, a stage or a camera, lights and film"—all funded by Warhol—"that was a gift and allowed us to do our art." Warhol himself claimed that he paid union wages but that his actors were almost never on set long enough for those wages to amount to much.

Warhol never gave up all financial ambitions for his new cinema; throughout his life, he had business ambitions for all his projects, no matter how misplaced those ambitions might have been. In the case of films, those aspirations might have been fed by fond memories of the profits he had made, in nickels and dimes, showing movies in his basement in grade school. They must also have been fed by the shimmering vision (or mirage) of Hollywood fortunes, which hovered out of reach before Warhol's eyes until the day he died. In 1965, he signed an unlikely contract that saw him getting a $5,000 advance, plus 50 percent of any profits, for an anthology of his films ("The Cinema of Andy Warhol") that was supposed to be assembled and distributed by the hotshot journalist George Plimpton. It's hardly a surprise that there's no sign the deal ever bore fruit; five decades later that would be like trying to make $50,000 off a Warhol film compilation—an improbable number even now that the artist is a household name.

———

"Artist Speaks of Leaving Pop Pictures for Films." The *New York Times* covered the Paris launch of Warhol's Flowers, and that was the paper's most important takeaway from it. As the opening began to fill with fancy guests,

said the *Times*, "Mr. Warhol began to describe himself as a 'retired artist' and spoke of plans to devote his life to cinema."

His interest in film was about more than just trying out an appealing new medium. It also counted as a final rejection of painting, the medium that had utterly ruled under the Abstract Expressionists and that had dominated for decades or even centuries before that. Even as he was painting his Flowers by the dozen, Warhol was hinting that canvas was losing its clout: "Movies are the most visually exciting art," he'd told the *Times*, "because they're the least static." His comments went on to become clearer and bolder. "I don't believe in painting because I hate objects," he said on camera in a 1966 documentary. "I hate to go to museums and see pictures on the wall because they look so important and they don't really mean anything." That same year, a British reporter quoted Warhol saying, "I hate paintings. And I don't think they should be put on walls. They should be played with. That's why I started making movies."

Other artists had started to incorporate snippets of projection into their work with paint, mounting a quiet resistance to the new media culture by folding it into the world of the Old Masters. Warhol preferred a full-blown surrender to the Dark Side.

Much later, Warhol recalled the moment when he'd first laid down his brush (or silkscreener's squeegee):

REPORTER: Ten years ago people were talking about the end of
    painting.
WARHOL: Well, I did. I always said that back then.
REPORTER: Was that tongue-in-cheek or did you really think that you
    had stopped painting?
WARHOL: I was serious.

His doubts about painting had already surfaced as he moved into Pop in early 1961, when he abandoned the painterly brushwork of his first Coke bottles. They matured in late '62, when he replaced his brushes with a printer's screens. One of his early silkscreened works was an image of Liz Taylor that borrowed (and distorted) the technology of 3-D movies to make Liz completely disappear from the canvas when you put on the custom-made glasses that came with it; instead of helping the art of painting do its time-hallowed job of depicting the world, here Warhol was using his new screening technique to enfeeble it. In 1963, as he worked on his last Death and Disasters and *Sleep,* he actually told that movie's sleeper that he was about to stop painting. The Boxes were one further step in that direction,

since they left behind the gallery wall and its hanging canvases as well as all signs of the handmade. (And, as Warhol discovered from visitors' hands-on behavior at the opening, his Boxes were close to being paintings that could be "played with.")

And then, with the Flowers, Warhol's doubts about painting showed themselves in full bloom: The floral silkscreens played on the suspicion, growing since the beginning of the '60s art boom, that paintings could no longer be much more than art-market wares. Even the most heartfelt of canvases were looking more and more like fancy baubles to decorate collectors' walls—more like "dress fabric," in Warhol's own words, than like Timeless Expressions of the Human Spirit.

By the very last months of the '60s, Warhol was working on an entirely object-free, conceptual "work of art" that consisted of nothing more than arranging a trip to Paris for his art-critic friend Gregory Battcock, and declaring that travel to be the aesthetic object. As Battcock himself had come to believe, "painting was really a waste. . . . It is just a fact: It is dead." Forget AbEx: The last meaningful painters, said Battcock, were Italian Old Masters like Piero della Francesca and Caravaggio.

Battcock—and Warhol, his inspiration—hadn't gone out on that limb all alone. The desire to declare painting D.O.A., or even to be one of its assassins, had a venerable pedigree on the most cutting edge of modern art, where Warhol always wanted to be. Duchamp had made a "last painting" of his own back in 1918, and then later declared—lied, actually—that he'd retired from the art-making game in favor of chess.

The monochromes that popped up on the far frontiers of 1950s culture, thanks to Warhol idols Rauschenberg and Yves Klein but also to the AbEx-er Ad Reinhardt, had also been seen as bringing painting to its end point—as, for that matter, had the "anti-art" appropriations of Pop itself in the early 1960s.

So by 1965, Warhol's own "retirement" from painting and turn to film wasn't just the weird caprice of an artist known for his eccentricity. It put him in the very vanguard of that moment's most serious thought about art—really at the tip of its spear. The year of his announcement, he was listed as a participant in several evenings staged by the uncompromising artists of the Fluxus group, who had about as much use for the "dead art" of painting as they had for a buggy whip. On one of those Fluxus nights, Warhol showed his latest film.

If Warhol needed final confirmation that painting was ripe for assassination he got it, in vivid terms, from a couple of the most intransigent members of New York's underground. One day in the fall of '64, the Factory

received a visit from Warhol's old friend Ray Johnson, always out there on the edge, accompanied by a woman named Dorothy Podber, "just about the wildest, way-out, wackiest, extraordinary creature that ever walked the earth," according to a member of their wild crowd. Podber was famous for her oversize pets, including an ocelot, and for the candy bowl she kept filled with speed. "She was a marvellous, evil woman. You didn't accept candy from Dorothy," recalled an acquaintance. She and Johnson, both close friends of Billy Name's, were known for visiting people and "doing things that were unbelievable," all under the banner of Johnson's art.

The day they showed up to do their latest "thing" at the Factory, Podber was dressed all in black, wearing black gloves that held the leash of a Great Dane named Yvonne, as Name remembered:

> She walked in and said, "Hi Billy," and I said "Hi." We were work-ing on something—Andy was working on silkscreening. But she had a little purse, and she took her gloves off and opened the purse, and took a pistol out, saw a stack of Marilyns leaning against the wall, shot it right between the eyes in the forehead, and then put the gun away and put her gloves back on and left.

Johnson had an old-fashioned, Romantic, un-Warholian disdain for the art market and everything it touched, and he'd already raged when Warhol had offered him money for art ideas. When he and Podber attacked War-hol's latest, market-driven, derivative objects—the Marilyn canvases that got shot were newly commissioned remakes of Warhol's first ones—Johnson was expressing his murderous contempt for what painting had become. The thing is, Warhol pretty much agreed with him. He'd started to fill orders for enlarged repeats of his greatest hits: those Marilyns that got shot, but also Jackies and even a bunch of new, bigger Tomato Soups, first commissioned (for $2,000) by the Campbell company itself as a present to its boss but then offered for sale to all and sundry, in various colors. And even as he was mak-ing such retreads, Warhol took to demeaning them as "dead paintings." He did a sloppy patch job on the bullet holes in the four victimized Marilyns, but when a collector friend later suggested getting the one he owned more fully restored, Warhol said he preferred it with its damage—"like it's a blemish, like it's a pimple," he said.

In the second half of the '60s, Warhol's canvases were almost all rehash-ings of his earlier works—Pop Art zombies that collectors couldn't tell from the real thing. They came close to turning his art into a pure, tradable com-modity, making Andy Warhol Enterprises something like a firm dedicated to

producing soup in bigger tins rather than in new flavors, with zero interest in fresh ideas about food. The user-friendly Flowers had already given a hint of this, except that their easy appeal camouflaged a serious conceptual undercurrent. As Warhol's sales and popularity grew, his challenge was to figure out how to keep that current flowing. He decided that film was the answer.

---

Warhol's move to film wasn't careerist and it wasn't mercenary. It was about his deep belief in the classic avant-garde mandate to Make It New, hammered into him by the modernists at Carnegie Tech. Even once he'd discovered filmmaking, he was always eager to move beyond his latest effort. *Empire,* one of his first filmic triumphs, also led him to leave its success behind: While that movie was silent, the Auricon camera rented to permit its half-hour takes was, as it happened, also designed to record sound right on the film. It ushered in a new age of Factory talkies.

Warhol first encountered the Auricon's capacities when Mekas used it for a movie called *The Brig,* which captured the raucous action in an Off-Broadway play set in a military prison: "He was very impressed with the possibilities of sound and how cheap, how simple, that was," Mekas remembered.

By Christmas, Warhol had finally bought an Auricon of his own, for the truly vast sum of $2,600—as much as he'd spent on anything but his house. He got to use the camera almost at once, this time to shoot his pre-Pop friend Emile de Antonio, who until then had always resisted Warhol's offers to work together.

De Antonio remembered changing his mind:

> One night I was very drunk in a restaurant that was fairly well known and he was at another table. I said, "Andy, I'll make a film with you."
>
> He said, "Oh, Deee, what will it be?"
>
> I said, "I'll drink a quart of whiskey in twenty minutes. Marine Corps sergeants have been known to die doing that and I am willing to risk my ass for you."

Warhol took de Antonio up on his offer, posing his friend on a landing of the Factory's unheated stairwell and setting up his new sound camera and floodlights one flight higher up. In still photos of the filming that survive, Warhol seems almost predatory as he shoots down at his friend and mentor. That sense of predation increases in the terrifying footage itself,

which Warhol titled *Drink,* to go with the verbs in his previous *Sleep* and *Eat.* We get to spend an hour watching de Antonio drink himself from sobriety, which lasts through far more shots of booze than most sergeants could manage, to incoherent mumbling: "A tiny Pope. Tiny Leo Castelli. A well-known Pope who scratches his balls every time he talks to you. It's sort of a sin to scratch your balls when you're the Pope. Why are you the Pope, Leo? There were many Leos who were Popes. The Leo I like best was Leo the Tenth." He moves on to full-on singing and ranting and finally, after a second bottle of booze, to drop-dead drunkenness—with the emphasis distinctly on "dead." And all the while we know that Warhol had to be behind the camera watching that dicey performance.

The final stills from that night show Malanga and another assistant hoisting de Antonio out of the staircase and over to the Factory sofa, where his worried wife and a friend are waiting. In the last shot in the series, de Antonio has opened his eyes, with a smile.

His good mood didn't last: "I get up in the morning with a terrible hangover, but lucid, I hope, as usual. I call my lawyer at once and say, 'Call Andy, tell him that if his film is ever shown, that it's his ass—we're going to sue him for a million dollars.'"

*Drink* was not screened for years.

It also had few real successors among Warhol's works.

As Warhol graduated from his silent Bolex to his sound Auricon, it looks as though he also decided to move on from the four-square observation that had ruled almost all his first movies. He now wanted planned dialogue for his films' soundtracks and figured that he'd need a wordsmith to help him get it. Ron Tavel was the helper Warhol chose, not because of his skill as a writer, apparently, but just because of the sheer number of words he turned out, on a weekly basis, for his readings at Le Metro coffee house in the East Village, where Malanga was a fellow reader. Tavel read with a bizarre, high-pitched voice "like the Serpent surely had in the Garden of Eden," he said, and it had garnered him a reputation among other poets.

One Wednesday night in November of '64, Malanga took Warhol to hear Tavel, and the Pop artist decided right off that he'd found the Factory's new word man, as Tavel remembered: "It was so Hollywood. He sent up a card that read 'Come to my table.' And there he was, sitting with his entourage. Andy asked, 'Wanna make movies?' I replied, 'Doin' what?' He answered, 'Reading.'" Tavel could read from the phone book, if he wanted, said Warhol: "I know you'll make it interesting—but try not to."

When Warhol first decided to have dialogue in his films he came up with the original and very Warholian idea that the words should come from

off camera and maybe have little or nothing to do with the image. "It was human sound itself that interested him at the moment," said Tavel, "rather than anything actually said."

By the middle of December, the two men were working on *Harlot*, filmed one evening in front of an ornate Factory couch. (Not the Art Deco one made famous in *Kiss*.) Surrounded by reporters and photographers invited to record the moment, Warhol pointed his new Auricon at the transvestite Mario Montez, who played a banana-eating Jean Harlow, and at Malanga and some other Factory denizens who hovered nearby and did just about nothing except proffer fruit to the star. Off camera, Billy Name, Tavel and another local poet gathered around the Auricon's microphone, offering boozy reflections on the action around Montez. (They'd secretly cut a slit in the curtain that Warhol had placed to keep them from watching the shoot.) The trio also pronounced on just about anything else that came to mind, from the hair on Name's nipples, which a lecherous Tavel had just fondled, to the recent death of Edith Sitwell, whose near-nonsense verse had been the soundtrack to Warhol's first months in New York.

Coherent conversation came mixed with long stretches of babble:

VOICE 1: Star is rats backward.
VOICE 2: Fiddles are made of cats' guts.
VOICE 1: Stars' guts backwards.
VOICE 3: No, the first is on the cat's guts. The second fiddle. What is
    that made out of?

For all their weirdness, *Sleep* and *Empire* seem almost rationalist compared to the absurdist flights of *Harlot*, which carried over even into its first screening at a Fluxus soiree, on a tiny, wrinkled bedsheet in a scruffy basement café that didn't even have a projector with sound.

Tavel was taken with his first Warhol collaboration: "In beautiful black and white, an epic of patience taking patience to watch, it is two reels of dividending thoughtfulness." A critic from *Life* magazine was less forbearing, describing *Harlot* as a barely droll joke with "the fleeting charm of a bright saying lisped by someone else's child." But since the critic's condemnation included all of Pop Art as well as such proven avant-garde treasures as Jack Smith's *Flaming Creatures*, Warhol must have been more pleased than annoyed at the coverage, which anyway filled a full page in the issue. After that "success," Warhol went on to ask Tavel to provide similar verbosity, and sometimes actual scripts, for more than a dozen other films shot over the next year or so.

Moving "up" to talkies could very well have signaled a new professional moment in Warhol's filmmaking: *Harlot* even merited a sound technician of sorts, and in fact a movie producer soon approached Warhol to do design work on a major film. But if anything Warhol was moving away from the values of the major studios and toward what his own ads modestly called "nonstatic" films. These had a casual, un-Hollywood wackiness that outdid (or underdid) even his first nonefforts on *Tarzan*. Warhol came to the very clever conclusion that the only way his homegrown operation could compete with Hollywood polish was to never even come close to matching it: "We have to make our movies look the way they do, because if you can make them look better bad, at least they have a *look* to them. But as soon as you try to make a better movie look good without money, you just can't do it."

Warhol's collaborations with Tavel ran from a loose (very loose) adaptation of the novel *A Clockwork Orange* to a chaotic and violent gay Western called *Horse* (the huge animal was brought up in the Factory elevator) to a wild, chance-infused lark called *Space,* with a Factory cast of thousands who did basically whatever they wanted, right down to tearing up the script they'd been handed. Screenplays by Tavel "could be anything from not-nothing to something," said Billy Name, remembering the wild improvisations the texts would spark. "He's such an intellectual wacko, such a skilled wacko, that you can't really say what he's doing because he may even change it while he's doing it."

*. . . in adoration of Edie Sedgwick.*

# 1965

*"Edie was the best, the greatest. She never
understood what I was doing to her"*

"At Tuesday night's dinner and preview at the Metropolitan Museum of Art," wrote the *New York Times,* "Mrs. Johnson appeared in a black faille strapless dress with a matching stole." "Mrs. Johnson" was Lady Bird, First Lady of the United States, and the *Times* report on her Met visit also recorded two unlikely guests the museum had invited to join her: "Andy Warhol, the pop artist [with] Edie Sedgwick, a vision in a lilac jersey jump suit and a furry shoulder purse." Not quite the venue or company you'd imagine for the first media appearance of Warhol and his most famous sidekick.

Mrs. Johnson and friends were previewing a blockbuster called "Three Centuries of American Painting," for which Warhol's friend Henry Geldzahler had organized the section on more recent art, up to and including Jackson Pollock—but only up to and including him. At the April opening, Warhol was there representing the next generation. And Edie Sedgwick represented his next art supply.

Sedgwick was twenty-one going on twenty-two, the deeply troubled scion of an old and "good" New England clan. Her father ended up owning a vast ranch in California, where he ran roughshod over his eight children, beating them and wrecking their psyches. One brother was sent to a mental hospital in Connecticut to be "cured" of his homosexuality. He hanged himself there. Another also died by his own hand, crashing a motorcycle at speed in New York. Sedgwick said she was the victim of incest: "I had lots

of attention from my father physically. He was always trying to sleep with me . . . from the age of about seven on."

During her deeply troubled adolescence, Sedgwick was in and out of institutions, where she got treated for bulimia and all kinds of mad, bad behavior. In her twenties, she got out and spent time in Boston, taking private art classes with a cousin and turning out skilled but outdated, and frankly adolescent, renderings of horses and mice. (A bunch ended up in Warhol's collection, where they were strange bedfellows with his Johnses and Duchamps.) She became part of a fancy, brainy Harvard set who were also hard partiers. In the summer of 1964, after coming into an inheritance that was supposed to have paid $10,000 a month, she moved to New York and began a desultory career as a model.

"She was charming. She suggested springtime and freshness," said Diana Vreeland, newly in charge of *Vogue* at the time. "But if you're an honest-to-God model, you go to the gym before you come to work; you have one boyfriend who buys you dinner. You go to bed good and early. No nonsense. You'd never see one in a nightclub. That wasn't Edie."

Warhol said he first met Sedgwick around midwinter, when she and her Harvardians showed up at a party in the midtown penthouse of Lester Persky, the man who had supplied the commercials for the Factory's *Soap Opera*.

"It was at my house, at this marble table, that I brought the two—Andy and Edie—together," said Persky. "Andy, as I recall, sucked in his breath and did the usual pop-eye thing and said, 'Oh, she's bee-you-ti-ful' . . . He was very impressed.'"

Warhol watched Sedgwick dance "a sort of balletlike rock 'n' roll" that she'd perfected for an underwater Bach-and-Rock disco that was being planned by her Harvard friends. ("Manqué people," Persky called them.) Because of that—or more likely, despite it—Warhol invited them all down to the Factory the next day, and she and Warhol went on to see each other now and then; he visited her in the hospital after one of her car crashes. "She was in a cast from her feet up to her neck; all of her ribs were broken," said a curator friend of Warhol's. "The doctors told Edie that she'd never be able to walk again. Her face was covered with scars, which was why she developed that heavy, strange make-up: those heavy eyebrows, they were to cover up scars across her forehead." Once Sedgwick could indeed walk again—her recovery seemed close to miraculous; she was seen dancing in a cast—Warhol couldn't resist putting her in front of his camera, shooting a series of Screen Tests that capture her astounding, ethereal but also quite peculiar beauty: Her eyes were Prince Planet big and when she smiled a dimple

in one cheek animated her entire face. "You just fell in love with her. No matter what—if you were straight or gay or what. No matter, you just fell in love with her," said one Factory regular. Another described her as a "fabulous person who glowed from within and radiated light . . . one of those beautiful and rare creatures."

She also had a deep fragility that couldn't be hidden. In one of Warhol's three-minute reels, her eyes well up, presumably from trying not to blink, but it's impossible not to read those tears as hard-earned and deep-seated. "She had a low, husky voice that always sounded like she'd been crying," said one onlooker. Often, she had been: "She was so beautiful and so helpless and so rich and so bananas," recalled her friend Danny Fields. Sedgwick combined the quirky, upper-crust verve of Katharine Hepburn in *Bringing Up Baby* with the wounded-bird appeal of the Laura character in *The Glass Menagerie*.

For a while, Sedgwick lived in her grandmother's fancy apartment on Park Avenue, driving the staff mad with her wild hours and unannounced guests. Her spending was out of control. She ran up huge accounts with limousine companies while giving their drivers vast tips in cash. She had caviar delivered when she was at home and when she was out she frequented the best and most fashionable restaurants, paying the way for friends and hangers-on of all kinds. "I just felt like we were redistributing the wealth," said Fields.

The musician John Cale, who entered the scene only in early 1966, as Sedgwick was passing out of it, still remembered days at the Factory filled with nothing more nourishing than milkshakes and junk food, and then dinner for everyone on Sedgwick's tab at her favorite restaurant, "and, WOW, steaks, hamburgers, dessert. Everybody would order a dessert which nobody would eat, except Edie. She would eat everybody's dessert. Thin as a rail, but she would eat like a horse."

When Sedgwick moved out on her own she decorated her little apartment with a stuffed rhinoceros named Wallow and other eccentric fancy goods. "Edie had the aura that she had because she had a kind of clout—she didn't have money, she had the illusion of having money," Malanga remembered. Despite her bohemian charms she was truly in the Social Register, in the days when that was more than a metaphor for class status.

Less than a year after getting her inheritance it was already running out, and her father put her on a meager (for her) allowance of $500 a month. "She complained about money, said she wasn't living too well. Meanwhile we were drinking Chateau Margaux," said a photographer in her crowd. She was also taking every kind of drug, from the barbiturates her doctors had started her on as a teen to the acid her Harvard friends kept in the fridge; she got

regular shots of speed-laced "vitamins" from an obliging Doctor Feelgood in New York.

Social status, wealth, eccentricity, drug abuse: It's no wonder Warhol took Sedgwick on as the latest subject for his art—she was the perfect cross between Jane Holzer and the A-Men. Any film he put her in basically wrote itself.

"Edie was incredible on camera—just the way she moved" was the official Warholian take on the Factory's new star. "She was all energy—she didn't know what to do with it when it came to living her life, but it was wonderful to film. The great stars are the ones who are doing something you can watch every second, even if it's just a movement inside their eye."

Sedgwick's first appearance in a major Warhol film came in mid-April, when he was shooting Ron Tavel's version of a torture episode from Anthony Burgess's *A Clockwork Orange,* which Warhol hadn't had the funds to option. "The thing is, if we used the name *Clockwork Orange* we would have been sued," recalled Malanga, who had come up with the idea for the adaptation. "We were going to call it *Leather*"—after all the bondage gear on display—"and then Andy didn't like it. He said, 'So let's call it *Vinyl,* because it's more plastic-sounding.'"

Malanga starred as the script's juvenile delinquent; his main job was to be drugged and tortured by the forces of order, played by some of the Factory's more ominous denizens. Sedgwick had no role at all, at least in the film as written, until Warhol decided to give her one at the last minute.

"I was pissed off because there was no part for a girl in the movie," Malanga recalled. "I said 'Why do you want to put a girl in it for?' But Andy wanted her in. Andy had his way. He said, 'Oh, she won't talk. She won't get in the way. We'll stick her in for decoration.'" And that's pretty much what Warhol did, sitting Sedgwick, her brown bouffant newly streaked with silver, on a silver steamer trunk and telling her to watch the action as a silent observer—in which role, as a kind of stand-in for Warhol, she managed to steal the show. Malanga and her other castmates recognized her surprising charisma as soon as the film came back from the lab.

It was enough to guarantee her a new star vehicle, conceived just for her and begun within days under the very appropriate name of *Poor Little Rich Girl.* Across two thirty-three-minute reels of sound film, Warhol captured Sedgwick at home in a posh flat, just waking up at 4 P.M. Stripping from nightie to bra and panties, she proceeds to get high on pot. Chuck Wein, a Harvard "friend" of hers who helped create the piece, stands off camera, asking questions clearly meant to underline how out of it she really is. It's the first time that we get a strong sense that there's a cruel side to Warhol's

neutral observation, which he launched with his Campbell's Soups and then made razor sharp with his Death and Disasters. When a visitor to the Factory accused Warhol of making "inhuman" films, he answered "No, they're supposed to be just very real. . . . You don't cover anything up. Everything is left in." But he was also scarily, almost inhumanly aware that the reality he set out to document had been partly constructed by him. "Edie was the best, the greatest," he recalled, just after she had left his scene. And then, coolly: "She never understood what I was doing to her."

Geldzahler explained that when it came time for Warhol to shoot Sedgwick, "what he did was help her—from his point of view—to become more Edie-like so that when he got it on camera it would be made available to everybody. . . . He treated her the way directors treat people. If he had to be mean to get the performance out of her, he'd be mean. If he had to be sugary, he'd be sugary. He was involved not so much with people's feelings as with what was going to appear on celluloid." Yet there's also a sense, in *Poor Little Rich Girl*, that Sedgwick comes out on top, since nothing Wein—or Warhol— can do manages to detract from her beauty and charm, even though her damaged mind and psyche have been cruelly revealed. *Poor Little Rich Girl* manages a rare combination of the adorable and the tragic, like watching Thomas the Tank Engine in a train wreck.

Jonas Mekas reviewed the film right after its first screening, saying that it outdid all other attempts at cinema verité and calling it "a piece that is beautiful, sad, unrehearsed, and says about the life of the rich girl today more than ten volumes of books can say." Or as Warhol himself put it, "She has so many problems that they just keep coming out. A new one every minute." Another Sedgwick vehicle called *Kitchen* showed her in such a state of mental confusion, when faced with the demands of a disjointed script, that Norman Mailer said that it was "almost unendurable to watch" but also possibly "the best film made about the twentieth century"—a mirror held up to its deepest dysfunctions.

Rather than making Sedgwick less attractive to Warhol, her charming incapacities turned her into almost mandatory arm candy. "They both were kind of these pale, frail, glamorous people, but Andy had always felt himself to be unattractive and to be with Edie was to *be* Edie for a season," said Geldzahler. Billy Name felt that the arrival of Sedgwick and her posse "sort of broke me and Andy up—because Andy and Edie became a real thing." It's worth noting that, as a "love" interest for Warhol, Sedgwick was about as boyish as any beauty could get.

Sedgwick's arrival couldn't have come at a better time, since Warhol had just suffered a setback in his lifelong quest for recognition. The star

photographer Richard Avedon, that old rival of Warhol's, had guest-edited the entire April issue of *Harper's Bazaar*, whose themes were "what's happening" and "the offbeat side of now." That obviously required constant nods to Pop, but aside from borrowing Warhol's signature photo-booth stylings for the contributors page—without giving credit for the "loan"—Avedon had left him out of the issue. There was full-page coverage of Rauschenberg, Johns, Lichtenstein and Oldenburg, plus Henry Geldzahler—but nothing like that for Warhol. Incredibly, Tom Wolfe's account of New York's new "Pariah Chic" had managed to ignore Warhol and his Factory, full of the chicest pariahs in town, even though it found room for Baby Jane Holzer and other nonpariahs who owed their chic to Warhol—as Wolfe himself had mentioned just a few months earlier. The magazine bookended Wolfe's Warhol-free piece with shots of models in Factory-silver space suits. As the final straw, Warhol's total absence from the magazine's discussion of underground film could only count as a deliberate diss, for all on the scene to see.

Twinning himself with Sedgwick was one way for Warhol to ensure that it wouldn't be easy to ignore him again.

Journalists started to bill the two as inseparable, inveterate partygoers, and that began within days of the *Poor Little Rich Girl* shoot. In a few weeks, the Sonnabend gallery in Paris would be opening a show of the Flowers—meant to piggyback, Warhol said, on the French taste for Impressionism—and for the first time he decided to make the trip, but now with an entourage. He ordered a new passport, which barely arrived in time—it might have been delayed, when, for the first time, the "a" was officially removed from "Warhola." He got Castelli to book flights for himself and Malanga, of course, but also for Sedgwick and Chuck Wein—at a cost of $1,600, as much as the gallery made off even the biggest of the Flowers. Warhol claimed that the four flights were a trade-in for the steamer ticket that Sonnabend had promised him. The dealer herself had asked him to bring along some kind of beauty queen—she must have noticed the extra splash he'd been making with Jane Holzer on his arm—and Sedgwick was chosen to fit the bill. Before meeting Warhol, Sedgwick had barely rated a phrase or two in society and fashion columns, which often cared more about her clothes than her. ("A new girl in town, Edie Sedgwick—a budding sculptor—arrived in leopard-printed velvet pajamas.") As a team, however, Warhol and Sedgwick became more newsworthy than either had been alone. Even their upcoming Paris trip was suddenly worthy of comment in a gossip column.

A few days before they left, Lester Persky borrowed the Factory to throw a grand good-bye for the Paris-bound quartet, modestly calling it the "Fifty Most Beautiful People Party." That auspicious name doesn't seem to have

helped it rate any press coverage at all, even though beautiful people did show up: Tennessee Williams, the newly defected Rudolf Nureyev and, especially, the wildly temperamental Judy Garland. The party gave the first sign, at least since Warhol's failed encounter with Garbo in the '50s, of him seeking out the stars of Hollywood's bygone Golden Age, which became a signature move of his in the 1970s. But there was always at least as much campy, ironic distance in his approach to those screen idols as there was starstruck worship.

Persky and Warhol recalled Garland's presence at the party in an interview they gave a dozen years later:

> WARHOL: It was the biggest fight in the world. Judy Garland and
> Lester Persky fighting! It was so unbelievable.
>
> PERSKY: She kept saying, "Why don't I ever act in one of Tennessee's
> plays?" And I said, "Well, the funny thing is, he doesn't think you
> can act." I said it jokingly, and she never forgave me for that.
>
> She was living at 13 Sutton Place in Miriam Hopkins's red-
> painted doorway house. She was there, and I picked her up, and
> after an hour, I kept saying, "Judy, don't you think we'd better go
> there?" And she said, "No, no, there won't be anyone there." And
> I said, "But I'm the host of this party, I've got to be there." And so
> finally we walked outside the door and I kept raising my hand for
> the taxis and her boyfriend would sort of wave them on. He said,
> "Miss Garland hasn't been in public transportation in 20 years." I
> said, "I'm not suggesting a *bus;* this is a *taxi.*" I said, "Let's walk,
> then!" It was only eight blocks. She phoned the Bronx and got a
> taxi from some beaten-up limousine service that used to work for
> MGM, and we were so late.
>
> WARHOL: But remember she was carried in by about five boys. And
> nobody paid any attention.
>
> PERSKY: It's hard to ignore Judy Garland, I can tell you.
>
> WARHOL: It was really sad.

Another partygoer remembered a "totally wasted" Garland taking the fight to Williams himself. "Fuck you, Tennessee, how dare you say I can't act?" shrieked the tiny actress. "You've gotta write something for me . . . you know damn well I'm very talented."

Jonas Mekas was also there, and his journal entry makes the situation sound almost like a setup, meant to underline the underground's new status at the center of culture: "It was sad to see Montgomery Clift, Judy Garland,

and a few others from the Hollywood crowd, all good people, but sad and lonely at the Factory. They disappeared among the new, underground 'stars' in Andy's loft. They were standing on the side; nobody even wanted to talk to them." Billy Name played bartender, mixing Garland her favorite cocktails (he claimed Factory people did not drink) and also acting as DJ on the newly silvered stereo, putting out a stream of Motown and rock. Nureyev, looking stoned, was inspired to teach Garland to Frug but their performance was studiously ignored by the evening's cool cats. "Everybody refused to recognize her. Simply refused," Ondine recalled. "The whole party was involved with drugs and the new kind of celebrity."

Warhol stood off to one side coolly taking in the "sordid" scene, said one of his guests, while the Factory's scruffy foil and broken mirrors reflected "images of speed freaks twitching through the crowd and a couple of indeterminate sex screwing on the red sofa."

---

"Andy Warhol Causes Fuss in Paris." That was the headline that ran over a big article in the international edition of the *Herald Tribune* in mid-May, a few days after Warhol had appeared at the launch of his show of Flower paintings—dozens and dozens of them, in even more sizes and colors than Castelli had hung. The article was by Warhol's friend John Ashbery, who talked about the crowds of Parisians drawn to the opening and how Warhol and Pop Art were "causing the biggest transatlantic fuss since Oscar Wilde brought culture to Buffalo in the nineties." The admiration was mutual. On the subject of Paris Warhol became "momentarily animated," according to Ashbery, and dropped his laconic pose: "I travelled all around the world, even to Khatmandu, but I never wanted to see Paris. Now I hate to leave. Everything is beautiful and the food is yummy and the French themselves are terrific. They don't care about anything. They're completely indifferent." That trip must have been the origin of Warhol's notable taste for foie gras.

During the ten days between their arrival and the show, Warhol and his crew had been busy conquering the French capital, thanks to a raft of introductions made by Sonnabend and other notables. They had themselves photographed as a foursome in a fur-strewn hotel bed, with Sedgwick in a filmy baby-doll nightgown, Wein bare chested under a biker's leather vest and Malanga caressing them both—and Warhol, of course, fully dressed. (Although in one shot taken in another room, he has on nothing but an unbuttoned shirt while a full-frontal Malanga lies next to him. Around the same time, Malanga sent a note to Julia Warhola that read, "Dear Mrs. Warhol. Andy told me to drop you a line to say that everything is O.K.

I'm watching out after him. Love, Gerard.") One day saw Warhol popping Seconal, a powerful downer, to Malanga's disgust, although another saw Gerard and some friends smoking such a vast "baguette" of hashish that he could barely feel his lips when he showed up at the poetry reading that Sonnabend had arranged for him at her gallery.

When a young rock star named Stash de Rola came across them at the Left Bank's famous Café de Flore, he had no idea who they were but was instantly drawn to the amazing beauty and charisma of Sedgwick, who he was clearly still half in love with fifty years later: "She had an extraordinary charm—a curiosity, an openness." And in Paris, at least, and to his eyes, there were no signs yet of her darker depths.

De Rola also hit it off with Warhol, after a conversation in which they agreed on a radical, Dada reading of the Flowers as childlike and mechanical and basically comic. (Warhol was not yet playing mute, said de Rola, so they could have a real exchange of views.)

"I was a beautiful looking guy so they were happy to have me around," de Rola recalled, and he was indeed one of the first and most extravagant of the '60s dandies, on top of being a real-life prince and also the son of the eminent and strange painter known as Balthus, making him a double aristocrat in Warhol's eyes. He became a fixture of their Paris walkabout. At a party given by a French intellectual who had written on Warhol for Sonnabend, de Rola hypnotized Sedgwick (it's hard to think of a more susceptible subject) and Warhol was left amazed: "Andy said, 'You have to come to New York and do it on film, and I will give you a wall full of Flowers.'" The trip never happened and the Flowers never changed hands.

De Rola was with the quartet once again when an aspiring young photographer asked them to pose for his portfolio at a new and exclusive nightclub, and they showed up with a crowd of white rabbits and guinea pigs as props. (Not a soul who was there remembers quite how or why the pets were acquired.) "Le tout Paris" drifted in off the club's dance floor to visit with them as they posed, including Catherine Deneuve and her sister and also Régine, the chanteuse and impresario who had first come up with the idea of the discotheque. There was an important first appearance in those shots: Sedgwick's black tights, worn with nothing but a sweater on top—the look that went on to define her, showing off "the best dancing legs since Betty Grable," according to one reporter and "doing more for black tights than anyone since Hamlet," according to another.

Sedgwick claimed that her signature outfit was forced on her by poverty, but as far as Warhol was concerned it proved that she was the true inventor of the miniskirt. He was wrong: Miniskirts had broken out a few months

earlier in both Paris and London. Sedgwick was just fashion forward. An old Harvard friend who remet her in Paris was amazed at the transformation of her style from preppy to looking like "a hooker from Mars."

After two weeks in Paris the four Warholians went on to Tangier, where Chuck Wein had spent some time. That town was famous as the delirious home of the beatnik William Burroughs, who Warhol had seen read at a star-studded loft party that took place just before the foursome left for Paris. The Moroccan town was also known for its endless waves of exotic rent boys. But all that left Warhol's traveling companions more impressed than he was: "It smelled all over of piss and shit to me, but they thought it was great, and Chuck I guess was interested in all the drugs there, and so the place was horrible. . . . I couldn't figure out why everyone liked it so much." They stayed for all of four days then moved on to London for another five. The fab foursome went unnoticed by the British press (Warhol's art had barely been shown there) but they did manage to sit for the hotshot photographer David Bailey, who photographed them in just the same rock-group pose he'd already used for a Rolling Stones cover.

After a full three weeks away, Warhol's hip quartet finally left again for New York. Sedgwick passed through customs with no problem. As Warhol and Malanga were marched off for separate screenings, Malanga saw his boss slip a stream of pills from his pocket. Warhol later described them as "a vitamin."

———

Although Ron Tavel wrote any number of scripts for Warhol, the most telling of their joint projects was also the least scripted one. For *Suicide,* filmed in early March 1965, Warhol simply pointed his sound camera at the scarred wrists of a young depressive who told the story of each of his death attempts. You could say that it's a talkie update on the silent Screen Tests, with the goal now of portraying a psyche as well as a face. Or maybe, as Tavel said, it was a moving-picture update on the most harrowing of the Death and Disasters, which showed jumpers frozen in midfall. Most important, it reveals once again that the real subject of all the best Warhol talkies was the edge and eccentricity of his intimates and hangers-on: All Warhol had to do was turn on his camera and record it. He had been wrong to imagine that his new sound movies would need written dialogue; the central job of Tavel's scripts was to bill the Factory's oddballs as stars.

This top billing of underdogs had begun as early as 1963, in Los Angeles, when Naomi Levine had starred as Tarzan's Jane and Warhol described her as "the Queen of Underground Movies." It continued a year later with Jane

Holzer, who Tom Wolfe had declared Girl of the Year—more ironically than not—and who was then supplanted in that pseudorole, in both the Factory and the press, by Edie Sedgwick. Billy Name remembered that Levine was so incensed at being unseated (twice) that she made a scene at the Factory one day when Sedgwick was about to be shot there for *Vogue*:

> She came in and she said, "Fuck this, and fuck all of you. I want you all to know I was the first Girl of the Year"—and she *was* the first girl of the year; she was for a brief time starring in Andy's movies—"I was the first girl!" She started knocking down the sets and I had to go over and grab her and drag her to the hallway door and slap her in the face, like you see in movies! And tell her "Wake up! You aren't the Girl of the Year."

Levine was on to something: Being Warhol's "queen," female or male, meant that you were right there at the heart of his art, as much as Campbell's Soup had once been, or Marilyn or Elvis.

The *New York Times* wrote an entire article on the supplanting of Holzer by Sedgwick. "Edie Pops Up as Newest Superstar" read the headline, giving Sedgwick the royal privilege of going by her first name—like Elizabeth or Victoria—while bestowing on her the new Warholian honorific of superstar, which had top ranking among that era's underground titles.

Warhol didn't coin the term, as has often been claimed. It didn't even originate with Jack Smith, as was the common myth that even Warhol bought into. Early in the twentieth century already, people were talking about the way opera maniacs—Warhol's predecessors—were using "superstar" to describe their favorite singers, and then the word lingered for decades, especially in sports but also in entertainment. The French book of film theory that Warhol owned had called Marilyn a superstar before Warhol ever used the term. If Marilyn just about deserved the title, mostly it was applied to lesser lights by a Hollywood publicity machine addicted to an overwrought, overheated rhetoric. (True stars don't normally need to be supersized.) Warhol was latching on to that hyperbole. Even Holzer and Sedgwick were barely more than one-year wonders—plain old "stars," at best, and barely even that. The other figures in Warhol films, even when they had the eccentric talents of a Taylor Mead or an Ondine, occupied a far corner of the underground that meant that their celebrity could never really have taken off. Some of them barely had talent at all. Their main claim to fame was the fact that Warhol had put them in front of his camera, which counted as enough to earn them the title. He considered them

interchangeable: "If one of our stars doesn't show up, we substitute some-one else." By the spring of '65, he was finally ready to put them on public display, as the latest branded product to tumble off the Factory assembly line: He arranged for a public screening of a (sanitized) print of *Couch*, the year-old film that was one of the first documents of the Factory's collection of oddballs and freaks.

As one art-critic friend of his pointed out, Warhol had thereby added the category of "found person" to the old Dada notion of the found object and the ready-made, meaning that any Warhol superstar had something in com-mon with Duchamp's urinal. Warhol was reveling in the absurdity of the mismatch between who his followers really were and the title he gave them, which was the same absurdity that had let a soup can become high art. It looks as though the first time "superstar" got used in mass-media coverage of Warhol was in a *Newsweek* photo of Mario Montez playing Jean Harlow, a role that was clearly a satire of stardom and our aspirations to it. One observer called Warhol's studio "the new Dream Factory, replacing Hollywood." But its new dreams, like most dreams, were built on delusions.

If there was a tragic side to the Factory, it had its roots in the fact that almost all of its superstars, however inept, took their Dada honorific as real. Warhol might not deserve all the blame he gets for the misery of some of his followers, but he really ought to have recognized the dangers of kindling the human ego: It's a fire that only death can put out once it's lit.

It's not that Warhol passed out superstardom at random to anyone who came along, just to prove that he could. Factory stardom wasn't about, or wasn't only about, showing that the judgments our culture makes about talent and worth are basically arbitrary. (Although Warhol's Pop Art, with its hints of postmodern relativism, had certainly been willing to go there.) Warhol mostly pointed the Auricon's lens at people who really did stand out from the crowd in one way or another—just not in the way that a mainstream audience reared on Hollywood would have recognized or approved of.

As Geldzahler put it, "He always picks people because they have some amazing sort of essential flame . . . personality, and he brings it out for the purposes of the films. And he never takes anybody who has nothing and makes them into something." The Harvard boy Chuck Wein, who gradu-ally displaced Tavel as chief kibitzer on Warhol's film sets, talked about the Factory's new cinema of the "Reel-Real," which meant, he explained, "that the reel is creating the reality. The actors can't be separated from their lives."

Just the fact of being dubbed a superstar could exaggerate whatever camera-ready qualities a Warholian already had. Ondine's caustic edge flourished under the encouragement it got from Warhol's camera. (And

from speed.) Sedgwick became more and more classically, and dangerously, Edie-fied over the course of her contact with Warhol and his press. Her bouffant hair gave way to a pixie cut, a couture wardrobe got replaced by her signature tights-and-shirt look and she shed so much fat that her five-foot-five frame came to bear hardly more than one hundred pounds of flesh. It was almost as though she were deliberately casting herself as the anti–Baby Jane, who had been celebrated for her high-end fashions, big hair and classic sex appeal.

All along, said Geldzahler, Warhol had been directing Sedwick's living performance: "He was really interested in the way she dressed; the way she looked; the way she put on her makeup. She was one of his ego images." Sedgwick's transformation, that summer of '65, must have been about returning the act of identification. Her more and more boyish frame and ever-shorter, ever more silvered hair were about becoming ever more clearly Warholized, so that the press would see her and her creator as one, as in fact it did. Warhol was happy to meet her halfway: His toupee seemed to grow out to match her shorter hair; his T-shirts and jeans tightened until they mimicked her tops and tights; while on camera for a documentary, he clattered about in high-heeled boots and brushed polish on his nails—for the first time, maybe, since he went full swish in college.

Betsey Johnson, the fashion designer and Factory regular, described Sedgwick as "the very beginning of the whole unisex trip." That was partly because Warhol was tripping right there beside her. He once claimed that he was the one copying her silver hair, not vice versa, "because I wanted to look like Edie because I always wanted to be a girl." He even began to mimic a slack-jawed little tic that hit Sedgwick's face when she felt put on the spot. Or was the tic assumed by him first? (Or did they both get it from a shy boyfriend of Warhol's who had displayed it already in his Screen Test?)

Within weeks of returning from their European trip, Warhol and Sedgwick had both adopted a striped sailor shirt as part of their new, ungendered uniform. This Breton look had taken its first Factory bow on the radical dancer and critic Jill Johnston, who wore it in her performance before Warhol's camera, right after the first Factory party in April of '64. (The experimental filmmaker Barbara Rubin assumed sailor stripes the following autumn.) The look appeared again on Malanga in Paris, in shots of the four travelers on their shared bed. A stripy top soon became almost mandatory among Warhol's closest companions: A columnist spotted Warhol wearing one even under formal wear.

Those Breton stripes had deep roots, first in France as the official outfit of Left Bank bohemia and then in the United States as its beatnik echo, with

a detour into biker-gang culture. (Warhol and Malanga silkscreened a still of Marlon Brando from *The Wild One*, which means they knew the famous striped shirt worn by Lee Marvin as Brando's biker rival.)

Once those same stripes moved to the Factory, and especially to Warhol's torso, they evoked a more particular double pedigree. By the 1950s, in the art world, the Breton top had become the trademark of Pablo Picasso, officially the Greatest Living Painter and therefore Warhol's supreme rival: In 1962, Warhol had gone to eight out of nine shows in a Picasso festival, checking off each visit on the festival's list. "I wonder if Picasso has ever heard of us," he asked a reporter, a month or two before he adopted the Spaniard's uniform. It can only have galled him when, in 1966, Picasso won a competition for "greatest living painter" by a landslide and Warhol didn't get a single vote, although the assembled critics and culturati had nominated a total of almost two hundred artists.

But Warhol's striped shirt also pointed to a more recent precedent with just as much cultural cred as Picasso: When Jean-Luc Godard's *Breathless* splashed down in New York in early 1961, sailor stripes were a constant presence in the wardrobe of the boyish, short-haired Jean Seberg—the obvious model for Sedgwick's own look four years later. (Warhol's connection to Seberg dated back to mid-1963, when she was photographed in his firehouse. He once waxed eloquent about how much he had liked Godard, at least until his "commune thing" had made his films "unbelievably corny.")

Pablo Picasso as tomboy: not a bad description of Warhol's new gender-bending artistic persona. It was also age-defying: "Collector's items for the young crowd" was how striped shirts had been described in a fashion spread in one 1964 issue of *The New York Times Magazine,* which Warhol couldn't have missed because it also had a major Pop story with an image of his Soups.

In August of '65, when *Vogue* decided to update the survey of "youthquakers" that it had first published the previous winter, it now felt obliged to add Sedgwick to the tally as well as the hot painters Larry Poons and Frank Stella. Warhol couldn't have felt great to have aged out of such features, but maybe it was enough to see himself there in Sedgwick's coverage: "With the Pop artist Andy Warhol on camera, undergrounds roll out like crêpes."

———

The same month that Sedgwick youthquaked in *Vogue,* Warhol gave her a star turn in an amazing solo film that came to be known as *Outer and Inner Space.* (That title was an insider's nod to *Inner and Outer Space,* a short from 1960 by the animation pioneer Robert Breer—just the kind of downtown avant-gardist that Warhol always wanted to impress, and outdo.) But neither

"solo" nor "film" are quite accurate words for what Warhol came up with for Sedgwick. In fact she appears as her own doppelgänger, addressing an image of herself that appears not on film but on videotape. The editors at *Tape Recording Magazine* had arranged for Warhol to borrow one of the newly invented portable (more-or-less) video recorders, so they could then interview him on what he'd used it for. "We were children of technology," Billy Name recalled. "It was like someone getting us a new pair of shoes." Although one witness said the equipment was so clunky as to be almost unusable, the masterpiece Warhol produced with it turned out to be the first-ever piece of video art, made just weeks before the first one by Nam June Paik, normally billed as video's foremost pioneer. Warhol had always been a closet technophile, keeping up with the latest in camera and stereo gear, but *Outer and Inner Space* counts as the first time he showed techno-friendly art, a major '60s trend he dabbled in for the rest of his life.

Like all really good art based on technology, Warhol's *Space* is much more about what the recorder let him do and say than about the machine itself. The new tech let him push Sedgwick into a televisual hall of mirrors: He shot 16 mm footage of the videotaped image of Sedgwick as it was fed through a TV, and of Sedgwick watching herself as she appeared on that television, and also of Sedgwick alone, without a television in view, doing her Edie act for his Auricon. The finished piece eventually got double projected onto side-by-side movie screens, with video and film imagery bouncing between them, so that Warhol's wildly Sedgwick-centered piece captured narcissism to the third power. It also provided a realist artist's accurate vision of her deeply fractured being, which made the piece as a whole stand for the fracturing that the boob tube was producing in everyone. If this new medium was the message then the message was sure to be splintered.

In his interview for *Tape Recording,* Warhol raved about how the new machine made him feel like Alice down the rabbit hole. (Lewis Carroll was a hero of the '60s avant-garde and Warhol always liked to cite him.) "It's so scary," said Warhol. "The tape machine is so easy to use. Anyone can do it. . . . I believe in television. It's going to take over from movies." He talked about video as sure to be the top new medium for spying on people and for homemade porn (accurate predictions, both), but of course he himself preferred to use it for art.

When the issue of *Tape Recording* came out in the fall of '65, its front cover was a close-up of Warhol in a striped shirt. The lead photo in the cover story showed Sedgwick sandwiched between Warhol himself and Warhol in a silkscreened self-portrait; she was styled so you could barely tell her from either one. It's clear that as far as the magazine was concerned, the art

Warhol made, and the subjects it showed, were just ways of getting a piece of *him*. That had become how his whole world was working. All the Factory superstars, including Sedgwick, didn't just appear on film and in the press as "reel-real" versions of *themselves*. In '60s celebrity culture, they were also functioning as avatars of Warhol, or more accurately, in art-historical terms, as his "attributes": Sedgwick or Ondine stood for Warhol the way a spiked wheel identified Saint Catherine in an Old Master painting, or an ox stood for Saint Luke. Even when the superstars appeared alone, their creator's offstage presence was felt. As they discovered when they moved on from the Factory, his superstars lost a lot of their cultural heft when they stopped being attached to the man who'd made them.

---

ANDY THE BEAUTIFUL, an anthem
*Sung to "America, the Beautiful"*

So beautiful, the treasured camp,
Of Andy Warhol's art.
The Campbell soup and Brillo pads
And things so chic and smart.
His majesty, his Royalty
Have made him our white dove,
The Prince, our King,
Of thee we sing,
Our sacred pop art love.

This was the song sent to Warhol in April of '65, on page five of a flower-covered newsletter called the *Andeeeeee MONTHLY (wee hope) GAZETTE*, produced by the Andy Warhol Fan Club of New York City. By the time Warhol was opening his Paris show he was happily boasting about the five fan clubs he had at home, "three in New York, one in Massachusetts, one in South Carolina. They're called 'Fannies.'" Warhol encouraged them: He mailed signed photos of himself and minor works of his art to their members and invited them around to the Factory. The Beatles and Stones had fan clubs. Warhol was the only fine artist who had one.

That summer of 1965 starts to put flesh on the idea of Warhol as a true pop culture star. Warhol's day began with a call to the new press agent he'd hired, dealing out the slightest scraps of Factory news in the hope that they would turn up in the press. Thanks in part to such efforts, he was becoming someone who was known less for what he'd achieved than for his "well-

knownness," as one '60s thinker defined his era's new idea of celebrity. "He is the subject of intense curiosity and heated discussions," wrote a stringer for the *Village Voice*. "What does he DO, people ask, that gives him such a reputation?"

There were hints of Warhol's celebrity status already in that *Newsweek* article from the end of the previous year. Although it had bits that still read like an art review a lot of it seemed more like a personality profile. For the first time, it suggested that Warhol was worth writing about as a character who happened to be an artist rather than as an artist who happened to be a character, which is how Picasso and Pollock had mostly appeared in the press.

The very idea of the artist-celebrity was so new, and so annoying, that the *Guardian* newspaper, across the ocean in England, felt it worth publishing an entire takedown of the *Newsweek* piece. It closed with a satirical, faux dialogue between a certain "Manly Borhol" and a critic named "Susan Soundbag" who ogles Borhol as she proclaims herself "all turned on to you, baby."

Even *Artforum*, a magazine for the deepest of art insiders, gave Warhol something close to movie-star treatment: The cover for its December 1964 issue featured a grid of six identical photos of Warhol himself, printed with the oversize dot-screen of his *Thirteen Most Wanted Men*—which might seem a normal move for an art magazine except that there was nothing about Warhol's art anywhere inside. Instead, the editors were using his new-found celebrity to sell an article on the straight photos of Dennis Hopper, one of whose shots was the raw material—but nothing more than the raw material—that editors had used for the faux-Warholian cover they'd cooked up, clearly with the idea that Warhol's face would grab readers.

Over the course of 1965, Warhol was mentioned in an article about food, in a piece about a hairdresser and in an article about gum art. An actor adopted "Warhol" as his last name out of sheer admiration for the artist— something that was still going on among pop and rap musicians fifty years later.

Warhol turned up in any number of gossip columns, now pointing to him as plain "Andy Warhol," without the identifier "Pop artist" that had once been needed to clue readers in to who he was. A *New York Times* feature that at first glance seemed to be about the shooting of a Warhol film turned out to be a piece on what toney people wore to appear before his camera. Even when *The Nation* set out to publish a serious article on Warhol as filmmaker it inevitably turned into a description of Factory life.

American papers even thought it worth their while to cover the tem-

pest in a teaspoon that erupted north of the border when Canadian customs agents refused to allow Warhol's Brillo Boxes to come in duty-free, as sculpture, and got the National Gallery of Canada to back up their decision. ("So silly, making a fuss about that" was Warhol's reaction to the coverage.)

In late March, Warhol and Malanga took the overnight train to Toronto for the gallery show that had asked for those Boxes, to display in the first survey of Warhol's Pop to be held anywhere. "A very tedious trip" was how Malanga recalled the ride, because instead of paying for berths Warhol had them sitting upright the whole way in coach. (Ivan Karp was smart enough to join them by plane.) In the two days that Malanga said they were there, Canadian media went wall-to-wall with its coverage. The CBC put Warhol on TV twice, including on a program where he was supposed to eat lunch and talk but in the end barely opened his mouth. The newspapers weighed in as well, siccing columnists and critics on the survey show and complaining when Karp did all the talking for Warhol. One paper even arranged a New York visit by a young Robert Fulford, later one of Canada's most famous journalists, so he could write the world's first really big Warhol feature, now forgotten because of its Canadian roots. The story included plenty of scene-setting detail—the Rolling Stones blaring over the silvered stereo; a silvered column with the complete lyrics to the Miss America theme song taped to it—but it also made room for unusually smart and sympathetic talk about Warhol's art.

It ended with a dialogue that Fulford winkingly offered up as "history's first pop interview":

Mr. Warhol, how did you get into the fine art business?
It was too hard to be in commercial work. This is a lot easier.
Mr. Warhol, to what do you attribute your success?
I attribute my success to my dealer Ivan Karp.
Can you really draw—I mean really?
No.
How much money will you make this year.
I don't know, but not as much as when I was a commercial artist.

Back in the U.S., it was several more months before Warhol finally made that much splash in the press, thanks to a fancy profile that ran under the headline "Superpop, or a Night at the Factory" in the Sunday magazine of the *New York Herald Tribune*. (The piece had originally been commissioned by the conservative *Saturday Evening Post*, but it got cold feet once the writer came back with his story.) The feature opened with a full-page

color photo of Warhol wearing a red-and-white-striped Breton shirt and lying sprawled on the red Factory couch, foiled walls twinkling around him. The text trotted out what we now know as Warhol clichés, because the artist was setting them in stone at that moment: There was his hair, now silver rather than blond and finally outed as an obvious wig; the shy hand-to-lips gesture that would soon be immortalized in his most famous self-portrait-as-a-young-naïf; his shocking talk about wanting to film a suicide. The *Tribune's* feature writer took the best part of a page before even mentioning Warhol's art and even then gave it barely a handful of lines, treating it more like another incidental detail of the Factory scene than like Warhol's reason for being.

By year's end, Warhol had earned such a big place in the public eye that he could appear in a trivia contest in *Newsday,* the newspaper of the Long Island middle class. The contest asked questions such as "What firm is assigned to guard the sealed envelopes containing the names of Academy Award winners?" and "What expression is associated with Fred Flintstone?"—and also, "Who are the three most famous female superstars in the underground movies of Andy Warhol?"

It's no wonder that 1965 was the first year Warhol won an entry in *Who's Who in America*. He got himself listed as three years younger than he really was and for the first time appears in print as the descendant of the grand-sounding "von Warhols."

*. . . in infinite regress.*

# 1965

FACTORY RIVALRIES | NEW ARRIVALS: PAUL MORRISSEY,
BRIGID BERLIN, BIBBE HANSEN | TOO MANY PARTIES |
MY HUSTLER | DANNY WILLIAMS MOVES IN, THEN OUT

*"Love with Andy would have been beautiful if Andy had wanted
to share my experiment & see me, but all he wanted was to
give me meals and have me meet his glamorous friends"*

A viper's nest.
A cock pit.
The court of the Sun King.

These now-standard clichés about the Factory came to life in the summer
of 1965, a month or so after Philip Fagan had taken off in disgust. Warhol had
returned from Paris and seen his new pal Edie Sedgwick finding her place in
his entourage, along with Chuck Wein and her other Harvard friends. They
were there alongside, and in competition with, the underground crowd
who had arrived first. The undergrounders felt they were an aristocracy of
radical culture, thus earning the right to lord it over the less courageous,
collegiate newcomers. The Harvard crew were trained to believe that they
were a nobility of class, breeding and education, thus earning the right to
lord it over—well, just about anyone. Conflict was bound to follow. It was
guaranteed, anyway, simply by the sheer number of people who were
becoming part of the Factory scene and because of how human primates
behave in groups. Billy Name talked about the insane competition that arose
as all the major players tried to influence the Factory's creative direction,
"and if someone was just there and they didn't let what we wanted to go on
proceed, we would find a way to squeeze them out."

An interview with Warhol gives some sense of the dynamic that led to the Factory's overpopulation of egos:

WARHOL: A lot goes on in the studio—it always looks so busy but nothing really is happening. There are usually so many different groups and they just seem to stay in different corners but it always looks so busy, but it really isn't.

INTERVIEWER: Now do most of the people just drop in or do they have some business there?

WARHOL: Usually they just drop in and they have business too. But it always looks very busy.

INTERVIEWER: A lot of people come to you now, don't they, and they ask to be in your films.

WARHOL: Oh yes, lots of people come by and if they're girls they usually take off their coat and walk around and they seem to be auditioning for something.

INTERVIEWER: Do you ever have any idea what they're auditioning for?

WARHOL: No, I never have an idea what they're auditioning for.

INTERVIEWER: But do you discover a lot of talent that way?

WARHOL: Mmmmm, well I think everybody is talented, so they really don't have to audition for me. It's just that it depends who is around, who's in the movie, and we don't go around looking for them.

INTERVIEWER: How do you find your stars?

WARHOL: Well, the stars are just around. Everybody is a star.

It's clear that Warhol thought of himself more as observer than as referee. And why wouldn't he? He hadn't taken any steps to assume the role of father or arbitrator; these people had just showed up in his world and mostly he left them to do as they pleased. He called the young hangers-on "the squirrels," and would rejoice in their absence when he was getting down to making art on the weekend.

"It seemed like a club of some kind," Henry Geldzahler remembered. "It was fun. And there was always a movie being made or being cast, or some kind of activity. Or Andy was making silkscreens in the corner. Or something was going on that was interesting. And it was a place that everybody knew they could go to." But he also remembered the danger he felt of getting swallowed up in an unhealthy dynamic between observer and observees: "Andy's a voyeur and he needs exhibitionists around, which is all right. I mean he's a cameraman; he's a filmmaker; he's an artist. . . . But

he's also kind of a sadist. He's a voyeur-sadist, and he needs exhibitionist-masochists in order to fulfill both halves of his destiny. And it's obvious that an exhibitionist-masochist is not going to last very long."

The Factory "scene"—reporters were soon eager to describe it as that—was built on that many-to-one codependence, which meant that it was a group creation as much as it belonged to Warhol alone. He let it happen just by throwing open his doors, but it was the people who came through them that became the true heart of the Factory.

"He provided people with an opportunity to try something. Where else would we have gone and run into all these people with all that creative energy going on—and all the same kind of blind ambition to have a dazzling future," said John Cale, the avant-garde musician who arrived toward the end of the year. "Everybody knew there was something going on—they didn't know what it was—but they didn't want to be left out, so they made something for themselves to do." According to Jane Holzer, Warhol allowed his studio to be used for poetry readings, for plays—for just about any kind of avant-garde experiment: "He used to let other artists do their thing there." A reporter called the Factory "a community center for eccentrics."

———

One of the enduring surprises about Warhol is that the placid, implacable, reticent persona that he projected to the outside world—"the symbol of the noncommittal, of laissez-faire, of coolness, of passivity," in the words of the experimental filmmaker Jonas Mekas—is in such clear tension with the malicious, loquacious side that some of his intimates saw. Most of the memoirs by Factory regulars sit poised between adoration and loathing. If Warhol could be idolized—"he treated everyone with respect, he never talked down to anyone. And he made everyone feel important. . . . I never heard anyone say 'Thank You' more than Andy," his assistant Pat Hackett wrote soon after his death—he could also be portrayed as both tyrannical and neglectful, like the bad, distracted mother of a big, neurotic family.

Danny Fields described a dynamic built around a communal crush that the whole crowd had on Warhol: "Andy manipulated people so that they would be in love with him. And then he would not let you know whether this was reciprocated. It was very hard to be in love with him. You would certainly not get unadorned affection in return. . . . You would suffer." But his Factory colleague Mary Woronov countered this view, insisting that Warhol "was not this Machiavellian guy who tortured people—or whatever they think he was. He was not like that: He was extremely fatherly."

On balance, that's probably the more common view of the situation, espe-
cially among people whose self-image and career were not too tightly tied
to their Factory years. "In spite of the gossip, I never saw Andy victimize
or torture anybody beyond shooting them in an awkward fashion," said
Woronov. "People victimized themselves in their hurry to be stars."

Taylor Mead felt that if Warhol sinned, it was mostly through omission,
failing to deliver on help that he'd offered: "He promises meetings with
people or various kinds of business or career things, but considering the
crowded life that he leads, the number of people that he deals with every day,
I think he does miraculously well." According to Billy Name, the problem
was that many of Warhol's younger companions were in no shape to accept
the career help that he offered. "He would tell them, as a great manager,
exactly which steps they should take. He told Edie exactly what steps she
should take to become a bigger star, and not just a Warhol star. These people
who Warhol engaged with were all underground people and they wouldn't
emerge. They would stay in the underground."

John Cale described the help the artist was happy to offer: "People say he
wasn't generous, he was cheap, but whenever I had a problem, for example
when I needed an album cover, he'd do it. I went to see him to ask for a cover.
He said, 'I'll get Yoko Ono to pose naked with you and we'll call it John and
Yoko.'" Cale dismissed the suspicions that Warhol triggered in even his
closest companions as "intellectual envy"—as a form of self-protection that
has us putting down rivals so we don't have to face the fact that they may
have more talent than us. According to Cale, the Factory attracted a collec-
tion of "incomplete" people who, despite their suspicions of Warhol, found
a kind of completion in his world, and a meaningful role they didn't have
in the world outside.

There was Paul Morrissey, a budding filmmaker from Yonkers who had
gone to the all-male Fordham University nearby. He had got his start in
films almost by accident, when he raised rent money by screening mov-
ies in the East Village storefront where he lived (shades of Warhol's own
screenings in his parents' basement) and then started to make some shorts
of his own, including one starring Taylor Mead and another based on Pop-y
footage of a Captain America comic book. In June of '65, Malanga attended
a Morrissey screening and decided to bring him into the Factory fold, realiz-
ing that his more technical skills might be of use. Although Morrissey once
said that his "skills" amounted to knowing a bit more than Warhol, "which
wasn't much"—in fact he was the one impressed by Warhol's Auricon, a
"revolutionary" piece of tech he had never seen before. Contemplating their

1960s collaborations, Morrissey described how "Andy ran the camera and I usually ran the sound."

This new arrival was slim and pretty but also amazingly nervous: He talked in fourth gear, spewing words in a high-pitched Bronx accent while twisting out hanks of his auburn curls. Factory friends considered him "devoid of sexuality of any possible kind," although he was happy to help Warhol find sex soon after they met, hooking him up with a young college friend.

Mostly, however, Morrissey was socially conservative. Before meeting Warhol he had made an antidrug short and was always pushing back against the chaos and abandon of the Warhol scene, and also against the looseness of Warhol's art. Other Factory types called him Father Flanagan, after the famous do-gooder priest. His more buttoned-down approach took over for a few years after 1968, when Warhol was shot, but in later decades Morrissey could seem unhinged in his hatred and contempt for his former mentor. Warhol, he summarized, "was autistic, dyslexic, frightened, timid and had no artistic instincts. . . . The notion that he had ideas and was able to do things was just crazy." The timid part might even have been halfway correct.

That summer also saw the arrival of a twenty-five-year-old named Brigid Berlin, also known as the Duchess and as Brigid "Polk" for her habit of dealing out "pokes" of amphetamine, right through a user's blue jeans. Berlin was the wildly spoiled, wildly traumatized and wildly neurotic daughter of the head man at the right-wing Hearst publishing empire. One '60s profile described her as a "chauffeur-driven-governess-coddled product of New York's Convent of the Sacred Heart, Foxcroft and Swiss finishing schools." Honey Berlin, her high-society mother, had got Brigid hooked on speed as a child to control her spiraling weight, when eating was the little girl's one way to assert control. In 1960, she had married a gay window dresser in the hopes of "converting" him to women, a goal she seems to have left behind when she went on to be Warhol's best friend, and occasionally his most passionate hater, in the 1970s and '80s. "Brigid was evil," said a superstar who arrived on the Warhol scene at the tail end of the sixties, when Berlin was becoming one of its most unchanging fixtures. "Her mouth, her look. I think it was that paranoia from that speed, and basically being unhappy. She always scared the hell out of me."

And then there was little Bibbe Hansen, a fourteen-year-old juvenile delinquent who had a cultural pedigree that was a match for Berlin's social rank: Bibbe was the daughter of the notable avant-gardist Al Hansen, who

had helped introduce Warhol to the Judson Church world. Warhol first met Bibbe on a Saturday gallery crawl, just after she'd been released from a spell in a girl's prison—a source of pride more than shame for her anti-establishment father. By Monday she'd become an after-school regular at the Factory, trading mascara with Edie Sedgwick and even starring in a Warhol film inspired by her time in stir.

Rounding out Warhol's scene were lesser Factory lights such as Ultra Violet, born Isabelle Collin Dufresne as the scion of a glovemaking family in France. She had aspirations to avant-garde culture—she'd moved on to Warhol after being some kind of muse or mistress to Salvador Dalí, as she never tired of mentioning—but her main skills seem to have been tireless self-promotion and overdressing. Ultra Violet was preceded at the Factory by Ivy Nicholson, a 1950s cover girl who was as stunning as she was eccentric. Early in her tenure with Warhol she had married the much younger John Palmer, who had helped with the idea for *Empire,* but that didn't stop her from writing a series of utterly nutty love letters to Warhol. In one she tells him that he has the capacity to make a major movie but only sex with her will let it happen: "The rhythm of fucking is where cutting is at." In another she tells Warhol that his entire entourage is imagining how much greater a genius he'd be "if he fucked or got blown by a woman."

"Drag queens and queers, children, street hustlers and rough trade, drop-outs and runaways, drug dealers and psychiatric basket-cases. We were all outsider insiders at the Factory," Bibbe Hansen remembered. Joseph Free-man, another teenager who became a fixture at the Factory, as "Little Joey," said that he has never bought into "the whole 'Andy Warhol the manipulator' business." He remembered people coming to Warhol in the hopes of being used, in one way or another, and then getting precisely what they'd expected.

Warhol was no Venus flytrap, attracting unwitting victims so he could then suck them dry. At worst, he was like some guileless flypaper, with a scent that led certain creatures to get stuck.

"I never thought that Andy should be responsible for solving our prob-lems," said Hansen. "I don't think he was any more equipped to do that than he was to deal with his own." She claimed that even Edie Sedgwick, Hansen's adored friend, got more fulfillment than pain from her Factory days. "She got to realize some of her fondest dreams and became immortal in the process. Some blame Andy for Edie's addictions and her death. Her family had a terrible history of misery and wrecked lives. . . . She was only with Andy for a year but she was a Sedgwick all her life."

Like any number of young people who Warhol took under his wing,

Hansen remembered him as kind and considerate and genuinely concerned for her welfare. An eighteen-year-old suburbanite who arrived from Chicago in the summer of 1966 also remembered the good care she got from Warhol and his minions, including making sure their naughty movies were only shown when she couldn't see them. (Although such scruples didn't stop Warhol from taking her to an "eye-popping" drag club.) "They were my protection from the big city," she said—an extraordinary role for them to play, since most outsiders would have considered the Factory crowd the epitome of urban risk.

Warhol encouraged his followers to explore themselves and their own creative ideas, without expecting them to become little Andys. Not long after Billy Name's arrival, Warhol passed him the Pentax camera he'd bought a few years before, thereby launching Name's career as the Factory's documentarian. Another young man had ambitions in filmmaking, so Warhol allowed him use of the Bolex and no doubt of the Factory's account at the film lab. He turned out some excellent little movies that had nothing to do with Warhol's own aesthetic.

---

INTERVIEWER: I have the impression that you like the whole business of being there in the studio and having all of this going on and watching it.

WARHOL: Yeah, well it just keeps everybody off the streets and it's sort of like . . . a daytime school for older people.

INTERVIEWER: So you think you're performing an important social service.

WARHOL: Oh yes, I really do . . . somehow the cops always think we're not.

Indeed, there was no fighting the aura of dissolution that had grown up around the studio, thanks partly to Warhol's own cultivation of that image in the press. Just on principle, the police began to show up now and then.

Already while Warhol was in Paris, Billy Name had sent him a frantic letter asking what should be done about a pair of detectives who had rooted around among the Factory's film reels, asking if there was a projector they could use to screen some. "I said no projector . . . I have placed the Factory in a state of 'TEMPORARILY CLOSED' and am trying to have it appear that no one is in at all times." (Name was smart enough to immediately ship out all reels that might count as porn.)

Footage from about a year later shows a trio of uniformed officers putting in an appearance during what seems to be a perfectly normal rock-band rehearsal.

When Warhol complained about cops, he made clear that his beef was with the ones who came by for no reason; he said he understood the ones who showed up when he gave a party, with all the crowding and clamor that entailed. In November, after police shut down a Factory party that Warhol hadn't even attended (he'd overslept and missed it), his landlord sent him a stern letter complaining about the fire regulations that had been broken by the crowding and the mess left behind in the building's public spaces. "Your lease, of course, does not permit such use and occupancy and you are hereby directed not to have any such parties in this building." It's unlikely the letter had the slightest effect.

Warhol took occasional stabs at calming things down, periodically closing the Factory to outsiders and eventually putting up a sign that read "Please telephone to make or confirm visits, appointments etc.—No Drop-Ins—All Junk Out!!" For a while at least, there was a strict rule that everyone had to clear out of the Factory between 6 and 7 P.M., no doubt to force a reset in the ever-mounting frenzy that might otherwise prevail. On weekends, you couldn't even get into the building foyer unless someone dropped a key down to you from a Factory window. (Or unless you knew that it was easy to pull down the ladder to the fire escape and climb up that way.) There was also some vague sense that it ought to be a drug-free zone, at least during the workday, before the Mole People came out to play. Bibbe Hansen said that if you wanted to do daytime drugs (and many at the Factory did) you went out to the park by the United Nations, or up to the roof or out on the fire escape— anywhere except in the studio itself. But given the kind of people Warhol was taking on board, none of that would have done much to impose order. He was getting a reputation for bringing such a doubtful gang along to any party that they were sure to ruin it. An acquaintance described him turning one soiree into "truly the most disastrous party I've ever been to, and it was all his fault—his eminence squashed everybody's chance of fun. . . . Warhol would sweep in with his entourage, stay a bit, talk to no one and then sweep out as though he had better places to go."

The Factory had lost the moderating influence of Warhol's former crowd of established aesthetes and culturati, who could no longer bear what the scene had become. His old boyfriend Carlton Willers was scared off by what he called Warhol's "film people"; he spoke about getting cut dead on the street when Warhol was with them, even though he got the same old cordial greeting if the two met alone.

Wynn and Sally Chamberlain were hardly delicate creatures, but even they made themselves scarce: "We became disenchanted with the scene that Andy was creating in the Silver Factory on 47th Street. Its undercurrent of heavy drug use, sexual madness and violence made us uneasy and we rarely went there." It had become the kind of place where the pay phone—the Factory's *only* phone—needed constant replacement, as speed freaks smashed it open when they needed coin for a fix.

Warhol used drugs too, but quietly, secretly, *efficiently,* by sneaking a cigarette or gulping down an Obetrol when he needed a jolt or taking a puff on a friend's spliff to relax. He preferred not to have witnesses, whereas drugs were central to the self-image of many of his most notable acolytes. Put Ondine in front of a camera and he would make a grand show of mainlining. Brigid Berlin went on camera "poking" herself through her jeans. Friends could tell when she was really flying high because flecks of spittle would form at the corners of her mouth. "Brigid, you're foaming," Warhol would say.

"Andy was like the Statue of Liberty: 'Give me your tired, your hungry—your drag queens, your junkies.' He was the saint of misfits. He was like a beacon drawing people to New York," said one of the people who had been drawn there. And yet it's a mistake to imagine that the artist who attracted this brigade of irregulars really thought of himself as belonging among them. Just as we don't imagine Brueghel as one of the dancers in his harvest scenes, so we shouldn't think that Warhol, as the Factory's head and creator, was also a true Factory type. At heart he was still solidly bourgeois, with his fine Victorian house, his love of fine food and his mom at home to take care of things. It so happened that he was a bourgeois who realized that there was still good art to be squeezed out of a bohemian scene.

———————

The influx of new characters into Warhol's studio led to some changes in the art that got made there. Ron Tavel remembered being squeezed out by Sedgwick and her gang, who disrespected the old-fashioned absurdist avant-garde that he represented. Sedgwick turned out to be both unwilling and unable to follow Tavel's disjointed scripts or direction. "Indeed," he wrote, in the highest of dudgeon, "it was evident to anyone who cared to really listen to the woman that she had absolutely no idea of what Andy was after or had ever done, of what the films effectively were or what they effectively would be"—although almost the same might have been said of him. The final straw came for Tavel in July. That's when Sedgwick, "rebelliously pre-programmed," as Tavel put it, by her "coup-minded drones," tore up a

screenplay of his on set. That destruction was probably just as well: *Space,* as the screenplay was called, was built on mystical premises that had nothing to do with Warhol's own aesthetic. Like almost all of Tavel's screenplays, when it came time to shoot it, his script operated as barely more than a jumping-off point for Warhol's study of character and dysfunction.

Once Tavel was gone, there was room for Chuck Wein to take over as Warhol's main movie sidekick. Not surprisingly, the Harvard grad came with more conservative notions about filmmaking than the Village poet had, and he was determined to introduce proper dialogue and more standard camera work into the Factory product. He got his way in September of '65, when they shot *My Hustler,* the most traditional movie Warhol had made until then, at least on the surface. It was an actual narrative feature, filmed on location with recognizable characters, comprehensible dialogue, an almost-coherent plot and even the occasional cut from one shot to another, a heretical departure from Warhol's earlier single-shot films. The setting was a borrowed house in the beach hamlet known as the Fire Island Pines, on a sliver of sand a few hours from New York that had been settled by gays over the previous decade. (Although Ondine found the area "definitely déclassé, my dear— definitely.") The first reel of the movie is about an older gay man who has used a Dial-a-Hustler service to procure some young flesh, which he then tries to keep out of the hands of a couple of "friends"—an older male hustler and a pretty young "fag hag," as the dialogue puts it. The second reel, set in the bathroom of the john's beach house, focuses on the gorgeous boy himself, as he flirts and spars with that older hustler whose career is nearing its end. Edie Sedgwick had originally been cast as the film's fag hag, but in the end had given the part to a girlfriend of hers. Wein and Sedgwick were on the outs at that moment, so she had no interest in helping him with his film, but she might also have recognized that the part she'd been offered hit too close to home, mirroring her actual relationship to Warhol.

Wein was credited as the film's writer and director (although it was still billed as "By Andy Warhol") but he had called on Morrissey and others for technical help. They took a stab at professionalizing the shoot, to the extent that anything professional could happen in Warhol's orbit. They even got their hands on a fancy Nagra tape recorder to replace the Auricon's lousy "optical" sound, but in the end there's no sign they used it. The finished movie's sound was as bad as ever.

Billy Name said that Wein and some other Warhol minions had one truly radical ambition: to get their master to try some classic Hollywood pans. "They were saying, 'He's refusing to pan. We've got the house over here and the beach over there and he won't pan.' . . . I think Paul Morrissey then took

over at that point." Warhol's resistance had nothing to do with ineptness, said Name, and everything to do with a more radical aesthetic than Morrissey and Wein could ever understand. In a rare moment of public self-awareness, Warhol had once told the playwright Ronald Tavel that he couldn't allow himself camera movements of any kind because his contribution to film history was the static camera. But on the set of *My Hustler,* Morrissey and Wein did wear Warhol down in the end: "Paul was there and Chuck was there and they were going on—'Yak, yak, yak'—and after a while you're just going to stop doing what you're doing if people are going to keep going at you," said Name. Yet the zooms and pans that did get into the film—wobbly and "headache inducing," according to one critic—feel so exaggerated and overdone that they almost seem to poke fun at standard canned camera-work.

Overall, *My Hustler* left behind the strangeness of the works that had first made Warhol's name in film: no endless, unmoving shots of static subjects; no footage of random weirdos being weird; no almost-meaningless dialogue. Oddly, that made the new movie closer to Warhol's Pop Art than his earlier films had been. With the Campbell's Soups and similar works, the "what" had always eclipsed the "how"—viewers felt as though the paintings gave direct, unmediated, unartistic access to the everyday products they showed, whereas the first films had attracted attention mostly for how they'd been made and for how unlike "normal" movies they were: for the length of their shots, their lack of plot, the dislocations in their dialogue. That is, *Sleep* and *Empire* and *Harlot* functioned more like traditional modernist paintings that were as much about art as about the subjects they showed—you could say Warhol's early films were still "drippy," like his first Coke Bottle paintings had been. They were too strange, in too many ways, to achieve Warhol's goal to "just find interesting things and film them"—or rather, by "just filming them," Warhol had turned his "interesting things" into fascinating but peculiar art.

And then came *My Hustler,* conceived as a relatively normal film with rather standard actors saying pretty normal lines, meaning that there was nothing to distract us from the work's one singular feature: that the main characters were a homosexual rent boy and his john. Warhol was asking his viewers to accept the unlikely proposition that, as subjects for a feature film, they were as normal as the husband and wife in a screwball comedy. *My Hustler* offered the possibility that gays on the make could live in our theaters the way Campbell's Soup lived in our kitchens. That possibility turned out to be accepted, at least among New York cinephiles: *My Hustler* had by far the most successful run of any Warhol film up until then, ad-

vertised as playing "every midnight indefinitely, by public demand." Paul Morrissey later claimed that it earned $30,000 in its first week at a soft-core porn house.

At this high point in his art-world power, it feels as though Warhol was revisiting the works in his 1950s exhibitions, with their conservative stylings but radically gay subject, and insisting that this time around audiences and critics would have no choice but to pay attention. Warhol, a grand master of passive aggression, had chosen not to dig in his heels when Wein and Morrissey took the filming of *My Hustler* in a conservative direction. That could be because he realized that a mainstream feel would let the film's gay content speak out all the more loudly.

In the fall of 1965, this kind of openness about homosexuality was becoming an almost-conceivable proposition, as Billy Name once explained:

> Not everyone at the Factory was gay, but there was a big gay aspect; but it wasn't treated specially, it was treated naturally. The Factory was probably the first place where homosexuality was treated naturally in the arts scene, rather than being something you weren't supposed to tell somebody about.

That summer, Warhol had received a magazine featuring one of his usual cagey interviews, and it ran alongside a long, very frank conversation between seven "practicing" homosexuals that ran under the title "Live and Let Live." Yet despite that title, the fact that the seven were "practicing" still made it obvious, said the magazine, that their names could not be provided.

That troubled, doubled perspective on gayness is typical of Warhol in 1965, and pretty much throughout his life. Although never in full-blown denial of his sexuality, Warhol preferred to be seen with Edie Sedgwick on his arm as his "girlfriend" (or so the press liked to bill her) than with the men he invited to share his home and bed. His art rarely offered an optimistic vision of gay culture as a normal alternative to a world of straights. It mostly seemed to capture a dark underside where sex is the overriding concern. *My Hustler* was premiered in a seedy former porn theater—ushers patrolled to catch masturbators—and eventually got screened with added footage of "male-to-male kissing" and "fully displayed genitals," as one critic complained. The movie billed homosexual life as louche and fringe and disreputable. It showed it taking place among hustlers and johns; among beautiful, unattainable youths and seamy older men on the make. Was that the only world Warhol was able to see himself in?

Thanks to *My Hustler*, Warhol's world came to include the latest in this older man's line of beautiful youths, and the second to move into his town house.

Danny Williams, from a fine New England family, first showed up at the Factory in the spring of '65 with the Harvard crowd around Sedgwick. Before arriving in New York, he had bopped around for a while as an editor and a soundman for various filmmakers, learning the ropes of his chosen profession. That gave him knowledge of equipment and techniques that made him extra useful to Warhol and Wein, as they moved their films on from Ron Tavel's more casual approach. Williams was the one who brought the Nagra on board to capture the sound for *My Hustler*. He also had notable skills as an electrician and a lighting man—a "gaffer," in Hollywood parlance. He played a big role in the light shows that Warhol began to produce early in '66, once rock promotion became part of the Factory business.

There's no knowing if it was the new arrival's skills that sparked Warhol's romantic interest or if Williams's romantic appeal got Warhol to let him take on ambitious Factory jobs. Either way, the young man was soon wearing Warhol's signature stripes, and sometime in early fall he moved into the house on Lexington, where his mother and Warhol's would chat on the phone. Warhol described Williams, obnoxiously, as having been a parting gift from Chuck Wein.

Williams was twenty-six and attractive, with a high forehead over hefty glasses that gave him a brainy look. "Nice-looking, about five ten, a little chunky, but in a cute way" was how he was described by Robert Heide, that Greenwich Village playwright who was involved in Warhol films at the time. "I know Andy had a very sexual relationship with Danny. You just sensed it when you were with them." The next year, Williams was confiding to his diary that "love with Andy would have been beautiful if Andy had wanted to share my experiment & see me, but all he wanted was to give me meals and have me meet his glamorous friends." Food and glamour: fine treats to offer a sweetheart by Warhol's lights, but without the depths that a young seeker like Williams was after.

Warhol did think highly enough of Williams to work with him on a film called *The Bed*, which Warhol had started planning a year before Williams's arrival, even before he'd bought the sound camera he'd need to shoot it. The movie was based on an off-off-Broadway play by Heide about two gay men "on booze and drugs stuck in a time warp and unable to get out of bed," as

Heide described it. "One of them thinks of committing suicide but instead decides simply to go out to buy cigarettes and a bottle of Coke"—a perfect subject for a Pop artist and his new lover to take on. It could even be that Warhol's interest in the dormant project was only rekindled by his crush on Williams and by the sudden importance of coupledom in his life, almost as though he were reshooting *Sleep* as a double act. Two-ness was built into how Warhol conceived the piece: He shot the action on one Auricon while Williams wielded another at the same time, generating a two-viewpoint, two-screen film that recalls the film-and-video piece that Warhol had recently done with and about Sedgwick.

Heide's play might not originally have been about Warhol and Williams, but the film of it certainly would have read that way to anyone who knew how it got made: Its two characters are a younger, dark-haired man being kept by a somewhat older blond, who describes it as "a very feasible arrangement, you and me." They lie in bed surrounded by books about cinema as well as the script from a play, *The Brig*, that was important to Warhol, while intoning lines like "Sex is dead. No God—God is dead. No, Nietzsche is dead." The younger man threatens to jump out the fifth-story window—shades of Freddie Herko—and accuses the older one of having "a father complex." As they squabble, a turntable set on endless repeat plays the Dave Clark Five singing "Any way you want it / That's alright by me," a lyric that itself repeats endlessly in the song.

Once Warhol had lent his Bolex to Williams—another sign of his respect and affection—the younger man also shot films that were his own creations, more obviously experimental than the Factory product but in a more traditional modern-art mode, with rapid-fire cutting and strange camera angles that hint at the psychedelic. That could be because they actually depended on psychotropics for their verve.

It looks as though Williams had been doing drugs before he'd even arrived in Warhol's orbit: His mother said he'd tried to convince her of the glorious benefits of amphetamines. There is also a tale that puts Williams front and center in one of the Factory's better-known drug episodes, remembered by several participants but only with a *Rashomon*-like diversity of recall. While on the beach-house set for *My Hustler*, Williams (or Wein) spiked the orange juice (or the morning eggs) with LSD, resulting in either (or both):

> a) Warhol seeing through walls, according to Wein, and madly cleaning and recleaning the kitchen while "high as a kite," as witnessed by Malanga. (Which would have been perfectly in keeping with

Warhol's long-standing tendencies toward obsessive compulsive disorder, as enhanced by LSD.)

and/or

b) Paul Morrissey curled up in a fetal position under the boardwalk, as discovered by Warhol, who had been too canny to drink or eat anything that didn't pour from the tap or come sealed in a candy wrapper. (Which would have been perfectly in keeping with Warhol's lifelong desire to seem a drug virgin.)

Whether due to the drugs or not, the shoot devolved into mayhem, with furniture chopped up for firewood and the general destruction of the borrowed house: "We were like little children in a playpen, or in a sandpit," said Paul America, the actor cast as the movie's young lead.

Over the year that Williams was a regular at the Factory, everyone there saw his drug use getting steadily worse.

Speed, or possibly the alcohol that Williams also abused, could have been behind an episode that happened sometime in the late fall, and that seems to have sealed Williams's fate with his new boyfriend. Warhol and he apparently got into a squabble over a screening that Williams was trying to arrange for a film that he'd worked on before coming to the Factory. Warhol saw that as competition or some kind of betrayal. Matters came to a head (literally) in a Greenwich Village restaurant, where an enraged and probably speeding Williams committed true lèse-majesté: He yanked off Warhol's wig, revealing his bald pate for several seconds.

Not surprisingly—and not all that unreasonably—that seemed to be more than Warhol could take, especially coupled with the major depressive streak that was starting to show up in Williams. He had to leave the town house, finding shelter instead in the rear reaches of the Factory. Billy Name, who later admitted being jealous of Williams, objected strenuously to cohabiting with him: "He was a very soft person, not up to my velocity, and he had a tendency to have nervous breakdowns, to become soft and physically unreliable in our working space. As far as I was concerned that was dangerous and placed us in jeopardy." But Warhol overruled Name, refusing to leave his young ex homeless in New York.

The breakup between Williams and Warhol couldn't have been all that brutal or final, because they continued to work together for the next six or seven months. In May, they launched into a commercial commission for Plaza 8, a bra company whose executives clearly felt that an ad with some Warholian verve would impress the youth market: "An Underground Film by Andy Warhol—High Priest of Pop," read the titles at the start of the spot,

which was not much more than one of the Factory's female superstars super-imposed on some standard lingerie footage. (Warhol's heart must not have been in the project: He was late turning it in—something that had rarely happened in his years as an illustrator—and it was so slipshod that it had to be reworked by some old filmmaking bosses of Williams's in Boston.)

For weeks at a time during the spring and summer, after his breakup with Warhol, Williams was on tour as the lighting wizard for the Velvet Underground, the Factory's in-house rock group. In Chicago, *Variety* had the temerity to refer to Williams as "mastermind" of the whole performance, and his tour mates read that as reflecting his view. Before long, Williams and his eternal rival Paul Morrissey had come to blows on a catwalk over who had which rights over which electric cables. "Paul's relationship with Danny Williams was really sadistic," Warhol recalled. "He put Danny through psychological terrorism. Danny was really treated like dirt. I used to lose my temper at Danny Williams myself, and scream at him." Indeed, Malanga felt that Warhol had been as guilty of abusing Williams as anyone. It couldn't have helped that Williams seemed to be angling for a share in Warhol's company, a move the artist could only have seen as presumptuous, and a threat. "Andy can't be both the largest shareholder and the least contributor," Williams wrote.

In his lair at the back of the Factory, Williams became a true speed freak and came to look the part. He showered maybe once a week, across the street at the Y. "Danny went from being a clean Harvard guy to being the worst druggy mess," said Gerard Malanga. Tavel, back at the Factory for a visit, painted a tragic picture of the young man, "increasingly bizarre in appear-ance, his hair matted, his glasses broken, encounter by encounter progres-sively lost to amphetamine":

> I would sit next to Danny at his massive desk and watch him scoop out the grime from its chisel-work with a penny. How many speed-freaks have I stared at in wonder doing that! But the others, like Ondine, chatted non-stop in accompaniment to their house-keeping. His nose always running, Danny sniffed a bit, but was otherwise very quiet.

In July, Williams showed up at his parents' house in Rockport, Massa-chussetts. After a normal family dinner, he took his mother's car for a drive. It was found parked on a pier near a rocky cove where Williams had once liked to swim.

Tavel said that, one afternoon at the Factory, he took a call from Wil-

liams's mother asking for news of her son, and that Warhol refused to get on the line. "Oh, what a pain," he is supposed to have said. "He's a pain, now she is. . . . I don't care where he is. He's just an amphetamine addict." If Williams had just been lost on a bender, Warhol's comments might have seemed unkind but also more or less true—and perfectly standard for an ex who feels disappointment in his former lover. Warhol's behavior has only come to seem worse than callous because Williams was never seen again. Only his clothes were later found, sitting folded by the sea.

Not too long after the disappearance, Warhol, perhaps in a moment of passive-aggressive regret, got a friend to write a kind letter to Mrs. Williams saying that her lost son's experimental films had an "innate brilliance": "I know that Andy Warhol was also and is of this opinion. Already the ideas [Danny] has given one of our nation's leading artists will be of great value to human kind in coming years."

*. . . in his cool-cat costume.*

# 1965

### ANDYMANIA AT THE PHILADELPHIA I.C.A. |
### WARHOL SCULPTS HIS PERSONA

*"I guess it'll all get so simple that everything will be art"*

PUBLIC RESPONSE TO THE WARHOL SHOW: It would be gratifying to believe that the Philadelphia public is so concerned with art that openings merit large newspaper spreads and must be extended over a period of several days. Even then however there would be something bizarre about the art objects having been removed on the second day of the opening. If ever it is necessary to document the fact that the artist and not the art is of primary concern to the public, surely this sorry episode makes it clear. The cult of personality can have no further flowering.

Those lines were published in the newsletter of a stodgy Philadelphia gallery, as part of the hubbub that greeted Warhol's first-ever museum survey, unveiled in October 1965 at the Institute of Contemporary Art. The I.C.A. was a new, noncollecting institution on the campus of the University of Pennsylvania that had announced its Warhol show by mailing out nine thousand prints of an S&H Green Stamp image of his. (Warhol had been too busy to produce them in time, however, so the museum director had them made and then himself signed Warhol's name to the ones sold as $10, "limited-edition" sheets.) Thanks to a flood of publicity, the Warhol survey's public opening—itself a new PR concept—became a madhouse. "I produced it as if it was show business. Because that's what it was, what it was meant to be—a media event," said the fiendishly well-connected new director of the I.C.A. "There were four TV news stations. Reporters from every magazine,

everyone from New York, every celebrity I could get down. . . . There was no question then but that Andy and his superstars were the event."

Campus police did crowd control as the artist's fans waited for the doors to open at the nightclub-ish hour of 9 p.m. More than 1,600 people poured in within the first hour, after which staff were too mobbed to keep track. The I.C.A. had announced in advance that the opening would "evoke Mr. Warhol's working atmosphere—music, dancing, people, films, and with journalistic and television coverage," and sure enough, the I.C.A. director Sam Green himself had painted the floors silver and ordered two turntables set up to blast out the latest rock. Other than such extras, however, visitors and TV crews found a suite of galleries whose walls were mostly empty except for a few nails. Some work had been damaged the night before at a "private" view that had been mobbed, so the gallery decided not to risk more harm from yet bigger student crowds. One wag commented that he had never seen a more beautiful display of "black nails on white wall," while another visitor complained that the crowds had clearly been "attracted more by the personalities than the art." Precisely.

"At 9:45 floodlights snapped on in the back room. In swirled Andy Warhol and his entourage. He wore a black T-shirt, black wind-breaker, black slacks and yellow wrap-around sunglasses. He was dressed for motor-cycling," read a Philadelphia monthly's postmortem, clearly commissioned even before the show had launched. "Edie Sedgwick, his girl friend, was at his side, a thin twentyish girl in a shocking pink, floor-length jersey tube." Malanga, Karp and Geldzahler were also there, along with the art critic David Bourdon, Brigid Berlin and others from Warhol's "band of pop-artistic merrymakers," in the words of a local paper. But that was not near enough entourage to keep Warhol safe from the hordes. Escorted by police, he and his followers eventually beat a retreat up a wrought-iron staircase that dog-legged up from the floor before hitting a dead end at the ceiling. (The gallery was in a grand Victorian pile originally built as the university library; the useless staircase survived from those days.) Warhol and friends sought shelter on the landing and, trapped there, looked down on their admirers with a mix of wonder and fear: Photos show a sea of faces gawking back up at them. Four cops held the crowd at bay, handing up souvenirs to be autographed. Warhol—or more often his acolytes—obligingly put "his" signature on commuter rail tickets, shirt cardboards, baby-food boxes and of course Campbell's Soup cans that fans had brought along to be signed. Sedgwick, who did much of Warhol's signing that night, also teased the crowd with the absurdly over-length sleeves of her pink Rudi Gernreich dress, like a sailor jigging for cod off a boat. The crush of people pushed three fans out a window and into

the hospital. Television footage showed the crowd carrying on "like so many Beatlemaniacs," according to one viewer, and that sounds right, and perceptive. "We want Andy!" shouted Warhol's devotees, and "Get his clothing!" At one point in the evening the artist surrendered his new, goggly sunglasses to an admirer, maybe the way a salamander abandons its tail to a hawk. (Once things calmed down, he sent Sedgwick to retrieve his eyewear.)

After being stuck in this limbo for much of the evening, Warhol and company were saved by firefighters who uncovered a trapdoor at the top of the stairs: "They came and they ripped it open with crowbars and they guided us through to another floor and went through the library stacks and through and down the fire escape, down the side of the building and into police cars," recalled Sam Green, the I.C.A. director who had shared Warhol's fate.

His full name was Samuel Adams Green, and he was a twenty-five-year-old art lover who had gotten the I.C.A.'s top job the year before. That was as much because of his pedigreed Yankee name, and his connections at the highest levels of Philadelphia society, as for the deep roots he had in cutting-edge art in New York. It was Green who had hosted the fur-strewn after-party for Warhol's Flowers show. His trademark "chin-strap" beard, sans mustache, can be spotted in any number of photos that show Warhol out and about in the Manhattan art world over the next several years.

The I.C.A. had been founded only in 1963, in theory to expose students to the latest in visual culture but in fact with a board more eager to put on surveys of Renoir and Gauguin. The Warhol show came about only because there was no funding for such big-name surveys and because of brilliant horse-trading and politicking by Green. He arranged for the chair of his board—Mrs. Horatio Gates Lloyd Jr., a.k.a. "Lallie"—to be invited to a fancy New York dinner, with Warhol seated by her as entertainment. Green recalled being happy to see that his artist had shed his "monosyllabic, shy act" for the night and was doing his best to charm his neighbor:

> Lallie Lloyd said, "Oh, Mr. Warhol. I'm terribly pleased that you're considering our tiny little insignificant museum in Philadelphia for a show of your work. Which I understand from Mr. Green is terribly interesting, and I shall be looking forward to it."
>
> So Andy said, "Ohh, Mrs. Lloyd, I think it's so terrific that you're interested in my work because I just think Philadelphia is terrific. I think you're terrific too. I'm doing movies now. . . . I think it would be so terrific if you'd be in one of our films."
>
> "Why, Mr. Warhol, nobody's ever asked me anything like that before. What would I have to do?"

"Would you fuck with Sam?"

She didn't miss a beat.

"Could I wear a blindfold?"

If Warhol could dare being as bratty as that, it may have been because he already had a long-standing entrée into Philadelphia's upper crust. For years he had been a guest of the eminent collector Henry McIlhenny, Green's distant cousin, who was on the board of the venerable Philadelphia Museum of Art and also on the I.C.A. board. That could only have helped Green make his case for the survey of Warhol's art, even though McIlhenny himself was no fan. "Everbody knew that he hated the stuff," said Green. "He ridiculed it, but he supported me."

When Warhol first met McIlhenny in the late 1950s his mansion on Rittenhouse Square had played host to several gay soirees for Warhol and his "decorator" friends, and the two had stayed in contact even once Warhol had moved into less tasteful circles. "Henry enjoyed very much having such shocking, anti-art artists for lunch, or for drinks, or for overnight. I brought Andy Warhol and the crew—Baby Jane Holzer and all those people—down any number of times, to spend the night on Rittenhouse Square," said Green. "He loved it." One night when Taylor Mead was in the party, or so Green told the story, McIlhenny's supercilious butler came up to ask what he wanted for breakfast next day, "and Taylor with his one eye drooping looked him up and down and up and down again and there was a long silence—and there was like a confrontation between the formal butler and this scruffy bohemian— and all the ladies stopped and the room was silent and Taylor waited and then looked him up and down and said, 'You.' And the butler didn't wilt at all, he didn't lose a beat, he said, 'Yes sir, and will there be anything else?'" The night of the V.I.P. preview at the I.C.A., Warhol and friends were given dinner at the mansion of the Horatio Gates Lloyd Jrs., out on the toney Main Line, before bedding down at McIlhenny's.

Not all of the city was ready for Warhol. A gang of leather-clad, switchblade-wielding "hoodlums" had planned to break up the opening, no doubt to get in a bit of gay bashing, but backed down at the last moment. Some of the city's elites preferred verbal mugging. Penn students climbed on their high horses, declaring the show, and Warhol's followers, "weird" and "disgusting"—"They're laughing at us as much as we're laughing at them." Their elders were split, it was said, between one faction of haters who believed that the whole event was an art-market hoax "and that the only question is whether the various agencies responsible for the show are in collusion" and another complaining that "the manner of presentation

and publicity are in very poor taste" and that the show itself was "aesthetically indefensible."

Warhol might have copped to the last of those charges. "Aesthetics," in the traditional sense, had never had much to do with his art to begin with, and at the I.C.A. he was really appearing as a retired artist, anyway. He'd been describing himself that way since the spring, so his first survey was really and truly a "retrospective," looking back instead of forward. In the first blush of Pop Art Warhol had always preferred to show his very freshest, latest work, but the I.C.A. show was full of now-ancient Coke Bottles and Dollar Bills, Elvises, Disasters and Boxes. Flower paintings that he'd conceived sixteen months earlier were the most recent pieces on view, because he'd barely made any art objects since. Even the films that Warhol eventually screened in Philly were getting long in the tooth: There's mention of extracts (and only extracts) from *Sleep, Eat, Kiss* and *Empire,* plus possibly some "preview scenes" from *Soap Opera.*

The "failure" of Warhol to break new aesthetic ground in the objects at the I.C.A. underlines why it ought to count as one of Warhol's most groundbreaking shows. Aesthetics had given way to a newly conceived and epochal, nonaesthetic work of art: Andy Warhol himself, "the enfant terrible of *pop art* in the flesh."

———

Warhol really had cast himself as more deliberately *terrible* than before. A local paper had predicted that he'd show up in his "usual paint spattered best," but this was the moment when he finally put that old Raggedy Andy look to rest. His I.C.A. appearance in "motorcycling" gear, with those eccentric ski-goggle glasses, represented a new, too-cool-for-school look that he was just then adopting. He'd even stuck a volley of safety pins through the neckline of his shirt, beating punk rockers by a dozen years. Within weeks, the first descriptions start appearing of Warhol in a biker's leather jacket. He broke it out on a return trip to Philly, completing his outfit with a bull whip. Warhol recalled how he'd got the idea for his leather look from the S&M habits of his old friend Wynn Chamberlain, and Warhol used it to suggest a new hard-edged persona. It shows up in footage and photos from then on. It was a look that trumpeted Warhol and his Factory as part of gay culture, but with an aggression that was very different from the light-loafered limp-wristedness that Warhol had championed in the '40s and '50s.

Where Warhol had once sold himself to commercial clients and collectors as pleasantly, safely eccentric, he was now pushing himself on the

larger public as a fascinating threat. Lou Reed, the rock musician who met Warhol a couple of months after the I.C.A. opening, was amazed at the scale of the transformation: "When you consider what he was like when he was doing art direction in windows and all that—with the suit, the tie, the whole thing. And then, one day, PHOOM! He's not Andy Warhola. Now he's Andy Warhol. He's in Levis and the wig and the jacket—fantastic! He created himself—you gotta love it. I was watching this like a hawk."

In July of '65, a flyer for a gallery show—in Buenos Aires, no less—could still describe Warhol as a Peter Pan, "so sweet and severe, so childish and commercial, so innocent and elegant." But already by September, Warhol had appeared at a party of jet-setters "like a refugee from an old Bela Lugosi movie, wearing a long black cape." In October, on the very morning of the I.C.A.'s public opening, the local paper was describing Warhol as looking like he came from "Spook Hollow."

The vacant pauses in his speech that had once seemed goofy and sweet, like the stutters of Jimmy Stewart, were starting to feel more like the squint-eyed reticence of James Coburn. Or maybe they were closer to evoking the sulking muteness of a junkie, meaning that Warhol was working to turn himself into one of his own Mole People. And why not? If he found such characters endlessly fascinating, why wouldn't the American public feel the same way, with himself as the type's perfect exemplar?

Starring live as his own greatest superstar, he had full control, 24/7, and the Andy show never had to stop. Unlike so many of the Factory superstars, he never got tagged with a public nickname, the way "Ultra Violet," "Viva," Billy "Name" and Mary "Might" (a.k.a. Woronov) did. For his strategy to work, he needed to remain a larger-than-life Andy Warhol.

When the *Village Voice* assigned David Bourdon to write about the opening in Philadelphia—did the *Voice* normally cover that city?—this serious art critic devoted vast attention to the I.C.A.'s star worship and hardly a word to Warhol's work. The same opening was still receiving coverage six weeks later, and as far afield as Shreveport, Louisiana.

The local Philadelphia magazine that covered the I.C.A. bash began with a full-page close-up on Warhol's face in those bizarre yellow glasses, making clear that its story on the mob scene was really a story about the new Andy-mania. The *Village Voice* piece actually ran under the Beatles-esque headline "Help!" The opening night at the blank-walled I.C.A. had set Warhol up as that kind of monumental figure in contemporary culture. As one observer noticed, "No one was complaining about the absence of the art; they were perfectly willing to settle for the personality, or, I suppose I should say, the personage."

Bourdon, who first met Warhol in the 1950s when he was still "impish and lots of fun," witnessed Warhol in the act of becoming his new self in the mid-1960s:

> When I would see him in public—we might both be at the same party or the same public gathering—he would walk right by me without so much as nodding or smiling, and a very fixed expression. He would behave that way toward practically everyone, because he was projecting his mysterious personality. But then as soon as he got home he would call me up and go into great detail about the party: "Didn't so-and-so look awful?," "Didn't so-and-so behave terribly?"

As early as the summer of 1964, the smartest young critic at the *New York Times* had written an entire essay arguing that Pop Art depended on "the idea of the artist as some sort of performer, or stage director, or actor, or mime." He mostly meant it metaphorically, imagining that the work of art itself was the "performance" that this new kind of artist produced. It wasn't much of a leap, however, to imagine that, in Warhol's case at least, the performing artist himself might also be the work of art that was being performed. That was a leap that writer after writer was willing to take in the later '60s.

When the I.C.A. invited the art critic Gene Swenson to give a lecture on Warhol during its survey, Swenson titled it "The Personality of the Artist," the same title he'd used eighteen months before on his essay for the Box show at the Stable. But at the Stable, that title had heralded his insistence that Warhol's personality had absolutely nothing to do with his art. Whereas at the I.C.A., Swenson recognized incontrovertible evidence that, whether he liked it or not, the art of Andy Warhol had now become inseparable from, or maybe replaced by, his persona: "Andy and Edie are, quite simply, stars. That much even I could gather."

One pan of the survey concluded that it wasn't about art at all but about "the Theater of the Absurd." Warhol, as that theater's chief player, should have been pleased by the put-down. There had always been something theatrical about the way he refused to be tied down to the simple facts of his own existence—about the way he'd always shaped his myth and persona to suit himself and please others. "He lies about his age, he lies about his birthplace. Basically he's a liar when he's being interviewed," Malanga once said, and Warhol told his own mother never to tell the truth. This made for an odd contradiction, even a paradox. More and more, Warhol was turning

himself into the very visible creator of his own works—into the famous soup eater behind the Campbell's Soups. And yet at the same time, he made this creator's persona seem increasingly obscure and hard to pin down. The more important Warhol seemed to be to understanding his art, the less available he was as its explanation. He was becoming the question mark at the heart of his pictures, inescapably present and yet completely opaque. Warhol's next self-portrait, the famous hand-on-mouth image that he crafted in mid-1966, presented him as a wordless sphinx—a maker of riddles who refused to answer them.

Reading period coverage of Warhol, the idea that "the primary creation of Andy Warhol is Andy Warhol himself" becomes so common that it can start to feel like an empty cliché. By the end of the decade, it had become the premise behind an entire feature in *Vogue* magazine: "'Andy Warhol' is a fiction, a disguise," it proclaimed. "'Andy Warhol' is Andy Warhol's greatest superstar." Yet that conceit can't quite count as a cliché, because it wasn't just a notion dreamed up by writers to get a clever slant for their pieces. For some of the most daring and serious artists of Warhol's era, an attempt to collapse art into life, and to make their lives count as art, had become a full-blown agenda.

The generation that followed after Abstract Expressionism was keen to let go of that movement's highfalutin notion of a pure art with purely artistic goals, set up in opposition to "the instrumentality of everyday life," as one scholar has put it. Larry Rivers and Frank O'Hara, two early apostates from AbEx, trumpeted the New Way: "We say 'life before art.' All other positions have drowned in the boring swamp of dedication. . . . The very nature of art, as opposed to life, is that in the former (art), one has to be a veritable mask of suffering, while in the latter (life) only white teeth must pervade the entire scene. We cry in art. We sing with life." John Cage, who led the charge they heralded, included duck calls and ringing alarm clocks in his compositions. "Art can operate in the manner of life," he liked to say, which led Warhol's friends among the Judson dancers to use steps borrowed straight from how people move around on the street.

Robert Rauschenberg went full Cage with the gnomic but vastly influential pronouncement that he made work "in the gap between" art and life. As explained by one early Pop curator, that meant (among other things) that by sticking a real shirt collar onto one of his "combine" paintings, Rauschenberg broke down any distinction between its presence "as an article of clothing and the same thing as an emotive pictorial device." One writer felt it was such

an important move that he coined the phrase "Combine Generation" for the youth of the 1960s.

There were already hints of Rauschenberg's art-life collapse in Pop's first days. "Pop artists have tried to make art attach itself directly to the life around it," said one early critic, while another called Pop Art "a constant crossover between what is called art and what is called life."

Warhol seemed to cross over more completely than any of his peers: The very first works that he made based on ads really had started life selling clothes in the Gunther Jaeckel window. They'd truly been "life" before they were "art." When his paintings of soup cans first went on display, it seemed to some viewers as though they might as well be real cans of soups. The first book on Pop Art, written by a pal and fan of Warhol's, proclaimed that the movement's artists were willing to go one step beyond Rauschenberg, altogether obliterating any art-life divide—a claim that incensed one of the book's reviewers.

Of course all this was mainly hyperbole: Most of the Pop artists, including at first Warhol, made objects that were quite clearly on the art side of the Rauschenbergian "gap," however much their objects might speak about a world beyond art. Even the Pop artists' occasional happenings were pretty clearly art-world productions, hived off from the normal un-arty life of most Americans. They were hardly intended for *The Ed Sullivan Show*.

There were, however, a few artists further out on the cutting edge who weren't working in the "manner of life," as Cage had put it. They were doing their best to make bits of life count as art.

In New York, George Maciunas, a leader of the Fluxus group, which Warhol had frequent contact with, had issued a manifesto calling for artists to "PURGE the world of dead art, imitation, artificial art, abstract art, illusionistic art" and instead to "promote living art, anti-art, promote NON ART REALITY to be grasped by all peoples." In that spirit, Maciunas's colleague Alison Knowles made a salad—as art—while their peer Yoko Ono came up with works of art that were no more than (she would have said, "no less than") the instruction to walk the city with a baby carriage or to touch the other people in a group. (Warhol was an Ono fan. One night when a reporter asked him and Robert Indiana to dinner, he tried to convince them to go to the macrobiotic restaurant where Ono worked. The food, he said, "makes you very wise." They declined. Ono was soon photographed hanging out at the Factory.)

An even more extreme pioneer named Alberto Greco declared that his new "living art" was to be "reality without touchups or artistic transformation"—the future artist, he said, wouldn't work with his brush but

with his index finger, simply pointing out things that he found. Greco drew chalk circles around people on the street so as to declare them his artworks. He once paraded in front of a prestigious group show wearing a sandwich board that read "Alberto Greco, artwork not in the catalogue." In 1965, he staged a guerilla raffle-cum-happening in New York's Grand Central station that involved various Pop artists. (But probably not Warhol.) Later that year, four days after Warhol's I.C.A. opening in Philadelphia, he executed what he called his masterpiece: He wrote "The End" on his hand and killed himself.

By the following spring, in a *Newsweek* cover story on Pop, Warhol had made a prediction that took the idea as far as it could go: "I guess it'll all get so simple that everything will be art." One afternoon a few months later, an art history student—later the world's foremost expert on Jasper Johns—watched and listened as Warhol worked and talked, and then jotted the following in her journal: "Wants art to be for everyone—total breaking down of the barriers between art and life, everything should be art."

Indeed, within a few years the most adventurous artists were founding corporations that counted as art, they were running restaurants that counted as art—and, as in Warhol's case, they were funding friends' travel and calling it art. Les Levine, a young conceptualist much admired by Warhol, went so far in redefining himself that at one point he declared that he had become an entire community "of poets, artists, engineers, film-makers etc."

This was the avant-garde that Warhol was engaging with as he played with self-creation that October evening in Philly. By the end of the decade he had reached its pinnacle, with one critic concluding that "in all matters, including the art-life dialogue, he has taken the most extreme position."

You can already see him toying with this idea of himself as a work of art as early as the spring of 1963, in the catalog for the groundbreaking "Popular Image" show in Washington. The editors had paired images of artists and of the works they made—but on Warhol's page you couldn't quite tell the difference. A reproduction of a Campbell's Soup painting sat beside a classic photo-booth strip of Warhol in his shades, breeding confusion between the man, his image and his art. Two years later, when one of the first books on Pop got published, the confusion became official: "The image that he presents to the world is as carefully composed as any of his paintings . . . everything about the man is calculated to enhance the image. And the creation works. Like a fully realized painting or sculpture, Andy Warhol has a presence."

Thanks to the celebrity persona he was building, he really did manage to make his life into an "artwork" that millions of Americans took into their homes when they opened the paper or turned on the TV. As his sidekick Paul

Morrissey argued, "Andy's biography should really be written just from his press clippings. . . . That's closer to the truth." By the middle of the decade, most ordinary people were much more likely to have heard about strange Andy Warhol and his bizarre Factory than about the particular virtues or vices of the Pop objects he had made. They might even have heard that he'd retired from making them—an eccentric step that only got them to pay more attention to him, not less.

One of the first and best attempts at a book solely on Warhol, unfortunately never published, outlined how he was the culmination of "that curious yet significant tradition in which the artist is his own work of art." That was a tradition, said the author, that included writers such as Byron, Whitman and Rimbaud and a line of modern artists that stretched from Duchamp ("the great forerunner") through Dalí, Dubuffet and Yves Klein—and that culminated in Warhol.

It didn't mention some more recent—female—precedents on the edges of his own Pop scene that might have been just as important to Warhol himself. Chryssa, the Greek artist whose newspaper paintings might have influenced Warhol's, was infamous for her radically bohemian theatrics, as was the Japanese artist Yayoi Kusama, who Warhol had shown with in his first group show and who claims to have inspired him. The sculptor Marisol, who Warhol had been close to in the early '60s, was even more publicly eccentric. In 1965, just as Warhol was perfecting his own vampiric persona, the *Times* was describing a "Marisol legend" that she'd built up around her exotic looks ("elegantly Spanish with a dash of Gypsy") and her "mysterious reserve and faraway, whispery voice, toneless as a sleepwalker." A fellow artist once described being around Marisol as "like being with a handful of mist or fog"—close to what people said about Warhol, at least once he hit on the mystery-man persona of his High Pop years. (Another woman of the art world, Warhol's dealer Ileana Sonnabend, had the same opaque manner.)

In its lead paragraph, the *Times* article about Marisol quoted Warhol himself raving about her as "the first girl-artist with *glamour*." Beginning already with Georgia O'Keeffe and Frida Kahlo, modern artists who were women had no choice but to build unusual personas for themselves, since Western society didn't offer models for how to be a woman who made art. As a visibly gay man, Warhol found himself pretty much in the same boat as these women; it's no wonder that he learned from their example.

Yet Warhol took his self-sculpting mission more seriously than Marisol or any of his other predecessors, distant or recent, male or female. They had all made works that could pretty much be appreciated apart from their maker's

theatrical presence. Byron, the noted seducer, wrote satirical verse meant to be enjoyed whether or not you were also wishing you could enjoy his bed. The works in Chryssa's Guggenheim show didn't depend on Chryssa's reputation for wildness; they were more peaceable than not. Whereas with Warhol, especially once he'd "retired" as a painter, the persona just about took over from the art.

You could even say that where his predecessors had used their personas to help sell the public on their work, Warhol came to use his works as props in the theater of his life. Endlessly repeating the Soups and Marilyns did not pay true artistic dividends, except insofar as it kept him in character as Andy Warhol, famous as the maker of Soups and Marilyns. These works had joined his superstars as his "attributes"—as the signature signs of his presence in the culture.

In the summer of 1966, Ethel Scull, Warhol's collector, sat complaining about him with Allan Kaprow, the Happenings pioneer. "The pity of Andy is that he's all public relations. The poor boy forgets that he's an artist," said Scull. "That's his art," replied Kaprow, and Scull simply had to agree. Even Warhol's own acolytes were on that same page: "Andy's a promoter who also creates—and his greatest creation is himself," said Paul Morrissey.

The one really close parallel to Warhol's thoroughgoing collapse of his art and persona came with Pauline Boty, one of the few female artists involved with the British version of Pop. She made paintings of icons of postwar femininity such as Marilyn Monroe, but she also adopted a public role as just that kind of movie-star figure, vamping in British media as the ultimate blond modette. For a 1962 photograph of her in front of one of her Marilyn paintings she assumed exactly the same sex-kitten pose as Marilyn does in the painting. And yet in that shot, as in all her public appearances, Boty's adoption of "blondeness" could also be read as taking a smart, ironic poke at such clichés. "Actresses often have tiny brains. Painters often have large beards. Imagine a brainy actress who is also a painter and also a blonde, and you have Pauline Boty," wrote one British journalist, clearly as confused by the various roles that Boty played as American writers were by Warhol's own pairing of smart paintings with a dumb-blonde act. Warhol certainly knew of Boty's work: He'd come across British Pop Art early on, and *Life* magazine had given her painting of Marilyn Monroe a full page in a memorial spread about the movie star's effect on art. Warhol must have noticed that, if only because his own Marilyns were peculiarly absent from the spread. Whether Boty's persona could have influenced his is a question we may never answer. She died of cancer in 1966.

Warhol's life-as-art maneuver, or for that matter Boty's, can sound a bit

like Duchamp's move with his urinal—taking nonart and declaring it art. But there's one crucial difference: Warhol wasn't just declaring his persona to be a work of art, by fiat; he was actually trying to turn it into one, in the traditional modernist sense that he wanted it to be intriguing, strange and unlike any other persona that was out there. Rather than displaying the "ordinary," as he had said he was keen to do with his Boxes, Warhol was framing his public life as something truly extraordinary—even, dare one say it, as something arty. If Dalí's public image looked like a caricature on the wall of fame at Sardi's Broadway bar, Warhol's was going to be layered and complex, more like a fine Picasso. Or, for that matter, a fine Warhol.

To have himself count as equal to the finest of his own creations, Warhol had to be as difficult to pin down, as ambiguous and multivalent, as any of his Soups or Disasters might be. Byron you could pin down: He was a sexy Romantic scoundrel (even if his verse could be very controlled). Dalí was clearly a Surrealist madman (even if his painting could be quite classical). But what, precisely, was Warhol? He was just as cryptic as anything he made, and in much the same way.

The philosopher Arthur Danto, writing just after Warhol's death, saw his persona as being close cousin to the Pop images he created: "We are one with this artist, whose own image is almost unique among artists: It has a reality on a par with his subjects, with which he is one."

Warhol's self-sculpting allowed him to get away with all kinds of peculiar, even embarrassing ploys—from dressing like Batman's sidekick Robin for an *Esquire* photo shoot in 1966 to appearing on *The Love Boat* in 1985—because, from 1965 on, everything he did could count as being between quotes. His gaucheries were performances by "Andy Warhol," the artwork, they weren't the natural behaviors of Andy Warhol, artist.

While there's a grand tradition of the self-created American hero—it long predated F. Scott Fitzgerald's Jay Gatsby—Warhol was taking it to a quite different place. Or maybe he was using that tradition as his raw material, as his Campbell's Soup Can. Rather than producing a stable new image he could inhabit and use, he produced one that was unstable, incoherent and often opaque or off-putting to its witnesses. Warhol's self-creation, that is, involved creating a true work of modern art.

———

It's important to recognize just how carefully Warhol constructed his public persona. A critic underlined the difference between the cultivated media image of Warhol as "free, eccentric, cool, drug oriented and certainly perverted" and the reality of his existence at home with his churchgoing

mother, where he avoided "excess of any kind." Another writer admitted to being surprised by what he found when he finally got to meet Warhol in the flesh. "Meeting you is rather startling," he said to the master. "I don't know what I expected you to be. Something sort of whispy and otherworldly, I guess, after all I've read. But you seem remarkably down to earth." Many years later, Warhol made his famous admission that he had spent the last decades playing a goofy cartoon character, with an Andy Suit as his costume. The anthropologist Edmund Carpenter told his friend Marshall McLuhan, the giant of media theory, that he might want to meet his fan Andy Warhol, "an extremely interesting guy & very articulate, once he gets past the WOW, GEE routine."

A photographer talked about the brains Warhol was so careful to conceal behind his slacker façade: "When other people weren't around, Andy and I would have theoretical artsy-discussions. The Frame: What does one do with the frame, doesn't the frame tyrannize you, how do you get rid of the frame. . . . Even though he always said he didn't, of course he did think about things like that." Another photographer, who first captured the Factory scene just as it was getting going, said that Warhol was the best sitter he'd ever encountered, since he always knew precisely how and where to pose to guarantee that his portrait would be compelling.

Warhol made sure to have someone around with a camera to document his act of self-creation. Almost from the beginning of the Factory Billy Name had been at hand with the Factory Pentax, and as he got skilled he built himself a darkroom in the women's toilet stall. Warhol also encouraged a couple of pros to show up over several years, imagining that a Factory picture book would be the result. Warhol then beefed up their team with Stephen Shore, a seventeen-year-old photo buff who went on to be one of the world's most sophisticated art photographers. Shore's unembellished, foursquare style has been vastly influential—and could never have existed without Warhol's observational example.

All that photographic documentation of Warhol in his various habitats got supplemented by a record of the words that he and others spoke there. In the late summer of '65, he began a voracious program of tape-recording whatever went on around him, starting out on the first-ever cassette player, a prerelease Norelco lent to him, and then graduating the next year to a high-end German reel-to-reel that let him record for eight hours at a stretch and that he lugged just about wherever he went, despite its seven-pound weight. "It doesn't matter what you record. Just record everything," he said, one day when he'd handed his recorder to a visiting fan.

Almost at once, Warhol started to imagine that his recordings could

somehow be turned into part of the Factory's art production. Endless record-
ings of Ondine were soon being talked about as a "taped novel" and eventu-
ally got published as one.

———————

If the avant-garde's interest in self-creation added prestige to Warhol's con-
structed persona, it had deeper roots in who and how he had always been:
There was no way to be homosexual in postwar America without self-
consciously playing a role, because the culture didn't leave you feeling that
there was any "natural" self you could inhabit. You were either playing at
being straight to hide being gay, or you were figuring out how to be gay by
adopting one of the models that had worked for others before you. In the
case of Warhol and many of his friends, that involved going camp. "To per-
ceive Camp in objects and persons is to understand Being-as-Playing-a-Role.
It is the farthest extension, in sensibility, of the metaphor of life as theater,"
Susan Sontag had written, and one of her followers explained that "Camp
is primarily a matter of self-presentation, not of sensibility." That is, it's not
about liking the wrong, tacky things (lots of people do that) but about know-
ing they are wrong and letting other people know you like them anyway.
Openly displaying a love of men, when you are a man, being the ultimate
example of that.

The celebrated British art-team known as Gilbert and George began a
lifetime's performance of gayness, as art, in the mid-1960s, not long after
Warhol had begun perfecting his own postpainting persona. The couple
made "art about life, not about art," they explained at their mobbed New
York premiere a few years later. As two "living sculptures," they immediately
launched into a wildly campy music hall number that Warhol was there to
witness.

Warhol's friend Larry Rivers once explained how the '60s art boom had
put New York's most successful artists "onstage" as never before, "in the
full glare of publicity," and one of Pop's first supporters had written that the
movement's artists had been the first to accept this "without cover-up." Being
a successful New York artist who was both Pop and gay didn't only put you
onstage in the '60s, it left you forever in costume.

*. . . promoting Nico and the Velvet Underground.*

# 1966

*"Our aim was to upset people, make
them feel uncomfortable, make them vomit"*

The Velvet Underground is totally unimpressive. Each one of their songs seems to last about three hours.

The band makes a sound that can only be compared to a railroad shunting yard, metal wheels screeching to a halt on the tracks. It's music to go out of your mind to.

The whole thing seems to be the product of a secret marriage between Bob Dylan and the Marquis de Sade.

It is only an extrusion of our national disease, our social insensitivity. We are a dying culture and Warhol is holding our failing hand and sketching the carcinoma in our soul.

Endless duration, chaos, insanity, social dysfunction—what was there for Warhol *not* to like about such a band, given his twenty-year devotion to the most aggressive avant-garde? The Velvets were the Death and Disasters of rock and roll, and Warhol recognized their significance before the music world did. If Middle America had been shocked—*shocked,* I tell you—by the longhaired Beatles singing "Twist and Shout," the Velvet Underground was realizing the true shock potential of rock.

Warhol's first encounter with the group came late in December 1965, at a crummy club called the Café Bizarre, with sawdust on the floors and erotic

murals meant to invoke the bohemian myths of a fading Greenwich Village. "A tourist dive" was how one of the Velvets remembered it, "and some sailors or something were in the audience of five, and we played something and they said, 'You play that again and we'll fuck the shit out of you.' So we played it again." That was the audience-unfriendly vibe that powered and defined the band from then on, said one of its founders: "We thought doing evil was better than doing nothing. . . . Our aim was to upset people, make them feel uncomfortable, make them vomit."

Barbara Rubin, an experimental filmmaker who was equally aggressive and uncompromising, had fallen in love with the group. She brought her friend Gerard Malanga along to an early night in the band's gig, and then Jonas Mekas and Edie Sedgwick joined them for another. The music was so impressive and enthralling that it got Malanga and Sedgwick up and dancing in an almost-empty club where the other patrons stayed stuck to their chairs. (Except maybe when they went to throw them at the band.) Although Sedgwick figured the Velvets must not know their instruments, she could sense the intelligence behind all the noise: "It's not like just banging on pots and pans."

Rubin decided to film one of the band's upcoming shows, so Malanga asked for help with the lighting from Paul Morrissey, who was himself so captivated that he finally got Warhol to show up for a set. "I was impressed by Andy," said the band's drummer. "I knew who he was; of course I knew—he was hot shit at the time. Andy was always in *Time* magazine. And I thought, 'Oh, that's cool.'"

The famous artist got to hear songs with Factory-worthy titles like "Heroin," "Black Angel's Death Song" and "Venus in Furs" (after the Marquis de Sade) played with enough menace and volume, not to mention distortion and feedback, to drive those sailors to their threats.

Warhol would already have known something of John Cale, who played keyboards and electric viola, an instrument described by one witness as sounding like "a cross between a bagpipe and a blackboard." Cale had worked with La Monte Young, the radical composer whose drones had accompanied Warhol's movies at Lincoln Center and who had (briefly) played in the Druds, that pseudo- or semiband of Warhol's. At the very start of that December, Cale had even been advertised as a soloist in a Young concert held at Jonas Mekas's Film-Maker's Cinematheque, a long-standing Warhol hangout. Even more impressive and unforgettable was the coverage Cale had got in the *Times* back in the fall of '63, when he appeared on the paper's front page as a pianist in the eighteen-hour performance of Eric Satie's *Vexations* that Warhol had attended. A series of *Times* photos paired Cale with John Cage, and made him look like the most fetching of

longhaired dandies. His role in the Satie had even landed him a spot on the vastly popular prime-time game show called *I've Got a Secret*.

Cale was a twenty-three-year-old Welshman who had studied modern music in London. Before even getting his degree, he had organized a concert of cutting-edge pieces by Young, Cage and Fluxus founder George Maciunas, and got mocked by the press for his efforts. Once he got to the United States, on a scholarship judged by Aaron Copland, Cale's world was much closer to Warhol's than to rock and roll. When he first saw the repetitions in Warhol's Pop Art, they reminded him right away of the repetition he'd found in his favorite new composers. Cale had actually worked in the same occult bookstore that had given jobs to a bunch of Warhol's friends, including Ray Johnson and Billy Name, and Malanga once had sex in Cale's apartment for an orgy scene in a movie by Barbara Rubin. In the spring of '65, Warhol himself had seen Cale perform with some other avant-gardists at a birthday party for Henry Geldzahler.

Lou Reed, the band's other keystone, did not have a résumé that could have got him noticed by Warhol. Born within a week of Cale, he was a middle-class Jewish kid from the suburbs who discovered rock and roll as a deeply troubled teen. He clawed his way into the music industry as a songwriter for a low-end pop label, which also asked him to cut tracks for them. One day, the label brought Cale in to do live promotion on a weird single Reed had worked on called "The Ostrich," and the two then became an unlikely team. They were soon living together in a $30-a-month flat, eating nothing but oatmeal and making ends meet by selling their blood and posing for fake news shots in the tabloids.

Moe Tucker, on percussion, was just as unknown as Reed yet drew Warhol's special attention for the singular, gender-bending fact that "Moe" was short for "Maureen," making her that most exotic of creatures: a female rock drummer. Refusing to be the "girl" in the band, she kept her hair tomboy short and her clothes baggy in an era that preferred its women in miniskirts and bouffants. Her drumming was also visibly exotic, since she played her kit standing up and preferred mallets to drumsticks and tom-toms to cymbals. The ensemble was completed with Sterling Morrison, a guitarist friend of Reed's from college: "I was a biker type and I hung around with nasty black people and nasty white people and I played nasty white and black rock 'n' roll music," he recalled.

The Velvet Underground had done live soundtracks for various underground films (they played behind the screen) and had starred in one called *Dirt*, created by a poet friend of Malanga's who had appeared in Warhol's *Couch*. The poet's shoot had, in turn, been filmed by a CBS crew that was doing a piece on underground cinema for the evening news—a piece that also featured Warhol. In New York's gossipy avant-garde, it's hard to imagine that

the Velvets were anywhere near as unknown to Warhol as the standard story about them implies.

When Warhol made his epochal visit to the Bizarre he was already in the market for some kind of Factory band. Since the summer, a theater producer had been planning a new discotheque in far-off Queens, with the idea that he could get Warhol and his crew to hang out there—for a grand payment of $500 a week. It was a cockamamie concept from the outset, but for some reason Morrissey thought it could make some kind of sense if only they showed up with a live band. Much later, he said that Warhol's interest in the Velvets was all about finding a new cash cow, but by then that had become Morrissey's standard put-down of his boss. In fact, Warhol could hardly have chosen a less commercial band with a less commercial sound. It's more likely that Warhol saw the Velvet Underground as his latest artistic adventure, part of Warhol's endless quest "to extend the idea of the paintbrush in his hand to other things," as Malanga has put it.

The previous spring, Warhol had told a journalist that even if it turned out that fine art itself was finished (hence his move to film), artists would hardly go away: "They'll become more like impresarios. They'll organize things rather than do them." And what better to organize, as an artistic act, than the most radical of rock bands? Sedgwick, speaking not long after that first evening at the Bizarre, already recognized that her friend Warhol was serious about what he'd seen and heard: "The music's very important to him because he believes that this sound is new—he recognizes that—and it's a special quality, and he knows a lot more than he ever, ever pretends."

Cale described Warhol as having been a perfect sounding-board and "definitely a co-conspirator in all of it. . . . Andy paid a lot of attention to you and made sure you felt great and appreciated."

Reed remembered his first encounter with Warhol:

> I loved him on sight. He was obviously one of us. He was right. I didn't know who he was—I wasn't aware of any of that, amazingly enough. But he was obviously a kindred spirit if ever there was one, and so smart, with charisma to spare—but really so smart. And for a quote 'passive' guy, he took over everything. He was the leader, which would be very surprising for a lot of people to work out. He was in charge of us, everyone. You look towards Andy—the least likely person, but in fact the most likely. He was so smart, so talented and 24 hours a day going at it.
>
> Plus he had a vision. He was driven and he had a vision to fulfill. And I fit in like a hand in a glove.

Bingo.

Interest? The same. Vision? Equivalent. Different world, and he just incorporated us. It was amazing.

Warhol had already flirted with the idea of adding rock to his art when he'd founded the Druds as a goofy "exhibit" for Washington's "Popular Image" show. He'd always been sorry that project fell apart. The Velvets let him reengage with the same chunk of youth culture at a more suitable moment, when rock had finally conquered America. Warhol knew this was so because, just weeks before uttering his line about impresarios, he'd been interviewed for a big *Time* magazine cover story that came with the banner headline "Rock and Roll: Everybody's Turned On." "Everybody" was an audience that always appealed to Warhol.

Rock, said *Time,* had become "the international anthem of a new and restless generation, the pulse beat for new modes of dress, dance, language, art and morality." The article described "hordes of shaggy rock 'n' roll singers" who were so "bizarre" they might have come straight out of some kind of *Malice in Wonderland.* (A nice alternate name for the Velvets, maybe.) With language like that, it was almost as though the magazine was pitching rock straight to Warhol. It went on to cite him as one of the hip culturati who could not do without the new music: "It makes me mindless, and I paint better," he told the writer, omitting the minor fact that he no longer meant to paint at all but to move on to ventures like . . . managing a rock band.

The day after first seeing the Velvet Underground Warhol had sealed some kind of deal to represent them—all they asked for were some amplifiers—although the gig at the discotheque in Queens ended up going to a more established band. On New Year's Eve, the Velvets got to watch their joint appearance with Warhol in that news spot on CBS, getting their first taste of his kind of fame. The band was featured first, as the exemplary subject for the "confusing" new art of underground film. The spot closed with Warhol, dean of the new cinema, pointing his camera at a blaring rock party.

Three days later, when the Velvets put in an appearance with Warhol at a weird outdoor fashion show (of girls in bathing suits, in January) a columnist was already describing them as "his new rock n' roll group." Within less than two years, it was Warhol's turn to be described in print as "the famous artist of the Velvet Underground," which must have pleased and nettled him in equal measure: There was always a tension in Warhol's psyche between enjoying the fame he'd helped win for others and a fear of ceding the spotlight.

———

So there was Warhol, newly christened as the hotshot manager of a band he must have hoped would be the next Beatles, and the first gig he landed for them made the Café Bizarre look like Madison Square Garden. On January 13, Warhol, the band and a team of accomplices all showed up in the grand ballroom of the exclusive Delmonico Hotel, as the evening's entertainment at the forty-third annual dinner of the New York Society for Clinical Psychiatry. That was maybe a half step up from playing a bar mitzvah.

It looks as though the shrinks hadn't even wanted the band at all, or known they were going to get it. They'd asked Warhol to come speak to them, out of their professional interest in his "mass communications activities." For years, psychiatrists had been called on to weigh in on the modern youth culture that Warhol represented: When he was a student in Pittsburgh they had commented on the risks and rewards of comic books and, more recently, one shrink had told *Time* that rock and roll was a useful outlet for "sublimated sex desires." Asking for a talk from Warhol was like getting the chance to put pop culture on the couch.

"But I don't speak," Warhol said, once he got the Society's offer to do so, "So I told them I'd just come." He also brought his band and friends along as part of a mad multimedia scramble. He and Malanga came in their best dinner jackets (with shades, of course, for Warhol) but that's where propriety ended. The evening began sedately enough, with a screening of *Eat* and a talk by Jonas Mekas explaining it as "a Zen kind of event." But then, as guests chowed down on their candlelit dinner (roast beef and string beans followed by the obligatory fruit-cup-with-a-cherry-on-top) Barbara Rubin ran into the room and, turning the tables on the assembled Freudians, began harassing them with sexual questions—"What does her vagina feel like?"; "Do you eat her out?"—while also assaulting them with her Bolex and movie lights. Mekas joined her with another Bolex while Billy Name manned the big Auricon, turning the whole evening into a chaotic parody of a Factory shoot—"a kind of community-action-underground-look-at-your-self-film project" is how one Warholian described it. Then things got worse. The room lights went out, footlights were turned on and the Velvets mounted the tiny dais. Longhaired and be-jeaned and almost crowded out by their amps and drum kit, they proceeded to offer the assembled doctors a "torture of cacophony," as one listener put it. The evening's 350 guests had been promised "The Chic Mystique of Andy Warhol," but that was not quite what they felt they had gotten.

"I'm ready to vomit," said one doctor before walking out. "Why are they exposing us to these nuts?" asked another. "It was ridiculous, outrageous, painful. . . . It seemed like a whole prison ward had escaped," offered a third. The evening's organizer tried to console and convince one of his colleagues:

"How can you be immune to art and the creative process? Surely you're aware of the barely visible line between genius and madness."

In Warhol's eyes, at least, the event must have seemed a success, since the chaos won the band its first press exposure, in at least three papers plus *Newsweek*. That means Warhol must have arranged in advance for at least four reporters to show up. Unfortunately, two of their stories used "Shock Treatment" in their headlines, which couldn't have been pleasant for Lou Reed. As a troubled queer teen, he had received such a "cure" and never felt he got over its jolts.

---

The reporting on the psychiatrists' dinner revealed a new player in Warhol's scene: a five-foot-nine faux-blonde called Nico. She was up onstage as a singer, "dishing out Bob Dylan-Negro blues-bossa nova-type material," according to one story, while the sound of the Velvets exploded around her.

Nico was the stage name of Christa Päffgen, a twenty-seven-year-old German who had bounced around for a while in the worlds of film and modeling and entertainment. Warhol first came across her in July 1961, when he saw her in Fellini's *La Dolce Vita*, in a small part that was still big enough to earn her the cover of *Esquire* magazine. They seem to have been at a party together late in 1963, but the first substantial meeting between Warhol and Nico came in May of '65, when friends brought them together in both London and Paris when he was there for his Flowers show. They formed enough of a connection for Nico to have reached out again when she was in New York in the fall, this time in her latest incarnation as a pop singer. Malanga remembered that he and Warhol grabbed a bite with her, "just to be social," and that they knew nothing about her singing career beyond the copy of her new single she'd sent Malanga. The recording had flopped, but that didn't stop them from bringing her along on one of their first trips to see the Velvet Underground, and then coming up with the notion of having her front the band they were supposed to manage. Malanga and Morrissey have both admitted that the idea had more to do with her looks than her musical talent. The Velvets needed someone who could act as a "spotlight," said Malanga, to make up for their dour and drab presentation. Or as Morrissey put it, "The combination of a really beautiful girl standing in front of all this decadence was what we needed."

The band, and especially Reed, put up some resistance to her presence but ended up caving. They were unknown musicians with a gig at a loser café and Nico was "this goddess," as Reed put it, hand-picked for them by a cultural celebrity known for his media savvy. In their early sets together, Nico was still singing Bob Dylan songs that made Reed grit his teeth. (Nico and Dylan had once been lovers and had stayed in contact.) But before long

the Velvets came up with material of their own that suited Nico's sound and persona and gave her just the edge needed to counteract her too-perfect blond looks. Not that she was as normal and faultless as her regulation Nordic beauty implied. "She had this kind of spacey way. It was kind of hard to understand what was in her mind when you were talking to her," said a New York photographer who she modeled for.

Nico never got fully incorporated into the Velvets—the billing was always "The Velvet Underground and Nico"—but she did make a real contribution that went beyond appearances. The Velvet Underground had been built around the standard model for a four-man rock group, although turned up to 11, gender bent and avant-gardized. (As one critic said at the time, they had "roughly the same relation to hit parade rock-and-roll as does Archie Shepp to mainstream jazz.") The addition of Nico, with her German accent and deep, mournful tone—almost a drone to match Cale's on viola—brought a unique Weimar feel. One critic called her a "cooler Dietrich" for "a cooler generation." So when Warhol combined Nico with the Velvets, it was as though he had decided to play a *Blue Angel* shellac from his camp days at the same time as an LP of new rock by the Stones. Although he tends not to get much creative credit for the Velvets, and had almost nothing to do with their music per se, Warhol's knack for the strange and the hybrid does seem to hover over what they became.

---

The press reported on another blonde who was on stage with the Velvets at the Delmonico: Edie Sedgwick. Her appearance that night feels like a surprise, given the oft-told tale that her "romance" with Warhol was already on the rocks by the fall of '65.

The standard story talks about a growing rivalry between the Factory crowd and Bob Dylan's crew. Sedgwick is supposed to have been a pawn in that fight between cultural monarchs, with Dylan and his pals finally seducing her away from Warhol—with "seducing" sometimes meant literally, depending on how crudely the story is told. (Dylan has always denied that he and Sedgwick were that kind of friends: "I don't recall any type of relationship. If I did have one, I think I'd remember.")

Dylan and Sedgwick had first met at the tail end of 1964—just when she and Warhol also got together, meaning that there's no clean, sequential passing of this "girlfriend" from one man to the other. In theory, Sedgwick started to veer toward Dylan sometime in August of '65, out of frustration with her situation at the Factory: She was running out of cash, her dad was barely ponying up and Warhol wasn't paying for her work on his films. "Why do I keep hanging on about Drella?" she said in a conversation taped with Ondine

around then, using a nickname for Warhol—a contraction of "Dracula" and "Cinderella"—that, according to Malanga, was always meant scornfully and was never said to the artist's face. (Chuck Wein once used it to begin a scathing note about an appointment the artist was late for.) Sedgwick did pull out of the shoot for *My Hustler* in September, which might hint at gathering tensions.

On the other hand, on October 1 the Factory had put out a press release all about Sedgwick's excellence and days later Sedgwick and Warhol had been covered as a duo at a high-profile party given for Dylan, making the split between the two camps sound rather less than complete. Sedgwick was very present indeed when Warhol was mobbed a few weeks later in Philadelphia. In November they were being described as "the most contemporary couple around," and in December they were noted at a fashion show together.

If a gap had started to appear between Sedgwick and Warhol, he might have been the one to start pushing it open. Warhol had a vast tolerance, even appreciation, for nuttiness—even drug-induced nuttiness—but only when it served some kind of creative goal, as it did with Ondine or Billy Name. With Sedgwick that fall, her strangeness was veering into pure, unproductive dysfunction, which was where Warhol tended to cut his losses. However much he had liked Danny Williams, or even maybe loved him, there was a point in the young man's drug use and depression where Warhol felt the need to shove him away. Sedgwick's decline would have happened around the same time, doubling its impact on Warhol.

Henry Geldzahler spoke about going to Sedgwick's apartment and finding it dark and grim, "and the talk was always about how hung over she was, or how high she is, or how high she was yesterday, or how high she would be to-day." It was the beginning of what Geldzahler called her "tailspin"—he placed a lot of the blame on Chuck Wein—and he described her as "very fragile, very hysterical, very thin. And you could sort of hear her screaming even when she wasn't screaming. You could hear the sort of supersonic whistling that you hear sometimes." Warhol seemed to acknowledge Sedgwick's scream in the last film he built around her. Shot in December of '65, it was called *Lupe* and re-created the suicide-by-pills of a minor Hollywood leading lady, but it was clearly more about Sedgwick's collapse than anyone else's. When it was shown as a double-screen piece, the last shot on both screens showed Sedgwick with her head on the toilet bowl, dead.

If not dead in real life, Sedgwick was at the least badly stoned when that was shot: A friend of Bob Dylan's had arrived on set with a pile of acid-spiked sugar cubes. At least one observer felt that this "attack" on the *Lupe* shoot signaled or triggered the final break between the Warhol and Dylan crowds, as Sedgwick switched her allegiance.

Paul Morrissey remembered her Dylan fixation: "Suddenly it was Bobby this and Bobby that, and we realized that she had a crush on him," he said. Warhol had heard, correctly, that Dylan had recently married, and he couldn't help letting Sedgwick know, according to Morrissey. "She just went pale. 'What? I don't believe it! What?' She was trembling. We realized that she really thought of herself as entering a relationship with Dylan . . . that maybe he hadn't been very truthful."

When a student reporter asked Warhol why he and his crew liked to diss Dylan, he said that it was simply because the singer was so very mean. "Don't you think Dylan's got a right to be mean if he wants to?" asked the student. "To everyone?" said Warhol.

Rather than having dumped Sedgwick, Warhol might have felt like he was the one who had been dumped by her. In a call to a friend, he once recalled that he and Sedgwick had been planning to find a theatrical agent to share, to help kick-start her acting career, but then she went looking for one by herself. "She was trying to push me out of the picture," Warhol recalled. "She had Dylan's agent. He was paying her bills. She just wanted somebody to pay her bills."

Not long after the *Lupe* shoot in December—some tales say that very evening—Warhol arranged to meet various cronies at an old Greenwich Village café. Although the details of the meeting have been embroidered every which way, it looks as though Sedgwick got there first followed by the playwright Bob Heide, who had written the script, such as it was, for *Lupe*. He got to listen to her complaints about Warhol: "I can't communicate with Andy, I can't get close," she said. The tension continued once Warhol arrived. It finally broke when Dylan pulled up in a limousine. "Let's split," he said to Sedgwick, and they did, sealing her break with the Factory. Once those two had taken off, Warhol asked Heide to walk him to the nearby spot where Freddie Herko had struck the ground a bit more than a year earlier. "When do you think Edie will commit suicide," Warhol is supposed to have said (with a "sardonic half-smile," in one telling). "I hope she lets us know so we can film it." If that tale makes Warhol sound like the worst kind of unfeeling voyeur, it's worth knowing that he always regretted that no one had been there with a camera to film his own near death at the hands of Valerie Solanas, on that June afternoon in '68. He was as likely to treat himself as an art supply as to give that treatment to any of his friends.

That Greenwich Village meeting is often taken as the mark of a tidy, frigid end to the Edie and Andy Story. Except that it wasn't.

Within weeks or maybe just days, Warhol had invited her along when he first went to see the Velvets at the Bizarre. In January she was invited to

join the band onstage at the Delmonico, where she went so far as to sing with them (badly). Sedgwick remained close enough to the Warhol scene to strike up a romance with band member John Cale, who found a home in her uptown apartment well into the new year. "She still possessed all the elemental magic, frayed beauty and presence of Marilyn Monroe," Cale recalled. "She was really a beautiful creature to be around." She was also still playing noblesse oblige, picking up the bill when the crowd would dine out.

In the first days of '66, Warhol and Sedgwick were given their own standalone photo in coverage of a horse race. Warhol kept the clipping, covered in big orange arrows that point to their photo. Sedgwick looks so skinny it's scary.

It would have been around this same time that Dylan made his famous trip to the Factory to have his Screen Test done, "grabbing" an Elvis canvas as payment on his way out: Photos taken from the Factory fire escape show it perched on the roof of Dylan's car as he drove away up Forty-Seventh Street. Other photos taken that day give no hint of any tension. Some show Dylan and Warhol in what seems to be friendly contemplation of various Elvises, and some versions of the story have Warhol offering one of them to the singer out of sheer admiration and enthusiasm. As late as the following fall, Warhol was telling journalists some kind of story about a nightclub that he and Dylan were working on together.

In mid-February, Sedgwick was still enough in the mix to get a weeklong program of screenings devoted just to the films she'd made with Warhol. When that somehow morphed into a Velvet Underground event, *Lupe* still opened the night and Sedgwick herself got top billing in ads. When the band began to play, she was onstage dancing with Gerard Malanga as a full-blown member of the Warhol troupe.

The press that Sedgwick and Warhol got as a couple carried through to an entire feature in March of '66 that stressed how the two represented an unlikely merging of blue blood and new blood.

Just around then, Sedgwick gave a long interview for a TV segment on Warhol, and she was still full of praise for him:

> If anybody looks straight into his eyes, it's so clear. Nobody could sit there and say: "Oh, this peculiar creature—what kind of distorted fantasies are being created or toyed around with." Andy is just as simple as the things that he says. . . . I really have the greatest respect for him.

Something else becomes clear from this interview: Sedgwick was losing it. In the eighteen pages of the transcript, her praise for Warhol is one of the

few relatively coherent passages. Most of the time you can barely make out what she's on about as she flits from topic to topic, thought to thought. She rarely finished a sentence.

Sedgwick had been agitating with Warhol for some kind of paying role in his new rock-band project: "What's my place with the Velvets? I'm broke. I have no money. Why am I not getting paid? . . . I just have nothing to live on," she said at dinner one night, going so far as to refuse to pay for the meal. But in the state she was in, it's hard to see what truly useful, fee-earning role she could have played in any project—and usefulness, of one kind or another, was the paramount virtue that Warhol sought even in his most out-there acolytes. When Sedgwick claimed that Dylan's manager had offered her some kind of film or recording contract, Warhol might have been happy to see her go.

Within a couple of months, the split seems to have finally become more or less official. When a reporter went to write an article on a Velvet Underground concert in April, Warhol's followers leaked the news that Nico had replaced Sedgwick as the Factory's "underground movie superstar."

It's said that in a moment of special nastiness, some of the Factory crowd spotted an even better replacement for Sedgwick. Cruising a bar on Times Square, they met a young office clerk named Ingrid von Scheven: "Doesn't this girl look like an ugly Edie?" someone is supposed to have said. As one Warholian recalled, "They cut her hair like Edie's. They made her up like Edie. Her name became Ingrid Superstar . . . just an invention to make Edie feel horrible." That couldn't have been hard. It couldn't have made von Scheven feel any better. "She really believed she was a superstar. She was absolutely brainless, graceless, senseless," recalled one Factory regular. "We treat her like dirt and that's the way she likes to be treated," said Morrissey at the time. A writer for *Playboy* described her as "the girl you necked with in the back seat after Friday-night high-school football games." He didn't mean it as a compliment.

Von Scheven was the butt of jokes for some time until at last her sheer energy and good humor won her the Factory's respect. "My favorite superstar is Ingrid Superstar because, because, because she's just *her*," Warhol said, a year or more after her discovery. "She's a real person; she's not phony. She's just her. She says and does whatever she happens to feel like doing and saying at the time." Which didn't stop him from making cracks like, "Is it true that you're slightly retarded, Ingrid?"

By May of '66, all of Warhol's talk about Sedgwick was most definitely in the past tense. This is when he utters those words of praise that sound like a eulogy: "Edie was the best, the greatest. She never understood what I was doing to her."

But even after all that distance had been put between them, Warhol and Sedgwick did not suffer a final and absolute break. More than a year later, in July 1967, Sedgwick had decided to move back to the West Coast, but her last stop before heading out was a country house on Long Island where Warhol was shooting a film. He received her there with nothing but warmth. A friend of Warhol's remembered a bunch of them out on a drive with Sedgwick, so stoned she was "floating somewhere in the cosmos," and then her disappearance at a rest stop on the highway: "She left for the bathroom. We finished our meals and waited for her. And we waited until I, the only other woman, went to fetch her. She was humming and doing nothing—perhaps looking at herself, perhaps not." Photos from that day show her looking emaciated and an absolute wreck.

Some of Sedgwick's Boston crowd tried to give her career a fresh start in a drug-fueled feature film that just about destroyed its producers, but she was a hopeless case. After several years of psychiatric treatment and confinement in New York and then California, on November 16, 1971, Sedgwick died of an overdose of downers. "We were never that close" was Warhol's reaction on first hearing of her death, according to some friends (and exploiters) of hers. That reaction was presented as irrefutable evidence of the artist's cold creepiness.

But Warhol's statement may have been close to the truth. It's pretty clear that Sedgwick's role in Warhol's art and life has been overstated. There were only four months, really, when she was at the heart of Warhol's creative world: From *Poor Little Rich Girl*, in late April of '65, through *Outer and Inner Space*, the video piece, in August. Even socially, the fact that endless gossip columns noted their many nights out together doesn't mean that they had that much going on at other times. True friendships are rarely forged by the popping of flashbulbs. Sedgwick herself said that she couldn't stand just hanging out at the Factory unless there was some specific task to be accomplished: "If you stay there and don't work, it becomes rather terrifying."

Sedgwick had the luck to fall into Warhol's orbit at precisely the moment that his celebrity was exploding, guaranteeing her an outsize place in his annals, and in ours, that she might not otherwise have deserved. Warhol had the luck to have Sedgwick arrive at just the moment when her fancy name and eerie beauty could help pull the media spotlight in his direction, illuminating that new work of his called Andy Warhol.

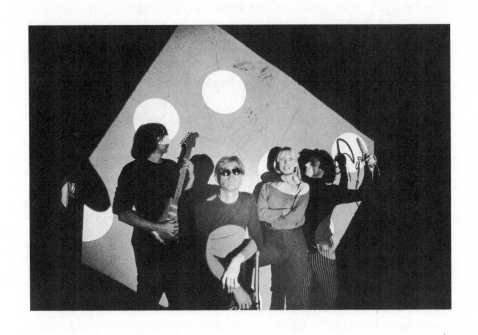

*. . . with stars from his Exploding Plastic Inevitable.*

## 28

# 1966

*"Despite his much-quoted wish to 'be a machine,' it
is doubtful, as a human being, that he has ever done
the same thing in the same way even once"*

Red-checked tablecloths, folding chairs full of splinters, floral wallpaper and
a stage with old curtains that looked like they came straight from a school
assembly—a sign outside proclaimed this to be the Polski Dom Narodowy,
the Polish National Home, and all that was missing was a polka band. Instead
the space hosted the "howling, throbbing beat" of the Velvet Underground,
accompanied by the latest in stage shows:

> The hall was a frantic fandango of action: the lights flashing on
> and off, the fragmented pieces of movies, the colored patterns
> and slides sweeping the mirrored walls, the steady white beams
> of balcony projectors, the Sylvania strip lighting writhing on the
> floor, flashing on and off like a demented snake who's swal-
> lowed phosphorus, the foot-long flashlights of Gerard Malanga
> randomly stabbing the darkened hall as he danced frenetically in
> front of the group.

And that's not to mention the bull whip Malanga squirmed with on-
stage, the eighteen woofers blasting three records at once (the evening's
posters promised "ULTRASOUNDS"), the Jazz Age mirror ball shooting

stars across the hall and, one week when the drum kit got stolen, Moe Tucker wacking at amplified trash cans which shed garbage each time she hit them.

Overlooking all this stood the unmissable figure of Andy Warhol himself, perched high on the balcony as the quiet new Lord of Misrule. When his art dealers had gone with him to spec out the Polish hall, they'd dismissed it as "a crummy, rotten, old place." That of course was catnip to Warhol.

At the beginning of April 1966, the Dom, as the venue was known, had witnessed the first appearance of the Exploding Plastic Inevitable, the name now assigned to the Factory's rock and roll spectacle. "It was a new kind of dancing—about being so high that people thought, 'I don't even need a part- ner, I'm just gonna twirl until I drop,'" recalled Mary Woronov, one of the Factory's own troupe of twirlers who were up on the stage with Malanga. "The audience became a part of the music by dancing. There wasn't anything like that before—all you could do was go to a cocktail bar that had a little piece of floor for the mambo or the twist."

For the rest of the month, the show pulled in an audience that was becoming the typical Warholian mix. There were slumming jet-setters such as "Flor, daughter of the late Dominican dictator Rafael Trujillo" and "Sharon McCluskey, a post-debutant in aqua chiffon and chinchilla." But there were also undergrounders like Eric Emerson, a gorgeous hair- dresser and dancer who got drafted into the show at once. "He really was the best dancer we ever saw," Morrissey recalled. "Did the ballet. He went up in the air, and Gerard was so jealous. He was doing it on the floor, and then we put him on stage." Also in attendance was a young John Waters, just launching into film and newly kicked out of his NYU dorm for pot smoking. (At the Dom, mattresses covered a side room that was dedicated to the comfortable consumption of marijuana.) As news got out, cultural royalty such as Dalí, Ginsberg and Rauschenberg also began to show up alongside the "carriage trade" in their limousines. "People came down there for the whole event, not just for the band," said one music insider. "It was the whole package."

That "package" was a new "total art form" that Warhol was promoting, where everything in his orbit, including himself, was up for grabs as part of his aesthetic product line: The Factory's superstars were on stage at the Dom, its band provided a soundtrack, any number of its films played behind and onto them, slides of Op abstraction got projected overtop while the frantic light show counted as the latest in "kinetic" art. Warhol was creating

a *Gesamtkunstwerk* that did Wagner proud. (Or saw him rolling in his grave.) The Exploding Plastic Inevitable was billed as "Warhol's latest work" when it got written up in one art magazine. "Since I don't really believe in painting anymore," Warhol said, "I thought it would be a nice way of combining music and art and films together."

But Warhol's paintings did have a place in the mix, if only as collateral used to secure the venue, run by the film buff who had premiered *Empire*. How better for a Pop artist to use the "dead" medium of painting than as all-American capital?

"Andy was pretty much the focus of the whole thing, and they were there more to see what he was up to," said Moe Tucker. "We were getting an older artist type of crowd. Most of the shows were played at galleries or art shows." As usual, Warhol had figured out precisely where he needed to be if he wanted to register as being on the cutting edge. And as usual, he knew he'd gotten there because others had already started to stake out the terrain.

At the end of October 1965, Jonas Mekas had run a wordy ad in the *Village Voice* for his upcoming festival on the very latest in "recent experiments to expand the dimensions of cinema":

> The programs will explore the uses of multiple screens, multiple projectors, multiple images, inter-related screen forms and images, film-dance, multiple exposures, hand-held projectors, balloon screens, video tape and video projections, and light and sound improvisations.

The list of artists involved read like a dream team of the American avant-garde—Stan Brakhage, Jack Smith, Al Hansen, Dick Higgins—and Warhol must have been very pleased to see his name included. He'd already dipped his toe in these waters with the projection of his films, almost as light shows, at various parties and photo shoots. He'd also been present at the "Lightworks Laboratory," a series of loft parties where radical lighting effects and pop music came together for the first time. (Warhol had started to borrow the "Lightworks" name at the Dom, until a lawyer's letter convinced him not to.) When Warhol first adopted the Velvet Underground as the Factory band it was as much about taking another step toward Mekas's "expanded cinema" and multimedia disco as it was about breaking new ground in music.

With their performances in and behind avant-garde films, the Velvets

had already started to explore this same territory in the weeks before they met Warhol. Barbara Rubin, who had first flagged them to the Factory, had been expanding her own cinema into double screens and colored gels for something like nine months. According to Moe Tucker, all this had come together for Warhol that night he first saw the Velvet Underground at the Bizarre:

> Apparently he had been looking for a band to play with this idea of having a multimedia show. I guess you can call it a show. And Barbara Rubin thought we would fit the bill. Andy liked us immediately and we just talked about his idea for the multi-media show, which, at that time, was still just an idea. Then he asked us if we wanted to do this, and we agreed.

The psychiatrist's dinner had acted as a low-risk proof of concept. Its coverage and even (or especially) the groans of its audience proved the show's potential as a Next Step in Warhol's everlasting quest for the new. "Despite his much-quoted wish to 'be a machine,'" wrote one canny writer at the time, "it is doubtful, as a human being, that he has ever done the same thing in the same way even once."

The successful first test at the Delmonico got Warhol to move the show, in early February, to a Mekas venue called the Cinematheque where it could get a proper art-world dry run. (This is where the Velvet Underground had already performed as the live soundtrack for underground films, some three months earlier.) After finding a decent reception at the Cinematheque, the show went on the road to see how it might fare in "the provinces"—in this case, film festivals on campuses in nearby New Brunswick, New Jersey, and far-off Ann Arbor, Michigan.

In New Jersey, at Rutgers University, the Velvets rented a PA system (for $131.25, as Warhol scribbled in his notebook; he also kept track of the band's heroin costs) and coaxed a performance from it that left one writer impressed, or possibly tortured: "Their sound—punctuated with whatever screeches, whines, whistles and wails that could be coaxed out of the amplifier—enveloped the audience with disploding decibels, a sound two-and-a-half times as loud as anybody thought they could stand."

The show had one especially notable outcome: It was when Billy Linich decided to become Billy Name, after seeing his real name on a poster for Rutgers and deciding it didn't look like what a star should be called. "So there was a form on the desk where I was sitting at the Factory and it had

'Name_____Address_____Telephone_____,' so I was just fiddling with a pen and I wrote Billy on the line and then stopped. And I said, 'Billy Name, that is a great pop name,' and I said 'Andy, next time we do a poster, put Billy Name.' And he said, 'Oh Billy, that's so cute, how'd you think of that?'" The new appellation, Name recalled, was "a way to relate to all the attention that came to the Warhol Factory without having to be a real person"—his way "of doing a Warhol."

Accounts of the Michigan trip, which came just a few days later, make it sound as though almost the entire Factory got packed into a rented RV with a bad alternator and a broken toilet—not the most comfortable of arrangements, especially given that Nico was driving and there was little to show that she knew how. (She had spent time in Britain, so she sometimes chose to drive on the left.) The writer John Wilcock went along and he described a "whole gang" of others: at a minimum, the four Velvets (who practiced at full volume inside the RV, thanks to the vehicle's spare generator), Nico, Warhol, Malanga, Danny Williams and Ingrid Superstar as well as Barbara Rubin and a friend who were there with movie cameras. Nat Finkelstein and Stephen Shore also went along to shoot stills. In Ann Arbor, the Velvets closed their concert with a never-released piece called "Nothing Song" that was very much something: A just about endless, ear-piercing stream of "noise and feedback and screeches and groans from the amplifiers." As Lou Reed remembered, "The effect of sound that it produced just vibrated all through the audience and through the hall . . . and they walked out onto the street and for about 15 minutes they still had these vibrations in their ears from this music."

Reaction to the show was split between those who called it "New York garbage" and others who couldn't get enough of its trash. A couple of "punky kids" in the front row rolled around on the floor like epileptics.

"If they can take it for ten minutes, then we play it for fifteen," Warhol is supposed to have told a student paper. "That's our policy. Always leave them wanting less."

The Michigan road trip must have reminded Warhol of the drive to Los Angeles for his Elvis show. Locals reacted with the same suspicion in '66 as they had in '63: Someone called the cops one afternoon when the RV stopped to feed its resident freaks. The police showed up again late one night when the vehicle's electricals died in Ohio. "Everybody was out of the bus to stretch our legs," recalled Moe Tucker, "and the next thing we know there's State Police surrounding us, saying, 'Who's in charge here?' Someone said, 'Andy . . .' Someone else said, 'No, don't send Andy out!'"

The officers made Warhol and his posse head straight for the county line by the light of headlamps hot-wired by Danny Williams.

———

Warhol always liked to say that his various projects were about finding ways to keep "the kids" out of trouble: "They're so many, and they are all so sweet." The Exploding Plastic Inevitable may truly have been a make-work project for idle hands. As Warhol's celebrity took off, the Factory seemed to be facing a population explosion. Malanga had brought a number of attractive young women into the fold. There was Mary Woronov—soon given her Factory name of "Mary Might"—a tall boyish student with a Slavic, quite exotic beauty who sped up her life with help from her mother's amphetamine bottles. She was acting and studying art at Cornell University, in upstate New York, when Malanga picked her up after a poetry reading early in '66. He used Warhol's Bolex to film her, with evident adoration, out on a nature walk. ("But we were not fucking, you know," she has taken care to emphasize. "I didn't have sex at the time. I was a total fucking virgin.") Woronov eventually showed up at the Factory on a studio visit with her art class and then didn't leave for another few years. She became known at the Factory for being as tough and uncompromising as Ondine, and, amazingly, for actually learning her part when Warhol cast her in a movie: "I memorized my lines because I wanted to be an actress, but no one else did. They wanted to be stars."

By the summer of '66, Woronov was already enough of a Factory fixture for Malanga to feel he was losing her, and to complain to Warhol about it in one of his typically petulant letters: "I felt an infringement when you wanted to have Mary as an escort to attend dinner at the Copleys. I always thought the socializing part was my dept. I was seeing Mary long before you had any connection with her."

Malanga's other Factory import was a seventeen-year-old debutante named Susan Bottomly, who he had brought back from Boston after a visit there. She was a slim brunette with a natural, all-American beauty that had already won her a magazine cover. But once she became part of Warhol's entourage—as International Velvet—she tried to make herself more exotic. By the time she showed up with Warhol at a survey of his art in October, she had become "a tall, ominous, conical girl who looked like a chic hangman . . . her face done in a deathly coffin pallor, her eyes sooted with kohl and fringed with lashes that might easily have been mistaken for the cat's whiskers."

Both Woronov and Bottomly found Factory employment, of a sort,

onstage beside the Velvets, as did other new Warholians such as the faux-Edie Ingrid Superstar, the young artist Ronnie Cutrone and the dancer Eric Emerson.

Danny Williams, who by now had moved from Warhol's home to the studio, was kept busy working on the rock show. The time he'd spent on film sets had made him a skilled electrician and a dab hand with a soldering iron; the E.P.I.'s fancy stage lighting was mostly his creation. It's hard not to think that amphetamines played a role in the pleasure he got from flashing lights and in the endless hours he spent designing them. Some of the diagrams he came up with to control the effects of his custom gear are so frantic they look like Jackson Pollocks. His newfangled strobes became an E.P.I. signature and were particular favorites of Warhol's. (They were also where Williams stashed his drugs.) There were still signs of closeness between the two men: In an interview they gave while the Dom show was going strong, Williams made it clear that they'd recently been sleeping together. Warhol was not happy discussing it.

The public already had rumors of the Factory as a speedy, trippy space. The E.P.I. made that image more concrete by putting it onstage for everyone to see. By taking his show on the road, Warhol could test what it would be like to give the Factory scene a new kind of public exposure, in the flesh, beyond the in crowd who knew it in New York. Warhol himself had taken on his new leather-clad public image—he's in his biker's jacket in most photos from the E.P.I. trips—and now he was recasting the image of his Factory to match. No one knew it as the hardworking studio it really was; in the popular imagination it became a mythic party place. As the E.P.I. toured it acted almost as the recruiting arm of the Factory, welcoming kids from the provinces into the fold: Warhol's next boyfriend, Richard Rheem, came onboard after a show in San Francisco; the teenager Susan Pile, who Malanga teasingly came to call his "little secretary," became a Warholian after seeing the Velvets in Chicago.

Almost two decades earlier, back at Tech, Warhol's teacher Balcomb Greene had talked about how the little-*a* art found in Frank Sinatra or Popeye depended for its excellence on the big-*A* Art of the avant-garde. He ended his course with a lecture insisting on the duty of the fine artist to energize popular culture: As his notes put it, "With the increased leisure which democracy provides—if entertainment does not provide more positive satisfaction (more approach artistry) the human animal will deteriorate."

With the E.P.I., Warhol could have proudly insisted, *pace* his critics, that he'd kept the decline of our species at bay.

———

As Warhol promoted his new band and its show, he must sometimes have felt like a bank teller, passing out cash to all and sundry.

His datebook page for Ann Arbor might as well have been scribbled by an accountant:

100—Nico
350—cash
150—CAR
8—Barbara
15—Danny
5—Sterling
5—Barbara
25 maureen
50 Paul
25·Gerard

It's hard to know whether to commiserate with Warhol for all those outgoings or wonder why he couldn't bring himself to pay out a bit more at a time.

Commiseration is probably more in order. The Factory was presenting him with ever more lunches and dinners to buy, more movies to shoot and develop and print, more amplifiers and drum-kits to procure, more gofers to pay. (If only $30 a week in the case of "Little Joey" Freeman, the fifteen-year-old who settled in at the Factory around the time of the Velvets' arrival.) Yes, Warhol was a cheapskate, according to just about every witness. Freeman said that whenever he came back from buying takeout at the local Burger Flame Warhol would eyeball the change he got back; the Factory boss would spring for a taxi only when an errand simply could not be run by subway. But that penny-pinching would have been easy for Warhol to justify. His ledgers for 1966 show just over $38,000 in income from fine art sales—still only half what he'd gotten seven years before for his illustrations—plus maybe another $5,000 in movie rentals and screenings. And then there were fully $32,000 in business expenses to be deducted from that. (Although Warhol traded art for much of the Factory's office equipment and AV and lighting gear.) He could afford to pay himself all of $7,000 in salary.

For the first time, commercial illustration could not come to the rescue. Nathan Gluck's output of blotted drawings came to an end early in the

New Year, either because the market had evaporated for such '50s stylings or because Warhol could no longer stand having his name attached to them. He didn't completely give up on the notion of a commercial income, but his efforts in that direction were on the unlikely side. That spring, he got some kind of contract to decorate a delivery van for Dannon yogurt, which had been trying to find a new market beyond "health faddists" and "calorie counters" and must have figured that Warhol would lend them a dose of hipness. A few records of the project survive but there's no sign it went anywhere or paid off.

Warhol seems to have imagined an even more improbable income stream coming from the sale of a pin-on button decorated with his line drawing of an actual coat button, complete with dangling thread. It was featured as "the in pin everybody's grabbing for" in the August issue of a magazine laboriously titled *In: For the Girl of Today, the Woman of Tomorrow—The Magazine That Shows You How to Be In.* (If you had to read it, you weren't.) But it doesn't look as though Warhol's 25 percent share in the proceeds paid many, if any, of his bills.

And then there were some attempts at avant-garde TV commercials—an oxymoron if ever there was one, yielding no successes for Warhol.

In the summer of 1965, Ira Sturtevant, the ad-man husband of the artist Elaine Sturtevant, had gotten Warhol working on a laxative spot. Filmed almost as a Screen Test, it showed an expressionless model holding the product under the light of a slowly flashing strobe while the camera gradually zoomed in on her. In voice-over, a somber man played Greek chorus: "New Cadence is the light laxative for constipation so often caused by tension, nerves or irregular living. I repeat: Cadence is for constipation so often caused by tension, nerves, or irregular living."

The spot deployed at least some of the strangeness of avant-garde film, which of course guaranteed it to fail when it got a test run in Maine. "I think it stinks" was the confidential opinion of one agency man. "Ira wants to use this to get attention for this product. The problem is that (from what we know about our buyers) they are little old ladies. They're not the avant-garde. . . . It's a big risk—going from something which has been tested (even if it isn't particularly new) to a complete unknown."

That failure was followed by the mostly failed commercial for the Plaza 8 lingerie line that Warhol shot the following spring with Danny Williams.

Toward the end of '66, one of New York's hottest agencies, called Grey Advertising, got in touch with Warhol already knowing that the ad they

wanted him to shoot for them would be unusable. A young staffer named Richard Frank, who was supposed to organize the agency's lunchtime screenings of directors' sizzle reels, instead got permission to ask Warhol to come in and demonstrate, live, how he might film the most avant-garde ad he could imagine. Invited to "sell" any product made by a Grey client, Warhol chose the painkiller Bufferin and proceeded to reveal maximum weirdness to the mobbed room of ad workers. One December afternoon, he positioned Malanga, Woronov, Baby Jane Holzer and eight more of his followers around the conference table in the room's center, in front of a 16 mm projection of old Screen Tests plus two video monitors that ran a test version of the Bufferin ad that Warhol had shot the day before. (Poor Frank, terrified that Warhol might pull a no-show at the lunch, had wanted to be sure to have something to screen for his bosses when the time came.) Warhol and Morrissey, each wielding an Auricon, then proceeded to document this "mixed-media event" while members of their cast improvised paeans to Bufferin. "I like Bufferin better than Coca-Cola," said one, as though updating the roster of brands in Warhol's Pop Art. "I just took two, and there was no stomach discomfort at any time," said another, passing judgment on pills that were different from the usual Factory fare.

"It was one of the most exciting events at Grey Advertising—you couldn't get through the door," recalled Frank. It also lost him his job. Frank had sold Warhol on the project by describing it as a way for the artist to get a foot in the door for ad work. When, not surprisingly, Grey did not come through as a client, Warhol began to screen his Bufferin footage as art. Frank could not make him stop and had to take the blame at the agency.

––––––

Given his commercial disappointments, Warhol's enthusiasm for the Velvets can be seen in a new light. Their week at Mekas's Cinematheque had brought in almost $5,000, and even if a lot of that income would have gone toward expenses—and was spread over fourteen performances—it still looked like there might be room to grow, especially in a less esoteric context and venue.

Once Warhol moved the show to the (relative) big time of the Dom, it was a popular hit, at least by East Village standards. An audience of four hundred let them gross $1,000 on a middling-good night, about the same as they'd seen on the road at Rutgers. Sometimes the club would sell all 750 tickets. That didn't leave a vast take to divide between so many players but was still the equivalent for Warhol of selling several new paintings each week.

At some point, Warhol and the Velvets met up at the Apollo Theater in Harlem for a concert by James Brown, one of the few pop acts that could rival the Velvet Underground for sheer disruptive energy. The vast crowds that he drew, and the much-publicized $70,000 he earned in one week, must have made Warhol hope for big things from his own new band if only they could score with the public.

Another James Brown factoid that was well known: By the time Warhol and the Velvets saw him, he'd sold 24 million records. They would clearly need to release one.

This was where Warhol's role as "manager" came into play. He'd already paid for new amps and instruments for the Velvets. He'd provided rehearsal space at the Factory and then performance opportunities at the Dom. Now he took a bit of his income from their gigs—maybe $700 or so, plus a minor silkscreen that he gave in trade—and spent it on getting them access to a modest recording studio, with a technician, for a few days at the end of April. The goal was to produce an album's worth of tracks that could be shopped around to any record company that was even marginally likely to sign a group like the Velvet Underground.

Once the band was in front of the mikes, Warhol's input on the music was somewhere between minimal and zero. He might not even have shown up all that often at the sessions, and when he did he was most taken with the flashing lights on the soundboard. Warhol liked the music just fine—the band would make him reel-to-reel demos that he'd listen to on his Uher as he taxied to work—but his vital contribution came in championing the Velvets' radicalism, as Lou Reed once recalled:

> He pulled me aside. He said, "Whatever you do, don't let them change it—don't change the words for them. Don't let them change it—don't try to clean it up or anything. Keep it the way it is." And so when we were there with these guys, they'd say, "Well what about the blah blah blah," and, "What do you think, Mr. Warhol?" And Mr. Warhol would say, "Oh, it's great the way it is." And that would be it. And because he was who he was, they did. If it was just us, there's no way it would have gotten through, but because he was there, it did. Plus these guys didn't like the music in the first place.

Warhol understood that the Velvets' true aesthetic achievement depended on being un-user-friendly—as un-user-friendly as a silkscreen of a suicide or a six-hour film of a sleeper. Without the keening of Cale's viola, or

the full squawk of Reed's guitar or lyrics about heroin and S&M, the Velvet Underground was just another rock band. David Bowie recalled his reaction when he first heard a test pressing of their album that had made its way to England: "I was so excited I couldn't move." Record-company reactions to the Velvets' recording also proved Warhol right, at least in terms of his avant-garde training.

"There's no way in the world any sane person would buy or want to listen or put anything behind this record," said the execs at Columbia Records. "You're out of your mind with this."

Over at Elektra, Reed recalled, the bosses declared both the lyrics and sound to be unacceptable. "This viola—can't Cale play anything else?"

Once again, as so often in Warhol's supposedly sold-out career, his desire for an artistic yield outweighed his yearnings for profit.

Reed claimed that when the Velvets finally did win a contract for an album, with MGM in early May, it didn't have much to do with the band's own appeal. It happened because Warhol agreed to supply the cover art. But rather than indulging in safely playful, salable Pop Art, as MGM must have hoped for, Warhol's famous record jacket aligned the Velvets with the hard-edged queer culture that the Factory was coming to represent. Warhol gave the album a plain white cover whose only decoration was a yellow banana skin applied in vinyl across its entire front; buyers were supposed to peel that skin off, foreskin-wise, to reveal a phallic-pink fruit floating proudly above Warhol's name. (The band's name got relegated to the back cover.)

Did that uncompromising graphic, along with the uncompromising talent of the band, help *The Velvet Underground and Nico* sell its almost respectable sixty thousand copies? Or did the unbending extremism of both cover and music keep it from selling five million? According to Moe Tucker, once the record was released, almost a full year after the contract for it had been signed, the band's label hardly made an effort to promote or distribute the insolent album. "I don't know why they signed us," said Tucker. "To keep us off the streets? It was a mystery. I mean, why did they sign us? For tax reasons? So they could write us off?" Fans could barely find copies, said Tucker, although that might have made it mean even more to those who did.

"It became the Rorschach test for who's cool, who's not," remembered one Velvet-een who drove from Austin to San Antonio to buy the record. "'Can you take the Velvet Underground, man? My, we *are* provincial.' The merest doubt and you're out. 'Don't darken my door again, and wipe off your chair as you get up to go—which I understand you're doing now.'"

The album's iffy lyrics got it banned from almost all radio stations, so that it only limped to 171st place on the *Billboard* charts. Over two years it paid all of $22,000 in royalties, to be split among a whole crowd of creators. Warhol's management company, incorporated as Warvel, took home one-fifth of that, barely enough to offset some expenses and just possibly make a tiny profit.

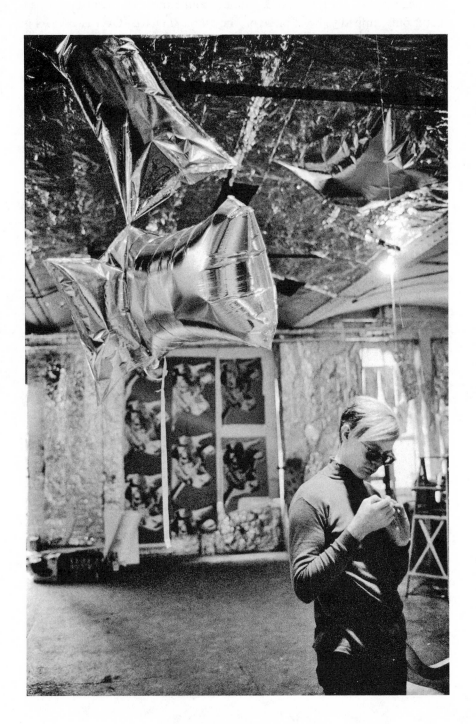

*. . . with his Cows and* Silver Clouds.

# 1966

## SILVER CLOUDS AND WALLPAPER COWS | JULIA WARHOLA AT HOME, AND AILING | RICHARD RHEEM MOVES IN, THEN OUT

*"I'm not doing paintings any more. I think I'll glue together some of the parts of old studies I did and sell them as whole paintings to get the money"*

X-CHANGE: You feed the factory. Supply the Warhol Works with items negotiable, well-used, or new (Technical equipment, free good dinners, terrific clothes, film, lights and work, what-have-you or what-are-you) ANDY WARHOL will certify your WAR-HOL WORK with his signature. For appointment call EL5–9941.

That classified ad appeared in the *Village Voice* in the spring of 1966. It gives the impression that, in his search for operating funds, Warhol had been reduced to treating his signature as a product to be bartered. But of course the ad was not a serious attempt to stock and feed the studio—Warhol had substantial industrialists (and restaurateurs) who he bartered with for that. The paragraph in the *Voice* was really the most public of artist's statements, proclaiming that any object or action in the world, maybe even any concept or entity, could now count as a work by Andy Warhol, at least once it had earned his signature by "feeding"—by becoming absorbed into—his Factory. One smart critic immediately read the ad, correctly, as "the most literal statement to date of Andy Warhol's message: That Art and Life are Interchangeable." That is, it was a broadside fired at any of our standard ideas about art, including the ones that had made painted canvases, or even silkscreened ones, count as uniquely valuable goods—the kind of uniquely valuable goods that were the source of funding for all the Factory's other

activities, as Warhol himself admitted. Yet his dedication to vanguard ideas left him happy to kill his one guaranteed income stream just when his dealer was announcing that Pop paintings were selling for ten times their prices of a few years before.

"I'm not doing paintings any more," Warhol said, in the spring of 1966. "I think I'll glue together some of the parts of old studies I did and sell them as whole paintings to get the money." But even that was too much of a capitulation to the old medium, as became clear with Warhol's second Castelli solo, a painting-free show that opened the week before the Velvets first appeared at the Dom in April. The Flowers exhibition had happened eighteen months before, and its endless repetitions had undermined the grandeur of painting even as it provided plenty of paintings for Leo Castelli to sell. This time, Warhol refused to pull punches or, more bravely, to replenish Castelli's stock. In the gallery's back room, the only "art" on view consisted of some comical yellow wallpaper industrially silkscreened with life-size cow heads in pink. Some critics had spotted, and attacked, the reference that his Castelli Flowers had made to interior décor; now Warhol made that reference the unavoidable, irrepressible content of his art.

The project had been triggered by the "poignant and pungent" imagery in Ivan Karp's own ironic collection of cow paintings, or so the dealer claimed, but as wallpaper the cows ended up becoming "something superpastoral, too large, too big, too ridiculous"—that is, something classically Warholian. (Another Warholian idea he pitched to a maker of wall coverings: "All white. All white paper.")

In the front room Warhol took nose-thumbing further. The walls of the room were quite blank but in its middle bobbed and floated a dozen or so pillow-shaped balloons, cut from a silvered plastic film and filled with helium. These were the so-called *Silver Clouds,* which counted as the latest in Warhol's hit-man strikes on painting: "I thought that there must be a way that I have to finish it off, and I thought the only way is to make a painting that floats. . . . The idea is to fill them with helium and let them out of your window and they float away." When the *Clouds* were eventually shown at the Ferus gallery in L.A., a few really did waft their way out the door.

There's a photo of Warhol playing with his *Clouds* at Castelli's while a fine Rauschenberg painting sits quietly in the background; that canvas comes off as an old maiden aunt who can't understand the youth of today. "I think painting is old-fashioned" was another insult Warhol leveled at the venerable medium.

"I really don't believe in objects," Warhol had insisted as he sat working on his *Clouds,* maintaining you could buy such inflatables "in a toy shop for practically nothing."

This was a fib. However much the *Clouds* were supposed to function as anti-art found objects, they were hardly an offhand conceit. Warhol had been figuring them out for quite some time and took them seriously as a project. The spark had come a full two years before when he was looking to collaborate with Billy Klüver, his engineer-friend who worked at the famous Bell Labs. Warhol's first idea was for the two of them to make a floating light bulb that glowed from inside, but Klüver discovered that the batteries would make it too heavy for liftoff. Warhol came up with the cloud concept sometime after that, when Klüver showed him a new silver film that 3M had developed to wrap soldiers' sandwiches. Klüver's attempt to cut the Mylar into a cumulus shape wasn't panning out when Warhol, the Great Simplifier, cut the Gordian knot: "Andy just folded a piece in half and said, 'That's a silver cloud.'" The pared-down shape made for a strong link to the minimalist sculpture that was just then hitting it big, but it also meant that the *Clouds* could be made right in the Factory, thanks to the simple heat-sealer Klüver's lab had provided. (Although in the end Warhol farmed out the sealing.)

The *Clouds* were first released (literally) on October 4, 1965, when Warhol and a crowd of acolytes launched a twenty-five-foot silver tube—or phallus—off the roof of the Factory and sent it "up to God, all the way up."

"Oh, it's beautiful, it really is—it's infinite because it goes in with the sky," Warhol said, caught on a recording that survives. "Oh, it is fantastic. This is one of the most exciting things that's ever happened."

As a good(-ish) near Catholic, Warhol's mind might have been unusually focused on the infinite by what was happening in the street below: Pope Paul VI was in New York on the first-ever papal visit to the United States, and he drove right by the Factory on his way from speaking at the United Nations. The troops of police guarding him were also focused on the Above—the city's rooftops, in particular—and were not amused to see a UFO in the sky. "All hell broke loose because they thought that we were trying to endanger the life of the Pope," said one Warholian in attendance.

Warhol's unrehearsed excitement over his floater hints that, like almost all conceptualists, his divorce from the "retinal" was always more polemical and intellectual than heartfelt. However much he slagged painting he could never quite give up on the pleasures of paint; the silver pillows, although intended to smother an old medium, also counted as an exciting new one. "They're very beautiful," Warhol said in one innocent, unguarded moment. "They seem to flow around and follow you." Rudolf Zwirner, one of Warhol's first German dealers, once sat in his gallery watching a roomful of *Clouds* bumping and grinding against each other, and suddenly recognized the delightful artistic orgy he was witnessing. Warhol's *Clouds,* he noted, clearly had their

own "social life." He also had another insight into them, and into Warhol's sophistication: He realized the *Clouds* were a close echo of a famous installation by Marcel Duchamp, who had once covered the ceiling of a Surrealism show in filthy coal sacks that were close to the same size and shape as the sparkling, floating balloons that were hovering by Zwirner's own ceiling. That connection and its reversals—from heavy, dark coal to light, bright Mylar—confirmed the dealer's view of Warhol as supremely intelligent and knowledgeable in the most old-fashioned, almost bookish sense. Warhol, the dedicated student of Duchamp, might have planned the echo from the beginning of his work on the *Clouds,* but if not he must have noticed it with their first test flights.

Within a few weeks of the Papal visit, a press release included a cryptic, teasing reference to Warhol's "Up Art, a new secret art form." As "floating sculpture" (the Factory's preferred term), the *Clouds* counted as part of the hot new Kinetic Art movement that was just then getting going. As early as 1961, the German collective called Zero had released a huge, clear balloon over Düsseldorf and, in New York, Warhol's friend Alfred Leslie had designed a helium-filled piece for an Amsterdam survey of kinetics called "Art in Motion." That show's splashy coverage in *Newsweek* gave shoutouts to Leslie himself and to Billy Klüver, who had consulted on Leslie's inflatable before he worked on Warhol's *Clouds.* By the middle of the decade, a notable young curator named Willoughby Sharp was knocking on museum doors with the idea for an exhibition called "Air Art," displaying inflatables of one kind or another by such future art stars as Hans Haacke and Les Levine and also Robert Morris, the minimalist who had been in the Green Gallery show that premiered Warhol's Pop.

Warhol's "floating sculptures" let him give a nod to this latest trend in new art materials, as one critic recognized right off. But as antipaintings allowed to float away, they also let him make clear that he knew better than to believe in that trend's old-fashioned, pre-Duchampian commitment to material objects. In New York, the Castelli Gallery, supported by the cerebral work of Jasper Johns, was home to the most serious of artistic philosophizing, which meant that by showing there Warhol could balance the role the *Clouds* played as frisky new sculpture against their function as caustic conceptualism. Despite the literal lightness of the *Clouds* they also counted as Warhol's weighty elegy for painting, even for art as a whole. Where one critic could write off Warhol's second outing at Castelli as "a pleasant little show," another could claim that it utterly ruled out "happiness or joy, even pleasure." That's classic Warhol, marrying irreconcilables.

The clever critic Robert Pincus-Witten—the young lover who had

apartment-shopped with Warhol a few years before—had made the connection between the Castelli show and that *Village Voice* ad for Warhol's signature on all kinds of goods. He recognized that Warhol was denying art as a unique and superior category, and also that there was trouble in store for any artist who denied the validity of art and still went on to mount a solo in a famous art gallery. He called it "the hypocritical position [Warhol] has suicidally forced upon himself." In the art world in 1966, with its mounting doubts about every one of art's institutions, there could hardly have been a more exciting position to be in.

The *Silver Clouds* had cost all of sixty-five cents each to be sealed and another few cents for the Mylar. Warhol, convinced they could be made to count as serious art, thought they might sell for $550 each—close to the current price of one of his Electric Chair canvases—and had ordered almost one hundred made right off. "You really think you will get away with something like this?" a reporter asked, when the price came up. "Yes," Warhol answered. His dealer disagreed. Castelli decided on a markup of no more than 5,000 percent, to a grand total of $50 for each *Cloud*.

The opening was a success: Security guards ("Pinkerton men") had to be stationed to do crowd control. But as visitors filed through they clearly weren't buying, even at such discount prices. Although the gallery sold thirty-four of the *Clouds* over the course of 1966, Warhol only earned some $400 as his share. That meant that his *Clouds* aped mass production but never actually convinced the masses to want them; they let Warhol play the role of art-world sellout without actually selling. The Cows, available as wallpaper rolls and single heads, did a bit better: They let Warhol take home about $1,300, although that was barely more than they cost to have made.

Maybe he earned a few extra dollars when *Vogue* used his *Clouds* as props in a fashion shoot, or it could have been enough for him to know that these gallery-born "paintings" could and did have another life in popular culture.

---

Wallfulls of goofy cows, bushels of bouncing balloons, bleach-blond artsies playing with whips as flashing lights danced across them—the word "corny" just has to apply to some of what Warhol produced in the middle years of the '60s. His production certainly broke every rule for what counted as serious art, even according to the much looser definitions ushered in by Pop—maybe even by the Jeff Koons standards of fifty years later.

Earlier weirdos, like those at the Judson, had always had an edge to their weirdness that gave it heft and cut it off from the ease of popular entertainment. However you judged their performances, they clearly belonged

to sophisticated high culture. Whereas by 1966, Warhol's strangeness had sometimes become easy to take: It was more wacky than transgressive. It feels as though Warhol now wanted to counterbalance or even camouflage the real aggression of some of the Factory's products—the dysfunctions of its superstars, the raging distortions of its house band—with light shows and inflatables that could pass as transgressive for an audience that watched Ed Sullivan.

Lou Reed had been obsessed with the idea of returning to the "real" in rock: "To my mind, nobody in music is doing anything that even approxi-mates the real thing, with the exception of us . . . a specific thing that's very, very real . . . isn't slick or a lie in any conceivable way." That same "realness" was what had attracted him to Warhol in the first place, he said, but could it truly be found in what was going on at the Dom? On stage there, Cale himself had doubts about the cheesy palaver that was framing his rigorous modern sounds. Malanga's whip dance was a translation of scary S&M into the language of *Shindig!* and *Hullaballoo* and the other TV rock shows on which he had in fact once appeared. Warhol described his own leather jacket as a "tacky" discount-store item, meaning that he wore it as camp costume, in quotation marks, not because he thought it could make a substantial counter-cultural statement. He knew perfectly well that by 1966, the old Brando look could hardly do that anymore. Warhol must have had the same distance from a lot of the stage show he'd crafted for the Velvets. Even while the Exploding Plastic Inevitable was running at the Dom, a giant *Newsweek* cover story on Pop was describing that stage show in the same breath as the new "no-bra bra" and "a Pow! Bam! commercial for Life Savers." Warhol's lightworks were having a hard time counting as artworks.

Impassive and aloof, Warhol had taken steps to set himself up as the ulti-mate in cool. ("If the bomb went off, Andy would look up at the mushroom cloud and say, as he does in his moments of greatest excitement, 'Wow.'") Yet here he was at the Dom allowing all kinds of uncoolness to transpire in his name. The uptown and suburban clientele the club was starting to attract was widely billed as signaling the end of the neighborhood's bohemian era. "We really wanted to go out there and annoy people," said John Cale. "So what happened? We had Walter Cronkite and Jackie Kennedy dancing to it." This made it easy for the culturati to dismiss Warhol's more recent produc-tion as corny middlebrow fare. It might have been read as an especially bad sign when the Junior League of Cleveland decided that Warhol was worthy of its Award for Distinguished Contributions to the Cultural Life of America. (Warhol accepted the prize but declined to attend the reception and fashion show that went with it.) It was surely no better a sign when the good burghers

of Ocean City, New Jersey, asked Warhol to head up their annual Boardwalk Art Show and accept its Merit Award—as several prominent illustrators had already done, they assured him.

By the time of the Castelli Cows and *Clouds* and the Dom shows, Warhol would have heard that his dear old friend Henry Geldzahler had definitively locked him out of the roster of artists representing the United States at the Venice Biennale. "Abstract art continues to offer the richest stylistic possibilities," the curator had said in a public lecture and, in a major newspaper profile, had declared Pop to be old hat. But while it's true that he included several abstractionists on his list for Venice he also invited Roy Lichtenstein, Warhol's rival as King of Pop. The real problem with Warhol seems to have been less his Pop Art per se than his increasingly unserious pop-cultural profile. That posed a notable risk to Geldzahler's status at the very serious Met: "The trustees were very edgy about me. Andy then had the Velvet Underground and was starting the film thing. I knew that if I took him to Venice there'd be a fantastic amount of publicity." Geldzahler's more conservative model of art could include a "straight" Pop painter like Lichtenstein but couldn't expand to include a Pop—or pop—*figure* like Warhol. The gap in ideas led to a deep freeze between the two friends that was subject to only occasional thaws.

If only Geldzahler had been a bit more flexible in his thinking, he might have seen that a half decade of careful artistic maneuvering had let Warhol suggest a different way of reading his mass-cult appeal: That by dint of sculpting his persona into a work of user-friendly Pop Art, he had also become his own pop-cultural subject. He himself, that is, was now the "low" soup can or comic book that he could put inside the quotation marks of Pop Art and elevate to the status of high irony. If Warhol and his Factory product could sometimes be called out as crap, Duchamp's toilet continued to transmute it into gold. And like all transmutations, Warhol's could make an impression only if it worked its change on the basest of materials. (Alchemists' gold mattered most because it had started life as ignoble lead; a move from silver to gold would hardly have impressed as much.) The *Silver Clouds* had to risk being trite novelty items if they were also going to spell out the Death of Painting. The Velvet Underground maybe needed an added note of exploding plastic corniness if Warhol's involvement was going to turn the band's low pop culture into high Pop Art. The transformation seemed to work: The impresario Gian Carlo Menotti began angling to bring Warhol and the Velvets to his elite festival in Spoleto.

"Andy Warhol" may have promoted some banal popular culture. Andy Warhol, the brilliant artist inside those quotes, could be counted on to turn it into art.

———

"Once we were in the Factory, the house was off-limits." That was how Gerard Malanga remembered the change he saw in Warhol's social life over the first years that they knew each other.

In the early heyday of Pop, Warhol's strategy had been to fold the people who mattered—de Antonio, Geldzahler, Karp, even the Sculls—into his eccentric existence in his town house. That had been his approach in his very first months in New York, when he'd invited his first contact at *Glamour* to visit him "any time" in the "very arty place" he shared with the lesbian dancer and her nudist partner. His doors had been even more open in his home on lower Lexington, especially once he'd fancied up his new parlor floor with Danish teak and Austrian bentwood. That all changed, drastically, once the Factory took off and Warhol moved on to living a life that was relentlessly public. To see Warhol—and you now *could* see Warhol, whoever you were—you went to wherever he happened to be, at a party or nightclub or the occasional Factory do. His home, on the other hand, now became a private space, with admission granted only as "a truly rare privilege," according to a Factory regular who was there for a few hours in 1966. Over the next two decades, ever fewer people gained access to Warhol's home life.

You might say that Andrew Warhola, or what was left of him, needed occasional shelter from Andy Warhol, the almost fictional creature who turned up on TV and in the press. Julia Warhola was the one other person who was a constant presence in his town house sanctuary, and Warhol kept her more and more to himself even as he was around less and less. "My son Andy is at home very little, he works a lot, he travels a lot on the airplane, he often goes to play music with the band," she complained in a letter to relatives. Her two remaining Sams plus Echo, the mynah bird, would have been her most reliable companions, especially once Nathan Gluck had done his last work for Warhol in early 1966.

It looks like Warhol's mother still cooked and kept house for her son, at least when he was there to be taken care of, but the caregiving started to go the other way too. As she advanced into her seventies her health continued to decline. The medical problems that Warhol had mentioned to Eleanor Ward only got worse in the following years. By Christmas of '64, a friend was sending good wishes to Julia Warhola after her recent stay in the hospital; Malanga remembered visiting her there with her son. Nine months later, Warhola's doctor was letting her know that her "moderately advanced pulmonary tuberculosis" looked like it was healing—good news that pointed to a crisis that had passed. (Although the illness triggered regular visits to

Warhol's house by the Department of Health.) And then she was back in hospital again for a month in mid-1966, after she came home one day and fainted, with blood pouring from her nose.

Warhol's mother certainly would have found some friends—or at least social contacts—when she made her regular Sunday trip down to her Greek Catholic church, a full seventy-five blocks south of their home. (Warhol chose not to join her, at least when Pittsburgh relatives were in town to do that duty.) She might also have found comradeship among the Rusyn speakers in the immigrant neighborhood around the church, where she liked to shop for familiar foods from the Old Country. But uptown, during the week, Warhol would have been pretty much the sum total of her safety net, responsible for any care and caring she was likely to get. Although she was a director of Andy Warhol Enterprises, Inc., and five-figure checks were regularly made out to her from the Factory's corporate accounts, they were almost certainly part of an accounting fiction. It's unlikely she saw or wanted or needed that kind of cash: Her annual donations to her church were in the $100 range as were the amounts she sent to her kin in Europe. Warhol made sure she had money for all such expenses and also to spend on shopping trips to the supermarket across the street. It's said that she didn't like to go further afield, since the streets north of them were starting to get dangerous.

"I'm not really that close to my mother," Warhol confided to one friend. "A lot of other people like her better, get along with her better, enjoy talking to her more." That's not as shocking an admission as it might sound. It's clear that the charming, harmless babushka that other people saw and enjoyed in Julia Warhola didn't capture the powerful impact she had really had on Warhol's life, or the complex feelings she engendered in the artist-son she helped create. If he once admitted that she was "so-o-o interesting," that probably made her more of a problem for him, not less.

In the 1950s, he—and she—had taken advantage of people's underestimation to turn "Andy Warhol's Mother," the innocent and charming Czechoslovakian peasant, into a force in his commercial career. Her award-winning faux-folk script was almost as popular as his images; some clients had their business stationery done up in her scrawl with no contribution at all from Warhol. With the arrival of all-American Pop Art, however, her persona got dropped, at least from Warhol's own fine-art repertoire. Warhola still seemed willing to inhabit that persona, at least one more time, when she was interviewed for an *Esquire* series on famous people's mothers. She went full babushka, recalling her Old Country marriage in the 'teens ("A day and a half with my mama; a day and a half with his mama") and her arrival in New York in the '50s ("Andy go to New York by himself. I prayed,

God, oh God, help my boy Andy. He no get job. I help him with a little bit of money. Later I visit him. One time, two time, third time. I stay.") It's telling that when the piece appeared, in late 1966, rather than reveling in his mother's peasant image Warhol was now angry that the reporter hadn't cleaned up her English into something less countrified. He complained to his brother John that it made her seem "completely mentally deficient."

Just weeks after that profile of his mother hit the newsstands, Warhol decided to do one of his own, as a color movie shot in his home on his trusty Auricon. The film is now known as *Mrs. Warhol* but it was originally called *The George Hamilton Story*, riffing on the well-known relationship between that actor and his oft-married mother. Warhol got his own mother to play the role of Mrs. Hamilton, although reconceived so she was not just divorcing her spouses but murdering them. As with all the other Factory "scripts," this one was just a jumping-off point for improvisation. Julia Warhola leaped in with glee. On screen, she switches back and forth between her fictional role as a dispatcher of twenty-five husbands and her real(-ish) persona as the film-maker's old mother. "I'm too old for you; you're just keeping me for cook," she says to the very young man playing opposite her as her latest spouse, and "If you be good husband, I always make you scrambled eggs." She admits to having had fifteen earlier spouses, saying that she has "been looking for another one . . . with one leg, so he can't beat me." In her role as Warhol's mom, she mops up spilled juice and shows her young "husband" how to iron undershorts. In front of the camera, Julia Warhola seems to display the same unusual mix of canniness and naiveté, sophistication and simplicity, that her son developed into an artmaking tactic.

The Warhola film was never given a public screening, no doubt because of the glimpse it gave into Warhol's domestic life. Not only did it display Warhol's mother and his town house (no other production had been set there since that one reel with Taylor Mead and his speed), but it revealed that boyfriends could also be part of his household. Julia Warhola's "husband" was played by a young man named Richard Rheem who was actually living with Warhol when the filming happened. Those seem to be his underpants that Warhola was ironing, raising the question of how clueless she really was about her son's sexuality. Malanga felt that she knew what the score was but chose to ignore that reality.

---

Richard Scofield Rheem II was born into California's Rheem Air Conditioner family, and Warhol met him in San Francisco on a trip in May 1966, at a party given by Rheem's artist uncle. Richard Rheem was a looker, with full,

sensuous lips and a boyish Christopher Robin haircut, and Warhol had suggested that the twenty-year-old should come to New York and star in one of his films. If the offer was offhand on Warhol's part Rheem certainly took it seriously. He wrote twice to Warhol that summer, offering and then re-offering to arrange a visit to the Factory during the two-week vacation owed him at his job with Hughes Aircraft. "My heart and soul are on fire and I'm filled with desire so will you please let me know?" he wrote to "Dear Mr. Warhol," and Warhol eventually did let him know, calling him up at the end of August. The long letter that Rheem wrote in return, now to "Dear Andy," is charming if a little scary in its eagerness. It begins, "What a turn-on, talking to you on the fone . . . you have a strange and wonderful speaking voice. . . . It made me weak," then goes on for six pages of self-revelation and breathless Warhol worship. It asks if Warhol happened to like Greta Garbo and Montgomery Clift—did Rheem already know they were gay icons?—and offers the wacky suggestion that Warhol make a movie starring Garbo and the Beatles: "She could be queen chicken of the sea and they could spawn & spawn all day." How could Warhol resist such guileless verve? He couldn't. Rheem was in New York within a few weeks, and was soon moving into the town house.

In the couple of months he lived there, Rheem seems to have become quite close with Warhol's mother, at least judging by the kidding between them that Warhol caught on film. Warhola turns "Richard" into the Rusyn diminutives "Richko" and "Richichko" and the two share secret talk about buying booze. Malanga said that Rheem was not around the Factory all that much during his relationship with Warhol, but he was around at least enough to have been cast in nine longer films, in one of which, *The Andy Warhol Story*, he actually plays the role of Malanga. Warhol also filmed his young lover in four Screen Test portraits, one of which captures him in a striped sailor shirt that might very well have been one of Warhol's.

The relationship seems to have been less vexed and charged than others Warhol had. Maybe that was what let it come to a stupid and sudden end. One day toward Christmas 1966, when Warhol and Malanga were walking toward the town house on Lexington, they spotted Rheem and another Factory lad hanging out together. They weren't lovers, but a jealous Warhol decided they were. "Andy had the locks changed the next day," recalled Malanga, some fifty years later—although in his diary at the time he wrote about how Rheem had "finally left Andy."

Regardless of who dumped who, Rheem wrote friendly notes to Warhol and his mother for the rest of the decade. Hard to say if Warhol responded.

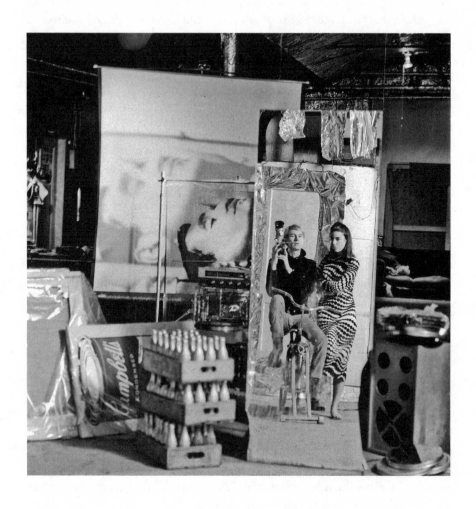

*. . . with a model as the Factory starts to get crowded.*

# 1966

*"Warhol's success depends upon his failure, on being a
magnificently cracked mirror with the silver chipping off"*

Repetition had always played a vital role in Warhol's art, but in 1966 it began
to take over.

That back room at Castelli's featured seventy-three identical cow heads
filling every inch of the gallery's walls. In the front room were those dozens
of *Silver Clouds,* with an endless supply of others waiting to be inflated. When
the Velvets premiered at the Cinematheque, fourteen rock and roll shows,
all featuring the same dancers and films and songs, got performed within a
single week. After the aspiring young actress Holly Solomon commissioned
her portrait from Warhol, he silkscreened the same photomat shot eight
times, hoping it would find multiple buyers. (Her husband, a hair-product
millionaire, decided they should take them all.) That portrait was itself a near
repeat of the Ethel Scull project from three years before, but with the theme
and variations of the earlier portrait reduced to all theme, no variations. It
did have one notable difference from its predecessor: The new series went
for $6,000, something like eight times the price of the earlier one. (Which
left the Solomons still paying only half the $12,000 fee quoted by Warhol's
long-standing nemesis Richard Avedon, who had been their first choice as
portraitist.)

Back in 1963, some of the most radical avant-gardists had said that the
most important art of their day consisted of "meaningless work"—"putting
wooden blocks from one box to another, then putting the blocks back to the

original box." That Warhol agreed becomes clear in the obsessive repetitions that began to shape many aspects of his life and career.

Even the repetition got repeated. The *Clouds* and Cows immediately began to travel the world, making appearances in Castelli-blessed shows in Los Angeles, Cincinnati, Hamburg and Cologne. Where almost all of Warhol's earlier exhibitions—the Soup Cans, Marilyns, Elvises, Boxes and Disasters—had been unique installations, the new shows could just about be mail-ordered from the Factory. Even the groundbreaking survey that Warhol had been given at the I.C.A. in Philadelphia was repeated, in a necessarily less groundbreaking form, at the I.C.A. in Boston, although it was much enlarged and also updated with the *Clouds* and Solomon portraits. (Also, with more protection for the now-precious objects: The Brillo Boxes were on a high shelf well out of reach of touchers, as Warhol was now specifically requesting.)

At the preview, Warhol once again showed up to mug for the crowd, this time in dirty tuxedo shirt, leather jacket and fully mirrored shades. Although the opening drew a record crowd—again—Boston's was less boisterous than Philly's, as though some of the novelty value had worn off. The survey got the same range of hesitant praise and heartfelt pans ("Warhol's work, by itself, is unquestionably without a future") but above all it got the same wall-to-wall coverage: The *Boston Globe* alone ran three pieces, all as much about the artist as his art. As before.

Warhol's exhibitions in Los Angeles, Cincinnati and Boston coincided with dates for the Exploding Plastic Inevitable, although it's hard to tell whether the music needed to piggyback on the art or vice versa. The Velvets and their performing Factorines (or was it the performing Factorines with their Velvet backing band?) went on to gig in something like a dozen different towns in 1966 alone, crisscrossing the continent from San Francisco to Cape Cod, from Hamilton, Ontario, to Wheeling, West Virginia, with plans for a tour across Europe as well (it never happened). But for all the changes in time and place, the basic plotline was always the same: band and performers head out; band and performers have adventures; band and performers get panned, sometimes praised; band and performers come home. As an aesthetic act, each Exploding gig was as much like the next as any two Soup paintings—whose original repeats Warhol had also taken to re-repeating once again, as he did with his Electric Chairs.

Or maybe the E.P.I. shows were more like Warhol's Flowers, with an essential sameness barely belied by variations in colorway.

At an E.P.I. show in Los Angeles in May, Warhol indulged in classic red-carpet talk, doing a fine dumb-blond impersonation: "I love L.A. I love Hol-

lywood. They're beautiful. Everybody's plastic—but I love plastic. I want to be plastic." Local journalists loved him back with lots of coverage. They were also happy to bill him as "part con man, part prophet" and "the biggest put on of them all." Warhol might have been presenting himself as a cheery confidence artist to counterbalance the very un-Hollywood darkness of the stage show he was promoting. "People on the West Coast hated the Velvet Underground," recalled Mary Woronov, who danced in their show. "They thought we were odd, weird, dark and evil. There was a big dichotomy: They took acid and were going towards enlightenment; we took amphetamines." The Velvets dressed all in black, said Woronov, while Los Angeles was awash in hippie colors. Malanga seems to have split the difference: Onstage he wore shiny black leather pants and a puffy sort of pirate's shirt with a psychedelic pattern.

The show happened at a nightclub suitably called the Trip, whose colorful poster for the Exploding Plastic Inevitable was built around Warhol and lighthearted Pop Art; it reproduced a cheery Lichtenstein explosion. But after an evening with the E.P.I. itself, a critic for the local alternative paper talked about "Warhol's attempted rape on whatever mental health I've accrued" and "an intense spatter of nihilism." And that was one of the kinder reviews. After a good first night packed with celebrities (they'd been rounded up by Dennis Hopper) the next few days saw audiences vanish and then a clash between the club's mob owners forced it to close. (The band was led to believe that the police had closed it down because Malanga's whip dance was pornographic.) Union rules said that in order to get paid, Warhol and his friends had to wait out their two-week contract, which they chose to do around the empty pool in a rented, faux-Medieval crash-pad called the Castle. "I remember sitting there one afternoon with Andy eating vanilla ice cream—we each had a quart, which we both finished. I remember that as a really nice moment," said Woronov. Nico spent her days tending to bunnies in the garden and Sterling Morrison recalled passing the time by spending down the money he'd earned from their Dom concerts, which had been paid out to them in paper bags full of cash.

In June, for a Chicago gig, Nico was off in Ibiza with her son, Reed was in hospital with hepatitis while Warhol was stuck in the Factory working on his latest movie, *The Chelsea Girls*. (He sent Brigid Berlin to sit for interviews in his place.) But even in the band's much diminished state—and playing in a sweltering club on the inauspiciously named Sedgwick Street—the Exploding Plastic Inevitable still got a uniquely rapturous reception, with the booking extended for an extra week. *Variety* raved about the show's "three-ring psychosis" and the band's "extremely interesting" music. (Although

the *Chicago Daily News* said, "Let's hope it's killed before it spreads.") Teens from the remotest suburbs made the trip in to see the band each night, obediently waving the strips of tinfoil they were handed at the door.

Things were different beyond the club. Malanga got in trouble for wearing an absurdly skimpy bathing suit on a Lake Michigan beach. John Cale got punched "just for having long hair," Moe Tucker remembered. "People were so unhip."

As the year wore on, the ensemble seemed to revel in such rock-band-on-the-road clichés.

In Provincetown, the performers threw feces out their bedroom window and one of them stole a painting from the local museum, just to see if he could. The Provincetown police were called when a dancer got strapped to a whipping post onstage; the cops didn't show up out of fear for his safety, but because the straps and whips being used had been stolen from a local purveyor of leather goods. "They got run out of Provincetown on a rail" is how one Warholian remembered the gig.

The E.P.I. team also indulged in the internecine rivalries that are a classic element of the road-trip genre, fully on display in a Letter of Complaint that Malanga addressed to Warhol, but which only ever lived in the poet's diary:

> *Dear Andy,*
>
> *It seems I'm always writing you letters to explain myself, my feelings, what's bothering me as you find it easy to say nothing, sometimes, when you know what you're thinking you shouldn't say or it is explained without words or without vibrations.*
>
> *I thought the Provincetown show got off to a rough but very good start, until you were so kind enough as to let Susan and everyone else not directly connected with the show get involved with Mary and I on stage. . . . I do not represent a "go go" dancer in the show but an interpretative-visual happening. You are slowly taking this away from me by allowing outside elements to interfere with my dance routines. . . . On more than one occasion I found my flashlight missing and then discovered that Roger was dancing with it somewhere near the end of the show. . . .*
>
> > *Faithfully,*
> > *Gerard*

---

To the public, Warhol was presenting himself as the ultimate freaky bad boy, with a raucous house band to prove it, but he was actually behaving

more and more like the owner of an emerging small business that needed constant attention if its output and income were not to drop. One of the central duties of Joey Freeman was to make sure that Warhol made his way to the Factory before the whole workday was lost, given the very late nights he kept: One night when Malanga called the town house at 2 A.M., he was surprised to find the artist home so "early." Freeman, still a teenager, would finish his morning classes in Brooklyn and then take the subway to the Lexington town house, hanging around until Warhol was ready to be hustled into his daily taxi to Forty-Seventh Street. Once they'd arrived, maybe around 1 or 2 P.M., Warhol put on his workaholic's hat. He would oversee whatever "product" the Factory was turning out that day, whether it was transcripts of his audiotapes, or enlargements of the vinyl banana from the Velvet Underground cover (for a show of erotic art) or the fabrication of bigger *Silver Clouds* or, often in the evening, the shooting of his latest movie.

"I wouldn't call it fun," said Mary Woronov. "I mean most of the time what we did was wait for something—I do not know what. You know, it was like, 'Are we going here?' 'I don't know.' 'Are we going there? Well, where is Warhol going?' 'Well, I don't know.' . . . I mean no one was having fun, it was really very tedious." In Warhol's studio, she explained, the "peasant" work ethic Warhol grew up with in Pittsburgh overrode any New York sense of play: "This man did not understand the idea of fun. He only worked, and he worked *hard*."

Lou Reed recalled how Warhol demanded the same of anyone in his orbit. "He would say to me, 'How many songs did you write today?' He'd say, 'How many songs?' and I'd say, 'Five.' And he'd say, 'Five? What's wrong with you? What is wrong with you? Why are you so lazy? Nothing's going to happen if you're so lazy.' . . . Every day, unrelenting, the same question." With his laser-like focus on production, you could say that Warhol himself had finally bought into the manufacturing model that his art had been selling to the public for half a decade. As products began to be rolled out innovation could be put on hold. In a classically Warholian paradox, that could even count as one of his art's most innovative moves.

In 1966 it looks as though Warhol caught on to something that had been true all along about modern art but that its artists could never admit: The experimentation of the twentieth-century avant-garde was awfully close to the advanced product development of the new consumer capitalism. They both depended on inventing an ever-new range of attractive goods in the hopes that one new product would hit it big; they also both depended on putting in place systems for producing those goods with enough profit to keep the factory—or the Factory—running. Warhol flirted with the

appearance of having sold out because he knew that selling out might just be the main thing his art was about. His training at Tech had already blurred the line between furthering art and furthering industry. Now he was making work that portrayed this blurred line. His art demonstrated the fundamental, unavoidable parallels between what Warhol and his peers and predecessors had been up to in the art world and how his patrons—a modern hair-product tycoon or lighting-supply magnate—made their businesses work. Moneymaking was a big driver of innovation in both art and business, however much most artists might deny it. The main difference between the two fields of endeavor was that the tycoons and magnates earned the kind of serious money that put them in the role of benefactor, and that kept Warhol and his peers playing supplicant. That was a relationship Warhol could never escape from, even when his art was selling at its best.

Bottom line, his art could make brilliant and subtle statements about his society's dependence on sales and selling out, but it could never actually sell the way Prell shampoo and its pearl did. It's not clear he really and truly had that as his goal.

If Warhol had truly hoped to make money as a rock promoter some group like the Monkees would have been the way to go. In terms of return on investment, the challenging Velvets were at best a loss leader that could help sell Warhol's with-it persona, which helped his paintings sell. Even after the band had a full year of touring and publicity under its belt, a gig in a major art school still only managed to sell out two of its four performances, providing a measly $2,600 in income to Warhol and all the show's talent and staff. On a visit to San Francisco, a series of back-to-back interviews had given Warhol the perfect chance to promote a local show by the Velvets, but the ever-ornery artist somehow forgot to mention it; the club's owner was furious. Warhol later admitted to having thrown the free publicity away: "I just wouldn't do business." He preferred to use it as an art supply.

In May of '67, a curator in Philadelphia offered Warhol the opportunity to create a genuine Pop product for sale to the masses. He made the smart choice to produce a perfume; by naming it "You're In" (say it out loud) he guaranteed it would tank, except as unruly art. There were other major defects in its product development. The scent was sold in silver-sprayed Coke bottles whose paint was dissolved by the liquid inside. (The bottles had originally been painted several years earlier as a present to Warhol from Billy Name, who hadn't had to plan for perfume resistance.) Also, Coca-Cola had not been asked for permission to use its bottle and objected as soon as it heard: "Its use as a container for a cologne constitutes a flagrant infringement and unfair

competition," Coke wrote, in the most sternly worded of letters. "Moreover, the use of 'You're In' on the cap or crown on our well-known bottle is in violation of Section 43A of the Lanham Trade-Mark Act." (At least Warhol had decided not to call his cologne "toilet water," as originally planned.) The artist could only have been flattered that Andy Warhol Enterprises, Inc., was considered "competition" by the mighty Coca-Cola Company—a lovely merger of Pop Art with life—but he knew better than to fight. He pulled the original product and instead sold the perfume in plain vials with a silvered Coke bottle offered "free" as a bonus with each one.

---

If there was one product the Factory had perfected by the end of 1966, that product was its extremist image. Warhol's public appearance in leather, the previous fall, had set the Factory on that course, and there had been hints of it earlier, but '66 was the year the extremism blossomed. Already in January, a reporter found Warhol playing the outsider cool cat, denying that his mother lived anywhere near or that he'd gone to art school. That reporter, like many others, noted how the Factory's silvery presence was beginning to tarnish: The foil was falling from the walls and the pay phone had been ripped from its moorings, screws and all, and now lay prone on a table. Its receiver was wrapped in a bandage. "It's just part of the style," explained a nearby teen. The Kinks and the Supremes had been replaced by the Tijuana Brass played at full volume. What greater sign of decadence could there be?

For the first time, it made sense for a prominent critic, writing in the art world's most venerable journal, to describe the Factory's "seediness" as one of its principal features—and virtues. "After prolonged exposure to Warhol's work, seediness emerges as almost a spiritual category. . . . Everything Warhol touches becomes intricately seedy, and maybe even unsuccessful (beautifully though)," he wrote. "Warhol's success depends upon his failure, on being a magnificently cracked 'mirruh' with the silver chipping off." That "mirruh" is a reference to Nico singing "I'll Be Your Mirror," one of the songs Lou Reed had written just for her, and in general the Velvets and their stage show were the most obvious marker of the Factory's move out to the edge. "It will replace nothing—except maybe suicide," Cher had said as she walked out on the band's opening night in L.A. ("It's just horrible" was Warhol's unusually heartfelt reaction to her departure.) A young Catholic who had seen the band said that it made "the weight of her sins" feel so heavy that she needed to rush to a church to confess.

An interview with Reed shows him thrilling to the wild possibilities that he said had opened up once the Velvets entered Warhol's world. He

talked about adding bagpipes to the band, or "thousands of guitars," or "an electric eye that could change pitch, and was fed by solar energy," and also about getting Moe Tucker to play her drums in a solo with thirty amplified metronomes or wearing a blindfold and earplugs, "because [then] you can never be out of rhythm." Warhol, he said, "is very beautiful, because he lets it all happen. . . . Anybody who made love to our music wouldn't need a partner."

Even the straitlaced Paul Morrissey was starting to play up the Factory's extremist image. He gave one columnist a peek at their louche lifestyle: "We eat at parties a lot. . . . We travel in a Chevrolet, four in front, six in the back. But lately we aren't getting invited to as many parties. The other day we were invited to this art gallery by Lady Sarah Churchill. Jayne Mansfield was there in a tacky blue gown that glowed in the dark. But us they wouldn't let in. We get thrown out of a lot of parties." Warhol himself is supposed to have put up a prank banner at the Dom announcing "Jasper Johns—Live Tonight," making clear that even his own sacred cows had become fair targets in the Factory's attack on establishment culture. The story is probably apocryphal, but the fact that it circulated shows the insurgent image Warhol was cultivating.

That image almost completely dominated Warhol's art making that year, maybe just because his art was now his films, and his films were more evidently radical than his paintings and sculptures had ever been. For all their potent innovations, his art objects had always had a peculiar straightforwardness: A soup can or supermarket carton, even maybe a blow-up pillow or roll of wallpaper, was not immediately and unavoidably weird. In fact, like Duchamp's urinal, these works' deeper weirdness as art stemmed from their strong links to perfectly normal objects all around us. That stood in strong contrast to Warhol's films, which were unlike almost any film a viewer might have seen in a theater, both in what they showed and how they showed it. Like Warhol himself and all his acolytes, a Factory film from 1966 wore its strangeness on its sleeve.

---

For a while in the fall of 1965, it looked as though Warhol the filmmaker might actually be heading in a more mainstream direction. He'd been working toward some kind of remake of a recent British hit called *The Yellow Rolls-Royce*—Warhol's backer had gone so far as to buy an old Ferrari and paint it yellow—but that plan somehow got replaced by one to make a full-scale 35 mm feature-length riff on Charlotte Brontë's *Jane Eyre,* updated and retitled *Jane Heir.* (Already, it's not sounding quite MGM.) In theory the movie was

going to be a full period piece, with shoots on location at the estate of Huntington Hartford II, the supermarket heir and museum owner, on Paradise Island in the Bahamas. Fancy costumes were to be recycled from Hartford's earlier staging of the Brontë novel, which had laid a $600,000 egg on Broadway. "We are planning to make money from it. Not just enough to cover the rent here at the Factory and the cost of processing film but a good deal of money," a reporter quoted Warhol as saying.

Warhol's radical move toward the mainstream was announced to the press—"Edie and a native cast are planned," wrote one columnist—and Warhol even staged a test shoot, of sorts, in a Philadelphia dance club. An investor was on hand there to explain the project: *"Jane Heir* is not an underground movie," said the blue-blooded Phillip "Fufu" Van Scoy Smith, who had recently had a walk-on in front of Warhol's Auricon and owned that yellow Ferrari. "It is a feature length film, and it will have a plot."

But Smith spoke too soon. When a casting director was shown an endless early script by Chuck Wein, she said, "Are you crazy? This isn't a script. There's no dialogue." Warhol engaged Ronald Tavel to do a rewrite, which cast even more doubt on any notion of plot or on the film's likely escape from the underground: Tavel's preferred title was *Jane Eyre Bare* and he wanted Mr. Rochester to be played by a black man. And then Warhol himself got scared off the project by a drunken Huntington Hartford who, according to Tavel, showed up one morning with a gun and proceeded to shoot up the Factory ceiling. (Earlier, Warhol had called Hartford "the most fantastic man in the world.") Tavel said that an "unresolved struggle over entitlements" delivered the movie's death blow.

Maybe in reaction to this failed attempt at mainstreaming, by the first few months of '66 Warhol's filmmaking had burrowed deeper underground even than before.

Take *The Closet,* which he shot toward the start of the year. It begins as nothing more than static footage of a closed closet door, from behind which come two voices discussing their stay inside. After almost ten minutes, the door opens and the audience sees Nico and a sweet-faced young man seated on stools, with ties and dresses hanging all around them. When the door to their haven—or prison—was closed, they had talked about opening it, but when they do they are blinded by the light that comes in. It's an obvious allegory of gayness, which in the mid-1960s would still have seemed radical: If you were in the closet in 1966 you were supposed to stay there, uncomplaining, and refuse to acknowledge that that was where you were. On the other hand, what the film *mostly* is, in classic Warhol fashion, is just two pretty people who are also pretty strange engaged in almost-random con-

versation. Warhol would never be so gauche or uncool—so predictable—as to insist on an old-fashioned allegorical reading.

That makes *The Closet*, and Warhol's other films of its era, harder to take even than *Sleep* or *Empire* had been. At least with those early experiments you had a sense of precisely what the premise was—you knew what you were up against as you watched them. With most of the films made in 1966, it looked as though you were getting some kind of narrative or story or argument, or even allegory, that you'd be able to follow, but then you were pretty much foiled in your every attempt. Maybe that was because Warhol's film came closer to tracking the real confusions and disjunctions of life and refused the pat order of most works of art.

Other off-kilter takes on realism from that summer included a shoot of the dancer Eric Emerson monologuing for an hour on an acid trip and another of Malanga and Marie Menken, the filmmaker who had first introduced him to Warhol, improvising an insane mother-son drama while the Velvets provided a live soundtrack. Warhol also planned on doing a sound reshoot of *Blow Job*, to be called *Eating Too Fast*, but the brattiest boy at the Factory ruined the shoot by blowing the star in the Factory stairwell before Warhol started filming.

But the key film of 1966 came in mid-June, when Warhol pointed his Auricon at Ondine, getting him to act out his Mole People persona as pope of the Factory scene. Dramatically spotlit in the darkened studio, Ondine, flying high on speed, sits on a couch and pretends to take "confession" from a series of Warhol followers. He questions Ingrid Superstar about her first sexual experiences (straight and lesbian), but also about the reason for her bad breath, while she fires back questions about how many lovers this pope has had (human and animal) and about his body odor. After an hour of such antics with various players, Pope Ondine is shown mainlining a hit of speed before taking on his final sinner, or victim, a Factory visitor called Rona Page. She confesses to "a low kind of love" for Jesus Christ, to which the Pope replies, "Blow him. It's as simple as that. Go right down on an image." The conversation goes downhill from there, with each one accusing the other of being a phony until, in a moment of truly scary and quite real violence, Ondine slaps his subject's face, hard, several times, and goes ranting off into the darkling depths of the Factory. You can almost see the light bulb going off in Warhol's head, as he recognizes that his new films should do for Factory life what the Velvets did for the Factory's sound: Dial it up to 11 and push it to the point of breakdown.

Warhol realized that the Factory's first "feature film" shouldn't be about some nineteenth-century governess and her Byronic employer; it should treat

audiences to the same pageant of creative dysfunction and dysfunctional creativity that Warhol got to see every day when he showed up at work. At some point late in the summer, after producing something like twenty half-hour reels of footage, Warhol decided to tie them all together, about as loosely as could be, under a single title: *The Chelsea Girls*.

His title and premise came from what must have been some of the last reels he had shot, on August 26, 1966. In them, four young women—the Factory regulars Susan Bottomly, Mary Woronov and Ingrid Superstar plus an outsider known as Pepper Davis—spend an hour in Bottomly's little room in the bohemian Chelsea Hotel, being as bitchy to each other as any high school clique. Their reels took off from a Ronald Tavel script about the North Vietnamese radio propagandist nicknamed Hanoi Hannah, much in the news that summer. ("She starts off each broadcast with the sexy announcement: Greetings, Dirty Imperialists," explained one article.) But in Warhol's hands the film really came to be about what female Mole People got up to by day, with Woronov more or less as a Popess Ondine laying waste to the minions beneath her. She gave almost as good a slap as Ondine, and arguably did an even better job of intimidation. Tears were shed.

Warhol's nondirecting "created a void that people felt compelled to fill with the most uncalled for and amazing shit," said Woronov:

> When he was directing a film it was insane. He wouldn't say anything. And yet that very vacuum, of his not doing anything, and constantly retreating, made everybody come after him. It made people act who had never acted before, because they were trying to get to him, and then all of the sudden their voice came out, and all of the sudden they were doing things. And it's because he retreated. Instead of barking orders and telling them what to do he would retreat backwards. You wouldn't hear a word from him.

When *The Chelsea Girls* premiered in September, Woronov and her three companions were in fact among the few "girls" in it, and their segment was the only one actually filmed at the Chelsea, but Warhol's delight in their footage got him to turn it into the project's governing idea. In an ad for the film's premiere, its other seven segments were each billed as taking place in a room at the hotel, with Pope Ondine hearing confession in Room 723, Malanga squabbling with his "mother" in 422 and Eric Emerson tripping in 416. It wouldn't take much for a viewer to figure out that those scenes weren't shot at the Chelsea, or in any other hotel for that matter, but Warhol

had never fled from the incoherent and capricious—as a well-trained avant-gardist, he reveled in both.

With his preternatural understanding of the culture around him, Warhol realized the instant name recognition that the Chelsea Hotel would bring to a movie meant as the most public coming-out of the Factory's extremists. On the day of the film's premiere, Malanga was referring to the new title as a "commercial idea" of Warhol's.

"Everything and everyone connected with the Chelsea Hotel bears an unmistakable stamp of originality," *Esquire* had said in a big feature on the hotel, published just when Warhol was beginning to gather his crew of originals. The Chelsea had long counted as one of New York's notable cultural landmarks; Warhol had known it since his first months in the city, when he lived around the corner in the loft he shared with the dance therapist and her nudist partner. The hotel's landmark status became official in June of '66, thanks to a much-publicized planning decision. The Chelsea's fame had spread to the rest of the nation only six months before Warhol's movie premiered, when a wire-service feature ran in even the tiniest papers and towns everywhere. That story gave a roster of the noted literati, past and present, who had lived and worked in the Chelsea's rooms: Mark Twain, O. Henry, Thomas Wolfe, Dylan Thomas (who died of drink there), William Burroughs and Arthur Miller (who stayed there after his divorce from Marilyn). But, said the piece, "chiefly the hotel attracts artists," listing off the abstractionists Willem de Kooning and Kenneth Noland but also Warhol's Pop-y friends Larry Rivers and Jim Dine—but leaving out Warhol's hero Yves Klein, who Warhol had once run into on the hotel stoop. Klein's great "Chelsea Hotel Manifesto" might as well have been called the Gospel According to the Chelsea Girls: "I am particularly excited by 'bad taste,'" Klein had written. "I have the deep feeling that there exists in the very essence of bad taste a power capable of creating those things situated far beyond what is tradition-ally termed 'The Work of Art.' I wish to play with human feeling, with its 'morbidity,' in a cold and ferocious manner."

When Warhol launched his hotel movie, any number of Factory types had already been living there, including Brigid Berlin, Nico, Susan Bottomly and Malanga, the last two briefly sharing a room in some conflict, despite walls covered with photos of the couple. ("She always throws her garments on the floor and the sink is always dirty and the refrigerator has been empty for three days," Malanga complained to his diary; he also mentioned that she paid the rent.) Warhol's film worked to establish the Chelsea, at least in the public's mind, as the workers' residence for the Factory. After the movie began to attract attention, Warhol immediately went back to the hotel to

*Crazy Golden Slippers,* 1957

Gunther Jaeckel display window with art by Andy Warhol, April 1961

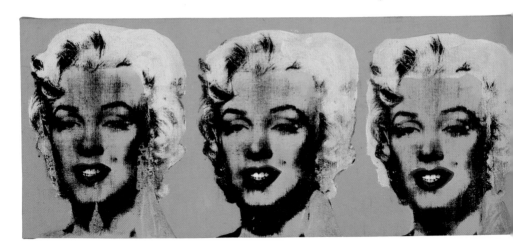

*Three Marilyns*, 1962

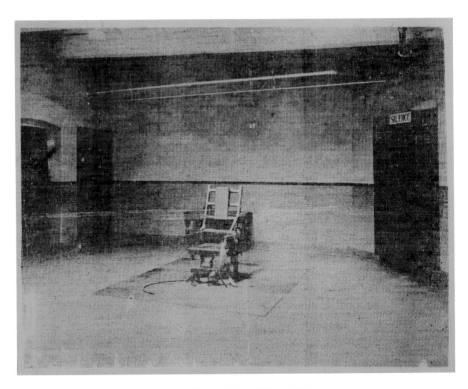

*Little Electric Chair*, 1964–1965

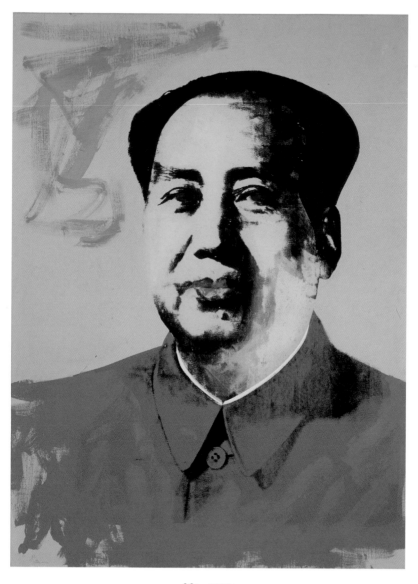

*Mao*, 1972

*Nan Kempner, 1973*

*Ladies and Gentlemen (Wilhelmina Ross)*, 1975

*Shadows,* 1978–1979, detail view

*Rorschach*, 1984

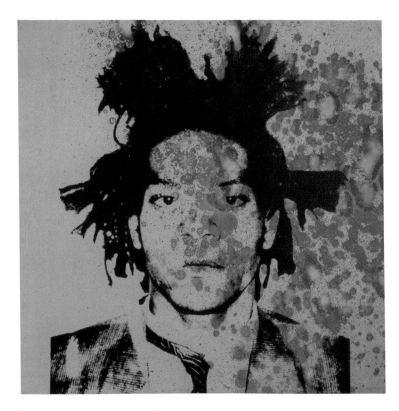

*Jean-Michel Basquiat,* ca. 1982

*The Last Supper,* 1986, detail

film some new scenes—Brigid Berlin dealing drugs from her room; Nico in her suite's kitchen—and then inserted them in place of original non-Chelsea segments. He made the film's lying title more nearly come true.

In 1966, Warhol had decided that his Factory should stand for a drastic alternative to mainstream culture, and his *Chelsea Girls* did a perfect job of standing for the Factory as a whole. The film's ads billed it as an eight-hour "epic film," a running time that linked it to the full workdays famously taken up (at least according to their coverage) by *Sleep* and *Empire*, Warhol's first exercises in audience torment. But if those works had already attracted attention for their torturous longueurs, *The Chelsea Girls* was so tough it made them seem like matinee fare. Reels from the new movie were projected on two side-by-side screens—apparently an idea of Billy Name's—which shortened the viewing time to less than four hours but also made for a murderously difficult experience. The audience's attention was completely split between the two screens, defeating the contemplative attentiveness that *Sleep* and *Empire* had encouraged. *The Chelsea Girls* foreshadowed the A.D.D. that smartphones brought to twenty-first-century screen time, but without supplying a phone's multiple streams of coherent information. In *The Chelsea Girls*, when the sound from both projectors was allowed to play at once all you got was chaos, since none of the dialogue could be deciphered. When only one projector's sound was turned on, it might very well be the sound for the segment that you least wanted to watch: You might see Pope Ondine and Ingrid in deep and presumably fascinating conversation while hearing the utter banality of Nico's dialogue as she puttered about her kitchen. That is, if you could make out any dialogue at all, in a movie mostly shot with Warhol's usual disregard for technical competence.

Warhol hadn't even made choices about which bits of footage should be screened beside which, or which soundtrack should be on at any given time. He didn't, that is, compose the movie's disjunctions in the way chaos got structured in a fine Cubist painting. The juxtapositions in *The Chelsea Girls* were meant to happen at the whim of whichever projectionist happened to be on duty, allowing for willful decisions about which reels should be seen next and which dialogue was worth listening to. "Every show became a new challenge to see what new combinations I could produce," remembered one early projectionist. "When the spirit moved me, I added a piece of distorted glass and waved bits of cardboard in front of the projector in rapid motion." Another projectionist said that after a day or two of screenings, he got absorbed in reading Herman Melville and didn't even look at what was on-screen when he got up now and then, at random, to play around with the images or the soundtracks.

Before long, to make everyone's life easier—but hardly easy—the Factory started offering theaters a sort of "score" for projecting the film. But even when that gets followed today, five decades later, viewers of *The Chelsea Girls* are still likely to feel that this ancient "classic" offers extreme challenges. By the end of most shows theaters are half as full as when the film began, even though only the most dedicated, long-suffering culture vultures buy tickets in the first place. Woronov, one of the movie's brightest stars, has talked about how its challenges force moviegoers "to not sit like zombies waiting for corporate garbage to fill their heads. . . . You're bored? Well, perhaps boredom is the beginning of imagination."

Back in the fall of 1966, a larger filmgoing public somehow felt a need for the aberrations of *The Chelsea Girls,* as that public came to grips with "a time of radical change in fundamental values and attitudes," according to the catalog for Warhol's Boston survey, published just as his first feature film was premiering. In what sounds like a rare moment of real critical introspection—at least in public—Warhol had recently talked about his interest in reviving the "social imagery" of the realist painters of the Great Depression. *The Chelsea Girls* can credibly be thought of as a '60s update on that earlier moment in art. For Jonas Mekas, "the terror and hardness that we see in *The Chelsea Girls* is the same terror and hardness that is burning Vietnam; and it's the essence and blood of our culture, of our ways of living."

In a long column in *Newsweek,* Jack Kroll, a longtime friend and supporter of Warhol's, said that the movie was the *Iliad* of a new, fractured generation. Even Kroll's review was half rave, half pan. The "sad, bad, mad, glad world" of the '60s counterculture had been captured with a "macabre veracity" in Warhol's film, he wrote: "It is as if there had been cameras concealed in the fleshpots of Caligula's Rome." Kroll felt safe in discussing such fare within hearing of *Newsweek*'s middlebrow readers because he'd started his piece by reassuring them that *The Chelsea Girls* was sure not to be seen "outside the flickering, hard-chaired 'cinematheques.'" He ended his piece by suggesting that the film was best left to film students and scholars. There was just one problem: He couldn't talk about Caligula's fleshpots and expect average joes to stay away.

The movie's first ads had promised a one-week run at a crummy little art house run by Jonas Mekas, and even that must not have seemed likely to sell out—and it didn't. Although the run did get extended (Mekas adored the film) on some nights barely thirty people showed up. The movie's best night sold all of 206 tickets, bringing in a grand total of $412, of which Warhol got to keep less than half. Warhol told a reporter that this had already made *The Chelsea Girls* his biggest moneymaker to date. (Which either shows the

pitiful take from his other films or his willingness to indulge in spin.) "I never want to be popularly accepted," Ondine had said not long before. "For instance, I won't appear in any movies other than Andy Warhol's, and they aren't popularly accepted."

But within weeks of Kroll's review and others in a similar vein, both positive and negative but always prurient, Warhol and Mekas took the gamble of moving the film to a fancy Fifty-Seventh Street theater—"where, ironically enough, many family-type flicks have premiered or returned for the kiddies over the years"—as part of an unlikely new venture meant to sell underground films to the mainstream. "There are 50 million moviegoers in the United States," Mekas had said in announcing the scheme. "If we reach a million we can go on making films." In the first two weeks that *The Chelsea Girls* ran in its posh new venue, the daily income could run as high as $2,500 and was never below $800. The gamble paid off, in money and more especially in mainstream attention, however nasty much of that was.

*Time* magazine growled that "there is a place for this sort of thing and it is definitely underground. Like in a sewer." The *New York Times* climbed onto an even higher horse and insisted that, now that *The Chelsea Girls* had moved to a normal movie theater ("with carpets"), it was time to "put a stout spoke in Mr. Warhol's wheel" and let him know that he had gone too far in depicting "the lower level of degenerate dope pushers, lesbians and homosexuals." What Warhol was discovering was that these were precisely the people America wanted to see at that moment, and that he could bill his Factory as the place that showed just how far they could go. "Films should depict things as they are—and here they are!" said one *Chelsea Girls* rave. "Warhol stumbled into the terror, frustration and agony of our time."

And then he discovered that money and fame just might be had there.

Not long before, Henry Geldzahler happened to have opined that Warhol would have to keep making paintings (which Geldzahler liked) to fund his films (which he didn't). As Geldzahler put it, "Joe Levine"—distributor of such fare as *Godzilla*—"is not going to give up his 4,000 theaters to Andy's movies." The laugh was on him. *The Chelsea Girls* was the first underground movie to hit the full range of first-run theaters, spreading news of Warhol and his Factory from Atlanta to Chicago to Los Angeles, from Berlin to Copenhagen to Paris. Warhol was in fact running out of paintings to sell, or so he said. But with reporters claiming that the movie had grossed a million dollars that no longer seemed to matter so much, for his wallet or his reputation.

The distribution network for movies, spread across thousands of cin-

emas, dwarfed the way fine art circulated among a handful of exclusive galleries and museums. That means that as it traveled the country from theater to theater, *The Chelsea Girls* gave most Americans their first chance to see work by Warhol firsthand. They often didn't like what they saw. "Who wants to pay a buck-and-a-half for some creep to tell you how boring and dirty life is," said one girl who left the movie halfway through. (She'd got a discount; tickets were usually $3.) But whatever viewers may have thought of Warhol's product, they came away with an image of him as debauchery's documentarian.

"Warhol's camera has grown daringly, shockingly candid," wrote Parker Tyler, the pioneering film theorist of Warhol's youth. What was most shocking, he said, was "the new sort of violence: the violence of sadists and masochists freed into their desired domain by courtesy of a stimulant such as amphetamine or an hallucinogenic such as LSD."

Warhol's reputation had gone from bad to worse, and he basked in it. When *The Chelsea Girls* was banned in Boston, he treated it as a badge of honor and a selling point. He continued to choose his blurbs from the worst pans the movie received: "A travelogue of hell!" and "Dirty" counted as perfect ad copy, at least for this particular film and its peculiar maker. Just in case anyone found violent gay drug addicts too tame a subject, that November of '66 Warhol announced that his next film would be about the assassination of John F. Kennedy, a theme so sacred to Main Street America that someone like Warhol could only take it on as a deliberate provocation. Of course, that was precisely why he made his announcement. Although footage of a warped pantomime of the assassination does exist, it was far too subversive ever to have been released, even under the name of a subversive like Warhol.

———

If the success of *The Chelsea Girls* had one take-home lesson for Warhol, it was that his outsider status was at last paying off. He paraded it in his most famous self-portrait image, which began life as a silver poster for his *Silver Clouds* show then got endlessly repeated, in every color under the sun, in a series of canvases on the walls of his Boston survey. It showed Warhol in what we now think of as his classic pose and persona, with a stare that's somewhere between vacant and knowing and two fingers held to his lips in the manner of some distracted and shy eight-year-old. Warhol had been putting fingers to lips in the presence of journalists and critics for something like eighteen months already, as though confirming that words might have a hard time leaving his mouth. By February of '66 a columnist was describing

it as his "characteristic gesture." That gesture didn't quite portray Warhol as one of the toughs and freaks of *The Chelsea Girls*. It billed him as something closer to a stunned and innocent observer of the chaos he had wrought, like a kid surprised to find that releasing his gerbils has gotten them eaten by the family cat.

Warhol used his films to unleash the worst of the underground on the American public, but even though he was the Factory's most famous denizen he took care to keep himself almost entirely absent from the movies meant to document its bedlam. Instead, in his own persona Warhol chose to advance a weirdness that was a touch less threatening. In August 1966, he willingly participated in an *Esquire* article titled "Remember the Sixties" that was meant to ridicule what people like him had gotten up to in the decade's first half. It illustrated its mocking premise by showing Warhol in costume as Robin, the comic-book sidekick, posed beside Nico in the more manly role of Batman—thus taking the mickey out of Warhol, Pop Art and the Batman craze all in one go. It's hard to think Roy Lichtenstein would have agreed to appear in that kind of goofy shot, but Ondine wouldn't have, either: In 1966, Warhol liked to occupy a middle zone between establishment and underground, even at the risk of being scorned by both. Willard Maas, Malanga's old poet friend and the most dedicated of bohemians, jumped up at an early screening of *The Chelsea Girls* to chastise Warhol's audience: "Why are you watching this film? He's been written about in *Time* magazine. He's only interested in money."

Warhol had begun supplementing his downtown uniform of black jeans, leather jacket and scuffed boots with looks that had more to do with hip (and hippie) fashion trends. In October, he went shopping at the Leather Man store in Greenwich Village, but rather than coming away with any of its famous S&M gear he spent $165 on two pairs of suede hip-huggers, in Royal Blue and a color named Iced Tea, to add to pairs he already had in shades called Blue Denim and Apple Green. (The pants seem to survive in his archive.) On a visit to San Francisco, he wore the green ones, which were almost fluorescent, with a matching green bandana tied around his neck that made him look like some kind of Hollywood Frenchman. By the end of '66, he could be seen in full Sergeant Pepper's regalia. He'd bought his outfit a full half year before the Beatles album came out, at the stylish vintage stores he and his crew had begun to frequent.

In the second week of November, Warhol took his newly stylish, salable strangeness to a Brooklyn department store, which paid him $500 to perform as himself on their ground floor. Before a crowd of something like eighty shoppers, he and Malanga silkscreened the word "FRAGILE" all over one of

the era's new paper dresses, with Nico still inside it. Coverage was explicitly the project's goal and it got plenty. Even the sober *New York Times* gave it a quarter page, interviewing one "motherly" Warhol fan who had come all the way from the Bronx as well as various doubters who turned up their noses at the idea that silkscreening might count as art. "If Reagan can win, we can do paper dresses" was Warhol's response. (He was referring to Ronald Reagan's recent election as California governor; the presidency was still a ways off.)

Within barely more than a week, Warhol was mugging for the press once again, this time in Detroit, on the unlikely site of the Michigan State Fairgrounds. Dick Clark, the famous emcee, was there to host a four-day "Carnaby Street Fun Festival" sponsored by a local supermarket chain, and a Motown publicist had come up with the idea that building the event around a "Mod wedding" would be guaranteed reporter bait. (Journalists everywhere took it.) The lucky bride and groom, miniskirted and in a wide floral tie, had been chosen via a radio contest, while the festival's musical entertainment was provided by rock stars Gary Lewis and the Playboys, the Yardbirds, Sam the Sham and the Pharaohs and a much less famous band called the Velvet Underground. Their promoter, Andy Warhol, was also very much there and very much noted as the wedding's planner, a role he took on for $1,500.

Seated on a carton of soup cans, Warhol gave the bride away while the Velvets played and a "bearded motorcyclist" bashed on a car with a sledge-hammer. ("Auto-destructive Art" was one of the avant-garde's newest and most notable movements at the time; Warhol's friend Al Hansen—father of Bibbe, the teen Factorine—had just written up its famous Destruction in Art Symposium in London, where he too had wielded a sledgehammer.) The nuptials that Warhol had arranged came with some snafus: An earlier couple bowed out after declaring the marriage "commercial" and "corrupting" and their replacements arrived in a Rolls-Royce whose doors refused to unlock. But despite these complications, or maybe because of them, Warhol declared the whole thing to be the latest instance of his Exploding Plastic Inevitable, expanding the embrace of his art even wider than before. That art's new media, more mixed than ever, were clearly meant to sell Warhol to a new and ever-broader, ever-younger audience. A few weeks earlier, Warhol had been talking about landing the Velvets in a three-thousand-seat theater in New York.

However invested he might have been in the alternative culture of the Factory, Warhol was still willing to be seen courting the mainstream. Not long after hosting his Michigan wedding he showed up as one of the 540 indispensable socialites invited to Truman Capote's famous Black and White Ball, held at his old haunt the Plaza Hotel in New York. While

guests all around him were wearing the most elaborate and expensive of fancy dress masks, he appeared in standard black tie without even his usual sunglasses. (He had set off from home in some kind of electrified cow's head, to echo his Castelli wallpaper, but ditched it almost at once; no one at the ball seems to have seen it.)

"We're the only nobodies here," Warhol is supposed to have said to Henry Geldzahler, who acted as his date that night. This wasn't false modesty. In all the ball's massive coverage Warhol got only the most occasional mention. He didn't even warrant play in a huge photo feature in *Vogue,* although it dropped scores of names and gave shout-outs to pals of his such as Cecil Beaton and George Plimpton. In 1966, the role of celebrity-artist was still brand new—enough to get you invited to a ball, maybe, but not to be its belle. But then, Warhol had only had a couple of years to perfect that role.

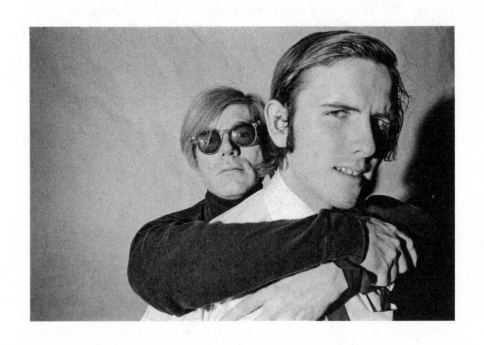

*. . . with his boyfriend Rod La Rod.*

# 1967

MAX'S KANSAS CITY | FLESH ON FILM: *BIKE BOY*
AND *NUDE RESTAURANT* | A CRUMBLING FACTORY |
ROD LA ROD | *THE ANDY WARHOL STORY* |
SUPERSTAR RUSSIAN ROULETTE

*"Sometimes when I think about Andy, I think he is
just like Satan. He has such a hold on all of us"*

A scenester waxes nostalgic:

> It's almost impossible to remember just how jarring and jagged
> the encounters were in Max's back room, bathed in the glow from
> the red fluorescent light sculpture by Dan Flavin, the inner sanc-
> tum where the tension declined or grew with the approach or
> departure of Andy Warhol. But the current was always on, low
> or high, and you taught yourself to endure the constantly climax-
> ing tension, and sometimes enjoy it, because that was the price of
> spectating or being involved with this particular bunch of freaks.

"Max's" was Max's Kansas City, and the above reminiscence was written
with all of three years' retrospection, in 1971, after the restaurant had al-
ready lost its famous edge and Warhol had mostly moved on. But for a little
while in the later 1960s Max's was the most exciting nightspot in New York.
What's hard to say is whether Warhol was there because of the excitement
or if the excitement was there because of Warhol. In either case, man and
mood coincided most nights of the week for several years.

Max's was founded at the tail end of 1965 by an ex-lawyer and serial
restaurateur named Mickey Ruskin. He was not known as Max and had
nothing to do with Kansas City. He was a self-confessed "nice Jewish boy
from Jersey City" whose restaurant had been named by a poet friend, pretty

much because the words sounded right. Ruskin had been moving among writers and artists for a while already, and he'd opened his latest place to give them a hangout.

The loft building he bought, cheap, was a narrow turn-of-the-century structure that had been crudely modernized. A huge sign that Ruskin installed on its façade was lettered in white on black glass for a vaguely Deco-diner look, although its lack of capital letters signaled some connection to the avant-garde. It advertised "steak—lobster—chick peas," keeping that same balance between American classics and what sounded like newer downtown tastes. Actually, those celebrated chick peas were dry and hard and basically inedible. Most people used them as projectiles. The free happy-hour wings and salad bar, on the other hand, fed more than a few starving artists.

Inside, a long front space lined with booths acted as a bar and dining room, a smaller back area was a hangout reserved for the in crowd and the open-plan second floor was "Siberia," where tourists and "straight, respectable, anonymous people" could be sent off to dine. That floor became a rock venue and disco late at night once they'd left. "I remember when you could take your clothes off upstairs and nobody noticed," recalled Ultra Violet. "I was dancing one night and it was so hot I took off my jacket and then I took off my blouse and of course I wasn't wearing a bra. But nobody seemed to care."

The mix of patrons was guaranteed by Ruskin's female bouncers, authorized to decide who would add most to the atmosphere, or the till. The toughest of them was the tiny Dorothy Dean, one of the very few African Americans who starred in Warhol's films. With a cutting wit that put that other Dorothy—Parker—to shame, Dean was supposed to have been the first person to call Warhol "Drella." Perched by the door at Max's, Dean would decide on a whim who she'd let in. "God forbid a man with a nine-to-five job, three kids and a mortgage should be seen at the bar," said one of her fellow bouncers.

Location is supposed to make or break every business that serves food and drink, so Max's ought to have flopped: The restaurant sat "in the night-time desolation of Park Avenue South," a couple of blocks north of the dicey, druggy mess of Union Square. It was surrounded by insurance companies that rolled down their shutters at six o'clock, but in fact a number of artists and filmmakers had begun to carve lofts out of nearby buildings—Jonas Mekas, for instance, and the laser artist Frosty Myers.

"That location was a stroke of genius," said one regular, pointing out that, whether by guile or luck, Ruskin had chosen a spot that was an easy trot for the bohemians of both West and East Villages and also a straight shot by cab or subway from uptown and midtown—and therefore from Warhol's Factory. Max's was the drain at the bottom of New York's underground. That

same regular said that as far as he was concerned, the '60s, as an era, was less a matter of a time than of a place: Max's.

Although Ruskin said that his restaurant was a hit right from the beginning, its first clients were the crowd of photographers who worked nearby plus older painters who Ruskin already knew from his days running a coffeehouse in Greenwich Village. These were the "heteroholics," as one waitress called them—the heterosexual alcoholic Abstract Expressionists. They were soon joined in Max's front room by tough-talking artists of every stripe, from leading abstractionists such as Frank Stella and Donald Judd to the more radical conceptualists, like Joseph Kosuth and Lawrence Weiner, who were eager to unseat them. Arguments were constant, fistfights common. The front windows got broken every few months.

Casting his mind back to the big shots and icons he encountered at Max's, the band manager Danny Fields coughed up a vast list that included the Warhol acolytes Taylor Mead, Brigid Berlin, Paul Morrissey, Gerard Malanga and Ultra Violet plus Leonard Cohen, Janis Joplin, Jane and Peter Fonda, Jimi Hendrix, Mel Brooks and Robert Rauschenberg, once seen doing a striptease. "You would think, 'This is Athens, truly,'" Fields recalled.

The explosive success of Max's Kansas City depended on the new '60s concept of a public bohemia: a group of artists and creators who were both countercultural and visibly successful. The raging new art market, plus everexpanding cultural coverage, put these supposedly marginal figures right in the center of the decade's social mix. As Ruskin admitted, the reason Max's had a perpetual line to get in was because, for just about the first and last time, the mainstream was eager to rub shoulders with the culture's most notable freaks, or at least glimpse them from a perch in "Siberia." It was almost inevitable that a prestige position would be reserved for Warhol, as the most public of public bohemians—almost the creator of the category, in fact. He became a confirmed Max-ist about a year after the club opened, just when its scene began to explode. His domain was the club's back room, which had begun as a neglected overflow space that no one else wanted until Warhol, in his typical love of abjection, had adopted it as his own. As Fields put it, Warhol was the one who "invented" the most famous space at Max's. This wasn't about the cramped back room itself, with its un-Warholian décor of plain restaurant furniture, standard red tablecloths and stretches of wood paneling. It was the social space that Warhol had pioneered.

Donald Lyons, part of the Boston gang that had arrived in New York alongside Edie Sedgwick, talked about a crowd of spectacular misfits and brilliant show-offs at Max's whose "career" involved "simply creating a kind of theatrical display of themselves. . . . This was their desire, was their fulfillment":

If you wanted a role in an Andy Warhol film you went to the back room and made yourself available. Some people took off their clothes while others brought their children. The high priestess of the back room was Andrea Feldman. . . . About two or three in the morning Andrea, the star of Warhol's *Trash,* would stand up, shout out "IT'S SHOWTIME," imitate Barbra Streisand and take off all her clothes.

"Showtime" for Feldman's male counterparts might involve standing up on a table and jerking off. A crowd of such lads, known to the waitstaff as the "back-room nymphets," would gather to see which alpha male they might latch on to. Warhol, meanwhile, was eager to latch on to the nymphets, literally, as he groped his way through their ranks: "He was interested in my dick, as he was in everyone's," remembered Corey Tippin, echoing stories told by just about every pretty young man who found a place at Warhol's table. "I wasn't sexually attracted to him," said Tippin, "but you knew you had the Power of the Penis around him."

Taylor Mead had "his" spot in the back room, a two-seater table under Dan Flavin's light sculpture where he would sit watching and kibitzing, keeping his back to the wall out of speed-induced paranoia. "One waitress told me that they voted on who was the best customer at Max's and I won." Less select under-grounders would come and go, taking up their stations, like courtiers, around the big round table where Warhol and his chief vassals gathered to bask in the human comedy. (Like one of King Arthur's more miscreant knights, the plus-size Brigid Berlin managed to break Lord Andy's round table: She lay across it one night and it never sat straight again, as Mickey Ruskin liked to point out.)

Warhol's people applauded the artist Jo Baer when she paraded through the bar in an Alaskan wolf skin, meant as a feminist's threat to its gathered men. They were less keen on Ivy Nicholson, most eccentric of Factory su-perstars, once she began to throw food. Not that this made her stand out. Ondine filled the air with the makings of a salad and a drunk once poured beer over Warhol's head. Mickey Ruskin would assign the back room to his waitstaff as punishment when they'd broken some rule. "What was so bad about the back room?" asked one of them, very rhetorically: "People pulling off their clothes, yelling and screaming, customers never having anything straight, their eyes were always dilated, and NO TIPS." Anywhere else at Max's people would eat and be happy to pay for the privilege, but in the back room the main comestible would always be one drug or another.

What made the back room such a hell for the staff was precisely what made it an attraction to anyone from the mainstream who wanted to witness

Bohemia's rarer specimens. Michael Caine used to head to the back room on his many visits to Max's. Other celebrities might stop in as well, but not always with good results. "One time Warren Beatty was sitting in the back room with sunglasses on, just waiting for people to come over and flock around him and be sycophants to his stardom—and nobody did. People were more impressed with the freaks they loved who were hanging out there."

Besides the social license it encouraged, Max's offered another major attraction: Mead and the bar's other luminaries were allowed to run tabs; the artists among them could pay them off in art. That was how Ruskin's great Flavin sculpture became the back room's light source. The bar's other spaces featured crushed metal and tied foam by John Chamberlain, a geometric abstraction by Frank Stella and even an immaterial piece made from laser light, which, shot from a studio across the street, bounced off a mirror set near the bar's front and ended up as a dancing red pattern on the back wall. "Going down Park Avenue and then the angle into Max's, it was like following a star," said one regular. The art that Warhol traded to Ruskin, mostly lost in the club's several fires, settled a tab that acted as a Factory bonus system: Underpaid workers like Billy Name were allowed to sign for meals. Many months, Warhol's bill could add up to something like $700, which Warhol paid with a steady stream of pictures.

---

In its May 1967 issue, the stodgy *Town and Country* magazine named Warhol one of the "New 400," those being men (only men) whose achievements were letting them replace the old high society of breeding and wealth. Could that doubtful accolade have helped convince Warhol to take further steps in solidifying his identification with extreme behavior? An alternative paper got him to write a gossip column called "Andy Warhol's Underground Confidential"—the title alone was a sign of his official place on the edge—and Warhol used the opportunity to publicize the chaos his followers were part of at Max's. "VIVA! was cornered by three vicious lesbians in the women's washroom at Max's the other night," he wrote. (Or, much more likely, got someone to write in his name.) "She really got the chills when one of the lesbians started climbing over the top of the stall. Just then, another woman—who is really a female impersonator— came into the washroom and VIVA! was able to leave with her virtue intact."

"VIVA!" was a (mostly) heterosexual woman named Susan Hoffmann, born a decade after Warhol, almost to the day. She received her deliberately cheesy nickname when she became one of the final superstars to join the Factory stable. Warhol rebranded her in honor of a newly introduced, very deluxe, very '60s marque of paper towels, "so pretty you'll display them with pride." (Luckily, the capital letters and exclamation point drifted off Hoff-

mann's nickname.) Viva's arrival signaled a change of direction in the crowd around Warhol that came into full effect a year or two later.

Like Brigid Berlin, Viva didn't have the downtown, countercultural pedigree of Billy Name or Ondine. (Warhol remembered chastising Berlin for thinking that the Flavin sculpture at Max's was just an obnoxious lighting fixture: "I said, 'Do you know that you've been sitting under a Dan Flavin for three years?'—and she didn't know what I was talking about.") Viva, "super self-involved, not exactly superintellectual," came from a fancy upstate family that summered in a grand spread on the St. Lawrence River. She and Warhol had met here and there in the early '60s when she was hoping to break into fashion illustration. She tried to borrow money from him and Malanga once tried to seduce her: "I said, 'Gerard, come off it. You know you're a fag. . . . I heard you were Andy's lover.'" Viva finally came onto Warhol's radar properly at a party in August of '67, when she was a barely aspiring model and actress.

Without much grounding in the avant-garde, Viva's eccentricity seemed more nature than nurture. She spoke with a whiny, high-pitched drawl that outdid even Warhol's. He was soon parroting her twang. Her body was as stick-figure thin as Twiggy's or Edie's but it came topped with an absurd frizz of red hair. After shooting her portrait, Cecil Beaton described her as "a photographic marvel" then gave the following details: "Her eyes are greenish grey like the outside of a hard-boiled egg yolk, and her teeth a dead colour; her nose is an anteater's."

Despite a fine convent education Viva's verbal diarrhea left her no time for social niceties: Any thought that could cross her lips did. This had the upside of making her a liberated woman before women's lib. She happily discussed her menstrual cycle and the sexual failings of her many lovers. When someone once asked why the actors in Warhol's movies were mostly gay, she answered that those films were the old ones: "They're all straight now. I've converted them." Warhol chose not to contradict her.

Once she began to star in Warhol's films, Viva had two specialties: She could outtalk even the Factory's best yakkers and her clothes would be shed on demand. "Viva, if only she would shut up, you could fuck her, but she never did," recalled Mary Woronov. That August night when Warhol and she met at a party, or so the story goes, he offered her a part in the next day's shoot on condition she go topless. Viva agreed but showed up with her nipples hidden under Band-Aids. Warhol read this, quite correctly, as a guarantee of weirdness to come.

"I don't know how Susan did it," said a mutual friend. "She must have hit Andy over the head with a frying pan or something but, somehow she convinced him that she was a creditable actress."

Viva's Band-Aids soon came off, allowing her to appear stark naked in a series of so-called sexploitation films, requested by the owner of a dubious movie theater who was looking for a softer, more arty alternative to outright X-rated porn. In its first week there in July of '67, *My Hustler*, already two years old, had earned Warhol $4,000. Warhol's connection to sex had the weird effect of making this master of the opaque and esoteric a favorite subject for girly magazines aimed at the average American male: By the end of the '60s, *Playboy, Penthouse, Cavalier, Jaguar* and *Swank* had all run features on him, crafted to gin up a lasciviousness that would be hard to find in him or his work. It's especially ironic that magazines in thrall to the straightest of male tastes would focus on an effeminate icon of gayness—just because his movies, and especially the stills from them, did allow the occasional sight of a female nipple or bottom, maybe with a flash of penis as well. "Andy makes the kind of movies he likes to make, and the sex was added later, because without it people wouldn't sit through them," said Paul Morrissey, recognizing the curb appeal that the magazines had latched on to. As Viva put it, "I'm nude because Andy says seeing me nude sells tickets." A magazine described her as the "owner of the best-known anatomy in town."

*Bike Boy*, an early vehicle for Viva, had its share of nudity, but none of it came with any heat. In it, Viva does her best to seduce a real working-class tough who made the mistake of agreeing to appear before Warhol's camera. "He was so good because he was so dumb," Viva recalled. (The movie was briefly titled *Dope* in his honor, and also *Super Stud*, a name it lost after stodgy magazines refused to print it.) The mismatch between Viva, a verbose black widow, and her guileless prey is more painful than sexy or funny, as must have been Warhol's intention. Neither character comes off well.

What especially distinguished Viva from other Warholians was her ability to ape highbrow talk without worrying too much about its content. As with Warhol, and more than anyone else in his retinue, you could never tell whether or not to take her words at face value. It endeared her to him. "We don't have anybody who looks good on film and is also smart and can talk about Winston Churchill," Warhol explained to Viva when he first took her on. She became the latest among his phone buddies, filling the 4 A.M.–to–6 A.M. slot with calls about her familial, financial and romantic troubles: "Always getting to the minimalist point, Andy advised, 'Go with him: big prick, big dick,'" recalled Viva. Photos taken in the early days of their friendship show Warhol gazing at Viva with what looks like deep affection.

A writer once called Viva "Andy Warhol's most valuable found object," and that doesn't sound too far off base. At least to Warhol's Dada-trained mind, it would have been less of a put-down than praise. But it also may explain a nasty

comment he once made to her: "You think you're way up there. You're just a little bitsy star." He later called her his "favorite person." The two quotes are not incompatible: The found objects an artist most prizes are usually the most trivial ones.

A movie called *Nude Restaurant* was the most compelling of Viva's vehicles because of its obvious humor. Viva, Taylor Mead and various lesser superstars defied all health laws by sitting naked in a food-service establishment where they took turns outchatting each other about random subjects. (The venue was called the Mad Hatter, allowing Warhol to align himself with Lewis Carroll for the umpteenth time.) Viva told a tale about her father pimping her out to a one-legged Swiss banker while Mead said he gave up weightlifting "because you have to keep repeating everything" and that it was only the third time he'd seen a woman's nipples. "That's the trouble with being around homosexuals," said Viva. "You always want to get covered up, because they can't appreciate you"—although she makes no attempt to cover up, despite being surrounded by homosexuals.

Of an evening at Max's, Viva could easily go from verbal sparring to a full-on brawl: "I'm always fighting with people," she once said. That was clearly part of her appeal to Warhol.

———

Warhol did not choose to surround himself with aggression and chaos only at Max's. The turmoil drifted deep into the Factory scene as well. Every Warholian has told tales of the backbiting and tattle-telling and jockeying for position that went on there, "a constant sort of fighting to get into the royal enclave," as Geldzahler described it. One reporter overheard a Factory woman conspiring against one of its men: "We've got to get rid of him. He's power-mad." And also a man attacking one of the women: "She's an evil pig, but Andy likes to have her around. I don't know why." Warhol gets billed as the vital catalyst behind these clashes. "How do you think Andy feels about the vying for attention that various people around him do from time to time?" an interviewer asked Brigid Berlin. "Oh, he loves it," she said. "You think he promotes it?" asked the interviewer. "He adores it," she answered.

Viva talked about the time Warhol deliberately stirred up "sibling rivalry" between her and the male stars in a movie where Paul Morrissey was manning the camera. "Paul doesn't want to film you anymore," Warhol is supposed to have said. "He only wants to film the *boys*. Hurry up, get your makeup on and get out there before it's too late." Records of Warhol's conversation confirm such behavior. It must partly have been about provoking the kind of outrageous conflict that made for such good watching in *The Chelsea Girls*. But it's

not clear that a camera had to be turning for Warhol, the Great Observer, to enjoy the spectacle of clashes among his followers. It's likely he witnessed the clashes first, among the tight-wound speed freaks and freak freaks in his entourage, then decided their histrionics ought to be caught on film.

Admittedly, that's the more innocent, aesthetic reading of what Warhol was up to. At a moment of particular bitterness, just as his role with Warhol was dissolving, Malanga preferred to read the Factory rivalries as a control mechanism deployed by Warhol. He said that Warhol built "a very primitive but effective monitoring system. If anyone stepped out of line that person's enemy would report back to Andy of any wrongdoings." But it's not clear that the Factory's unruly population needed much encouragement from Warhol to misbehave in these ways. Malanga's diaries reveal the same kind of petty conflicts and conquests, "scandals" and shamings, that you'd find among just about any crowd of ambitious young people who spend too much time together, with too little outside direction. When Warhol talked about his film and rock projects as ways to keep "the kids" busy and out of trouble, this might have been more than a flip line. It's clear that Warhol felt that the sudden arrival of his army of acolytes and hangers-on was mostly uninvited and out of his control. Again and again, he comes across as more bemused by it than either thrilled or dismayed. The distance he felt from the Factory's "kids" left him refusing to play the adult in the room, even though he was a good decade older than most of his followers. He behaved more like the cool-cat senior in high school who the freshmen do everything to impress and who looks on with amused condescension. "Sometimes when I think about Andy, I think he is just like Satan," said Viva toward the end of her Factory era. "He has such a hold on all of us. But I love it when they talk about Andy and Viva."

Given the magnetic pull that Warhol exerted on his minions, nonintervention was probably his greatest sin. His Svengali presence, coupled to vast quantities of drugs that got abused for months on end, was probably all it took to trigger the Factory's mischief.

John Cale described the predatory partygoing that went on under the Warhol banner:

> As we flew around the city we were never less than ten and often as many as twenty. We didn't so much attend parties as invade them, and Andy's coterie were not fakes. No sooner had we entered somebody's house than we would be combing the bathroom for prescription drugs and checking out the cupboards for free clothes.

Malanga's diaries have him taking several different downers and a hit of acid within the span of just a few days, not to mention popping speed whenever a performance of some kind was called for. Warhol's own drug consumption might not have matched his acolytes', but he wasn't as abstemious as he often claimed to the press. A visitor from California described getting Warhol "really, really high" on pot he'd carried across the country: "He had this character change, and became really butch, swearing and stuff—everyone said, 'Whoa!'" And however often he did or did not indulge, it looks as though Warhol wasn't beyond feeding the habit of others. One college journalist who shadowed Warhol when he appeared with the Exploding Plastic Inevitable in San Francisco described the artist as traveling with "a great big bag of pharmaceutical-type pills: libriums, valiums, uppers, downers."

———

As the Factory staggered through its fourth year, Billy Name was deliberately allowing its silver décor to crumble. "I wanted it to be fresh in the beginning and then slowly decay into whatever it became," he recalled, but Warhol himself was less sanguine about the deterioration. "It used to be so pretty," he said, looking on at the faded glory of the Factory's final days. Photos show that its once lofty spaces were now packed to the rafters with accumulated junk. By the end of '67 reporters were noting that the Silver Factory had lost almost all of its former sheen. Even its trusty old elevator was showing signs of breakdown.

That could also be said of the Factory's always-precarious social life. A love letter to Warhol from Ivy Nicholson, the former cover girl, shows her peculiar view of their relationship:

> My love for you is very strong and so am I. All power is involved with sex everyone knows this. You have power you dominate me which is phenominal no man has ever dominated me. I only wish to give you more please accept my love. . . . You are to me my every dream. I am yours so say the stars up above.

She actually published an announcement of her (fictitious) "engagement" to Warhol in the *New York Post*. Unburdening himself to a cab-driving friend, Warhol said that Nicholson was demanding that he pay for her to go to Mexico so she could get a divorce and come back and marry him. "I've decided to really be straight with Ivy and tell her that, you know, she's crazy," said Warhol. He might have regretted his straight talk. He first gave her the news at Max's one night in June, causing her to throw her food across the back room, "and I ran out because I didn't, you know, like I didn't want there to be a scene."

Back at the Factory, Nicholson shat behind the famous couch "so that a part of her would remain with Andy," according to one onlooker. When Billy Name then frog-marched her out of the space, she sent the elevator back up with another turd sitting on its floor. "I thought, 'What can I do that's really obnoxious?' Then I thought, 'I can shit!'" Nicholson recalled. "And Andy said to me, 'You pooped in the elevator? No one ever did that before! Please come back.'"

Nicholson's letters, to Warhol and others, continued to speak of their marriage for another half decade. In 1969, after she had decamped to Paris, she arbitrarily got her son's private school to forward his tuition bills to Warhol, which didn't stop her from calling him "damned evil" and informing him that she was disgusted at his choice "to remain a faggot." In the years since, she never stopped imagining that Warhol got an erection whenever she revealed her legs: "He didn't have time to stick a banana down his pants so there *it* was. This happened every time I wore a mini-skirt. Look at my legs! . . . The way to turn a gay guy straight is wear a mini-skirt and see what happens."

In the summer of '67, Ivy had become so love mad that she said she was willing to settle for sharing Warhol with "Rodney," a new lover of his known as Rod La Rod who injected almost as much chaos into the artist's life as Ivy had. Warhol remembered his young boyfriend's "jangling nerves" and Gerard Malanga called their relationship "truly masochistic." He described how Rod, "a retard, obnoxious, an embarrassment," would slap and punch Warhol even in front of others at dinner parties, a public torture that Warhol seemed to enjoy. He was breathless with excitement one night at Max's after his tape recorder captured his lover getting into a fight. At the Factory, but also beyond it, the two men's silly horseplay—"kid stuff," according to one observer—could easily become something closer to a proper beating delivered by Rod. Warhol seems to have been complicit in the violence—Rod liked him to slap back—but that didn't stop the older man from sometimes ending up in tears. "They'd smash each other to ribbons. Then they'd make up. It was just wonderful. They'd found each other," recalled Ondine, whose tastes always tended toward the extreme. He found more tenderness and genuine affection in Warhol's chaotic affair with Rod La Rod than he'd seen in any of the artist's earlier romances.

Rod (born Rodney W. Thomas) was a tall, blue-eyed Alabaman with long sideburns and lank brown hair who claimed to have been a roadie for Tommy James and the Shondells. By late '67, he was telling a journalist he worshipped two gods: the racist politician George Wallace and Warhol, "the Great White Father." He'd first arrived on the Factory scene in the fall of '66, when he worked as sound man on a film that gives more evidence for Warhol's growing masochism.

Warhol had a notion that he wanted a flamboyant, drug-abusing young poet named René Ricard, from Edie Sedgwick's Boston crowd, to play him in

an autobiographical movie to be called *The Andy Warhol Story,* which must have been conceived as a companion piece to the biopic Warhol was filming with his mother that November. Ricard agreed to play Warhol but only, he recalled, to have a chance to get revenge for what he saw as the artist's "manipulations." (Ricard had been banned from the Factory after Warhol accused him of stealing a Brando painting, an act perfectly in keeping with the poet's usual behavior but possibly committed by Paul America, star of *My Hustler.*) When the time came for the shoot, Ricard was flying high on a double dose of Obetrol and insisted that they find the long-absent Sedgwick to play opposite him. Miraculously, she was in New York and reachable. She agreed to appear and once she'd arrived on set—some three hours later, zonked out on downers and looking a mess—Ricard and Sedgwick began the cruelest of satirical improvisations. They made fun of Warhol's hands-off art making and attacked how he dealt with his acolytes. "I played him the way he behaved to the people under him," said Ricard. "She played herself according to how she felt about him then. . . . I have nightmares about what I did in that movie." And yet, watching himself get torn to shreds, Warhol insisted they shoot a second reel after the first reel of horrors was done.

Warhol's boyfriend Richard Rheem played Malanga in the same film, and when Warhol dumped him soon afterward Rod La Rod slid into the place that was now vacant. The contrast could hardly have been greater between the sweet, well-bred Californian and the vicious, violent Southerner— "sullenness itself," as one friend of Warhol's described him. The change stands pretty well for the direction that Warhol's whole life and art were heading. In a letter Rod sent a few years later, when he was serving in the army, he described himself as having been Warhol's "toy," but if anyone had been a toy it was Warhol, acting as Rod La Rod's bouncy-clown punching bag.

There's at least one tale of Warhol taking on Rod's role as the Factory sadist. Warhol is supposed to have invited a sensitive young hippie named George Harris for what Harris thought would be a "date" with the artist. (This was the same young man shown putting a flower into a soldier's rifle in the famous photo from the March on the Pentagon in 1967.) Instead of romance, Harris found himself attacked by "some male friends of Andy," who spent all night beating and burning him with cigarettes while Warhol looked on with pleasure. "They told me the police won't listen to a faggot," Harris told a friend who wanted him to go to the authorities the next day.

---

The height—or nadir—of the chaos that gripped the Factory in 1967 came in November. That's when a strung-out, gun-toting friend of Ondine's, known as Sammy the Italian, needed money to settle a drug debt and was told that

the Factory was the place to get it. (That false suggestion apparently came from Dorothy Podber, the dedicated troublemaker who had shot a pile of Warhol's Marilyns a few years before.)

The story gets told any number of ways by any number of tellers, but the gist of it is that Sammy came flying into the Factory demanding cash of the assembled Warholians, who included Warhol himself plus Nico, Paul Morrissey, Taylor Mead, Billy Name and assorted others. The assault was so unlikely, and the assailant so gorgeous, that at first Warhol and the others figured he was staging a spontaneous audition for one of their films. That impression began to wear off when he lined them up on a couch and started waving his gun around; it evaporated entirely when a giggling Nico wondered aloud whether the gun was loaded, prompting Sammy to loose a round into the room. In his addled state, he then removed all but one of the bullets from his gun and threatened to keep pulling the trigger until he was given some cash. "He had the gun. He pointed it at us. Click. Four clicks!" Warhol remembered, exactly twelve months later. Dollars began to appear before anyone heard the last two clicks—or rather, a click and a bang, or even worse a bang right away. At this point, it seems that young Sammy suddenly began to feel bad about what he'd done. "I don't want to hurt anybody! I actually need the money! I don't want to hurt anybody!" he said, surrendering his gun to one of the younger superstars in the room. That "dopey kid" then said he'd rather not have it, thank you very much, and promptly passed it back. Morrissey, more levelheaded than most of the crowd (which isn't saying much) declared that he'd be happy to be the gun's keeper and finally received it from Sammy, burying it in the sofa pillows behind his back.

At some point in this bizarre affair, Sammy the Italian thought it would be a nice move to tie a woman's rain hat onto Warhol's head (or on Mead's, in one telling) and that was his undoing. "Who is this punk insulting a genius!" said Taylor Mead to himself (or about himself, maybe) and he threw his full ninety-seven-pound-weakling's body at the aggressor, who was busy wrestling with Morrissey for the gun: "It was like jumping on a brick shit-house, though, and then he pulled out a knife," said Mead. Still intent on defeating the invader, Mead put the rain hat on his fist and punched out a Factory window. He screamed for help from the shocked patrons of the Y.M.C.A. across the street and then—or so Mead claimed—proceeded to rip the window frame out to use as a weapon against Sammy. Faced with an enraged underground poet, the Italian and his lookout wisely took off down the Factory stairs, with Morrissey vainly trying to shoot the gun as they fled. ("I didn't know how to do it, or something," he confessed.) Mead sent the window frame clattering down after them.

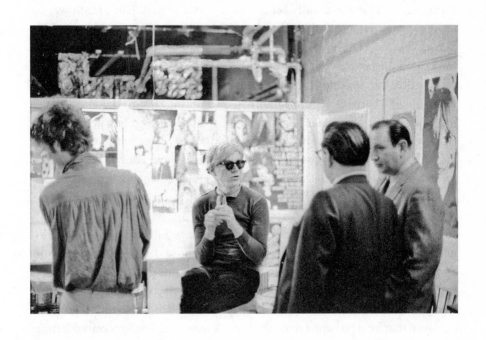

*. . . working on a deal.*

## 32

# 1967

*"I would be running around saying, 'Come on Andy, give me some damn money, what the hell's the matter with you?'"*

In 1967, life at the Factory was about as stimulating as Warhol could afford it to be. That was lucky, because his art making was taking a turn toward the dull and predictable. At least when it came to traditional painting and sculpture, he was truly the ex-artist he had claimed to be. He came out of retirement only to satisfy patrons who wanted versions of his Greatest Hits.

The curator Alan Solomon, who had organized the Boston survey for Warhol—and had also left him out of the 1964 Venice Biennale—came to the Pop artist for help in filling the contemporary-art section of the giant American pavilion at Expo '67 in Montreal. That world's fair, held in celebration of Canada's centennial, opened in the spring and went on to be the best-attended such festival, ever. But rather than coming up with important new work worthy of the event, Warhol, the now-former painter, simply enlarged six of the fingers-on-lips self-portraits that he'd provided for his Boston show. Once again he presented himself as a wordless enigma, in paintings that were more about expanding his presence and persona as an international man of mystery than about impressing anyone with his artistic imagination. Like most of the works by Solomon's twenty-two other artists—including such Warhol friends (and rivals) as Roy Lichtenstein and Jasper Johns—the enlarged self-portraits hung down in midair in the vastness of the U.S. pavilion, a stunning geodesic dome designed by Buckminster Fuller. After a visit to the fair, Warhol reflected on his paintings: "They're the worst things there. The U.S. building at Expo is so beautiful, they should have left it

empty." His artistic judgment was dead-on, in this case as in most others.

Other portrait commissions were no more ambitious, at least in aesthetic terms.

Toward the start of the year, when the Leo Castelli gallery was hosting a tenth-anniversary show, Warhol had been given photos of twelve Castelli artists to screen onto canvas as a celebratory project. He did his best from this weak starting point, playing with the croppings and shapes of his portraits to give them some hint of variety, but in the end the series could have represented any dozen people off the street as silkscreened by any decent Warhol imitator. Its one point of interest was a clever circularity: Where the other artists were represented in the show by one of their classic works, Warhol's piece was also a comment on the show and Castelli and his stable. That is, it was both in the exhibition and about it. The banality of its portraits could even be read as poking quiet fun at the idea of the portrait-worthy art star—of which Warhol, of course, was the prime example.

In the fall, Sidney Janis, the dealer who had helped launch Pop Art five years before, got Warhol to do a portrait made up of eight little canvases showing him through the decades, based on old family photos and some more recent headshots. The result was a weaker version of the Rauschenberg series Warhol had come up with in his first months of silkscreening, just about when Janis was first showing him. But whatever its faults, the commission served an important function: When Janis donated the series to MoMA, almost while the paint was still wet and without having seen it himself, it added a second major Warhol to that prestigious collection, on top of the gold Marilyn donated a full five years before. The Janis portraits also came with a third MoMA donation that has gone almost unnoticed: Warhol asked that the gift include the silk printing screen for a much larger Janis portrait, a full eight feet tall, to be displayed free-standing and lit from behind. Rather than fleeing the mechanical, industrial implications of his silkscreen technique, Warhol wanted it underlined, as though that process was the real art of the Factory, with the canvases as mere by-products. Getting that screen into MoMA may actually be considered a bit of a consolation prize. Warhol had used it to print a vast mural made up of seven almost-identical, black-on-white headshots of a smiling Janis that stood brilliantly for the size of any top dealer's ego, as it looms over the artists who feel under his thumb. That, Janis explained in a reassuring letter to Warhol, was pretty much why he'd declined to buy or donate the mural. He knew a left-handed compliment when he saw one.

When Nelson Rockefeller, governor of New York, then took his turn as a Warhol patron, he got four big portraits that were only interesting for the wild colors that Warhol splashed here and there across the politician's scowling

face, in an early version of the stylish color work Warhol would use for some of his more commercial contracts in the 1980s. Rockefeller had had a hand in the demise of the *Thirteen Most Wanted Men* mural back in '64, so maybe it's no surprise that his portraits feel phoned in. Warhol never forgot a slight.

Warhol might have been even less inspired by the circumstances behind some huge remakes of his three-year-old Flower paintings. They were produced to settle a copyright claim brought against him by the photographer who had shot the blossoms in the first place. She maintained that after Warhol had refused to pay the reproduction fee she had quoted he went ahead and used her photo anyway. When her lawyers' first gambit demanded that all the paintings be destroyed, Warhol's Dada response was "Wouldn't that be marvelous!"—but he went on to settle instead, letting two of the new Flowers represent a $6,000 payment to her.

Warhol always preferred barter to paying cash. His main attorney took paintings as payment for all his legal work, certainly the best deal that attorney ever struck. In '67, Warhol must have seen his Flowers settlement as an especially profitable trade: Somewhat smaller paintings of his, on any number of subjects, were still being valued at only $500.

It was a year of legal squabbles.

Already in January, the Campbell Soup Company had come after Warhol for not getting permission to use their famous can label on the announcements for his I.C.A. Boston survey.

All year, Lou Reed was disputing the rights and payments owed to the Velvets.

Eric Emerson, the nude acid-tripper in *The Chelsea Girls*, brought lawsuits that demanded $250,000 each for the unauthorized use of his footage in the movie and of his image on the back of the Velvet Underground cover. He ended up settling for all of $1,000, but he did manage to get a judge to ban the screening of his *Chelsea Girls* scenes in New York State and MGM to airbrush him out of the Banana album, forcing it off the market for a number of weeks.

Mary Woronov went after Warhol over her acting fee and Paul America got a retrospective payment of $2,500 for having played the hustler in *My Hustler*, back in '65. "I think Andy was always *willing* to pay, but somehow he was never there when I called," the actor told the *Times*, while downplaying the payment he got to a mere $500. "He's so sweet, but he's . . . Andy. You can't argue with him and get him to write checks. He just 'oohs' and 'aahs' and calls in someone to take over the conversation for him."

Moe Tucker remembered the hard work she had to do to collect the gas money she needed from Warhol just to make it into Manhattan from her parents' suburban home: "I would wind up chasing him around the Factory, and

we turned it into a slapstick routine, you know, after the first time. I would be running around saying, 'Come on Andy, give me some damn money, what the hell's the matter with you?' 'Oh no, just a minute, he would say,' and he'd go skittering off somewhere."

Warhol might not have been skipping out on his debts just out of long-standing habit. Money seems to have been as tight as ever. "There was no cash flow to pay anyone," recalled Billy Name. "All the money he got from selling the paintings went into making the films." For Name, at least, it was enough that Warhol paid the Factory rent and bought food "sometimes when we needed it." In 1967, studio revenue would have been even worse than before, since it looks as though Castelli had very few of Warhol's older paintings left to sell and a handful of new portrait commissions would hardly have made up the difference. They would barely have covered the superstars' tab at Max's. In Paris, Ileana Sonnabend's sales may have been a bit better but were still only adding up to some $10,000.

———

Just about the time that Warhol's painting sales were slowing, deluxe editioned prints were being tried out by many artists as a new income stream—to their dealers' chagrin, since they were often left out of these deals. Warhol's first steps as a major printmaker produced one of his best works of fine art, and one of the least known. Already in July of '66, a Broadway lawyer and art collector who owned the elite Racolin Press had proposed publishing a set of Warhol prints as "a book dealing with President Kennedy." By the following summer, Warhol was well along with work on the project: a portfolio of eleven big silkscreens, presented as a giant unbound book, that did a brilliant job capturing the drama that played out on the day of JFK's assassination. Titled *Flash—November 22, 1963*, the portfolio reproduced media images of such things as the gun that Lee Harvey Oswald used to shoot Kennedy, of the window in the Texas Book Depository that he shot it from and of a smiling Jackie in the motorcade, unaware of what's about to happen.

Warhol paired each image with a page or two of teletype text that broke the news of the day's events—slowly, painfully, across any number of telegrams, just as Americans received dribs and drabs of information across that gruesome day:

FIRST LEAD KENNEDY
DALLAS, NOV. 22--PRESIDENT AND MRS. KENNEDY AR-
RIVEDX HERE TODAY IN THE SECOND DAY OF THEIR SWING
THROUGH TEXAS.

FLASH

DALLAS--SHOTS AT KENNEDY MOTORCADE

FLASH

DALLAS--TWO PRIESTS SUMMONED TO KENNEDY X IN
EMERGENCY ROOM.

FLASH

DALLAS--PRESIDENT KENNEDY DIED AT 1 P.M.(CST)

Around the same months in 1967 that he was working on *Flash,* Warhol
was playing up his public image as an unfeeling freak; to a certain extent, he
might have been living his life as that kind of character. But the *Flash* portfolio,
originally titled *Andy Warhol's Tribute to John F. Kennedy,* shows how directly
and powerfully he could still respond to a tragic subject without falling into
bathos or simplemindedness. The dislocations and gaps between his various
images and their texts even capture some sense of the unfilled gaps that people
have found in the truth about the assassination; there's something cinematic
about Warhol's silkscreens, as though we're looking at frames from Abraham
Zapruder's footage of the shooting and still finding that something is missing.
(An ambitious, much-reviewed book about movies had just paired Warhol and
Zapruder as filmmakers.)

As usual, Warhol the Great Sponge had found inspiration for his *Flash—
November 22, 1963* in the work of someone else: His college hero Ben Shahn,
who a few years earlier had published a deluxe book of prints called *November
Twenty Six Nineteen Hundred Sixty Three.* (That was the day newspapers ran their
coverage of JFK's funeral.) Shahn paired pages from a memorial poem with
prints that were equally poetic, but in the old sense that they were opaque,
overwrought and uninformative: a dark woods; a crow; a black horse, unbri-
dled.

Warhol's Kennedy project had an even more immediate precedent in a
New York exhibition called "Dallas, November 22, 1963," which had gathered
together a series of JFK images by a famous printmaker named Antonio Fra-
sconi. His approach was a touch more documentary than Shahn's but had most
of the same faults. The images were dark, with a welter of standard expression-
ist hatch marks, and a New York critic found them "resonant with the disbelief,
the grief and the sorrow millions felt." Bizarrely, the critic also insisted on the
show's debt to Warhol's art, even though Warhol had never believed in such
facile "resonance." Warhol couldn't have missed that strange shout-out and, as
competitive as anyone, he used *Flash* to demonstrate how that Dallas day really
needed to be commemorated in modern art worthy of the name.

As Warhol moved forward with editioned prints, *Flash* turned out to be

exceptional in its heft and innovation. In the summer of 1967, when he was still working on that JFK suite for Racolin, Warhol also launched his own Factory Additions, an in-house enterprise dedicated to turning out prints that were salable repeats of his early Pop subjects, and that stayed under Warhol's control. (An entire notebook survives in which Warhol kept track of which prints he signed for who—with Castelli listed as one of these "clients," apparently with no more right to a print than anyone else; Sonnabend complained of being left in the dark about Warhol's editions.) For the first Factory Additions project, a commercial silkscreening firm was paid to pull 2,500 prints of Warhol's classic Marilyn image from five years before, now much enlarged and issued in portfolios that featured the signed print in ten different colorways, from magenta on blue to pink on olive. Their psychedelic, Op Art–y eye appeal had the downside of making Warhol look as though he'd abandoned his Duchampian, antiretinal roots. That suited some segments of the art world that had always wanted to link him to safer, more traditional, less conceptual values by praising him in old-fashioned visual terms—in terms of a work's color sense or composition or technique. But if that kind of praise does seem appropriate to the Marilyn prints, there are also hints that Warhol might have been playing a double game: Since the color combinations were not in fact chosen by him, they let him toy with sophisticated ideas about the end of authorship at the same time as they helped the images sell. And anyone willing to look at all closely can see that a few of the prints show us Warhol at his most uncompromising. In one image, deliberately bad color registration gives Marilyn a pink mustache and "the hideous jarring note of a nightmare yell," as a London critic wrote when he saw the print for the first time. Another image, printed from a negative, just about explodes Marilyn's face. A third, done in ghoulish shades of black and gray, makes her look like Bela Lugosi in drag. So much for Warhol as a doting fan of celebrity glamour. Announced five years after the movie star's death, almost to the day, the Marilyn portfolio seems as much about her dysfunctions as her triumphs. "With these images of a nothingness more poignant than despair," wrote the same Londoner, "glamour has gone a long street-car ride from High School dreams."

In early '67, the editor of one art magazine actually predicted the replacement of fancy gallery paintings with "machine-made assembly-line stuff—mass-produced art like Andy Warhol's Campbell soup tins," to be sold direct to the average joe. With his Factory Additions, Warhol was doing his best to make that prediction come true, although his prints were priced for joes who weren't quite average and, as it happened, he didn't start mass-producing his actual Soup images until 1968. It could be that the repetition and lack of novelty in most of Warhol's print editions needs to be seen as one of their virtues, or

at least as one of their subjects: His prints were "assembly-line stuff"—the art-world equivalent of cans of soup—and therefore counted as yet another commodity he was making art *about*. They held a mirror up to the unthinking mass consumption that Warhol was now encountering among America's collecting class. As one writer marveled, grudgingly, "as a creative artist he is original in that he eschews the original and creative," and as early as 1962 Warhol himself had already asked, "Why should I be original? Why can't I be non-original?"

Warhol certainly started churning out his prints to make money. But that didn't detract from his genius, since that genius had always mined how Americans buy. You could even argue that the "sold out" repeats of Marilyn and the Soup Cans were more important, as foreshadowings of '80s postmodernism, than *Flash* was as a last great gasp of modernist innovation.

———

It may be true that most of Warhol's works from 1967 were retreads of creations he'd finished years before, but there was one major, exciting project that was still underway and getting more attention than ever: the living sculpture called Andy Warhol. That persona was an ongoing work that risked disappearing if Warhol stopped tending to it, like a drawing in invisible ink that needs to stay drenched to be seen.

Warhol's public profile didn't demand that he make genuinely important new art; given the fame he had already racked up, he just needed to make enough art, publicly enough, to remain recognizable as "Andy Warhol, the artist." His latest art objects, and maybe even some of his films, were becoming more like props in the ongoing Andy Show than independent and important works of the imagination. By using them primarily to pay his bills, Warhol was even giving a first glimpse of a role he'd perfect in the following decade, as the pioneering maker of what he came to call "Business Art."

By the beginning of 1967, the success of *The Chelsea Girls* looked like it was going to be the key to Warhol's biggest dose of fame (and infamy), not to mention bringing in vital funds. In New York, its run had taken it from theater to theater right until June, for a total of almost four hundred screenings. That made it by far the most-watched underground movie of the era, maybe ever. In those first six months of the year, it had earned Warhol $25,000, including $9,000 from the sale of the British rights. Nothing like the "million dollars" one paper reported, but not a bad take—although still not beating what Warhol had made doing six months of blottings a decade earlier.

As *The Chelsea Girls* took off across the nation, Warhol eagerly rode the movie's coattails, to venues both great and small.

In January, a New York bookstore ran an ad proclaiming that "AW and

the Chelsea Girls will draw the winning names in Marlboro's literary sweep-stakes." You wonder which "girls" Warhol chose to do the draw with—and why he bothered at all.

In late March, he showed up with seven acolytes, including his beloved Rod La Rod, for the movie's Los Angeles premiere, at the flagship theater in what one writer described as "the first hippy chain." The venue was called the Cinema Theater, with a redundancy that sounds almost Warholian. Its marquee read "Genuine Ersatz: Warhol's Chelsea Girls," but Warhol chose not to stay in the genuinely ersatz Gene Autry Hotel the promoters had booked him into. He preferred the grand old Beverly Hills where he'd had a free night or two back when he was shooting Taylor Mead as Tarzan.

On this third visit, L.A. could hardly have offered Warhol a better welcome. At the Beverly Hills, he discovered that Liz Taylor was a fellow guest, so he got to invite her to his *Chelsea Girls* opening. The premiere received the full range of coverage, from mass media (NBC TV) to elite (*Cinema Magazine;* Pacifica radio) to alternative (the *Los Angeles Free Press*). Among the local movie critics, at least one doubter became a convert. He trumpeted *The Chelsea Girls* as "one of the most disturbing movies ever made . . . a modern *Purgatorio.*" (A hater referenced Dante's *Inferno* instead.) But if the film itself helped win back Warhol's early reputation as a maker of the toughest anti-art—its reception recalls those aghast L.A. reviews of his Ferus Soup Cans five years before—he somehow couldn't bring himself to drop his usual camouflage as a superficial gadabout. He raved about the local beauties ("the people are cleaner and more gorgeous here than anywhere else") and the plastic pleasures of a Universal Studios tour ("inside or outside the place, it was very difficult to tell what was real").

Warhol invited a reporter to join him and his crowd for an endless evening on the town. They began at a rock concert by Iron Butterfly, probably doing one of their first-ever public performances of "In-A-Gadda-Da-Vida," confirming Warhol's amazing Zelig presence in our culture. They then moved on to a private party and then to a Teenage Fair where "hundreds of yummy teenyboppers" enjoyed rock bands, frozen bananas, stalls selling paper dresses and a "psychedelic freakout," complete with strobing light show, put on by the West Coast Pop Art Experimental Band, a new troupe happy to give Warhol full credit for their ideas. The marathon outing concluded at a nightclub where Susan Bottomly met David Hemmings, the star of Michelangelo Antonioni's *Blow-Up,* at whose New York premiere Warhol and Co. had been photographed a few months before. Hemmings took the superstar home "and painted her body with his own version of the currently popular psychedelic poster art," according to the reporter, who notably failed to reveal his source for this rather private info.

It's a strange fact that *The Chelsea Girls,* Warhol's toughest work of art, was acting as an excuse for Warhol to show off an oddly goofy Pop persona that had not yet fully given way to the scarier one from Max's back room. Warhol toured with the movie to its many premieres and did the same ingénue act at each one, backed up by an ever-changing cast of Factory characters. At an April press event in Washington, D.C., he was accompanied only by five male followers "of a rather staggering innocence," according to one article. When Warhol said that *The Chelsea Girls* was shown on two screens a reporter asked "Simultaneously?" and Warhol, feigning idiocy, answered, "No, at the same time." (That one was worthy of the Beatles.) When asked his age, Warhol turned for help to Rod La Rod, who answered with an absurd "Twenty-six."

In San Francisco, where *The Chelsea Girls* was grossing a "sizzling" $16,000 during its opening week in late August, Warhol once again showed up wearing leather, as he had in L.A., but otherwise played it meek once again in his actual comments. As usual, it was his retinue that got to stand for the Factory's growing degeneracy. Nico and Ultra Violet were in attendance, to represent the studio's distaff side, and they threw in an occasional naughty quip, but Paul Morrissey did most of the talking. He didn't hesitate to express disgust for acid-tinged, soft-core hippiedom and praised the tough culture of speed and smack: "There's a lot to be said against San Francisco and its love people, and a lot more to be said for the New York hard-core degenerate." Warhol's Factory, that is, was more an anticipation of 1970s punk than a participant in the '60s culture of the Summer of Love. In San Francisco, the Factory's New Yorkers lived up to their degenerate image by unleashing "pandemonium" in their hotel, running naked through the halls and consuming vast quantities of pharmaceuticals.

The most prestigious appearance that *The Chelsea Girls* won for Warhol came when he was invited to show his movie in the New Director's section of the Cannes film festival in May of '67—not as an entry in the competition proper, for some reason, but at least as an auxiliary, hors concours event. He arrived with quite a crowd—Malanga, Morrissey, Nico, Rod La Rod, Susan Bottomly and a bunch of others, including even Eric Emerson, whose lawsuits must not have seemed that big a thorn in Warhol's side. "I couldn't afford to pay them for working in *The Chelsea Girls,* so I paid them with the trip," Warhol explained, while the trip was still in progress. He had some actors actually sign releases acknowledging that the funding of their travel stood in for their $1,000 fee.

If getting the invitation had been a thrill, Warhol and his "kids" were down in the dumps when they showed up—ages late, as always—for an interview at the grandest hotel on the famous Croisette in Cannes. It seems the bosses at the film festival had found every kind of excuse not to screen *The*

*Chelsea Girls,* after all, even though that year's festival was said to have been all about the distinctly Warholian themes of "callous sex" and "character alienation." Malanga, wearing hippie green velvet to the interview, said that their film's naughty bits had scared off the festival organizers, since they had already suffered one scandal over some dirty lines in a film of James Joyce's *Ulysses.* For a minute, Warhol dropped his impassive pose and wallowed in his annoyance. He said all his films were "trash . . . because life is trash," and then he unloaded on the Cannes potentates: "They're so old, they should be running a grocery store. . . . Before, people fell asleep during my films. When they didn't walk out. But the Chelsea Girls is packing them in. Why? Because it's dirty."

The article from Cannes is as telling for what it leaves out as for any news it gives: In the spring of 1967, the reporter felt no need to include any explanation of who this "Andy Warhol" might be that he's writing about, or why he might be worthy of a story.

The upside, if any, of the Cannes cancelation was that it left the Factory gang plenty of time to enjoy the high life on the Côte d'Azur, with Nico driving them to the nearest posh hangouts and once again almost killing them on the way. This trip gave Warhol his first full taste of high-class life in Europe, which he turned into a steady diet over the following decades. He was especially happy to have had the chance to dine with Brigitte Bardot and her "ball-bearing heir" husband, telling the actress that she'd been his first choice as the star of *Sleep.* "She's really very . . . very sweet, really sweet," he recalled as soon as he was back in New York. In Cannes, he "treated" the couple to a private screening of *The Chelsea Girls* in his elaborately wallpapered hotel room: "We'll just project onto the wall," Warhol said. "It could get interesting."

From Cannes Warhol went to Paris, where he got to frequent celebrities once again, dining two more times with Bardot and attending a three-hour speech by Charles de Gaulle. He enjoyed it despite claiming not to have understood a word: "He had a lot of style and it was sort of great," Warhol said, using words that might have described his next two decades of on-again, off-again Francophilia.

After the rebuff in Cannes, in Paris Warhol finally got the satisfaction of a French premiere for *The Chelsea Girls,* screened at the new home of the Cinematheque Française, a mecca for the world's cinephiles. The event attracted "big buff and critic turnout," according to the coverage it earned in *Variety,* and suffered only some twenty walkouts, a better tally than at many a New York screening. One French writer went so far as to describe the film as "beautiful." Taylor Mead was then living in Paris, and the night that he went to a screening he witnessed a pile of his French painter-friends

all leaving the theater at once. This conservative reaction to *The Chelsea Girls* made him accept Warhol's invitation to return to New York and the Factory.

Warhol's most important appearance in Paris was at the third solo show that Ileana Sonnabend had just opened for him. It presented the *Thirteen Most Wanted Men* for the first time since they'd been glimpsed at the New York World's Fair three years earlier, on that single day before they were silver-washed out. (Warhol had printed the Sonnabend versions onto canvas using the original screens from the mural.)

France had first got to know Warhol's art through the Death and Disasters show he'd referred to as "Death in America," at Sonnabend in 1964, so it's no wonder that the latest exhibition got him billed as a continuing scourge of the American Way. One writer who called Warhol "as much a master of Pop Art as of New York's nightlife"—as though his art now needed to be brought out from under the shadow of his partying—said that with his *Most Wanted* canvases Warhol was forcing his bourgeois collectors to lionize a crowd of public enemies. Another, describing Warhol as "an activist filmmaker," claimed that the American government had banned all public display of the paintings, which happened not to be true and was anyway something more likely to happen in France than the United States.

The most daring Parisian critics saw Warhol as the great painter of modern life—the latest, that is, in a grand tradition born in the France of Courbet and Manet:

> Today's beauty is violent, and its violence is a well-oiled, finely tuned mechanism served by ruthless computers that give you, twenty years in advance, promises of war and hunger—a death always renewed in its violence. To express the modern world, Warhol uses aggressive, direct, brutal means, like the brutality of life itself. He uses the most extraordinary and the most insidious forms of violence, coldness, and impersonal truth.

For Warhol's Parisian fans, his *Thirteen Most Wanted Men* represented "an act of dissent, an awakening, a coming to consciousness"—all this, precisely one year before the Paris "revolution" of May 1968.

Not surprisingly, Sonnabend had a hard time making sales from this "tough exhibit," as the dealer called it in a letter to Warhol. Not a single picture changed hands during the run of the show itself, she said, apparently answering an anxious query from Warhol. It took another six months for the canvases to begin to find homes, mostly among German collectors, who've often had a taste for Warhol at his most critical. The Paris exhibition did bring one

benefit to Warhol's finances: It got Sonnabend to offer him a running stipend of $1,000 a month, on top of the $2,000 he was already getting from Castelli. (Warhol asked that the check for the first payment be made out to Billy Name, so his accountant wouldn't know to declare it on his taxes; Warhol's dislike of the I.R.S. knew no bounds.) The *Most Wanted Men* also cemented Warhol's European reputation as the most serious of artists, and one who was seen as deeply worth owning. For the next two decades, his standing and sales in Europe balanced out an America that couldn't quite decide on his worth.

Warhol always loved repetition and the familiar, so it's no wonder that he headed to London after Paris, as he had two years before when he was traveling with Sedgwick, Malanga and Chuck Wein.

A reporter caught up with the Warhol crowd the day before they were supposed to leave for New York, when for some reason they had just been kicked out of their hotel. Looking like "a piece of limp dusty string," the frustrated Warhol talked about upcoming London gigs—for the Velvet Underground (which never happened) and for his art, at Robert Fraser's gallery (also never happened). This is the time he said he lived only on "Obetrol pills and black coffee," and proceeded to gorge on chocolate, nuts and marzipan, "his favourite sweet." He complained about being made to take (and pay for) a cab to a nearby destination, when he would have preferred to walk. And he groused about how much he disliked travel, ever since the "three day" round-the-world trip that he'd done ten years earlier—whereas in fact he'd go on to spend decades selling himself and his art all over the globe.

———

When Warhol returned to the United States, in late May of '67, the Velvets were still in the Factory picture, but barely. Their album had appeared in March to just about zero acclaim and even less radio play. That same month, after the Polish hall had been leased to another outfit, Warhol was offered an old gym for the band to perform in. Leaving its trampolines and basketball hoops in place, he billed the cavernous space as a club called the Gymnasium. The location was lousy, however, out on the far east edge of the Upper East Side; the acoustics were atrocious and the band's handful of shows there were often half empty. "They weren't trying to please anybody, and they weren't trying to look good," recalled one onlooker. "They were just there in whatever they wore that day, sometimes with their backs to the audience, getting the sound they wanted. No showmanship." Some official "party nights" went well, attracting everyone who was anyone in New York, but already within a few weeks of the Gymnasium's launch a gossip column was announcing that its "glamor of dirt, sweat and dears is over, done, finished"—a column

that proved, more than anything, that there was now nothing so slight in Warhol's life that it escaped the eye of celebrity watchers.

When Warhol had then taken off for France, the band resented that Nico, Gerard and their other stage-show mainstays had been invited along while the musicians themselves were left at home, losing the chance to try for gigs in Europe. (In London, Warhol did confer about their prospects with the Beatles' manager Brian Epstein.) After more than a year of working with the artist, said Cale, "the Velvet Underground had slipped from being his number one project way down his list of priorities." Malanga remembered Warhol growing frankly bored with the work of tending to the band's needs, both material and emotional—and Warhol appreciated boredom only in art, not in life.

Almost as soon as Warhol and his usual suspects had returned from London some of them went to join the Velvets for a concert in Boston, only to find that Lou Reed now refused to appear onstage with Nico, the Warhol "discovery" whose presence he had always resented. Cale felt that this refusal acted as "a symbolic cutting of the umbilical cord with Warhol," and the Velvet Underground's final appearance as Warhol's house band came soon afterward, in what happened to be one of their most prestigious engagements.

On June 3, the band played in a fund-raiser for Merce Cunningham's dance company, a "country happening" organized by the VIP architect and Warhol patron Philip Johnson. Performing at Johnson's famous Glass House in Connecticut, the Velvets got to appear on the same bill as Cunningham himself and their hero John Cage, whose composition was for "balloons, windshield wipers, fan belts." Their audience consisted of some four hundred of New York's most powerful culturati, strolling the grounds as they scooped wine from barrels. Strangely, the Velvets came to a decision to break with Warhol in the limousine carrying them home from the very coup he had just scored for them.

Tension had been building for a while—Lou Reed had begun to call Warhol "Drella" to his face—and Reed finally "fired" his artist-manager during a talk they were having about the band's likely future. "I'd never seen Andy angry, but I did that day," said Reed. "He was really mad. Called me a rat. That was the worst thing he could think of."

In July, legal work made the split official, although as late as December Malanga was still writing to Warhol about European gigs they might nab for the Velvets, as though little had changed in the relationship, and there are records of the occasional contact between Warhol and the Velvets right through the late '60s. Years later Reed felt fine describing Warhol as "a very, very good person—a very good, honest person who's enormously talented."

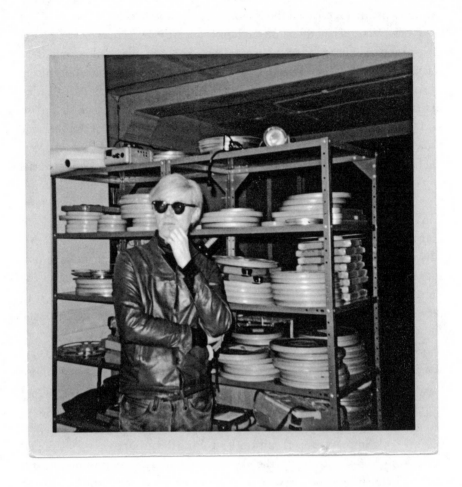

*. . . the dedicated filmmaker.*

# 33

# 1967

FOUR STARS—25 HOURS OF FILM | A: A NOVEL—24
HOURS OF TALK | ANDY WARHOL'S INDEX
(BOOK) | A FAKE LECTURE TOUR | EXIT GERARD
MALANGA | THE SILVER FACTORY SHUTS DOWN

*"Andy thought it would be nice if he could invent another
person in place of himself. . . . Somebody who was a
little more talkative and looked a little more dashing"*

It was the tiniest of picture palaces, carved out of the basement of the grand Wurlitzer Building off Times Square. The organ builder had designed the theater as a showcase for its instruments, providing room for up to two hundred potential buyers to take their ease among gilt curlicues and faux-Roman pomp. On the evening of December 15, 1967, with the organs long gone and the curlicues on their way to uncurling, the fading little theater, now in the hands of Jonas Mekas, welcomed Warhol and his crew for what they knew would be a long night. And then a long day. And then some more longueurs the following evening. They were there to watch the premiere—also, the final showing—of the Factory's magnum opus for that year: A dusk-to-dusk screening of the vast numbers of scenes, vignettes and stories Warhol had been committing to film for the previous ten or twelve months, now spliced together into one vast, meandering epic. "It was a salmagundi," said a young woman who starred in some of its reels. "Who knew what would end up in that movie?"

After months of publicizing the new anthology under such titles as *Vibrations, Since, Sins* (described as "all about love"), *24 Hours* and then *25 Hours Since,* by December Warhol had finally settled on *Four Stars,* written **** and thus giving the film the highest rating in the critic's arsenal, in advance of any critic actually seeing it.

Early in 1966, the Wurlitzer picture palace had seen the art-world

launch of the Velvets and then in the fall had premiered *The Chelsea Girls* before sending it on to conquer the nation; the new film project must have been inspired by the mass appeal of its predecessor. But right from the start, only a few months after *The Chelsea Girls* had begun to take off, Warhol had imagined the challenges of his new compilation outdoing the trials of the old one: Rather than a paltry eight hours of footage projected across two screens, the new anthology would stretch all the way across a twenty-four-hour day—or even, just to be ornery, for an extra hour beyond that. It would involve some eighty half-hour reels of film, projected so that as many as three images ran on top of each other on the theater's single screen, with soundtracks often colliding as well. Henry Geldzahler and John de Menil, a new Texan patron of Warhol's, had the unlikely idea of getting the entire delusional mess of *Four Stars* premiered at the august Metropolitan Museum of Art. "Wouldn't it be great?" wrote de Menil to the museum's director. The director clearly decided it wouldn't be.

The night of its actual premiere in the Wurlitzer building, Warhol and Paul Morrissey were in the projection booth improvising the order of their reels, as when *The Chelsea Girls* launched. This time, however, they did not quite trust to chance: They made sure to run the best material first and the "crappiest, most boring stuff" in the morning hours, Warhol said, when they figured the audience would be half asleep. The paid projectionist that night said that various superstars barged into his booth to demand that their particular reels be screened in prime time, and that he had to chase them away.

A teenage fan of Warhol's arrived only at breakfast time, when the worst reels were screening, but adored what he saw and continued watching for the next twelve hours: "Everybody in it was so interesting—everyone had an interesting look and everything they said was just bizarre," he opined, and, "Great!—I mean a color movie over a black-and-white movie or a black-and-white movie over our color movie. I mean, it's just so fantastic, it looks like poltergeists over poltergeists in different colors and patterns and intricate divisions." According to a more objective viewer, "It looked like a random compilation of everything that has been shot over the last year or so. I saw thirteen hours of it, and staggered out, exhausted to the point of hallucination: I kept seeing snow covered landscapes all around me, though the weather was in fact clear and mild."

In print ads, the four stars of the title were presented huge and in quotation marks, as though they were quoting from a reviewer who had found the film enthralling. Actual critics tended to be far less enthused, even though most of them watched only the one-hundred-minute reduction that took over

from the full version. A writer for *Variety* said that whereas *The Chelsea Girls* could at least be seen as "a vision of hell," the new compilation seemed "random footage with no narrative or thematic framework whatsoever"— which as it happened was a pretty accurate description but also Warhol's obvious aim. His latest project landed at a moment in American art and culture, and in his life, where incoherence seemed the most interesting and honest option. *Four Stars* supplied plenty of it.

"What would be the reaction to a critic or a person who went to one of your films who just said 'rubbish, trite nonsense, boring, etcetera?'" asked a TV host. "Uh, that's the way we feel about it," answered Warhol—but perhaps taking all those insults as praise.

Some of the reels in *Four Stars* seem to have been planned as quite separate, freestanding features but then got pulled into the compendium with no regard for how they might fit together.

The *Loves of Ondine* tracked the Factory's favorite gay speed freak as he tried to get it on with various women, coming up with such seductive lines as "You're not just a bloody bore, you're a very dumb bloody bore," and "I find you physically attractive. Your left tit has completely bowled me over." Ondine the Insulter had provided the most stirring, popular moments in *The Chelsea Girls,* so it's easy to see why Warhol would return to that well in compiling *Four Stars.* "Ondine was brilliant, and scathing and so funny," said Susan Pile, Malanga's "little secretary," who counted Ondine as her best friend at the Factory. For a while she lived with him in a mad loft filled with amphetamine addicts, the innocent Barnard student sleeping among them in a hanging bed "like Snow White surrounded by A-heads," she said.

The blasphemous film called *Imitation of Christ,* shot in early 1967, had first been conceived as a thirty-one-day Life of Jesus but ended up as an absurdist family drama in which Brigid Berlin and Ondine play a badly matched mother and father with a dysfunctional son. (Or maybe that made it a Life of Jesus, after all.) That went into *Four Stars* as well, accounting for a full eight hours of its footage—but not of its running time, given that reels could get projected on top of each other.

The dozens of other reels in the anthology mostly showed peculiar vignettes of superstar life. You could say that *Four Stars* functioned as a Factory highlights reel, with all the lowlights and midlights left in as well. *Gerard Has His Hair Removed with Nair* had a title that spoke for itself (but also to Warhol's lack of body hair, according to his lover John Giorno, and to the depilation that Marcel Duchamp demanded of his models and lovers). *Allen and Dickin* showed two men in bed talking about LSD, Buddhism and love. The *Four Stars* episode called *High Ashbury,* shot in a "hippie pad" in

San Francisco, was described as presenting footage where "people sit on the floor, smoke marijuana, and listen to rock music. A baby is featured prominently, and his crib is seen. A person playing a wind instrument is joined by a drummer."

Within a few years of the *Four Stars* premiere, the American Film Institute provided a delightful list of keywords prompted by the piece, and they might just function as the best account of it:

> Housemaids. Hoboes. Judges. Hitchhikers. Hippies. Children. Sexuality. Male homosexuality. Parenthood. Rape. Death. Travel. Bathing customs. Buddhism. Religion. Motion pictures. LSD. Docks. Beaches. Marijuana. San Francisco. Sausalito. Long Island. "Imitation of Christ."

For the Factory denizens who watched the film that December night (and day, and night) "it was sort of like your summer vacation or your yearbook up on screen," recalled Pile. As a student at Barnard she was still subject to curfew, so she watched for the film's first few hours, went back uptown for a rest, then caught up again in the morning—only to find a good number of the same people still there.

Early on, Warhol had claimed that he'd dreamed up *Four Stars* because they'd started a distribution company, making it sound as though the project had commercial roots. At Cannes, when he'd announced that he was working on the piece, he talked about cutting it up "into eight quickies [so] more people will pay more often," as usual playing at selling out when he was actually turning out material that there was no way to sell. The twenty-four-hour film had some funding from Bob and Ethel Scull, Warhol's longtime collectors, but even then making *Four Stars* had eaten up the entire $30,000 profit that he'd ended up making on *The Chelsea Girls*, Warhol claimed.

Even college kids were left as baffled by *Four Stars* as any old codger might be: "Mr. Warhol, is there a purpose to a film like that?" asked a student at a test screening's Q&A, to which Warhol answered, "We have fun making it."

Paul Morrissey acknowledged that *Four Stars* was too hard to screen, and too tough on its viewers, to have any future at all. The best the Factory could hope for, he said, would be for someone to take an interest in releasing its soundtrack: "You could turn it on for two or three hours at night like you would read a big novel." Not the most likely of scenarios.

Even the *Loves of Ondine*, with its promising title and shreds of plot, came off as "just so much random footage," according to one reviewer, and had almost unwatchable scenes. That summer, for instance, Warhol had borrowed

a country house on Long Island to use as a set for a few of the episode's reels. He invited along a way-out, anti-Castro rock band, the Banana Cuban Boys, and any number of drugged-out youngsters—"a coterie of silly people," as one observer called them—and then filmed the ensuing mayhem. A vast and disgusting food-fight-cum-orgy was the least noxious of the weekend's explosions, "with piles of spaghetti, rice, sour cream, and tomato sauce hurtling through the house," according to a local paper's report. "Two of the actors hid in bathrooms, terrified."

As Ondine paraded around in women's clothing some young straights almost came to blows over their rights to one of the weekend's young women. Photos record the total trashing of the house—even a tree being chopped down on the grounds—while Warhol looked on. But despite the insanity the artist was bathing in, he impressed a visiting photographer with his intelligent, very serious talk about the art he was making and the skills it took and even about cultural policy in Latin America.

Warhol's own, uniquely weird view of his new footage was that it was still "empty, empty, empty—it's too beautiful, too planned." To be properly artistic his art needed to be still cruder, if such a thing were even possible. Only then could it be truly modern, he said, by being truly without feeling.

———

*Four Stars* wasn't the only full-day artwork that Warhol had on the go in 1967. He was busy working on a vast, twenty-four-hour novel based on the pile of tapes he had recorded of Ondine one day in the summer of 1965, back when Norelco had lent him that hottest of new products, a cassette recorder. The result was as unforgiving as anything Warhol had ever done. The screeching guitars of the Velvet Underground seem like birdsong in comparison. Even *Four Stars* is easier to take, if only because interminable watching demands less labor than endless reading. "Realism. We're pushing realism to its fullest extent," Paul Morrissey explained, shortly before the novel was released. "Fiction is dead. . . . Andy's novel does the same thing the films do: record reality all the way."

At first, a sensible Warhol was calling his new book *24 Hours,* at least while that was still the name of his film project. After that, the novel was referred to as *Cock* and then as *My Epica.* (That last title gave an unlikely nod to *My Ántonia,* the frontier novel by the erstwhile Pittsburgher Willa Cather, whose short story "Paul's Case" had inspired Warhol's splat of bloodred paint in college.) For a little while the book's title was *24 Hours of Amphetamine,* then the *Loves of Ondine*—another tie-in to *Four Stars*—before finally settling down as simply *a,* the first letter of the alphabet, in lowercase. (For clarity's

sake, and against Warhol's wishes, the publisher released it as *a: a novel,* as though that subtitle might pacify readers.) Some insiders might have still got the reference to amphetamines and to A-Men like Ondine; it seems that both he and Warhol were speeding on 50 mg tabs of Obetrol as they taped. But the title could also be read as the most minimal statement of what writing could be: That first letter could stand for all the others used by an author, the way Warhol's single-color "blanks" stood for anything that could be painted on canvas. (There were, briefly, thoughts of doing further books called *b, c* and so on.) Or maybe you could read the title as the indefinite article: The book was "a" novel, without making any grander claims about what else it might be beyond that. It was a generic example of the entire literary form, that is, meant to stand for all other possible novels the way supermarkets had begun to sell generic products that could stand in for more particular, more ambitious brands—*a* soup, rather than Campbell's Soup, or "cola" versus Coke and Pepsi. (One scholar has claimed that Warhol's Campbell's and Coke paintings came at just the moment when generics had started to threaten such brands.)

By March of '67, Warhol was getting Ondine to sign away his rights to the book, for the princely sum of $250 plus 1 percent of royalties, and then in May the Factory lawyer was fussing the details of an agreement with Grove Press, one of the most daring of New York publishers, to actually produce the book. One of the firm's editors had both hated the first draft Warhol had submitted the previous fall and thought it needed to be published: "I reluctantly recommend, I guess, that Grove Press prove itself the publishing house of 1967 by bringing out this shockingly mechanical slice of avant-garde life."

The contract had Warhol submitting a finished text by the end of June, which was a safe bet since there was not much actual "writing" to do beyond transcribing the tapes. That had been underway for a while already, thanks to the efforts of a trio of teenage girls hired just to do that job plus Factory regulars such as Susan Pile, Pat Hackett and even at the end Moe Tucker, once her work with the Velvets had started to dry up. Tucker, paid a weekly fee plus all she could eat and drink at Max's Kansas City, was prudish and churchgoing and took exception to some of the language on the tapes:

> I would go to the Factory each day and sit with the tape recorder and the earphones and start typing stuff, and after a day or two Paul Morrissey came to look and see how I was doing. He was reading it—what I had done was leave blank spaces where all the dirty words were. Like if he said "fuck," which to me in those days was a horror, I left four spaces. Paul said, "Oh no, what are you

doing?" I said, "You know I don't like that kind of talk, so I don't
want to type it." The next thing you know, Andy comes over and
sits on the desk and says, "Oh Moe, you're not typing the curse
words." I said, "I don't want to do that. If you don't want me to
continue, that's fine." "Oh no, that's fine. Could you just put the
first letter in?" I said, "No, no, 'cause that would be helping you."
And he said, "Oh, okay," and walked away. That was the end of
that.

In fact, Tucker's squeamishness was greeted by Warhol less as obstacle
than as inspiration. A clever scholar named Lucy Mulroney has shown that
the final book has all kinds of marks of censorship—rows of Xs canceling out
certain passages; others actually marked "censored"—that were added late
in the editing process and didn't really cut out anything that can be heard on
the tapes. They were faux censorship, meant to make the book seem juicier
than it really was. They aligned it with Grove's famously scandalous, actually
censored novels such as *Lady Chatterley's Lover*.

Although Ondine and his friends supplied plenty of naughty gay talk in
the book, its wickedness may have needed a bit of extra underlining, given
how hard it was to make out any content at all in the chaos of uncorrected,
badly typed transcriptions of badly recorded tapes:

> Oh, uh.
>
> Okay. Uh, HOW TO BECOME A PROFESSIONAL HOMOSEX-
> UAL or how to be a good fag. It's hard. xxxxx It's gonna be hard
> work because you—you're obviously off to a late start. I think I have
> a dime, Drella.
>
> What's the . . . us I'll tell you all about it.
>
> Well, come over here. What the hell is this? Would you hold it? No
> this. (Drella talking in background.)
>
> Okay.
>
> D *in background*—Oh okay.
>
> xxxxxxxxxxxxxx Whose are these?
>
> (S) I don't know.
>
> It's perfection.
>
> Maybe it's Rink's.
>
> Have you ever seen anything more perfect? What kind of a pillow
> is this? Shall we smoke.
>
> Is this plugged in?

Uh no, but maybe we can.

I guess it's plugged in. It's working. We just saw Wee Carter-Pell
and Bedroom Billy and somebody else in uh Stark's and uh . . .

All this incoherence wasn't just a by-product of Warhol's refusal to in-
tervene in the transcriptions, as though he wanted the honesty and direct-
ness of the book's process to shine through. He actually made the transcripts
less intelligible than they originally were, replacing the real names of most
speakers with weird pseudonyms and sometimes putting the words of one
speaker into the mouth of another. The apparent, true-to-life rawness of the
book was actually the product of deliberate calculation, just as Warhol's first
Campbell's Soups looked like unworked transcriptions of can labels but were
actually made with tons of care. Or maybe the oddities in a were most like
the "errors" that Warhol took care to introduce into his silkscreens but which
did not by any means have to be there. He wanted a powerful reality *effect*
and was happy to manipulate the real to get it.

There was even manipulation lurking behind the book's founding
premise: that it recorded an uninterrupted, twenty-four-hour span of Fac-
tory antics. Warhol had started out making that come true, the way he really
had shot the Empire State Building for seven straight hours. In the case of his
novel, however, life and exhaustion intervened and the book's last chapters
were actually cobbled together from tapes made at various times.

It's easy to see a as the latest phase in the diversification of Warhol
Enterprises, busy expanding its profit centers from painting, to film, to rock,
to prints and finally to publishing, with side ventures into scent and button
making. The first mention of the book pretty much bills it as that. It's also
necessary to acknowledge that Warhol did not—or could not—let this expan-
sion dilute the challenges he'd been trained to expect from serious modern
art, including his own. Other 1960s authors published books that pretended
to be transcribed from recorded conversations but that had actually been
tidied up into normal, legible prose. With the support of the dedicated
avant-gardists at Grove, Warhol untidied his tapes to make them as radi-
cally unpalatable as the best (or worst) of Grove writers like Samuel Beckett
or Jack Kerouac.

———

Another book project from 1967 also seemed to thumb its nose at any
readers not hip enough to bear with its games. Or rather, it blew them a
raspberry—literally, thanks to a silly fart device built into one of its spreads.
Another spread presented readers with a pop-up castle with photos of vari-

ous Warholians inserted into its windows above the inscription "We're attacked constantly"—a reference to the Velvet Underground's sorry reception in Los Angeles and their stay in the rented Castle there. A full gatefold was devoted to a cutout of Bob Dylan's big "Jewish" nose that lifted up to reveal a surgically "fixed" version beneath. (Shades of the revisions Warhol made to his own nose, in early photos he retouched.) An insert of little paper tabs stamped with Warhol's signature came with the text "FOR A BIG SURPRISE!!! Tear out and place in a container of warm water"; if you did that, you got to watch Warhol's name float away and disappear, in his latest polemic against authorship.

This was *Andy Warhol's Index (Book)*, and the publisher this time was Random House, a big, mainstream firm recently acquired by RCA, itself a major 1950s client of Warhol's that had also acquired Hallmark, the patron for Warhol's Christmas tree. The book's editor at Random House told Warhol that he embraced the *Index* as a chance "to do something as revolutionary in the publishing world as your paintings, your films, and 'The Velvets' have been in their respective fields." The book never quite lived up to such ambitions: It was no *a*. Ideally suited to its Christmas release date, it was more like a distillation of Warhol's Factory scene in book form, perpetuating its least threatening image of playful brattiness—like *The Chelsea Girls* with its sex and drugs and violence taken out. "It's very nice also very funny. Perhaps the most interesting thing about it is that I can't say any more on it than that," read a smart note to Warhol from Jonathan Richman, a young fan soon to make New Wave history with his band the Modern Lovers. (John Cale of the Velvets gave him a leg up.) Joey Freeman, the youngest of Warhol's acolytes, found that the *Index* had "nothing worthy of the underground—it was like a child's book for dark adults. . . . It's not really an Andy Warhol product. You could say it was a Factory product."

In the beginning, before it became a pop-up book, the *Index* had been conceived mostly as a vehicle for the Factory's vast piles of photos. "Andy thought there was a way to make money off of all those photographs," said Freeman. Indeed, most of the finished book's pages reproduced Xeroxed black-and-whites of Warhol's crowd in action, shot over the previous year or two by Billy Name and Factory regulars Nat Finkelstein and Stephen Shore. (Finkelstein had actually initiated the project, primarily as an outlet for his Factory shots; there were squabbles over how big a share of the profits he should get and that led to him breaking with Warhol.) Other pages reprinted funny interviews with a babbling Ingrid Superstar and with Warhol himself. (A German reporter's ponderous questions were printed in Teutonic black-letter type.) There was a wacky, childlike side to the '60s counterculture and

Warhol's *Index* plugged deep into it. Some of its pop-ups had actually been designed for Random House children's books. Warhol fell in love with them when he saw them in his editor's office.

Even the title had a bratty backstory: Originally, it was going to be *The World of Andy Warhol*, until assembled Warholians quite correctly judged that to be tacky. Instead they came up with *Andy Warhol's Index*, nodding to both the papal index of forbidden books and also to the idea that the project would be an index to Warhol's films, billing them as compulsory rather than forbidden watching. When Random House objected that they were supposed to be selling a *book*, Billy Name delivered a title page with the word "book" added in parentheses.

Although produced by the nation's most famous art studio and published by a giant firm with access to the latest pop-up and printing technologies, the book managed the look and feel of the funky, homemade zines that '60s kids were so busy turning out.

Some critics found the book hard to figure out, but the public didn't seem to agree. It became one of the only Warhol books that found a decent audience. After a massive book launch party just before Christmas—the guest list ran to more than twelve pages—the *Index* went on to sell more than twelve thousand copies over the holidays alone.

---

Factory brattiness was presented to the nation in person in the series of thirty or more lectures that Warhol toured with, starting in the late winter of 1967.

"At a safe, safe estimate—conservatively speaking—the lecture business in the United States now amounts to $100-million a year," said a speakers' agent named Robert Walker, in a huge *Times* article about the thriving new market for talks. (Warhol kept a clipping of it.) Warhol's pal George Plimpton had a sideline in lecturing and so even did the publisher of Warhol's *Index (Book)*; it's no wonder that Warhol himself sought a piece of that action. Actually, it was the action that sought out Warhol: Walker, a young shark among agents, told the *Times* that he had already scheduled fifty talks for Warhol before he even approached him as a potential speaker. The college audience for Warhol's films and the Velvets was also becoming a vast new speakers' market: baby boomers, raised on TV, were desperate for "the snap, crackle and pop of flesh-and-blood personalities," said the *Times*, and had a special taste for "kooks, cuckoos and controversy." As one collegian explained, he and his friends would listen to anyone who "upsets the trustees, because that's what it's all about." To meet that demand, Walker sold talks by a "ghost catcher," by a "séance lady and witch," by the editor of the *Worm*

*Runner's Digest* (lecture title: "What Makes a Worm Learn")—and by a kooky artist named Andy Warhol, guaranteed to upset any trustee.

Warhol got something like $750 per appearance—his fee went up and down—and he was always left to pay all expenses for himself and the superstars he always brought along, meaning that profits must have ended up being much smaller than planned. Warhol would start his appearances with a screening, most often of trial reels from *Four Stars* but also, at least once, of his experimental Bufferin commercial. This was "no more unsatisfactory than one of Warhol's paintings of '100 Campbell's Soup Cans,'" wrote a reporter at one of his lectures. "It was a piece of pop art in itself." Not everyone was that understanding. The head of one student union that brought Warhol in said that he and his classmates had endured "a most disappointing, most boring, indeed unprovocative performance by Andy Warhol. . . . He showed himself to be a poor spokesman of the art form which he has been purported to represent."

Strangely, at venue after venue audience bile seemed addressed less at Warhol's impenetrable films than at the Q&As that followed them, which were mostly Q and not a lot of A. When a question did get answered, it was almost always with some mix of anomie and disdain, confirming the bad-boy-and-girl reputations of Warhol and his superstars.

Q: What were their aspirations?
VIVA: [To] do a Hollywood epic, with Charlton Heston playing the
    Virgin Mary. I'm going to play God.
MORRISSEY: To make money off the films.
Q: What did it take to act in a Warhol film?
VIVA: Most women and fags can do it because they're used to prancing
    around.
Q: What was the significance of their films?
MORRISSEY: No significance, just to be looked at and forgotten.
Q: Did Warhol disagree with Morrissey's views, or was Morrissey
    Warhol's spokesman?
WARHOL: Yes to both answers.

And a final question from one disgruntled audience member: "We sat through your film. Now would you please talk to us for three minutes on any subject of your choosing?" To which Warhol replied, "I could hum for three minutes."

"We're in entertainment," Warhol told a friend, after getting back from giving talks in Miami, Tuscaloosa and "uhh, ummm . . . someplace else—

Iowa I guess." But it doesn't look like Warhol and his team made much effort to be entertaining or even to entertain themselves. They don't seem to have taken any pleasure in their touring; Warhol was especially disappointed in the lack of sexual adventure to be had from the "bunch of hair dressers" who showed up to see him on the road. Morrissey made no bones about telling one of their audiences that, with the financial futility of *Four Stars,* the only reason they gave lectures at all was to raise money for what truly mattered to them: films. And Warhol himself gave a warning to paying audience after paying audience, "We don't like to lecture. We don't have anything to say."

The organizers of a Warhol "talk," at a college in New Jersey, threatened not to meet the fee he was charging for the nontalking he'd done: "We paid for Andy Warhol, and we didn't get two words out of him," one of them insisted. For some reason, their threat caught the attention of the national media and within a day or two a wire story headlined "Students: Is 'Silent' Warhol Worth $750?" appeared in scores of newspapers across the country, from Sedalia, Missouri, to Manitowoc, Wisconsin. It was a symptom of how the American public's view of Warhol as a lovable, childlike Popster—at worst as an amiable scamp—was giving way to conceiving of him as a pernicious, suspect force, part of the larger social breakdown seen on the horizon.

After a night of witnessing Warhol give near-monosyllabic responses, one of the three thousand listeners who showed up for him in Salt Lake City had had enough: "He had no right to sit up there and come off with those answers. I've seen local people with more to say than he does." The event's arrangers started digging into what had gone wrong at his talk. We don't have their side of the correspondence that followed, but here's Morrissey's response from a few weeks after Warhol's appearance: "We do not understand why you should believe that Mr. Warhol did not appear in Salt Lake City." Actually, he understood perfectly well, since he had been on that Western tour and knew that, despite sporting silver hair and a black leather jacket, the man studiously not speaking from the dais beside him was Allen Midgette, an occasional visitor to the Factory who had made appearances in a handful of its movies and was now being paid to do some live acting.

A reporter happened to have been at the Factory to witness the birth of the subterfuge:

> The two Andy Warhols looked at one another from behind their round, dark goggles. The Andy with the silver hairspray can in his hand squirted the other Andy's hair again and stepped back for a good look. Then he tossed a striped wool scarf around the other Andy's neck and zipped up his leather jacket. As Andy

handed Andy his plane ticket, everyone in the Factory laughed and cheered. "How many Andy's can we make in a day?" asked Ondine. . . . "We'll flood the country with them," shrieked Viva.

"Hope we are not busted," Morrissey wrote in a postcard to Malanga. But they were. Organizers in Utah had their suspicions almost from the start: Morrissey said that the impersonation had faltered when Midgette ran out of silver hair spray. Those suspicions were confirmed when a New York friend of Warhol's happened to pass through and agreed that photos of the lecturer did not show the Pop artist.

Warhol tried to equivocate, but local press and then the *Los Angeles Times* got on the story and he finally had to admit the deception, all the while claiming—possibly with some truth—that he'd done his audience a favor. "I don't really have that much to say. The person who went had so much more to say. He was better than I am. He has what the people expected. They liked him better than they would have me." That didn't get him off the hook. Over the following months he had to repeat the four Midgette lectures, this time in his own person. One Oregon college actually had him swear before a judge, on a Bible, that he was, in fact, himself.

What Warhol never did admit was that he'd already tried out Midgette at the very beginning of his lecture tour: A photo from one March event is clearly of the imposter. Midgette recalled how challenging it had been to start playing a man he hardly knew and didn't much like and to talk about work he cared for even less. "The first question was 'Mr. Warhol, are you gay?'" Midgette recalled. "And I said, 'No.' And the whole place was silent." At another one of his impostures, Midgette declared that his paintings (that is, Warhol's) were nothing more than a joke. "The audience was shocked," said one young woman who was there. "It was as bad as hearing God is dead."

Well before the Utah fraud, Warhol had already transplanted their hoax into his *Index (Book)*, where the back-cover photo of Warhol is in fact of Midgette, with Warhol's signature stamped onto his upper lip. The Midgette impersonation was just one more battle in Warhol's war against established art-world ideas of authorship, authenticity and the unique—it was "an experiment in mistaken identity," he'd insisted to the friend who'd unmasked him in Utah. Getting Midgette to be his doppelgänger wasn't that different from churning out almost-interchangeable, Factory-made versions of Marilyn or the Flowers. Midgette, you could say, was just Warhol himself offered up in a new colorway.

Morrissey presented Midgette's appearances as some kind of extension of Warhol's larger act of self-creation: "Andy thought it would be nice if he

could invent another person in place of himself. . . . Somebody who was a little more talkative and looked a little more dashing." At least one smart fan who was present in Salt Lake City realized that this was right, and that the subterfuge was perfectly in keeping with the basic premises of Warhol's art. "Your double didn't look much like you but it was very appropriate that you sent a double anyway," he wrote. "You must be the first artist to raise a lecture tour to the level of a work of art."

At the Salt Lake City lecture, Warhol and his team had just about announced what they were up to: They had Midgette project Factory footage that he himself appeared in. "I mean, he was standing right there while the movie was on," Warhol said, a few months later. "If they don't know the difference . . ."

———

One figure was notably missing from the whole lecture fiasco. He was also absent from the *Index*—or rather, he was there, but only by virtue of having his name visibly, almost comically crossed out on the title page: ~~Gerard Malanga~~.

Billy Name had done the canceling, but it looks like he was one of many who had dreams of seeing Malanga disappear toward the end of '67.

For a good while, the heady air of Warhol's Factory had been inflating the poet's ego. Already the previous year, Malanga had boasted to his girlfriend Susan Bottomly that he was the *real* Andy Warhol—the Factory's true creative force—and he had also been spreading word that he was the "most irreplaceable" part of the Exploding Plastic Inevitable "because no other dancer could interpret the Velvet's music as well as build up a concrete structure of dance around their music and the light show, and interpret their music into choreographic arrangements the way I do." (As far as Morrissey was concerned, Malanga was "posing, not dancing.") A frustrated contact in publishing complained about getting a note from Malanga that was like "having received a letter from a spoiled child" and a magazine feature went on to describe Malanga as having "the narcissistic delusions of a poet of the romantic period who sees himself as beautiful and gifted." That hardly made him easy to have around.

His narcissism had only been reinforced when, in the fall of 1966, he fell madly, absurdly in love with a stunning Italian heiress named Benedetta Barzini who lived across the street from Warhol. Her father, Luigi, was a world-famous author, so she was already cultural royalty before she came to New York to model, eventually being declared one of *Harper's Bazaar*'s "100 Great

Beauties in the World." The relationship with Malanga, as such, barely lasted and seems to have involved only one night in bed, although Malanga took that very much to heart: "For the first time in five years she had a rebirth as a woman. . . . Benedetta has reached womanhood. We have become one person," he confided to his diary the following day, after she'd had her first period in a while. (Not that being "one" with Barzini stopped him working hard to sleep with other girls.) Malanga even had short-lived dreams of marriage with the Italian. (In the New Year, Malanga sent a sad note to his mother paying her back for wedding rings she had bought for them but that, he informed her, would no longer be needed.) Whatever the truth of his relationship with Barzini—decades later, she dismissed him as "a poet that was at the time Andy's lover"—Malanga was led to flights of fancy that included publishing endless poems and photo essays about her, which left her nonplussed or even annoyed. Malanga went so far as to nab and copy the Screen Test that Warhol had shot of Barzini: "He would have my head if he ever found out," Malanga told her.

Malanga's relationship with Barzini, and especially his secrecy about it, seems to have led to a cooling-off with Warhol. Diary entries show his growing doubts about his boss: "Andy likes playing games with my head, thinking he can break me; but just when he thinks he has me, I break loose from under him," wrote Malanga, and "Andy is chemically destructive. . . . [He] is climbing the international ladder of social trash." Neither was an entirely inaccurate observation, at that point in Factory life, but they stand as a clear sign that the bloom was off the hibiscus.

"I left Andy in August of 1967," Malanga recalled. "I got fed up with the scene. I said, 'Fuck this, I'm going to Italy.' I bought a one-way ticket. A week before I was leaving, Andy tried to bribe me to stay: 'Oh, you can come to the premiere of *The Chelsea Girls* in San Francisco.' I said, 'Gee, I'm sorry, but I'm showing a film at the Bergamo Film Festival.' Andy said he knew I had a one-way ticket, if I needed money to get back to call him, he'd send it to me. He lied through his teeth. I was stranded in Europe for six months."

The film Malanga was showing was a montage about the Barzini family that was "poetic" in just the way that Warhol would have called out as corny. It was the latest chapter in Malanga's (unwelcome) paean to Benedetta, who he just couldn't let go of. Her father had to send threatening letters to Malanga and his publisher to prevent them from printing some of the Benedetta poems. After getting himself in some kind of serious trouble with the Bergamo festival and with Italian customs agents, Malanga finally set himself up in Rome as a dashing, starving import from New York: "I have adopted

the dress of a 19th-century composer or poet, wrapped in a long velvet black scarf and black military coat with braid and West Point collar," he told one correspondent. "My hair is long and always teased."

Malanga had crossed the Atlantic with barely a cent in his pocket, and his letters show him begging money from Warhol and even from his impoverished mother, both of whom told him to simply come home. "You have a lot of nerve to write and tell me you are broke. I am broke, too. You made me cry all night thinking of you," wrote his mother in one reply. Months later, she was completely fed up: "I do not want you for my son and another thing why didn't you write a little letter to me and wish me a happy birthday. You just send me a stupid picture of yourself."

Malanga eventually found a solution to his poverty that didn't involve his mother—or Warhol, for that matter, which is precisely why it counts as one of his more foolish moves.

"You never sent me any money," he wrote to Warhol at the beginning of December, "so I devised a plan whereby I have had a silkscreen made for a painting I must make, an Andy Warhol painting, of course, in order to survive." Then, ten days later: "Monday I sell the Andy Warhol portrait of Che Guevara to a buyer of paintings. . . . I'm not kidding about having silk-screened a painting, and if ever someone suspects that the painting isn't yours, you'd better say it is, otherwise I could go to jail for forgery."

Of course, someone suspected almost at once. Malanga had chosen to sell his forged painting, plus twenty Che Guevara prints on paper, in a show at the most prestigious avant-garde gallery in Rome. (It had already exhibited Cy Twombly and hosted an evening with Taylor Mead.) Despite the show's good reviews and fine sales, the owner had the savvy to write to Leo Castelli for information about "Warhol's" new Che Guevaras. Maybe the Roman dealer realized that there was something un-Warholian— something overwrought and un-camp—about silkscreening a recently deceased revolutionary hero.

As his situation in Rome got more and more sticky, Malanga pleaded with Warhol not to rat him out, sending any number of amazingly clueless letters: "The art work was made in the best of taste and with love. If I had proceeded to make a Marilyn Monroe or a Flower painting then I could very well understand your claim for forgery; but not for a subject such as Che Guevara which we probably would have made if I were at the 'factory.' . . . I became you for both of us." Malanga even had plans to offer his old boss the singular honor of a partnership in the new masterpiece of filmic art Malanga was at work on in Rome—it would make *The Chelsea Girls* look like a "fairy tale," he noted, helpfully—allowing Warhol to keep the massive distribution

fees Malanga was sure it would earn, or at least any fees up to the $3,000 that "their" Che painting had brought in.

After several months—Malanga thought he'd been deliberately left to sweat, and maybe he was—Warhol finally took pity on him and had a telegraph sent to Rome: "CHE GUEVARAS ARE ORIGINALS HOWEVER MALANGA NOT AUTHORIZED TO SELL." Malanga avoided jail and sent Warhol a thank-you note, sort of:

> If you had decided to not "authorize" the art work, I certainly would have been "denounced," Italian style . . . and charged with "forgery" which is an international offense with sentences ranging from 15 to 20 years or more. . . . I suppose, now that all these complications have begun to snowball, you probably have no intention of letting me have the money from the sale of the painting.

Viva's reaction to the note was to say that Malanga "has flipped out; he really has." Warhol's was to vow never to speak to his assistant again. By late in the summer of '68, however, a forgiving Warhol had let Malanga back into the fold, although he never recovered the status he'd started out with as Warhol's "sweetest Gerry." He was soon on his way out again.

Granted that Malanga was a foolish, conceited kid, was his fault quite as bad as it seemed? After all, he'd been watching Warhol playing games with authorship for almost half a decade. Just around the time Malanga was going to Italy, Warhol was refusing to take credit (or blame) for the Factory's creativity: "It's not really me that's doing it, it's the people we have." And already within a month or two of first starting work, Malanga had been involved in the following conversation with Warhol and a friend named John:

> JOHN [TO MALANGA]: You know how you should get yourself in the news? You steal Andy's silkscreen for your painting and then sell it as an Andy Warhol. And then Andy Warhol could come into court and say it's not an Andy Warhol, and it would just be so great, it would be in all the papers.
> WARHOL: You want to do it?
> MALANGA: The thing is, you'd back out afterwards. You coward.

---

Malanga's disappearance was just one sign of the centrifugal breakup of the Silver Factory. Its denizens were falling away almost as quickly as the foil on its walls.

Mary Woronov was another departure. Despite her aggressive personality, she knew how to look after herself. Once *The Chelsea Girls* went into wide distribution she had her mother threaten a lawsuit to get her daughter a share of the take. Toward the end of '67, when the *Index (Book)* was on its way to publication, she simply refused to sign a release for it without getting properly rewarded. (Others had signed for the grand sum of one dollar.) "Warhol was very *very* angry, and I stopped going to the Factory," Woronov recalled.

Susan Bottomly had more or less left the scene after the superstars' trip to Cannes (it had led to modeling gigs in Europe) while Stephen Shore and Nat Finkelstein, two Factory photographers, and Joey Freeman, Warhol's teenage art assistant, were all moving on. The Velvets had already left.

Billy Name was still around, but his foothold at the Factory was starting to look shaky. "There was a lot of competition about how things would go, direction-wise, between me, Paul and Gerard. . . . We all had our ideas: We never argued but you knew that in order to get it to come out the way you wanted it to, you had to be there all the time, be the one doing all the work—taking care of everything." It's pretty clear that, by his own measure, Name had started to lose out. He had been absent from Cannes and the other notable Factory appearances of '67 and rarely played a role in the raft of new films being made. His function as Factory "foreman" had been taken over almost completely by Paul Morrissey, who was now referring to himself as Warhol's "business manager." He had begun to strike formal, profit-sharing deals with Warhol that left Billy Name notably out. Name hadn't lost his affection for Warhol, defending him from a friend who worried that Name was being oppressed: "Andy is not cruel to me. He is my benefactor. He is kind to me and loving and he gives me a home." But there's no doubt that that sounds a bit like the words of the classic neglected wife.

There was a notable waning of interest among Warhol's first cultural patrons. De Antonio was busy with his far-left documentaries, Geldzahler had moved on to abstract artists, Sam Green and Alan Solomon had curated their fill of Pop and even Leo Castelli wouldn't give Warhol any more solos for quite a number of years: He ranked only eighth among the gallery's top ten bestselling artists—two slots below even the minor AbEx painter Jack Tworkov. Among Warhol's early collectors, the Tremaines had long since lost interest, the Sculls had shifted focus to contemporary trends such as land art (while nevertheless supporting *Four Stars*) and Leon Kraushar, an investor who had actually commissioned nonportrait paintings from Warhol, had just keeled over from a heart attack that autumn of '67.

The Factory's doom was declared on September 27, 1967, with the deliv-

ery of an innocuous-looking letter from the managers of the studio's building: "You are hereby notified that the landlord elects to terminate your month to month tenancy of the above premises effective the 31st day of October, 1967, and that the term of your tenancy relating to said premises expires on said date." The old building, which had survived so much in its nine decades of existence—even rehearsals by the Velvets—was due to be demolished, making way for parking and a parkette behind a giant skyscraper. After four years of glorious and vainglorious existence, Warhol's famous Silver Factory had come to the end of its days.

In the winter of '62 to '63, Warhol had found his firehouse. It helped transform a rich virtuoso working at home into a fully professional studio artist.

In the winter of '63 to '64, he found, and founded, his Factory. It let him construct a new image of himself as celebrity artist with retinue.

In the winter of '67 to '68, Warhol was faced with a question: What kind of space would he find next, and what new kind of artist would he be there?

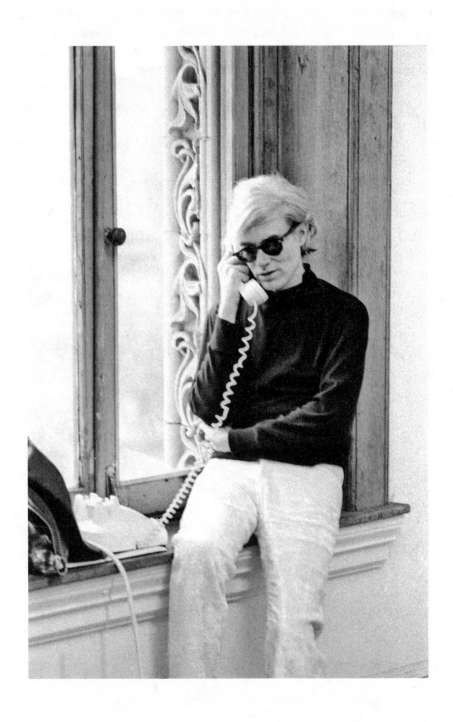

*. . . on his new white phone in his new white studio.*

# 1968

A NEW STUDIO ON UNION SQUARE | LONESOME
COWBOYS IN ARIZONA | ORDER REPLACES
CHAOS | LAST OF THE FACTORY CROWD | FANCY
FRED HUGHES | A SURVEY IN SWEDEN

*"A mélange of homosexual sex, conversation, rape,
conversation, transvestitism, conversation, homosexual
incest, conversation, masturbation, conversation,
heterosexual seduction, talk, talk, talk and an orgy"*

The space was all air, light and reflection. Three tall French windows let the sun in through a narrow front façade that faced east across a wide open park. A softer north light poured in from more windows off to one side, bouncing off polished wood floors. Two vast desks sat nearby. Their dark tops were covered in glass that reflected the people working at them; they rested on mirrored boxes that might as well have been pieces of minimalist sculpture. The desk accessories were equally modern and lustrous: A transparent "In" tray for bills "so we can see how much in debt we are"; a plexiglass cube with a butterfly lodged inside; white plastic telephones. Rubber plants and phallic cacti filled the odd corner. "Very Park Avenue, Swedish Modern" was how one downtowner described the setting. "Very clean studio; very swanky, could eat off any part of it."

Thus did the Factory become "the studio," as of the first weeks of 1968.

"We're moving, you know. Downtown," said Warhol to one of the last visitors to the Silver Factory before the wrecking ball hit. "We've got a bigger place. We'll have more space so maybe we can make the films—well—better somehow."

The search for a new home had begun in the fall, assigned to Billy Name and Paul Morrissey as their final power struggle. Name found a huge ground-floor space on Fourteenth Street just east of Union Square, right across from

the old Academy of Music concert hall and a few blocks from Max's Kansas City. It was a classic artist's studio in the spirit of the Silver Factory, but more so—too much more so for Warhol.

Morrissey found something in the same neighborhood but very different, and it won the day. His hunt had led him to the vacant sixth floor of a narrow Victorian building on the west side of Union Square, closer yet to Max's. It was a neighborhood Warhol had known for ages: In the 1950s, his friends Corkie Ward and Charles Lisanby had both lived nearby and the designer George Klauber, Warhol's gay mentor, had a studio there.

Morrissey's find was in what was then called the Union Building, a wild, neo-Moorish affair that had once included a minaret; that put it at odds with the modern style that Warhol favored in art but was in keeping with his old camp tastes for anything fin de siècle. Built in the glory days of Union Square as a fashionable address, the building had now gone to seed, harboring a scruffy Packard Electronics store on its ground floor, next door to Klepper Folding Boats and Tents. Classic New York coffee shops filled both ends of the block but Warhol mostly preferred to send out for lunch from around the corner at Brownies, one of the city's first health-food spots. On Warhol's sixth floor, some of the façade's taste for ornament had made its way inside, in turned wooden moldings and window frames, but those worked fine as a foil for Warhol's minimal furnishings. That marriage of vintage and modern was just then catching on among savvy decorators.

"We'll show Billy that he won't be able to put any silver here, it will be so nice and bright," said Morrissey to Susan Pile, on her first visit to the Union Square space before they'd moved in. Pile remembered how "Paul was a force and Billy was just a silent weapon—he wasn't contentious and Paul was hard to resist." A friend of Warhol's joked that Morrissey loved to give "pointers" to people about how to do their jobs: "I think he could run a department store very well. He has his own mind and likes to be on the move a lot. He's fantastic—and so full of shit."

Warhol's new headquarters had a few attractions that went beyond its look. The rent was not too steep: Just over $400 for 3,200 square feet—a third more than the final rent they'd been paying on Forty-Seventh Street, where they'd had slightly less space. In a lefty late-1960s context, the building's block got extra cachet from being full of union offices of one kind or another. In fact, the Union Building itself housed the Communist Party of New York. A year after Warhol moved in, the top story got rented to the illustrator Saul Steinberg, an older rival of Warhol's from the 1950s who had now fallen behind in the race for fame. Meeting him in the elevator couldn't have hurt Warhol's ego. Steinberg became a regular visitor to Warhol's studio in the early 1970s.

The lease on that sixth floor was signed two days after Christmas, and luckily Warhol was able to hold on to the old Factory for a few months while they got the new studio ready.

For much of January, Morrissey would spend mornings stripping moldings on Union Square before heading to the old space to work with Warhol. (He was known as a mad refinisher; his home was packed with half-restored vintage items.) Billy Name, for his part, eventually took on the task of walling off the dark back end of the space as a screening room; painted black, it suited his mole man tastes.

With desks up front and projections in back and a little cubbyhole office for Warhol in between—and not much room for silkscreening, anywhere—the Union Square workplace made concrete and final the long-standing conceit that Warhol had become a full-time moviemaker: He listed his new space in the phone book as "Warhol Andy Films Inc."

It took months for the office to arrive at its full plastic look: The earliest photos show an unvarnished floor, filing cabinets as table bases with plain wooden doors as their tops, and—shades of the Silver Factory and its unreliable inhabitants—a pay phone by the door. By February 5, however, enough had been done to allow Warhol and his gang to move in. Barely an object or two made the trip south with them: Some oak file drawers and one of the Factory's factory clocks were deemed worth saving; so was the famous couch, although it got stolen off the curb in midmove. (The handy casters that had made it appeal to Name in the first place were also its undoing.)

The new studio heard the same kind of 45s that Warhol had played uptown for years: "I Heard It Through the Grapevine," "(Sittin' on) the Dock of the Bay," "Love Child." Billy Name's opera albums also came downtown and were played at high volume. "That gives this place some class," said a new employee.

After the muddle on Forty-Seventh Street, that was precisely the goal. "I remember answering the phone, 'Factory,'" recalled one employee, "and Andy saying, 'Why don't you just say studio?'" That was the rule from then on, although often broken. One dedicated avant-gardist described the new space as "an office, or more like a funeral parlor—everyone in suits, and black."

———

Warhol Andy Films Inc. began to truly live up to its name and new image a few weeks after taking possession of the Union Square space. That was when work began on the most mainstream(-ish) movie Warhol had yet undertaken: a full-blown Western shot on location in the desert, with costumes, cast and

crew plus a plot and script—or at least vague hints of such, all soon aban-
doned, as usual. It looks as though there were even plans, from early on, to
shoot lots of footage and then edit it down—the most radical Hollywoodism
Warhol had dared to date.

The first news of the project came early in November 1967, when War-
hol was giving one of his *Four Star* screenings and nontalks in Arizona. He
(not Allen Midgette, this time) told a reporter that he'd fallen in love with
the desert five years before, when he'd crossed the country by car, and now
wanted to come back to do a shoot there. The movie would be called *The
Unwanted Cowboy*. That sounds like just another of Warhol's innumerable
tossed-off ideas, except that within a few weeks he had started casting for it
and by late January of '68 he, Morrissey and more than a dozen actors, crew
and hangers-on had actually returned to Arizona to start shooting *Lonesome
Cowboys*—a new title chosen on the advice of theater owners who said that
skin flicks with plural names (*Alley Cats, Dirty Girls*) did better box office.
Warhol showed up in the Western gear he'd started to buy on his previous
trip: boots and jeweled belts, a vast twenty-gallon hat and an overwrought
dude-ranch jacket made from leather and snakeskin. The setting also kick-
started his taste for Native American textiles, which became a focus of his
manic collecting for the next two decades. Within a few years, he'd got some
kind of stake in a Taos rug store and was lecturing a dealer on Native art as
abstraction.

Warhol's cowboy movie had the most unlikely of origins, even by his
standards. It began when Viva got a new boyfriend who called himself Julian;
he thought his name sounded enough like "Juliet" for him to suggest that he
and Viva should be cast in a gender-switched version of *Romeo and Juliet*. As
Morrissey helpfully explained to the readers of a girly magazine, "in our ver-
sion Romeo is younger than Juliet, and Juliet goes after him. The girl's name
is Romona, and the guy is called Julian. And Romona has a male nurse."

With the decision to bring everyone West, Shakespeare's Fair Verona
became Old Arizona. (That was another title tried out for the film.) And
just in case the gender switching wasn't confusing enough, Romona-Romeo
was now a Wild West madam and Julian-Juliet, her "true love," was gay,
like all the other cowboys in the film. The actual Julian, whose real name
was Andrew and who was too quiet to be much of an actor, was moved
to a bit part and replaced in the starring role by a curly-haired, Italianate
Romeo named Tom Hompertz who Warhol had met at one of his lectures
and who, as it happened, was just about completely nonverbal. "He never
speaks," said Morrissey. "Never ever. He just doesn't speak. Which makes
him hard to work with. He's great with Viva, because she talks enough for

both, but with anybody else . . ." Mead tried to inject some order into things by referring the actors to the scrap of synopsis he'd been given, but Warhol was having none of that: "Oh, Taylor, too much plot," he said, preferring his usual improvisation. This from a man who insisted that his new Western would be "directly competing with Hollywood. . . . We've already proved that our experiments were successful, and we're going on from there. Our plan is to reproduce the glory, the glamor, and the grandeur of Hollywood studio-made films of the '30s."

The shoot for *Lonesome Cowboys* started, appropriately enough, in the rain on a fake Wild West set called Old Tucson, used for various movie and TV Westerns plus gunfights staged for tourists. News of Warhol's presence soon spread, attracting an audience both of artsies from nearby universities and of upstanding local townspeople eager to be shocked by the carryings-on of New York degenerates. The locals got at least some of what they were looking for: Viva, the only woman on set, was surrounded by a crowd of mincing gay cowboys who committed such atrocities as comparing their glutes and using a manly hitching post as a barre to practice ballet poses, all under the watchful eye of a sheriff played by a "drag-queen extraordinaire." The county's real sheriff kept an eye on things from a helicopter until Viva told him off for ruining the movie's sound; the next day he moved his observation post to a water tank, surveilling the strangers through a telescope. After a day of such distractions, and a set rental of $500, Warhol accepted an invitation to move their shoot to where they'd been staying: an artist's commune named Linda Vista that a local professor had just founded farther out in the wilderness.

The new, countercultural setting was more suited to a Warhol shoot. It also made things slightly more comfortable—the actors' cabins were now nearby—but not much more efficient. Students and townies soon began to show up again to ogle the action. The set became something like a local attraction, offering up the rare sight of cowboys kissing cowboys and taking long public pisses as the camera rolled. Things got truly out of hand, however, when, in the heat of improvisation, the crowd of gay and bisexual actors began to rip off Viva's clothes and sexually assault her. Viva once claimed that most of the male cast had already done so in her cabin over previous nights, and now that violence was being revealed on an open set.

"All the art students from the neighboring universities came and brought their children," recalled Viva, and the sight of her being assaulted was too much even for the most liberal of those parents, not to mention for the more conservative Arizonans who had also borne witness. It led to the kids of the commune's founder being ostracized at school and to a complaint being

made with the FBI. Washington opened a file on Warhol that wasn't closed for another nine years, wasting the manpower of various field offices and sending "a perfect FBI man" to check out the studio any number of times.

Viva's sexual assault wasn't the first one to be seen in an underground movie: There had been one in Jack Smith's *Flaming Creatures* and another, viewers said, in a Susan Bottomly reel from Warhol's own *Four Stars*. But this latest assault did seem to confirm that at a moment in American history that was feeling notably grim, the culture's larger negativity had invaded Warhol's films. Although the ever-jolly and often clueless Taylor Mead said that the Arizona shoot was the most cheerful one he'd ever been on—he'd scored in the nighttime cabin action—the footage itself showed that the violent absurdism of *Lonesome Cowboys* was a million miles from the cheerful inanity of Warhol's *Tarzan and Jane,* shot with Mead less than five years before.

As a final touch to the chaos, Viva had a meltdown on the way home when, having shown up without ID, she wasn't allowed to drink at the Phoenix airport bar: "Look who I'm with," she screamed at some poor airport cop, "famous people!"

Morrissey described the movie they eventually edited from the footage as being about "a group of brothers in the West. . . . They aren't really brothers, they're, well, sleeping together, or whatever, but they say they're brothers so people won't talk. There were supposed to be some lines about that, but the way we work, well, they forgot to say it, so you sort of don't know whether they're brothers or not. A new brother comes along—that's Tom Hompertz—and there is jealousy. Viva wants to seduce him but he gets disgusted and runs off with Eric Emerson, who's the liveliest of the brothers."

A magazine writer summarized the film, more accurately, as "a mélange of homosexual sex, conversation, rape, conversation, transvestitism, conversation, homosexual incest, conversation, masturbation, conversation, heterosexual seduction, talk, talk, talk and an orgy."

All that talk included Eric Emerson delivering a stoner monologue, onscreen, that wasn't *quite* up to the standards of the classic philosopher-cowboy:

> I can touch myself and feel it . . . I feel when the sun comes up: It's hard to stop. When the moon goes up it's just the opposite of stopping. Feeling can be had all day long, you can do whatever you want. . . . If you don't have any money you don't have a job, because that's where money comes from. I don't have a job. I can sit out here and play with myself all day long. . . . I've fallen so in love with feeling itself, I wear boots now so I don't get contact with the cactus.

One of the other actors said that the movie's larger contribution to American filmmaking was to feature history's most extended on-camera urination ("it was the longest piss; Andy shot the whole thing") and, despite Paul Morrissey's attempt to ban all vulgarity, more cursing than had ever been tried before. As the same actor put it, "I said, 'Fuck this. You fucking asshole, you bastard. You bitch, you cunt, you fucking no-good pimp mother-fucking asshole.' . . . It was like doing Shakespeare—it was a whole new language, doing it in front of a camera. . . . This stuff—believe me, we affected Hollywood major movies. We broke the ground."

When the movie was released, a full year later, it got mostly scathing reviews. Even the *Village Voice* deployed a flamethrower:

> As long as Warhol could indulge the indolence of his somnambulist superstars, male, female, and transvestite alike, the boredom of talky nonactions could be rationalized as random episodes out of the encyclopedic realism of a 24-hour day. But once he is forced to play genre games, the undisciplined narcissism of his ménage clutters the screen with giggly egos out of synch with each other and with any coherent conception.

All the pans make it clear that Warhol's most "Hollywood" of films was actually one of his most challenging products. The deliberate toying with failure that had always been such an important part of modern art, and that Warhol had absorbed already as a student, saw its apotheosis in *Lonesome Cowboys*. The effect of that "failure" was made all the more potent because Warhol had adopted so many markers of mainstream movie culture—cuts and pans and zooms; close-ups and establishing shots; costumes and sets— and those had raised expectations for conventional content and effects (a "coherent conception") that Warhol the avant-gardist could not bear to deliver. His refusal to "succeed" made the movie all the more shocking and trying. Shot eighteen months to the day before the Stonewall riots, the movie was more explicitly queeny and camp than anything else Warhol had released; it treated America's sacred subject of the Western Frontier with truly gay abandon. As *Lonesome Cowboys* tells the tale, the West was won thanks to feather boas and mascara, with peyote and hemp as the driving force.

*The Chelsea Girls* had allowed average Americans to descend into Warhol's underground, where they found pretty much what they'd expected; *Lonesome Cowboys* lofted the underground up into average America, a much scarier proposition. When it was shown in Atlanta, the local police photographed audience members for inclusion in its files of "undesirables."

———

On the last day of January, when Warhol arrived back in his new Union Square studio, the world he settled into was very different from the one he'd lived in for the four years of his Silver Factory. The *Lonesome Cowboys* shoot was the last gasp, you could say, of that earlier scene's fertile chaos. "The new art is business," Warhol told a reporter in the spring, and that aphorism launched a new approach to his life and his art that would mold both for the following two decades, and then shape his reputation for all the years afterward.

The change had already got underway in the last months of the Forty-Seventh Street space. Paul Morrissey, beginning to displace Malanga and Billy Name as Warhol's second-in-command, had sought "a more business-like atmosphere," said Susan Pile, by having a third of the old Silver Factory partitioned off as office space, complete with the latest in electric typewriters. "It looks so awful. I hate it so much," Warhol said, despite having allowed it to happen. It's as though he saw his tidy future coming but was still uneasy about abandoning a messy past he'd worked so hard to achieve.

"Everything is going wrong, and I decided that we're going to get organized and really do things right," he told a cab-driving friend around the same time, complaining of equipment thefts on Forty-Seventh Street. "Nobody can sit at the Factory. They have to sweep or clean up, or if they don't they have to leave." But restoring order to a studio gone chaotic was only part of Warhol's rationale. On that same taxi ride, he made it clear that rebellion had left the cutting edge to become the new status quo: "Now everybody, you know, they want to freak out, so they just put on funny clothes and stuff like that—then they become like everybody else."

The only way forward, Warhol realized, was to take a step back toward tidier times, with Paul Morrissey as his in-house reactionary. "Drugs are old-hat now," Morrissey said, in an appearance alongside Warhol just as they were still settling into Union Square. "This year it's alcohol and vitamins and healthy outdoor things like that." Such views were mostly for show: Nightly visits to Max's Kansas City by Warhol's gang were hardly teetotal, drug-free affairs. But one result of the slow renovation of the new studio was that it became off-limits for the months when work was being done, forcing Warhol's social scene to transfer wholesale to Max's, as "a kind of substitute Factory," in the words of someone who watched the shift happen. With Max's absorbing the countercultural energies left over from Forty-Seventh Street, the Union Square space could adopt its corporate aura—"kind of cold, not very welcoming," as the same witness put it.

Morrissey was in charge of keeping order, becoming Big Bad Brother

Paul, eldest sibling among Warhol's crowd of pseudochildren, "who shoves them all into line and keeps the operation going in as businesslike a way as possible," according to a reporter writing that same spring of '68.

Warhol began to make the same shift in his public persona. Instead of promoting a bohemian eccentricity—it had started way back, with those carnival masks he'd provided to his first patrons—he was now revealing a more mainstream side. It was one of his typically contrarian gestures: "We've been building up this camp image for years, and now that people expect it, we're serious," he'd said, just as his move was underway.

A journalist who'd met him not long before expressed his surprise at finding "a quite ordinary, conventional individual; a nice guy, really, not one of those wise types you usually run into in the show-business-public-personality circuit." Another dwelled at some length on how Warhol's life followed a surprisingly orderly pattern that included dealing responsibly with "personal and business matters," moving forward with his filmmaking and even taking care of his ailing mother. Warhol, now described as "soft-hearted and understanding," went so far as to allow the reporter to meet the old woman. That reporter's account of even some of Warhol's stranger habits made them sound more routine than bizarre, or routine at least for someone as bizarre as him. Every night after closing time at Max's, she wrote, "Andy heads home to spend the next few hours watching ancient movies on television, eating chocolate-covered cherries and having long telephone conversations with the people he has just left. When the movies go off and the early-morning exercise programs come on, Andy goes to bed."

Warhol's "return to order" included a major shakeup in his social circle. Rod La Rod, an almost perfect symbol of the old Factory *dis*order—his very wildness had been a turn-on for Warhol—was dumped just weeks before the move to Union Square, after Morrissey and others led a campaign to oust him. (He dropped in on Warhol one last time, in late February, silent and glassy eyed: "He said he was never going to call me again," Warhol said. "What's he doing here?") Ivy Nicholson had been exiled after leaving behind her fecal keepsake while Ron Tavel and Mary Woronov had both drifted off into radical theater after their confrontations with Warhol over money. Ondine joined them there. He didn't have an explicit or a dramatic break with Warhol, but after choosing not to join them for the Tucson shoot—he feared a shortage of amphetamines—he steadily disappeared from view. Some of the younger Warholians who arrived in '68 never even had the chance to meet Ondine. Within just a few years, he was looking back at the Factory with vitriol and a sense of betrayal: "Whenever I see Warhol or Morrissey on the street, I'm going to ignore them. I mean, I may even spit. I mean, I can

no longer tolerate this. I'm living a life of abject poverty because of those motherfuckers."

Taylor Mead mostly absented himself too after his star turn in *Lonesome Cowboys*, since he felt Warhol wasn't keeping a promise he'd made, just that winter, to help Mead make his own movies, cut a record, appear on TV, publish a book: "He never did any of it."

Viva, queen of disorder, was another bad fit for the studio's orderly new regime. One day in the spring of '68, raging at not having been given a key to the Union Square building, she did her best to remove its doorknob using only a dime and a bobby pin, saying, "They locked me out, and I'm going to lock them in." Warhol happened to show up while she worked. "Why don't I have a key to this place? I'm not treated with any respect around here," she shouted and, with a reporter watching, promptly swiped Warhol upside the head with her purse. "You're crazy, Viva" was his cool response.

By that fall, David Bourdon received a "hysterical telephone call" that shows Viva and Warhol fully on the outs. "They're trying to do to me what they did to Edie Sedgwick, whatever it is they did to her," said Viva. "But they'll find I'm a crumb of an altogether different cookie." She imagined lawsuits and Warhol retaliated with insults, at least in her version of events: "If it weren't for me," Warhol is supposed to have told her, "you wouldn't be anybody. I made you what you are today. Look where you were two years ago."

Viva was gone from Warhol's circle by the end of November, thanks to a ticket to Paris that he bought her ("sullenly," she said) plus a gift of $700 as a "dowry" for the French actor she was supposed to marry there, but didn't.

Billy Name, one of the first and most important of the Factory regulars, made a slower but even more notable exit. Even before the move, he'd been retreating more and more into himself and into his dark corner of the not-so-Silver Factory. In the months after the move, he retired almost completely into a darkroom built for him at the rear of the new studio, despite objections from Paul Morrissey. "He would tell Andy things like 'Oh no, Billy can't stay there because he'll paint the whole place silver,'" Name said. By late that spring, he was complaining that Warhol had never lived up to their long-standing "understanding" that he'd be paid $100 a week. ("He owes me money. I lost money with Andy.") Increasingly disgruntled by the new "management position" that Morrissey had usurped from him, he barely emerged from his lair for more than a year. "Andy didn't need me anymore" was how he remembered feeling. If he came out at all, it was only at night, when he could be seen looking for sex in the cruising grounds of nearby Stuyvesant Park.

"Billy had always seemed to know exactly what he was doing, and I just

didn't want to butt in" was how Warhol (or a ghostwriter) later justified his noninterference.

Name shaved his head: "He said the hairs were growing in, not out," reported Lou Reed, a former lover who had gained admittance to the hermit's refuge in the darkroom. He spent his days in Blavatskian meditation on the occult, as un-Warholian a pursuit as could be. "Another part of why I sealed myself away was, I discovered that when you are approaching thirty, you are having your first Saturn returns. The planet Saturn comes back to the place where it was at your birth," Name once explained, if that counts as an explanation. He had become the official Factory astrologer: "When Viva wanted to know if she should get a nose job, I cast a chart for her. And it came out 'no.'" He decided to start going by the name "S"—just that one letter—"for 'Essence,'" as he put it.

Appropriately, his major food source was Campbell's Soup, eaten cold, condensed and straight from the can, from a supply the company had gifted to Warhol. It's said that Billy worked his way through all thirty-two flavors, although that's at odds with mentions of yogurt containers as the darkroom's principal output—and with Billy's own admission to having also ordered takeout from Brownies. In a stroke of luck for all concerned, the darkroom had been converted from a large bathroom, with one of its toilets left in working order. Eventually, one day in 1970, all that was left of Name was a famous note, scrawled with a broad red marker: "ANDY—I AM NOT HERE ANYMORE BUT I AM FINE."

Ondine felt that his old friend had been betrayed by Warhol. "Billy was so loyal to that man. For a year he waited in the back room for somebody. And nobody was there. Andy Warhol was no longer there. He had gone somewhere else. . . . [Name] was in touch with something so spiritual that most people would be frightened by it. He wouldn't come out with those mediocrities." Ondine's account of Warhol's new crowd wasn't entirely wrong. What he couldn't understand was that, twenty years before the heyday of Jeff Koons, mediocrity was on its way to becoming the new excellence.

Malanga, who predated even Billy among Warhol acolytes, disappeared only slightly less dramatically. He'd been in Rome forging paintings as the Factory searched for its new home, and he had to steer clear of his angry boss for some while after returning to New York. His absence helped cement the change of direction in Warhol's world.

On March 8, 1968, a photographer came to Union Square to shoot a famous group photo that's come to be titled *Friends of the Factory*. But the photo is most striking for how few of the thirty-two people it captured were Warhol "friends" of real note, and how well it stands for the demise of the old Factory.

If Morrissey came to replace Billy Name as the studio foreman, you could say that Malanga's role as prime minister of Warholand was filled by a recent arrival named Frederick Hughes. According to Malanga, Hughes had set out from the start to displace him, and Hughes did indeed end up lasting twenty years as Warhol's right-hand man, versus Malanga's five. When Malanga showed up one day in the summer of '68, on Morrissey's invitation, Hughes wrote a note to Warhol saying "I've given up fighting the inevitability of Gerard"—as though his boss would agree that, by then, Malanga ought to have been evitable.

Warhol and Hughes had their first notable encounter on June 3, 1967, at that deluxe Merce Cunningham fund-raiser staged at Philip Johnson's Glass House. Warhol was still representing the avant-garde: He'd brought the Velvet Underground as part of the evening's experimental entertainment. Hughes was there as part of high society: He'd helped arrange the whole thing, as adjutant to John and Dominique de Menil, the Franco-Texan millionaires who were the evening's principal patrons and who Warhol had known for several years. Although Hughes was only twenty-three, he'd already acquired the manner and manners of the nation's elite, which must have appealed to Warhol. His taste for privilege was growing. That night in the Connecticut countryside, Warhol and Hughes were inseparable, chatting as they perched on a garden wall:

> While they talked, the Cunningham company performed to the score by John Cage. Fred and Andy talked during cocktails on the lawn, and the boxed dinner from the Four Seasons Brasserie. They talked through the fireworks and while the Velvet Underground began to play. They talked as some people, hot from dancing, jumped into the pool. They talked while others, chilly in the cool June air, decided, without knowing that the damper was closed, to light the logs in the Glass House fireplace. They may have talked until the police and firemen arrived, saying the party was over.

Hughes had had a fine education in modern art in Houston, in a college art department funded and run by Dominique de Menil. She'd arranged for his class to meet such art stars as René Magritte and Roberto Matta and, most notably, Duchamp—all figures collected by Warhol. She'd also arranged for Hughes to work in the Paris gallery of her mentor Alexander Iolas, the flam-

boyant dealer who had granted Warhol his first New York show and would go on to organize his final one. Back in Houston, she let Hughes, a favored student, work on several exhibitions in the university gallery, including one with mostly Pop Art that he'd only just hung when he and Warhol met. It included any number of works by Warhol's friends and rivals and three by Warhol's very favorite artist—himself. No wonder the two men hit it off.

"I recognized in Fred Hughes a young man who had not only an exceptional eye," said Dominique de Menil, "but also an instinct for what was important, for quality." Hughes's younger brother said that Fred had been indulging that instinct from the youngest age, decorating their childhood room with "stuffed hawks, human hair wreaths, box-framed butterflies, a tiger rug, a beaver top hat, bamboo shades, and some pre-columbian fertility goddesses." Classical music played nonstop from big brother's transistor radio and he'd already formed the ambition of being one of the world's best-dressed men—a title he went on to win, three times.

As a relation of the millionaire Howard Hughes, all that might have been par for the course—except that the relationship was a fiction offered up by Fred, who went so far as to wear a black armband and sigh, "Oh, Uncle Howard," when the tycoon died. Fred Hughes's father, Fred Sr., was actually a salesman for the Chromcraft Corporation, "the Distinguished Name in Dinette Furniture." And while it was true, strictly speaking, that the family lived "down the street" from the de Menils, as Hughes liked to mention, that was a very long way down a very long street, in a neighborhood that was much more humble. (Friends in Texas took Hughes's gambits in stride. As one of them recalled, "We'd all roll our eyes and say, 'There goes Fred.'")

Despite his modest roots, or more probably because of them, Hughes went on to be the epitome, or almost a caricature, of an uptown toff—"a man about town, like they say, a cosmopolite obsessed with social vanity but lacking social conscience" was how Malanga later described him. The actor Richard Gere once said that Hughes was the only native Texan he knew who spoke with a British accent. Hughes was an early adopter of the slicked-back Valentino hair, "as shiny as a coat of molasses," that became a sign of the counter-counterculture of the 1970s. Hughes, said a fan, "repioneered short hair in reaction to hippie cops and the Charles Manson look," thereby recasting tradition as vanguard. Just a few years before, when Warhol and the Silver Factory had been all about leaving tradition behind, such thoughts would have been inconceivable.

But all this posing developed mostly after Hughes had met Warhol, and partly through the artist's encouragement. Back in Houston, Hughes had started out as "the sweetest kid, dressed normally," according to a critic who

met the young Hughes through the de Menils. For a full year after his arrival on Warhol's scene, Hughes still had the long, lank hair of a Haight-Ashbury dandy; he was known for having purchased a cape and purple velvet boots that climbed past his knees. A photo from months into Warhol's Union Square era still shows a longhaired Hughes looking all of fifteen years old and wearing a psychedelic green-satin shirt; he'd spend weeks in a single pair of pants.

For Warhol, the strongest, first sign of Hughes's elite status was no doubt his recognized role as the "dauphin" of John and Dominique de Menil. That day when the couple's guests had headed up to see Cunningham at the Glass House, they'd first gathered for champagne and caviar at the de Menil town house where Fred Hughes was visibly in residence. That, Hughes said, was the initial impetus for Warhol's interest in him. Fran Lebowitz once described Hughes as "a social climber from an Edith Wharton novel." Warhol was eager to join him on the ascent.

Although the look and manner Hughes later perfected could make him seem a stuffed shirt, part of his appeal came from a foppish, tomfooling side that he never completely lost. "He's so dizzy. He's so dizzy. Really dizzy" was how Warhol once described Hughes, giggling over some jeans the younger man had just spray-painted gold. Almost everyone who knew Hughes said he could be a delightful and very funny companion—even, for one younger gay man, "very loving and very mentoring." One friend's eulogy recalled how "everything was charmed with Fred. He danced like Fred Astaire. He had the beauty of Cary Grant. And the smarts of Noel Coward." But his closest companions have also mentioned a darker side. Hughes's complex, conflicted sexuality had him dating sparkling young fiancées in the evening and then cruising for the roughest of rough trade at night. He'd wake up with bruises. At other times he had established boyfriends. "Pansexual" was how one old friend described him. His wild abuse of alcohol and drugs could bring out a cutting rage that no one was immune to, even Warhol. The two had started having nasty fights as early as 1972, but those got more vicious in their last few years working together. Hughes's fury was further unleashed by the multiple sclerosis that became obvious in the early '80s and finally killed him in 2001.

In 1968, one of the first signs of Hughes's expanded role in the new Warhol ecosystem came with the décor on Union Square. While all involved seem to have agreed that they wanted the loft to function as a tidy anti-Factory, Morrissey had wanted it to look like an utterly utilitarian office, so that "the kids" who Warhol needed for his films would come "just for business, just to find out about a job, and then they'd leave." Hughes, on the other hand, wanted something sleek and snazzy that would put visitors at ease and make some kind of splash. After giant fights, the newcomer Hughes

got his way, although the frugal Warhol kept him on a tight leash. The new desks were in fact made cheaply enough, with filing cabinets for bases and felt-covered wood under their glass tops; Hughes only got to mirror those bases on the sides that visitors could easily see. Nevertheless, he was so proud of the Union Square décor that he was soon planning a tour of the space for *House & Garden* magazine.

---

As Warhol must have hoped from their first meeting, Hughes soon became useful as a go-between with the de Menils. Early in '67, a local bishop had asked the couple for help finding art to fill the Vatican pavilion at a world's fair being planned for Texas. Unable to think of much recent religious work, the de Menils suggested commissioning new pieces from big-name living artists, including Robert Indiana, Jasper Johns, Robert Rauschenberg and, of course, Warhol. (One assumes the clerics involved did not know that those four were all homosexuals. The de Menils must have.) To see how fairs and art might intersect, Warhol, Hughes and the de Menils flew by private jet to the American Pavilion at Expo '67 in Montreal, where Warhol was showing his fingers-on-lips self-portraits. Warhol seems to have returned from the trip with the determination to give Texas a film that was more adventurous than his silkscreens in Montreal. At that rebellious moment in his career, you'd expect him to have provided something controversial, on the order of the blasphemous *Imitation of Christ*. Instead, either awed by that private jet or inspired by some inner piety, he came up with an idea that was much more well behaved. The de Menils had asked for a work "appropriate for a church" and Warhol proposed giving them never-ending shots of sunsets, thereby transplanting the contemplation of his *Empire* footage from an awe-inspiring urban subject to the sublime in nature. Yet that wasn't at all the reading Warhol himself gave of his film. After shooting some early reels by the sea, he explained what he saw in terms that came straight out of the art-for-art's-sake art world, as it stood in 1967: "It's like a painting, really. It was pretty, because it was just like a stripe painting with a little round ball that kept moving down, and the water was getting a different color." Warhol re-alized that the abstractionist Mark Rothko, known for compositions split in two like earth and sky, was at work on a dusky series of canvases for the de Menils; *Sunset* would have counted as both homage to the older master and a little poke at him.

Or maybe the real motivation for *Sunset*, and also for its affable quietude, was less artistic or pietistic than frankly financial, as Warhol more or less ad-mitted in an interview. He ended up squeezing $15,000 out of the de Menils

as an advance just toward shooting expenses, an absurd overestimate whose surplus ended up being siphoned off toward the cost of *Lonesome Cowboys,* or so Warhol's ghostwriters were claiming in the '80s. After shooting sunsets in San Francisco, Manhattan (from Fifth Avenue, overlooking Central Park) and the Hamptons (on the weekend of the nude food fight) Warhol learned that the church pavilion had been canceled, after all. A few of the reels that he'd shot ended up in *Four Stars*—what footage didn't?—which meant that Dominique de Menil might have seen them the following spring when she arranged for Warhol to screen excerpts from that movie and the *Imitation of Christ* at the Catholic college she helped fund in Houston. "Andy is a wonderful person. Such substance" was de Menil's reaction to his offerings, but the college's divines were less convinced. Their patron had also made them put up with Jack Smith's *Flaming Creatures,* and then with the Houston premiere of *Lonesome Cowboys,* and all this led the college to break with the de Menils.

Although the end of the decade was still another two years away, Warhol's 1960s feel like they were coming to a close already by the first months of 1968. Projects like *Sunset* and the JFK prints seem like last gasps of the straightforwardly experimental art making he'd embarked on in 1961, with its aim of making new objects that used a new look to talk about new subjects. By '68, that kind of traditional modernism, built around artistic *things,* was being drowned out by Warhol's postmodern play with his own persona, and by his toying with business, publicity and his retinue as new artistic media, more thoroughly "mixed" than any media had been before. The contrast between the two options began to come clear toward the start of the year—in Sweden, of all places.

———

On February 9, 1968, in Stockholm, it was at most a few degrees below freezing but Warhol, always cold-blooded, was wearing two pairs of shocking-pink tights under his latest East Village outfit: a green turtleneck, brass-buttoned peacoat and pants so well worn they had holes in them. (Hence the visibility of at least the top pair of tights; we don't know how news of the lower pair leaked to a reporter.)

"I was going to send someone that looked like me," Warhol said to his art-critic friend David Bourdon, who had also made the trip, "but they found out about it and I had to come myself. It worked once before, though, and nobody knew the difference." A strange claim given that, just the day before, the *New York Post* had run Warhol's confession about the Allen Midgette hoax. He might have figured that news of it could not yet have reached Bourdon in Sweden.

The "they" who had nixed Warhol's doppelgänger were the organizers of a giant Warhol retrospective that was previewing that February day at Sweden's Moderna Museet (the Modern Museum). The museum was famous, especially among Americans, as Europe's most ambitious venue for contemporary art. All of New York's vanguard had appeared there: Cunningham and Cage, Johns and Rauschenberg (the latter with his daring all-white canvases, refabricated to his specifications by Swedes), Oldenburg and Rosenquist and, in one of Europe's first surveys of Pop, Warhol himself, back in 1964 when the museum published a famous essay on him by Geldzahler. "It's part of our policy to follow up on people who we have shown before when they continue to do interesting things," said Pontus Hultén, the museum's director. Described by Bourdon as "a tall, dark, well-tailored man with a black mustache and a relaxed air of assurance," Hultén had known Warhol since the late 1950s and had been an admirer since the Soup Can days, even attending the launch of Warhol's Silver Phallus into the sky above the visiting Pope. He didn't for a second buy Warhol's goofy, aw-shucks persona. After working with Warhol on their survey, Hultén described him as "extremely sensitive—really one of the most penetrating and analyzing sensitivities I have come across."

While the supposed "retrospective" in Stockholm left out far more of Warhol's best work than it included, it probably gave as good a sense of his high '60s sensibility as you could ask for. Visitors were hit with it while still some ways from the door: The museum's entire neoclassical façade was covered, ground to eaves trough, in the magenta and yellow of Warhol's cow wallpaper, making clear from the start that he was not—or was no longer—a maker of discreet precious objects. The message was hammered home inside, where no piece was presented as a one-off. Marilyn appeared twenty times in her latest multicolored incarnation, with each of the ten prints from Warhol's new portfolio appearing twice across a huge grid. Ten Flower paintings were also sent over to Stockholm, each one now ten feet to a side, and they were joined by ten bed-size enlargements of Warhol's *Silver Clouds,* hardly worthy of their title now that they were in clear plastic rather than silver and unable to get airborne at all. (Warhol spent good money on getting them manufactured with the proper valves, but Stockholm was short on helium, or so says one tale; another claims that Warhol's *Clouds* never arrived so huge plastic bags had to be used instead.) A dozen of Warhol's Electric Chairs were also shown, once again as new, bigger paintings specially silkscreened at Stockholm's expense.

The entire show now proved that Warhol "originals" could always be newly made, even for a survey that billed itself as a retrospective—and espe-

cially for a survey that could never afford to bring in works from collectors scattered all over the United States and beyond. It was a freelance curator named Kasper Koenig, soon to be an art-world potentate, who first pitched the idea for the show to an eager but skeptical Hultén; he convinced the Swede it could be managed by getting Warhol to remake a slew of his classic works and send them to Stockholm as a single shipment of rolled canvases. The exhibition's marriage of economy and conceptual heft became especially clear in its vast stack of five hundred Brillo Boxes, which this time did not have their logos silkscreened onto wood, as in their first incarnation in 1964, but were real packing cartons, in cardboard, ordered by the museum direct from Brillo itself and shipped flat across the Atlantic. With the new, manufactured boxes Warhol had "closed the circle," Hultén said at the Stockholm opening: "The real thing is just as functional in expressing his point regarding quantity and interchangeability."

Visitors to the Moderna Museet did not have to make do with Warhol as an old-fashioned provider of objects, however repeated and diluted those might have been in the show. There were also his films to be seen. Three projectors shone a spliced-together reel of excerpts from *Sleep, Eat* and *Bike Boy* onto walls in the same rooms that held Warhol's spotlit paintings, for once giving equal billing to old and new media. (Surplus lights bought from a TV station made this possible; at the time this was seen as an "inspired" innovation in exhibition design.) The museum also scheduled thrice-weekly, double-screen showings of *The Chelsea Girls,* "the most important film done in the last 10 years," as Hultén described it. He said it revealed Warhol to be "probably one of the most moral of artists. He's concerned with ethical situations."

To complete his show's portrait of Warhol, Hultén included plentiful photos of Silver Factory life and even got a local band to play "ricocheting blasts" of Velvet Undergound–ish noise at the opening. (The Velvets themselves were supposed to bring a rock opera of *The Chelsea Girls* to Stockholm, but that fell through.) The Factory photos were repeated, in even greater quantity, in the show's phone book of a catalog. Given how few non-Swedes were likely to make it to Stockholm, the book was designed to function more as a portable substitute for the exhibition than as the usual companion to it. Printed cheaply and priced to sell, the book consisted of page after page of Warhol's Pop works, including dozens not in the survey, each one reproduced any number of times, as though repetition itself were the real medium that the book had to convey. There were also endless photos of Warhol's acolytes in bohemian action and no text at all beyond pages of sound bites supposed to come from the mouth and mind of Warhol himself:

I never read. I just look at pictures.

I never wanted to be a painter. I just wanted to be a tap-dancer.

In the future everybody will be world famous for fifteen minutes.

That last and most famous of all Warhol quotes owes its spread almost entirely to its place in the Moderna Museet catalog, since there's only the slightest of evidence that Warhol ever said it—or not at least until after everyone was already quoting it back to him as his best-known bon mot. Like almost all of Warhol's mots, it's not clear it's even that bon, especially given the vastly different ways it's been read over the decades—either as pointing to how swiftly the new fame will fade ("no one now will get more than fifteen minutes") or to how widespread it will be ("everyone will get their fifteen minutes") or to how global all fame will become ("minor celebrity will soon spread around the world"). But of course the substantial doubts about the quote's paternity, and about its precise meaning and import, just make it an even purer and greater example of Warholian instability—a real masterpiece in the genre, you might say. Even if he wasn't the one who first conceived the quote, it couldn't mean much of anything to the culture at large until it became part of his larger production.

Warhol could only have been pleased with the huge spotlight that Hultén's exhibition shone on him. In one form or another, the exhibition traveled to Amsterdam, Bern, Berlin and Oslo, and even to the vastly prestigious Documenta festival in Kassel, near the border with East Germany—"the most important international show in Europe," as Ileana Sonnabend took care to emphasize to Warhol. It cemented Warhol's status with a European audience, and a European art market, that had been growing for several years. "What he's talking about is very serious, very tragic—the very basic problems of existence—mass living in the cities—the vacuum of modern existence," said Hultén, and some version of that became pretty much the standard European view of Warhol, at least among his admirers and collectors.

Mostly deprived of the artist's actual presence, and of tabloid gossip about him and his crowd, the Swedes, Germans, French and Italians could read Warhol through his work and through their own view of the American culture it portrayed. Already by 1971, a critic was referring to Germany as home to Warhol's "apotheosis." Rudolf Zwirner, an early dealer of Warhol's in Cologne, said that after the debacle of German culture represented by World War II, his generation was especially open to the new artistic energies coming out of an America they viewed as a savior: "We were coming

out of the ashes, like a phoenix, thanks to the United States." As Geldzahler explained, "If you're used to home-made soup"—his own condition in upper-class America—"then [Warhol's] hundred soup cans is terribly depressing. If you're used to no soup at all"—the postwar German condition—"then the hundred soup cans is an elevating vision."

Even before Hultén's survey opened, Zwirner had paid Warhol a visit in New York and ordered four of his Marilyn portfolios, while also trying to nab parts of the Stockholm show to sell. As far as Zwirner was concerned, Warhol had changed the entire culture: "High and low didn't exist anymore." He also realized that, against expectations, Warhol's "excess" supply could help his market rather than hurt it: Once a picture fetched a good price there was another rather like it just waiting to go for even more. Warhol came to do some of his best business with and through Zwirner and a network of other dealers in Northern Europe, who were especially good at placing his works in the continent's new museums and with the collectors who donated to them. Europe's commercial dealers were even eager to show and sell his films as actual market commodities, something that was unheard of in the United States. The Stockholm opening had coincided with the closing day of a Warhol solo at the Munich gallery of Heiner Friedrich, a figure who would go on to be one of Warhol's major supporters in New York, and it was fol-lowed by Warhol's first commercial show in London.

However useful the Swedish survey might have been to Warhol, its very success inevitably raised some niggling doubts. When he looked at the por-trait of himself that the show had taken such care to convey, Warhol would have seen an image that was starting to feel pretty dated. One Swedish critic specified that he liked the show *despite* the fact that it offered "nothing new, nothing to be surprised over." Indeed, there was no sign of Warhol's latest work and tastes, let alone of his new, more cleaned-up persona, at odds with the exaggerated bohemia that the photos in Stockholm portrayed. *Lonesome Cowboys* was nowhere to be seen (it still needed editing) and the professional-ized Union Square vibe was equally absent.

If anything, the Stockholm show brought home a certain emptiness in the works on its walls. In their repetition of earlier images and conceits, the Stockholm pieces ran the same risk of exhaustion that all works of art run once they become commodities—literally, in the art market, but also in the marketplace for high culture. There was no way anyone, least of all Warhol, could have felt the same excitement in the presence of these late remakes as people felt when the Marilyns, Electric Chairs and Brillo Boxes first ex-ploded into view as incomprehensible, intolerable statements. The new ver-sions were eminently tolerable and comprehensible, not as bold statements

anymore, but as attractive objects that people wanted to see and own. In the last years of the '60s, lots of Warhol's younger colleagues were feeling that nearly all traditional, object-based art had lost the impact and gravitas it once had. To eyes like theirs, and to eyes like Warhol's, the repetitions and superficialities of his Stockholm works, now supersize and in splashier colors, could easily be read as painting a bold picture of that loss of heft, in a way that a show of his early Marilyns and Brillos might not quite have done. That could make the new survey as a whole seem more important and smart, but it also turned the objects in it into nothing more than illustrations of a poignant, end-of-days situation.

Warhol had taken a stab at introducing at least one truly new note into his retrospective. For its first day or two, he replaced his own movies with the instructional footage that came with the museum's rented projectors, so that visitors got to see endless images of fingers threading film into the very machines that were projecting those fingers—a lone bit of up-to-date, self-referential conceptualism added to a show that otherwise risked being read as pure Pop. (Ileana Sonnabend didn't get it: "This stands out like a sore thumb," she told Warhol, "and disturbs the unity of the show.") Warhol had also taken one small step to update his image. In planning his trip to Sweden, he'd left behind his standard crop of well-known acolytes in favor of Viva, the only superstar of post–*Chelsea Girls* vintage. She made a splash at the opening in what sounds like an almost 1970s look: high beige boots and a flowery 1930s dinner dress that reached all the way to the floor, all topped by a "Brillo hair-do (crinkly and uncombed)" that calls to mind the soft perms soon to be on every woman's head.

"We brought Viva along because we were going to do a dirty movie here in Stockholm," said Warhol, "but the plans didn't work out." Those "plans" had not, however, been for yet another of Warhol's underground stabs at sexploitation but for a fully commercial production, with major Swedish funding, that would have satirized the country's own porn industry. Even as he watched his old Pop career play out in the Moderna Museet, Warhol was taking steps to forge a new one that tried to create new forms of popular culture instead of simply riffing on old ones.

By wrapping up that Pop career with a giant, showy bow, the Stockholm survey signaled that everything in it definitively belonged to the *past*. Now Warhol was free to move forward.

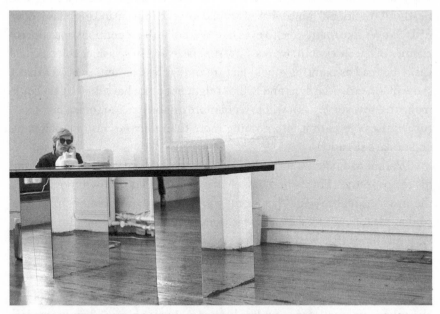

*. . . unwounded and at work in his new studio, and the same scene right after his shooting.*

# 1968

VALERIE SOLANAS | SCUM MANIFESTO | I, A MAN |
THE SHOOTING | THE HOSPITAL | THE ARREST

*"My life didn't flash in front of me or anything.*
*It was too painful"*

It was a classic .32-caliber bullet. Not a gunsel's gut-busting .45, not a sissified .22, but an all-American .32—the canned soup of bullets, you could say, on the market since 1899, a year after Campbell's Condensed hit the stores.

The slug pierced Andy Warhol's right side just under his arm and he began to bleed out, lying there gasping for air from a punctured lung. Then the shooter turned on Fred Hughes. He had dropped to his knees nearby, raising his hands in prayer and pleading, "Valerie, I'm innocent!":

> She puts the gun next to his head and says, "I'm gonna shoot you!" And he says, "Oh, Valerie, don't shoot." She says, "I have to." And the elevator door opened—right?—and she was about to shoot Fred! Like that! You know? No reason why it opened! Nobody was on the elevator. And Fred said, "Oh, there's the elevator. Why don't you get on Valerie?" That was great of him to say that, because he was about to have his head blown off. And she said, "Oh—that's a good idea." And she went on the elevator.

That was how Paul Morrissey remembered the last of two or three traumatic minutes, around 4:30 on June 3, 1968, that split Warhol's life into a "before" and "after" and almost ended it.

———

"Valerie" was Valerie Solanas, a thirty-two-year-old who was one of the lesser figures from Silver Factory days. When Warhol first met her, late in 1965, she

was already a fixture of Greenwich Village street life, literally living on and from the neighborhood's streets as she panhandled and hustled for her daily bread.

> Sometimes people would ask, "Where do you come from?"
> "The river," she replied.
> "Where do you live?"
> "Nowhere."
> "Who are you?"
> "No one."

Solanas was far from being your average homeless person, even on days when she had no roof over her head—or was actually sleeping *on* a roof. (She could often raise enough for a tiny room in the darkest depths of the Chelsea Hotel; she would eat, alone, at the nearby Horn & Hardart automat.) After a troubled childhood on the East Coast—she said she'd been molested by her father—she did very well in college, studying psychology at the University of Maryland, College Park, but quitting grad school in Minnesota after a single year. She ended up afloat in New York but never quite lost her intellectual ambitions. When she wasn't earning rent from begging or sex work she was doing her best to disseminate her radical ideas, which attacked the rampant misogyny she saw and had felt in the world all around her. Her philosophy of gender came together in a twenty-one-page mimeographed booklet called the *SCUM Manifesto*, setting out the principles of the Society for Cutting Up Men. Founder, Valerie Solanas. Sole member, Valerie Solanas.

She previewed its aims in a recruitment poster that came decorated with a proudly erect female middle finger. S.C.U.M was being formed, said the poster:

> —To effect a complete female take-over, to end the production of males. (It's now technically possible to reproduce without the aid of males and to produce only females.)
>
> —To begin to create a swinging, groovy, out-of-sight female world.
>
> —To end this hard, grim, static, boring male world and wipe the ugly, leering male face off the map.

Despite suffering from evident mental illness, Solanas was not out of step with a lot of the other radical thinkers whose ideas were percolating

through and out of the era's counterculture. If Abbie Hoffman could tell readers to steal his book (and make bombs), and the Black Panthers could suggest shooting back at white pigs, it wasn't that out there to argue that the genuine, centuries-long oppression of women could only end with a knife to the throat of the patriarchy—or maybe a slug to its chest. Or such an ending could, at the very least, be suggested in vicious satire. "All her hate was in her writing," said an acquaintance. "In person she was gentle, not aggressive at all."

At a time when Warhol's image, his art and his Factory were all becoming vested in the extremes of underground culture, Solanas's combination of brains, aggression and oddity made her a good fit for his crowd. Mental illness was hardly a disqualifier for the Factory's favor: The brilliant critics Gene Swenson and Jill Johnston had spent time in mental hospitals, as had Edie Sedgwick and plenty of other notable companions of Warhol's. "Nobody suspected anything about Valerie Solanas," said Billy Name. "She was a dyke and a writer. A literary dyke, butch, very typical, so there didn't seem to be anything out of the ordinary about her"—or she was no more out of the ordinary, at least, than a gay speed freak who styled himself the Pope or an obese heiress who liked to shoot up through her jeans and reveal her breasts to any passing camera.

Solanas herself was never particularly close to the heart of Warhol's scene—"she only came around two or three different times, and she was never on a social basis," said Morrissey—but she became one of the many promising eccentrics who might show up. Her first visit came when she gave Warhol her first notable piece of writing, a funny, absurdist play titled *Up Your Ass*, about a streetwise hustler who takes a john or two for a ride. Warhol loved how dirty it was, but it made him figure that Solanas must be involved in some kind of sting operation by the police—he actually called a friend to check out her bona fides. Maybe Warhol's doubts about Solanas led him to lose track of the script in the Factory mess; he couldn't find it when Solanas soon asked for it back. Yet he clearly didn't take his own suspicions too seriously: In the late summer of 1967 he cast Solanas in a film called *I, a Man*, a sexploitative riff on a dull Swedish skin flick called, of course, *I, a Woman*. Warhol's new movie had actually been ordered up by a soft-core porn theater, and Paul Morrissey called it their "first film with a story"—if only a bare one, involving one guy cruising eight women. As one of those women, Solanas pretty much played herself, complete with the butch headgear that had won her the Factory nickname of "Valerie Barge Cap." She did a fine job of dominating the man mashing her: "I've got the upper hand, you must not forget that," she said to her castmate. "Your instincts tell you to choose

chicks, right? My instincts tell me the same thing. Why should my standards be lower than yours?"

Getting the part, and being paid $25 for it, must have given Solanas some sense that Warhol appreciated her talents. (Although he once said he'd cast her just to slip her some much-needed cash.) At a screening of the rushes, said an onlooker, she and Warhol seemed "very relaxed and friendly." The letters Solanas wrote him about the film in August of '67 are fairly respectful and sane: She asked for her name to be spelled right in the press; she complained about faults in the movie's sound but praised its camerawork. (Although a postscript to her critique starts displaying signs of paranoia, imagining that Warhol changed words in her footage.) That same month, she enclosed a pretty measured note with the S.C.U.M. poster she sent to Warhol: "Maybe you'd like to post it in your Factory. . . . Maybe you'd like to join the men's auxiliary."

Fred Hughes called Solanas "a very, very brilliant girl" and said that Warhol would chat with her on the phone, trying to move her on to projects other than "this kind of crazy manifesto business." Even at the very end of '67, Warhol and Solanas had a long conversation—one of many—in which she doesn't sound all that much more disconnected than he does, as they discuss vibrators, women as "the prettiest machinery around" and Warhol's role in the S.C.U.M. auxiliary. "You are *in* the Men's Auxiliary," said Solanas, "but you are by *no* means on the Escape List. You know, you not only have to be good, you have to avoid evil." In the spring of '68, before Solanas had become infamous, one journalist felt her worthy of a mention as one of Warhol's more notable acolytes.

That was about when her eccentricity began its turn to insanity. Solanas became increasingly paranoid: She thought her room was bugged and her mail was being read. She took to making threats at Max's: "I'm going to get all of you men," she said to Lou Reed.

Her paranoia spread to Warhol's loss of the typescript for *Up Your Ass,* a loss she'd actually known about for two years already and which she'd clearly remedied by producing other copies. But she now read the script's disappearance as intellectual piracy, part of a grand conspiracy between Warhol and an avant-garde publisher named Maurice Girodias. She thought the Frenchman had forced her into a contract that just about left him owning her soul. (In fact, he'd given her a first payment of $500 toward a novel of her life that he couldn't have been certain would ever materialize.) Even when Warhol sent her to the Factory lawyer for reassurance, she refused to recognize that the agreement was no more controlling than any other. No one could make her believe that Warhol had less than no interest in

commandeering her writing. She took to calling him at all hours to complain about her situation.

By early '68, Solanas's letters to Warhol were dripping with venom. "Toad," she wrote, "If I had a million dollars I'd have total control of the world within 2 wks; you & your fellow toad, Girodias (2 multi-millionaires) working together control only bums in the gutter." Another said, "Daddy, If I'm good. . . . Will you let me do a scene in one of your shit movies? Oh thank you, thank you." Even after Warhol made the conciliatory, altruistic offer of a ticket home from California, where Solanas was visiting her sister, all he got back was "You can shove your plane fare up your ass," sent in an envelope addressed to him, at home, as "A. Warhol, Asshole."

"We have a lot of funny people hanging around and they all come and go and they don't bother anybody and we don't bother them," said Warhol. "But she was a real nuisance and we didn't pay much attention to her."

Warhol was an unlikely target for abuse from a warrior for women's rights. He might not have been a card-carrying feminist, and probably didn't pay as much attention to the new feminist art as he might have, but he always made more space for women, in his art and his scene, than did the vast majority of male artists of his day, whose florid misogyny was a social disease. A female gallery mate remembered that Warhol was already showing real respect for female artists in the 1950s. By the 1970s he was declaring Native American textiles to be "yet another proof that women are the world's major artists" and later he rattled off Lynda Benglis, Alice Neel and Louise Nevelson as his three favorite female artists—at a time when most of his male peers would not have chosen to name a single one. Strong, distinctive women were front and center in his movies, and in his entourage, as they certainly weren't in the rest of American cinema or society. When Warhol paid Solanas to appear in *I, a Man,* her strength and brains and character must have had as much to do with it as any charitable instincts that might, for once, have gripped Warhol. Ever since college and probably well before, he had identified more closely with women's culture than with the mainstream's machismo; the contempt Warhol had suffered as an effeminate gay man certainly had something in common with the misogyny borne by every woman in postwar America. That's why we have to imagine that Solanas's attack had almost nothing to do with the reality of Warhol, or even with her own politics, and everything to do with the delusions in her head. But fully two years earlier an author had recognized that Warhol's countercultural elevation was also inviting an inevitable and very real fall: "It was only a matter of time," he had written, "before someone would rise to the provocation and shoot, and Andy come tumbling down."

On the morning of Monday, June 3, 1968, New York was a pretty unexciting place. The front page of the *Times* had a standard mix of late-1960s stories: one on a march against poverty; another on integrated colleges; stories on troubles in France, Italy, Israel, Turkey and, of course, Vietnam. The city itself barely rated a mention. Even the weather was unremarkable: The forecast called for a high in the midseventies, with clouds and the occasional shower.

Warhol must have slept in—he usually did, and right then he had jet lag because he'd just returned from shooting a surfer movie (of sorts) in San Diego. Anyway, there wasn't all that much to leap up for that day, or to look forward to that whole week. He had no paintings to screen, the *Sunset* commission for the de Menils had fallen through and the only other movie work left on his plate was some editing for *Lonesome Cowboys* and for his new surf footage. He made his usual morning phone calls, including to Fred Hughes, who told him about the muggers who'd attacked him the previous night on his way home from Max's, taking his favorite watch. New York wasn't what it had been when Warhol first moved there, nineteen years earlier almost to the day.

Warhol got dressed, putting on an outfit suited to his post-Mod, Union Square persona: dark, wide-wale corduroy pants, fitting loosely; a dark sweater with a pale bandana that Warhol tucked tight around his neck; a finely cut chestnut-leather jacket that had taken the place of his black biker's gear. ("Because everybody else wore black leather jackets, he wore a brown leather jacket," recalled Billy Name.) He grabbed his latest freebie flight bag—this time from Irish International Airways—and his trusty Uher tape deck and headed out to lunch with Bert Stern, a photographer most famous for the portraits he did of Marilyn Monroe in her final days but who had also shot Edie Sedgwick. Then, uncharacteristically, Warhol walked from midtown to his new studio, where he had a chat with the janitor before taking the elevator up to the sixth floor and the fate that awaited him there.

That same day Valerie Solanas had gotten up early, in whatever room she was then occupying; she'd been kicked out of the Chelsea Hotel the previous October. ("She wanted to dispose of all men," said the manager. "Her activities didn't really go down well with the tenants.") She took unusual care of her appearance, putting on eye makeup, lipstick and a dress, all almost unheard-of, for her. One of Solanas's first stops was at the home of her friend May Wilson, a sixty-three-year-old bohemian artist from Ray Johnson's crowd who lived in a studio apartment next door to the Chelsea.

For a little while, Wilson had been letting Solanas store a bag of "laundry" under the sofa bed, making jokes to friends about the outline of a gun you could make out inside it—one of two weapons, a .32-caliber Beretta automatic and also a .22 Colt revolver, that were on Solanas when she was arrested that evening. Sitting on the coffee table was an art magazine in which Wilson's son had recently published a major article—on a certain Andy Warhol.

From there Solanas traveled all the way across the city to Brooklyn, to visit with another bohemian named Margo Feiden, who was in her early twenties and known as the youngest producer to have had a show on Broadway, and one of the rare women to do so. Solanas—apparently with business of all kinds on her mind that day—was cold-calling Feiden with the latest version of *Up Your Ass*, to get her to give it a production. Feiden had been out on an errand, and when she got back she found Solanas on the stoop of her apartment building, smelling "loud" and dressed weirdly in a winter coat and gloves that completely masked her gender. (People suffering from psychosis often wear more clothing than seems called for.) None of this seems to have raised doubts in Feiden, who asked the strange stranger into her apartment.

The two women spoke for hours and Feiden found Solanas "fascinating"—irrational, yes, but also deeply intelligent, answering questions about S.C.U.M. "the way you might have prepared for your orals for a PhD." Feiden finally confessed that she would not stage the play. "Oh, yes you will," replied Solanas. "I'm going now to shoot Andy Warhol and that will make me famous, and that will make the play famous, and you will produce it." And she brandished a gun to prove her intentions. "You don't want to do that; don't go kill him," Feiden said, without effect. Once Solanas had left, Feiden tried to prevent the crime, she claims, making calls to Warhol's police precinct and to her own, to police headquarters and to the mayor's office as well as to her cousin who hung out with Warhol at Max's. (Solanas hung out there too, and she must have got Feiden's particulars through the cousin, since Feiden was not in the phone book.) All Feiden found at the other end of the line were either incredulous cops or message takers.

Solanas headed back to Manhattan, and once she got there it could be that she made one more stop before heading off to find Warhol. Another addendum to the tale of that day has her showing up at some point on Gramercy Place, where the publisher Girodias lived and worked, with the intention of assassinating the man she saw as Warhol's coconspirator. Girodias was on a trip to Montreal at the time, and the story has it that Solanas was told as much by an assistant, which forced her to give up on him as her first victim.

The fog around the Girodias episode also seems to have settled around everything that happened for the rest of that day. It is an established fact that in the late afternoon Andy Warhol's body ended up pierced by Valerie Solanas's .32-caliber bullet. But every incident in the immediate lead-up to that fact of the bullet's flight soon entered a *Rashomon* universe, with each witness giving a different account of events.

It looks as though Solanas arrived at the Union Square studio some-time before lunch—Hughes said he saw her on the sidewalk outside when he went out for a bite. She then took the elevator up to the sixth floor in search of Warhol. Morrissey told her his boss wasn't there and lied that he wouldn't be in for the rest of the day. Not taking him at his word, Solanas left and returned several times. Just as she was getting ready to go up one more time, Warhol himself showed up beside her on the pavement in front of the Union Building, where they were joined by Jed Johnson, the studio's latest Boy Friday who was back from running an errand at a local hardware store.

According to Fred Hughes, the three of them were "chatting nicely" as they emerged from the elevator, which opened directly into Warhol's new studio. Billy Name was at the very back, doing his usual darkroom work in a space behind the screening room. Morrissey was up front, by the elevator, tending to office duties at one of the big new desks, and Fred Hughes was sitting typing a letter at the other one nearby. Still many months away from a full embrace of his famous Savile Row look, Hughes was sporting long hair, sideburns and a bright green Mod shirt. The curator and critic Mario Amaya, Brooklyn bred but with a newly acquired British accent, was fidgeting nearby in a tidy suit and tie. Recently arrived from London, he had been waiting for some time for Warhol to show up for a meeting about a possible U.K. exhibition of his Soup Cans. That spring, Warhol's clipping service had sent him Amaya's pan of his first solo show in London, where he called Warhol's art "tired and overworked," so you have to wonder how the conversation might have gone.

Solanas's presence didn't seem to make much of an impression on anyone; in those early days on Union Square, drop-ins seem to have been almost as common as they'd been on Forty-Seventh Street. Warhol compli-mented Solanas on her dolled-up look. He introduced her to Amaya, who found her "creepy and quiet and moody and peculiar," and therefore, he said, very like many of the other Silver Factory types he had met. Hughes asked her a snide question about whether she was still writing dirty books. Morrissey admitted to having lied about Warhol's plans for the day, and then, trying to get rid of Solanas, teased and badgered her as she did the same in

return. Everybody laughed at the repartee, said Hughes, and then Morrissey turned to the phone that was ringing on his new desk. It was Viva, looking for Warhol, so Morrissey handed over the phone and walked through the double doors of the screening room and then to the bathroom at the very back of the studio. Jed Johnson had gone in the same direction to deal with some fluorescent lights he'd just bought.

Warhol sat down in the new, Eames-y office chair vacated by Morrissey and took Viva's call. Amaya, resigned to still further waiting, turned to look for a cigarette, only to have his attention grabbed by several loud bangs. At first he thought they were coming from outside care of "some nutty New York sniper," while Fred Hughes figured they might be explosions in the building's Communist Party offices. (Earlier that year, right-wing extremists had been caught planting bombs at a Marxist bookstore on the block; in July it got blown up.) Amaya yelled "Hit the floor" and he and Hughes fell to the ground, only to hear a shout from Warhol: "Oh, Valerie, no, no!" Amaya looked up to see Solanas standing by the artist with her Beretta, "like one of those guns you see in *Dick Tracy*. She was going at him full blazes." Her first shot or two had missed Warhol—one might have hit the ceiling—as the artist dove for cover behind a desk. He knocked the table's heavy base all askew and almost dislodged his old Bolex camera, smacking his head in the process. Solanas came close and took another shot at point-blank range, just inches from Warhol's leather jacket as he cowered on the floor, and that one of course connected, plowing through him and into the hardwood floor. "Guns are so quick," Warhol said, recalling that moment a few months later. "A person comes in with a gun, and there's not time to think." Solanas squeezed off another few rounds at Amaya where he lay on the ground—so much for any reasoned motive behind her gunfire—with one bullet piercing the loose flesh on his back while another dug into a distant baseboard. Wounded, but only barely, the curator managed to flee through the door to the rear screening room, breaking its lock as he passed and then holding the door closed against Solanas by brute force. She also tried the door on the little side office where Jed Johnson had taken cover, but he held it shut as he saw the knob turning.

Solanas was getting ready to add Hughes as a third victim, he said, when the elevator behind her made a noise, reminding her of its existence. She turned to press the call button—the elevator didn't appear mysteriously, as in Morrissey's later, hearsay account—then returned to the task of killing Hughes. According to some stories he only survived because her automatic jammed when Solanas pulled the trigger. The elevator arrived to carry her off before she could try her luck with her revolver.

She left disaster behind her. Warhol lay on the ground, screaming in pain as he bled to death and trying to draw air into his ruptured lung. "I can't! I can't!" he said, gasping so hard he couldn't make clear what it was he couldn't do. Fred Hughes, unharmed, channeled his inner Boy Scout and decided to give Warhol mouth-to-mouth—not exactly the recommended treatment for someone who is conscious and still breathing. It's guaranteed agony if that person has a chest wound. "My life didn't flash in front of me or anything," Warhol recalled, as always rejecting cliché. "It was too painful."

At the far back end of the studio, Morrissey hadn't heard the shots but the presence of a bleeding Amaya by the screening-room door had let him know something was very wrong. The two men emerged into the bright front room to see the full mayhem Solanas had wrought.

Billy Name, for his part, said he did hear some kind of bang but at first didn't want to open the darkroom door and ruin the work he was doing. When he eventually emerged, "Andy was lying there in a pool of blood. I went to him and took him up in my arms and I started crying." Mistaking Name's sobs for guffaws, Warhol said to him "Oh Billy, don't make me laugh, it hurts too much." Paper towels were applied to soak up some blood. Hughes called the cops and an ambulance.

At just that moment, by the strangest of coincidences, it was Gerard Malanga's turn to step out of the elevator, wet from a recent cloudburst. A few days before, in a conciliatory mood, Warhol had agreed to pay $50 toward a mailer advertising a first survey of Malanga's films and the poet had stopped by to collect the funds. He'd brought along a posse of downtown friends, including Al Hansen, Bibbe Hansen's father and an audacious artist who Warhol had long admired. Hansen has recorded the scene that he found:

> The doors opened on madness: Mario Amaya jumping around, blood all over his shirt back, someone's legs sticking out behind the far desk, to the right an arm. Fred Hughes and Jed kneeling, holding the someone's hand, tears in his eyes. Mario presenting his bloody back and earnestly asking over his shoulder, "Did it go in me? Did it go in me?" . . .
>
> "Who's the other one"—I nod toward the desk. Dig it, that's how far beyond my comprehension it was. Paul Morrissey said, "It's Andy"—Andy!—"Valerie Solanis, that ugly dyke, came in with a gun and shot him!"
>
> Holy shit! I jump across to the desk. Fred Hughes: "He's dying and

there's no ambulance. Where are the doctors, the cops?" Andy is lay-
ing there the way bad gunshots do, like a sick dog or cat—his eyelids
flutter. "How long since you called?" There's not much blood. No
sirens. Billy Linich, crying, stands looking down at him. Jed wipes
his forehead tenderly. Andy Warhol with bullet holes in him, laying
in his blood on the floor of his studio.

Hansen decided to go hunting for a doctor, asking in the building and
then out on the street, heading for a pay phone to call for help but finding
it already taken by a guy spreading news of the shooting. When he finally
found an unoccupied booth on the corner, he had no change. When he
borrowed a dime and dialed the police department, the phone rang eight
times with no answer. (New York's 911 service, the first in the nation, was
introduced four weeks later to the day.) Just then a crowd of cop cars poured
into Union Square, one of them crashing into a cab. Hansen gave the police
a run-down of what had transpired and a description of Solanas, then he
headed back upstairs. "Andy looks as if he's sinking. Jed is still kneeling next
to him holding his hand. He could go any minute and there's nothing like a
hand to hold at a time like that."

When the ambulance finally arrived, some twenty minutes after the
shooting, its crew couldn't do a whole lot. Back then they had little medical
training. They ended up folding the grievously wounded artist into a trans-
port wheelchair and, for reasons unknown, carrying him down six flights of
twisting stairs. Still in his bullet-holed leather jacket, Warhol lost conscious-
ness and was loaded into the ambulance. Amaya climbed in beside him and
they drove off to Columbus Hospital, barely a half-dozen blocks away. The
driver wanted $15 to turn on the siren. Amaya told him Leo Castelli would
pay. (A chief resident at Columbus in '68 later called Amaya's whole siren
story "anecdotal nonsense.")

Realizing that a vast crowd of gawkers and reporters was already be-
ginning to gather, Malanga decided that he needed to get to Julia Warhola
before news of the shooting reached her through crueler channels. Poverty
almost foiled his own good deed: Paul Morrissey handed him cash to
take a cab but Malanga took the subway instead. "I kept the money," he re-
membered. Just as Warhola opened the door to the Lexington town house,
Malanga could hear the phone ringing; he barely managed to get to the
call before her. It was a friend of hers, calling to say that news of Warhol's
shooting had been on the radio. Malanga white-lied to Warhola that her son
had hurt himself in the studio, and after bearing with the old lady's endless

preparations for a trip out into the city, he finally hustled her into a cab for the ride to the hospital.

Viva was the second Old Warholian to arrive at the site of the shooting. When she'd placed her call to the still-unhurt Warhol she was at a fancy beauty parlor in midtown, near the Museum of Modern Art. Her hair was being dyed for a role in *Midnight Cowboy*, a new faux-underground movie that had a scene set in the studio of a Warhol doppelgänger, and she wanted to perseverate with the real Warhol about her part in the film. "I was on the phone with Andy," she explained to a reporter a few hours later. "I heard the shots, four or five of them. But it sounded like a whip, so I thought they were just fooling around." It took her a while, and another call or two to the studio, to decide the whole thing was for real, and then she made a dash for Union Square. She emerged from the subway to the same chaotic street scene that Malanga had bathed in. Bystanders yelled, "Look—it's his wife" as she made her way through them and up to the studio. By then the ambulance had left, the police were starting to take apart the crime scene and she decided to follow Warhol to the hospital. Fred Hughes and Jed Johnson couldn't join her, since the cops shipped them down to the local precinct house as "material witnesses"—meaning, said Hughes, "that Jed and I had done it." The police gave those two the third degree and refused to give them news of Warhol all evening. Officers also detained Paul Morrissey and Billy Name, but only for an hour, since they hadn't actually seen the shots being fired. At some point Viva made her own appearance at the precinct, to reveal what she'd heard on the phone with Warhol.

Upstairs at the hospital, the surgeons were doing their mad work on Warhol, slicing and stitching and saving his life. Downstairs, the lobby became precisely the scene a bad scriptwriter would have imagined.

Old lady Warhola starred as a babushka, *in* a babushka, weeping and wailing and praying for her "good, religious boy." The doctors eventually had her sedated.

Warhol's friends and followers brought the old Silver Factory back to life in the hospital waiting room, to the delight of the assembled press. Malanga was dressed in the latest, last gasp of hippiedom, with an embroidered shirt worn open to reveal his manly chest, which was covered in assorted necklaces. His face was framed between bushy sideburns worthy of the Las Vegas Elvis and he'd wrapped a long silk scarf around his throat, like some kind of Left Bank poet. Viva was in buckskin, with Tonto fringes hanging down everywhere; her eyes had a fringe of false eyelashes. Other Warholians, major and minor, hung around in braless chiffon or leather jackets, accessorized

with dark glasses and, in one case, a bathtub chain and plug worn as jewelry. For all their finery, those who were truly close to Warhol looked exhausted and traumatized.

Brigid Berlin, Taylor Mead, Leo Castelli and Ivan Karp were also there, with Karp keeping the reporters fed on "beautiful, fluent art-shop talk about Andy's art." Ingrid Superstar made an appearance as well, carrying photos of herself and the wounded man and also of herself baring her famously perfect breasts. Rod La Rod wept in the lobby for his ex-lover.

"How many tears, how many crocodiles?" asked a writer who witnessed the scene.

Ultra Violet, never one to waste a photo op, arrived rather later than the others, after making herself presentable in a Chanel suit, white fishnets and a towering Upper East Side hairdo, complete with ringlets at her temples. "She showed up at the hospital looking like she was going to be photographed in *Vogue*," Viva recalled in a catty note she sent to Warhol a few weeks later. "Must have taken her at least 3 hours to get dressed & made up." Hordes of bored reporters, waiting for news of the wounded man, had to make do with sound bites from Ultra: "Andy was dealing with this kind of underground emotion. It can be dangerous. . . . She may have been in love with Andy. Who can tell?"

John Wilcock, a *Village Voice* founder who had once traveled with Warhol and the Velvet Underground, gave a quote that turned out prophetic: "Andy is the kind of guy who if he doesn't die immediately—won't." After a publicist described the hospital as having "the second best intensive care unit in the city," the medical director came down with news from the O.R.: Warhol now had a fifty-fifty chance of surviving, an estimate which of course turned out to be wrong by 50 percent.

———

The one person who took steps to dress down on that traumatic evening was Valerie Solanas. She had wiped off all her makeup except for a bit of mascara and had traded her dress for beige slacks and torn sneakers, worn with a blue turtleneck under a bright yellow sweater—a look described by a female reporter as distinctly "mannish," but by a more sympathetic observer as "mild butch." That's what she was wearing a bit before eight o'clock when she turned herself in to a rookie patrolman in Times Square. "The police are looking for me," she told him. "I am a flower child. He had too much control over my life." Her capture made the evening news and got into the late edition of a tabloid that Julia Warhola was clutching in the hospital.

A mad media scrum met Solanas at the police station where she was brought for booking. "I have a lot of very involved reasons," she told the crush of journalists. "Read my manifesto and it will tell you what I am."

She gave a longer interview to a local radio station:

Q: Valerie, why did this happen?
A: Because he's a piece of garbage.
Q: You know he may die?
A: Good.
Q: Do you mean that?
A: Yeah, I do.
Q: Why do you hate him so much?
A: Because he's him.
Q: What do you think is going to happen to you now?
A: I have no idea. I don't care. I'm looking forward to going to jail, because there's nothing out here but fucking garbage.

At her arraignment, with Mario Amaya in silent attendance, she offered a few more words. "I was right in what I did! I have nothing to regret. I feel sorry for nothing. He was going to do something to me which would have ruined me," she said. "Warhol had me tied up, lock, stock and barrel."

Solanas was charged with the attempted murders of both Warhol and Amaya and with possession of a firearm. "You must realize that this is a serious charge," said the judge. "That's why it's going to remain in my competent hands," she replied. Disagreeing, the judge forced her to accept public counsel, from a lawyer who described her as utterly unforthcoming— "very tense, like a rubber band stretched out as far as it could go." The private lawyers that Girodias then hired for Solanas found her equally impossible to work with and full of paranoid delusions. The judge decided he'd better have her competence checked in the infamous psych ward at Bellevue hospital.

That mad day began to wind down as Solanas was led away to her fate and Warhol was transferred from surgery to intensive care, with tubes snaking in and out of his body. That very evening, Amaya was already well enough healed to dine out on his flesh wound, displaying it to an art-world crowd that included the art critic and doctor Brian O'Doherty. Playing doubting Thomas, as O'Doherty put it, he got to inspect the "nasty-looking purple little hole."

Viva and Malanga trundled Julia Warhola into a cab and off to her home, where she slept with the help of the hospital's pills. That night the

two Warholites, fearing for the life of their leader, found comfort in each other's arms.

"That Warhol was the first artist to be 'assassinated' is a dubious distinction," wrote the critic John Perreault some two years later. "Nevertheless, it does say something about his importance and his charisma, his penetration into dangerously archetypal zones."

Another critic, Warhol's old friend David Bourdon, had fewer doubts about the distinction: He thought that the shooting might just be Warhol's greatest work.

*. . . documenting his scars in his room at Columbus Hospital.*

# 1968

*"You know, we gotta get some bigger things
to hide behind at the Factory"*

Warhol spent eight weeks in the hospital, almost to the day. After the first night's surgery his recovery had gone pretty well, all things considered. For a little while he'd needed a breathing tube, which left him with a scar where his throat had been opened to put it in. And there had been plentiful anti-biotics, which had one benefit beyond killing the bacteria spilled from his blasted gut: He said that for the first time since high school his acne cleared up completely—a quite substantial blessing, at least in the terms of his peculiar psyche. At first he was on serious sedatives, which he said he'd hated, and after those wore off he was able to piece together what had happened to him on that fateful afternoon in June. He even took strange, classically Warholian comfort from it. Death itself, he realized, must always be painless: "If you don't wake up it does not hurt. It's only when you wake up it hurts."

The sedatives and near-fatal injuries had caused moments of confusion. "For days afterward, I kept thinking, 'I'm really dead. This is what it is like to be dead,'" Warhol recalled the following year. "You think you're alive, doing all the usual things like getting on a bus, or taking a subway, but in fact you're really dead. It was days before I realized I was actually still alive." While still in intensive care, Warhol heard reports of another shooting and another death that helped increase his perplexity: In the early hours of June 5, news had come in from Los Angeles that Senator Robert Kennedy, JFK's brother and a leading presidential candidate, had been shot. Hit several times—with one bullet entering almost exactly where Warhol's had—Bobby Kennedy

teetered on the edge of death for a full day, finally succumbing to his injuries despite surgeons who worked at least as hard as Warhol's had. His remains were immediately shipped to New York for a service at St. Patrick's Roman Catholic cathedral, which happens to be the very church were Warhol's own memorial was held two decades later. Not surprisingly, a befuddled Warhol confused Bobby Kennedy's shooting with his brother the president's, and even with the artist's own: "I couldn't distinguish between life and death yet, anyway, and here was a person being buried on the television right in front of me" was Warhol's recollection a dozen years later.

Warhol would have been dismayed by the assassination. In late '64, he had actually signed his name to an ad that ran in the *Times* in support of Kennedy's Senate run. But he would also have been unsettled, at least once his mind was less addled, by the spotlight that Kennedy's shooting stole from his own newsworthy close call. Maybe in part because of the late-afternoon timing of Solanas's "visit" on June 3, the front page of the next day's *Times* had granted Warhol only two "below-the-fold" columns; that same "paper of record" gave Kennedy a full six-column banner on the afternoon of June 5. For some time, Warhol's friend David Bourdon had been working on a big feature on the artist for *Life;* Solanas's attack had put it in play as the magazine's next cover story. "That's his dream," Morrissey said, when Bourdon called him at the hospital to give him the news. Warhol had to give up on that dream when Bobby Kennedy's assassination bumped Bourdon's feature right off the schedule again. In the end it never ran. Anyway, the artist Bourdon had reported on before the shooting was not the one who came out the other side.

A week after being admitted to hospital Warhol was declared "still critical, but showing improvement," and it seems he spent fully eighteen days in a room in intensive care that he shared with an overdosed drug addict. A coterie of powerful friends soon tried to get Warhol moved to a fancier hospital (the same hospital where he later died prematurely) but Columbus managed to prove the excellent care it could give. Things looked grim at first—visiting relatives were horrified at Warhol's grotesquely swollen face and head—but the doctors were soon able to take him off all machines and were growing optimistic about his recovery and a move out of the I.C.U. For some time, however, Warhol's family were still just about the only people allowed in: Brothers and nephews descended from Pittsburgh to look after Warhol in the hospital. They also looked after his mother at home, where she was less and less able to take care of herself.

Viva and Malanga had to make do with hanging out in their finest finery in the hallway outside Warhol's room and writing long notes to be handed into him by a certain Sister Theresa. (Columbus was a distinctly Catholic

hospital, which must have pleased visiting Warholas; once Warhol had got his own room, there was a crucifix over the bed.)

"WHAT THE FUCK—WE WANT TO SEE YOU—WE DON'T CARE HOW BAD YOU LOOK," read one of the notes handed in from Warhol's pair of acolytes. (They lived together for a few months that summer.) One day early on they took matters into their own hands, sneaking in through a back door for the quickest of visits to a mentor who was still hooked up to tubes and wires. "Hope we didn't overexcite you," Viva wrote soon afterward. "We were *so happy* to see you." (Four years later, she tried to get him to refund the cash she'd spent sending him flowers, or at least so Warhol claimed in his diary.)

In addition to her notes Viva also sent in her own Kodak Instamatic. Once he'd got his own room Warhol made good use of it. He had someone take pictures of him indulging in his daily pleasures: Warhol in a hospital gown, a white kerchief on his head where his wig should have been, lying on a weirdly ornate wooden bed and talking on the latest in Princess phones; or, Warhol sitting up in a chair under the room's ornate wooden lamp, using his little Uher reel-to-reel to play back conversations he'd already had. His other amusement was watching TV: He'd spent an absurd $60 to rent one for just his first month.

Warhol's caregivers had apparently expected him to be some kind of strange monster from the underground, and they were surprised when he turned out to be a quite regular, respectful patient: "They keep saying, 'You're not at all like we expected.' They probably think it's a put-on," Warhol said from his hospital bed. Even Malanga was impressed by the sick man's thoughtfulness when, on one of the poet's first visits, Warhol reached into his sidetable for the $50 check that he'd planned to hand over on the day of the shooting—"I thought, 'How sweet that he remembered.'"

---

Gifts of food and candy began filling Warhol's room, but having learned the hard lesson that some random nutter could want him dead he had his big brothers taste everything before he did. What younger sibling doesn't somehow imagine that the family's older ones might be invulnerable? Or maybe expendable, in Warhol's case.

The room also saw the arrival of untold telegrams, get-well cards and letters, from old friends, relatives, patrons, acolytes, peers and utter strangers. Best wishes were expressed by everyone from the photographer Dick Avedon to the Shakespeare scholar Paul Bertram. Brigid Berlin mailed Warhol long letters proclaiming how dull things were without him around. (War-

hol wouldn't let her actually *visit* for fear she'd steal from the nurses' drug cabinet.) Edie Sedgwick sent him an especially poignant note, written in a twelve-year-old's cursive on a Beatrix Potter card: "You are one of the few people who really matter to me, and I can't bear the thought of anything bad happening to you." The return address on the card was the New York State Psychiatric Institute. Her friend Ed Hood did a TV interview where he heaped praise on the wounded artist, denying that Warhol could have been in any way the cause of his own downfall: "He's probably one of the most gentle men I've ever met," said Hood. "I think of him as one of the major artists of the twentieth century and hope that by the twenty-first he'll be recognized as such." His hopes were fulfilled.

Even Warhol's ex-lover Richard Rheem sent a message full of love and prayers, although he addressed it to Julia Warhola not Warhol. Philip Fagan, his earlier boyfriend, took time off from his Eastern self-discovery to send a letter from an ashram in Kuala Lumpur.

Warhol's recovery wasn't easy. There was some kind of setback in mid-July that involved a bad fever: "Dear Andy," wrote Fred Hughes, "I have been so worried. I talked to Paul at the hospital and was so sorry to hear how terribly hard it has been for you. . . . We love you more than anything." In another note he mentioned Warhol's trouble eating and gaining back weight, and also some depression. But the patient slowly began to revive. When his sixteen-year-old nephew George came in wearing the bullet-holed leather jacket he'd rescued from his grandmother's trash, Warhol was strong enough to object: "Andy says 'Hey! I want that, you can't have it!' I said, 'Gee, Bubba was throwing it out.'" (Warhol eventually passed the jacket on to Brigid Berlin, who years later ended up throwing it out.)

Whatever the state of his health, the irrepressible Warhol treated his hospital room as mission control for his studio's doings. "You know, we gotta get some bigger things to hide behind at the Factory," he told Fred Hughes already in mid-June. Warhol himself knew just the thing: A head-high crumple of galvanized steel he had recently got from the sculptor John Chamberlain. Chamberlain had called his sculpture *Papagayo,* meaning "parrot," but he must have meant that tropical name as a joke. The piece was a dour, gray-on-gray hulk that stood by the new studio's front door and set a mood of High Modern sobriety.

A few weeks later, indulging in yet another gesture that was likely to have more symbolic than real-world effect, Warhol ordered gates and locks for the studio windows six stories up. "This is going to cost a bit (gates $60 a piece)," wrote Fred Hughes in a memo to his bedridden boss. In another, Hughes wrote "This business is strictly a failure without you." That must

have scared and pleased Warhol in equal measure. Hughes detailed Paul Morrissey's horror at the $24 they spent each month for their answering service and also mentioned the steps they were taking to run future film rentals out of the new studio. (One strange thing about the Hughes letters: They show constant errors in spelling and grammar that seem at odds with his elite persona.)

Billy Name sent Warhol news of their novel *a,* that tape-recorded day in the life of Ondine that was at last coming together in proofs; he wrote of the arrival of the studio's new typewriter, percolator and refrigerator, adding, "Send me a check if you can just for eating."

Malanga supplied Warhol with the nitty-gritty details of his own financial troubles but also filled him in on gossip: "The 'superstars' are making such a scene amongst themselves to see who is going to come out YOUR favorite; it's almost like hairpulling and eye-scratching"—music to Warhol's gossip-starved ears.

Maybe the hottest news that Warhol got from Malanga was about goings on up in Harlem on the movie set for John Schlesinger's *Midnight Cowboy.* That Hollywood project told the story of two of Times Square's gay grifters and was a clear knock-off and dilution of Warhol's own interest in New York's underbelly. Costing $3 million—maybe three hundred times the Factory's most expensive film—it faked the grit that in Warhol's movies was (almost) for real. Schlesinger replaced Warhol's rejection of plot with old-fashioned storytelling, which of course was what let *Cowboy* win its Best Picture Oscar. "Hollywood has gone underground," wrote Brigid Berlin to Warhol at the time—but in fact it was mostly skimming the surface.

The screenwriters even created a part for an underground filmmaker, at first intended for Warhol himself and then passed on by him to Viva—it was the role that had prompted her visit to the hairdresser on the afternoon Warhol was shot. Her main scene in the movie involved hosting a wild "Factory" party for which Warholians of all kinds were rounded up as extras, paid an extravagant fee of $100 a day—plus lunch—as their leader lay healing in the hospital. The casting list for the scene lists fifty-seven roles, including "6 male hippies, 9 female hippies, 2 hustlers, 1 poetic fag, 1 bum, 2 drag queens," as well as "dike ladies," a "Buddah type pot roller," and a "Polynesian prince." The film set was hung with original Warhols rented from the Museum of Modern Art.

"We've been going to the Schlesinger set every morning at 8:00 AM," wrote Malanga to Warhol. (The poet was listed among the casting list's "hippies.") "This entire venture seems so much to me like going to school, seeing old classmates: Velvet, Viva, Ultra, Paul, the Johnson twins"—meaning Jed, the assistant who'd been in the studio when Warhol was shot, and his

brother Jay. "Lunch boxes are distributed to us at 2:00 PM every day; we sit on folding chairs."

All for a scene that lasts less than ten minutes in the final cut. The footage is so chaotic that its actors can barely be made out, and bohemian clichés far outweigh authentic details.

Smaller bits of news, both cheering and grim, also came drifting Warhol's way.

Before he'd even been released from the hospital, the Garrick Theater in Greenwich Village, which had been home to screenings of many of Warhol's films, was renamed in his honor. (It wasn't that much of an honor, according to one young moviegoer: "The Garrick was such an unbelievable dump—it was really gross.") Max's Kansas City also paid homage, suspending all dancing in solemn commemoration of the shooting, even though some customers found such gloom quite anti-Warholian. And the judges at an international competition in Warsaw had awarded Warhol first prize for a clever poster he'd done for Lincoln Center that was a Pop-ified enlargement of one of the center's own movie tickets. (What Warhol didn't know was that the award from communist Poland had made him suspect at the State Department, as he already was at the Department of Justice for *Lonesome Cowboys*.) Maybe most flattering of all was the opinion piece, written by his art-critic friend Gregory Battcock, declaring that "Warhol was shot because he brutally and brilliantly exposed the underlying hypocrisies of the modern culture. . . . The artist has lined himself up, both socially and artistically, with those elements most determined to crush the prevailing establishment."

On the grim side of the ledger was a new issue of *Time* magazine mostly devoted to mourning Bobby Kennedy and finding room for Warhol only in a harrumphing little editorial that blamed the artist, as much a victim as the dead politician, for the social breakdown editors saw all around them: "Americans who deplore crime and disorder might consider the case of Andy Warhol, who for years celebrated every form of licentiousness . . . photographing depravity and calling it truth." To add insult to Warhol's very real injury, the headline on the cover of the very next week's issue of *Time* was "The Gun in America," a story that was clearly inspired in part by Warhol's shooting but didn't mention him once. Worse, its cover image was a revolver rendered by his longtime rival Roy Lichtenstein.

If Warhol found it strange to be billed as the villain of his own story, it must have been even stranger to discover that some people considered Solanas its hero. The day after the shooting, a few of the city's more radical feminists were already handing out a flyer that included an all-capped paean to her attack on Warhol:

VALERIE LIVES

ANDY WARHOL SHOT By VALERIE SOLONAS. PLASTiC MAN VS. THE SWEET ASSASSIN—THE FACE OF PLASTIC/ FASCIST SMASHED—THE TERRORIST KNOWS WHERE TO STRIKE—AT THE HEART—A RED PLASTIC INEVITABLE EXPLODED—NON-MAN SHOT BY THE REALITY OF HIS DREAM (AS THE CULTURAL ASSASSIN EMERGES—A TOUGH CHICK WITH A BOP CAP AND A 38—THE TRUE VENGENCE of DADA—TOUGH LITTLE CHICK—THE "HATER" OF <u>MEN</u> AND THE LOVER OF <u>MAN</u>—WITH THE SURGEON'S GUN—NOW— AGAINST THE WALL OF PLASTIC EXTINCTION—AN EPOXY NIGHTMARE WITH A DEAD SUPER-STAR—THE STATUE OF LIBERTY RAPED BY A CHICK WITH BALLS—THE CAMP MAS- TER SLAIN BY THE SLAVE—AND AMERICA'S WHITE PLAS- TIC CATHEDRAL IS READY TO BURN. <u>VALERIE IS OURS AND THE SWEET ASSASSIN LIVES</u>.

S.C.U.M. IN EXILE

Warhol, a swish gay undergrounder, might not seem the most obvious symbol of the misogynist establishment, but the truth is that the feminist celebration of Solanas had almost nothing to do with him, little to do with who his attacker really was or what she actually thought, and everything to do with her as a pure, freestanding symbol of sexist oppression, and of the extreme steps that seemed the only way to reverse it. "Valerie's is a voice in the wilderness shouting her rebellion, saying she will accept no arguments to the contrary, allow no loopholes or fancy devices that could be used to counter her argument. She is everywoman in some basic sense," wrote one of the more radicalized members of the women's movement.

The reality, and sheer unfairness, of what Solanas had actually *done* did sink in with many of the more moderate and politically astute feminists. Betty Friedan, the pioneering president of the National Organization for Women, wrote a panicked telegram to a board member who was a major Solanas supporter (and who, weirdly, was studying with the philosopher Arthur Danto, one of Warhol's most eloquent advocates): "DESIST IMMEDIATELY FROM LINKING NOW IN ANY WAY WITH VALERIE SOLANAS. MISS SOLANAS MOTIVES IN WARHOL CASE ENTIRELY IRRELEVANT TO NOW'S GOALS OF FULL EQUALITY FOR WOMEN IN TRULY EQUAL PARTNERSHIP WITH MEN."

Ironically, while Solanas's *SCUM Manifesto* was being held up as "the most important feminist statement written to date in the English lan-

guage," controversy around Solanas herself ended up causing a major rift among feminists.

———

> Paul informs me that he's about to make his first independent film to be produced by Warhol Films, Inc. How nice. I think I remember having that same idea when I was in Rome, and after all who discovered Paul in the first place and created that monster? ME. I have a few ideas of my own for feature length inexpensively paid films, but I suppose when you are well you won't want to hear me out.

Gerard Malanga wrote those aggrieved lines in a long letter that he mailed to Warhol in the hospital, just two weeks after Solanas had landed him there. Aside from bearing witness to the infighting that had infected Warhol's scene for years and would never quite disappear, it also gives a first hint of a major new dynamic that would rule Warhol's career for the following half decade. "Paul" was Paul Morrissey, and during Warhol's illness he made the first of a series of films that bore his boss's name, as "producer," but had little creative input from him.

"When Andy was shot, then we stopped doing these experiments," Morrissey once explained. "'Cause they were Andy's experiments, and I felt I had learned a lot from them and sort of utilized this notion of allowing the actors enormous amount of free rein as far as dialogue goes—and just utilized that, but within a story that I told the actors to follow." Morrissey's films were precisely the hybrid creatures he described: He took the improvised dialogue of Warhol's films, and their eccentric and unskilled amateur acting, and grafted those Warholisms onto a more traditional approach to plot, editing and camera work that meshed with the tastes of the general public—tastes that came closer to Morrissey's own, since he'd never really been a happy avant-gardist. "Stan Footage" was the name he liked to use for the eminent experimentalist Stan Brakhage.

From the viewpoint of Warhol's other acolytes, Morrissey's move was a putsch, and they were probably right to see it that way. When Morrissey jettisoned the old Factory "experiments," it was in part just because they were "Andy's." Warhol's illness gave the studio's second fiddle a chance to conduct. "We have to keep the cameras running," he said—but that "we" was a "me."

Morrissey recalled that over the course of "six or seven weekends," as Warhol recovered from his wounds, he set out to shoot a movie about a gorgeous young hustler named Joe who is trying to raise money so his wife's girlfriend can have an abortion. This was *Flesh*, which Morrissey made at the

request of the same porn theater that had done well with *My Hustler*. "The idea for it came because John Schlesinger filmed *Midnight Cowboy* that summer when Andy was shot in New York, and they were spending $3 million of United Artists' money to make a story of a hustler and it didn't seem that realistic," recalled Morrissey, who decided that he could make a better version at one-hundredth the cost.

Opening with a shot of its hardworking hero asleep—in a nod to Warhol's own *Sleep*, or maybe a dig at it—*Flesh* went on to give a blow-by-blow record of Joe's day as he encountered, serviced (often), and talked to (mostly) an aging photographer, a topless dancer, a pair of transvestites and an ex-marine.

"We want our films to have stories the public will identify with," said Morrissey, which doesn't sound quite right. How many members of their audience could really have been bisexual male prostitutes? But there is a sense that viewers could imagine themselves into what they were seeing specifically because it was constructed as a fiction—as a "story"—rather than as a glimpse of some reality they could never be part of, which was what *The Chelsea Girls* had provided. Real Warhol movies, you could say, appealed, when and if they did appeal, because of their distance from normal experience—in that sense, they were an example of classic avant-gardism. Morrissey's movies, on the other hand, tried to make the weird seem strangely approachable. You might even say that Morrissey is guilty of what Warhol had always been accused of: Making bad movies just because he didn't know how to make them any better. Morrissey's films can be easily read as failed attempts at mainstream Hollywood moviemaking, whereas Warhol's almost always feel like art films built around a deliberately abortive encounter with Hollywood.

In a few hundred words of trenchant analysis, Jonas Mekas talked about *Flesh* as the equivalent of one of the more average pieces of naughty prose published by Maurice Girodias—an ironic comparison, given what one of Girodias's authors had recently done to the film's producer. "*Flesh* is constructed, plotted, and executed with a definite calculation to keep one interested in it," said Mekas, whereas according to him a true Warhol film didn't really care if it got your attention or not. Mekas described *Flesh* as representing everything that a true Warhol movie *wasn't,* and confessed himself "a little bit amazed that anyone could mistake it for an Andy Warhol film."

But that was where Mekas was wrong. However much *Flesh* wasn't *by* Warhol, and even maybe pushed back against his innovations as a filmmaker, it was most definitely "an Andy Warhol film," given that it was the first product to come out of the sleek new offices of Andy Warhol Films, Inc. Its ads proclaimed *Flesh* to be "presented by" Andy Warhol the way a classic Hollywood picture might be "presented by" Warner Bros. or Paramount. As a

corporate project, *Flesh* was indeed a very important new work by Andy Warhol, and more so than if his eye had once again been behind the camera or his finger on the splicer. As a venture that really did go on to earn significant profits—more even than *The Chelsea Girls*—it was just about the first work of Warhol's that was absolutely, completely and evidently a product of that new artistic genre he would come to call Business Art. (His *Jane Heir* feature might have been one as well, but of course it never came close to being made.) Warhol may even have intuited that *Flesh* had to be very clearly *not* by him, as a work of cinematic art, for it to just as clearly be by him as Business Art. His recent remakes of the Flower and Marilyn pictures could still be thought of as—or rather, confused with—works of art that had traditional, unbusinesslike aesthetic goals. It was harder to make that mistake with *Flesh,* that utterly un-Warholian "presentation" by Andy Warhol Films, Inc.

If Warhol's act of self-creation was truly supposed to count as an artistic act, then who Warhol was mattered as much as any works he turned out—or, at the very least, what he turned out had to elaborate on the kind of "who" he was. In the summer of 1968, as he lay in the hospital, his assistant Paul Morrissey was helping him perfect the role of impresario he'd launched with the Velvet Underground. Poor Morrissey: With *Flesh,* he might have thought he was at last calling the tune, but he was still just helping execute the boss's ideas.

Morrissey's first solo effort on Union Square might not have had much effect on Warhol's art or aesthetic, but it did play a vital role in altering his social world. As the Silver Factory's undergrounders began to drift away, a new crowd took over that had more or less been cast by Morrissey that summer of '68.

The stunning Joe Dallesandro, hard bodied, blond and very pansexual, had won the role of the young hustler in *Flesh.* Fatefully, Dallesandro arrived at Union Square for the very first time just minutes after Warhol got shot. "I showed up thinking that I was going to be the bodyguard," said Dallesandro. (Interesting that there was already some sense of threat to Warhol.) "On my first day they were taking Andy out on a stretcher and I went up to Paul and said, 'Well, I guess I don't have a job.'" On the contrary. With Warhol off sick, Morrissey moved Dallesandro up from gofer and guard to the leading man in *Flesh.*

"The time I got involved was the time we were starting to do more and more movies for the people," Dallesandro recalled. "I didn't know that *Flesh* was going to be successful, but I knew it was a movie that people would go see, that they wouldn't walk out saying, 'Goddam—why did I sit there all that time? I was so bored.'"

Dallesandro was probably the most unlikely of Warhol superstars, ever—or at least the one where the title seemed most ironic. He'd had no intention of working in films, let alone in avant-garde art, when he first landed a bit part in a reel from *Four Stars*. It was 1967 and he'd been visiting friends in a Greenwich Village tenement when he wandered into the apartment where Warhol and Morrissey were shooting and then agreed to wrestle with Ondine in front of their camera. "The first thing I did when they asked me to sign a release was ask, 'Why?' I just didn't believe that people would actually go and see this stuff." When his reel was shown as part of Warhol's *Loves of Ondine*, a reviewer found Dallesandro just about the only decent thing in it, "good looking and natural-acting enough to have a show business career beyond Warhol." He was cast again as one of the gay ranch hands in *Lonesome Cowboys* but found that Warhol's reliance on conversation as blood sport didn't suit his more physical talents. Morrissey's more structured directing let Dallesandro bask in the camera's adulation without having to compete for attention with costars who might have faster tongues.

Dallesandro, eighteen years old when he came on the scene, had a background as hardscrabble as they come: His mother was fifteen when she got together with his father, a sailor. Dallesandro and his little brother Robert (who later acted for a while as Warhol's driver) spent their childhoods with foster parents.

> I was a real criminal when I was a kid—car thief, got shot in the leg by the police, 36 holes in a stolen car I was in. (Lucky I lived through *that* one.) . . . When they sent me to jail finally I was 15, and they said, "This reformatory we're gonna send you to has a lovely school, and church, and grass, and cows." (You know, not regular grass you smoke, but grass and cows.) . . . All my friends went to college. I didn't realize till I was older that I was lucky I didn't waste all that time going to school.

By the time he drifted into Warhol's world Dallesandro had spent time tossing pizzas and posing nude for "physique" magazines. He talked about film acting being the first "profession" he'd ever been able to stick with. By the time Warhol was back on Union Square, and Morrissey had finished shooting *Flesh*, Dallesandro was firmly ensconced in the new studio, doing all kinds of drudge work, from operating the elevator to answering phones at the front desk. "I remember basically my job was to keep as many people out of the Factory as I could," he said. "It wasn't so much that I was the star of the movies as I was there to frighten the other guys off. Cause I was a scary

little kid. So they set me at the front door with a stuffed dog." That canine was Cecil, a taxidermied Great Dane that Warhol had bought, for "protection," from a junk store that claimed he'd been Cecil B. DeMille's pet. He never was, but he had been a prize-winning show dog; it's not clear he had similar success in guarding Warhol's studio. Dallesandro had a better bark and bite.

---

*Flesh* brought another two notable players into Warhol's orbit: Candy Darling and Jackie Curtis, transgendered actors who played small but memorable parts in the movie alongside Dallesandro. Warhol had actually met the pair at least a year earlier, when, as he said, "drag queens still weren't accepted in the mainstream freak circles." ("Mainstream freak" is a lovely oxymoron, typical of an artist acutely aware of complex social structures.)

Warhol later reflected on his interest in gender switching: "I'm fascinated by boys who spend their lives trying to be complete girls, because they have to work so hard—double time—getting rid of all the telltale signs and drawing in all the female signs. . . . It is very hard work to look like the complete opposite of what nature made you and then to be an imitation woman of what was only a fantasy woman in the first place." Although the diction sounds more like a ghostwriter than Warhol, we can imagine that the thoughts might be his, or at least that he might have agreed with them. Yet their distanced, objective, even "cisnormative" tone camouflages how deeply Warhol himself had always been involved with gender play.

There was that college self-portrait as a girl and then lots of play with drag in the 1950s. As an illustrator, his dainty stylings were themselves a kind of transvestitism, which was what helped his drawings sell. And there was that golden shoe of his that was actually dedicated to Christine Jorgensen, America's first famous transsexual. By 1963, the Fluxus artist Dick Higgins was addressing an envelope to "Cindy Warhol" at the Lexington town house, and then Warhol's very first sound film starred the drag queen Mario Montez. Writing one of the earliest books on Pop, Warhol's friend Mario Amaya, the other victim of Solanas's gun, stressed that the gender play of camp was one of the "important hallmarks of the new art." Some eighteen months before *Flesh* was filmed, Warhol was already so linked to gender fluidity that a documentary about a drag contest showed its winner strolling through New York, dressed as a boy and with a perfect blond-on-top Warhol wig; the contest's organizer talked about trying, and failing, to enlist Warhol as one of its judges.

Especially for a man of that era, Warhol was remarkably astute in his

understanding of crossed genders. In footage shot of him in the early 1970s, he drew a more careful distinction than most people would have between "drag queens," who merely dress as women for "eight hours a day," and the "people who think they are really girls" who he felt were most worthy of a place in his entourage. He was so keen to stress his own gender bending that he once claimed, falsely, that he had got the idea for his silver hair from Edie Sedgwick, "because I wanted to look like Edie because I always wanted to be a girl"—not "dress as a girl" but "be a girl," a much stronger assertion.

In a Q&A with a notably silly journalist, Warhol was asked what drink he would be, if he were a drink? A Pink Lady. What article of clothing? A slip. What part of the human anatomy? A teat. What famous person? Christine Jorgensen.

Warhol faced repercussions for his interest in switched genders: A few years after he began to hang out with men who dressed (or identified) as women, he said that connection had caused some Long Island worthies to nix his purchase of a fancy summer home. But of course that was nothing compared to the risks that real transgendered people faced. Taylor Mead talked about his admiration for the courage of Candy Darling and her gender-fluid friends, since even in gay-friendly Greenwich Village the local gangs would regularly beat them up. "They were walking around oblivious to the dangers," said Mead. As late as 1970, *Life* magazine felt called upon to write an entire editorial lambasting the self-evident, intolerable corruption of American mores and morals represented by the movie *Myra Breckinridge* and its transsexual heroine, a part that Darling had been desperate to play but which went instead to the indubitably female star Raquel Welch. Her gender was safely unbent.

Candy Darling was born James Lawrence Slattery, in Queens, and grew up farther out on Long Island gazing at the nearby home of Christine Jorgensen. Darling was a flamboyant blonde, in Kim Novak mode, who eventually lived full-time as a woman and took female hormones. She and Warhol met in the fall of 1967, on her first visit to Max's Kansas City, when she had to be cajoled into breaking a law against men in drag frequenting restaurants, even though the savviest people often could not tell she was born male. (The photographer Francesco Scavullo once tried to sneak her onto the cover of *Cosmopolitan* as a standard female model, but got cold feet once it looked like he might actually get away with it.) The first time Jed Johnson met Darling, he thought she was the most glamorous woman he had ever seen. She could indeed pass as a Hollywood leading lady so long as you didn't look too closely at her disastrous teeth, which would fall out at inopportune moments. Ironically, when Darling and Ultra Violet once got up to dance at a curator's pri-

vate club, his membership was instantly revoked because the club banned women taking a spin on the dance floor together.

Warhol once complained that Darling didn't have the kind of salable "act," and theatrical drive, of some of the transvestites he knew who made good money, but that was because her gender dysphoria was about much more than a performance. Darling referred to her penis as "my flaw" and said she drew such fine attention because she was like the "women on the screen." According to Warhol, however, Darling actually wanted to be a non-Hollywood woman, "with all the little problems that a woman has to deal with—runs in her stocking, runny mascara, men that left her. She would even ask to borrow Tampaxes, explaining that she had a terrible emergency." Her quotidian but quite real challenges included remembering that women were supposed to wrap their robes right over left while men wrapped the other way. Her goal, she wrote in her diary, "is to be a beautiful woman, rich and married by 1971. . . . If I am going to be a woman I want the whole thing a home in the suburbs, a husband and strange as it may sound children."

Darling appeared in several Morrissey movies and got good parts in some plays, including one by Tennessee Williams. On stage, she passed so well that one confused critic praised her for giving "the first female impersonation of a female impersonator." But you could argue that Darling's most important and natural role was as arm candy for Warhol, who could use her extreme artifice to inject genuine grace, glamour and even femininity into his post-Factory world. The two appeared together on TV and in the gossip columns, with Warhol describing Darling as his greatest-ever superstar. (Way back in 1950, Warhol himself had tried to be Darling, almost literally, when he signed himself "Candy" in illustrations for a girl's magazine.) "Candy's sense of life was that it should perpetually be beautiful and elegant—but it so often wasn't," said one observer. When she died of leukemia in March 1974 Warhol cried—but did not go to the funeral. Darling was outfitted in women's clothes for the viewing and then buried in them.

Jackie Curtis, who appeared beside Darling in *Flesh,* was born John Curtis Holder Jr., and grew up on the tough streets of New York's Lower East Side. He was a slim and boyish underground playwright who Warhol always referred to as "him." Curtis actually met Warhol before Darling did, when he was staying for a while at the Y.M.C.A. on Forty-Seventh Street: "I just went over to the Factory and just decided to get myself in film before it was too late." Curtis sometimes took hormones and passed in and out of drag. In the book that got written on Warhol, Curtis is described as "the anti-transvestite transvestite." When Curtis died of an overdose in 1985, he was buried as a man. Warhol didn't go to that funeral, either, but he sent flowers.

Holly Woodlawn (originally Haroldo Santiago Franceschi Rodriguez Danhakl, from Puerto Rico) was the last of the trio of transgendered people to enter Warhol's circle. The two met when Ondine brought her to a launch party for *Flesh* in the fall of '68, and Woodlawn went on to star in two Andy Warhol productions. She thought of herself as a sultry femme fatale but came across as "Jackie Mason impersonating Carmen Miranda," according to Bob Colacello, a Warhol staffer who came on the scene just a little bit later. "Candy was always very together, very much a lady; Holly was a tramp," said the photographer Francesco Scavullo, who knew and shot them both.

Warhol's transgendered companions never really had the kind of close, constant contact with him that had been typical of the biggest superstars of the Silver Factory. The gender-fluid trio came closer to functioning as useful social props, brought out now and then, than close attendants on Warhol. One critic described them as "like Marcel Duchamp's Rrose Selavy turned inside out or upside down," and that gets at a sense that the most important role they played had to do with Warhol's post-Dada art. If his major art project had become his own indeterminate, ever-slippery self, then Darling, Curtis and Woodlawn were close analogues or even models for that: As "drag queens" they were, by definition, utterly self-created creatures but they also never quite settled into single, stable personas. Their disjointedness came partly from a society that refused to let them resolve who they were but also, according to Curtis, from the pleasure, even enlightenment, that came from refusing stable, approved roles. Earlier superstars like Ondine or Edie Sedgwick could be summed up in pretty simple terms as their own identifiably weird selves—they each had a signature brand of instability that seemed fixed and enduring. The transgendered superstars who replaced them never had, and weren't really allowed to have, that kind of consistency. They certainly appealed to Warhol for the gender fluidity that he'd also toyed with, but the fluidity itself mattered to him as much as the genders it worked on.

Warhol's transgendered trio helped him stake an early claim to a post-Stonewall culture where being swish became swank, as gay culture moved out of the closet and into the disco. Warhol had been too flamboyant for an earlier generation of elite gay New Yorkers. But in the decade after his shooting, the markers of queerness that he'd always borne became close to a badge of honor, at least on New York's club scene.

*. . . with his boyfriend Jed Johnson and Jay, Jed's curly-haired twin.*

# 1968

HOME FROM THE HOSPITAL | EDITING *LONESOME COWBOYS* | 100 HAPPY ROCKEFELLERS | JULIA IN DECLINE | JED JOHNSON MOVES IN | BACK IN THE SADDLE BUT STILL SORE | PAT HACKETT, ULTIMATE GHOSTWRITER | HOSPITAL BILLS, LAWSUITS AND RUBBER CHECKS | PROFITABLE PORTRAITS

*"The scars look pretty in a funny way.*
*It's just that they are a reminder that I'm still sick*
*and I don't know if I will ever be well again"*

On the afternoon of July 28, 1968, Andy Warhol clutched tight to the arm of his nephew Paul as he entered his town house for the first time since he was shot. The wounded artist was still "very weak and frail-looking." He had to take a breath every few steps as he negotiated his home's many stairs. Just shifting Warhol from the hospital to his Lexington house, seventy blocks north, had been a laborious process, said the nephew, known as "Paulie." He was the son of Warhol's big brother Paul, and was on summer vacation from his graduate work in the seminary at Catholic University in D.C., where his priestly education was being financed by Warhol.

In the hospital, when his uncle seemed on the verge of death, Paul Jr. had arranged for a Byzantine priest to give Warhol the Last Rites particular to their Rusyn traditions. When those turned out to have been premature—by two decades—he visited the sick man almost daily in the hospital. ("Shall I try my hand at seducing him?" Viva had written to Warhol in the first weeks of his hospitalization, after she'd impressed the nephew with how well she knew how to pray.) Paul Jr. then stayed with his uncle for a week or so once he was back in his town house.

Warhol was delighted with the care he had gotten at Columbus. The

nurses had waited on him hand and foot, and he was so impressed by the kindness of the Puerto Ricans among them that he came up with a new idea for a film about the work Puerto Ricans did in the city despite their reputation as "the ones causing so much trouble." The doctors had healed his wounds, which was a more than minor miracle given how bad things had looked in the O.R., but you could hardly say he was quite cured when he got out. He was in bed for several weeks, with drainage tubes in his side and frequent visits from a nurse, Nancy, to check them and change his dressings. In mid-August, he was back in surgery to have infected fluid drained from his abdomen, which required removing one rib. Despite fine care and surprising resilience, Warhol would never fully recover from what Valerie Solanas had done to him.

As the story was later told, the weeks after his return from hospital were all about leaving crisis and drama behind and finding a new normal: "When I called people up and they heard my voice for the first time since the shooting, sometimes they'd start to cry. . . . But I just tried to get everything back to a light gossipy level as quick as possible." For a while at least, his doctors had convinced Warhol to give up his daily dose of uppers, and that helped the famous night owl become a homebody. "I started to really enjoy being home in bed, surrounded by candy, watching TV, talking and taping on the phone," he said. (He was back on his Obetrol for the rest of the decade and added a nightly dose of Seconal, a sedative, to help him come down and get to sleep.)

After settling in for ten days, which spanned his fortieth birthday on August 6, Warhol's very first sortie took him to Times Square, to see peep shows and "restock," as he put it, on naughty magazines—"the really dirty, exciting stuff" that was his equivalent to a bedridden kid's comic books. He might not have imagined re-creating the gymnastics in the porn magazines any more than a little boy imagines leaping tall buildings in a single bound.

In parallel to such earthly pursuits, it looks like he also had a new engagement with religion. Lying mortally wounded in hospital, he had promised God his devotion in exchange for being permitted to live—or so says one tale—and once he'd recovered he claimed to have found a new fear of God. He went on to make more visits to church than before, stopping by for those few quiet moments before or after mass, or whenever the whim took him.

He also reengaged with what might have been his deepest creed: art. Without leaving the town house, he slowly got back to making things.

The front room of the house, once a true "factory" where Nathan Gluck churned out illustrations, became an editing suite. During the few hours Warhol could work every day he began to cut the raw footage of *Lonesome Cowboys*. As his first attempt at a more-or-less narrative film, he wanted to edit it down to a standard two-hour running time, leaving behind the endless expanses of avant-garde cinema for something closer to mainstream moviemaking.

The previous summer, he'd been on television talking about how he was going to abandon all art in favor of making "conventional movies." In the context of the TV spot that comes off as the latest Warhol put-on. Viva and Paul kept the jest going on a podium with Warhol in February, when they'd claimed their highest aspiration was to cast Viva as God in a moneymaking biblical epic. *Lonesome Cowboys* was clearly in that same satirical vein, but even for Warhol to successfully spoof Hollywood conventions his new movie couldn't unspool endlessly as his more obviously arty films had. It had to have some of the feel of a standard feature film. Warhol, brutally cut up by his surgeons, now had to perform similar surgery on his Arizona footage.

While still convalescing, Warhol also went back to painting, as he had several times since declaring the medium's death three years earlier. He worked on a commissioned series of one hundred portraits of Happy Rockefeller, the moneyed second wife of New York governor Nelson A. Rockefeller, whose own portrait Warhol had recently done. Ondine said he remembered visiting a still-frail Warhol and seeing the little pink paintings the size of paperbacks lined up all along the first floor of the town house. (They were soon assembled into a single ten-by-ten grid.) Warhol had done maybe a half-dozen society portraits before, but the sheer number of identical Happys in the new work—all smiling broadly as per her name—make it stand out.

Nelson Rockefeller had left his first wife for Happy, and his hasty remarriage to the much younger socialite had cost him his chance at a presidential run in 1964. When Warhol was painting the portrait grid commissioned in 1968, the governor was once again trying for the Republican nomination, this time against Richard Nixon; for Warhol to paint the politician's once-shameful second wife as a relentlessly cheerful First Lady–in-waiting made a certain sense, as a quiet comment on the political situation and her new role in it as an "asset."

Or maybe Warhol's relentlessly "happy" paintings had just as much to do with his own state of wounded *un*happiness. Consciously or not, it

might have functioned as a magic talisman, conjuring future cheer the wounded artist could only imagine. Forget for a minute the grid's one hundred faces—some are hard to read anyway—and it's easy to see a striking similarity between its mottled range of pinks and magentas and the look of Warhol's healing torso, crisscrossed with scars that were still glowing and lurid.

Warhol's *Happy Rockefeller* also looked ahead to where he would be heading as an artist over the next few years, when he was busy perfecting the ever more vacant, comment-free portraiture that would become his specialty. The one hundred identical Happys could stand for the first one hundred of the society portraits that would soon become his main artistic production. With his wounds barely healing, Warhol was pointing to his future as the purveyor of trademarked, mass-produced luxury goods.

———

As Warhol quietly, cautiously got back to work, he had the company of two geriatric Sams, the last survivors of his Siamese horde. He might have seen rather less of his mother, since she spent much of the day in bed in her basement. She was sick, taking medication (or more often missing it) for her chronic tuberculosis and heart condition, illnesses that made it that much harder for her to climb the stairs out of her little flat. Five months after Warhol's discharge, it was his mother's turn for a trip to the hospital, where she spent more than two weeks with cardiac trouble. A little while later, she was being prescribed Dexamyl (a.k.a. "purple hearts") a potent mix of amphetamine and barbiturate she was told to take "when feeling unhappy."

Aside from her physical ailments and depression, Julia Warhola was also showing signs of dementia. (Warhol called her "sort of batty.") She would invite strangers into the house and eventually she began the wandering caused by brain diseases like Alzheimer's. At the time of her son's shooting, however, she was still well enough to have a coherent conversation with Viva about the suitors who had once pursued her, saying that her body was "like a magnet" that attracted any good man, and that she'd pass one on to Viva as a potential husband—unless of course Viva and Warhol tied the knot, as the old lady desperately hoped.

A phone call between Warhol and his old friend Sam Green, who had curated his Philadelphia survey, gives some sense of the situation once Warhola's dementia really set in:

WARHOL: I have to go out to the store *again*.
GREEN: Why?

WARHOL: Well, you know, I have to go—I did some shopping this
morning, but I have to go out *again*.

GREEN: Oh. Where do you shop?

WARHOL: The store's right across the street.

GREEN: At Gristedes.

WARHOL: Yeah, Gristedes is really—it really is great.

GREEN: It really is great.

WARHOL: And they don't, they don't understand why I go shopping
every day. I buy so much stuff. And they, I, I bet they just can't—
you know I don't know what they think I—well I just throw—I
don't know what. What do I *do* with it? I don't—I can't imagine.

GREEN: I don't know. What do you do?

WARHOL: I don't—I don't know.

GREEN: Well who eats it?

WARHOL: Well I don't. It's just—my mother hides it. Then it all goes
bad, you know, every day, and then I find it all over the place.
Well it's just, just one of those nutty things she does.

GREEN: Why don't you put—why don't you put a lock on the
refrigerator?

WARHOL: Well then, then, I mean you know, I don't know. Then it's
just too nutty.

GREEN: Why does she hide—?

WARHOL: It's just, you know—that's what's happening. It's just sort of
nuts.

The recovering artist, the aging cats and the declining mother clearly
needed care, and a new Warholian showed up at the town house just in
time to provide it: He was Jed Johnson, the studio drudge who had ridden
in the elevator with Warhol and Solanas on that dramatic afternoon in
June. He began by stopping by the Lexington house after each day's work
to bring Warhol his mail. He might also fetch some groceries or fix the oc-
casional dinner. His visits became longer and longer as he took to tidying
as well, and to helping Warhol with the editing of *Lonesome Cowboys*. "Jed
loved the editing of the films, because it was very solitary," recalled a later
partner of Johnson's. "He was painfully shy. Painfully, painfully shy."

By early fall he had moved in, judging that Warhol and his mother were
in "such bad shape" that they needed more substantial help. "I ended up being
there all the time," said Johnson, "so I just stayed."

And stayed.

Over the next dozen years, he came to fill the traditional role of de-

voted young spouse. Gerard Malanga said that for the first time, Warhol had "got somebody that he could love in Jed. Whatever boyfriends Andy had prior to Jed were distractions to his art . . . but Jed was very helpful." Bob Colacello, on the other hand, believes it was a case of a patient falling in love with his nurse. A friend who met Warhol and Johnson a few years later described their relationship as "successful." The younger man, he said, bore an uncanny resemblance to one of the life-size nudes that Warhol had drawn in the 1950s, as though Warhol had at last realized an earlier ideal.

Johnson was a nineteen-year-old college kid from California who had arrived in New York in early January, on a one-semester walkabout with Jay, his fraternal twin. (Montreal had been their original destination but border agents had turned the two longhairs back.) On their third day in Manhattan they got mugged, losing their wallets and needing to find instant jobs to make ends meet. Luckily, when they visited Western Union to wire home for a bailout the clerk offered them work as telegraph boys, complete with the darling uniforms that always came with that job. "They came to the Factory in 1968 delivering a telegram to us in these bell-boy outfits," recalled Billy Name. "Andy was there, Paul and Gerard and me, and we just looked at them and said, 'We want you to come work for us!'" "Wouldn't you rather be working inside?" offered Morrissey, as extra incentive on that cold winter's day. He had been struggling to strip the new studio's vast expanse of wood trim and was eager to see Jed Johnson hired, at least part-time, to help with that job and then with all the other chores that came with the new space—especially with sweeping the floors, which was a task that Warhol had a strange focus on and that new staffers often began with. Even Fred Hughes had begun by assuming the broom. The brothers were soon promised parts in *Lonesome Cowboys* until that was nixed by Morrissey, although he did eventually enlist Jed Johnson's help in shooting and editing *Flesh*. Johnson always collected a salary, but signing rights at Max's may have made up a bigger chunk of his compensation.

By April, Warhol was talking about two young men who were "fixing up" his studio, using terms that make clear his interest in them wasn't purely about renovations: "They're like the prince and the pauper: The more masculine one, Jed, has long hair. The prettier one has a crew cut and is more feminine. They're so pretty. They're from Sacramento." Although the brothers had spent their early years in rural Minnesota—Jed always kept a Midwestern reticence—the reference to their college town wasn't random: They seemed like classic California beauties, slim boned and boyish, with slender, hairless bodies that recalled the Renaissance teens

who Donatello loved to sculpt. With key money loaned to them by Warhol, the brothers moved from a hovel on the Lower East Side—the neighborhood had appalled their new boss—to an apartment on Sixteenth Street just east of Union Square, around the corner from Max's Kansas City and one street over from Fred Hughes's place, at precisely the same point on the block. They were now firmly fixed in the Warhol orbit.

Jed Johnson described himself and his brother arriving in New York as "flower children from San Francisco," and he, at least, always had a quiet, innocent manner. (Jay was more of a wild man.) "I think nearly everyone in the Factory was a little in love with Jed," said the Warhol staffer Bob Colacello. "There was something so appealing about Jed's shyness and calm. He spoke so softly you had to lean in close." After the Solanas attack in June, Johnson had wept tears at the hospital and then was a constant visitor to Warhol's room. Johnson also sent over charming, ingenuous letters that seemed to arrive almost daily. "Yesterday, I saw the *The Graduate*," he wrote in one. "I was expecting it to be a very serious movie but it wasn't and I found it very interesting and enjoyable. Today, I stripped the paint off a board."

Another note talked about an outing Johnson had made to a gathering on Staten Island, and it gives important insight into his youthful psyche: "The party turned out to be a reunion for all the Queers in New York. I found most of them to be really detestable and such bores. Really the only enjoyable times I've had in New York have been with you." Jay Johnson has said that when he and his sibling first lived in New York they had not yet recognized that they were gay. (Another letter from Jed to Warhol wonders about a girl that Jay had been hanging around with, although a third talks about "playing cupid" between Jay and the stylish illustrator Antonio Lopez, who had been a high school friend of Malanga's.) Warhol, said Jay Johnson, was Jed's very first boyfriend. His growing affection for the older man, and the fact that it was returned, represented a major moment of self-discovery.

Over the course of the fall, as Jed Johnson settled into his new domestic life with Warhol, he began to assume more and more household duties. He took Warhol's mother out for her regular visits to the doctor, despite the fact that, in her senility, she accused him of trying to poison her. He moved the bed around her room when she complained that she could smell babies buried in the basement wall beside it. (The neighboring town house housed the Fertility Institute of New York—which as it happened treated infertility, not unwanted pregnancies.)

Johnson also set about bringing some order into the rooms upstairs, which had grown steadily more chaotic over the previous decade. "It was

Clutter City. He'd saved everything, every piece of junk mail, every empty box and tin can. I sorted things out—put cans with cans and paintings with paintings." Johnson then proceeded to paint the walls and organize Warhol's overflowing collections into some kind of coherent décor. His efforts gave a first hint that within a decade Johnson would become one of New York's top decorators, with a signature style you could call controlled overconsumption. That was a modified, reined-in version of Warhol's own aesthetic of accumulation—a queer, camp style the artist had first learned about, decades back, from Truman Capote's first novel and then from the café décors of Johnny Nicholson and the Serendipity crew.

At home, Warhol and Johnson functioned as husband and husband, sharing a bed and a domestic life. A friend remembered a moment when someone denied that another gay couple were lovers: "Warhol said, 'That would be like saying that Jed and I were just friends.' And Jed got mad, and said, 'Well, we are.' But they weren't—believe me, they were lovers." Johnson confirmed this to a later partner, while also giving the impression that the sex with Warhol had been "at a schoolboy level."

After the death of Warhol's cats the two even got a shared pet, the sausage dog Archie—named either for Archie Bunker, as Warhol sometimes said, or, as seems more likely, for a black man named Archie who cruised Union Square and was known for his oversize penis.

Johnson and Warhol's coupledom was less evident out of the house among strangers. In public, there was no physical display of the relationship, "no lovey-dovey or anything like that," said one observer of the Warhol scene. Something like twelve months after the shooting, a journalist profiling Warhol wrote about a meal the two men shared with a crowd of people at an Indian restaurant, but could only hint at the subtle tenderness in play between them:

> Warhol saw to it that everybody got enough to eat. In particular,
> he fed a new young friend named Jed, an extremely rangy, mute
> Californian. "Take some of my curry," he'd say, shyly—as shyly as
> Jed would take some and thank him.

Although Johnson described himself to a workmate as "asexual," rather than gay, Warhol's lack of romantic display was a cause of tension in their relationship and helped lead to its eventual failure. "Jed was always trying to get his attention," remembered Jay Johnson, "and that was frustrating for Andy, because he thought he *was* giving it to him. . . . Jed wanted to

really trust that Andy really loved him." Warhol could also be a jealous and controlling partner, with a fear of theft, of fire and of strangers that became something close to paranoia after his injury. The rounds he would do checking doors and locks evoke incipient OCD; one of Johnson's first jobs in the house was to organize the installation of a major alarm system. Warhol also became more of a hygiene freak than ever, hating to shake hands with people and cleaning house like a maniac: "I can't go to sleep if I know there's dust in a bureau drawer. I have to get out of my bed and get the vacuum cleaner and vacuum clean the drawers. . . . I may even start vacuum cleaning my chocolate-covered cherries before I go to bed."

But Johnson could also be a challenging spouse. He mentions depression in one of the first letters he sent to Warhol in the hospital and he himself ended up in hospital, twice, in 1970 and 1978, from suicide attempts that very nearly killed him. After the first attempt, Warhol visited his sick partner and expressed his sorrow to Jay: "I don't know why Jed would do that. I really care about him." An unfortunate side effect of this self-harm was that Johnson's dreams of piloting planes fell through: He paid for flying lessons but when it finally came time to get his license, he discovered that the suicide attempt ruled him out as a pilot. It's a cruel irony that he ended up dying in the crash of TWA Flight 800 off Long Island, in 1996.

---

It took until early September for Warhol to resume his daily trips down to Union Square. The man who showed up there was very different from what he had been right until Solanas fired her gun. He'd turned forty in the meantime, but his body had aged by decades. "I can't do the things I want to do," he reported.

Warhol had never been beefy, but he lost so much weight in the hospital that, for a while at least, his face had the vampiric look of his final self-portraits, under a wig that made him seem more taxidermied than ever. The frantic slicing that the surgeons had done in saving his life had left him with a severely weakened abdominal wall; his intestines now pressed through to his skin, eventually leaving him with a "football-size" hernia that ran the length of his belly and protruded by several inches. It took a surgical girdle to keep his innards in place, and he wore one for the rest of his life. He had them dyed pastel colors by Brigid Berlin, although it's hard to know if this was for his own sake or for the pleasure of boyfriends. Dismay at his own transformed body—not to mention continuing pain— might account for rumors that the shooting left Warhol with a limited in-

terest in conventional, bed-bound sex. (Other kinds of sex remained on the table.)

"I'm so scarred I look like a Dior dress," Warhol said within days of returning to work. Warhol's body certainly had a New Look of its own, complete with Dior-worthy ruching. It soon became the subject of some of the most poignant images ever made by Richard Avedon and Alice Neel, two of that era's finest portraitists. Warhol had allowed them to turn him into the last of his tragic Pop figures, somewhere between dead Marilyn and Jackie the survivor. Or maybe they turned him into the culmination of his own Death and Disasters. With help from Solanas, the cliché that Warhol was his own greatest work of art came true on the surface of his body. He was surprisingly happy to reveal his mutilated torso to people he barely knew. He went topless for several photographers and before Neel had ever thought of him as a sitter he'd said to her, "Why don't you paint me with my scars?"

"The scars look pretty in a funny way," he told a reporter. "It's just that they are a reminder that I'm still sick and I don't know if I will ever be well again." He never was. When he first returned to the studio, bloody fluids would still sometimes leak out onto his clothes and he was still claiming to be in "constant pain" four years later. His wounds and his operation, especially the delicate reattachment of his esophagus, left him unable to eat quite properly.

The damage that Solanas did to Warhol's psyche is much harder to document. There's endless debate about it. Billy Name said that after the shooting his old friend had become "the Cardboard Andy, not the Andy I could love and play with. He was so sensitized you couldn't put your hand on him without him jumping. I couldn't even love him anymore, because it hurt him to touch him."

"Andy died when Valerie Solanas shot him," said Taylor Mead. "He's just somebody to have at your dinner table now. Charming, but he's the ghost of a genius." Various onlookers declared him a "walking ghost" and "the angel of death."

But for every insider who found him saddened and reflective and scared, or "a zombie, more dead than alive," there was another, like his dealer Leo Castelli, who found him "more relaxed and sweeter than he had been before." Ingrid Superstar went so far as to say that Warhol was "even more profound and more beautiful now than before if that's possible," while Baby Jane Holzer declared that he'd come back from near-death "kind of as an angel. . . . He did so many good things and was such a kind person."

She called him "one the happiest people I know," and another observer said that he lost all of his earlier, artificial aloofness, becoming talkative, responsive and even "lovable." Warhol himself sometimes projected a sunny image: "Before I thought, it would be fun to be dead. Now I know it's fun to be alive," he told one reporter—in Pittsburgh, no less, a city that wasn't known to leave Warhol chipper. On another occasion he said that his injuries had caused no change in him at all, except that he no longer took off his clothing.

Warhol's first truly public outing came on September 5, when he attended the wrap party for *Midnight Cowboy*. Hanging out beforehand with a *Village Voice* reporter, he had waxed philosophical about his postshooting life and career, and was well enough to do his classic, playful job of spreading more confusion than clarification:

> I'm trying to decide whether I should pretend to be real or fake it. I had always thought everyone was kidding. But now I know they're not. I'm not sure if I should pretend that things are real or that they're fake. You see, to pretend something's real, I'd have to fake it. Then people would think I'm doing it real.

But there were also moments that sound like more sober introspection: "Since I was shot, everything is such a dream to me. I don't know what anything is about. Like I don't even know whether or not I'm really alive or— whether I died. It's sad. Like I can't say hello or goodbye to people. Life is like a dream."

Warhol had always been nervous—he picked his poor fingernails to pieces—but he returned to his studio more anxious than ever.

"I wasn't afraid before. And having been dead once, I shouldn't feel fear. But I am afraid. I don't understand why. I am afraid of God alone, and I wasn't before. I am afraid to go to the Factory," Warhol told the *Voice*. Strangely, one writer had sensed the artist's terrors on his trip to Stockholm, almost six months before he had reason for them: "He who has met Andy Warhol when he has taken off his obligatory black glasses sees a face that is as dead and devastated as a war front after the action has moved on. He is a person scared to death."

Viva later remembered the postshooting Warhol as especially terrified of women, and that she'd started to feel shut out of his world. (But given Viva's erratic behavior, there might have been good reasons to be afraid of her and to give her a wide berth.) Bob Colacello, who began work in the

studio in the early 1970s, remembered that Warhol was veering close to full paranoia: "You wanted to hug Andy and protect him—but you couldn't. . . . You felt he was so frail." The sound of a car backfiring would have Warhol jumping out of his shoes.

At the new studio, Warhol replaced the open access of the Silver Factory with some semblance of high security. Jed Johnson built Sheetrock walls so that the elevator that had given Solanas such easy entry in June now gave onto a tiny white vestibule. A new Dutch door, lockable and split in the middle, sealed the vestibule from the rest of the studio and could only be unlocked from inside, with a buzzer—but was mostly kept unlocked, anyway, according to one German art student who, in 1972, wandered in off the street on the off chance of meeting the great Andy Warhol. Random flower children were known to do the same. The Dutch door, Warhol recalled, "wouldn't stop anyone with a good kicking foot, never mind a gun." Cecil the stuffed dog and his partner Joe Dallesandro were Warhol's security detail. Despite their presence, said Brigid Berlin, Warhol would sit in his tiny office "petrified that someone's going to come in the elevator door without ringing."

After a couple of armed junkies had penetrated the studio's modest defenses, a big steel door was installed, with a little bulletproof window and a sign that read "Knock and Announce Yourself," coupled with a security camera. One evening after his staff had gone home Warhol panicked when he realized he'd have to ride the elevator down by himself.

As late as 1973, when *Vogue* asked Warhol to write about what was "on his mind," he included the following list:

> Are the lights on or off?
> Is the water off?
> Are the cigarettes out?
> Is the back door closed?
> Is the elevator working?
> Is there anyone in the lobby?

And yet none of Warhol's fears had kept him from resuming much the same public life that he'd had before being wounded. Maybe appearing in the papers reminded him that he was, in fact, still alive. After showing up at that party for *Midnight Cowboy* in early September, by the middle of the month he was spotted at the premiere of a movie about a Mod crime caper whose scapegrace hero, played by James Coburn, made "Pop-porno sculptures." (You can see why Warhol got the invitation.) The following week

Warhol was hosting a launch party of his own, in celebration of *The Marble Index,* a new album by Nico, this time without the Velvet Underground behind her. The guest list was a vast A to Z of New York's cultural scene, including everyone from Michelangelo Antonioni, the director of *Blow-Up,* to the art historian Leo Steinberg, by way of Norman Mailer and George Plimpton and all the old Factory personnel. Coverage that went out on the newswires talked about a crowd of two hundred guests—just about the number of invitees on the list—"dressed in Indian headbands, dresses that opened to the waist, one wedding gown, a few tuxedos, velvet suits and dirty blue jeans." Warhol (or possibly Nico's label, Elektra) splurged on wines from the celebrated 1947 vintage while feeding the guests picnic snacks. Before dancing began they sat on the studio floor taking in Nico's album, which didn't take long because its producers had put only fifteen minutes of music on each side. "It kind of made us want to slit our wrists," they said. "After it was finished, we genuinely thought people might kill themselves." Some reviewers had warmer feelings toward the sheer radicalism of what Nico had come up with, described as "bleak, lovelorn incantations sung like an IBM computer with a Garbo accent," all set against John Cale's landscape of "undulating, ululating concertinas and organs and cellos and electronics." One review felt that Nico had managed to capture "the universe of her despair, an existential world of absurdities and contradictions."

Warhol himself described the album, in thoroughly un-Warholian terms, as "beautiful," and then got in what sounds like a quiet little dig: "Nico spent the whole summer writing it in the bathtub. She works well there." You have to wonder if Warhol was maybe trying to put just a bit of distance between himself and an album and a party that sound like they represented precisely the '60s counterculture he was busy moving away from. Back in the spring, Warhol had made a rare in-person appearance in Pittsburgh to give one of his classic nontalks, and his hometown friend Imilda Vaughan had complained to him about his outfit: "The hippie thing is sort of passé now—even in Pgh." He was photographed in velvet and hippie frills in a fashion spread for the November 1968 issue of *Look* that must have been shot while he was still convalescing—he looks both embarrassed and ill. By the time of Nico's party, the crowd's headbands and dirty jeans must have struck Warhol as notably out of sync with the clean and businesslike studio that surrounded them.

That fall of '68, the studio was getting down to business with a staff that now included Malanga. The poet had all of seventy-five cents left in his pocket and was dining on care packages from his old friend Marie

Menken, so he had agreed to come back to the fold and take on the work of managing the rental of Warhol's art films, to be run direct from the new studio.

He told his diary about showing up there on July 29, the day after Warhol was discharged from the hospital:

> I go to the factory to pick up the typewriter Fred buys for me to duplicate the co-op's mailing list for FILMS, INC. tells me that Paul most likely will pay me $1.50 an hr for my work but my work is worth more in effort than any ordinary typist and I demand $1.75 which, by the way is the legal minimum standard, whether or not Andy declares me. Fred doesnt disagree with the terms Andy calls while Fred is out getting me the typing paper this is the first time ive spoken with Andy Pie since last seeing him in the hospital when Viva and I sneaked in the back door.

The businesslike Pat Hackett was added to the team a month later. She was a Barnard undergrad with little sign of the countercultural pedigree that earlier acolytes had arrived with. Warhol first brought her on part-time as a volunteer typist, which she considered "a good way to inject some glamour into my college years." Sharing Warhol's tiny, cluttered office, wedged off to one side between the new studio's front and back rooms, Hackett began by typing up the hours of conversation Warhol had recorded while convalescing. Over the next two decades she moved up to being his trusted confidante, collaborator and, especially, ghostwriter. Many famous Warholisms may in fact be Hackettian.

Hackett settled into her most vital role in the early 1970s, when she began keeping a record of morning calls between herself and Warhol. Those were ostensibly so that Warhol could let her know the previous day's expenses but soon came to function as a diary of what had gone on in Warhol's life. When this was published in 1989 as *The Andy Warhol Diaries,* three questions arose that have yet to be answered: How much of the truth did Warhol transmit to his confidante, how faithful was she in transcribing it and what truths were left sitting in the 90 percent of the diary entries that never made it to print? The confusion that Warhol loved to spread continued to propagate after his death.

———

"For the first time we would have made some money this year," Warhol said in his first postshooting interview. "But my hospital bills took all of

that. Our grosses are very big, but the net is practically nil. And we plow what we net back into our experimental films. But the Beatles have a lot of money and we're trying to talk them into setting up a nonacting foundation for us." Nothing came of the Beatles ploy (if it ever existed outside of Warhol's head) but he was certainly in need of a new business model.

Even as his body was slowly gaining strength he was facing a huge new threat to his financial health. His very first postshooting appearance had him sitting in court, one month to the day after leaving the hospital and still pale as death, to contest a claim against him for $80,000. Phillip "Fufu" Van Scoy Smith, the blue-blooded backer of the *Jane Heir* debacle, had sued him for that amount the previous year. After Warhol had ignored a summons in the case—he'd thought it was a joke when it had been served on him at Max's—Fufu got a summary judgment against him. For Warhol to crawl out from under the threat took more than two years of appeals and thousands spent in legal and private-eye bills. And even then Warhol only escaped because Fufu was so nutty he failed to follow through on the final court date.

Meanwhile, Warhol had mounting bills to pay. His fixed costs were only going up, what with his new, higher rent on Union Square and followers who were looking more and more like employees (Fred Hughes, Jed Johnson, Gerard Malanga)—or, even worse, business partners (Morrissey)—and needed to be compensated accordingly. His actors were also demanding pay as they never had before. (Maybe the *Midnight Cowboy* gig had spoiled them.) Free meals at Max's no longer counted as sufficient recompense, although when Warhol returned to work in September he found that his tab had mounted to $3,000.

Lab fees had also gone through the roof, as Warhol's films had gone from silent black-and-whites to color and sound, and now involved footage which—shock, horror—might actually be edited out of the final work. While Warhol was in hospital, his film lab was sending invoices for $6,000 and asking for a sizable payment before they'd do any more processing.

By the end of July, Warhol's new landlord was complaining that the artist was a full three months in arrears on his rent, meaning that he'd already fallen behind even before winding up in Columbus Hospital. As he said to the *Voice* reporter, his eight weeks convalescing there only made his financial situation that much more dire. He once told his old friend Emile de Antonio that his medical bills from the shooting had come to $16,000, "and I had to pay for it all myself." Invoices back him up on that number (he was charged $500 for blood alone) and that would have counted as a huge bill in those days, especially if Warhol's insurance agent really did pocket

his premiums instead of signing him up for a health plan, as the artist once claimed. Although Fred Hughes later denied that Warhol was having money troubles that year, letters from that summer show Hughes hoping to get the de Menils to cover his boss's hospital costs. (But then deciding that would be tacky.) Month after month, Warhol ignored increasingly frantic requests for payment from the surgeon who had saved his life. A bill sent six months to the day after the shooting is marked "PAY UP YOU BLOWHARD." Warhol eventually mailed him a check for $1,000—only one third of what was owing, and it bounced—and finally, with no warning, sent over a messenger with a full portfolio of ten Soup Can prints and part of a Marilyn suite, in a trade the doctor had never agreed to, with an artist he'd barely heard of, for art he didn't like.

The surgeon would have been more eager, maybe, if he'd understood how Solanas's assault would make Warhol's market take off. That had been Henry Geldzahler's first thought when he got news of his friend's injury: "Do you know what that does to the values of the paintings," he'd said to his boyfriend, adding, "Don't ever tell anyone that I said that." One dealer remembered how Warhol's works became something like a commodity: "People were willing to buy them at any price. It was like holding onto IBM stock. People didn't even like them"—a situation that persists to this day.

But the health of Warhol's market meant more for his collectors than for his own immediate cash flow. That fall, he was complaining that he had so few paintings left to sell that he was going to start framing and selling his printing screens instead. (As he'd done not that long before with the Sidney Janis portrait screen; he'd also shown a screen, made from a still of the rape scene from *Four Stars,* in an erotic art show in Scandinavia.) If there was money coming in, it was only in dribs and drabs, and from all kinds of funny, unreliable sources.

Malanga's business doing college film rentals was at best a mom-and-pop operation, he said, that involved arranging a handful of rentals each month for a salary of $50 a week. (He'd moved up from an hourly wage.) The lecture bureau still owed Warhol a couple of thousand dollars when he got shot, but it would obviously be a while before he'd be appearing at lecterns once again, which neither Warhol nor his audiences could have much minded.

There were occasional direct sales of works to institutions and collectors. In June, while still in hospital, Warhol sold a $1,200 copy of the footage for that same rape scene—bought, improbably, by a New York State

body in charge of circulating films to colleges and lesser museums. In July, someone in Houston was offering $5,000 for a big Flower painting that had been shown in town, from which Warhol would have to pay a commission to the Texan who'd made the connection. (This is important as one of the first examples of Warhol using such random agents to sell his art, as he was soon doing all the time.) There were also a couple of Pop tapestry projects that Warhol was involved in, on top of his various print editions. The Flowers were selling well enough but the Kennedy assassination series, although started earlier, was only just coming together as Warhol began his recovery.

Warhol got the idea that he could raise some extra funds by going after Eleanor Ward for amounts he thought she still owed him, from when he left her Stable Gallery more than four years earlier. The legal fight dragged on for years.

Morrissey, with an equally keen but maybe less ambitious concern for their bottom line, decided to save the studio a few dollars by having its pay phone removed—it seems to have cost a monthly fee—but that could hardly have put the business in the black.

The following spring, when a reporter wondered where the money came from to meet payroll and pay for production costs on the movies, Warhol answered that they were still depending on income from *The Chelsea Girls,* at last beginning to turn a real profit more than two years after its premiere and after its expenses were first incurred. "But making movies is so expensive," Warhol explained. "We still have to do a portrait once in a while to get money so I can keep experimenting."

---

With portraits, which he went on to do much more than "once in a while," Warhol had hit upon the secret to funding the next two decades of his career. It was Fred Hughes who had really gotten that income stream flowing. In June of '68, faced with piles of bills and a boss still in a hospital bed, he had the idea of lining up a series of portrait commissions from his longtime patrons John and Dominique de Menil. Two projects were waiting for Warhol once he was back at work on Union Square in the fall: a posthumous portrait of Jermayne MacAgy, a beloved Houston curator who had shared the de Menils' adventures in art, and another one of Dominique herself. By October, Warhol had rented a new space on the tenth floor of the Union Building as a place where he could settle down to the muddle of silkscreening without disturbing the order that Fred Hughes had imposed down-

stairs; before long he'd added space on the eighth floor as well, amid rooms he'd rented for storage. Warhol's "retirement" from messy art making and into the tidiness of film production had lasted all of three years. Once the new portrait labors were fully underway, even the dapper Hughes could get press-ganged into helping: One night, Warhol kept him working in the studio right through the dinner hour; by the time they left the dandy was covered in paint.

The two de Menil commissions were obviously not the first portraits Warhol had ever been paid to do. But they were just about the first ones that used the same square, forty-inch format that he'd used for earlier, uncommissioned Pop paintings—of Marilyn, Liz and Jackie—and that he then went on to use for hundreds of society and celebrity portraits in the '70s and '80s. From the de Menil portraits onward, Warhol almost always insisted on using this same format, even at the risk of losing contracts from moneyed patrons who preferred other sizes and shapes. The reason for the insistence, Warhol said, was that he dreamed of some day having a show at the Metropolitan Museum of Art that would be called "Portrait of Society," and would include canvases of every person he'd painted since the shooting, in identical sizes.

Such a serial conceit goes against the standard notion that important portraits are supposed to be about the utter uniqueness of their individual sitters, captured in equally great, unrepeatable works of art. And indeed those initial MacAgy and de Menil portraits, for all their watershed position in Warhol's career, were based on generic snapshots of the two women and don't do much to reveal their particular virtues or qualities, or Warhol's pictorial skills. One well-known critic and early Warhol fan went so far as to say that Warhol's portraiture was "essentially cosmetic, a skin-deep treatment of surfaces rather than a probing of the individual's character." (See color insert for an example.) Antonio Homem, who worked extensively with Warhol at the Sonnabend gallery, was present as Ileana Sonnabend herself sat for the artist and has concluded that "anybody who says that a portrait by Andy captures a personality is out of his mind."

You could say that the two de Menil paintings that launched the series, considered with all those that followed, come together instead into a reworking of the Campbell's Soup catalog that Warhol showed in his very first Pop solo at Ferus: Where that show had presented the entire range of Campbell's flavors, with almost no stylistic embroidery, the portraits were now giving a similar display of one luxurious "brand" of humanity.

Not long after completing the two de Menil commissions, Warhol,

with his unfailing insight, was telling his old friend Emile de Antonio that absolutely all of art was really a version of the "social register." That makes his vast series of society portraits stand as a possible summation of his entire artistic practice—maybe of *every* painter's practice—as things stood at a moment when he had already declared and redeclared the Death of Painting, a medium which for a while already had been looking like nothing more than Park Avenue decoration. Ironically, if the portraits were truly subordinate to the Social Register that listed their sitters, that very fact brought them into close contact with the hottest trends in late-1960s Conceptual Art, which Warhol never let out of his sight. The postpainting artists of the new Conceptualism—like Warhol, they were nearly post-*art*—preferred to cede aesthetic control to some system that would generate their images for them, the way Warhol's portraits depended on the social accident of how and when they came to be commissioned rather than on Warhol's own choice of subject or treatment. A couple of years before Warhol was shot, the Japanese New Yorker On Kawara had launched his celebrated Date Paintings, which became a fifty-year series of close to three thousand canvases, which Warhol particularly liked. Each work began life in the morning as a classic avant-garde monochrome, which the artist then interrupted—defaced, you might say—with the boldly hand-lettered date on which it was painted. Warhol's society portraits are a similar record of an artist's existence in the world over several decades, although they reveal the social and maybe economic forces he was subject to rather than the chronological or cosmological ones registered by On Kawara.

If these readings of the portraits make any kind of sense, they give Warhol a sophistication and critical edge that balances the role of lackey that all court portraitists have had to assume to get commissions. Warhol's society portraits show an underdog subtly twitting the alpha dogs without their knowing it has happened, like a virtuoso confidence artist who takes pride that his marks never realize they've been fleeced. (Sometimes, Warhol's own twitting wasn't so subtle: He and his makeup artist Gigi Cutrone used to get a private laugh out of making extravagantly dressed doyennes strip, wrap themselves in a dirty cloth and assume whiteface—all for the sake of looking more "beautiful," they were told, in their Andy portraits.) Warhol, painting portraits of the high and mighty in the '70s and '80s, evokes Francisco Goya as he painted the last dregs of the Bourbon nobility in Spain in all their tawdry decay—which was a parallel already being drawn before Warhol was that far along in his portrait project. In 1971 his

portraits were said to depict "the vacuous patron class that is supposed to support fine art in this country" as painted by "not only our greatest realist, but our greatest moralist as well," according to the critic Barbara Rose, who first drew the comparison to Goya. "Warhol stands in a line with the bitterest challengers of society's hypocrisies and conventions."

There's a sense that across his entire life, Warhol knew he was sharper than the mainstream society he often swam in, and also that he was happy to keep that very useful knowledge to himself. Growing up gay had made him especially expert at this kind of camouflage, and at taking potshots from behind it. That too may have transferred to his portraits. By the early 1970s, Gerard Malanga was describing their style and tone as "not anything but gay," while acknowledging that Warhol would be the first to deny it: "I could just picture him shrieking, 'What, my paintings homosexual?!'"

In the fall of 1968, John de Menil wrote about Warhol as "a marvelous man whose human quality usually is distorted by the desire to turn him into a star of the sensational, when his pioneering work is serious and deep." That accurate description probably accounts too for the depth and seriousness of the portraits the de Menils of this world got from Warhol, beginning that same fall—portraits that were deeply diagnostic despite their apparent superficiality. As one of Warhol's dealers explained, however keen Warhol might have seemed to carve a place for himself in Park Avenue society, his place in art history mattered even more: "He pretended he wanted to show at Tiffany's, but he really wanted to show at MoMA and the National Gallery."

Believing as strongly as he did in classic avant-garde innovation, Warhol must have realized that, in the long run at least, his portraits might win him more museum space than more obviously shocking kinds of work. If Duchamp had said that the only radical move left for artists would be to show "calendar paintings," Warhol could have realized that society portraits might also do the trick.

Not that an eagle eye for posterity stopped Warhol from keeping a firm grip on more immediate concerns. "He's a Pittsburgh boy who made it big in New York," said another Pittsburgher who did the same. "I kind of chuckled . . . [that] with his obvious vanity portraits, he's taken the people that are the most vain and most into themselves and created a commissions structure—for survival." One year after Warhol had begun his portrait campaign, he sent a telegram to a staffer at Apple Records in London:

DELIGHTED WITH IDEA TO DO PORTRAITS STOP POL-
ICY IS NEW PAINTINGS MUST PAY FOR A SMALL FILM

STOP THEREFORE INITIAL PORTRAIT MUST COST DOL-
LARS 25000 STOP EACH ADDITIONAL PAINTING WITH
VARIATIONS IS DOLLARS 5000 STOP ALL PAINTINGS ARE
DONE IN LARGE SCALE PLEASE SEND PHOTOS OF YOKO
AND JOHN BOTH TOGETHER AND SEPARATELY YOURS
ANDY

*. . . with his postshooting regulars: Paul Morrissey, Joe Dallesandro amd Candy Darling.*

# 1968-1969

FUCK, A BLUE MOVIE | FORAYS INTO CONCEPTUALISM:
VACUUM CLEANERS AND SUPERSTARS FOR RENT |
"RAID THE ICEBOX" AND THE MUSEUM AS ART |
FLOATING CHAIRS AND RAIN MACHINES | VIDEO
VENTURES | A SUNDAE FOR SCHRAFFT'S

*"Andy is always very intuitive about leaving when
he knows things aren't going in the right direction"*

*Fuck.*

That was the title of the "small film" that Warhol's new portrait commissions were funding when he first returned to Union Square. It was also the last film, ever, that was fully a work by Andy Warhol rather than a "production" of Andy Warhol Films, Inc.

Warhol described it as "a movie that was pure fucking, nothing else, the way *Eat* had been just eating and *Sleep* had been just sleeping." With his typical mix of competitiveness and passive aggression, he started work on the film just when Morrissey was preparing to release his *Flesh*. There's a story that Morrissey tried to get his own back by giggling as they shot the sex scenes in *Fuck*.

Viva claimed that she was the one who'd first come up with the idea for the film, a year before, one day when she was tripping on acid. Warhol cast her as one of its two *Fuck*-ers, alongside her ex-boyfriend Louis Waldon, who'd had a small roll in *Flesh* and had done some minor porn work. Warhol was still walking with a cane and looking "ashen and wan" one Sunday in late August when he met the two actors in a Central Park café to discuss the movie. "When Andy said he wanted us to make love, I knew it wasn't going to be a dong-and-balls movie," Waldon said, "it was going to be sensitive"—which just shows how far he was from understanding Warhol's aesthetic. It had always inclined toward pornography, not erotica:

In the early days of the Factory, Jane Holzer had declined to star in a Warhol movie about an Avon Lady in which she was supposed to "go into a real-life family and fuck every man, woman and child who was in sight on film." (She later decided that she probably should have accepted the role.) The day Warhol took a crowd of friends to see the hard-core *Deep Throat,* he said it was one of the most exciting films he'd ever seen. In 1972, a death announcement for his mother actually listed him as an "adult film producer." Lucky she didn't live to read it.

Viva, as clueless about her mentor as Waldon, imagined that Warhol's *Fuck* would be "a leisurely, sensual pas de deux." She was appalled when it wasn't. Seeing the raw footage threw her into a tizzy and led her to withdraw further from the Warhol scene. Warhol had to beg her to sign a release for the film, "so I can show it once at the Whitney."

*Fuck* was shot for $2,000 on a single, sunny Saturday in September in the Greenwich Village apartment of the art critic David Bourdon, high up over the Hudson River. Warhol said he liked the apartment's "tacky modern" sensibility—shades of the new Union Square studio—but Bourdon was reluctant to lend it until Warhol played the sympathy card: "C'mon David, help me get on my feet again." For Warhol to be back on his feet he had to be making art, although Viva later decided that Warhol's occupational therapy doubled as sex therapy: "My own idea about *Blue Movie* wasn't, as I believed at the time, to teach the world about 'real love' or 'real sex' but to teach Andy."

The movie has some of the ingredients of true porn: Viva's in a filmy, peek-a-boo one-piece (Waldon has a hard time undoing the snaps on its crotch) and four years before *Deep Throat,* oral sex is already a big theme, with the couple debating the taste of Waldon's postcoital penis at some length. Paul Morrissey walked off the set when the action got explicit, apparently upset that he hadn't managed to clean up Warhol's act. But deep down the movie is still more avant-garde than erotic. The actors break through the "fourth wall" to speak to the production crew—they name both Morrissey and Hughes—and the feature has a strong blue cast because Warhol used film-stock color-balanced for incandescents to shoot under window light: "It makes it like arty," he said soon after he discovered his error, "so it could be an art movie—it really is so beautiful." That tint also provided a revised title that could actually run in mainstream ads and reviews: *Blue Movie.* Whether the color shift was deliberate or not, it made *Fuck,* for all its raunch, more explicitly aesthetic than most other recent Warhol films, echoing the experiments with saturated, unnatural color he

had launched with his early silkscreens or the colored projections of the Exploding Plastic Inevitable. For art-world insiders, it also made an obvious reference to *Rose Hobart*, a famous deep-blue movie by Warhol's longtime hero Joseph Cornell—making it very likely that what Warhol called his "accident" with film stock was actually a deliberate move.

When Viva and Waldon aren't actually shown in the act, as mostly they aren't, they are shown in banal conversation about such things as the actors' athlete's foot and gonorrhea and views on Vietnam. In playing his role, Waldon himself was eager to find a bit of plot to cling to, fishing for something closer to Morrissey's *Flesh* than to classic, plotless Warhol: "For me, this situation was two people having their last fuck. We meet for the last time, and we do everything backward—we meet, we fuck, we eat." Improbably, he described the movie as "a beautiful, beautiful love story."

As usual, Warhol's camera stayed entirely static, doubling Warhol's real-life role as a silent, disengaged voyeur. "He merely wanted to find out how 'normal people' acted with each other," according to Viva. (As though that were something she could ever illustrate.) Like most of Warhol's acolytes, she read his actions as motivated by his personal foibles and needs rather than by the demands of his art. At dinner that Saturday night, Warhol said he thought the footage they'd shot was "beautiful" and one critic felt that it achieved "an unchallengeable feeling of documentary genuineness."

If *Blue Movie* revisited the single-action conceits of *Eat* and *Sleep*, it was more wandering and less rigorous than either of those, as one random fan pointed out direct to Warhol in a letter: "It doesn't look like a Warhol film, more like something by the typical sexploitationer. . . . 'Blue Movie' wasn't you." (Warhol's admirers were always generous about sharing their views on his art and life.)

At first, only Warhol insiders got to see the film, until all four reels were screened at a benefit for Mekas's *Film Culture* magazine in June 1969. The following month, a three-reel, 105-minute version, with the new *Blue Movie* title, replaced *Lonesome Cowboys* at the newly named Andy Warhol Garrick Theater on Bleecker Street. *Blue Movie* let Warhol make history yet again: It was the first movie to show explicit sex and also get full theatrical release. That might have been Warhol's goal from the beginning, because of the film's role in a longtime rivalry between him and Stan Brakhage, that competing king of underground film who had once attacked Warhol's work. Earlier in 1968, when Brakhage showed an even more explicit film of his called *Lovemaking*—it showed straight sex and gay sex and

even erotic scenes between children—it caused such a commotion that it basically disappeared from view. With *Blue Movie*, Warhol was able to prove that his status in the culture at large let him achieve what Brakhage, his elder, could not.

The film pleased some serious viewers. Timothy Leary told Viva he loved it. A critic saw it as having "a deeply ingrained sadness that communicates the pathos of being unable to find in the present some Eden of infancy." But most mainstream reviewers were pretty negative and the local authorities were even less impressed. They seized *Blue Movie* early in its run, arrested three theater employees and fined the Garrick manager $250; Waldon took off to Italy to avoid subpoenas. As Warhol pointed out, the police went out of their way to censor his obscurely naughty art when they were happy to let contemporary Times Square movies like *Judy's Box* and *Tina's Tongue* play to much larger crowds. Warhol correctly noted that no true pornaholic would have tolerated the few, mild-mannered money shots to be had well along in *Blue Movie*, scattered among all that less-than-sexy chatter. None of that mattered; on appeal the judges still said that *Blue Movie* was porn. To keep the content alive Warhol released the work as a book, with the full text of its gripping dialogue set beside selected stills.

"*Blue Movie* was real," Warhol said, "but it wasn't done as pornography—it was an exercise, an experiment. But I really do think movies *should* arouse you, should get you excited about people, should be prurient."

That's a strange claim for someone whose genius as a filmmaker lay with movies that might easily put you to sleep. The less frigid *Blue Movie* might therefore prefigure Warhol's coming dive out of the sleepy avant-garde and into the mainstream of "exciting" popular culture—or rather, a dive into the mainstream *as* avant-garde. "I've given up art. I want to do movies that have nothing to do with art, and nothing to do with good design," Warhol had said to his friend David Bourdon just after his studio moved to Union Square. Except for the accidental artiness of *Blue Movie*'s blue tint, you could say that project met those new criteria. That didn't mean any other films followed after it.

Even the least arty of Warhol's movies couldn't have given him the same charge in 1968 as his movies did in 1965, when he first declared himself a full-time filmmaker. It wasn't the works' fault: The idea of Warhol *as* a filmmaker, in 1968, was simply a less exciting proposition than when he'd first made a splash by trading the vintage prestige of painting for film as *the* radical new medium.

Postshooting, had he settled too deeply into filmmaking to be com-

fortable remaining there? "Underground Movie Producer Fights for Life After Wounding" was the July 4 headline in a newspaper in McKeesport, Pennsylvania—Warhol's supposed hometown—while a photo of the just-wounded artist in the New York *Daily News* described him as "filmmaker Andy Warhol," with no need anymore to mention the other art forms he'd bravely given up. The following spring, an article about the new avant-garde films of the crushed-car sculptor John Chamberlain said that his birth as a filmmaker was utterly indebted to Warhol's moviemaking strategies, "which have now become conventions." Warhol, the diehard innovator, couldn't have been happy as the author of the latest variety of "conventional" art.

"I can't imagine any serious critic giving more than, say, ten minutes of consideration to the films of Andy Warhol," wrote one prominent reviewer in the year after the artist's near death. "Warhol was just a trend, a phase of our self-corruption. Like the Beatles, he has almost become respectable." That "respectable" status was brought home to him, even more brutally, within the first month of public appearances after his recovery. On October 7, 1968, Warner Bros. gave the New York premiere of *I Love You, Alice B. Toklas,* one of the first pot-themed movies. Warhol was at the launch party, where he painted one of his '50s-style butterflies on the female lead's thigh. Peter Sellers, the British comic, starred as an American lawyer who abandons his life as a square for a "groovy" hippie existence with a flower child. In one scene, Sellers, toking on a hash pipe while dressed in a paisley shirt and black tights, talks with his gorgeous young conquest about the latest Warhol movie. That fictional work, dreamed up by the *Toklas* screenwriters, is a six-hour film dubbed *Mondo Teeth:*

GIRLFRIEND: It's the best picture he's ever made.

SELLERS: Who's in it?

GIRLFRIEND: Nobody. Just teeth.

SELLERS: Just teeth? Whose teeth?

GIRLFRIEND: You know, *teeth.* Animal teeth, insect teeth, false teeth. Just shots of teeth.

SELLERS: Oooh. What a fantastic idea. What an incredible conception. Teeth, teeth, and yet more teeth. Wow—*teeth!* Is it in black-and-white, or color, or what?

GIRLFRIEND: That's what's so groovy about it, Harold. I think it's whatever you want to see in it. I think he's a genius, Harold.

SELLERS: Yes, he's a genius.

GIRLFRIEND: And you know Herbie said there's one sequence in which
    they split the screen about thirty-two times.
SELLERS: One for each tooth!

"My movies are empty, empty, empty. They're too beautiful, too
planned," Warhol had said earlier in the year, in a moment of self-doubt and
self-critique. Seeing himself so easily caricatured in a Hollywood spoof could
only have confirmed those doubts. *Blue Movie* brought his five years as a
filmmaker to an (in-?)glorious close.

---

"Andy is always very intuitive about leaving when he knows things aren't
going in the right direction," Gerard Malanga had written in his diary back
in the summer of 1966. He was talking about Warhol's talent for quitting a
party at just the right moment, but his observation holds true for Warhol's
career as an artist as well. The thing is, leaving implies you might have some-
where else to go to, but it's not clear that after making his last movie Warhol
had an obvious next destination.

"I wonder if you feel compelled to get out of something when people's
aunts start doing it?" asked one random fan who wrote to Warhol in hospital.
"I mean, are films actually your bag, no matter what anyone else is doing,
or is something taken out of it for you now that all the straight people are
filming? Well, you can be sure that whatever you do, films or not, it'll catch
on." Warhol himself might have felt less certain.

On his first full day at home from the hospital, *Newsweek* magazine
published a big trend story that declared that Pop Art had been super-
seded by Conceptualism: "Young artists, like 'prodigies' in mathematics
and chess, move closer and closer to pure idea." As one young critic was
quoted as saying, "A profound dematerialization of art may lead to the ob-
ject's becoming wholly obsolete." Warhol, now an old-timer notably shut
out of the article, seems to have had a momentary urge to help the young-
sters in their dematerializing mission. "Objects on walls seem to have all
been done," said Warhol in the fall of '68. "I like empty walls better than
putting things on them."

He would hardly have been shocked at the notion that the ideas behind
art could matter more than its objects: He'd known Marcel Duchamp's
thoughts on "non-retinal" work for more than two decades and his own Pop
Art had been read at first as completely cerebral and unvisual. In the last
days of the 1960s, Warhol scribbled a few pages of notes under the head-
ing "Conceptual Art," with schoolboyish observations such as "emphasis on

mind rather than eye or hand" and "simplicity—use the least means to carry out the idea." Just around then, Fred Hughes observed that Warhol was getting especially excited by "ideas rather than art . . . new concepts rather than the physical thing."

Warhol received (and kept) invitations to the pioneering conceptual-art shows of L.A. dealer Eugenia Butler, and would probably have seen her infamous presentation of Dieter Roth's rotting cheese on a trip to California in May 1969. A few months earlier, Warhol's status had been high enough in such brainy art circles for the young hotshot Joseph Kosuth, who got a full page in the *Newsweek* feature on Conceptualism, to have included Warhol's line about "15 minutes of fame" in works he showed in Butler's gallery, well before that quote had gone at all viral. Already the previous year, Warhol had asked Kosuth for his autograph after seeing some early conceptualist shows that he'd mounted; by the early '70s the two men were gallery mates at Castelli's and agreed to do a trade: a portrait of Kosuth by Warhol for a piece of Kosuth's own word-based art. Before long, Warhol was declaring himself a fan of the "danger-oriented" conceptualists Vito Acconci (famous for masturbating noisily in an art gallery) and Chris Burden (for getting shot and crucified).

Warhol was in fact so strongly associated with Conceptualism that he was invited to participate in an object-free project called "Instructions," for which Kosuth and his peers submitted directions that a collector was supposed to follow to "create a new situation."

On the Fourth of July 1976, when a newspaper published a bicentennial feature titled "How Will We Live," Warhol's contribution saw him predicting that material art would soon be disappearing entirely, to be replaced by entirely ephemeral talk about it. One critic billed all of Warhol's postshooting work as essentially "posthumous"—they were a series of statements about the nature of art made after the artist had given up on art itself. Or maybe he had killed it off, even before Solanas had (briefly) done the same to him. It's surprising how many times Warhol, creator of one of art history's largest bodies of work, declared himself opposed to art objects of all kinds. When one potential patron called the Union Square studio to buy a painting, Warhol said, "Oh, we're out of art" and hung up. He sometimes hinted that he had never really thought of his objects as more than props in a single, ongoing conceptual piece. Leo Castelli actually blamed Warhol's Pop Art for first launching the new Conceptualism that "we are stuck with," as the dealer put it in the early '70s.

Warhol made feints toward projects of his own that left no material trace. It's said that he asked Jasper Johns, one of the last great object makers

in American culture, to let himself be masturbated as a work of performance art—something the shy Southerner wouldn't have been likely to agree to. There were penises in Johns's art, but they were as prim as the ones in Michelangelo or Rodin. (That said, Johns did feel comfortable contributing a penile drawing to the "Cock Book" of Brigid Berlin.)

Warhol also floated the conceit of renting out his superstars as exhibition-worthy works, with the $5,000 fee counting as an art supply. He actually completed a "piece" that consisted merely of vacuuming an exhibition space then displaying the vacuum and the bag full of the dust it picked up—echoing the important "Maintenance Art" projects of the Feminist pioneer Mierle Laderman Ukeles. (In case anyone thinks Warhol didn't fully engage with such projects, unpublished diary entries show him cabbing around New York looking for the perfect vacuum, laying out an absurd $88 on the one he decided was right—and then making three more shopping trips until he found an even better one for double that.)

Warhol got especially excited by the idea of making art that could be seen only from a vast distance through binoculars, or, more radically, of putting live people in windows as art objects to be seen from a distance. Warhol's least material piece of all was that trip to Paris that he funded for his two art-critic friends, with the trip and everything that happened in it counting as an Andy Warhol work.

———

In a paradox typical of Warhol, his most ambitious and influential conceptual project was also fiercely material, even though it didn't involve making a single work of art. "Raid the Icebox," as it was called, saw him choosing 404 objects from storage at the art museum of the Rhode Island School of Design and then touring them as an exhibition, or maybe as an example of his art, to a bunch of other museums. Outside the art world, this is one of his least-known creations. Inside that world, its influence rivals Warhol's "discovery" of photo silkscreens in 1962. In the five decades since Warhol's "Icebox" show, any museum with an ounce of ambition has invited artists to build exhibitions from the stuff in its vaults, the weirder and more Warholian the better.

Like his Soup Cans, Dollar paintings, Disasters and Flowers—like almost all of Warhol's most important inventions—he sponged the idea and even the name for "Raid the Icebox" off someone else. In February 1969, Warhol's patron John de Menil was being shown around the RISD museum by a director who lamented how many of its forty-five thousand artworks had to pass their days in storage. That director was no doubt angling for a

grand new de Menil wing to relieve the congestion. Instead his guest suggested getting some prominent outsider to select a few tucked-away gems for temporary display. If the selector's name were big enough, de Menil said, it might get curious visitors to take a closer look at the overlooked works that got chosen. No name being bigger than Warhol's, at least in the mind of de Menil, he brought his favorite artist on board to do the choosing. But if anyone imagined that Warhol was going to go bobbing in the vaults for neglected treasures, according to normal notions of such things, they didn't know their man.

Warhol arrived for the first of six long visits to the museum wearing brown suede pants and one of his new tailored leather jackets, with one shoe cut open to relieve the agony of an ingrown toenail. Maybe in a sour mood because of the pain in his foot, he proceeded to let it be known that he hated "old art," and especially paintings, and that he'd actually prefer if someone else would do the choosing for him, relinquishing artistic control the way his hero John Cage had taught him to.

Succumbing to the will of his patron, however, Warhol "let it be known by a slight nod or murmur, or a scarcely perceptible blink, which paintings were to be picked out and which ones passed over," according to an observer. Warhol would have preferred to have his painted selections exhibited on ranks of crammed storage racks, he said, so most couldn't be seen at all, but he settled for having piles of them stacked haphazardly against the exhibition wall, propped up on sandbags exactly as he'd come across them in storage.

The finds that Warhol most wanted to put on view were more obscure than any painting. On descending into the vaults, his very first choice was—as Cage would have wanted—the very first thing he saw: several closetfuls of antique shoes, from France, England, the United States, even China. Warhol wanted them exhibited in the same flower-papered wardrobes that held them in the musty basement at RISD. What about the wardrobe doors? someone asked. Were visitors really going to be allowed to open and close them? "Spectator participation," Warhol replied, invoking one of the avant-garde's latest buzzwords.

Warhol, for so long New York's go-to guy for shoe drawings, probably had a genuine interest in that footwear. That was clearly true as well for the piles of Native American textiles and baskets he selected. He admitted to having started to collect them the previous year. Some of the fine art he selected was just as obviously to his taste: a Daumier drawing like the ones he'd riffed on in college; one of the faux-primitive paintings of Florine Stettheimer, whose works had first cemented his friendship with Henry

Geldzahler; even a nice little Cézanne that Warhol actually hoped was a fake. "If that's real, we won't take it," he said, before Dominique de Menil, a more old-fashioned aesthete, convinced him to exhibit the Cézanne despite its authenticity.

An academic painting of a dozen dishy male bathers actually had Warhol exclaiming "Oh, I like that one." One junior curator at RISD remembered not being surprised that Warhol "liked funny things as much as he would like Greek sculpture," but the truth is that, for "Raid the Icebox," he mostly avoided making the obviously camp, ironic choices that people expected of him. The director was surprised to see Warhol passing on the museum's porcelain figurines and Victorian snuff boxes.

Instead of helping the museum show off the quality of its holdings to visitors, according to the de Menils' initial idea, Warhol set out to undermine the ideas of tasteful discrimination and connoisseurial contemplation that museums normally stand for.

The museum director recalled "exasperating moments when we felt that Andy Warhol was exhibiting 'storage' rather than works of art, that a series of labels could mean as much to him as the paintings to which they refer." He was right. The sheer jumble of objects Warhol put on view just about guaranteed that no single one of them would be seen to best advantage, even when it didn't come stacked under or behind some other piece.

Over the years, as the RISD director complained, the museum staff had allowed its vaults to turn into "grandma's attic, or even worse, into a junk shop," but that was clearly just the condition that Warhol wanted to evoke in his countercuratorial exercise. When Warhol asked for the shoe cupboard, the costumes curator chided him: "You don't want it all, because there's some duplication." Warhol gave her a look and got it all. He insisted that "Raid the Icebox" should include all fifteen of the museum's almost-identical Windsor chairs, which had only been acquired to cannibalize for spare parts.

At one point, Warhol pointed through the window at a gingko in the museum's sculpture garden. "I want that tree," he said. The museum director turned to his assistant: "Write that down: Tree to the right of the bust of Ingres."

"What is beautiful to the artist, becomes beautiful" was how Dominique de Menil justified her support for Warhol's basement finds. But he was arguing that what is ugly to the artist might also become beautiful, at least once it had museum muscle behind it. Rather than train the gallery's spots on a newly revealed treasure, Warhol suggested choosing some truly lame object and giving it that same masterpiece treatment. What better way to

underline the capriciousness of the art world's value judgments? The director at RISD recognized that, in the Duchampian '60s, "the attitude with which one regards an object is sufficient to define it as art, or not." Warhol's project seems to have been making the bolder claim that this same kind of arbitrariness had been what gave museums their power all along, long before the '60s struck. Rather than being a demonstration of aesthetic merit, said one review of Warhol's final product, the show proved "that such merit is an invention of critics and curators."

Warhol's anti-aesthetics continued even once "Raid the Icebox" had actually opened in its first venue, in October 1969 at the Rice University art gallery funded by the de Menils in Houston. Showing up late to the opening with Jane Forth, his brand-new sixteen-year-old superstar, Warhol stood holding his tape deck while she stuck its microphone at other guests and asked juvenile questions like "Are you a good fuck?" As one local remembered, "They stayed for perhaps fifteen minutes, never varying from that mode—he not saying a single word—then they were gone."

Warhol seems to have been in a less caustic mood when he arrived for the show's opening at the art museum in New Orleans the following January. The museum's young curator, who spent a splendid couple of days touring Warhol's crew through the city, seems to have channeled the playful transgression behind "Raid the Icebox." He displayed its paintings as Warhol had wanted, on rows of chain-link storage racks packed so close together that the works on them could hardly be seen. On opening night, guests weren't allowed in until ten o'clock and even then they could access the exhibition galleries only by first traipsing through the museum's basement storage rooms. When they arrived at its grand neoclassical court they found it decked out in Pop splendor, with a Wurlitzer jukebox and mirrored disco ball. Hot dog carts in the shape of hot dogs had been invited in from the streets of the French Quarter. That impressive if somewhat out-of-date Pop celebration won the approval of a local paper as "a delightful blending of a Mardi Gras ball and a hippie happening. . . . There were togas and tuxedos, super mini-skirts and evening dresses, buckskin jackets and Edwardian suits, top hats and felt hats from the 1930s, long hair and short hair, high heels and bare feet." As one guest exclaimed, "My gosh, it's the establishment mingling with the anti-establishment." And indeed, with the '60s having just passed away, that was a distinction that meant less and less.

All that was missing from the party, for most of the evening, was an artist named Andy Warhol. After doing his glad-handing duty for about half an hour, he retreated to his hotel room and the old movies on its TV.

---

An amazing notebook from around 1970 shows Warhol running through a different art idea on every page: "The same story script done by two different actresses," reads one; "Portfolio: 1–50 Ejaculations/Photos of Cumming," reads another. Many other of his ideas in the notebook are, sadly, just riffs on things he'd already tried.

Some unusual projects that Warhol took beyond the idea stage show him grasping at straws, for instance when he got an estimate for the fabrication of "a unit for use in demonstrating a floating chair by passing a solid metal ring around the chair to show that there is nothing holding it up," or when he tried to design a robotic trash can controlled by its owner's clapped hands, or took steps to have some exotic Swedish phone booths shipped to him in New York. (It looks as though his hospitalization interrupted all progress on that front.)

The art world's new interest in both technology and the environment launched another direction in Warhol's postshooting art: As part of an art-and-technology program at the Los Angeles County Museum of Art, he came up with contraptions to counterfeit wind, rain and snow. After endless trial and error (mostly error) a pretty goofy version of the rain machine ended up at the 1970 World's Fair in Tokyo. Duchamp had made a rain machine of his own way back in 1947, so Warhol was once again exercising his talents as sponge, and there were Duchampian echoes as well in a stainless-steel pudendum and bust that Warhol had Malanga wear to a fashion show.

But it looks as though he felt that his best bet for a new direction lay in using the era's new technologies to keep a comprehensive record of the reality around him, as a kind of all-encompassing, multimedia still life and self-portrait. This was something he'd started earlier but went at with a vengeance beginning in late '68. He kept at it for the rest of his life.

A big *Vogue* profile focused on Warhol's reel-to-reel tape recorder as his "latest self-protection device . . . pointed at anyone who approaches, turning the situation into a theater work." This was the machine Warhol had hooked up to his phone in the hospital and then at home to tape the hours of gossipy calls that he made. "I'd provoke any kind of hysteria I could think of on the phone just to get myself a good tape," Warhol recalled, thinking back on the months after his injury. "Since I wasn't going out much and was home a lot in the mornings and evenings, I put in a lot of time on the phone gossiping and making trouble and getting ideas from people and trying to figure out what was happening—and taping it all." In the studio, with his art making in a kind of limbo, he remembered feeling reassured by the recording process:

"When harmless-looking friends or friends of friends stopped by, I'd step out and tape and photograph them, and then I'd go back into my office and wait for somebody else to drop by."

After 1970, when he moved on to cassettes taped on Sony's new TC-40 Action-Corder ("for on-the-go professionals . . . as small as an instant camera and as easy to use") he would introduce it to his victims as "my wife, Sony." He ended up recording something like 3,500 cassettes. He even brought his latest incarnation of a Sony recorder—a Walkman—to the hospital room where he died in 1987.

Warhol had an innate and amazing ability to spot the compelling in the quotidian. One night in the late '60s, he was at a busy party where talk was competing with a tinkling cocktail pianist, and the scene suddenly set his artist's antennae abuzz: "I never realized it before, but party noise is wonderful." Another time, Warhol watched from the studio window as New Yorkers emerged from a subway stop below: "Look at them, they're like ants. Oh, isn't it weird? It's like they're on wheels. Look at that one, he's out of step. Nobody else is out of step." These were the kind of moments he knew he was capturing when he set out to set down everything that happened around him.

"Sony" took up residence in a shopping bag that was Warhol's constant companion; beside her sat her little brother, a Polaroid camera always ready to pop out. Like the cassette recorder, the camera let Warhol record the simple presence of almost anyone he encountered; by the early 1970s it was as much a symbol of his arrival at an event as his silver wig. On Union Square, he also started using it to keep a record of his visitors, and to keep them nonplussed: "I'm doing Polaroid snapshots of all my friends, the girls with their breasts hanging out and the boys with their genitals hanging out. Would you mind?" said Warhol to a curator visiting from England. "No, of course not. What are you going to use them for?" was the reply. "Oh, I don't know yet. I'm just taking the pictures." The whole thing sounds like a reprise of Warhol's penis-drawing campaigns of the 1950s minus the artiness of life drawing. The sheer banality of his gaze, and its relentless repetition, turned the most taboo subject into something utterly quotidian: A Polaroid of a penis became like the record of a call about shopping. Given Warhol's conflicted feelings about sex (but not about shopping) this might have given him some kind of solace.

For more public consumption, within six months or so of his return to the studio Warhol began work on *Nothing Special*, a six-hour TV *special* (hence the title) commissioned by NBC in which he'd simply record whatever happened to take place in front of one of the new portable video cameras

that were just then taking off. "In New York, apartments have a channel five which allows you to watch anybody who enters the front door. That will be my show: people walking past the camera," said Warhol. "We'd just sit there and wait for something to happen and nothing would."

Morrissey said that the boob tube was a more natural home for Warhol's particular brand of documentation than movie theaters had been. "It would be much better to have that kinda thing in your home, on TV," he said, "where you don't have to watch it if you don't want to." Warhol himself had come to realize that television, channel-surfed "straight through" without a break, was much like his own *Chelsea Girls* or *Four Stars,* "just one whole big thing." As he said to the author of one of the first articles on television as art, "my movies have been working towards TV. It's the new everything. No more books or movies, just TV."

Given all that, a reporter writing early in 1969 wondered why *Nothing Special* had not been realized: "They wanted us to do it for nothing," said Warhol. He was still talking about reviving the project as late as 1981, when he was finally beginning to break into TV after more than a decade of trying. In the meantime, for lack of a paying sponsor, he turned the premise of *Nothing Special* into one of his personal artistic projects, getting various hired hands to record anything and everything that happened in the studio onto endless hours of videotape, producing yet another serial "piece" by Warhol that is now known as the Factory Diaries. "Andy was a hoarder—it was another thing for him to hoard," said Michael Netter, a videographer—one of the first—who Warhol hired to do many of the first tapes. "There was no distribution in mind. It was chronicling a diary. David Bowie shows up, and it's on video." Or the stripper Geri Miller shows up, and that's on video. Or the "ladies" from *Town and Country* magazine.

When it came time to contribute a work to a water-themed show organized by Yoko Ono late in 1971, Warhol considered showing his rain machine, the obvious choice, but then decided against it. He went instead with a clever riff on his Factory Diaries in which he simply pointed his camera, in tight close-up, at the studio watercooler and let its microphone pick up all the gossip and chitchat of the staff and hangers-on gathered around it, off camera. (Ono thought this wasn't "aquatic" enough and wanted to display some kind of copy of the tape immersed in water. Warhol smartly nixed that idea.)

---

What's odd about Warhol's eager work as a transcriber of passing life is that he took it on at just the moment when he was getting the strongest of signals,

from the public and critics, that maybe he shouldn't. His first major experiment in the art of recording had been *a*, his transcribed "novel" of a day in the life of Ondine. After more than three years of gestation—Billy Name worked on its final formatting as one of his last projects before disappearing—Grove Press finally released it in December 1968.

As published, a typical chunk of its first page read:

> You're a clunk. Are there any way stations on the way that we have to (*honk, honk*) like uh, I, wha—(*noise*). If we go through, through the park, is there ANY place we can keep calling your uh, I mean right through the, uh, phone call. Is there any place where we can keep call him if we—Answering service . . . Are you (*cars honking, blasting*). Are there difFERent places—are there different places where we can call your ans—oh. Want some cake? Nah. A little juice, anything? I know where we can get some. *hurriedly*—oh yes, let's get some. Fantastic, baby. Yeah. Good. Oh you can't pretend that you're not here. Oh, okay, all right. You're uh, I mean— Aw right. You're uh, you're uh, here, yeah. Okay. You're here. Okay. You definitely are here. Uh (*noise*). Hey, what time is it? Do you know it's exACTly—it's two o'clock?

A typical review, in *Time* magazine, ran under the headline "ZZZZZZZZ." (An accidentally ironic choice, since four years earlier an avant-garde "sonnet" written in homage to Warhol had consisted of fourteen long lines of those same Zs.) *The New York Review of Books*, then a new voice on the intellectual left, waxed fully wroth, describing the work as "the death knell of American literature" and its protagonists as "Untermenschen . . . insulated from the past, from pleasure and pain, from humanism and the heroic tradition." Both reactions were just about dead-on; with hindsight, however, it looks like they should have been couched as praise rather than criticism. A total flight from humanism, heroism and the evidently gripping, to plunge deep into the world of the banal and sleep-inducing, was one of Warhol's notable contributions to radical art—and he knew it. "I don't think plot is important," he said in 1969, in an unusually long and serious discussion of his filmmaking. "If you see a movie of two people talking you can watch it over and over again without being bored. You get involved—you miss things—you come back to it—you see new things. But you can't see the same movie over again if it has a plot because you already know the ending. . . . This is my favorite theme in movie making—just watching something happening."

This uniquely Warholian "theme" had already been recognized the year before by the French theorist Gilles Deleuze, who felt that Warhol's banalities helped present things "as they are," freed from the tyrannical ordering schemes of language and culture. Warhol was determined to pursue that theme, even after the critics lambasted his novel and it had passed to the remainders bin. Warhol, so often accused of pandering to public taste, was in fact the great contrarian of American culture.

---

In the final weeks of the Silver Factory, a new teenage fan and friend of Warhol's named Jonathan Richman—later one of the pioneers of New Wave music—sent the artist a drawing inscribed "the avant-garde has been dead since the 1920s." Richman was channeling a view some of his elders were also starting to spout. Clement Greenberg, emperor of all postwar critics, complained that "the larger art public now wants, and knows that it wants, contemporary art that looks like avant-garde art. . . . The avant-garde would seem to have proven, finally, just as unable to protect itself from the infiltration of the middlebrow as every other department of culture in our society." The fact that he could publish those words in *Vogue,* under the title "Where is the Avant-Garde?" was itself proof he was right.

Warhol himself acknowledged that countercultural ideas had become watered down through contact with the mainstream. The pseudo-underground party in *Midnight Cowboy* bore immediate proof to him of that fact. At the close of the 1960s, the new popularity of any culture that was off the beaten track made it "hell for people trying to stay ahead, like Andy Warhol," said an *Esquire* cover story headlined "The Final Decline and Total Collapse of the American Avant-Garde." Although the article itself was almost exclusively about cutting-edge theater, its famous cover art consisted of a photomontage of Warhol himself getting flushed down a giant can of tomato soup, as though he had come to stand for the entire cutting edge in any discipline. He'd been thrilled to get the call for the cover shoot, not only because any publicity was good publicity but also, maybe, because becoming the symbol of the avant-garde's ruin would give him no choice but to move on from it. Across his entire career, he never gave up on the idea of radical innovation that he'd been trained in at Tech. It's just that it slowly dawned on him that the obvious markers of the late-1960s vanguard—weird media, or antimaterial concepts, or new technologies—could no longer get him there.

The best way forward, it turned out, was down.

Instead of commenting on popular culture from on high, as Pop Art had, or standing on its countercultural margins with *The Chelsea Girls,* Warhol began to plunge right into the thick of the mainstream, as its own pet avant-gardist. It's as though Marcel Duchamp had decided to give new life to the urinal he'd shown as art by installing copies of it in washrooms all over town for the average joe to pee in. He might look more than ever like a plumber, but those in the know would see that as his most daring move yet.

In the months before Warhol got shot, he and Duchamp had in fact been planning a twenty-four-hour filmed portrait of the Frenchman, but he died one month after Warhol's return to work. That killed the film project, but maybe it helped Warhol to move beyond Duchamp's example, or to take his work to its logical conclusion. Where Duchamp's urinal had involved a transformation of the banal into art, if only by the artist's say-so, Warhol's update involved jettisoning transformation altogether so that banality itself, left to do its banal thing, could count as high art.

As Warhol described his 1960s work, he'd wanted to make "bad" art "because when you do something exactly wrong, you always turn up something"—which was pretty much the standard avant-garde model of the twentieth century. By the early '70s, Warhol had left behind his search for the strikingly "bad" in favor of making normal, salable, good-enough work, to see what that might "turn up."

"I think it should be pointed out," said Billy Name, in one of his last public appearances by Warhol's side, "that Andy's sort of beyond sophistication." What could be more sophisticated?

If Pop Art had been about the market for American commodities, Warhol's new "art" would involve plunging right into that marketing. In September, in one of his first postrecovery appearances, he told a tabloid that he was going to move into promoting cosmetics, "for girls with beautiful thoughts."

Within weeks, a still-convalescent Warhol was paid to shoot a deluxe, sixty-second TV commercial for a new ice-cream sundae, called the "Underground," that was meant to un-stodge the Schrafft's restaurant chain, a longtime favorite of Warhol's known for its blue-rinse clientele. "Andy liked the cucumber sandwiches with no crusts," said a young friend who dined there with him. And that was exactly the image that Schrafft's hoped to shed. The company hired one of the hottest new ad agencies in New York—run by a Pittsburgher who had gone to Tech—and set out to capture the youth market. "I don't want to alienate anyone, but that's where the action is," said

the chain's president. (The new dessert consisted of nothing more dynamic, however, than Schrafft's same-old vanilla ice cream served with tired old chocolate sauce, whipped cream, and a maraschino cherry.)

Warhol's previous attempts at TV advertising, shot on film, had mostly been duds, pulling in neither attention nor money. The Schrafft's commercial, one of Warhol's earliest experiments in video, earned him a handsome fee of $7,000 for just about one day's work, actually went to air, and made a splash there. A *Playboy* article described the ad as "widely discussed," and Warhol cared enough about it to have got, and kept, various display items that Schrafft's had designed around the ad to help sell its product in the restaurants themselves. Within a few years, Warhol was telling the *New York Times*, "You know, I'm really in love with TV commercials. I think they're among the best things on TV and they should run much longer than they do." Schrafft's was so happy with their avant-garde ad that they ran ads advertising the advertisement. Or maybe they were doing their best to convince resistant customers that Warhol's off-putting weirdness was actually something to treasure. "I really didn't understand the fuss they made over it," said Warhol. "It only took half an hour."

Warhol had shown up at the TV studio in his underground uniform of leather jacket and shades. As *Flesh* star Joe Dallesandro remembered that day, his boss then got to work with him and Viva, both topless, and the studio's new technology. "He was very interested in getting the special effects and making all the colors change. Kind of like a psychedelic electric light show," said Dallessandro. "It was Andy given a television studio to do whatever he wanted. . . . The motherfucker's got absolutely no talent. No original idea in his head. So when we get there and the guy said, 'The camera can do this,' Andy said, 'Oh yeah, I like that. Do that. Do that.'" In the end, it's hardly surprising that the half-naked actors didn't make it to the food ad's final cut. Instead, the spot came off as a psychedelic experiment in still life "with all of the mistakes TV can make kept in," Warhol told *Playboy*. "It's blurry, shady, out of focus." It was meant to recall the look of a badly tuned color TV, Warhol said, in yet another example of him reveling in the careful cultivation of failure. Warhol's contact with the technologies of commercial TV—even with the "mistakes" they allowed—made him feel that the cutting-edge video experiments going on in the art world were primitive and "corny."

One article thought the ad worth describing in all its unappetizing detail: "The screen fills with a magenta blob, which a viewer suddenly realizes is the cherry atop a chocolate sundae. Shimmering first in puce, then fluttering

in chartreuse, the colors of the background and the sundae evolve through many colors of the rainbow. Studio noises can be heard. The sundae vibrates to coughs on the soundtrack. 'Andy Warhol for a SCHRAFFT'S?' asks the off-screen voice of a lady. Answers an announcer: 'A little change is good for everybody.'"

According to Dallesandro, "It was the most boring piece of shit, but he was paid a lot of money to do it"—one of many examples of a Warhol follower not following what the master was up to, and coming to despise him in the process. The head of Schrafft's hit much nearer the mark: "We haven't got just a commercial. We've acquired a work of art." The ad even earned pride of place in *Art in America* magazine—just where Warhol's Pop had scored its first-ever coverage back in 1962—as the lead image in a major essay on the artistic potential of television, amid a slew of other works that were distinctly noncommercial and museum-bound—distinctly "arty," to use a favorite insult of Warhol's.

His Schrafft's ad was an artwork whose virtue lay less in what it was like (although those off-screen coughs are indeed wonderfully strange) than in how it circulated and what it was selling—or in the simple fact *that* it was selling. The ad was named one of the "Fifty TV Films of the Year," and earned a Certificate of Excellence from the distinctly commercial American Institute of Graphic Arts—a supporter of Warhol's ad work in the 1950s. By the spring after the spot appeared, *New York* magazine's Teevee column was paying serious attention to Warhol's "award-winning" ad as "a mischievous burlesque of commercial slick . . . carrying the commercial tradition of establishing the Product as object of exotic desire to its hilarious extreme."

"Hilarious" is a key word here. As Warhol dove headfirst into commercial and popular culture, it was never because that was a natural fit for him and his art. If he appealed to the corporate sponsors of that culture, and to their paying customers, it was always as a wacky outsider shipped in from the cutting edge. It's clear that Schrafft's wasn't really interested in the innovations the artist brought to its TV ad for their own sake; the owners were interested in those innovations as a sign that they'd got Warhol, the radical artist, to sign on to their team. Without having his name and persona attached to their campaign, and its sundae, the whole thing made no sense. Warhol could only ever be part of the consumerist mainstream as a kind of avant-garde mascot, defanged by the very fact that he was willing to participate in its culture. "Andy Warhol's name is a household word like Ringo, Ultra Brite, or Raquel Welch," said that *Vogue* profile from 1970. But it's not

clear that he fit into American households with anything like the same ease as a Beatle, a detergent, or a bombshell. Or that anyone wanted him to.

Around the same time that Warhol was selling Schrafft's sundae, the Braniff airline got him to star, as himself, in his first appearance in a TV ad. The commercial shows him playing a cartoon version of Andy Warhol, his skinny, ailing body barely filling an airplane seat beside the giant frame of the heavyweight boxer Sonny Liston. The ad agency's creatives dressed Warhol in an outdated black-leather jacket and had him spouting pseudo art talk about work he hadn't made in years: "There's an inherent beauty in soup cans that Michelangelo could never have imagined existed." The spot's punch line is that Liston, a genuine figure from mainstream popular culture, stares at the gabby, wacky artist without uttering a word, as though the gulf between them is too big to bridge. The reality of who Warhol actually was, let alone his true genius, mattered so little to anyone involved in the ad (even or especially to Warhol himself) that when it turned out that he'd spoken too quietly during the commercial's shoot the ad agency was happy to dub in another voice, whiny and swish but otherwise quite unlike his.

The fact that the editors of *Sports Illustrated* found the ad worthy of coverage gives an idea of how deep had been the penetration into the mainstream by Warhol—or, at least, by some image of Warhol that the mainstream preferred to see.

This wasn't the first time Warhol the outsider had played mascot. You get a sense that in the 1950s his camp manner and fey illustrations appealed to some art directors as a little piece of gay "decorator" culture that they could safely assimilate into their magazines and social world. Warhol was happy to be the pixie they were looking for if it would help him sell. As homosexuality began to find a place in television culture in the early 1970s, it was with swish figures like Charles Nelson Reilly playing a similarly unthreatening role as jester. That makes it hard not to notice a parallel between the two outsider roles that Warhol always had to play, as both a (more or less) avowed homosexual and an avant-garde artist. There's some poignancy in watching him try to get both accepted into the mainstream, and in how he could do that only by removing any threat that either might pose to it. Here and there, in his diaries and private conversations and even in a few public statements, you get a sense that Warhol was less than thrilled at always having to play the fool. Like some of the classic fools in literature, he also seemed to know that this role actually gave him a certain power over those who couldn't see that he was playing it, and thus a sense of his own superiority over them.

"For me, the most confusing period of the whole sixties was the last

sixteen months," Warhol is supposed to have said, looking back at that period from a distance of more than a decade. Yet those months, for all their confusion—or maybe because of it—turned out to be a watershed in his career. They show Warhol leaving behind an old, countercultural cutting edge and going out instead on a new one built around his complex interactions with popular culture. In the twenty-first century, his most important heirs would follow him there.

*. . . with a (borrowed) Academy Award.*

# 1969

VALERIE SOLANAS GETS OUT | MORE SURGERY |
ROLLING STONES ALBUM COVERS | HOLLYWOOD
FILM PLANS COLLAPSE (TWICE) | GERARD
MALANGA'S "MALE PARADE" | THE BIRTH OF
*INTERVIEW* | BUSINESS ART, THE NEXT STEP
AFTER ART | FROZEN FOODS AT THE ANDY-MAT

*"I have old scars and I've gotten some new ones.
And you can't tell which one hurts more. It's really funny"*

Paul Morrissey remembered a day just before Christmas 1968 when the phone rang in the Union Square studio. He picked up as Warhol looked on. It was Valerie Solanas.

SOLANAS: Hi. Listen Paul, I gotta talk to Andy.

MORRISSEY: Well, he's not here to talk to you. Where are you? Where are you, Valerie? Are you still in jail?

SOLANAS: No, I'm out of jail. Listen, I gotta talk to Andy. I need $20,000 for my legal defense.

MORRISSEY: Oh really?!

SOLANAS: Listen, it's OK. Tell Andy it's OK. I don't have anything against him, but I need the money to pay my lawyers. But don't worry—I don't expect him to give it to me as a gift. I'll let him hold the original manuscript of my *SCUM Manifesto*.

MORRISSEY: Well we don't have $20,000, and if we did we wouldn't give it to you, especially for this. And we don't want your *SCUM Manifesto*.

SOLANAS: Listen, he can help me a lot. I really need the money to pay the lawyers, but I really want something else from him too.

I want him to get me on the Johnny Carson, Merv Griffin shows,
because he knows all those people. He can get me on like that!

And that'll help me too. Then I can ask for money on the shows.

MORRISSEY: We can't get anybody on the Johnny Carson show! Stop
calling!

Morrissey's next conversation was with the police, who confirmed that
Solanas was in fact free and on the streets of New York once again. A sup-
porter had fronted the $10,000 for her bail. Years later Warhol remembered
his reaction: "My worst nightmare had come true—Valerie was out."

Back in September, newly recovered from his wounds, Warhol had told
several reporters that he forgave Solanas and that he wouldn't press charges.
Writing from the Matteawan State Hospital for the Criminally Insane a few
days later, she returned the favor by saying that she too was willing to forgive
and forget: "I'm very happy you're alive + well, as, for all your barbarism,
you're still the best person to make movies with, + , if you treat me fairly,
I'd like to work with you." That collaboration couldn't have topped Warhol's
wish list, but Solanas didn't let up. "You can ride along only so far with Viva,
Bridget Polk + the rest of your trained dogs," she counseled him in one of
many letters that followed. "Having worked and associated with me, you've
had a taste of honey, + it must be awfully difficult to have to go back to Viva
saying 'Fuck You' in restaurants."

Solanas's call to the studio in December was a mistake. Morrissey ap-
peared in court to say that she'd threatened them and that got her locked up
again. "This is terrible!" said the judge. "Who gave this woman bail in the
first place?!" To which the prosecutor replied, "Oh, you did, Judge!"

The district attorney pursued the case against Solanas—he didn't need
Warhol to "press charges"—and in February he let her plead to first-degree
assault rather than attempted murder. His office told Morrissey that bring-
ing the murder case all the way to trial might simply end in Solanas being
ruled mentally ill, although Morrissey saw that as a disgusting cop-out: "She
tried to kill, with two guns, four or five people!" he protested. The sentenc-
ing happened in June, and although facing a maximum of fifteen years in
prison Solanas was given only three, with one off for time served, but she
was still furious at her sentence. "I didn't intend to kill him," she said. "I just
wanted him to pay attention to me. Talking to him was like talking to a
chair." Of course Warhol and his people had wanted her locked up for much
longer. "You get more for stealing a car," said Lou Reed, complaining that
the light sentence reflected the contempt Warhol was held in by mainstream
America.

Almost as though Solanas still had some power over Warhol, even from prison, the wounds she'd inflicted were acting up again. In March he spent another eleven days in the hospital for surgery to close a leaking fistula and fix some breathing troubles, an operation performed, at Warhol's insistence, by the same surgical team that had saved his life the first time. "I have old scars and I've gotten some new ones," Warhol told a reporter in May. "And you can't tell which one hurts more. It's really funny." He still suffered drainage at least through the fall, and records from a year later show him filling lots of prescriptions and buying barbiturates regularly—for pain and insomnia, probably.

Not long after the second surgery, an art-critic friend quizzed Warhol on his state:

> I asked him how he felt after all the operations that had been necessary.
>
> "It's all the same. I mean, I can eat everything. But it's different. It feels different."
>
> How?
>
> "I mean . . . maybe it would have been better if I had died."
>
> For the first time there were visible signs of emotion.
>
> "I mean it's so-o-o awful. Everything is such a mess. I don't know. It's so hard."
>
> I mentioned that he seemed cheerful and full of new projects.
>
> "Yes, I know. But you have to . . . you know, you have to pretend."

Warhol wasn't the only one coping with the psychic effects of violence in those last years of the '60s. What had happened to him seemed mirrored in the entire nation's emotional life. The assaults on Warhol and Bobby Kennedy in June, following on the murder of Martin Luther King Jr., and the burning of Washington and Chicago in April, had put the nation ever further on edge. As Warhol lay recuperating at home, he had heard news of the battles at the Democratic convention in Chicago, of continued crisis in Vietnam, and of the Soviets pushing into Czechoslovakia—"tanking," as the artist put it, through the Warhola homeland.

The new hazards were even closer at hand in the New York Warhol loved. The cheery Big Apple of *Guys and Dolls* that greeted him when he'd first arrived was on its way to becoming the nightmare metropolis of *Taxi Driver*.

In February of '68, when Warhol's studio was just making its move down-town, a sanitation workers' strike had filled the streets with one hundred thousand tons of trash, and the National Guard had almost been called in as scab garbage collectors. It took decades for the city to get clean again, and New Yorkers had to learn to see filth as normal.

In June, on that grim afternoon when Warhol and Solanas crossed paths, the Union Square he arrived at wasn't what it would have been fifteen years earlier, when several of his cultured friends lived nearby. Drug dealers, junk-ies and rough trade had taken over the park. "We are asked by strangers if we would be interested in uppers, downers, heroin, or marijuana sold as loose joints," noted an art director from Miami who visited Warhol's studio with his wife. "They are $1 each; cocaine is $75 a gram." Poised above this commerce, Warhol's new studio building began to suffer any number of bur-glaries, as a letter from the landlord warned its tenants. As surgeons were working on Warhol at Columbus Hospital, his old friend Ray Johnson was fetching a paper to get news of the shooting when he got mugged, with a knife. That led Johnson to leave New York for the country, for good. Warhol stayed, but like all New Yorkers he had to get used to chaos that would have been unthinkable just a decade or so before.

When Warhol and his crew had sat down for his first postshooting in-terview, Viva told the reporter about the home invasion she'd just suffered from "a professional attacker—all he does is beat up people." (In her usual fine form, she'd managed to smash her assailant's skull and send blood spat-tering everywhere.) Later, after those armed junkies had invaded Warhol's still-unfortified studio, he stayed home for a week. He responded with terror to the news that another employee had been robbed at knifepoint: "Oh, I'm freaking out, it's just too scary. I mean, I don't feel like going out anymore, it's too scary," he said in a call recorded the day after the attack. He loved to hide cash in his boot and would not have liked the idea of parting with it, especially under threat of bodily harm.

New York's murder rate had more than tripled since Warhol arrived in the city; days after Warhol's own near death, President Lyndon B. Johnson ordered the formation of a U.S. National Commission on the Causes and Prevention of Violence. "I don't know what to say about the violence and all that going on now," Warhol announced one day, when contemplating his own early '60s Death and Disaster works. Their dangers were starting to look so quaintly mild-mannered. "Don't you think New York is scary?" he asked a reporter from Los Angeles.

Warhol was a fan of shocking headlines: He was supposed to have been delighted that his great tabloid painting *129 Die in Jet!* was based on a front

page from six years to the day before he was shot. But the late-1960s menace he was encountering wasn't news he could use. There had been a whiff of critique and politics in his Pop Art, but most of it also evoked the optimism of the 1950s when he'd first found success in New York. Liz, Marilyn and Elvis hit stardom in the cheery decade before Warhol began to depict them; Campbell's Soup was an even older, cheerier product of American know-how. The Brillo Boxes, though based on a brash new graphic design, were all about an Eisenhower-era belief in the cleansing magic of U.S. goods. Even when Warhol depicted more dramatic subjects—the electric chair or Jackie after Dallas—you could see their drama as having been neutralized and made commonplace by the sheer fact of having been painted by the limner of Campbell's Soup. Warhol had made a complex art of the '60s from his immersion in the happy clichés of the times just gone by; his Pop Art needed that tension to work. All this made a new, post-1960s reality of threat and anxiety especially inhospitable to him, as both artist and man. He'd need to find a new direction.

———

It was only in the late spring of '69 that Warhol seems to have been fully back in the saddle, with a high-profile commission that saw him engaging directly with popular culture once again, this time without any Duchampian distance from it. In April, Mick Jagger was writing to offer him the cover of the latest Rolling Stones album. "In my short sweet experience," said Jagger, "the more complicated the format of the album, e.g. more complex than just pages or fold-out, the more fucked-up the reproduction and agonizing the delays. But, having said that, I leave it in your capable hands to do whatever you want."

Warhol had known the Stones since the fall of 1964, when Jane Holzer arranged to bring together America's biggest Pop artist and Britain's baddest rock band, in the United States for its second tour. The following summer, Warhol had wanted to involve the band in *Vinyl*, his (sort-of) film version of *A Clockwork Orange*, but the collaboration didn't pan out, and for that matter neither did the record cover Jagger wrote to him about in 1969. By the time the artist and the band finally did work together, in early 1971 for the cover of their upcoming *Sticky Fingers* album, Warhol came up with something as complicated as anything Jagger could have feared two years earlier.

The artist designed one of the most ambitious record jackets to date, yielding the most "fucked-up" production troubles and excruciating delays. It looks as though there was a moment when his concept was actually re-

jected and Warhol was looking for a kill fee. But once it got the go-ahead, his cover consisted of a close-up on the crotch of a man wearing jeans, with a real zipper glued in that you could open and close. It was a clever promotional gimmick: Ads for the album read "'Sticky Fingers'—Unique Cover Design By Andy Warhol—3.38 each LP—With Real Zipper and 10 Great Songs." (Note that Warhol and his zipper get billed above those "10 Great Songs.") It was also a packaging disaster, since the zippers managed to scratch and warp the vinyl inside, especially when albums were stacked for shipping to record stores. The cover photo itself must also have given pause to retailers: It was bad enough that it zeroed in on a man's crotch, but the huge bulge inside it saw Warhol taking the Stones' bad-boy image to a new level. In the space of four years, American culture had moved so far that the phallic hint of the Velvet Underground's "banana" cover could become all phallus, no hint.

(For years, there was debate about who could take credit for the cover's bulge, which was claimed by several young men whose crotches Warhol had brought before his camera. "You can tell your anatomy, if it's you or not. That's all I can say," said one claimant.)

However naughty and daring that crotch might have been, however, it signaled Warhol's continuing move away from the creative vanguard. The cover itself was not notably avant-garde by the standards of that moment's fine art, or even Warholian: A buyer would have had to look for the cover's credit line to know who designed it. The project's suggestion of same-sex desire was the only thing that might have given Warhol away as its author, but even that got offset by the virility of the band's image and music, "aggressive, noisy, irreverent and supremely self-confident," as one critic put it—not words that could ever have been used of Warhol, or of many gay men of his generation. The gay subtext to Warhol's latest commercial commission recalls the appeal of his 1950s illustrations, except that it was so much less central to the work his cover did in the culture. Despite its wildly high profile—or, more likely, because of it—the Sticky Fingers cover was about as close as Warhol the Pop artist ever came to being purely an eye and a name for hire, filling a client's image needs rather than his own.

Warhol charged the band $4,000 for his work on Sticky Fingers, which looked good at the time but soon led to seller's regret. "That became a number-one album and I only got a little money for that," he told a friend when the record had finally come out. "The next time I do anything, I'm going to try to get a percentage. Like a penny on every album sold."

While Warhol was putting on his graphic artist's hat for the Stones, he was also testing what life there was left in his role as filmmaker. By the beginning of May 1969, he was at a press conference for the long-awaited premiere of *Lonesome Cowboys*, having his laconic answers "translated" by Morrissey, according to a report by the film theorist Parker Tyler, whose work Warhol had known since college days. "Morrissey underlined Warhol's admission that his own painting was 'junk,'" wrote Tyler, "and that in any case his films bear no conscious relationship to his painting. His films seek to be entertaining, Morrissey declared, and entertaining only. 'No art please' is the tacit gimmick." Morrissey no doubt meant all this as a quiet little dig at his boss and now rival, but Warhol could have taken it as a complement. No-art was looking like his recipe for new art as the 1970s approached, and no-art, as Warhol had proven with the Schrafft's commercial, might include art forms so popular they didn't have a toehold in museums and galleries. "Gee, David, you're still into art? I can't understand. You should've expanded into entertainment," said Warhol in a call to his art-critic friend David Bourdon.

It's not clear how entertaining the plotless *Lonesome Cowboys* could really have been for a moviegoing public accustomed to the adventures of Herbie the Love Bug. Its entertainment value must have mostly come from the last-gasp picture it gave of underground weirdness. But that was still appealing enough to draw capacity crowds. *Variety* wrote an entire article about the success of Warhol's new outreach to a mass public, and the article's title is like a miniature profile of the artist at this point in his career: "More Structured, Less Scandalized Warhol Aiming for Wider Playoff." The piece talked about the "smacko" box office that *Cowboys* did during the first week of its run, when it broke the one-day record at the mainstream (if tawdry) cinema where Warhol had managed to get it shown. All that was enough to get Warhol dreaming of the full-blown Hollywood mainstream, and working his contacts to make something happen.

"If only someone would give us a million dollars," he whined, to anyone who would listen or help. He professed grand plans to take his superstars on location—to Japan, India, Paris—and began to wax lyrical about such classic Hollywoodisms as the "terrific abstract cuts" of Orson Welles. "Actually, I want to make a movie now using straighter people than the unusual ones we've used," Warhol told a reporter for *Playboy*. Just before he was shot he (or more likely Morrissey speaking for him) told another girly magazine, *Jaguar*, that a major Hollywood studio was already in the market for a new Warhol movie. By that fall, Warhol seems to have thought of filling that demand by selling the movie rights to his novel *a*, "so Ondine and I could

see great-looking actors like Troy Donahue and Tab Hunter playing us." He approached his old friend Lester Persky, a newly minted film producer, who replied *"Please,* Andy. I'm trying to forget where I came from. It's literary *properties* I'm looking for—not atrocities." Further "atrocities" soon pitched by Warhol included *Dracula's Baby,* the first horror movie with a nude cast, to be set in Brooklyn Heights with "a very interesting rock score" written by the poet Edith Sitwell, Warhol's literary idol during his first years in New York.

And yet—"incredible as it may seem," as one Hollywood columnist exclaimed—the majors really did come looking for a Warhol-signed project that winter of 1968–1969. Morrissey joined forces with an L.A. writer named John Hallowell on a screenplay pairing real movie superstars and the Factory superstars who had aped them. *Variety* reported that the $100,000 project was going to pair Candy Darling as the leading lady with walk-ons by such figures as Natalie Wood and Troy Donahue, who happened to be true stars both of movies and also of Warhol's Pop paintings.

"It looked like Hollywood was finally about to acknowledge our work and give us money to make a big-budget 35mm movie," Warhol later wrote. This, after all, was the very moment when "advanced" filmmaking was gaining a mass-market appeal it had never had before, or would again: A jaw-dropping roster of new talents such as Robert Altman, Francis Ford Coppola, Stanley Kubrick, and Martin Scorsese were on their way to infiltrating "normal" Hollywood movies. It didn't seem utterly absurd for Warhol, a recognized master of radical film, to join their ranks. Jane Holzer remembered doing some acting in Hollywood and being astounded at the interest in Warhol's radical filmmaking: "Here were these directors whom studios had given a lot of money to asking me, 'How does he make a film,' you know. 'Tell us because we want to make films like him'—I mean, it fucking blew my mind."

Warhol loved the access that the casting of his new project gave him to movie stars. He teased Hallowell for dropping Hollywood names but was delighted when the writer got Rita Hayworth to call him—"but somehow we couldn't really talk to each other, maybe because she was shy and I was shy. . . . She was very sweet, but it was sad because she was slurring her words and sounded sort of lost. She said she just knew I'd make her 'the most super star of all.'" For all his love of famous people, Warhol always mixed wide-eyed admiration with flinty schadenfreude.

The actress and the artist did cook up a plan to appear together on the Academy Awards broadcast a couple of years later. It fell apart, however,

when Warhol got blackballed from the show by one of the stuffier Academy members.

By the early summer of 1969, Hallowell had arranged for Columbia Pictures to fly Warhol and a little band of acolytes out for a first meeting— even though the press had already been announcing a September release date for the finished film. In L.A., Warhol and his people were feted at a discotheque called the Factory, whose name alone proclaimed the artist's settled place in the popular imagination. Warhol had a grand time hobnobbing with celebrities, according to Jed Johnson, who joined him on the trip. There's a nice symmetry to the fact that the city that had hosted Warhol's first Pop Art solo, just seven years before, was the site of his first major attempt to move beyond Pop.

When it came time for the business of pitching the new movie, the actual meetings with the studio were going fine, at least by Warhol's reckoning. Then Morrissey thought to mention a planned sex scene with a Great Dane—off camera, he assured everyone—which sent the executives into shock. They canceled the project "for 'moral reasons,'" Hallowell told Warhol in a call, after the artist had returned to New York: "Don't you love it? . . . They're about as moral as Attila the Hun."

Writing a while later, however, Hallowell implied that Warhol's incurable, irrepressible weirdness was the true problem. Even for a meeting with the studio head, the artist had arrived late and with his entourage in tow and then sat sphinxlike as Morrissey gabbed. Executives weren't convinced that Warhol was a bankable product or that he could make a film that was. As Bob Colacello later put it, "Andy wanted to be Louis B. Mayer and Jean-Luc Godard at the same time"—an oxymoronic desire.

After the Great Dane episode, Warhol waited for a definitive answer from Columbia for all of four days—barely a moment, in Hollywood time—then packed up his superstars and went home. A new Warhol staffer remembered the artist's frustration when he got back: "Andy's thing was that they brought him out to Hollywood just to put him down. . . . You don't do that to somebody like Andy. He was so shy and he was very sensitive and he didn't like it. . . . It's not interesting to be flown out to be put down."

And yet, despite Warhol's "sensitivity" and the utter failure of that first shot at Hollywood, he tried again all of two years later, once again riding Hallowell's coattails, short as they were. (Warhol's taste in middlemen was often doubtful, possibly because his insecurities prevented him from imagining that he deserved more powerful associates or, equally plausibly,

because deep down he preferred interesting strivers to true, dull success stories.) Hallowell had become obsessed with the inside access he had to a rock star named John Fogerty, of the band Creedence Clearwater Revival. As far as Hallowell was concerned, Fogerty might as well have been the offspring of Beethoven and Elvis. When the writer came up with the idea of a movie that paired his "rock god" and the art god named Warhol, the pitch made Hollywood executives "come apart at the seams"—or so he claimed, at least.

Warner Brothers agreed to fly Warhol and his posse out to L.A. for further talks, meeting the artist's demand for first-class tickets for all and a Carey limousine to meet them when they arrived. (The latter was maybe a quiet nod to his cute '50s friend Ted, who was from that limo dynasty.) The grand old Beverly Wilshire Hotel acted as mission control for the visit: "ANDY WARHOL at one end of The Sixth Floor, in a Suite. ROCK GOD at the other end of The Sixth Floor, in a Suite. SUPER STARS sprinkled in between," recalled Hallowell, a few months later.

Warhol did endless, manic shopping for antiques—he didn't hesitate to wake up one dealer in the middle of the night to get a look at his goods—and he also visited Marilyn's grave, snapping Polaroids of everyone and everything he saw. He partied in some of Hollywood's grandest mansions, with some of its grandest people—George Cukor, Shelley Winters, Leslie Caron—and he even did a TV appearance on Regis Philbin's first talk show, where he naturaly let his followers do the talking for him.

Like his earlier L.A. visit with Hallowell, this one lasted precisely four days. And once again, Warhol left empty-handed.

"They say the movie will *go*. Odds are ROCK GOD will say YES," wrote Hallowell in an account of Warhol's visit, not long after it happened. But Rock God stayed silent and the movie went nowhere, like every time Warhol tried to woo Hollywood.

The problem may have been that, deep down, Warhol was still—and always—thinking of his dive into pop culture as his latest high-art performance. With the Schrafft's commercial, he had taken up advertising culture by infecting it with a wacky avant-garde aesthetic; his mainstream clients thought they could profit from the infection. The producers in Tinseltown weren't quite so sure. They didn't mind a bit of artiness creeping into films like *Easy Rider* if it gave them a product that filled a niche market. But they had no interest in seeing some weirdo artist muscling in on the actual popular culture that they had always controlled.

Or maybe they simply realized that no matter how much Warhol tried

to go popular, his weirdness would always win out. An unpublished diary entry about a screening of *The Discreet Charm of the Bourgeoisie*, Luis Buñuel's surreal masterpiece, gives a rare glimpse of Warhol's true tastes, and true sophistication:

> I thought the movie was wonderful wonderful wonderful, and it was reminiscent of Bunuel's earlier movies, especially the cockroaches coming out of the piano, and it was so much fun remembering how Bunuel used to work with Salvador Dalí many years ago. The dreams were so great, and there were so many of them, and everything was so clever and witty and French. The French certainly know how to use irony. It's wonderful how loyal they remain to the good old jokes. I think the symbolism in that movie will give me things to think about for a long time to come. If there was ever a movie that deserves commercial success it's this one. . . . Later, after the movie, outside on 57th Street, a young man came up to me and asked me how I liked it, and I was practically speechless because how could I put into words my admiration for a talent so vast as Bunuel.

It took Warhol a while to recognize that he would only ever appeal to the masses as the misfit among them. He could dress in Lacoste, but his silver wig would always be there on top.

---

The first L.A. debacle had ended just a few days before the first anniversary of Warhol's deliverance from death, which was marked at his studio with a lunch ordered up from its usual purveyor, Brownies health-food restaurant on Sixteenth Street. (Warhol toyed with healthy eating for years, occasionally backsliding to liquor-filled chocolates and mashed potatoes.) A year had passed, and Warhol wasn't much closer to finding a way forward for his art. His Hollywood options weren't looking good but he still seemed to have film, or at least the movie business, on his mind.

"Isn't the art scene today revolting? I wish I could find a way of making it worse," said Warhol to his old friend Cecil Beaton. He did. Within a few weeks of his return from L.A., Warhol had rented a grand old theater in the East Village as a place to screen an ever-changing, nonstop, morning-to-midnight roster of crude gay pornography, under the title "Gerard Malanga's Male Magazine" and sometimes "Gerard Malanga's Male

Parade"—with no sign that, for this one project, Warhol himself ever cared to have his own name attached to it. He went out of his way to describe Malanga as "embarking into business on his own" with the venture, in a gossip column that came out just before the films began to screen. The ads for Malanga's "parade" quoted (or more likely, misquoted) Warhol's art-critic friend Gregory Battcock on the offerings as "genuine anti-art statements" and "among the most important artistic documents created during our time." But Jonas Mekas's review was probably more accurate in describing the "all masturbation program" as "pretty ridiculous and very depressing." There must have been quite a contrast between the genteel, allegorical ladies painted in the vintage theater's murals and the men in motion on its screen, and in its seats.

According to the early Warhol biographer Victor Bockris, Malanga and Morrissey were put in charge of the place, where they used the prestige of underground film to charge $5 a ticket for snippets of porn that would cost half that to watch in Times Square. Joe Dallesandro played projectionist and seems to have run a side business in "services rendered" to customers on a couch near his booth, while the ticket taker was skimming a share of the gate. Everyone made good money from the project except Warhol, who closed it down after six weeks, ironically at almost the same moment that the police shuttered *Blue Movie*.

———

It was one of the signature projects of Warhol's final two decades, and it too had a cinematic slant. Its genesis myth says that it came about because Warhol was too cheap to buy movie tickets: "We needed to get passes for the New York Film Festival—press passes, which we were denied originally. So we decided to start a magazine so we could, you know, be accredited," said Gerard Malanga. Thus was born *Interview,* one of the most notable publishing ventures of the late twentieth century.

Unless, as Malanga and others have also claimed, it came out of Warhol's desire to give Malanga "something to do." Renting out the Silver Factory flicks turned out to be much less than a full-time job, and the "Male Parade" had lasted only a few weeks.

Both explanations sound like just the kind of simplifying myths that Warhol liked to spread to cover up the real complexities of his life and art and intentions. After all, what festival organizer would really have denied tickets to a film superstar like Andy Warhol? And even if Warhol was denied them, no amount of money he could have spent on festival tickets would have come close to the thousands it would cost to launch a

magazine, no matter how crude and homemade. Anyway, Malanga dated the origins of *Interview* to the spring of '69, and therefore before anyone would have been likely to ask for, or be denied, a press pass for a festival that ran at the end of September. (One way or another, Warhol ended up getting his pass.) A letter from Malanga shows that work was already well along on the first issue of *Interview* by July.

A more likely birth story for the magazine has Warhol phoning his friend John Wilcock, a *Village Voice* founder who was then putting out an underground tabloid called *Other Scenes,* to complain about his lack of traction with Hollywood:

> Off-handedly I said, "Well Andy, all my friends publish newspapers; why don't you produce a paper?" It was met with a noncommittal grunt, but ten minutes later Andy called again. "What kind of a paper?" he asked in that querulous, uncertain voice. I remember telling him that a film paper would be an obvious choice. . . . What style would the paper follow? I asked, figuring that anything Andy came up with would be imaginatively innovative. "I want it to look like *Rolling Stone*," he said determinedly, to my surprise.

Warhol and Wilcock agreed on a fifty-fifty partnership, with Wilcock taking care of design, typesetting, printing, and distribution, and Warhol's team taking care of the content. "It was really Andy and me, as the only editors. . . . Paul's name was strictly figurehead," said Malanga, who also recalled having artistic control over the page design, since "nobody else wanted to do the dirty work."

The first issue looks like it came out in September—its tyro editors forgot to date it—under the title *inter/VIEW: A Monthly Film Journal,* which gives some idea of how much Warhol was still thinking in filmic terms. (It also bore the tag line "First Issue Collectors Edition," wishful thinking that later came true, with a vengeance—a fine copy can go for $1,000.) That word "journal" gives a sense that Warhol, despite his speed date with Hollywood, was still toying with avant-garde erudition. Even nineteen issues later, *Interview* still had the subtitle "Andy Warhol's Movie Magazine," showing that he thought that movies—if not "film," any longer—could help sell a publication to the public.

Put out under the corporate banner of the elite-sounding Poetry on Films, Inc., the whole first issue was in tension between high and low. "A mishmash—it was inclusive," said Malanga. The images on the cover were

taken from Agnes Varda's *Lion's Love*, "an intellectual film trying to be commercial," but they featured Viva and its male stars without clothes, in a kind of Page Three gambit moved to page one. (And to the back page as well, which was given over to a still of a topless actress who looks barely pubescent, from a long-forgotten movie about a Warholian shrink who films his patients' doings with a hidden camera. The magazine's many bare breasts were Wilcock's idea, because he found they'd always helped the sales of his other publication.)

Inside *inter/VIEW*, a thoughtful essay by Jonathan Lieberson, later of the *New York Review of Books,* came peppered with stills from old Busby Berkeley movies. "Advanced" film reviews written by Taylor Mead and Ondine as well as poems by Malanga and others came paired with a bikini centerfold of Raquel Welch and the barely edited transcript of an interview with big-budget director George Cukor (*The Philadelphia Story, My Fair Lady*). An early review of the first two issues cheered them for treating movies ("not 'Cinema,' you effete ding-alings!") as "art in the service of pleasure, fun, titillation (ah, titillation) amusement, wonderment, imagination, excitement, fantasy and the 'head.'"

As time went on, *Interview* lived up to its name by giving more and more space to taped conversations and less and less to brainy analysis. Warhol's bride "Sony" was put to work every month in aid of a project that counted as the apotheosis of his longtime interest in recording every detail and moment in his life and environment, now expanded to include an entire social set that had him, and especially his magazine, at its center. "By personally participating in these interviews, month after month, the limelight reflected on Andy himself. In many ways, *Interview* became both a vehicle *and* advertisement for Warhol," recalled Bob Colacello, who ran the magazine in the '70s. "Andy also liked tape recording because it was cheap—good writing costs good money. Any college kid could turn on a tape recorder, ask a few questions, then type up the tape."

Pat Hackett remembered the operation as so low-budget, at least at first, that when a libel lawyer had insisted, at the last minute, that a reference to someone as a "drag queen" needed to be changed to plain "queen," Warhol and his entire "newsroom"—meaning Malanga, Morrissey, Hughes, Jed Johnson and Hackett herself—had to sit making the change, with black markers, in copy after copy. "This is like doing penance," Morrissey said. "'I will never call him a drag queen again, I will never call him a drag queen again.'" Writers got paid all of $10 or $20 per article, but even an old Factory hand like Taylor Mead had a hard time collecting those modest fees: Warhol told him that an early editor had absconded with the magazine's funds. The

artist did have a big enough commitment to his new publication to surrender his new tenth-floor "painting studio" as its offices.

Malanga said that when the first issue came out, he was greeted as a star at Max's: "All of a sudden here I am at the head of a magazine, which was basically a newspaper modeled on *Rolling Stone*." Too bad he lasted only two more issues. Malanga got into a fight with Morrissey and Hackett over their cuts to a poet friend's work, and then got his revenge by billing Hackett as "pencil pusher" on the following month's masthead. Almost fifty years later, he still remembered Hackett's shrieks when she saw the issue, and a furious Warhol walking out of the little office he shared with her: "You're fired!"

With Malanga gone, *Interview* eventually lost all its poems and most of its "serious" content while also gradually moving away from movies and toward pop and celebrity culture. Warhol said that one of its goals had been to get kids to "dress up again," and for a while the subtitle changed to "The Monthly Glamour Gazette." Not that the first few years' product was anything like the slick publication that was making a splash a decade later. Warhol was still talking about closing the magazine after its second anniversary—although he was determined not to refund money to subscribers—given that out of five thousand copies being printed each month under two thousand copies were actually getting sold. That was barely enough to serve the total clientele at Max's. It was certainly not enough to turn any kind of profit. The magazine, Hughes remembered, "wasn't exceptionally practical. Andy just wanted some of his poet and writer friends to look busy."

And even once some businesslike investors came on board and circulation moved up into five figures, the magazine's expenses almost always exceeded income. "It would just be great if it could pay for itself," Warhol said in the summer of 1977, when the magazine had just made $56 in profits on a six-month revenue of $108,000. "I always thought it should be for new people, but I guess there aren't enough new people to buy it. You go to these rock concerts, and they can fill up a place with 30,000 people. It's funny. They aren't the same people who look at magazines." He once claimed that putting celebrities on the cover had just been a trick to get people to read about the *"new* people" that he had always really wanted to feature inside.

The truth is, it took many years before Warhol was willing to shelve the innate contrariness of an avant-gardist and permit the "concessions to commerciality" that *Interview* investors were always hoping for. As a well-trained modernist, Warhol had always said he preferred interesting errors to dull perfection. "Why do you have to spend so much time proofreading?" he'd ask the staff at his magazine. The interviews that Warhol himself conducted had to be carefully "redacted" by staffers so that "something too hot

for publication" would not appear in print. As late as 1974, when a *Newsweek* feature raved about how *Interview* was now on "the lacquered coffee tables of international trend followers," the writer could still point out that Warhol's magazine managed to misspell Jack Nicholson's name—on its cover. But that little remnant of strangeness was also part of the magazine's success. The outré artist's essence that Warhol still trailed kept *Interview* just that touch more compelling than its more truly mainstream competition.

"Not everything was Andy's idea, but Andy was the magazine," said a staffer from its late-1970s heyday. "The magazine would have never looked like it did if Andy hadn't been there. Like with the films—he didn't do anything, but he did everything. It's very difficult to explain. The man had the ideas, the courage first, even if everybody else was helping. Andy was Andy. Andy was the genius."

———————        ·

Years after the event, Warhol recalled his return to the Union Square studio: "I was confused because I wasn't painting there and I wasn't filming there. I would just sit in my tiny office and peek out toward the front at Paul and Fred taking care of business." Before long, however, it dawned on him that in "taking care of business"—shooting movies under his name, selling his prints, and finding him portrait commissions—his peons were executing a new kind of art for him, the way Malanga and others had executed some of his early silkscreens. "I knew that work was going on, even if I didn't have any idea what the work would come to," Warhol wrote. That corporate "work" turned out to be some of the most important art he ever made—"Business Art," he came to call it, "the step that comes after art." It established that everything this artist would do as head of Andy Warhol Enterprises, Inc.—as portraitist, publisher, publicist, celebrity or salesman—counted as components in one boundless work, part performance art, part Conceptual Art and part portrait of the market world he lived in.

"You're a killer of art, you're a killer of beauty, and you're even a killer of laughter," said a drunken Willem de Kooning to Warhol at a party at the end of the '60s. The last of America's Old Masters was right; he just didn't realize that he'd zeroed in on the true, important achievement that would dominate Warhol's later career.

"The new art is really a business," Warhol told a reporter late in 1969. "We want to sell shares of our company on the Wall Street stock market." That never happened and was probably never supposed to. But, coming after his 1950s persona as a fey window dresser and his '60s costume as a shade-wearing hipster, Warhol's '70s uniform as hardheaded capitalist, at

the head of any number of corporate enterprises, must have seemed right for the times.

"I'm a commercial person," he said in a documentary shot in the early years of the Union Square studio. "I've got a lot of mouths to feed. I've gotta bring home the bacon."

He almost always billed his society portraits as a purely financial venture, easier and more profitable than the other arms of his corporation (which they were) but also more annoying (which they also often were): "If we could just make a living out of movies or the newspaper business or something—it's so boring, painting the same picture over and over," he said, after doing just that for the better part of a decade.

He was equally forthright about how little creative investment he had in the later films. From *Flesh* onward, he was happy to give Morrissey all the credit for the movies that came out under the Warhol name. (With the exception of *Fuck*, which Morrissey wouldn't have wanted on his résumé, anyway.) Warhol recognized that his own role was limited to funding and branding: "What's funny," he said, "is that people pay three dollars because it says Andy Warhol." He knew that the late movies became true "Warhols"— that's how they were almost always described in the press—only as instances of his new Business Art, which meant that his CEO persona gave him yet another chance to play with normal notions of authorship, and to undermine them. All this drove Morrissey just about mad, since he felt he was the only real "author" of his movies and could never understand the more complex, avant-garde games Warhol was playing in accepting a role as a new kind of corporate creator.

Warhol's role in *Interview* was also more supervisory and managerial than strictly creative. In 1972, his name went on the cover even as he was surrendering almost all the work on each issue to a team of more or less talented underlings. One of the magazine's early editors said that Warhol never even read an issue until it had returned from the printers.

The fact that *Interview* didn't chalk up a profit was not a sign that it was a failed artwork, even in Business Art terms. If the magazine didn't find a buying audience, that just made it like so many of the more adventurous art objects that Warhol had turned out over the years. Its losses could be likened to the costs of the art supplies that had gone into Warhol's least understood Pop paintings. As a good avant-gardist, Warhol knew better than to judge a work by the reception it got from the public—a lack of public could even be proof of a work's long-term importance. That applied to his creations as a Business Artist as much as to any objects he made. Unlike any real-world commercial enterprise—including the making and selling of

paintings—Warhol's Business Art counted as a success even when it didn't bring in a penny.

In the mid-1970s, Warhol (or a ghostwriter) summed up his position with the famous proposition that "being good in business is the most fascinating kind of art. Making money is art and working is art and good business is the best art." But like most Warholian aphorisms, that one doesn't shed much light on what he was really up to, since the "business" he took on was only rarely "good," at least in standard Wall Street terms.

The real, very Warholian creativity came in making the statement at all rather than in trying to realize its claims. Coming up with the conceit of Business Art, that is, let Warhol produce objects and offer them for sale while insisting that the offering, more than the objects, counted as the art. It was the performance that mattered, not its cash results. In the early 1980s, when Warhol was often billed as a full-blown sell-out, he reacted with unusual venom when his print dealer said they were going to be having a chat about Warhol-brand bed linens. "No. We're not," Warhol told him. "Sonny, I've turned down millions of dollars in deals for sheets and pillowcases and I'm not going to do it for you." In one unpublished diary entry, he said it was "so sick" that rich people could spend $5,000 on sheets.

The aphorism that "Good business is the best art" tells us less about Warhol's real desire for success in business than it tells us about his eagerness always to move forward into virgin territory in *art*—in this case, by dressing it up as business. Irving Blum remembered that, for a while after the shooting, he'd been convinced that Warhol's career had come to an end. "Many people thought that," he said, "and we were wrong."

Very.

Although Warhol only really took on the full mantle of Business Art at the tail end of the 1960s, the groundwork had been laid from the earliest days of Pop. After all, the very first Pop work of his that got into a notable show was that image of two hundred one-dollar bills that he priced at $200, thereby coming just about as close as you could to reducing art to its exchange value. That was certainly a subtext in almost all the paintings Warhol went on to make. Even—or especially—the jolly, apparently superficial Flowers of late '64 could be described by one critic, already writing in almost Business Art terms, as "empty metaphysical vessels that are continually being filled with real money, which is an undeniable triumph, sociologically."

Warhol's own people could buy into this image of Warhol's art as essentially mercenary. "Painting was for Andy not art at all but a way of gaining as much capital as possible," Malanga once recalled, admittedly in a moment of post-Warhol dudgeon. "The least thing ever on Andy's mind was art, or

a very twisted or distorted sense of it. What was merely passed off as art only took a few minutes to execute—for me to silkscreen—while he reaped the financial take." Malanga wasn't entirely wrong. With his rejection of the handmade and of conventional, personalized authorship, Warhol had been functioning as the CEO of an artmaking "factory" for several years, very much in the tradition of past art-world CEOs such as Vasari or Rubens. "Was Michelangelo a businessman?" asked a reporter. "Yes, he made a lot of money while he was working," replied Warhol. What's most interesting about Warhol's version of that venerable role is how much more eagerly he promoted it to his audience than any Michelangelo ever had.

One of those ads he placed in the *Village Voice* in 1966 read as follows: "I'll endorse with my name any of the following; clothing AC-DC, cigarettes small, tapes, sound equipment, ROCK N' ROLL RECORDS, anything, film, and film equipment, Food, Helium, Whips, MONEY!! love and kisses ANDY WARHOL, EL 5–9941." Such a public announcement—it used the real Factory phone number—can't only, or mostly, have been a way to truly bring in cash or goods; it proclaimed that, henceforward, selling out and branded sponsorship would count as signature Warhol moves. Or maybe as his latest art supplies.

He talked in quite open terms about aiming to make profits off the most esoteric of his movies, even the utterly unsalable twenty-four hours of *Four Stars*. In fact it was in discussing the surprise profits from *The Chelsea Girls*, just as he was moving into his businesslike new studio, that he came out for the very first time with the claim that "the new Art is Business."

This was such an obvious fact about Warhol, even for a mainstream audience, that already in February of '68, *Monocle* magazine was inviting Warhol to contribute to a goofy survey it was doing that asked the question "Why I sold out." As the editors wrote to him, "we feel our coverage of artists would be woefully inadequate if you were not represented." Although to our ears this may sound like an insult, they could hardly have meant it as that; at the time, Warhol's self-portrayal as a Business Artist was clearly beginning to gel in the public imagination as yet another of his zany conceits.

Out on art's cutting edge, Business Art might even have been seen as a necessary and brilliant aesthetic move, given the widespread sense that object making had reached a dead end and that some kind of Conceptual Art or real-world performance would have to be the way forward. Money and business were frequent subjects of this new "social sculpture," as it was called by the German art star Joseph Beuys. (In one 1983 tally of artists' press coverage, Warhol came second only to him.) When another artist attacked Warhol as "without talent, a publicist and not an artist," Beuys leaped to his

defense: "Andy Warhol has—and that's where I relate to him—been able to draw society, work, business into his art."

Business-as-art was already in play in the art world as early as 1965, when the poet John Giorno, Warhol's ex-boyfriend, had founded his company called Giorno Poetry Systems as a way of "playing with corporate models," as he put it. Within a few years, the art press was giving front-cover exposure to Iain and Ingrid Baxter, of Vancouver, when they became the N. E. Thing Co., offering (pseudo-) corporate services of all kinds—and calling it art. (Warhol kept announcements of their shows.) In New York, Les Levine, an acquaintance and a young rival of Warhol's, had opened and run a restaurant—as art. He also bought five hundred shares in a volatile stock and declared that the profits or losses from the investment would count as a work of art.

By 1969, *Life* magazine, no less, could feel comfortable running an entire story on these money games that artists were playing. It was almost certainly written by David Bourdon, the *Life* staffer who was Warhol's close friend, and featured Levine's stock market work and another piece that asked the Whitney Museum to take out a $100,000 loan against its collection and to invest the amount instead—as art. That piece was by Robert Morris, whose sculpture *Slab* had sat in front of Warhol's dollar painting in the same group show that had revealed his Pop Art for the first time, back in 1962.

This was the art-world context that Warhol's notion of Business Art was born into, and reveals it as the latest example of his desperate desire to keep up with his artist peers, and to leave them in his dust. Whereas *Life*'s roster of Business artists mostly did their corporate work in museums and galleries, with a wink and a nod to their audience of insiders, Warhol dove deep into the real business world, deliberately confusing the categories of "business" and "art" as no one had before.

That made it possible for the critic John Perreault, writing already in the early '70s, to talk about how "the business of art, as Warhol has hinted at through his works, can be the subject of art" and how "the art system itself can be an art medium. In a business culture, art business can become an efficient comment, not only upon art, but upon business and upon the business culture." Or as another critic put it in the early 1970s, after contemplating Warhol's newfound status as corporate commodity: "Merging life and art more closely than any Dadaist or Surrealist could imagine, Andy is the Zeitgeist incarnate."

And yet Business Art wasn't a pure abstraction for Warhol, or some kind of facile conceit, as it was for his peers in Conceptualism. He was at least

as eager a craftsman when working on his new, corporate production as when he was making paintings or films. He realized that, once he decided to fully take on a Business Art project—and there were plenty he left by the wayside—it ought to be well realized. According to one staffer who first arrived in '69, "business advisers were always amazed at how good Andy was at really understanding the basic concepts of a deal and getting it across—and Andy *was* very good."

Warhol had started out in Business Art with projects that only played at commerce—those endorsement ads in the *Voice;* his You're In perfume—and some later ones were hardly more credible. No one was *really* going to rent his superstars for $5,000 apiece. But it wasn't long before the new, Union Square version of Warhol really did reach out in all directions for commercial opportunities. He tried to get German TV to pay him $600 per minute of on-camera time. (The producers declined.) He agreed to sponsor editioned multiples of all kinds, from Warhol-branded bricks to a Marilyn-shaped soap to Warholian Jell-O molds. (He had a lifelong love of aspics and jellies.) In 1976, the catalog for a high-end department store was selling his services as a private filmmaker for $150,000; a decade later, a different catalog was offering his custom-made portraits, at $35,000 a pop, in a project promoted by Aramis cologne. (Buyers would also get their portraits reproduced, "for free," on nine hundred Christmas cards.)

The next year, Warhol had got everything in place to open the first in a chain of Andy-Mat diners. "They're for people who eat alone," he'd explained a full three years earlier, when he'd started working out the idea. "You sit at a little table, order up any sort of frozen food you want, and watch TV at the same time. Everyone has his own TV set." In the final investor prospectus and architect's drawings—produced by a leading follower of I. M. Pei, the great modernist—the TVs are gone. (Warhol's backers must have realized there was money to be made from less lonely customers.) But the frozen-food concept is still in place: "Techology of defrosting in stages, varied heating times and temperatures for each food item, guarantee that every dish will arrive at table at the peak of its pre-frozen perfection." The whole thing was to be under Warhol's "total artistic control," which might have been a mistake: He intended his "diner" to serve French champagne and creative cocktails, but at Pop-y tables whose place settings would include a child's food "pusher." There were plans to expand to five American cities and Paris—and eventually to London and Tokyo too—but the whole thing died when Warhol ran into some kind of real estate trouble with the Madison Avenue flagship.

Corporate ideas that never got quite so far (luckily) included a chain of

shops that sold goods of one color, a Warhol makeup line, and also neckties made from his paintings' cutoffs. It was never easy to tell which of these counted as simple business propositions and which were Business Art conceits. But the whole point was that, with Warhol, the two were exquisitely, agonizingly blended.

Anyone with more traditional notions of art could dismiss his new corporate persona and practice as purely venal. When *a: a novel* was released in the winter of '68, the critic at *Newsweek* complained that it wasn't *really* by Warhol at all: "He has neither edited it nor written it; he has merely marketed it." But of course that was what made it so distinctly one of Warhol's new works; that, and the fact that even with him as its marketer, it had a good chance of being a commercial flop.

Even Warhol's dear friend Brigid Berlin had a hard time wrapping her mind around his new Business Art model as genuine art. She might have cultivated an extravagant weirdness in her person, but her lack of art training left her stranded when it came to the far reaches of "social sculpture" where Warhol was setting up shop. "I think Andy is a business genius. I don't think he's an artist. He's in another field all of its own. He should be in some town like Chicago, in a big tall building, with his office and his secretaries," Berlin said in a video shot in 1971, before Warhol had even gone far yet with his Business Art. "He gets me really upset when the only thing he can talk about is money. . . . If I try to talk about art with Andy, he steers me off. He completely steers me off." He realized, as Berlin couldn't, that the most interesting way to talk about art, at that moment, was to talk about money. The truth is, most of the art world couldn't follow him when he went there.

Only Warhol's most sophisticated fans could see that his new practice inside the world of commerce might also hint at a critique of that world. Warhol's earlier Pop objects had already "exposed the shoddy mechanics of both contemporary art and society," wrote his lefty friend Gregory Battcock. The artist's final rejection of art of all kinds—of the "form of art itself"—was the most appropriate next response, said Battcock, to "an art and culture market that has debased every shred of meaning that picture making may have had." By declaring Business Art to be the "step that comes after art," Warhol was setting it up as a repudiation of what had come before. That idea of John Perreault's that "art business can become an efficient comment, not only upon art, but upon business and upon the business culture" implied a "comment" that was also condemnation.

The critique implied in Business Art also functioned as a dose of self-protection: Warhol could never be accused of selling out once he'd declared his sell-out to be a work of art with a critique built in. Just when Warhol's

final illness was laying him low, one young critic was grappling with the fact that even work by Warhol that was evidently "bad" and clearly made for purely commercial reasons (there was plenty of it, in his last decades) might actually be functioning as a superlative work of Business Art. What was a fan to do, wondered the critic, with the fact that Warhol's latest self-portrait—his final one, in fact—"has been rendered on canvas in small, medium and large, on T-shirts (extra extra large only) and used in an advertisement for retail-brokerage services for individual investors"?

In 1917, Marcel Duchamp had taken a humble urinal and, simply by declaring it art, turned it into the most influential work of the twentieth century. Five decades later, Warhol proposed treating the product launch, press release and spreadsheet as art. That had an equally profound effect on the fifty years of art that followed.

*. . . in a fashion shot with his businesslike crew—and Archie the dachshund.*

# 1970 -1971

A WARHOL RETROSPECTIVE (AGAIN) | BOB
COLACELLO AND VINCENT FREMONT COME ON
BOARD | ANDY WARHOL, SUPER-SHOPPER | NEW
PATRONS: SANDY AND PETER BRANT | L'AMOUR AND
ITS CROWD | VIP LIVING | FAILURES IN THEATER:
ANDY WARHOL'S PORK AND MAN ON THE MOON

*"It's only suits and ties around him now.*
*We were all dropped"*

In early May 1970, what was quite possibly the most important exhibition of Warhol's life was about to open. And a reporter for the venerable *Los Angeles Times* could barely get him to talk about it. Warhol's comments strayed instead to his tour of the MGM back lot, to his love of abstraction, to the latest improbable movie he was pitching: *Specimen Days,* a comedy about Walt Whitman's time as a Civil War nurse. As for "Andy Warhol," the first American retrospective of his art that was about to open at the Pasadena Art Museum—where he'd once witnessed the first U.S. survey of his hero Marcel Duchamp—all Warhol could say was that it wasn't what he'd hoped for. "I wanted the Pasadena show to be one image—the wallpaper with the cows' heads. One image. That would be nice. Just keep the same thing and never change it." That was all Warhol wanted the world to see of his art, in a retrospective set to tour to notable museums in Chicago, Eindhoven, Paris, London and, finally, New York.

In Pasadena, he had yearned to skip the opening but did turn up after all, only to discover that L.A.'s most important artists had not—almost as though his old Pop Art was no longer necessary viewing. Faced instead with a crowd of society types, he fled to the director's private dining room, where he and his entourage disappeared into a cloud of pot smoke.

"I wanted them to let me do something new," Warhol had complained

to a phone buddy even before arriving in L.A. "But they said that it was a retrospective and a retrospective means you have to show all those old things. So I guess it's O.K. But I would rather have done something new and up-to-date." He had at any rate insisted, to the curator's annoyance, on limiting the "survey" to a very few series of serial works—Campbell's Soups, Death and Disasters, Brillo Boxes, Flowers and Portraits—as though to cut down on the impact of any one piece. Ganging up each series on a single wall, Warhol got as close as he could to the wallpaper effect he had hoped for.

He got even closer one year later, when the show went on view in New York, across the entire fourth floor of the Whitney Museum of American Art—where he'd also hoped to avoid the opening. This time, Warhol did manage to cover the space floor to ceiling in cows, paying out of his own pocket for enough paper to shroud even the museum's odd modernist window ledges. And then he hung his Pop canvases over the wallpaper, "in whose garish and assertive surface the paintings all but drown," complained the conservative critic Robert Hughes in *Time* magazine.

"We fixed it like this so people could catch the show in a minute and leave," Warhol told a reporter who was touring the survey. "It's old-fashioned, it really is. Now that you've seen it, let's go across the street to Schrafft's." (He drank straight vodka once they got there.)

In fact, said Warhol on another occasion, he had hoped to paste up his wallpaper backward, cows to the wall, and leave his so-called retrospective at that. "Because it would be more interesting that way," he said. "You have to do something that's up-to-date and different. It doesn't matter what you do outside of New York. What matters is New York. It's show business."

And "show business"—Warhol's true show business of "interesting" art—did not permit him to live in the past, as a member of the official, retrospective-deserving artistic establishment. The last thing he wanted to do was join Jasper Johns and Robert Rauschenberg as one of the "decadent princes presiding over a vanishing art world," as Warhol's old boyfriend John Giorno accused him of doing. Not long before his Whitney survey opened, a Warhol Soup Can had made it to the cover of an *Archie* comic; soon after, one critic described Warhol as "probably the most famous artist in the 20th century" while another said his Pop works at the Whitney were "generating nostalgia like a bunch of old TV reruns"—all good (or bad) signs that decadent princedom was on the way. What's peculiar is that, at that particular moment, for Warhol to break out of the art establishment he had to join the establishment-establishment, or at least look like he was joining it.

At his Pasadena opening, he had worn a leather jacket and came surrounded by acolytes in "hippie finery," said a reporter, as part of a scene "that

was to blow your mind over." A year later, at the Whitney, he was in a preppy gingham shirt under a V-neck sweater and corduroy sports jacket worthy of the Ivy League. A classic blonde bombshell was by his side.

Just as the Whitney show was due to launch, the *New York Times* ran an article that talked about how Warhol was looking to move on from "the twisting guts and bloodied spirits" that had powered 1960s art so as to make "a new start, unencumbered by the encrusted reputation of the 'old' Andy Warhol." Hence his decision, said the *Times,* to change his too-famous name to John Doe.

"Things had changed," Warhol said, recalling the final months of the 1960s on the last page of his memoir of the era, published at the dawn of the Reagan '80s. "All the morality and restrictions that the early superstars had rebelled against seemed so far away—as unreal as the Victorian era seems to everybody today." In the new post-Pop career just then opening up, Warhol latched on to the new nonrebellion and ran with it. If he once confessed that his shooting, and the new conservatism it had triggered in his circle, had killed off his creativity, it turned out that the conservatism itself was going to provide a new creative model.

Warhol's old avant-gardism had been built around the threat it posed to the status quo, but the establishment was now vulnerable enough without Warhol piling on. He didn't need to wear a motorcycle jacket to shock the bourgeoisie when real bikers were quite present enough on the nation's highways. (So the gritty new movies were claiming, at least.) Average New Yorkers didn't need to see nutters and drug addicts in a Warhol film; they could find plenty of them lurking under the burned-out lamps of Central Park. As a new decade dawned and Warhol's wounds finally closed, he seemed determined to forge a new composure, in both his art and his life, that functioned as a shield against the kind of chaos and edge that he'd reveled in, had even cultivated, during his Factory days—and that was so clearly going out of fashion.

Before the '70s were far underway, Mickey Ruskin, owner of the once-radical Max's Kansas City, was complaining about a "general drift to the right in the country" that was making his clientele too "family," and about how even Warhol had largely abandoned the place except for the occasional "business lunch"—a meal that could hardly have been common in Warhol's Silver Factory era.

The famous photos that Avedon shot in the fall of 1969, of a leather-jacketed Warhol surrounded by his louche Factory crowd—including such old-timers as Malanga, Taylor Mead, Eric Emerson and Viva—come closer to being re-creations of a previous underground moment than documenta-

tion of Warhol's reality in his tidy new office on Union Square. In what was clearly revisionist history, Warhol was soon claiming that even in the 1960s he'd never been attracted to rebellion itself: "It was business. . . . I was only attracted to people who talked."

Mead recalled how Warhol, postshooting, had abandoned all the "bizarre people" like him. "It's only suits and ties around him now. We were all dropped." In a phone call just weeks after the Whitney opening, David Bourdon and Ondine talked about how Morrissey, the drab conservative, had "ruined" the once-radical Warhol:

> BOURDON: He's never going to be the way he was again.
> ONDINE: It's horrible to look at him on the street, to be his friend and realize that he's a cop out. . . . Did he shoot his load?
> BOURDON: No, nothing is happening in the '70s. The '70s are just dreary.

And yet within a couple of months, Bourdon was on the phone with Warhol himself, mocking how their friends Yoko Ono and John Lennon were still using '60s expressions like "blow your mind"—all of two years out of date at the time—and insisting that the couple desperately needed to find a new "1970s image."

"Yeah," said Warhol, happy to agree given that he'd already found one of his own. Fred Hughes had helped him perfect it. Hughes had started wearing a tie to work while Warhol was in hospital and eventually got his boss to join him as a patron of New York's finest "cravateur," replacing Warhol's old allegiance to the Leather Man. On his visit to "Raid the Icebox" in Houston, Hughes's home turf, Warhol actually wore a double-breasted suit worthy of Clark Gable, accessorized with a floppy silk bow tie—polka-dotted, no less. When a friend complained that a gorgeous Hollywood action hero who Warhol admired was lacking in substance—"he's not a fish you'd want to talk to"—Warhol replied, "Who cares!? That's the '70s." This, from the man who'd built his '60s scene around "talkers."

By the fall of 1972, Warhol was telling his diary that "we are trying to clean up and straighten out, wear ties." When he and his gang showed up in Venice for its annual film festival, *Vogue* was describing them as "really very establishment, these days . . . dressed very Classic." Its photos showed Warhol looking quite Lido in a white sports coat and black turtleneck and Fred Hughes all in 1920s whites, earning him the caption "very Scott FitzG.!!" A couple of years later, an Italian fashion magazine focused on Warhol as a leader in the "return to conservatism" in men's style. It quoted him in praise

of a "university" look and before long he was going full preppy, wearing jeans with a tie and a Brooks Brothers button-down shirt—white, such as no one had worn since the '50s.

"A whole generation that has never worn them is ready to discover the white shirt," his old friend Eugenia Sheppard had pointed out in a column. Hughes went even further toward a high-society style—at least as he imagined it—by adopting a Mayfair wardrobe that eventually included imported Savile Row suits, Lobb shoes and Penhaligon's Blenheim Bouquet cologne.

Brigid Berlin, the only Warholian to the manor born, was already objecting to the transformation barely a couple of years into it: "I just find it all really so phony I can't stand it. Fred waltzes thru a room—he glides like Willy Durant, the dance teacher of the 50s."

Hollywood glitz drifted into the studio's décor as well. Within little more than a year of its launch, the space went from looking like the airy headquarters of a modern architect to evoking some talent agent's office. The huge windows that ran down one side of the loft had their glazing covered with big sheets of mirror. The entrance wall facing them—the back of the newly built "secure" vestibule—got mirrored as well, so that anyone standing between saw their own sweet, beautiful self reflected back and forth ad infinitum. Other walls in the studio got hung with big photos of movie stars. There were color headshots of classic talents from Hollywood's glory days—Joan Crawford, Katharine Hepburn, Ginger Rogers, Shirley Temple—and of new Warholian talents like Dallesandro and Viva, all photographed in show-business close-up.

The parody of Hollywood that had been in play at the Silver Factory—think Mario Montez as Jean Harlow—became simulation and homage at the Union Square studio.

Warhol reflected on the appeal of the backlot on one of his early 1970s visits to Tinseltown itself: "You walk around there and everything is fantasy but it seems real. You know those movie stars stayed on those lots for 30 years and made movies and never left the world of fantasy but they got to be everything they wanted to be and nobody got hurt. Maybe fantasy is the answer—nobody gets hurt."

For a while at least, Warhol's trio of transvestites provided the particular dose of hurt-free Hollywood artifice that Warhol needed. The fact that they were "freaks," to use Warhol's term, made them a last link to Silver Factory extremism—that was how Avedon had portrayed them in '69—but their freakishness was built around a commitment to the imagery, even the values, of the American mainstream that Warhol was starting to embrace.

Their heroines and role models were Kim Novak and Rita Hayworth,

not Georgia O'Keeffe and Gertrude Stein, let alone Valerie Solanas. "I think Kim Novak just took over my life and I actually lived through her," Candy Darling once said, adding that Loretta Young was another model, "because she was beautiful and she was gracious and you don't see that any more in women . . . but in those days, that was the ideal." The peculiar mix of transgression and reaction that the transvestites represented may have helped ease Warhol's allegiances away from black leather and toward Lacoste. That blonde bombshell who had kept the preppy Warhol company at his Whitney opening was in fact Darling herself.

Once Warhol had finalized this shift of cultural allegiance the transvestites drifted toward the edge of his life, lingering only for as long as Morrissey continued to cast them in films.

---

"Because inter/VIEW was Andy Warhol's magazine, nostalgia was perceived as new, the rejection of the avant-garde as the height of avant-garde," recalled the journalist Bob Colacello. He was on the magazine's staff, and sometimes at its head, for much of the '70s. He counted as a dedicated foot soldier in Warhol's "rejection of the avant-garde"—even if, like Fred Hughes and Paul Morrissey, he might have been more committed to the rejection part than to its vanguard potential.

Colacello was a second-generation Italian-American who had grown up solidly middle class, and much more American than Italian, in suburban Long Island. ("The only Italian thing we have left in our family is eating pasta," Colacello once said.) With a father who worked in commodities trading and a mother who sold evening dresses at the local branch of Saks Fifth Avenue, the family's cultural contact with Manhattan was limited to twice-yearly visits to Radio City Music Hall. So Colacello's exposure to Warhol's Silver Factory had to come in Washington, D.C., of all places, when he was enrolled in international relations at stodgy Georgetown University. He settled in as one of its more rebellious students—which wasn't saying much—letting his hair grow, dealing and smoking pot and going to see Andy Warhol's Chelsea Girls again and again and again. By the time his "studies" were over, a career in the foreign service seemed less appealing than life as a filmmaker, so he moved to New York and enrolled in the graduate film program at Columbia, to the disgust of his "very Republican" parents. During his studies, some writing he did for an indie newspaper won him a freelance assignment for Interview, and an invitation to pay an after-class visit to Union Square. Dad immediately forbade the meeting: "I'm not only going to break your movie camera, but I'm going to break your legs if you go to work for that crazy person." And

Colacello of course accepted the invitation, taking the train in from his parents' home on Long Island.

"I felt like Lana Turner or Troy Donahue or somebody getting a call from Louis B. Mayer or Jack Warner," he recalled. "I went up to the Factory and I had to be buzzed in past the bulletproof door. There was Andy Warhol sitting at the desk eating vegetable purees from Brownies health food store and he said 'Oh hi! Paul Morrissey likes your things. Would you like some food?'"

The relationship matured slowly, with Colacello submitting only the occasional piece to *Interview*, but before long things got serious. At Columbia, Colacello had been studying with the *Village Voice* film critic Andrew Sarris, who got his students to take on some of the vast number of reviews that the weekly newspaper needed. In October 1970, Colacello was assigned to cover Morrissey's latest movie, *Trash*, and he filed a piece of questionable student writing, with an opening sentence that ran on for eighty-five words, commas scattered at random and famous names dropped like coins in a fountain. There was one telling phrase, however, that caught the attention of the Warhol crowd, and most certainly of Morrissey: *Trash*, wrote Colacello, was "the best Warhol film yet." *Interview* had just lost its editor, an unreliable and possibly larcenous contact from Silver Factory days; that rave about *Trash* somehow made Colacello, with no editing experience, look like a fine replacement, as per Warhol's lifelong throw-'em-in-the-deep-end management strategy. (Which had the added advantage of costing much less than hiring people with skills.)

In one role or another, Colacello spent the next dozen years with Warhol. As a diehard Republican, he joined Morrissey in moving the enterprise away from its 1960s roots. Not long after coming on board, Colacello, the former pot dealer, was leading his *Interview* staff in mocking the weed fiends who'd been in with the in crowd just a few years before, when Warhol's protégés were smoking up on the *Lonesome Cowboys* set. "If anyone even dared to come in that [Union Square] Factory and lit up a joint they would get thrown out," recalled Jane Holzer, who had begun to show up again in Warhol's cleaned-up world. "I have been with Andy in a taxi cab, someone lit up and he just falls apart. He doesn't want it. It really upsets him."

Another straitlaced staffer arrived on the job at almost the same time as Colacello, and ended up lasting even longer. He was Vincent Fremont, "Mr. Reliable, Vincent Straight-Arrow in his horn-rimmed glasses, company man to the core, hard-working, diligent, loyal, good," as Colacello described him. Fremont was from San Diego, with an artist-father who had taken his twelve-year-old son to the Soup Can show at Ferus gallery in L.A. Fremont

had first come to Union Square in August of '69, at nineteen, as a longhaired member of the Babies, a faux-band ("we had ideas, we were conceptual") that was part of the Beach Boys entourage. In New York, the band's two other nonmusicians wanted to check out Warhol's scene, which they'd already tasted that spring, and then Fremont somehow managed to stay on at Union Square as a factotum. He started out with the usual first job of floor sweeping and then took on occasional freelance gigs as a writer and script reader, making ends meet by working at Paradox, the famous macrobiotic restaurant where Yoko Ono had worked. He'd join Warhol's crowd for late nights at Max's. "I used to say I went to the University of Andy Warhol," Fremont recalled. "I didn't go to college. He had an old-fashioned work ethic, you started from the bottom and worked your way up."

Fremont came on staff at the studio early in 1971, settling in as a rock-solid, lifetime member of Warhol's inner circle. With Fred Hughes as the studio's faux Englishman, Fremont eventually assumed an all-American look that was "Ivy League and plantation," according to one admirer of his: "Pale blue shirts with white collars, penny loafers, linen suits." He had the manner of a "model yuppie accountant," according to another observer, and indeed he took on the task of managing the studio's books. "There would be stacks of bills. I would spread them out on the floor and try to put them in some sort of order," he recalled. "Then Andy would start begrudgingly writing checks." It wasn't long before Warhol bestowed upon him the glamorous title of vice president of Andy Warhol Enterprises, with the unglamorous job of keeping some kind of order in its sprawling affairs. Where other staffers got to jet around the world with Warhol, he was left to tend things at home, "handcuffed to the desk," as he put it, without getting even one trip abroad.

Fremont had a second role that was closer to his heart, and probably to his boss's: He came to be in charge of the studio's eager and varied efforts in TV and video, many of which never bore fruit. Warhol had bought one of the first Sony Portapak recorders and also a more heavy-duty video kit that got mounted on a weird A/V cart, with lighting attached. Fremont wheeled that over whenever a Factory Diary seemed worth recording—which was pretty much always. "There was no distribution in mind—it was chronicling, a diary," said Michael Netter, a young painter and videographer who had gone to Georgetown with Bob Colacello. He had introduced Warhol to the new video technology and then came on board to help Warhol use it. Television was becoming an accepted medium and subject for advanced art, and Warhol was not about to be left behind. Netter remembered how Warhol faked technophobia when in fact he had gotten to know the studio's equipment backward and forward. "I was being paid, but I didn't think of it as a job," Netter said.

On top of taping hour after hour of Warhol at work and play, Netter and Fremont managed to capture the famous visit by a very young David Bowie, arrayed in flowing locks and yellow Mary Janes, who did a cringe-making mime routine and got the cold shoulder from Warhol. "Miming was dead and Bowie was bad at it," Netter remembered. "And you should never do mime for Andy Warhol, Mr. Irony." Their videos also recorded visits by Paloma Picasso, who did a "reverse striptease" that took her from nude to dressed, Netter said, and by a certain Neke Carson, who used a paintbrush held in his rectum to paint a portrait of Warhol. In the video, Warhol shoots Polaroid after Polaroid of his anal portraitist before finally breaking the silence: "Do you ever have to go to the bathroom when you are doing this?"

Fremont did oversee some video projects meant for public consumption, but they rarely found an audience, at least for his first few years there. Warhol's *Nothing Special* refused to die as a concept and was soon joined on the drawing board by such things as *Nothing Serious* (a hybrid cooking/variety show, with some soap opera thrown in), *Phoney* (about phonies who liked to talk on the phone) and *Fight* (friends fighting). "All we did in those days was develop ideas," said Fremont. "Andy was not interested in getting on cable television"—or maybe not interested because not able, at least at first. Eventually, Fremont and colleagues did manage to place a couple of projects on public-access cable, a few spots on *Saturday Night Live* and, just before Warhol died, a variety show all his own on the fledgling MTV channel.

---

The C-Suite at Andy Warhol Enterprises was now complete.

Fred Hughes was there to sniff out portrait patrons or other fine art commissions, and sometimes to sell Warhol's older works: Fine art, of one kind or another, was still the studio's big profit center, with fewest expenses. Bob Colacello had *Interview* more or less under control. Vincent Fremont was handling the forever-budding TV business and much of the studio's administration and financials. Paul Morrissey was turning out his peculiar brand of semimainstream "Andy Warhol" movies, working more as a partner than an employee, getting his share of the take on his projects.

And Andy Warhol, at the top of this corporate ladder, got extra busy . . . shopping.

He had been an eager accumulator at least since the mid-1950s, but his collecting went mad in the years after he was shot. Obsessive tendencies that had been latent since his childhood illness may have been brought to the surface by his body's new traumas. While he was in hospital, he got Fred Hughes to save the stamps on all the random mail that arrived, for a

"collection" that could never have amounted to anything worth keeping. (It still exists.) Once Warhol was fully recovered, said Jed Johnson, he began to shop for at least two or three hours almost every day. (Having "staff" must have freed up his schedule.) It got to the point that he gave the impression of spending more time in stores than at the studio—especially since the studio happened to be just up the street from one of the city's biggest concentrations of antiques dealers. And even when Warhol was at work in the studio, random people would drop by to try to sell him something—"an Oriental rug, old movie posters, or somebody else's dreary paintings," recalled a visiting journalist. The minute Warhol showed up in New York's antiques malls, some dealers would come running with likely offerings; others would wait in their booths for him to come calling, meanwhile raising the prices on any objects he was likely to want.

On the phone with a friend, Warhol chided himself for not being selective enough: "Buying just anything—that's what's wrong with me." He was right, except that the manic accumulator lived side by side, in Warhol's complex psyche, with a savvy connoisseur. There were almost always treasures scattered among the bric-a-brac. One dealer talked about Warhol's eye for unusually repaired objects that no other collector would touch—a taste right in line with the interest in defects, fracture and failure that was typical of the most serious modern art since Picasso.

Fine modern art was in fact high on Warhol's shopping list in the '70s, as it always had been, but now his collecting pushed further than ever toward the cutting edge. He bought pieces by young experimenters such as Keith Sonnier, Dennis Oppenheim and Richard Long as well as works by new Old Masters such as Jasper Johns, Roy Lichtenstein, and Donald Judd. Out of the $9,000 he spent on art at Castelli's gallery in 1969, $2,000 went for one of Richard Serra's weighty lead Prop sculptures, about as uncompromising a piece as could be imagined. Within a few years Warhol was looking to buy work by the land artist Michael Heizer as well as "relics" from the performances of Chris Burden, that young Californian famous for nailing himself to a VW Beetle and for having himself shot. Even as Warhol was looking more and more like a New Conservative on the surface, deep down he was still an Old Radical.

Warhol's tastes in collectibles other than art were, to say the least, more wide ranging. Vito Giallo, the 1950s assistant of Warhol's who opened a vintage-goods shop, remembered his old boss buying "rows and rows of mercury-glass vases, copper lustre pitchers, Victorian card cases . . . thousands of rare books, 20 or 30 at a time, dozens of 18th- and 19th-century Spanish Colonial crucifixes, and santos three or four at a time, and sixty boxes of

semiprecious stones, all in one gulp." Warhol himself attributed his tendency to buy "junk" rather than investment-grade pieces to misplaced frugality: "I tried to learn how to be Jewish, at the wrong time," he said. (His private conversation comes littered with such ethnic stereotypes.)

When Warhol was in L.A. to talk movies in May 1970, a receipt shows him spending more than $5,000 at a single antiques store, out of the crowd of them he shopped at on that trip. The eighteen items on that receipt range from a Northwest Coast basket at $40 to a rare Northwest blanket at $1,800, by way of seven Navajo rugs. That single year produced an entire box of such receipts, almost always marked either "props," under the pretense that the objects were for movie use, or "no tax—for resale," returning to Warhol's long-standing conceit that he dealt in antiques. (But if he really did have a stake in that Taos rug shop, maybe he sometimes did do such dealing; in his final years, he was still talking about opening an antiques store, to be called Warhol Hall.)

Fred Hughes once said his first art outing with Warhol was to the National Museum of the American Indian, and it looks as though Warhol had first begun buying Indian artifacts just because they were sold cheap at a store around the corner from him. Within a few years, however, he was being written up as one of the notable connoisseurs of Native crafts. Those were, not incidentally, the preferred home goods of the era's leading abstractionists, whose works Warhol had also collected. "No self-respecting abstract painter would be caught today without a Navajo rug in his SoHo loft," wrote a critic friend of Warhol's in late '71, in a rave review of a whole raft of Native art shows then filling New York museums and galleries. A serious and up-to-date aesthetic agenda often lies hidden beneath the sheer acquisitive fervor of Warhol's buying. One of his most reliable and longtime antiques suppliers talked about the path the abstract-loving collector followed, over more than a decade, from geometric vintage quilts (in keeping with his '50s tastes for Americana) to geometric Native rugs to the modern geometries of prewar Art Deco.

Art Deco was the subject of an early-1970s collecting trend that Warhol eagerly followed, or maybe helped set. That Jazz Age style was undergoing the kind of revival that Art Nouveau had seen when Warhol was first buying his Tiffany and bentwood furnishings in the 1950s. In November 1970, Warhol's friend Lil Picard published an entire article called "What is Art Deco?" in which she credited Pop artists as pioneering fans of the style, dwelling especially on a Deco wardrobe she'd spotted early on in a Factory screening of the Warhol film *Camp*.

Confirming Picard's idea of Deco as just the latest in a line of "Kitsch-

Camp" revivals—and maybe hinting at a lingering gay aesthetic—Warhol developed an insatiable taste for early plastic purses and bracelets and, especially, for modest Depression-era chromeware. "The shapes are really modern and the things they were done for are really modern," Warhol said. "It was the time, I guess, when Chock Full of Nuts and Horn and Hardart were really big." (That "I guess" may be disingenuous—he's talking about the culture of his childhood.)

But Warhol could also head up-market, to the very finest products of Europe's elite Deco cabinetmakers, including such masters as Émile-Jacques Ruhlmann and Carlo Bugatti. Asked how much he had spent on such Deco treasures, Warhol said "I can't put it in terms of money. It's my life." That probably applied as much to the act of shopping as to the items he bought.

Warhol's most museumworthy purchases settled in as unlikely studio furnishings on Union Square. Always thinking of the tax man, Warhol made a point of publicly describing his purchases, however grand, as movie props that, once filmed, had moved into the studio as office furnishings, taking their place beside an out-of-tune upright piano that had somehow shown up. Even more improbably, Warhol would describe his 1920s antiques as sources for designs he could trace into his art.

The most luxurious Deco creations he favored often came with lavish pedigrees that connected them to the salons of French viscounts and Indian maharajahs or to the staterooms of the S.S. *Normandie*—or with stories of such pedigrees, at least. This gives a hint of a new direction in Warhol's life: In the early 1970s, he was doing his best to climb up into the social circles of the kind of people whose names would someday add luster to the pedigrees of art objects he himself had made.

———

Warhol's turn toward upmarket Deco, and upmarket people, got its start on a trip to Paris in the fall of 1970. Ileana Sonnabend, Warhol's Paris dealer, had a hand in introducing him to some high-end antiques dealers, from whom she bought Deco wares that turned into exhibitions she hosted on all the movement's major creators. (Warhol could recite those shows' titles by heart.) Warhol's 1970 trip spawned a famous shopping tale about a visit to the showroom of the great, late silversmith Jean Puiforcat, where the salespeople parted with an entire cabinet of what they considered outmoded Deco treasures for "little more than scrap value," according to Fred Hughes, who was there along with some other shoppers who split the booty.

Those shoppers may have been as important to Warhol as the silver wares he shared with them: They were Sandy Brant and her husband, Pe-

ter, the preppy, twenty-three-year-old son of a cultured Jewish immigrant who had made big money in the paper industry. The younger Brant had recently begun to spend serious money on current art, getting advice from Leo Castelli and the Swiss dealer Bruno Bischofberger, who had recently paid a studio visit to Warhol and left with more than $400,000 worth of important early Pop paintings, which would have been by far Warhol's biggest sale up until then. On his mentors' advice, Brant took to tracking down the finest Warhols wherever he could find them, even while honeymooning in Africa. Castelli finally brought artist and collector together early in 1969, and Brant became part of Warhol's new high-society circle. Before long he was close friends with Fred Hughes and took to visiting Union Square a couple of times a week.

"I got the idea that anything Andy did was art," Brant said. That made him take an interest, and a share, in Warhol's less traditional projects, more as a patron than as an investor looking to make a killing. (Brant was doing that already in his father's industry, where he went on to be a paper-mill billionaire.) His first venture with Warhol was what had brought them all to Paris in November 1970: A couple of months earlier, they had signed a contract to partner on a new Warhol film about "a young girl in Paris looking for a husband." Brant and Bischofberger were funding it to the tune of $100,000, vastly more than had gone into the two features Morrissey had completed by then.

According to Hughes, their Deco shopping had gone on during lunch breaks from the movie shoots, which this once seemed to have been as much under Warhol's direction as Morrissey's. The artist was behind the camera much of the time—he forgot to start the film rolling on several takes and overexposed many shots. Jed Johnson was alongside him doing sound, the occasional bit of camera work and, later, the film's editing. Warhol of course affected his usual insouciance: "Shooting in Europe is really like taking a paid vacation," he told a reporter on set. A member of the cast taught Warhol to crochet, and he would sit there with his yarn as his staff fussed over the details of the filming. (Happy to bend genders by taking up "feminine" crafts, he'd already learned to do needlepoint in hospital after being shot.)

The movie got released (and flopped) several years later as L'Amour, but one of several working titles had been Les Pissoirs de Paris, driven by a plot strand that had the fancy son of an American entrepreneur trying to sell urinal deodorizers to the Parisians. (Was this a typically Warholian poke at Brant, who himself was there in Paris as the fancy son of another American entrepreneur?) The cast would arrive, without permits, at one of the city's public urinals and then Warhol would drive up in a van with the camera

mounted in back, gumshoe style, and keep shooting until the cops showed up and forced them all to move on to the next unsupervised pissoir. Indoor scenes were shot in the Deco-decorated apartment of Karl Lagerfeld, then a rising star in fashion design. He'd signed on to the project as a friend of the movie's leading lady—leading teenager, actually—who was the only actor specified from the beginning in all the production contracts: That was Jane Forth, a new Warhol protégée who was distinctive enough to almost deserve the title of superstar that soon drifted her way.

Forth, a high school dropout from Grosse Pointe, Michigan, had been introduced into the studio's social circles sometime in the spring of 1968 by Jay Johnson, Jed's twin brother, who she was dating. In October of '69, an accident of history led Morrissey to cast the sixteen-year-old in that new movie of his called *Trash,* about the sexual escapades of a drug addict. By the next summer Forth had made enough of a splash around town, and in various media, for *Life* magazine to give her a three-page color spread as the New Twiggy, even while admitting that her face was "bizarre." The ninety-seven-pound girl, "with all the curves of a broomstick . . . knock-kneed and bow-legged," had shaved her eyebrows down to vestigial nubs, making her look half Martian. That didn't stop her from appearing as Warhol's preferred arm candy once he had recovered enough from the shooting to travel to shows of his in Houston and Pasadena. The two were also late-night phone buddies, chatting as they watched the same old movie on their TVs.

By the summer of 1970, staying in Paris with Fred Hughes and a misbehaving Jay Johnson, Forth was writing to Warhol with news of their ditzy antics. *L'Amour,* shot in Paris a few months later, was inspired by the "really naughty" life the youngsters had already been living there. That life continued during the many weeks of filming: The actors got thrown out of three hotels in the course of the production. In her interviews, Forth comes across as shockingly clueless and adolescent, as though *looking* interesting left her under no obligation to actually *be* or *act* interesting. Compared to Forth, Edie Sedgwick might as well have been Susan Sontag.

Warhol's movie seems to display the same cluelessness as its star. It rambles from goofy scene to goofy scene, sex joke to sex joke, bare nipple to bare nipple, as though the teenagers starring in it had also directed it. That was pretty much the view of one of its few trained actors, who was disgusted to find that Warhol had a "'let's play games and shoot a movie today' attitude."

In a pan in the *Times,* the film critic Vincent Canby said that even the movie's best scenes could not compete with the most meager distractions on offer at the time—with "late-night talk shows, a new album by the Carpenters, the Watergate scandal, kung-fu movies, dining at Blimpie's, and a

number-one best seller by Jacqueline Susann." But that kind of complaint about *L'Amour*, shared by most critics and probably by almost anyone who has watched it, misses the point. Warhol, so deeply steeped in the avant-garde, could never actually make something that would function as a truly popular entertainment, even though he once told a friend that the "whole idea" of the movie had been to appeal to "the ordinary people." He could only create a simulation that pointed out to popular culture from inside the weird world of high art, the way his Soup Cans pointed to mass commodities without ever selling to the masses. *L'Amour* is such a desultory bit of moviemaking because it didn't need to be particularly well made, or genuinely entertaining, to do its Warholian job of drawing attention to aspects of culture that its maker found compelling. Like a Warhol Brillo Box, you could say that *L'Amour* was a handmade, homemade ready-made, standing in for the pro versions of frothy entertainment turned out by Hollywood. You'd never criticize a Warhol box for not working well as a shipping carton, and it makes just as little sense to complain that *L'Amour* doesn't do the same job as the slick Tinseltown originals it is all about.

Above all, Warhol's ferocious ego and ambition as an artist wants us to always recognize that he's the one doing the pointing. Making a weirdly lousy, off-base movie was a fine way to achieve this. You could never confuse Warhol's creation with the genuine Hollywood entertainments that it was talking about.

Not long after *L'Amour* had wrapped, a British magazine ran a big feature on the shoot, claiming that the film's hackneyed plot, ludicrous dialogue and halfhearted Hollywood ambitions represented Warhol's retreat from the cutting edge. All he now wanted to know, said the writer, was "what do the stars look like? Never mind what they say or do—Are their clothes fashionable? Is their hair set just right?" Forth, posing topless, had already won the cover of *After Dark* magazine; her costar Donna Jordan landed the cover of French *Vogue* in the very month they were shooting their movie. (Warhol incorporated Jordan's cover triumph into the plot.) So that British feature wasn't completely off base: Forth and her friends represented a new gilded (or at least silver-plated) youth that more than confirmed Warhol's split from the outdated undergrounders of the Silver Factory. His new acolytes were more *Gentlemen Prefer Blondes* than *Chelsea Girls*.

The Paris movie had another provisional title, *Les Beautés*, that captured the old-school frivolity, and superficiality, that was now captivating Warhol. The two girls affected a look straight out of Hollywood's Golden Age, "wedgie shoes and fox-fur capes and mid-calf skirts, with makeup to match" for an effect described as "spectacularly *kitsch* . . . a walking, talking exercise in

sartorial camp." In Lagerfeld's apartment, wrote the British reporter who covered Warhol's shoot, "it is 1930. Everything is white and beige like a Jean Harlow set." The following summer, on trips to a rented country place on a manor-lined road in East Hampton, Warhol would watch the "kids" from *L'Amour* laze about to the sounds of Gershwin's *Rhapsody in Blue,* as though living a scene from *The Great Gatsby*—which Hollywood was about to turn into a vastly influential costume drama. The Fred Hughes aesthetic was ascendant.

----

Corey Tippin, a sometimes roommate of Hughes who had a part in *L'Amour,* read the movie shoot as a public relations ploy meant to function as "Andy's entrée into French and European society." While the movie's young actors were being bounced from lodging to lodging, Warhol, Johnson, Hughes and the Brants stayed in deluxe comfort at the Hotel de Crillon at the foot of the Champs-Élysées, in what may have been Warhol's first introduction to the highest of high living. They socialized with stars like Omar Sharif and Marisa Berenson and with various Rothschilds.

Forget Schrafft's. As the '70s dawned, Warhol's receipts started being for meals at Maxim's in Paris and La Grenouille in New York, for first-class hotels and flights. Some of this must have happened under the influence of Sandy and Peter Brant. Although only in their twenties, the pair had already acquired seriously upper-crust tastes. A gossip column included them on a list of the VIPs at a Warhol opening as "one of the chicest looking young couples in Manhattan." Already when he was in college Peter Brant had developed a blue-blooded interest in horse breeding; by the mid-1970s he'd moved on from toney equestrianism to polo and racing. He established stables of his own and eventually a polo club as well. "The paper business is business business," explained Brant in one horsey profile. "The horse business is pleasure business, a lot of fun, though it has also been very profitable." That absolute blending of business and pleasure, profit and culture, was another lesson that Warhol learned from Brant, who described himself as being "the 'suit' in the picture" when the two hung out together.

Even the trove of Deco silver that the pair discovered at Puiforcat got transformed from an aesthetic opportunity into a business prospect. The two New Yorkers drew up a contract that had them producing facsimile pieces in partnership with the Parisian silversmiths.

Brant's involvement with Warhol soon extended to *Interview,* the Union Square outfit's most ambitious new project and one that was having a hard time finding its legs. "Andy made you feel that he was very vulnerable, and

you wanted to protect this man," Brant said, recalling how Warhol didn't even have the resources to buy the cheap newsprint the magazine was being printed on. Not long after the two met, Brant arranged to handle the paper problem through his industry connections. Later, after a couple of earlier funders pulled out, he came more fully on board, bringing along Bischofberger, the Swiss dealer who had been Brant's first mentor in art and had been trading in Warhols for a little while already. By the summer of '72, a new corporate entity called Motion/Olympus, Inc., was born on Union Square, just to publish *Interview*. It gave Warhol a half share in the magazine, with the other half split between Brant and Bischofberger, who together put up $55,000.

With its new corporate partners, *inter/VIEW* also changed its brand identity. The magazine's subtitle, with its references to "films" and then "movies," finally disappeared altogether, while the title itself lost its slash and odd capitalization to become simply *Andy Warhol's Interview*, with that title splashed in the artist's own handwriting right across the magazine's cover. Where Warhol's identity had once been sealed by his mother's folksy, fey, innocent cursive, it now got marked by the scrawl of an artist too confident, too busy and above all too important to take care of his writing.

The publication was now trading more on a potent brand name than on any particular content it needed to promise its readers.

———

Warhol seems to have realized that there was potential in brand expansion even before the new *Interview* had launched. Instead of reserving his famous name for homegrown projects like Morrissey's movies and the magazine, a little after the *L'Amour* shoot he got the idea of letting someone else present a Warhol-branded play. The project began in-house when he got his hands on a bunch of old tapes of Brigid Berlin's quarrelsome calls with her mother and realized they might have some kind of dramatic potential. (According to one tale, Brigid Berlin had sold him the tapes for pin money; another account has Warhol taping the tapes when Berlin played them to him over the phone.)

Warhol rejoiced in the vast stacks of transcripts that Pat Hackett was producing from these recordings and so asked her to try her hand at turning them into a drama he'd already decided to call "Pork." "Andy loved the theater and having a play produced was another creative ambition of his," Hackett recalled. But her boss eventually decided that he'd better let a professional director see what could be made of Hackett's preliminary product—"29 acts that would have lasted 200 hours," as the director dis-

missed it, with more than a bit of exaggeration. Thus was born *Andy Warhol's Pork,* a play of perfectly normal length "boiled down and punched up" from Warhol's original by Anthony J. Ingrassia, a young veteran of off-off-Broadway productions who had been chosen to deploy the Warhol brand. "Tony turned it all into more of his own play than Andy's," said Hackett.

The final script's characters are recognizably Warholian: Brigid Berlin becomes the large and topless "Amanda Pork" and Warhol is a bewigged "B. Marlowe," alongside "Vulva," standing for Viva, and "Billy Noname," obviously, for Billy Name. ("All characters are purely fictitious," said the program, but that didn't stop Berlin and Viva from raging at their portrayals and pulling even further away from Warhol, at least temporarily.) Despite that cast of Factory characters, however, Ingrassia's slapstick theatrical action, with manic figures pretending to shit and douche onstage, doesn't seem to have had any of the ambiguity and observational poise of a real Warhol work. "I'd like to have it more open-ended, make changes in the material every day," Warhol said, after the show's first run had already ended. "I also believe in changing directors, and thereby interpretations. And I'd like to see real people doing real things on stage." None of which Ingrassia had been willing to take on. Instead, his fully scripted piece had become a broad parody of the Silver Factory scene, now an endless three years in the past, as seen from the wrong end of a telescope that didn't even have Warhol looking through it.

Warhol had some kind of involvement in casting and watched at least a few rehearsals. Attending night after night of a downtown test production at the alternative La MaMa theater, in May 1971, he split his sides laughing at all the inside jokes. After that run had already ended, a *New York Times* arts writer (rather than the theater critic) got around to giving it a surprisingly kind reception, "as good, dirty fun." But in August, after the play had moved on to an off-beat venue in London, it got savaged by most of the critics there. They called it "as boring as a plate of baked beans," "the nearest thing to a theatrical emetic we are likely to see," and a "witless, invertebrate, mind-numbing farrago." Weirdly, the short-lived show also got covered in *Penthouse,* which filled five pages with naughty photos from the production while primly and hypocritically complaining about its lack of "any hint of beauty in physical processes or of anything to set the supreme human pleasure apart from obscenity."

After its two weeks in New York and a month in London, the show disappeared completely from view. That didn't stop Warhol from taking other stabs at the theater. The following year, he looked into producing a Lerner and Loewe—and Lou Reed—musical about the Factory, about as unlikely a project, and trio of collaborators, as could be imagined. He also came up with

another idea for a theatrical he called "Party": It involved inviting his friends to hold parties onstage as the latest attempt at off-Broadway realism. Then, in 1975, he left realism quite behind when he actually produced an outer-space musical called *Man on the Moon*, written by John Phillips of the Mamas and the Papas and directed by Morrissey, who knew zero about stage work. ("I'm not a theater person, really," he declared to a visiting reporter as he sat in a Broadway theater, directing a theater piece.) The musical was just barely under closer Warholian control than *Pork*, and did much worse: After a month of disastrously chaotic previews it won the most savage reviews—"for connoisseurs of the truly bad, 'Man on the Moon' may be a small milestone"—and closed after five days.

One day when Warhol's friend David Bourdon was having a private chat with John Lennon, Bourdon said he'd enjoyed *Pork* only because he knew all the people it skewered, admitting he would have hated it otherwise. In public, more diplomatically, Bourdon observed that Warhol seemed to have given up the role of creative artist in favor of becoming an aloof executive producer "whose chief interest is the supervision of an efficient and profitable company."

Like any good company, Warhol sometimes put its name on a product, like *Pork* and *Man on the Moon*—even those poor Andy-Mats—that didn't pan out. Or were these "failures" actually successful products of Warhol's deep commitment to artistic mistakes?

*. . . at his Montauk property in a shot inscribed to his friend Steven M. L. Aronson.*

# 1971-1972

*"It's gonna be Internal Revenue
that gets him, not a gun"*

Early in 1969, overdue bills almost got the phone service shut off in Warhol's studio. A year later the IRS was threatening to file liens for $15,000 in taxes still owing from 1968, and by September 1970 his Union Square landlords had started eviction proceedings for unpaid rent.

If art is said to come from the deeper recesses of an artist's psyche, Warhol's Business Art seems to qualify. Its roots must have been as much in his profound neuroses around money as in the Conceptual Art all around him. It seems likely that all those bills remained unpaid because Warhol, child of the Depression, had a deep-seated resistance to creditors. It's also possible that sometimes there really wasn't enough money to pay them, however much was coming in. As Julia Warhola once said, "I can't understand Andy. He makes $100,000 and spends $125,000. I don't know how he does it."

Warhol's personal tax return for 1969 makes him look comfortable but far from rich. Although he declared $86,000 in personal income he also claimed almost half that in deductions, leaving a pretty modest take-home for a man who was beginning to live it up. On the other hand, some of the numbers on the return seem fishy: He claimed barely $9,000 in income from selling paintings, even though a statement from Leo Castelli for that very year shows $30,000 in sales and other dealers were also selling Warhol's work, which had been soaring in value. Early in 1970, Peter Brant

had arranged things so that an early Campbell's Soup he owned fetched $60,000 at auction, making Warhol the most expensive American artist alive at the time, the kind of record that lifts an artist's entire market. A good Marilyn or Electric Chair could go for something like $30,000, and Warhol and Hughes started upping their prices. "Fred was a fairly ruthless, ambitious businessman," said one dealer who bought their wares, and Warhol was quietly brutal as well. When it came time to close a deal, they played good cop, bad cop with the buyer.

Income from Factory Additions, the arm of Warhol's operation that issued his prints, was also adding up. When *Flash*, the JFK portfolio, was finally released late in '69 its two hundred copies sold quickly, netting Warhol almost $40,000—$25,000 more than imagined when negotiations had begun three years earlier. The year after *Flash*, Castelli paid Warhol $20,000 for eleven portfolios from his latest Flowers edition—leaving another 239 portfolios in the edition already sold or on offer by any number of dealers.

The studio's movies were clearly also bringing in serious revenue. On top of *Lonesome Cowboys*, with the "record shattering business" it did in its New York run and the "box office power" it had shown on the West Coast early in '69, there was the summer success of *Blue Movie*, earning a first-week take of $16,000, more than five times what the film had cost to make and a record for the tiny, three-hundred-seat Garrick (now "Andy Warhol") cinema. Morrissey's *Flesh* did huge box office in Germany and his *Trash* went on to make more money than any other Warhol release. A national distributor had guaranteed placement in one hundred theaters, and that had Morrissey predicting ticket sales of at least $1 million, leaving a gross of $400,000 for Warhol's company.

And yet Warhol often insisted that the actual *profits* from his films were never any good. Morrissey claimed that *Trash* only yielded a profit of some $300, which then had to be split between him and Warhol. That would have actually been an unusually good return for one of their films, according to the tax returns for the various Warhol subsidiaries created to produce them. The one for *Lonesome Cowboys* shows the movie making only $600 in profit on revenue of $75,000 and most of the other movies do similar numbers. The 1969 tax return for Andy Warhol Enterprises, responsible for Warhol's art production, looks similar: A gross income of $160,000 yielded a taxable income of only $3,500. Warhol denied being a millionaire, claiming that he made almost no money off his businesses. The dealers "get all the bread," he said.

Some fiddling with tax deductions was almost certainly involved in Warhol's low profit figures.

Warhol would give Brigid Berlin a few dollars here and there for any random receipts that she'd picked up around town, dropped by strangers after they'd bought such high-ticket items as alligator purses. ("It's gonna be Internal Revenue that gets him, not a gun," Berlin was predicting a few years later.) And then there were all Warhol's own receipts for "props" and "costumes" and "office equipment," all properly purchased but pretty clearly goods for Warhol's own use. In his diary, Warhol went so far as to refer to an antiques dealer as a "prop salesman," and to call shopping "propping," just in case the taxman might think to snoop in those pages. An IRS agent wasn't happy about such expenses but somehow they didn't get Warhol into too much trouble. He was lucky. His friend Peter Brant ended up going to jail for similar trickery, after the tax man questioned what use his paper companies had for silk sheets and scalp treatments.

Bigger fiddling seems to have been involved in the paying out of profits and corporate salaries. On a single day in February 1969, Warhol wrote checks to his mother totaling $70,000, disbursed from four different corporate entities he controlled, all enclosed in a cheesy butterflies-and-flowers greeting card that read "Because We're Friends." Those payments sure look like some kind of tax dodge, putting money in her hands to end up in Warhol's. Vincent Fremont once said that Warhol had such hatred for the IRS that at tax time the air in the studio had a palpable charge.

Other dodges might have been only a shade less dubious. He let the art museum in Pasadena fabricate, and keep, one hundred Brillo Boxes for his survey there, then claimed them as a $200,000 donation, which would have been the value of the original Brillos from 1964, not of recent remakes. It looks like he did the same for a hundred Corn Flakes boxes that he allowed the Los Angeles County Museum of Art to make and keep. By denying traditional ideas of authenticity and of the unique "original," Warhol scored real artistic points. He also scored financially.

Warhol and others have claimed that the IRS first came sniffing at his returns under Richard Nixon, as political retribution. The artist had done a witty and caustic fund-raising poster for the campaign of George McGovern, Nixon's Democratic opponent in the 1972 race for president, that featured Nixon's bilious face, blown up big and tinted green like the Wicked Witch of the West. But what IRS officer wouldn't have smelled a rat in Warhol's returns long before that? The tax man was on the case well

before Warhol took his shot at Nixon and didn't let go after power passed to the Democrats.

Whatever his profits, and however he made or kept them, Warhol had money to spend as the new decade dawned.

After having already bought a Volkswagen station wagon in the name of Factory Films in April of '69, the next year Warhol went on to pay almost $9,000 for a stunning, tobacco-brown Mercedes-Benz 280SE sedan. It came fully loaded with all that era's fanciest extras: power steering, automatic transmission, air-conditioning, electric windows, electric antenna, tinted glass, white radial tires, an eight-track tape player and an extra rear speaker. The second car got claimed as an expense by Factory Additions, Inc., although the classy Merc was hardly the best vehicle for that company's print deliveries. The sedan was far more likely to be seen delivering Warhol to his endless social engagements, print-friendly or not. (Joe Dallesandro's brother Robert must have mostly been behind the wheel, since Warhol himself could not drive the car he'd just paid for.)

An even bigger purchase had come just before the car, when Warhol—or rather Factory Films, Inc.—paid $65,000 for a little studio complex that spanned the Bowery's Skid Row and scruffy Great Jones Street. Warhol immediately evicted its three artist-tenants: "I've put in 25 years of sweat as a painter," said one of them, "and now I'm being kicked out by a guy who made it on Brillo boxes. It's a cultural crime." Another evicted painter complained that Morrissey had told him that he had to "make way for the great man who creates environments, not just paintings." If Warhol really had been planning to scale up his art making by moving into the new space, as Morrissey implied, that never happened. For years he had plans for building a theater on the lot but in the interim he lent studio space in it to artist friends and in '83 rented the entire Great Jones Street building out to Jean-Michel Basquiat. "He always thought of the Bowery as the greatest investment there was," said an artist-assistant who lived in the property for a while.

David Bourdon felt his friend was actually ashamed of the scruffy purchase but John Lennon said he'd witnessed Warhol showing it off: "We were driving past one day and he said, 'Oh, look, you can stay in my house if you like.' And he pointed to this little shack." The artist and the Beatle almost went on to buy property together, but nothing ever came of it.

Like any good child of immigrants, Warhol clearly believed in buying real estate. Also in hiding his purchases. In the fall of 1971 he was adamantly denying to Brigid Berlin that he'd just bought a country house—which of course was precisely what he had done. It was more an estate than a house.

A tastefully ramshackle main lodge and four country-style cottages, all white clapboard and gray shingle, sat on 20 acres of clifftop property near the village of Montauk, out on the far, wild tip of the Long Island peninsula. That was 120 miles due east of New York and well over three hours away by car. It was an area that appealed for its "no-chic chic" and "upholstered rusticity," according to an early story on its moneyed, faux-bohemian scene. Warhol's property was called Eothen, from the Greek for "dawn" or "eastward," as christened by the Western baking-soda millionaire who had built it back in 1931, staying in it all of two weeks each fall when the striped bass were biting.

As usual with Warhol, the Montauk purchase had come about through a social connection, in fact the very oldest one he had in New York. Tina Fredericks, the editor at *Glamour* who had given Warhol his first commercial assignment twenty-two years earlier, had become a fancy real estate agent, and one rainy fall day she took Warhol on a Long Island house-hunting tour. It seems he was tired of watching $1,650 go down the drain each month on rent for that fancy East Hampton country place where his "kids" had played Gatsby. Fredericks remembered other properties leaving Warhol cold and then Eothen for some reason sparking his interest, either despite or because of its isolation, up a winding road from a funky, windswept fishing village way out beyond all the fashionable towns in the Hamptons.

"I just remember him liking it immediately and buying it—boom, like that," said Fredericks. Warhol liked the place so much that he was willing to outbid a rival buyer by $20,000, paying out the vast sum of $225,000. Half of it came from his co-owner Paul Morrissey, who like Warhol was feeling newly flush with the income from *Trash*.

Just before Eothen, Warhol had been eager to close on a different Long Island house—the one whose neighbors had stopped him from buying because of his transvestite friends. The difference between the two homes marks the transition between the Andy Warhol of the 1960s and the figure he was becoming at the start of the following decade, almost as though buying in Montauk had helped flip a switch. The first house was a stunning and radical modernist structure designed by Warhol's patron Philip Johnson, working for a fellow art collector. All glass and steel, a good part of it was cantilevered out over water. It was visibly and deliberately cutting-edge, like the image Warhol had crafted for himself throughout the decade of Pop. The Montauk place, on the contrary, bore all the signifiers of genteel understatement. It felt like the kind of summer compound some WASP banking family might have been visiting for generations,

taking care to let its fixtures persist in a state of well-mannered distress. When Warhol was settling in Montauk, Ralph Lauren—another immigrant, born *Ralph Rueben Lifshitz*—*was* breaking through with a new line of Polo menswear built around nostalgic, upper-crust Americana. Warhol's old friend Bill Cunningham reviewed the collection as "purely acceptable establishment taste with an overdose of elite snobbism." (Cunningham knew whereof he spoke: He was the scion of establishment snobs.) If Polo had added buildings to its brand, Eothen would have been on the list. That made it a perfect summer home for Warhol as he began to climb into high society.

Warhol did not buy his property because he longed for sea air. "City life is much cleaner than country life. You have to take too many baths in the country," he once said, and when asked directly if he liked going to the country—while in a car driving there—he answered with a straightforward, laconic "No." He did admit that he admired the ocean as "the biggest abstract thing around," adding, truthfully, "there's a lot of rocks there, too."

As for Eothen, Fredericks claimed that Warhol "hardly spent any time there because his toupé kept blowing away." That isn't quite accurate. Plenty of visits are recorded, sometimes on film or video, and his wig is in place even down on the beach. But he's clearly not a natural shore dweller. When summer guests are seen gamboling with lots of skin on view he's wearing pants and long sleeves and a big broad-brimmed hat, just as he had for seaside outings with friends two decades earlier. In Montauk, he sometimes topped off the outfit with a faux-snob pith helmet, under an umbrella that added still more sun protection.

Warhol's main interest in Eothen came from what it meant socially. The Montauk neighborhood had begun to attract a particular breed of elite culturati. Warhol's near neighbors there were Edward Albee, the well-bred playwright; Peter Beard, a bohemian photographer who came from old money; and Dick Cavett, a Yale-educated WASP who had his own high-end talk show. Warhol's compound helped move him into such circles. His first coup in that direction was a big one. The summer after he bought Eothen, he managed to rent its main lodge—the Big House, Warhol called it—to Princess Lee Radziwill, who was a titled Polish noble by marriage and an American aristocrat by association, via her big sister Jackie Kennedy, ex-Queen of Camelot. The still-married Radziwill was dating the recently divorced Peter Beard, Warhol's Montauk neighbor, so Eothen was perfectly placed to allow the relationship to proceed with discretion. Decades later, Radziwill had fond memories of the floors made of huge flagstones and two

vast fireplaces facing each other, and how the Big House hadn't been lived in for ages but still smelled of "cedar and sea."

Paul Morrissey treated the former First Sister's presence as some kind of affair of state, telling the guests in his cottage that they'd better stay inside whenever Jackie visited. Warhol, however, was clearly more comfortable in this new company. Radziwill recalled him shedding his patina of weirdness as he settled in with her and her kin, on his weekend visits to one of the lesser cabins on the estate. "He loved children and was inventive with them," said Radziwill, echoing statements from other parents over the decades. "He was something of a pied piper, always keeping their attention, always admiring and encouraging them at whatever they did." Films and videos, from that summer and the next, show Warhol totally at ease, playing on the beach with various combinations of Radziwill and Kennedy kids and, of course, documenting what was going on in both moving and still images. He and Radziwill talked again and again about movies he might cast her in—she had acting ambitions—and he did a portrait of her from one of the Polaroids he'd snapped, printing it onto canvas not as a commission but just for his own private pleasure, no doubt intending it as both fine art and memento. He gave a couple of tiny versions of it to the princess (he always called her that) but he kept the studio's standard forty-by-forty-inch canvas just for himself. He still owned it when he died.

Warhol might have had his head turned by his fancy new friends, but he was no fool. He knew perfectly well that he was in their world on sufferance, so long as they found him useful or amusing. Radziwill portrayed herself as someone with a taste for anyone "off-beat or a bit kinky." According to Warhol, her sister Jackie, recently become Mrs. Onassis, viewed him as a more respectable, rather less dangerous version of the paparazzo Ron Galella. As far as the Kennedy set was concerned, said Warhol, "We're their new toys." But for all that social insight he was always eager to be played with. He kept a classic summer-house scrapbook of life at Eothen, complete with autographs of the rich and famous who visited. Asking for those signatures instantly established Warhol as a courtier and fan rather than an equal. His lifelong insecurities prevented him from ever believing he could measure up, even when he was more successful and indubitably more important than the celebrities he spent time with. He was a gay man whose roots were in the wrong class, culture and city to ever let him count—to himself, at least—as someone of real note.

"We're going to put up gold plaques that say 'Lee slept here,' 'Jackie slept here,'" Warhol said, soon after the sisters had left that first summer.

There was one fancy figure in Radziwill's retinue who ended up a genuine friend. The princess was chummy with Truman Capote, gay idol of Warhol's youth, and the two men became properly close for the first time when Capote came to visit Radziwill from his own Long Island country house. Capote was the scene's consummate snob, and it took Radziwill's imprimatur to make Warhol someone worthy of close association. Once the bond was formed, however, it lasted right until Capote's death a dozen years later, with the interesting wrinkle that Capote's star was falling at just the moment when Warhol was becoming Mr. Everywhere. Doing his best to keep Capote afloat, creatively and in high society, Warhol ended up giving Capote piles of coverage in *Interview* as well as assignments to do for the magazine, which Capote only sometimes came through with.

Radziwill's stays at Eothen made for a couple of polite and orderly summers, politely noted in the social columns with only a rare mention of rent money changing hands. (Although one columnist did feel compelled to explode the rumor that Warhol was the *co-respondent,* as the British would say, in Radziwill's divorce from her Polish prince.) A couple of years later, another bunch of famous tenants were much more boisterous, this time getting coverage from rock journalists. Working toward a major U.S. tour and a new album, the Rolling Stones decided that Eothen, in its remote gentility, would be the perfect place to crank up their amps for rehearsals beyond the prying eyes and ears of their fans. Young men with dogs guarded the estate's approach, while the group's British cook complained that her day's work on a properly American shrimp gumbo went to waste when the lads preferred to order equally American pizza.

"Sensationally loud music welled through the windows, into the ruts and hollows over the tangled crab-grass," said a local paper, which described the dogs and wolves and coyotes howling in distress. Nearby motels and dive bars filled up with Stones fans desperate for a sighting.

The thought of the wild Stones carrying on at old-school Eothen shouldn't really strike us as any more strange than the fact that Warhol, once Lord of the Silver Factory, was the compound's owner. In the decade they'd known each other, the musicians and the artist had moved on from being rebels to icons. Even once they'd started to tread water as creators, the fame they collected for their '60s talent and daring won them social status in the '70s and beyond. After one Stones concert, Warhol noted that concertgoers now listened to the band with quiet attention; the Stones arrived at his property in a Bentley. Neither Warhol nor the Stones ever became completely establishment, since their status depended on being symbols of

an alternative culture. But the establishment welcomed them in as accept-able entertainers, or maybe retainers.

Mick Jagger and his wife Bianca had both attended on Lee Radziwill when she'd stayed at Eothen before the Stones did. They became regulars in Warhol's circle for years to come. Or, as he might have asked, was he the one moving in theirs?

*. . . in his Union Square studio, looking a bit worse for wear.*

# 42

## 1972-1973

JULIA WARHOLA HEADS HOME TO DIE │ CHAIRMAN
MAO AND THE UN-DEATH OF PAINTING │ BITING INTO
EUROPE'S UPPER CRUST │ THE POLAROID BIG SHOT,
FOR BIG SHOTS │ GALLSTONE WARNING │
FRANKENSTEIN AND DRACULA IN ROME │ WITH
WARHOL, LIZ TAYLOR IS IN *THE DRIVER'S SEAT*

*"I think about my bird that died. If it went to bird heaven.
But I really can't think about that. It just took a walk"*

Who will be with me, Andy, when you go to Europe? Who's
going to be here with me? Will you lock the house? They
would steal everything from you, my son, they would come at
night. . . . During the day is one thing, but at night I'm afraid
to sleep here by myself. Understand, Andy? At night I would be
afraid to sleep. But why would you care about that? If only I didn't
have stomach problems, if only I could overcome this somehow,
but I don't think I will be around for very long, because my breath
gets stuck.

Julia Warhola spoke those words in Rusyn one day early in the 1970s, as her
son did a test run of his new video equipment at the Lexington town house.
She lay in her little bed against the raw brick walls of her basement room,
weary, sick and fretting that she wasn't much of a model for Warhol to be
taping. She refused his cajoling offers of food. "You want some potatoes?
You want some potatoes cooked?" he said in English. "A sandwich? Good
sandwich, sandwich?"

As the old woman confused her basement with the one they had shared

two decades earlier, on Seventy-Fifth Street, her mind wandered. She mourned the fine pedal sewing machine that her *Andriiko* had thrown out years before: "I wouldn't want to sew on an electric machine even if you gave it to me for free." She raged at the "old bitch" of a hairdresser who she blamed for her scabby scalp: "For my 25 dollars, she burned my head with that strong evil stuff. I could have had her arrested for what she did to my head, it's been hurting for such a long time."

Even as Warhol was finally recovering from his surgeries, he must have realized he was losing the one person who had always been there for him. His mother spent a week in the hospital early in 1970, apparently for a stroke, needing transfusions and then home visits from a nurse right through the summer. Tubercular, with a bad heart and failing mind, Julia Warhola had constant doctor's appointments for the rest of the year, sometimes almost weekly. The police once found her wandering the streets and managed to get her home only because the pill bottle in her bag had her address on it; when Warhol got back to Lexington that evening he was annoyed at the idea that cops had been traipsing through his house. That same desire for privacy was what had kept him from hiring live-in care for his mother, as his siblings had hoped he would. Jed Johnson, for his part, thought Mrs. Warhola would have done better in a nursing home but Warhol was against that too even though he admitted to being exhausted from cooking for her. With all the travel he and Johnson were beginning to do, she must often have been left alone for others to care for, or sometimes to care for herself.

In the fall of '69, Warhol was called back from the shoot in Paris by his niece Eva, Paul Warhola's daughter, when she said she had to leave the old woman's side to get back to her own life. "I told her, 'What life?' She could have just lived in New York and kept taking care of my mother, but she wouldn't." He could have done the same. By the following spring, poor old Mrs. Warhola had suffered the deaths of her two ancient cats and of her mynah bird as well, though it ought to have had lots of life left. Those absences left her more isolated in her basement than ever.

As 1971 dawned, Warhol had to skip New Year's Eve festivities because of his mother's needs. By early May, he had engineered a major change for his sick mother. "I guess you were right about the whole idea of getting her back to Pittsburgh," wrote Eva, from her new life in Denver. "My mom wrote and said that she's eating real good that she's not having any problems with her. . . . I'm sure she will be much happier. There's people around so she won't have to feel lonely."

But it wasn't long before Warhol's mother became too much for the Paul Warholas to handle. In her dementia, she made the crazy accusation that her grandson Jamie was stealing her shoes. By mid-June Julia had a second stroke that landed her in a coma and in the hospital for more than a month. When she regained consciousness it was clear that she could no longer be looked after by relatives: Her mind was far gone and she was incontinent. Ignoring Warhol's objections, the brothers found a nursing home to put her in. It was just across Schenley Park from her old Dawson Street house and she spent the last fifteen months of her life there. The bills went straight to Warhol; he called daily but never visited. He did talk about using "The Warhola" as the name for the new theater he was planning for his Great Jones Street lot.

In September 1972, one of his cousins from the Zavacky compound in Butler, Pennsylvania, wrote Warhol a gently chiding letter—the latest of several—after her most recent visit to old Aunt Julia:

> I don't think your mother will be in this world too much longer. She is steadily weakening and I think she's clinging desperately to life in order that she may see you again. Her subconscious mind is filled with thoughts of you and I don't think God is pleased with your staying away. . . . It was pitiful for me to see her walk down the hall and inquire at every door if anyone has seen you, because, she told them in our language, that she is ready to go to Butler with me and doesn't want to leave you alone. In fact, she once tried to move a heavy wardrobe in her room because she said that you are bashful and are hiding behind it. . . . I look forward to hearing the good news that you honored your mother's last wish on earth—to see her son—you.

That last wish went unfulfilled. Julia Warhola, having just turned eighty-one, died of a third stroke on Tuesday, November 28, 1972, a fact that seemed to leave Warhol strangely cold when his brother John called him with the news. Answering his brother's sobs in quick, clipped tones— maybe his reserve came from shock—Warhol said he could not attend the funeral because it would make him much too "nervous." He told his brother again and again to make sure to keep their mother's death as secret as possible. He also dwelled on getting the very cheapest of funerals, since such proprieties were meaningless, said Warhol the good avant-gardist. He also reminded John that Julia—secretly as avant-garde as Warhol?—would have

shared those views. On the Sunday before her death, Warhol had skipped an important meal with bigwigs: "I just couldn't get myself to go to lunch," he told his diary, apparently because he'd had news of his mother's decline. But on her death day itself he was perfectly normal and busy. He had three servings of lasagna for dinner.

Warhol told his brothers to order "the cheapest funeral" for their mother, and he did not attend. Even Warhol's closest friends—even Jed Johnson—only discovered Julia Warhola's passing much later, by accident, from her other sons. If strangers inquired about Warhol's mother, she was always out shopping at Bloomingdale's. In that sad fall of '72 a reporter asked Warhol what was on his mind. He answered, "I think about my bird that died. If it went to bird heaven. But I really can't think about that. It just took a walk."

---

Just as his mother was beginning her final decline in Pittsburgh, Warhol, maybe feeling some release from his filial duties, was beginning to consider his first major painting project since the shooting. The first, in fact, since he'd conceived of his Flowers back in 1964. An early sign of this breakthrough came in September 1971 in a comment Warhol made, apparently out of the blue, on a call with his friend David Bourdon:

> I've been reading so much about China. They're so nutty. They don't believe in creativity. The only picture they ever have is of Mao Tse Tung. It's great. It looks like a silkscreen. It's the only picture they ever have of him—they don't believe in people being creative.

Within a couple of months, those observations had become inspiration, expressed with Warhol's usual mix of insight and free association—or maybe it was insight *born* of free association. "Since fashion is art now and Chinese is in fashion, should I do some Mao portraits?" he asked Bourdon in another call, as they contemplated the stalled creativity of 1960s art stars like Robert Rauschenberg. "I could make a lot of money. Mao would be really nutty . . . not to believe in it—it'd just be fashion. And still a portrait is not considered a painting. Fashion is art now. . . . Don't do anything creative, just print it up on canvas." Warhol talked about rendering Mao "like the same kind of posters they have in China . . . you know where they do them really big and silkscreened. They hand paint them." (See color insert.)

The move from observation to inspiration seems to have been triggered by a desperate appeal that Leo Castelli had made to Peter Brant: "Leo would say to me, 'You've got to get Andy to work. He hasn't done anything since the '60s.'" The Mao project that resulted, which ended up spawning something like 2,700 images, began fairly humbly—and democratically, maybe even communistically—as a huge print edition published by Multiples, a company that specialized in selling contemporary art at a price point accessible to the masses, or at least to America's rising middle class. Each of the edition's 250 portfolios contained ten different prints, which sold for $550 each or $4,500 for all ten—not cheap, but within the realm of the possible for with-it homes across the nation. The potential gross from the prints came to well over a million dollars, and sales were brisk.

When the series launched at Castelli's in New York in November 1972, the *New York Times* did not so much as mention it, giving some sense of how far Warhol's star had fallen in the American art world. (Warhol himself skipped the opening.) A few months later, when the Mao prints were shown on the West Coast, a rare review dwelled on their new look and technique, which produced "loose, brushy effects that remarkably resemble painting." Warhol's Pop works had managed to produce an effect of mechanical reproduction, but had used the most casual of artisanal silkscreen techniques to get there; in contrast, the new Maos used a complex, multiscreen process, deployed by a professional silkscreening studio, to simulate the unmechanical accidents and expressive marks of traditional hand painting.

In each of the portfolio's ten prints, which all look quite different, Mao's head gets surrounded by scribbles, screened in a matte black that makes those marks look like last-minute, hand-drawn additions. In the various prints, the Chairman's classic Mao suit changes color from purple to yellow to red, with splashes of darker and lighter tone that make it look almost—but only *almost*—hand painted. Actual texture gets added by the prints' heavy inking, which can make the surface look embossed, like an "oil painting" published by Hallmark. In the Multiples brochure meant to help sell the portfolio, a disingenuous Warhol claimed that the very calculated and artificial spontaneity of his prints came about because it was simply "easier to be messy." He then added, as something between an about-face and a non sequitur, "Abstract Expressionism is the greatest phase of American art." Never has a tongue been further in cheek.

Warhol's Maos, for all their Pollocky mess, could hardly have been further from the social disengagement of abstraction. When Warhol's paintings

of Mao Zedong were first appearing on the scene, real live Maoists were roaming the halls of every college department, taking potshots at their less radical colleagues' bourgeois ideals. Maoist insurgents were roaming the jungles of Sri Lanka, taking real live shots at government troops. The famous Little Red Book that supplied the image Warhol used for his paintings was filling revolutionary pockets everywhere.

In the world's most populous nation, Chairman Mao himself was busy enforcing Communist orthodoxy, sending people tagged as intellectuals off to dig latrines for farmers. In the United States, Richard Nixon was earning headline after headline for his rapprochement to that autocrat, with a trip to China announced a couple of months before Warhol's first chat with Bourdon and then realized just as the Mao series began to get made. (Warhol got to make his own trip to China exactly one decade later, when he was paid to lend his presence to a club launch in Hong Kong. He liked the Great Wall.)

Warhol's dear old friend Emile de Antonio, the Marxist documentarian who had helped birth the first Soup Cans, was just then hard at work on a famous film about contemporary painters, including Warhol, but nevertheless took care to be on the record saying, "If I have to make a choice between American painting and the attempt to turn men's minds and the search for a collective soul, then I'm more interested in what Mao is doing than in the art of my friends." At the other end of the political spectrum, one newspaper reader reacted with horror to a photo showing a suite of Warhol's Maos: "Mao Tse-tung murdered about 60 million Chinese and caused poverty and starvation in all of China. . . . To put prints of such a person on the wall is equal to putting Satan in New York to replace the Statue of Liberty."

Like Warhol's best Pop from a decade before, the Maos were happy to straddle celebration and critique. Despite the real and necessary political engagement signaled by Warhol's choice of subject, they refused to reveal their maker's intentions. "Idea-wise," said one critic, "the message seems to be that even so militantly puritanical and anti-capitalistic a figure as Chairman Mao can be transformed into a commercial object to grace the walls of decadent, bourgeois living rooms." Sure, but the pictures might also have sent the opposite message, to please the likes of de Antonio: That even a bourgeois living room—even the touch of a "sold-out" Western artist—could not negate the ineluctable progress of Mao's efforts to turn men's minds and find a collective soul. Or then again, maybe it could. One particularly smart critic talked about the Maos as "images of historic menace to the ruling class" which, in Warhol's hands, offered his ruling-class patrons

"both a delicious horror and a promise of emotional mastery over it: they can hang it on their walls."

And Warhol himself, as always, refused to admit to any investment at all in his content, one way or the other. He told a gossip columnist that he'd chosen Mao as his theme one day when all he had on hand was red and orange paint: "Those were the only colors I had, so I thought of someone who would look right in those colors."

Unlike *The Chelsea Girls* or "Raid the Icebox," the Maos didn't mark any fundamental departure from what Warhol had been up to from the beginning with his Soup Cans and Marilyns. He had returned to his old Pop games. But with his new, vitally topical subject, he does seem to be trying to raise the stakes of Pop Art even as he works as hard as ever to muddy its waters. The Maos seem to have been made very much in the sarcastic, Dada spirit of Warhol's first conversations with Bourdon about his "really nutty" idea. Almost every detail from those early phone calls is there in the finished project.

The Chinese, Warhol had said, "don't believe in creativity," and sure enough, by reproducing what was coming to look like the most reproduced image in history, Warhol was inoculating himself against any charge of Western-style innovation.

"Just print it up on canvas," Warhol had said, "really big and silkscreened"—which was precisely what he did when he got a technician to screen his Mao image onto four vast canvases, each as big as any Rubens altarpiece.

Warhol had talked about taking his inspiration from the "posters they have in China," and his own Maos did a pretty good approximation of such ubiquity. The project let loose some two hundred canvases of a single image on the art world, plus another 2,500 copies on paper. In communist China, a single icon of Mao ended up everywhere from a grandmother's dresser to the Tiananmen gate; in the capitalist West, Warhol's Mao has ended up everywhere from the offices of doctors and lawyers to the walls of every big new museum.

Even the weird contradiction in Warhol's description of the Chinese originals—"it looks like a silkscreen . . . they hand paint them"—is a pretty good description of his own Mao image, if maybe in reverse: "It looks hand painted . . . he silkscreens them." In Warhol's Mao prints on paper, all the "painterly" marks were in fact laid down through a screen with a printer's squeegee, not by hand with a brush. In his Mao "paintings," the actual image was also completely the product of screening; the thick brushwork on most pieces had nothing to do with the portrayal of Mao, but was an almost

arbitrary mess of strokes laid down on the canvas mostly before the figure got printed overtop. Rather than revealing the essence of Warhol's expressive soul or searching brush, that mess of paint came closer to being a knowing comment on brushwork, or more like a joke about it. Warhol boasted of completing the painting on twelve huge Maos in one day, imagining the output he could achieve if he kept up that rate: "I wish I was an Abstract Expressionist. It's so easy, not drinking and painting up a storm." He talked about his new brushwork as "abstract pseudo-painting," something he could do, he said, "without even thinking. . . . You can be messy, and just drip all over the place."

Aside from being easy and fast to do, Warhol's sloppy style also brought a boost in efficiency: It spared him the fussy alignment between tidy, local underpainting and the image screened overtop that had slowed down his Pop production. Now he could rough in his background colors at speed, then send the canvas off to have its image printed overtop knowing that his "expressive" strokes would camouflage any weirdness in how the two layers came together.

One evening when Warhol was working on one of his biggest Maos, so huge it could only be made on the floor of his studio's sixth-floor screening room, a video from the so-called Factory Diaries captured him laying down paint on the canvas before it was sent to his Swiss-trained printer for screening. (That final stage was where the real heroism and virtuosity came in; the vast Mao pictures—the silkscreener insisted on calling them "prints"—were murderously hard to squeegee.)

As Warhol worked, he explained his process to Jed Johnson and Archie the dachshund and others who were keeping him company: "The sloppier it is the better," he said, "just be sloppy and fast." He said he painted the way Julia Child cooked, a foodie reference to the messes and muddles the French Chef was known for. Warhol's invocation of sloppiness wasn't hyperbole, the way Warhol's nods to machine production had been. The video shows Warhol pushing paint around like crazy, sometimes using his housepainter's brush to mix an almost random bunch of colors right on the surface of the canvas, so as to cover its 160 square feet in the half hour he had before the camera ran out of tape. It was all so casual Warhol had no trouble talking to his entourage as he raced through the job. When Archie got pawprints on the piece, Warhol used his fingers to smear away the damage. He sometimes comes off as less Julia Child than the Muppets' Swedish Chef.

Despite all the chaos visible in the Maos, they have often been read, especially in the art market, as part of Warhol's 1970s return to order—as

an antidote, that is, to the out-there, unsalable experiments in film, self-creation and conceptualism that he'd gotten up to just before. The Maos have been taken as the sign of a grand and heroic re-embrace of painting on the part of a certifiably great master: Surely his repudiation of that best-selling medium could only have been meant in jest? In fact, the unruly mess of the Maos can just as easily be read as that repudiation's apotheosis. Just as he was making his Maos, Warhol the avant-gardist was still declaring the death of painting, even the exhaustion of all art. It doesn't seem far-fetched, therefore, to imagine that he might have been jealous of China's one-image art world, where "the only picture they ever have is of Mao Tse Tung," the rest of them having been quite tidily killed off in the country's revolution. Warhol's new "celebration" of painting is just as easy to read ironically, as the latest nail he drove into its coffin.

An interviewer once drew Warhol's attention to the contrast between his Pop works, which had been impersonal and without any sign of the artist's "hand," and some of the society portraits of the 1970s which "have a lot of brushwork and drawing, and are expressionist by comparison." To which Warhol replied, "I really would still rather do just a silkscreen of the face without all the rest, but people expect just a little bit more. That's why I put in all the drawing." He liked to dismiss works he painted with a brush as "hand jobs," and waxed sarcastic about adding "abstract, de Kooning squiggles" to make his portraits come off as "more intellectual." He explained away his return to paint as nothing more than the latest art-world fashion—Leo Castelli agreed it was—and once admitted that he preferred the Polaroids of his sitters to the paintings he made from them.

When Warhol offered to trade a portrait of the hotshot Joseph Kosuth for one of the younger artist's conceptual works, Kosuth knew to choose the "straight" portrait Warhol turned out (i.e., "without all the rest") over another one he did that came with brushwork. On the other hand Henry Geldzahler, who should have known better, once rejected a portrait Warhol had done of him in the mid-1970s because it was too close to the Polaroid it was based on: "You've left out the art!" he complained. A few years later, Warhol said he wanted to have another crack at the assignment. "I'll put the art in this time," he teased, and then coughed up a new portrait full of "juicy brush strokes."

The "art" of those strokes might have been Business Art. "I could make a lot of money . . . not to believe in it—it'd just be fashion" was how Warhol had launched his thoughts on the Maos. He was signaling his willingness to embrace—or to pretend to embrace—stylishness for the sake of the money it could make. The Maos' "hand-painted look," Warhol said, "is more in fashion

now." Not long before, when some investors were forming a consortium to buy a series of Warhol portraits, he offered them the choice between a crisp and a brushy technique. They chose the brushwork, leaving Warhol with no doubts about where his market lay.

Sometimes, the brushwork on Warhol's portraits actually existed quite independently of their faces, thanks to an almost assembly-line technique: An assistant described Warhol literally mopping paint onto a huge expanse of canvas all at once, and only afterward deciding where to silkscreen faces onto it to best "painterly" effect.

As the Maos were beginning to sell, Warhol talked about abandoning the radical, anti-authorial "we" he had used to describe art making in the Silver Factory (even when no one but he was involved in a work) and going back to the traditional "I" of the brush-wielding artist (even when technicians were involved in turning out each painting). There's even a blank notebook where he's practicing different versions of his signature. In marketing terms, Warhol's new "I" made perfect sense. Given the anti-anti-establishment culture that was taking off in the 1970s, the idea that a celebrity artist like Warhol was at long last coming back to the hand and the brush seems to have been an irresistible selling point, regardless of the vexed subject he'd chosen for his Maos. Knowing Warhol, he reveled in that tension between sales and subject.

Warhol sold the first ten Maos he painted to Bruno Bischofberger in Switzerland, who arranged for a show of them at a notable museum in Basel and then at a prestigious gallery in Turin. After that, another 130 Mao paintings, in all kinds of sizes, were involved in an elaborate sales deal between Warhol, Brant, Castelli and the venerable Knoedler Gallery. It saw the largish paintings going for almost $30,000—the same as a major early Warhol—and the total approaching $2 million, with a prepayment to Warhol of $600,000, regardless of how many paintings ended up selling on to collectors.

In February 1974, after Warhol's Maos had been out in the world and on the market for about eighteen months, Ileana Sonnabend arranged for a big spread of them to be installed in the Musée Galliera in Paris. That was a grand Beaux Arts space newly dedicated to the very latest in art and culture, and his chance to show there seems to have had special meaning for Warhol, as museum exhibitions always did. He used the occasion to give his paintings a post-Pop edge as that latest of New Things, installation art: He ran with a suggestion from Sonnabend that he make a Mao wallpaper to hang behind his canvases, the way he'd hung cows on the walls of his Whitney survey. Between the Maos in the wallpaper and the Maos in the paintings that hung in front of it, something like two thousand Chinese chairmen were on view at once.

Warhol's Business Art depended on getting his Maos to pass with collectors as the product of old-fashioned bravura, with each canvas presented as the product of a single moment of inspiration with the brush. But when it came time for Warhol to appear in public as a museumworthy avant-gardist, he was keen to make clear that playing games with seriality and mass production was still the order of the day. The handmade was just a byplay that he'd added to his main gambit.

In the spring of 1971, Warhol walked into the atelier of silkscreener Alexander Heinrici for the very first time, carrying an unusual Polaroid that he'd taken the rare step of bringing down to the printer himself. "It was the Baron Rothschild nude, with an erection, on a grand chair," Heinrici recalled, thereby explaining Warhol's in-person courier work. "Can you make a screen of this and then make a print on canvas?" Warhol had asked. Heinrici did both, but with unknown results: That portrait of a priapic Eric de Rothschild, then thirty years old, has never been revealed to the public. ("I just love it so much," said Warhol as he worked on the painting. "The idea is so good." And also, later, "He's got a nice Jewish dick.") The portrait nevertheless counts as a landmark, signaling the start of Warhol's climb into the highest of international high society.

The ascent continued at the end of that year when Warhol got invited to the Rothschilds' celebration of Marcel Proust's centenary. It took place at the absurdly grand Chateau de Ferrières, near Paris, and counted as yet another "ball of the century" in an era that seemed to declare them by the dozen. Warhol, looking genuinely dapper in white tie—he must have been thrilled to see his photo in the coverage—got to dine on the same lobster and foie gras as the Duchess of Windsor, Princess Grace of Monaco and Elizabeth Taylor, who was a near royal that night by virtue of the $3 million in jewels that Warhol spotted on her. (Some of them were even hers.)

"It was just unbelievable," an awestruck Warhol told a friend some days later, "sitting with Richard Burton, Elizabeth Taylor, Audrey Hepburn behind me." He was especially pleased that Burton had actually condescended to shake his hand: "He was so sweet," said Warhol. Burton's "sweetness" that night extended to writing in his journal that his fellow guest looked "like a cadaver when still and a failure of plastic surgery when he moved . . . [a] horror-film gentleman." Within the year, however, the ascendant Warhol was being described by a Rothschild—Pauline, this time—as one of the people she "especially enjoys knowing well."

Warhol also got a private tour of the Chateau Lafite winery from Eric

de Rothschild himself, who comes off as quite buttoned-up in the notes on the visit. He especially impressed Warhol with his magnums: "Oh Fred, we have to order those big bottles. They look like art. We're going to buy big bottles and put them in museums." When Warhol died fifteen years later, the notes from his Lafite visit were in the desk in his bedroom.

———

Warhol's nude of the young baron marked another beginning in the artist's career: It launched the new process he would use for almost all of his later silkscreened works. Instead of handling the screening himself, as he had done in the '60s, he would take or find the photo that he wanted to use as a work's image, then get a pro to make it into a screen and print it onto canvas, offsite. There was an obvious reason to make all work on the nude happen discreetly out of sight, but Warhol clearly enjoyed what it had felt like to farm his labor out. His fear of fire also made him eager to banish silkscreening solvents from his studio. For the rest of the decade, the subways were full of minions carrying photos and canvases back and forth between Warhol and his printer, since Warhol rarely made the trip himself.

For all the "juicy" brushstrokes Warhol might introduce in his underpainting—and he was adamant that no one else should be involved in that stage of the work—the rest of the process was more hands-off by far than his "machine production" at the Silver Factory had ever been. Still, when his later patrons came to collect their treasures, Warhol often kept up a pretense that they'd been freshly produced in the studio's back rooms. Heinrici remembered that when he first began to do silkscreens for Warhol, the artist complained that they were too perfect to pass as the master's works: "In the future, you have to make some mistakes, or people won't think it's a Warhol." It took some practice before the Swiss-trained printer could get the knack.

Another technical change came about in Warhol's art not long after Heinrici came on board as his printer. In May 1971, Polaroid premiered a weird new camera called the Big Shot. Before long Warhol became its biggest fan, and probably its only fan among artists. He came to use it for the vast majority of his portraits. When the camera was discontinued after just a couple of years he spent the next decade on the lookout for used Big Shots he could stockpile as spares. He even got friendly Polaroid staff to help him find them.

The camera was an absurd-looking thing made of clunky plastic, like a respectable Polaroid camera from the 1960s that had a ten-inch tube grafted

onto its front and a silly little lens stuck on at the end. "This is the cheapest model," Warhol said when a reporter noticed it protruding from his flight bag. That was certainly how it looked, and it really did cost only $20. But that didn't make it any less of a secret weapon for Warhol. He wasn't using the Big Shot ironically, as a toy he pretended to take seriously—as a piece of pop culture, that is, used to high ends. It was a truly functional, almost unique piece of equipment. As usual, Warhol's man-of-the-people pose hid sophisticated knowledge and tastes.

"Big faces—the kind of pictures you want most" read the full-page ads that Polaroid ran for their new product. "Its length takes the place of expensive cameras with complicated lenses or special attachments. Pictures are almost all face, the kind you get in portrait studios"—and precisely the kind that Warhol needed for his new '70s art. That long tube on the camera's front let its plastic lens function as a telephoto, such as pros used and still use to get a flattening and flattering effect in their portraits. At last, the Big Shot let you take a Polaroid headshot from far enough away that your sitter's nose didn't get distorted into a Jimmy Durante proboscis; it was sort of the selfie stick of its day. But the Big Shot's cheap, low-tech plastic construction meant that, unlike the giant studio cameras that could shoot flattering instant portraits, it was light enough to be handheld. You could use it almost like the snapshot Instamatics that Warhol had always loved. It even called for the same cheap flash cubes they did. It basically couldn't be used without them, since its bargain optics barely let in any light. But even that helped the camera yield a faux-studio effect: Its flash cubes got mounted right above the lens, with a little diffuser in front, which meant that any face that you shot became almost shadowless. That did the job for Warhol, who needed his sitters' faces to look as graphic and flat as could be—like painted soup cans, almost—and as free of incident as skin could get. As Warhol once put it, the Big Shot "dissolves the wrinkles and imperfections." That was helped out, before the picture was taken, by an insanely thick coat of white makeup that Warhol ordered applied to every bit of exposed flesh on his fanciest female sitters. After the shoot, still more significant plastic surgery could take place by working on the photographic image in the early stages of the silkscreening process: "I had to take out the wattles and the bags under the eyes, and the crow's-feet," said Warhol's printer. Not that that stopped any numbers of patrons for returning their portraits when they still weren't flattered enough.

"Bruno is one of the best persons," Warhol was telling a friend not long before Christmas of 1971. "I mean, he is so sweet and such a good person. He just loves art so much." That was quite an endorsement for Bischofberger, given that he and Warhol were in the middle of negotiating a portrait agreement that was far more financial than aesthetic and easily might have bred nastiness on either side. The deal, which closed early the next year, gave Bruno Bischofberger exclusive rights to all European commissions for Warhol's portraits, to be priced at $25,000 for a first canvas and $5,000 for following ones of the same image. The price for those "extra" canvases eventually went up to $15,000, and the whole deal is strangely reminiscent of the cheap enlarging that drugstores used to do, where for a small extra charge you could get your image printed several times onto a single sheet of photo paper. Warhol had used just such prints in *Esquire,* late in 1969, for a big spread of his snapshots—including a self-portrait with scars taken while in the hospital.

For a while, Warhol seems to have been unsure of how far he could go, or could admit to going, in letting his portrait project take over his art production. There had been a "portrait" section in the survey that toured from Pasadena in the early '70s, but it had mostly shown Marilyns, Lizes and Jackies; the only contemporaries on display were eminent art worlders whose presence would not ruffle feathers.

In the fall of '72, he told one reporter that he only did "an occasional portrait if someone asks us to do one" and let another writer know that his plan was to do only two portraits a year, naming Brigitte Bardot and her art-collecting ex-husband as that year's pair; as subjects, they still preserved some link to art and to Warhol's earlier Pop movie stars. In fact, however, Warhol had forty-five portrait canvases all on the go around that same time. The year's subjects had included everyone from a German mail-order tycoon to a TV producer to Yves Saint Laurent, a new friend who was busy just then transforming the branding and marketing of high fashion, as Warhol was doing for high art.

At first, Warhol had tried to give some edge to his portraits, so they'd look more like "serious" art. Several of his earliest sitters found themselves looking distinctly unattractive. Before long, however, Warhol the Business Artist—or possibly Warhol the anti-avant-garde avant-gardist—had decided that his society portraits were better off flattering, as such paintings had done in the days of Velazquez or Sargent.

At a New Year's Eve party in St. Moritz, in 1973, Warhol approached the car-racing legend Jackie Stewart with the idea of doing portraits of him "with sport as a background and all that you've done"—the way George

Washington had been painted with scenes from his battles behind him. "Andy, I couldn't afford the kind of money you're commanding at the moment," Stewart said, to which Warhol replied, "I'll give you the paintings as long as you give me the global rights to the prints and lithographs." Stewart called his failure to follow up on the offer the worst business decision of his life. A few of Warhol's collectors had already begun to treat his portrait commissions as business ventures, ganging together to buy "shares" in series of portraits that could then be resold. That could only have got him thinking in similarly corporate terms.

A few months later, at the same time as Warhol's Maos were getting the fine art imprimatur of their Galliera show, the first big public spread of his recent portraits was being presented at Ileana Sonnabend's gallery across the Seine. It still included art-world figures such as Sonnabend herself and Leo Castelli but now there was also a cheesy-fancy Venetian jeweler named Attilio Codognato as well as Yves Saint Laurent and Helene Rochas, an older star of the Parisian fashion scene. One reviewer in Paris referred to the portraits as tender. Another called them cruel. Those two poles have shaped the thinking about Warhol's portraits ever since. Either way, that moment in Paris signaled that the link between Warhol's art and his social scene had been fully forged.

———

Cannes, Mexico City, Zurich, St. Moritz, Milan, Venice, London, Munich, Hamburg, Berlin, Frankfurt—those are a few of the international destinations Warhol had touched down in during the first few years of the 1970s, leading up to his Rothschild successes. He was often accompanied by Brant or Bischofberger and almost always by one or both of Fred Hughes and Bob Colacello. (A catty friend of Warhol's called that pair "the head waiters.") If a trip wasn't built around appointments with portrait sitters and patrons from the start, a hunt for them began at once on arrival, maybe even on the plane on the way over. Warhol was forever prodding Hughes and Colacello to offer any rich person they encountered the chance to become a genuine Warhol— "popping the question" was the artist's phrase for the ask, and his staff were expected to keep popping like popcorn.

In April of '73, Warhol took a brief, distinctly unplanned break from his manic travel, sales and self-promotion.

"I have never seen anything like it in my life, and I've seen a lot!," said his friend Diana Vreeland, remembering a dinner party where she and Warhol were guests. "Andy arrived with Fred and literally crumpled to the floor in the most excruciating pain imaginable! Somehow, we got him into the bed-

room and onto the bed, and we called for an ambulance, which in New York is like sending out for Chinese food—they take forever! Andy was writhing in pain, but quiet as a lamb." The problem was gallstones, which usually go unnoticed but in the worst cases can feel like the most agonizing heart attack, which was clearly the case for Warhol. He was admitted to hospital for treatment that would normally have included a straightforward and final cure: Surgery to remove his gallbladder, preventing a serious and potentially deadly infection. But the surgeons were reluctant to operate on someone whose wounded body had already been through so much. Their hesitation was probably compounded by Warhol's extreme resistance to going under the knife.

All Warhol's friends talked about the tremendous fear of hospitals and operations that took hold of him after he was shot. Even by the standards of irrational terrors, however, it didn't make a lot of sense. He must have known that he was only alive at all because of the surgeons who had operated on him five years before at Columbus Hospital—he'd raved about the care he got—and that his mother's life had also probably been saved by the cancer surgery she'd had a quarter century earlier. Even his second operation to correct the drainage from his bullet wounds had pretty clearly done more good than harm, despite the pain he suffered afterward. It could be that his mother's death just six months before his gallbladder attack had made him particularly nervous about his own survival, and that he somehow linked the long-ago removal of his father's gallbladder, which seems to have been perfectly successful, to Andy Sr.'s death more than a decade later. (His brothers have sometimes imagined some connection.)

Whatever the reason, instead of surgery Warhol underwent a hit-or-miss treatment with medicine and diet instead. For years he got prescriptions for various stone-dissolving drugs of doubtful effectiveness; from that spring onward he fussed more than ever about what he ate. Where he had once reveled in the perfection achieved at Dumas Patisserie, steps from his town house ("it has a special flavor, buttery, and is the best bakery in the world") he now claimed to be dedicated to toast and tea, boiled chicken and corn. "Nothing complicated, no salt or butter," he told one food writer. "I like to go to bad restaurants, because then I don't have to eat. Airplane food is the best food—it's simple, they throw it away so quickly and it's so bad you don't have to eat it." Warhol was exaggerating his asceticism for the sake of giving good quote. He went on to enjoy lots of fine restaurants on a regular basis and often talked about what he ate there—liver with kiwis, the latest in nouvelle cuisine, was not out of the question. Although some

friends do recall the piles of food he left on his plate or merely pushed from one side to the other.

You could say that the prescriptions Warhol filled and the food he fussed over did some good: He survived another fourteen years of chronic gallbladder troubles. Or you could say that they did far too little: It was his gallbladder that led to his death when those fourteen years were up.

---

In the months after his crisis, Warhol was still being very careful about what he ate. While his whole table at a fashionable restaurant in Rome gorged on fettuccini with truffles, he ordered prosciutto with figs, hold the prosciutto. But at least he was well enough to have made the trip over to Rome.

In a year of constant travel, Warhol spent more time in the Italian capital than anywhere else overseas. The reason, for once, had little to do with his new art and/or business of portraiture. He had on his movie producer's hat instead. Warhol had been talking for ages about getting someone, anyone, to give him that fabled "million dollars" to make a mainstream(-ish) entertainment, filmed on Hollywood-worthy 35 mm stock. Now Warhol had found such a patron, in the person of the leading Italian producer Carlo Ponti, whose credits included many of the most famous and profitable art-house movies of the era: Fellini's *La Strada*, David Lean's *Doctor Zhivago* and *Blow-Up* by Michelangelo Antonioni.

For a while already, Warhol had been interested in filming some kind of gore-fest—he'd been talking about *Dracula's Baby*, that "musical horror film"—and by the end of 1972 Paul Morrissey had written a pair of film treatments to scratch his associate's itch. One of the treatments, sticking to the vampire theme, was titled *Blood for Dracula*. The other, *The Frankenstein Family*, came complete with actors' names already penciled in plus plenty of awkward writing: Dr. Frankenstein, his wife and three children, said the treatment, "are distinguished by their unusually wide apart-set eyes—a case of inbreeding extending to a distortion of the eyes." Despite that challenge to the movie's prosthetics team, Warhol and Morrissey managed to sell the idea of both films to Ponti. The European profits already garnered by Morrissey's *Flesh, Heat* and *Trash,* plus the art-world reputation of their "presenter" Andy Warhol, would have gone a long way toward convincing the Italian that those paired horror flicks would be his latest success. By March of '73, a contract had been inked committing Ponti to spending $800,000 on the two movies, to be filmed back-to-back on the famous Cinecitta sound-

stage in Rome, with fees of $100,000 to be split between Morrissey and War-
hol, plus a cut of the profits. By May Day, Warhol was in Rome to join his
regular team: Morrissey, Fred Hughes and Jed Johnson, plus Pat Hackett and
Bob Colacello on occasional visits.

Presented with a budget unlike anything they'd ever seen, Warhol and
Morrissey instantly enlarged their ambitions: Not only would they shoot in
35 mm, but they'd go for 3-D as well. That clumsy technology meant that
Morrissey had to give up on the freewheeling directing and acting he'd
always used and basically turn out standard, scripted, stilted movies that
were not much different from other midbudget entertainments coming out
at the time, except that they had more nudity and still cruder violence.
Gene Siskel, not yet twinned with Roger Ebert, declared Morrissey's *Flesh
for Frankenstein* a total failure, "a mixture of abject lethargy and repulsive
gore." Many other critics were less kind and even crueler to his *Blood for
Dracula*.

"We used to make films just for ourselves, but it got boring," Morrissey
had told a reporter a few years before. "It's much more of a challenge trying
to do something that will entertain millions. It's better discipline—and in
the long run it will make better movies." In 1973, the long run had yet to
arrive.

Actually, the two movies did entertain well enough to do good box
office, especially given their modest costs. The *New York Times* forecast a
$10 million gross for *Frankenstein* alone. But it looks as though the way
Ponti had written their contract kept Warhol and Morrissey from ever see-
ing their share of the profits. That disappointment made for a major rift
between Warhol and Morrissey, who stayed in Europe after the shoot and
never worked on a Warhol project again. The relationship wasn't helped by
the boots-and-swagger-stick style Morrissey decided to adopt during the
production, which sounds like it was worthy of Josef von Sternberg at his
most tyrannical. His collaborators Pat Hackett (doing daily work on the
scripts) and Jed Johnson (working as production manager and then editor)
complained to Warhol of being treated like peons, although their efforts
may very well have saved the production.

Morrissey was already known for bouts of grumpiness, but the pressures
of the Roman shoot pushed it to new levels. "He was so funny last night,"
Colacello said, gossiping with Warhol in a Roman taverna. "He came over
and said, 'Like this beer? Like this beer? It's the worst beer in the world.'
Everything here is 'the worst in the world.' He said the beer was the best in
Germany, but when he was in Germany everything was 'the worst in the
world' there, too."

Warhol seems to have had a far better time of it in Rome. He and an ever-changing roster of young associates were staying in a villa—the Villa Mandorli—out on the Via Appia, where all the fancy people lived. It came with a green space where Warhol would sometimes garden, maybe for the first time since he won that prize for his flowers on Dawson Street. There was also a long-suffering but devoted Italian cook who Warhol both pitied and admired as she did her best to cater to his difficult "kids." In the villa, Warhol and Jed Johnson were living openly as a couple, or rather a family, given the constant presence of Archie, Warhol's beloved dachshund. (One morning when the dog peed their bed, Warhol worried about what punishment Johnson would inflict if he found out.) "I thought they were really *intime,* like a couple," said Daniela Morera, a frequent visitor who had recently been named the "Milan Correspondent" of *Interview.* "I saw them in a very sentimental and sweet way many times." By all accounts Johnson had a calming effect on Warhol, tempering his manic socializing.

The other members of the Villa's New York crowd got up to all sorts of revelry, and rivalry, which Warhol delighted in witnessing. One night's drunken insanity saw Joe Dallesandro calling Morrissey a "fag" right under his window. "Shut up down there, you creep" was the reply. That was followed in the wee hours by any number of people sharing the same bathtub and finally by a reconciliation between Dallesandro and Morrissey, who had been on the outs throughout the film shoot. In general, the crowd were very hard drinkers, with Fred Hughes drinking harder than most. Warhol himself was far from a teetotaler.

Warhol had always taken pleasure in observing human foibles so the conflicts at the villa put him in seventh heaven. "Dinner was ready so I ate," he recorded in one diary entry. "We had fish that the boy in the editing room sold to Jed. Paul said, 'Where did it come from?' Jed said the boy's mother owned a fish store. Paul said, 'That doesn't mean anything.' Jed said, 'Then it doesn't mean anything. Don't eat it.' Silence."

Warhol was able to keep some distance, both managerial and emotional, from the troubled film production that his name was attached to. When he saw rushes, he always found them "great." That remove left him plenty of time to mingle with the local elites—"the ultrachic and aristocratic upper crust of Rome society," said one disgusted observer—and also with its legendary film people. He got to meet the director Vittorio De Sica (*The Bicycle Thieves, The Garden of the Finzi Continis*), who told him he admired his paintings. He also got to watch the madness of a shoot by Federico Fellini. Warhol witnessed a procession that included "a blind accordion player, a little boy pulling his cane, people with baskets marching by, a horse carriage again, a

big huge plastic tree," and then to join the director in his private dining room at Cinecitta:

> Everyone was nice, and charming. . . . Weird food. Strong wine. Chianti. Tried to tell him about *Pink Flamingo* but it got lost in the translation. He liked *Clockwork Orange*—thought it was good. It was a movie I thought was terrible. Paul is right, Fellini must really have wanted to be a painter and paints movies. . . .
>
> I don't think I could ever learn a foreign language. I'd just laugh or something every time I had to say a word—I'd just have to make it funny or something.
>
> Back to Villa. Worked.

The high point of Warhol's social schedule in Italy came from an encounter with a figure not from Cinecitta but from Hollywood. In August, after Warhol had been back in New York for a chunk of the summer, he returned to Rome in a whole new role: as an actor, not in one of his own movies but in an Elizabeth Taylor vehicle called *The Driver's Seat*. She was playing a troubled woman who came to Rome in search of a new lover who would also be willing to kill her. Warhol had a bit part opposite her as "a rich creep of undisclosed nationality and occupation" who Taylor rejects in her search for Mr. Right (and Wrong). Warhol was obviously offered the part because of his high-profile name and face, and because the producer was a friend. He said he accepted it for the chance to spend time with Taylor, the woman whose face he had silkscreened so many times exactly one decade before, and because he thought he would not have any lines to say. He was disappointed to find that he did and could barely handle the stress of learning them.

Warhol and Taylor had crossed paths at that Proust gala in '71, but that didn't seem to count (for Warhol) or be remembered (by her). When the Roman meeting did come it was in Taylor's movie-star trailer, where she complained that she'd never got a copy of her famous Pop portrait and Warhol angled for the chance to make a new one: "It would be great if I could take a few Polaroids and do a new portrait of you, because the other one was from newspaper photographs and this would be better and uh . . . uh, I could give you one." Things got more intimate, and much stranger, when they bonded in that trailer over injuries they had both suffered: Liz got Warhol to feel her crushed vertebrae and he actually undid his shirt to show her his bullet wounds. A couple of days later he hosted a vast lunch for Taylor at his villa, with food prepared by every cook in the neighborhood, none of which she

ate, and a crowd of local socialites in attendance, none of whom she greeted before taking off in some kind of huff. Warhol blamed his tape recorder for scaring her away.

The two met again in Rome in October to shoot another scene for Taylor's film, when they bonded more deeply and launched a friendship that lasted many years. Warhol never got to do that second portrait of her. Taylor did wangle a copy of her first one from him.

*. . . with "The Beautiful People": Halston, Bianca Jagger and Liza Minnelli.*

# 1974

*"The 'social climbing' thing just isn't true.*
*Oh, but why does it bother me so much?*
*I don't know why, it just does"*

One lunchtime in February 1974, on the ancient Île Saint-Louis in Paris, a footman stood behind every diner in the grand Galerie d'Hercule of the Hotel Lambert, where Voltaire and George Sand had once walked. The plates and utensils were golden and the guests were equally gilt. There was the meal's absurdly snobbish host, Alexis von Rosenberg, Baron de Redé. (Rich, yes, but the "von" and the title were fake.) Joining him at table were the Baroness Marie-Hélène de Rothschild, the Princess de Polignac and the Baroness de Waldner. Other visitors included members of the less exalted nobility that culture can cough up, such as the rising fashion designer Yves Saint Laurent and his collaborator and muse Loulou Le Bailly de la Falaise, the daughter of a marquis. Also present: the American painter Andy Warhol, underdressed in jeans and sports jacket, with his attendants Frederick Hughes and Robert Colacello. Warhol was in Paris for his Mao show at the Galliera, and this was the world he was eagerly climbing into at the time. His neighbor at lunch was Madame de Rothschild herself but, sensing that he was angling for a portrait commission, she spent the whole meal turned away toward Saint Laurent. It didn't matter. Little Andy Warhola, the red-nosed Rusyn from Dawson Street, took genuine, wide-eyed pleasure in finding himself admitted to such rarified circles.

"Andy really liked Paris," said Jed Johnson, who often joined him there. "He was more accepted in society there than he was in New York, and he loved that. It was glamorous." Already in 1973, Fred Hughes had kitted out an antiques-filled apartment on the Seine's Left Bank to function as Warhol's European headquarters. Hughes was even more fascinated than Warhol with the highest of high life, and he pushed hard to place it at the center of his boss's enterprise.

"Let's make a whole different magazine. Get rid of the underground stuff. Make it a magazine for people like us." With those words, Hughes helped relaunch *Interview* as the house organ of the studio's socializing.

"Little by little, *Interview* became more and more about fashion and society as well as movies" is how Bob Colacello remembered the transformation. "We kept expanding the notion of what movies were. We started interviewing people if they ever had been in a movie for one minute, or if they had designed something for a movie, or if they had ever met a movie star. Or if they had ever seen a movie. And then the magazine gradually became more and more about Andy's social life, which was all-encompassing." *Interview* was becoming, said Colacello, "the inside chronicle of celebrity life in the seventies."

Even before Warhol's palatial lunch in Paris, within a span of three issues his magazine had done features on Yves Saint Laurent and Loulou de la Falaise, Warhol's fellow guests there, and on Princess Christina of Sweden, who far outranked those French nobles he'd dined with. Warhol kept that interview for himself to conduct.

"Andy established an immediate intimacy with the celebrities he interviewed," remembered a staffer at the magazine who witnessed the process. (She was, typically, a senator's daughter.) "They trusted him; after all he was one of them. . . . He could cajole a story out of the most sullen, aloof subject." To establish himself as "one of them," however—so as to sell portraits to the rich and famous, and to sell them on the idea of appearing in *Interview*—Warhol had to make himself come off as more conservative and mainstream than he really was, or at least had been in the previous decade. Along with Fred Hughes, who had impeccable pretensions to status (if no real claim to it), Bob Colacello played a role in this subtle move to the Right. He had grown up in a Republican household; his parents had become reconciled to their son's work with Warhol only when they heard that Nelson Rockefeller, Republican governor of New York, was a patron of his art and had shown up at the studio. Colacello never shed his parents' politics, becoming a vital link between Warhol, a lifelong Democrat and pro-

gressive, and patrons (even presidents) on the right. The *Wall Street Journal* described how *Interview*, under Colacello's sway, saw success by running "monthly photos of 'the millionettes,' the offspring of wealthy families, looking sheepish and arrogant at the same time, along with pictures of the glamorous at parties." *Interview* was living up to its sometimes subtitle as "The Monthly Glamour Gazette."

Colacello himself began to write a monthly partygoer's diary called "Out" (i.e., ". . . on the town," not ". . . of the closet"—although Warhol would have certainly loved, and probably intended, the double entendre). Glenn O'Brien, Colacello's classmate at Columbia and a former *Interview* colleague, described "Out" as "devoted to shameless social climbing" but also as "refreshingly honest and sometimes endearingly tacky" in its status seeking.

There's no doubt that social climbing was becoming a major activity on Union Square, since the studio's portrait work and its magazine both depended on that for success. "We're trying to reach high-spending people," said Colacello, when asked about the magazine's mission. "The trend in our society is toward self-indulgence and we encourage that." The same could have been said of Warhol, at least in his portrait-hunting mode. What could be more self-indulgent than for some dour German industrialist to spend his hard-earned deutsche marks having himself commemorated by the king of American Pop Art?

Social climbing was closer yet to the heart of Fred Hughes: His self-worth had a lot to do with the size of his friends' investment accounts and their family's ancestry. Warhol was well aware that Hughes was laughed at for "having his nose up in the air," as the artist put it, and he was happy to join in the laughter. And yet Warhol himself could never bear being described as a climber. When a biography of Edie Sedgwick was about to appear that had all kinds of stories that might make Warhol look bad, the only thing that got to him was being described as someone who was forever looking to rise. "Meeting rich kids wasn't anything to me. . . . The 'social climbing' thing just isn't true. Oh, but why does it bother me so much? I don't know why, it just does." One reason might simply have been that it was true and Warhol wished so much that it weren't. He—in the shape of a Warhol impersonator—eventually made the cover of *New York* magazine for a story on "Social Climbing: How to Do It in the 80s."

There's no way to look at Warhol's postshooting life and career and not feel that he was as easily impressed by social status as by real achievement. So many of the people he spent time with were deeply shallow so-

cialites, perfectly content to spend their time contemplating wealth and the pecking order. He could sometimes seem the same—obsessed with who was "up there," in his famous phrase, and who wasn't. Warhol was left all agog by his visit with the family of Hans Henrik Ágost Gábor, Baron Thyssen-Bornemisza de Kászon et Impérfalva, in their vast Villa Favorita on the banks of Lake Lugano. "The place looked so glamorous, and it was huge," Warhol said. "The bathroom was huge and our rooms had at least eight important original works of art by Chagall, Renoir, etc. I couldn't believe it."

But it's also possible that Warhol's ferocious schmoozing was truly driven by professional and even artistic necessity. Warhol's old friend Jonas Mekas, most dedicated champion of underground and avant-garde values, felt that even when Warhol seemed to be in the thick of high society he remained an outsider hard at work observing what went on there. It's certainly true that the comment on social status that's embedded in Warhol's portraits depended on the time he spent among elites; Goya could not have given us his view of a decaying Bourbon court if he'd stayed at home reading Spinoza.

"I never quite understood why Andy needed to prowl the city as he did," said Maura Moynihan, a young fellow prowler with less stamina. "A typical evening with him would include stops at Howard Johnson, a Broadway opening, a rock star's birthday party, and the requisite appearance at a disco. Once I questioned him about this excessive party going, and he replied swiftly: 'Maura, it's *work*.'" Any number of his friends and staffers asked the same question and got the same answer.

Given that gadding about was work, Warhol, the workaholic, was bound to spend as much energy on his social labors as on laying down paint. Or more, since painting might have been declared dead but playing people was still a lively and complex art. It didn't actually come as easily to Warhol as aesthetics, so maybe he enjoyed the challenge. Hughes and Colacello were forever mortified by the social missteps that Warhol committed when they were out together, and his diaries are littered with his own laments for his faux pas. On the other hand, there's also a clear sense that Warhol's love of the anti-aesthetic, in all things, led him to enjoy getting things wrong among people as much as among paints. He seemed to apply that favorite artistic aphorism of his, "When you do something exactly wrong, you always turn up something," to human relations as well. In his tales of that visit to the Thyssen-Bornemiszas' villa he almost took pleasure in recalling how he stepped in dog shit—inside the house. After tracking it down a hallway, with a maid in pursuit with a rag, he ended up

"deodorizing" his shoes with an antiperspirant stolen from Fred Hughes. "It was very successful," he said.

Sometimes it can seem that Warhol wanted to spread news of his social incompetence as widely as possible, almost as though he were inoculating himself against those accusations of social climbing. In the summer of '72, when he visited Stevie Wonder's dressing room after a Rolling Stones concert, Warhol couldn't seem to keep himself from discussing images with the blind musician: "I made the mistake of saying, 'Do you see yourself on TV and in the beach party movies?'" Warhol told his diary. He also offered to buy the musician a movie camera and the next day went out and did just that, which got covered in the press—in clippings which Warhol carefully kept, alongside the receipt for the camera as a business expense. Stevie Wonder himself seemed to think of the strange gift as a friendly denial of his disability, and he went on to shoot films with it. Despite his cultivated persona as an insensitive fool, Warhol might just have been wise and sensitive enough to have intended the gift that way.

It's remarkable that the phrase "up there" doesn't actually occur even once among the hundreds of pages of his diaries. When Warhol used it among his social-climbing acolytes he may have meant it more than half ironically. "You're really up there, now" was his way of mocking their elitist aspirations, and his own. For all his undoubted status seeking, Warhol always kept some perspective on the behavior of the mighty.

That very first time he ever got press, for his fruit-truck drawings, the eighteen-year-old Warhol complained about the "new-rich" women who had him climbing six flights of stairs with one pound of tomatoes just to impress their friends. Decades later, when his world was filled with nothing but the rich, new and old, he could still keep some distance from their ways. He told a story about the disgusting behavior of certain socialites who had invited him to screen one of his films at their Long Island estate and then had him use the servants' entrance once he got there.

Remembering his trip to the Thyssen-Bornemiszas, Warhol mentioned the laborers who watched the baron's vast Mercedes limo go by, with Warhol in it, and how they probably wanted to throw rocks. His sympathies seemed to lie with the throwers. "It gave me a funny feeling: All that glamor, riches—people won't let that go on." One assistant said that Warhol actually expressed full-blown disgust with the social elites he felt compelled to court: "I hate them," he said.

When it came time to publish his "official" philosophy of life, Warhol included a leveler's statement you'd have been unlikely to get from a baron: "If the President would go into a public bathroom in the Capitol, and have the

TV cameras film him cleaning the toilets and saying 'Why not? Somebody's got to do it!' then that would do so much for the morale of the people who do the wonderful job of keeping the toilets clean. I mean, it is a wonderful thing that they're doing."

Henry Geldzahler flatly rejected the notion of Warhol as social climber: "He was Mount Everest: People climbed him." Warhol may have been so annoyed at the accusations of status seeking because he knew that in the long view of history, his lofty achievements as an artist gave him the upper hand in all his relationships with the temporarily mighty. How could he be seeking status if he already had more of it than the people he schmoozed? (But it could also be that even Everest never quite believes that it's worthy of all the attention and looks to Rushmore for approval.)

Warhol once talked about how hard it was to keep track of the minute distinctions that Park Avenue people made about what was classy and what was déclassé—the kind of distinctions Fred Hughes seemed to get by instinct. "Is Southampton really better than East Hampton?" Warhol asked. "Is Fifth better than Park? Is Grenouille really better than Orsini's? Is butter really better than margarine? It's too hard to decide. That's why I summer in Montauk, shop on Second, lunch at Brownies, and put Welch's grape jelly on my bread. At least I'm sure I'm really wrong."

Warhol billed the trappings of wealth that he was acquiring—"room service, suites, and caviar"—as being required by the high-end business he was in, and maybe as a dangerous side effect of it. "When you see these people with money you think that you have it too," he explained to his unmoneyed friend David Bourdon. What he didn't say is that it also makes you hunt for more of your own. He could eat caviar by the bowlful. And he did.

———

While Bruno Bischofberger was building a European coterie (and client base) for Warhol, the artist himself was cultivating the new American beau monde of the 1970s, whose members were even easier to feed into *Interview.* Warhol's Montauk neighbors Peter Beard and Dick Cavett were both granted space in the magazine. So were the new rock royals Mick and Bianca Jagger: In a perfect storm of social connections, their interview was conducted by Lee Radziwill, princess of Camelot, that first summer that she was in residence at Warhol's Eothen. John Lennon and Yoko Ono also got covered in *Interview,* as two more big names who Warhol could now count as friends, at least as the word was understood in the weird universe of celebrity friendship.

And of course all this socializing went hand in hand with Warhol's never-ending hunt for portrait commissions. While Mick Jagger was rehearsing at Eothen, Warhol photographed him for a series of prints and paintings that were marketed by various art profiteers. The prints were signed by both Warhol and Jagger in a session that went on all night "with a lot of white powder involved," according to Warhol's silkscreener.

Lennon and Ono were harder for Warhol to pin down, leading to a hilarious game of cat and mouse where the three paranoid celebrities tried to figure out who was using who and who had the most to gain from a portrait of the couple, while their mutual friend David Bourdon did his best to remain unsinged as their middleman.

"I personally feel that if Andy does us in a painting that would create a new image for him—aside from Jacqueline Kennedy and the cow. I think it would be a nice image for his painting for the next five years," Ono explained to Bourdon. There had been some kind of kerfuffle around an Elvis painting that the couple thought Warhol was charging too much for. Commissioning the portrait was supposed to be some kind of consolation prize for Warhol—although Lennon didn't want Warhol thinking that they *needed* him to do the portrait. "John thinks that I shouldn't mention it," said Ono, "because we don't want any favors from anybody—we are in a position that we don't need anybody's favors." Warhol, meanwhile, was complaining that Ono and Lennon made "a million dollars a day" but were too cheap to have him do their portrait, for a price he'd inflated only to a measly $50,000. Lennon, for his part, wanted Bourdon to remind Warhol that he and Ono sometimes were *paid* to sit for portraits. Ono's bargaining position was that Warhol hadn't charged Jackie Kennedy anything for the pictures he'd done of *her*. Bourdon's rejoinder to that now seems chilling: "That was when Kennedy was assassinated. At least you still have John."

Bourdon eventually threw up his hands. "I can just see the three of you carrying on negotiations for the portrait for a year," he told Warhol. "I thought *you* were complicated, but they're really up there with you."

———

Warhol's cultivation of a current Rolling Stone and a former Beatle, even of Radziwill, still had links to who he had been in the '60s. A fresh social circle opened up for Warhol as he got close to the fashion designer Halston (born Roy Halston Frowick) whose clothes and name came almost to stand for the '70s.

The two men had known each other, vaguely, for most of the previous decade, as two strivers striving on the New York scene. Like Warhol, Halston came from the boonies—Iowa and Indiana—had dressed windows and then risen through the ranks of the department store world. He had an earlier incarnation as a hatmaker, supplying Jacqueline Kennedy's celebrated pillbox, which she can be seen wearing in so many of Warhol's Pop silkscreens. As late as Thanksgiving of 1971, Warhol could still mention the designer, then nearing the high point in his career, as "this boy, Halston" who he had chatted with. Warhol took pleasure in knowing more than "that boy" about the origins of the miniskirt. Only a year later, however, Halston was designing an evening dress from a fabric printed with Warhol Flowers and the two men were described as "friends" in coverage of the Coty Award Halston won for his fashions. For the prize ceremony at Lincoln Center, he got Warhol to come up with a peculiar (and slightly out-of-date) "happening." It mixed Halston's high-end clients, including one who was asked to cook breakfast onstage, with Warhol's latest crowd of semisuperstars, including the large-size Pat Ast, who jumped out of a cake, and the stick-figured Jane Forth, who brought her infant son and had him playing the bongos. A surviving phone call shows Warhol working through his ideas for the show, struggling to balance Halston's tendency always to "underplay" and his own attraction toward camp and overstatement. In the end Warhol came up with a classically Warholian resolution to his dilemma: He would present his Coty event as a realistic, underplayed depiction of an overstated party thrown by Halston's friend Ast who, as it happened, was the kind of larger-than-life person who couldn't resist anything campy—including the "corny" idea (in fact Warhol's, not hers) of deciding to jump out of a cake. "It's trying to say what's what" was how Warhol summed up his attempt at camp realism. On the night of the event, its almost philosophical complexities seem to have been lost on the audience. "Will someone please tell me what that was all about," asked a senior designer in the audience, while the *Times* reviewer proclaimed that Warhol's event "produced shudders, even from the performers." (Warhol himself managed not to be there.)

It's clear that Halston was eager to borrow some avant-garde patina from Warhol, since his own fashions were admired for tasteful innovation rather than extreme transformation. One review of the Coty show found his designs frankly conservative. In art-world terms Halston would have been the equivalent of a purveyor of High Abstraction, compared to Warhol's post-Dada, protoconceptual radicalism. But Warhol nevertheless

had something he could borrow from Halston: the glamour of the fashion world, and contacts with the glamorous people who designed elite clothing, sold it, wrote about it and, especially, bought it—and might just buy portraits of themselves wearing it. As a successful artist, Warhol had always been close to a few high-end tastemakers, but he was always coming at them from the outside, as it were: Serious artists might be in touch with the beau monde but they were not supposed to be *of* it. Artists, that is, appealed to the wealthy and powerful for the whiff of bohemia and profundity that clung to them, wafting off the important cultural work that their creations did. Designers, on the other hand, were absolutely supposed to be "in" with the in-est crowd. Their job was to make sure that the monde remained beau, and they could only do that from inside. Halston could invite Warhol in.

As Warhol shifted his socializing—and his appeal—from the stars of the underground toward America's more established elites, Halston became a pivotal connector for him. Fred Hughes had wanted to remake *Interview* as "a magazine for people like us," which also meant remaking Warhol into a person like *him*. Into someone, that is, who wanted to mix with the Halstons of this world. "I think the new art now is the fashion shows," Warhol proclaimed, just around the time that he was doing one for Halston.

Halston had already been featured in that watershed issue of *Interview* where Warhol's signature was first splashed across the cover. The designer's various friends, models and collaborators—Elsa Peretti, Diane von Furstenberg, Pat Cleveland—all got featured over the following years. His designs became staples of *Interview* fashion shoots and helped bring about the idea that such shoots ought even to exist. Contact with Halston nudged Warhol, and his magazine, toward an ever-greater interest in fashion, to the point that its covers started to be shot by the mainstream photographer Francesco Scavullo, who also did the front of *Cosmopolitan,* and the masthead even had a credit for a "fashion editor." The change of focus brought a new and larger readership, as well, and with it a new and much bigger ad base: Advertising space doubled in the mid-1970s, with Halston's own ads leading the way for other fashion firms. On New Year's Eve in 1975, a few months after Warhol had bought back sole ownership of the magazine from his backers (for a princely $1,000), the *Wall Street Journal* reported *Interview*'s circulation at 77,000, calling it "the premier magazine of what used to be called 'The Beautiful People.'" ("We prefer to call them 'glamorous,'" corrected one of the magazine's editors.)

If Warhol's interest in Halston helped bring about the shift in focus at *Interview*, it's hard to tell if that was goal or side effect—whether Warhol hung around with Halston's fashion crowd in order to help *Interview* find subjects, readers and ads, or whether the magazine's coverage, and advertising clout, helped him leverage a place for himself in that crowd. *Interview* staff were driven crazy by the number of times Warhol would offer the magazine's cover to someone he was courting, either as an advertiser, a portrait patron or a social connection. "I got really drunk last night," Warhol once explained to Colacello, "and gave away at least ten covers. And I think I told them all they could be next month."

Halston, never modest, described how he had "really opened up a whole facet of society to Andy that he hadn't been in before. I mean, he was more of a downtown boy and I was an uptown boy and I introduced him to so many uptown people. That really did help."

Halston came to rent Warhol's Montauk place year after year, using it to entertain a circle of intimates that included the entertainer Liza Minnelli and also Martha Graham—as well as Warhol himself, who would weekend in his little cottage by the compound's gate. ("Feel free to sleep in any bed on this property except this one," read a note he would leave in his bedroom when he wasn't there.) "He met Liza through me," Halston said. "I gave Liza her first Andy Warhol pictures. I bought them for her as a wedding present, and a birthday present and stuff, and I talked Liza into having her portrait done."

In town, Halston bought a fine modern town house designed by Paul Rudolph, dean of architecture at Yale and the father of American Brutalism. The house was in the heart of Warhol's haunts on the Upper East Side and Warhol became a regular guest at the infamous parties that were hosted there. Even when he wasn't there, he was there: In an all-white décor that was rigorously minimal, Halston's many Warhols provided a rare note of color. A bunch of them were portraits of the designer himself, which he'd commissioned from Warhol in the summer of '74, when they'd first begun to be really close. Host, friend, patron, advertiser—Halston filled so many of Warhol's needs in the '70s.

"He's just so interested in Halsman, or Talsman, or whoever his fruity designer is on Madison Avenue," said Brigid Berlin, in her inimitable way, gossiping about her perennial frenemy Andy Warhol and his new friend. "It's just all so faggy, faggy, faggy, faggy."

But really, it wasn't. Halston was a person of tremendous, even neurotic control: All his employees were made to wear black so as not to distract him when he designed; there had to be a new legal pad and fresh

box of markers on his blank desk every day when he got in. "The slightest deviation from the norm enraged him," an assistant recalled. That hardly conformed to the era's stereotypes of the wacky gay man. Halston might have partied hard with his "boys," but he did his best not to let that be the public face of his fashion enterprise, which was all about catering to the new conservatism of the 1970s establishment. He was tall and athletic and traditionally handsome, not at all like the clichéd image of a slight and swish queer artiste. His friend Warhol, who did conform to that image, seemed to be moving away from it, at least in the public face of his art. He had not made work with truly gay themes for the longest time, unless you count the "makeup" that he painted onto the faces of some of his Maos. (Was he casting his mind back three decades to "Make-up in Films and Life," the talk that the flamboyant critic Parker Tyler had given at Outlines gallery?) *Lonesome Cowboys* had probably been Warhol's last fully gay-themed creation, back early in 1968, at just the moment when *Confidential,* an aggressively mass-market tabloid, was launching a full-blown, cover-page attack on Warhol as the "deviant" maker of a new flood of "homo films." The "deviancy" in *Cowboys* was followed by the relentlessly hetero-sexual *Fuck* as the very last film that was truly Warhol's. The conceptual projects that followed were almost uniformly gender-neutral. "Raid the Icebox" might very well have been an homage to all the gay curio shops that Warhol frequented, but you had to already be immersed in that cul-ture to catch the reference. The society portraits that came next almost never seemed to commit themselves to the sexual identity of their sitters, even when those were close to openly homosexual. Warhol gave an almost macho look to Alexander Iolas and Philip Johnson, two of his earliest post-Pop portrait subjects.

When sex and gender did finally get reintroduced into Warhol's art, in the early spring of 1974, the impetus didn't come from him. It came via a young dealer named Luciano Anselmino, based thousands of miles away in Italy—"very flamboyant, very funny," as Colacello described him.

---

"The Gilded Grape is a Times Square institution that makes an art of tacki-ness and a dish of vulgarity," said an article in a gay newspaper. "You can sit there in a state of near hysteria as the midtown's hunkiest hustlers and wild-est prostitutes, its transvestites on the half-shell, drug dealers in puce ve-lour, and lamed-out tourists mill about like celebrities at a nightmare promo party concocted by a mafia capo whacked out on amyl nitrate." How could such a spot *not* have been the place where Warhol would seek inspiration

for the most important and daring paintings he'd done since his Flowers? Warhol and some titled Europeans had been among the slumming "tourists" who showed up there one night in '74, when the artist had his beloved Polaroid and Sony stolen from under his chair. (No point complaining to management: The club was run by the mob to launder money skimmed from other nearby bars.)

For a while, Warhol was making the Grape a regular destination, and he once brought Anselmino along. The Italian was blown away (metaphorically) and was soon writing to Fred Hughes about getting Warhol to do a big series—more than one hundred canvases—of portraits of Grape-ish transvestites. Not, he explained, characterful figures like Jackie Curtis, Holly Woodlawn or the recently deceased Candy Darling, who had been so much in Warhol's world until just a few years before, but cross-dressers who were "completely anonymous and impersonal." The dealer was looking for the utilitarian Campbell's Soups of transvestitism, that is, reflecting an entire category of social "product," not the deluxe versions who might each appeal in their own right. Choosing the right kind of drag queens, wrote Anselmino, would bring the project within "Andy's spirit of research."

Meeting in person with Anselmino later that spring, on a visit with Bob Colacello to the dealer's gallery in Turin, Warhol's first reaction was to take a pass on the project, claiming that drag queens were "out." Around this same time he was busy talking about how the studio's films had been dropping their transvestite stars, since "the girls seem to be getting their energy back, so we've been using real ones a lot again."

Warhol asked the dealer to come up with some other idea, but Anselmino took another crack at explaining the kind of figures he was hoping Warhol would paint: "They shouldn't be beautiful transvestites who could pass for women, but funny-looking ones, with heavy beards, who were obviously men trying to pass." Somehow, that brought Warhol around, at least tentatively. "Well, maybe we could do it," he said. "We can put a wig on Bob. He has a heavy beard."

The context for the meeting might have played a role in Warhol's agreement. The previous fall, Anselmino had commissioned Warhol to do a big series of portraits of the Dada artist Man Ray, whose reputation had been rising after decades of neglect. That was partly through the shows, editions and publications that Anselmino himself had organized and that Warhol kept on top of: Warhol took a good part of his payment for the Man Ray portraits in trade for the older artist's works. The only reason Warhol had made the trip to Turin in the first place was to sign his new prints of Man

Ray, which Anselmino planned to publish along with an image by Jasper Johns and a text by Henry Miller. Warhol could hardly have asked for better company to be seen in.

The Man Ray connection meant that Anselmino's suggestions about the new transvestite project were coming from someone linked in Warhol's mind to the grand tradition of old-world modernism that he'd known and admired since college days. Anyway, Warhol knew perfectly well that Europeans had always found more substance in his work than most Americans did; following the suggestion of an Italian dealer had a chance of leading him to making new works as substantial as anything he'd made before. Anselmino, a big admirer of the Mao series, must have planned the transvestites as a counterweight to the overlight society portraits that Warhol was so busy limousining his way across Europe to make. When Anselmino had told Hughes that pictures of cross-dressers would be in the spirit of Warhol's "research"—badly Englished Italian for the idea of an artist's fundamental project—he was saying that the series would be worthy of Warhol's best, most significant earlier art. It's clear that once Warhol started working on the series, he agreed. Even more than the Maos, the paintings of transvestites moved him into truly vexed, hefty territory that left Pop Art far behind.

The Drag Queens had one other big point in their favor: Anselmino signed a contract to pay Warhol almost a million dollars for more than one hundred paintings, plus one hundred portfolios of ten prints based on them. The Italian ended up titling the series *Ladies and Gentlemen*. (See color insert.)

Back in New York in late July, Warhol did take a stab at Polaroiding Colacello in a woman's wigs, but in the end agreed with the younger man that he made a lousy drag queen. Realizing that he needed the skills of professional cross-dressers, Warhol sent Colacello and a couple of other young men out to find transvestites to model for him.

They steered clear of the more high-toned drag clubs, where they might have found the scene's convincingly feminine Candy Darlings. Instead, they headed to the cruising zones of the far West Village and, especially, to the Gilded Grape. "The vagaries of drag are what make the Grape de rigueur for out-of-towners," said that article about it, "but Diana Vreeland would not, my dear, be particularly impressed." One white drag queen danced with a syringe nestled in her décolletage. It was the obvious place to find the kind of figures Anselmino had asked Warhol to paint—since that was where the Italian had first seen them.

"We would ask them to pose for 'a friend' for $50 per half hour," said

Colacello, citing a figure that was twenty-five times what an artist's model might get for posing in a school. "The next day, they'd appear at the Factory and Andy, whom we never introduced by name, would take their Polaroids. And the next time we saw them at the Gilded Grape, they invariably would say, 'Tell your friend I do a lot more for fifty bucks.'"

Warhol ended up having more than a dozen transvestites brought to the studio, where their Polaroids became the basis for 268 canvases—way more than Anselmino had called for. The vast majority of the extra paintings stayed in Warhol's studio until the day he died, as a record of his commitment to his new subject.

Actually, it wasn't that new. In coming up with his idea, Anselmino couldn't have known that he was plugging into an interest of Warhol's that dated back decades. There was that time in college when he painted himself as a girl; early in the '50s, he saw his gay mentors make home movies in drag and he also drew them in women's clothes; by the dawn of the '60s drag queens were showing up at his parties and he got to watch his friend Ted Carey trying on a dress. Warhol's *Ladies and Gentlemen* series almost seems meant to show that, fifteen years later still, in a far more permissive America, the transgression involved in cross-dressing still had plenty of force. By not painting a truly successful trans woman such as Candy Darling, Warhol could underline the vital gap between the male sex of his models and the female gender they assumed, and how that gap was part of the cultural meaning and force of drag. The sailors and truck drivers who cruised cross-dressers at the Grape weren't looking for women, or even for adequate woman-substitutes; they were looking for something closer to a third gender, or rather for two genders made to collide.

In his Warholian memoir, Colacello made fun of politically oriented Italian critics who saw the works as attacking the "cruel racism inherent in the American capitalist system, which left poor black and Hispanic boys no choice but to prostitute themselves as transvestites." That reading of the painting's social context may not have been spot-on (though it wasn't that far off), but it did zero in on something important: Every one of the trans-gendered models that Warhol turned into a painting was a person of color, adding a racial dimension to a project that hadn't been conceived with one from the start. There were plenty of white cross-dressers in New York, at the Grape and working city sidewalks; a couple of them even made their way in front of Warhol's Big Shot. But he chose not to paint them. He understood that the identity issues layered onto gay men and gender became that much more complex once issues of race were piled on top. By far the most famous

drag figure in popular culture, precisely when Warhol was doing his series, was the black comedian Flip Wilson in his persona as Geraldine.

Warhol couldn't have fully understood all the meanings of drag for the marginalized people of color who posed for him; he certainly treated them more as paid models, or even as curiosities, than as individuals whose full stories he wanted to tell. But as a larger cultural phenomenon—the only thing Warhol was any good at painting—he gave them their due. The scholar Jonathan Flatley has argued that the sheer quantity of Warhol's Drag Queen paintings makes them read as an homage and a gesture of solidarity. As we watch these people dress up and make up and organize themselves for Warhol's camera, they shed the passivity of a normal paid model who strikes poses at the artist's whim. Instead, they become the same kind of self-creators that Warhol had been for so long.

Warhol's Polaroids of his cross-dressed sitters already did a fine job pointing to the knots of race and gender at the heart of American culture. But those convolutions took over completely in the crazy paint that Warhol applied to his paintings, often using his fingers to move it around. In some of the *Ladies and Gentlemen* canvases he painted his figures to look like the African masks that influenced early Modern art, turning the paintings into a parody, almost, of Western ideas about blackness, gender and race. (Picasso's landmark *Les Demoiselles d'Avignon* is the obvious counterpoint.) In other works, the paint got so wild and thick that it looked like the worst makeup job ever seen on the Grape's drunkest drag queen, giving new force to Geraldine's famous tag line, "What you see is what you get." (That line might also have been Warhol's, at least in the plastic persona he had adopted in the '60s.) In so many of Warhol's later canvases his brushwork reads like a joke about paint, aimed at all the naïve collectors who still believed in painting's magic virtues: He once talked about his portraits as Abstract Expressionist paintings with photos silkscreened overtop. But in the *Ladies and Gentlemen* canvases, the paint seems to have real meaning, standing for the layers of camouflage and concealment his models chose to assume. Legibility gets sacrificed to surface effect, in both paintings and the painted. Warhol knew something about self-creation, yet his drag queen paintings make clear that the identities he'd always crafted for himself were straightforward, almost minimalist, compared to what his models had taken on. They were the Jackson Pollocks of self-creation, and that's how they come off in his paintings.

Just as he was working up his transvestites, Warhol created the first canvases of his mother that he'd made since leaving Pittsburgh. It's hard not to notice that they are painted in the same manic style as the transvestites,

once again doing more to veil than to reveal, or maybe revealing the sitter's own veils. Julia Warhola's face, so much like her son's in life, is sometimes close to buried under the frantic strokes of Warhol's childlike finger painting. In some of the canvases, that can feel like signs of a scared child's frantic caresses. In others, Warhol's scribbles come very close to being a petulant crossing-out.

When a reporter asked Warhol if he'd done the portraits "for" his mother, the way his other portraits were executed for their paying subjects, Warhol answered "Yeah—Yeah, I did." In some strange way, his lie might have gotten at the truth.

———

"I used to run into Andy at dinners and things around town," said the editor and publisher Steven M. L. Aronson, remembering several years of friendly social encounters in the early 1970s, including a dozen visits with Warhol to the Gilded Grape. "At one of these shindigs he told me that he wanted to write a book himself—himself! That's a good one!—and that I should edit it. He said he had noticed my name in the acknowledgments of a book he was reading called *Cole* that I had edited at Holt, Rinehart—I remember thinking, 'He reads books that closely?'" Yes, Warhol read that closely, often, and indeed he did want to write a book, maybe directly inspired by the one where he'd noticed Aronson's name.

*Cole* was a lighthearted almost-biography of the Broadway composer Cole Porter, gathering together all kinds of clippings, snapshots, letters and anecdotes, not to mention lyric sheets, to paint a picture of Porter's life and work. (*Cole* was designed by Warhol's old *Bazaar* friend Bea Feitler, which might have been what triggered his interest.) A rave in the *New York Times* had described the book as "a piece of social history as exquisite in its design as a Porter lyric," and gave Feitler a loud shout-out. The writer called Porter's work "carefree, cheeky, wise [with] enough sting to shock and enough style to please." He talked about Porter's contacts with Ethel Merman, Bea Lillie, Noel Coward, Tallulah Bankhead—all figures in Warhol's personal pantheon—and about how Porter "hid his seriousness and hard work from society. He believed in artifice." Given the unlikely connections always made in Warhol's brain, it's not hard to imagine him seeing himself in some of those details, and taking note of the editor who'd put the package together.

The book of his own that Warhol pitched to Aronson, eventually called *The Philosophy of Andy Warhol,* gives a similarly lighthearted view of what made Warhol tick, using a similar collage technique, although in words

alone, not images. Maybe it was conceived as a counterweight, in writing, to the darker turn his paintings were taking with the *Ladies and Gentlemen* series. An early outline submitted to the mighty firm of Harcourt, Brace, Jovanovich, where Aronson had been named copublisher, had chapter headings like "Work" ("work as the meaning of my existence"), "Money" ("the beauty of the dollar"), "Family" ("I believe in intermarriage: Fags with dykes") and "Religion" ("the glory, grace and grandeur of the Roman Catholic church"). It looked set to give some kind of blow-by-blow account of the way Warhol thought about life as he lived it, as seen from the inside, by him.

Or, at least, as seen by an employee who would be paid to play Warhol. A contract with Bob Colacello, from May of '74, gives him all the duties of writing the book in Warhol's name, from its research to final indexing, with no right to get credit but a guarantee of half the net proceeds from the project. Before long Warhol decided that his book should have even more cooks involved, so he took to getting Brigid's comments on Colacello's work, then feeding those for further reworking to Pat Hackett, who ended up producing two-thirds of the text, and many of its ideas as well. Warhol also weighed in with his own editorial insights, "with amazing clarity of vision sometimes, fumbling abstract intuition other times, always making it better," Colacello confided to his diary at the time. "He told me that the book should have more 'nutty lines.' He said it should be funny, but not too funny, so that people couldn't be sure if we were serious or not." But another time, Warhol said that his goal was for the book to have as many easy laughs as a Neil Simon play.

In the final product, the balance came close to what Warhol had asked for from Colacello. The book's table of contents ended up including head-ings like "Atmosphere," "The Tingle," and "Underwear Power." The text featured such classically Warhol(-ian) "lines" as "Think rich, look poor," "People should fall in love with their eyes closed" and "They always say time changes things, but you actually have to change them yourself," all gracing the T-shirts of undergraduates in the years since. And yet there's no way to know which of those words ever graced Warhol's own lips. Al-though much of the book had its origins in tapes of Warhol talking, only parts of it show the profoundly weird and truly revealing leaps of thought found in Warhol's real conversation. "If Andy had an interesting thought on anything, Pat would take it and embroider it," said Aronson, admitting that a few of the book's bon mots were dreamed up by him. Others, the tapes show, started out in the mouths of friends Warhol talked to. The *Philosophy* reads like it was put together by a team of people, maybe including Warhol

himself, trying to dig up Andyisms that for the most part were tidier, less challenging, than the real divagations of his brain, and vastly less complex than his art.

Even Warhol's preferred, more challenging title got watered down. The book was supposed to have been called simply *The,* a definite article to follow on from the indefinite article *a* that he'd used for his taped "novel" of Ondine, which itself had followed from the single-verb titles of his early films like *Sleep, Eat* and *Drink.* But in the end the best he could get out of the editing process was an oversize first word in the very wordy final title: *THE Philosophy of Andy Warhol: From A to B and Back Again.* (The "A" in the subtitle standing for Andy and the "B" for Brigid Berlin, who appears in some of the book's long passages of transcribed dialog, which are often *The Philosophy* at its best.)

"Andy was hoping to take the world by storm, as an author and a philosopher," Aronson remembered. His author explicitly described the simplifications and clarifications that he and his team came up with as an effort "to be commercial, because I think being commercial is so great—if you can do it. But, commercially, I can't seem to make it."

The book did indeed flop, to Warhol's deep embarrassment and distress. The first time that Harcourt, Brace, Jovanovich tried pitching it to bookstores and book clubs they showed almost no interest. A letter from Bill Jovanovich, the giant hunk of a publisher who Warhol idolized, tried to sooth the artist's nerves, telling him that they'd be relaunching the book with a "publicity—promotion—selling campaign" more reliant on Warhol's "reputation" and "presence" than on the actual contents of his volume. Warhol, eager to help, couldn't agree to submitting to the torture of TV interviews but he did have the idea of signing vast numbers of books in advance, to encourage bookstore preorders. He signed thousands more during his cross-country book tour, which eventually even took him to London. Huge lines of people would form at each stop he made, asking him to sign everything from a woman's crotch (in a centerfold) to the obligatory cans of Campbell's soup. His yeomanly efforts made no difference. On relaunch, the book was still a flop.

"Andy's weird didn't work," said Aronson, given the kind of straightahead PR expected of an author on a book tour. "He was a world-famous figure, but you couldn't use him." There was no way this particular author could re-create, live, the tone and contents of a book that he hadn't had that much of a hand in producing, anyway. The many dinners held to celebrate the publication weren't enough to do the trick, either—even the huge bash

thrown by Castelli, which was followed by a group visit to the Anvil, the very raunchiest of gay sex clubs. Unlike in fine art, where the promoter's job is to work a bit of snake-charmer magic on a few hundred collectors, book promotion demands mobilizing a vast mass of more regular readers who actually want to hear what you have to say. "He just wasn't commercial, except for the art," said Aronson.

That might be because Warhol's mass celebrity actually depended on his distance from the mainstream; he functioned as an accessible symbol of the avant-garde that average people could ogle. The art his avant-gardism actually produced, however, wasn't meant to have any true appeal to average joes, and didn't need to sell to them. In fact, to stand as a great modern artist—to be worth ogling for his weirdness—Warhol had to make work that did *not* have too much easy appeal. Where the Ondine novel *a* had conformed to that model, as a landmark work of radical writing, *The Philosophy* didn't satisfy the demands of high literature and also didn't satisfy the demands of people who were shopping for a more normal bedside read. You could say that it didn't work as art and it also didn't work as Business Art, within the world of mass-market publishing where it was supposed to live.

"He respected almost in a childish way anyone who could bring out a book," said Aronson. After his initial surprise at Warhol's literacy, the publisher came to realize that "books were very, very important to him." (The Harcourt book might have been especially important, since the firm had been one of the ones that rejected Warhol's fey submissions in the early '50s.)

Warhol wanted to know about every step in the publishing of his volume, from its design by the great Herb Lubalin, an old friend of Warhol's from the 1950s, to its marketing and sales. "I never had an author who was that obsessive," Aronson said, remembering the daily queries he'd field from Warhol about the latest sale numbers. And always, always, they were disappointing.

That didn't stop Warhol from hoping for better. Once he set his mind on making his mark in a certain discipline, whether rock music (with the Velvets) or publishing (with *Interview*) mere failure wasn't enough to discourage him. He'd be a Renaissance man if it killed him—or emptied his bank account. He had signed on with Harcourt for another two books and had no intention of giving up on his career as an author. The first book was *Her,* an as-told-to memoir of his new friend Paulette Goddard, a Ziegfeld Girl of 1926 who was once married to Charlie Chaplin and had been the

lover, it was said, of Diego Rivera, George Gershwin, H. G. Wells, General George Patton and Clark Gable. She stood, at least in Warhol's mind, for all the glamor of Hollywood's Golden Age, and for all its juicy secrets. The only problem was that, faced with Warhol's tape recorder, Goddard refused to dish any dirt, or to talk about anything much except the furs and jewels that had become her closest companions. After endless taping and transcribing, Warhol handed in a phone-book-thick manuscript that contained, as Aronson discovered, not one trace of worthwhile narrative. Not to be put off by this news—failure, after all, had been a recipe for success in modern art—Warhol decided to take a stab at revision, but the resubmission was not much improved. "I had the distressing distinction," Aronson recalled, "of rejecting him and *Her* a second time."

The second rejection occurred in a fancy French restaurant—Aronson said that Warhol was always a fine *fresser* in his company—where the wannabe author tried to explain what had gone wrong with his Life of Goddard. "She was expecting me to turn it into, like, art and I didn't know how to," Warhol said. "The way she wanted me to treat her was the way I would want someone to treat *me* in a book—I would love somebody to write some wild biography of me where nothing was real and it was kind of all crazy and art."

That was at least partly what Warhol himself provided in the other book he had promised to Harcourt, late in '74: *POPism,* the "autobiography" of his life in the 1960s. (The advance for the failed *Her* ended up being deducted from the one for the new book.) "I never wrote it, never read it" was the account Warhol gave to one of his old superstars. This time, Warhol's text was entirely ghostwritten by Hackett—with major edits by Aronson, later—based in part on a few interviews that Warhol did grant her but mostly on interviews with a vast number of Warhol associates. Their memories were even worse than his, and often more drug-addled. Emile de Antonio actually congratulated Warhol on how the book put "my words in your mouth." Other passages depended, sometimes verbatim, on the boxes of clippings that Warhol handed over to Hackett. The outcome was a Life of Warhol that did not reliably coincide with the life he actually lived. It gets wrong even the weather on the day he was shot and the number of bullets that hit him. It may have pleased Warhol all the more for that.

More troubling is the plain-Jane prose it is written in, which has almost nothing to do with the challenging voice and mind of the "I" that Hackett and Aronson were impersonating, as it survives in a good number of verbatim records.

The book as published was not at all "crazy" or "art" and only partly the not-real biography that Warhol had said he preferred. Like *The Philosophy*, *POPism*'s compromises with Warhol's true and fascinating weirdness had no payoff, in terms of either sales or elite appeal, when it was finally released in 1980.

*. . . at a boozy lunch in the Broadway studio.*

# 44

## 1974-1975

A NEW HOME | JED JOHNSON DECORATES | RETURN
OF BRIGID BERLIN | *TIME CAPSULES* AND
THE FINE ART OF JUNK | HIGHBORN INTERNS |
A ROLLS-ROYCE TO THE DIAMOND DISTRICT |
THE *INTERVIEW* LUNCH AND ITS PREY

*"Andy was completely difficult. I don't see
how anybody could live with Andy Warhol!"*

It wasn't a mansion, quite—it was only twenty feet wide, and a row house—
but it was certainly an impressive piece of property, on a deep lot on East
Sixty-Sixth Street right in the heart of the Upper East Side. Built in 1902, it
had four stories of gracious, high-ceilinged rooms, a portico with columns
and a facade with carved limestone swags. It looked like a banker's home,
because it had been. For decades, it housed the family of a blue-blooded
J. P. Morgan vice president who had been tasked with gathering the ransom
for the Lindbergh kidnapping. (The $50,000 had been actually lodged in the
house overnight, locked in an upstairs closet by one Thomas Tring, butler.) A
decade earlier, under its very first owners, the house had witnessed the union
of Miss J. Archibald Murray, of the Knickerbocker and Union Clubs, to Lord
Doune of Scotland, a marriage "of great interest to society in New York and
many other cities . . . marking as it does another alliance between two leading
families of the Old World and the New," said a "special cable" to the *New York
Herald*. This was a home with as substantial a pedigree as any social climber
could hope for. Warhol was the one who got it.

Warhol moved up in the world, from Eighty-Ninth Street, by moving
twenty-three blocks farther down in Manhattan. He liked to say that his new
house had belonged to "somebody's WASP granny," an immigrant's boast
dressed up as self-deprecation. Now he was around the corner from the
deluxe modern home his new friend Halston was just then buying, he was

blocks from his elite dealer Leo Castelli and he was surrounded by a crop of ambitious millionaires all set to have the portrait question popped.

But there could have been more than just social and professional ambition involved in Warhol's real estate buy. His endless shopping saw his Lexington house near to bursting. It seems likely that Jed Johnson pressured his packrat partner to size up in the hopes of getting him to pare down in the process. The new house was also a sort of offering from Warhol to his young lover, who had taken unusual pleasure in beginning to decorate the Lexington town house; Warhol wanted to give him a bigger canvas to work on. Warhol's home buying was also a clear sign of his commitment to domesticity with Johnson; he may have been angling for the same in return.

By the fall of '73, Johnson was touring dozens of properties, jotting down notes to keep Warhol abreast of the search. By the New Year, the house on Sixty-Sixth Street was passing inspection. (It shouldn't have: The plumbing was leaking within months of their arrival; the elevator went on to have constant problems.) In late January of '74, Warhol put together $310,000 to close the deal, getting a bargain price, said Fred Hughes, because of the stock market crash of a few weeks before. Crash or not, between the portrait business and his film productions Warhol was clearly feeling flush: In the decade and a half since his peak as an illustrator Warhol had more than quintupled what he felt able to spend on lodging.

By summer's end Warhol had put another $70,000 worth of renovations into the house, had installed the highest of high-end kitchen appliances, had specced the fanciest of stereos, with six giant walnut speakers, and had hired movers to spend five full days carting over his piles of stuff, after Johnson had taken months to sort through it. ("And this was when he'd only just begun to shop," Johnson observed.) The Native crafts, folk ceramics, vintage advertising and various bric-a-brac Warhol had been collecting for decades got packed into boxes that went straight to the top of the new house, where they were never unpacked again.

The only notable paring down that the move inspired involved armfuls of Warhol's 1950s illustrations. "He tore the old work up and we threw it into jumbo plastic trash bags," Johnson recalled. "We hauled these outside and left them in front of other people's houses down the block and around the corner because he was afraid someone would be curious to know what Andy Warhol was getting rid of in bulk and decide to retrieve it. This was the one and only time I ever saw him throw anything away." Warhol, recently become portraitist to the high and mighty, didn't want anyone to know those quaint old drawings had once poured from his pen.

The aesthetics of the new house actually had a major effect on the shape

of Warhol's domestic life. "When he saw that the few pieces of furniture he'd bought (primitive country furniture) now looked out of place in these new surroundings where the spaces were high and classical," said Jed Johnson, "he encouraged me to shop for appropriate furniture to fill up those spaces." Johnson's "shopping" turned into a dedicated hunt for period furnishings that would suit their new home, which had been built to echo the elegant Federal style of Thomas Jefferson's era. The bills for all this had Warhol on the ceiling, not so much because they were high—even fine American antiques were still underpriced then—but because someone else had incurred them in his name. Yet he was enchanted by the results. "By this time he'd visited enough rich peoples' houses to know what they looked like when they were done well," said Johnson. "He told me that the antiques made him feel rich." Before long Warhol began to join Johnson on his antiques hunts, "looking for American furniture down in Philadelphia or whatever," recalled Vincent Fremont. "Andy was very active."

On some such trip Johnson discovered Leo Sans, the craftsman who had redone the Tiffany stenciling on the walls of Mark Twain's house in Hartford, Connecticut. Johnson got Sans to turn Warhol's home into Stencil Heaven. "Nothing modern. Strictly old-fashioned values. Nothing like his tomato soup can or high-heel shoe," recalled Sans. He went so far as to do elaborate Orientalist stenciling on the ceiling of one room, in case its absurdly rococo bronze chandelier wasn't ornate enough on its own. Sans remembered Warhol feeding him ("we got fat there!") and praising him as well: "Leo, I like what you are doing. It's more substantial than what I do. I deal in gimmicks. The only difference is, my gimmicks pay big."

Before long Johnson had committed various rooms in the house to one or another period look. The grand dining room, the drawing room and the couple's bedroom became tributes to Federalist pomp, with the occasional Napoleonic touch. By some miracle, the old four-poster that Warhol had bought back in 1960, for $175, was in fact a mahogany gem from the early nineteenth century, so it survived into the new décor, stripped and restored and then refitted with the most elaborate period hangings. The upstairs room Johnson claimed as his own was themed Victorian, with an occasional moment of Arts and Crafts rigor. Johnson also left one room "modern"—Ralph Lauren modern, you might call it—to house his partner's Art Deco collection and major works of contemporary art by Lichtenstein, Johns, Twombly and others.

As he finished up his efforts on the Sixty-Sixth Street house, Johnson got a contract to perform similar miracles on a New York apartment owned by Pierre Bergé, the partner (in business and life) of Yves Saint Laurent. From

there, Warhol's young love launched an impressive career in decoration that was still growing when Flight 800 fell out of the sky.

The new décor on Sixty-Sixth Street marked a real change in the cultural and social context that Warhol was swimming in. In the 1950s and '60s, his bentwood and folk art, not to mention his Danish teak, still had strong links to the modernist, avant-garde culture of MoMA. By the mid-1970s, with Jed Johnson's interventions, the couple were living surrounded by something between Park Avenue pretension and gay-fabulous pomp. At home, and most nights when he was out with the nabobs, Warhol had left behind his earlier allegiance to innovation and cutting-edge values, which survived only in some of his most personal art. A Jed Johnson décor could have made it into *Architectural Digest*, as eye candy for the Chanel set, but the black-clad readers of *Domus* would never have stood for it, despite some links to a nascent postmodernism.

But maybe Warhol's new domestic setting had less to do with aesthetics than with mental health. Johnson's manic decorating gave his life a focus it had been lacking, which was good for his fragile psyche and therefore for Warhol's too. Although Johnson and Warhol started out as inseparable companions, there came a point where Johnson didn't share his partner's unending taste and patience for socializing and nightlife, and tensions developed when he chose to stay alone at home. That home now had a whole new meaning for him, as both an offering from Warhol and a field for his newfound talents. Johnson's impressive labors on the décor helped to correct a power imbalance that inevitably existed between a famous, successful and rich older man and a much younger partner who had never finished college and had at best a few film skills to his name, which themselves had come from his partner's projects. At the same time, that new balance left Warhol off-kilter. "It was always difficult because he didn't know what he wanted from other people," Jed Johnson once said. "He wanted you to be successful but, on the other hand, he wanted you to be dependent. Success would have meant independence, so there were always contradictions. He was hard to please."

At first, Warhol was happy to help Johnson show off his talents as a decorator by hosting dinners in their fancy new house. But within months, receiving at home was causing Warhol such obvious discomfort, and their social events together were such disasters, that Johnson decided to let it drop. He figured that Warhol spent so much time with other people at the office, in restaurants, and at parties that he needed one place where he could be alone. Suzie Frankfurt preferred to see her old friend's behavior as simple neurosis: "I couldn't understand his relationship with Jed, it was so convo-

luted. I thought Andy was just crazy about Jed but it was so in the closet. I just think that Andy was very difficult like that. He wasn't ever generous. He wouldn't let Jed have anybody in the house. He was crazy! Andy was completely difficult. I don't see how anybody could live with Andy Warhol!"

After a while, the house became a strongbox instead of a home, with Warhol as the keeper of its treasures. "He kept most of the rooms locked," Johnson recalled. "He had a routine. He'd walk through the house every morning before he left, open the door of each room with a key, peer in, then relock it. Then at night when he came home he would unlock each door, turn the light on, peer in, lock up, and go to bed."

Despite the splendid settings Johnson had prepared for Warhol—or maybe in quiet spite of them—the artist preferred to spend time in the basement kitchen, where he'd insisted on keeping an ancient porcelain sink that he had re-installed to run the whole length of one wall. Some nights—but not many—he would entertain there, with a TV sitting on top of its original shipping box, and blaring, as he fed a few notable friends. Some mornings he would cook marmalade at his new stove.

Maybe the room reminded Warhol of his mother's basement kitchen on Lexington.

———

It is sometimes said that short of enduring war, the death of a loved one or a serious illness, moving is one of the most stressful ordeals a human can undergo. After suffering the death of his mother and then his gallbladder attack, Warhol chose to move not once, but twice, in a year that also had him turning out innumerable portraits of something like thirty-five different people, expanding *Interview,* jetting back and forth to Rome for his movies and working on his vast transvestite project, the most profitable commission he'd ever received. Even as he finished moving house, in August of '74 Warhol went on to move his entire art and publishing operation to new digs on the northwest corner of Union Square, catty-corner and across Broadway from the building he'd been in since 1968. He had been facing a big rent increase in the Union Building, and with so much going on there across three different floors consolidation made obvious sense. "We needed more space. It's as simple as that," said Ronnie Cutrone, Warhol's art assistant at the time. Fred Hughes had wanted Warhol to buy the entire Union Building but once that idea was, thankfully, nixed—imagine all the time wasted collecting rents and arranging repairs—Hughes and Vincent Fremont noticed a "For Rent" sign across the square and visited the 12,500 square feet of space on offer. They loved it, and though it took some work to overcome the doubts of a landlord

who was not thrilled at the thought of Warhol as a tenant, after a while the space was theirs.

Hardwired for thrift, Warhol insisted that his staff carry some of their boxes across the square by hand. "It'll be one less thing for the movers to move," he would say. "They charge by the hour you know." And all this schlepping was going on in the August heat at almost exactly the same time that Warhol and Jed were moving in on East Sixty-Sixth. Even Warhol's high tolerance for chaos and multitasking must have been challenged by the amount of change going on in his life.

The new offices (that plural had now become fitting) occupied the entire third floor of the building at 860 Broadway. Decades earlier, it had been home to S&H Green Stamps, whose products had been the subject of some of Warhol's earliest Pop Art. Their vintage offices came with a grand, wood-paneled boardroom, shipped over from England and perfectly suited to Warhol's newly conservative image. When Fremont and Hughes first saw the space, the boardroom was surrounded by yawning empty spaces interrupted only by slender cast-iron columns; they must once have been filled with typists and clerks.

Any money the move saved on rent must have been more than offset by the $25,000 cost of a substantial renovation, needed to make the new rental suit the multiple needs of Warhol's multiple enterprises, not to mention the peculiar needs of the man at their head. The bulletproof door was ferried across Union Square and bolted into the new entranceway, to be joined by a new surveillance camera. (Although the way it was installed meant that the only thing it was likely to reveal about a potential intruder was a bald spot.)

These security measures were soon augmented by an impressive array of electronics that made the place seem as well secured as Fort Knox. In fact, they were components in a radio installation that Warhol had acquired from the young high-tech artist Keith Sonnier. "Andy's big fascination," Sonnier recalled, "was with how it looked like a surveillance camera in the foyer of a factory." Actually, the work's equipment only processed radio signals coming in from outside and did not include a single lens.

The landlord refused to pay for the armed guard in the lobby that Warhol had hoped for, so the artist sometimes took it upon himself to play watchman. If for some reason Vincent Fremont wasn't there to lock up at night, Warhol would do the rounds of the workplace, checking all the ashtrays and even pulling out the plugs of the photocopiers "so they won't start a spontaneous combustion." (Reluctantly, he'd leave the fridge plugged in.) On the nights that other people *were* there to close up shop, Warhol would simply remind them, endlessly, to do the same checking and rechecking. His staff

might have him almost out the door before seeing him run back in just for one last check of the rear-studio sink. On the rare occasions that Warhol had no choice but to go into the empty office by himself he carried a sharp stick—"in case the elevator doors stick, so I can pry myself out"—and would let someone know he would be there.

"Andy's Factory persona was very different from his public persona," recalled one of his youngest retainers, who spent both daytimes and evenings with Warhol. "At the office, he was grumpy, penny-pinching and suspicious, a small-business owner convinced that the people on his payroll were slacking off. He was the father-figure, the boss, we (Fred, Bob, Ronnie Cutrone, etc.) all acted like the naughty kids, sneaking out for a smoke, hiding things he would disapprove of. My strongest memory of him at the Factory is wearing an apron and carrying a broom; he did a lot of sweeping up." The new studio had a strange mix of thrift and extravagance, according to a staffer who arrived some years into its existence: "There was no hot water, just cold water, yet we had limousine service, and charge accounts at Le Cirque and Mr. Chow's."

Beyond the steel door and camera the new workplace included offices for Fred Hughes, Vincent Fremont, Bob Colacello and Pat Hackett, although she mostly worked at home. And somehow, Warhol managed to make sure that all his helpers' spaces were more permeable than not—way stations on the natural migration paths through the studio rather than real offices where someone might retire for privacy.

The floor was more or less divided between a suite of rooms for Andy Warhol Enterprises, home of art and films and video production, and another suite for *Interview* magazine.

AWE definitely got the better deal. The heart of its suite was a huge front room lit by an arc of windows facing onto both Union Square and Broadway and decorated with some of Warhol's choice Art Deco pieces. Its new walls went unpainted for years, however, since Warhol, with his brilliant eye for the avant-garde, had come to consider the drywall's spackled joints a kind of ironic abstraction. He'd got that idea three or four years before and then the move to 860 Broadway let him realize it: "Where the nails go in, and then you put plaster on the nails, so that the nails don't show up—that's a look I like." This was the room where clients and patrons were received, portrait sitters were Polaroided and all kinds of business was conducted at a pair of desks with a pair of phones and two big books that Warhol's social invitations got stapled into—one for day, one for night and with the sense that all Factory staffers might avail themselves of their contents.

Of a quiet afternoon, Warhol would install himself in one of the room's

big windows to read the newspaper, sucking the soft centers out of fancy chocolates and then spitting out whatever was left into a handy paper towel. "He wasn't supposed to eat chocolate because of his gallbladder," Fremont recalled. (Fried chicken was another food he considered forbidden.) An assistant felt that Warhol's frequent presence in the window was a gesture of generosity to fans who might like to see him perched there.

Hughes made a home for himself at one end of this front room, eventually half hiding himself behind some movable screens, and at its other end Vincent Fremont had an office that also functioned as an anteroom to the wood-walled boardroom, casting him in the role of greeter to any eminences that might make their way there. Warhol hadn't ordered up a real office of his own; he would wander among the desks of his underlings, sowing a bit of chaos as he went. "Andy just liked sharing," said Fremont, with more than a hint of sarcasm.

Beyond that front room, further back into the depths of the floor, Warhol had what you might call his "formal" painting space, which had been converted from a screening room that they'd installed but never used, given a pause, or maybe a cessation, in the studio's cinematic productions. "The whole 'Factory Films' thing just stopped once we moved to 860," recalled Pat Hackett. As a room meant for projection, this new painting space was windowless, but Warhol must have realized that an artist who was no longer making anything like traditional art hardly needed the daylight of a traditional studio. Better to save the more windowed rooms to receive paying clients, the vital elements—the "light" and "color" and "form"—in Warhol's Business Art. After being welcomed with a chat and drinks in the front room or boardroom, any clients who rated a "studio visit" with Warhol were ushered into the former screening room, where the artist did in fact work on his tidier and tamer canvases. A number of them were usually leaning up against the walls as not-so-subliminal suggestions of portraits that could be painted or works that might be bought.

Guests were rarely invited beyond a locked door at the far end of that space, out into another much bigger but equally dark one where Warhol would work on more personal and sometimes more scurrilous projects. Nude models might likely be involved, of either sex, sometimes doing much more than just posing. "There were two Andys," said an assistant of his. "The one outside, for *Interview,* and the artist Andy, in the back room." When *Interview* Andy kept artist Andy too busy to use that back room, Fremont would pursue his experiments in video somewhere in its dark depths.

Finally, out beyond even Warhol's painting space there stretched the storage he needed for all the art he made—yes—but mostly for the goods

he couldn't stop buying and the files he couldn't bear to throw out and even for old broken chairs that had made their way from the basement below the Silver Factory, to the eighth-floor storage in the Union Building and now, with no greater chance of ever being fixed or used, to the Broadway studio.

With Andy Warhol Enterprises taking up easily four-fifths of the floor space, the workers who made *Interview* happen were left with their own little fifth, a long strip of open office furnished with crude old desks and chairs and lit by windows that gave onto a dark back alley. It wasn't that Warhol disdained the magazine or its staff—he spent money and time trying to keep their efforts afloat—it was just that his artistic enterprises had an older claim on his heart, and put money in the bank.

Warhol's twin operations shared the same floor, and he once claimed his publishing and his silkscreening were "the same thing, but in another room." But the truth is there wasn't that much free flow between them. As Brigid Berlin once joked, "If you asked any of those kids who work at *Interview* which celebrity in the world they'd most like to meet, I think they'd all say 'Andy Warhol'!"

With the move to 860 Broadway, Berlin, now receiving a salary, came to represent the public face of Andy Warhol Enterprises. Perched at one of the big desks in the main room, she was the Cerberus of the new office, keeping a close watch on anyone seeking admission. But that role was more symbolic than real. "If a tank had rolled by and you'd asked her, 'Did a tank come by?' she'd look up completely unaware," Vincent Fremont recalled. Berlin said that she had started out doing some transcribing and typing but before long was more committed to her ever-present needlepoint. Her irrepressible eccentricity made her a last living link to the wild days of the Silver Factory. That, coupled to her true blue blood, earned her permission to harass and tease Warhol as even Fred Hughes never quite did. "She acted like his wife, meaning she would yell at him for something, and they would bicker," said Fremont. Their evening phone calls were legendary (and recorded). When Berlin once called home from a show of her art in Germany, she went on at such length that Warhol had time to roast a chicken. (Given the era's long-distance charges, that bird cost Warhol a fortune.)

Berlin recalled being the first person to arrive at the office every morning:

> But as soon as I got there I would watch the clock all day till I could leave. And every year I left five minutes earlier, and Andy used to look down at his watch and say, "Where are you going?" I'd say, "I'm going home."

"Well, the fun's just beginning," he'd say. And then he'd give me a hundred dollars and tell me to go to the liquor store and get some Irish whiskey and I'd come back and make Irish coffee, get smashed, tell Andy he was a slob and that I hated him.

(The money for the booze came, as all such moneys did, in the form of a single hundred-dollar bill, liberated from a secret stash of them that Warhol kept hidden in an old cookie tin; it was unearthed in the studio several years after his death and still had $14,000 in hundreds left in it.)

Whatever the previous night's revels, Berlin would be waiting at the front door when Fremont arrived to unlock at 8:55. The moment they got upstairs the phone would ring, with their boss on the line just making sure that the operation was getting underway and that his interests were being protected. "You're not throwing out anything are you?" he'd ask Berlin. "God help us if we threw out a coffee can," she remembered.

———

As so often with Warhol, such psychic quirks led to major art. As his people made the move to 860 Broadway, Warhol's obsessive thrift—or was it compulsive hoarding?—produced a conceptual project as peculiar and significant as anything by the official makers of Conceptual Art.

For something like thirty years, Warhol's ever-growing dislike of trash cans had led to an enormous accumulation of miscellaneous papers, from his commercial invoices to naughty gay magazines to just about all of his tickets stubs from the opera, the theater and movies. After being stored for a while on upper Lexington, or Forty-Seventh Street, or possibly even in the artist's earliest flats, all of these leavings of Warhol's life had sedimented out into the rooms Warhol rented on the eighth floor of the Union Building. As Vincent Fremont tells the tale, the boxes this detritus came packed in were too big and heavy to be carted across Union Square by anyone except the professional movers whose load (and bill) Warhol wanted to lighten. Fremont went out to get more manageable cardboard boxes for all this dross to be transferred to. "These could be time capsules," he said to his boss, and then watched a light bulb go on in Warhol's head: *Time Capsules* they became, worthy of an artwork's capitals and italics. Once Warhol had declared them art—some kind of cross between sculpture and conceptualism—the boxes got their own storage racks in the new offices, and a shelving diagram.

The initial *Time Capsules* held all the old stuff Warhol had already accumulated: Julia Warhola's correspondence and Christmas ornaments from

decades earlier, or piles of commercial illustrations and ads that had missed being destroyed in Warhol's move to Sixty-Sixth Street. But almost at once new *Capsules* were being born, filled with whatever new detritus Warhol generated. A standard size of cardboard box would be positioned beside any desk where Warhol worked, at the ready to receive whatever he swept into it—often your average artist's junk mail but sometimes bills that ought to have been paid or documentation of major business ventures or even works of art by Warhol or his friends. Entire reels from his films have been found buried in such boxes.

Like a lot of the most notable conceptualism, Warhol's new piece was meant to be ongoing rather than fixed and final—built around an algorithm rather than preconceived choices and tastes. The particular algorithm that Warhol deployed to govern the contents of his *Time Capsules* read as follows: *Include anything and everything.*

"It'll all get so simple that everything will be art," Warhol had predicted back in 1966, after expanding the Factory's production to include films, video, wallpaper and, arguably, himself and his superstars. Now he was finally making that prediction come true in full.

The year of the studio's move, for instance, a McDonald's had opened on Union Square, steps away from the new building's front door. At first he'd been appalled at the prospect of its arrival, "with litter all over the streets, the trashy bums all drifting over here, robberies on pay day." (So much for Warhol's automatic love of anything demotic.) But after years of health-food lunches from Brownies, Warhol switched allegiances and invited Brigid Berlin to join him in his apostasy. "He said, 'Oh Brig, you're just going to love it. It's the most fabulous place,'" Berlin recalled several decades later. "Everything was so cute. The hamburgers were wrapped in tissue paper. There were little plastic stirrers for the coffee, and apple pie in a box that folded on both sides and slid right out when you opened it." Once the duo had carried their lunch back to eat in the office, there was only one thing to do with the packaging they had left over: Add it to the latest *Time Capsule* that was in progress, as the most recent in the stream of eccentric art supplies that Warhol had used since launching into Pop Art. And here's an entry from a twenty-first-century inventory of the 538 items in *Time Capsule* number 212, which is now stored alongside its 609 fellows in The Andy Warhol Museum in Pittsburgh:

FOOD/ PRODUCTS:
Packaging: Two McDonald's French fry sleeves.
Sodium Chloride: two paper packages, each containing four rows

of table salt, each having McDonalds logo on recto and each measuring approximately 1¼ x 1¾ inches.

The *Time Capsules* reveal Warhol to be an artist of such power that his algorithm continued to operate even after his death. *Time Capsule* 84 of his accretive "sculpture" includes a letter to Fred Hughes that refers to "the late Andy Warhol."

If the accumulation in the *Time Capsules* now looks random—it was supposed to—there was plenty that got left out, and the objects in some boxes come from so many different years that Warhol clearly did some deliberate mixing and matching. "All the times I was helping him packing and sealing them, it's not like he'd just throw stuff in," said his 1980s assistant Benjamin Liu. "It was, like, this goes here, this goes there." *Time Capsules* could become resting places for objects of genuine importance to Warhol, such as the signed Shirley Temple photo he received as a child and had up over his mantel as his Pop Art took off, or the photographic prints that he ordered of his bullet-pierced body being loaded into the ambulance that day in June.

At various times, Warhol made pie-in-the-sky plans to present the *Time Capsules* as salable works of art, for $100 each, or $5,000 or whatever he thought his market would bear at any random moment. "When you go through them there's things you really don't want to give up," he said, on one of several occasions when he went back into a box he'd already shut and then couldn't put it down. The idea was that patrons would be buying the boxes sealed, sight unseen, but there was talk of putting an original Warhol drawing—or maybe a Godiva chocolate—into each one, to guarantee at least some kind of treasure for each purchaser.

One day, after seeing the estate of the movie star Joan Crawford up for sale in an auction house, Warhol daydreamed about auctioning his *Time Capsules* too, but in an art gallery, and tweaking them first to take advantage of his own iconic status: "I would try to make every box a little interesting. I'd throw in one of my dresses, or an old shirt, a pair of underwear—something great in each one." Warhol realized that, whatever items his *Time Capsules* might hold, they also functioned as a portrait of their art-star creator.

Warhol knew that the whole premise behind his *Time Capsules* was that someday other people would be going through what he'd chosen to preserve in them. The title he'd given them implied that very thing. Yet that didn't stop him from filling his boxes with personal letters from lovers and friends, or doctors' reports on his most intimate ailments. The project's algorithm demanded it, and with Warhol, artistic demands always came first.

In a lifetime of creative eccentricity, Warhol's *Time Capsules* were certainly the most eccentric work of art he ever created, but they had roots in what had come before. Warhol's early boyfriend John Giorno was also a compulsive archivist, he once explained, and he got that tendency from the Beat poets before him. In Warhol's own career, the *Time Capsules* clearly grew out of the "Raid the Icebox" project that he'd pulled from the vaults at the museum in Rhode Island. With the *Time Capsules,* Warhol was creating his own mad accumulation of castoffs while also inviting future artists and curators to "raid" it as they pleased. (Many have pleased to do just that, in exhibition after exhibition of the *Capsules'* strange contents.)

There was another, more recent, more direct antecedent to the *Capsules* that might have been more influential for Warhol even than his own "Icebox" project, and once again establishes him as a sponge of genius proportions. In April 1974, some four months before Warhol began to move his papers, a pioneering installation by the hot German artist Gerhard Richter was being shown by Heiner Friedrich, a dealer who had already shown Warhol and would soon become a major patron. The work was called *Atlas* and consisted of a vast archive of all kinds of random-seeming photos and newspaper clippings that Richter, a German votary of Warhol's, had been saving up for years. In New York, in 1971, Richter had painted an important canvas of Brigid Berlin, so he was already on Warhol's radar. News of Richter's show with Friedrich clearly made that radar go crazy.

Richter's *Atlas* and Warhol's *Time Capsules* are probably the two most important pieces in the early history of what became a major "archiving" movement in contemporary art, and it looks like the Warhol has its roots in the Richter. But while the *Capsules* may in fact sponge off the *Atlas,* their loony tunes scope and ambition take the German's idea to the next level.

Echoing so much of Warhol's best Pop Art, his *Capsules* manage to seem absolutely straightforward and "ostensive"—they simply point at whatever is in them—while at the same time coming off as thoroughly obscure and baffling. That means they come especially close to the superficially superficial, what-you-see-is-what-you-get persona that Warhol had launched for himself at the Silver Factory. The hundreds of thousands of items in the *Time Capsules* seem to reveal everything you could ever want to know about the man and artist named Andy Warhol. They also do more to confound, overwhelm and even foil his biographers than the most direct of his lies ever did.

Or maybe Warhol realized that he had placed himself so much at the calm center of his era's cultural storm that what he accumulated in his *Time Capsules* counted as the deposits of an entire epoch. Going through them is truly an archaeological act.

---

Before the move, *Interview* had already been transforming itself from a "Film Journal" to a "Glamour Gazette." The new offices let its staff live up to that transformation. Supplementing the highborn Brigid Berlin in her role as receptionist were various high-toned Europeans—a Parisian lad, a Venetian lady—who were then joined, as *Interview* interns, by the women Colacello dubbed the English Muffins. They were members of the British upper class such as Catherine Guinness, of the ancient brewing empire, and Lady Anne Lambton, daughter of the Fifth Earl of Durham, who appeared at Warhol's side at engagements all over New York, the country and even around the world. Fernanda Eberstadt, then a teenager from New York's own upper crust, felt that Warhol had a genuine and particular attachment to Guinness, a young woman with a "slightly inhuman coldness and detachment that appealed to him." Both Guinness and Warhol would do their evening rounds, as socialites are supposed to, but might just as happily stay home to watch television.

Eberstadt remembered Warhol's fascination with the private-school world that she herself moved in: "He was curious about Upper East Side life: he didn't like it much, but he was curious in a sort of anthropological way. Old families, old money. He was especially curious about their frailties and secrets—it seemed to amaze him that rich kids might have zits or problems getting a date." He was thrilled when she had him (and Hughes, Colacello and Guinness) to her own private school for lunch, and terrified when the headmistress came over to scold her for her unannounced guests.

At 860 Broadway, the "work" of such young ladies as Eberstadt and the English Muffins was split between humble Girl Friday chores during the day—taking phone calls, watering the plants, fetching lunch from Brownies, transcribing *Interview* interviews—and glamorous nighttime duties at all the openings, parties and dinners that Warhol attended. (Sometimes, these weren't so glamorous: A press agent's photos show Catherine Guinness and Warhol at a 1974 fund-raiser for a Democratic politician. The event was so gauche that it had all the guests wearing stick-on name tags, like at a dentist's convention, just in case someone didn't recognize that they were talking to Andy Warhol.)

The British damsels usually came into the Warhol orbit through Fred Hughes, whose snobbish tastes grew year by year. Both Guinness and Lambton were actually engaged to Hughes at one point or another, although it looks as though such "engagements"—Hughes had several more, plus one actual marriage—were not what most people would mean by the word. "I

was given an engagement ring and I accepted it, but I don't know if I ever knew when [the engagement] started or ended," Lambton told a reporter. "It was a very old-fashioned relationship. A very courtly relationship."

At least for some of the women Hughes "courted," the relationship was also platonic. Eberstadt referred to her stint as Hughes's "girlfriend" as a "semi-romance."

Warhol's relationship with Hughes was possibly even more vexed, going from a crush, to love-hate to, sometimes, more hate than love. "His feelings about Fred were very complicated," Eberstadt recalled. "I think he encouraged Fred's mythomania, his pretense of being a Texan aristocrat playboy, with strings of glamorous titled girlfriends. Fred was a pretty out-of-control alcoholic, and I think Andy kind of enjoyed having this hold over him."

The moment Warhol moved to Sixty-Sixth Street, Hughes moved into the old town house on Lexington, paying rent—and thereby, obeisance—to the man whose achievements gave meaning and structure to his own. Warhol arranged a new, $60,000 mortgage on the building, apparently to pay for the extensive alterations his new tenant-friend wanted done. Despite Hughes being in residence, the house was expensed as an art gallery and a reception space for Andy Warhol Enterprises. An accountant warned Warhol that he'd better keep a "daily guest log." It must have been mostly blank, or highly padded with the names of all the upper-class Londoners that used the place as their New York crash pad.

A couple of years later, Diana Vreeland told Warhol a story about Hughes that shows that Warhol was partly to blame for any tensions between the two men:

> He was criticizing my behavior towards a certain person. I was being very bossy and difficult and very grand and the whole bit. And he said, "You don't have any right to treat the girl that way. You treat her the way Andy treats me." And I said, "That's alright, because you're the best friends I've ever seen." He said, "Yes, that's something else again. I just want you to know that's no way to treat anybody."

Warhol didn't deny Hughes's account of his treatment.

But Warhol and Vreeland also discussed Hughes's own increasingly erratic behavior, and especially his memory lapses. "I think he's so funny, the way he forgets, don't you think?" said Vreeland. "Then the things he remembers. So much is going on in his mind. Sometimes you have his attention and then other times you haven't. You never know which it is

because he never gives a reaction." To which Warhol replied, "That's the fights we have. . . . Fred used to treat me so great. When he doesn't treat you that great and then you think—but then you know the real person. He's still a great person."

A sad fact that neither speaker could have known is that they may have been describing early signs of the multiple sclerosis that later felled their friend.

Warhol spent a pretty penny swanning about town, and the world, with the English Muffins Hughes had brought into his life. (Receipts for their flights survive in his papers.) But that was nothing compared to what he laid out for an even more impressive British toff seen hanging around 860 Broadway some eight months after the move there: A 1974 Rolls-Royce Silver Shadow, custom ordered the previous fall with a brown-on-black body, black leather seats and a burled walnut dash. With a price tag of $30,000 and a weight of more than two tons, it was the ultimate symbol of having arrived. If, as Fred Hughes once claimed, Warhol had a horror of appearing "conventional or grand," he clearly worked hard to overcome that hang-up.

With the Rolls as Warhol's biggest splurge, a flood of other acquisitions must have felt almost like a show of restraint. He had been buying antique furniture, folk arts and weird pop-culture items for a couple of decades already, and his buying went into overdrive on all those fronts even as he moved up in life. In 1975, a single invoice from just one antiques dealer was for almost $30,000; months later the dealer was still begging Warhol to pay it; ditto, months still after that.

Other invoices—piles and piles of them—show his shopping heading in a new direction. "One diamond bracelet/platinum mounting/56 emerald-cut diamonds—$8,500," reads one receipt; "props/bracelet w. large citrine—$1020.62," reads another. Warhol was as happy buying unmounted stones as actual jewelry, and he became an unlikely favorite of the Hasidic merchants in the Diamond District on West Forty-Seventh Street, which Warhol liked to call the Street of Dreams. "He had all these secret little dealers on the inside of the buildings," recalled Joan Quinn, a fellow jewelry nut who became West Coast editor of *Interview*.

Warhol might leave a dealer's booth with dozens of loose gems, caring more about quantity than quality. He wasn't buying jewels to enjoy their glitter and perfection, or to let them be enjoyed or worn by others, or even with any real thought of reselling them. He bought them for the sake of the value they stood for, almost in the abstract, and mostly for the sake of buying them. (Which, come to think of it, was why many collectors had always bought his paintings.) "I'd ask him why he bothered to buy twenty

little things instead of one big one for the same price," Johnson once wrote. "The answer should have been obvious to me—one big thing would have required less shopping."

Just because the shopper involved was Warhol, with his past and baggage as an artist, that shopping had and has a different meaning than for other victims of the buying bug. Acquisition, of one kind or another, had always had a peculiar and central place in Warhol's creativity. His early Pop Art had involved the acquisition and amassing of imagery—of consumer goods, of movie stars, of disasters—and then in the Silver Factory he had "acquired" eccentrics and superstars who he could capture on film and then on audio tape. When he presented his "finds," whether in the twenty-four hours of the movie *Four Stars* or across the five hundred pages of printed transcripts in his novel *a*, it was not so much about the pleasure anyone would take in witnessing them as about the pleasure he took in collecting them. It was about Warhol's own, unique openness to the world and everything in it, and to "liking" what he found there: "I like everything because it's hard to make a movie, it's hard to do a play, it's hard to bake a cake, it's hard to eat, it's hard to do anything," he once said. As far as Warhol was concerned, just being alive in the world was so hard that to "like" anything in it was a kind of victory.

When it came to his jewels, he didn't need anyone else to like them or even to know that he had them. A friend said that Warhol would sometimes carry a handful of loose diamonds in his inside breast pocket, not to show off to others but because it thrilled him that he alone knew they were there.

"Andy had the peasant's wisdom that if people (either the very rich or the very poor) knew that you had anything good, they'd probably try to take it away from you," recalled Johnson, speaking the year after Warhol died. "So he hid what he had. It was inconspicuous consumption. He'd wear a diamond necklace, but only under a black cotton turtleneck. I walked into the room once as he was looking over the top of his glasses at a sparkling piece of jewelry. I asked, 'What's that?' He said, 'Nothing. It's nothing.' I said, 'But it looks nice.' 'Oh it's not, it's nothing,' he said, nervous, and he shoved it into his pocket. Of course I never saw it again." Warhol's old friend Henry Geldzahler, scion of diamond merchants, found the artist's gem obsession "creepy" and "extremely fascist." Johnson talked about how Warhol would hide jewelry under their bed or in the folds of the canopy above it.

In the three years after his double move, Warhol expensed almost $250,000 in "props" to his company. Many were never seen after they were bought.

Not that such extravagance canceled out Warhol's cheap gene. All the flea market dealers remember how hard he pressed them for deals and dis-

counts. At the office, getting him to buy a new tape recorder or coffeepot was a major enterprise. Once, when Warhol sent a junior staffer out to get oranges to press for juice, he chastised her for not getting a receipt. He'd planned to expense the fruit as props, he explained: "First I'll take a picture—a still life—and then we'll make the juice." Colacello remembered that Warhol obliged them to keep old batteries, in case they became valuable once the price of copper went up.

You have to wonder how far Warhol's tongue was really in his cheek when he riffed, in *Vogue,* on buying one of the new electronic calculators:

> I could take it with me to Grand Union [supermarket] and get a lot of different things and add each one on my calculator and get a whole basketful and tally it and leave the basket and then go to Gristede's or Sloane's or First National and get exactly the same things and add them up and whichever store's basketful is less, go back to that store and buy the basket.

––––––––

Warhol spent two or three hours a day shopping, but he might have said *only* two or three hours. If he sometimes had to cut his shopping trips "short" (by his standards only) it was because Fred Hughes had need of him in the wood-paneled boardroom at 860 Broadway. That's where Hughes would organize the famous *Interview* lunches, as many as three or four in one week, which mixed potential advertisers with potential interviewees with potential buyers of portraits or art, throwing in young models or artists with potential as well and the occasional dealer or curator. There might be "Hollywood stars or Eurotrash princelings," as one observer said, but also hungry creatives who needed free food. The lunches represented all Warhol's enterprises "intertwined in a tense and giddy tangle of work and play," according to Bob Colacello. Jerry Hall was discovered at that lunch table, and Halston was sold Maos there. One lunch brought together Paloma Picasso and Georgia O'Keeffe, another saw John Lennon meeting Liza Minnelli. And it was that mix of people and opportunities that made the events special. Sitting around Warhol's fine Deco table, an advertiser would feel honored to be in the presence of a top tycoon, who might be there in the hopes of meeting the next hot artist, who might be there—as the whole crowd was—to bask in the presence of the great Andy Warhol, who, depending on the baskers, might prefer to have been somewhere else. Sometimes he didn't show up at all, or only late, and then only to pacify Hughes. He might hide for most of a lunch in his painting studio, popping into the boardroom for a minute now

and then just to see who his fame (and his minions) had managed to pull in. Some of the guests whose presence he slighted had probably been invited by Warhol himself, who could have eccentric ideas about who might buy an ad or a portrait, or who might look good on an *Interview* cover.

In the early days, lunch was health food ordered in from Brownies, its modesty made up for by the quantity of booze on offer to wash it down— wine, cocktails, spirits. Hughes eventually upgraded the fare to salmon-and-caviar sandwiches, at least when lunch was served to such grand folk as Eric de Rothschild. By the end of the decade, said Colacello, "lunch at the Factory was an international status symbol, like Rolex watches or the Concorde, as obligatory a stop on the Grand Tour of Manhattan as a night at Studio 54."

As an investment, the lunches paid off for Warhol in both real capital and social capital. The ads and portraits and paintings that got sold around that boardroom table funded Warhol's ever-growing staff; the socializing that went on around it procured the invitations that sent that staff out on the town to further promote the Warhol brand. A virtuous circle, you could call it, except that the table was oblong and most days there wasn't much virtue around it. An early lunch included Leni Riefenstahl, the Nazi Party's pet filmmaker. The open bar became an irresistible and unresisted temptation to some of the studio's younger members—to Warhol's artist assistants, especially, but also Bob Colacello and Fred Hughes, who both became serious drinkers.

"When I first met Bob I just couldn't stand him," said Warhol's old friend Suzie Frankfurt. "All he did was drink vodka and do coke and he was really uncivilized."

*. . . asleep on the Concorde.*

# 45

## 1975-1977

*"I wanted to just rush home and paint
and stop doing society portraits"*

It was lucky that Archie the dachshund loved caviar, because he ended up eating a bunch of it. Warhol did the same, with equal pleasure, as it was fed to him from five-pound tins at the Iranian embassy to the United Nations. Certain portrait patrons were so important that they couldn't be courted in the studio's boardroom; you had to head out to them. The Shah and Shah-ess of Iran were such folk, whose portraits Warhol envisioned as the ultimate masterpieces of his Business Art, or at least of his portrait business. (There were never strict borders between the two categories.) In his imagination, he saw his images of the Persian royals replicating endlessly into every ministry and courthouse in Iran and embassies and consulates worldwide.

Not that you could ever pop the question direct to such people. You courted them first through their courtiers. In the case of the Shah and his kin, Warhol's New York intermediary was Iran's ambassador to the United Nations, Fereydoun Hoveyda, Ph.D., son of a princess and brother of a prime minister—also, a serious film critic and trilingual author. He held his own court at the sliver of a graystone that was his official residence. It was not unlike Warhol's house on Sixty-Sixth Street, and built the same year, but grandly positioned catty-corner to the Metropolitan Museum of Art and its treasures, which had always meant so much to Warhol.

Alongside the mandatory diplomatic stuffed shirts, Hoveyda, in purple

bow tie and paisley jacket, hosted cultural types such as Karl Lagerfeld, an old friend of the ambassador's German wife, or Francois Truffaut, who thrilled Warhol one night by saying that his films had been influenced by the artist's. Warhol had first been invited to join the party the autumn of his two moves, bringing along an eleven-guest posse that included Lee Radziwill and Diana Vreeland. Other nights Warhol's retinue might feature Paulette Goddard or Mick Jagger, not to mention Lady Anne Lambton and Catherine Guinness, those posh English Muffins. There was clearly an equitable exchange of cultural capital between Hoveyda and Warhol.

Before targeting the Iranians, for a while Warhol had been working every angle to get a commission from Imelda Marcos, the kleptocratic First Lady of the Philippines. He wined and dined her and even suffered through a three-hour movie that sung her praises, but he could never get her to bite. The Hoveyda connection made the Iranians look like a better option.

---

Colacello described almost monthly visits to the Caviar Club, as Warhol's crowd called Hoveyda's receptions. Finally, in May 1975, Warhol's diplomatic mission saw its first major sign of success: An invitation to a White House dinner in honor of His Imperial Majesty Mohammad Reza Pahlavi, Shah of Iran, and his Empress Farah Diba—or, as the society pages called the couple, the Shahanshah Aryamehr ("King of Kings and Light of the Aryans") and his Shahbanu.

Warhol, a Democrat who had followed the Watergate scandal as closely as anyone, must have felt a touch strange staying at the Watergate Hotel and then going off to be hosted by President Gerald Ford, Richard Nixon's pardoner and Republican successor. He can't have minded seeing his name printed in the next day's *Washington Post* as one of the president's 121 guests, alongside untold Great Men of Washington but also Fred Astaire, Pearl Bailey, Merv Griffin, Bob Hope and Ann-Margret. (The actress had been invited by Ford himself, because "the Shah likes pretty girls.") But did it give Warhol pause that, not so many years after having been a symbol of esoteric artistic culture, he was now being invited to join a crowd of aging entertainers from deep in the mainstream?

Warhol can't have missed that the presidential party he'd just enjoyed had been preceded by mass demonstrations in the park across the street. The Iranian students protesting the oppressions of the Shah—the man Warhol was angling to paint—were so afraid of repercussions at home that they hid their faces behind masks.

That accounts for the reaction Warhol had, some eight months later,

when news came down from Hoveyda that the Empress of Iran had decided to give Warhol the singular honor and opportunity of traveling to Tehran to paint her portrait. "Let's go there right away and do it," Warhol is supposed to have said to Colacello, "before something happens."

Maybe Warhol's haste was what had him, Colacello and Hughes arriving in Iran in the high heat of a Persian July.

"We stepped off the Air Iran plane and there were a dozen schoolgirls singing songs and showering us with rose petals," recalled Colacello, and the rest of their trip was equally VIP. When they weren't hanging about their air-conditioned hotel rooms and ordering up caviar at $20 a pound—Warhol's idea of truly successful tourism, according to Colacello—they were travelling out to posh suburbs that the friends of the Pahlavi regime were busy filling with McMansions. "It reminded me of Beverly Hills," Colacello recalled, "except that they had Persian carpets by their pools." Warhol's vision was sharper, and more original. On the way to appointments with the elites he observed the Arabic graffiti on the streets of Tehran, and noticed that it outdid, in elegance at least, the graffiti then proliferating in New York, which was still going unnoticed by all but the most advanced aesthetes. "Their writing is much more beautiful than ours," Warhol said in an interview. "All the writing is great, even the signs."

They took a stab at visiting the sights beyond Tehran but had to bag their plans when Warhol just couldn't manage the brutal summer sun. Photos show him squinting in the glare, dressed for guaranteed overheating in a black jacket, dress shirt and tie.

A few days after arriving in Tehran, Warhol and his "kids" at last achieved the goal of their trip: to have the Empress posing in front of Warhol's Big Shot. When the artist got back to the hotel from her palace, his praise for the Empress and her home was weirdly effusive. "I finally realized, as he said it in louder and louder tones, that he was afraid his hotel room was bugged," said Colacello. Warhol had understood, after all, that the modern, sophisticated, Westernized, culture-loving Shah was in fact the head of a crooked police state.

Even Ambassador Hoveyda recognized the regime's culture of corruption: "The example of the royal family," he later wrote, "was a source of contamination which infected every level of society."

It looked set to infect Warhol as well. He continued to cultivate the Shah's family and retainers for another year and more, managing to do a portrait series of the Shah's sister. Thanks to the magic of the Big Shot and silkscreen, Warhol turned a ferocious behind-the-scenes potentate, well into middle age, into an innocuous Middle Eastern ingénue. When he eventually did a canvas

of the Shah himself, from an official photo of the ruler in dress uniform with epaulets, it was even more bland, although it's not hard to imagine the Shah's slit of a mouth ordering up an execution or two. (When it came time to work up his canvas of this particular sitter, Warhol was warned not to do the "lipstick trick" he'd practiced on the face of Chairman Mao.)

If the Iran portraits were not much as art, as Business Art they were a decent success. The Empress paid almost $200,000 for a dozen portraits of herself, including a few intended for state companies and Iran's embassies in Washington and at the United Nations. But the portraits never got to do the work they were supposed to in impressing other sovereigns with Warhol's skills as a portraitist. After the Islamist revolution in 1979, one of the portraits was slashed, another disappeared and three that had sat unsold in a gallery in Tehran ended up back in Warhol's studio, keeping company with another four that had never left New York and eight portraits of the Shah and his sister. The ayatollahs must not have asked for final delivery of those.

Meanwhile, Warhol's product line for autocrats was doing enduring harm to his reputation as an artist. "Fascist chic's recording angel," he was dubbed in a front-page article in the *Village Voice*. It was headlined "Beautiful Butchers: The Shah Serves Up Caviar and Torture," printed above a big photo of Warhol next to the Empress herself, with her silkscreened portrait behind them. After painting her husband, Warhol got "pied" by an activist. The sad irony—or poetic justice—is that he never even got paid for his portraits of the Shah and his sister.

"I disapproved of Andy's involvement with the Shah and the Marcoses and I didn't like Bob Colacello," said Warhol's old friend, the art critic David Bourdon. "I thought Bob was one of the most reactionary right-wing people, and I really resented the way he manipulated Andy into those situations where might and money was right, so I just plain dropped out, as a lot of people did."

Warhol's portraits could, and still can, seem to have a critical edge when contemplated as one serial project—as an inventory of human commodities, not tomato soup this time but lobster bisque. But the social links the portraits forged between Warhol and iffy elites couldn't easily be shaken off. Goya too must have seemed complicit to the republican opponents of his Bourbon masters—after all, he took the nobles' money and honors and gave them the portraits they wanted. (Even if maybe they shouldn't have wanted them.)

Even a detour into Democratic territory hadn't helped Warhol's image resist the taint of the Shah. Back in August 1976, well into the presidential campaign, the *New York Times* had sent Warhol to Jimmy Carter's hometown of Plains, Georgia, to do a portrait of him for the cover of its Sunday maga-

zine. "We went to the Carters' house and I took some Polaroids of Jimmy and Rosalynn," said Warhol (via a ghostwriter) in his book *Exposures*. "The house was very normal. They were very normal. We got along well. I spent most of the day in Plains taking pictures of men dressed as peanuts. Jimmy Carter gave me two big bags of peanuts which he signed. That made the whole trip worthwhile." Photos from the visit show Warhol wearing one of the many "safari jackets" he got from his friend Yves Saint Laurent, which make him look both fashionable and, in Georgia, like an explorer on the march in a foreign land.

Warhol returned to New York with a surprisingly serious, studious cover image of Carter, belying both men's reputations for cheer. He eventually got the image printed up in several expensive editions as fund-raisers for the Carter campaign, apparently not scared off by the IRS attention that had supposedly followed from his last support for a Democratic nominee.

But in the end, even if Carter seemed the anti-Shah, by working for both left and right, Democrat and autocrat, Warhol only ended up seeming more noncommittal and mercenary: a Big Shot and brush for hire to the highest bidder; an artist who meant business, and only business.

Business Art was a clever and daring conceit of Warhol's, and it paid real dividends as Conceptual Art. That was why some of the youngest, toughest artists had been so eager to try it out a few years before. It also came with serious downsides. Because it reduced all of Warhol's works to their lowest common denominator as merchandise, it implied that their actual content, as images, barely even mattered: As far as Business Art was concerned, that is, a portrait of Carter was the same thing as one of the Shah. That was dead-on as a comment on the art world and the art market, but also made it look as though Warhol himself didn't make any distinction between his two portraits' sitters and was asking us to ignore their differences too. The thing about Business Art—what makes it so wildly tricky and compelling—is that every work that it gathers under its wing can and does also exist as plain old-fashioned art, ready to be judged on its own merits. In Warhol's works that were most business-y, those merits could be close to nil. In the late '70s, Warhol turned out plenty of works that were mostly just merchandise. He was usually egged on by dealers and patrons who loved money as much as he did but sometimes understood art rather less.

In 1977, a rich young financier named Richard Weisman, the son of some important L.A. collectors, collaborated, or colluded, with Fred Hughes in getting Warhol to produce a series of salable portraits of ten famous athletes holding the tools of their trades, and paid $15,000 each for their sittings. Chris Evert got posed with her tennis racket, Jack Nicklaus with a golf club, Mu-

hammad Ali with raised fists. They were famous people painted by a famous artist, showing off what made them famous—not the most sophisticated or subtle of conceits, and it produced paintings that were just as simpleminded. One twist added at least a glint of humor to the project: According to clichés about both gay culture and sports, Warhol, the swish, was an unlikely figure to be doing a project about athletic prowess. He must have smiled as he scrambled America's standard gender codes, offering up his male sitters, at least, as objects of gay desire rather than icons of manly achievement. They were his new crop of Most Wanted Men, married to his latest Business Art venture. When a critic asked Warhol if the Athletes were mostly a "business deal," Warhol's answer was "a wry smile and the blink of a shrewd eye."

The Athletes kept company with other dealer- or patron-inspired projects. A series of portraits of people's pets (and some stuffed ones), funded by Peter Brant and a gallery owner in England named James Mayor, was, well, a series of pet portraits. Paintings of a collector's Volkswagen Beetle were suitably automotive. Paintings of a dealer's manor house were not much more than deluxe ads for real estate. No wonder Warhol suffered so many pans in his last decade. There was plenty to complain about, and the bad works made it harder to see the true genius behind the best ones, both early and late.

Maybe the most interesting thing about the dealer-sponsored projects was that they did not always find many buyers. Warhol's attempts to sell out—or to simply sell at all—weren't as successful as people have often imagined. He'd make money off the trial paintings he did in each series, since dealers had to pay up front for those: As Mayor said, "It was cash and carry." But the trials only rarely led to commissions. It turned out that few millionaires actually wanted a Warhol of their Weimaraner or of their country house. As Mayor eventually figured out, owners may in fact want paintings of their pets, but mostly they want bad ones. When Warhol skipped Jimmy Carter's inaugural to go hunting for pet portraits in Kuwait—"to pick up some cash," as he told Mayor—not a single sheikh came forward with a photogenic falcon.

Even the Athletes didn't find buyers: "People who liked Jack Nicklaus did not like Andy Warhol," Vincent Fremont recalled. One Houston dealer gave the sports pictures an entire show, mostly as a favor to Hughes and Warhol, but didn't manage to sell a single one. As a loss leader, however, the Athletes were effective: They attracted a clientele for Warhol the portraitist, she said.

The people-portraits were the only product line that reliably paid off for Warhol: One Texas couple paid $190,000 for fully eighteen paintings of

themselves, and they were hardly alone in their eagerness to see themselves in (or as) art. That success also made the portraits an albatross around Warhol's neck. He'd denigrated them from the very start as mere money raisers for his filmmaking, and he didn't become much fonder of them as they took over his life. He told his diary that after looking at the landmark modern art at the new Centre Pompidou in Paris, "I wanted to just rush home and paint and stop doing society portraits." Even in a published interview he was willing to say that "I mostly do portraits, so it's just people's faces, not really any ideas." By the mid-1970s, he might paint a new sitter every other week.

And not a few of those sitters were pains in the neck. A rich German woman rejected her portrait because she wanted it covered in glitter, and because it was in the same hues as some rival's painting. The letter to Warhol that asked him for a redo included the helpful information that "her favorite colors are pink-red." An American man complained about not having been rendered in "more than one primary color and black and white."

When a friend suggested that Warhol ought to court a millionaire couple who collected "all that spiritual junk," Warhol knew he'd have to deliver portraits to suit their tastes: Black-on-black ones, he suggested, to echo Ad Reinhardt's "spiritual" abstractions, or portraits where the faces were numinous and almost invisible.

During his wooing of the Philippine First Lady, Warhol talked to the love of his life about the trials of being a wannabe court portraitist: "Archie, you're going to meet Mrs. Marcos. Oh, if you'd only talk, Archie, we wouldn't have to do things like this." Warhol would have preferred to be the stage mother of a performing dog than an artist forever popping the question.

Two centuries earlier, Warhol's great predecessor Thomas Gainsborough had found himself stuck in the same portraitist's predicament: "If the People with their damn'd Faces could but let me alone a little," he wrote to a friend, "I should soon appear in a more tolerable light." Instead of "this curs'd Face Business," Gainsborough hoped to prove himself, artistically, by painting landscapes. That was Warhol's choice too. Sort of.

------

Tuesday, March 15, 1977: Victor came down with a nude pose-er. I'm having boys come and model nude for photos for the new paintings I'm doing. But I shouldn't call them nudes. It should be something more artistic. Like "Landscapes." Landscapes.

After that first mention in his diaries, Warhol's nudes went on to be "landscapes" whenever they came up later. The series grew to include 94

silkcreened canvases, more than 40 drawings and two editions of prints, all based on 1,664 Polaroids and 47 rolls of film showing almost 50 different models. Warhol was clearly more deeply invested in the project than in just about anything he'd done since being shot. The finished works that came out of it offered tasteful rear views of attractive male bottoms, such as might have been made in any traditional art class, and also those same bottoms presented doggy style, with testicles hanging below. Waist-to-thigh "portraits" of naked women, relatively demure, were joined by crotch shots of a porn star with a penis that hung halfway to his knees and others of a man with his penis erect. A handful of canvases zoomed in on an anus and penis about to meet.

For more details on the execution of these works, one can refer to the entry in volume 5(b) of the complete catalog of Warhol's paintings, an eminently scholarly enterprise: "Foreplay and sex acts, including masturbation, fellatio and anal intercourse, were part of many of the sessions." We can take the word of such an authoritative source that, for more than a year, the rear spaces of Warhol's studio became a place where normal office etiquette was left far behind. For a while at least the back painting room was off limits to the studio's teenage helper. The "studio visits" for Warhol's regular portrait patrons did not include taking in his latest creative efforts.

"There were always a number of portraits to do," recalled Warhol's assistant Ronnie Cutrone. "That was work. But then there were other times when Andy would say, 'OK, now what are we going to do for art?'" Warhol once complained about the oppressive docility of "work" on his paid portraits: "People always feel they want to look more like themselves, and stuff like that, [rather] than get something that's more imaginative." And then he talked about the "more imaginative" painting he might do if he was working just for himself, without any client involved. When he found time to make that come about, the result was as transgressive as he could manage. In the 1950s, Warhol's flight from his commercial labors had almost always led him toward making fine art with a gay undercurrent. By the 1970s, that same creative drive led him into white water.

His guide to this new territory was the "Victor" mentioned in Warhol's diary: Victor Hugo Rojas, known simply as Victor Hugo, a former lover of Halston's who continued to live and work with the designer. He was the wild man to Halston's control freak. Although he'd entered Halston's life as a hard-bodied callboy, with darkling good looks and a classic pornstache, he had ambitions in art and before long took control of the Halston boutique's windows. In a brilliant act of counterprogramming, he took mannequins that came dressed in Halston's cool and elegant clothes and put them in settings

that were hot and troubling: He turned one into a gun-toting Patty Hearst and made others pregnant under their demure Halston dresses. Warhol was particularly fond of a Thanksgiving window by Hugo that had featured real turkey bones. Warhol told a story about a Halston dinner party where Hugo covered the feet of live chickens in red paint and then released them to "sign" the floors, and stairs, and walls of a borrowed country place.

As Warhol put it, and understood it, Hugo was "always making art everywhere." Once, that consisted of painting on top of a portrait that Warhol had done of him, in a gesture Hugo justified as a remake of Robert Rauschenberg's famous erasure of a drawing by de Kooning. Hugo later slashed the portrait and penetrated the slit with a dildo and his fist. This was the man Warhol once described as "the greatest artist in the world," and went to for help when he was looking to radicalize his own sleepy career as a portraitist. Warhol got Hugo to find the models for his bodily "landscapes" and then to join those models in front of the Big Shot.

Hugo's recruiting job "really took a guy who knew how to hang out at the baths," said Ronnie Cutrone, who assisted on Warhol's Landscapes project. "Victor Hugo did that really well. He would recruit people from the baths in those days. I was there for all the shootings but not for the recruiting. The choreography was basically strip and make yourself comfortable. Andy was a very shy, coy voyeur. He was like, 'Oh, oh, oh, that's so great. Oh, what can it do? Oh, what a big one. Boy, I wonder how it would look stuck in there?' . . . And there would be guys sucking and fucking, and Andy would be taking pictures. Later they euphemized the series and called it the *Torsos*." A friend of Hugo's remembered him clubbing until 4 A.M. then heading to Warhol's studio for a photo session.

Warhol took photos of men involved in every kind of sex act, but when it came time to making them into paintings only a few of the tamer shots got silkscreened. All three of the modestly naked women Warhol shot made it into the finished "art" he produced, versus something like forty nude men who did not, despite (or because of) the gymnastics they had gotten up to before the camera.

"There were times when, even in my opinion, things would go a little overboard," said Cutrone, a mostly straight man whose tastes in sex ran wide and deep. "It just got to interfere sometimes with office work and some of the other painting. Very rarely did it bug me, but there were times when I thought, 'Oh, my God, we have one of those shoots again. Here we go.' We'd be right in the middle of a project, he'd give me five things to do, and then we had to 'entertain' these guys." Warhol always insisted that the shoots were work, not play, let alone sex. But he also once told a staff

member, "If you're working, if you don't like it, if it's not fun—I mean, it's just not worth doing."

For some while, Warhol's "work" on his *Torsos* was taking place just one closed door away from the young people trying to keep the studio and *Interview* running. Cutrone recalled how the blue-blooded Brigid Berlin took particular exception to the backroom antics, and at a certain point in June Fred Hughes finally drew the line. "No more raunch here, Victor," he said, insisting that all hijinks be exported to Hugo's loft, just up the block on Fifth Avenue. Once there, the sex became even more hot and heavy, as recorded in Warhol's hard-core photos. Those included wrists bound in duct tape and all kinds of penetration. "Andy was jerkin' off in the bathroom in between taking the pictures," Hugo later claimed. A single one of those loft pictures got silkscreened on canvas, and it and five others also became editioned prints now known by the title *Sex Parts* and (more descriptively) *Fellatio*.

Victor Hugo claimed that Warhol never actually touched his "models," but this hands-off approach doesn't mean that we ought to view any of these works as the abstract "landscapes" or aestheticized "torsos" that their public, palatable titles have been meant to suggest. If Kenneth Clark had famously distinguished between the "nude" body seen in art and the "naked" one we all see in the mirror, Warhol preferred a third category: the "hot" body seen in porn or in the baths where the likes of Hugo spent time. "Movies should arouse you, should get you excited about people, should be prurient," Warhol had said at the start of the decade, when he was busy denying that his *Fuck* was porn. Seven years later, with the *Torsos* and *Sex Parts,* Warhol was proving that he truly did believe in the power of prurience.

None of the *Sex Parts* prints or paintings were ever shown or sold by Warhol, and Ronnie Cutrone said that they were a "personal" project of his boss's: "It was something that Andy needed to do. . . . I think *Sex Parts* was a final announcement or affirmation of his homosexuality."

In July of '77, just as he was entertaining Victor Hugo's "models," and they were entertaining him, Warhol told his diary that he'd been down to Greenwich Village cruising with Hugo. (The idea was that when young men approached for a word with the famous artist, Hugo would pounce.) Warhol was impressed by the sheer number of gay men out on the street ("everybody who couldn't afford Fire Island") and bought himself what he called a "fairy shirt" whose decoration was "just a list of names of people who're gay all over it like Thoreau, Alexander the Great, Halston, me." The very idea that such a shirt might exist, and that one of its living heroes might be allowed to buy and wear it, in public, sets the stage for what Warhol and Hugo got up

to with the *Torsos* and *Sex Parts*. Warhol had toyed with gay drawings in the 1950s and had come close to gay porn in some of his early films, but the audience for those drawings was still far in the closet and the most explicit films were meant to stay deep underground. Now that Warhol was a major figure in the public eye—the kind worthy of being named on a T-shirt—it feels as though his new pornography was meant to test the limits of what kind of art he could dare to put into the world.

In the person of the photographer Robert Mapplethorpe, Warhol had a Jones to keep up with. A few weeks before Warhol's first diary entry on his new "landscapes," Mapplethorpe had opened a show of his own explicit gay erotica, in one of the new artist-run galleries that had all the cred at that moment.

———

It's no surprise that, having dared to make works for the boudoir, Warhol would set others in the toilet. With a supply of penises on hand as "sex parts," it may have seemed only natural to let them do the *other* thing they were good at. Warhol's *Piss Paintings* were born that summer of 1977, and survive to this day as a handful of pale canvases with tell-tale brown stains dripped and puddled here and there across them. Brigid Berlin said that they got their start when one of her pet pug dogs (she always had two) peed on a canvas that Warhol was due to paint on, but instead of raging he professed himself pleased with the result and set out to make more of the same, without help from canines.

"I remember the smell of urine on a hot summer afternoon in the back room of Andy's studio at 860 Broadway," Vincent Fremont recalled. "During the creation of these paintings the doors were kept closed and no one was allowed to walk through uninvited." Not that it sounds as though there would have been a lineup to get in on this particular act of creation.

Ronnie Cutrone remembered the process involved, at least in the earlier *Piss Paintings:* "We would set up a giant canvas in the back room against the wall, and guys would come in with their combat boots. Gay men at that time had suddenly turned butch. They wore flannel shirts and cut their hair short and wore combat boots. . . . They'd make their paintings with boot marks and urine stains." He talked about the making of the works as itself a kind of performance piece—a radical one that is imagined by anyone who looks at the finished pictures and knows how they got made.

With these peculiar paintings, Warhol had found something artists had been looking for since his college days: a middle way between the grand old figurative tradition, with its evocations of our human bodies, and the

avant-garde traditions of abstraction and even of Dada. There was no deny-
ing the bodies brought so strongly to mind (and, for a while, to nose) in the
*Piss Paintings*. But those canvases were also very clearly part of the abstract
tradition. Talking with Colacello, Warhol brought up Jackson Pollock as a
reference, and a target, of his new paintings. (A couple of years earlier, War-
hol had plans to do a Pollock biopic.) The *Piss Paintings* took aim at the grand
spiritual claims always made for the dripped paint of Abstract Expression-
ism; they also evoked a macho gesture made by Pollock himself, who once
peed in the fireplace of a patron who annoyed him. The joke about AbEx
that Warhol made with his urine works, and that joke's larger anti-art mes-
sage, brought them under the Dada umbrella, which was confirmed by their
obvious nod to Marcel Duchamp's urinal. (Just a few years before, Warhol
had acquired one of Duchamp's remakes of that piece.) They also pointed to
Piero Manzoni's infamous *Artist's Shit,* from 1961, which packaged the artist's
excrement in tin cans.

Maybe most important, the *Piss Paintings* allowed Warhol to make the
first full-blown change of style in his paintings since his earliest photo silk-
screens. From the very beginning of his Pop career, he had complained that
the art world forced painters to repeat themselves ad nauseam—and for well
over a decade he'd suffered just such a fate. The *Piss Paintings* at last let him es-
cape it. He took them seriously: A helper named Walter Steding remembered
making a foam rubber dog turd and gluing it to one of the paintings: "Ronnie
[Cutrone] said, 'Andy, you should see what Walter did to your painting; it's
fabulous.' And Andy exploded."

When Colacello told Warhol that his old friend Diana Vreeland felt that
the studio's art had lost its edge, Warhol's reply was "Did you tell her about
the *Piss Paintings?*" But you have to wonder which ones he meant: the ones
he'd started making in 1977, or those almost identical ones he'd made around
1960, right before his move into Pop, and that he had just recently been talk-
ing about with a critic? He'd found those earliest *Piss Paintings* wanting, and
they hadn't improved almost two decades later. They were a fine little joke
and conceptual gambit, but they lacked the visual impact, even splendor, that
made Warhol's best work so good, and so complex. Visually, they were just a
bunch of unprepossessing brown marks.

A series of ejaculatory "come" paintings weren't any better, or even that
much fresher or different as an idea. Warhol had already mooted the concept
back in the fall of 1971, in a tumble of words that poured out in a call with Da-
vid Bourdon: "I've got to do my come book. . . . I'm gonna sell my come—do
the book with it—artificial insemination—25 babies—isn't that a good idea?"
That summer of '77, Warhol and Victor Hugo both tried ejaculating onto

stretched canvases, for an effect that was even less impressive than when they'd pissed on them.

Rather than abandoning the idea of body-fluid art, as he had first time around in the early '60s, Warhol came up with a solution for making it look as exciting as it sounded. No one knows how, but Warhol learned that urinating on top of paint freshly mixed up from various copper powders yielded a series of oxidized splotches in every shade of green, highlighted against a background of metallic pinks and golds. (See color insert.) Once he'd figured that out, his new *Oxidation Paintings,* as they became known, had all the conceptual and bodily oomph of the plain urine-on-canvas pieces while also working as quite decent abstractions, in the mode of middlebrow but much-touted art stars such as Jules Olitski. (The *Oxidations* also look a fair bit like the marbleized paper that Warhol himself had used for his first abstractions, shown at the Loft Gallery back in 1954: Those too had involved fluids applied to a surface, and the interaction between two different substances.)

Warhol started taking the execution of his *Oxidations* more and more seriously, so as to fully control their final look. Random combat-booted pissers were mostly abandoned, as were the occasional woman (including Cutrone's wife) who had been brought in to try their luck: "I brought up a girl, and she squats and just makes a puddle. And Andy went, 'Oh there's no brushstroke.' So we learned the hard way." Although a few intimates continued to leave an occasional trace on the project, Warhol and Cutrone soon became the principal pissers, taking turns downing coffees and then heading to the rear studio to try their luck on the copper-coated canvases.

The two men couldn't simply wait for the urge to come on by itself, because the copper paint still had to be wet for the urine to penetrate and oxidize it properly; paintings that sound casual and "natural" were actually constructed with as much care and hard work as any Pollock. (Cutrone said that both he and his boss were too "piss shy" to do this vital aesthetic labor while being watched.) Warhol even had the notion that he could get bolder effects if he and Cutrone dosed themselves with vitamin B before a spell of "painting," but it looks as though that was just wishful thinking.

"The *Oxidations* had technique," he insisted a few years after they were done. "If I asked somebody to do an *Oxidation* painting, they just wouldn't think about it and it would be a mess. Then I did it myself." In the larger *Oxidations,* some of the more delicate and controlled skeins of green were probably done by dripping urine from bottles or cups. "I think I may try *brushing* the piss on the Piss paintings now," said Warhol in one diary entry, but the next day admitted that it didn't quite work. Even once the paintings were done, he took care to diagram how he wanted certain groupings

of them to be hung, as though their aesthetics would suffer in other arrangements.

Although Warhol was still on stipend with Leo Castelli (if only for a lousy $3,000 a month), there's no sign that the dealer had any interest in showing these new "personal" projects. But that was not because the artist preferred to keep them private. He was happy to place his *Torsos* and his *Oxidations* with a Los Angeles dealer named Doug Chrismas, known for showing the most advanced West Coast Conceptual Art and abstraction. Chrismas toured the forty-nine *Torsos* he got from Warhol to spaces in Venice, Los Angeles and Vancouver, and to an art fair in Paris. "The show looked good—cocks, cunts and assholes" was Warhol's comment in a diary entry from Los Angeles. A nice big review was positive(-ish), but the critic turned somersaults to make the *Torsos* safe for work, describing them in basically abstract terms: "Through manipulation of color and paint texture there emerges a visual energy potent enough to mimic the rhythms of orgasm." Well, sure, but the giant penises and proffered anuses kind of got you there too. Despite another review that, amazingly, declared the unmistakably "asexual nature" of the *Torsos,* Warhol knew perfectly well that it was those "cocks, cunts and assholes" that really made the paintings matter. They also did him no favors on the sales front. Despite mounting the *Torsos* in four different cities, Chrismas only managed to sell about half the paintings he had taken, on credit, from Warhol.

Chrismas did even worse selling the *Oxidations,* which he only showed at yet another art fair in Paris, where they didn't make much of an impact. Although they did get one review, all of five lines long, that praised them as abstractions, comparing their "bitter beauty, their perfect bite" to the "gauche and needlessly provocative" *Torsos.* (Seems that no one explained just how the *Oxidations* had come to be "bitter.") It's notable that the *Torsos* and *Oxidations* flew sufficiently under the radar for Warhol to have been left completely out of "Extended Sensibilities: Homosexual Presence in Contemporary Art," one of the first-ever shows of explicitly gay work, staged in 1982 at the New Museum in New York.

That same year, three mural-size *Oxidations* did score a big noncommercial success for Warhol when they got included in the great Documenta exhibition in Germany. Warhol could hardly have hoped for a finer honor. Benjamin Buchloh, most serious of Europe's serious thinkers about art, remembered how seeing the *Oxidations* at Documenta gave him "one of the rare, and increasingly impossible experiences that one searches for in exhibitions: To be utterly stunned by an unknown work by an unknown artist." Buchloh didn't figure out that the paintings were by Warhol until he found

their label. That would have had their maker beaming: Warhol never could stand artists who repeated a few recognizable moves again and again; in this one case, at least, he'd proven that he hadn't.

"What the paintings exuded," said Buchloh, using a notably apposite verb, "was an unforgettable sense of rightness which they conveyed through a radicality that was as precarious as it was right in the sense of offering one of the last, if not the last, installment of a totally credible and necessary painterly act."

*. . . in the Broadway boardroom—alone, for once.*

## 1977-1980

STUDIO 54 | SHADOW PAINTINGS | PORTRAITS AT
THE WHITNEY | BAD, THE LAST MOVIE |
JED JOHNSON LEAVES

*"When Jed went out late, Andy went home early,
and when Jed went home early, Andy went out late"*

Just north of Times Square, at Fifty-Fourth Street, something like one hundred limousines had made Eighth Avenue into a parking lot as they turned to drop their charges in front of a little 1920s opera house. There, one thousand people were waiting to join four times that number who had already been admitted to the new disco inside. Warren Beatty and Frank Sinatra were among the limousined who gave up the fight and went home.

"Some in the crowd wore clown suits," wrote a reporter from Washington, filling in her hometown dullards on New York's most hyped nightclub launch. "Others added a tarty-looking touch of gold or silver, and still others were a mix of nostalgia, three-piece business suits, Left Bank superchic and underground disco super casual." The dance floor was a mob scene of men dancing with men and women with women and even, shocking to say, the occasional male-female couple. Half a million dollars—half a million 1977 dollars—had been spent on décor. That paid for a lighting rig worthy of stadium rock, a dance-floor backdrop that evoked a volcano and strange props that flew down from above, including the man in the moon with a huge cocaine spoon under his nose. A disco-scene publicist explained how all that money might be earned back:

> For a lot of blue-collar working kids—hairdressers, store clerks, even low-echelon professionals—dressing up to go dancing and be seen is where they spend most of their money. When people come here, they can play out their fantasies with others watching

with binoculars from a balcony. How can you resist? For one night
it makes you feel you're really making the scene and that's what's
really most important.

On April 26, 1977, the opening night of Studio 54, blue collars were in
short supply. Cher was in attendance, according to that witness from D.C.,
as were Tennessee Williams and Margaux Hemingway. Ditto Lady Maria
St. Just, Prince Marino Terelino y Borbon ("the queen of Spain's grandson"),
and the American fashion legend Charles James. One person who somehow
was not worth a mention: the (former) Pop Artist Andy Warhol. He must
have been there, even if that night's guest list shows that he was only penciled
in as an afterthought, after hundreds of other names had been typed into
place. He was certainly there night after night, week after week, month after
month, over the two years that the club's famous scene lasted.

"Combining theater, disco, café, nightclub and every other entertain-
ment divertissement known (and some unknown) to 20th Century Man,"
said the opening-night press release, "Studio 54 and the three forward-
thinking young men who dreamed it up—Stephen Rubell, Ian Schrager
and Jack Duschey—hopes to bring some of the good life to midtown." They
succeeded, in spades. Rubell and Schrager, two thirty-somethings from
working-class Brooklyn, had discovered the crazy new energies unleashed
in New York's gay discos and decided to transfer that to a venue with appeal
to all comers, gay and straight, white and black, rich (very) and poor for the
moment. Once it was clear that there would always be more aspirants than
could ever get in, Steve Rubell stationed himself at the door every night to
"curate" the perfect Studio 54 crowd. "It's like mixing a salad or casting a
play," he once told Bob Colacello. "If it gets too straight, then there's not
enough energy in the room. If it gets too gay, then there's no glamour. We
want it to be bisexual. Very, very, very bisexual."

You were more likely to get in if you were wealthy, but it was no guar-
antee. "Rich guys with women decked in diamonds wouldn't add anything
to the party," said Schrager. But the party always welcomed rich guys and
girls, with or without diamonds, who were also famous, or anyone else who
was the same. "Diana Vreeland, Doris Duke, and Mayor Abe Beame all made
appearances," said Colacello. "General Moshe Dayan of Israel was seen chat-
ting up Italian sex bomb Gina Lollobrigida. Mick Jagger danced with Mikhail
Baryshnikov and Rudolf Nureyev with Rollerena, the roller-skating drag
queen." That list makes it clear that, for all their talk of a "democracy of the
dance floor," the founders of Studio 54 set more stock in A-listers than in un-
known disco prodigies: The skilled dancers were bait for the famous names,

who were bait for coverage and the drink-buying crowds it drew. Andy Warhol, famously famous for being famous, fit perfectly into this equation, and could be counted on to bring along other bold names such as Liza Minnelli, Bianca Jagger or Margaret Trudeau. (Funnily enough, he already knew the building: It was where he'd gone to watch the Velvet Underground record the Banana album.)

Warhol had true VIP status, coming in through the back door when crowds out front were too vast and then heading down to the storage areas in the basement. That's where special guests could do their special things—indulging in coke and quaaludes, of course, and sex on the "disgusting" mattresses spread about on the floors, but also in conversation, with the noise of the music and dancing coming in only as a dull thud from above.

Upstairs, flashing lights and booming woofers encouraged a manic mood. Omnipresent drugs guaranteed it: Amyl nitrite "poppers" kept the sex hot and cocaine kept the dance throbbing. "We weren't out to self-destruct; we just wanted to stay up later," Colacello recalled. "Heroin was verboten and Jimmy Carter's surgeon general conveniently classified cocaine as nonaddictive."

Warhol told his diary that, as Colacello watched Bianca Jagger take poppers one night, he said to Diana Vreeland, "It really becomes more like pagan Rome every day," and she said, "I should hope so—isn't that what we're after?"

Another entry in Warhol's diary reads: "Bob says he saw me put a little coke on my gums when we were in Mick's room, but I didn't really. I mean, my finger was in my mouth, but, uh . . . okay, so I didn't leave there until 4:00." Colacello insists that the coke was consumed, and that Warhol then asked him to buy a second hit. Quaaludes also came Warhol's way from time to time, and he might even get properly "bombed" on them. But his drug of choice was alcohol, once again consumed in prodigious quantities as it had been in the '50s. Warhol once called himself a "bedroom drinker," and he confessed to a young friend that he had a problem with liquor, and asked him if he'd join him at Alcoholics Anonymous.

Warhol adored the attention and coverage that Studio 54 won him, and there was the bonus that fellow guests might turn into portrait patrons. He declared one visit "a good work night" because an aging aluminum heiress had told him that her face "would be okay" the following week for a photo session.

"Andy came from the American work ethic," said Ronnie Cutrone. "It wasn't even fun to go out with him, because it was always work." That same ethic was in play throughout the club, according to another Warholian: "It

was usually older people looking at younger people, hoping to get laid, or it was younger people looking to further their career with the older people, and hoping that you wouldn't have to get laid. Everybody was working everybody."

But for Warhol, at least, Studio 54 didn't only have an instrumental appeal. He genuinely liked being there.

He didn't dance much, although Bianca Jagger once got him on the floor to give her bored paparazzi a new kind of picture to take. And his gossiping would have been mostly curtailed by the boom of music. But there was so much to see, and to photograph—in the boom of the club, Warhol's tiny new Minox camera took over where his Sony could not tape.

Anything could and did happen in the co-ed bathrooms, for instance, and in the wee hours the old opera-house balconies saw frantic couplings. If Warhol never got that down-and-dirty himself he certainly enjoyed the parade: The club's waiters and busboys were gorgeous young things in shorty gym shorts and T-shirts; the velvet rope always parted for similar beauties off the street. Most notable among them were Robert and Richard Dupont, seventeen-year-old twins who drifted into Warhol's orbit just as Studio 54 opened. They arrived as the Lasko brothers, from rural Connecticut, but became "Duponts" under the spell of New York. Warhol's relationship to such young men was complex.

In 1987, Richard Dupont described Warhol as having been their "Professor Higgins," but back in 1979 he'd written to the artist, saying, "I once loved you, and wanted you." He has since said that Warhol would masturbate him—"I think he did genuinely like me"—or ask him to masturbate in front of others. Both brothers have publicly claimed that Warhol was involved in an attempt to film them naked without their fully informed consent, maybe while they were drugged. They also express nothing but fondness for him to this day. Robert Dupont remembers Warhol being so fatherly that they called him "Pops" ("he liked that") and that he would give the brothers $50 or $100 if they were short of cash after a night out at the club.

Sometimes that might be near dawn, with Studio 54 as the last destination for Warhol after a long night of other parties. Or the artist and his people might leave the club on the earlier side—say, 2 or 3 A.M.—and head off to further decadence.

One night a visit to Studio 54 was followed by a trip to a lap-dancing bar, with women presented on some kind of roulette table, Warhol said, that served up their privates to the eyes of the men around it. "One of the hookers looked at me and said, 'Oh my God, oh my God.' And then the girls came over and one said, 'Oh will you buy me a drink?' I did—I didn't know yet that

the drinks were $8.50 apiece. And then more girls came and they made me feel really good, like I was straight. . . . I ran out of money. Then we left and went next door to a gay porno movie. Catherine wanted to see it and it was a glory-hole movie and it was too peculiar and we just stayed for ten minutes."

Warhol once recited an evening's lineup of events to Pat Hackett:

| | |
|---|---|
| 5:30 | Roberta di Camerino's at "21" |
| 6:00 | Barneys for Giorgio Armani |
| 6:30 | MOMA for the Rolling Stone anniversary |
| 7:00 | Cocktails at Cynthia Phipps's |
| 8:45 | Dinner at La Petite Ferme |
| 10:30 | Joe Eula's party |
| 11:00 | Halston's |
| 12:00 | Studio 54 for an animal benefit |
| 1:00 | Flamingo's for a tit-judging party that Victor arranged for me to go to. |

In his three previous decades in New York, Warhol had never been any kind of stay-at-home. But Studio 54 ushered in a new level of social activity that dominated his last ten years as his earlier carousing never quite had. There wasn't much chance that Warhol would once again become the true cultural force his Pop Art had made him by 1965, and he must have known it. But Studio 54 gave him a shot at a truly pop celebrity, of the kind he'd documented back then in his paintings of Marilyn and Liz. One night in the early '80s, at a birthday party for Larry Rivers in an Upper East Side restaurant, a young bystander witnessed Warhol taking full if ironic ownership of his celebrity status: "There was a little bit of a commotion; I remember a red carpet being rolled out, and a fanfare of three or four trumpeters, and then Andy Warhol walked in."

Warhol's new comfort on the public stage was witnessed by Daniela Morera, a frequent visitor to New York from Italy, where since 1973 she had born the grand title of "Milan Correspondent," or even "European Editor," for *Interview*:

Andy had changed. He was not afraid anymore. He began to speak with different people, and we started to go out every night to Studio 54 and all of that. I have to say that during the last days of Studio 54, I saw Andy talking to young kids and touching them, even kissing freely. From Max's Kansas City to those days was a total evolution. A complete personality change. He behaved just like everybody else at

Studio 54, while before at Max's Kansas City, he behaved like no one
else. I was totally shocked when I saw him sticking his tongue in the
mouth of a young boy at Studio 54!

---

"Someone asked me if I thought they were art and I said no. You see, the
opening party had disco," said Warhol. "I guess that makes them disco dé-
cor." In the '60s, Warhol had hidden his gravitas and ambition behind his
identity as the underground's aloof Zombie King; early in 1979, he was taking
shelter behind his latest persona as disco's ditzy Queen of the Night. Can you
blame him? How is an artist supposed to respond to some rude idiot who asks
if his latest works are worthy of being called art? There's the Pollock reply of
a punch in the face, or Warhol's more elegant and ironic assimilation of the
slight. In fact, the "they" being cast into doubt were a new and vast body of
paintings called the *Shadows,* and they were some of the most ambitious and
challenging works Warhol would ever make. (See color insert.)

In the final months of 1978, he had created more than one hundred big
canvases, each the height of a tall man, tidily brushed or messily mopped in
different bright colors and then silkscreened in black with some kind of photo
of . . . something. There was a tall pointy form, almost like a witch's hat, and
a shorter oblong that stretched out from its bottom, along with what could
be a horizon line in behind. Warhol's title told viewers they were seeing a
shadow, or shadows, but the images were too obscure to let them know what
kinds of objects might have cast them.

There was a rumor—almost certainly false and spread partly, and
maybe accidentally, by Warhol—that the shadows were cast by the penises
supplied to the rear studio by Victor Hugo. (Although Warhol seemed to
help that rumor along by getting the press to run a photo of him sitting in
front of the *Shadows* with a huge contractor's level springing erect from his
crotch.) At the actual opening of the *Shadows'* first exhibition, visitors seem
to have been told that the imagery was sourced in "the tile glimpsed by Warhol
one day at his business quarters." Since then, Warhol's assistant Ronnie
Cutrone has come forward to say that the shadows he photographed for
Warhol were thrown by children's building blocks, or, on another occasion,
that he built some kind of cardboard maquettes and then shot the shadows
they threw. Surviving contact sheets prove that the real source was that
cardboard—not made into orderly "maquettes," in any normal sense of the
word, but rather cobbled together into almost random shapes. Those are
hard to make out even in straight photos, let alone via their shadows. But
all that vagueness and doubt was just the point.

As Cutrone once explained, Warhol's goal had been to make work that borrowed the prestige of pure abstraction, which he had recognized since his days at Carnegie Tech, but without actually giving up on depicting the things around him in the world. The *Oxidations* had already worked toward that merger of abstract and worldly; the shadows photographed by Cutrone, illegible and natural at the same time, were the perfect source image for another kick at that can. Silkscreened on top of seventeen bright colors, Cutrone's shadows also looked good enough to decorate even the proudest disco.

When Warhol let loose his quip about disco, he had just witnessed the installation of sixty-seven of his *Shadows*, edge to edge, around the entire circumference of one of the most respected commercial galleries in New York, in the newly fashionable SoHo arts district. The gorgeous gallery—eight thousand square feet of space interrupted only by a cavalcade of the neighborhood's classic cast-iron columns—was run by the German dealer Heiner Friedrich and bore his name. By showing with Friedrich, Warhol would have been overjoyed to be following in the footsteps of such recognized avant-gardists as Cy Twombly, the venerable and venerated master of scribbles, and the minimalist string-sculptor Fred Sandback. The show's goal necessarily had to do with reputation, not sales: Friedrich had already acquired 102 of the *Shadows* for an art foundation he ran with his wife Philippa de Menil, a younger member of the Houston clan that had been supporting Warhol for the decade since his shooting. The foundation, given the good Texas name of Lone Star (but later rechristened Dia), supported a handful of "advanced" artists by buying and showing their work in depth, even promising some of them their own museums. Warhol was joining an august company that included his old band-mate La Monte Young, the drone master, and Dan Flavin, whose neon had lit up the back room at Max's.

Warhol's *Shadows* had a pedigree that made them worthy of that company. They had roots in Roman stories about how the art of painting began life as shadows cast on a wall, and then also in early shadow works by Warhol's Dada heroes Marcel Duchamp and Man Ray and by Robert Rauschenberg. Warhol had made his own shadowy "Rayographs"—a.k.a. photograms—in art school, and in fact every screen used to print his Pop and post-Pop works was made using technology that deployed that same kind of shadow casting to capture a photographic image.

Warhol's *Shadows* also paid homage—if maybe winking homage—to the great traditions of abstraction. From college days yet, Warhol had known the riffs on pure color that the Bauhauser Josef Albers had titled *Homage to the Square;* Warhol's multicolored *Shadows* might easily be conceived as an Homage to the Splotch. ("The German—he died a couple of years ago; he

does the squares—Albers. I liked him; I like his work a lot," Warhol said a few years later.)

Cutrone himself had talked about Warhol's paintings as nodding toward 1950s Abstract Expressionism, and there is in fact a striking resemblance between the trademark peaks and valleys painted by Clyfford Still and the "dunce cap" shape in the *Shadows*. (Bob Rauschenberg himself had pointed out the resemblance to Warhol.) Warhol also knew all about Mark Rothko's AbEx studies in gloomy color that the de Menils had installed around all the walls of a chapel in Houston; the *Shadows* might be considered their bopping disco cousin.

More recently yet, and with more recent prestige, the young conceptualist Joseph Kosuth had made a work built around a photo of a shadow, and an actual shadow, and also some text about shadows. Warhol knew it intimately, since just a few years before he'd received it in trade for a portrait he agreed to do of Kosuth.

Warhol's *Shadows,* installed in Friedrich's gallery so as to fill a viewer's entire field of view, were as up-to-date as could be. They married the very latest in "systemic" and "process-based" abstraction to "site-specific installation art," a genre that began to be hot in the '70s. Already at the start of the decade the young critic Peter Schjeldahl had raved in the *Times* about a new "environmental" work by Warhol's old rival in Pop James Rosenquist, installed in no less a venue than Leo Castelli's gallery. Schjeldahl talked about being astonished (but in a good way) by the work's lack of figuration, which had been Rosenquist's stock in trade for years. And Schjeldahl described how the twenty-six *Shadows*-size abstractions by the ex-Pop artist had been painted in "mostly bright, acidic, slightly harsh or super-pretty hues" and placed edge to edge on all four walls of the gallery, so as to function as "subsidiary elements in an encompassing theatrical ambience; they are décor." He might almost have been describing Warhol's *Shadows,* if they really had functioned only as abstraction. But Warhol's complex history as an artist invited more complex readings than that.

Warhol, most object-oriented of artists, chose a title for his Friedrich paintings that had viewers hunting for the pop objects that had cast his shadows—a stove's pilot light? a faucet? a golf cart?—even as the paintings themselves consistently foiled them in their quest.

And as critics have always noticed, the flow of almost identical images, one abutting the next, instantly evokes a series of movie frames by Warhol the filmmaker. You could imagine the sixty-seven paintings in Friedrich's gallery representing just some two and a half seconds of footage—from a camera panning across a dark corner, say—and looking abstract only

because we haven't seen the legible shots that preceded and followed it. "There's a *Blow Up* quality of criminality to this exhibition," said one critic, "very cinematic." As an art experience, the closest analogue to the *Shadows* may be Warhol's *Empire*, from fifteen years earlier, a movie that has always counted as one of his most deliriously challenging and rewarding of works. Both the film and the paintings give us themes explored over time with very little variation: the famous skyscraper, just sitting there almost unchanged as we watch; almost-identical silkscreened shadows, one giving way to the next as we pass. Both invite us to imagine, at first, that they are one-line conceits that don't bear further looking: *Empire* might be like nothing more than a cozy fireplace in the visual background, as Warhol once suggested; the *Shadows* might be digestible in "two minutes," the way Warhol pretended his wallpapered Whitney show ought to be taken in, as one review of the *Shadows* themselves pointed out. And both film and paintings actually repay endless contemplation of their subtleties, for those with the stomach to watch a building for eight hours or to really dig into sixty-seven—or 102—almost identical canvases, given that even contemplating a roomful of the most varied Rembrandts can be exhausting after a pretty short time. "You've seen one, you've seen them all," griped a rival artist at the *Shadows* opening.

One glowing review of the Friedrich show said the *Shadows* were "full of mystery and deeply hypnotic" in their refusal of normal meaning. Calling the paintings "provocative and engaging," the critic went so far as to see them as almost divinatory: "There is something in the air now—call it postmodernism, romanticism, the death of an era or the birth of a new golden age whose roots are in the old—but Warhol too seems enticed by its elusive scent."

Another friendly review said that Warhol was "just" a painter of disco décor the way Michelangelo was "just" a guy who painted ceilings. The piece closed by claiming, grandly, that the *Shadows* in fact suggested "the abyss that lies to either side of the place where Warhol chooses to live: *now*."

Warhol had actually been disappointed in the *Shadows* opening at Friedrich. He claimed that of the four hundred fancy people invited from the *Interview* list only a bare handful had come—no Halston, no Steve Rubell, no Catherine Guinness. Maybe that was because those kind of people were not truly interested in him as a daring artist, but only as a celebrity and disco fiend—as one of *them*, that is. Instead, the opening hosted real art-world types such as Philip Johnson, Warhol's longtime collector, the critics Gregory Battcock, David Bourdon and Robert Rosenblum plus a whole bunch of artists. Still more impressive, for Warhol, was that the *Shadows* launch "turned out to be more of a punk opening, all the wonderful usual fantasy

kids that go to openings like that." That is, the kind of "kids," probably still in art school, who cared about what was truly daring in contemporary culture. The show's reviews made it clear that Warhol's *Shadows* had achieved that kind of status, more than anything he had made in quite some time. That must have thrilled him.

Also thrilling: The $1.6 million that the Lone Star Foundation had just paid for all 102 of Warhol's *Shadows*.

After a very uncertain start to the decade, Warhol's '70s looked set to end well.

———

At the tail end of 1979, Robert Hughes, art critic for *Time* magazine and most ardent of Warhol foes, let loose one of the most famous of art-critical zingers:

> Warhol's admirers are given to claiming that Warhol has "re-vived" the social portrait as a form. It would be nearer the truth to say that he zipped it into a Halston, painted its eyelids and propped it up in the back of a limo where it moves but cannot speak.

Hughes was lambasting "Andy Warhol: Portraits of the 70s," the art-ist's second Whitney solo in eight years, curated by Warhol's close friend and sometimes salesman David Whitney, whose obvious conflict of interest somehow went unremarked. The pan from Hughes canceled out the end-of-decade optimism that the *Shadows* had promised to Warhol at the year's start.

Warhol had been thinking about the Whitney show since the spring, not long after his *Shadows* came down, when he settled down to do triage on all the portraits he'd done that decade, whittling them down to the fifty-six sit-ters that was all the Whitney's fourth floor—its *entire*, cavernous fourth floor, mind you—had room for, given that every sitter was going to be shown in a pair of canvases. Old '60s friends like Henry Geldzahler and Ivan Karp made the cut, in almost-matching pairs of recent paintings. So did new '70s patrons such as Sao Schlumberger and Giovanni Agnelli, as well as contemporary celebrities such as Liza Minnelli and Halston. But Warhol also chose a few portraits of the mighty dead that broke away from the idea of the "society portrait" that might otherwise have dominated the show, and even sunk it. Chairman Mao was there, in a special little "temple" custom-built in the mid-dle of the floor to house three giant Maos, peering at each other across the triangular construction. (Which, as it happened, had a passing resemblance to Rothko's chapel in Houston.) Golda Meir, the recently deceased Iron Lady of Israel, also got wall space, as did an Iron Lady of Pittsburgh whose im-

age must have come as a real surprise to almost everyone who saw it: That was Julia Warhola, the artist's mother, at last admitted to the ranks of the departed. (Warhol had disclosed her death in print a few weeks before—in Pittsburgh, no less.) Mao and Mom look to have been last-minute additions; they didn't make it into the catalog's list of works.

Before Robert Hughes's vitriol hit, Warhol had a moment to savor what looked to be a success. For his opening-night dinner, le tout New York gathered at a restaurant around the corner from the Whitney, with a patroness footing the bill for ninety meals. Afterward, at the opening itself, "shutters snapped and the champagne bubbled and the $50-a-ticket crowd exchanged talk large and small," said the Times society pages, reporting on the aristocrats, movie stars and doyennes in attendance. Two weeks later, when Hughes let loose with his blunderbuss, Warhol was able to put on a brave face: "They gave me two whole pages," he told Colacello. "With three photographs. In color." But by then Warhol also knew that Hughes was just one in a crowd of deprecators.

Writing only days after the opening, Hilton Kramer, the chief critic at the Times, showed himself as brutal as Hughes, if less stylish: "Shallow and boring" was about the best punch he could deliver. It could be, however, that some of Kramer's complaints gave Warhol a weird kind of satisfaction, not only because the critic was such a well-known hater of the new but also because those complaints showed that the show had let Kramer grasp what Warhol was really doing, even if the critic despised it. Kramer's pan correctly noticed, and took grave offense at, the "debased and brutalized feeling" Warhol managed to add to portraits that ought otherwise to have sat within a grand tradition of flattery. (Which was where Hughes incorrectly saw them sitting.) Warhol, said Kramer, made every sitter "look ugly and a shade stoned, if not actually repulsive and grotesque." At the Bourbon court in Spain, Kramer might have been the one courtier to notice what Goya had really done to the royals.

Kramer even figured out that Warhol's portraits had caught on, early, to the late-1970s return to emotive brushwork known as neo-Expressionism—although he couldn't understand that their "slapdash," "smeary," and "unfinished" look also cast doubt on the sincerity of that latest return to (dis-)order. Warhol's paint was, after all, applied in the background, haphazardly, before any image had even appeared on the canvas to trigger his emotions.

But Kramer's piece did supply one absolutely fatal insult, worthy of pistols at dawn: It got played across two miserable little columns on page C19, across from a wall of cheap tombstone ads and under the gripping title "Whitney Shows Warhol Works."

It took an actual, full-blown fan of Warhol's to deliver the coup de grace. Robert Rosenblum's gushing catalog essay for the Whitney show billed Warhol as "an ideal court painter to this 1970s international aristocracy"—as a fawning traditionalist, that is, rather than the ground-breaker Warhol imagined himself to be. Rosenblum said that Warhol, "a celebrity among celebrities," had "revived the visual crackle, glitter, and chic of older traditions of society portraiture," while also capturing "an incredible range of psychological insights among his sitters." (So Mao is supposed to be legible, in Warhol's painting, as a power-hungry ideologue with a total contempt for human life?) According to Rosenblum, Warhol's brushstrokes offer "an extravagant, upper-income virtuosity which appears to be quoting, for conspicuous consumption, a bravura tradition that extends from Hals through de Kooning."

Rosenblum had unloaded the full inventory of clichéd portrait skills on Warhol. And if there was one thing Warhol hated, it was cliché.

———

If Warhol was facing trouble in his art career out in public, he was facing even more in his love life at home. Things had been unraveling between him and Jed Johnson for some time.

Their early years together had gone well. There had been fancy, glamor-ous visits to St. Moritz, Paris, Rome, even Tokyo, as well as more cozy, famil-ial visits with Johnson's family. (His mother was thrilled by perfume she got from Warhol, and his sister became a frequent visitor in New York.) A mutual friend said that Johnson gave Warhol something he desperately needed, "a sense that he lived with someone, that he went home to someone, that he had a very structured life at home."

Of course there were moments of domestic strain, like when Johnson felt he was being asked to be Warhol's cook and maid. And those were sensibly resolved by, for instance, getting a pair of sisters, Nena and Aurora Bugarin, to do the cooking and cleaning instead. (One of them lived on the top floor of the house; the other came in from outside to help; Warhol developed a taste for their traditional Filipino meal of stuffed fish.)

Johnson's natural feeling of professional subordination to his partner also looked set to resolve, as he honed his skills as a filmmaker and be-came ever more vital to the work on Union Square. After assisting on the *Frankenstein* and *Dracula* movies in almost every capacity, Johnson got to strike out on his own when Morrissey decided not to come back into the fold at Warhol, Inc. Already in the fall of 1974, planning was underway for Warhol and Peter Brant to back Johnson on a new feature film to be called

*Bad,* returning to the one-word titles of the Factory era. After all, this was a *Bad* movie to be presented by someone who had once said "Anything bad is right," and "If you consciously try to do a bad movie, that's like making a GOOD bad movie."

"Andy said he didn't care what it was about—he just loved the title," said George Abagnalo, the young staffer who first came up with the idea for *Bad.* Abagnalo had come on board at the Union Square studio not long after Warhol was shot, appearing out of the blue as an absurdly cinephilic sixteen-year-old ready to lend a hand on any and all things filmic. (But not willing to comply when Warhol made a pass, asking him to drop his pants.) For *Bad,* Abagnalo came up with a plot and synopsis and then Pat Hackett honed the dialogue. Johnson played director and editor on the most ambitious project ever to bear Warhol's name. Fred Hughes had costed it out at a full $1 million, to be assembled by an ever-changing roster of industry backers (and their banks) working in joint venture with Warhol as the film's "producer and artistic director."

The *Bad* storyline involved a working-class woman in Queens who runs a beauty parlor out of her home—and, also, a ring of hit women for hire. Bette Davis and Angela Lansbury were approached for the lead, but neither bit. Warhol and Johnson had to settle for Carroll Baker, not much of a star but irresistible to Warhol for having been in *The Carpetbaggers,* a film he had watched and rewatched, and for having played Jean Harlow in a biopic that was, shall we say, a bit more faithful to history than Warhol's own *Harlot.*

By October of '75, the Abagnalo and Hackett script was finished, and was dying a death by a thousand cuts. ("Can a substitute be found for Estelle breaking 6 plate glass windows?" was one producer's question. "That's a lot of $$$$.") Warhol and Hughes were still hunting for financing in early '76 (the budget had ballooned to $1,300,000) but by July were at last on location in Queens, where they allowed a local reporter to visit the set. He described *Bad* as Warhol's first attempt to go commercial in the United States, with a union cast and crew, 35 mm equipment and a proper eight-week shooting schedule. There was even, to the reporter's obvious amazement, "an actual script," featuring hit girls who "drop babies from windows, stab dogs, burn movie houses, steal the mails, blow up cars," starring alongside "a paraplegic and his vengeful wife and an insane young mother of identical twins with conflicting personalities."

Johnson, described as the youngest-ever director of a commercial feature, was mostly silenced by his nerves, so his close friend Hackett played spokeswoman:

> We wanted to make a professional film so we could have coffee on
> the set every morning. You really know you're up, working. We
> also needed parts for women; they're the ones hanging around
> The Factory who need work. . . . We love the polish of making
> a film with a professional crew. If you can direct a film like this
> you can do anything; run a country. Next, we're getting together
> a small African nation.

Many small African nations have certainly worked far more efficiently
than the *Bad* shoot. In the 1980s, Abagnalo remembered Johnson as "totally,
100% incompetent," and that the production was saved only by the know-
how of the cameraman.

Still, once the movie was edited and at long last released, in the spring
of 1977, it got a few half-decent reviews. ("*Bad* is not a movie to recommend
to anyone without a warning," wrote Vincent Canby in the *Times,* "but the
film is more aware of what it's up to than any Warhol film I've seen to date.")
There were also a vast number of pans. ("Warhol, even as a producer, makes
all of life seem like a soiled diaper.") More important, given the project's cen-
tral role in Warhol's Business Art, *Bad* somehow failed to make any money,
partly because of poor distribution arrangements. Warhol eventually had to
assume a painful $500,000 loss on *Bad,* vowing never to invest in a film again.
He didn't.

Warhol blamed Johnson for the failure, which led his young partner to
abandon filmmaking—and thus the place he'd carved for himself in Warhol's
studio—and plunge deeper into his decorating. But the timing for Warhol's
mostly unfair attack on Johnson could not have been worse, because the art-
ist almost at once supplied good grounds for a counterattack:

> Monday, November 7, 1977—Raining very hard. It was a bad day,
> "family" problems. Jed came by the office and was in the back in
> my working area and when he saw the stacks of Polaroids of all
> the "landscapes" I photographed for the Shadow paintings—all
> the closeups of cocks and things—he began screaming that I had
> degenerated so low to be spending my time that way and he left,
> really upset, and it ruined my afternoon. . . . Anyway, I was upset
> about Jed being upset so I decided to treat myself to junk food. . . .
> I called Jed and he hung up on me. . . . Later, at the Studio 54 party
> for Diane de Beauvau, Diane's name was up in lights. And I went
> over and screamed at Jay Johnson and Tom Cashin for not telling
> Jed the things I asked them to to calm him down. So I screamed

and didn't have a good time. . . . I didn't have my camera, I wasn't
in the mood. Then I went home and took the dogs out and they
wouldn't pee.

This was the beginning of the end of the relationship between Johnson
and Warhol. As Bob Colacello saw it, "after *Bad*, when Jed went out late, Andy
went home early, and when Jed went home early, Andy went out late."

Or maybe it was the middle of the end, really, since several onlookers
have said that the relationship had been deteriorating for a while even before
the *Bad* and *Sex Parts* episodes. Catherine Guinness said that the two men
had been "getting on very badly" for some while and Abagnalo remembered
Johnson having actually "left" Warhol several times by then. He engaged in
heavy petting at Studio 54 and had certainly had at least one real affair, which
had involved some domestic violence on the part of his boyfriend and then
a cruel reaction from Warhol, who called Johnson "a tramp and a slut." A
friend of Warhol's described how Johnson had "left him emotionally but still
lived in Andy's house—to Andy's desperate chagrin."

Warhol's plunge into the louche world of Victor Hugo didn't help the
situation. Johnson didn't have the background to understand how that scene
could have artistic potential, and he was too straitlaced to want to join in.
(For a young gay man in 1970s New York, Johnson's morals were as tradi-
tional as his decorating.)

The launch of Studio 54 that same fall confirmed the growing chasm
between the two lovers, according to Johnson himself:

> When Studio 54 opened things changed with Andy. That was
> New York when it was at the height of its most decadent period,
> and I didn't take part. I never liked that scene, I was never com-
> fortable. I was always really shy and really had a hard time socially
> anyway, and I didn't like the people. Andy was just wasting his
> time, and it was really upsetting. I'd try to get something going
> and he just wasn't supportive of it. He just spent his time with the
> most ridiculous people. So things changed.

Things didn't fall apart all at once. Despite his growing independence as
a decorator, Johnson still traveled with Warhol to London and Kuwait that
November of '77 and continued to make such trips for the rest of the decade,
pursuing what he called his "education" at Warhol's side. And Warhol did ten-
der portraits of Johnson, including some with Amos, their second dachshund.
They were "sort of to keep the peace," according to Johnson's brother Jay—a

material substitute for the tender emotions Warhol was so bad at showing. "Jed missed the affection—verbal and physical. Andy wasn't capable of expressing it in the way Jed needed," Jay Johnson remembered. "Jed felt very strongly about the relationship. He definitely had strong feelings for Andy, and it caused him a lot of pain."

In the spring of 1980, after being with Johnson for a decade, Warhol went after the very idea of love in an interview: "The first thing I always tell my friends is not to fall in love. . . . Love is too hard. You have to get involved with people. I don't think it's really worth it. It's never like it is in the movies." He denied having been in love even once: "I'm just fascinated by everybody." Even if Johnson told himself that all this talk was just Warhol playing his usual games with the press, it couldn't have felt reassuring.

It didn't help that Warhol couldn't keep his eyes, or his thoughts, and sometimes his hands, off the gorgeous young lads he saw on the Studio 54 dance floor most nights: There was Kevin Goodspeed, "big and like my old crush from the sixties, Rodney La Rod," and those faux-Dupont twins, and any number of busboys. Warhol's new silkscreener, the bawdy Rupert Jasen Smith, remembered frequent wild nights spent out with his boss: "I was young and energetic, and Andy was going through a kind of a break-up with his boyfriend Jed Johnson." An assistant of Smith's remembers asking Warhol about a strange doodle he once added to his signature. "Well, it's a broken heart," Warhol explained.

At Christmas in 1977, Johnson showed up at Warhol's studio with a bruise on his head where Warhol had slammed a door in his face.

Three months later, Johnson's pain had boiled over into catastrophe. He locked himself in a closet and took an overdose of quaaludes, one of the few drugs he took—normally—for pleasure. In a panic, Warhol called Jay Johnson to deal with his brother's second suicide attempt, but he was gone from the house by the time Jay arrived to rush the sick man to the hospital. If Jed Johnson's goal had truly been to kill himself, he very nearly succeeded. It took a five-night stay in the hospital to leave him well enough to go home again, and only on the okay of a psychiatrist. "It's so embarrassing. Why would you embarrass me like this?" was how Johnson remembered being received by Warhol.

Things were never again right between the two men. In July, Johnson bagged out of a trip on the Concorde to see Warhol's *Athletes* in London. "Gee, everybody's seat is full, except Jed's" was Warhol's laconic comment on the flight.

Stuart Pivar, an antiquing friend of Warhol's, claims that the artist was desperate for his help in finding a new home for Johnson. Yet when Johnson did get an apartment of his own—a vintage three-bedroom, no less, next

door to Pivar's place in a gorgeous neo-Gothic building just west of Central Park—Warhol described it in an October 1980 diary entry as "an office for his decorating business so his clients and all the workmen won't be tramping in and out of the house all day anymore, so that'll be a relief." It could be, however, that Warhol was hiding his desire to be rid of Jed from Pat Hackett, who transcribed the diaries from daily phone calls: She and Jed were extremely close, so Warhol would not have let her in on any machinations involved in Jed's departure. ("Darling. . . . If only things weren't so impossible for us" is the ending on one of Hackett's letters to Jed.) Something else that Warhol's diaries don't mention is that the purchase depended on him as cosigner on a loan, an arrangement that got spelled out in a strangely businesslike letter that Johnson wrote in late November: "Dear Mr. Warhol, This is a brief letter intended to confirm our conversation today. . . ."

"Have you ever been in love?" a TV reporter asked Warhol that winter. "Uhhhhhm . . . no," he replied.

Four days before Christmas, Johnson told Warhol that when he came back from his usual Colorado skiing trip (he co-owned a house in Vail with Peter Brant) he would be moving out of the Sixty-Sixth Street place he lived in with Warhol and into his new West Side apartment—with Alan Wanzenberg, an attractive and eloquent young architect with whom he had, in fact, already been having an affair since the summer, possibly with Warhol's tacit approval. The Warholians who knew of it were terrified that it might ruin the delicate balance in the artist's world—and in theirs. As events unfolded, it did.

"A terrible day, no Christmas spirit at all," said Warhol in his diary entry for the day after Johnson's departure. That year, he did not give out his usual Christmas silkscreens to staff.

He did receive a lovely Victorian Christmas card from Johnson:

*Andy*

  *I don't know what you are looking for. Sorry you didn't find it at home. I don't think (or don't want to think) you'll get it from your Victors and Kevins and nights at Studio 54. You did have all my love and respect. I'm sorry it went wrong.*

  *Thinking of you with sincere love,*

                              *Jed*

*. . . as a blonde.*

# 1981

*"I might be well known, but I'm sure not
turning out good work"*

On New Year's Eve of 1980, Warhol found one of Jed Johnson's socks un-
der their bed, and it made him miserable. Another detail about that inci-
dent: Warhol narrated it to a new phone pal of his, a "handsome Princeton
boy" who had become one of the new crowd of ephebes whose presence
had helped drive Johnson away. Without Johnson to provide ballast at home,
the public, flirtatious, disco-going Warhol completely took over the artist's
life and persona. Already the day after Johnson left, Warhol sent roses to a
handsome twenty-seven-year-old vice president at Paramount studios named
Jon Gould, who by chance was yet another twin with a brother named Jay.
Warhol had been noticing him for a while. "I want him to get Paramount to
advertise in *Interview*," Warhol told his diary (and therefore his diarist Pat
Hackett, Jed Johnson's close friend) as an explanation for why the flowers
had been sent. That businesslike cover must have worn off as Warhol kept
his florist busy, daily. "I think the roses that I keep sending him at work are
embarrassing him, so I'd better stop. He tries to play it macho," Warhol said
ten days later. Gould was a closeted gay man who would eventually become
something like a boyfriend to Warhol.

As Warhol waited to see what luck he'd have with Gould, he set about
making himself as attractive as he possibly could, to all comers. He began to
diet obsessively. By mid-April he commented that "Everyone was telling me
how wonnnnnnderful I looked thin, but I feel so weak." In the spring of 1980,
with his home life still intact, Warhol had wanted to go from 140 pounds to
a slim 136, which he said was his proper weight. A year later, he had dieted

down to an absurd 110 pounds "and I really got scared. My stomach's shrunk," he said. He was right to be scared. He was referring to himself as having been "anorexic" and by June of '81 he was bedridden with what the doctors were calling "walking pneumonia"—a bacterial infection at least as unpleasant as a bad chest cold or the flu that kept him from traveling. The combination of depression after Johnson's departure and a warped body image did Warhol real harm. Self-portraits from 1977 and 1981 look like the before-and-after shots of a victim of a major famine. "I'm desperate and anxious. Something is wrong with me and I can't figure it out," Warhol said, talking about how boy-crazy he felt that summer of 1981. "I'm desperate. Isn't that an awful thing? I don't know what it is. I'm so desperate I don't know what to do. I'm ready to kill myself."

Even after his illness he was still obsessed with his weight. He managed to gain a few pounds but even at 115 he knew he was too thin: "I can feel my nerves grating against my bones." And then when he gained another four he foolishly said that he wanted to lose them again: "I like the way I look at 115 so I decided not to eat."

He also started to work out, at first on the Nautilus machines at the house of a countess friend, under the eye of the personal trainer who came with them, and eventually exercising with that same trainer almost daily on gym equipment he got installed at the very back of his studio at 860 Broadway. That must have been better for his health than simple starvation.

One year after Johnson's departure, at Christmas, Warhol was start-ing to feel better—or at least less bad—about himself: "I'm just starting to get a good body. I wish I'd started exercising when I was young. I could have had a good body all my life." (The funny thing is that he had started working out in the 1950s, long before it was fashionable, and had weights and an exercise bike even in the Silver Factory, where they came across as ironic props in the footage and photos shot around them but where they also got real use.) The workouts worked. Warhol, who had always pre-sented himself as a poster-boy for ninety-seven-pound weaklings, liked to surprise much younger friends by beating them at arm wrestling, which had become a "favorite pastime" of his. There's even a video that shows him amazing his trainer with the forty-two push-ups he managed to do, a tally you might barely expect from a twenty-something jock. (The cameras trained on Warhol must have brought out the beast in him.)

That same Christmas season of 1981 was when Brigid Berlin began dyeing Warhol's surgical corsets in pastel colors, as they still survive in piles in his archives. "She does a beautiful job on them," Warhol said. "The colors are so glamorous, but it looks like no one will ever see them on

me." Things were going nowhere with Jon Gould, his not-yet-paramour at Paramount, or with anyone else, for that matter. Although the idea that those trusses could ever be "glamorous" was sheer fantasy on the part of a wounded Warhol.

Always an early adopter of new technologies, Warhol completed his post-Johnson makeover by replacing his ancient hard contact lenses with a new kind of soft contact that could be worn all day and night. Those had just been approved by the FDA, and even then only for the nearsighted, but luckily for Warhol he qualified, with a vengeance: "It's so scary to wake up in the middle of the night and be able to see," he said, after getting the new lenses. They weren't sharp enough for drawing or reading ("Do they have bifocals you can wear with contacts?" he wondered) but they allowed Warhol to appear in public as a non-four-eyes who could actually recognize the faces of any young beauties he might meet.

Back in 1976, Warhol had talked about trying to be *un*beautiful, to make sure no one fell in love with him. After getting dumped by Johnson, that was certainly no longer his strategy. He had always been secretly hungry for romance—for real, old-fashioned coupledom—and the hunger only increased once he'd settled fully into singlehood in the spring of 1981:

> Now I'm living alone and in a way I'm relieved, but then I don't want to be by myself in this big house. I've got these desperate feelings that nothing means anything. And then I decide that I should try to fall in love, and that's what I'm doing now with Jon Gould, but then it's just too hard. I mean, you think about a person constantly and it's just fantasy, it's not real, and then it gets so involved, you have to see them all the time and then it winds up that it's just a job like everything else, so I don't know. But Jon is a good person to be in love with because he has his own career, and I can develop movie ideas with him, you know? And maybe he can even convince Paramount to advertise in *Interview,* too. Right? So my crush on him will be good for business.

Warhol's eager attempts at beautification weren't only for at home, to help him find a mate. They also had a lot to do with a new public image he was crafting for the 1980s, as the latest in the long line of "selves" he had chosen to create. After being the elf of 1950s illustration, the imp of 1960s counterculture and the king of 1970s social climbing, he would be a Joe Normal for the '80s, which was maybe the most improbable role he ever played. He

became less and less invested in being the odd man out in American culture and more and more interested in presenting himself to the mainstream as someone who wanted to join it.

Unlikely as it may seem, in his first months being single he took up the idea of becoming a fashion model. Already by April he'd succeeded, as announced in a column in the *Los Angeles Times,* which of course Warhol kept as a clipping: "Looking for a male model with glasses and platinum-blond hair—one who does a little painting on the side? Pop artist Andy Warhol has joined Zoli Modeling Agency's roster of fabulous faces."

The idea of a funny-looking, shy, awkward, bewigged avant-gardist going full Zoolander was clearly felt to be newsworthy, and Warhol the publicity hound must have known it would be. A reporter soon approached Warhol with questions about his new modeling career and a typescript of his wonderfully eccentric interview survives:

> I've only been doing it for about three weeks, and I've had around 12 jobs. The first job I was asked to do was a job for Barney's. I was in Paris last week and I went to this great men's shop. I think it was Daniel Hechter's. I was just wandering in and this salesman just kept staring at me. I assumed he thought that I was the artist Andy Warhol, or something like that, but he didn't. Just came up and said, "Gee, aren't you the model that was in the Barney's ad in *GQ?*" God. That made my day, my week. It made my year.
>
> My first nervous job was yesterday, when I did the Van Lac runway job. It was my first runway, and today's my second. I don't think it's a runway today, I think it's just mixing and mingling with a Bill Blass suit on. But yesterday was my first, going out in public as a model. Well the kids—the girls—were just so sweet. Actually, I want to be a girl model. I think models should become skinny again. I weigh 114 to 117, and the good thing about it is, I can wear—I can't stand woolen pants—so I can wear double pairs of pants on top of my blue jeans, so it fills me out and I look like I'm wearing a 30-inch waist. It's worked out—I don't have to take my pants off. But the *shocking* thing is to take my shirt off and everybody sees my scars, and everybody looks away.

One subject Warhol dwelled on in the interview was how *normal* his fashion tastes were. "I think if you wear the classics, you're safe," he said, and listed the utterly tasteful Perry Ellis as his favorite new designer, L.L. Bean and Eddie Bauer as his favorite jacket makers and cotton as his fabric of

choice. He'd come a long, long way from some of his wilder get-ups as Plastic Man of the '60s. "I can't wait to do my $2,000-a-day job" is how he ends the interview, in his typically faux-mercenary mode. "I want to be in the L.L. Bean or Brooks Brothers catalog."

Paige Powell, a young woman who joined Warhol's circle a few years later, remembered how much Warhol loved the status that came with saying that he was one of the "faces" at an elite modeling agency. She also remembered how he paid for that status by having to cope with his dread of walking down a runway in front of a live audience. The fashion-show organizers would sometimes give him a camera to hold as a prop, so he'd have something to distract him from his terrors. "They'd yell at him, 'Take a picture, take a picture'—because he was frozen," Powell said. "But he couldn't even get the camera up to take a picture, his hands were shaking." Warhol told Powell that the only reason he modeled was to be able to write off his trainer and his very fancy cosmetologist. But the more likely truth is that, whatever his fears, it was just the opposite: He trained, got his chest waxed, and had facials—possibly even plastic surgery—so that he could model.

In signing with Zoli he'd had to face down the most violent objections from Fred Hughes: "It's something I want to do so I ignored him," Warhol said to his diary. Colacello was equally negative. "Bob told me that I look like a fool on the runway doing my modeling jobs. I told him I didn't care, and he said that he cared, that it made his job harder if I looked like a fool."

Actually, Warhol had his own strange idea that looking like a fool was precisely what he needed to do to *succeed* at modeling, given that he could never compete on the same terms as the young beauties next to him in the photo studio or on the runway. "I think I have to figure out a way to be more of a buffoon, to fall down or something," he said. (He attempted just such a pratfall in the fashion show that came a few days before his death; in retrospect it reads as more tragic than comic.) His slapstick was probably based on his old Picassoid idea of failure as success, but also on a peculiar notion he had that modeling would launch him into the most unlikely of new careers: "I want to be a comedian. And I decided this is a good stepping-stone. Because I just get so nervous, I can't do live TV. I can only do taped TV, and I'm pretty bad at that, but I think I could be a comedian and I thought this is sort of a way to ease into it."

---

Back in the 1960s, Warhol had used *The Chelsea Girls,* the *Index (Book)* and the massed photos of the Silver Factory in his Stockholm catalog to present a home-grown, in-house vision of who he was and how he encountered the

world as an undergrounder. In the 1980s, Warhol was equally committed to controlling and creating the image he presented, but now that image was very different and he took even more complete control of its creation. He'd bought his tiny Minox "spy" camera on a trip to Europe in 1976, and ever since he'd been using it to document just about every second of the new life he'd been living in the thick of high society. As the '70s wrapped up, his studio's new publishing arm—Andy Warhol Books—released a volume of the photos he'd taken during that decade. It was originally called *Social Disease,* after the compulsive need to socialize that Warhol mentioned in his introduction (via ghostwriters Bob Colacello and Brigid Berlin), but the book got retitled *Andy Warhol's Exposures* once the marketers realized that its original, much more accurate and appropriate title wouldn't sell in small-town America. "Everybody thought that people would think it meant venereal disease," said Warhol. "So we changed it."

Like every book that Warhol ever released, *Exposures* didn't sell terribly well. Only about twenty-five thousand copies ever left the bookstores. But it is nevertheless one of his most important productions, as has almost never been recognized. Stylistically, it helped cement a new, shoot-from-the-hip, casual mode in American art photography, launched by the landmark "New Documents" photo show at MoMA in 1967. But the utter spontaneity of Warhol's uncomposed, snapshot aesthetic made the famous "accidents" cultivated in the MoMA shots of earlier street photographers like Gary Winogrand or Diane Arbus seem as orderly and structured as any Leonardo. Warhol's just-the-facts-ma'am style was already de rigueur on the vanguard of the art world, where Warhol always longed to be, since it had been used for a decade already by Conceptual artists who wanted to document their most radically ephemeral, antiretinal projects. The photographer Stephen Shore, who had worked on Warhol's *Index (Book)* as a teenager, had started taking independent art photos in that same documentary mode. But once a certifiably famous fine artist like Warhol picked up on it, it automatically got full recognition as a new way of taking pictures.

*Exposures* also did something important in Warhol's own development as an artist. For the first time, it let him reveal himself as the closet photographer he had always been, from his schoolboy use of the family's Brownie through to pictures he shot in photo booths in the early '60s and on even to his snapshot-ish use of 16 mm movie film to record the Factory crowd. Some six months after Warhol released the book, visitors to his painting-filled studio heard a declaration that must have taken them by surprise: "I told them I didn't believe in art, that I believed in photography."

Beginning already in Warhol's college years, most of the drawings and

paintings he produced had been based on photographs, whether taken by him or by someone else. Relying on those photos had let him craft an art that, at its very deepest level, was about ostension—about simply picking something out in the world and pointing to it, with no more arty agenda than that. The sheer, unnecessary, impractical volume of photos he took of the transvestites who modeled for his *Ladies and Gentlemen* series—and for that matter of many of his paying portrait sitters—suggests that the subjects themselves mattered at least as much to him as any best-selling paintings he might make to represent them. You could even argue that the florid, almost random brushwork that he laid down on his canvases, mostly before they were even silkscreened, was a way of signaling that all that paint was just empty window dressing demanded by buyers; it could have been slapped down differently—and was—without making any real difference. All that truly mattered was the photo that got printed on top, as the final "touch" that turned the fancy object into fine art worth the name.

With *Exposures,* Warhol's photographic pointing-out was at last allowed to take center stage. Its shoot-from-the-hip, spy-camera look made clear that all that counted in each shot was the *what* of its subject, not the *how* of its photographer's aesthetic choices. (Of course, those shots' nonaesthetic soon got turned into an *aesthetic* of the nonaesthetic. That was an aesthetic—a desirable *look*—that lasted well into the twenty-first century, especially in the fashion images of in-demand photographers like Wolfgang Tilmans and Juergen Teller.)

The *what* that Warhol chose to present in *Exposures* was the elite and fashionable society he had been exploring in person for the entire decade, from soon after the bullet holes in his body had closed. *Exposures* has sections on Bianca Jagger, on Halston, on the Kennedy-Radziwill clan and, of course, on Studio 54. But one of the most important things about the view of that elite world that Warhol provides in *Exposures* is that *he isn't in it,* or only camouflaged, Zelig-like, among its onlookers. After all, we rarely see him mixing with his subjects, since he's almost always the one behind the camera, looking on from afar. (Some of the photos must really have been snapped by his staff, since he's visible on the sidelines in a few of them, but in Warhol's world that doesn't change authorship: "It was his camera and his film. That's how it worked at the Factory. The person pushing the button was just a tripod for Andy," said Christopher Makos, the photographer who did darkroom work on many of the book's images and might have shot a few.) The photos in *Exposures* are of rich or famous or beautiful people, but as seen through the eyes of an onlooker who can barely get his act together to hold

his camera straight or to make sure that his subjects aren't cut off by the edge of the picture. Within a few months of the book's publication, the art critic Peter Schjeldahl talked about Warhol as a "watcher of the rich" who played a unique role as witness to the ills of what Schjeldahl eagerly called late (i.e., senescent) capitalism: "His underclass childhood somehow left him amoral as a man and incorruptible, because profoundly indifferent, as an observer. It is not necessary to like him to appreciate what he gives us with his art. . . . He has the terrible virtue of not caring particularly what happens as, with camera and tape recorder, he is present at every happening in his significant social microcosm."

In *Exposures,* the photographer of that microcosm is one of us—Joe Normal, once again—looking at high society with as much slack-jawed wonder as any true outsider. That hadn't been the message in Warhol's 1960s publications: In the *Index (Book)* and the Stockholm catalog he was the constant *subject* of photos by other people, who couldn't get enough of his extreme specialness. Those '60s books were part of his self-creation as an eccentric celebrity emerging out of the underground. That was just what he began to undo in the '80s, with his presence on the runway or in your average magazine ad. All the sudden, he was the guy paid to wear the clothes, and only for an hour or two, not the guy buying them at Barney's. (And this at a moment when he could afford them better than ever.)

Even in *POPism,* Warhol's ghostwritten memoir of the '60s that got released in 1980, the first-person voice is so prosaic that it feels like Warhol, the mild-mannered narrator, is a remote observer of Warhol, the wild-man artist that the book is about. You might even say that *POPism* was at least as much about establishing Warhol, the narrator, as an '80s mainstreamer as it was about painting a picture of the avant-gardist he had really been some fifteen long years before. Maybe that's why it disappointed its baby-boomer readers, who, once again, failed to snap up this latest Warhol book. They wanted help in reliving their fantasy of the '60s; they didn't want to be reminded of the pedestrian reality of the '80s that was fogging their rose-colored glasses.

The image of Warhol as wide-eyed, remote observer—the character revealed in both *POPism* and *Exposures*—hardly reflected how things really stood at the moment those books were produced. By the end of the 1970s, Warhol was the ultimate insider, a wealthy celebrity partygoer who Steve Rubell wanted in his corner to guarantee the success of his nightclub. Warhol's old friend Sam Green, curator of that first Philadelphia survey in '65, made a pile of recordings of gossipy phone calls from the '70s where Warhol

sounds as comfortable as anyone could be in the elite world he had joined. But that wasn't the impression Warhol wanted to present to the outside world. Maybe, as so often with this artist, he had come to an early realization that the gilded youths of midtown disco were becoming passé and that, circa 1980, the down-to-earth underdogs of the East Village were about to replace them. Punk and graffiti were taking over from Gloria Gaynor and a man in the moon snorting coke.

In November of '79, just as *Exposures* was getting its first reviews, the death knell was sounding for Studio 54:

STEVE RUBELL: So, are you gonna come visit me?
ANDY WARHOL: Oh, yeah.
RUBELL: You should do a picture of me in prison. I'm going.
WARHOL: Why?
RUBELL: Because I have to go. I stole two and a half million dollars from the government. But I would like you to do just like a drawing.
WARHOL: Where is all the money?
RUBELL: Hidden in an apartment in New York.
WARHOL: No! You don't have to give it to them?
RUBELL: They don't know. They only think I took two and a half million. You love money.
WARHOL: Oh, Money is fun. It's fun to have money, isn't it?

It's hard to know which might have troubled Warhol more: the closing of his favorite club or the thought of someone doing three and a half years in prison for fiddling his taxes. Money was fun, but it also took work to hold on to.

---

In May 1981, Warhol was being photographed for a magazine story in front of a new series of silkscreened paintings he had recently completed. They were called the *Myths*, and showed ten supposedly iconic figures from American culture: Superman, Mickey Mouse, Santa Claus, the Wicked Witch of the West and so on. And Warhol's reaction, as recorded in his diary? "I almost threw up, they looked so sixties." He wasn't wrong to feel a bit sick. The new images really were rehashings of work he'd done almost two decades before. They looked as though some lesser creator had read a description of how this famous artist named Andy Warhol had once made images

based on America's cultural icons and then decided to take a stab at the same conceit. The surprising intensity of Warhol's Marilyns and Elvises got diluted to death in the *Myths;* they lack both surprise and intensity. The series fails even in purely visual terms, abandoning the extreme consistency that had tied together all the canvases in any of Warhol's best Pop series. (It had sometimes made them close to interchangeable.) The Superman print from *Myths,* for instance, is a straight repeat of a pretty uninspired frame from a recent comic book, drawn years after its hero had mattered most in the culture; ditto the image of Mickey Mouse. (Warhol had wanted to do *only* Disney characters, which would have done a lot to tighten the series, but his dealer overruled him.) Uncle Sam and "Mammie," on the other hand, were based on newly shot photographs of models hired just for the series, so as to avoid the copyright problems that Warhol had faced when he used other people's photos. And then the print called *The Star* was different still, built around a vintage photo of the Mata Hari character played in 1931 by Greta Garbo, who by 1981 was hardly the archetypal "star" anymore. The only image that does come as a true surprise, and that is truly potent, is one titled *The Shadow,* ostensibly portraying a character named Lamont Cranston, who was the hero of a 1930s radio drama about a millionaire crime-fighter with the power to make himself invisible by "clouding men's minds." Orson Welles created the role, which came with the once-famous tag line "Who knows what evil lurks in the hearts of men? The Shadow knows," and the program had been a favorite of Warhol's when he was little. But that didn't come close to making the Shadow a truly iconic "myth" of American culture; only oldsters or radio buffs would even have known who he was by 1981. The print nevertheless stuck out as by far the most powerful and original image in the series, thanks to the model Warhol had chosen to pose as the hero who clouds men's minds and knows the evil in their hearts. That model was Warhol himself, presented in a deeply mysterious image that showed just a sliver of his actual face and then a long, distorted shadow stretching out from it, in a close evocation of a famous self-portrait-as-shadow by Warhol's hero Marcel Duchamp. Invisible yet present and potent; confounding yet heroic; iconic yet ungraspable—Warhol as Shadow was perfect typecasting.

"I had a fight on the phone with Ron Feldman, he's so awful, he didn't want to take the whole series of Myths, he only wanted to take the specific images that are selling the best and I thought he was just awful, and I wound up yelling and I hate to yell on the phone," said Warhol in a diary entry from the fall of '81. Ronald Feldman was the art dealer who had initiated the *Myths* series. The previous year he'd arranged for a series of paintings and prints

called *Ten Portraits of Jews of the Twentieth Century* (Kafka, Einstein, Gershwin, Freud, etc.) that was at least a little bit stronger. In 1983 he sponsored the weakest series yet, on endangered animals. "Animals in make up," Warhol called them, and felt the makeup job he'd provided might help their subjects survive.

Feldman and Warhol had had dealings earlier in the 1970s that involved some certifiably avant-garde art. Late in 1973, for instance, Feldman had staged a Marcel Duchamp survey in his gallery, which occupied the old Stable space where Warhol had his first New York solo. Warhol showed up there as the most avid of collectors, bartering a portrait sitting with Feldman against a 1964 remake of Duchamp's landmark urinal. A few years later, Warhol was getting Feldman to supply him with art by one of Duchamp's youngest successors in radicalism, the California performance artist Chris Burden. "When I showed Chris Burden, I had two buyers: Jasper Johns, and Andy Warhol," Feldman recalled. "Andy did Electric Chairs; Chris Burden had himself shot. There's not a big gap there." Warhol was drawn to Feldman, said the dealer, because he showed the most challenging art, not only by Burden but also by Joseph Beuys and Hannah Wilke. For decades thereafter, Feldman's gallery continued to show some of the most political and aggressive creations around. But when it comes to the Warhol projects initiated by the dealer, it is clear that, however varied their images may be in subject and look, they all come together as the purest examples of Business Art.

The print portfolios that helped Warhol bring home the bacon were under the special supervision of Fred Hughes, who had become more and more the studio's chief bacon wrangler: Ideas for projects normally passed through Hughes's financial filter before they went to Warhol for artistic approval. "I never talked about money to Andy; I talked about money to Fred," said Anthony d'Offay, a dealer who showed Warhol in London in the '80s. When he once suggested rounding off a $531,000 payment he owed to an even $500,000, Hughes replied, "Who the fuck do you think you are? If you're a tradesman, call at the back door."

One of the problems with the Feldman projects, and similar ones from the same era, is that so much of their content and structure were decided by others. "You tell me what to do and I'll do it" was the mantra Warhol repeated to his last dealers, said d'Offay, who remembered it as "a shocking conceptual idea." Possibly, but it was also the recipe for art that wasn't always worthy of Warhol. He no longer went to the people in his circle just for the seed of an idea; he let them water and prune and harvest it. It was Feldman who had insisted, from the beginning, that there be maximum

variety within each project they worked on, abandoning the repetitions that were so central to Warhol's artistic concept. And it was Feldman who came up with the projects' themes, and then offered Warhol checklists of possible Jews and myths and endangered species to choose from. The dealer even found most of the images that Warhol used as the basis for his silkscreens.

But if all that delegation weakened Warhol's work as fine art, it clearly fostered its success as Business Art. The *Jews* were supposed to have sold out before their first launch, in Miami. Within a few years Feldman was claiming that he had almost sold out the *Myths* and *Endangered Species* as well, although he refused to confirm a reporter's estimate that Warhol had grossed something like $5 million from just those series. "He makes a lot of money" was all Feldman would venture.

Warhol's role as profit-spinning CEO did not, however, spare him doubts about the whole Feldman enterprise, which he voiced over the phone to Hughes and also to himself in his diary, at the moment when the *Myths* were due to go on view: "I called Fred in East Hampton and told him what a bad deal he'd made with Ron Feldman, that I was with Leo Castelli and that I wasn't supposed to be having a show with Ron Feldman in the first place and having such a big show of mine would make his gallery famous, and that the pictures were too big and too awful."

A bit after Feldman's *Myths* show, Warhol visited a suite of galleries full of sculptures by Henry Moore, a titan of modern British sculpture but not exactly in the vanguard by the '80s: "Really impressive. Like forty figures, gigantic. I mean, my work looks like nothing compared to that stuff," Warhol confided to his diary. "I might be well known, but I'm sure not turning out good work."

Warhol complained that the critics at the *New York Times* didn't review the *Myths* show, but he probably should have been glad they didn't. The headline on the little news brief the paper did publish was "A 1960's Rerun." Exactly one year earlier, when the *Times* critic Hilton Kramer reviewed a museum show of Warhol's *Jews,* he compared it to the "many afflictions suffered by the Jewish people." Admitting that this art-world debacle wasn't quite the Holocaust or the Destruction of the Temple, he said the show was nevertheless vulgar, "reeked" of commercialism and that its contribution to art was "nil." For this once, Kramer's anti-Warholism wasn't just the empty rage of a reactionary. Warhol, who officially believed in ignoring reviews, apparently took that one to heart. Maybe he sort of agreed with it.

Even if Feldman's projects did bring in some serious money, Warhol couldn't really commit to the head-spinning premise behind his notion of Business Art—to the idea that business successes could, by Duchampian fiat,

come to also be counted as artistic successes, and that a check from a dealer might be a fine and fascinating ready-made.

In the 1980s, it seems as though Warhol was starting to feel more oppressed than excited by his commercial enterprise. When an interviewer mentioned that he knew a young artist who made objects, films and videos and also played in a band, Warhol replied, "If you don't get so involved in business, you can have the time. Since we have a business here, I can't do all the fun things I did at one time." A staffer once asked him why he was ordering bulletproof eyeglasses, of all things, and he gave a weird workaholic's answer: "Well, if I get hurt and keep my eyes, I can keep working." When the same person asked him to donate to some good cause or other, he explained that he felt he was working for a "cause" every day of his life: funding jobs for the "kids" in his studio. "I need to be as busy as I can, making paintings—they're my project; the kids are my project," he said.

This wasn't a project Warhol always seemed that keen on. In 1986, a reporter asked him to talk about the role he'd played as the leader of the Silver Factory crowd. "That's negative, to me it's negative. I don't want to talk about negative things," Warhol said. "Well, what about these happier days at the present Factory? Now you're a corporation president," replied the reporter. "It's the same," said Warhol.

---

Product, good or bad, had to be turned out. By the dawn of the '80s, Warhol had taken all kinds of steps to expand the capacity of his production line, mostly through outsourcing. While 860 Broadway played host to the planning and designing of all the new series, as well as to any background painting that was called for, the silkscreening itself—whether onto painted canvas or printmaker's paper—was outsourced to a contractor named Rupert Jasen Smith, who had replaced Alexander Heinrici in the last years of the '70s. Smith was a new-minted BFA, still in his twenties, who lived and worked in a big loft on Duane Street in Tribeca, a scruffy industrial neighborhood in those days, and dangerous. Smith slept at one end of the space, cooked in its middle and oversaw Warhol's printing at the other end, in a work space where pandemonium reigned, according to an employee of Smith's named Horst Weber von Beeren. The chaos was "like an abortion on a kitchen table," said von Beeren, who did the actual silkscreening along with two other skilled printers. Smith himself, who von Beeren said was too short to manage the mechanical squeegee, supervised from afar. More than anything, Smith handled the contacts with Warhol.

Ventilation was pretty much nonexistent in the loft, despite noxious

fumes from the inks and solvents, and even on the hottest summer day Smith
would turn on the heat in the room to make works dry more quickly, since
Warhol was in an eternal rush to get his images off to dealers and patrons. Ac-
cording to von Beeren, Smith and Warhol had an elaborate charade worked
out whereby Smith would deliver the still-damp canvases to the back rooms
of Warhol's studio, without being seen by the client, and Warhol would then
fetch them out, "as though he had worked for ages on them himself." When
it came to works on paper, Warhol was more fully hands-off. Smith would
show up at 860 Broadway with the preliminary "acetate"—the photographic
film from which a printing screen was made—and once Warhol had approved
it or indicated changes, Smith and his staff would pull dozens and dozens of
trial prints in every imaginable combination of colors and inks. Interestingly,
"Mrs. Warhol" (as the printers called their main client) would often call in
and ask for hues that he'd used for his most famous Pop works: "I want the
Elizabeth Taylor green from 1965," he'd say, and sure enough the jars of col-
ored ink would be labeled with the names of old works—"Campbell's Soup
Red" or "Marilyn Green." The trial prints would provide a gamut of possi-
bilities from which Warhol would then choose the colorways he wanted to
see repeated in the published edition, with salability as the main criterion,
according to von Beeren. Although Smith and his printers were supposed to
destroy the stock of unused proofs, Warhol was absolutely right to suspect
that that didn't always happen, or maybe rarely did. "We considered it our
own artwork—part of our creativity," recalled von Beeren. The market for
Warhol's proof prints has been in turmoil ever since, especially since Ru-
pert and his staff were often the ones to sign Warhol's name to his images—
sometimes with his knowledge and approval, but sometimes not.

The Duane Street team, most of whom were themselves trained as art-
ists, could sometimes play an important role in Warhol's 1980s aesthetic. It
was Smith, for instance, who first sprinkled Warhol's work with "diamond
dust"—actually, ground glass glued onto a piece to give it that Studio 54 twin-
kle. Warhol had his doubts about this gesture of Smith's as being explicitly
and excessively "artistic." (Although it echoed nicely with a similar effect
he'd gotten two decades earlier when he glued sparkly black sandpaper to
Pop paintings based on vastly enlarged matchbooks.) The three men who
did the actual printing for Smith had more than doubts. They simply detested
the stuff: "It would be in your shoes, your eyes, your hair," said von Beeren.

Not waiting for Warhol's approval, Smith was particularly liberal in ap-
plying his sparkles to a portfolio of still lifes of women's footwear that War-
hol had him turn out in 1980, and for which Smith had even found the pile
of shoes from which Warhol chose his props. "I'm doing shoes because I'm

going back to my roots. In fact, I think maybe I should do nothing but shoes from now on," Warhol said, as though his embrace of a new kind of commercialism for the '80s gave him license to revisit his shoe days as a commercial artist of the '50s. ("He always paid homage to I. Miller shoes," said one of Warhol's later companions. "We'd always be walking in that area, Fifth and 57th Street, and he would always say, 'They gave me my first job.'")

As Warhol's production ramped up, and more and more money started to come Smith's way, more and more of it got spent on drinking and drugging and cruising, to the point that Smith sometimes couldn't pay for paper or his silkscreeners' salaries. Smith ran the shop "like a dictator," according to one of his youngest silkscreeners, "barking out orders but smashed out of his mind, drunk as could be." Some mornings when the printers arrived to do their work Smith would still be unconscious in bed with his latest young conquest. Although Smith and Warhol were frequent companions on the party circuit, the artist made a point of never venturing up to Smith's Duane Street studio, said van Beeren, partly for fear of having to take responsibility for the noxious labor situation there. According to one worker, van Beeren himself liked to smoke cigars as he pulled prints—with a can of gasoline sitting nearby, as solvent. If Warhol could often be kind and considerate to those he was close to, when it came to business he didn't mind outsourcing his ethics as well as his production.

"Warhol never walked through the door in that place. He was getting to be a health freak, and would never have exposed himself to those chemicals," recalled a worker who breathed them.

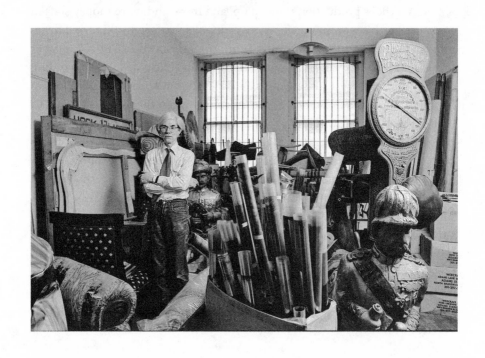

*. . . with a handful of his treasures.*

## 1982-1983

THE NEW ART KIDS | WARHOL AND BASQUIAT |
RORSCHACH PAINTINGS | SHOPPING AND COLLECTING

*"I like all paintings; it's just amazing that it keeps, you know,
going on. And the way new things happen and stuff"*

"There's this whole group of kids doing this bad art. . . . Then Bruno comes
along and says 'I'll buy everything,' and these kids get used to big money,
and I don't know what they'll do when it's all over—Oh but by then it'll be
something different, I guess." Warhol made that entry in his diary in the fall
of 1980, just when a group of young artists—soon-to-be-famous "kids" such
as Keith Haring, Kenny Scharf, Julian Schnabel and Jean-Michel Basquiat—
were climbing into the art-world spotlight, now focused on an emerging new
scene in the East Village. And the thing about those kids, as far as they mat-
tered to Warhol's life and career, is that for all the "badness" of their art he
really wished he were one of them. He had been, more or less, for a few years
in the early '60s, as he achieved international fame and some kind of fortune
with his discoveries in Pop Art. If there's one force that shaped Warhol's en-
tire life and psyche, it was a desire to climb back onto that cutting edge, as
almost no older artist has managed to do. His "by then it will be something
different" shows an acute awareness of how one movement in modern art
had always given way to another ("every fifteen minutes," you might say)
but it also holds out promise that there's always one more chance to jump on
the bandwagon.

   "He was very much aware of the scene," said one much younger friend
who remembered going with Warhol to the opening of the über-hip PS1 art
center a few years before, and who introduced him to some new downtown
artists. Warhol recognized that the early-1980s art world was a close repeat
of the early '60s, at least in terms of an explosion in publicity and sales, and
he wished he could be part of it. "I got so nervous thinking about all these

new kids painting away and me just going to parties, I figured I'd better get cracking."

Jeffrey Deitch, a dealer who became a major supporter of Warhol's young rivals, remembered the older man's fascination. "He got a lot from their energy, and he was always drawn to a youthful vision. You could see how his interest in them was tremendously meaningful." That interest also came with critique. Warhol could see that the art his juniors made was quite unlike his own breakthrough in Pop because, by most normal art-historical standards, it was actually quite conservative, even at times reactionary. A lot of it revisited the tried-and-true aesthetic values, and clichés, of "self-expression," of "the artist's touch," of "authenticity," "imagination" and "inspiration"—all the conventional artistic premises that so many artists in the '60s and '70s had been trying to escape. Warhol complained when the newcomer Julian Schnabel ("[he] does sort of bad paintings. . . . He's very pushy") asked to do his portrait and then was actually going to make him *sit* for it, like in some old-timey portrait studio, even though the messy and "abstract" end result was certain not to look a whole lot like the sitter. "I guess I have to because he wants the inspiration," said Warhol, the contempt for that last word fairly dripping from his tongue.

"He really is determined to be a big star," Warhol observed, and after a later visit to Schnabel's studio said it was the most pretentious afternoon he had ever spent.

For Warhol, a closet conceptualist who was Duchamp's greatest heir, you weren't doing much of anything as an artist if you weren't questioning the most fundamental tenets of what art *is* and what artists can do. Those were the terms that made Warhol's best art count as great; they also made the art of the new kids count as "bad," at least for Warhol and anyone with his values. At just the moment that Warhol was encountering this new art, usually dubbed "neo-Expressionist" or "New Image" painting, Benjamin Buchloh, the most rigorous proponent of that era's New Art History—and soon to be the most rigorous of Warhol supporters—was publishing its definitive takedown. "The specter of derivativeness hovers over every contemporary attempt to resurrect figuration, representation, and traditional modes of production," Buchloh wrote. The new kids on the block, he said, had won "instant acclaim" only by "affirming the status quo under the guise of innovation."

Not that such doubts stopped Warhol from dipping a toe into the new movement. Artistically speaking, he was nothing if not open-minded, like a venture capitalist worried about missing out on a rising company. Early on, Warhol had actually bought a number of paintings by George Condo, an

East Village neo-Surrealist who, just by chance, had briefly worked printing Warhols for Rupert Jasen Smith. When Condo had his first solo at Barbara Gladstone's prestigious new gallery, Warhol showed up and even praised the publication that came with it: "I wonder if I could use the same catalog, and just change my name for George's?" he quipped. Condo read that riff on authorship as a classically Warholian conceptual gambit, which it was. But it was also a classically Warholian response to a rival. It sounded like a compliment—and maybe it was one—but it was also just possibly hinting that it was the simple success of the art, rather than its specifics, that mattered. That is, Warhol was saying that he would have liked to have his name on such a with-it show and book, but not necessarily because of the objects featured in them.

Warhol arranged to visit Condo as he worked: "You just walk up to the painting and do whatever you want?" the older artist exclaimed, as he took pictures of the scene. "I could never do that!" He *couldn't* do it because everything he'd learned about contemporary art told him it was something you *shouldn't* do. His diaries are full of mentions of new works that he clearly doesn't have much respect for—"Fred Flintstone" graffiti by Kenny Scharf; pretentious paintings by Schnabel—but that he thinks he still ought to buy, at least when they haven't already soared past his budget. Warhol told his diary about his attempt to buy a piece from a Scharf exhibition: "I figured it would be $4,000 or $5,000. So we left there and when I called later on after thinking about it they said it cost $16,000. I mean, these are kids right off the street getting these prices!"

The "alternative" art world these fresh young things were building for themselves in the East Village was weirdly conservative and quite avowedly mercantile. It favored the idea of the commercial gallery—however scruffy and artist owned—over arm's-length state funding and the nonprofit "artist-run centers" that had mattered so much to the previous generation of downtowners. One observer talked about cultivating a notion of "art before the dole"—before the National Endowment for the Arts, that is—that sounds weirdly like something from the Reagan playbook. That must have left Warhol strangely ambivalent. He was more linked to the art market than anyone; his Business Art depended on it. On the other hand, as a Duchampian conceit, Business Art—like much of his art—couldn't have existed, and wouldn't even have been legible, without its grounding in unsalable, avant-garde Conceptual Art.

When an interviewer tried to corner Warhol into talking about the new figurative art that all the kids were making, the artist was comically evasive. "For a whole new generation of figurative artists, you're now the Picasso

figure of sorts," said the writer. "Many young artists I speak to name you as a major inspiration. What do you think about this new image-oriented art?" Warhol's reply was that he liked "every art in New York—it's so terrific and there's so much of it. . . . There are so many artists that are so good now that it's very hard to pick out one or two." And then he picked out two young artists, Lynda Benglis and Scott Burton, whose distinctly nonfigurative work was just the latest development in good old avant-gardism.

---

Warhol eventually got to know most of the up-and-coming boys on the new scene (they were almost all boys), but the first one he became close to was Jean-Michel Basquiat. Basquiat had been a child prodigy, of sorts, born in 1960 into a middle-class family. He'd been exposed to art and high culture early on but life at home was troubled—his mother was often institutionalized—and he eventually dropped out of the artsy, alternative high school he attended. Warhol first noticed him as a street artist and graffiti painter—as "the kid who used the name 'Samo' when he used to sit on the sidewalk in Greenwich Village and paint T-shirts, and I'd give him $10 here and there and send him up to Serendipity to try to sell the T-shirts there. He was just one of those kids who drove me crazy."

Warhol was scared of Basquiat at first (and maybe always). He told an assistant to keep Basquiat out of the building on Great Jones Street after seeing him sleeping rough in a doorway nearby. But the fact that Warhol remembered Basquiat's graffiti tagline, "SAMO" (for "same old shit"), might show that he also recognized him at once as more than just another one of "those" kids.

Unlike the other graffiti artists who were starting to be recognized right then, and who were mostly focused on achieving an impressive look and style in their spray paintings—one of them, famously, covered an entire subway car with his version of Warhol soup cans—Basquiat made simple graffiti scrawls that were much closer to text-based art or public poetry, and usually had political and critical undertones:

SAMO©, 4 THE SO-CALLED AVANT-GARDE
SAMO©, AS AN ALTERNATIVE 2 "PLAYING ART" WITH
THE "RADICAL CHIC" SECTION OF DADDY'$ FUNDS,
(SAMO©) A PIN DROPS LIKE A PUNGENT ODOR,

These works were even collaborative—"SAMO" was a shared "brand" assumed by Basquiat and another high school artist named Al Diaz—which

brought them yet closer to the forefront of the official, lefty avant-garde, where the dissolution of individual authorship was a major preoccupation. (Warhol had been as preoccupied with it as anyone.)

"We wanted to do some kind of conceptual art project," said Diaz. "What we were doing was more like Greco-Roman graffiti, making commentaries on the world around us and that set us aside. We thought we were a little bit ahead of the game." Circa 1980, your average subway tagger did not cite classical antiquity, let alone use its culture to get "ahead" in the game of conceptual art.

By the time Basquiat started to make his mark in the art world, the figurative canvases he was painting were actually less novel than his wall writing had been, and more traditionally expressive. His stick figures, crude faces and weird settings were scrawled and smeared and slapped down in the classic faux-outsider mode that sophisticated modernists (including Warhol, in the '50s) had been playing with since the days of Picasso, Klee and Dubuffet. Basquiat himself, always more art savvy than he let on, might have recognized that his style was old-fashioned and a touch clichéd: Asked why he painted "like a mad child," Basquiat replied, "They want an idiot savant, they get an idiot savant." But there was nevertheless something there that caught Warhol's attention.

When Warhol looked at Basquiat, a precocious, fearless, drug-abusing black street kid from Brooklyn with crazy haircuts and an attitude, it could very well be that he saw . . . himself, as he'd been back in the 1950s, when he was first attempting to break out as a fine artist. The superficial differences are obvious but the deeper similarities are more important. Like the young Warhol, a virtuoso channeler of Ben Shahn and Jean Cocteau, the young Basquiat wasn't doing much that counted as important or daring in stylistic terms. But what both he and the twenty-something Warhol did manage was to take an established visual vocabulary and use it to talk about what was mostly unspeakable in the mainstream art world of their moment: Homosexuality, for the young Warhol, and for Basquiat race and how it plays out as class. The relative conservatism of their art's style made it the perfect vehicle for content that had to stay on the down-low. Style, for both artists, was the sugar that sweetened content's pill. Or was it a smokescreen that obscured the true, antiestablishment nature of their art? Fab 5 Freddy, a black friend of Basquiat's from the world of graffiti, remembered idolizing Warhol before the two even met. He said that Warhol's outlandishness, as a zany gay man, automatically tied him to the outsider status that blacks were stuck with.

The difference between the fates of Warhol and Basquiat tells us a lot

about how things had changed over the course of almost exactly thirty years. To find success in the world of fine art, after a decade of trying, Warhol had to leave behind his Shahn-isms and find a whole new kind of work to make, without the gay content he had once counted on. Basquiat got recognized almost at once, in an art world that was less allergic to "alterity" than it had been in the Eisenhower era. ("The Other" as a concept was coming into fashion at the same time as Basquiat was.) That same art world was also more desperate than ever to find new stock for its ballooning market, even if that meant turning to such marginalized figures as a black kid from Brooklyn, *on* the street even if he might not really be *of* the street.

Or it could be that such a kid was less able to resist the blandishments of the art establishment than some overeducated, hard-nosed conceptualist might be, and less likely to push back against them. For a new breed of young and unschooled collector—or a breed schooled only in art's old, romantic clichés—Jean-Michel Basquiat, fresh from the park bench, was a much less scary proposition than Chris Burden, fresh from the college lecture hall. Basquiat was certainly sexier, and also easier to sell.

The first time that Warhol and Basquiat met, after their early encounters on the street, was for a lunch date at 860 Broadway arranged by Warhol's ambitious Swiss dealer Bruno Bischofberger. This was the same Bruno who had got the "kids" used to big money, as per Warhol's earlier diary entry, and was now busy putting Basquiat "on easy street," Warhol said. He and Bischofberger had a deal whereby Warhol would do a portrait of any of the Swiss dealer's new artists in exchange for one piece of their work. That afternoon Warhol took Polaroids of Basquiat so he could fulfill his end of the bargain with a quick silkscreen job, but the younger artist one-upped him instantly: Rather than staying for lunch, Basquiat took off with a Polaroid of him and Warhol together and, as Warhol remembered, "within two hours a painting was back, still wet, of him and me together."

Here was Warhol, a veteran slayer of painting who had recently declared its replacement by photography, being forced to deal once again with wet paint. In an interview done just the previous year he was still advertising himself as one of painting's original and most committed haters, saying that he'd only returned to paint after being shot because it was easier to work in than other media. And then, by the middle of the '80s, he was suggesting, with some bemusement, that maybe he'd been wrong to count painting out: "I like all paintings; it's just amazing that it keeps, you know, going on. And the way new things happen and stuff."

As the newest of "new things" happening in the '80s, the young painter Basquiat was simply irresistible to Warhol. Over the course of the next sev-

eral years, the two men became frequent companions and occasional col-
laborators, bridging a thirty-year difference in age and an even bigger gap
in culture and background. Or maybe that cultural gap wasn't really all that
big. Each man had been raised in an outer neighborhood of a major city, had
been encouraged by an ambitious mother who recognized his early promise
in art, had frequented an encyclopedic museum specially dedicated to the
cultural education of the masses—Basquiat had been a regular at the Brook-
lyn Museum—and had adopted an outsider costume as part of his hard-won
artist's persona. Raggedy Andy and Jean-Michel in rags might have been cut
from the same cloth. Even the obvious difference in race could have been less
significant than it seems. Warhol's early trials as a gay Rusyn in Pittsburgh
might have given him some insight into what blackness entailed for Basquiat
growing up in New York, especially as an artsy "African American" who was
in fact of Haitian and Puerto Rican descent—almost as much of an interlop-
ing immigrant as Warhol, that is.

Warhol might even have realized that he and his new colleague were
as important for their profound acts of self-creation—simply for *who* they
were—as for any of the actual art objects they created. They had become
living examples of the kind of "social sculpture" that the German artist
Joseph Beuys had been proposing as a replacement for the traditional ob-
jects of Western art, grown stale through repetition. Beuys and Warhol saw
their works cross paths as early as 1972—in the fine company of Duchamp,
as well—and had finally met in the spring of 1979 at a Dusseldorf show of
Warhol's sexy *Torsos*. Warhol did the German's portrait, complete with a
sprinkle of flattering "diamond dust," later that year in New York, at just
about the same time as he would have been feeding Basquiat those first $10
bills. The two new Old Masters were big fans of each other for the rest of
their lives. Warhol spontaneously offered to help fund Beuys's *7,000 Oaks*
project in New York and Beuys's thanks came with "ever lasting love." For
all the differences in their art, Basquiat and Beuys make sense as the two
figures in the wings as Warhol tried to find his way in the '80s.

Basquiat was hanging out with Warhol one day in the fall of 1982, a few
months after their first lunch, when he reached into his pocket, according
to Warhol, and offered to pay back the $40 he said he owed Warhol from his
days selling T-shirts, "and I said oh no, that's okay, and I was embarrassed—I
was surprised that's all I'd given him, I thought it was more." It needed to be
more, and to stay in Basquiat's pocket, if Warhol was going to keep his elder-
statesman status in their relationship, something that was harder and harder
to do as Basquiat came into his own. When Warhol made the portrait of Bas-
quiat that was supposed to be in trade for Basquiat's "wet" painting of him,

its image came silkscreened on top of one of the coppery-green *Oxidations,* the only time Warhol did such a crossover. (See color insert.) It was Basquiat himself who had asked to be portrayed on top of that piss, but it's nevertheless hard not to see the painting as some kind of challenge to the younger man, or statement about him—as Warhol's first feint in the pissing match that always underlay their friendship.

Warhol got to watch, as spectator and sometimes companion, as Basquiat jetted to shows in Europe, snorted vast piles of cocaine and started painting in Armani. (Shades of the young Warhol splattering his Brooks Brothers suits; Basquiat had already shown up in a high-fashion jacket and tie to that first lunch with Warhol.) The drugs burned a hole through the younger man's nose, according to Warhol, and also through his budget.

Warhol had a ringside seat to much of this extravagance thanks to Paige Powell, a new staffer he became close to at *Interview.* She'd won his respect by selling ad space to unlikely new clients like Hasselblad cameras and Rose's Lime Juice; she'd hoped to sell ads to a condom maker too, but Fred Hughes nixed the idea. Powell lived around the corner from Warhol, so that strengthened their bond, and they went on to spend a great deal of time together over the following years, both at work and at play.

Although Powell had come to *Interview* straight from college in Portland ("they had never met anyone from Oregon before—I was like an alien") within days of arriving she became involved in promoting the graffiti scene in the Bronx. She soon began dating Basquiat, which turned out to be a difficult business.

"I was completely reclusive, worked a lot, took a lot of drugs," Basquiat admitted a few years later. "I was awful to people."

However stormy the relationship with Powell turned out to be, it had the effect of calming Warhol's initial fear of Basquiat, Powell recalled: "I was kind of the conduit, getting this 'thing' going between the two of them." Warhol would join them on dinner dates, she said, functioning as a strange mix of boss, mentor and friend. At a moment when Basquiat was considering asking Paige to marry him, he even felt he needed to ask Warhol to approve the match. "Only if she keeps working for *Interview* magazine" was Warhol's strange reply, offered either as a way of making sure that he stayed involved with the couple or simply because he feared the loss of a good employee.

At one point, said Powell, the friendship between the two men took over and she was left watching from the sidelines. Keith Haring remembered how Warhol and Basquiat "exercised together, ate together and laughed together." They also painted together in Warhol's studio at 860 Broadway, or at least

in the same spaces there if not always at the same time. For several years in the early 1980s, Basquiat joined the company of Warhol "regulars," who ranged at that point from the older collector Stuart Pivar to the young and louche photographer Christopher Makos to the eccentric Paige Powell herself. ("Paige is just so nutty, she laughs so loud at nothing. I would put her in the category of schizophrenia," Warhol said in his diary.) And that's leaving out Hughes, Fremont, Hackett and Jon Gould, not to mention lesser acolytes such as Victor Hugo or the young Warhol collector Todd Brassner, who was the artist's special companion in his hunt for vintage watches. All of these planets that revolved around Warhol had distinct orbits, coming into alignment only now and then. Basquiat in particular seems to have traveled a wandering path mostly his own, intersecting with Warhol's at unpredictable moments but appreciated whenever he came into view.

One day in the fall of '83, when Basquiat showed up with almost no warning at Kennedy Airport for a trip with Warhol to Milan, the older man found him "just so nutty but cute and adorable," despite there being "snot all over the place" as Basquiat blew his nose in paper bags.

At least Powell was getting him to deal with his body odor, Warhol said, returning to a "failing" of Basquiat's that never stops coming up in the diaries. One entry from Milan indicates either Warhol's perfect understanding of Basquiat or his utter, dangerous cluelessness: "Jean Michel came by and said he was depressed and was going to kill himself and I laughed and said it was just because he hadn't slept for four days, and then after a while of that he went back to his room." The next day, Warhol said, he "got" his young friend (or attendant?) to paint portraits onto plates, to be given out to the guests at a dinner. When they were about due to leave Milan, Basquiat stayed behind to be with his young colleagues in art Keith Haring and Kenny Scharf, who had flown in for some high-profile appearances in the fashion world. Ten days later, this was the only entry in Warhol's diary for that day, at least as it was published: "Jean Michel came by and I slapped him in the face. (laughs) I'm not kidding. Kind of hard. It shook him up a little. I told him, 'How dare you dump us in Milan!'"

By the time of the Milan trip, Warhol had rented Basquiat both floors of his property on Great Jones Street as a live-in studio, for the sizable sum of $4,000 a month. But even then Warhol found himself having second thoughts:

> Jean Michel called, he wanted some philosophy, he came over
> and we talked, and he's afraid he's just going to be a flash in the
> pan. And I told him not to worry, that he wouldn't be. But then

> I got scared because he's rented our building on Great Jones and
> what if he is a flash in the pan and doesn't have the money to
> pay his rent?

The new arrangement let Warhol take in the scale of Basquiat's sudden rise, which made Warhol's first Pop acension look like nothing. Even once Basquiat was paying so much for Great Jones, for at least the next year he also kept the room at the Ritz he had been living in. That still left him the funds to get an architect to make him a huge concrete table that almost filled the main room at Great Jones. (Fifty feet long, Warhol said the table was, but he never saw a number that he didn't want to multiply by four.) And when the young man tired of his table, he just smashed it to bits.

This was the other side of Basquiat that Warhol got to witness: a descent into chaos and domestic squalor. He didn't bathe nearly enough, his rental was a pigsty and he shared it with a wake-and-bake friend from the streets. But none of this shook Warhol's considerable faith in Basquiat's artistic potential. That faith extended to agreeing to Bischofberger's idea that the two artists should collaborate on shared paintings, first working along with a third member of the dealer's New Image stable named Francesco Clemente and then, without telling Bischofberger, producing paintings just as a December-May duo. Warhol even got them a paying gig working together on a New Year's illustration for *Vogue*. (Although the painting never ran: "Its subject matter—dentures and skulls—was a little depressing," explained the great editor Anna Wintour in her apology to Basquiat.)

"Painting with Jean-Michel was not easy," recalled Haring. "You had to forget any preconceived ideas of ownership and be prepared to have anything you'd done completely painted over within seconds. . . . Andy loved the energy with which Jean would totally eradicate one image and enhance another." There was a bit of anti-art in it that Warhol understood.

Pairing his most established star with some of his newest ones must have struck Bischofberger as an almost sure bet, at least in terms of sales, even though it's not clear that it made good sense artistically. Once the Warhol-Basquiat mash-ups were finished, early in 1985, they were too disjointed to truly fit Basquiat's expressionism, which depended on traditional ideas of coherent aesthetics across a canvas. They fit better with the values of Warhol's conceptualism, or even with a Dada urge toward creative destruction and willed incoherence. There was something almost chance based and Cagean about the collision between these two artists' styles—like the collision of randomly tuned radios and duck calls that Cage had brought about on TV

in 1960, more for the sake of the collision itself than for the beauty of the "music" that got produced.

The problem was that in those terms, the younger artist's contribution became just the latest art supply deployed by Warhol, the conceptualist—it became a ready-made that Warhol could "rectify," as Duchamp would have said, as he saw fit. Although collaboration was an interesting, almost avant-garde concept in the abstract, it didn't mesh well with what these artists were up to otherwise. It was too advanced a concept for Basquiat and too old-fashioned for Warhol, and it failed to truly bring them together.

As a *New York Times* critic put it, in a notably stinging review of their collaboration that ran in September 1985: "Art historians may be able to relate this manifestation to the automatist poetry that certain Surrealists wrote collectively"—in the 1930s—"but here and now, the collaboration looks like one of Warhol's manipulations. . . . Basquiat, meanwhile, comes across as the all too willing accessory." Or a "mascot," as the critic also described him. "Oh, God" was Warhol's response to that line, reading the early edition of the Friday paper late at night on Thursday, before most people would have been awake to find it on the stoop.

It's said that getting that fierce pan led Basquiat to put distance between himself and Warhol. He may have realized that the critic had hit on something, especially since a show of those works failed to sell. "Jean Michel hasn't called me in a month, so I guess it's really over," Warhol said later that fall, sounding like a jilted lover.

The break between the two men was never complete; such breaks rarely were, with Warhol. (Even Paul Morrissey and Gerard Malanga never stopped popping into his life.) Basquiat continued to occupy the studio on Great Jones Street up until Warhol's death and for another year beyond that—right until the day, in August 1988, that his last girlfriend found him on the floor by his bed, felled by a cocaine-and-heroin cocktail.

---

"Cabbed to Keith Haring's ($8.50). And he had such beautiful painted kids there, all like Li'l Abner and Daisy Mae. Wearing earrings and punk fun clothes." Diary entries like that give a sense that what Warhol found most interesting about the art-world "kids" of the '80s was not so much their work as the new scene around it. That scene was the latest "social sculpture," and Warhol was eager to collect it. He could be spotted taking it in at the pop-up galleries of the East Village as well as in rough nightspots like CBGB, the Mudd Club and the Pyramid Club, with its funky drag shows and wet-

boxer-short contests. A new assistant named Benjamin Liu was responsible for "knitting Andy into the downtown scene," said one of its scenesters. Liu knew Haring and Scharf, and they began to show up at Warhol's studio and helped add a younger set to Warhol's evening rounds. What they did not do was produce much of a shift in Warhol's own art. There may have been some superficial—and mostly ironic—expressionism in Warhol's commercial portraits and prints, but he made a clear distinction between those and the "personal" works he also turned out, which were as thoroughly cool and conceptual as anything he had ever made. They had the brains and heft of the early Brillo Boxes or paint-by-number works, and also their total sophistication, without actually rehashing Warhol's Pop Art moves.

In 1983, when Warhol was casting about for fresh ideas, a new assistant named Jay Shriver suggested doing paintings based on the famous Rorschach personality test, then still in common use by psychiatrists. Warhol took up the proposal, deciding to make his own blots rather than riffing on the standard set that doctors showed to their patients. (Actually, Warhol had mistakenly thought that the Rorschach test worked by getting patients to do their own blotting. By imagining them in his own artist's shoes, he cast those patients as AbEx painters eagerly revealing their inner states.) With the goal of seeing if the page-size blots "could work really big," Warhol and his team—pretty much whoever he could commandeer—would lay down a puddle of thinned paint on one half of a huge canvas, then fold that in half and squeeze it flat with homemade rollers. Once unfolded, the finished work displayed a fantastical but symmetrical blot running down its middle. (See color insert.)

"I really worked hard to make them look interesting. It wasn't easy," Warhol said, while also admitting that the pieces might have been just as good if he hadn't. Shriver said that whenever something went wrong in the execution of a work, Warhol had a phrase that made it go right again: "Well, that's just part of the art." That even covered works that Warhol knew would someday disintegrate because they were made with an iffy technique.

Although the suggestion for the Rorschach paintings of the '80s might have come from Shriver, the idea had roots in the artist's own history. In art school in the '40s, Warhol and his peers had been made to do Rorschach-y blots of their own, and there was also a Rorschach as one of the very few illustrations in his psychology textbook, which advertised it as "made by the author according to the same principles." (Like the Warhol Rorschachs it preceded, that "homemade" illustration defeated the whole idea of the real Rorschach set, which was standardized so that you could compare different patients' responses to the same images. The psych text probably couldn't afford the reproduction rights for one of the official blots.) In the 1950s, War-

hol's former assistant Nathan Gluck had experimented with Rorschach-style blots as an art form, later gifting a whole book of them to Warhol, who had already experimented with his own folded-image abstractions. And then, more recently, Warhol's old friend Joseph Cornell had tried out the idea of Rorschachs as art in 1971, the year before he died.

As usual, however, meanings changed drastically once Warhol took up the blot: In the hands of the man who helped reintroduce imagery into postwar art, Rorschach's patterns automatically became statements about abstraction and its undoing, about painting and its pitfalls. (A couple of years before, Warhol had gotten an estimate for an automatic painting machine whose nozzles could place pigment at 65,025 randomly chosen points on a canvas; a price tag of $50,000 meant it was never built.) The Rorschachs were both incredibly dumb and ham-fisted—just a bunch of big splats such as most any child might play at—and as sophisticated as any painting could be. They were a distillation of the very idea of "interpretation." You could say that they stood for all the other works of art that we could ever be invited to "read."

"The Rorschachs is a good idea," Warhol told one interviewer, "and doing it just means that I have to spend some time writing down what I see in the Rorschachs. That would make it more interesting, if I could write down everything I read." Warhol said the same thing to others, sometimes adding that he'd be even happier to hire someone else to do the interpreting in his place, the way Allen Midgette had lectured as him: "All I would see would be a dog's face or something like a tree or a bird or a flower. Somebody else could see a lot more."

Attempting to "read" the Rorschachs would be taking their patterns seriously, in a way, as producers of meaning, while also suggesting that all readings of art are likely to be free-ranging and almost arbitrary. If Warhol hadn't been too busy bringing home the bacon to carry out his idea, the interpretations he produced would have turned his new "abstractions," which might easily come off as purely visual objects, into the kind of text-based, research-heavy, even antiretinal art that the most with-it postmoderns of that moment were attempting. In the 1980s, advanced art schools across the nation were digging deep into psychoanalysis, and into language; in their complexity and erudition, not to mention their gleeful wit, Warhol's Rorschachs were keeping up with the scholastics and maybe even leaving them in the dust.

Somehow, it doesn't seem surprising that Jasper Johns, that other great nontalking thinker, would be the only person with enough sense to show interest in the new paintings. According to Shriver, he made a special effort to see Warhol's Rorschachs and then got a couple from him in a trade.

The Rorschachs give a beautiful illustration of how Warhol's mind was constantly hunting for the strangest, most paradoxical solution to any problem. At his best, Warhol didn't think outside the box. He thought outside any artistic universe whose laws would allow boxes to exist. Warhol always wanted to make work for a world where $x$ and $not$-$x$ could be true at the same time.

"How could they be bad paintings?" Warhol asked, thinking aloud as a writer quizzed him about his Rorschachs—"bad" painting, of one kind or another, being the ambitious goal that Warhol had always set himself. It was easy to make "good" paintings, that is, that looked just like Rorschachs—in fact it was impossible to blot one that didn't come out "right," which meant there was too little at stake in the blotting. "What I mean is how can I make these look bad? How can I make them look different from the Rorschach tests and still be the same? Change them and have them look the same? But there must be a way. How about an all-black square? That's an idea . . . a black square that's folded." It would be an indubitable Rorschach, but without any of the signature *look* of the psychiatrist's blots. And, as it happened, that final non-Rorschach would also have been a riff on Kazimir Malevich's pioneering *Black Square,* from 1915, the holy icon of abstraction that gave birth to every reductive work that came after. Too bad Warhol never realized it. Someone else should. It would count as a genuinely posthumous Warhol and therefore, in the simple weirdness of that concept, as a very authentic piece of his. It would be completely in keeping with how Warhol's mind and art worked.

———

Weird and wooly collaborations with a drug-abusing youngster, uncommissioned and most likely unsalable.

Piles of giant Rorschach blots, ditto.

If Warhol felt he had the freedom to spend time on such "personal" projects, frowned on by the businesslike Fred Hughes, that was because he had never in his life had so much money coming in. A financial statement drawn up for 1981 shows his art bringing him $1.7 million in net income that year, before taxes, on a gross revenue of almost twice that. Despite bad reviews, the Whitney's recent portrait show seems to have drawn endless new sitters to Warhol's studio. And for once he didn't have to spend any of their fees to bail out *Interview,* which had at last declared a tiny profit. Warhol estimated his net worth at somewhere around $20 million. Early in 1982, the business magazine *Forbes* devoted an entire feature to a new class of millionaire artists just then being born, and it gave big play to a photo of Warhol.

Warhol's newfound wealth didn't only buy him more time to make his own art, it also bought him more *stuff* than ever before. With Johnson no longer present as a moderating influence, Warhol's shopping became positively manic. After he died, entire rooms in his town house were found almost entirely blocked by shopping bags still full of seemingly random purchases. Those shopping bags began to crowd into his home in the first years of the 1980s, bearing what would become the 3,371 lots of goods auctioned from Warhol's estate—and those were just the objects that seemed to have some resale value.

A typical purchase that might not have been terribly resalable came in the summer of 1982, when Warhol visited a "teeth store," as he called it, that Jay Shriver had somehow found high up in a Chelsea building. The artist spent almost $500 on a lifetime supply of antique dental models and denture molds, including a giant set of aluminum teeth that sound almost like Pop Art. (Those have since disappeared.)

Similar acquisitions happened most weekday mornings and pretty much every Sunday, when Warhol would meet his collector friend Stuart Pivar, recently retired from a business in plastic. Straight after the artist's mandatory visit to church the pair would head to the city's flea markets and antiques bazaars, not to mention to all the gift shows and "schlock art" shows and other trade fairs that happened at New York's convention center. Warhol's church visit must have provided the taste of the immaterial he needed before taking his Sunday's full plunge into material goods; that churching drove Pivar crazy because it made them miss the early-bird finds in the antiques malls.

Pivar remembered his friend as a painfully slow shopper, taking his time with every single cookie jar or plastic barrette—or rare Indian basket—that came his way. "He had optical loupes for eyes," said Pivar, describing how Warhol would take off his glasses to get the closest of close looks at all the objects he came across, holding them bare inches away from his shockingly nearsighted eyes.

In the 1980s, Pivar introduced Warhol to all-new shopping opportunities in nineteenth-century art, then out of fashion and underpriced. Pivar and Warhol were not so much interested in Realist or Impressionist pictures, whose worth and prices came certified by established art history. (Although a $100,000 landscape by Courbet was possibly Warhol's most valuable possession.) The pair were more likely to head for the slick, sentimental canvases turned out by Victorian academicians or by the French painters sometimes known as Pompiers. Pivar collected them first, with the seriousness of an antimodernist, but when Warhol bought them it was as a

postmodern, for the pleasure of flipping norms. For a fairly brief moment in the 1980s and '90s, art history was toying with giving as much time to the Pompiers of this world as to Courbet and Cézanne. In 1986, the new Musée d'Orsay in Paris opened to the public with such a recalibration in mind, and Warhol's new art purchases put him in that vanguard. Those same fresh ideas had made a market for the New Image art of Warhol's young '80s friends, and had made him give their paintings the time of day.

"Let's go trade my stuff for real art," Warhol would say to Pivar, and they would, at least when the things Warhol wanted came close to being worth as much as his own works. As a good democrat (and Democrat) his tongue was at least partly in cheek—as most postmodern tongues always were—when he spent $3,000 for copies of two enormous portraits of George III and his queen, which Pivar, an unironic and conscientious collector, saw as an utter waste of money. In Warhol's collection ("hoard" might be more accurate) those royals joined a bare-breasted odalisque by a certain Georges Jules Victor Clairin, a sleepwalking damsel (also bare-breasted) in a marble by an American senti-mentalist named Randolph Rogers and an indubitably bubbling brook in a dusky landscape by Maxfield Parrish.

And all along, Warhol was eager to keep Fred Hughes in the dark about all such purchases, which didn't conform to the Texan's ideas of good taste and sober acquisition—of goods, but also of cultural capital.

"Andy was a hoarder of the worst stripe," said Pivar, who got an occasional glimpse of the massed clutter inside the artist's town house. "He would whimper, 'Stuart, what am I going to do?' I tried getting Andy to engage a crew of kids to start emptying things out but he refused." Even though Warhol's hoarding went against some of his most basic aesthetic intuitions, the most he could do about it was to complain to his diary: "I'm so sick of the way I live, of all this junk, and always dragging more home. Just white walls and a clean floor, that's all I want. The only chic thing is to have nothing. I mean, why do people own anything? It's really so stupid."

Pivar connected Warhol's accumulation to something few other War-holians have commented on: the artist's significant bouts of depression. "He would call and talk about the bottle of pills he was looking at," said Pivar. "Andy was clinically depressed for years. He knew I would make all kinds of desperate sardonic jokes to talk him out of it." Although Pivar was hardly an intimate friend of Warhol's, and the two did not have much in common, his distance from the artist's inner circle might have made him a better confidant.

Pivar felt that his friend's compulsive acquisition was a neurotic re-sponse to the psychic wound of Johnson's departure, and to Fred Hughes's

increasing disdain and condescension. But the tensions might have been more internal, and older: Warhol's cheery shopping might have acted as a mental counterweight to the dark thoughts he often seemed to have, without any particular cause. As far back as the early '50s, his first boyfriend mentioned him breaking into spontaneous tears. Shopping let him spot value in a world that could otherwise seem valueless.

"I've got these desperate feelings that nothing means anything," Warhol once confided to his diary (and thus to Pat Hackett), admittedly soon after Jed Johnson left him. Around that same time, Bob Colacello had arranged for Warhol to help out with a suicide-prevention charity: "I told Bob how could he do that, since he knew I was for suicide, and he got crazy and didn't know what to say. He said I'd better not open my mouth. And I guess I better not kill myself, either." When a reporter asked him if he "believed in" feelings and emotions, Warhol answered, "Well no, I don't. But I have them. I wish I didn't."

Even in his good early years with Johnson Warhol was already thinking and sharing dark thoughts. "Maybe Andy's right," Johnson said in a moment of professional crisis in 1974. "Life is too hard."

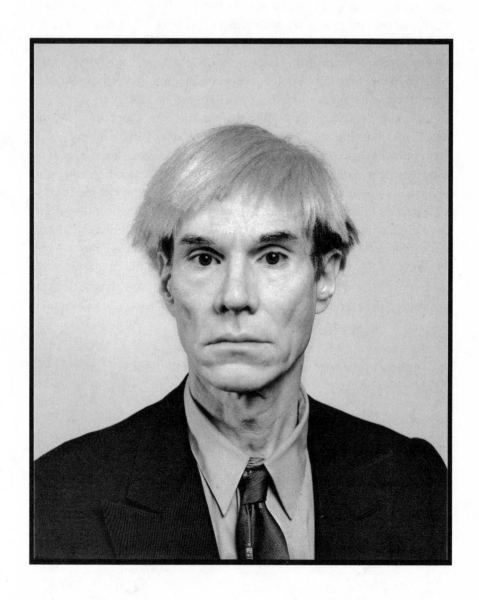

*. . . thinned out for modeling.*

# 1982-1986

THE CON-ED STUDIO | ANDY WARHOL TV |
TENSIONS WITH FRED HUGHES | AD WORK |
*THE LOVE BOAT* | CAMOUFLAGE PAINTINGS |
JON GOULD | AIDS | WARHOL'S CHARITY

*"Andy—Every Move You Make—makes me happy!*
*XXX—Jon"*

"Beautiful."

Andy Warhol repeated the word three times in telling his diary about the biggest purchase he had ever contemplated. "Buying it would be like buying a beautiful piece of art, this beautiful space," he said. "It goes up five floors and there's no heat, it's just like one shell, but it's so perfectly beautiful. I could put in hot air and toilets and it would be an artist's space."

He was talking about a sprawling electrical substation built in 1929 by Consolidated Edison, New York's power company, and decommissioned in 1970. It was down the street from the Empire State Building, with one entrance on Madison Avenue and then narrow arms that stretched out to both Thirty-Second and Thirty-Third Streets, filling a strange "T" of land squeezed between other structures.

At first, Warhol had resented Fred Hughes's insistence that they needed a bigger headquarters than they had at 860 Broadway, so there'd be room for *Interview* and the video projects to continue expanding. There was clearly a risk of seeing his own art making swamped, and of being driven to new bacon-bringing labors.

But he'd given in. After ruling out another floor in the Broadway building—rent there had just jumped by 50 percent—in late 1980 Warhol was looking at any number of options, from a big town house near his first apartment on lower Lexington to a huge old warehouse already full of artist tenants to a sweet little office building on a sliver of land on Fifth Avenue. He

must have been especially tempted by an offer of space in the McGraw-Hill Building, a green-tiled Art Deco marvel near Times Square (and the Gilded Grape). But on October 19, 1981, he laid out $2 million, most of it borrowed, for the purchase and renovation of the ConEd building, as most seemed to call it. A few weeks later, he was raving about his new acquisition as "just sensational, so beautiful, you just can't believe it. . . . The best thing is the roof terrace, it's like a terrace for a beautiful, glamorous apartment." The building might as well have been made for Warhol: With its three arms and three entrances, his magazine, studio and video projects could each get their own wing and identity.

The *New York Times* considered the purchase worth a story and the sheer scale of the project must have given Warhol heartburn. Inside the building's forty thousand square feet of raw space he and his team had plans to install a big "ballroom," for entertaining (it somehow ended up as Warhol's painting studio) and a video space with a fancy lighting rig (Warhol later claimed that as his space for drawing) and even, as Warhol said, bathrooms and heating. That heating, with industrial ducting installed across all the ceilings in the building, took some time to come online: Vincent Fremont has talked about buying extra socks to get him through his first winter there.

All three of the building's street fronts had big windows and lovely old-fashioned detailing, and there was some of that inside as well: The original high-gloss tiling in the lower levels had a nice industrial-chic feel, making this the only one of Warhol's so-called Factories that actually felt like a site of mass production, although one that had been distinctly gentrified. Warhol's fancy renovation installed bleached-wood planking throughout and custom offices for its top denizens. Fred Hughes had a space that had a strangely regal, medieval décor, with red walls worthy of a cardinal's robes and royal-blue bookshelves topped with Gothic spires. He was, after all, declaring the then-princely income of $235,000 on his tax returns, which almost certainly means he was pulling in much more than that. (On the other hand, with a laundry bill of $1,200, Hughes needed every cent he could get.)

Warhol complained endlessly that he had the worst office in the structure, stuck away in a lower corner, until someone pointed out that he had planned things that way. It was important to him to keep whining rights.

———

The move had mostly been triggered by the phenomenal growth of *Interview*. That had started when Bob Colacello was editor. In the year that Warhol bought the ConEd building, revenue from circulation had doubled and ad sales had increased by 50 percent, changing a loss of $100,000 into a first dab

of profit. As far as Warhol was concerned, that had made Colacello too big for his britches: When he came to Warhol to ask for a stake in the business he got turned down, so he walked out. "It's awful of him to just leave with no notice," said Warhol. "Bob has gotten so grand, he goes to these rich people's places and he thinks he should have it all, too." Warhol filled the position with a longtime staffer named Gael Love, who was "tough as a Hermes Saddle," according to one *Interview* veteran. Ad pages multiplied and the magazine had to go from being stapled to having its binding glued on.

Love continued the trend that saw movie stars and celebrities on the covers, although Warhol, never quite as starstruck as people think, had always had his doubts about the virtues of such magazine clichés. Love even overruled Warhol when he wanted to put Keith Haring on the front of *Interview*: "I was thinking it would be good to have an artist on the cover, art is so big now, but they wouldn't let me." But Warhol managed to remain a ghostly presence at *Interview*'s head, with a light touch but an eagle eye. Love liked to tell the story of an evening when she and Warhol were having cocktails: "Completely out of the blue, he asked me: 'How much money do we make off each subscriber?' I said, 'Oh, about this much.' He said, 'Oh, no, I thinks it's closer to this amount.' And do you know, he was about 8 cents off."

Warhol tried to have a direct effect on circulation by handing out the magazine to anyone and everyone he came across; his daily antiquing was also an occasion to distribute *Interview* far and wide. Countless New Yorkers remember seeing him stationed on uptown street corners, passing out copies like an old-time newsboy. Love complained that all that freebie circulation was irritating the newsstands that actually sold the magazine for them.

But even Love's ascension and the move to Thirty-Third Street couldn't turn the magazine into a well-run professional enterprise, according to its European editor Daniela Morera. Fred Hughes was still a wild card at its helm and low salaries kept the industry's best "practical people" away. That didn't stop Si Newhouse, the publishing magnate, from making an offer for the magazine. Although a deal never got made, Paige Powell said that the ever-insecure Warhol was overjoyed that a big shot like Newhouse might actually want something that was his.

By March 1985, the cover story for *Artforum,* the art world's most prestigious magazine, was declaring *Interview* to be Warhol's "greatest triumph: the vehicle of his constant presence in the media, the sign that he is part of the machinery generating the *now*."

*Interview* might have been the most public face of Warhol, Inc., but Vincent Fremont's video projects had been catching up for a while, and they were granted their own spaces in the new building. After all, the year that Warhol graduated from college—the same year that TV began to broadcast in Pittsburgh—a favorite teacher of his at Tech had made that proclamation, in print, that "television may produce a new audio-visual art form." Three decades later, Warhol, art's great polymath, could hardly ignore the medium.

The studio's first, very modest success had begun as a failure, of sorts, brought about by Warhol himself, on purpose. While still at 860 Broadway, Warhol and Fremont had taken a meeting with the team at *Saturday Night Live,* who broadcast only three weekends a month and so had a spare Saturday slot that Warhol was pitching to fill. The *SNL* people had shown some interest in his pitch, which was for a ninety-minute TV version of *Chelsea Girls,* but it was Warhol himself who decided not to follow through, despite his unceasing hunger for exposure. He knew that his video people needed more skills, and more experience deploying them, before they could risk going on air. "Andy correctly said, 'Well if it doesn't work it's my name that's going to get the bad review,'" Fremont recalled. "I was absolutely crushed, but he was absolutely right." To lessen the disappointment, Warhol told Fremont to get together a professional crew—and professional camera equipment worth $40,000—to see what they could do in rented slots on the new public-access TV. That was airtime that the commercial cable companies were obliged to reserve for content produced by the public, which included the artist Andy Warhol. Anton Perich, a sometimes waiter and regular at Max's, had already made a splash with public-access videos: "Television was the last taboo—I faced TV like Don Quixote," he said. It was past time for his friend Warhol to do the same.

At a moment when *Interview,* and its owner, were becoming more and more fashion obsessed, it only made sense that Warhol should come up with the idea for a series called *Fashion*—just "a fashion magazine on TV," as Warhol described it. Its ten episodes launched in 1979 and gave feature coverage to well-known designers like Halston but also to makeup artists, models and various fashion insiders. It was one of Warhol's lesser efforts, partly because he was barely involved except as a funder and postmortem kibitzer. "The classic thing he would say to me was 'Oh, the show looks really great.' And later he would take it apart piece by piece," said Fremont. Warhol was well aware that the show's producers had a conservative aesthetic that had almost nothing to do with what his own art had always been about, and he said so in print. "I always believed in shoot-and-show,"

Warhol said in a little feature on his new program. "They're cutting it now and I think it's too condensed." But just as Warhol had planned, the *Fashion* tryout gave Fremont the chops to move on to full-blown variety shows actually bearing his boss's name.

"I feel that television is the media I'd most like to shine in," Warhol had said back in '75. (Or at least he'd signed off when ghostwriters put those words in his mouth.) "I'm really jealous of everybody who's got their own show on television." So he gave himself one.

First came *Andy Warhol's TV,* which started out in half-hour cable slots that Warhol actually paid for and then got a second season whose episodes were purchased by something called the Madison Square Garden Network. That was a channel meant to help the famous arena branch out from its focus on sports, although Warhol's program turned out to be a branch further than it had intended to go. As Warhol got over his terminal shyness and began to make more and more frequent appearances as host and interviewer, the program became a zany video magazine that could bounce from Warhol himself to Frank Zappa to Pee-wee Herman, with any number of detours along the way. Warhol's name still had enough pull to nab stars as old and famous as Georgia O'Keeffe and as young and famous as Steven Spielberg, mixed up with any number of ungreat unknowns plucked from Warhol's own staff. As many as thirty guests could flash across the screen in some thirty-minute episodes. As Fremont recalled, "The attention span on cable—it was becoming evident that there wasn't any."

The program didn't exactly catch fire, but it did do the job it was supposed to as a proof of concept for Warhol-produced video, to the point that *Saturday Night Live* came calling for content again. Despite an "audition" that left Warhol cranky—"they gave me an hour, and all of a sudden my time was up, and they all walked away and talked about something else"—the 1981 season of *SNL* ended up airing three pretaped segments of Warhol himself, solo, doing distinctly weird (and vaguely wonderful) stuff, for all of a minute or two each time for a fee of $3,000 per appearance.

One segment had him knocking the comedy show itself: "In the first place I never thought I'd be on *Saturday Night Live* because I hate the show and I never watched it. I never thought it was that great. And then, if you're home on a Saturday night—Why are you home on a Saturday Night?" Another saw him ad-libbing about death as he got made up for TV: "I don't believe in death because I always think if somebody dies they actually just go uptown, they just go to Bloomingdale's and they just take a little longer to come back. Death means a lot of money, honey. Death can really make you look like a star."

Warhol was pleased with the spots' public effects: "Instead of people on the street saying, 'There's Andy Warhol the artist,' I hear, 'There's Andy Warhol from *Saturday Night Live!*'" The same spots did less well with the critics, when they got mentioned at all. The *Times* said that one Warhol segment "just sat there and died." But anyone who knew the latest in deadpan video art, from such figures as Bruce Nauman or William Wegman, would have caught on to what Warhol was doing. "I don't think he'll really do television because television isn't ready for him," Viva had said as the '60s ended. It's not clear it was ready for him even a decade later.

Warhol's studio only really began to hit its stride with TV after the move to the ConEd building. In 1984, Fremont negotiated a partnership with MTV, the music-video network that was just then coming into its own and could afford to take chances on Warholian strangeness. "A lot of the bigger cable companies thought we were too far out, or too scary for them," said Fremont. "When we got to MTV, they're the ones who understood it."

MTV and Warhol each put up $12,500 per episode and what they got for their money was a series of half-hour segments that, predictably, went by the name *Andy Warhol's 15 Minutes*. But the cliché in the title belied content that was truly peculiar, and made for the strangest of relief (if that was what it was) from the network's diet of music videos. "I don't know what else you can do to these videos to make them different," Warhol had said a while before, one morning as he watched MTV. "They're all the same." He clearly set out to add something different to the mix.

Hosting more comfortably than ever before—or more comfortable in his visible and charming discomfort—Warhol presented a truly curious fusion of pop and highbrow content in his work for MTV. One episode had William Burroughs, the '50s Beat poet, being interviewed by Chris Stein, the '80s guitarist for Blondie. Another began with a young violinist playing Jules Massenet and ended with Shakespeare recited by Ian McKellen, on his way to becoming "Sir Ian." In between it presented Bo Diddley, the rock and roll legend, and the Fleshtones, masters of neo-garage. The sheer variety on view, including moments of Warholian dialogue that feel like pure non sequiturs, gives a hint of random collisions that John Cage might have been proud of.

Fremont said that Warhol, quite rightly, felt deeply invested in this latest show—metaphorically but also literally, in that he put extra money into the budget to boost its production values. He would call Fremont both before and after each episode aired, to anticipate and then dissect. And for once Warhol's investment in TV paid off, at least critically. The *Village Voice* said that *15 Minutes* was a welcome antidote to the tameness of most

MTV content: "Thanks to the independence given its makers, this program rippled with unusually lively personality."

Unfortunately, it never got to be a major part of Warhol's portfolio. Single episodes in 1985 and 1986 were followed by two more early in 1987—and then a fifth that was interrupted in midproduction by the death of its founder. It had to run as a memorial to him.

Warhol's last TV project came with a strange postscript: The president of MTV, who had okayed his program, ended up buying his town house on Sixty-Sixth Street.

———

Warhol might have closed on the ConEd building in late '81, but it took until the spring of '83 for the big renovation to be close enough to completion for anyone to move in. The staff at *Interview* arrived first, and Warhol played his old trick of making them carry the contents of their desks to their new workplace sixteen blocks north. "My back was just killing me," Paige Powell recalled. Vincent Fremont's video team and Fred Hughes followed later. By the end of June 1984, the studio at 860 Broadway was left with Warhol and Brigid Berlin as its only occupants.

Warhol's purchase of a grand new home for his enterprise had an immediate effect on his art, but not quite as you'd expect: Rather than giving him a new place to paint, it let him make better use of his old one once he was alone there. "He got to turn 860 Broadway into a big mess," Vincent Fremont recalled. "It became an artist's studio, in total." Huge canvases lay unrolled here and there, the bathroom sinks got covered in paint and you never knew what artist-kid you might find visiting. This was when Warhol and Basquiat really got busy collaborating, and competing, on their joint works, often using canvases as big as the huge spaces could hold. "Seeing all that clear empty space, it was just so beautiful. . . . Like the loft I always wanted," Warhol said.

Warhol's diaries make clear that he was envious of all the youngsters who could just get on with making art, without the corporate baggage that he had piled up. By the mid-1980s, it looks like he was beginning to tire of his budding identity as a media magnate. Business Art was losing its appeal. In the new building, especially, there was an awful lot of bacon to bring home, to a lot of open mouths, and that was feeling more like a burden than a sign of success. To get an idea of the scale of Warhol's enterprise, consider the transfer from 860 Broadway to the ConEd building, even after the *Interview* staff had already installed themselves there: A moving company estimated that it would take twenty men working to load four 40-foot trucks, over four

Saturdays, to get everything transferred, at a cost of $35,000. With all the duties and expenses that came with being the Big Boss, even making money doesn't seem to have felt like its own reward anymore.

It couldn't have helped that Fred Hughes, who had got Warhol started on his path to wealth, was no longer the helping hand he had once been. Hughes had always been eccentric, and he and Warhol had long had squabbles. Already in his early days at Warhol's side he'd had huge mood swings: "Fred is so funny, because all of a sudden he'll just snap and have so much energy," Warhol said to a curator friend back in 1971. "He'll be just dull all day, you know, and you can't understand why, and then all of a sudden he'll just brighten up and he'll just be so active and he'll have so much energy and you don't know what. And it's so funny."

But as the '80s progressed eccentricity became gross misbehavior and squabbles became proper fights. As early as 1981, after a party in France, Bob Colacello witnessed Hughes unleashing a drunken tirade at Warhol as they got driven home in a limousine:

> I'M SICK AND TIRED OF YOU ACTING LIKE YOU HAVE ANY-
> THING TO DO WITH INTERVIEW, ANDY! WHEN I'M THE
> ONE WHO DOES ALL THE WORK! AND WHAT THANKS
> DO I GET? YOU AND BOB TAKE ALL THE CREDIT. THAT'S
> ALL I EVER HEAR. ANDY AND BOB. BOB AND ANDY. ANDY
> AND BOB. BOB AND ANDY! ANDY AND BOB! THAT'S WHO
> EVERYBODY LOVES. THEY TREAT ME LIKE A PIECE OF
> SHIT!

Warhol defended Hughes, that time, when Colacello insisted that he needed drying out, but over the following years it was clear something was wrong. One hint may have come the year of his tirade, when his commissions from selling Warhol's art dropped by almost a third (to a still-healthy $110,000). Antonio Homem, of the Sonnabend gallery, said that Hughes, in his arbitrariness, aggression and manipulations, was busy making a "disaster" of the market for Warhol's art: "People didn't believe in the prices, people didn't believe in *anything* about Andy."

Over the following years, said Christopher Makos, the relationship between Warhol and Hughes was like nothing so much as "a really bad marriage where the couple can't get a divorce." Makos witnessed Hughes out drinking all night, and a nephew of Warhol's who helped out at ConEd saw Hughes come in some days "really high." He became known for dropping his pants in nightclubs and at a party in France he did an anti-Semitic impersonation of

Hitler: "Who is this horrible Fred Hughes?" asked one fellow guest. "He's so drunk. He's so terrible." The collector Stuart Pivar said that Hughes became increasingly cruel to Warhol, taking "fiendish pleasure" in pointing out the kinds of trivial mistakes in his conversation that left Warhol particularly mortified. Like more than a few of Warhol's closest associates, Hughes's entire identity was built around being the retainer of a man whose artistic genius he couldn't quite grasp—the upper-crust Hughes was no avant-gardist—and who he saw as in some ways his inferior. That could only have wreaked havoc on Hughes's fragile ego and its desperate need to assert itself.

Even once Hughes had in theory sworn off alcohol, in mid-1984, Warhol complained that he was acting weirdly "grand," as he once had done only when drunk. Later that year, Warhol's diary entries describe Hughes as "crabby" and full of "attitudes"—"we haven't been hitting it off," said Warhol. He was particularly struck by a change in Hughes's memory, which had once been phenomenal but now had him asking for help with the names of people he had known for ages. Warhol doesn't seem to have realized the cause, or Hughes may not have confirmed it to him. Early in the summer, after complaining of a numb hand and tingling legs and actually falling off a horse, Hughes had been tested for multiple sclerosis. Six months later, when Warhol was noticing those memory lapses, the diagnosis must have been confirmed. Hughes didn't pull out of his role in Warhol's business, but neither man took the pleasure they'd once had in building it up.

———

The commercial contracts of the mid-1980s certainly seem more pedestrian than almost anything Warhol had done before. His very best corporate commission almost had the sophistication of one of his I. Miller ads from the '50s: In paintings for an Italian yarn manufacturer, Warhol turned tangles of unspooling wool into witty versions of Jackson Pollock abstractions. But most of his ads didn't rise even to those modest heights. He signed an advertising contract with Levi's jeans that spelled out each and every feature he was supposed to underline in his imagery: button fly, stitching and red tab on the pocket and so on. Only one thing made the Levi's gig better than the most uninspiring of his '50s ads: He no longer had to wait thirty days to get paid. A postscript on the assignment letter said that the check was already in the mail.

For other ad work Warhol himself appeared, as himself. In weird Japanese TV commercials for TDK audiotapes he starred alongside a woman dressed like an albino tiger. He also cameo'd, for maybe three seconds, in a commercial for Diet Coke that had him next to a bunch of ex–beauty queens

on a float. He again played himself in the "Personalities" Vidal Sassoon hair campaign. In what has to count as the low point in all his paid appearances, he was featured in a comically dull print ad for Golden Oak office furniture. It showed him standing behind a monstrous executive desk with one hand on a box of Brillo pads and the other on a can of Campbell's Soup. But the Golden Oak ads are not different in kind, only in degree (of awfulness), from all the other ones he appeared in.

Even Warhol's most famous 1980s ad, for which he did a Pop-y painting of the Absolut Vodka bottle, is really just another kind of personal appearance. The label was not an actual example of Warhol's art, as posterity might understand it, but a kind of generic reference to it. The simple presence of his signature style said "Warhol was here"; the image had nothing to do with any real effort to make art that mattered beyond how well it sold, or how well it sold a product. Pitching the Absolut concept to the vodka's importer, a marketer explained that Warhol's painting "will combine a 'high society' image with a strong branding. . . . In addition, it will give the product the endorsement of Andy Warhol." The same pitch could have accompanied Warhol's work selling sparkling water for Perrier, or cars for Mercedes or the new dried soups for Campbell. All of these were true and perfect Business Art, but of course that conceit was now almost as old, and almost as tired, as Warhol's Pop silkscreen technique. Business Art, once a radical conceptual move, had become just plain old business, as dull as selling Brillo pads.

That problem didn't apply only to Warhol's most explicitly commercial work of the 1980s. It was equally and maybe more shamefully true of his final fine art portfolios: Images of vintage toys, of "classic" ads, of "cowboys and Indians." They were as much about moving product as any of his actual ads were, except that instead of advertising someone else's merchandise, images bearing Warhol's look and name were now being used to market themselves.

Homem, of the Sonnabend gallery, remembers being distressed at how deeply Warhol had commercialized his artistic production, and at how that had, paradoxically, hurt the commerce for his more serious work. "If you went and offered—in those days—$250,000 to Warhol, you could make an edition; you could make a series of paintings," said Homem. "He could make anything you wanted on anything you wanted. And you hear that and you're sort of like, 'Oh, dear.'"

There was one product promoted by both Warhol's ads and his prints that was distinctly less pedestrian than either: the strange man named Andy Warhol. In the process of putting his name on a vodka ad or a print of John Wayne, Warhol was also continuing to spread awareness of himself.

It's not clear that Warhol's desire to sell himself as a celebrity was as

purely commercial a proposition as his sale of images. It had less to do with Business Art, or even with business, than with his latest act of self-creation as a "social sculpture." Being famous certainly helped bring in contracts, clients and freebies, but there seemed to be more to it than profit alone. Even after Warhol had spent four decades promoting the changing personas he'd assumed since college, they still feel like unlikely products to try to sell to mainstream America. Those personas are more like the oddest, most unsalable of his Car Crash paintings from the '60s than like a pleasantly Warholian silkscreen of a toy robot from the '80s. You get the feeling that Warhol, the ultimate and lifelong outsider, saw a real, worthwhile and fundamentally artistic challenge in inserting himself into the culture at large.

The ultimate example of that came in 1985, when he agreed to make a guest appearance on the two hundredth episode of an execrable, long-running TV show called *The Love Boat*, by that point dropping fast in the ratings and with only seven months left until cancellation. For the previous eight years the show had presented the "endearing" adventures of the cast and passengers on a cruise ship, with guest appearances by an ever-changing roster of Hollywood stars of yesteryear, including such luminaries as the parents from the *Brady Bunch* show and Ursula Andress, who had been the first Bond Girl—more than two decades earlier. This was the tough cultural nut Warhol was trying to crack when he agreed to do a cameo on the program.

At first Warhol had doubts about accepting, and it took some serious enticements from the show's two producers to get him to agree. They promised him a role in drawing up their shortlist for the thousandth guest star due to appear on a later show. (After some wrangling, the producers procured Lana Turner, third on Warhol's list after Liz Taylor and Sophia Loren.) More alluring yet was an offer of commissions to paint that thousandth star as well as both producers and one of their wives. Once Warhol had taken this bait, his diaries record a serious case of the nerves, which got worse as his trip to Los Angeles approached and he started to see drafts of the script: "One of the lines I have to say is something like 'Art is crass commercialism,' which I don't want to say."

Warhol seems to have settled down once he got to L.A. for the ten-day shoot, in late March of '85. He was picked up at the airport in a white limousine, as he took care to note, and since his trip coincided with the Academy Awards he was all agog at the stars he got to meet. Suzanne Somers, an actress then famous as a sitcom dumb blonde, said that they simply *had* to do lunch. (And then she stood him up.) And Orson Welles called him over to his restaurant table specifically to say hello, which Warhol took as an honor.

It's hard to say which pleased Warhol more, meeting such stars or being treated as one of them:

> Got dressed and went over to Spago where Swifty Lazar was having his party for the Academy Awards. . . . I had to sign like 800 autographs. All the press was there like Susan Mulcahy and Barbara Howar. And Cary Grant and Jimmy Stewart came and just everybody came after the awards. Faye Dunaway and Raquel Welch.

The next day his diary said "the paper had me as the big star at Swifty's," and that was absolutely and quite surprisingly true. Breathless coverage of the party in the *Los Angeles Times* listed Warhol at the very top of the "'A' Team" that attended the agent's affair—higher than Johnny Carson or Michael Caine—and he was the only guest mentioned twice.

Maybe that soothed some of Warhol's worries about the *Love Boat* shoot, since his days spent on set didn't elicit any terrified diary entries. He was pleased to get a proper star's trailer. He must have been even more pleased that he only had to be on-screen for under three minutes and that his lines were cut in the end to precisely the following:

–"Hello, I'm—"
–"And this is—"
–"Hi."
–"Hi Marina."
–"Mary?"
–"Oh."
–"Well, that's mine."
–"Thanks."
–"Maybe you two would like to get together with us here in L.A.?"

He did pretty well on all of them, although his extra-long last line did come out a bit wooden—but sixteen whole syllables was a lot to ask of someone as terrified of organized speech as Warhol. "Flubbed my lines in the morning, felt bad about it. Worked all day," read Warhol's diary for April 1.

The episode's writers cast Warhol as the most standard caricature of "Pop Artist Andy Warhol." They showed him in silver and sky-blue bomber jackets, listlessly snapping photos of the cruise ship's bathing beauties. (The female ones only; the closest the program came to outing its guest artist was when a Rotarian from Kansas called him a "flakeball." A drag queen role was cut from the first draft of the script.)

On the plus side, at least Warhol was allowed to appear as some version of himself; the other seven guest stars on that "special" two hundredth episode had to take on goofy roles in its so-called plot. And every single one of those seven was either a near nobody or a has-been: How much of an ego boost could it have been for Warhol to appear next to Andy Griffith and Milton Berle, both looking ancient and exhausted, or to play his main "dramatic" scenes opposite the actress who had been Ron Howard's mother in the defunct sitcom *Happy Days*?

In 1965, Warhol had made his grand entrance at the Philadelphia I.C.A. as the Vampire King of the Silver Factory; here he was, two decades later, being billed as perfect company for fading TV stars and long-in-the-tooth comedians. With his *Love Boat* appearance, Warhol the avant-gardist had at last achieved a full absorption into popular culture, but had it been worth the price? Selling yourself must be less fun when people start viewing you as a product from Kmart.

---

Warhol's appearance on *The Love Boat,* his only truly successful foray into Hollywood, saw him aiming for maximum visibility in popular culture. Soon after returning to New York from that gig, Warhol was asked to don his fine art hat once again, and this time he aimed for a strange kind of disappearance. Area, a giant downtown nightclub he frequented, was built around the idea that every couple of months its décor and entertainments would reflect a new theme: "Fashion," "Natural History," "Science Fiction" and, in May of '85, "Art." Amazingly, the club managed to get some of the biggest artists of the era to provide pieces, including conceptualist Sol LeWitt, land artist Michael Heizer, youngsters like Jean-Michel Basquiat, Keith Haring and Francesco Clemente and, of course, Andy Warhol himself, described, no doubt to his dismay, as the scene's "elder statesman."

Rather than providing some watered-down, temporary version of one of his signature works, as most of his rivals were doing for the club, Warhol prepared a much smarter, more daring piece he called the *Invisible Sculpture.* It was just his own living self, standing inside an empty glass vitrine beside a standard white pedestal, with a wall label that declared him to be both the subject of the piece and its medium: "ANDY WARHOL, USA, INVISIBLE SCULPTURE, mixed media, 1985." It was an obvious riff on, or response to, two decades' worth of articles that had described him as his own greatest work; he actually told one writer that he'd been working on the Area piece for twenty years. And that piece showed how the "work" produced through his self-creation was modest and mute and unimpressive, not the silver-clad

show-off who had just taped *The Love Boat* but a normal fifty-six-year-old human, looking a bit worse for wear and doing precisely nothing to impress his audience. He was canned soup, not eel bisque finished with smoked cotton candy. And of course that's really what we all are, underneath our Dalí mustaches or Capote cowlicks.

Only by presenting himself as Andy Warhol the artwork did Warhol finally get to take off the Andy Suit he'd always worn when he had to play artist. He had become his own Duchampian urinal, worth looking at only because the artist in him had said he was, earning the right to do so thanks to decades of artistic labor.

This was the kind of off-kilter "personal" work that filled Warhol's last years. He had plans to do an exhibition that would ask us once again to look at the overlooked, showing just the pedestals he had been buying cheap in his antiquing, free of the sculptures meant to go on them. (As usual, he was up-to-date on the latest trend in postmodern art history, which had scholars paying as much attention to frames and pedestals as to the works they presented.)

Warhol also talked again and again about doing a self-deprecating exhibition called "The Worst of Warhol" that would include just about everything except the fancy paintings that had made his name—"all the really horrible stuff that had never worked out," he said, or maybe all the stuff that he actually knew was him at his most daring. It would include an annoying "sculpture" made from ringing alarm bells as well as a piece that would be nothing except real money stuck to a wall, since that was what he said his paintings represented, anyway, to most collectors. Also due for inclusion would be a series of boxes that he'd filled with cement and the films he had shot then never taken out of their canisters.

Invisibility and a certain kind of humility were also at stake in one of the last projects that Warhol assigned himself, even though its huge canvases were as material and impressive as almost anything he had made.

"Rupert came by with finally some good paintings that I've done. I could actually have a good show, 10' x 36' Camouflages." Warhol made that entry in his diary just about two years after finally leaving the space at 860 Broadway for his new ConEd building. The room he was painting in, the one originally planned as a ballroom in the renovations, might have inspired the huge dimensions of the new works; their excellence and complexity, as fine art, look like a reaction against the banality of Warhol's recent moves into popular culture. Big enough to suit the S.S. *Normandie,* Warhol's Camouflage paintings were nevertheless the anti–*Love Boat.* (See color insert.)

The art assistant Jay Shriver recalled Warhol searching for a premise for

a new batch of works that he wanted to make just for art's sake, uncommissioned and without any plans for sales. Shriver supplied that premise, as he had for the Rorschachs: He had been using camouflage netting in his own art and suggested that maybe his boss could also find inspiration in it. Warhol did, simply by blowing up its trademark blobs and using that pattern itself as abstract art, silkscreened across vast expanses of canvas that made even his Rorschachs look small. In one of his typical digs at the suspect fine-ness of fine art, he talked about how the new project let him make paintings "by the yard." There are indeed something like sixty or seventy of the Camouflage paintings, which Warhol cared about so much that he'd actually visit his silkscreener to supervise their making, something that was otherwise almost unheard of.

Like the *Oxidations* and the Rorschachs, the Camouflage paintings are as abstract as any image could be—what could camo ever be a picture *of?*—while also being tied as closely as possible to real things in the world. You might even say the Camouflage paintings were trompe l'oeil, since they look precisely like the actual textiles they represent.

But they are even more complex, even baffling, when they're read as the purest of abstractions. After all, the most basic function of abstract art is just to be seen, except that here Warhol is making abstractions out of a pattern whose only real function in the world is to remain completely unseeable. He even had the idea of showing Camouflage paintings on a wall covered in the same pattern—using camouflage to camouflage the camouflage pattern itself.

Warhol's Rorschachs, for all their abstraction, had been all about the act of "reading into" that is so important when we respond to art. For all their similar blotchiness, his new camouflages were about the *illegible* in art—*anti-*Rorschachs, you could call them, foiling our attempts to see and know.

The complexity only escalates when Warhol makes his "abstract" camouflage pattern collide with realistic images. When he melds the pattern with silkscreened portraits of himself or of Joseph Beuys, it feels like he's arguing for the artists' peculiar hiddenness and mystery. When he makes his camouflage creep across the Statue of Liberty, he evokes the militarization of America. The hawkish Ronald Reagan was into his second term as president when Warhol got busy camouflaging; just before Reagan's first election, Warhol had called the prospect "scary." It looks as if the entire Camouflage series might have its roots in an effort Warhol had recently launched to somehow make "war pictures" that measured up to his best art. That was no doubt meant to help balance his growing reputation as a maker of art lite and of fluffy culture, but it was also a reflection on the nation's state of affairs.

In another painting with a weirdly warlike tone, Warhol's camo, done in battle-fatigue greens, almost completely obscures an image of Leonardo da Vinci's *Last Supper,* silkscreened at almost the size of the original mural. (See color insert.) It's hard to tell if the collision of camouflage and holy scene stands for a battle waged between true saintliness and the worst of this world or if the cruel camo cancels out and denies the very possibility of goodness, overriding Leonardo's hopeful vision. Warhol was certainly more prone to pessimism than optimism when it came to judging the behavior of humans.

Or, more likely yet, the painting might have more to do with art than anything else, as is so often the case with Warhol: The camouflage pattern does a pretty good job of simulating the damage that made the original Leonardo just about as illegible as Warhol's camo version. Warhol actually signed a petition to make sure that damage was left alone by restorers.

Shriver might have provided the impetus for Warhol's late work with camouflage, but the ground had already been prepared. Warhol's hometown offered him early models: During World War II, students at Warhol's alma mater had worked on camouflage patterns and had even shown them in art exhibitions, as had the more senior artists who Warhol got to see at Outlines gallery. And then in 1964 in New York, Warhol went to the opening of a French Pop artist, Alain Jacquet, who used camouflage patterns in his art and was wearing a suit made of camo the night Warhol met him.

But Warhol had more immediate and recent reference points than that. Paige Powell heard him mention the camouflage he saw on National Guard trucks at the Park Avenue Armory, which he passed every Sunday on his way to church. And he couldn't have missed the camouflage fashions that had been everywhere on the punk and New Wave scene for almost a decade already. By January of '81, the distinctly un-punk *Seventeen* magazine was running a seven-page feature headlined "Go Wild over Camouflage," with a sidebar on the crazy colors the pattern was starting to come in—just as it did in some of the artworks silkscreened by Warhol. Two months after the *Seventeen* piece, a wire service was spreading the news that the trend had got to America from the halls of haute couture in Paris—an even more Warholian source, especially given that his friend Pat Cleveland was credited with being camo's pioneer. For the 1983 Christmas décor at the high-trend fashion store Fiorucci, a young friend (and crush) of Warhol's named Philip Monaghan actually covered the entire space in camouflage fabric he had hand-painted. He claims that when Warhol did his usual routine of asking for art ideas, "I pointed at the camouflage and said, 'Andy, it's about war.'" The next day Monaghan's friend Benjamin Liu called him from Warhol's studio: "What did you say to him? Everybody is out buying anything with camouflage!"

So it turns out that one of Warhol's fiercest and most fiercely conceptual projects may actually have been a Pop appropriation from pop culture, after all. And that, in turn, made it fit with a new movement of ironic '80s abstraction called Neo Geo that used abstraction to comment on the state of the world. Warhol, almost sixty years old, had managed his usual trick of keeping up with where art was heading—although the Camouflage works were so strong and so smart that they pretty much put him in the lead.

Also as usual, Warhol's fine works had the hardest time finding a place in the world. Almost all of Warhol's Camouflage paintings remained in his studio until they were brought out again after his death, a fate they shared with his Rorschachs.

———

Andy Warhol always seemed to like ganging up the major changes that went on in his life, maybe to get them all over with at once. In 1968, having just changed studios and returned from the hospital, he received Jed Johnson into his home. In 1974, as his staff were hauling boxes into the supersize studio on Union Square, movers were hauling his furniture into the fancy new town house on Sixty-Sixth Street. And in 1982, with massive renovations to the ConEd building getting underway, Warhol ushered in an equally big change in his domestic situation: The house on Sixty-Sixth Street became home to Jon Gould, that young Paramount V.P. who Warhol had showered with flowers just moments after Johnson moved out.

Watching the courtship develop is both sweet and sad. Warhol, one of the era's most powerful and caustic cultural figures, behaved like a lonely, lovesick puppy. In April of '81, he cooked an early Easter dinner for Gould, and told his diary about giving his crush a tour of the house "to impress him, and I was hinting like crazy that it could all be his, that there was a room with his name on it." But by the next day, with Gould away visiting family, Warhol's diary entry was notably less upbeat: "Went home lonely and despondent because nobody loves me and it's Easter, and I cried." A few days later he diagnosed the trouble: "I've been thinking that all my problems are because I'm feeling old. And I'm seeing all these young kids just budding. So I've pinpointed the problem." His solution was to get closer to the "young kid" Jon Gould, so that some of his youth might rub off.

Gould was twenty-seven years old when Warhol met him, with fine old New England roots. He had beefy good looks and the hard body of a college athlete, and Warhol couldn't get enough of both. The artist shot endless videos and photos of Gould, often with his top off. Christopher Makos had introduced the two men in the first place, and Warhol offered him a

rare Jaeger-LeCoultre watch if only he could get Gould to sleep with him, but we can't tell if anything came of it. (We do know that Makos never got his watch.) Gould's tragic flaw was that he refused to publicly admit he was gay, despite it being common knowledge in most of the circles he and Warhol moved in. One Mother's Day, when Warhol and Gould went to visit the younger man's family in Massachusetts, Paige Powell accompanied them as Warhol's "girlfriend" and therefore, she said, as his beard. Gould asked Warhol to stop mentioning their romance even in his diary.

"I love going out with Jon," Warhol said, "because it's like being on a real date—he's tall and strong and I feel like he can take care of me. And it's exciting because he acts straight so I'm sure people think he is." Warhol's "excitement" was rooted in a real dysfunction in Gould's psyche, and it ended up hurting Warhol himself, for whom Gould could never become more than a strange and unreachable object of desire.

The extended courtship shows Warhol doing everything in his power to win Gould's heart, mostly by taking him important places, by introducing him to important people and by treating him to important presents. Warhol gave Gould a double strand of Bulgari pearls (he wore them to the beach), a pair of antique carousel horses, and, most extravagant of all, a portrait that he painted of him. (Warhol produced dozens of versions of the Gould portrait, surely for reasons of the heart, not for profit.) Warhol took Gould on a helicopter ride over Manhattan for his birthday and a yacht tour of the waters around it, not to mention flying him to Palm Beach and the Caribbean island of St. Martin. On visits to Aspen, Warhol would do his best to keep up with his athletic young love, even going on snowmobile rides and trying his hand at skiing—and almost breaking his wrist while he was at it. On one of those visits, Warhol had the paranoid thought that Gould had tried to kill him by sending him falling off their snowmobile and over a cliff—but into soft snow. (Unknown to Warhol, another driver had thrown snow in Gould's face.) "I confronted Jon," said Warhol, "and he told me I was just being crazy and I was relieved." The fact that Warhol could have such thoughts at all gives a sense of the lack of trust in their romance.

But one way or another, Warhol was clearly head over heels for his new lad. One of Warhol's vanishingly few letters is addressed to Gould; its typos recall the ones Warhol had left in his last notable attempts at amorous correspondence, back in the 1950s:

> My Dearest Jon,
>     As I sit here in the office everyone has gone. I'm so lonely and thinking of
> you. I love you so much I can't tell. Whenever you're in California I spend

*all my time alone crying and thinking of you. I as if no-one else exists in the*
*world. I wish you were here now just so I could smell you and kiss you on*
*the ears.*

*Please hurry home, I can't live without you.*

*All my love forever,*

What's especially poignant is that the letter isn't signed; since it survives
in a Time Capsule it was almost certainly never sent. It stood for the power-
ful emotions that Warhol might never have dared to express to his closeted
semi- or pseudoboyfriend. Warhol kept piles of close-ups on Gould's body and
face that he'd torn from photos that once included other people; so clearly
touched and retouched by Warhol's hands, they come across as sacred relics.

Fred Hughes described Warhol's relationship with Gould as "the most
serious love affair in Andy's life," and it wasn't a complete pipe dream, or
obviously unrequited. Warhol received countless valentines and greeting
cards from Gould, scribbled with phrases like "Andy I missed you . . .
tonight. . . . Monstrously XXX John." When Gould gave Warhol a Para-
mount desk agenda for 1985, the younger man used a pen to change the
epigraph printed at the front from "Every Move You Make" to *"Andy—*
Every Move You Make—*makes me happy! XXX—Jon."*

Gould's 1983 Christmas card to Warhol read:

*Andy—*

*Merry Christmas and Happy New Year. May we continue to grow together*
*and love one another—my vision is for it (us) to get better and better.*

*Love*

*XXX*

*Jon*

*Thanks for you*

"Andy was infatuated with Jon, and Jon was fascinated by Andy," said
Christopher Makos, adding that a lot of Gould's fascination was actually with
the artist's money. But Warhol himself clearly had every reason to believe in
Gould's real and profound affection, and there's not all that much reason for
us to doubt it. A young friend who was with Gould and Warhol on one of
their snowmobile rides described them as "completely a couple" who clearly
adored each other.

Warhol himself wasn't immune to ulterior motives in the relationship.
He couldn't resist imagining that Gould's position at Paramount, however

lowly, might end up giving the studio an entrée into Hollywood, while Gould, eager to move from marketing into production, thought a project with Warhol might be his ticket there. (A friend of Warhol's who dug into Gould's position at Paramount described him to the artist as "vice president in charge of inter-office memos.")

Warhol's diaries show him in delicious will-he-or-won't-he agony for month after month and never really settling down into the comfort of a reliable romance. After something like two years of dating, Warhol was still on tenterhooks about Gould's commitment to him: "He says he needs to be his own person, and I always feel like he's just about to leave, so I never can feel relaxed."

None of which had stopped Gould from agreeing to move in with Warhol, maybe as early as 1982. He slept in Johnson's old "office" upstairs rather than in Warhol's room because, Gould claimed, the dachshunds would fart on him in bed. (Archie and Amos held a grudge against the new arrival, barking whenever he showed up.) A pillow with the needlepoint inscription "A.W. + J.G." marked their new domestic arrangement. It was quite possibly sewn by Warhol himself. But even as Gould stayed under Warhol's roof he also got the artist's help in buying an apartment in the famous Hotel Des Artistes off Central Park—weirdly, a building next door to where Jed Johnson had bought his place a few years before, also with assistance from Warhol. Gould didn't want to get mail at Warhol's home, so his new apartment functioned as a very expensive post office box.

A new and tragic source of anxiety entered the relationship early in February 1984: A seemingly fit young Gould was admitted to the hospital with pneumonia for almost a full month, with Warhol visiting him nightly. (So much for Warhol's paralyzing fear of hospitals.) When the sick man got back to Sixty-Sixth Street, Warhol told the Bugarin sisters to wash the couple's clothes and dishes separately. Whether Gould or Warhol fully admitted it—to themselves, or to each other—it must have been clear that the younger man was suffering from AIDS, the disease that would kill him in something like thirty months.

As he awaited his fate, Gould began to spend more and more time in Los Angeles and eventually bought a house there. On a visit to the city in early '85 for some *Love Boat* preparations, Warhol told his diary that Gould was "trying to move into production at Paramount, so he has to be out here more." You wonder if Warhol really believed in that justification for their increasing separation. The day before, he'd gotten the news that *Interview* had just lost a second editor to AIDS.

Despite Warhol's germophobia, he seemed to view Gould's growing ab-

sence from his life purely with sorrow, not relief. "After investing so much time, money and effort into having a relationship again, and it just collapsed in front of his eyes—I think he became very disenchanted," said Makos, who spent more time with the couple than just about anyone. When he was in L.A. to shoot *The Love Boat,* Warhol's pleasure in that moment of cultural triumph was tempered by the more and more evident failure of his romance: "I was depressed. Jon went back to New York, I guess he didn't want to be linked with me in L.A. He never gave me keys to his new house, so I guess I'll never be staying there, and I'm . . . Oh, I don't know. Life is interesting, I guess." Warhol said he was keeping an eye open at parties for "someone to fill the new vacancy as my New York Wife," which sounds far more sardonic than hopeful. Back home a couple of months later, Warhol ended a day's diary entry with real bitterness: "I went to sleep, facing life alone."

Jon Gould's illness was just Warhol's most intimate brush with a plague that had been lurking for several years already. He was already talking about "gay cancer" as early as February 1982, and being as paranoid about it as anyone: "I'm worried that I could get it by drinking out of the same glass or just being around these kids who go the Baths." Many of his own "kids" did just that.

A year later, after a false rumor went around about Calvin Klein's health, Warhol was worried that the designer had kissed him too hard and that the stubble from Klein's beard might have pierced his skin and passed along the virus. In the fall of '83, Warhol threw out a sandwich he'd just bought because he realized it had been made by a gay man. That was a few weeks after a doctor had checked the T-cell count in Warhol's blood, a crude test for AIDS used before they had identified the HIV virus.

There was certainly plenty to fear from the disease. It was raining death on Warhol's world. AIDS struck down Zoli, the head of his modeling agency, the year after Warhol had become one of its models. Robert Hayes, Gael Love's predecessor as editor of *Interview,* started missing work for one illness or another and then died from AIDS in July of '84, followed by his fellow editor Peter Lester six months later, then Warhol's old friend Ted Carey, then Perry Ellis, Warhol's favorite designer, then the curator Mario Amaya, who had taken a bullet from Solanas at the same time as Warhol, and finally his dear old friend Sam Wagstaff, who died a month before Warhol himself. Days before Warhol himself passed away—not from AIDS—he read a *Vanity Fair* article on the toll that the disease was taking on the arts community: In its grid of fifty photos of victims, ten were of people close to Warhol.

The tragedy of AIDS might have affected Warhol's art. Overlaid onto all kinds of more human imagery, his camouflage pattern is easy to read as

an infectious ooze on a microscope slide. Warhol also worked on a series of paintings known as the Physiological Diagrams, based on medical graphics of the human body's insides. When the British dealer Anthony d'Offay had Warhol do a series of self-portraits—the last ones he would do, although no one could have known it—the artist produced images that turned his face into something close to a death's head. D'Offay turned them down in favor of slightly less searing versions because, said the dealer, mortality was already too much in the air at the time: "I felt so strongly about it because, if it doesn't sound absurd, it was tempting fate. . . . I always had thoughts of death when Andy was with me," recalled d'Offay. He nevertheless let the artist show some self-portraits "infected" by the camouflage pattern. Warhol noted d'Offay's initial rejection of the more haggard self-portraits in the same diary entry where he recorded his terrified reaction to a patron whose AIDS had triggered dementia.

"I'm telling you, I don't want to know anybody ever in my life," Warhol said when he heard news of a "big TV producer" out in Hollywood who also had AIDS. "It's so much better just going to dinner. There's different ways to have fun, different kinds of people to have fun with. I don't need romance." Jon Gould, and his disease, were clearly on his mind.

On September 21, 1986, Warhol said that his diary would have to "write itself" about some news from Los Angeles that he could not bear to discuss. Three days earlier, Gould had died there in the hospital, a seventy-pound shadow of his former hale self. He was mentioned in the *Vanity Fair* piece, but as a victim of AIDS who'd been so closeted his name could not be revealed.

---

In 1986, Warhol was "kinder and easier to be around than at any time since I'd met him," Pat Hackett later recalled. Paige Powell agreed, saying that Warhol was starting to display a gentler side that was once known only to a few very close companions. Powell heard that he bought a home for one of the Bugarin sisters who tended his house, and that seemed in keeping with who he was becoming. She witnessed his new tenderness toward animals: One evening at his favorite Japanese restaurant, he couldn't eat the lobster he'd just ordered plucked from its tank. Both Powell and Stuart Pivar noted Warhol's commitment to feeding the neighborhood pigeons every Sunday morning—early, so no one would notice him at it. "It's my charity," he said to Pivar.

It's hard to know the cause of Warhol's softening, whether it was the tragedy of AIDS that he was witnessing firsthand or the normal mellowing that often comes with age. It does look as though abandoning all thoughts of

romance, which AIDS and his troubles with Gould had made him swear to do, led to thoughts or at least fantasies of new and more peaceable domestic arrangements. Powell said that Warhol had some kind of strange notion that somehow she and he might marry, and that the notion came complete with a visit to Bulgari to choose a ring. (Although in his diaries, Warhol said such a marriage would be absurd, and that Paige would be "barking at the wrong tree" if she entertained it.)

Powell had also talked about a charity dinner at which she and Warhol were seated with the head of an adoption agency, and how touched Warhol seemed to be. "It was a benefit to get Harlem kids adopted," Warhol confided to Pat Hackett the following morning. "And when you see these kids you do really want to adopt one. They're so cute. I'll give money to anyone who'll raise one of these kids. Spread the word." Powell said that later that same day he told her to get him the papers it would take for him to be that adopter; he stuck with the idea for some while more, even imagining Powell as his coparent, she said. This wouldn't have been the first time he'd had such thoughts. Back in the 1950s he'd offered to adopt Imilda Vaughan's baby, and over the following decades his fondness for children, and their attraction to him, never slackened.

One teenage girl who was close to Warhol in the 1980s remembered Warhol as "a sweetheart" who acted like a kind and protective uncle, getting furious, for instance, when an older acolyte offered her drugs. And two days after Warhol's death, another young woman who he'd befriended when she was thirteen wrote to Fred Hughes with her memories:

> Once a week, Fridays after school, I'd arrive at the Factory. Andy would stop what he was doing and spend time with me, talk to me. He would always remember everything I'd ever told him, and ask for news of what had happened between visits. Had the boy I liked at school asked me out? Had the test in science gone well? Was the party on Tuesday fun? And on and on. These questions are what he gave me. For perhaps the first time in my life I felt okay about myself because if Andy Warhol cared about what I did then maybe, just maybe, I was okay, not a void but a young woman.

Even adults were coming to see Warhol as a similarly affirmative force: "Andy to me was so positive—it was a great positive injection just to talk with Andy," said the Swedish friend who had arranged the Absolut vodka contract. "All the people around were made happy by him."

In the mid-1980s, Warhol made some effort to shift his public image from an empty-headed, navel-gazing socialite to someone who cared about the society around him. With the help of a ghost-writing editor named Craig Nelson, he published *America,* a book of photographs that included phrases such as "I wish somebody great would come along in public life and make it respectable to be poor again." And, "They guess that there are between 300,000 and two million people living on the streets in America. This country is so rich. And I think I see more homeless people on the street every month. How can we let this keep happening?"

Warhol even took a dig at his own media persona:

> With people only in their public personalities, and with the media only in the Now, we never get the full story about anything. Our role models, the people we admire, the people American children think of as heroes, are all these half-people. So if you have a real life you can get a lot of crazy ideas from this information. You can think you're a real loser, and you can think if only you were rich or famous or beautiful, your life would be perfect, too. The media can turn anyone into a half-person, and it can make anyone think that they should try to become a half-person as well.

By the time Nelson knew Warhol, any trace of the blood-sucking Drella had disappeared: "He was this sweet little gay guy who worked like a dog." Nelson said that one of his aims as he helped with the book was to rehabilitate Warhol as the hard-core Democrat he'd been all along, in the context of a nation under the sway of Ronald Reagan's right-wing culture. The cover of the book even dared to feature the Statue of Liberty veiled under scaffolding, as though the American Way had itself suffered damaged.

Paige Powell led Warhol toward some quite practical do-gooding. At Thanksgiving in 1985, when her family in Oregon seemed too far away for her to visit, she decided to look for a New York soup kitchen where she could volunteer. "You know, I'd like to do that too," said Warhol, asking her to find a volunteer's gig for him. All the church programs being fully staffed by the time Powell went looking, she tried the Salvation Army. They said that they could use "her friend" as a bell-ringing Santa on the corner right by his studio, if he would agree to take a full three-hour shift. "I said, 'Andy's gotta do this.' And he was kind of reluctant, but he said, 'OK.'" He wouldn't wear the whole Santa outfit, she said, but donned at least the hat and some kind of Kris Kringle facial hair—for all of forty-five minutes. "Hey, you're supposed to stand there for three hours! You made the commitment," Powell complained,

but to no avail. Warhol said he had too much work to do upstairs in his office, but the next day he asked Powell to look into soup kitchens once again. She eventually found a place for their good works at the gorgeous Episcopal Church of the Heavenly Rest on the posh Upper East Side, right beside the Guggenheim Museum on Fifth Avenue, and they went to serve food to the poor there that Christmas, and then on several holidays the following year. "Andy worked so hard," Powell recalled. "He was cleaning the floors, folding up the chairs."

In the hagiography that naturally poured forth from friends right after Warhol's death, his soup-kitchen stint was billed as a sign of notable saintliness and religiosity, but that probably oversells it. The good deed was initiated by Powell, not Warhol, it happened at a church from a denomination that rejected Warhol's own Pope—a "good Catholic" could surely have found work to do in a church that didn't descend from Martin Luther—and there's no reason to think that Warhol would have been less happy doing good in a setting that had no religion involved at all. (It's unlikely that he'd seen his Santa outfit and bells as having sacral implications.) As for serving food to the poor being somehow unlikely for an artsy like him, and therefore a sign of his unique piety, he was joined at Heavenly Rest by friends and retainers who included Stuart Pivar, a Jew, and also the committed sinner Victor Hugo, who managed to yell at the diners he was meant to help.

The mid-1980s were years when many members of the art world were tending the open wounds of lovers, friends and strangers who had contracted the AIDS virus, and along with it the contempt of mainstream society. The founders and members of the AIDS groups ACT UP and Gran Fury were the true saints of Warhol's world. By that standard, admittedly a very high one, Warhol's deed in the soup kitchen was good but not great. He was not by any means AWOL during the AIDS crisis, as people have claimed: He participated in any number of benefits and even signed-on as "co-chairperson" of one. But compared to his peers who watched over the dying and took to the streets—they included plenty of atheists, Jews and Buddhists—Warhol was just your better-than-average sinner.

If we're tempted to see the common decency of Warhol's final years as a late-in-life conversion to virtue, that may be because we've failed to understand that Drella was decent all along.

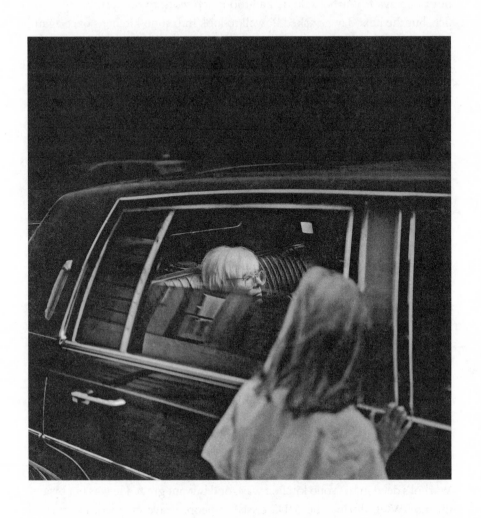

*. . . on one of his last limo rides.*

# 5 0

## 1986-1987

CRYSTAL THERAPY | LAST SUPPERS IN MILAN |
STITCHED PHOTOS | THE LAST RUNWAY |
GALLBLADDER TROUBLE | THE FATAL SURGERY

*"The best way to go is fast. It's like going to sleep"*

In his desperate search to avoid certain death, Jon Gould might have helped end Andy Warhol's life.

"I'm going to go to a doctor who puts crystals on you and it gives you energy," Warhol told his diary in the late summer of 1984. "Jon's gotten interested in that kind of stuff—he says it gives you 'powers,' and I think it sounds like a good thing to be doing. Health is wealth." It doesn't seem likely that the crystals did anything for his health, but they certainly touched his wealth.

By the next day, Warhol had made the first of many visits to an expensive quack named Andrew Bernsohn who said he could "program" crystals to do all kinds of curing. Warhol's pimples would vanish, said this doctor, once he wore a crystal that could restore the health of his pancreas. In one early session, Bernsohn "asked" the crystal Warhol had been told to buy—from a crony supplier—how long it "wanted" to be programmed for, and it "answered" that it needed a full four days of Bernsohn's attention. "So I'm going to wait four days and then I have to have it with me always and not more than ten feet away when I'm asleep. I really do believe that all this hokum-pokum helps, though. It's positive thinking," Warhol said when he reported back to Hackett. "He said I had some negative powers in me and I asked him how long I would have to come to him and he didn't tell me. It's so abstract. But you do feel better when you get out."

Warhol, a brilliant skeptic and even cynic in the byways of fine art, turns out to have been a helpless innocent when it came to science and health. Even as he stood in his vitrine as his own *Invisible Sculpture,* as hard-nosed a

piece of art as anyone could ask for, he wore the crystal pendant that almost never left his body. One skeptical friend described it as "a really cheap thing with some kind of gel inside. . . . It tells you what mood you're in."

Six weeks after Bernsohn had hooked him, Warhol got reeled in on a visit to a Dr. Reese, the "chief crystal doctor"—cash in advance, of course:

> They run their hand over you in funny places and say code letters, you know, and they'll say they've run into a "hole" or something like "There's a hole here escaping," and they'll say, "C85, 14, 15 D-23, circumvent 18, 75 dash 4. . . ." And then he said something and Dr. Bernsohn said, "Oh he doesn't have any feeling"—about me. And the doctor said to me, "I'll tell you about it next week," after the other doctor said, "I didn't know I had such an extreme case."

When Warhol ran into a Harvard kid from Silver Factory days, he got a lecture on gullibility: "He couldn't believe that someone as smart as me would start believing in crystals after I made it all through the sixties and everything and laughed at all the hippie stuff." Warhol got still more push-back when he made the mistake of going for one of his crystal "treatments" with his friend Stuart Pivar, who was a trained chemist. "I would speak very frankly—'What kind of bullshit is this?'" said Pivar. "They all knew it was bullshit, and charged Andy for it." The crystals were supplied, it so happened, by the chief doctor's son, and Warhol paid $10,000 for a "special" one from Canada that was in fact radium ore. Others, the "healers" said, had been energized by contact with the pyramids of Giza or the Wailing Wall in Jerusalem.

There were moments when Warhol's natural skepticism seemed to return, especially when the crystalologists started to talk about trading crystals for $50,000 worth of his portraits, about needing patrons to fund their research and about how they wanted Warhol to join them in Tibet. (Jon Gould, desperate and dying in his struggle with AIDS, made the trip.) Warhol was particularly unimpressed when an anticockroach crystal that he'd put in the office kitchen seemed to make the bugs multiply. And he did note that a special crystal meant to ward off misfortune failed to stop a young woman from grabbing the wig off his head at a book signing. Mostly, however, Warhol was a lamb led to slaughter at the hand of his quacks. (He was a regular with a certain Dr. Linda Li who, although licensed as a chiropractor, had introduced him to the crystal folk in the first place. She kept reinforc-

ing their gibberish while spouting more of her own about Warhol's brother "invading" his crystals and the black magic that lay hidden in the numbers in his telephone book.)

When a young staffer questioned Warhol about his crystal-izing, he answered, "I was always jealous of girls because they live longer, and now I know why—crystals. Diamonds really are a girl's best friend." He would dunk a crystal in the water he boiled for his morning oatmeal.

All of that naiveté might have done no harm, if not for the fact that he was consuming snake oil just when he was truly ill and badly needed real medical treatment. An onlooker at a 1986 show in London described Warhol as "the most sickly looking individual I'd seen who wasn't actually sick." But Warhol almost certainly was.

Both Christopher Makos and Stuart Pivar have talked about the almost constant pain that they saw Warhol bear in the later '80s, and Warhol was probably sicker than even they knew. Whether as cause or effect of his illness, he looks positively emaciated in many photos, and Pivar spotted his friend taking drops that he assumed were narcotic. Brigid Berlin has noted his ever-present supply of Demerol tablets. The source of the trouble, she said, was Warhol's gallbladder, which had periodic flare-ups after that first crisis in 1973. Warhol simply refused to have it removed, even long after he had recovered enough from his gunshot wounds to undergo another operation. He didn't deny that the illness was there; he had friends bring him medication that he'd once tried in Japan and that he hoped would dissolve his gallstones. (It didn't work on the particular type of stones that he had.) He also changed his diet, eventually replacing alcohol with tea, avoiding most meats and taking in vast quantities of vitamins and raw garlic, according to Sam Bolton, the young "sweetheart" of Warhol's last years. But the only proven treatment was surgery, and that was the one treatment Warhol would not accept, even after Brigid Berlin had her own gallbladder out with only the best of effects, as Warhol acknowledged: "She was radiant and God, she really has a beautiful gallbladder scar, you can hardly see the staple marks." (Berlin made him a gift of the stones removed by the surgeons.) Warhol had found his friend Maxime de la Falaise looking "great" after the same surgery. But instead of following their example, late in 1986 Warhol let his latest gallbladder attack go completely untreated, so that the now moribund organ became dangerously infected. Amazingly, even Warhol's most expensive crystals seemed to fail him.

---

"He was so ill when he came to Milan—he was in such pain." That was how Daniela Morera, European editor of *Interview,* recalled Warhol's arrival for what turned out to be his final exhibition, in late January 1987.

If only he hadn't been suffering, the visit might have been cheery. Warhol's Milan exhibition was the culmination of a project he had been working on for almost two years. It had begun with a million-dollar commission from the Milanese dealer Alexander Iolas, the same man who had given Warhol his first-ever show in New York thirty-five years earlier. A bank with offices in a former orphanage in Milan had asked Iolas to fill a huge space in its building with art, and he at once came up with a suitably splashy idea: Since the orphanage was across the street from the building that housed Leonardo da Vinci's *Last Supper,* he would ask several artists for riffs on that masterpiece. It turned out that Warhol was the only one to accept Iolas's invitation, maybe because his peers saw no future in going head-to-head against one of the greatest and best-known paintings in the Western canon. (See color insert.) It's hard to know whether Warhol took up Iolas's offer because he was attracted to the challenge or because of the money that came from facing it. Or maybe because he'd already started to riff on that Leonardo anyway, doing his usual virtuosic sponge routine after a much younger artist had sent him a fourteen-page package about *her* ambitious (but quite terrible) project based on the *Last Supper.* Whatever the origins of Warhol's latest Leonardism, when he mentioned the Iolas commission in his diaries it was with contempt for himself as a sellout: "I'm doing the Last Supper for Iolas. . . . So I guess I'm a commercial artist. I guess that's the score." Although with almost equal self-deprecation Warhol told an Italian paper that the Last Suppers made him count instead as a "Sunday painter" because, as he said, "During the week I have to earn my living and fund my fifty staffers. That is why [the project] took so much time. But I worked hard on it."

He nevertheless took some shortcuts in arriving at his finished pictures, which needed to be big, and multiple, to fill the 6,500 square feet of space he now had all to himself. Four mammoth canvases and twenty-one smaller pieces made the trip to Milan, of the one hundred or so that Warhol painted.

When it came time to make his new suite of sacred pictures, Warhol found easy inspiration in the works of Sister Corita Kent, the rebel nun whose sacred Pop Art had itself borrowed heavily from Warhol, in the first place. From her he sponged the idea of using brand names and corporate logos to convey religious double entendres. Kent had lifted the "Big G" logo and tagline from General Mills foods to stand for a big-G God, and in one of his Last Suppers Warhol reproduced a big "G" from General Electric that was very close to Kent's. He included the Kentian phrase "the Big C" in another

Last Supper painting as a reference to both Christ and cancer—"gay cancer," most likely, which was busy killing Iolas, the painting's sponsor, when Warhol saw him in Milan. Where Kent used Wonder Bread's branding to conjure up wonder at the divine, Warhol used the owl-eye symbol from Wise potato chips and the dove from Dove soap to similar effect in his images of a wise and loving Christ.

In other works for the project—including all the ones that actually made the trip to Milan—Warhol repeated his own well-worn Pop conceits. When he had Leonardo's *Last Supper* silkscreened sixty times onto a single canvas his achievement wasn't twice as great as when he'd repeated the *Mona Lisa* half that many times in his *30 Are Better Than One,* back in 1963. Both works are about their subject's ubiquity as an artistic and a cultural icon, and in fact Warhol had bathed in *Last Supper* reproductions from an early age. He said that when he was a kid, he and his brothers were expected to cross themselves whenever they passed the version his mother had stuck up in their house; in college, a textbook had raved about how Leonardo's painting, which it splashed edge to edge across the page, "unites all the leading threads of Christian thought with the most significant inventions of the gothic and classical art moods."

Warhol himself denied that his source had any special meaning for him: "It's a good picture. . . . It's something you see all the time. You don't think about it." He told his assistant Benjamin Liu that his goal was to make the famous old painting "exciting again." Another time, Warhol said that his goal in repeating and repeating the same image of Christ had been to turn out "transgressive" art, like the two Crucifixes that another artist had recently included in a deliberately sacrilegious painting in New York. A friend had actually told Warhol that if he attempted to copy Leonardo's sacred image he would be "hanged and crucified," a warning that Warhol seems to have read as a challenge.

While it's true that one Italian journalist quoted Warhol on the properly religious inspiration that had sparked his Last Suppers, there's a good chance that he was saying what he knew would go over well in Catholic Italy. (He told another journalist in Milan that he'd painted all the works there entirely by himself, by hand, an obvious lie since all of them were silkscreened—but it was a lie that Italy's traditionalists would eat up. Less endearing might have been his answer when someone asked what connection he had to Italian culture: "Spaghetti.")

Warhol's assistant Jay Shriver insisted that Warhol had given him no hint of any religious interest or intent as they worked on the series for more than a year, or for that matter at any other point in their long collaboration.

For Shriver, Warhol was using the Last Supper as "just another button to push."

The sheer repetition in Warhol's vast series can more easily be read as a dilution of the original painting's unique power than as a celebration of it. Warhol said that his goal was to make sure that anyone who wanted a Leonardo *Last Supper* could have one. (Of course they already did, through reproductions, and only the very rich could have afforded one touched by Warhol.) When Warhol and Basquiat reproduced Leonardo's Christ figure on ten body-size punching bags, it seemed less like a symbol of spiritual battle than like an invitation to sock it to the Savior—closer to sacrilege, that is, than to worship. The two paintings in which Warhol obscured Leonardo's image with a camouflage pattern seem equally unworshipful.

But most of the Last Supper works do have one thing that links them to the landmark Pop paintings they sprang from: Like the Soup Cans or Electric Chairs, they seem to ask for a strong reading of some kind, either pro or con of their subject matter, even as they refuse to come down on one side.

Not that such subtlety seemed to matter to the thousands of Italians who showed up for the opening, eager to take in Warhol, the famous American pop artist, while mostly ignoring the pictures he made. The ubiquity of his source image might actually have done Warhol a disservice: Leonardo's *Last Supper* was so well known, especially to the Milanese, that the new versions of it barely needed more than a glance to be taken in. Or maybe this was precisely the effect Warhol intended, once again guaranteeing the one-minute read that he said he'd hoped for at his Whitney retrospective in '71, but even more to the point in Milan: If you barely had to glimpse Warhol's teaming Last Suppers to absorb their subject, didn't that do a fine job of underlining the cultural saturation of Leonardo's original image? Warhol's Italian audience had even less interest in studying that original: A couple of "diligent Germans" made the trip across the street to judge how Andy measured up against Leonardo, as Iolas had thought most people would.

The show's opening was an absolute zoo that Warhol nevertheless chose to suffer through, according to Morera:

> In Milano, darling kids from the South of Italy came by train. They traveled all night: People in the art business, graphic designers, fashion people from everywhere. We were expecting five hundred; around five thousand came. The whole street was blocked; it was the most incredible scene. I couldn't believe it was real. Andy was so exhausted; he was in so much pain. I found a little table in a corner. I asked two of the guards to push it in front

of Andy, Chris Makos, and me because the crowd was suffocating us and we didn't have any defense, nothing. Then Andy, after signing the posters, *Interview* magazines, invitations, and any other piece of paper available, started to sign glasses, ties, bags, bras, scarves. Everybody was giving him something to sign. They were craving for the guru's signature. Finally, I said, "Andy, you're tired, let's go." "No, no, I'll finish it," he answered. He was so sweet, so sweet, really, very generous with everybody till exhaustion—a real pro star!

Warhol nevertheless tried to get out of important interviews Morera had arranged, complaining of a severe pain in his right side. "You could see in his face that he was very sick, and in pain," said Morera. "His face was like a skeleton." Everyone who saw Warhol in Milan seems to agree with her, even though he was well enough to shoot at least nineteen rolls of snapshots of his trip, including at a lunch he agreed to attend at Gianni Versace's palazzo, and his diaries barely mention anything more than a "flu" that he blamed Morera for passing to him. It's hard to know if the recollection of Warhol's familiars was affected by what they learned later about his true sickness, or if Warhol downplayed how bad he really felt when he reported back to Pat Hackett from Milan.

A friend named Ricky Clifton said that on the night of the opening Warhol was well enough to sit through an entire opera at La Scala, when the plan had been for him to only pop in. (Warhol's attendance that night led to an invitation to direct there, said Clifton, who suggested to Warhol that he should stage Puccini's *Girl of the West* as *Lonesome Cowboys*.) But the next night Warhol skipped a date to go out with Clifton, and his diaries confirm that he spent that day in bed with a fever and that he felt utterly terrible the next day on the flight home.

"On the plane a milestone happened," said Warhol. "I was in the *International Herald Tribune* and I didn't even bother to clip the article. I just—didn't—care. So I've gotten to that point. Maybe it was just that I felt so sick." He gave Hackett an even surer sign of just how lousy he felt: He said he forgot to get a receipt for his limo ride home from the airport.

———

Warhol had a lot on his plate, and on his mind, when he got back to New York.

He was working on a new batch of black-and-white photos that he was having stitched into grids on a sewing machine. Earlier that month he'd had

a big show of these works, which had sold well and also gotten the best re-view that Warhol had seen in ages, although it's hard to say why. They were just his standard snapshots, now sewn together—a slender conceit—but a smart new *Times* critic thought that their installation made them sing: "By rendering subject matter irrelevant through repetition and variety, and by exploiting a wide variety of formal devices without an allegiance to any of them, he negates the conventional notion of an artistic 'eye.'" Warhol was so proud of the praise that he carried a clipping around in his pocket.

The opening of that photo show had been mobbed and Warhol had done his usual signing routine: "I worked myself to death. . . . I went home and went to bed early, I thought I would shake this cold." Dr. Bernsohn "cured" it the next day with an extra-special application of crystals. One guest at the photo opening said that he had never seen Warhol looking so skinny, but he seems to have been strong enough to carry on pretty much as usual for the next several weeks.

That January, Warhol also had plans to get back into filmmaking, since he'd just optioned a hot new book, *Slaves of New York,* by a young woman from his circle named Tama Janowitz. Less ambitiously, but no doubt with a greater chance of profit, Warhol had negotiated with a German dealer to do portraits of Beethoven and with a British dealer to do a series of silkscreened views of Paris. He also had another iffy print portfolio underway for Ron Feldman, on the history of television.

Right after Milan Warhol still complained of "stomach troubles," dosing himself with Maalox and canceling a fancy dinner, but he was soon tell-ing his diary about a wonderfully cheap chili meal that he'd eaten—adding the possibly portentous question, "Could that have been a mistake?" Eating "extra food" at another restaurant was also "a mistake," Warhol said. He seemed to be making a lot of those early in '87. "I sat in a funny position and I got a pain and it didn't go away," he said, after eating a pile of vinegar chips. "So now I'm throwing out all the junk food. I guess it was a gallblad-der attack."

He guessed right, but the next ten days or so seem to have passed with-out further incident: He worked hard, went out plenty and ate with relish—and also got treated by Dr. Li several times. The few blue notes in his diaries are about the illnesses of others: Liberace had just died from AIDS, and Robert Mapplethorpe was sick with the virus and would soon be dead—but not before Warhol.

It seems Warhol was hiding how sick he really was from Pat Hackett, and thus from his diary. Days where he said "nothing much happened" were actually spent in bed.

On Saturday, February 14, Warhol had an appointment to have collagen injected into his wrinkles by Dr. Karen Burke, a dermatologist who had become a good friend. Warhol's complaints about the pain in his right side worried her. He asked her for narcotics to ease his suffering, but she wouldn't give him anything until he agreed to go for a sonogram. He did, and the news wasn't good: His gallbladder looked bad, with two stones lodged inside, and at the very least he'd need to get it looked at by Denton Cox, Warhol's general practitioner for the previous thirty years.

Sunday things seemed to be going better, and on Monday, after a morning spent watching TV—and therefore skipping the office or shopping—Warhol went once again to Dr. Li, who "massaged" his damaged gallbladder. He then spent a normal afternoon at the office watching, in wonder, as the ambitious young painter Julian Schnabel made some kind of a play for Fred Hughes's attention. That night when Dr. Burke called to see how Warhol was doing he said that Dr. Li must have sent one of his gallstones down the "wrong pipe" because his pains had gotten so much worse. She begged him to finally see Dr. Cox.

Despite the illness and doctoring Warhol was carrying on with his life. The week's main event was an appearance on Tuesday afternoon in a New Wave fashion show that Vincent Fremont was taping for the studio's next MTV episode. The show was being held in a cavernous new club called the Tunnel, on the ground floor of an ancient and frigid warehouse near the river in Chelsea. "They sent the clothes over and I look like Liberace in them," Warhol told Hackett. "Should I just go all the way and be the new Liberace? Snakeskin and rabbit fur." He was sure that the runway's other guest star, Miles Davis, would come off better, and he wasn't wrong. In the hours of video that survive, Warhol looks pretty foolish for a man his age—mutton dressed as lamb, as the British like to say. But if you didn't know he was supposed to be ill, it's not clear that you could tell just from the recordings. He looks less sick than bored, although he did his best to mug for the camera now and then, especially when he and Davis were onstage together. Only Warhol's staff and close friends knew the real score.

"I was very concerned," said Fremont. "There were only a few of us who knew how much pain he was in. . . . The gallbladder situation was serious." Stuart Pivar said that Warhol's teeth were chattering from the cold and that when the artist was finally done on the runway he was ready to collapse: "Get me out of here, Stuart, I feel like I'm going to die!" He bowed out of a fancy dinner that evening and took so many sedatives that he didn't answer the phone when Pat Hackett made her morning call the next day, which scared her so badly she had Aurora Bugarin go and check on him.

Warhol at last called Dr. Cox, who told him to come in to his office at once. A thorough examination showed that things were no better than expected: Warhol's gallbladder was severely infected and inflamed, and he was told that it might kill him if it wasn't removed. Warhol still refused any hospital care, however, so Cox dosed him with powerful antibiotics and put him on a diet of clear liquids, to give his gallbladder a rest from more demanding eating. Then Cox sent Warhol off for an immediate second opinion from Dr. Bjorn Thorbjarnarson, an Icelandic-born surgeon who was professor of surgery at Cornell's medical school and had been chief of surgery at New York Hospital. He was sixty-six years old, and a member of the prestigious American Surgical Association. He had been chosen to remove the gallbladder of the Shah of Iran, which must have meant *something* to the Shah-painting artist.

Thorbjarnarson repeated what Cox had said, but with even more urgency: Warhol needed to be free of that gallbladder, now. Warhol pleaded for a nonsurgical option—"I will make you a rich man if you don't operate on me," he said—but Thorbjarnarson stood firm. So did Warhol. He simply would not agree to a hospitalization. "He was obviously very, very afraid of surgery," Thorbjarnarson recalled. Right there in the office, the surgeon called Denton Cox and asked him to talk some sense into Warhol. The best Cox could do was to get him to seek yet a third opinion the next day, and still another sonogram.

The third doctor agreed with the first two and when the new sonogram came back it gave them extra ammunition: The gallbladder was more inflamed than ever, because one of the stones had now become lodged in its "neck." Cox called Warhol at home with the results, warning him of "the absolute imperativeness of his being admitted to the hospital and that surgery was emergent, needed and necessary," as the doctor later remembered.

That Thursday night, Warhol headed to Serendipity, the very first of his haunts in New York, for a meal all of sweets, ignoring his clear-fluids diet. Ever since Warhol was shot, said the café's owner Stephen Bruce, "he would always come in for a frozen hot chocolate or lemon-ice-box-pie, 'cause they weren't hard foods, they were very easy to digest." In his irrational premonition of death, Warhol might have thought he was attending his own Last Supper, with a Serendipity frozen hot chocolate as its perfect sacrament. (Because his premonition proved correct doesn't make it more rational; there are plenty such "warnings" that do not pan out.)

On Friday morning, Warhol phoned Dr. Giuseppe Rossi, the surgeon who had saved him from dying of his bullet wounds two decades earlier, in the hopes of getting him to do the cutting again. Rossi was out of town, so all

Warhol could do was leave a message on his machine; the surgeon received it Monday morning, after it was too late.

After that, Warhol made the decision he'd needed to all along: He would ignore his premonitions and go under the knife with Thorbjarnarson. He spent a few hours tucking his valuables and cash into his home's hiding places, then called Stuart Pivar to ask for his limo and driver to take him off to his "appointment"—with fate, as it turned out. Although his doubts about surviving did not lead him to cancel a Sunday date at the ballet, which even in the best of postoperative circumstances he could never have kept.

Warhol arrived at New York Hospital at about eleven, dressed in a black beanie, a long black scarf and a quite formal black coat by Jean Paul Gaultier, worn over a black Calvin Klein leather hoody. (Underneath he wore Y-fronts by the same designer, dyed pink.) A black Gaultier knapsack held a classically Warholian collection of stuff: acne cream, a shaver, four extra pairs of glasses (including two with dark lenses), a Braun travel alarm, an Olympus point-and-shoot and a Sony cassette recorder with eight tapes. Warhol must have remembered the fine taping he'd done after getting shot.

In typical fashion, he asked the clerk at admissions, name-tagged "Barbara," if any big stars were patients that day and received the happy news that he was the biggest. She asked for a name to put on the forms, and he gave her her own. When she demurred he settled for "Bob Roberts," to keep news of his admission from spreading. When this same Barbara asked Warhol for his Blue Cross and Health Insurance numbers he rattled them off from memory, something that the clerk later said she had never witnessed before. It was final evidence of a brain and memory that didn't work quite like other people's.

Warhol said he didn't want visitors and never got any, except Vincent Fremont. At the studio, only Fremont, Hughes and Hackett had been told that the boss was going under the knife. Even Thorbjarnarson didn't learn of Warhol's decision until later that day, when he was surprised to hear Cox tell him that the artist had overcome his fears and would be his patient in the O.R. the following morning.

By about three o'clock Friday Warhol had settled into his room, with a lousy TV that made it hard to hear *Divorce Court* plus a pile of magazines and books: the memoirs of Jean Cocteau but also a new biography of Sinatra, high and low kept in balance to the last. Warhol got visits from Fremont and from Cox and Thorbjarnarson, who ordered IV antibiotics, because of Warhol's slight fever and elevated white-blood-cell count, and also fluids to fight his dehydration. Warhol made a last late-night call to Paige Powell, who still

didn't know where he was calling from. He gave her some errands to do, clearly planning to be back in the saddle very soon.

The next morning Warhol was on the operating table by eight forty-five, attended by the usual team of surgeons and somehow with his wig still in place. Three decades later, Thorbjarnarson talked about the operation as having been successful but tricky, partly because of the mess of Warhol's neglected gallbladder, falling apart from gangrene as he fished it out, but also from the scar tissue filling Warhol's insides. Once the surgeon had opened Warhol's abdomen, through the same incision Rossi had used in '68, it also became clear that he couldn't avoid the major job of fixing the "monumental" hernia that that original incision had caused. It was an operation that even Thorbjarnarson, who'd treated such conditions before, found challenging in this extreme case. Too bad Warhol never got to enjoy his newly flat abdomen and the final discarding of his corsets.

After three hours and twenty-five minutes on the table, and another four hours in recovery, Warhol was back in his own room again, awake and feeling pretty fine, all things considered. Clearly pleased to be alive, and maybe surprised as well, he chatted with Cox and Thorbjarnarson when they came to check on him. "He looked to me like one of the healthier patients that I have seen postoperatively," Thorbjarnarson recalled.

Warhol's operation has almost always been called "routine," as most gallbladder surgeries are. But that morning's "routine" operation was routine only for a routine patient, which did not at all describe Warhol. His entire system had been terribly damaged by the shooting in 1968 and its medical aftermath, which included years of eating troubles and weight loss, made worse by his warped body image. There was also a struggle with colitis in '83 and then with anemia in '84. Warhol's health and eating habits couldn't have been helped by a self-confessed addiction to Valium, causing constipation so bad that he needed a daily enema. Over his recent weeks of illness he'd also become severely dehydrated, which had worried his doctors as they suggested surgery. And then there was the diseased gallbladder itself, an apparently inherited condition that Warhol ought to have gotten fixed, surgically, long before. He'd let it take its toll for almost fifteen years, no doubt further weakening his overall constitution.

After general anesthesia and major abdominal surgery, even the healthiest patient runs a significant risk of sudden, "idiopathic" ("we-don't-know-why-it-happened") death. Someone walking down the street can drop dead from a "cardiac arrhythmia" (i.e., a stopped heart) without any obvious cause. For a patient like Warhol, ailing and even facing death before he arrived at the hospital and needing an operation that was more complex than expected

once he got there, twenty-first-century doctors would guess at something like a 4 percent chance of his body failing after surgery. Those are less like the odds of being hit by lightning than of being in a car crash—which is something that might be unlikely but still doesn't seem an utter surprise to anyone when it happens.

Warhol's "crash" happened the night after his surgery, in the hours before dawn when death is most likely to strike. (As suggested in a study published the very month Warhol died.) The private-duty night nurse Warhol had hired found him doing well for the first several hours. She helped him make a bunch of phone calls, including to his old assistant Ronnie Cutrone, who heard the unlikely news that Warhol would be home "tomorrow"; eventually the nurse saw her patient settle down fine to sleep. After that, her notes show Warhol looking "pale" at four thirty and "paler" at four forty-five, when she could barely get a pulse and realized there was something terribly wrong.

Reacting to the disaster, she and the floor's other nurses began CPR and paged the cardiac arrest team. A good ten doctors and nurses were there within minutes and found a situation that was already almost hopeless but not completely so. They put a breathing tube down Warhol's windpipe and managed to find a heartbeat they hadn't expected. It didn't last. His heart quivered and stopped. "The best way to go is fast. It's like going to sleep," Warhol had once told his friend Truman Capote. The doctors weren't about to agree. They went to work once again, trying the full range of drugs that might just revive their famous patient. (Unlike when Warhol was shot, this team knew who they were treating and the significance of his demise on their watch.) They shocked his fibrillating heart to bring it back to life, twice, as they faced a body becoming as gray as the one that arrived in the emergency ward at Columbus Hospital in June of '68.

But this time the Luck of the Rusyns had run out. Andy Warhol died, for the second and last time, on February 22, 1987, at 6:31 A.M.

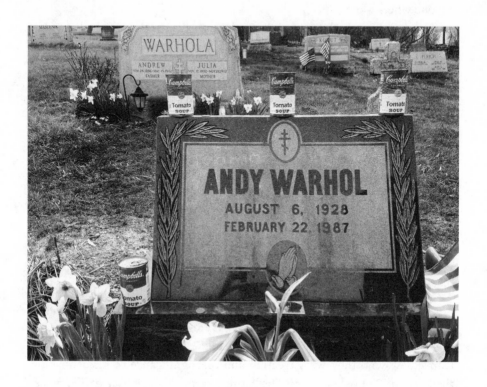

*The tombstone in Pittsburgh in 2014.*

# POSTLUDE

## AFTERLIFE

- Andy Warhol's funeral took place on February 26 at a Byzantine Catholic church in Pittsburgh, attended only by his family and a handful of New Yorkers handpicked by Fred Hughes. The artist was buried near his parents, in a modest suburban cemetery.
- A lavish memorial service was held at St. Patrick's Roman Catholic Cathedral in New York on April 1. The church was packed with more than three thousand people. Eulogies—not completely inaccurate— were given by Yoko Ono and the art historian John Richardson.
- Immediately after Warhol's death, a fearsome Fred Hughes had rushed to lock down his house and sequester its contents. Warhol's brief will was filed for probate within three days. At that point, his estate was valued at an absurdly low $15 million. Two years later, a fuller accounting set its value at $215 million. Today, just the art he left would be worth billions.
- Warhol left Fred Hughes and his two brothers $250,000 each. The brothers objected but gave up their claims in exchange for their share of a $3 million settlement that New York Hospital offered late in 1991, after litigation over Warhol's death.
- Warhol directed that the rest of his estate be used to set up a foundation "for the advancement of the visual arts," with no instructions on what that might be.
- In 1988, the estate sent the best of Warhol's personal effects, from art by Jasper Johns to old cookie jars, to be auctioned by Sotheby's. The three thousand lots ended up fetching $25 million, almost double the high estimate.
- Over the following three decades, the Andy Warhol Foundation for the Visual Arts became one of the world's largest private supporters of contemporary art. In 2018, it gave away $14 million, funded from an investment portfolio of $300 million and an aggressive licensing program. Images by Warhol have been seen on everything from

skateboards to Calvin Klein bras and briefs, leaving the artist either smiling from the Beyond or rolling over in his grave.

- The Foundation ended up holding vast quantities of Warhol's unsold paintings, prints, drawings, photos and ephemera.
  In 1994, many of the best of those works were used to help found The Andy Warhol Museum in Pittsburgh, one of the most important one-artist museums in the world. It also received Warhol's vast archive, including his 610 Time Capsules and hundreds of other boxes of vital and fascinating records—and junk.
- In 2002, the Foundation began publishing a full catalogue raisonné of Warhol's Pop and post-Pop paintings and sculptures. By 2019, seven vast tomes had been released—so far, covering only the years up to 1979.
- The market for Warhol's art exploded after his death. Within weeks, his prices had more than doubled. One dealer remembers paying $500,000 for a Marilyn estimated at $75,000. The Warhol market has been thriving since. In 2013, *Silver Car Crash (Double Disaster)* sold for $105 million, then the most paid at auction for a work of American art.
- Popular culture has had a deep fascination with the Pop artist. In 1994, a rock band decided to name itself the Dandy Warhols. A rapper has since dubbed himself Warhol.SS.
  In 2019, Burger King decided that the best Super Bowl ad it could run would be nothing more than vintage footage of Warhol eating one of its hamburgers. The ad went viral, generating what were said to be more than three billion "media impressions."
- Warhol's art-historical reputation has more than kept pace with his popular appeal. Something like one thousand scholarly articles have appeared on his work, along with some five hundred books of all kinds. In 1989, the Museum of Modern Art mounted a landmark Warhol retrospective. Since then, hardly a major museum in the world has failed to host some kind of Warhol extravaganza. The huge Warhol survey that opened at the Whitney Museum of American Art in 2018, ninety years after his birth, drew record crowds.
- The critical skepticism that Warhol lived with has evaporated in the years since his death. It's looking more and more like Warhol has overtaken Picasso as the most important and influential artist of the twentieth century. Or at least the two of them share a spot on the top peak of Parnassus, beside Michelangelo and Rembrandt and their fellow geniuses.

# A NOTE ON SOURCES

*Warhol* was researched by interviewing more than 260 lovers, friends, colleagues and acquaintances of the artist and (more reliably) by consulting some 100,000 period documents. Those documents included letters, diaries and oral histories; educational, medical and financial records; datebooks, inventories, appraisals and ticket stubs; transcripts, audio and video recordings of conversations as well as vintage footage, magazines and newspapers. Previous biographies as well as studies and documentaries on Warhol and his era were also invaluable.

Many records were unearthed in the archives and collections of The Andy Warhol Museum in Pittsburgh while others, also in Pittsburgh, were held by the Carnegie Library, the Senator John Heinz History Center, the Pitt Men's Study and the archives of Carnegie Mellon University and of the Carnegie Museum of Art.

Records were also consulted at the Smithsonian's Archives of American Art, the Library of Congress, the New York Public Library, the Beinecke library at Yale University, the Harry Ransom Center of the University of Texas at Austin, the Fales Library at New York University, the archives, library and film department of the Museum of Modern Art, the Thomas J. Watson Library at the Metropolitan Museum of Art, the Archives Center at the Smithsonian's National Museum of American History, the New School Library and Archives, the archives of the New-York Historical Society, the Special Collections Research Center at Syracuse University, the Williams College Museum of Art, the Wisconsin Center for Film and Theater Research at the University of Wisconsin–Madison, the Anthology Film Archives, the Litchfield Historical Society, the New York City Municipal Archives, the Roy Lichtenstein Foundation and the estates of Nathan Gluck and Ray Johnson.

*Full endnotes for this biography are available in its e-book edition and at www
.harpercollins.com/warhol.*

---

The following sources were interviewed for this book, in person or by phone,
e-mail or letter:

George Abagnalo, Ann Adelman, Len Amato, Mark Andrejevic, Frank
Andrews, Ruth Ansel, Harrison Apple, George Arnold, Steven M. L. Aron-
son, Michel Auder, Waldo Balart, Gordon Baldwin, Steve Balkin, Kaye Bal-
lard, Fay Barrows, John Bauer and Christine Bauer, Iain Baxter, Horst Weber
von Beeren, Peter Bellamy, Kevin Beres, Roberta Bernstein, Ben Birillo,
Irving Blum, Sam Bolton, Randall Borscheidt, Peter Brant, Todd Brassner,
Fred Brathwaite (a.k.a. Fab 5 Freddy), Stephen Bruce, Jean Jacques Bugat,
Karen Burke, Karen Bystedt, Dorothy Cantor, Sean Carrillo, Tom Cashin,
Sally Chamberlain, Michael Childers, Ricky Clifton, Bob Colacello, Nancy
Collins, George Condo, Adam Cooper, Meg Crane, Maurizio Daliana, David
Dalton, Sarah Dalton, Jacques d'Amboise, Anna Taylor Delory, Jack Deren,
Neil Derrick, Marie-Claude Desert, Jim Dine, Lois Dodd, Anthony d'Offay,
Sepp Donahower, Betty Asche Douglas, Rosalyn Drexler, Richard Dupont,
Robert Dupont, Virginia Dwan, Fernanda Eberstadt, Frederick Eberstadt,
Arthur and Theodora Edelman, Abby Ehrlich, John Eichleay, David Ellis,
Carole Eppler, William Fagaly, Trevor Fairbrother, Carolyn Farris, Ron Feld-
man, Nick Felt, Nye Ffarrabas, Edward Field, Elizabeth Murray Finkelstein,
Rudy Franchi, Richard Frank, Joseph Freeman, Vincent Fremont, Frank Ga-
luska, David Gamble, Robert Gangewere, Vito Giallo, Bob Gill, John Giorno,
James Glickenhaus, Arne Glimcher, Bobb Goldsteinn, Adam Gopnik, Ter-
ryn Greene, Joseph Groell, Cornelia Guest, Pat Hackett, Timothy Haggerty,
Deborah Hallam, Bibbe Hansen, Ashton Hawkins, Johnnie Moore Hawkins,
R. Couri Hay, Ed Hayes, Brooke Hayward, Leon Hecht, Robert Heide, David
Heilbroner, Alexander Heinrici, Joe Helman, Jon Hendricks, Ken Heyman,
Roger Hilton, Victoria Leacock Hoffman, George Holmes, Antonio Homem,
Blake Hornick, Pat Hudson, Bobbi Humphrey, David Hungerman, Freder-
icka Hunter, Timothy Hursley, Jean-Claude van Itallie, Tommy Jackson,
Gillian Jagger, Jasper Johns, Jay Johnson, Michael Kahn, Edward Kasinek,
Alex Katz, Bill Katz, David Katzenstein, Jim Kendall, Leonard Kessler, Ja-
mie Kirkavitch, Stanislas Klossowski de Rola, Alison Knowles, Barbara and
Ed Knowles, Josh Kornbluth, Paul Kossey, Joseph Kosuth, John Krug, Tom
Lacy, Kenneth Jay Lane, Jack Lenor Larsen, Elizabeth Laub, Alfred Leslie,
Robert Levin, Andrew Levine, Les Levine, Allana Lindgren, Louise Lippin-
cott, Christopher Makos, Gerard Malanga, Michael Malce, Reese Marshall,

Rhoda Marshall, Julie Martin, James Mayor, William McCarthy, Jonas Mekas, Cayce Mell, Sam Mellon, Duane Michals, Gertrud Michelson, Sharon Middendorf, Philip Monaghan, Marcelo Montealegre, Elise Mooshagian, Daniela Morera, Paul Morrissey, Patty Mucha, Susan Mulcahy, Edgar Munhall, Billy Name, John Namojski, Craig Nelson, Michael Netter, David Newell, Ivy Nicholson, Johnny Nicholson, Nancy North, Barbara Novak, Glenn O'Brien, Brian O'Doherty, Claes Oldenburg, Yoko Ono, Lucille Ormay, Angel Ortloff, George Ortman, Gloria Pace, Robert Pallenberg, Penelope Palmer, Billy Parrott, Philip Pearlstein, Anton Perich, Caroline Perkins, David Petras, Greg Pierce, Susan Pile, Robert Pincus-Witten, Stuart Pivar, Phillip R. Poovey, Paige Powell, Debbie Priore, Joan Agajanian Quinn, Toby Rafelson, Marshall Reese, John Righetti, Adam Ritchie, Clarice Rivers, Dale Roberts, Esther Robinson, Therese Rocco, Dorothea Rockburn, Gemma Rossi, Dr. Giuseppe Rossi, Philip Rostek, Vivian Rowan, Ed Ruscha, John Ryan, David Salle, Irving Sandler, Thomas G. Schaefer, Jerry Schatzberg, Charles Schmidt, Richard Schulman, Robert Schwartz, Ann Scott, Pamela Sharp, Andrew Sherwood, Stephen Shore, Cathy Silvestri, Maria Silvestri, Webster Slate, Chuck Smith, Patrick S. Smith, Roger Smith, Emma Snowdon-Jones, Alan Soley, Christina Soley, Tina Soley, Keith Sonnier, Wayne Stambler, Suzanne Stanton, Walter Steding, Michelle Stuart, Martha Sutherland, Simone Swan, Marshall Swerman, Ron Taft, Bjorn Thorbjarnarson, Corey Tippin, Robyn Tisman, Olaf Tranvik, Richard Turley, Cathy Tuttle, Jac Venza, Anna Mae Wallowitch, Stewart Redmond Walsh, Alan Wanzenberg, Brownie Warburton, Abby Warhola, Donald Warhola, George Warhola, James Warhola, Joshua White, Carlton Willers, Peter Wise, Bill Wood, Matt Wrbican, Hanford Yang, La Monte Young, John Zavacky, Kett Zegart, Rudolf Zwirner.

*This biography could not have been written without the resources of The Andy Warhol Museum in Pittsburgh and its unrivaled archives or without the assistance and collaboration of its staff.*

# ACKNOWLEDGMENTS

This book was born when my brother, Adam, convinced me that there might be a biographer lurking inside me; Andrew Wylie then proposed that Andy Warhol might be that biographer's subject and became my agent. Daniel Halpern, founder of Ecco, sealed my fate as a biographer by buying our Warhol proposal. The directors of The Andy Warhol Museum in Pittsburgh, first Eric Shiner and then Patrick Moore, let that proposal become this book by granting me access to their museum's rich resources and absurdly helpful staff.

Matt Wrbican, the museum's late and much lamented archivist, got me launched down the Warhol rabbit hole; I'm pleased to say that half this book came into his hands before he passed away and that his illness never tempered his annotations. His successors, Erin Byrne and Matt Gray, helped me plunge still further into the depths of Warholiana. I will miss their white gloves. Curators Greg Pierce and Geralyn Huxley gave me access to the museum's trove of films and videos and helped me understand them. Claire Henry and her colleagues working on the catalogue raisonné of Warhol films at the Whitney Museum of American Art led to still further understanding. Gerard Malanga gave more of his time, more generously, than any other member of Warhol's world.

Three interns—Noël Um, Daria Zlobina and Gabriella Caputo—made notable contributions to this book's early chapters while this nation's remarkable tribe of archivists and librarians—most especially Marisa Bourgoin of the Smithsonian's Archives of American Art—were endlessly helpful in all the book's stages. Lucy Hogg contributed research to every one of this volume's fifty chapters and acted as its photo editor.

Whenever I was stumped by a thorny historical puzzle, I knew I could call on Jay Reeg, Ben House and Thomas Kiedrowski, three great Warhol aficionados, and on Tony Scherman, who wrote *the* book on the artist's Pop

era. Paul Maréchal lent a hand on Warhol's illustrations and Dr. John Ryan came to the rescue whenever I was dealing with medical subjects. At the Andy Warhol Foundation for the Visual Arts, I could always count on the encouragement of Joel Wachs and Michael Dayton Hermann.

My beloved friend Arden Reed, late of Pomona College, was there for me whenever I needed to pull out of the weeds and Think Big. He is sorely missed.

My friends Aaron and Barbara Levine were there for me whenever I needed to feel energized about art. Also, whenever I needed a fine meal.

In 2015, I had the good fortune to try out some of my first Warholian writings on my fellow fellows at the Leon Levy Center for Biography of the City University of New York and on its director Gary Giddins and his deputy Michael Gately. In 2017, I got to impose more mature ideas and research on my colleagues at the Dorothy and Lewis B. Cullman Center for Scholars and Writers at the New York Public Library, on its director Salvatore Scibona and on his lieutenants Lauren Goldenberg and Paul Delaverdac.

My readings in Warhol began at the Pacific coast cabin of Renée van Halm and Pietro Widmer; seven years later, I got to celebrate the conclusion of my labors with them in that same delightful spot. Along the way and across the continent, many pages were written in the Atlantic coast cabin of Lucille Hogg, who managed to believe (or pretend to believe) in the labors of an errant son in law.

Once I had a vast first draft of *Warhol* in hand, the legendary Warholian Gary Comenas took on the labor of reading it, never grumbling at that burdensome task. The same task was also undertaken by my long-suffering sisters, Morgan and Alison, and by my brother-in-law, Alvy Ray Smith, as well as by Lisa Ramshaw and David Miller.

That draft would never have evolved into this volume without the efforts of Gabriella Doob, my unflappable editor at Ecco. Virtuoso copy editing by Mark Steven Long caught errors that would have left me red-faced had they seen print, while Andrea Molitor oversaw a production team that guaranteed that they didn't. Trina Hunn made sure the book passed legal muster; Carolina Baizan saw it through its final, fussy stages; while Allison Saltzman, Suet Chong and Renata De Oliveira produced its elegant cover and interior design.

I end by thanking my dear friend Alex Nagel, who has been by my side for the greatest art-looking moments in my life, and my parents, Irwin and Myrna, who gave me the emotional and intellectual ballast to survive this absurd project.

My son, Aaron, and his wife, Natasha, have given me Tesslyn, Brynlee and Graydon: I wrote this book so that they could someday read it.

The following people also helped in the research and writing of *Warhol:* Lauren Abman, Oliver Adelman, Matthew Affron, Donald Albrecht, Rick Armstrong, George Arnold, Andrew Arnot, Tom Atkins, Anthony Atlas, Laura Avedon, Kevin Balazs, Jason Baumann, Frances F. L. Beatty, Jessica Beck, Brook Bender, Irving Bennett, Kathryn L. Beranich, Rosa Berland, Christine Berry, Jesse Best, Jean M. Bickley, Benjamin Birillo, Jr., Claire Blatchford, Vera Bondy, Janet Borden, Frank Born, Maria Braeckel, Jeffrey Bragman, Justin Brancato, Allison Brant, Kristin Britanik, Erica Rocchi Brusselars, Bill Buchanan, Greg Burchard, Jason Burdeen, Misha Cannon, Andrea Caratsch, Victoria Cardona, Nicholas Chambers, Christophe Cherix, Tamar Chute, Vincent Cianni, Ken Cobb, Randy Cook, William Bryant Copley, Bryan Cornell, Julia C. Corrin, John Coulthart, Lisa Craig Morton, David Crane, Thomas Crow, Christina da Costa, John Dalles, Deborah Davis, Steven Day, Elizabeth Dee, Luis De Jesus, Stuart Denenberg, Rose Dergan, Donna de Salvo, Jose Diaz, Andy DiOrio, Caroline Donadio, Deirdre Donahue, John Eichleay, Jr., George Eichleay, Justin Eng, Stephen Ennis, Carole Eppler, Sarah Falls, Nicholas E. Felt, Leah Fisher, Susan Fisher, Dyan Foley, Gerard Forde, Hal Foster, Richard Foster, David Frank, Jessica Frank, Peter Freeman, Patricia Fried, Jonathan Gaugler, Ian Gillingham, Stephen H. Goddard, Nathaniel Goehring, David Goss, Johanna Gosse, Paul Grant, Barbara Graustark, Garth Greenan, Andy Hain, Robert Haller, Nick Hallett, Nora Halpern, Larimore Hampton Pivar, Julie Hanon, Kelly Haydon, Larissa Harris, Rose Hartman, Jon Hendricks, Crystal Henry, Linda M. Hocking, Harold Holzer, Jim Hoon, Bill Hooper, David Horowitz, Jennifer Hostler, David Hungerman, Timothy Hursley, Mike Huter, Maria Ilario, Luke Ingram, David Joel, Catherine Johnson, Cassandra Johnson, Monica Johnson, Fatima Kafele, Richard Kaplan, Edward Kasinec, Stephanie Katsias, Carissa Katz, David Katzenstein, Christina Kennedy, Norman Keyes, Selby Kiffer, John Klacsmann, Bruce Allen Kopytek, Jeff Kreines, Prem Krishnamurthy, Helene Glick Landman, Yvette Lang, Heidi Lange, Emily Lansbury, Elizabeth Laub, Owen Laub, Karen Lautanen, Marie Leahy, David Leddick, Sarah Lehat, Cassidy Lent, Jonathan Lethem, Robert Levin, Aaron and Barbara Levine, David Lowenherz, Elaine Lustig Cohen, Nora Lyons, Cindy Lysica, Henry Martin, Nicholas Martin, Timothy McDarrah, Chris McMurtry, Paul Maréchal, James Martin, Miriam Meislik, Charlotte Ménard, Rossy Mendez, Anne Marie Menta, James Meyer, Kate Meyer, Melissa Meyer, Kate Miller, Lauren Miller Walsh, Tomas Minnick, Maria Morreale, Juliana Morris, Linda Mulhauser, Edward K. Muller, Lucy Mulroney, Patrick Nagle, Tommy Napier, Francis Naumann, Sean Nevin, Sherri Nickol, Sara Ng, Michael O'Connell, Maartje Oldenburg, Jake Oresick, Nicholas Ostness,

Michelle Oswell, Jonathan Padget, Val Pennington, Jonathan Perlman, Russell Perreault, Marylynne Pitz, Frances Pollard, Jeffrey Posternak, Robert Preece, Kathryn Price, Neil Printz, Greg Priore, Debbie Priore, John Putch, Amanda Quinn Olivar, Melissa Rachleff Burtt, Louis Rachow, Jill Reichenbach, John Righetti, Marina Rodriguez, Clara Rojas-Sebesta, Tyler Rollins, Peter Rosen, Elena Rossi-Snook, Rob Roth, Elaine Rusinko, Anastasia Rygle, Nina Schlief, Vito Schnabel, Ali Schreiber, Mark Schulgasser, John Schulman, Jamie Schutz, Andrea Schwan, Tracy Schweizer, Nita Scott, Russell Scott, Mark Sendroff, Patrick Seymour, Bill Sherman, Rebecca Shock, Anthony J. Silvestre, Elaine Simms, Ron Simon, John Smith, Laura Smith, Stephen Soba, Hilary Spann, Tom Sokolowski, Deborah Solomon, Judith Stein, Kathryn Stevens, Sam Stewart, Robin Strong, Jeffrey Sturges, Scott Sullivan, Elisabeth Sussman, Philip Sutton, Susan Swedo, Ashley Swinnerton, Dru J. Taliaferro, Albert M. Tannler, David Tarnow, Kimberly Tarr, Alexander Taylor, Tamara Thornton, Robyn Tisman, Alexander Tochilovsky, Brendan Toller, Elizabeth Tufts Brown, Michael von Uchtrup, Conrad Ventur, Mia Vitale, Christian Viveros-Faune, Gail Waite, Joan Waltermire, Jay Warhola, Steven Watson, Melissa Watterworth Batt, Chelsea Weathers, Raymond Wellinger, Angela Westwater, John Wilcock, Alette Winfield, Adam Weinberg, Jeffrey Weiss, Jay Wingate, Reva Wolfe, Lynn Zelevansky and Lucas Zwirner.

# CREDITS

**PHOTOGRAPHS THROUGHOUT**

Frontispiece: Michael Childers, *Andy in New York Studio 1976*.

Prelude: Richard Avedon, *Andy Warhol, Artist, New York City, April 5, 1969* (1969). © 2020 The Richard Avedon Foundation.

Chapter 1: Unknown photographer, *Julia, John, and Andy Warhola* (ca. 1930). The Andy Warhol Museum, Pittsburgh; Founding Collection, Contribution The Andy Warhol Foundation for the Visual Arts, Inc. 1998.3.5247.

Chapter 2: Unknown photographer, *Andy Warhol* (ca. 1941). Courtesy the Estate of Margaret Girman Ellis.

Chapter 3: Roger Anliker, *Mute Song (Andy Warhola)* (1949). Courtesy Dale O. Roberts.

Chapter 4: Unknown photographer, *Andy Warhol, Dorothy Cantor, and Philip Pearlstein on Carnegie Institute of Technology Campus* (ca. 1948). Philip Pearlstein papers, circa 1940–2008. Archives of American Art, Smithsonian Institution.

Chapter 5: Philip Pearlstein, *Andy Warhol in New York City* (ca. 1949). Philip Pearlstein papers, circa 1940–2008. Archives of American Art, Smithsonian Institution.

Chapter 6: Unknown photographer, *Andy Warhol at His Easel*. Courtesy Manuela King.

Chapter 7: Unknown photographer, *Andy Warhol* (1950s). The Andy Warhol Museum, Pittsburgh; Founding Collection, Contribution The Andy Warhol Foundation for the Visual Arts, Inc. T3751–T3756.

Chapter 8: Duane Michals, *Andy Warhol and His Mother Julia Warhola* (1958). Courtesy Duane Michals and DC Moore Gallery, New York, © 2018 Duane Michals.

Chapter 9: John Ardoin, *Warhol at Serendipity*. Courtesy Serendipity 3.

Chapter 10: Duane Michals, *Andy Warhol* (1958). Courtesy Duane Michals and DC Moore Gallery, New York, © 2018 Duane Michals.

Chapter 11: Unknown photographer, *Andy Warhol and Ted Carey* (c. 1958). The Andy Warhol Museum, Pittsburgh; Founding Collection, Contribution The Andy Warhol Foundation for the Visual Arts, Inc. 1998.3.10667.75.

Chapter 12: Hervé Gloaguen, *Andy Warhol in New York, United States in 1966* (1966). Gamma-Legends/Getty Images.

Chapter 13: Unknown photographer, *Andy Warhol at Work in His Studio at 1342 Lexington Avenue* (1962). The Andy Warhol Museum, Pittsburgh; Founding Collection, Contribution The Andy Warhol Foundation for the Visual Arts, Inc. 1998.3.10857.19b.

Chapter 14: Ken Heyman, *Warhol in His Lexington Avenue House* (1964). © 2020 Ken Heyman.

Chapter 15: Photographer unknown, *Andy Warhol* (1962). The Andy Warhol Museum, Pittsburgh; Founding Collection, Contribution The Andy Warhol Foundation for the Visual Arts, Inc. T293.

Chapter 16: Alfred Statler, *Andy Warhol's Art in His Studio at 1342 Lexington Avenue, New York City* (April 1962). © 2019 The Andy Warhol Museum, Pittsburgh. All Rights Reserved; Museum Purchase, Accession Number: 2014.7.8e. Art works © 2019 The Andy Warhol Foundation for the Visual Arts, Inc./Licensed by Artists Rights Society (ARS), New York.

Chapter 17: Ellen Johnson, *Andy Warhol* (1963). The Andy Warhol Museum, Pittsburgh; Founding Collection, Contribution The Andy Warhol Foundation for the Visual Arts, Inc. TC27.124. With permission of the Ellen H. Johnson Estate. Art works © 2019 The Andy Warhol Foundation for the Visual Arts, Inc./Licensed by Artists Rights Society (ARS), New York.

Chapter 18: *Photo-booth Strip of Andy Warhol and Gerard Malanga, Inscribed by Malanga to the Poet Charles Henri Ford* (1963). Courtesy and © Gerard Malanga.

Chapter 19: Ellen Johnson, *Andy Warhol in His Firehouse Studio* and *Andy Warhol Pulling a Silkscreen* (1963). Courtesy the Ellen H. Johnson Estate.

Chapter 20: Sam Falk, *Andy Warhol Sitting on Brillo Box at The Factory* (May 1964; reprint 1990). The Andy Warhol Museum, Pittsburgh; Gift of Jay Reeg. Sam Falk/The New York Times/Redux.

Chapter 21: Bob Adelman, *Andy with* Most Wanted Men–John Victor G. (1963) *at the Leo Castelli Gallery* (1965). © Bob Adelman Estate, Courtesy WESTWOOD GALLERY NYC. Art works © 2019 The Andy Warhol Foundation for the Visual Arts, Inc./Licensed by Artists Rights Society (ARS), New York.

Chapter 22: Stephen Shore, *Andy Warhol with a Flower Painting* (c. 1965). ©
Stephen Shore, courtesy 303 Gallery, New York. Art works © 2019 The
Andy Warhol Foundation for the Visual Arts, Inc./Licensed by Artists
Rights Society (ARS), New York.

Chapter 23: Duane Michals, *Andy Warhol, Gerard Malanga and Philip Fagan* (c.
1965). Courtesy Duane Michals and DC Moore Gallery, New York, ©
2018 Duane Michals.

Chapter 24: Steve Schapiro, *Andy Warhol Looks Adoringly at Edie Sedgwick* (c.
1965). Corbis Premium Historical/Getty Images.

Chapter 25: David McCabe, *The Four Faces of Andy in the Closet of Jacques
Kaplan's Apartment, NYC* (1965). Courtesy Cipolla Gallery.

Chapter 26: Jerry Schatzberg, *Andy Warhol, Studio Portrait* (1966). © Jerry
Schatzberg, 1966.

Chapter 27: Stephen Shore, *Andy Warhol Promoting the Velvet Underground: and
Nico* (1966). © Stephen Shore, courtesy 303 Gallery, New York.

Chapter 28: Hervé Gloaguen, *Andy Warhol and the Velvet Underground in New
York* (1965). Gamma-Legends/Getty Images.

Chapter 29: Stephen Shore, *Andy Warhol with His Silver Clouds* (c. 1966). ©
Stephen Shore, courtesy 303 Gallery, New York.

Chapter 30: Jerry Schatzberg, *Andy Warhol, The Factory* (1966). © Jerry
Schatzberg, 1966.

Chapter 31: Stephen Shore, *Andy Warhol with His Boyfriend Rod La Rod* (1966).
© Stephen Shore, courtesy 303 Gallery, New York.

Chapter 32: Marshall Swerman, *Andy Doing Business* (c.1967). © Marshall
Swerman.

Chapter 33: Roberta Bernstein, Warhol in 1968 in the early days of the
Union Square studio. Courtesy Roberta Bernstein.

Chapter 34: Marshall Swerman, *Andy on Phone: Union Square Factory* (1968).
© Marshall Swerman.

Chapter 35: Marshall Swerman, *Andy at Desk* (1968). © Marshall Swerman.

*NYPD Photograph #49598-1, June 4th, 1968, from Box 825: View of Office Crime on
Union Square.* Courtesy NYC Municipal Archives.

Chapter 36: Andy Warhol, *Self-Portrait,* 1968. The Andy Warhol Museum,
Pittsburgh; Founding Collection, Contribution The Andy Warhol
Foundation for the Visual Arts, Inc. 1998.3.14800. © The Andy Warhol
Foundation for the Visual Arts, Inc./Artists Rights Society (ARS), New
York.

Chapter 37: Cecil Beaton, *Andy Warhol and the Johnson Twins* (1969). © The
Cecil Beaton Studio Archive at Sotheby's.

Chapter 38: Richard Avedon, *Andy Warhol and Members of The Factory (#11),*

*Left to Right: Andy Warhol, Artist; Paul Morrissey, Director; Joe Dallesandro, Actor; Candy Darling, Actor; New York, October 30, 1969* (1969). © 2020 The Richard Avedon Foundation.

Chapter 39: Jonas Mekas, *Warhol with a Borrowed Academy Award* (c. 1971). Courtesy Jonas Mekas.

Chapter 40: Oliviero Toscani, *Warhol and His Friends Wearing Suits* (c. 1973) (*from left:* Frederick Hughes, Vincent Fremont, Andy Warhol, Ronnie Cutrone, Bob Colacello, Sean Burnes). Courtesy Oliviero Toscani Studio.

Chapter 41: Peter Beard, *Andy Warhol* (1972). © Peter Beard, courtesy the Peter Beard Studio. Collection of Steven M. L. Aronson.

Chapter 42: Duane Michals, *Andy Warhol* (c. 1974). Courtesy Duane Michals and DC Moore Gallery, New York, © 2018 Duane Michals.

Chapter 43: Robin Platzer, *Celebrities During New Year's Eve Party at Studio 54: (L-R) Halston [kissing unidentified], Bianca Jagger, Jack Haley Jr. and Wife Liza Minnelli, Andy Warhol* (1978). The LIFE Images Collection / Getty Images.

Chapter 44: Christopher Makos, *Andy at Stones Lunch*. © Chris Makos.

Chapter 45: Christopher Makos, *Andy Asleep on Concorde*. © Chris Makos.

Chapter 46: Robert J. Levin, *Andy Warhol in the Conference Room at The Factory with Totems, VCR, Television and Moose Head Taxidermy Mounted on the Wall* (1981). Courtesy Robert J. Levin.

Chapter 47: Christopher Makos, *Altered Image*. © Chris Makos.

Chapter 48: Robert J. Levin, *Andy Warhol in a Storage Room at The Factory* (1981). Courtesy Robert J. Levin.

Chapter 49: Neil Winokur, *Andy Warhol* (1982). © Neil Winokur.

Chapter 50: Peter Bellamy, *Andy Warhol in a Limousine* (1986). © Peter Bellamy.

Postlude: Blake Gopnik, *Warhol's Tombstone in Pittsburgh* (2014). © Blake Gopnik.

Concluding image: Karen Bystedt, *Andy Warhol*. Reproduced with the kind permission of Karen Bystedt.

## INSERT PHOTOGRAPHS

Andy Warhol, *Crazy Golden Slippers*, 1957. The Andy Warhol Museum, Pittsburgh; Founding Collection, Contribution The Andy Warhol Foundation for the Visual Arts, Inc. 1998.3.3466 © 2019 The Andy Warhol Foundation for the Visual Arts, Inc. / Licensed by Artists Rights Society (ARS), New York.

Gunther Jaeckel display window with art by Andy Warhol, April 1961. Art works © 2019 The Andy Warhol Foundation for the Visual Arts, Inc. / Licensed by Artists Rights Society (ARS), New York.

Andy Warhol, *Three Marilyns,* 1962. The Andy Warhol Museum, Pittsburgh; Founding Collection, Contribution The Andy Warhol Foundation for the Visual Arts, Inc. 1998.1.60 © 2019 The Andy Warhol Foundation for the Visual Arts, Inc./Licensed by Artists Rights Society (ARS), New York.

Andy Warhol, *Little Electric Chair,* 1964–1965. The Andy Warhol Museum, Pittsburgh; Founding Collection, Contribution The Andy Warhol Foundation for the Visual Arts, Inc. 1998.1.14 © 2019 The Andy Warhol Foundation for the Visual Arts, Inc./Licensed by Artists Rights Society (ARS), New York.

Andy Warhol, *Mao,* 1972. The Andy Warhol Museum, Pittsburgh; Founding Collection, Contribution Dia Center for the Arts 1997.1.21.© 2019 The Andy Warhol Foundation for the Visual Arts, Inc./Licensed by Artists Rights Society (ARS), New York.

Andy Warhol, *Nan Kempner,* 1973. The Andy Warhol Museum, Pittsburgh; Founding Collection, Contribution The Andy Warhol Foundation for the Visual Arts, Inc. 1998.1.593 © 2019 The Andy Warhol Foundation for the Visual Arts, Inc./Licensed by Artists Rights Society (ARS), New York.

Andy Warhol, *Ladies and Gentlemen (Wilhelmina Ross),* 1975. The Andy Warhol Museum, Pittsburgh; Founding Collection, Contribution Dia Center for the Arts 2002.4.22 © 2019 The Andy Warhol Foundation for the Visual Arts, Inc./Licensed by Artists Rights Society (ARS), New York.

Andy Warhol, *Shadows,* 1978–79, detail view. Photo: Bill Jacobson Studio, New York. Courtesy Dia Art Foundation, New York © 2019 The Andy Warhol Foundation for the Visual Arts, Inc./Licensed by Artists Rights Society (ARS), New York.

Andy Warhol, *Rorschach,* 1984. The Andy Warhol Museum, Pittsburgh; Founding Collection, Contribution The Andy Warhol Foundation for the Visual Arts, Inc. 1998.1.297 © 2019 The Andy Warhol Foundation for the Visual Arts, Inc./Licensed by Artists Rights Society (ARS), New York.

Andy Warhol, *Jean-Michel Basquiat,* ca. 1982. The Andy Warhol Museum, Pittsburgh; Founding Collection, Contribution The Andy Warhol Foundation for the Visual Arts, Inc. 1998.1.499. © 2019 The Andy Warhol Foundation for the Visual Arts, Inc./Licensed by Artists Rights Society (ARS), New York.

Andy Warhol, *The Last Supper,* 1986, detail © 2019 The Andy Warhol Foundation for the Visual Arts, Inc./Licensed by Artists Rights Society (ARS), New York.

# INDEX

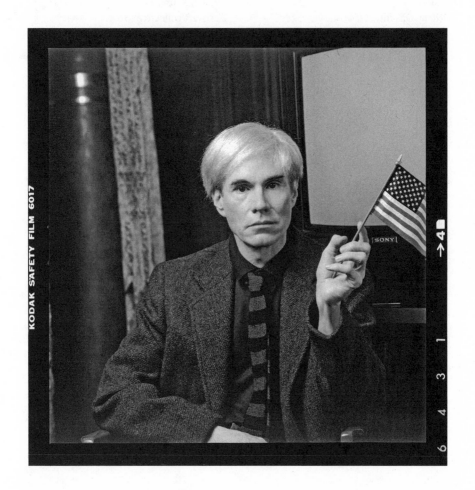